*THE GLORY OF VENICE*

| DATE DUE | | | |
|---|---|---|---|
|  |  |  |  |
|  |  |  |  |
|  |  |  |  |
|  |  |  |  |
|  |  |  |  |
|  |  |  |  |
|  |  |  |  |
|  |  |  |  |
|  |  |  |  |
|  |  |  |  |
|  |  |  |  |
|  |  |  |  |
|  |  |  |  |
| GAYLORD |  |  | PRINTED IN U.S.A. |

*Art in the Eighteenth Century*

# THE GLORY

Royal Academy of Arts, London, 1994 / National Gallery of Art, Washington, 1995

Jane Martineau and Andrew Robison *Co-editors*

# OF VENICE

*Yale University Press*   *New Haven & London*

In Washington the exhibition is made possible by generous support from Mobil Corporation

This catalogue was first published on the occasion of the exhibition
*The Glory of Venice: Art in the Eighteenth Century* organised by the National
Gallery of Art, Washington, and the Royal Academy of Arts, London

Royal Academy of Arts, London
15 September–14 December 1994

National Gallery of Art, Washington
29 January–23 April 1995

In Washington, the exhibition is supported by an indemnity from the
Federal Council on the Arts and the Humanities.

Sponsored in London by Sea Containers Ltd.
in association with its Hoverspeed,
Venice Simplon-Orient-Express, Hotel Cipriani,
Hotel Splendido and Villa San Michele subsidiaries

Banking facilities have been provided by Banco Ambrosiano Veneto

The Royal Academy is grateful to Her Majesty's Government for its help in
agreeing to indemnify the exhibition under the National Heritage Act 1980,
and to the Museums and Galleries Commission for their help in arranging
this indemnity.

Catalogue design by Derek Birdsall RDI
Typeset in Monotype Poliphilus with Blado Italic by Servis Filmsetting Ltd
Printed in Italy by Fantonigrafica-Elemond Editori Associati

© 1994 Royal Academy of Arts, London

ISBN 0-300-06185-4 (cloth)
      0-300-06186-2 (pbk)

Library of Congress Catalog Card no. 94-61010

Cover illustration: (front) Canaletto, *A Regatta on the Grand Canal* (detail),
1733–4 (cat. 136) Her Majesty The Queen

(back) Giambattista Tiepolo, *Rinaldo and Armida in her Garden* (detail), *c.*
1745 (cat. 90) The Art Institute of Chicago, Bequest of James Deering

*Exhibition Coordinators*
Annette Bradshaw
Cameran G. Castiel
Charlotte Stirling
Elaine Trigiani

*Editorial Coordinator*
Robert Williams

Translation from the Italian by Caroline Beamish
Translation from the German by Alisa Jaffa

*Photographic Coordinator*
Miranda Bennion

*Installation design in London:*
Jasper Jacob Associates

*Installation design in Washington:*
Gaillard Ravenel, Mark Leithauser, Gordon Anson

# Contents

# Committees

# Foreword

Irresistibly we are drawn to Venice to celebrate that extraordinary city's capacity to inspire great art. It is now more than ten years since the Royal Academy mounted *The Genius of Venice*, which was dedicated to Venetian art of the sixteenth century. The National Gallery has presented several exhibitions of Venetian graphic art as well as paintings by two of its greatest masters, Titian and Veronese. So it seems only natural that our two institutions should combine resources and turn our attention to the second great flowering of Venetian art in the eighteenth century.

In the eighteenth century Venetian artists once again achieved a dominant position. They succeeded not only in reviving the genius of the age of Titian, and particularly, of Veronese, but also in looking forward, with Piranesi and Canova, to the Neo-classicism and Romanticism of the first half of the nineteenth century. But above all the eighteenth century belongs to Giambattista Tiepolo, an artist of seemingly boundless virtuosity, who perhaps more than any other of his generation represents all that was magnificent in pre-revolutionary Europe. Venetian artists were sought-after throughout Europe. Sebastiano Ricci worked for Lord Burlington, as visitors to the Royal Academy can see today; Piazzetta, who produced some of the most noble religious paintings and most romantic idylls of his age, sent them throughout Europe during his lifetime; Tiepolo painted some of his greatest frescoes in Würzburg and in Madrid; the pastels of Rosalba Carriera were the toast of Paris; Canaletto, as can be seen from one of his finest works borrowed from Prague, painted the Thames with no less facility than the Grand Canal; Bellotto immortalised the great cities of Central Europe – Dresden, Vienna and Warsaw; the sculptor Canova defined a style that was to dominate European and American sculpture until the arrival of Rodin. Venice was the most dynamic, enterprising and outward-looking artistic centre in the eighteenth century, rivalled only by Paris.

That the exhibition should be able to demonstrate this so conclusively is due to the enthusiasm and cooperation of many individuals: Dr Andrew Robison of the National Gallery of Art has been the curator of the show, working in close cooperation with Jane Martineau and Norman Rosenthal of the Royal Academy; Sir Michael Levey has from the inception of the project given freely of his advice and has written a most perspicacious and entertaining introduction to our catalogue. The burden of editing this volume and of seeing it through the press has fallen on the shoulders of Jane Martineau and Andrew Robison; to them, and to all the authors of this volume, we offer our sincere thanks.

As always, an exhibition such as this cannot take place without generous sponsorship, and in London we are particularly happy that Sea Containers Ltd., who in 1983 sponsored *The Genius of Venice*, has agreed once again to underwrite the realisation of the project. In Washington we are delighted that the exhibition has the most generous support of Mobil Corporation. We wish to thank James Sherwood and his colleagues at Sea Containers Ltd. and Lucio Noto and his colleagues at Mobil Corporation for making it possible for us to introduce a new generation to the glory of Venetian art in the eighteenth century.

But it is especially to the many owners of works of art, public and private, that our institutions and their audiences owe the greatest debt of gratitude. Our friends in Venice and the Veneto, Dott.ssa Giovanna Nepi Sciré, Soprintendente ai Beni Artistici e Storici di Venezia, Professore Giandomenico Romanelli, Direttore dei Musei Civici di Venezia, and Dott.ssa Filippa Alberti Gaudioso, Soprintendente ai Beni Artistici e Storici del Veneto, have made many works in their care available and have also opened many doors to us. The way in which the Venetian artists of the Settecento went into the world is reflected also in the fact that many of the most outstanding works are found in museums and private collections outside Italy. To all these friends and colleagues, who have agreed to lend some of their greatest treasures, we extend our warmest thanks.

Sir Philip Dowson CBE
President, Royal Academy of Arts

Earl A. Powell III
Director, National Gallery of Art

# Lenders to the Exhibition

AUSTRIA
Vienna, Graphische Sammlung Albertina 67
Vienna, Kunsthistorisches Museum, Gemäldegalerie 236
Vienna, Austrian National Library 80

CANADA
Montreal, The Montreal Museum of Fine Arts Collection (Musée des Beaux-Arts de Montreal) 92

CZECH REPUBLIC
Prague, Roudnice Lobkowicz Collection 133

DENMARK
Copenhagen, Statens Museum for Kunst 232
Hilleröd, Nationalhistoriske Museum på Frederiksborg 22

FRANCE
Paris, Musée du Louvre, Département des Peintures 204

GERMANY
Berlin, Staatliche Museen Preussischer Kulturbesitz
 Gemäldegalerie 117
 Gemäldegalerie, on loan from the Streit Foundation 51
 Kupferstichkabinett 116, 142, 180
Cologne, Wallraf-Richartz-Museum 78
Dresden, Staatliche Kunstsammlungen
 Gemäldegalerie 254, 255, 260
 Kupferstichkabinett 111
Hamburg, Hamburger Kunsthalle 2, 261
Mainz, Mittelrheinische Landesmuseum 233
Munich, Staatsgemäldesammlungen,
 Leihgabe der Bayerischen Hypotheken- und Wechsel Bank AG 201
Munich, Staatliche Graphische Sammlung 53, 54
Nuremberg, Germanisches Nationalmuseum 5, 71
Potsdam, Stiftung Schlösser und Gärten Potsdam-Sanssouci 162
Stuttgart, Staatsgalerie 39, 52, 123, 131, 234, 235
Worms, Museum Kunsthaus Heylshof 219

GREAT BRITAIN
Her Majesty The Queen 7, 10, 28, 30, 31, 35, 45, 47, 48, 64, 136, 137, 146, 147, 184
Birmingham, Private Collection on loan to Birmingham Museums and Art Gallery 135
Birmingham, The Trustees of the Barber Institute of Fine Arts, The University of Birmingham 40
Cambridge, Lent by the Syndics of the Fitzwilliam Museum 119, 120, 192, 212
Canterbury, The Royal Museum and Art Gallery 208
Chatsworth, The Duke of Devonshire and Chatsworth House Trust 3, 4
Edinburgh, The National Galleries of Scotland 56, 104
Hinton Ampner, The Ralph Dutton Collection (The National Trust) 174
London, The British Library Board 15, 24, 25, 50, 82, 85, 95, 108 154, 158, 169, 177, 249
London, The Trustees of the British Museum 262, 263
London, The Trustees of the National Gallery 124, 138, 220, 221 a, b, c
London, British Architectural Library, Royal Institute of British Architects 246
London, The Trustees of Sir John Soane's Museum 139
London, The Board of Trustees of the Victoria and Albert Museum 19, 20, 21, 110, 165, 207, 258, 259
Oxford, The Visitors of the Ashmolean Museum 127, 175

HUNGARY
Budapest, Szépmüvészeti Múzeum 9, 113, 161

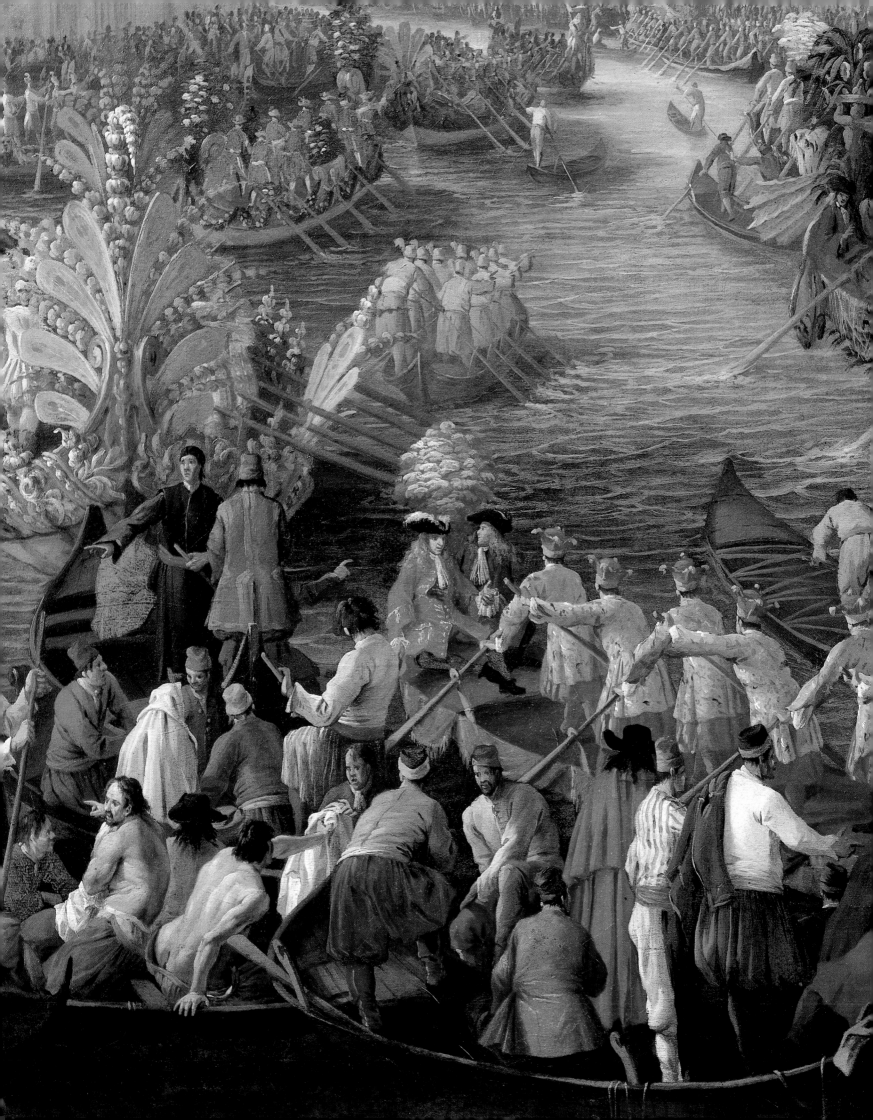

# The Glory of Venice

Andrew Robison

Venice and her territories had many glories in the 18th century, from her physical appearance of winding canals bordered by churches, palaces and squares, to a rich cultural and intellectual life, to her famous and sumptuous festivals, to an international circle of admirers – both of her beauties and of her brains. For our purposes here, however, the glory of Venice in the 18th century was the extraordinary vitality and quality of her visual arts, which endowed not only the city but much of civilised Europe with thousands of outstanding and beautiful works of art. Indeed, the great quality of Venetian 18th-century art struck contemporaries, and this art was immediately successful not only at home but abroad. Throughout the period foreign as well as native merchants, princes, collectors, connoisseurs, prelates and kings sought to acquire works from Venice by her artists, and repeatedly solicited the artists to come to their own cities and towns to work there. Widespread appreciation has varied somewhat from artist to artist and from place to place over the past two centuries, but has continued, so that fine examples of Venetian 18th-century art are now spread throughout the world.

Selected from this rich multitude of surviving works, the present exhibition begins just at the opening of the new century – the earliest works here can be dated to about 1706 – and concludes just at its close – the latest works are from around 1800. Landscapes and views, historical scenes and allegories, architectural fantasies, decorative and humorous pieces are included; and the importance of serious and grand religious art is explored through altarpieces as well as through more intimate works. The criteria for the selection here are primarily five: quality, variety, distinctiveness, balance and delight.

Among the most outstanding qualities of Venetian 18th-century art, perhaps the foremost is that handling of brilliant but warm light which floods so many of its images and cannot fail to remind one of the bright but soft light still frequently encountered in the city and its former territory. Typical Venetian emphasis on colour continued in this period, with artists still using the rich reds, golds and sepias, deep velvety greens and blues from Veronese and his century, but also emphasising soft blues, lilacs and mauves, lighter greens and pinks, and whites of an extraordinary range, from snow to ivory to every shade of cream. Creativity of composition is immediately apparent in specific works, such as Sebastiano Ricci's painting *The Liberation of St Peter* (cat. 8) or Carlevaris's etching *Altra Veduta del'Ponte di Rialto* (cat. 24), but is also made an explicit challenge in entire series like Domenico Tiepolo's 24 etched variations on compositions for *The Flight into Egypt* (cat. 230).

Luca Carlevaris, *Regatta on the Grand Canal in Honour of Frederick IV of Denmark* (detail of cat. 22)

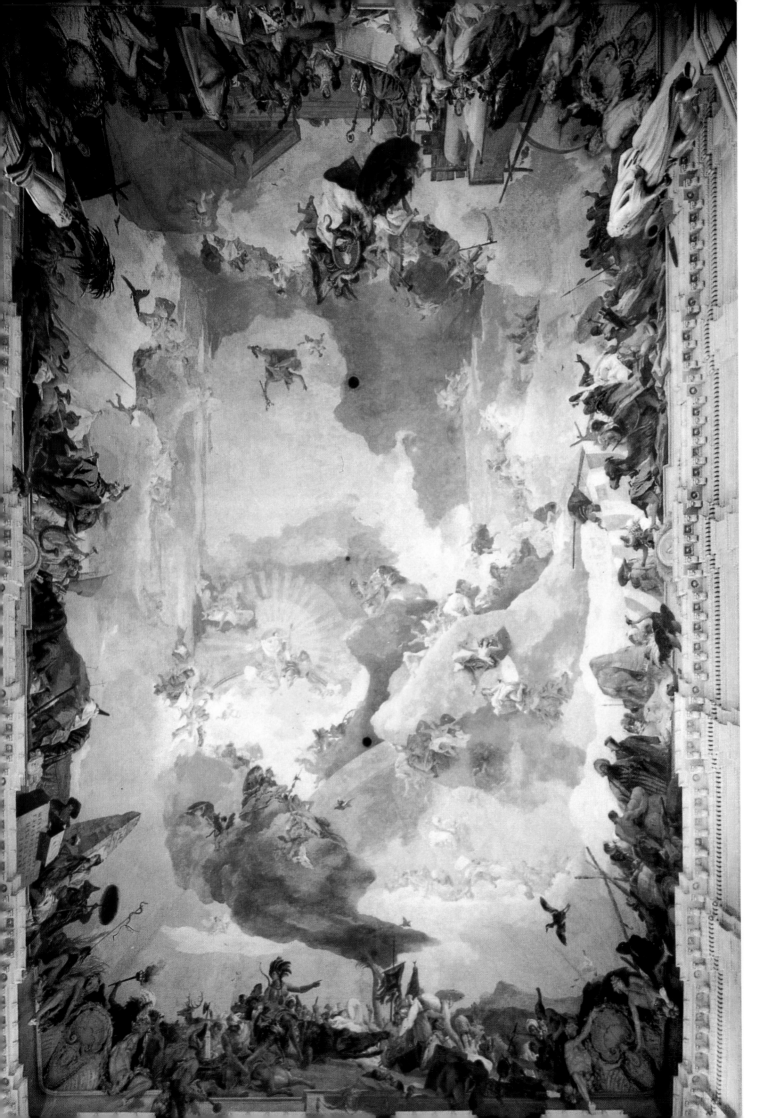

A theatrical sense of gesture, and a delicate, courtly sense of grace dominate much of Venetian art in this period. However, they are joined by an extraordinary range of emotion, from the powerful but quiet nobility of so many of Giambattista Tiepolo's female figures drawn from history, religion and myth to the intense piety of his *St Agatha* (cat. 117) or Piazzetta's *St James* (cat. 70). The true gaiety of Canaletto's *Regatta* (cat. 136) contrasts with the highly sympathetic bourgeois contentment of Pietro Longhi's *The Married Couple's Breakfast* (cat. 184), or the moving pain and despair in the faces of Tiepolo's Apollo and Canova's Orpheus (cat. 114, 285). The expression of intensely real personality is further evident from the head studies included here by Sebastiano Ricci or Amigoni or Nogari to the explicit portrait of the charismatic scholar Carlo Lodoli by Alessandro Longhi (cat. 242), or the searching personal scrutiny of self-portraits by Piazzetta and Rosalba Carriera (cat. 67, 45).

The art of this period also shows extraordinary facility in the handling of media. Typical of many Venetian painters, Pellegrini exults in the sheer, free manipulation of oil paint as a three-dimensional as well as colouristic substance (cat. 39, 40), while Sebastiano Ricci (fig. 2), Tiepolo or Canaletto combine in the same picture the full range, from soft layers of glazes to bold impastos (cat. 5, 90, 136). A similar assured ease and exploratory variety of use occurs in all the artistic media, from the gouaches by Marco Ricci to the pastels of Rosalba, the etchings of Domenico and Lorenzo Tiepolo to the marble of Corradini and Canova. Perhaps this facility occurs above all in the drawings, chalk drawings like those of Piazzetta, and especially the pen and wash drawings by many artists but culminating in those of Giambattista Tiepolo, who created form swiftly and authoritatively through nervously – or effortlessly – searching lines, and almost miraculously fluid but exact indications of shadow and mass through quick flashes of wash.

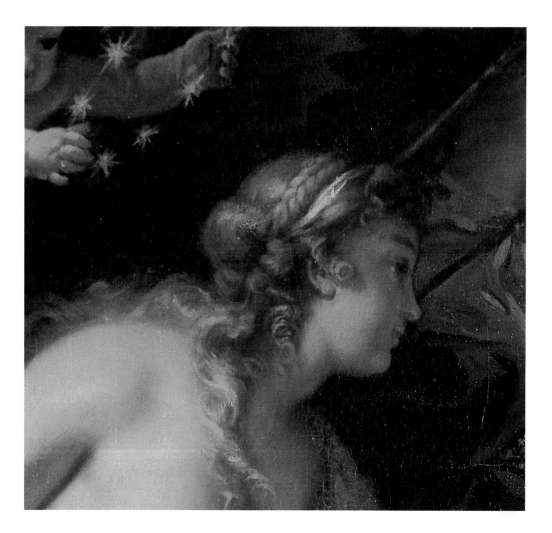

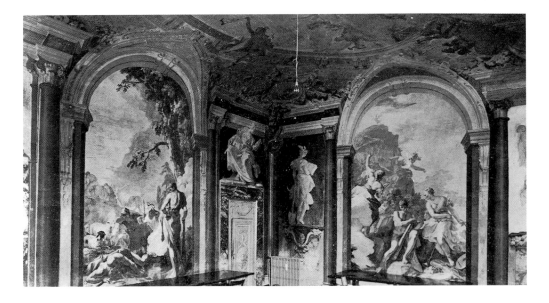

*Figure 3:* Sebastiano Ricci, The Hercules Room, frescoes, *c.* 1706–7, Palazzo Marucelli-Fenzi, Florence, Università degli Studi di Firenze

In showing these qualities, our selection is broad, yet emphasises the finest artists and the finest work of the period. Thus, many excellent and interesting artists appear; however, Giambattista Tiepolo dominates, joined by Piazzetta, Canaletto, Francesco Guardi and Piranesi. The greatest practical limitation on our selection regards fresco painting. With their brilliant light, soft colours and encompassing designs, frescoes are among the greatest glories of Venetian art (fig. 1). They are unforgettable for those who stand below the frescoes painted on soaring ceilings and surrounded by those covering the enveloping walls, which transport one to new worlds (fig. 3). However, monumental frescoes cannot be safely moved, nor can a real sense of their effect be given when fragments are removed from their original setting. In every other respect, we have included works from all those media in which Venetian art was among the best in the 18th century: paintings, drawings, prints, illustrated books, gouaches, pastels and sculpture.

This focus on quality is balanced by a desire to show variety: of artists, media, subjects, periods and styles. One might use 'Venetian' to mean only art created in Venice – or art created for Venice – regardless by whom, including artists from foreign countries. Instead, our portrayal concerns artists born or brought up or trained or long resident in Venice, who saw themselves as Venetian, that is, 'Venetian' art as by Venetian artists. However, among those we have included almost 60 different Venetian artists, and their works created not only in the city and Venetian territories but also in foreign climes. Indeed, one of our main themes is the wide travel of Venetian artists during this period, and their outstanding production abroad as well as at home. Variety of subject has also been a goal. Sebastiano Ricci's elegant mythological and religious subjects may be familiar, but in addition to those we also show more unusual aspects of his interest in, for example, extensive landscape (cat. 11) and design for sumptuous furniture (cat. 12). As examples of stylistic and emotional variety, while popularity has long attended Rosalba's soft and elegant pastels of idealised figures and Pietro Longhi's charming paintings of lighthearted bourgeois genre scenes, we also show how these artists were capable of penetrating realism, with the former's vision of physical ugliness revealing spiritual beauty in *Sister Maria Caterina* (cat. 44), and the latter's moving portrayal of an emaciated man dying in *Extreme Unction* (cat. 185), where Longhi surprises us with an anticipation of the intensity of Goya.

A third primary criterion for our selection has been distinctiveness, works distinctive of these artists from this place and time. Naturally, some characteristics of Venetian 18th-century art are shared with earlier Venetian art, and some with 18th-century art in other countries. Even those shared characteristics may have a special or distinctive flavour here, such as that brilliant but soft

light which one recognises from Ricci to Tiepolo and from Canaletto to Guardi and the early Piranesi, or such as those evocative combinations of figures and symbols in drawings and etchings of capricious compositions which seem to have meanings tantalisingly close to explication but remaining ever elusive.

The unity of the visual arts is characteristic of 18th-century Venice, and though not exclusive to this time and place is a dominant feature and a guiding principle in the selection and the organisation of the exhibition. This unity is seen not only in general stylistic relationships between different artists or works in different media, such as might define characteristics for any school or period, but very concretely through the remarkable spread of activity by major artists into many media. In 18th-century Venice an unusual number of the foremost painters also produced original prints, from Carlevaris and Marco Ricci to all the Tiepolos and Canaletto, Marieschi, Fontebasso and Bellotto. Further, the revival of great book publishing in Venice during this period owes much to the extended participation of major artists in preparing designs for illustrated books. Piazzetta and Giambattista Tiepolo are only the most famous to be extensively involved in illustrating books, and they were joined by many others, from Balestra at the beginning of the century to Novelli at the end. Leaving aside monumental architecture, stage design was also practised by many of these artists. In addition, their drawings show their attention ranged further over what we now call the decorative arts, especially interiors, wall designs, furnishings and festival gondolas (fig. 4). Examples of all these works extended through various visual arts have been included, integrated with other works by the same artists to show both the breadth of their range, and the coherence between the arts.

*Figure 4:* Giambattista Tiepolo, *Festival Gondola*, pen and brown ink and wash with watercolour on paper, 46.9 × 78.9 cm, *c.* 1740, Private Collection

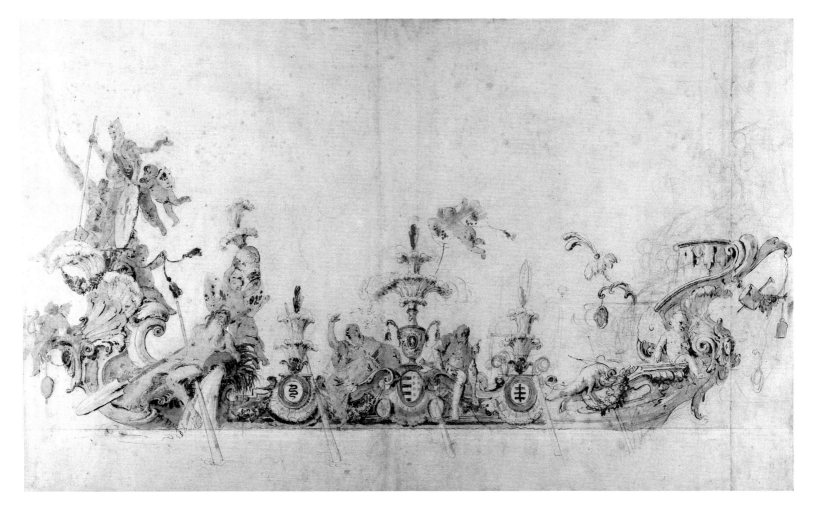

Balance is one of the main goals in our selection, though one of the most difficult criteria. Venetian art for Venetians was predominantly religious, eulogistic, or lighthearted and humorous. For many foreign visitors to her territories, the charms of prospects in the city were dominant, and recorded in innumerable views. Artists and scholars sought and found great art works of the past, both in their original locations and in recent Venetian collections. For some of the more perceptive of the foreigners – one thinks of the Goethes, father and son, or of Lady Mary Wortley Montagu – the intellectual freedom, the seriousness of republican virtues in an age of monarchies, the culture of sophisticated conversations and bookshops were dominant features of Venice and the Veneto. And for the less perceptive, Venice as city of pleasure, gambling and licence and showy entertainments was what they remembered. In the remarkable way that Venice and the neighbouring mainland still absorb so many visitors, show so many different aspects to their residents and transients, so did they then. While her art can be mined for examples to support many of these aspects, balancing them all is the trick we have tried.

Finally, one criterion for selection of 18th-century Venetian art has to be delight: to inform, to surprise, but also to charm. Making a selection with severely limited numbers inclines one to choose the grand works, those that have impact in their scale, complexity and power to represent their artists at the most impressive. Venetian art in this period certainly offers many such works. However, as one of the characteristic pleasures of this art is also the small, the intimate, the charming in the best sense of the word, we have tried to retain some space for examples of this lighter side. Zanetti's caricature of himself drawing a caricature (cat. 47), Faldoni's simple but ravishing portrait of a Venetian bluestocking (cat. 50), Francesco Guardi's imaginary ruins in paintings smaller than one's palm (cat. 221a, b, c), or Novelli's sketch of a boy holding up his baby sibling to watch the peep-show (cat. 251), works like these have to find their place in any true portrayal of the glory of Venice.

Rather than organising our selection by media or by theme, we have attempted to keep together works by the same artist, including all those in different media, as far as conservation restrictions allow. For the most important artists with the greatest number of works, such a monographic grouping forms a complete section of the exhibition. For others, several artists' works are grouped together into sections according to relationships of period, subject and style. These sections proceed in a generally chronological fashion through the century until the final ones, which exception is explained below.

The multi-media approach to each artist seems appropriate in an age in which the same artist was interested in such a variety of media, and where one medium, for example oil painting, was no longer so exclusively important or exclusively representative of the finest art, as opposed to other forms. With this integrated arrangement, 18th-century Venetian art yields not only such obvious comparisons as, say, between preparatory drawings and finished works, but also interesting relationships to give a more complete and adequate picture of an artist's range and personality. For example, Giambattista Tiepolo was interested in mysteriously capricious subjects involving exotic oriental figures in settings with echoes of antiquity, as we know not from his paintings but from his drawings, and above all from his etchings (cat. 111, 112). He also had great feeling and capacity for caricature, which is barely perceptible in paintings or etchings, but extensively in drawings (cat. 122). And, while I can think of no evidence from his paintings or drawings that Tiepolo was even faintly anti-authoritarian, one of his finest designs for book illustrations, the headpiece for a chapter in an edition of Milton (cat. 108), shows Death as Sin's companion dressed in robes which are provocatively reminiscent of those he uses for ecclesiastics and monarchs. Indeed, the mere fact that major Venetian artists like Tiepolo and Piazzetta, so intensely Catholic in their religious paintings, would contribute so

openly and effectively to a fundamentally Protestant, even Puritan, project like the elegant publication of Milton's *Paradise Lost* already gives a broader picture of their intellectual and cultural range.

The patterns of influence between the media in this period are complex, and also argue against separating them. Important paintings have always influenced other arts, as Piazzetta's *The Supper at Emmaus* (cat. 61) provoked Antonio Guardi's drawing of the same subject (cat. 193), or Giambattista Tiepolo's paintings inspired his sons' etchings (cat. 231, 240). But in this period one may also find a Piazzetta drawing of *Erminia and the Shepherds* (cat. 81) being transformed into an engraving to illustrate a book (cat. 80, 82), which book illustration the Guardis then copied on a vastly expanded scale into a major oil painting (cat. 191). Or a print made by Piranesi in Rome but brought back to Venice (cat. 264) gives the basic composition for Canaletto to make a painting and a finished drawing when he goes to London (cat. 146). While it is understandable that Rosalba's pastels (cat. 43) might influence her oil paintings (cat. 46) both in subject and style, it is perhaps characteristic of this period that not only her images (fig. 5) but also her pastel style should influence no less a painter (and not a pastellist!) than Giambattista Tiepolo (cat. 127).

*Figure 5:* Rosalba Carriera, *Courtesan with a Parrot*, pastel, 59.8 × 50 cm, 1720–1, The Art Institute of Chicago, Helen Regenstein Collection, 1985.40

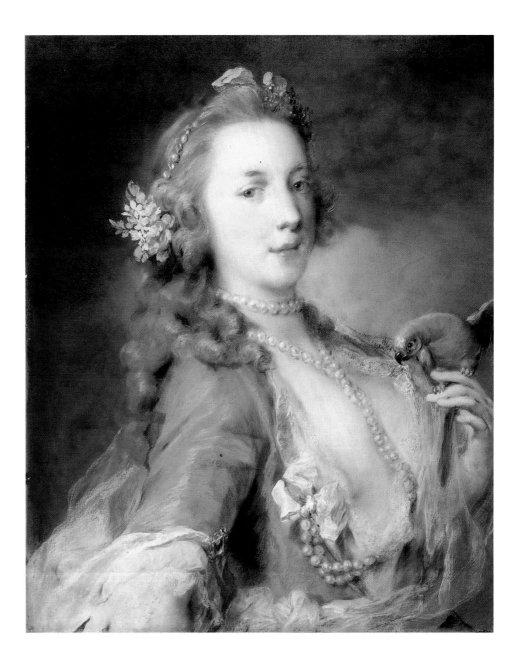

The great advantage of a survey as opposed to a single artist's selection is, of course, that one may find striking comparisons simultaneously to support the awareness of mutual influence of artist on artist, as well as the distinctions between artistic personalities. To see in juxtaposition Tiepolo's *Martyrdom of St Bartholomew* (cat. 94), painted just after Piazzetta's *St James led to Execution* (cat. 70), and for the same church, leads to reflections on the younger artist's homage to the older, what in his early years Tiepolo took from Piazzetta, and how much he changed even then. We have tried to provide many of these direct comparisons. For example, the masterpiece of Carlevaris's regatta paintings (cat. 22) can be seen near the masterpiece of Canaletto's (cat. 136). The lighthearted self-reflection on a portrait painter in his studio by Giambattista Tiepolo (cat. 92) can be compared to that by Longhi (cat. 183) and that by Domenico Tiepolo (cat. 225), where the subject is transformed into an entertainment for children. The quality of finished head studies is well known for Rosalba (cat. 43–6), Piazzetta (cat. 63, 66–8) and Tiepolo (cat. 115–16), but is also clear for Sebastiano Ricci (contrast cat. 6 with cat. 7), some of Amigoni's strongest drawings (cat. 53, 54), and continuing from the exoticism of Antonio Guardi (cat. 192) to the realism of Giuseppe Nogari (cat. 179). Providing numerous examples of these direct comparisons, running like leitmotifs through the sections of the exhibition, has been one of the most interesting aspects of selecting the works, and we hope they will likewise intrigue the visitor.

Just as the richness of Venetian art during the early- and mid-18th century allows for multiple readings of its themes, so the variety of Venetian artists in the second half of the century allows for varied interpretations of the end of the era. Concentrating on the Venetians' inability to resist the military tidal wave of Napoleon's conquests at the end of the century, which led to the destruction of the Venetian state, and combining that with a limited selection from tourists' accounts which emphasises a whirl of parties and festivals and the self-enclosed remoteness of the Venetian nobility, one may portray Venetian life as increasingly divorced from concrete political and economic realities in the world at large and thus increasingly fragile in status. One may look for parallels of fragility or unreality in certain artistic developments, such as Francesco Guardi's frequent use of a delicate stylised line, theatrically mannered figures and lightness of form in his late works, and see his coincident removal from the harder realities of his earlier style and of Canaletto as emblematic of social and political developments toward the end of the glory of Venice. Alternately, similar political and societal themes can be said to be found artistically by focusing on those cases in such late artists as Novelli or Domenico Tiepolo, where figures and compositions from earlier artists' grand or serious works are sometimes reused and transformed into modish or humorous versions, and – I believe falsely – isolating those aspects of their art as indicating a narcissistic self-reflection aware primarily of high fashion and manners rather than more serious external developments, leading to an enclosed and melancholic end to the artistic glory of Venice in the 18th century.

In this exhibition, however, continuing the theme of the peripatetic Venetian artists seen throughout this period, we have chosen to end our story with three such artists from the second half of the century, Piranesi, Bellotto and Canova. Not only do they, coincidentally, represent an artistic culmination in three different media: graphic art, painting and sculpture; all three also stand out in two further ways.

Other peripatetic Venetian artists – the Riccis, Pellegrini, Amigoni, the Tiepolos, Canaletto – travelled as far as or further than these three. In general, however, the former largely continued to work in a Venetian style little influenced by the art of the countries they visited; indeed, that was just what they were hired for; and they always seemed oriented towards returning to their native Veneto. With Piranesi, Bellotto and Canova, after they trained in Venice and absorbed

her art and developed their early mature style, they left the territory. While they returned to visit their native city, effectively they went to live in foreign cities and countries where their Venetian style developed in new ways in reaction to the art and the nature they experienced abroad. None the less, they continued in many ways to think of themselves as Venetian. Piranesi called himself a 'Venetian architect' for decades after he moved permanently to Rome. Bellotto appropriated his uncle's Venetian name and signed himself 'Canaletto' until he died; indeed, in 1765, after great success in the North, and being by then the foremost painter in Dresden, Bellotto symbolised his success by portraying himself in the dress of a Venetian Procurator. Even after the close of the century Canova tried to obtain from Venice paintings by Tiepolo as well as views of his native city, and at the end of his life Canova chose to return to Venice to die.

The primary reason we end with Piranesi, Bellotto and Canova is because all these Venetian artists from the second half of the 18th century set important precedents and exerted influences not only on the art of their time but also on the art and culture of the next century. Thus, these three highlight the continuing importance of Venetian 18th-century artists after Napoleon's destruction of the Venetian state in 1797. Piranesi is perhaps unique in having such a widespread influence not only on writers and artists of Romanticism, but also on wide varieties of Neo-classical art, from the refined forms of Robert Adam to the imaginary extravagance of Boullée and Ledoux. Bellotto's sensitivity to the shapes and colour and atmosphere of landscape, seen from his early paintings (cat. 253), developed to such sensitive portrayals of the natural world in his late works (cat. 256) that one can hardly resist thinking of their prescience for the great French landscape painters of the early 19th century, whereas his striking composition of ruins (cat. 260) might as easily be seen as precedent for German Romantics. Finally, Canova, who at the start of his career reflected Baroque or Rococo Venetian interests (cat. 284), also stood in a continuing Venetian tradition of classicism, and became such a hero of Neo-classicism throughout Europe that his role can hardly be overemphasised. Thus, Venetian art in this period contains many elements which may have passed from fashion to be revived in appreciation by much later observers; but these three artists at the end serve as a reminder that in some crucial ways the glory of Venice also contains elements which survived the destruction of the Venetian state to play their role in the development of European art and culture in the immediately succeeding decades.

# Introduction to 18th-Century Venetian Art

Michael Levey

I

*Venice the bell from every city bore, —*
*And at the moment when I fix my story,*
*That sea-born city was in all her glory.*
Byron : *Beppo*

Taking as its subject great yet easily assimilable art, from a famously civilised and articulate century, in a world-renowned city familiar even to those who have never visited it, this exhibition may seem at first sight to require nothing so portentous-sounding, or so formal, as an Introduction.

After all, it is one of the great, indeed glorious, achievements of Venetian art at the period that it re-created – and has fixed indelibly for us – the appearance of Venice, its canals, squares and churches, its lagoon setting, its customs and its inhabitants, through countless paintings and drawings and prints. They are marvellously informative social documents, as well as being marvellous works of art. Never before, and never since, has one city been the subject of such an extensive and detailed artistic survey.

There still remains plenty to explore and comprehend in those works of art, but leading creators of them like Canaletto and Francesco Guardi, and Pietro Longhi, nowadays need no introduction. Rather, it is they who can often serve, better than words, to introduce us to their city in their century.

Less obviously perhaps, but no less compellingly, do the successive generations of the figure painters, Sebastiano Ricci, Pellegrini, Pittoni and Giambattista Tiepolo, speak of Venice, recalling the long tradition there of sensuous, colourful, essentially painterly painting, exercising its spell over Europe. Other categories of picture as interpreted there, like the landscape and the portrait, contribute to bring Venice to mind, alluring us rather than roughly insisting upon our attention. And the whole concept of the 'caprice' composition, etched and drawn, in addition to being painted, seems a thoroughly Venetian one in its mixture of the factual and the fanciful, of the serious and the whimsical, asserting the freedom of the imagination.

Even if no paintings had existed, we would still be wonderfully well-informed about 18th-century Venice – and have evidence of the amount of artistic activity there – through the medium of the print. Of course there were also, and often related, drawings of every kind and of the greatest beauty. It was the print, however, which developed into being a Venetian speciality, and this exhibition offers a good idea of its range and its quality. Whether original in composition or reproducing some painting or drawing, prints helped disseminate knowledge of an artist's work beyond Venice. Skilful technique resulted in prints which reproduced the character of drawings so well, even to conveying the medium of those, that they could almost pass as originals.

Venetian drawings and prints of the period lead on to the illustrated books, handsome in themselves and often very handsomely bound. They too are redolent of Venice. The city and its artistic ideals fall into accord, and are conditioned by – contained within – the larger sphere of the century.

The 18th century does not immediately appear remote, either in time or as a concept. We have been told often enough that it was an age of elegance and indulgence – and also one of reason. Society everywhere seems to have been pervaded by an atmosphere of *douceur de vivre*, difficult to recapture and sometimes liable to sound like a cross between Chanel No. 5 and aerosol room-freshener. Something combustible was also in the air, however, and the century culminated in an explosion that wiped any smiles of hedonism and reason off society's face. The French Revolution abolished the French monarchy, but revolutionary repercussions spread far beyond France. The old, established order of Europe received a severe collective fright, and before the century closed it was confronting the unforeseen and threatening figure of Napoleon.

Although Venice survived as a city, as a power the Venetian Republic notoriously did not. Politically and economically, it had been dwindling and decaying for most of the 18th century. And in 1797 the last in the line of 120 Doges, going back to the 7th century, abdicated, in recognition of the *fait accompli* of Napoleon's victories in North Italy. Venice became an appendage of the Austrian Empire.

The fate of the city which for centuries had been the centre of a mighty maritime empire would move more than one great English poet to mourn: 'When her long life hath reach'd its final day'. But increasingly during the previous decades shrewd external observers had detected its decline. It had become a famous tourist attraction, outwardly still serene and splendid, still going through all the symbolic ceremonial of ruling – even of ruling the Adriatic – but inwardly it was rotting.

Looked at like that, the spectacle has, at least in retrospect, its own fascination. And the fascination is greatly heightened by the fact that those years from 1700 onwards are the very period when the visual arts of Venice flared up in a final, multifarious and brilliant blaze. The darker the background the more thrilling the spectacle – as of an extravagantly illuminated liner heading for the rocks. Sunset, with all its pleasurable and poignant associations, has often seemed the suitable hour to evoke for the atmosphere around the sinking ship of the Republic.

Nor can one deny that there is aptness in the metaphor. Regardless of the end of the Republic, it was the close of greatness for painting in Venice. None of the geniuses of the period left any vigorous artistic posterity. Giambattista Tiepolo really was the last grand-scale imaginative painter, not solely of Venice but of Italy. The death of Francesco Guardi in 1793 (a few days before Louis XVI went to the guillotine, incidentally) sounded the knell of the whole Venetian school of painters, though hardly anyone noticed or cared. None of the chief figures lived to be aware of the humiliating collapse of the Republic in 1797 – with the exception of Canova. But by then he had settled and become celebrated in Rome.

Like Goya and like David, Canova successfully carried his art out of the old, *ancien régime* world into a 'modern' one. Unlike them, he enjoyed a career which increased in fame and honours the longer he lived. Indeed, he might be said to have had his revenge for Napoleon's humbling of Venice, since aesthetically he conquered the conqueror and subsequently would be involved in the return to Italy of at least some of the works of art removed to Paris by Napoleon.

Such references remind us of how fast, as well as violently, events had moved, and how distant consequently had become the life and arts once flourishing specifically in 18th-century Venice. The explosion of the Revolution and the fall of the Republic had sealed all that off for ever, making it far more remote than would be suggested by mere chronology.

For Venetian art there were and there remain (as there tend to do for *ancien régime* arts of the period generally) obstacles to reaching any just, appreciative understanding. While the art produced took on a certain glamour (whiffs of *douceur de vivre* are noticeable), it also attracted a certain disfavour, partly because it seemed to be bound up with a decaying system of government and a doomed, presumed hectic style of carnival life: 'The revel of the earth, the masque of Italy!'

In reality, although it may have suited the government to encourage that image, and thus attract revenue to the city, there was nothing of revelling about the Venetian state as such. Its grandeur and gravity, embodied in its red-clad Senators, were almost anachronistic, and there was some piquancy in a Europe of monarchs and princes in the tremendous, impersonal dignity of a state that continued to be a republic. Its workings appeared the more aloof and mysterious, and they were meant to be. Contact was not encouraged between foreign ambassadors and the nobility, themselves a fairly closed circle. Nor was the government inactive. Quite apart from the promulgation of laws, it had a system of spies and kept a firm, suspicious surveillance over morals and political opinions, especially as disseminated through books and even by the spoken word. Rose-tinted as were the recollections of *ancien régime* Venice published by the singer Michael Kelly in his *Reminiscences* (1826), he also recalled the warning given to him by a theatre manager there in 1782: 'never utter one word against the laws and customs of Venice'. More sophisticated people needed no warning.

The city experienced by the foreign visitor, especially if he or she came idly, without any specialised interest or purpose, provided a spectacle for the eyes – and for the ears, since music was so prevalent – but was not easily penetrated in more profound ways. With regular processions, feasts, opera, concerts and the daily 'theatre' of lively bustle in the Piazza S. Marco, Venice may have appeared on the surface delightfully or deplorably hedonistic, according to taste. Not every visitor had a temperament as cool as Gibbon's or could pass such a stinging judgment that the spectacle had afforded him, 'some hours of astonishment and some days of disgust'.

Behind the orchestrated show, there existed other Venices, religious, literary and – often forgotten – labouring. It was among Canaletto's achievements, as stressed in the final paragraphs below, to depict the latter. There was a Venice of sober erudition as exemplified in the aristocratic scholar Flaminio Corner (Cornaro), patiently studying the history of the Venetian churches, and publishing his studies in numerous volumes. More relaxed and social literary activities are represented by Gasparo Gozzi, poet, prose writer and journalist, who edited a Venetian journal, *La Gazzetta Veneta*, in the years 1760–1. In a male-dominated society there were yet one or two women writers, including Gozzi's admired wife, Luisa Bergalli (see cat. 50). Gozzi's younger brother, Carlo, was also a poet and writer of plays and satiric fables, a champion of the old *commedia dell' arte* traditions, who opposed the 'realistic' innovations of the most famous playwright of the period, Goldoni, whose work has kept its vitality. We think of Goldoni primarily as a writer of amusing, naturalistic comedies but he was also the writer of many opera libretti, and he wrote one serious play, *Pamela*, performed in Venice in 1750, based on Richardson's widely read novel.

Even the literary quarrels and rivalries, and the polite 'light' literature of the day, which time has turned insipid if not heavy, point to activity. To relate the literary life to the visual arts is a complex, somewhat tenuous matter, though one or two references occur *en passant* below. Count Francesco Algarotti, himself a peripatetic, cosmopolitan figure, dropping in on his native city, was probably unusual in uniting strong literary ambitions (see cat. 85) with equally

strong and perhaps more instinctive interest in painting, especially contemporary Venetian painting. The friendship he established with Giambattista Tiepolo was itself untypical – at least on Tiepolo's side, for he was not comparably friendly with any other *littérateur*.

Music in 18th-century Venice is a topic too vast for treatment here, but too important to be passed over unmentioned. For one thing, it was probably the one area where native and foreigner met, literally or metaphorically, and certainly in admiration of contemporary music-making. As well as the opera, Venice provided concerts associated particularly with the four chief charitable foundations of the Ospedali, of which the Pietà (see cat. 125) has a double claim on cultural interest, since to its celebrated female orchestra and singers, and its employment of a famous composer, Vivaldi, who has returned to fame in the 20th century, can be added the architectural, sculptural and pictorial importance of the church of the Pietà, a focus of artistic activity of every kind around the mid-18th century.

Vivaldi, described by the French traveller, the Président de Brosses, in 1739, as 'an old man with a mania for composing', left Venice for Vienna in 1740, dying there in the following year. A priest, and the composer of music for the Pietà, he also composed operas and plenty of other secular music, as did Baldassare Galuppi, who lived to 1785 and was from 1762 *Primo Maestro* of S. Marco, where the music was more strictly liturgical. *Pace* Browning, Galuppi never wrote a 'Toccata'. Music in S. Marco is the subject of an elaborately finished late drawing by Canaletto (dated 1766) and annotated by him as of the '*Musici che canta nella Chiesa ...*' (Kunsthalle, Hamburg).

The Président de Brosses and Michael Kelly are merely two witnesses, of different dates, and among many, to the Venetian passion for music. Since Mozart visited the city with his father in 1771, it would be nice to have his or their views, but the evidence is somewhat ambiguous, although Leopold Mozart wrote home complacently of the social demand on them from members of such noble families as the Cornaro, Grimani, Mocenigo, Dolfin and Valier. And Mozart was contracted to write an opera for 'the magnificent and noble theatre of San Benedetto', for performance in a subsequent Carnival season – which he never did. But the Mozarts gave a concert in Venice, and what a concert might be like in those years is conveyed in a slightly later drawing by Francesco Guardi (cat. 208).

Ultimately, for the ordinary daily life of Venice, as experienced by Venetians, of every class, there is the prolific evidence offered by Canaletto. Once only did he present, and on a notably large scale, a conspectus of society which ranges from a figure of the Doge, through the ranks of Senators and ambassadors, to a dwarf, in his memorable painting of the Doge processing on St Roch's Day from the church of S. Rocco (cat. 138). Most artistic concerns of Venice are there or are adumbrated, for it includes the annual exhibition of paintings which took place in the *campo* outside the church, and it shows the church façade under boarding while a new, more handsome, one is being executed. Not too fancifully can we postulate music at the mass the Doge has just attended. And we can definitely document current improvements to the church interior, including the striking statue of the young, turbaned *David* by a leading sculptor, Marchiori (fig. 6). Since the slightest provocation, such as the official 'entry' of a Senator on appointment as a Procurator of S. Marco, served for the publication of complimentary literary effusions (e.g. cat. 83), something similar might have commemorated at least a Doge's first official visit to S. Rocco. What is unmissable in Canaletto's composition is the blend of the dignified and the informal, of a great Venetian state occasion set amid the ordinary Venetian people.

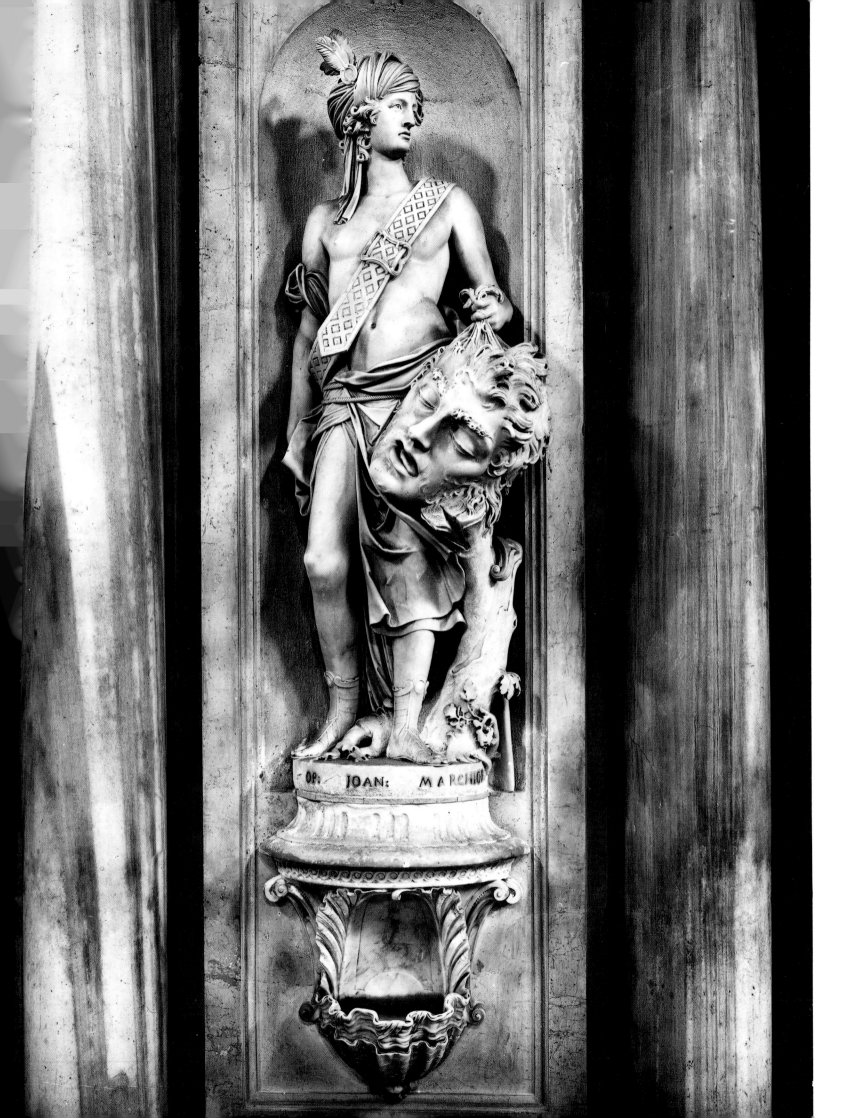

OP: JOAN: MARCHIOR

The painting transcends conventional ideas about the view-picture, and in itself it corrects any lingering tendency to see 18th-century Venice as a sort of proto Las Vegas. For that relief there should be much thanks. Canaletto is admittedly not a social historian but he constantly convinces us of being not a propagandist, though he is proud and patriotic, but a keen-eyed, unofficial surveyor of Venice in most of its visible aspects. He reports on a city being cared for physically, being renovated frequently and often being substantially enhanced by new buildings. Perhaps Francesco Guardi, living into more vexed times, seems better at hinting that Venice is on the wane. Yet it would be well to be cautious about such an interpretation, for Guardi is quite at home delineating a high society wedding-feast (cat. 209), taking place after the French Revolution had broken out, and he bothered to record one of the latest buildings put up in 18th-century Venice, the secular temple of a new opera house, the Teatro La Fenice, inaugurated in 1792. As Wilde's Dr Chasuble remarked in another context, 'that scarcely points to any very serious state of mind at the last'.

Art historically, 18th-century Venetian art has suffered from several disadvantages, beginning with some under-valuing of the tradition of 16th-century art, that above all of Veronese, from which it partly derives. Then there is the fact that in its own century aspects of it already met with indifference, tinged with hostility, occasionally even in Venice. And finally, it suffers from being inevitably overshadowed by the massive, respected, arguably 'progressive' achievements of art elsewhere in Europe in the two centuries which flank it. When the solemn pageant-drama of Western Art is being staged, the arts of 18th-century Venice are bound to make only a fleeting, rather fragile appearance. In that performance they are not so much an interval but the equivalent of a quick drink in the interval, pleasant, doubtless, but a bit of a diversion.

This exhibition provides an opportunity to consider whether delight and refreshment, which are indeed qualities inherent in much of the art created, constitute the whole story, especially when that story includes, if only by implication here, a chapter on the churches, built as well as adorned to the greater glory of God (though also to Venice). Steady emphasis on the allure and colour and invitation to visual pleasure exuded by some of the art can lead to unfortunate assumptions that it must therefore be insufficiently profound and 'good' – for puritan notions taken long to die, not least in art-historical circles.

The reputation of Giambattista Tiepolo, who in confident, creative sweep of genius was the Rubens of his century, probably still suffers from the popular connotations of his city and his period. Questions may be raised about how seriously he could exercise his imagination in a climate of 'reason'. And such questions were being formulated, tacitly or otherwise, in his own sceptical, sophisticated age, touching on the controversial matter of what is 'true' and 'false' in art. It was a significant moment when in 1760 Gasparo Gozzi compared in print Tiepolo's imaginative scenes with Pietro Longhi's 'imitations' of life, and concluded that Longhi's pictures were no less 'perfect'.

It may well be that Gozzi's private preference was for the work of Longhi, and in the second half of the century the majority of enlightened European thinkers would have had similar preferences for 'truth' in art. Reviewing the Salon of 1761 in Paris, Diderot in one acid sentence – though he went on to pen many more – dissolved the fabric of a whole imaginative idiom, and stigmatised all its creators, when he wrote of Boucher, '*Cet homme a tout, excepté la vérité*'.

*Ancien régime* Venice was, in several ways perhaps, resistant to '*vérité*'. Where the visual arts are concerned it sheltered and nurtured, as it traditionally had, every expression of the unfettered imagination. Plenty of paradoxes abound, however, about attitudes there to individual artists.

*Figure 6:* Giovanni Marchiori, *David with the Head of Goliath*, marble, 1743, S. Rocco, Venice

27

Canaletto might be popular for his view-paintings with visitors and foreigners, the British most famously, but contemporary taste in the city probably tended to judge those works aesthetically inferior to invented, 'capricious' compositions. When finally – and it was finally – Canaletto was admitted to the Venetian Academy in 1763, at the age of 66, he chose to paint as his reception piece a picture skilfully poised between the factual and the fanciful (cat. 148). But the imaginative and colourful figure paintings of the Guardi brothers (whose sister was married to Giambattista Tiepolo) seem to have attracted little attention or won them much respect. And while Goldoni claimed that his muse hailed Pietro Longhi's as 'sister', Longhi's work was little known outside Venice.

For better or worse, 18th-century Venice had no equivalent to Diderot – had in fact little organised art criticism, and during the active life of most of the major artists they lacked any champion in print to welcome or defend the new 'school' they represented. That may not have bothered them, but it puts us the more on our mettle to look attentively at what they created. And given a situation and a century a little more complicated than always appears, there seems some function for an introductory essay.

2

The 18th century opened at Venice in no mood of gloom. In fact, the old, heroic days of the Republic had seemed to return in the later decades of the previous century, when a robust warrior-figure, Francesco Morosini, was Doge. The treaty of Karlowitz in 1699 gave European sanction to the Republic's possession of the Peloponnese territory which Morosini had personally been involved in wresting from the Ottoman Turks, gaining the Venetian the honorific 'Peloponnesiaco'. Two of the seated lion statues still to be seen, on guard as it were, outside the Arsenal at Venice, had been brought back from Athens by Morosini, and the Senate ordered them to be inscribed accordingly. At his death in 1694 a triumphal arch, decorated with paintings, was installed in the Doge's Palace as a memorial to him, adding one more monument to the rows of images of Venetian history, in triumphant terms, filling the rooms of the palace.

On the artistic stage the curtain rose to reveal a scene thoroughly animated and *en train*, lit by the rays of a rising rather than setting sun and soon to approach high noon. Half-mysteriously, or so it appears, Europe rapidly realised that new, exciting talents were on that stage, applauded them and sought their services.

Employment of those talents at Venice, by Venetians, was a sporadic, slightly chancy affair. Several of the best painters got some of their best opportunities away from the city, whether it was no further off than Florence, as had earlier happened for Sebastiano Ricci (cat. 1), or abroad, in England, France, Holland and Germany, which variously drew Ricci himself, his nephew Marco, Pellegrini and Amigoni.

Something of Tiepolo's career was foreshadowed in the travels of that generation of decorative figure painters. He would create the most magnificent of his fresco schemes in the Residenz at Würzburg and the largest of them all in the Royal Palace at Madrid (see cat. 128), the city he showed no urge to leave and where he would die. And although seldom if ever patronised by the British, he was to paint an altarpiece for the Spanish embassy chapel in London (cat. 113).

The figure painters, the 'history' painters in the period's terminology, were by no means all of them Venetian by birth, but Venice and earlier Venetian painting had conditioned them. There were also older, able practitioners in and around the city – men like Antonio Bellucci (1654–1726) and Tiepolo's first master, Gregorio Lazzarini (1655–1730), for example – whose careers straddle the two centuries (as does Sebastiano Ricci's) and whose style possesses some of the fluency and lightness, of touch and tone, to be developed by the 'advanced' figures in this exhibition. Bellucci was prototypical in another way, for he had gone to work in Germany before the end of the 17th century (and he later came to England).

The new-seeming decorative idiom was concocted from mainly old ingredients. One important non-Venetian element was represented by the work of Correggio, whose paintings often look astonishingly *dix-huitième*. The example of the peripatetic Neapolitan Luca Giordano (who died in 1705) provided another. Famed for his speedy execution, brilliantly gifted as fresco and easel painter, he had transformed a paintbrush into a luminous torch and had left in S. Maria della Salute more than one glowing altarpiece.

But the essential ingredient was local, and lay in the work of Paolo Veronese. Masterpieces of his could be seen in Venetian palaces and in churches. The great and influential secular canvas of the *Family of Darius before Alexander* (National Gallery, London) could be seen in the Palazzo Pisani, and the *Marriage Feast at Cana* in the convent of S. Giorgio Maggiore. It was Napoleon who bore it off to the Louvre, where it has remained.

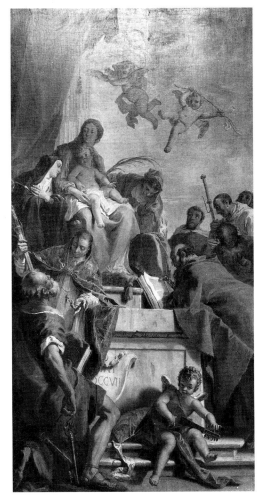

*Figure 7:* Sebastiano Ricci, *Virgin and Child with Saints*, oil on canvas, 406 × 208 cm, dated 1708, S. Giorgio Maggiore, Venice

What Veronese meant to Venetian artists of the 17th and 18th centuries could be the theme of a book. Yet it has to be remembered that French interest in Veronese had been manifested long before Napoleon's peculiar form of tribute. The French response to Venetian paintings and painters at the start of the 18th century was in part a feeling that here were the heirs of Veronese. And with Sebastiano Ricci the inheritance extended to virtually dressing up, artistically speaking, in his ancestor's clothes.

Nevertheless, it is Ricci who takes a predominant place among the Venetian decorative painters at that time. As early as 1708 he painted an altarpiece (fig. 7) for Palladio's great church of S. Giorgio Maggiore which, as it were, supplies a Veronese for the church, which lacked one. It is Veronese interpreted in an airy, slightly lazy, manner but with sumptuous expanses of sheer colour, making the final work a positive banner for the 'modern', painterly cause. Competent and industrious, Ricci could tackle any commission and all subjects. He shows to advantage in other Venetian churches. To the series of pictures for S. Stae he contributed an even more airy, almost aerated *Liberation of St Peter* (cat. 8) but he could produce a pleasing mythology (cat. 5) or an Old Testament nude, as in the *Susanna* (cat. 4), in a richly realised setting, echoing Veronese, even to the use of Palladian architecture. And on the small scale of a preparatory sketch (cat. 9) he could, especially in his late years, display surprising *brio*.

For the early 18th century the 'history' painters loomed large on the Venetian scene. But some of the vitality of the period – and some of its novelty – should be credited to artists in quite other categories of composition. Nothing will adequately 'explain' the emergence of Marco Ricci, who might be visualised capering like a monkey beside the imposing organ-grinder figure of his uncle, so wayward and high-spirited does he seem, though marvellously versatile as well. He can be amusing in his sharply satiric, proto-Hogarthian interiors of opera rehearsals (cat. 26) and utterly serious in atmospherically subtle, small scenes of the north Italian countryside (cat. 35), invested with such a direct eye for nature that Corot might have envied it. Sometimes the organ-grinder and the monkey collaborated on landscapes (perhaps one such is shown in the

opera rehearsal, hung as it is between portraits of uncle and nephew) and on patently fanciful compositions (cat. 37).

In every medium Marco had his contribution to make. As an etcher he created some consciously fanciful capricious landscapes with ruins (cat. 34) which anticipate Piranesi. Altogether, his use of etching as a medium signals the new importance it would have for artists in Venice, giving scope for freedom of the imagination and also for dissemination of the prints themselves. Following Marco Ricci's example, such committed painters as Canaletto and Giambattista Tiepolo would extend the limits of their art by utilising etching to conjure up often semi-private worlds of poetic fantasy. And the young Domenico Tiepolo revealed his abilities in the medium by his variations on the subject of the *Flight into Egypt* (cat. 230). The supreme exponent would be Piranesi, who showed that a great artist need not paint at all. He could prove his greatness, and become internationally famous, entirely through his etched work.

Among the constellation of talent available in Venice at the opening of the century two stars were to have their appeal especially for visitors to the city: Rosalba Carriera and Luca Carlevaris. The pastel portraits of Rosalba could take on a souvenir status, emphasised when a foreign sitter posed in Venetian masquerade costume. But there was much more to her art and her widespread popularity. She is something of a key to the whole period and receives further attention below.

The category of view-picture was virtually the new century's creation, and one could argue endlessly whether it came into existence as the result of demand or grew in demand once Carlevaris and then Canaletto showed its potential, as souvenir or record and as a work of art. To a remarkable degree, Carlevaris was the prime creator of it in Venice, and he set the agenda, as it were, for the most famous specialists who followed, Canaletto and Francesco Guardi, and also Michele Marieschi. The composition Carlevaris evolved for treating the subject of the regatta on the Grand Canal, originating with his painting of that held in honour of the King of Denmark in 1709 (cat. 22), was adopted and went on being replicated, decades later, by both Canaletto and Guardi.

It was Carlevaris – no hack worker but a 'learned', respected figure – who saw how to make the view picture more than just a piece of topography, embracing the inhabitants of Venice as well as its architecture. Drawings and sketches by him (cat. 19–21) confirm his powers of lively observation. That the view-painter should include society in his vision was instinctively and enthusiastically endorsed by Canaletto, who saw that it should take in shadow and sunlight as well – quickly achieving thrilling, atmospheric effects which eclipsed any Carlevaris had attempted.

However, Carlevaris had been a pioneer in another medium, once again that of etching. In publishing what is virtually an illustrated guidebook, without text, to Venice, the *Fabriche, e vedute di Venetia*, in 1703 (cat. 24), he stated his purpose was to make known to foreigners the splendours of the city. Etching allowed him to address not only the visitor but the armchair traveller, and he presented a Venice beyond the familiar areas like the Piazza, presenting it with a keener feel for atmosphere than usually appears in is paintings. His volume stands as the inspiration for subsequent books of etched views of the city, notably the *Prospectus Magni Canalis* (1735), instigated by Consul Joseph Smith and collaborated on by Canaletto and Visentini.

For a comprehensive 'picture' of the Venetian artistic scene at the beginning of the 18th century, introducing us to some for the chief patrons and conveying its international ramifications, there exists no better single source than Rosalba Carriera, as much in her role as correspondent as artist.

3

Much of Rosalba's postbag survives – inclusive of many letters to her – and it is obvious that she was quite unusually literate for a Venetian artist of the period, cultured and intelligent without any claim to be erudite. For no other contemporary artist is there a comparable literary treasure-trove, and one can guess there never was.

Although she made journeys to Paris and Vienna, she was resident in Venice and active for over half a century. Like a benevolent, hyper-industrious spider, she spun a web of contacts reaching out to Düsseldorf, Utrecht, Leghorn and London, in addition to Vienna and Paris. By 1700, when she was 25 and had not yet left Italy, she was in receipt of appreciative, begging letters from a Parisian collector. As late as 1756 she was hearing from the pastellist Catherine Read in London.

Rosalba's art exercised an appeal which is crucial to understanding the first half of the century – throughout Europe. Her chosen medium of pastel had bloom and allure, an air of spontaneity and speed (akin to some of the qualities of fresco), intimacy, small scale and suitability for being despatched, as her pastels constantly were, to destinations abroad. It is hardly an exaggeration to say that work could be obtained from her by mail order.

It was a chief factor in the general popularity of Rosalba that she could cater for two typical needs: the imaginary and fanciful – with her, usually female 'heads' – and straightforward portraiture, of men and women indifferently. Her graceful 'fancy' pictures have affinities with the work of the decorative painters, Ricci, Amigoni and her brother-in-law, Pellegrini. They were probably more highly esteemed aesthetically, not least by her, than her portraits. It was on '*quelque petite tête*', for example, that she was working in the early summer of 1721, for despatch to Watteau in Paris, whom she had previously met and portrayed. Her progress was hindered, however, by the demands of British visitors for their portraits. She described herself pithily as '*attaqué par des Angles*'.

As a portraitist she proved to be highly accomplished, with an acute eye for physiognomy and able to achieve a good likeness of sitters whom she barely knew. With no sitter was she more acute than with herself, gazing with impressive honesty at her unpretty, unsmiling features. One of the finest of those images, elderly, direct, dignified, she gave to Consul Smith (cat. 45), who had been a steady patron of hers and built up a large, heterogeneous collection of her work, long ago unfortunately dispersed.

While Rosalba's fanciful heads (cat. 46) meet, in their way, a demand for the ideal, the more 'truthful' aspect of her work is allied to the taste for topography and genre, and thus to the observation of humanity displayed by Carlevaris, Canaletto, Francesco Guardi, Pietro Longhi and also by the less well-known Zompini, with his gritty studies of daily, working life in Venice, published in volume form and with a title that has its own truthful emphasis: *Le Arti che vanno per via nella Città di Venezia* (cat. 188). And a last twist was given to the subject of genre by Domenico Tiepolo, the same artist who had performed ingenious variations on the sacred theme of the *Flight into Egypt*, and who always loyally collaborated with his father in

creating kingdoms of the imagination, but whose deepest response was to the actual, factual, local environment (e.g. *The Burchiello*; cat. 236). He inherited his father's wit, and he turned it, like a gentle hose, on the diversions and new fashions he lived to witness (cat. 228), not dowsing them in scorn but sprinkling them with affectionate irony, as though recognising that under temporary freaks and changing styles nothing changes in human nature. His was the most graceful of *adieux* to the *ancien régime* — not surprisingly, since it was the world in which he had grown up.

As it has reached us, Rosalba's correspondence mentions none of the Tiepolo family, nor Canaletto, though she can scarcely have been unaware of further new developments in Venetian art. Piazzetta is named in a letter to her, where he is spoken of in respectful terms as '*pittore celebre*'. But her knowledge of and friendly acquaintance with Balestra, who had been her teacher, and Carlevaris ('Signor Luca') is assumed by more than one correspondent, and in fact Carlevaris's daughter, Marianna, was one of her pupils. Bencovich (cat. 71) writes to her, rather glumly, as one might expect ('the world is too wicked'), but is grateful for the report he has had in Vienna about the exhibition of paintings on St Roch's feast-day in 1733 — not so far in date therefore from Canaletto's painting of the occasion.

Best of all, because of the letters Rosalba's sister, Angela Pellegrini, regularly sent her, the *va-et-vient* of Pellegrini and Sebastiano Ricci, with the odd reference to Marco, takes on vivid shape. Once or twice Pellegrini himself seizes a pen and dashes off a breathless, exuberant letter (the equivalent, almost, of some sketch by him), with jokes and *aperçus* on his life and his reactions. Arriving in Paris in 1722, he found that the new buildings made the city 'more beautiful than ever'.

Angela Pellegrini keeps her eye on the rival painter, the '*amico R*', as perhaps slyly she calls him at one point. As Ricci arrives in England, so the Pellegrinis depart for Germany. Later, Angela Pellegrini hears that though Ricci is receiving plenty of commissions from his English patron, the Duke of Portland, he has not received a penny in payment. As for Marco Ricci, she says, no mention is made of him, 'as though he was not alive'. Whatever the prickly Pellegrini–Ricci relationship, both Marco and Sebastiano had their portraits taken by Rosalba when they were eventually back in Venice.

At the time Marco was sitting in 1724, Rosalba began (as we know from her 'diary': really a terse record of sitters) a portrait of one of the two chief collectors of contemporary Venetian art living in Venice, though not native: the distinguished German soldier Field Marshal Johann Matthias von der Schulenburg (born in 1661). The other was the English merchant Joseph Smith (born *c.* 1674). They are very much presences in this exhibition, in Schulenburg's case positively by a portrait of him by Piazzetta (cat. 66). Rosalba's postbag includes a few letters to give substance to another collector, a native Venetian, a connoisseur and also a scholar, Anton Maria Zanetti the Elder (born in 1679), in contact with both Smith and Schulenburg. He was an intrepid traveller who visited Paris and got as far as London, which at first gave him a distinct culture shock; it was 'one vast Babel'. Zanetti seems the most attractive figure of the three personalities, sufficiently learned to publish a book on antique sculpture in Venice (cat. 84) and sufficiently light in hand to draw amusing caricatures, including one of himself (cat. 47).

The artistic activities of this trio assumed the greater importance since the Venetian Republic offered little official patronage at the period. And the Venetian Academy, often under consideration as a project, was established only in 1750, which seems late for a city with such a

long and proud history of art. Nothing in Venice approached the bureaucratic but powerful and fruitful centralised machinery of the arts in France, under the monarchy. In Venice the greatest patron was, or could be, the Church – which in practice often meant a religious order or confraternity, a group of benefactors, or a testator, and the 'sponsoring' of a programme of building or rebuilding, and of decoration. The Republic might contribute by, for instance, diverting some proceeds from the government-run lottery. But, of course, artists looking for Church patronage had to be capable of serving its ends. Pietro Longhi is an example of a painter who began by executing a few tentative religious frescoes (in the church of S. Pantaleone) but developed a very different speciality and found support presumably from largely private, patrician patrons.

Like Othello, Marshal Schulenburg had done his adopted state some service. He was instrumental in the lifting in 1716 of the Ottoman siege of Corfu, then a Venetian possession, and subsequently stretched the imagination of Canaletto by commissioning from him a view of the island under siege. Among the more public celebrations of the success involving Schulenburg was a 'sacred military oratorio', on the theme of Judith triumphant, with music by Vivaldi, performed at the Pietà.

Schulenburg deserves to be saluted, artistically, for his patronage of several painters, not least Antonio Guardi, whom he employed extensively and exceptionally. He owned view pictures by Carlevaris and Marieschi, as well as Canaletto, and was early a patron of the young Zuccarelli, sharing him, as it were, with Smith. He was also a patron, perhaps the sole serious one, of contemporary sculptors. His collection included several bronzes by the Paduan sculptor Francesco Bertos (see cat. 59) and he owned what was apparently the first treatment of the theme of the veiled face, a favourite subject of Antonio Corradini's (e.g. cat. 58). Although his collection contained nothing by one of the most gifted sculptors of the mid-century, Gian Maria Morlaiter, Morlaiter was to be the creator of a floridly grand bas-relief monument to him in the Arsenal (fig. 49), put up by decree of the Senate after his death in 1747.

Among history painters Schulenburg showed a fondness for Pittoni, who at his best can indeed be impressive (cat. 55, 56), but little or no interest in Tiepolo. Above all, his patronage is distinguished by his response to another great artist, Giambattista Piazzetta. We do not know but can guess that a real affinity existed between the aged soldier, to whose features Piazzetta gave unforced, unflattered but profound humanity (cat. 66), and the artist who unselfconsciously invests his own features with the same quality (cat. 67). Schulenburg was to own some twenty drawings and thirty paintings by Piazzetta – tribute enough to his attitude. It was a unique holding of Piazzetta's work, but then Piazzetta was a unique phenomenon in Venice, a strictly non-peripatetic figure but admired as a creative giant, respected by, and a powerful influence on, his fellow-artists, Tiepolo among them. He might not travel, but his fame did. He might be a slow painter, especially of large-scale pictures, but he was a fecund, superb draughtsman, whose drawings were widely prized and frequently engraved.

For Schulenburg Piazzetta created some large and haunting paintings (cat. 76, 78–9), which have to be described as pastoral genre, though they have little of the everyday about them; and though there may be a vein of humour in them, they are ambiguous in mood, as in meaning, as well as strangely timeless. They are unexpected works to be created in 18th-century Venice – at least in the Venice of received opinion. And their brooding power must make us pause. Piazzetta seems as artistically serious as if he were painting one of his mighty, sculptural altarpieces, stamped with thoughtful authority. As genre they stand somewhat isolated – or, rather, tower like sombre, rugged cliffs, reducing some of the surrounding contemporary art to

the status of coloured foam. We can believe the creator of these paintings to have been, as he was described after his death, 'fond of solitude and therefore somewhat melancholic'.

Schulenburg had no monopoly of Piazzetta. Joseph Smith owned some paintings and drawings by him, though probably no great paintings of genre. Smith also might have claimed to have done the state some service – that of Venice no less than the British one – in ways pacific and cultural and, in today's jargon, by bridge-building. Apart from the Consulship, he received no official recognition. On the artistic scene he was far more dominant than Schulenburg, engaged in multifarious activities as patron, collector, middle-man and publisher. As he lived until 1770 (dying in the same year as Giambattista Tiepolo), he offers vast scope for study. Yet much is unclear about him, beginning with his appearance. No portrait of him seems to exist, although one may wonder if his large holding of Rosalba's work could have included one by her.

In addition to paintings, drawings and etchings, Smith collected gems, coins, medals, manuscripts and books. He was in a position to assemble the perfect representative collection of contemporary Venetian art, but he failed to acquire paintings by Giambattista Tiepolo, or by the Guardi brothers, and made no large holding of Pietro Longhi's work. Whatever the explanation for the 'gaps' in his taste, it cannot be explained as a matter of his being indifferent to the younger generation, because he responded enthusiastically to the art of the highly innovative Piranesi, 40 years his junior.

Smith can hardly be dissociated now from Canaletto, whom he patronised and promoted, and of whose work he formed an unsurpassed collection, of drawings as well as paintings, and of etchings too, when Canaletto turned etcher (to Smith was dedicated the volume of his etchings). Yet Smith has significance for Venice at the period in many other ways. He supported the opera (his first wife was a celebrated, retired opera singer, Mrs Tofts). It was to him that Goldoni dedicated his comedy *Il Filosofo Inglese*. Smith's interest in architecture, the architecture especially of Palladio, was clearly informed, and he patronised the multi-talented architect-painter-engraver Antonio Visentini in all those capacities (see cat. 153, 158).

Smith's Palladian interests have wider, intellectual implications, reminding us that what constituted 'good' and 'bad' architecture was a much-discussed, controversial topic in Venice, and discussion could grow heated when some major new building was being planned. Among Smith's friendly acquaintances was Padre Lodoli (cat. 242), whose heterodox 'Socratic' views on architecture – and on much else – seem to have been as brusquely no-nonsense as his appearance would suggest.

Palladian Smith is complemented and extended by Smith the bibliophile and Smith the publisher. He financed and published books under the name of his employee, a young classical scholar, Giovanni Battista Pasquali. For the Smith-Pasquali press Visentini designed a device of a shining figure of Minerva, with the motto '*La Felicità delle Lettere*', which was the title of the allied bookshop near the Rialto.

Smith's press was concerned with publishing works of serious scholarship in editions which are often typographically austere compared with the poetic effusions and the big, illustrated books of the period, yet fine in quality. In addition to Palladio's works, it published a learned edition of Virgil and Guicciardini's *Della Historia d'Italia* (cat. 158). Maybe Smith rarely sat down to read the Virgil, but he took some interest in the visual aspects of classical antiquity and was a subscriber to the two volumes dealing with the Venetian public collection of antique

sculpture, *Delle Antiche Statue Greche e Romane ...*, by Zanetti and his identically-named younger cousin. The first volume of that was published in 1740 by another leading publisher, Giambattista Albrizzi, close friend and patron of Piazzetta, who produced some of his finest and most enchanting drawings for Albrizzi's publications.

It was Piazzetta who provided the frontispiece for *Delle Antiche Statue* (cat. 84). Minerva is shown standing before the figure of Venice enthroned, indicative of the city as protector of learning no less than the arts, but more intriguing is the view of Venice Piazzetta has composed as setting, a detailed depiction of the area around the Molo, with the angle of the Doge's Palace, the Library and a few boats. There he meets Canaletto on his own ground, conceivably having glanced at some Canaletto composition. That anyway he managed topography adroitly, Smith would have had to agree.

# 4

By the mid-1720s Rosalba was as popular and busy as ever, but her postbag no longer reflects the contemporary situation in Venice, already dramatically changed by the arrival of Canaletto and Giambattista Tiepolo, born in 1697 and 1696 respectively. That they had 'arrived' artistically was speedily apparent in the city, and beyond. In effect, they joined the established, admired figure of Piazzetta, despite the discrepancy in age. Canaletto actually collaborated with Piazzetta on one of the series of *Tombs*, devised by the ex-impresario Owen McSwiney (cat. 135), as he did with Pittoni on another.

Tiepolo was not involved in the series. Perhaps he was not approached, or perhaps the prospect of collaboration held no appeal for him. His exclusion is an odd, accidental foreshadowing of English indifference to him throughout his career – and broadly throughout the 19th century. But in Venice his name was quickly made. He really seemed to have sprung onto the scene, and the qualities of his style were aptly summed up by a perceptive amateur, Vincenzo da Canal (no relation to Canaletto) as 'all spirit and fire ... rapid and free'. Not only do the words seem well-chosen to characterise Tiepolo's style but they serve remarkably well for that of Canaletto's earliest view pictures, created about the same time (cat. 134). The two young artists shared a Promethean daring, a determination to bring new fire – and light – to the art they practised, and by so doing astonish their elders.

Tiepolo's arrival was the least anticipated perhaps of all in 18th-century Venice. It took him a while to understand the full range of his own gifts, and we must remember that there was no contemporary Venetian exponent of fresco painting to point him in that direction. No frescoes by either Pellegrini or Ricci had been executed in the city. He saw the greatness of Piazzetta, fell deeply under his influence and pays him homage in his early oil paintings (the loutish Alexander in his jokey *Alexander and Campaspe in the Studio of Apelles* (cat. 92) is very much conceived as a Piazzettesque 'type', perhaps for fun). In contributing to the series of canvases of saints' lives for S. Stae, Tiepolo found himself working beside Piazzetta, metaphorically speaking, and his *St Bartholomew* (cat. 94) is full of stylistic echoes of Piazzetta's *St James* (cat. 70). Yet by the mid-1720s Tiepolo had revealed himself as a master in the medium of fresco (in the radiant ceiling of the Palazzo Sandi in Venice; fig. 29) and already could look around confident in the knowledge that no artist could surpass him as a fresco painter. It was probably his mastery that made fresco fashionable again in the city. All his natural fire and facility could be poured molten into a medium in which Piazzetta had no urge and no natural ability to work. Aesthetically, he was as repelled – we may guess – by fresco painting as Tiepolo was exhilarated by it.

Thus they could carve up the artistic territory under what became a joint reign. That they were the two outstanding history painters of the day was widely recognised (but Pittoni was not ignored). Twice, on major occasions, in major new churches – the Gesuati and the Pietà, both designed by the most talented of contemporary local architects, Giorgio Massari – Piazzetta remained the earthbound artist, executing an altarpiece, while Tiepolo soared high overhead, frescoing the ceiling with a heavenly vision (cat. 125). At the Gesuati there was additional piquancy because Tiepolo also painted an altarpiece, complementing Piazzeta's stern, superb trio of male Dominican saints by a trio of female Dominican ones. As the great examples included in this exhibition emphasise, the altarpiece was a prime category of painting for the period. Tiepolo, Piazzetta and Pittoni were all at their most emotionally intense in such work. Again and again, the effect of the altarpieces is one of dynamic piety. They too bring all heaven before our eyes, and the air in them is stirred by the beat of angels' wings.

The trajectory of Tiepolo's career as a fresco painter took him far beyond Venice, as it was bound to do. His course could be likened to that of the Sun's chariot which he frescoed on the ceiling of the gallery of the Palazzo Clerici in Milan (cat. 107). And as he travelled through life, he left a glittering trail not solely of frescoes and large-scale oil paintings, but oil sketches, pen and chalk drawings, studies for important schemes (cat. 100), caricatures and even a few wonderfully limpid, sensuous landscape drawings (cat. 119, 120), patterns of light and shade economically washed on to paper. In mid-career his energy found a new outlet in etching (cat. 112), and he lost himself in a dream world of fantasy and magic which would be a direct inspiration to the young Piranesi.

At the end of Tiepolo's trajectory he had passed out of Venetian ken. It was far away, in Spain, that he gave – to what audience we do not properly know – the most unexpected display of all. With a final, fresh, fiery burst of creativity, he wrought a number of small religious paintings, sketches in handling yet totally autonomous as works of art, sometimes tragic in intensity, as in theme (*The Entombment*, cat. 132), and sometimes of extraordinary simplicity and stark originality (*The Flight into Egypt*, cat. 131).

Canaletto had not stood still stylistically over the same period, though his progress may seem less exciting, and it was also less publicly conducted. It used to be thought that his art declined as he grew older, but that is too simplistic, for he obviously had method in the tighter, colder manner he adopted in his later work. He was still determined to miss nothing in the world around him, and had embarked on often elaborate caprice paintings as well. He too had turned to the medium of etching. His etchings were published around 1744, and the frontispiece alone shows Canaletto in poetic, Piranesian mood, brooding, as it were, on strange ruins and weeds and water, with humanity subordinate, barely present, in a realm as magical, in its way, as that of Tiepolo's etchings.

The decade of 1720 saw Canaletto and Tiepolo establish themselves, but it was only in the subsequent two decades that they matured as artists. And those decades are the richest, most productive, of all for artistic achievement of every kind in Venice. Venetians took note of what was happening and prepared to inform the outside world. In 1733 Anton Maria Zanetti the Younger published a drastically revised edition of Boschini's 17th-century *Ricche Minere della Pittura Veneziana*, which stated that it came right up to date ('... *al presente 1733*'), and in 1740 there appeared the first edition of Albrizzi's illustrated guide to the city and its monuments, 'ancient and modern', beguilingly entitled the '*Forestiere* [stranger, foreigner, visitor] *Illuminato*' – ideal adjective for the age of enlightenment.

*Figure 8:* Giorgio Massari, S. Maria del Rosario (The Gesuati), Venice, 1725–36, façade

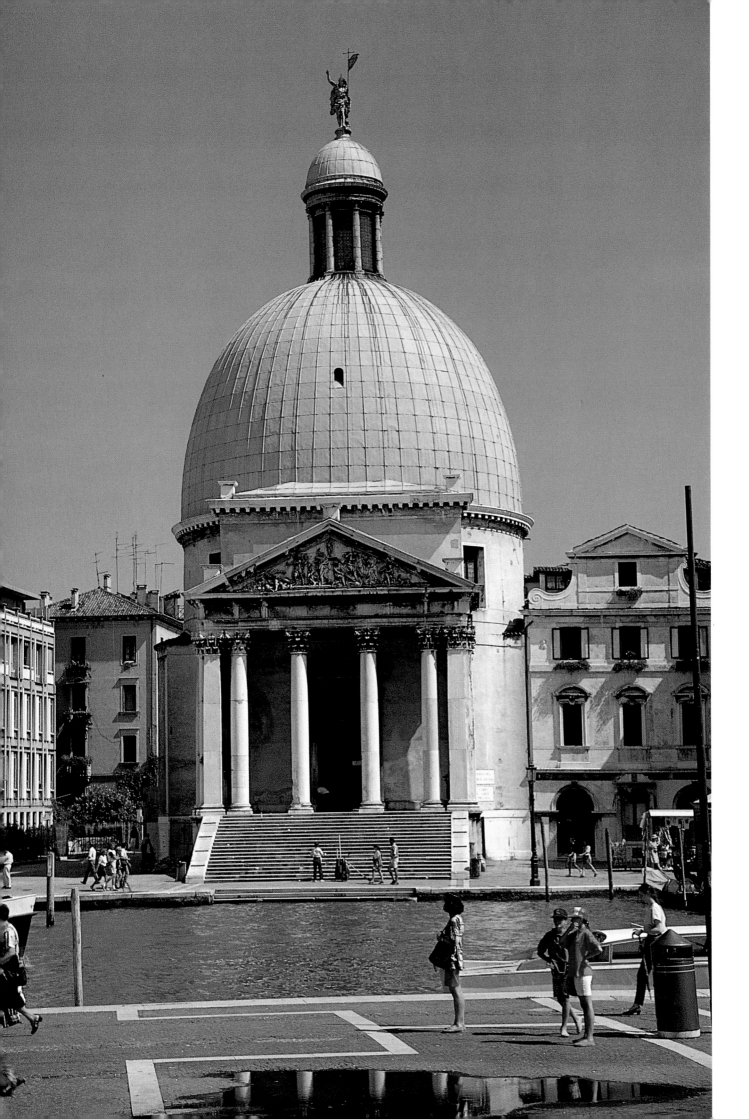

## 5

Surveying even cursorily the two decades that run from 1730 is almost as daunting as exciting, so thronged are they. But it would be wrong to think that they marked the end of artistic energy in the city, for surprising developments lay in store, and each subsequent decade had its fresh personality, overlapping with older figures, right up to Canova's manifestation in such early, *émotionné* work as his statues of *Orpheus* and *Eurydice* (cat. 285, 284), executed in the 1770s, while Pietro Longhi and Francesco Guardi were alive and active. Nor did Canova forget his Venetian environment. As late as 1804 he was writing from Rome to an acquaintance in Venice to ask if he could acquire for him a *modello* by Tiepolo and some view paintings of the city. By then, neither request was easily to be satisfied.

The face of Venice was partly changing in the 1730s. Two major churches, occupying prominent waterfront sites were added. Scalfarotto's domed church of S. Simeone Piccolo (fig. 9), which so memorably confronts anyone coming out of the station at Venice, had typically taken a good many years to build but was consecrated in 1738. It provided a new motif for Canaletto, which he studied in several drawings and paintings, probably prompting in turn Guardi's paintings of the view.

Much more architecturally distinguished was the Palladian-style church of the Gesuati (fig. 8), a masterpiece by Massari, facing across the Giudecca Canal towards Palladio's church of the Redentore and by no means outfaced in the relationship. It was in the course of construction when the Président de Brosses was in Venice in 1739 and gained his approval: '*une très-belle église . . .*'. By that date Massari had won the competition for the rebuilding and expansion of the Pietà complex, also on a prominent site, on the Riva degli Schiavoni. What he designed was a larger and more imposing building than the exterior we know today, with the church façade flanked by the wings of the hospital itself. And although it would not be until 1760 that the church was consecrated (an occasion noted in the *Gazzetta Veneta*), it is such a fundamental museum of all the arts of 18th-century Venice that it is relevant regardless of precise date.

Within its cool, elegantly elliptical interior are to be found not just Tiepolo's ceiling fresco and the high altarpiece begun by Piazzetta (finished by his pupil, Angeli), and four other interesting altarpieces, but gracefully intricate ironwork, sculpture in bronze and marble and a painted, wooden opera-box of a pulpit, on tall, scrolled legs, movable, and designed apparently by Massari himself. Some of the sculpture is by Morlaiter, who is seen more extensively throughout the interior of the Gesuati (fig. 48). There his work includes a fluidly dynamic statue of Moses and a vast, swirling, serpentine framing of cloudy draperies, interspersed with airborne angels, which sweeps in almost *art nouveau* style around a small picture of St Dominic.

A single piece of sculpture could enhance a public site, and in 1742 a statue by Marchiori of St John Nepomuk (weathered, yet still *in situ*) was put up on the corner of the quay facing the Grand Canal beside the Palazzo Labia. View-painters took note accordingly, and Canaletto went back to insert the detail in one of the view pictures he had earlier painted for Smith.

The 18th century was the last great age of church-building in Venice. By contrast few large-scale palaces were built, but one huge exception is the Palazzo Grassi, built by Massari, and begun in 1748, bulking majestically among the line of palaces along the Grand Canal.

*Figure 9:* Giovanni Antonio Scalfarotto, S. Simeone Piccolo, Venice, consecrated 1738, façade

In 1743 another artist, claiming to be an 'Architetto Veneziano', had announced his arrival by publishing his first book of etchings: Piranesi, whose *Prima Parte di Architetture, e Prospettive* appeared that year, when he was age 23. It was the same year that his exact contemporary, Bernardo Bellotto, Canaletto's nephew, was noted as now being – along with his uncle – 'very famous' for view pictures. Bellotto would soon be lost to Italy altogether, going off to northern Europe, where his urban views (cat. 255, 260) and his picturesque landscapes (cat. 256) would gain a note of 'realism' more usually associated with 19th-century art. 1743 was also the year when Count Algarotti, back in Venice, noted the emergence of yet one more talent, that of the boy Domenico Tiepolo, already beginning 'to follow in his father's footsteps'.

Breathless as what is sketched above may be, it conveys something, even in that breathlessness, of how much was happening in the arts and how far from static was the physical entity of Venice in those years. In Morlaiter's exuberant fantasy framing in the Gesuati lie seeds of the exuberant fantasy of the *Grotteschi* of Piranesi, and so on. Architecture as such cannot be included in this exhibition, but without Massari's two great, though different, churches of the Gesuati and the Pietà there would not have been the important opportunities they provided for Piazzetta and Tiepolo – and for leading sculptors as well.

The 1730s were a particularly felicitous time for Piazzetta's art. It was then that he revealed the copiousness of his imagination in designing illustrations for books, stimulated no doubt by his friendship with Albrizzi. The first volume of the *Œuvres* of Bossuet, illustrated by Piazzetta, appeared in 1735 (cat. 77). And by 1740 Piazzetta's illustrations to Albrizzi's edition of Tasso's *Gerusalemme Liberata* were seen by Goethe's father then visiting Venice, though the superb book itself (cat. 80, 82) was not published until five years later.

While Tiepolo's occasional contributions to book illustration are peripheral to his art (though surprisingly late did he draw one frontispiece, cat. 130), Piazzetta's are central to his. Nor can he be accused of slowness or lack of productivity in that area, for he drew hundreds of designs, from complete illustrations of specific scenes to decorative head- and tailpieces (cat. 80) for the Tasso, and some of the less important *qua* illustration are the most inventive, sprightly and delightful of all. He deserved Albrizzi's gratitude. Among the ways Albrizzi repaid his friend was to publish after his death an account of his life and work (in an album of engravings after his drawings, *Studj di Pittura già dissegnati . . .*, 1760; cat. 89). It may not sound much in itself, but no other Venetian artist of the period received equivalent biographical attention.

Piazzetta's illustrations for the *Gerusalemme Liberata* aptly remind us that the new wave of painters included Antonio Guardi and his younger brother, Francesco, then working largely or exclusively as a figure painter. If the Guardi family caused little stir at the time, any lack of attention has been more than redressed by recent scholarship. A mention, in a will of 1731, of copies done by 'the brothers Guardi' tells us they were around. *Apropos* copying, Antonio utilised one of Piazzetta's compositions for his painting of *Erminia and the Shepherds* (cat. 191). His style as a painter is the very opposite of Piazzetta's, however, with its flickering touches of pigment and sparkling, prismatic colour.

Antonio Guardi seems to have been employed only rarely in Venetian chuches, but a graceful memorial – too slight to be termed a monument – of his style is in the organ panels (fig. 50) painted for the fairly obscure church of the Angelo Raffaele. There, even the normally domestic setting of the subject of Tobias curing his father's blindness is transferred to a wide, vaporous landscape, and both it and the group of figures have a misty, mirage-like quality. With

hindsight, the treatment of landscape has a familiar look, possessing much in common with the later, half-fanciful lagoon paintings of Francesco Guardi.

In the early 1740s Zuccarelli was evolving his Arcadian vision of the countryside, sweetened perhaps but presented freshly then, and Michele Marieschi, oscillating somewhat between various influences, including Canaletto's, fought – as it seems – to create his individual style as painter of views and caprice pictures, and also published a series of etched views of Venice in 1741. One of those shows the Campo S. Rocco with spectators examining the paintings exhibited for the saint's feast-day.

The same decade was that in which Pietro Longhi perfected his novel category of genre picture, as far as Venice was concerned: the small scene dealing with life in the city, and chiefly of leisured life. Whatever reservations one may have about his aesthetic quality, the originality of his subject-matter, and his sharp eye in recording it, must be recognised. He takes us into patrician homes behind Venetian palace walls, and out into the public places of Venice, answering the needs of his society by mirroring it, much as Lancret was doing more elegantly in France and Hogarth more satirically in England.

Longhi lived on until 1785, comfortably able to witness the success of his son, Alessandro, as a portrait-painter. Alessandro first created a local stir of approval in 1760, when he showed at the annual S. Rocco exhibition the portrait of an inn-keeper. Painting in oils, and more solidly, more 'realistically' than had Rosalba, though he enjoyed no international fame, he embodied new tendencies, less concerned with charm than with the facts. And he documented his contemporaries in writing too, publishing in 1762 a useful *Compendio*, with etched portraits, of the renowned 'history' painters of the day (cat. 243).

The title alone precluded a 'life' of Canaletto, nor was Francesco Guardi mentioned. The artist Guardi increasingly became, in the second portion of his career, was hardly classifiable. View pictures and caprices merge as categories in paintings that are imbued with intense response to Venice but less for its bricks and mortar, or its inhabitants, than for its watery setting, its scattered islands, its sense of illimitable distance and silence amid crumbling fragments of ruin or in an isolated boat floating between the sea and sky. What Guardi seeks to capture, one might think, was the intangible essence – almost, the idea – of Venice.

Guardi's art failed to decline, grew more subtle, arguably more 'modern' in his very late years, since it is clear that subjects as such had ceased to be important to him. It was his own sensations that he sought and seized. As effectively the last great painter of the Venetian Republic, he saw it out in glorious style, not drowning but waving.

However, it was not Guardi, for all his genius, but Canaletto who created the great icon, beacon too, of the period. In the so-called 'Stonemason's Yard' (fig. 10) Canaletto has summed up life and work — and art — in 18th-century Venice, doing so on a large scale, with unique penetration and with lasting resonance. A humble, untidy, unfamiliar area of the city, tucked away from tourist gaze, is the scene of the daily round of labour, for women, it should be noted, as for men. This is the 'vérité' lying behind carnival masks and revelry. The city is lived in and used: washing is hung out on lines, and rooms are aired, and floors are swept. Above all, art is being created in the midst of it: stone is being chipped and crafted to make a building beautiful — not a palace, still less houses for ordinary citizens, but a church, that of S. Vidal, nearby, out of sight, at the right.

That work must go on, unglamorously, for it is indeed work, to fulfil the strong, endemic Venetian determination to build and sculpt and paint in honour of God and to the enhancement of the Republic. What we witness is itself a traditional activity (from stonemason backgrounds came several artists, Piranesi among them) and it is being practised in obedience to tradition. A new façade in Palladian style had been designed for S. Vidal by the architect Andrea Tirali, but the money for that work came from funds bequeathed by a 17th-century Doge, whose wishes are shown as devotedly carried out many years after his death. And Canaletto's absorbed stone-carver serves as a symbol of other artists contemporaneously employed on the interior of S. Vidal, sculptors and such painters as Sebastiano Ricci, Pellegrini and Piazzetta (cat. 74).

Not death in Venice, not inertia or indifference, but life, vitality and creative energy in Venice are what Canaletto sees and celebrates, himself creating a magnificent work of art in which to enshrine his vision and belief. And the array of works of art assembled in this exhibition provides resounding confirmation that he is telling the truth.

*Bibliographical Note*: A complete bibliography for the essay above is not feasible or necessary but some books, etc., gratefully utilised for it, and valuable for further reading, deserve mention: Bettagno, in Venice, 1993[1], pp. 30–8; Binion, 1990; Haskell, 1980, pp. 245–83, 405–10; *idem*, 1960[2], with first published reference to Canova's letter of 1804; Howard, 1980, pp. 193–212; Kaley, 1980; Niero, 1979; Sani, ed., 1985; *idem*, 1987, pp. 73–84; Talbot, ed., 1993; Vivian, 1971; see also London, 1993.

*Figure 10:* Canaletto, *Venice: Campo S. Vidal and S. Maria della Carità: 'The Stonemason's Yard'* (detail), oil on canvas, 1.238 × 1.629 m, *c.* 1726–30, National Gallery, London

# The International Taste for Venetian Art

*Italy:* Francis Russell

It is not easy for posterity to comprehend the status of the Venetian Republic in the Settecento. Visible wealth, historic ceremonial and a lingering memory of the triumphal defence of Corfu against the Ottoman Turks in 1716 ensured that the city remained far more than a mere magnet for the tourist. However immune to change her political institutions, however inward-looking her patrician families, Venice was still the centre of a significant trading empire. Foreign merchants clustered there and her artists and craftsmen were keenly aware of the possibilities of patronage coming from without. As the Maronite families of Aleppo turned to Venice for their looking-glasses, so patrons throughout Europe employed painters from the city.

It was natural that Venetian artists in the 18th century, many of whom were born on the mainland, dominated the cities of the *terraferma*, where the Republic's territories ran from the delta of the Po to Brescia in the west, were defined to the north by the barrier of the Alps and followed the Adriatic littoral as far as the republic of Ragusa to the east. Patterns of patronage were determined by both regional and individual taste and experience, but the 'balance of trade' in works of art and artists — to misuse a contemporary term — with the rest of the Italian peninsula was overwhelmingly to the Venetians' advantage.

Two closely contemporary portents help to define the artistic relationship of Venice with other Italian centres. Mindful of the city's traditional artistic strength, Ferdinando de' Medici, Grand Duke of Tuscany, sent one of his foremost painters, Antonio Domenico Gabbiani, to Venice in 1699 expressly to study colour; while within a year Sebastiano Ricci from Belluno, who, more than any other of his generation, re-established the credentials of Venetian painting and had already found employment in Bologna, Parma and Piacenza, in Rome, and subsequently in Milan, was at work on his first major public Venetian commission, the decoration of the vault of the choir of S. Sebastiano, now destroyed. Ricci's ability to absorb the spirit of Veronese assured him an European *réclame*. The new century would carry him first to Schönbrunn and subsequently to Florence, where his decorations for the Palazzo Marucelli-Fenzi of 1706–7 (cat. 1) and frescoes in the Palazzo Pitti of 1707–8 have an elegance and ease denied to the work of Tuscan contemporaries. The Grand Duke Ferdinando was a patron of discrimination. Other picture buyers were more cautious — or economical — in their commissions: thus the Lucchese businessman Stefano Conti in the same decade secured works by Lazzarini, Balestra, Bellucci and Fumiani, though he had the prescience to secure views from Carlevaris and, later, from the young Canaletto; while Raimondo Buonaccorsi of Macerata in the Marche selected two Venetians, Lazzarini and Balestra, to contribute to the project for the gallery of his palazzo.

The doyen of ex-patriot Venetian painters was Francesco Trevisani (1678–1746). Born in Capodistria, he had left Venice for Rome in 1678 and by the turn of the century was recognised as one of the leading painters in that city. Despite his absorption of a Roman *gravitas*, Trevisani never wholly lost his Venetian bearings and it was fitting that he was called in to supply an

altarpiece for the church of S. Rocco at Venice in 1734. The very success of the painters of Rome and Naples meant that there was little scope for Venetians in those cities. But other openings existed.

In 1723, Rosalba Carriera, then fresh from her Parisian triumphs, was induced to visit Modena to portray the princesses of the house of Este. The rich city of Milan, which lacked an outstanding indigenous school and whose territory bordered that of the Republic, was a fruitful source of commissions. Diziani supplied a major altarpiece for S. Maria della Visitazione in 1734. But this pales into insignificance beside the Milanese activities of Giambattista Tiepolo, whose frescoes of 1731 at the Palazzo Casati and of 1737 at S. Ambrogio were followed in 1740 by the great ceiling fresco of *The Course of the Chariot of the Sun*, painted for Marchese Giorgio Clerici at Palazzo Clerici in 1740 (see fig. 35). The closely contemporary altarpiece of S. Filippo Neri at Camerino is arguably the last of the long series of major Venetian works painted for the Marche.

Italian patrons looked to the Venetians almost exclusively for altarpieces and decorative frescoes. Pietro Longhi's clientele seems to have been limited to Venice and the *terraferma* and there was little demand elsewhere in Italy for Canaletto's views of Venice, despite Conti's commission of 1725. But two great artists of the next generation were inspired, perhaps partly because of Canaletto's ascendancy in the field of Venetian topography, to take their talents elsewhere. Piranesi settled in Rome in 1740, while the young Bellotto worked briefly in Lombardy, painting views of Gazzada (fig. 57) and the villas of Vaprio d'Adda of breathtaking distinction, before travelling further afield.

There was a marked decline in the number of major commissions for Venetian painters from elsewhere in Italy in the later decades of the century. Only the decadence of the indigenous school at Genoa enabled Domenico Tiepolo to win the competition to decorate the Gran Sala of the Ducal Palace there in September 1782. His fresco, *The Glory of Jacopo Giustiniani*, executed in 1785 but destroyed in 1860, was in a sense Venice's last victory over the rival republic with whom she had contended for trade over so many centuries. The victory was pyrrhic. The greatest Venetian artist of the emerging generation, Antonio Canova, had left in 1779 for Rome. However committed the members of her Academy, Venice was in eclipse among the artistic centres of Italy even before Bonaparte's troops so rudely destroyed the Serenissima in 1797.

## *The Habsburg Empire*:    Christoph Becker, Axel Burkarth, August Bernhard Rave

At the beginning of the 18th century the international art market was boosted by an outbreak of collecting mania among the ranks of the European aristocracy. New, and in some cases extensive, collections were built up in just a few decades, and provided the Italian art market with an opportunity to meet these demands. Although the main focus of these collections was the Old Masters, the work of contemporary artists was also collected. A number of painters were induced to follow the routes of the exported paintings to the courts of princes north of the Alps, where the prospect of long-term employment and attractive commissions beckoned.

The imperial capital of Vienna acted as an irresistible magnet for artists from northern Italy. The military defeat of the Turks at the gates of Vienna in 1683 had set the house of Austria on

the way to becoming a major European power. With the victories of the Imperial armies in Hungary and at Siebenbürgen in the following years, Vienna moved from the periphery to centre stage in the expanding Habsburg Empire. By the early 1690s the Imperial capital was in the throes of an unprecedented building boom, which rapidly transformed it from a frontier fortress. After the turn of the century the spirit of competition began to affect the nobility and particularly the upper ranks of the army, who had new palaces, pleasure seats and huge parks built in the partially destroyed city and on the open ground on the outskirts which had been laid to waste during the Turkish wars.[1]

Army commanders and generals who had shot to fame as 'defeaters of the Turks' were among the most prominent building patrons; they included Dietrichstein, Kaunitz, Harrach, Mansfeld-Fondi, Starhemberg, Liechtenstein and Prince Eugene of Savoy (1663–1736), one of the greatest generals of the day.[2] Their new showpieces demanded a level of artistic accomplishment that could not be met by local artists. In the summer of 1700 the French ambassador at the court of Vienna remarked sarcastically that not one of the Viennese artists would have been entrusted with painting a shop sign in Paris.[3] From the very beginning the Austrian nobility turned to Italy, and the traditional bond linking the Habsburg monarchy with Italy[4] encouraged the influx of Italian artists and their work.

Many of the Viennese patrons of the arts were familiar with the Italian centres of art, either from doing the Grand Tour in their youth, or from military or diplomatic tours of duty. Against the backdrop of the threat of war from the Turks and the War of the Spanish Succession (1702–13), Venice was alive with diplomatic activity and always a favourite stopping place. A number of patrons were even of Italian origin, for example the Imperial Field Marshal Enea Silvio Caprara (1631–1701), who, at the turn of the century, played a decisive role in finding attractive commissions in Vienna for artists from his home town of Bologna. Besides the Bolognese, there were also the Neapolitan artists, whom the Viennese came to know after the conquest of Sicily during the War of the Spanish Succession. But in the field of painting, it was the Venetians who were supreme in establishing the 'Habsburg imprint' at the courts of the minor princes throughout continental Europe.

*Figure 11*: Sebastiano Ricci, *The Assumption of the Virgin*, oil on canvas, 674 × 364 cm, *c.* 1733–4, Karlskirche, Vienna

The tradition linking Venetian painting with the house of Habsburg went back to the time of Charles V and Titian. The alliance was both aesthetic and political. Faced with the acute threat from the Turks to Venetian holdings and trade in the eastern Mediterranean, in 1694 Venice had entered into the so-called Holy Alliance as an ally of the Emperor against the Ottoman Empire. Later, during the War of the Spanish Succession, Austria had to maintain a military presence on the Italian peninsular in order to justify its claims to the former Spanish dominions.

Whereas the Florentines were still influenced by the *disegno* tradition, and the Romans emphasised the intellectual and classical in art, the Venetians insisted on the dominance of colour.[5] This colouristic tradition, which is documented in the writings of the Venetian theorists from Ludovico Dolce (1508–68) to Marco Boschini (1613–1704), was also in opposition to the classicising artistic theory of France under the rule of Louis XIV. Consequently Venetian painters could serve the Habsburgs and their allies by supplying appropriate visual rhetoric to enter into artistic competition with the Habsburg's political enemy, France.

At the beginning of the century, while the Emperor Leopold I (1640–1705) was still alive, the court of his son Joseph, crowned King of Rome in 1690,[6] had attracted the most talented

politicians and soldiers, including Prince Eugene, who had a passion for the arts. Joseph also began to attract Venetian painters to Vienna; one of the first to arrive, in 1702/3, was Sebastiano Ricci, who only a few years before had worked for Louis XIV during his time in Rome.[7] He was commissioned to paint the ceiling in the so-called *Blaue Stiege* in the palace of Schönbrunn. By the time he was crowned Emperor in 1705 Joseph I summoned Antonio Bellucci (1654–1726/7) to Vienna, where the artist remained as court painter to Charles VI (1685–1740) after Joseph's early death in 1711. When the Viennese Emperors gave commissions to Venetian artists it was for works of a propagandist character, particularly in the time of Charles VI, who increasingly demanded that art should serve the state.[8]

In 1702 Bellucci was commissioned by Prince Johann Adam Andreas of Liechtenstein to paint the ceiling in the banqueting hall of his newly completed palace in the city.[9] Bencovich worked in Vienna from 1716 onwards, and his influence on Venetian, as well as Austrian, painting extended until the second half of the 18th century. Rosalba Carriera, a friend of Bencovich, came to the Habsburg residence at the invitation of the Emperor Charles VI. Bernardo Bellotto was in Vienna from 1759 to 1761. The Venetians remained an essential part of Viennese court art until well past the middle of the century, during the reign of Maria Theresa.

A drawing by Sebastiano Ricci (British Museum, London) illustrates a panegyric allegory dedicated to Charles VI to mark his ceremonial entry into Milan in 1711; evidently it was the design for a larger project. Ricci's most prestigious commission, however, was the large altarpiece of *The Assumption of the Virgin* (fig. 11) which he painted towards the end of his life for the Emperor's great showpiece, the church of St Charles in Vienna designed by Fischer von Erlach. Its *modello* is shown here (cat. 9). Titian had painted the same subject for one of the greatest churches in Venice, the Frari. The greatest Venetian artist of his time, Titian, had been court painter to Charles V; with his political and dynastic aspirations, this was of great significance for Charles VI, who regarded his Habsburg namesake as an exemplary ancestor. In virtually no other place is Imperial pride presented more effectively by a Venetian painting than in the church of St Charles.

Prince Eugene of Savoy, who had earned military fame at the battle of Zenta in 1697, and was awarded the title of Imperial Field Marshal in 1707, was regarded as the most distinguished of the aristocratic collectors and patrons of architecture. The contents of his gallery of paintings, and the circumstances under which they were assembled, are remarkable. As a collector, he was distinctly Francophile. His admiration for Cardinal Mazarin's taste expressed itself in his choice of Pierre-Jean Mariette (1694–1774) as his agent, and from 1717–18 Mariette organised the collections of both the Prince and of the Emperor Charles VI, to the great satisfaction of his employers.[10] Mariette was a wily dealer with contacts with the most important agents and patrons throughout Europe. It was he who brought the Viennese court into closer contact with the Venetian art trade, when he was given a free hand to purchase works of art in Venice on behalf of Prince Eugene. In order to recruit new artists and to maintain contacts between Vienna and the princes and allies loyal to the Emperor at the courts at Düsseldorf, Pommersfelden and Dresden, Mariette used the services of a middle-man in Venice, Antonio Maria Zanetti the Elder (1679–1767), an artist and engraver whom he had met through the French banker Pierre Crozat (1665–1750). After visits to Paris, London and Vienna, from 1736 Zanetti lived in Venice, where he was in charge of the Marciana library, which every visiting foreign prince had on his itinerary, and which was the centre for information of every kind. Zanetti, with his wide circle of artist friends, including Sebastiano Ricci and Rosalba Carriera, was the leading connoisseur beside Algarotti and respected as a discreet source of

information concerning bankrupt Venetian aristocrats or convents and monasteries prepared to sell works of art.

Marshal Johann Matthias von der Schulenburg (1661–1747) was the personification of Habsburg diplomacy in the city of Venice. Celebrated as a hero after a brilliant military career, and in particular after lifting the seige of Corfu by the Turks in 1716, he was a protégé of Prince Eugene. Like his patron, Schulenburg began collecting at the latest in 1720, concentrating on the work of artists who had not journeyed northwards. His collection, which he later transferred to Berlin, included thirteen pictures attributed to Piazzetta. Schulenburg commissioned works from Sebastiano Ricci, collected Michele Marieschi and Francesco Guardi, owned 43 paintings by Antonio Guardi, and signed up Giovanni Battista Pittoni. His collection proves that in the 18th century there was no such thing as a 'private collection' savoured only by the owner and his intimates: the specialised collection of Venetian art was certainly restricted to the rich and the powerful, but the acquisition and display of paintings were frequently a means to furthering political ambitions. That this socially influential soldier was well aware of the role of Venetian art north of the Alps is evident from his ability to apply his diplomatic skill in exploiting his connections with the Imperial court, with the princes loyal to the Emperor and not least with the Teutonic Order.

In 1708/9 Bellucci left Vienna temporarily for Düsseldorf, to work at the court of the Elector Johann Wilhelm von der Pfalz (d. 1716) of the Wittelsbach house, a close relation of the Emperor and an ardent supporter of the Habsburgs. In 1713/14 Pellegrini was also summoned to the Düsseldorf court, where he stayed until 1716. The two artists worked together in the Bensberg Palace. Here was a manifest example of Venetian art in the service of political propaganda. Bellucci glorified his Rhineland patron in the style of Rubens's Medici cycle (there was a great collection of works by Rubens at Düsseldorf), and Pellegrini, who also painted the altarpiece in the garrison church, adapted himself to Bellucci's style when producing for the palace the fourteen allegorical portraits and historical paintings of events in the life of the Elector. The thematic programme of the Bensburg cycle, namely praise and legitimisation of the Elector Johann Wilhelm, recalled the events of 1708, when he was appointed to the Electorate after the honour had been withdrawn from his cousin, Max Emanuel of Bavaria, who had supported the French king.[11] It was not until Max Emanuel was rehabilitated and had returned to Munich in 1715 that he permitted Venetian artists such as Amigoni to paint for him once more.[12]

On its way westwards Italian art followed the lines of political allegiance established by the Habsburgs. In 1688 Louis XIV had occupied the Imperial territory on the Rhine and the Palatinate with his armies; the battle for the Rhineland provinces and the threat from the Ottoman Turks in the south-east unleashed a great struggle for power in Europe; dynastic ambition became the driving force in the conflict between the Habsburgs and the Bourbons in their struggle over succession of the Spanish crown.

Whereas France had an efficient state apparatus organised on modern lines, the Imperial Union was still feudal in character. Proximity to the Emperor offered the German princes the chance to ascend the ladder of the Imperial system, and the princes of the Church, who held nearly 50 independent bishoprics and abbeys, formed a solid front in support of the Emperor. As the bonds between the Emperor and his client princes grew closer, and as the French became increasingly intent on breaking up the expanding sphere of influence of the House of Austria, the courts of the German princes became the scene of diplomatic battles. Against this background it is obvious how the princes used art to underpin their power and claims to status,

as well as to glorify their military prowess. Seen from their perspective, military achievements and patronage of the arts were two sides of the same coin. For, just as success on the battlefield did honour to a prince, so patronage expressed the princely virtue of munificence, and investment in the arts was evidence of a prince's splendour in times of peace.[13]

Life at these courts, and lavish expenditure on the arts, were intended to impress foreign ambassadors and spies, and to promote diplomatic exchange between the courts. The carefully staged appearance of a ruler's palace was closely bound up with political aspirations and could do much to enhance his reputation: the reputation of a prince could, in some cases, even compensate for lack of real power. The choice of acquisitions made by the German princes can hardly be described as a reflection of their preferred taste. The German Electors were driven by what is best termed 'purchasing policy'. In every one of their painting galleries, the collections of the individual courts reveal a desire to present their owner in a favourable cultural light.

In the Rhineland, the family most loyal to the Emperor was that of the Counts of Schönborn. The Elector Lothar Franz von Schönborn (1655–1729),[14] the first of his line to be educated for the priesthood and as a diplomat in Vienna, and not in France, was a staunch champion of Habsburg interests. He is a prominent example of the close link between politics, money and patronage. His loyalty to the Habsburg cause paid off; for his support of Charles VI, Lothar Franz earned the sum of 100,000 *gulden*, and spent the entire amount on art.[15]

The painter Johann Rudolf Byss (1660–1738) from Vienna was recommended to Lothar Franz as a skilful and knowledgeable gallery director, whose reputation rested in no small part on his paintings for the Imperial audience chamber at the Hofburg in Vienna. Byss worked on assembling the Schönborn collection of paintings, for which a special gallery was installed in 1713 at Schloss Pommersfelden to house the 250 pictures that were bought in the space of just a few years. The use of a private agent as an intermediary had provided a considerable number of works by contemporary Venetian painters, including Bencovich's *Sacrifice of Iphigenia* of 1715 (cat. 71), and these paintings were exhibited in key locations that were showcases for the prestige of the Schönborns. Lothar Franz was Pellegrini's most important patron, both at the palace of Pommersfelden and at the Residenz in Würzburg, and he also promoted his career among the German nobility.

Lothar Franz's two nephews maintained the link with the court at Vienna. The elder of the two, Johann Philipp Franz von Schönborn (1673–1724), had been appointed to a number of politically important benefices between 1700 and 1714, including the church of St Bartholomew in Frankfurt am Main, where the German Emperors were crowned. Johann Philipp was also a patron and promoter of Pellegrini, commissioned paintings from him for his uncle at Pommersfelden, and in 1713 recommended this widely travelled artist to his brother, Friedrich Karl von Schönborn, in Vienna. Friedrich Karl's political career culminated in his appointment as Imperial Vice-Chancellor, a position he held until 1734. He was the sole heir of Lothar Franz, and, on his retirement, took Venetian artists back to Pommersfelden with him to decorate the Residenz and the court church at Würzburg; Bencovich was appointed court artist in Würzburg, and paintings by Piazzetta and Pellegrini were purchased for the gallery at Pommersfelden. After the death of his uncle, Friedrich Karl virtually doubled the number of paintings there.

It was via Pommersfelden and Würzburg that the most important links were established between Venetian painters and the Dresden court of Augustus II, called the Strong (1670–1733), Elector of Saxony and, from 1697, King of Poland, and his son Augustus III (1696–

1763). Diziani was the first of the Venetians to reach the court of Dresden, followed by Pellegrini, who arrived from Vienna in 1725. Pellegrini's chief works in Dresden, apart from completing the altar in the court chapel, are the paintings at the southern end of the Zwinger, which allude to the reign of Augustus the Strong. In 1726 the engraver Andrea Zucchi (1679–1740) moved to Dresden together with his son Lorenzo (1704–79); Rosalba Carriera arrived in 1746, in the same year as Bellotto, who was appointed court painter and was later to work in Vienna at the invitation of Maria Theresa in 1759.

Although only just over 100 paintings were purchased in the course of Augustus the Strong's 40-year reign, he laid the foundations for the Dresden gallery by expanding the categories of objects in the collection. The court was exceptionally magnificent, and the collections of art and natural history were closely linked with court ceremonial.[16] Augustus III succeeded his father as King of Poland in 1733. He converted to Catholicism at Baden, near Vienna, and was married to one of the daughters of the Emperor Joseph I, thereby strengthening his ties with the Habsburgs. It was not just Venetian paintings that flooded into Dresden. In the course of one single year, 1742, the King, who had already visited Venice while Crown Prince (and had his portrait painted there by Rosalba Carriera) acquired 715 paintings and numerous graphic works, some of which are still kept in their original albums.

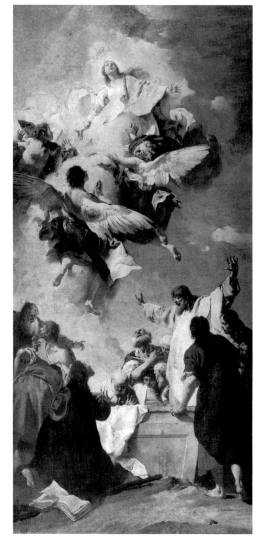

*Figure 12:* G.B. Piazzetta, *The Assumption of the Virgin*, oil on canvas, 517 × 245 cm, *c.* 1735, Musée du Louvre, Paris

The acquisition in 1744 of the collection of Francesco III Farnese, Duke of Modena (with paintings by Titian, Correggio and Veronese), formed the basis of the Italian section, and the conversion of the palace on the Jüdenhof to accommodate the gallery and a guest wing provided a further place beside the castle and the Zwinger where art and diplomacy combined. Where art was concerned, money was no object: Augustus and his minister (and rival in cultural affairs), Heinrich, Count Brühl, were known to be so eager to buy, that impoverished aristocrats from throughout Europe would come to Dresden to offer their entire collections for sale.

Also at Dresden was Count Francesco Algarotti (1712–64), an Italian scholar and diplomat, who arrived by way of Paris, London, Danzig and Berlin (where he had been in the service of Frederick the Great, King of Prussia). There he worked on the ambitious project of installing a painting gallery for Augustus III.[17] Algarotti acquired works from Sebastiano Ricci, Pittoni and from Piazzetta, including *The Standard-Bearer* (Gemäldegalerie, Dresden). Further paintings by Piazzetta came from the Wallenstein collection at Castle Dux in Bohemia.

Algarotti was linked to a second generation of dealers and agents who specialised in Venetian art and maintained the flow of pictures moving northwards. In 1736 the entire collection of Zaccaria Sagredo was put up for sale. During the 1730s and 1740s the art trade reached those courts which had been more inclined towards the French. From 1742 Frederick the Great's Potsdam gallery contained two paintings by Marieschi (cat. 162), acquired for him by Algarotti.

The Elector Johann Wilhelm of the Palatinate (1658–1716, ruled from 1690) was married to a sister of the Emperor Leopold. A loyal supporter of the Habsburgs with a distinguished military record during the War of the Spanish Succession,[18] he employed Antonio Bellucci and Pellegrini. He was succeeded in 1716 by his brother, Karl III Philipp of the Palatinate (1661–1742), who also patronised Venetian artists, and in 1736 summoned Pellegrini to decorate the palace at Mannheim, after he had finished working in Dresden.

Clemens August of Bavaria (1700–61), of the house of Wittelsbach, was the son of the Elector Max Emmanuel (1662–1726) who had defeated the Turks. Archbishop of Cologne from 1723, he was appointed High Master of the Teutonic Order in 1733 by Imperial decree. He had many palaces built and, having paid three visits to Venice, he knew a great deal about the city's artists.[19] On Clemens August's commission, in 1733 Piazzetta painted his great altarpiece of *The Assumption of the Virgin* (fig. 12) for the Church of the Teutonic Order in Sachsenhausen, Frankfurt (where the emperor-elect was usually housed during the coronation festivities). It is surely no coincidence that it alludes directly to the Riccis' painting in Vienna (fig. 11). Piazzetta's painting stands as an aesthetic testament to the oath of loyalty sworn by Clement August to the Imperial House on assuming the role of High Master of the Teutonic Order in 1732. Before appointing him to the post the Emperor had imposed certain conditions; he had to acknowledge the pragmatic sanction and support the Emperor against the threat posed by the Turks and the French.[20] It is ironic that this, of all paintings, should have been taken to France at the time of Napoleon.

The commission for this politically significant picture – publicly exhibited in Venice before being transported to Germany in 1736 – was the breakthrough that finally brought Piazzetta recognition in northern Europe after the death of Sebastiano Ricci in 1734. As a result, virtually no other Venetian artist was in such demand with ambitious aristocratic patrons of the arts. Clemens August became one of his greatest patrons.[21] Although Schulenburg already owned a painting by Piazzetta in 1731, there was a noticeable increase in the number of his works acquired after 1736.[22]

Piazzetta was represented in almost every gallery under Habsburg influence, and was held in the highest esteem in Germany for several decades. A great admirer was the Berlin collector, Sigismund Streit (1687–1775), who had made his fortune as a merchant in Venice, and possessed numerous works by Piazzetta, as well as paintings by Amigoni (cat. 51), Pittoni, Sebastiano Ricci and *vedute* by Canaletto.[23]

In 1735 Pittoni was commissioned to decorate the Residenz of the High Master at Mergentheim as well as to paint three altars in the church of St Clement in Münster. Also in the 1730s Clemens August ordered paintings for the palaces at Nymphenburg and Schleissheim from Amigoni and commissioned Tiepolo to paint the ceiling at Nymphenburg.

Philipp Carl von Eltz, Imperial Chancellor and Bishop-Elector of Mainz (1665–1743) also bought works by Venetians; he owned one of the two small versions of Ricci's altarpiece for St Charles's in Vienna. His nephew and heir, Hugo Franz, Count von Eltz (1701–79), Provost of Mainz Cathedral, was a man of wealth and influence. His collection contained seven works by Piazzetta alone.[24] A number of paintings from this collection, including Ricci's *bozzetto* and two Old Testament scenes by Diziani later entered the Bavarian state collection of paintings and were kept at Aschaffenburg.[25]

The success of the Venetian painters north of the Alps appears to have paved the way there for the Tiepolos, father and son. Clemens August was one of the first German princes to employ Giambattista, when he commissioned the altar in the chapel of the Nymphenburg Palace in about 1739. Presumably as a result of this, the diocesan provost, Herculan Karg, shortly afterwards secured the services of the artist for a similarly large-scale work for the Augustinian monastery at Diessen.[26] The Eltz collection also contained two Tiepolo paintings, a Last Supper and a landscape with figures,[27] but it is uncertain whether they were made for the Elector of Mainz himself or for his nephew. Nevertheless paintings by Tiepolo appeared only

occasionally in Northern collections, and major commissions from German princes were rare, even though the artist had a great advocate at the court of Dresden in the person of Algarotti. Algarotti had made a gift of paintings by Tiepolo to the Prime Minister, Count Brühl, yet paintings by Tiepolo were not added to the royal collections until much later. Apart from the artist's many commitments at home and his high fees, numerous rising German artists, who were considerably less expensive, were being hired, especially in the south of the Empire. This gave the Swabian artist Johann Zick (1702–62) his great opportunity to undertake painting the Imperial Hall of the Würzburg Residenz, until Tiepolo was summoned.[28]

The death of Charles VI, the last male heir to the house of Habsburg, in 1740, brought in its wake profound changes in the political situation of the old Empire. Its effect on the artistic aspirations of the court should not be underestimated. Following the interregnum of 1740–2, the coronation of Charles VII (1697–1745) was the first time that a member of the house of Wittelsbach had been crowned Emperor since the late Middle Ages. Whereas before the Empire had been threatened by external forces – such as the French king – now the house of Habsburg faced its most dangerous challenge, not so much from the rival Wittelsbach dynasty, but from Frederick the Great (1712–86). In the political and territorial struggles with Maria Theresa, Charles VII became a mere pawn on the political chessboard of the Prussian monarch. Frederick sought to secularise the Church territories along the River Main and in Bavaria, so that they could be added to the Bavarian Electorate as a way of boosting the Wittelsbach Emperor's hold on the throne. This objective directed against the Habsburg court of Vienna was a flagrant attempt to undermine the feudal basis of the Empire, and compelled the Habsburgs as well as the affected bishoprics, Würzburg among them, to rally in defence. Although the initiative ultimately failed, the rumour of Frederick's intentions was perpetuated by the Habsburgs and persisted far longer than the threat of secularisation.

Karl Philipp Heinrich von Greiffenklau (1690–1794)[29] was created Prince-Bishop of Würzburg in 1749. He employed Pellegrini at Mainz and Würzburg and commissioned the ceiling panels at Veitshöchheim. By 1750 the time had come for him to nail his colours to the mast by having the Imperial hall (Kaisersaal) of his Residenz at Würzburg decorated with propagandist frescoes. With the death of Charles VII in 1745, Maria Theresa become Empress, and the pragmatic sanction was universally recognised after the Treaty of Aix-la-Chapelle (Aachen) in 1748. The Prince-Bishop entrusted the painting of the ceiling the Imperial Hall to Giambattista Tiepolo who, unique among his contemporaries, could provide Germany on the eve of the Neo-classical age with one final explosion of Venetian colour, glorifying the Habsburg dynasty (fig. 1): the Emperor is acknowledged as supreme feudal lord on a superhuman scale; the figure of Europa, meanwhile, manifests the notorious Eurocentrism of Imperial policies. Tiepolo's ceiling frescoes above the left staircase hark back to the legacy of Charles V, and the four continents to the greatness of the Habsburg Empire that once spanned the world.[30] By 1753 European alliances were changing. The struggle for global supremacy was to be played out in the New World, where Britain and France were to face one other. Without naval power, its dynastic base firmly anchored to the continent of Europe, the house of Habsburg had no hope of playing a part in the struggle for the New World.

## *Paris*:   August Bernhard Rave

During the reign of Louis XIV Venetian artists shared the fate of the Italian musical companies, who were banned from Paris. Yet, even at this time changes were emerging in the

Parisian Académie. The supporters of Rubénisme, who exalted colour, gradually gained the upper hand over the advocates of the classic style, the Poussinistes. It was not until the Duke of Orléans became Regent that the cultural dictates imposed by the Court gradually eased.

One Venetian painter, however, had already worked for Louis XIV as early as 1692. The French Academy in Rome had selected Sebastiano Ricci to make a copy for the King of Raphael's *Coronation of Charlemagne* in the Stanza dell'Incendio in the Vatican. Sebastiano's style understandably reminded the King of Veronese's. The Director of the Académie, La Teulire, praised the '*inclination française*' of Sebastiano's copy after Raphael.[31] Sebastiano does not seem to have visited France until 1711–12, when he was *en route* for England with his nephew, Marco. Marco had already been in England, and would have been familiar with the work of the French painter Charles de La Fosse, who had decorated Lord Montagu's town house between 1689 and 1692. In Paris it is quite likely that Marco would have shown his uncle the decorations at Versailles by La Fosse and Antoine Coypel and those in Les Invalides. Sebastiano stayed in Paris again on the way back from England in 1716, a year after Louis XIV's death, as the banker Pierre Crozat informed Rosalba Carriera in a letter.[32] This great collector and patron, who had befriended Watteau, introduced Ricci to the Parisian art scene. Crozat himself had recently returned from an extended Italian journey, in the course of which, through Zanetti the Elder, he had established his first contacts with Venetian artists. His house in the rue Richelieu became a meeting-place for French and Venetian painters.[33] Sebastiano met the aged chancellor of the Paris Académie, Charles de La Fosse, from whom he had to endure sarcastic comments about his paintings in the style of Veronese.[34] As well as Watteau, he probably met French artists who had been in Italy, such as Jean-François de Troy, Louis de Boulogne, Jean Raoux, Antoine Coypel, Jean Jouvenet and François Lemoyne; some years later Lemoyne sought out Sebastiano in Venice. Sebastiano was made a member of the Académie (see p. 61).[35]

Included in Sebastiano's luggage on his arrival in Venice in 1716 was a small self-portrait by Crozat, a gift for Rosalba Carriera; Rosalba used it to make a pastel of her patron which she sent to him in Paris.[36] There was a lively correspondence between Crozat and Rosalba, and a few years later he persuaded her to visit Paris. She arrived there in 1720 accompanied by her sister, Angela, and her brother-in-law, Giovanni Antonio Pellegrini, and remained there as a guest in Crozat's house until March of the following year, all of which she recorded in her diary.[37] Rosalba's work was greatly admired by the French nobility, who were flattered by her pastel portraits; one of her sitters was the ten-year-old Louis XV. Her portraits had a considerable effect on contemporary French portraiture and her popularity raised the status of this genre within the Académie; she was the first foreign woman painter to be admitted into it.

Giovanni Antonio Pellegrini was the most widely travelled Venetian painter of his day. In 1719 he stopped briefly in Paris, on his return from England. In 1720 he was commissioned to paint the Banque Royale, which prompted Lemoyne to submit alternative designs.[38] His decoration of the Mississippi Gallery in the French capital was destroyed shortly after completion, but he also painted the high altarpiece for the church of the Augustinian monastery in Paris.[39] In 1733 he was made a member of the Académie; he had already been elected member of the painters' guilds in The Hague and Amsterdam.

Jacopo Amigoni, who had worked in England since 1729, spent the summer of 1736 in Paris in the company of his friend Carlo Broschi, called Farinelli, the most illustrious castrato opera singer of his time, who had come to Paris to give concert performances, and to appear at Versailles.[40]

Giambattista Tiepolo was brought to the attention of Mariette by his friend Zanetti, who acquired a number of prints by Tiepolo for him in Venice.[41] The artist never travelled to France himself, although in 1760 he presented the French king with a painting. Two large, early *vedute* by Francesco Guardi (Waddesdon Manor) were originally owned by Louis XVI.[42] Another of Guardi's early works was presented by the former French ambassador in Venice to the museum at Albi.

Pierre Crozat's house was the first port of call for the Venetian artists. Through his friend Zanetti, Crozat had excellent contacts with Venetian artists, and his collection included numerous paintings, not only by Old Masters such as Veronese, but paintings and prints by contemporary Venetians.[43] Crozat favoured the colourists rather than the tenebrists. In his collecting he was helped by Pierre-Jean Mariette, also a friend of Zanetti.[44] When Crozat died in 1741, it was Mariette who catalogued his collection before its sale. In 1772, with Diderot as intermediary, a considerable number of the pictures owned by Crozat's heirs passed into the possession of the Russian Empress Catherine the Great.[45]

## *Scandinavia and Russia*:  August Bernhard Rave

The courts of Spain, Sweden and Russia also offered opportunities for Venetian artists; their representatives in Venice were constantly on the look out for talent. Some of the rulers even came to Venice themselves: Frederick IV of Denmark arrived in 1709 and bought from Rosalba Carriera a series of lively pastel portraits of leading ladies in Venetian society.[46] The festive regatta held in his honour was recorded by Luca Carlevaris (cat. 22). However, the most discerning of the Scandinavian collectors was Count Carl Gustav Tessin, son of the architect of the royal palaces in Stockholm.[47] A bursary awarded to him as a young man by the Swedish king had enabled him to travel in France and Italy to study architecture and art, in the course of which he had taken lodgings for three months in Venice. With the end of the Thirty Years War, palace building projects were resumed, and Count Tessin was appointed royal advisor in artistic matters. In 1735 a diplomatic mission took him to the Habsburg court in Vienna, where he doubtless saw Sebastiano Ricci's frescoes in the palace of Schönbrunn and his altarpiece in St Charles. From Vienna Tessin went to Venice.

In 1736 Tessin wrote to the architect Carl Hårlemann, his partner in Stockholm's royal building project. The letter[48] mentions the most famous artists to be found in Venice at the time: Canaletto, Giovanni Battista Cimaroli, Pittoni, Piazzetta, Mattia Bortoloni, Francesco Polazzo, Giuseppe Nogari, Antonio Joli and Giambattista Tiepolo. Work in Stockholm was offered to Tiepolo, but he proved to be too expensive for the Swedish court. Most of the extensive collection of Venetian Settecento painting in the National Museum in Stockhom today was privately acquired by Tessin, including pictures by all those artists mentioned in his letter. Tessin bought a substantial number of the prints by Venetian masters from the famous Crozat collection when it was auctioned in Paris in 1741.

By the end of the Thirty Years War Sweden had gambled all and lost; Russia, however, had emerged as a new power. As well as instigating economic and technological initiatives in Russia, Peter the Great established a new capital, St Petersburg, and soon artists from abroad began to arrive there. Some Venetian sculptors went to work there; but sculpture was also imported direct from Venice.[49] Pietro Rotari worked in St Petersburg from 1756; Francesco

Fontebasso was summoned there in 1761 to decorate the Winter Palace. Fontebasso returned home a year later via Mitau, where he worked for the Duke of Karelia, whose collection in 1780 included works by Amigoni, Diziani and Maggiotto.[50] Jacopo Guarana was invited to work at St Petersburg, but never went because of the murder of Tsar Peter III.

In 1747 the Russian Prince Youssoupov had acquired a painting by Tiepolo for his collection in his palace of Archangelskoye near Moscow. While he was ambassador in Turin between 1783 and 1789 he bought two pendants, *The Meeting of Antony and Cleopatra* and *Cleopatra's Banquet*. In all he is said to have owned seven works by Tiepolo, for which the architect Giacomo Quarenghi installed a Tiepolo gallery in the Prince's new palace near St Petersburg.[51] Francesco Algarotti mentioned that the Russian Count Vorontsov had also had 'a number of ceiling paintings in his palace near St. Petersburg' painted by Tiepolo; one of them could have been *Mars and the Graces* (see cat. 239), which after the death of Vorontsov passed to Catherine II, who hung it in the Chinese pavilion at Oranienbaum near St Petersburg.[52] However, Tiepolo's most prestigious Russian commission was probably that given by the Empress Elizabeth Petrovna for the ceiling painting in the Throne Room of the Winter Palace at St Petersburg. Tiepolo's son, Domenico, must surely have been involved in this work as well. The artist refers to one of these great paintings, which have disappeared, in a letter written to Algarotti in 1761. A *modello* of the *Triumph of Venus* (Prado, Madrid) is probably for one of these ceiling paintings; their subjects are known from engravings by Lorenzo Tiepolo and from two drawings once in the possession of Mariette.[53]

After Catherine the Great succeeded to the throne in 1762 a large number of Venetian paintings entered the Imperial collection. Following the death of Augustus III and of his minister Count Brühl in 1763 Venetian art fell from favour at the court of Dresden. That is how Tiepolo's painting of *Cleopatra's Banquet* (Melbourne), which had been bought by Algarotti for the Dresden gallery in 1744, came into the possession of the Empress of Russia after the sale of the collection in 1765.[54] In 1769 Catherine acquired Tiepolo's *Maecenas Presenting the Arts to the Emperor Augustus* from the collection of Count Brühl.[55] She also bought the major part of Mariette's collection from his heirs in 1772. The same year Pietro Antonio Novelli completed *Creüsa Imploring Aeneas to Rescue Anchises from the Flames of Troy* for Catherine.[56] Word soon spread throughout Europe that the Russian Empress was prepared to pay handsomely for works of art. This allegedly prompted the wording of the will of Count Hugo Franz von Eltz, who stipulated that after his death the major part of his collection, which contained over 1,231 paintings, was to be sold, if possible, to Russia.[57]

The Russian court acted as a magnet to artists, especially Venetians, who were no longer held in such high esteem elsewhere. In 1767 Bernardo Bellotto, accompanied by his son, left Dresden for Warsaw in order to obtain a recommendation from Stanislaus II Augustus Poniatowski so that he could enter the service of Catherine II. But the Polish King, himself a great admirer of Venetian painting, offered Bellotto the position of court painter in 1768, and the artist remained in Warsaw until his death in 1780.[58]

In 1782 Catherine's heir, the Grand Duke Paul Petrovich and his wife, Maria Federovna, who was from the house of Württemberg, spent the week of 18–25 January in Venice. On the occasion of this grand visit of the 'Conti del Nord', who were travelling incognito, Venice staged all manner of festivities in honour of her guests, and Francesco Guardi – possibly at the request of the Grand Duke – recorded the events (see cat. 208) in six paintings, three of which have survived, although none, apparently, came into the possession of the Russian court.[59]

## *Spain*:   August Bernhard Rave

In 1735, when Italians were being chosen to decorate the Royal Palace in Madrid, the architect Filippo Juvarra recommended four Roman painters but only one Venetian: Pittoni.[60] By the time Ferdinand VI ascended the throne in 1746 the Spanish court was more favourably inclined to Venetians. In 1747 Amigoni was made Court Painter, an appointment he owed in part to his friendship with the famous castrato Farinelli, who was able to alleviate the King's melancholy with his singing. Amigoni worked in the palace at Aranjuez and at the Buen Retiro and was the first director of the Real Academia de San Fernando, founded in 1752; he died in Madrid in the same year.[61]

Towards the end of Ferdinand's reign a political *rapprochement* was beginning between the Spanish Bourbons and the Habsburgs.[62] When the King died without issue in 1759 he was succeeded by his half-brother, Charles III, who had been King of Naples since 1737. He summoned Giambattista Tiepolo to fresco the Royal Palace in Madrid.[63] The chosen theme for the throne room was 'the regions of the world pay homage to the Bourbon Spanish monarchy'; the iconographic programme had been drawn up by a Benedictine monk, Martín Sarmiento,[64] and the plan had been discussed with Tiepolo in Venice before he left (cat. 128). After the completion of the throne room in 1764, Tiepolo frescoed the ceiling of the Saleta, the audience hall, with the *Apotheosis of the Spanish Monarchy* and that of the Sala de Guardias with the *Apotheosis of Aeneas* (1765).[65] In 1766 Tiepolo was elected a member of the Spanish Academy and in January 1767 he informed the King that he was prepared to take on more large-scale work and was commissioned to paint seven altarpieces for the Franciscan Church of S. Pascual Baylon in Aranjuez, which had been founded by Charles III in 1765.[66] The altarpieces were installed only in May 1770, when the church was finally completed; but Tiepolo had died in March. Less than a year later the paintings were removed by order of Charles III and replaced with paintings of the same subjects by Anton Raphael Mengs and his followers in the Neo-classical style. Mengs was the favourite artist of the Queen, and since 1761 had been working at the Spanish court as *Pintor de Cámara*. The frescoes in the Royal Palace survive, Tiepolo's last great work of propagandist art.

## *England*:   Francis Russell

It is fitting that this exhibition should open in London, for British patronage was of importance to the careers of many of the key artists of 18th-century Venice. Commerce had long been a bond between the Republic and England, and Venetian Renaissance pictures had been keenly admired in a country whose portraitists owed not a little, through the medium of van Dyck, to Titian. The great burgeoning of English patronage in the early years of the 18th century reflected a new economic and a revived political power, but the pattern of its expression was to a significant extent determined by the level of local talent. English architects were more than able to realise the aspirations of their patrons. But except in the field of portraiture, painters in London, whether indigenous or naturalised, were quite simply unable to hold their own with Continental counterparts.

Charles Montagu, 4th Earl – and subsequently 1st Duke – of Manchester, who was sent to Venice as Ambassador Extraordinary in 1707, was keenly aware of both the strengths and the deficiencies of his countrymen. His seat at Kimbolton Castle was being recased by no less an architect than Vanbrugh, but, emulating his cousin and neighbour the 1st Duke of Montagu,

whose embassy in Paris led to the employment of a succession of French artists and craftsmen, Manchester responded to the opportunities he found in Venice. Carlevaris recorded his state arrival, and on his departure in 1708, the Earl took both Pellegrini and Marco Ricci with him. Once in England the two worked both for their patron and for a number of his political associates, including Lord Carlisle. Pellegrini's enchanting decoration of the staircase at Kimbolton (fig. 13) was indeed considerably surpassed in scale by his work, now destroyed, for Carlisle at Castle Howard, Vanbrugh's first architectural masterpiece, for which Ricci in turn supplied overdoors.

Pellegrini remained in England until 1713, returning in 1719 to serve another of Manchester's associates, the 1st Earl Cadogan, at Caversham. Marco Ricci left in 1710, but reappeared after little more than a year with his uncle, Sebastiano; both remained until 1716. With the exception of one major public commission, Sebastiano's *Resurrection* in the apse of the chapel of Wren's Chelsea Hospital, London, their employers were plutocrats of impeccably Whig allegiance, who expected an Italian sophistication and elegance purged of Catholic rhetoric. The architectural ascendancy of Vanbrugh was already challenged and the three artists were all employed by the most influential patron of the emergent generation, Richard Boyle, 3rd Earl of Burlington, whose Palladian sympathies were surely gratified by Sebastiano's debt to Veronese (fig. 14). Alas, losses outweigh the survivals. Pellegrini's decorations at Cowdray and Portland House have vanished without trace: Sebastiano's spirited oil sketches represent his scheme of 1713–14 for the Duke of Portland's chapel at Bulstrode; and for his massive undertakings for the Duke of Buckingham at Buckingham House, arguably the most influential secular building in the country, we have no more than the accounts to go by, which totalled £5,060. The Riccis' departure in 1716 coincided with the arrival of Andrea Bellucci of Treviso, who also worked at Buckingham House. His major patron was, however, the extravagant Duke of Chandos, whose prodigious mansion at Canons amazed contemporaries but was to survive for no more than a generation.

The Venetians thus made a significant contribution to the decoration of many of the most spectacular London houses of the period. Owen McSwiney's knowledge of their success surely led to his celebrated speculation – if speculation it was – to commission a series of allegorical tombs of Whig worthies; and equally Consul Smith's personal patronage of Pellegrini and the Riccis can be seen as conforming with, rather than anticipating, established taste in British patrician circles.

Smith of course was not the first merchant to act as an intermediary between British patrons and Venetian artists. But his activity was on an unprecedented scale. With the apparent exception of Amigoni – who spent a decade in England, 1729–39, and worked at houses of such distinction as Mereworth, Moor Park and Wentworth – every Venetian painter who secured significant British patronage for over half a century was in some way beholden to Smith. The rich traveller on the Grand Tour would sit to Rosalba Carriera, who exercised a more direct influence on British contemporaries than any other Italian painter of the century, as portraits by Knapton, Hoare and so many others exemplify. The British taste for topography was already well catered for in Rome. With Smith's active encouragement, Canaletto embarked on a course that was calculated to appeal to the Grand Tour market and did so with such success that his vision of Venice has lain behind all subsequent representations of the city. After exploiting for two decades the golden vein he had struck, Canaletto visited England in pursuit of patronage when political upheavals on the Continent diminished the flow of tourist commissions. Many of the more important patrons of his English period already owned canvases he had painted in Venice, but others included the opinionated Lord Chesterfield who

*Figure 13:* G.A. Pellegrini, *Musicians*, oil on plaster, *c.* 1710, Kimbolton School

needed overdoors and an overmantel for Chesterfield House, the most stylish London palace of the day. The Earl, like the Duke of Richmond, turned to Canaletto and to Antonio Joli for no better reason than that no indigenous painter could supply his needs. The influence of Canaletto on subsequent generations of British artists was, however, to have a profound influence on the evolution of topographical art in Britain; ironically, in the following century British artists, including Turner and Bonington, would far outshine any local painters in their response to the magic of Venice.

Smith's interest in Canaletto's success was echoed by his early championship of Francesco Zuccarelli, who was in England for a decade from 1752 and again in 1765–71. Zuccarelli's sunny pastoral scenes became progressively more formulaic. Yet these never lose their enchantment. In his second London period, during which he was elected a founder member of the Royal Academy, the painter supplied outsize canvases for both George III – who had already bought those from Smith's collection in the sale of 1762 – and his erstwhile mentor John Stuart, 3rd Earl of Bute.

By comparison with that of Marshal Schulenburg, Smith's view of Venetian painting was limited. He owned drawings but no significant paintings by Piazzetta. The Consul's failure to patronise Tiepolo should be seen, however, less as a reflection on his taste than as evidence that the painter was fully committed elsewhere, not least in the service of the very Venetian patricians who showed an understandable reluctance to associate with boisterous foreigners on the Grand Tour. None the less it is somewhat ironic that the first major Tiepolo to reach Britain, *The Finding of Moses* (cat. 104), was bought as a Carletto Caliari by no less a connoisseur than Bute, who first visited Venice in 1767 and settled there in 1768–70. Like his friend the Resident, Sir James Wright, Bute sought out works by the masters of the Cinquecento and eschewed those by contemporaries, reserving his patronage for printmakers and botanical artists. It was he who secured the reversion of the Residency in the city for John Strange, whose interest in the arts made him in so many ways the cultural successor to Consul Smith.

While Smith's holdings of contemporary work had been complemented by his collection of Old Masters, Strange's priorities were different. He was, it is true, a patron of Francesco Guardi (see cat. 216), whose views of his villa indeed epitomise our sense of *villegiatura* in the Settecento. Earlier pictures, however, mattered infinitely more to him. His interest in Vivarini and Cima placed him indeed in the uneconomic vanguard of taste. Strange's pioneering enthusiasms were not widely shared, but there is evidence that from the 1770s onwards British visitors to Venice were more likely to leave with Old Masters than with modern pictures. Thus the 3rd Duke of Dorset secured a Wouwerman, while Sir Abraham Hume, so well served by the dealer Giuseppe Maria Sasso, responded to the Cinquecento. More remarkably, the future Lord Cawdor bore off Bellini's *Doge Leonardo Loredan* (National Gallery, London). To complement his museum of antiquities he also commissioned Canova's *Cupid and Psyche* (fig. 70). The sculptor would be pursued by British patrons throughout his career and thus well into the new century, but in their eyes he was a Roman rather than a Venetian phenomenon. When in 1814, after the generation's dislocation heralded by the French invasion of Italy, the British could once more travel freely in Italy, those who sought works by living artists and who flocked to the studios of Canova and other sculptors in Rome were content to leave Venice with nothing more substantial than gouaches by Giacomo Guardi. But ironically it would not be long before the greatest of all collections of drawings by Tiepolo passed into English hands when, in 1842 and 1852, Edward Cheney acquired nine volumes of studies (cat. 110), some of which had been owned briefly by Canova.

For Italy there is no fully comprehensive study of the relationship between Venetian artists and patronage in Italy outside the Veneto. Haskell, rev. 1980, charts the activities of Ferdinando de' Medici, Conti and Buonaccorsi, among others. The contribution of individual artists can be followed in the standard monographs, recorded elsewhere. For Trevisani see Di Federigo, 1977.

There is no general study of the activities of Venetian artists in England, but see Allen, in Birmingham, 1993, pp. 30–7; for decorative projects see Croft-Murray, II, 1970, and sections in the relevant monographs: for Sebastiano Ricci see Daniels, 1976[1]; Knox, 1988, p. 846ff. Sani, 1988, is understandably enough far from complete for a complete survey of Carriera's English commissions. For Canaletto see Constable, rev. Links 1976, *passim*, and Links, 1977. For Consul Smith see Vivian, 1971 and *idem*, 1989. For Strange, who deserves a full monograph, see Haskell, rev. 1980, pp. 373–5.

1. Csendes, 1985, pp. 179–86; Lorenz, 1985, pp. 235–48 (with further references; *idem*, 1983, VII, p. 21ff.
2. Braubach, 1963–5; Heilingsetzer, 1988, pp. 120–37, with further references.
3. Observations by the Duc de Villars, quoted by Braubach, 1963–5, I, p. 274.
4. Wandruszka, 1963.
5. Hüttinger, in Pfäffikon and Geneva, 1978, p. 7.
6. Ingrao, 1979.
7. Wessel, 1984, pp. 65–6.
8. Matsche, 1981.
9. D'Arcais, 1964, pp. 99–101.
10. Heinz, 1963, pp. 115–41; Braubach, 1965, pp. 27–43; Scott, 1973[1], pp. 54–5.
11. Kultzen and Reuss, 1991, X, 2, pp. 103–74.
12. The Düsseldorf collection was transferred to Munich only later under the terms of agreement of the House of Wittelsbach. This acquisition was a most important addition to the Bavarian State Painting Collection, providing the foundation of its Venetian Settecento collection, and is the product of the Habsburg orientation of the Palatinate line of the house of Wittelsbach; Rave, 1993, pp. 398–412; Holler, 1986, pp. 14, 18ff.
13. Warnke, 1985, p. 289ff.
14. Schröcker, 1978; *idem*, 1981; Bott, 1989, pp. 112–28.
15. Hubala, 1989, p. 27.
16. Heres, 1991.
17. Algarotti, VIII, 1792, pp. 353–74; Ferrari, 1900, pp. 150–4; Schmitt, 1921, pp. 256–61; Posse, 1931, suppl. 26.
18. Garas, 1971, pp. 60–88.
19. Goehring, 1934, p. 364ff; Cologne, 1961; Vey, 1963, pp. 193–226; Demel, 1987, pp. 79–108.
20. Demel, in Cologne, 1961, pp. 84–8.
21. Vey, 1963, pp. 193–226.
22. Binion, in Hanover, 1991, pp. 16–22, note 19.
23. Rohrlach, 1951, pp. 198–201; *idem*, 1974; Schreiber, 1974; Schleier, in Hanover, 1991, pp. 32–7.
24. For Philipp Karl von Eltz the man and the politician, see Durchardt, 1969; for Hugo Franz von Eltz, *idem*, 1969, pp. 251, 255. For Venetian paintings in the Eltz Collection in Mainz, see Holst, 1951, pp. 136–9; *idem*, 1960, pp. 164–5.
25. Kultzen, in Munich, 1986, X, 1, p. 58ff; *idem*, in Kultzen and Reuss, 1991, X, 2, pp. 55–6. The paintings that appear under Diziani in the Munich catalogue (1991) are listed as biblical scenes by Pellegrini in the Eltz Collection; cf. Holst, 1951, p. 138.
26. Fort Worth, 1993, pp. 192–5.
27. Holst, 1951, p. 139.
28. Büttner and Mülbe, 1980, pp. 24–5.
29. For Karl Philipp Heinrich von Greiffenklau, see Amrhein, 1890, pp. 203–4.
30. Ashton, 1978, pp. 29.
31. For the La Teulière quotation see Rosenberg, 1976, p. 122ff.; for Ricci's copy of Raphael and his encounters in Paris, see Wessell, 1984, pp. 65–71.
32. Wessel, 1984, p. 70.
33. Scott, 1973[1], p. 14ff.
34. Wessel, 1984, p. 67.
35. The painting is in the Louvre; see Daniels, 1976[2], no. 349, p. 120.
36. Scott, 1973[1], p. 15.
37. Carriera, ed. Sensier, 1865.
38. Wessel, 1984, pp. 71–3.
39. Haskell, 1966, p. 435.
40. Boris and Cammarota, 1990, p. 194; Scott, 1973[1].
41. Scott, 1973[2], p. 56.
42. Haskell, in Venice, 1993[1], p. 24ff.
43. Stuffmann, 1968, pp. 11–144.
44. Scott, 1973[2], pp. 54–9.
45. *Idem*, 1973[1], p. 18.
46. Haskell, 1966, p. 423.
47. Larsson, in Hanover, 1991, pp. 38–41.
48. *Ibid.*, p. 39.
49. Androsov, 1993, pp. 380–5.
50. Holst, 1951, pp. 131–40.
51. Ernst, 1963, p. 64.
52. Levey, 1962, pp. 118–9; Knox, 1979; Brown, in Fort Worth, 1993, p. 294.
53. Brown, in Fort Worth, 1993, p. 296; Frerichs, 1971, pp. 233–52.
54. Holst, 1960, p. 136ff., p. 140ff.
55. Brown, in Forth Worth, 1993, p. 222ff.
56. Haskell, 1980, p. 455.
57. Holst, 1960, p. 165.
58. Kozakiewicz, I, 1972, p. 183f. Recently a painting of *The Ecstasy of St Theresa of Avila* from the circle of Rosalba Carriera turned up on the Cologne art market, allegedly from the estate of Prince Poniatowski. See *Die Bestände der Kunsthandlung Julius Böhler, Munich*, auction catalogue (Kunsthaus Lempertz, 14 May 1994), Cologne, 1994, no. 42, p. 60.
59. Azzi Visentini, in Venice, 1993[1], p. 180.
60. Haskell, 1966, pp. 453–4.
61. Gualdaroni, 1974, p. 129–47.
62. Wandruszka, 1963, p. 48–9.
63. Whistler, 1986, p. 199–203.
64. Brown, in Fort Worth, 1993, p. 304ff; Jones, 1981, pp. 220–7.
65. Brown, in Fort Worth, 1993, p. 310ff., p. 313ff.
66. Whistler, 1985, pp. 321–5; Brown, in Fort Worth, 1993, p. 318ff.

*Figure 14:* Sebastiano Ricci, *Bacchus and Ariadne*, oil on canvas, 271.8 × 655.5 cm, Royal Academy of Arts, London

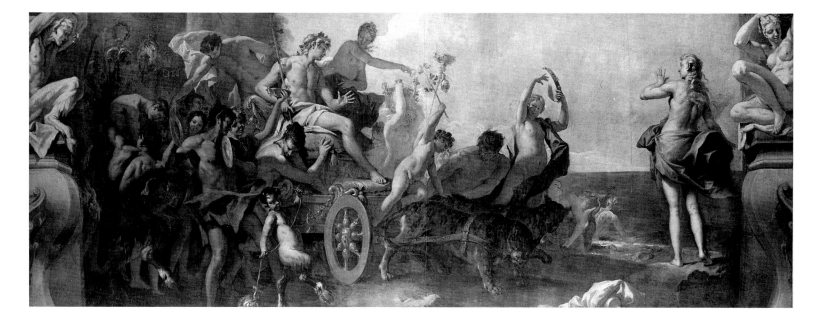

# Aspects of Cultural Politics in 18th-Century Venice

Giovanna Nepi Sciré

Politics in 18th-century Venice was characterised by a self-contradictory effort to preserve the status quo in the increasingly difficult defence of a myth of grandeur and prestige which had by then become illusory. At the same time, political, economic and social interrelations – not only at home but abroad – endangered the very survival of the Republic. Even so, provisions and initiatives undertaken in regard to the artistic patrimony, wherein the government could boast a tradition of several centuries, were exemplary, and such as to inspire modern legislation of conservation throughout Europe.

The establishment of an academy of painting and sculpture toward the middle of the century was a vital necessity for the artists themselves rather than a spontaneous initiative on the part of the state, and it represented an attempt to keep in step with the most advanced aspects of contemporary artistic culture, despite the fact that the works of the theorists of the Enlightenment, which had inspired the proliferation of similar institutions throughout Europe, were not widely read in Venice. The very meaning of an academy and the historical function of such an institution do not seem to have been determinative in the evolutionary process of the figurative arts in 18th-century Venice. If anything, the first manifestations of a precedent for the academy, starting in 1679, were prompted by the reformatory ideals diffused throughout the course of the 17th century, evident in the new awareness of the figurative arts as liberal arts, which prompted the attempt to free the arts from the chains of the guilds, and from their too-intimate association with more manual crafts. To be sure, economic motivations were not entirely lacking in this development.

As in France, the idea of the institution of an academy in Venice in the 17th century had marked the increasing detachment and liberalisation of the jealous corporational mentality of the guilds. Thus in Venice on 23 December 1679, the painters ('*depentori*' in Venetian dialect) formally requested the Senate for the right to separate from the manual arts, which included 'gilders, miniaturists, draughtsmen' (*indoratori, miniatori, disegnatori*), and also 'leather toolers and gilders, craftsmen working with paper, pot-makers, house-painters, and whitewashers' ('*quoridoro, cartoleri, pignateri, dipintori da travi e bianchegini*'), and asked to be incorporated under the title of the 'Academy of painters under the supervision of the Magistracy of the Administrators (*Provveditori*) of the Commune'. On 31 December 1682 the Senate granted the requested separation, though as yet there was no mention of an academy but only of a 'College of painters' ('*Collegio dei pittori*'), a term that definitively replaced '*depentori*'.[1] The College was thus a professional union, and it survived until the Napoleonic era, its activities developing parallel with – and indeed sometimes antagonistic with – those of the Academy.

On 14 August 1723, sculptors also obtained the right to separate from stonecutters and to form their own 'college'. In the following year, the Regents of the University of Padua (*Reformatori dello studio di Padova*), magistrates charged with supervising schools and universities, presented the Senate with a document from both colleges, repeating the proposal for the establishment of an Academy. They were acting in the hope of a renewed flowering of the arts.

There was a general perception of artistic decline just at the very moment when the city was reassessing its indisputable artistic supremacy in Europe, which arose from a sense of their 17th-century predecessors' having failed to profit from the great inheritance of the Renaissance. But above all, what is most evident in the artists' appeal to the Senate is the wish to emulate the examples of the other similar institutions and the wish not to be excluded from the closely-knit international community of the arts and from the cultural exchange that characterised that community.

Sebastiano Ricci, who had requested admittance to the Académie of Paris in 1717, received an immediate acceptance on condition that he send an example of his work. He complied in the following year with a painting of the *Triumph of Knowledge over Ignorance* (Louvre, Paris), which led to the enthusiastic confirmation of his candidacy.

On 27 September 1705, thanks in part to the intervention of her friend Christian Cole, secretary to the British ambassador to Venice, Rosalba Carriera was accepted by the Roman Accademia di S. Luca. Her reception piece, a miniature of *Innocence*, was warmly received. Rosalba was also presented to the Académie Royale in Paris by its director, Antoine Coypel, with a pastel portrait of Louis XV. Her membership was confirmed on 26 October 1720, while she was resident in Paris (an exception to the rule barring admittance of women to the Académie having been made on her behalf). She was fêted and honoured by all the foremost members of society and the French intelligentsia. Her reception piece, a very delicate pastel (Louvre, Paris), was executed on her return to Venice and dispatched from there the following year. It represents, as the artist wrote in the accompanying letter to the Académie, 'A muse presenting a crown of laurel to the French Academy, judging it to be the only one worthy to wear it and to preside over the others'. On this same occasion, Giannantonio Pellegrini, Rosalba's brother-in-law, put his name forward and was unanimously accepted, though he sent his reception piece only in 1733. In 1723 Sebastiano Ricci had been admitted *ad honorem* to the Accademia Clementina of Bologna, followed by Giambattista Piazzetta in 1727.

For another 26 years the proposal to establish a Venetian Academy languished, a delay symptomatic of 18th-century Venetian politics. Only on 3 March 1750 did the College dare to call attention to 'a certain room of the flour warehouse at S. Marco' – which had been used

*Figure 15:* Canaletto, *The Molo, Looking from the West: Il Fonteghetto della Farina*, the first seat of the Venetian Academy, oil on canvas, 66 × 112 cm, *c.* 1735–40, Giustiniani Collection, Rome

occasionally in the past by painters – requesting that this room should be used as a site for academy meetings (see fig. 15). Paradoxically, by this date the representational arts in Venice were known throughout Europe. At any rate, the College's request was heeded and in 1754 another room assigned for its use. Both rooms were refurbished from 1756, and decorated with works by members of the Academy. Giambattista Piazzetta was nominated director of this first Academy, born in silence, as yet experimental and unofficial. Piazzetta had demonstrated his exceptional gifts as a teacher in the flourishing, well-organised studio at S. Zulian, site of a drawing school since 1722, if not earlier. Unfortunately, there is no documentation of his activities as first master of the Academy, except for a group of preparatory figure studies (Pierpont Morgan Library, New York) which the editor Albrizzi had persuaded Piazzetta to collect for the use of novice students. The artist's old friend had them engraved by Bartolozzi and Pitteri. This collection is probably representative of the didactic material that Piazzetta would have used for his lessons at the Academy.[2]

Piazzetta died in 1754, and the reopening of the Academy was delayed for two months. During that time, inspired by members of the Accademia Clementina of Bologna, Antonio Zanchi and Gian Maria Morlaiter had prepared the statutes that were to govern the new institution, which selected Giambattista Tiepolo as its first President on 5 February 1755. On 20 January 1756, the Regents of the University of Padua approved the statute proposing the establishment of the Academy with a membership of 28 painters and 8 sculptors, each of whom was obliged to present an example of his art as soon as possible.

Among the members were figure-painters, that is, history painters – who were naturally given priority because of their essential role in teaching in life-classes – portraitists, landscapists, ornamental painters, architects, illusionistic painters and, of course, sculptors. Among the most notable names, apart from the President, the counsellors Giambattista Pittoni and the sculptor Gian Maria Morlaiter, and the Piazzettesque painters mentioned above, there were Gaspare Diziani, Francesco Fontebasso, Domenico Tiepolo, Pietro Longhi, Giacomo Guarana, Jacopo Marieschi, Gerolamo Mengozzi Colonna, Antonio Visentini and Antonio Guardi. Missing from the list were Canaletto, who was then in London, and Francesco Guardi, who was nominated an Academician only in 1784, after having completed his official commissions of paintings commemorating the arrival of the Russian noblemen known in Venice as the 'Conti del Nord' and Pope Pius VI. Guardi's nomination came a few years after the elections of Canova and of Angelica Kauffmann, both protagonists of a new style. Among the sculptors were Gai, Bonazza, Giovanni Marchiori, worthy if somewhat elderly masters.

The fundamental subject of study at the Academy, from 18 October, the feast day of St Luke, patron saint of painters, to Ash Wednesday, was, in the words of the statute, 'to draw a male nude in a pose to be determined by the masters'. This fundamental importance conferred on drawing from the nude model in an artistic centre that had always made colour of prime importance, was the consequence of the diffusion of the theories of Winckelmann and his followers. Indeed, these ideas and writings played an important role in the constitution and organisation of many European academies. Only those who were already expert draughtsmen were admitted to this studio, that is, those with experience in copying plaster casts or models of ancient monuments. During his direction of the Academy, Piazzetta must have provided students with small clay models of the caryatids executed by his father Giacomo for the great wooden sculptures of the library of the Dominican friars of SS Giovanni e Paolo. The caryatids represented 'heretical writers refuted by the Dominicans', which were then either given away or forgotten, and ended as part of the Institute's property (Galleria G. Franchetti alla Ca' d'Oro, Venice, on loan from the Gallerie dell'Accademia).[3]

Academy students always had free access to the palace at Rialto which Filippo Farsetti, and after him his nephew Daniele, had generously opened to young artists. Farsetti had acquired an exceptional collection of plaster casts and reproductions of ancient sculpture, as well as original terracotta models by Gian Lorenzo Bernini, Alessandro Allori and Stefano Maderno. These works constituted the fundamental pieces for study for successive generations of Academy students.[4]

It is probable that the Senate, having finally granted its approval to the Academy, hoped to reap some financial benefit from it. One could not ignore the fact that the city's economy had grown, thanks to the demand for Venetian art, the patronage of foreigners and the large sums of money that artists earned abroad and brought back to their city. Entirely lacking from the Venetian statutes, however, were any of the ideals that, albeit far from the principles of Winckelmann and his circle, had subtly permeated the regulators of other European academies.[5]

If Venetian commerce and economy were in need of resuscitation, the exceptional quality of the work of artisans still produced in small shops where traditional skills were kept alive might have given the impression that further provisions for the future of art were unnecessary. These traditional artisans made lace and porcelain, glass, furniture and silver, as well as objects of common daily use.

Painters of the Academy school were placed under the protection of the Virgin Annunciate, of St Luke and of St Mark, while the Four Crowned Martyrs were designated the patron saints of the sculptors. According to the statutes, images of these patron saints, plus some others, were to decorate the study room and were to be produced by the Academicians. They were not always prompt to comply, however. Initially, the work was divided among the artists: Tiepolo was to paint the Annunication; Pittoni, St Mark; and Angeli, St Luke, while Fontebasso, Maggiotto and Morlaiter were to carve the patron saints of the sculptors.

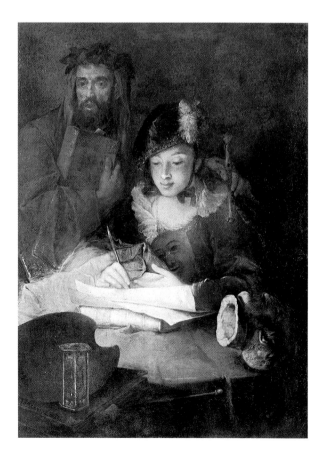

*Figure 16:* Alessandro Longhi, *Painting and Merit*, oil on canvas, 128 × 93 cm, late 1770s, Gallerie dell'Accademia, Venice

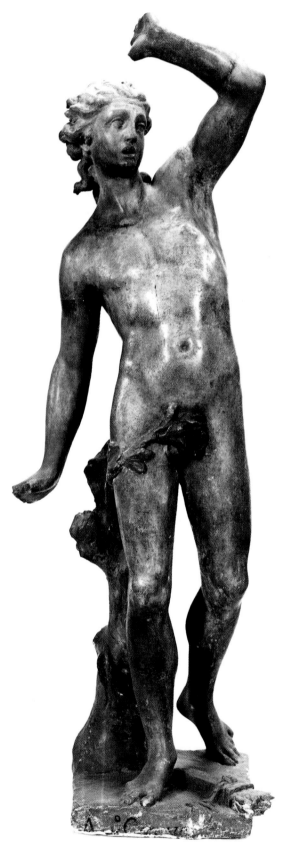

The statues of the Four Crowned Martyrs were never executed, however, perhaps because the sculptors constituted only a minority of the membership. The *Annunciation* was painted by Pittoni in 1758 (Accademia, Venice).[6] The paintings of *St Luke* and *St Mark*, by Marinetti and Angeli respectively, came to the Galleries after the suppression of the Institute and were placed in deposit at the Camaldolese Hermitage of Monte Rua in 1827.

Portraits of the doges under whose government the Academy existed were also to be provided. Pietro Grimani was the first, his portrait based on a lost original by Nazzari. His successor, Francesco Loredan (doge 1752–62), was portrayed by Fortunato Pasquetti, who also painted the portrait of Marco Foscarini, doge from 1762 to 1763. In June 1767, Alessandro Longhi was given permission to take this portrait to his home, to use as a prototype for the portraits of Alvise Mocenigo IV (1763–78) and Paolo Renier (1779–89). Longhi, elected to the Academy in 1759, is represented also by his work *Painting and Merit* (fig. 16). The title of this allegory, the most unusual of the presentation pieces, is derived from the engraving based on the painting and dedicated by Longhi himself to the British Consul in Venice, John Udny.

Pittoni succeeded Tiepolo as President of the Academy and was able to have the almost non-existent annual stipend raised to 480 ducats – even this a risible sum of money. He also managed to prolong the drawing classes into the summer. Gaspare Diziani replaced Pittoni in 1761 and introduced the study of architectural perspective to complement the study of painting. On the other hand, little space was reserved for view-painters. This prejudice reflects a considerable and surprising lack of appreciation for a genre of painting much favoured by foreign patrons. The first view-painter to be elected was Antonio Joli, who had studied in Modena and then in Rome as a student of Pannini. But in truth, Joli's reception piece, *Roman Baths*, is more an essay in perspective than a view *per se*. On 16 January 1763, Canaletto's candidacy was rejected while Francesco Zuccarelli, Pietro Gradizzi and Francesco Pavona were elected, the last two mediocre artists who none the less had been employed in various European courts. On 11 September of the same year Canaletto was finally granted Academy membership, with four votes against him – not as a view-painter, however, but as a professor of architectural perspective. Two years later he presented his painting (cat. 148).

During 1762 the ceiling of the Sala delle Riduzioni was frescoed by Giacomo Guarana at a cost of 100 ducats. The subject was *The Triumph of the Arts and of Fame over the Vices*, with the perspectival framing elements painted in *chiaroscuro* and gold by Francesco Zanchi.[7] After much encouragement, Pietro Longhi, who taught the nude, contributed an exceptional example of his work as a genre painter, *The Philosopher Pythagoras*, demonstrating his own ability in the subject that he taught. In 1763 the landscape painter Francesco Zuccarelli exhibited his *Landscape with St John the Baptist*, an unusual subject for the artist, seemingly an attempt to measure himself against figure-painters. A *Landscape with Fountain* was presented by Giuseppe Zais in 1765, in the hope of obtaining the title of Academician, which he was to receive only in 1774.

Apparently without any such self-promotional intention is the *Institution of the Eucharist*, finally given in 1778 by Domenico Tiepolo after repeated requests. The subject is to be understood as a symbolic comparison of the communion of the Apostles with that of the Academicians, who ended their school year on Ash Wednesday. Even non-Venetian artists became members: the Bolognese Luigi Crespi, an honorary academician, in keeping with a custom widespread among other academies, presented his very beautiful self-portrait dated 1778. He wears the garments of a painter, with symbols of his literary activity nearby (Accademia, Venice).

Engravers were also numbered among the honorary members of the Academy. They enjoyed great prestige for their essential role in reproducing works of art before the invention of photography. Among them were Pitteri, Wagner and Francesco Bartolozzi, whose portrait inexplicably came to be presented to the Academy as the work of another member, Domenico Pellegrini.

Every year there was an open competition among the students. Prizes were awarded to the best first- and second-year students who displayed their works in the Sala delle Riduzioni. Beginning in 1775, a prize was established for students of sculpture. In that year the second prize was won by Antonio Canova, who was not yet twenty years old, for his copy of a plaster cast in the Farsetti collection (now in the Accademia), representing the famous antique group of the *Wrestlers* in the Uffizi. A few years later the young artist requested nomination for Academy membership, presenting his small, very refined terracotta of *Apollo* (fig. 17); his request was unanimously granted in 1779.

By this date, tastes were changing. In addition to Canova, the new nominations to honorary membership were Batoni and Mengs in 1775, and in 1781 Angelica Kauffmann, the only woman to be elected. Her election was already symptomatic of the new, decisively Neo-classical direction of art. After the fall of the Republic, the French governor requested a programme of reform for the Academy, which, in 1807, was transferred to the complex of the Carità (now part of the Accademia Galleries). The Academy was to have the same regulations as those of Bologna and Milan.

There was an active campaign to preserve the artistic patrimony of Venice. The Republic's first regulations in this regard date from the beginning of the 15th century. Contrary to common opinion, this conservation of works of art was not limited to the pictorial arts, even though those initiatives remain the most visible and best documented.

During the course of the 18th century, Lombard masters from that same region that in the Renaissance had provided Venice with sculptors, architects and stonemasons, dedicated themselves assiduously to the cleaning of stone decoration both inside and outside monumental buildings. And if these efforts can only dubiously be categorised as 'good maintenance', they are also an index of changing taste that preferred the clarity of stones and marbles to the polychromy which had been superimposed on these materials over the centuries.[8]

The progressive elimination of these accretions – not only in Venice but throughout Europe – exposed buildings to the attack of atmospheric pollution, which had begun with the diffusion of industries founded at end of the 18th century. A five-year plan of restoration was projected for the Doge's Palace in 1754. Ten years later the roof was repaired, and further repairs were made in 1777 under the direction of Bernardino Maccaruzzi: the courtyard was laid with paving stones – previously it had been paved in brick – and the foundations were examined and strengthened, in addition to the two well-heads.

There was equal concern for the conservation of churches. In 1754 the bronze doors of S. Marco were cleaned and repatinated, and the internal and external stairs were repaired. On Christmas Eve of that same year, the silver of the high altar was returned, after having been restored and regilded at great expense by the goldsmith Gerolamo Pilotto. But more important still was the maintenance and repair of the mosaics by a team of workmen under the direction of Pietro Monaco with a monthly budget of approximately 300 ducats. In addition, the capitals, pinnacles, statues and other stone ornaments were cleaned. And on 6 August 1759 the

*Figure 17:* Antonio Canova, *Apollo*, terracotta, height 61 cm, 1779, Gallerie dell'Accademia, Venice

Patriarch consecrated the high altar of the Basilica of S. Maria della Salute; the altar had been earlier restored by the sculptor Giusto Le Court. Similarly, in S. Pietro di Castello, the altar and predella dedicated to S. Lorenzo Giustiniani were restored.

Though the work of superintending and preserving public monuments, notably paintings, had never been wanting in Venice, these responsibilities were systemised and formalised in 1689 with Giambattista Rossi nominated by the Provveditori al Sal as Superintendent with an annual stipend of 130 ducats.[9] At his death in 1703 the Senate selected as his successor Giovan Vincenzo Cecchi, who was to concern himself with making recommendations for restoration rather than taking decisive action, entrusting work to painters as the need arose. At this time there was as yet no overall programme, and the attempt to redefine the responsibilities of the conservator or superintendent, on the death of Cecchi in August 1724, appears to have been an effort on the part of the Republic to confront the preservation of its patrimony in a more incisive manner. At this very moment, the College of Painters (Collegio dei Pittori) applied to the Senate for the right to undertake the task. The first reaction was surprise, if not open displeasure, but the determination of the request and the conviction with which the College defended the worthiness of the work of restoration, convinced the Senate. Subsequently, after the foundation of the Academy, its members alternated in undertaking this task. Unfortunately, their supervision was disappointing, and this was due in large part to the fact that the Academicians, especially the painters, were more interested in appearances than in conservation. The result was that they repeatedly restored the same works of art, even though their restorations were assigned to well-known masters. This was the case with Tintoretto's *Paradise* in the Doge's Palace, which in less than a century was restored by Rossi, perhaps by Cardinali, by Francesco Fontebasso (fig. 18), and finally by Pietro Edwards.

The dispersal, sales and thefts of works of art both in Venice and on the mainland was not unknown in earlier times, but during the 18th century this pattern became alarmingly widespread because of the changing economic conditions of the nobility and of the clergy. In the face of this continuous impoverishment, Anton Maria Zanetti the Younger, who had been directly involved in the new edition of Boschini's *Minere della Pittura* of 1733 — in effect, a guide

*Figure 18:* Francesco Fontebasso's repainting of Jacopo Tintoretto's *Paradise*, Doge's Palace, Venice

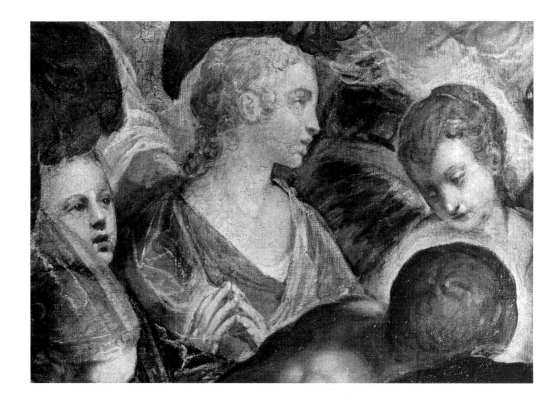

to the city – suggested to the Tribunal of the State Inquisitors the compilation of an inventory of all important paintings in the churches, schools, monasteries and other sites in the city and the surrounding islands.[10] This urgent appeal did not go unanswered. On 12 July 1773, the Council of Ten issued a decree assigning Zanetti the responsibility of compiling a 'Catalogue' of all existing works of art, specifying what they represented and giving the name of the artist. This information was to be recorded and signed for on the back of the relevant receipt or record by 'the respective superiors, parish priests, guardians and directors, with responsibility for the work and the prohibition of alienation under any title whatsoever'. With this act, sanctioned by a Republic which was already close to becoming a mere object of barter among the powers of Europe, was born the modern practice of cataloguing, with criteria largely inspired by the Venetian initiative.

New men were sought also for the work of restoration, and the exigencies of a radical rethinking of the problem were keenly felt. The choice fell on Pietro Edwards, a Venetian of English ancestry, a painter and a restorer. To him was assigned the care of 'public paintings', the last great undertaking of the Republic, which was no longer the commissioner of new works of art but the attentive custodian of the prestigious patrimony that in the course of centuries had accumulated in its public buildings. These works could indeed be defined as public art *par excellence*, even if the Republic's curatorial responsibility had progressively been extended to include private and Church property. The accomplishments, the personality and the theories of Edwards proved most influential in late 18th-century Italy, as well as being the best documented. In 1786 he produced a general account of work that had been completed and a plan for the better conservation of monuments; documents that give us an understanding of his exceptional scientific knowledge, his rational working methods (in the context of his times) and the enormous amount of work undertaken in the laboratory of SS. Giovanni e Paolo, the old refectory of the Dominican convent where public works of art were restored at least until Rossi's day. In eight years Edwards was able to repair 405 paintings, averaging approximately two square metres each.

Work continued at the same place until 1797, when it was abruptly interrupted, due to the French occupation. An order was issued to dismantle the restoration laboratory immediately ('*nel momento*'), so that the space might be used for a military hospital. Shortly after, with the Napoleonic suppression of the Church, began the most widespread and shocking dispersal of an artistic patrimony of incalculable value – that same patrimony which the dying Republic had sought by every possible means to protect and to bequeath to the future.

1. For the history of the Venetian Academy see Dell'Acqua Giusti, 1873; Fogolari, 1913[1], pp. 241–72, 364–94; Bassi, 1941; *idem*, 1978, p. 239; Pinto, 1982, 6, II, p. 859–76.

2. Nepi Sciré, in Venice, 1983, pp. 215–19.

3. See Moschini Marconi, 1970, pp. 231–2. Ten *bozzetii* of *telamoni* belong to the Gallerie. In 1976 another six *bozzetti* were offered for sale to the state, then in the possession of the antique dealer Apolloni in Rome. Unfortunately the sale did not take place. For the realisation of the library, dismantled in the suppression of the monastery, see Zorzi, 1972, pp. 603–4.

4. In 1804 a very large nucleus of this material was bought by Tsar Alexander I – the attempt of Paul I to acquire the entire collection in 1782 having failed – and is now shown in the Hermitage in St Petersburg. What was left was bought in 1805 by the ruling body of the Venetian Academy. The terracottas are shown at

Galleria G. Franchetti alla Ca' d'Oro, Venice. See Androsov and Nepi Sciré, 1992.

5. See Pevsner, 1982, chapters 3 and 4.

6. For this, and other works cited belonging to the Academy, now in the Gallerie dell'Accademia, see Moschini Marconi, 1970, and Nepi Sciré and Valcanover, 1985.

7. Mistakenly thought to be lost; see Pinto, op. cit., p. 860.

8. Livan, ed. 1942, *passim*.

9. For the story of the restoration of Venice in the 18th century see: Conti, 1971, pp. 145–72; Olivato Puppi, 1974, XXXVII, I; Conti, 1981. For Rossi see the Archivio di Stato di Venezia, Senato, terza filza 1088, 22 April 1686; Merkel, 1981, p. 36, Nepi Sciré, 1984, pp. 28–9.

10. For Zanetti's cataloguing see Olivato Puppi, op. cit., Negri Arnoldi, 1981, pp. 11–12.

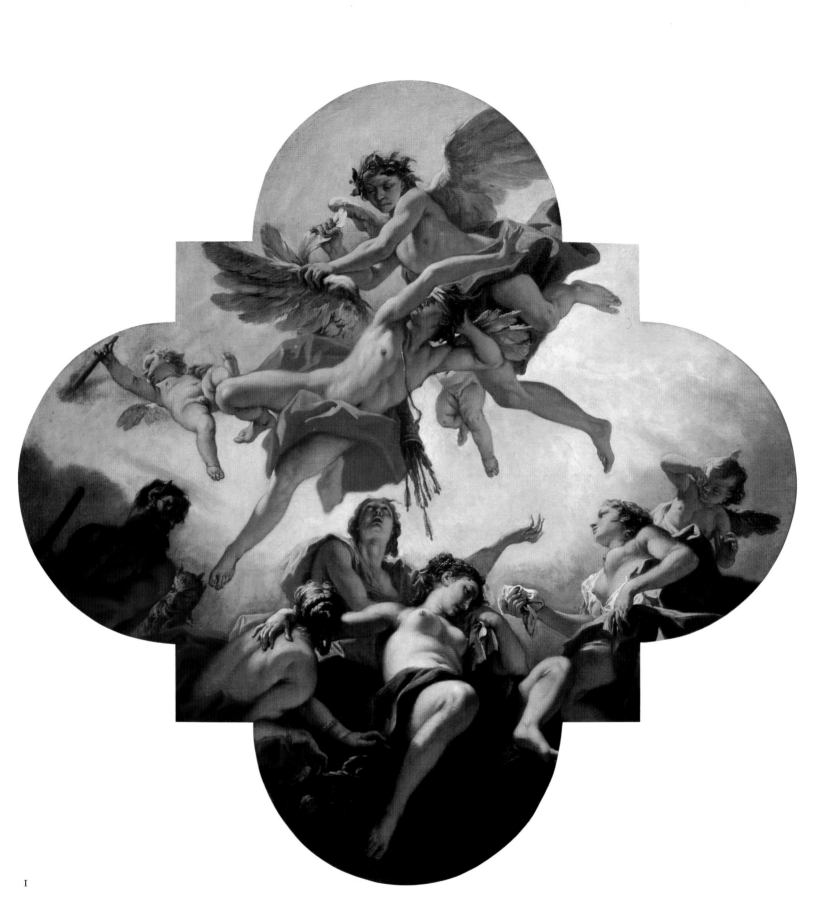

I

SEBASTIANO RICCI
*The Punishment of Love*
1706—7
oil on canvas, 285 × 285 cm
Università degli Studi di Firenze

# 1: *Sebastiano Ricci & the New Century*

## Francesco Valcanover

For most of the 17th century Venice was left out of the extraordinary artistic developments taking place elsewhere in Italy – in Bologna, Rome and Naples – where dazzling innovations followed each other in rapid succession, triggered by the Carracci family's neo-Venetian classicism, Caravaggio's naturalism and the uninhibited Baroque inventiveness of Bernini and Pietro da Cortona. All the major European artists, within their different national traditions, and as part of a greater network of interchange, drew nourishment from this radical renewal of the arts: the French brothers Le Nain, Poussin and Claude, Zurbarán and Velázquez in Spain, van Dyck and Rubens in Flanders, Frans Hals and Rembrandt in the United Provinces. Some of these artists had spent time in Venice, where they became fascinated by the Venetian painters of the 16th century, notably Titian, Tintoretto and Veronese. Yet in Venice, during the first decades of the 17th century, followers and imitators of these great painters dissipated their inheritance, producing pedestrian, timid reworkings of the old themes, ignoring the innovatory ideas of Carlo Saraceni (1579–1620), the Venetian follower of Caravaggio, of Fetti (1588–1623) from Rome, Liss (1595/7–1631) from Holland, or Strozzi (1581–1644) from Genoa, all of whom went to Venice, attracted there by the legacy of the great 16th-century colourists after they had already absorbed a variety of painting styles, particularly those of Rubens and van Dyck.

Sculptors were working in the same atmosphere of stagnant conformity, and were harking back to the late Mannerism of Alessandro Vittoria and Gerolamo Campagna. Architecture produced one fine flower in Baldassare Longhena (1597–1682), whose basilica of S. Maria della Salute, a skilfully articulated octagon and dome containing an open circular ambulatory, prefigures the Baroque buildings of Rome. In the mid-17th century painting came to life again in the personality of Francesco Maffei (1605–60) from Vicenza, who transposed 16th-century traditions into Baroque exuberance, and the Florentine Sebastiano Mazzoni (1611–78), whose paintings combine wit and imagination with great elegance. Their lessons in free composition and colour enlivened by light were ignored by the painters influenced by Ribera, adherents of the tenebrist school, so called because of their use of strong *chiaroscuro* and the crudely realistic subjects they favoured. Exponents of this school include Giambattista Langetti (1635–76) from Genoa, the Bavarian Carl Loth (1632–98), and Antonio Zanchi (1631–1722) of Venice. The influence of Maffei and Mazzoni became increasingly important during the last quarter of the century, when painting was once more appreciated for its decorative qualities, subjects were chosen at random, there was an easy elegance in draughtmanship and brilliant colours were again employed, the last the fruit of a revival of interest in the great 16th-century colourists, in particular Veronese, and of a familiarity with the styles of Carracci, Pietro da Cortona and the mature work of Luca Giordano.

The revival of painting was echoed in sculpture after the arrival in the Veneto of Giusto Le Court and Filippo Parodi, the heralds to the figurative style that became established at the outset of the 18th century in Venice. The many painters who contributed to the transition from the

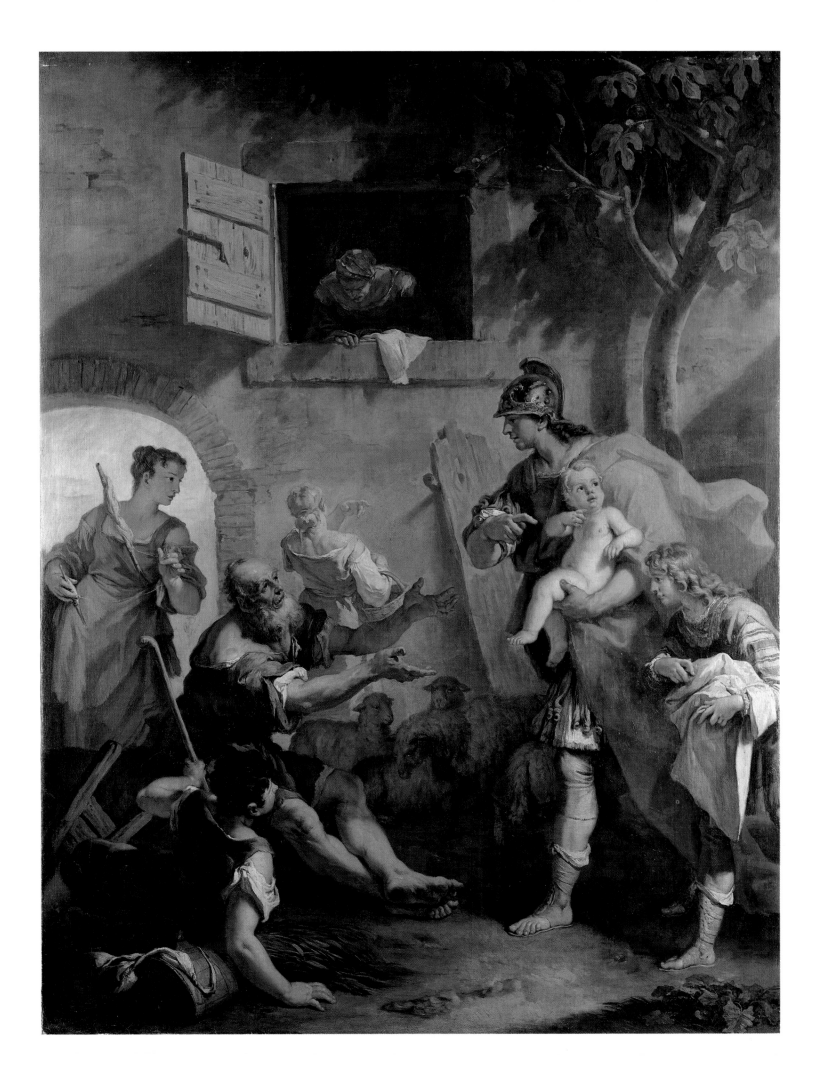

Baroque to the Rococo include the Venetians Andrea Celesti (1637–1711), Giannantonio Fumiani (1650–1710) and Antonio Bellucci (1654–1726), and Louis Dorigny (1654–1742) from Paris. But more than any of them, Sebastiano Ricci was impatient to escape from the provincial atmosphere of Venice: frequently he made journeys to other major Italian cities for long periods; later he became one of the first of the many artists who, in their different fields, regained for Venice an international role in European art in this, her final glorious artistic season.

Sebastiano Ricci was born into a poor family in Belluno in 1659.[1] At the age of twelve he began work in the studio of the painter Federico Cervelli, who had reacted against the current fashion for violent contrasts of light and shade favoured by the contemporary Baroque painters. The brightness and originality of Cervelli's palette pointed the young Sebastiano in the direction of the imaginative freedom and uninhibited use of colour of, not only the Florentine Sebastiano Mazzoni, but of Francesco Maffei from Vicenza and, most important of all, of the Neapolitan Luca Giordano, who had visited Venice for a second time in 1667, when he absorbed the lessons of the 16th-century Venetian painters, in particular Veronese. Forced to leave Venice in a hurry in 1681, having threatened to kill a young woman he had seduced, Sebastiano began a long peripatetic period, travelling to all the most important Italian cities. In Bologna, where he is documented in 1681 and in 1682,[2] he was fascinated by the decorative schemes of Annibale Carracci and also was in contact with Carlo Cignani, a refined interpreter of the art of Carracci and Reni.

Having won recognition in artistic circles in Emilia, Ricci received his first important commission at the end of 1685; this was for the decoration of the oratory of the Madonna del Serraglio, next to the castle of S. Secondo in Parma. He worked in collaboration with Ferdinando Galli, known as Bibiena, a talented designer from Bologna, who contributed the architectural *trompe l'œil*.[3] The work was completed in 1687. The frescoes on the cupola and walls demonstrate Ricci's genius for large-scale decoration and for creating theatrical effects, combining naturalism, in the style of Annibale Carracci and Tebaldi, with a purity and almost musical harmony learnt from Correggio and Parmigianino, which he may have taken indirectly from Cignani, whose frescoes in the Palazzo del Giardino in Parma (1678–81) he must have seen. The influence of Parma and Bologna is still present in Sebastiano's second important undertaking in Emilia, the paintings commemorating Pope Paul III, founder of the Farnese dynasty in Parma and Piacenza. These were commissioned by Ranuccio II Farnese, Duke of Parma, for the family palace in Piacenza and were executed between 1687 and 1688.[4] The twelve surviving canvases (Museo Civico, Piacenza) have all the stylistic traits that distinguish Sebastiano at this date: his simplification of the intricacies of Baroque composition, the linear tension of his modelling and his technical facility with bright, warmly coloured brushwork.

Sebastiano returned to Bologna, but then ran off to Turin with one of the daughters of the landscape painter Peruzzini; only the intervention of Duke Ranuccio saved him from the death penalty. In 1691, still under the protection of the Duke, he went to Rome, where he was enthralled by the work of Pietro da Cortona, Giovanni Battista Gaulli and Andrea Pozzo. He also came into contact with artists at the French Academy in Rome. Sebastiano reinterpreted the grandeur of Roman Baroque in a manner that prefigures the Rococo: his groups of figures have abundant nervous energy and his colour schemes are so vivid as almost to detract from the narrative. An outstanding example of this is the fresco of the *Apotheosis of Marcantonio Colonna* (1693–9) on the ceiling of the Sala degli Scrigni in the Palazzo Colonna at SS. Apostoli.[5] He continued in this vein for the frescoes in the ossuary chapel in S. Bernardino alle Ossa (or dei

Morti) in Milan, a project begun before the death of his protector Ranuccio Farnese in December 1694 and completed at the end of 1695. During his stay in Milan he may have met Alessandro Magnasco from Genoa, whom he was to get to know during his years in Florence. They share a nervy, scintillating manner of painting, in which images are set down so fast as to be almost in shorthand; Magnasco used this style to paint real 'fantasies', which have no connection with the contemporary grand manner, Sebastiano to give emotion and significance (in the Rococo manner) to sacred and profane Baroque painting.

Sebastiano returned to Venice in September 1696 and married Maddalena Vandermer, formerly the mistress of the Duke of Parma. At this stage, before he reached his definitive stylistic idiom, he seemed still to be tied to decorative forms that lie somewhere between the Bolognese academic style and Roman Baroque. This is evident in the large body of paintings completed before he went to Florence; outstanding examples include the paintings from the ceiling of the Palazzo Mocenigo-Robilant (Staatliche Museen, Berlin) and the Querini Stampalia, Venice; the decoration of a room in the Palazzo Fulcis in Belluno; frescoes and an altarpiece of St Gregory in the basilica of S. Giustina, Padua (1700); and the four ceiling paintings in the church of S. Marziale in Venice.[6] In 1702 Sebastiano's *Allegory of the Princely Virtues* (fig. 19), painted for the blue stairway in the Palace of Schönbrunn in Vienna,[7] made him the foremost painter of his generation, ahead of Pellegrini and Amigoni, in promoting the new Venetian style. Thus, at the beginning of the 18th century, Venice became a major European artistic centre.

*Figure 19:* Sebastiano Ricci, *Allegory of Princely Virtues*, fresco, 7.33 × 12.5 m, *c.* 1701–2, Blue Staircase ceiling, Schönbrunn Palace, Vienna

3

SEBASTIANO RICCI
*The Flight into Egypt*
*c.* 1713
oil on canvas, 87.3 × 113 cm
The Duke of Devonshire and Chatsworth
House Trust

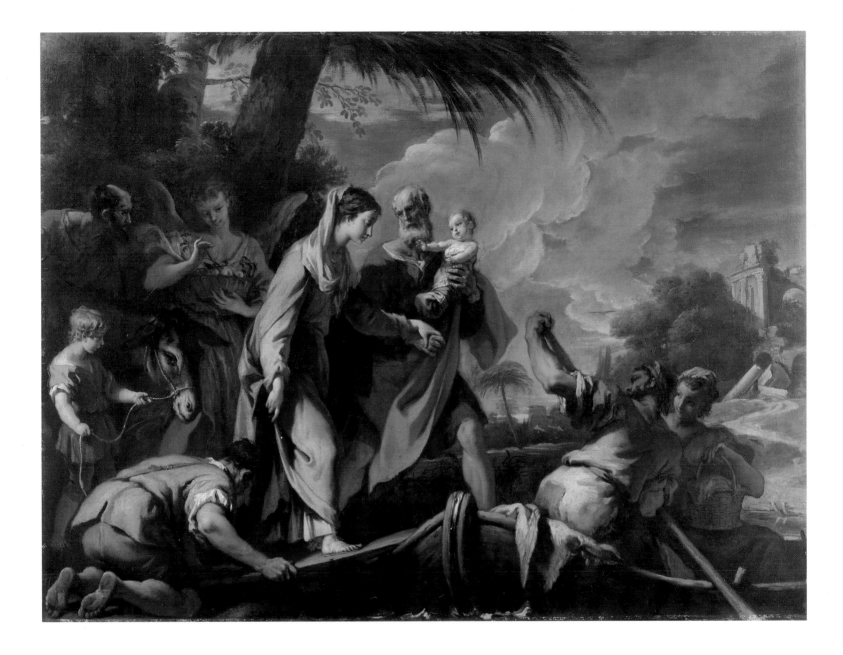

The moment in Sebastiano Ricci's career when he turned towards the Rococo style came during his period in Florence, where he stayed with his nephew Marco between 1706 and 1708.[8] While working on the series of frescoes and paintings illustrating the *Victory of the Virtues over the Vices*, his largest work, including the *Punishment of Love* (cat. 1) in the Palazzo Marucelli, he increasingly rejected Baroque solutions in favour of the Rococo style; this is amply illustrated in the fresco decorations in the ante-chamber to the apartments of Prince Ferdinando de' Medici in Palazzo Pitti. Here the mythological scenes show self-confidence and wit; lines are tangled and open-ended; colours are chosen from the palest end of the spectrum and embellished with sparkling watery effects and shimmering reflections, traits that are also present in paintings of the same date or a little later than the Florentine works, such as *Harpagus Bringing Cyrus to the Shepherds* (cat. 2) and *The Childhood of Romulus and Remus* (Hermitage, St Petersburg). The tremendous outburst of colour in Ricci's work in Florence was reinforced when he renewed his study of Veronese. This is evident in his *Virgin and Child with Saints* (fig. 7) of 1708 in S. Giorgio Maggiore, and in the paintings made in England.

Sebastiano Ricci and his nephew Marco reached London in 1712,[9] and they soon overtook Pellegrini in popularity. Their customers included the young Richard Boyle, Earl of Burlington, Henry Bentinck, Earl of Portland and Charles Talbot, Duke of Shrewsbury. Sebastiano's paintings of this period have a Parmigianesque elegance, possibility an indirect influence via van Dyck, whose portraits were in many British collections; this is particularly noticeable in the mythological scenes (fig. 14) made for Burlington House, now the home of the Royal Academy, and for Chiswick House, and also in the religious paintings of this date, such as *The Flight into Egypt* and *Susanna and the Elders* (cat. 3, 4). The *Bacchus and Ariadne* from Pommersfelden (cat. 5) belongs to this particularly happy moment in his career: the arcadian dream of an irretrievable age of bliss is transposed into the Rococo language of the dancing rhythms of the linked figures, the clear, transparent colours and the musical subtleties of the marine setting's diffused light.

4

SEBASTIANO RICCI
*Susanna and the Elders*
1713
oil on canvas, 40.5 × 32.3 cm
The Duke of Devonshire and Chatsworth
House Trust

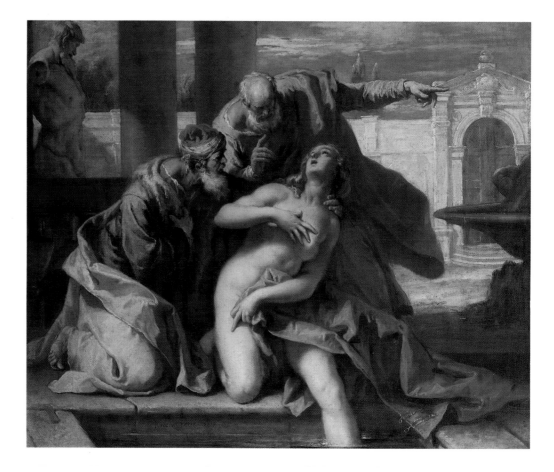

SEBASTIANO RICCI
*Bacchus and Ariadne*
*c.* 1716
oil on canvas, 126.5 × 175.5 cm
Germanisches Nationalmuseum, Nuremberg

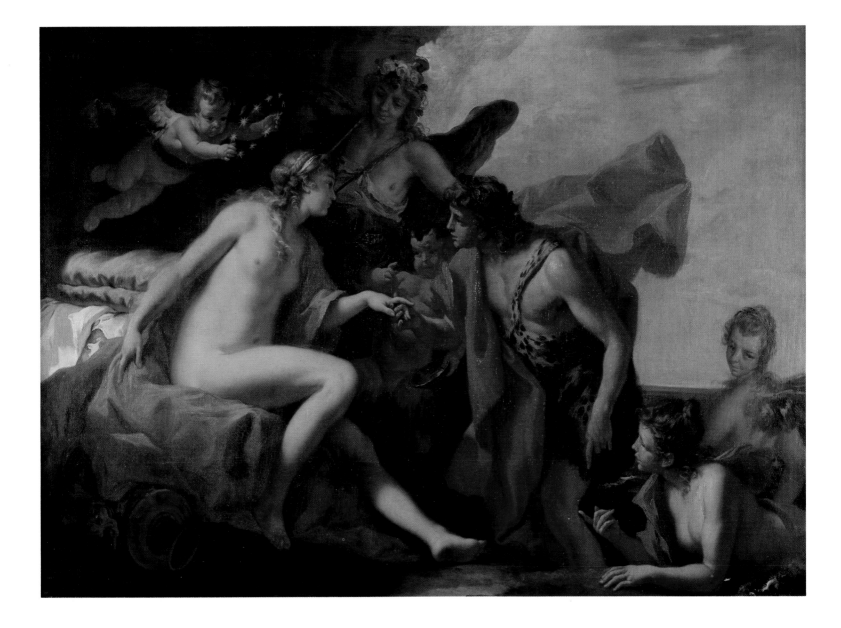

6

SEBASTIANO RICCI
*Head of a Girl Wearing a Ruff*
1716–20
black chalk, pastels, heightened with white, on
greyish blue paper, 38.4 × 25.3 cm
National Museum of Sweden, Stockholm

7

SEBASTIANO RICCI
*Head of a Pharisee*
c. 1729–30
black, white and red chalks, 31.2 × 24.4 cm
Lent by Her Majesty The Queen

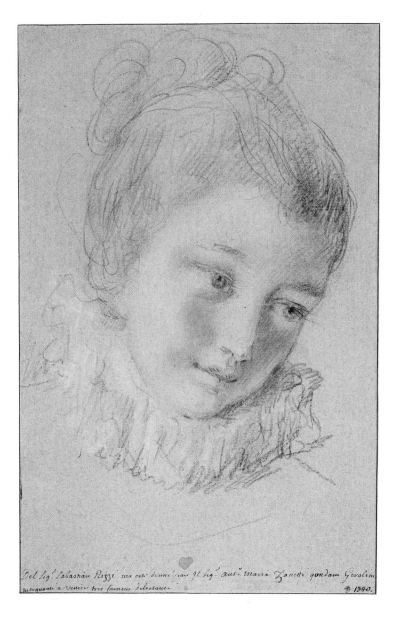

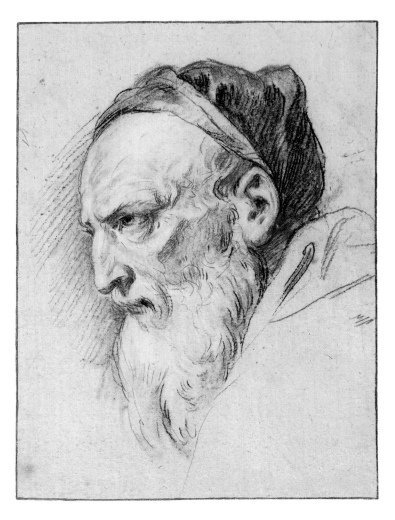

Sebastiano left London in the spring of 1716 and went to Paris, where he met artists working in a similar vein as himself, including Crozat, Charles de La Fosse, Jouvenet and the young Watteau. Above all it was Watteau's refined sensitiveness to the world of love and of women that impressed the Venetian painter, as some of his drawings bear witness (cat. 6). Sebastiano's stock was so high during his brief stay in Paris, and his international reputation so great, that he was unanimously elected to the Académie Royale de Peinture et de Sculpture; he sent his *morceau de réception*, the *Triumph of Knowledge over Ignorance* (Louvre, Paris) from Venice to Paris in 1718.

Sebastiano's style did not change greatly during his later years. For most of the time he remained in Venice, working in collaboration with his nephew Marco, who was by now permitted to paint more than just backgrounds. They worked frantically to satisfy the demands of their customers, many of whom came from beyond Venice. The most demanding of their commissions were the elaborate decorations for the Villa di Belvedere in Belluno (demolished in 1880); the large group of canvases painted *c.* 1720 for the Palazzo Taverna in Monte Giordano; work carried out for the King of Sardinia between 1724 and 1733; and, from the early 1720s, their work for a new patron, the banker and merchant Joseph Smith,[10] who was to become British Consul in Venice in 1744.

Mythological stories, biblical scenes, religious triumphs often preceded by sketches drawn with the lightest, most sensitive strokes, create some of the most joyous Rococo compositions. Of particular interest for an understanding of 'history painting' in Venice at the start of the 1720s is the series of Apostles painted 1722–3 by twelve artists of varying backgrounds and abilities for the church of S. Stae. The confrontation and challenge was most evident between the greatest exponents of the international Rococo style, Sebastiano Ricci and Antonio Pellegrini, and the rising stars of the new generation, Giambattista Piazzetta and Giambattista Tiepolo. To the luminosity and delicacy of the composition and colour of Pellegrini's *St Andrew* and Ricci's *Liberation of St Peter* (cat. 8) – the inspiration behind one of Antonio Guardi's panels of *The Story of Tobias* in the Angelo Raffaele, when the Rococo style reigned supreme in Europe – can be contrasted the dramatic realism of Piazzetta's *St James Led to Martyrdom* (cat. 70), with its strong *chiaroscuro* contrasts deriving from Giuseppe Maria Crespi, and of Giambattista Tiepolo's *St Bartholomew* (cat. 94). Although it is influenced by Piazzetta, Tiepolo's *St Bartholomew* already displays a livelier figurative style, the chromatic scale already gives an indication of the superb decorative style he was to develop, and which he began to reveal only a little later (*c.* 1726) in the frescoes in the Palazzo Arcivescovile at Udine.

Just as the great new protagonists of Venetian and European painting appeared on the scene, Sebastiano began to show occasional signs of a rather tired, academic style, particularly in his work for churches (examples formerly in SS. Cosmo e Damiano, Venice; Basilica di Superga, Turin). Yet, in the altarpieces for the church of S. Alessandro, Bergamo (1731), and for S. Rocco, Venice (1733), and in the great *Assumption* (fig. 11) commissioned by the Viennese court for the Karlskirche, on which (after having made the marvellous *modello*, cat. 9) he worked with his assistants during the final months of his life, he fully earned his position as one of the foremost international artists of the early 18th century. He was able to convey the spirit of evanescent lightness that was one of the hallmarks (and by no means the least important) of that century.

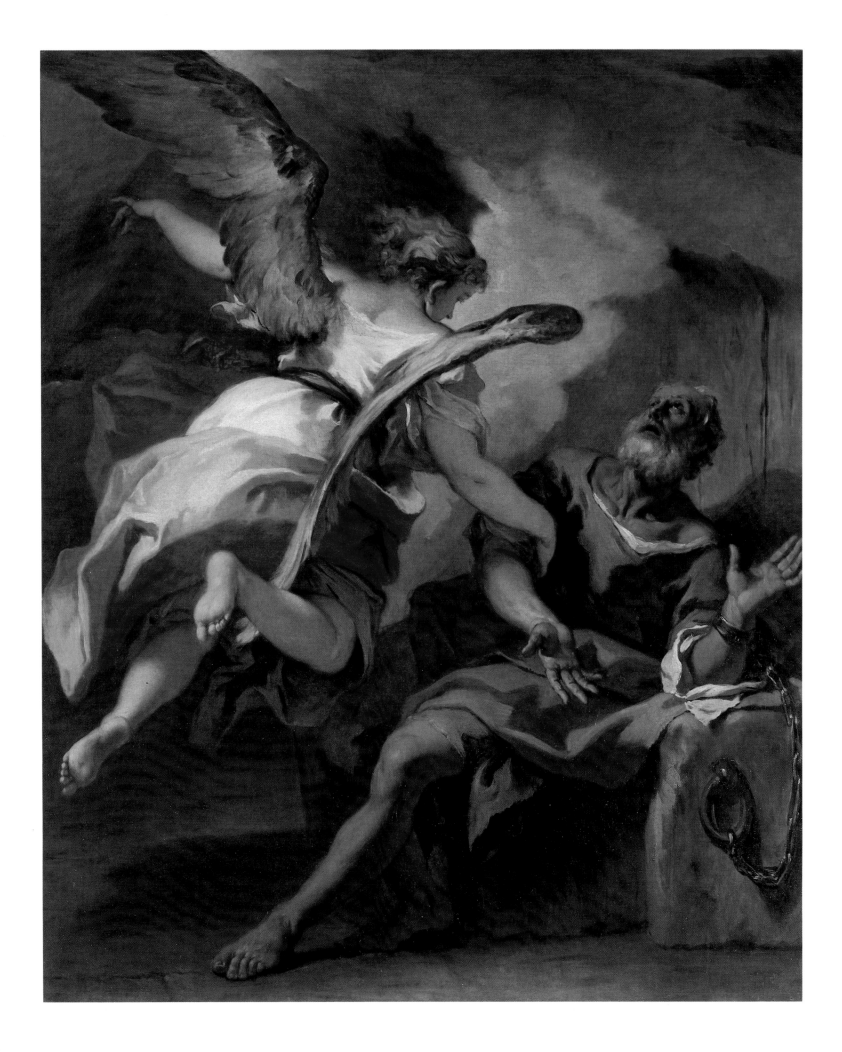

8

SEBASTIANO RICCI
*The Liberation of St Peter*
1722
oil on canvas, 165 × 138 cm
S. Stae, Venice

9

SEBASTIANO RICCI
*The Assumption of the Virgin*
1733–4
95 × 51.5 cm
Szépmuvészeti Múzeum, Budapest

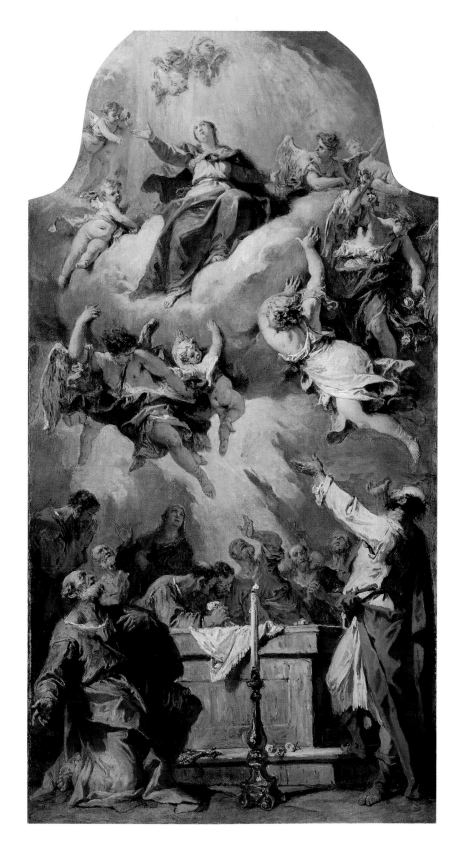

10

SEBASTIANO RICCI
*Bacchus, Reclining Woman and Silenus*
1708–10
pen and wash in two colours, golden brown and
grey-brown, 28.1 × 27.9 cm
Lent by Her Majesty The Queen

11

SEBASTIANO RICCI
*Extensive Pastoral Landscape with Hill-town*
c. 1720
pen and brown ink and wash, 37 × 52 cm
Gallerie dell'Accademia, Venice

Sebastiano's graphic work is crucial for an understanding of his art; two volumes (Her Majesty The Queen, and Accademia, Venice) contain some of the most characteristic drawings (cat. 10, 11).[11] The 344 works, almost all dating from his time in Florence, demonstrate his consummate mastery of a variety of techniques. His preferred medium, however, was pen and ink shaded with wash, almost always over an initial pencil sketch, in which he rapidly jotted down his ideas with extraordinary skill. His lightning sketches, his careful preparatory studies and his sheets for patrons and connoisseurs incline to the decorative and airy, even when there are overt references to painters such as Titian, Veronese, Giulio Carpioni, Cortona, Bernini or Alessandro Magnasco, or when the influence of Rembrandt or of Watteau is almost palpable. In two exceptional drawings in the Accademia, Venice, Sebastiano appears as a landscape painter (cat. 11) in a positively arcadian style, although he was is no less attentive than was his nephew Marco to the close observation of nature; he was also the inventor of elaborate Rococo furniture fantasies (cat. 12) in the same imaginative spirit as that of Andrea Brustolon.

Sebastiano Ricci died in Venice in 1734.[12] His pictorial fluency, elegant in its drawing and festive in its colour, provided a stimulus for all the painters of the next generation: Pellegrini, Giambattista Tiepolo and Antonio Guardi in Venice, Paul Troger and Maulbertsch in Austria, François Lemoyne, Boucher and Fragonard in Paris and, in London, the great portrait painters from Hogarth to Gainsborough.[13]

12

SEBASTIANO RICCI
*Bed with Sea-horses and Fortune*
pen and brown ink and brown wash over black chalk, 25 × 20 cm
Gallerie dell'Accademia, Venice

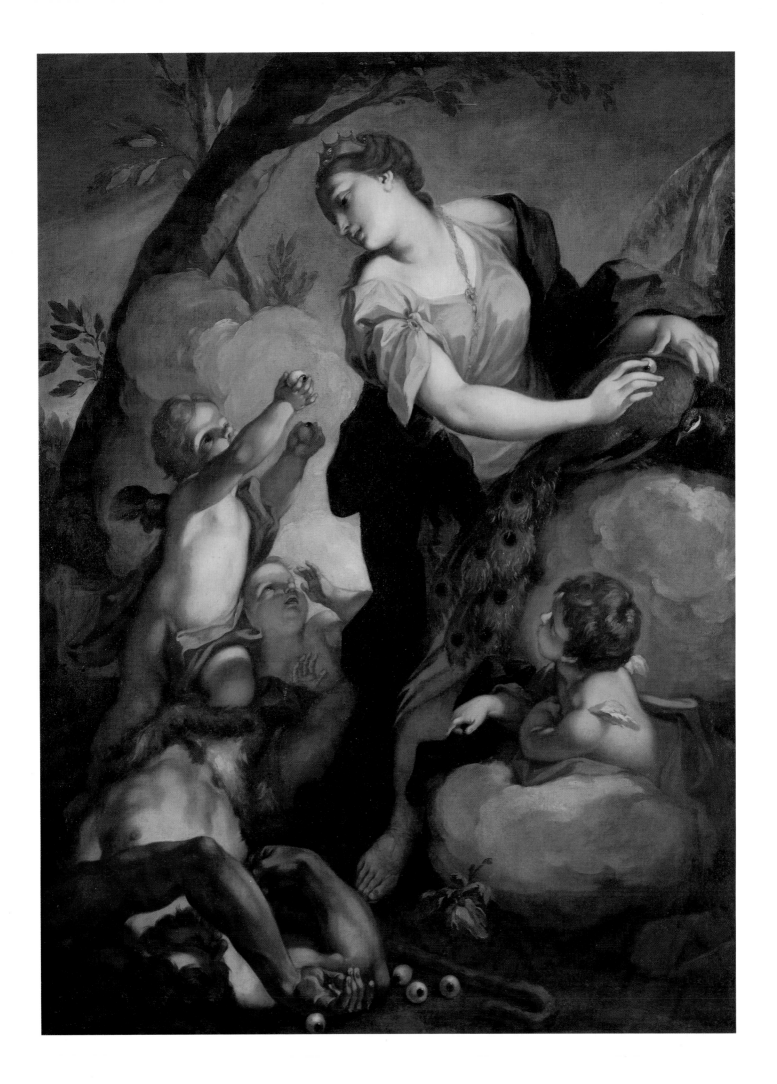

ANTONIO BALESTRA
*Juno Placing the Eyes of Argos in the Peacock's Tail*
*c.* 1714
oil on canvas, 167.7 × 104.2 cm
Chrysler Museum, Norfolk, VA
Gift of Mr Emile E. Wolfe

*Figure 20:* Antonio Balestra, *The Virgin and SS. Stanislaus Kostka, Luigi Gonzaga and Francesco Borgia*, oil on canvas, 1704, S. Maria Assunta (The Gesuiti), Venice

Like Sebastiano Ricci, but with different intentions and results, Antonio Balestra,[14] after an initial training in Venice, sought to follow the modern path by visiting the most important centres of Baroque art in Italy. He was born in Verona in 1666 into a family of rich merchants. On the death of his father he interrupted his study of literature and his painting lessons in the studio of a minor local artist, Giovanni Ceffis, and, with his brothers, devoted himself to family affairs. In 1687 he was able to return to his studies and went to Venice to attend the art school run by Antonio Bellucci (1654–1726). Here Balestra abandoned his allegiance to the *tenebroso*, or 'shadowy', school of painting and made forays into a more decorative style, both in composition and in colour; this he was to develop over the next ten years. Bellucci's instruction did not stop Balestra working at academic drawing, nor did it deter him from studying Tintoretto. After short visits to Bologna and Parma, Balestra went to Rome *c.* 1690, with the young Tuscan painters Tommaso Redi and Benedetto Luti; there they entered the studio of Carlo Maratta, an established exponent of Roman and Bolognese classicism. Following Maratta's example, Balestra showed particular interest in antique and contemporary sculpture, as well as in the work of Raphael, Annibale Carracci, Guido Reni and Domenichino. He opened his own '*Accademia di nudo gratis e a proprie spese*' (life-classes held at his own expense). His inclination towards a classicising, eclectic style of painting, garnered from his familiarity with the Roman artistic milieu, is demonstrated in his competition drawing *The Fall of the Giants*, which won first prize in the drawing-class at the Accademia di S. Luca in October 1694.

Balestra then moved to Naples, where he studied the work of Lanfranco, Luca Giordano and Francesco Solimena, then, half way through 1695, he returned to the Veneto and thereafter divided his time between Verona and Venice. He rapidly achieved fame with a series of small paintings for private clients. His *Annunciation*, painted in 1697 for the church of S. Teresa degli Scalzi, Verona, shows the marks of his immersion in the Baroque art of central Italy, both in composition and in the vivid interplay of light and shade. In 1700 he was briefly in Lombardy, and then went to Emilia to study – in Balestra's own words – the works '*a me tanto gradite del gran Correggio*' (which I so much admire by the great Correggio). This sojourn made him aware of the graceful figural compositions and soft, clear colours that were coming into vogue in Venice at the beginning of the 18th century. Though favouring the new style, Balestra did not abandon the dignity and formality of the classical tradition, and in this he differs from his contemporaries Sebastiano Ricci and Pellegrini, who were both firmly integrated into the international Rococo style.

Balestra's artistic independence manifests itself in his religious painting as well (fig. 20), first with the *Annunciation* in the church of S. Tommaso Cantauriense, Verona, and the *Ecstasy of St Francis* (Castelvecchio, Verona), both painted at the beginning of his time in Venice (1700–18), and persisting right up to the *St Cosmus* and *St Damian* canvases painted in 1717–18 for the church of the Sisters of Misericordia in Padua (now in the basilica of S. Giustina). The preparatory drawings (Museo Civico, Bassano) for these two huge scenes, with their somewhat melodramatic rhythms and contrasts of light and shade reminiscent of Solimena, are interesting for the light they throw on Balestra's graphic work; of outstanding quality is his *Venus Appearing as a Huntress to Aeneas and Achates* (cat. 14).[15] Balestra embraced the Rococo style in his mythological paintings more than he did in his religious work; his mythological works, such as *Juno Placing the Eyes of Argus in the Peacock's Tail* (cat. 13), have an arcadian languor which proved to be popular with his customers among the Venetian and Tuscan aristocracy, and even with those abroad. His foreign clients included Lothar Franz von Schönborn, Elector of Mainz, and the Elector Palatine, although he declined the latter's invitation to visit his court at Düsseldorf.

In 1719, when Piazzetta and Giambattista Tiepolo were the rising stars in Venice, and beginning to rival Sebastiano Ricci, Balestra went to live permanently in Verona. His enormous production of altarpieces for the churches of Verona and Lombardy bears tell-tale signs of the production line. Less conventional are his secular and biblical paintings; here his lively narrative skill, elegant and supple figures, and the brilliance of his cool tones point towards his last great undertaking: the frescoes illustrating scenes from the *Aeneid* for the villa at Illasi designed by his architect friend Alessandro Pompei in 1738, only two years before Balestra's death in Verona.

Balestra's achievements may have been different from those of his contemporaries in Venice, most of whom were caught up in the new fashion for the Rococo, but his loyalty to the classical style was not without effect on the artistic development of Venetian painting. His students, who later went in very different directions, included, in Venice, Giuseppe Nogari, Pietro Longhi and Mattia Bortoloni, and, in Verona, Giambettino Cignaroli, Pietro Rotari and Giovanni Battista Mariotti. His exceptional skill, first recognised in 1727 when he was accepted at the Accademia di S. Luca in Rome, was admired well into the 18th century largely thanks to the engravings made after his paintings. He was also influential as a teacher through his signed etchings, the best-known of which being the frontispiece to *Li Cinque Ordini dell' Architettura Civile di Michel Sanmicheli*, edited by Alessandro Pompei in 1735 (cat. 15).[16]

## 14

ANTONIO BALESTRA
*Venus Appearing as a Huntress to Aeneas and Achates*
*c.* 1713
pen and brown ink with brown wash over black chalk on laid paper, 233 × 162 mm
National Gallery of Art, Washington
Ailsa Mellon Bruce Fund

ANTONIO BALESTRA
Frontispiece and title-page vignette in Antonio
Pompei, *Li Cinque Ordini dell'Architettura Civile
di Michel Sanmicheli*, published by Jacopo
Vallarsi in Verona, 1735
etchings
*c.* 31.7 × 43 cm (open book)
The British Library Board, London

L I
CINQUE ORDINI
*D E L L'*
ARCHITETTURA
C I V I L E
DI MICHEL SANMICHELI
Rilevati dalle fue Fabriche,

*E defcritti e publicati con quelli di Vitruvio, Alberti,
Palladio, Scamozzi, Serlio, e Vignola*

D A L
CO: ALESSANDRO POMPEI.

I N  V E R O N A.  MDCCXXXV.
Per JACOPO VALLARSI,
CON LICENZA DE' SUPERIORI.

Venetian sculpture of the late Baroque period reflects the influence of those sculptors resident in the Veneto who had trained in Rome, the most important of whom were Giusto Le Court and Filippo Parodi. Orazio Marinali and Andrea Brustolon were among those who fell under their spell.

Orazio Marinali was born in 1643 near Bassano del Grappa; he was married there in 1665. At about this date his father Francesco, a wood-carver, moved his family and workshop to Vicenza; he had already taught the rudiments of his craft to his three sons, Orazio, Francesco (1647–1727) and Angelo (1654–1702).[17] By the time Orazio's name appears in the list of members of the Fraglia dei Muratori e Tagliapietra di Vicenza (Guild of Stonemasons) in 1674 he was probably already familiar with the artistic circles of Venice thanks to his father, and he had visited Rome.[18] In a resolution passed by the city council of Bassano on 27 July 1681 concerning the erection of a statue of the patron saint of the city, the three Marinali brothers are named as 'illustrious sculptors of the city of Venice'. Evidently the Marinali family had hitherto worked principally in Venice, in a partnership that, though fraught with disagreements and misunderstandings, was to continue for some time;[19] there is documentary evidence, as well as some signed pieces of sculpture, to show that they carried out a variety of commissions in the Veneto during the 1680s and '90s.[20]

In Venice Orazio was trained in the studio of Giusto Le Court (1627–79). Le Court, a Flemish sculptor from Ypres, had probably spent some time in Rome before moving to Venice half-way through the 17th century. There he revived the local tradition for sculpture which had fallen into decline since the time of Alessandro Vittoria and Gerolamo Campagna. Le Court introduced the Baroque style, with inflexions, sensual, direct and expressive, from Rubens and Bernini. The most important example of this new sculptural language is the theatrical and extravagant high altar in S. Maria della Salute, completed *c*. 1670 to fit harmoniously into its surroundings to the design of the architect of the church, Baldassare Longhena. Marinali's earliest documented works, including *Christ Meeting St Veronica* carved for the church of the Vergini in the Castello quarter of Venice in 1675 (Staatliche Museen, Berlin), and the statue on the altar of the Rosary in S. Nicolò, Treviso (1679), still show the influence of Le Court; but their detached dignity also betrays traces of the vigorous modelling and sharp effects of light and shade of the Lombard sculptors active in Vicenza soon after 1650, in particular Tommaso and Matteo Allio, Giambattista Barberini, Rinaldo Viseto and Francesco Pozzo.

With the support of a well-run workshop housed in the town-house of the Garzadori Da Schio di Costozza in Vicenza, and increasingly engaged in the aesthetics of architectural and garden design, Marinali evolved his style away from the heavy modelling he had originally favoured. His later work is more extrovert and brilliant. Allusions to Venetian painting abound, and sometimes he puts his own interpretation on the work of painters such as Giulio Carpioni, Pietro Vecchia or Francesco Maffei. He was ready to take on any type of sculpture, from single figures of sacred subjects to large, complex ensembles. The most extraordinary example of this type of work is the group of plaster and bronze figures, bas-reliefs and statues executed between 1690 and 1703 for the basilica of Monte Berico in Vicenza.[21] Marinali's vast output of statuary in soft stone, executed in part by his workshop, designed to add drama and surprise in parks and gardens, shows the sculptor in an even more relaxed and self-confident mood; his subjects were peasants, slaves, revellers in fancy-dress, mythological figures and allegories of the Seasons and quarters of the globe (fig. 21); they prefigure the full-blown 18th-century extravagances of Antonio Bonazza. Marinali's spontaneity can best be appreciated in the few places where his schemes have remained more or less intact: the Villa Conti-Lampertico di Montegaldella, Vicenza, and the Villa Revedin-Bolasco in Castelfranco Veneto.

*Figure 21:* Orazio Marinali, *Pantalone*, stone, Villa Conti-Lampertico, Montegaldella, Vicenza

ORAZIO MARINALI
*Bravo: An Old Man*
*c.* 1710
marble, 58 × 56 × 30 cm (excluding base)
Fondazione Scientifica Querini Stampalia,
Venice

ORAZIO MARINALI
*Bravo: Boy with a Hat*
*c.* 1710
marble, 62 × 56 × 34 cm (excluding base)
Fondazione Scientifica Querini Stampalia,
Venice

Marinali's documented drawings are typically Rococo in their brilliance and vivacity.[22] His innate gift for modelling can be judged from his small terracotta sketches,[23] his portrait busts and his character sketches. The two busts in the museums of Vicenza and Bassano represent their subjects with genuine spontaneity, free from any Baroque mock-heroics: his taste is already inclining towards Neo-classicism.[24] In his character pieces, on the other hand (the Querini Stampalia in Venice and the Villa Pisani in Stra have the most important collections; see cat. 16, 17), he draws the maximum chromatic effect from the polished marble, chiselling the surface into violent contrasts of light and shade. The gentle melancholy he manages to instil into his arcadian and grotesque figures, in a multitude of different postures and guises, is utterly individual. Marinali died in Vicenza in 1720. He was the most original sculptor of his generation in the Veneto, stylistically bridging the gap between the Baroque mawkishness of the 17th century and the realism, Neo-classicism and Rococo of the new century.

In contrast to Marinali, Andrea Brustolon, at the moment of transition between the Seicento and the Settecento, singlemindedly adopted the spirited Rococo style.[25] He was born in Belluno in 1662 and served his first apprenticeship with his father Giacomo (1638–1709), a wood-carver, and his uncle Agostino Ridolfi (1642–1727), a local artist who painted in the style of the tenebrists Carl Loth and Antonio Zanchi. At the age of fifteen he moved to Venice and began work in the studio of the Genoese Filippo Parodi (1630–1702), an architect, sculptor and wood-carver and a very important figure for Brustolon's development. Parodi contributed to the revival of sculpture in Venice and in Padua in the 1680s and '90s by introducing the mature Baroque style of Bernini and his followers. Brustolon may have had first-hand experience of Bernini's art from a brief sojourn in Rome *c.* 1680; some of his notes and sketches of both antique monuments and 16th-century works suggest this. A group of 72 drawings (Museo Civico, Belluno)[26] includes copies of works by Agostino Ridolfi, Sebastiano Ricci and Luca Giordano; these were sketches to be submitted to customers; ideas for compositions; details of work being planned, or of work to be reused in the studio. Abandoning his Baroque style with its heavy *chiaroscuro*, Brustolon shifted to something quicker, more edgy, totally lacking in *chiaroscuro* – increasingly belonging under the heading 'Rococo'. One of the earliest works of his that can be reliably dated, the *Altar of the Souls* in the church of S. Florian in Pieve di Zoldo of 1685 (fig 22), demonstrates his predilection for Parodi's decorative exuberance and for traditional Venetian iconography: every macabre detail is gathered into a loose yet complete compositional framework, rich in pictorial interest.

Brustolon established himself permanently in Belluno, his native city, around 1695, in the studio in via Mezzaterra in which his father Giacomo and his brother Paolo both worked. Besides fulfilling the ever-increasing number of commissions coming in from the area around Belluno and even from Venice itself, he seems to have completed his masterpiece sometime during the first decade of the 18th century. This was the furnishings for the palace of Pietro Venier in the Fondamenta S. Vio, of which 40 items still remain: the impressive console table designed to hold vases of flowers (cat. 18); figures of naked Moors; allegories of the Seasons and Elements; pedestals for urns; ceremonial seats enriched with *petit point* and cross-stitch (Ca' Rezzonico, Venice).[27] In a daring synthesis of the uninhibited audacity of Francesco Pianta (*c.* 1632–92) and the expressive powers of Giacomo Piazzetta (1640–1705), and with extraordinary inventive freedom, playful even to excess, Brustolon's figures peep out from all the decorative elements – rocks, tree-trunks, fronds and tendrils. All is elegance and refinement; naturalism and invention happily coexist. The virtuosity of the carving and the blending of the colours and tone of the materials – ebony, reddish-brown boxwood, multicoloured porcelain and embroidery – achieve a height of expression that surpasses the Baroque, heralding the diaphanous weightlessness of the Rococo; this style, combining sculpture with painting, later found its highest expression in Venice in the work of Giovanni Morlaiter.[28]

*Figure 22:* Andrea Brustolon, *Altar of the Souls* (detail), wood, 1685, S. Florian, Pieve di Zoldo, Belluno

18

ANDREA BRUSTOLON
Porcelain stand in the form of Hercules
conquering the Hydra and Cerebus, with river-
gods and Nubian slaves ('*La Forza*')
*c.* 1700
boxwood and ebony, 2 × 1.67 m
Ca' Rezzonico, Museo del Settecento
Veneziano, Venice

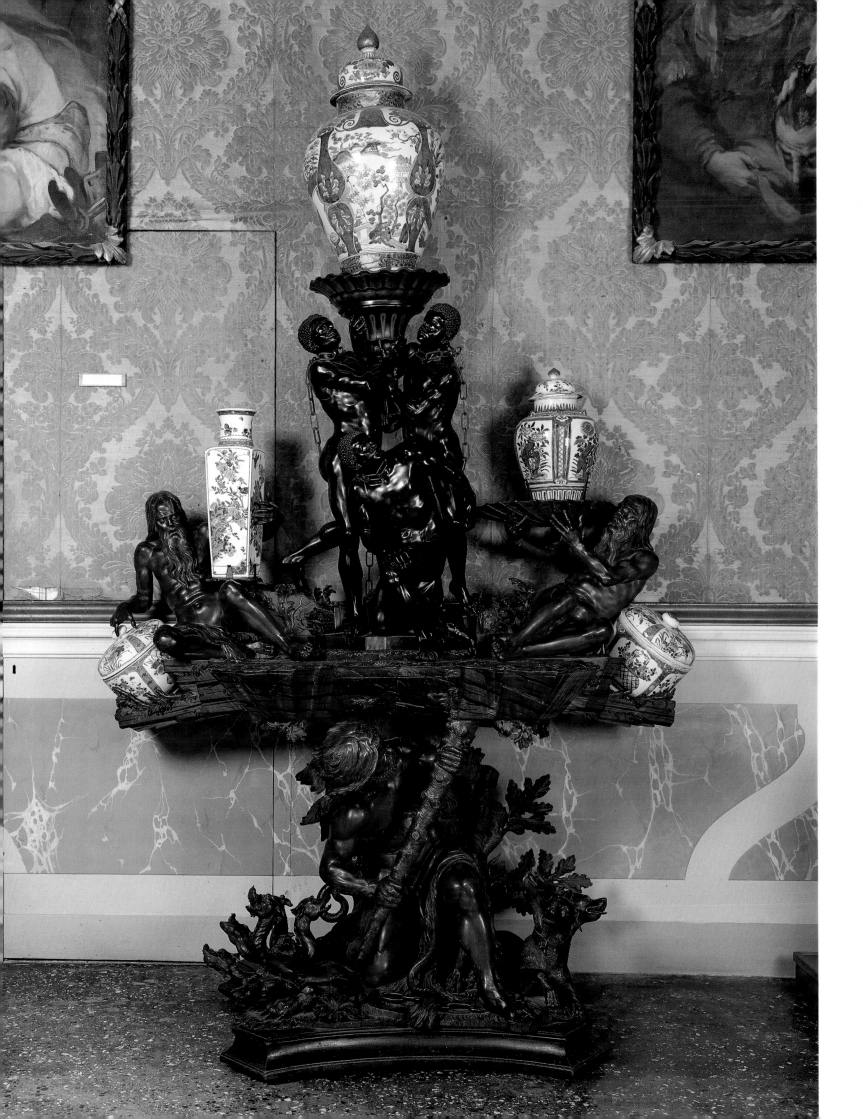

The lively carving of the Venier furniture is typical of Brustolon when he was engaged in commissions that appealed to his imagination: crucifixes, altars, religious or mythological statues like the six extraordinary pieces in the Zugni-Tauro collection in Feltre (1727). Particularly elegant are his candlesticks, his tabernacles and his picture-frames, densely decorated with cherubs and animal and vegetable motifs. His many followers and imitators never surpassed him in skill until, in the 19th century, Valentino Besarel (1829–1902) created works that are often mistaken for Brustolon's own.

Brustolon died at Belluno in 1732. When the generation of artists born in Venice in the 1650s and '60s finally disappeared, the city had been a major centre of Western art for some time, and was intricately woven into an international network of relationships and exchanges. The credit belongs most of all to Sebastiano Ricci and his immediate successors, Pellegrini and Amigoni, who spread throughout Europe the language of the Rococo, born at the end of the 17th and the beginning of the 18th centuries in the *boiseries* of Versailles and the *hôtels particuliers* of Paris. Admired by critics and scholars, patrons and clients, Sebastiano Ricci should not, however, be regarded solely as a representative of the Rococo. His bright palette and glowing colours were important characteristics of Venetian and European painting as it developed in the 18th century. Sebastiano's choice of subjects was wide: sacred and profane history, portraits, landscapes, views and genre scenes, interpreted through the kaleidoscopic facets of different religions and cultures that characterise the periods of the Rococo, the Enlightenment and the early stages of Neo-classicism.

1. For more information about the artist's exuberant private life see Sagrestani, 1971, pp. 201–2. Contemporary sources include Pascoli, II, 1736, pp. 378–86; Oretti, c. 1780; Moretti, 1978, pp. 96–125; Derschau's comprehensive monograph, 1922, was followed by others of equal importance: Daniels, 1976[1]; idem, 1976[2]. Also see the essays in Udine, 1975[1]. For the differing critical attitudes towards Sebastiano Ricci and his position in the first decade of the 18th century in Venice and in Europe, see especially Longhi, 1946, pp. 34–5, 39, 68; Levey, 1980, pp. 43–8; Pallucchini, 1960[2], pp. 9–17; idem, I, 1981, pp. 298–303; Pilo, 1976; Rizzi, in Udine, 1989.

2. For an account of Sebastiano Ricci's early activity in Bologna see Novelli, 1982, pp. 346–51.

3. Quintavalle, 1956–7, pp. 395–415.

4. Arisi, 1961.

5. De Vito Battaglia, 1958, pp. 334–56.

6. The controversy over the dating of this group of paintings is summarised in Rizzi, in Udine, 1989, pp. 31–2.

7. Garas, 1963, pp. 235–41.

8. D'Arcais, 1973, II pp. 18–25; 1973, IV, pp. 15–28; 1973, VI, pp. 6–13.

9. Osti, 1951, pp. 119–23; Croft-Murray, 1970; London, 1978; Daniels, in London, 1978[1].

10. Vivian, 1971, especially pp. 22–9.

11. For the album of drawings in the Gallerie dell'Accademia see Morassi, 1926, pp. 256–73; for the Windsor Castle album see Blunt and Croft-Murray, 1957, pp. 45–67. Further contributions in Milan, 1975; Valcanover, in Udine, 1975[2], pp. 183–90.

12. The goods and chattels left by the artist in his will, inventoried on 19–20 May by the notary Luca Fusi (Zampetti, 1969–70, pp. 229–31) have led people to conclude that Ricci was well-off when he died. A second inventory with valuations of the paintings, drawn up by Gaspare Diziani and Domenico Fontana, shows that most of the paintings were by Sebastiano Ricci himself. A copy of a painting by Tintoretto, another of a Carpioni and four copies of paintings by Luca Giordano bear witness to the painter's taste; see Moretti, 1978, pp. 119–21.

13. Sebastiano Ricci's influence on other Italian painters of the 18th century can be studied under his name in the index of artists in Milan, 1990[3].

14. For Antonio Balestra's life and work, with information supplied by the artist himself, see Dal Pozzo, 1718, pp. 186ff.; Pascoli, ed. D'Arcais, 1981, pp. 109–48. More recent studies include Battisti, 1954, pp. 26–39; D'Arcais, 1974, pp. 359–66; idem, 1981, I, pp. 387–8. On Balestra in the context of his artistic contemporaries in Verona: Marinelli, in Verona, 1978, pp. 31–75. Useful for its list of photographs and a monograph: Polazzo, 1978.

15. Few of Balestra's drawings are extant, though this must have always been one of his preferred modes of expression: D'Arcais, 1984, pp. 161–5.

16. On the engravers who reproduced Balestra's paintings and on his activity as an engraver see Albricci, 1982, pp. 73–88; Pilo, 1987, pp. 22–50.

17. See Tua's comprehensive study of the three Marinali brothers and their entourage, 1935[1]. Also, less complete studies by Fasolo, 1942, pp. 45–75; idem, 1943, pp. 207–9. A more up to date version of these can be found in the critical and biographical studies, and the catalogues in Semenzato, 1966, pp. 33–8, 96–106. Recent contributions to the understanding of the personality of Orazio Marinali, both in the context of the artistic life of Vicenza and of his relationship with contemporary painters in the Veneto include Nava

Cellini, 1982, pp. 4–5, 187–93, 197; Milan, 1990[3], pp. 226–46.

18. Marinali's very brief apprenticeship in Venice and his move to Rome are mentioned by Verci, 1775, pp. 285–98, but this has not yet been supported by documentary evidence.

19. For recent documents on the activities of the Marinali family and their relationship with one another, including details of their workshop and clients, see Puppi, 1967, pp. 195–215; Saccardo, 1981.

20. Semenzato, 1966, pp. 101–2, 104.

21. Barbieri, 1960.

22. Most of Marinali's graphic works are in the Museo Civico, Bassano. On the attribution of various drawings previously considered to be by the Marinalis see Saccardo, 1983.

23. Many are to be found in Vicenza. See Barbieri, 1962, pp. 142–65.

24. The publication of four hitherto unknown high-reliefs depicting rustic heads in profile encouraged Bacchi, in Milan, 1989, pp. 42–3, to reconsider the influence exercised on Orazio Marinali by 'several very lively characters from local artistic life, from Francesco Maffei to Pietra Vecchia'; this has been reiterated by scholars on various occasions.

25. An excellent profile of Andrea Brustolon is provided by Semenzato, 1966, pp. 47–9 and 114–8; following this, a monograph by Biasuz and Buttignon, 1969, is rich in detail and fully illustrated; it contains an ample bibliography. See also Draper, 1984, pp. 85–9.

26. The drawings have been exhaustively described by Lucco, 1989, pp. 38–84.

27. The most up to date and detailed study of the fornitura Venier is by Alberici, 1980, pp. 162–84, 321. Among other things this informs us of the date 1706 carved into one of the Ethiopian warriors; the large Correr seats (Ca' Rezzonico, Venice) and the Pisani seats (Quirinale, Rome), traditionally attributed to Brustolon, are excluded from the catalogue.

28. With less felicitous results Brustolon took on two very demanding commissions in the shape of two altarpieces, freely plagiarising from contemporary paintings by Sebastiano Ricci and Gaspare Diziani. These are the Death of St Francis Xavier (1727) and a Crucifix made for the Jesuit church of S. Ignazio in Favola, Belluno, and now in S. Pietro. The white leaded surface of the two bas-reliefs is painted 'to resemble marble', according to the wishes of the purchasers; Brustolon reiterates the type of marble altarpiece created in the style of Bernini by such sculptors as Algardi, Ercole Ferrata and his own teacher, Parodi. His shapes are no longer exuberant. His consummate skill seems to have congealed into obsequious sobriety.

19, 20, 21

LUCA CARLEVARIS
*Gentleman in a Tan Great-coat*, 18.7 × 76 cm
*Lady with a Fan Seen from Behind*, 22 × 98 cm
*Lady with Fan and Mask*, 17.2 × 93 cm
three drawings mounted together, pen and ink
over pencil or charcoal
The Board of Trustees of the Victoria and
Albert Museum, London

# II: *Townscapes & Landscapes*

## William Barcham

Luca Carlevaris was the generator of the large-scale urban view of Venice that became immensely popular in the hands of Antonio Canaletto and, later, Francesco Guardi. Marco Ricci devised a totally new vision of landscape, composed of elements drawn from many earlier artists, which led to all subsequent developments of the genre in the Veneto. This exhibition unites the two artists because both were significant innovators in the first years of the 18th century and each invented types of images that enjoyed enormous success throughout the century. But the links between the two artists extend further. Neither was born in Venice but hailed from smaller cities in the northern Veneto, the Venetian territory on the mainland, specifically from Udine and Belluno. Both worked for Venetian patrons, but their careers were launched by foreign diplomats resident in Venice. Finally, Carlevaris's mature *vedute*, or urban views, and Ricci's fully developed landscapes were indebted in part to 17th-century painting in the Netherlands.

Carlevaris became popular as a landscapist during the final decade of the 17th century. His early pictorial ideas were derived from a wide variety of 17th-century landscape painters, among them Salvator Rosa, Claude Lorrain, Viviano Codazzi and Pieter Mulier (the Cavalier Tempesta), and he produced a series of biblical narratives, dark and turbulent in mood and set amid lush vegetation, as well as imaginary views of ports, naval battles and architectural ruins. He began painting city views around 1700, recording the festivities staged for several foreign notables during the first decade of the century – for the French and British ambassadors in 1701 and 1707 respectively, and for the Danish king, Frederick IV, in 1709.[1] The Venetian tradition of recording state entries and civic festivals in paint stems from the late 16th century, when Andrea Vicentino painted the *Meeting of Henry III of France with Doge Mocenigo* (Doge's Palace, Venice) and the *Dogaressa Morosina Grimani in Piazza S. Marco* (priv. coll., Trieste) for example. Joseph Heintz (*c*.1600–78), a painter from Prague who worked in Venice during the third quarter of the 17th century, continued the type, and from him Carlevaris learnt how to fill a scene with bustle and gaiety and catch the excitement of Venice's civic festivities. But he transformed his predecessors' stick-like figures into more convincing approximations of reality.[2]

The urban view saw its fullest flowering in the 17th century in the Low Countries, Rome, Naples and Venice, which were all linked through the singular figure of Gaspar van Wittel, known in Italy as Vanvitelli, who was born and trained in the Netherlands and visited Venice in the 1690s when he produced several views of the city, including *A View of the Piazzetta and Doge's Palace* (fig. 23) which is dated 1697. Beginning in the 1680s van Wittel made his career depicting the buildings and squares of Rome, where he settled for the rest of his life.[3] His contribution to view-painting is the broad and panoramic sweep he gave his works, in which everything – centre and periphery, near and far – is sharply focused. Light plays a fundamental role in his paintings, and the scenes are enlivened by a multitude of small figures.[4]

22

LUCA CARLEVARIS
*Regatta on the Grand Canal in Honour of Frederick
IV of Denmark*
1709
oil on canvas, 135 × 260 cm
Nationalhistoriske Museum på Frederiksborg

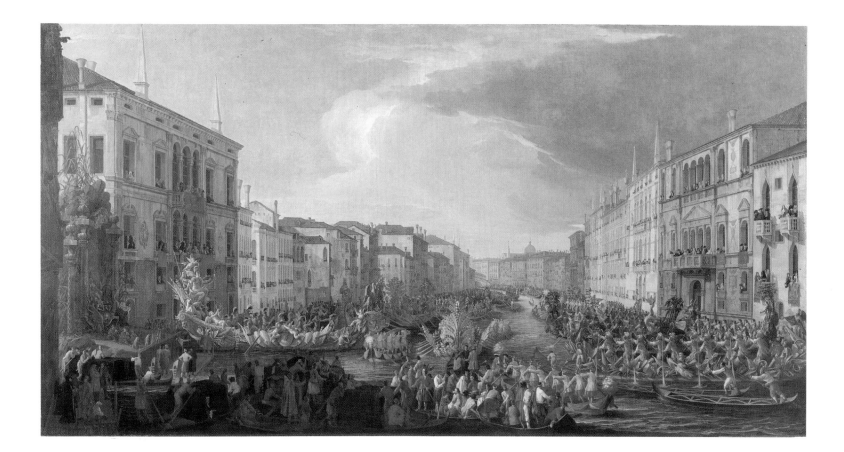

LUCA CARLEVARIS
*The Bucintoro Departing from S. Marco*
1710
oil on canvas, 134.7 × 259.3 cm
Collection of the J. Paul Getty Museum,
Malibu, CA

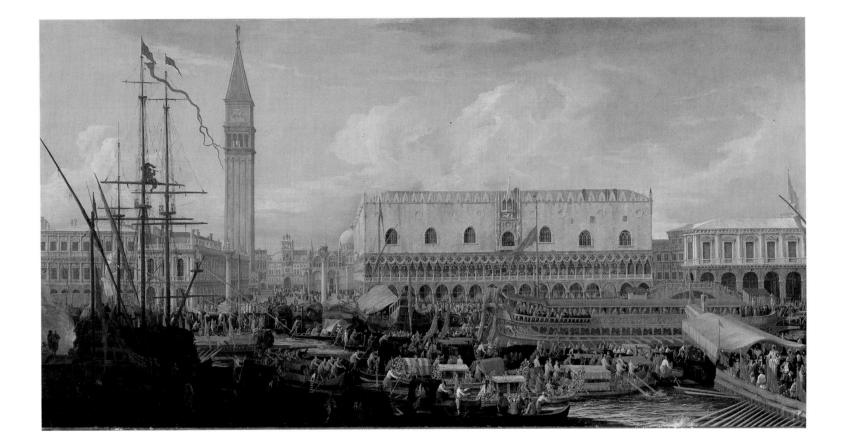

Many elements distinguish Carlevaris's views from those of his immediate predecessors. The two most striking differences are his point of view and the mass of humans that populate the scenes. Carlevaris's viewpoint is usually close to the ground (or canal), so that viewers experience urban architecture not from somewhere in mid-air but close-up, as they do in reality. In effect, we feel ourselves to be part of the city, participating in it rather than merely observing it. This is evident in the canvas Carlevaris painted for Frederick IV of Denmark, commemorating the King's visit to the city in March 1709, as well as in its related work, completed in 1710 (cat. 22, 23). Frederick was then enjoying a personal triumph resulting from his alliance of 1699 with Russia and Poland, which had been formed to weaken neighbouring Sweden. No other city but Venice could have mounted more splendid public events for him than those of the Regatta on the Grand Canal and the gathering of sea-craft in front of the Doge's Palace, and no painter but Carlevaris would have been able to compose more splendid compositions than the paintings now in Denmark and Malibu. The brilliantly costumed figures and ornately decorated boats in the *Regatta* complement those in the *Bucintoro Departing from S. Marco*. Furthermore, the former's deep recession into space, determined by the canal and the minutely described façades on either side of it, contrasts with the broad expanse of the latter, emphasised by Carlevaris's panoramic depiction of space, the wide southern façade of the Doge's Palace, and the long Bucintoro sitting before it.[5]

Important to Carlevaris's realisation of Venice are his *macchiette*, the small daubs of colour he used to represent Venetians. Carlevaris's eye for pose, gesture and dress in all classes of society introduces new richness of imagery in the tradition of view-painting. The animated figures enliven the paintings and offer movement and quotidian action that make them seem tangibly real. Carlevaris first drew the figures on paper, copying them from people he saw in the streets; he then transformed them into lively oil sketches (cat. 19–21), and finally he incorporated them into the *vedute*. The woman wearing the small black mask called the *volto* or *larva*, usually held in place by biting on to a small 'tongue' on the back, was prepared, for example, for a figure standing in the boat on the far right side of *The Bucintoro Departing from S. Marco*.

In 1703 Carlevaris published his *Fabriche, e Vedute di Venezia* (*The Buildings and Views of Venice*), a book containing over 100 etchings that depict, often in a formulaic manner, the churches, palaces, bridges and public spaces of the city.[6] It derived in type from 17th-century series of printed views, the most important of which had been Giovanni Battista Falda's *Vedute delle Fabbriche . . . in Roma* of the 1660s. Carlevaris was skilled in the convincing depiction of

*Figure 23:* Vanvitelli (Gasper van Wittel), *A View of the Piazzetta and Doge's Palace*, oil on canvas, 98 × 174 cm, dated 1697, Museo del Prado, Madrid

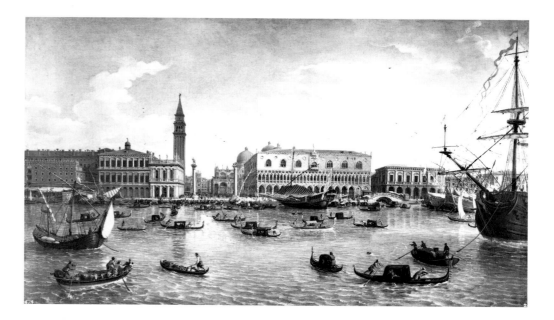

challenging perspectives and found no difficulty in rendering the topographic complications of Venice, whether the scene showed a wide open space, looked down a canal or *fondamenta* (a street embankment) or rendered the complicated arching of a bridge (cat. 24); his expert depiction of space confirms his fame as mathematician and perspectivist.[7] Carlevaris's rendering of the endless variety of architecture in Venice is impressive, too, and he was successful in recreating the city's multi-faceted activity, its gondolas and commercial vessels plying the waterways and its pedestrians walking, chatting and working. Finally, Carlevaris's streaked skies, passing cloud formations, and evening sunbursts often capture the unique peculiarities of the lagunar city.

24

LUCA CARLEVARIS
*Le Fabriche, e Vedute di Venetia, disegnate, poste in prospettiva et intagliate da Luca Carlevarijs*, published in Venice by Giovanni Battista Finazzi, 1703/4
volume 1 of 2, containing 104 etchings, folio, 28.3 × 76.7 cm (open book)
The British Library Board, London

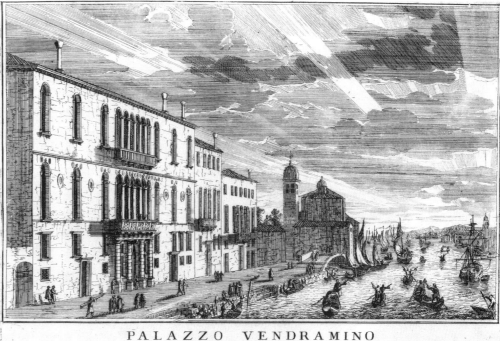

PALAZZO VENDRAMINO
alla Guidecca

ALTRA VEDVTA DEL PONTE DI RIALTO

25

GIUSEPPE VALERIANI
*Altra veduta di S. Giorgio Maggiore verso la Gracia*,
etched by Filippo Vasconi after a drawing by
Giuseppe Valeriani, in *Il Gran Teatro delle
Pitture e Prospettive di Venezia*, vol. II, published
by Domenico Lovisa, Venice, 1720
etching
33.2 × 46.5 cm (platemark),
c. 49.5 × 135 cm (open book)
The British Library Board, London

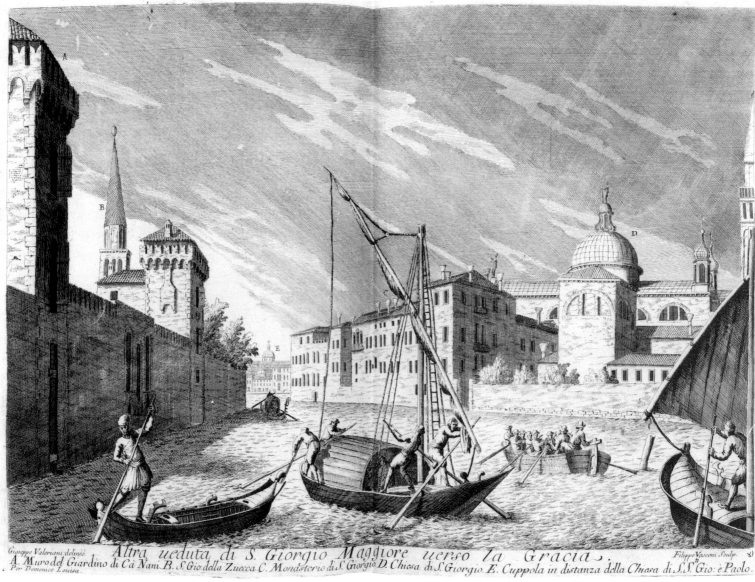

Giuseppe Valeriani delineo.    *Altra veduta di S. Giorgio Maggiore verso la Gracia.*    Filippo Vasconi Sculp.
A. Muro del Giardino di Cà Nani. B. S. Gio: della Zuecca. C. Monasterio di S. Giorgio. D. Chiesa di S. Giorgio. E. Cuppola in distanza della Chiesa di S.S. Gio: e Paolo.
Per Domenico Lovisa.

Carlevaris is a prime example of an artist who worked in the right place at the right time. His success as a view-painter came just after the Treaty of Karlowitz (1699) with which Venice finally concluded two exhausting wars fought against the Turks, the War of Crete (1645–69) and the First Peloponnesian War of 1684–99.[8] The State was at peace, and life could apparently return to normality. But Venice was burdened by debt from its wartime expenses, and no longer held its former position in the international political arena. None the less, the State longed to convince itself, and to assure others, that it retained its former prestige. Symptoms of the Republic's nostalgia for a lost age of glory appear in several cultural and artistic manifestations of the early 18th century, among them a revival of Palladio's architectural style and a renewed taste for Paolo Veronese's paintings. There was a fashion, too, for cycles of ancient Roman heroic narratives to decorate the walls of the *saloni*, or reception halls, of patrician palaces in order to associate Venice's ruling class with models of ancient virtue and provide it with a visual genealogy.[9] The appearance of Carlevaris's large oil paintings glorifying Venice at that time is surely related to this delicate moment in the Republic's search for its historical identity and enduring national vitality.

Carlevaris's strengths as a painter are coupled with his weaknesses. By 1710 he had evolved a type of Venetian view convincing in its depiction of deep space and expansive vision, but thereafter he barely developed the genre any further. Although his etchings of 1703 depict many of the city's lesser-known buildings, his paintings rarely explore areas outside Piazza S. Marco; they almost never show the city's constantly changing climatic conditions, and the cast of characters, while broad in type, is repeated from one painting to another. Although his first views are innovative and must have caught the contemporary Venetian art public by surprise, his subsequent output does little to increase our appreciation of him. His reputation has suffered most because Antonio Canaletto, Venice's greatest *vedutista*, began painting views only two decades later. But despite Carlevaris's lesser fame, he was the first to recreate Venice's urban spectacle in paint convincingly.

Carlevaris's historical importance as an artist must further be measured by his significant impact on subsequent Venetian art. First, the views of Canaletto are unthinkable without Carlevaris's example, which is clearly seen not only in the younger painter's *Regatta on the Grand Canal* (cat. 136) and the *Bacino di S. Marco* (cat. 139), but also in Canaletto's paintings of the public receptions offered to the French ambassador in 1726 and the Imperial ambassador in 1729; both works are based on Carlevaris's earlier formulae.[10] Carlevaris's prints for the *Fabriche, e Vedute di Venezia* had progeny too. In 1717, and again in 1720, Domenico Loviso published *Il Gran Teatro delle Pitture e Prospettive di Venezia*, a two-volume edition of more than 100 etchings reproducing views of Venice and of famous paintings adorning its public buildings.[11] Giuseppe Valeriani's *Altra Veduta di S. Giorgio Maggiore verso la Gracia* (cat. 25), which was etched by Filippo Vasconi, depicts Palladio's famous late 16th-century church designed for the Benedictine Order in a view much less frequently seen than that enjoyed from the Piazzetta and the Doge's Palace across the Bacino di S. Marco. As Carlevaris had done in his prints, Valeriani emphasised the city that existed not for tourists but for ordinary Venetians.

Marco Ricci's earliest paintings, like Carlevaris's, are dark landscapes of windblown, cloud-filled scenes, the majority of them containing small, dramatically gesticulating figures.[12] Monumental trees arching overhead create pictorial breadth, and bright streaks of sunlight break through the darkness. Ricci's early development is complicated to trace, however, because of his custom of collaborating on individual works with other artists. For instance, in 1705 he painted the water and rocks of a *Landscape with Hermits* (present whereabouts unknown); the figures, landscape and fields were painted by three different artists.[13] Because of this propensity to collaborate and the lack of early signed paintings, Ricci's youthful style poses complex questions. But it is generally agreed that his sources lie in the work of the great 17th-century landscape painters, Claude Lorrain, Gaspard Dughet and Salvator Rosa, among others. He also followed a 'naturalistic' school of landscape painting practised in the Veneto during the late 17th and early 18th centuries by the German Johann Anton Eismann (*c.*1613–*c.*1698), the Dutch artist Pieter Mulier, and by the Italians Antonio Francesco Peruzzini (1655–1725) and Bartolomeo Pedon (1665–1733). Indeed, the differences between some of these painters' landscapes and Ricci's early works have not yet been fully sorted out.

26

MARCO RICCI
*The Opera Rehearsal*
oil on canvas, 47.5 × 56 cm
Private Collection, USA

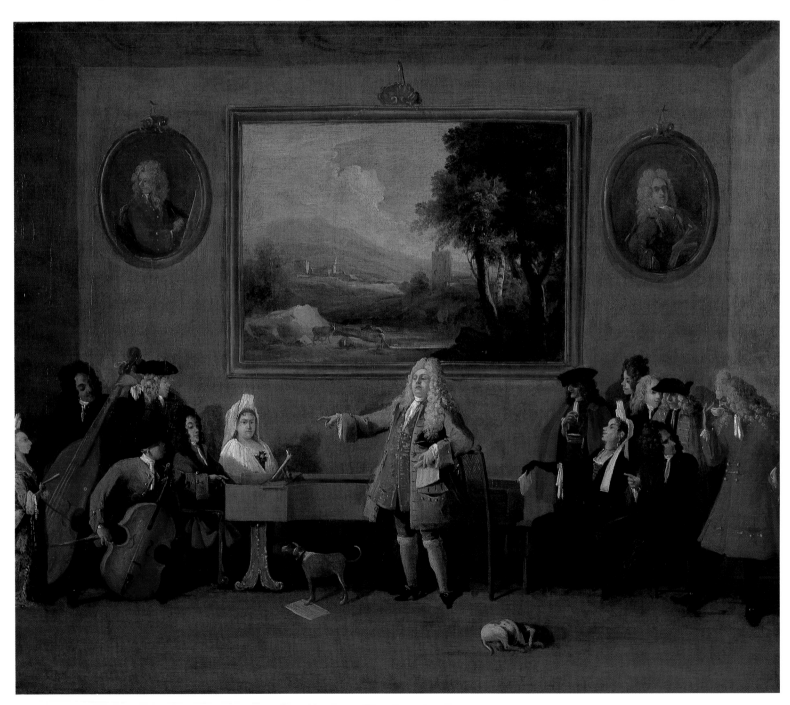

Adding to this complex mixture of landscape styles was the debt Ricci owed to the 16th-century image of nature found in the art of Giorgione, Titian and Domenico Campagnola. The vision of broad valleys surging up to craggy mountains and the rolling hills and rivers enlivened by the presence of medieval towns that occur in many of Ricci's paintings, drawings (cat. 29) and prints can be traced back to their works. The painter from Belluno was attracted to them because of his predecessors' fame but also because sections of the landscapes in their paintings must have resonated for a native of the Italian Alps. Dutch 17th-century painting also played a role in determining Ricci's pictorial vision of nature.[14] But much closer in time than the art of his 16th- and 17th-century forerunners was that of the Genoese Alessandro Magnasco, whom Ricci knew personally and with whom he may have collaborated. Magnasco's brilliant handling of loose paint and his long, thin, wiry figures are echoed in a number of Ricci's early landscapes. Finally, a significant ingredient in Ricci's art was the professional relationship he enjoyed with his uncle, Sebastiano Ricci, with whom he sometimes collaborated.

In 1707–8, the 31-year-old Ricci came to the attention of Charles Montagu, 4th Earl of Manchester, who was in Venice as British ambassador. Having commemorated his formal entry into the Doge's Palace of 1707 in a painting by Carlevaris (Birmingham Museums and Art Gallery) that he sent home, Lord Manchester decided that it was equally sensible to ship an Italian painter or two back to England to work for him on his return. Collaborating with Giovanni Antonio Pellegrini from late 1708 until the spring of 1711, and with his uncle Sebastiano from 1712 until early in 1716, Marco produced scenery for the opera stage in London, and decorated Lord Manchester's houses in London and at Kimbolton as well as those of other members of the British nobility. It is from one of these two English sojourns, probably the second, that one of Ricci's few interior scenes, his wry *Opera Rehearsal* (cat. 26), must date. The scene shows the famous *castrato* Nicolini (Nicolino Grimaldi, 1673–1732) accompanied at the harpsichord by Nicola Haym, with other identifiable personages, including the famous soprano Catherine Tofts, gathered either to play or listen.[15] The figures are humorously characterised, even caricatured: Nicolini's crooked finger, perhaps correcting Haym in his playing, could be lifted from Michelangelo's *Creation of Adam* on the Sistine Chapel ceiling; the woman giving herself airs on the right of the painting, the crusty man wincing while sipping either coffee or the even newer beverage of tea, and the amusing contrast between the two dogs, one facing the music and the other happily oblivious to it. A grandiose landscape in Ricci's finest bucolic style dominates the room, and two oval portraits of Marco and his uncle Sebastiano flank the landscape, giving the gathering its most dignified note.

*Figure 24:* Marco Ricci, *Farinelli in an Oriental Role*, pen and brown ink over black lead, 30 × 16.7 cm, Her Majesty The Queen

Ricci's principal activity was as a landscapist, and his paintings can be divided into four basic categories: bucolic pastorals or Alpine views (cat. 27, 28), violent country storms (cat. 36), ruins (cat. 32) and scenes of villages or courtyards (cat. 35). Many of these are painted in the traditional medium of oil on canvas but about half of his *œuvre* was done in tempera on kid- or young goatskin (cat. 27, 32, 35, 36); all these last works are small in size, measuring about 30 × 45 cm.[16] It appears that Ricci introduced this combination of paint and support into Italian art, for although tempera was an age-old medium and goatskin had been used in Italy to cover furniture and trunks for centuries, they had never been combined for easel paintings. Parchment, that is, calfskin, had sometimes been used, and Ricci may have seen such works in Florence, where he worked *c.* 1706/7, or during his travels through the Lowlands or in England.[17] Why he chose goatskin instead of calfskin is unclear, but his success with this novel combination of paint and support is demonstrated by the number of works he executed in this manner and by his results, which are singular and felicitous. He used paint on goatskin in a number of ways, sometimes painting in a sketchy manner and leaving the skin's texture bare, at other times applying thick daubs of colour to produce an opaque and richly textured finish. The bright tonalities and smooth surfaces Ricci achieved in this genre were a response to the same early 18th-century taste that judged pastels attractive. In fact, the greatest Venetian practitioner in pastel, Rosalba Carriera, was the sister-in-law of Pellegrini, with whom Ricci collaborated in England from 1708 to 1711. Evidently Ricci was prepared to try his hand at different styles and techniques. He was receptive to varying landscape styles, agreeable to collaborative efforts, willing to produce different types of imagery, and capable of painting pastorals or storms, delapidated ruins or busy little towns, in either oils or tempera.[18]

27

MARCO RICCI
*Extensive Pastoral Landscape*
*c.* 1730
tempera on kid or goatskin, 30.8 × 45.7 cm
The Metropolitan Museum of Art, New York,
Rogers Fund

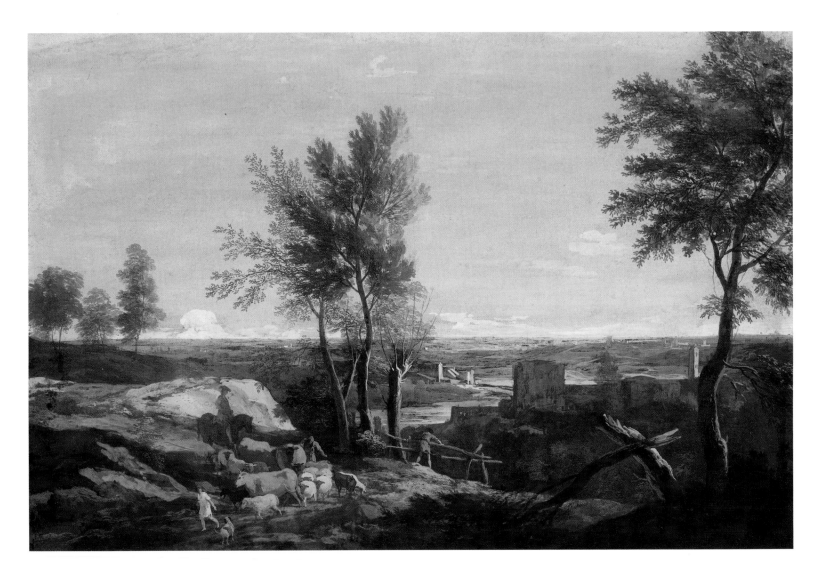

MARCO RICCI
*Wooded River Landscape with Shepherds*
1725–9
oil on canvas, 73.7 × 125.1 cm
Lent by Her Majesty The Queen

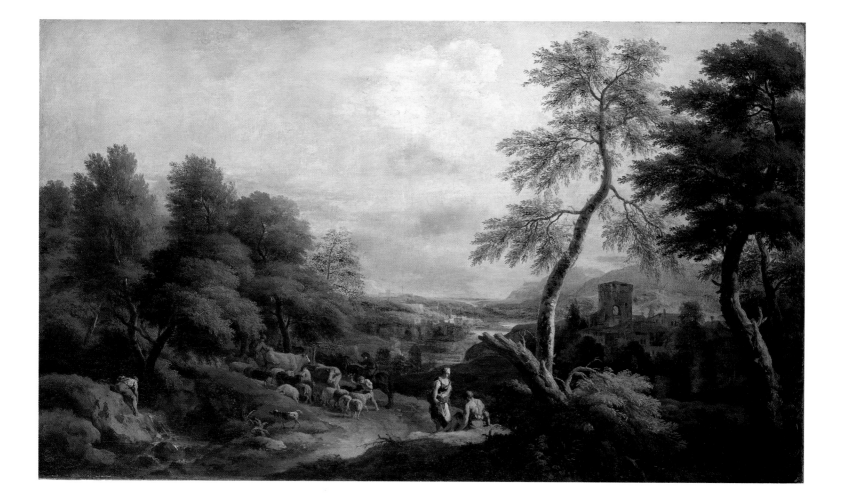

29

MARCO RICCI
*Fortified Village along a River*
1720s
brown ink over traces of graphite, 26.4 × 37.5 cm
National Gallery of Art, Washington
Gift of Mrs Rudolf J. Heinemann

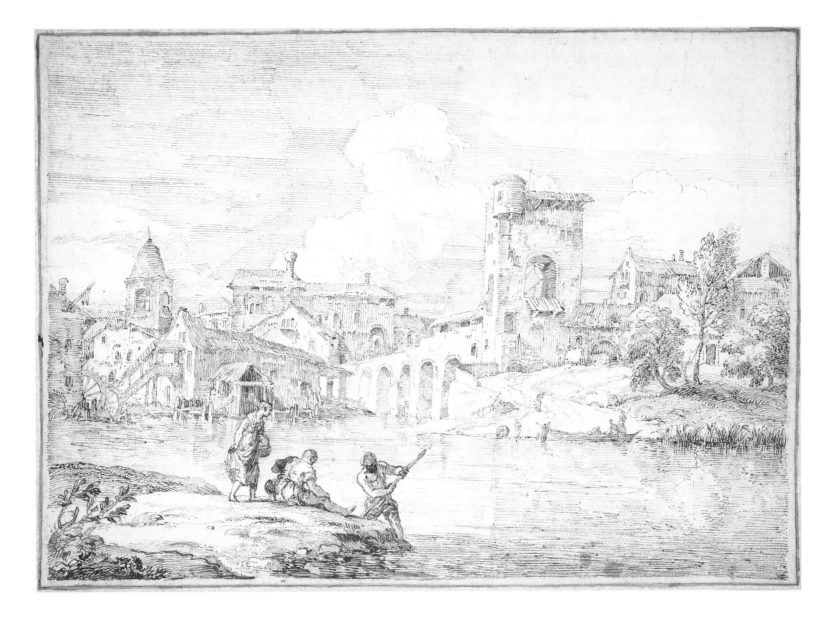

MARCO RICCI
*Palatial Interior with a Wall Painting and Furniture*
*c.* 1726
pen with brown wash over black chalk,
40.3 × 25.9 cm
Lent by Her Majesty The Queen

MARCO RICCI
*A Villa Courtyard with a Fountain*
*c.* 1726
pen and brown ink, 36.4 × 30.3 cm
Lent by Her Majesty The Queen

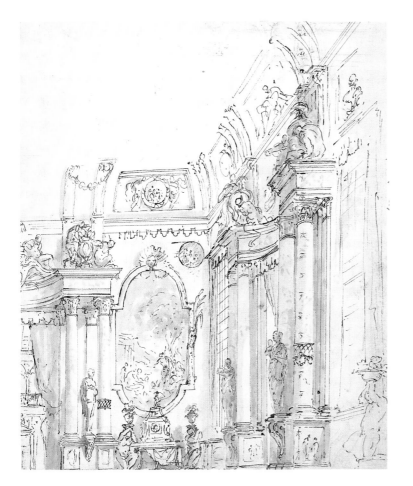

Between 1716, when he returned definitively to Italy, and his death in 1730, Ricci continued to paint landscapes; he also collaborated with Sebastiano on monumental figurative paintings, designed scenery for the opera stage (cat. 30), drew caricatures of contemporary singers (fig. 24), and produced over two dozen beautiful etchings of landscapes and ruins (cat. 33, 34). Those depicting landscapes or towns capture the light, atmosphere and buildings of northern Italy. The scenes of ruins, however, are completely imaginary and evoke nostalgia for a world now prey to decay and corruption. Ricci's contrasts of deeply shadowed monumental structures and brightly lit surfaces seen against streaked skies filled with quickly moving clouds affirm his brilliance as a printmaker. His success in the field foreshadows the later achievements of other, younger, Venetian artists, Canaletto (cat. 143), Giambattista Tiepolo (cat. 109) and Giambattista Piranesi (cat. 269).

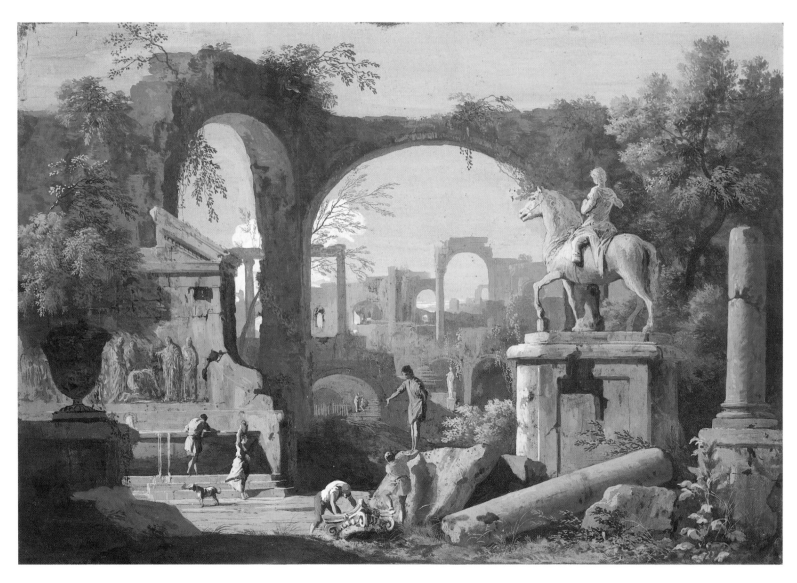

32

MARCO RICCI
*Capriccio of Roman Ruins*
tempera on kid or goat skin, 31 × 45.5 cm
National Gallery of Art, Washington
Ailsa Mellon Bruce Fund

33

MARCO RICCI
*Classical Ruins with Plunderers*
etching, state 1 of 2, 24.4 × 35.2 cm
Museo Biblioteca Archivio di Bassano del
Grappa, Remondini Collection

34

MARCO RICCI
*Classical Ruins with a Sphinx*
*c.* 1725
etching, state 1 of 5, 40.5 × 32.3 cm
Museo Biblioteca Archivio di Bassano del
Grappa, Remondini Collection

35

MARCO RICCI
*The Courtyard of a Country House*
tempera on kid or goatskin, 31.1 × 45.7 cm
Lent by Her Majesty The Queen

MARCO RICCI
*Stormy Landscape*
*c.* 1725
tempera on kid or goatskin backed with paper,
30.9 × 44.7 cm
National Gallery of Art, Washington
Ailsa Mellon Bruce Fund and Gift of David
Tunick

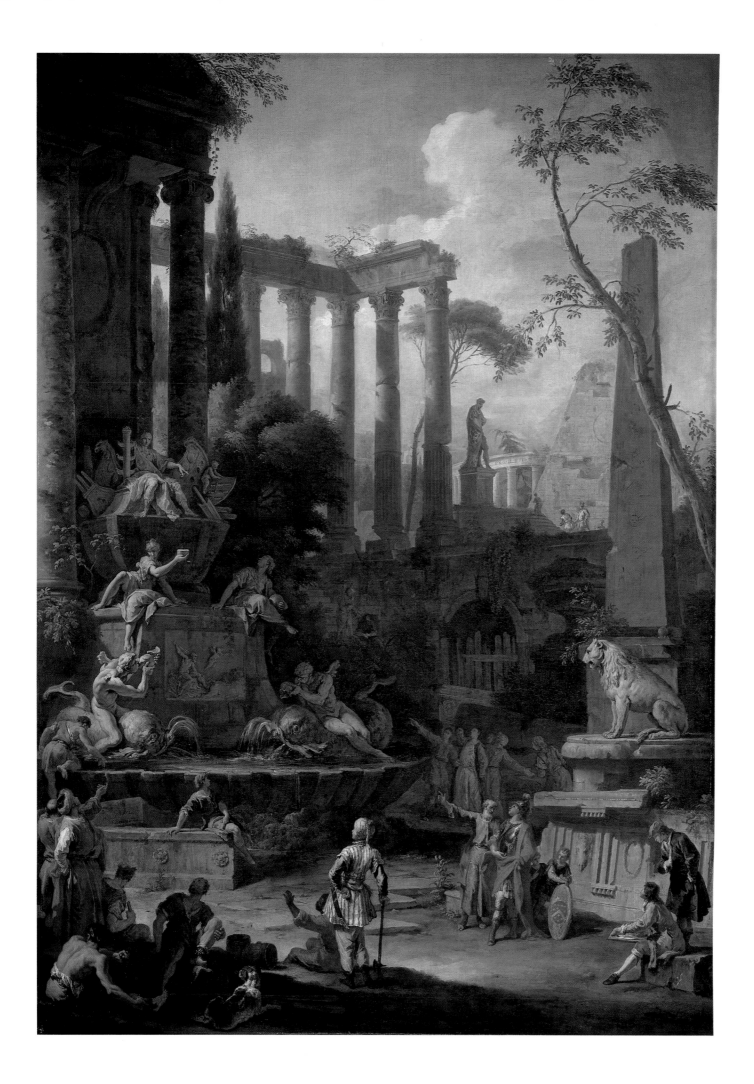

While in Venice during the 1720s, Ricci took part in a large-scale decorative commission destined for England. This was a series of 24 paintings, each to commemorate a famous Briton of recent times. The enterprise's creator was Owen McSwiney, an Irish impresario, who had worked successfully in the London theatre at the beginning of the century when Ricci first knew him but who later was declared bankrupt and emigrated to the Continent to make his fortune there. McSwiney persuaded a number of contemporary Venetian and Bolognese painters, among them Canaletto and Piazzetta, to collaborate on the so-called 'tombs of illustrious men', many of which were to decorate the dining-room of Goodwood House, the Duke of Richmond's country seat.[19] Working in collaboration with his uncle Sebastiano, who painted the figures and sculpted monuments for the 'tombs' of the Duke of Devonshire (The Barber Institute of Fine Arts, Birmingham) and of Admiral Sir Clowdisley Shovell (cat. 37), Ricci executed the landscapes and ruins on the two canvases, which were completed by early 1726. The 'tombs' represent a unique commission in Ricci's long career, but his pictorial contribution to them sums up his varied and prolific output. Combining rich and elegant natural elements with ruins and grand architectural monuments, these eccentric paintings manage to combine the elegiac and poetic landscapes that are his most significant contribution to 18th-century Venetian art.

37

MARCO and SEBASTIANO RICCI
*Allegorical Tomb of Admiral Sir Clowdisley Shovell*
c. 1725
oil on canvas, 222.3 × 158.8 cm
National Gallery of Art, Washington
Samuel H. Kress Collection

1. For the painting of the French ambassador, Cardinal César d'Estrées, now in The Hague, see Amsterdam, 1990, p. 118–19; for that of Lord Manchester, the British ambassador, now in Birmingham, see Rizzi, 1967, pp. 87–8, figs. 31–4. For the two paintings in this exhibition, see Rizzi, 1967, pp. 88, 93, figs. 39, 40, 43, 44; and *Getty Museum Journal*, 1987, pp. 186–7.
2. For Heintz, see Pallucchini, 1981, 2, figs. 440–1.
3. Briganti, 1966.
4. That Carlevaris knew van Wittel's paintings is not at all certain, although Giannantonio Moschini wrote in 1806 that Carlevaris went to Rome; see Moschini, 1806, p. 49: 'He went to Rome as a very young man, and while there on his own, he tirelessly copied many views and perspectives on paper of both the city's ancient and modern buildings, their interiors as well as exteriors'. It is also possible that the two painters met in Venice during the late 1690s.
5. The J. Paul Getty Museum, Malibu, also owns a version of the *Regatta* that is dated 1711.
6. Rizzi, 1967, p. 102, and Gorizia and Venice, 1983, pp. 11–29.
7. Bartolomeo Nazzari's portrait of Carlevaris (Ashmolean Museum, Oxford) portrays the painter resting on a globe with a compass in hand. Carlevaris's father had been an architect of sorts as well as a cartographer; he died when his son was six years old, so there is little likelihood that Luca trained with him.
8. See Norwich, 1989, pp. 572–3.
9. Knox, 1975², pp. 96–104.
10. See Constable, rev. Links, 1989, nos. 355 and 356.
11. See Gorizia and Venice, 1983, pp. 230–4.
12. For a representative group of generally accepted early works by Ricci, now in the Gemäldegalerie,

Dresden, see Scarpa Sonino, 1991, pp. 120–1, cat. O 25–32, and Belluno, 1993, pp. 180–3, cat. 1–3.
13. Scarpa Sonino, 1991, pp. 117–18, cat. O 14, figs. 21–2.
14. See Belluno, 1993, pp. 73–80.
15. Ricci produced two different scenes of musical rehearsals, each with variants. See Scarpa Sonino, 1991, pp. 118–19, 126–7, 150, cat. O 15, 53–5, 69, and T 47, figs. 59–65; and Belluno, 1993, pp. 190–1, cat. 9, and see p. 102, figs. 3–6. The seated woman in white may be Catherine Tofts, a soprano who later married Joseph Smith, future British consul to Venice, and who died insane. Sonino points out, however, that the face in cat. 26 differs from that of the woman also identified as Tofts in the painting at Castle Howard; see Scarpa Sonino, cat. O 53, p. 126.
16. Scarpa Sonino, 1991, numbers 119 oil paintings and 124 works in tempera. This count does not include Ricci's collaborative paintings in oil with his uncle Sebastiano and the many lost canvases from his English period.
17. Paintings on vellum were made by Giovanna Garzoni (1600–70) who worked in Florence and Rome (see Florence, 1986–7, *Pittura*, pp. 459–65); Hans Bol of Mechelen (1534–93; see Washington and New York, 1986, p. 71) and John Dunstall of Chichester and London (d. 1693; see London, 1987, p. 121). Works on animal skins are usually either botanical or nature studies.
18. Despite his artistic adaptability, Ricci seems to have had a difficult character; see 18th-century statements reprinted in Scarpa Sonino, 1991, pp. 64–5.
19. For McSwiney's commission, see Haskell, 1963 rev. 1980, pp. 287–91; Mazza, 1976, pp. 70–102, 141–51; and Knox, 1983, pp. 228–35.

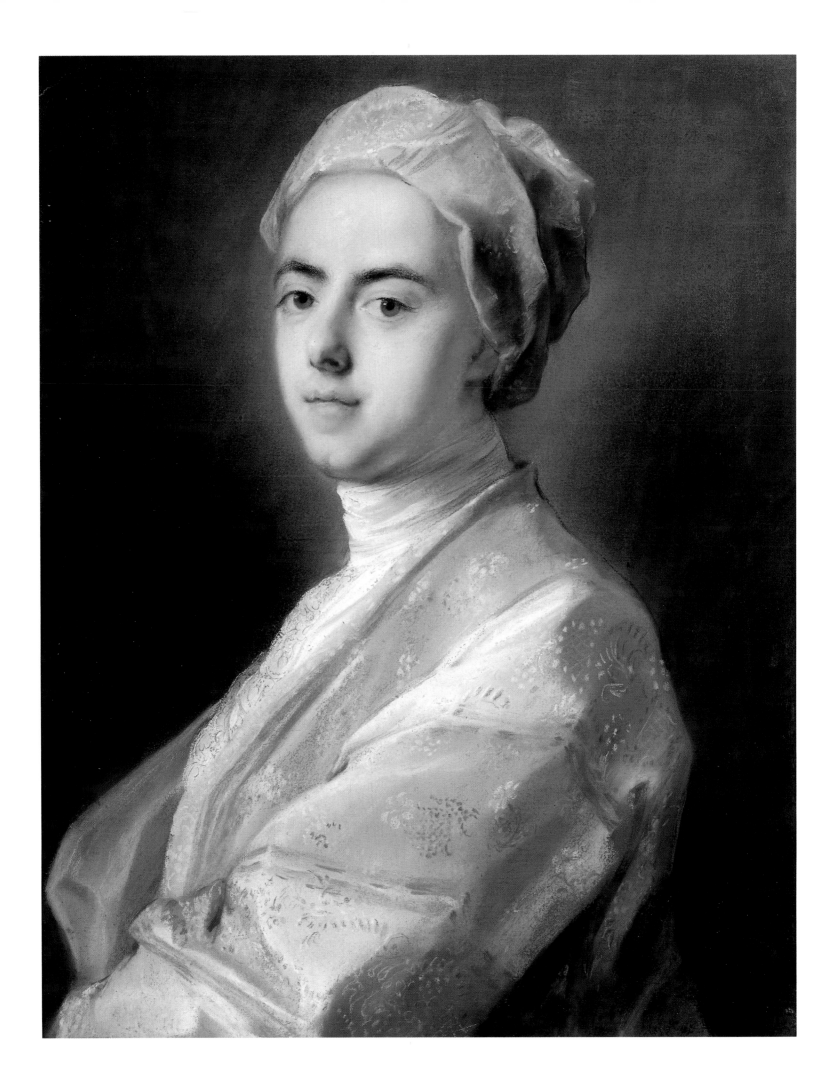

# III: *Rococo Artists*

## Alessandro Bettagno

At the beginning of the 18th century a 'second generation' of Venetian artists promoted an energetic and brilliant, unmistakably Rococo, style. Antonio Pellegrini, Rosalba Carriera, Anton Maria Zanetti the Elder, Jacopo Amigoni and Giambattista Pittoni were all born during the last quarter of the 17th century. Marco Ricci also belongs to this group but, as a painter of views and landscapes, he is discussed in another section of the catalogue.

Besides the coincidence of their birth dates these artists have in common a distinctive way of thinking, seeing and painting. All were 25 years old at the turn of the century, and all were eager to look beyond Venice for their models, rejecting the *tenebroso* style of the older generation and the dictates promulgated mainly by Bolognese artists. They were searching for a non-academic style, and their work is fresh, often bright in colour and light of touch, devoid of heavy sculptural qualities.

Antonio Pellegrini was born in Venice in 1675 and trained in the studio of Paolo Pagani (1655–1718), accompanying his master to Moravia, and staying in Vienna from 1692 to 1696. His training therefore was international, and he learnt early in life to handle large-scale decoration, yet despite this, his distinctive style owes most to his stay in Rome in 1700. He went there 'knowing that he needed to study more', according to the French collector and friend of the family, Mariette, who had it from Pellegrini's wife, Angela Carriera. Pellegrini went to Bologna as well, but it was Rome that left its mark. Here he fell under the spell of the Genoese painter Giovanni Battista Gaulli, known as Baciccio. He returned to Venice in 1701, and the innovative qualities of his work were soon recognised; he had gone beyond Sebastiano Ricci, who had influenced him to some extent, as had Luca Giordano's later style. These bright, soft and airy paintings were a perfect complement to the work of Rosalba Carriera in particular; Pellegrini married Rosalba's sister Angela in 1704.

In the autumn of 1708 Charles Montagu, Earl (later Duke) of Manchester, at the end of his diplomatic mission to the Venetian Republic on behalf of Queen Anne, took with him to London Antonio Pellegrini and Marco Ricci. The Earl, a keen opera lover, needed artists to paint the scenery for his operas. What better choice than the young, talented figure painter and landscape painter, who had worked together in the presbytery of S. Moisè and who were generally regarded as the most advanced painters of their generation in Venice?

During his stay in England from 1708 to 1713 (he returned briefly in 1719) Pellegrini made a favourable impression on the Whig nobility of the day, including the Duke of Manchester and Charles Howard, 3rd Earl of Carlisle. He and Marco Ricci were employed as scene-painters in the Queen's Theatre in the Haymarket, first on sets for *Pyrrhus and Demetrius*, by Alessandro Scarlatti and Nicola Haym and later on Antonio Maria Buononcini and Silvio Stampiglia's *Camilla*, both adapted by Owen McSwiney. Almost immediately after his arrival in London Pellegrini was commissioned to decorate the staircase in Lord Manchester's London house in Arlington Street (now destroyed).

38
ROSALBA CARRIERA
*Young Man in an Embroidered Jacket*
c. 1741
pastel on paper, 57 × 45 cm
Private Collection

39

GIOVANNI ANTONIO PELLEGRINI
*St Cecilia*
oil on canvas, 72.2 × 40.5 cm
Staatsgalerie, Stuttgart

A more demanding commission for Pellegrini and Marco Ricci was the decoration of Castle Howard, in Yorkshire, recently redesigned for the Earl of Carlisle by John Vanbrugh, who had started life as a playwright before becoming an architect. The same circle of patrons provided the next commission for the two artists, to provide a series of paintings for Burlington House, the London residence of Richard Boyle, 3rd Earl of Burlington, who was only seventeen years old at the time; his mother and mentor, Juliana, Dowager Countess of Burlington, commissioned the paintings. These paintings were given to Sir Andrew Fountaine and removed to Narford Hall in Norfolk. The subjects were drawn from ancient history, literature, mythology, and allegory, and included decorations of trophies, masks, vases and festooned overdoors in grey monochrome with touches of brilliant colour.

Sebastiano Ricci arrived in London in 1712 and remained there until 1716; he must have been astonished at the markedly Rococo direction that Pellegrini's painting had taken. There was a spirit of rivalry between the two Venetians, Pellegrini and Sebastiano Ricci, and also between Ricci and James Thornhill. Angela Carriera, writing to her sister Rosalba on 1 July 1714 relates that Sebastiano Ricci, who was working mainly for Lord Burlington, was having trouble selling his work because the prices asked for his paintings were so high. The presence of his uncle in town had done little for Marco Ricci's reputation. She also reports disagreements between Marco Ricci and Pellegrini. As well as working on a large scale, both artists sold easel paintings, and, in Pellegrini's case, portraits.

Although Pellegrini lost the competition to paint the dome of Wren's St Paul's Cathedral to Thornhill in 1710, he was asked to become a director of the Academy founded in London by Godfrey Kneller, the court painter, and in 1711, he was invited to decorate the stairway (fig. 13) at Kimbolton Castle, Lord Manchester's country seat; he painted a *Triumph of a Roman Emperor*, in the style of 'the school of Verrio and Laguerre, but he treats them with a verve of which few other painters at that time, whether in England or elsewhere, would have been capable' (Croft-Murray).

42

GIOVANNI ANTONIO PELLEGRINI
*The Head of Pompey Presented to Julius Caesar*
*c.* 1707
pen and brown ink, brown wash, over red and black chalk, 28.7 × 37.3 cm
The Metropolitan Museum of Art, New York
Gift of John S. Newberry

In 1713 Pellegrini moved to Düsseldorf. His new patron, the Elector Johann Wilhelm von der Pfalz, immediately commissioned him to decorate the ceilings of two large stairways in the castle of Bensberg, recently built to designs by the architect Matteo Alberti; Pellegrini's paintings show the *Fall of Phaeton* and the *Fall of the Giants*. In 1714 he painted a number of canvases for the same castle with historical and allegorical scenes exalting the von der Pfalz family. Stylistically he reinterpreted Rubens, in a thoroughly modern and decorative manner; his painting has an imaginative dimension, like some pagan fairy-tale.

Johann Wilhelm's death in 1716 brought this project to a halt, and Pellegrini moved to the Low Countries, where in 1717 he was elected a member of the Academy of St Luke in Antwerp, and in 1718 he is recorded as a member of the guild of painters in The Hague. In 1719 he made the acquaintance of Lord Cadogan, who invited him to return to England to decorate his country seat, Caversham Park, in Oxfordshire, of which nothing now remains. Thereafter Pellegrini was destined for a peripatetic career, moving incessantly around the courts of Europe.

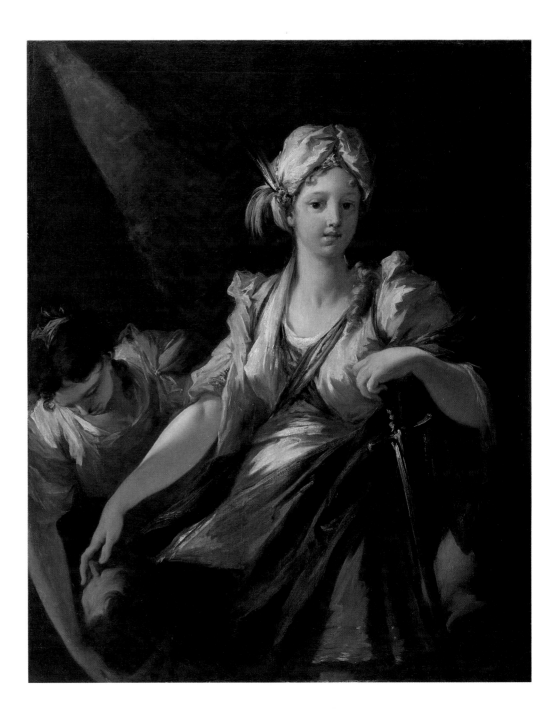

40

GIOVANNI ANTONIO PELLEGRINI
*Judith with the Head of Holofernes*
*c.* 1710
oil on canvas, 124.7 × 102 cm
The Barber Institute of Fine Arts, Birmingham

GIOVANNI ANTONIO PELLEGRINI
*Venus and Cupid*
oil on canvas, 103 × 126.5 cm
Private Collection

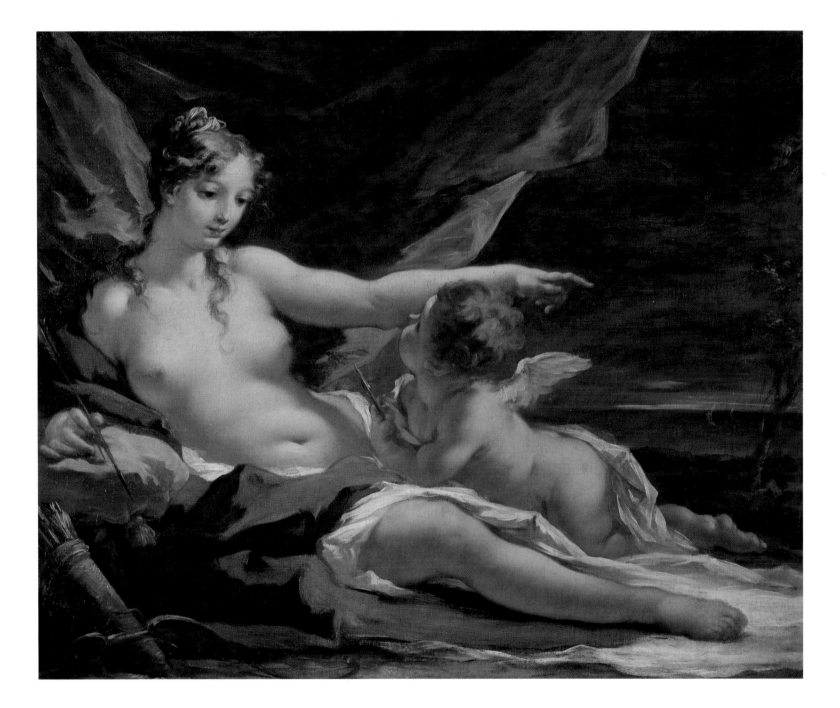

ROSALBA CARRIERA
*Allegory of Painting*
*c.* 1725
pastel on paper, 45.1 × 35 cm
National Gallery of Art, Washington
Samuel H. Kress Collection

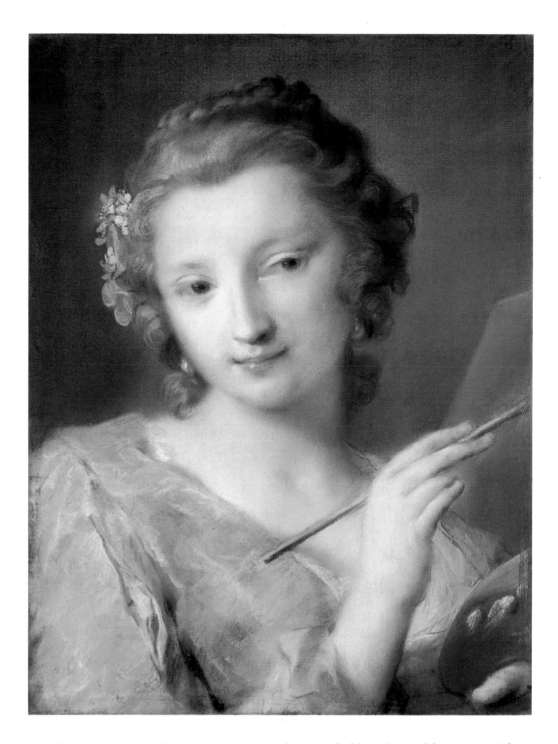

Rosalba Carriera trained with Diamantini, and was probably influenced by Campori from whom she absorbed hints of academic classicism later strengthened by her acquaintance with Bencovich and Balestra. Her *Portrait of Anton Maria Zanetti the Younger* (*c.* 1700; National Gallery, Stockholm) reveals the influence of pastel drawing as practised in central Italy by artists such as Baldassarre Franceschini, known as Il Volterrano, Benedetto Luti and Robert Nanteuil. Already Carriera has a light touch, but there is still evidence of firm drawing. Early in her career she decided to work in pastels, and also painted miniatures in tempera on ivory, preferring intimate portraiture to other subjects. Her miniatures were an immediate success in France, as her correspondence with the French collector Vatin in 1700 shows.

Stylistically Carriera soon set off in the direction of the Rococo, and must have been influenced by her association with Pellegrini on his return to Venice in 1701. As a result of this influence, Rosalba gradually abandoned painting in a style that relied on superficial glamour in favour of more expressive and graceful forms in the manner of Maratta.

Symptomatic of Rosalba Carriera's rapid rise to fame, and of its importance for the development of the Rococo in Venice, was the warm respose to her miniature painting, *Innocence*, presented as her reception piece to the Accademia di S. Luca in Rome in 1705. The English diplomat Christian Cole, writing on 19 September 1705, quotes Maratta's appreciative comments on the problems inherent in painting such subjects, and in painting 'white on white, which you have done like a great master; Guido Reni could not have done it better'.

It is clear that Rosalba's stylistic roots were not exclusively Venetian. Demand for her work came from all over Europe, at first mainly from Germany. Maximilian of Bavaria visited her in 1704; Duke Christian Ludwig of Mecklenburg commissioned work from her in 1706 and the Elector Palatine Johann Wilhelm von der Pfalz from 1706 to 1713. She entered into correspondence with him, maintaining contact through his secretary Giorgio Maria Rapparini,

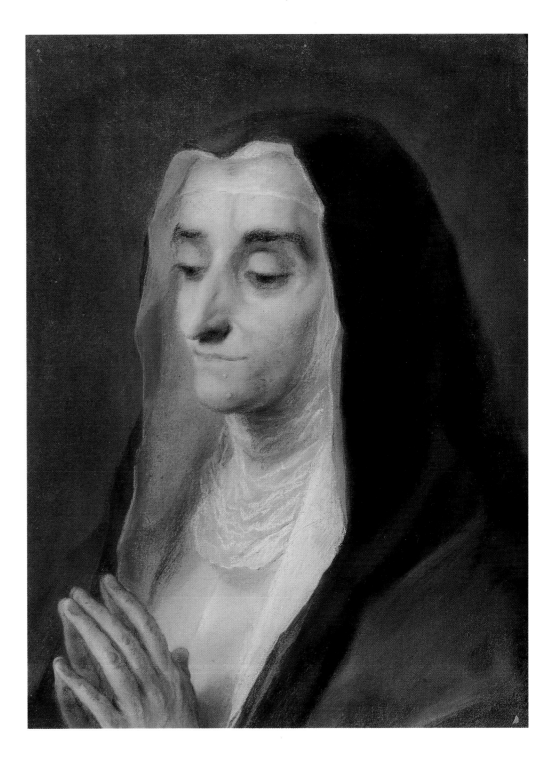

44

ROSALBA CARRIERA
*Sister Maria Caterina*
1732
pastel on paper, 44 × 35 cm
Ca' Rezzonico, Museo del Settecento
Veneziano, Venice

at a time when other Venetian painters, including Pellegrini and Amigoni were working for the court at Düsseldorf. In the winter of 1709, Frederick IV of Denmark requested works from her while he was staying in Venice. In 1713 the Prince of Saxony, the future Augustus III, King of Poland, was in Venice; for many years he was one of her most loyal and admiring patrons.

In 1707 Nicolas Vleughels visited her in Venice, keeping her in touch with the developments in contemporary French portraiture. France and things French were of great interest to the Venetians at this period; Vleughels may have drawn Rosalba's attention to the work of Antoine Watteau. Her continuing interest in French painting must have been reinforced by her meeting with Pierre Crozat, the King's treasurer and a keen connoisseur and collector. Crozat visited Venice in 1714 and made many friends there, including Rosalba and Anton Maria Zanetti the Elder. Pierre-Jean Mariette, another formidable connoisseur and collector, arrived in Venice from Vienna in 1718 and struck up a friendship with Zanetti and Carriera; the direct result was the departure of both artists for Paris.

45

ROSALBA CARRIERA
*Self-portrait*
c. 1744
pastel on paper, 57.2 × 47 cm
Lent by Her Majesty The Queen

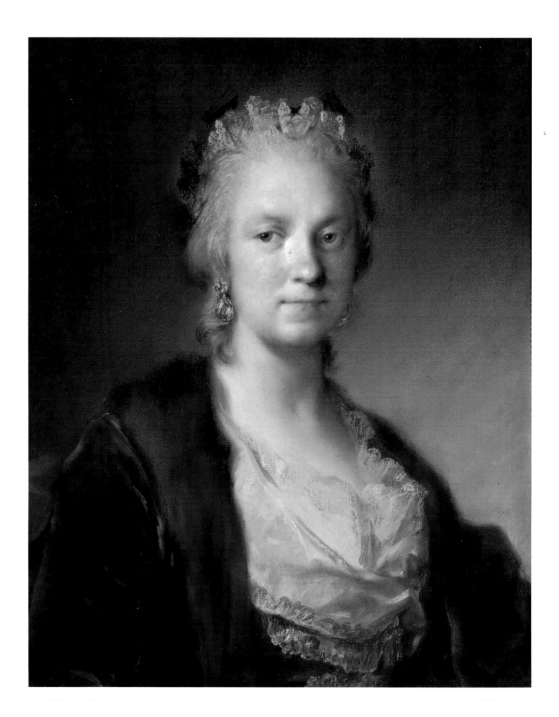

ROSALBA CARRIERA
*Spring*
*c.* 1720–1
oil on canvas, 60 × 45 cm
Guido Rossi, Milan

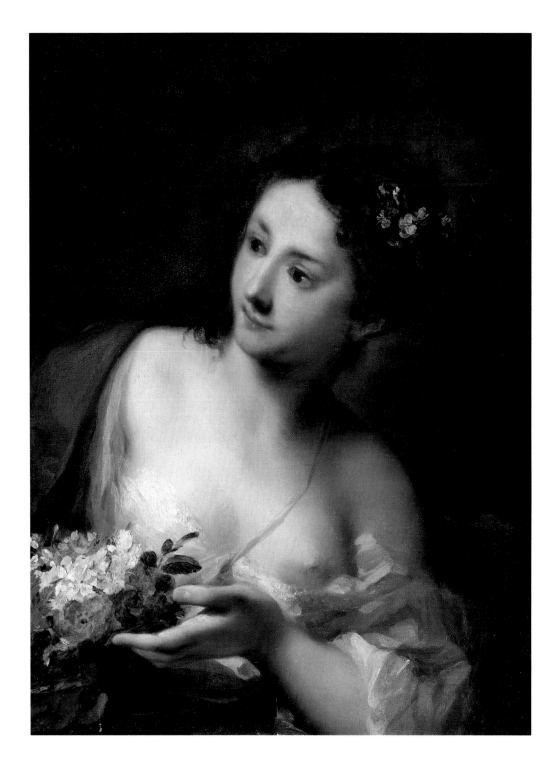

Between 1719 and 1720 a group of the Venetian artists of the 'second generation' lived in Paris; Pellegrini, Rosalba Carriera and Anton Maria Zanetti the Elder were linked artistically by their stylistic ideals, and personally by long years of friendship. In 1719, Pellegrini stopped in Paris *en route* from London to Venice; there he visited John Law, the banker and Minister of Finance, and accepted the commission to decorate the ceiling of the Banque Royale. He returned to Paris a few months later and stayed for a year, as did his wife Angela, her mother, and her sister Rosalba Carriera, who was the guest of Pierre Crozat in his house in the Rue de Richelieu from April 1720 to March 1721.

The sojourn confirmed Carriera's success as a fashionable portrait painter. As a guest in the Hôtel Crozat she imbibed the avant-garde spirit of that milieu. While the presence of La Fosse suggests a revival of the academic tradition, visits to Watteau and exchanges of gifts are evidence of their mutual esteem and sympathy, which produced anti-academic leanings and the rejection

of the 'hierarchy of styles'. Her success with both traditional and modernist artists may have owed something to her relationship with her aristocratic French clients, which took off from the moment the Prince Regent, Philippe d'Orléans, paid her a visit.

Rosalba responded directly to the personal requirements of her clients; sitters are not portrayed merely as their standing in society would warrant, but as they believe themselves to be (cat. 38, 44). Carriera enters into the mind of her sitters, depicting their physical appearance in such a way as to give the same pleasure as a mirror image (cat. 45). This demanded a simplification of structural details so that the face is the focus of attention. This typically rococo style of portrait painting was the key to Rosalba Carriera's success and also perhaps the key to her relationship with Watteau. After her return to Venice she sent her *Muse chasing Apollo* (Louvre, Paris) to the Academy as her *morceau de réception*, and the *Mercure Galant* of February 1722 praised it for its typically Rococo qualitites: the 'gracefulness' of the image, the 'lightness' of touch and the brilliant gem-like quality of the colour.

While Rosalba Carriera was winning praise for her work, Pellegrini was busy with the decoration of the ceiling of the Salle du Mississippi in the Banque Royale, a vast undertaking which also won him fame, even if only for a brief time; two years after its completion the bank was converted into a royal library and the decorations destroyed. But during their short life Pellegrini's paintings provoked quite violent reactions amongst Parisian art-lovers, even if they did not inspire imitations. Although Pellegrini's allegorical theme was in the French Baroque tradition, he managed to present it in a coherent manner, loosening the allegorical structure to increase its decorative impact, and lightening the composition with bright, luminous tones. This explicitly Rococo aspect of his work was misunderstood by commentators such as Mariette, who judged Pellegrini to be 'an apprentice who undertook the decoration of a vast ceiling as any other painter would have undertaken a painting on an easel'. In spite of the fact that he adopted the somewhat unusual medium of oil on plaster, Pellegrini executed the huge work with great virtuosity, working on it for eighty days (as Zanetti the Younger noted).

Like Rosalba Carriera and Pellegrini, the third of the Venetian artists in Paris at that time, Anton Maria Zanetti the Elder, spent his time very fruitfully in Paris, also visiting London and Holland. He was by now more than just the greatest connoisseur and collector in Venice: he was one of the leading European figures in the field. Zanetti and Rosalba had cultivated the same network of friends and acquaintances in the early years of the century and were themselves old friends. Zanetti trained in the studios of Bambini, Ricci and Balestra, then went to Bologna to train under the Viani; like Carriera, he entered the world of banking and commerce when he worked for an Englishman, Thomas Williams, who lived in Palazzo Balbi near the SS. Apostoli. Joseph Smith, the future consul, himself a talented businessman as well as a connoisseur, was in partnership with Williams as an dealer in art. Williams also knew Christian Cole, Rosalba's admirer. Zanetti was first and foremost a scholar; for him it seems that engraving was only an afterthought. He had the entrée into Venetian society, but the encounters that most influenced him were his meetings with Crozat in 1716 and with Mariette in the winter of 1718–19. As with Carriera, these whetted his appetite for a trip to Paris.

Zanetti's acquisitions at this time included graphic works by many European artists, the most prominent (numerically as well as in terms of quality) being Callot, Cort, Dürer, Goltzius and Lucas van Leyden. His three-volume collection of the complete engravings of Rembrandt was extremely rare, as was the large collection of drawings by Parmigianino that he purchased from Lord Arundel. To be included in Zanetti's collection was the aim of many contemporary artists in Venice, as witness his collection of rare and unique artist's proofs by Canaletto and the

47

ANTON MARIA ZANETTI
*Self-portrait in a Mask, Drawing a Caricature*
pen and brown ink, 28.4 × 20.9 cm
Lent by Her Majesty The Queen

Tiepolos which he had bound into albums (cat. 112, 142, 230). Zanetti's taste for Rembrandt, for instance, or for Northern landscapes, influenced contemporary Venetian artists. For example, under the guidance of Zanetti, Marco Ricci started his career as an engraver and was influenced by Flemish landscape painters.

After the period spent together in Paris in 1720–1, Pellegrini, Carriera and Zanetti went their separate ways. Their ideals were now similarly cosmopolitan,and they had patrons throughout Europe. Their copious correspondence bears witness to their large network of friends and contacts. Rosalba Carriera settled in Venice, occasionally making forays to Modena, Gorizia or, in 1730, to the court in Vienna, always to make portraits. Pellegrini was ceaselessly on the move, drumming up commissions: in April 1721 he travelled via Strasbourg to southern Germany and Swabia, with a stop at Füssen, then on to the Tirol; returning to Venice in early May. He was in Füssen in June 1722 to paint a second altarpiece, and another at Ettal. At about the same time he painted the *Martyrdom of St Andrew* in S. Stae, and the ceiling of the library in Palazzo Pisani at S. Stefano (now in Marble House, Newport, Rhode Island). In later years he courted patrons in central Europe: in Würzburg and Dresden in 1724 and 1725, in Vienna in 1727–30 where he decorated the dome of the Salesian church. He returned to the Palatine court and in 1736 painted four ceilings in the castle at Mannheim for Karl Philipp von der Pfalz. He returned to Venice in the summer of 1737, staying there until his death in 1741.

48

ANTON MARIA ZANETTI
*Seven Men Standing on a Quay*
pen and brown ink, 34 × 49 cm
Lent by Her Majesty The Queen

49

ANTON MARIA ZANETTI
*Raccolta di varie stampe a chiaroscuro*
published by Zanetti in Venice
*chiaroscuro* woodcuts printed from three blocks,
23 × 18.5 cm (open book)
National Gallery of Art, Washington
Rosenwald Collection

Zanetti, meanwhile, kept alive his contacts throughout Europe, making his house in Venice an obligatory stopping place for every connoisseur or artist visiting the city. The international circles he frequented and the collections he visited stimulated him in his capacity as engraver and draughtsman. He was particularly impressed by 16th-century colour prints, and began to try out the same technique and to work on a series of *chiaroscuri* (cat. 49) which were published as a collection three times: in 1731 a single volume edition of forty copies, and in two volumes in 1739–43 and in 1749. The 1749 edition was combined into one volume in 1751, and a letter of dedication to the Prince of Liechtenstein and an index were added. The preparation of the *chiaroscuri* first by drawing in red chalk then by transferring the drawings to woodblocks and testing the different colours is illustrated in an album (Museo Correr, Venice) which contains eleven drawings by Zanetti which once belonged to Marshal Schulenburg.

For his engraving and publishing business Zanetti found a skilled and hard-working partner in Giovanni Antonio Faldoni. Faldoni had also spent a long time in Paris, where he had improved his engraving technique and developed a cosmopolitan outlook that made him sympathetic to Zanetti's various publishing schemes, acting not only as translator, but also lending intelligent support to the artistic direction of the business. Faldoni promoted an engraving technique, already in use in Venice, which was derived from Claude Mellan. Cross-hatching was eliminated, and shading consisted of parallel lines variously modified to give the effect of modelling or of light and shade. Faldoni could handle this technique with masterly virtuosity (cat. 50).

Their collaboration began in the years 1724–7; Faldoni worked longest on Zanetti's volume of prints after drawings of Parmigianino which took over seventeen years to complete. Of the engravings, fourteen are by Faldoni, two by Zanetti, and one each by Andrea Zucchi and Carlo Orsolini. While this project was going on another collection of engravings, prepared

from Zanetti's red chalk drawings, on the *Statue Antiche...* (*Ancient Greek and Roman statues to be found in the antechamber of St Mark's Library, and in other public places in Venice*) was published in two volumes in 1740, once again in collaboration with Faldoni (cat. 84). It was while they were working on this job that Faldoni quarrelled with Marco Pitteri, who had been called in to retouch some of the plates. Faldoni was known to have a difficult temperament; he had already been in dispute with Bartolomeo Nazzari. His relationship with Pitteri, a young, very talented engraver, was important, however; he had taught him engraving with evident success, and Zanetti had begun to take an interest in him.

After the middle of the century Zanetti began to notice the gradual disappearance of artists and friends of his own generation, and an accompanying waning of interest in scholarship and collecting, as he understood it. The world he had known, gently analysed and mocked with subtle irony in his two collections of caricatures (cat. 47, 48), was passing from view. He remained active into his old age, collaborating with Zompini on a collection of engravings entitled *Arti che vanno per via* (cat. 187, 188). He exchanged letters with Francesco Algarotti, the connoisseur of the younger generation most likely to inherit his mantle. A few years before his death in 1767, Zanetti's sharp and ironic humour encouraged Goldoni to dedicate his comedy *Il ricco insidiato* to his friend, implying that the connoisseur was one of the first enlightened supporters of his theatrical revival. In 1761, the year Goldoni's play was published, Zanetti received formal recognition of his merits when he was given the title of count by Maria Theresa, Empress of Austria.

Jacopo Amigoni is included in the 'second generation' of painters because of his style, which is characterised by a sensuality expressed in sweetness of form and extenuated elegance. It is generally accepted that his style derives from familiarity with the work of certain Neapolitan painters of the generation after Giordano, in particular Paolo de Matteis, but also Solimena and De Mura (Longhi, 1920). Yet, other influences are also discernable: the bright palette; the revival of Veronese, which had been promoted by an older generation of Venetian painters, including Gregorio Lazzarini and Giovanni Segala, and the more classical style under the influence of Maratta favoured by Antonio Balestra. These tendencies give credibility to the suggestion that Amigoni collaborated with Antonio Bellucci, who was popularising a similar style in central Europe at the time. Perhaps Amigoni worked with him at Bensberg between 1705 and 1711.

Amigoni and Pellegrini's documented meeting in Düsseldorf in 1717 was certainly not their first. Pellegrini may have been surprised by Amigoni's almost avant-garde interpretation of the Rococo style, in keeping with the most advanced European taste. Soon after their meeting in Düsseldorf, Amigoni rapidly evolved a more personal and advanced manner than anything yet developed by Pellegrini. The decoration of the castle at Nymphenburg in 1718, and the first series of decorations in the Benedictine abbey of Ottobeuren show Amigoni's fully developed style. The vast paintings in the castle at Schleissheim, executed between 1720 and 1723, were followed by a second, much more important commission at Ottobeuren where he decorated the Abbot's chapel and the chapel of St Benedict in 1725. In this enormous undertaking he seems to be adapting himself to Pellegrini's style, sharpening and lightening forms with Rococo elegance and acquiring a new felicity of touch and delicacy of definition. A brief return to Italy, from November 1725 to May 1726, was long enough for Amigoni to fall under the influence of Sebastiano Ricci, as shown by his later work at Schleissheim and Ottobeuren, as well as in Augsburg, Benedicktbeuren and Eichstadt.

50

GIOVANNI ANTONIO FALDONI
*Componimenti poetici delle più illustri rimatrici d'ogni secolo*, by Luisa Bergalli, published in Venice by Antonio Mora, 2 vols, 1726, vol. I open to show the engraved frontispiece, a portrait of Luisa Bergalli
17 × 22 cm (open book)
The British Library Board, London

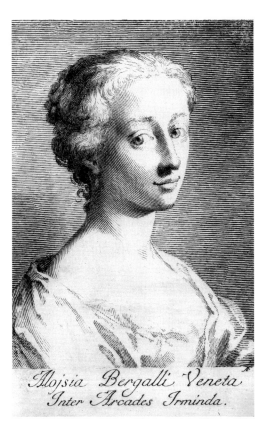

51

JACOPO AMIGONI
*Bathsheba*
*c.* 1739–47
oil on canvas, 115 × 150 cm
Staatliche Museen Preussischer Kulturbesitz,
Berlin, Gemäldegalerie, on loan from the Streit
Foundation

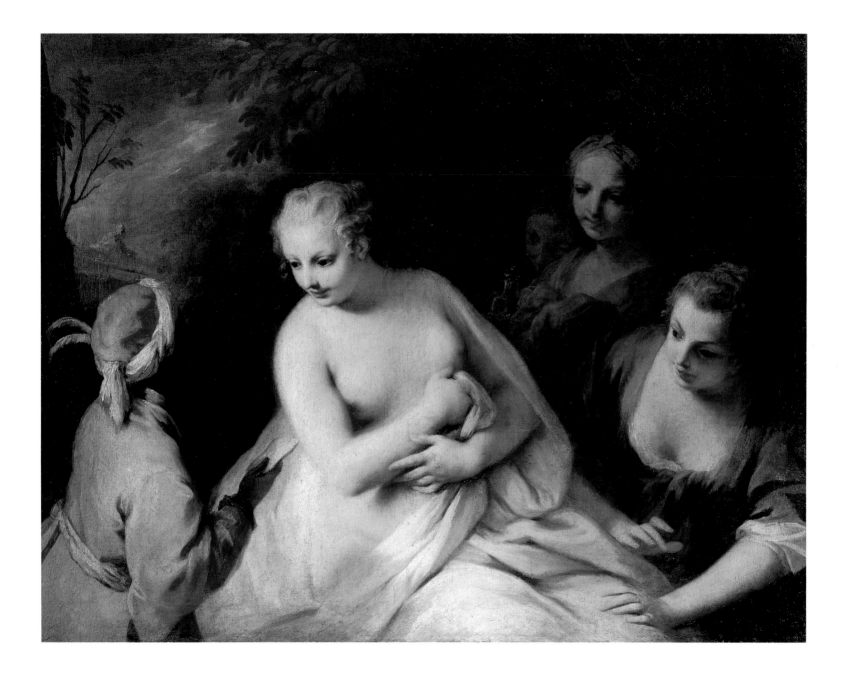

JACOPO AMIGONI
*The Meeting of Habrokomes and Antheia*
1743–4
oil on canvas, 97.5 × 125 cm
Staatsgalerie, Stuttgart

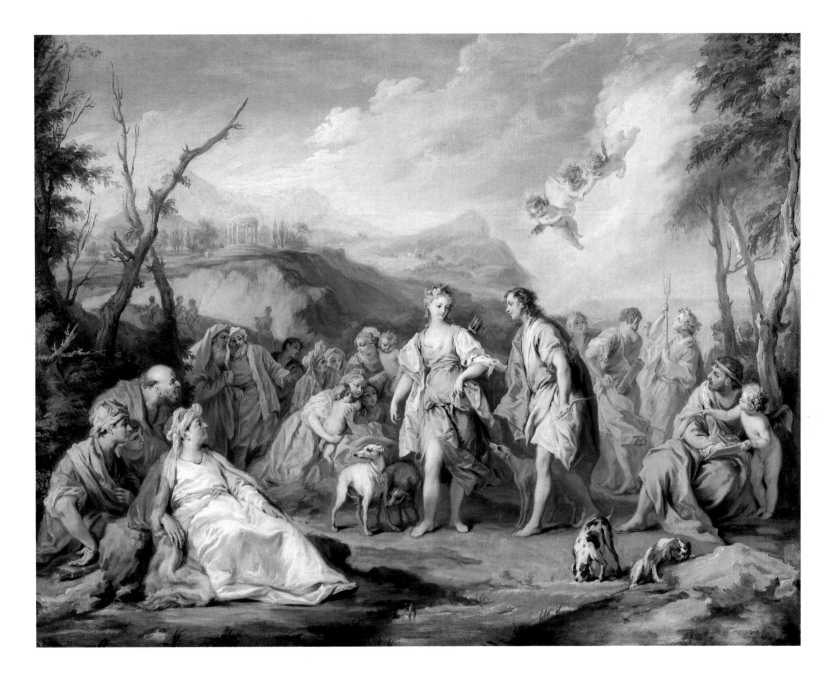

54

JACOPO AMIGONI
*Head of a Bald Man in Profile*
1740s
black and white chalk on brown paper,
28.4 × 22.9 cm
Staatliche Graphische Sammlung, Munich

By 1729, Amigoni was in England where he stayed for ten years. He had arrived with the celebrated opera singer Farinelli whose friendship helped him to find work in the theatrical world in London. Vertue noticed that in England Amigoni concentrated on portrait painting, and on the painting of historical subjects 'which he never practisd before he came to England'. Vertue adds: 'but haveing a plesant invention and disposition of his draperyes his mixture of little Cupids the tenderness of colouring all together had something pleasant and new that the courtiers and quality presd him, to imploy him in portraits' but he had 'a reluctance', preferring history and the 'money therefrom'. The success of Amigoni's portraits was endorsed by the commissions he received from George II to paint members of the royal family. As a history painter Amigoni adapted his work to English taste, adopting a different manner from that of Pellegrini. The subjects most favoured were mythological or literary, above all scenes of gallantry; these, however, are not set in vague, dreamlike surroundings, but are more direct, more arresting, thanks to Amigoni's thoughtful compositions and exquisite sense of colour.

Amigoni's second period in Venice lasted from his return from London in 1739 until 1747. From Venice he seems to have provided a regular supply of painters to work in London. He apparently encouraged Canaletto to go to London, and possibly also Antonio Zucchi. In Venice Amigoni reverted to a more classical style, also evident in Giambattista Tiepolo's work at this time, as well as that of Piazzetta. This development in Tiepolo's style has been explained by his friendship with Algarotti. Certainly at that date Algarotti's and Amigoni's tastes coincided remarkably. Algarotti commissioned Amigoni to paint a picture for August III's gallery in Dresden: *The Meeting of Habrokomes and Antheia* (cat. 52). Here Amigoni's drawing is perceptibly livelier, his *chiaroscuro* more exciting thanks to the influence of Tiepolo. During these years in Venice Amigoni built up an international clientele. Soon after his return he painted some pictures for Sigismund Streit, a merchant from Berlin resident in Venice. Streit had in his possession a portrait, painted for him by Amigoni in 1739, four subjects from the Old Testament, one of them a *Bathsheba* (cat. 51), and six smaller paintings of biblical and mythological themes. Given the great popularity of Amigoni at the time, such a collection of his paintings must have been a source of pride to the German collector, and a sign to others of his progressive taste.

53

JACOPO AMIGONI
*Head of a Young Woman with a Shawl*
1740s
black and white chalk on brown paper,
29 × 25.2 cm
Staatliche Graphische Sammlung, Munich

In 1747 Amigoni went to Spain and stayed there until 1752. He was invited by Ferdinand VI, possibly through the good offices of Farinelli. His late style is illustrated by the *Farinelli with a Group of Friends* (National Gallery of Victoria, Melbourne). The celebrated singer, Amigoni's friend and travelling companion, is portrayed holding the insignia of the order of Calatrava, awarded him in 1750, probably the year the portrait was painted. With him are the Milanese singer Teresa Castellini, the poet Metastasio and a Hungarian page with a dog. Amigoni is there too, looking as if he had been added at the last minute as a mark of friendship. Although he probably was also awarded the Order of Calatrava he is not holding it; he defines his own role by wearing his painting clothes, and showing his palette and paintbrushes.

Giovanni Battista Pittoni's uncle was a mediocre painter of the *tenebroso* school, and his nephew had to escape gradually from his influence. Nevertheless, Pittoni retained an interest in historical and mythological subjects rich in melodramatic effects. Pittoni's regard for Bencovich is evident in his early paintings, and he also learnt from Piazzetta the importance of *chiaroscuro*. Balestra, Ricci, Giordano and his successors and Solimena all contributed to a style that Pittoni very soon made recognisably his own. Highly ornamental, exciting yet also elegant; the resulting synthesis is true Rococo virtuosity. In the soft treatment of light, and in a particular way of abbreviating his broad and richly coloured brushstrokes Pittoni reveals his Rococo inspiration. His shows a marked predilection for religious themes and for erotic subjects, particularly those with implications of cruelty (sacrifice especially); his treatment of these subjects is theatrical, even melodramatic. By the beginning of the 1720s his style was fully developed, as can be seen in *Diana and Actaeon* (cat. 55). Pittoni emerges as a bold colourist, capable of organising highly complex, sensitive and elegant compositions. His colours are clear and well modulated.

At this moment in his career Pittoni's international reputation looked secure. At the end of 1721 Owen MacSwiney was charged by Lord March (later 2nd Duke of Richmond), to commission Pittoni to paint the figures in some of the series of canvases of commemorative tombs of famous Englishmen of the Whig ascendency (cat. 37, 135). He had further commissions from August II of Saxony, and later from Marshal Schulenburg and from Clement August, Prince Elector of Cologne, as well as from Algarotti.

Around 1725 Pittoni adopted a calmer, more pietistic approach in religious works such as the *Martydom of St Thomas* in S. Stae, which hangs next to paintings by Piazzetta and Tiepolo. A new naturalism emerges, reminiscent, at times, of Piazzetta. Pittoni's artistic stance at this time is well-illustrated in the altarpiece for S. Maria dei Miracoli in Venice, *St Jerome with an Angel, St Peter of Alcantara and a Franciscan* (cat. 56), dated *c.* 1725–7. Here his Rococo artificiality is at its height, even compared with the paintings in Vicenza; but the colour is handled smoothly, with subtle modulations of light and shade and, within the limits of such an unnatural mode of expression, Pittoni's naturalism has increased.

In about 1727, Pittoni was commissioned to paint frescoes in Palazzo Widmann at Bagnoli. In these frescoes, 'the Rococo makes its first appearance in a patrician country house with representational frescoes, that is to say with human figures used in a decorative scheme to create an illusion of reality' (Zava Boccazzi). In the 1730s Pittoni continued to work in private houses in Venice, unlike most of his contemporaries. He also worked for private collectors, scaling down the dimensions of his paintings and often producing series of related subjects. One of his most important customers was Marshal Schulenburg. At the same time, Pittoni was doing a tremendous trade in altarpieces, some for churches in the Veneto but most for Lombardy. He had the opportunity to work with a group of Venetian painters, including Tiepolo, Piazzetta

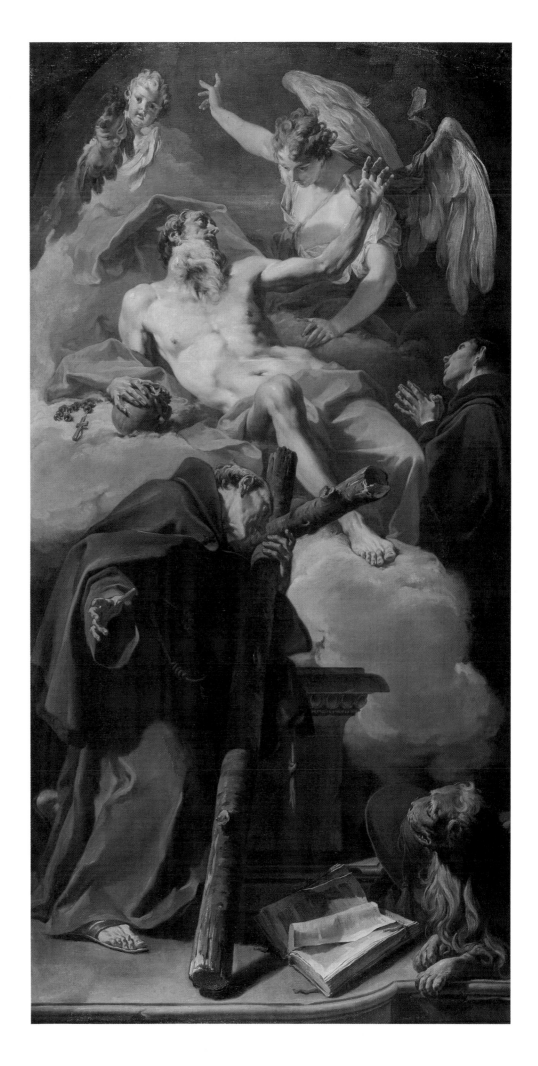

56

GIOVANNI BATTISTA PITTONI
*St Jerome with an Angel, St Peter of Alcantara and a*
*Franciscan*
1725–7
oil on canvas, 275 × 143 cm
National Galleries of Scotland, Edinburgh

55

GIOVANNI BATTISTA PITTONI
*Diana and Actaeon*
*c.* 1722
oil on canvas, 149 × 200 cm
Pinacoteca Museo Civico di Palazzo Chiericati,
Vicenza

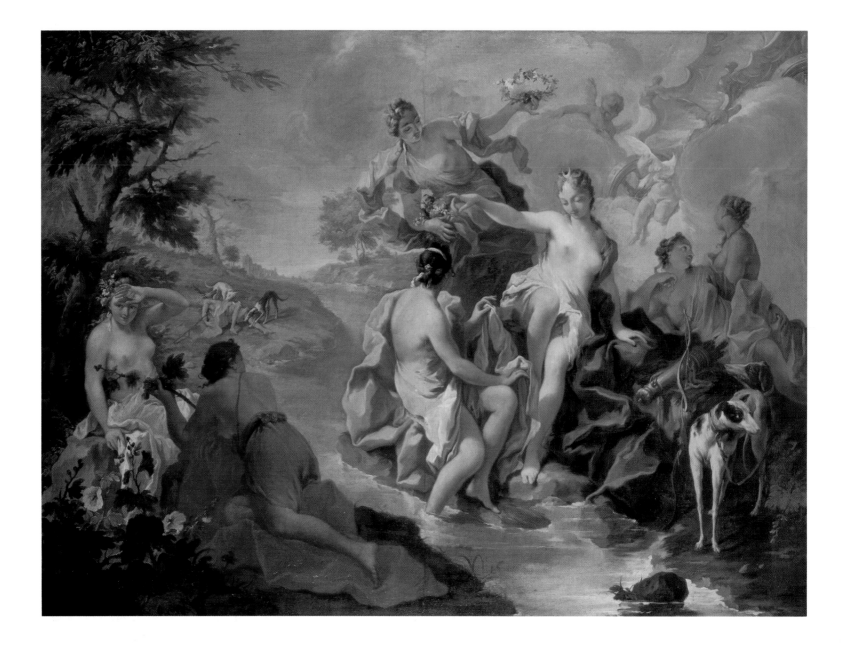

and Pellegrini, in the basilica of S. Antonio in Padua when the old altarpieces were replaced; his contribution was the *Martydom of St Bartolomew* painted in 1735. But he gained his greatest successes working for foreign clients.

Pittoni was often the only Venetian to take part in collective enterprises; he was able to adapt his individuality for the sake of stylistic unity, as when he collaborated with Agostino Masucci, Sebastiano Conca and Francesco Monti in a series of historical scenes for the royal palace in Turin, under the supervision of Juvarra. In 1742, on his return to Venice he contributed to another series for August III's gallery in Dresden, working on an idea of Algarotti's. Tiepolo, Piazzetta, Amigoni Pittoni and Zuccarelli were each given a subject to suit his style; Pittoni chose a historical subject with powerful theatrical potential: *Crassus in the Temple of Jerusalem* (1743–4) of which only the *modello* (Accademia, Venice) survives.

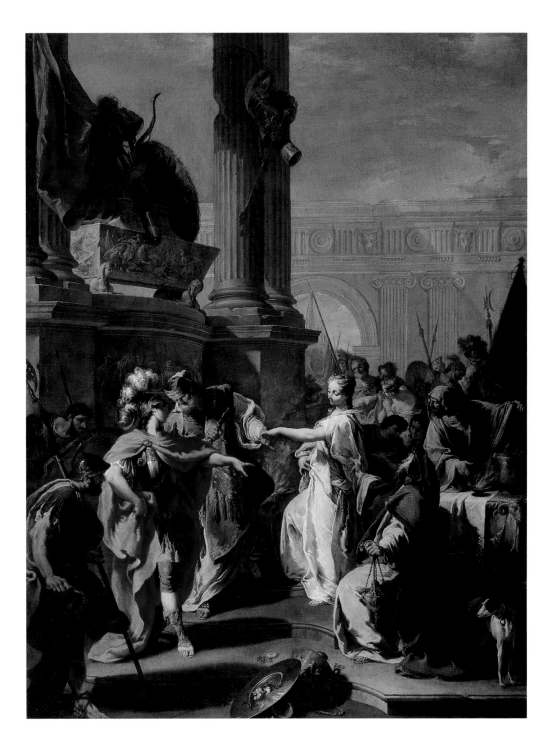

57
GIOVANNI BATTISTA PITTONI
*The Sacrifice of Polyxena*
early 1730s
oil on canvas, 128.3 × 95.3 cm
Collection of J. Paul Getty Museum, Malibu, CA

Venetian sculpture of the early 18th century was still predominantly classical in style. A new note, however, was introduced in the sculpture of Giuseppe Torretto who evolved an elegant manner and was able to express charm and sentiment. Marinali (cat. 16–17) evolved an explicitly decorative and free style, concentrating on the play of light and shade, which has much in common with the virtuosity of contemporary Rococo painting. Antonio Corradini united the two tendencies and, alone among Venetian sculptors, rivalled the best of the 'second generation' painters. Like those painters he too played a leading part on the international stage. While he had links with the 17th-century tradition, he also anticipated certain aspects of Neo-classicism; introducing his celebrated veiled figures (cat. 58).

Early in his career, in 1709–10, Corradini contributed to the decoration of the façade of S. Stae, making three statues for the tympanum, and others inside. In 1717 he completed his *Veiled Faith*, formerly in Palazzo Manfrin, which was engraved by Tiepolo. Antonio Balestra praised the figure in a letter to Gaburri, pointing out the technical virtuosity of the piece, the high quality of its design and, above all, its charm. This is the first appearance of the theme for which Corradini became famous. Thereafter he received a seemingly unending stream of important commissions. In 1721 he made the statue of *Virginity* in the church of the Carmini, one of his finest works. Soon after it was placed in the church it was drawn by Giambattista Tiepolo so that Zucchi could make an engraving of it to dedicate to Zaccaria Sagredo. The novelty of his sculpture lies in increasingly sophisticated draughtsmanship rather than any change of basic design. He simplified volume, minimising contrasts of light and shade. While retaining the monumentality of his figures, he was able to infuse them with grace and charm in accordance with contemporary taste.

From the early 1720s Corradini was involved in a variety of schemes abroad as well as receiving important commissions in Venice. In 1722 work on the new Bucintoro, the state barge, began, under the supervision of the naval engineer Stefano Conti of Lucca, who was also a well-known collector. Corradini was commissioned to supervise the sculptural decorations. In 1723 he was active in establishing a college of sculptors within the Academy, with the intention of distinguishing sculptors from stone-dressers, and in 1724 he was invited to supervise the restoration of the Scala dei Giganti in the Doge's Palace. In the 1730s he worked further afield with many important architects in Prague, Vienna, Dresden, and in the 1740s achieved great success in Rome and Naples.

The sculptor Francesco Bertos pursued refinement in his sculpture almost to the same degree as the most advanced of the 'second generation' painters. His style developed from a neo-mannerist rather than from a classical background like Corradini's. Bertas reinterpreted mannerism as a kind of hedonistic artificiality; his forms are highly polished, softly tensed and at times display exquisite workmanship. Most of his commissions were for private patrons, and this influenced his choice of subjects which are usually mythological or allegorical. The results, however, are not without their ambiguities, perhaps specifically at the request of Bertos's highly sophisticated clientele. His work was included in the most important artistic collection in Venice of the day, that of the Procurator of St Mark's, Zaccaria Sagredo (1653–1729). This is probably the provenance of the allegorical groups, *Calumny Carrying off Fame* and *Folly Supporting Spring* (cat. 59). Bertos particularly excelled in small-scale sculpture, and in small and medium-sized bronzes. In these collectors' pieces his style is purely decorative, without any structural logic and, in a similar way to the painters of the same period, he interpreted the most innovative Rococo decorative ideas in complex and sinuous forms.

58

ANTONIO CORRADINI
*Puritas (Bust of a Veiled Woman)*
*c.* 1717–25
marble, 61 cm (height)
Museo Civico Correr, on loan to
Ca' Rezzonico, Museo del Settecento
Veneziano, Venice

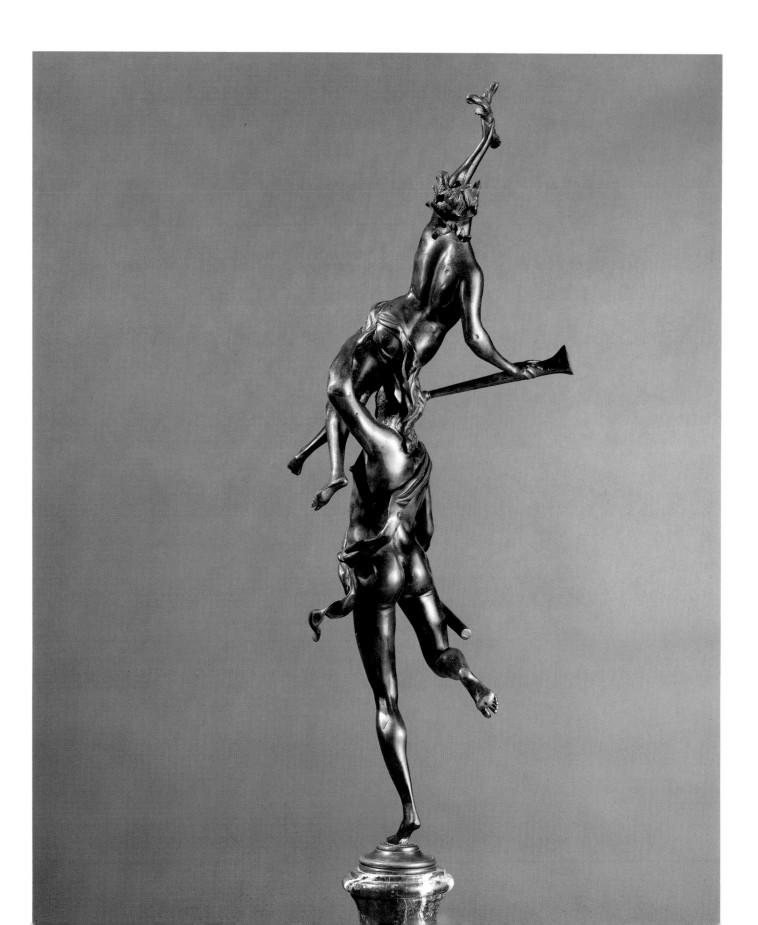

FRANCESCO BERTOS
(?)*Calumny Carrying off Fame*, and (?)*Folly
Supporting Spring*
*c.* 1710–25
bronze, each 57 × 23 × 24 cm
(excluding later marble base)
Private Collection

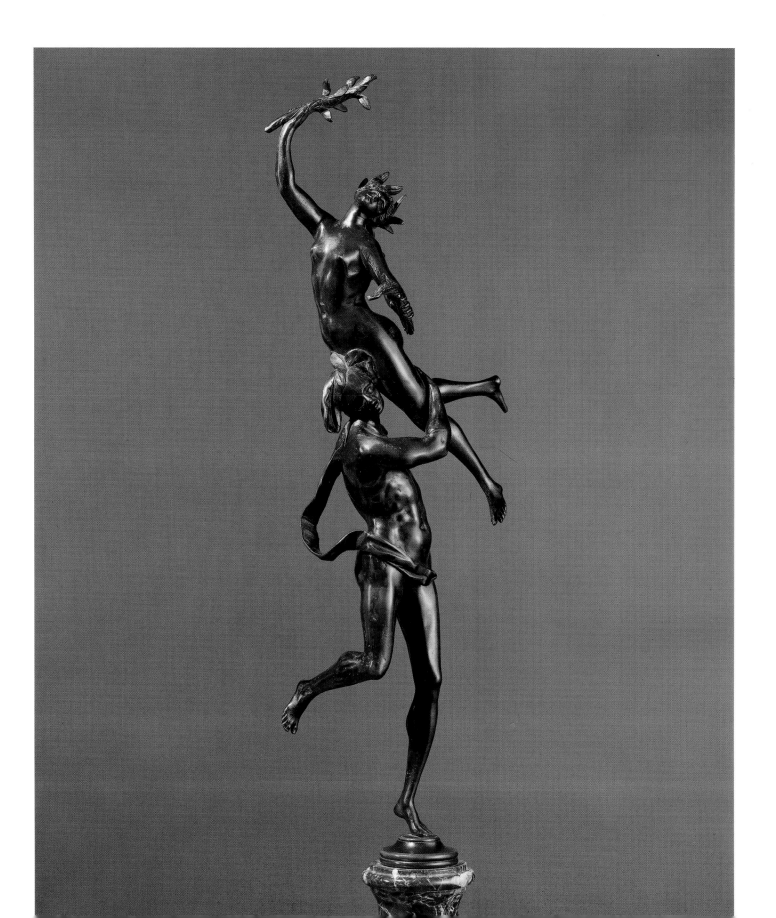

# IV: *The Piazzetta Paradox*

Alice Binion

For the cultural historian, Piazzetta is an attractive figure on the 18th-century Venetian scene. But for the student of art, and of Piazzetta's art in particular, he is an enigma. Caravaggio's powerful impact on Italian, and indeed European, painting began around 1600 and took some generations to subside. The Venetian Rococo, which reached its apogee of grace and light over a century later, would seem to have left Caravaggio's shadowy impress far behind. Yet the towering Venetian Rococo master Giambattista Piazzetta may fairly be described as Caravaggio's last great disciple even if that designation fails to describe him in full.[1]

Piazzetta was intimately involved in the rich artistic life of Rococo Venice. By profession a painter of both religious and secular subjects, he also won distinction as a draughtsman and book illustrator. He was frequently chosen as inspector and restorer of 'public pictures' in his native Venice, and was occasionally called upon to act as official assessor of works of art. He also served as consultant to some of the great patrons and collectors of his age, Venetian and non-Venetian alike, among them the King of Poland, several German Electors, Count Brühl, and Marshal von der Schulenburg. Piazzetta does not appear to have relished the commercial side of art, however, and is nowhere on record as picture dealer, a lucrative sideline for many of his colleagues. He was evidently respected and liked by his fellow artists, as they frequently chose him to fill various functions and offices in their professional association, the Collegio dei Pittori. In 1723 and repeatedly thereafter the Collegio elected him Prior. Throughout his entire career Piazzetta seems also to have directed a private art school (*scuola di nudo*) about which we know only that life-classes were held there and that it was apparently open not only to apprentices, but to artists of all ages. A drawing by young Giambattista Tiepolo called *An Artist's Academy* (cat. 91) is in all likelihood an accurate rendering of a life-class in Piazzetta's school. In 1750 Piazzetta became the first director of the newly founded Venetian State Academy, where he taught drawing until his death in 1754.

Piazzetta and Tiepolo were the dominant artistic personalities of Venice in the 18th century. In works of art history they are frequently paired only to be treated as opposites: 'Tiepolo the conforming genius and Piazzetta the non-conformist'.[2] If Tiepolo was highly celebrated in his time, so too was Piazzetta, despite his rejection of the aesthetic tenets and standards that guided most of his contemporaries. Indeed, by producing naturalistic pictures suggestive of Caravaggio and Rembrandt, Piazzetta may at first appear gigantically out of step, as public taste was for a highly decorative style stressing a luminous charm and elegance bereft of conspicuous substance or gravity. However, Piazzetta lost none of his patrons or public.

60

GIAMBATTISTA PIAZZETTA
*Nude Woman Seated*
1715–18
black and white chalks on paper, 52.8 × 396 cm
Collection Rondinelli

This anomaly needs to be highlighted. Something about Piazzetta's solemn mode appealed to his contemporaries, whose high regard for him shows in numerous written accounts. One instance will suffice. As early as 1733 the great connoisseur Anton Maria Zanetti the Elder praised him for his expert handling of *chiaroscuro*.[3] And the same Zanetti acclaimed him years after his death as the 'grand master of shadow and light . . . who brought great honour to the Venetian school'.[4] It is therefore understandable that in our century Piazzetta should be seen as a 'Courbet of the Venetian Settecento', but puzzling that he should be thought to be 'raising a passionate protest' against the prevailing taste of his times.[5]

Piazzetta the non-conformist did not deliberately reject the frivolities of the Rococo or crusade for an austere reform of art. By temperament he appears to have been contemplative, reflective, given to solitude, even a bit melancholic. He was known for his laborious slowness in elaborating painted compositions. Probably he was just as slow to accept change. His whole life long Piazzetta remained committed to naturalism and, with drastic variations in intensity, to a Seicentesque *chiaroscuro*. Leaving aside the major exception of his luminous ceiling of *The Glory of St Dominic* (1725–7) in the church of SS. Giovanni e Paolo, it was only late in his life, in his mid- to late-fifties, at the summit of his career, that he responded directly to the spirit of the age. He created some of the loftiest pictorial images in a Rococo idiom of his own devising, naturalism and all. He transmuted grave Baroque themes out of the past into idyllic genre-like scenes, such as the large pastorales of *c.* 1740 (cat. 76, 78, 79), and infused religious subjects with the erotic tinge then pervading Venetian art: witness his *Rebecca at the Well* at the Brera (fig. 25), which is nothing if not an amorous encounter.[6] The Rococo flavour of Piazzetta's highly personal art showed in a lightening of his palette, but above all in his handling of his subjects. For all that, he remained fundamentally a Baroque artist: after his brief incursion into the Rococo he gradually reverted to his old shadowy gravity. Something in Piazzetta's depths must have put him at ease with his weighty, plebeian protagonists cast around with mysterious dashes of darkness.[7]

The naturalist-tenebrist impetus that originated with Caravaggio affected his followers thoughout the Baroque age in varying degrees, culminating in a profound and widespread revival in Venice and the Veneto in the last third of the 17th century. Piazzetta could not have escaped exposure to this resurgent Caravaggesque vogue from his earliest childhood. Born in 1682, the son of an established sculptor and woodcarver, he grew up in an artistic milieu. The elder Piazzetta at first intended his son to be a sculptor, and Giambattista Albrizzi (1698–1777), a reliable source, records that the child was given clay to learn modelling and in due course a chisel for carving.[8] Zanetti, who knew Piazzetta well, saw in this informal childhood apprenticeship the determinant of Piazzetta's expressive *chiaroscuro* and partiality for massive figures.[9] Moretti suggests that Piazzetta, when composing pictures, modelled small figures in wax or clay to distribute his lights and darks correctly.[10] And when in the mid-1690s he was sent to learn the painter's trade under Antonio Molinari (1655–1704), he assimilated his master's style and modes, as was normal with apprentices. At that time Molinari's art still very much reflected the taste of the Venetian *tenebrosi* for violent subject-matter, although he had softened their *chiaroscuro* and tempered their coarse naturalism. We may assume that when Piazzetta left Molinari he, too, was painting that way.

No period of Piazzetta's career has undergone more speculative scrutiny than his stay in Bologna,[11] mainly as regards the benefits he derived from his presumed association with Giuseppe Maria Crespi (1665–1747). Though undocumented, contacts with Crespi, then Bologna's leading genre painter, were unavoidable for Piazzetta.[12] But nothing warrants the frequent assumption that Crespi imparted his tenebrism to Piazzetta. A fair guess is that Crespi and Piazzetta, who both liked painting dark pictures, found kindred spirits in each other. More, Crespi almost certainly introduced Piazzetta to genre painting, which was not practised in Molinari's studio or elsewhere in Venice. Mementos of Crespi were to sneak into some of Piazzetta's later pictures. The stunningly beautiful 'lost profile' of the angel in a dozen pictures by Piazzetta including the *Ecstasy of St Francis* in Vicenza (cat. 75) may well be an unconscious reminder of Crespi's *Lute-player* (c. 1700; Museum of Fine Arts, Boston).[13] The clearcut testimony of Albrizzi in his biography is that in Bologna Piazzetta studied the Carracci and above all Guercino, whose manner he strove to imitate. It is primarily Guercino's teaching that Piazzetta brought back with him to Venice when he embarked on a career of his own around 1704.[14]

*Figure 25:* Giambattista Piazzetta, *Rebecca at the Well*, oil on canvas, 102 × 137 cm, c. 1736, Pinacoteca di Brera, Milan

No paintings by Piazzetta are documented for the period 1705–22. And none of the nine biographies of him published in the 18th century provides helpful chronological clues to this ill-named early period (he turned 40 in 1722). Albrizzi noted, however, that after his return from Bologna Piazzetta speedily made his mark in Venice and 'received many honourable and advantageous commissions'. Only some 30 of his paintings have generally been accepted as belonging to the so-called early period.[15] They are dark and mostly show half-length figures placed against an undefinable background. The scenes were from the Seicento repertory, but Piazzetta gave them each a new twist by representing a moment or an episode rarely if ever depicted before. This was to remain his constant practice; as did his habit of consulting literary sources. One example will suffice. The young hero of Piazzetta's *David with the Head of Goliath* (fig. 26) is not represented in the traditional way as contemplating the severed head or presenting it to the viewer. Instead, Piazzetta chose the moment when, after the deed, the young victor grabs the severed head by its hair to roll it into a blanket and bring it in full haste to Jerusalem. Piazzetta's chosen moments are usually closer to the literary sources for a story than to the customary artistic renderings of the story.

It is often difficult to date a Piazzetta painting: a late picture does not always look discernibly different from an early one. A case in point is the handsome yet puzzling *Supper at Emmaus* (cat. 61). No satisfactory consensus has emerged as to its date. The present tendency is to view it as a late work, though its horizontal format with half-figures and its emotional appeal reminiscent of Piazzetta's tenebrist contemporary Bencovich may once again swing the pendulum the other way. Whatever its date, this moving picture with its glorious still-life will be a joy forever. Piazzetta never painted objects such as this still-life merely for decorative purposes: here the asparagus, a spring vegetable, serves as a symbolic allusion to Christ's resurrection.[16]

*Figure 26:* Giambattista Piazzetta, *David with the Head of Goliath*, oil on canvas, 84.5 × 99 cm, Gemäldegalerie, Dresden

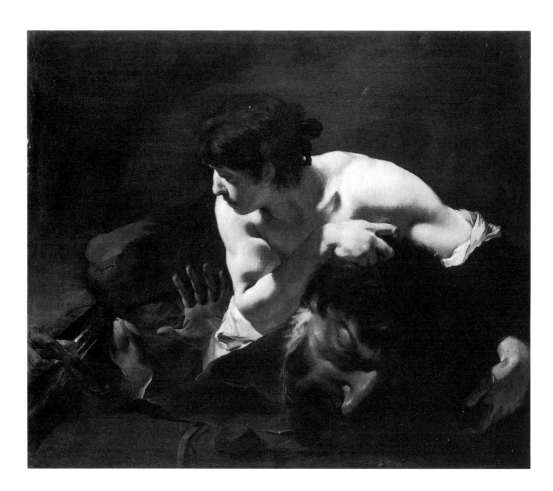

GIAMBATTISTA PIAZZETTA
*The Supper at Emmaus*
*c.* 1740?
oil on canvas, 108.6 × 141.3 cm
The Cleveland Museum of Art
Purchase from the J. H. Wade Fund

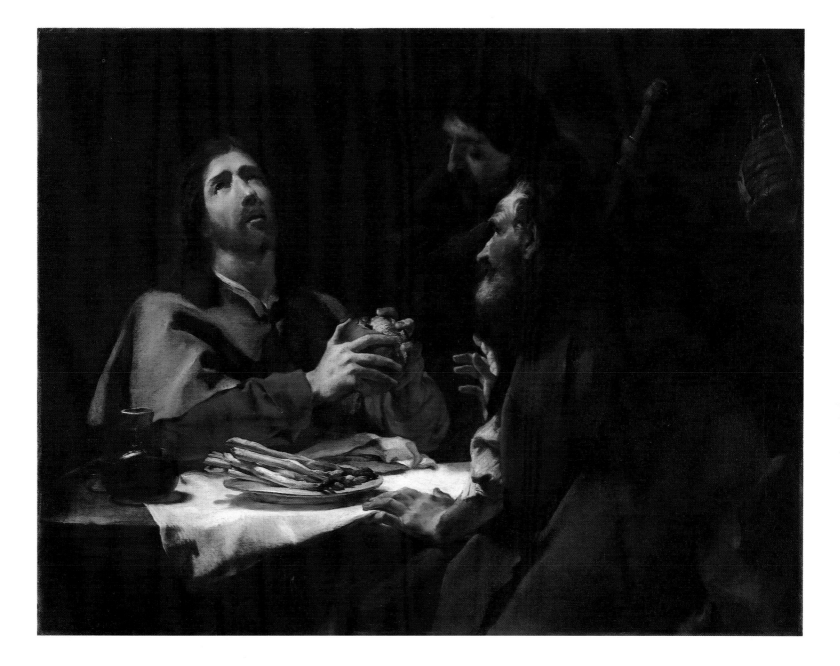

GIAMBATTISTA PIAZZETTA
*Portrait of Giulia Lama*
*c.* 1712–14
oil on canvas, 69 × 55 cm
Fundación Collección Thyssen-Bornemisza,
Madrid

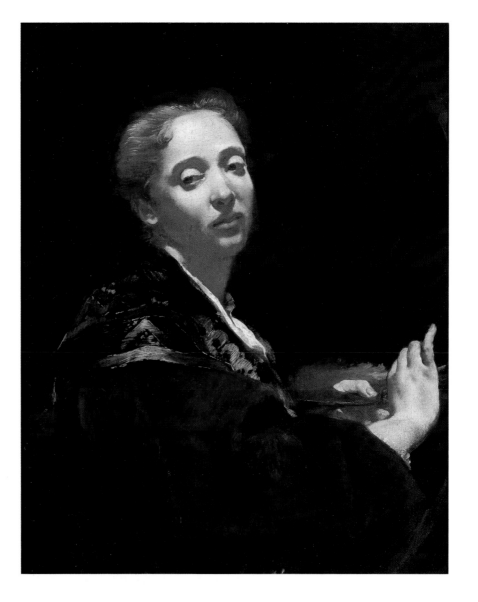

The masterly portrait of Giulia Lama (cat. 62), Piazzetta's only known portrait painted from life, dates from his early period.[17] He gave Giulia the same shadowy eye-sockets and swollen eyelids as his Madonna in the large fragment now in Detroit, though Giulia's portrait must have been painted slightly earlier, perhaps around 1712–14. She is shown at her easel, but with her head turned towards the viewer. Her slightly parted lips suggest that she is talking. Rightly or wrongly, her expression has often been seen to denote 'surrender' or 'anxiety'. Piazzetta painted her with a sympathy and tenderness so rare in portraiture. It arouses curiosity about their undocumented personal relationship and even lends some credence to an old tradition that it was intimate and intense.[18]

Piazzetta established his international reputation as a brilliant draughtsman early in his career, even before 1720, and made his mark as a painter only later.[19] No doubt he felt more at ease with chalk in hand than with a brush. In a letter of 1736 the astute Swedish connoisseur Gustav Tessin, who considered Piazzetta the first artist of Venice and who acquired both paintings and drawings from him, characterised him aptly as '*grand dessinateur et peintre très entendu*'.[20] The fine drawing of a *Nude Woman Seated* (cat. 60) must have been executed shortly after Piazzetta's return from Bologna.[21] It attests to the extraordinary mastery of draughtsmanship already achieved in his youth. Nudes were rare with Piazzetta, and this one does not appear to have been either an academic study or a preparatory drawing. Its large size, high finish and lyrical quality suggest that it was made as an independent work of art.

Much sought after by connoisseurs were Piazzetta's large finished drawings of heads and half-figures known as *têtes de caractère*, of which several are shown here (cat. 63, 64, 65, 68). Piazzetta's slowness in completing his commissioned paintings was lamented by his patrons and biographers: Tessin typically called him a snail. But he must have worked faster on paper or else he could not have drawn heads from life for a steady income to support his family as Albrizzi recorded. D'Argenville mentions in his biography that Piazzetta boasted of having earned 7,000 *zecchini* with his fancy heads.[22] At that rate, as heads usually sold for two *zecchini* apiece, Piazzetta would have drawn over 3,000 of them. These heads are today still the best known and best loved of his works. Zanetti in 1732 judged that no one ever drew better in that genre.[23] The appreciation of drawings, which had grown slowly during the Renaissance and gained momentum in Vasari's time, peaked in the Rococo age. Traditionally drawings were kept in portfolios or in the cabinets of connoisseurs, only the most precious being covered with glass. But Piazzetta's heads, produced as independent, highly finished works of art, were intended to be framed and displayed on a par with paintings. Somewhat later in France, Boucher's drawings of attractive heads of young women were also hung on walls or, because of the great demand for them, multiplied by Bonnet's and Demarteau's new method of making prints to look like drawings. Piazzetta's *têtes de caractère* usually show the head and shoulders of a single figure, such as the *St Stephen* (cat. 68). Less frequently he packed two or even three heads onto a single sheet (as in cat. 64, 65).

63

GIAMBATTISTA PIAZZETTA
*A Young Man Embracing a Girl*
*c.* 1743
black chalk, heightened with white on blue paper faded to grey, 39.5 × 31.6 cm
Curtis O. Baer Collection

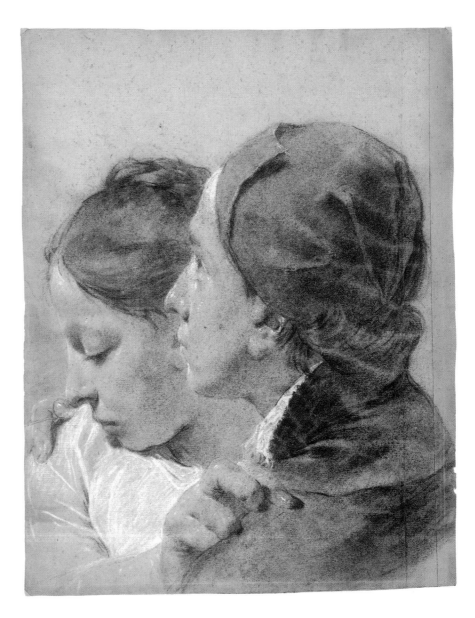

64

GIAMBATTISTA PIAZZETTA
*A Bravo, a Girl and an Old Woman (The Procuress)*
*c.* 1740
black chalk, heightened with white on grey-brown paper, 40.6 × 55.5 cm
Lent by Her Majesty The Queen

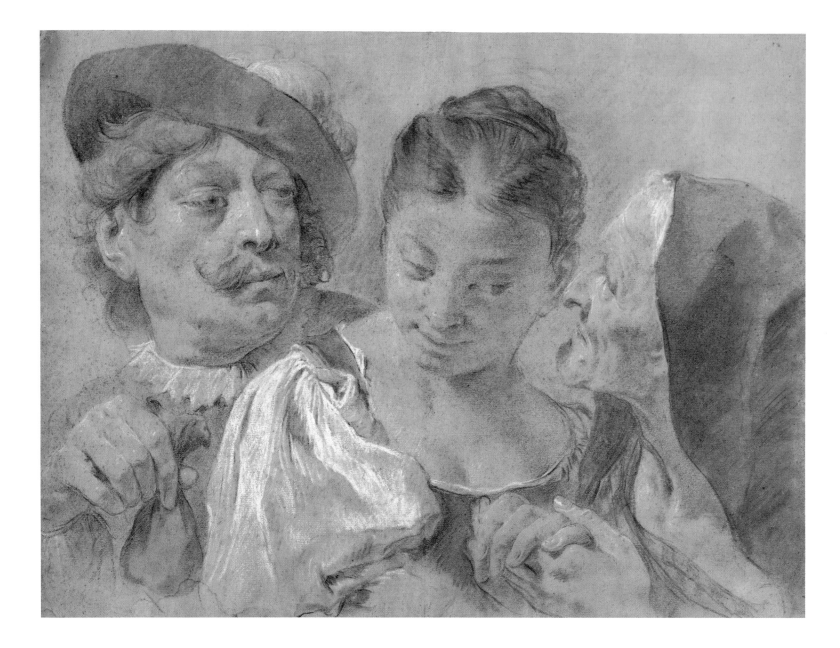

65

GIAMBATTISTA PIAZZETTA
*Young Woman taking a Pink*
*c.* 1740
black chalk, heightened with white, on paper,
40.2 × 54.9 cm
The Cleveland Museum of Art
Purchased from the J.H. Wade Fund

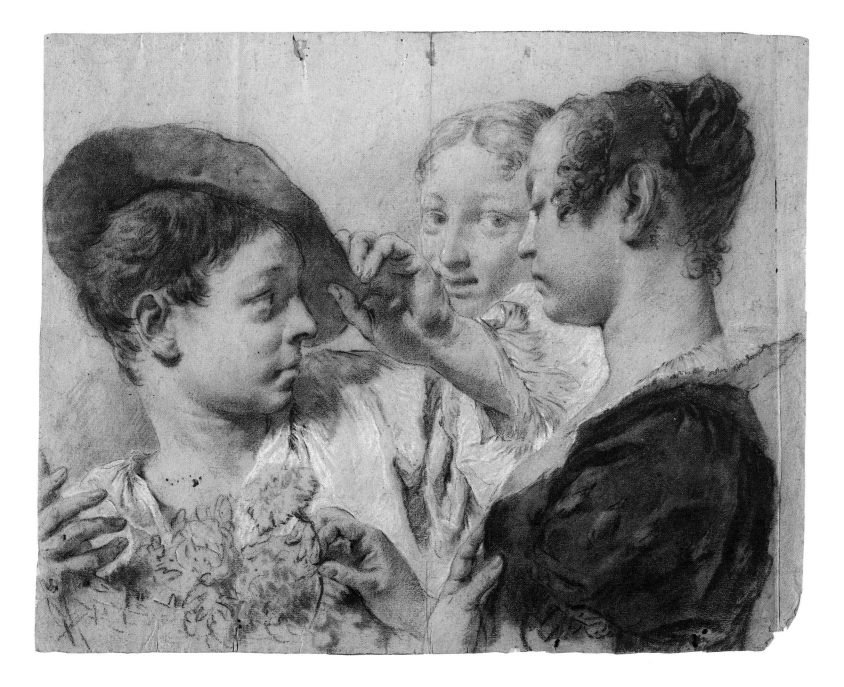

In most of these drawings, made from life, Piazzetta dispensed with shadows. The extraordinary tactility of the figures was obtained by his singular technique of modelling by smudging the chalk instead of using hatching. Most of the fancy heads can be viewed as genre. Others are heads of saints, such as *St Stephen* (cat. 68), clearly identified by the stone in his right hand and the palm of martyrdom in his left (he was martyred by stoning). This drawing was no doubt framed and viewed as a devotional picture. At least one painted version was derived from it.[24] Others are actual portraits, among them the beautiful head of Marshal Schulenburg, one of the great collectors of his age, for whom Piazzetta worked as painter and consultant in the late 1730s and early 1740s, guiding and counselling him in artistic matters.[25] Schulenburg owned thirteen paintings and nineteen drawings by Piazzetta. In the portrait shown here (cat. 66) Schulenburg appears as a typical grandee of the time. He was then in his mid- to late-70s and declining after a serious illness. His eyes are tired and lack expression. But his mouth, slightly tinged with bitterness, still projects energy and determination.

66

GIAMBATTISTA PIAZZETTA
*Portrait of Field Marshal Johann Matthias von der Schulenburg*
1738
black chalk and white heightening on grey-
brown paper, 38.3 × 33 cm
Civico Gabinetto dei Disegni,
Castello Sforzesco, Milan

67

GIAMBATTISTA PIAZZETTA
*Self-portrait at the Age of Fifty-two*
1735
black chalk, heightened in white on
paper, 35 × 24.1 cm
Graphische Sammlung Albertina, Vienna

It is not possible to assign dates to Piazzetta's fancy heads, as their style did not vary significantly.[26] Of the two that are signed and dated, one is particularly precious: a self-portrait of the artist wearing a wig (cat. 67). It bears an autograph inscription stating that he made it at the age of 52. Though little interested in portraiture, Piazzetta made several portraits of himself — some painted, some drawn, and one etched (cat. 89), although he never represented himself as a painter. In the series of engravings of *The Twelve Apostles* by Pitteri, made in 1742 after drawings by Piazzetta, the *St Thaddeus* (cat. 69) is the most striking with its bold frontal pose. Perhaps this quality explains why it has even been viewed as a self-portrait.[27] In any case, the engraving illustrates a near and strikingly successful printmaking technique, with lines dissolved into discontinuous dashes, developed by Marco Pitteri to capture the soft tones and crumbly quality of line in Piazzetta's chalk drawings.

68

GIAMBATTISTA PIAZZETTA
*St Stephen*
black and white chalk on faded blue paper,
40.4 × 35.4 cm
Private Collection

69

GIAMBATTISTA PIAZZETTA
*St Thaddeus*
1742
etching by Marco Pitteri, 43.3 × 32.5 cm
The Metropolitan Museum of Art, New York
Gift of J. G. Phillips

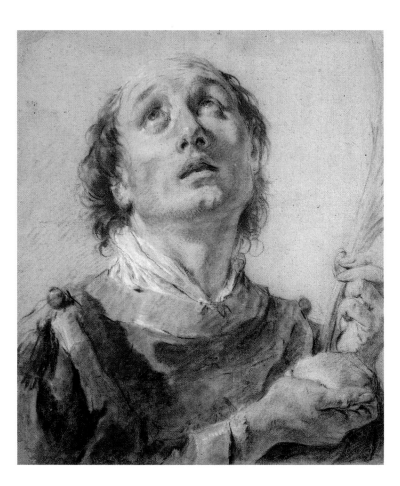

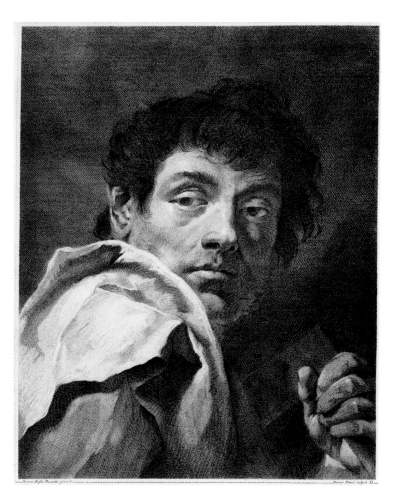

GIAMBATTISTA PIAZZETTA
*St James Led to Martyrdom*
*c.* 1722–3
oil on canvas, 165 × 138 cm
S. Stae, Venice

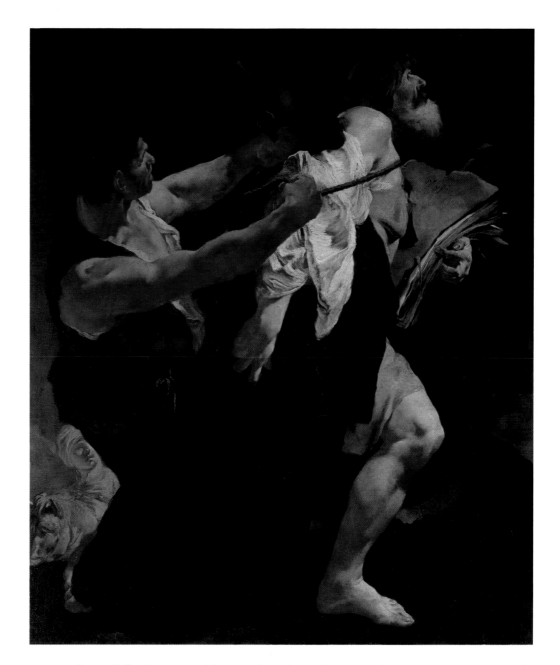

Piazzetta's first fully documented historical work is *The Arrest of St James* (cat. 70), one of a series of twelve apostles commissioned from different artists for the church of S. Stae. It dates from 1722, when Piazzeta was already 40. A pivotal work, it is like a summation of Piazzetta's art up to that moment. It stands drastically apart from its eleven companion pieces in its disturbingly brutal naturalism and striking immediacy. It splendidly attests to Piazzetta's disregard for current norms. One may not like to think of St James as a dishevelled hobo held by a brutish guard, but there is no forgetting that crude pair once it has been seen.[28]

How very much Piazzetta differed from *all* his fellow artists is best seen when he is likened to Federico Bencovich, who was viewed as his *alter ego* and whose works were said to be indistinguishable from his. But Bencovich's celebrated masterpiece, *The Sacrifice of Iphigenia* of 1715 (cat. 71), reveals an altogether different artistic personality. Bencovich's are not bulky, well-modelled sculptural figures solidly planted on the ground, but nineteen insubstantial phantoms, only two of which can be identified with certainty. And his inclusion of several female figures besides Iphigenia and Artemis shows a disregard for his subject unthinkable in Piazzetta. Bencovich's originality lies elsewhere: in his gift to conjure up, through ghostly surreal light and colours, a sense of impending doom and horror before the slaughter to come.

What set Piazzetta apart from his contemporaries in art, and even from the followers he trained, was his deep concern for the meaning of a work and his seriousness in approaching his material, above all in his religious paintings. For Piazzetta, content was always as important as style. Thus for his altarpieces of the 1720s he handled his subjects inventively even without rejecting the traditional iconography. In the *Virgin and Child Appearing to St Philip Neri* (cat. 72, 73) he gave a double identity to his majestic Virgin by subtly merging two distinct iconographic types. On the one hand she is the vision that Philip is reported to have had. But she is also the Virgin of Mercy, identified by the vast cloak which, blown upwards, is emphatically displayed with the help of two cherubs. This double identity is conveyed as well by her singular yet highly expressive stance. Her arms, in which she holds the child, are turned to the right, while her head looks the other way: towards the cloak, her attribute as Virgin of Mercy, and towards praying Philip, whom she will protect along with his congregation by extending the cloak over him.

Of all Piazzetta's works, the *Guardian Angel with SS Antony of Padua and Gaetano Thiene* (cat. 74) is the most difficult to fathom. Piazzetta conveyed the importance of the guardian angel in Christian life through the overwhelming stage presence that he lent it. The major role of a guardian angel is to protect and guide those in need, especially children, and to help redirect those who have strayed from the right path to God. In the church of S. Vidal in Venice, Piazzetta's painting was placed over a subsidiary altar to the right of the high altar, where the host must have been permanently housed in the tabernacle. It is to the high altar that Piazzetta's angel points, showing the way to God, which may be reached with the help of the sacraments, a typical sentiment in Counter Reformation art. The two saints, Antony of Padua and Gaetano Thiene, were revered for their purity. It has been suggested that Piazzetta introduced the theme

71

FREDERICO BENCOVICH
*Sacrifice of Iphigenia*
1715–19
oil on canvas, 182 × 287.5 cm
Germanisches Nationalmuseum, Nuremberg

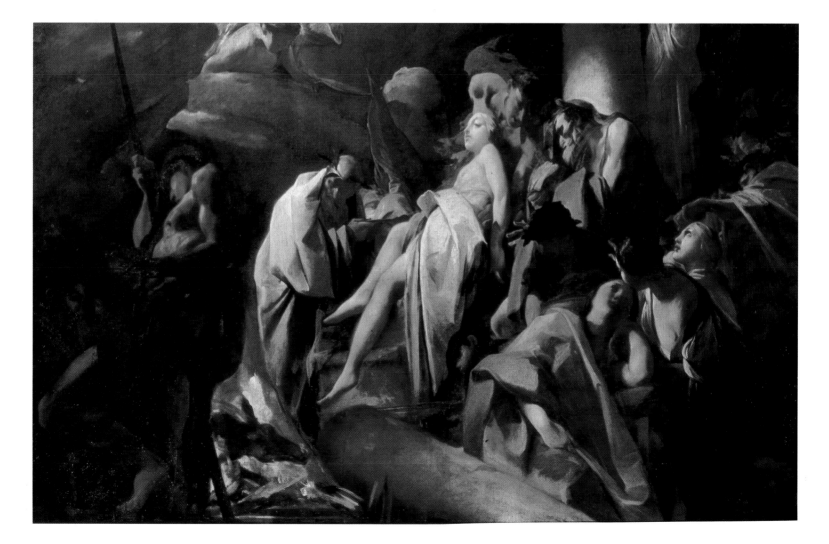

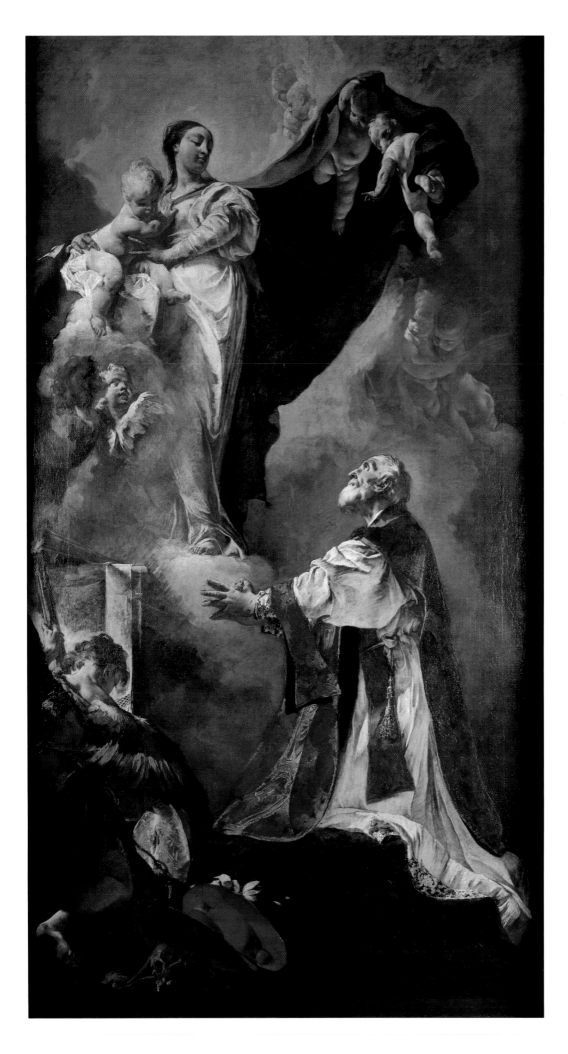

72

GIAMBATTISTA PIAZZETTA
*Virgin and Child Appearing to St Philip Neri*
1725/6
oil on canvas, 367 × 200 cm
S. Maria della Fava, Venice

of chastity in order to link the three otherwise unrelated participants, for the angel wears the symbol of chastity, the tassel attached to the golden cord.[29]

The long gestation known to have preceded Piazzetta's execution of each of his paintings may not have been due exclusively to a neurotic indecision or compulsive reworking so often intimated by his patrons and biographers. Albrizzi made excuses for Piazzetta, invoking – rightly, it would seem – a constant search for artistic perfection. Piazzetta was a learned man and composed his images accordingly. As a careful study of his work reveals, Piazzetta familiarised himself thoroughly with whatever story he was to narrate in paint, especially with the literary sources available to him. Particularly instructive in this respect is *The Ecstasy of St Francis* (cat. 75). In no way does it conform to traditional iconography. Piazzetta's highly original composition rests on a careful reading of the literary sources on Francis, above all *The Little Flowers of St Francis* but also Tomaso da Celano's and Bonaventura's early biographies. Piazzetta renders the essence of Francis's mysticism movingly and with the most economical of means. All early texts stress Francis's obsessive desire to imitate Christ, to 'suffer with him', to become mystically 'one with him'. Tomaso da Celano related that 'the Passion of Christ was always before St Francis's mind' and that Francis ardently desired to 'crucify himself with Christ'.[30] Bonaventura referred repeatedly to Francis's obsession with the image of the Cross,[31] and Francis's immediate followers posited that after the stigmatisation 'Francis was transformed into a living Crucifix'.[32] It is this transformation that is rendered in the Vicenza masterpiece. The Cross, symbol of the Passion, is rendered through the intersection of the arms of Francis and of the angel at the very centre of the picture, and is further suggested by the two planks of wood of the shed. The swooning Francis is levitating, and here Piazzetta's source was again literary. Whenever Francis had mystical visions he was 'raised above the ground and suspended in the air'.[33] Here he is seen being lowered to firm ground again, suggesting Christ's descent from the Cross. The beautiful motif of the hand of the angel holding the saturated cloth is taken from a passage in Celano.[34] The only element of the painting that remains elusive is the bucket with the cloth attached to the shed; its meaning may yet emerge, as Piazzetta never used accessories for merely decorative or compositional purposes.

Piazzetta's personal reference to and reinterpretation of basic religious texts reminds one of his great predecessor Rembrandt. Also like Rembrandt, Piazzetta was to experiment continuously throughout his career with the formal and expressive possibilities of *chiaroscuro*. The contrasts between light and dark are harsh in his early works, there being no light in the shadows. His pictures of the 1720s are still dark, but already in the Fava altarpiece of 1725 light permeates the shadows with varying intensity. Most often he infused the shadowy passages with a coppery or reddish shimmer that carried over into the lighter transitional areas, generating an intensity suggestive of fire and heat: this effect is particularly suited to works such as *The Ecstasy of St Francis*. In the mid- and late 1730s Piazzetta traversed a phase of distinct lightening, felicitously styled his 'Rococo season'.[35] In the celebrated, large *Assumption of the Virgin* (fig. 12), painted for the Elector Clement August of Cologne in 1735, Piazzetta launched his own brand of Rococo. The warm, expressive light of the 1720s yielded to a cooler daylight – intense, to be sure, but offset by large areas of transparent, and semi-transparent shadow. For Piazzetta that was bright, even if by the standards of a Pellegrini or a Sebastiano Ricci it was subdued. Newton, whose theories of light and colour were then going the Venetian rounds, may have led Piazzetta to experiment further with daylight. So, too, may his presumable contacts with Canaletto, who was then banishing shadows from his *vedute* and striving after ever purer light.[36] After his brief excursus into the world of light on light, Piazzetta resumed his sombre ways, as is already manifest in the *pastorales* he painted for Schulenburg around 1740 and in the Parma *Immacolata* with its darkish clouds closing in on the Virgin from all sides.

73

GIAMBATTISTA PIAZZETTA
*Virgin and Child Appearing to St Philip Neri*
1724–5
oil on canvas, 112 × 63.5 cm
National Gallery of Art, Washington
Samuel H. Kress Collection

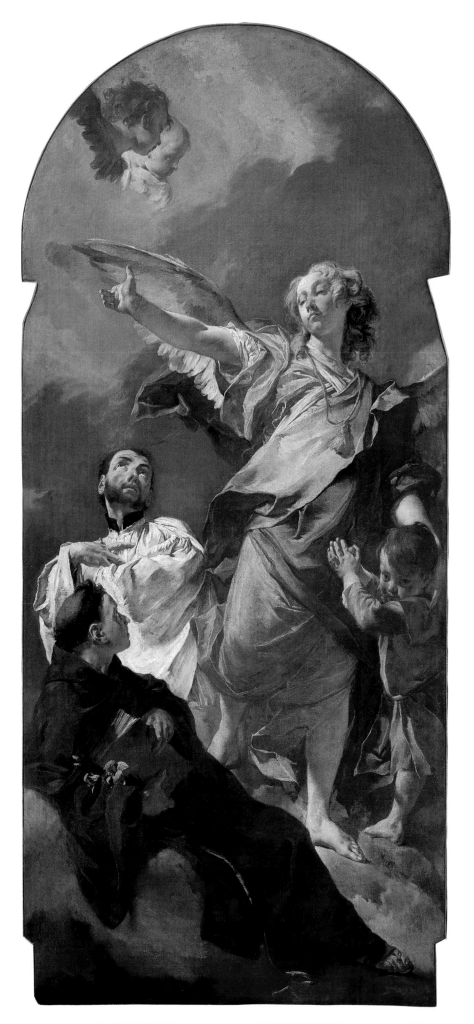

74

GIAMBATTISTA PIAZZETTA
*Guardian Angel with St Antony of Padua and St*
*Gaetano Thiene*
1727–30
oil on canvas, 250 × 112 cm
S. Vidal, Venice

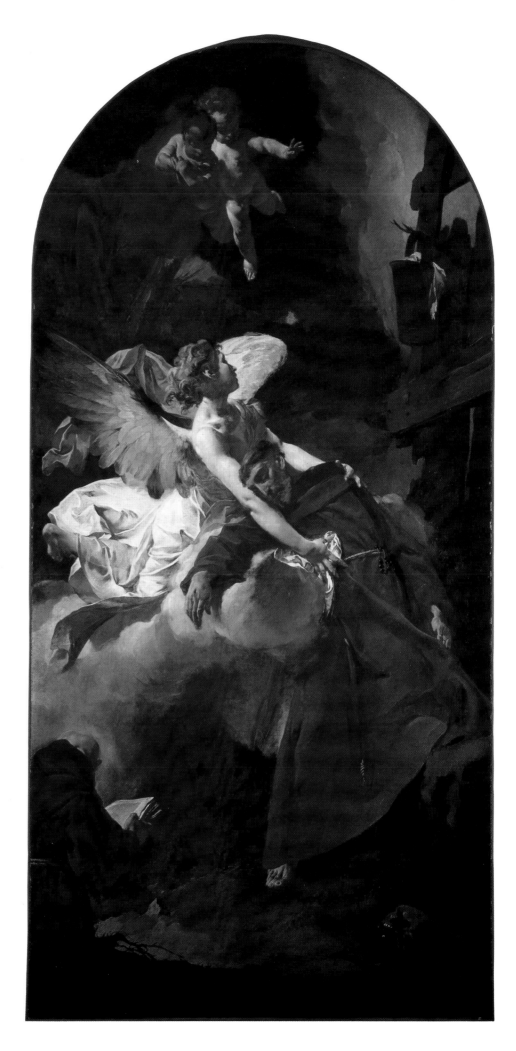

75

GIAMBATTISTA PIAZZETTA
*The Ecstasy of St Francis*
1729
oil on canvas, 379 × 188 cm
Pincoteca Museo Civico di Palazzo
Chiericati, Vicenza

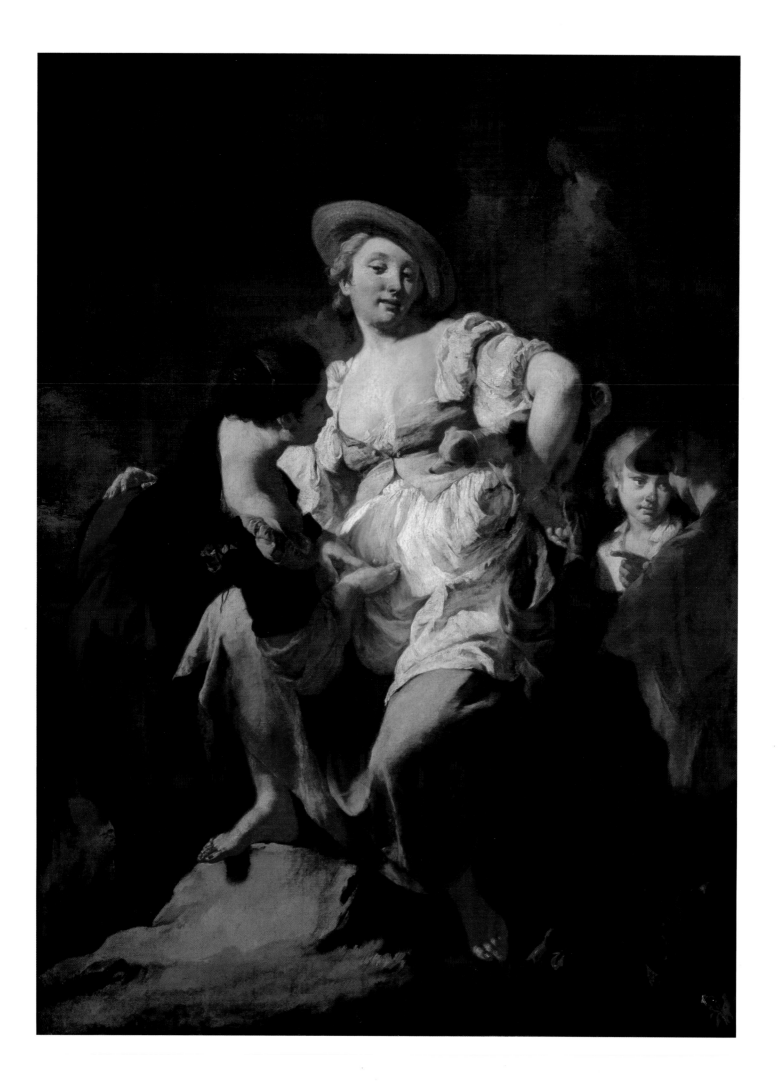

GIAMBATTISTA PIAZZETTA
*'L'Indovina' ('The Fortune-teller')*
oil on canvas, 154 × 114 cm
Gallerie dell'Accademia, Venice

77, 77a (overleaf)

GIAMBATTISTA PIAZZETTA
*Oeuvres de messire Jacques Benigne Bossuet . . .*
published in Venice by G. B. Albrizzi,
1736–58
10 volumes, quarto
28 × 44 cm (open book)
Mr H. D. Lyon, London

Around 1738–45 Piazzetta painted a group of large genre scenes involving plebeian protagonists, mostly peasants of both sexes. Of this group only three pieces, which have come to be known as Piazzetta's *pastorales*, or pastoral idylls, are extant (cat. 76, 78, 79). Others are known from engravings made after them, and related works by Piazzetta's assistants are also on record. This group constitutes a well-defined category of bucolic low-life subjects with strong erotic overtones. The compositional elements are all closely related to the drawings of erotic genre-like *pastorales* that Piazzetta was then providing for his friend the publisher Albrizzi to be turned into engraved book illustrations.

Piazzetta's *pastorales* have drawn much intense scholarly investigation. There is a consensus as to their exquisite artistry and poetic mystery. So is there a consensus as to the difficulty of decoding them. The so-called *Indovina* (cat. 76) is a choice example.[37] The iconography unquestionably derives from the Dutch 17th-century genre imagery of mercenary love. That Piazzetta was familiar with such Dutch prototypes is evident from his drawing of the *Bravo, a Girl and Old Woman* (cat. 64) at Windsor. The most convincing view is that both the women in the *Indovina* are whores, and the brunette, through her 'put-your-money-here' gesture, is negotiating their services with the two men.[38] But one should not overlook the crucial little dog, who softens and partly disguises the crudeness of the story. That visual buffer between the two groups reinforces this reading of the *Indovina*, for in 17th-century Dutch and later Rococo genre painting the dog, otherwise a symbol of fidelity, represents the lover or sexual partner.[39] The two other *pastorales* (cat. 78, 79), commissioned by Marshal Schulenburg and completed in 1740 and 1745 respectively, are pendants and also erotic genre scenes, though their specific meaning is

78

GIAMBATTISTA PIAZZETTA
*Idyll on the Beach*
1745
oil on canvas, 196.5 × 146 cm
Wallraf-Richartz-Museum, Cologne

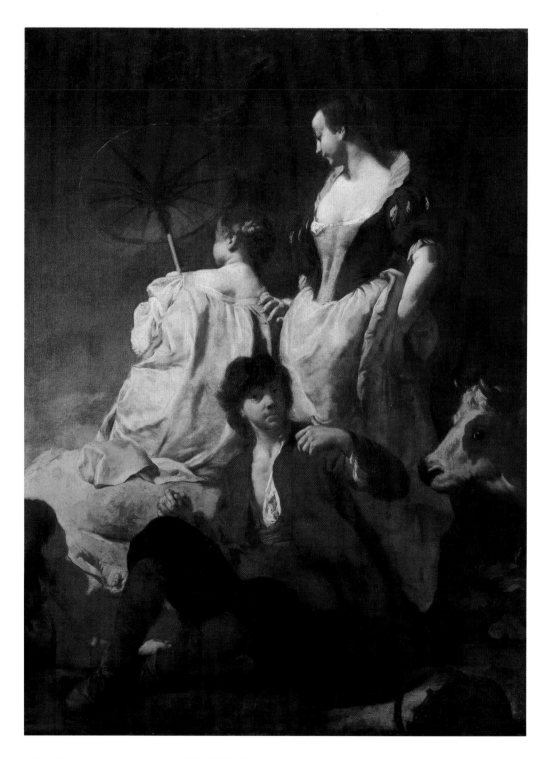

even more elusive. Some of the book illustrations made after designs by Piazzetta for Albrizzi's *Oeuvres de Bossuet* (see cat. 77)[40] appear to be variations on erotic themes related to those in the *Indovina* and in the ex-Schulenburg *pastorales*. In the *Shepherd with Elegantly Dressed Young Women* a rustic male is rebuffed by two city girls: one of them looks meaningfully at the little dog while both point to two peasant girls in the distance as likelier candidates for his courtship. *The Horseman and Two Shepherdesses* is apparently an illustration on the power of wine (see the barrel) to induce drowsiness and thwart sexual desire. The little dog is climbing in vain, and the sober, alert girl in the centre will fail to attract the sleeping horseman. This illustration helps to elucidate the Chicago *pastorale* (cat. 79), which also appears to be about the power of Bacchus (the boy with the basket of grapes) to thwart desire: the boy Bacchus will stop the dogs from catching the ducks.

79

GIAMBATTISTA PIAZZETTA
*Pastoral Scene*
1740
oil on canvas, 191.8 × 143 cm
The Art Institute of Chicago
Charles H. and Mary F.S. Worcester Collection

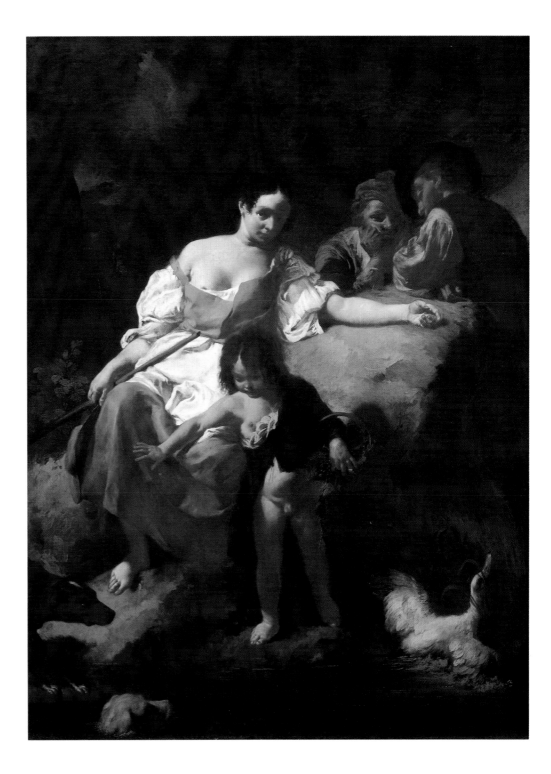

*Dal Mago incitati i due guerrier, un viene,*
*Dove il pino Fittel gli attende in porto.*
*Spicciar la vela, e pria del gran Tiranno*
*D'Egitto i legni e l'apparecchio han scorte.*
*Fa vele il vento; e tale il nocchiero hanno,*
*Che ben lungo viaggio estimano corto.*
*All'Isola rimota alfin si spunta,*
*Da dar le forze sono, e i vezzi vinte.*

## CANTO DECIMOQUINTO.

I.

Già richiamava il bel nascente raggio
All'opre ogni animal che 'n terra
alberga;
Quando venendo ai duo guerrieri
il saggio
Portò il soglio, e lo scudo, e l'aurea verga.
Accingetevi, disse, al gran viaggio
Prima che 'l dì che spunta, omai più s'erga.
Eccovi qui quanto ho promesso, e quanto
Può della maga superar l'incanto.

(171)

---

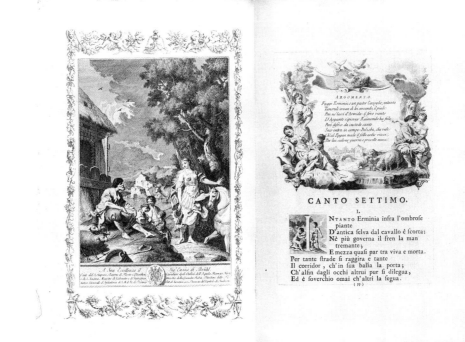

*Fugge Erminia, e un pastor l'accoglie; intanto*
*Tancredi invan di lei cercando, il piede*
*Pon ne' lacci d'Armida: il fero vanto*
*D'Argante espugnar Raimondo ha fede;*
*Però disfida che custode stanno*
*Sente entrar in campo Belzebù, che vide*
*Ch'al Pagan manco il fello oltre riesce;*
*Per lui indran guerrier e proietti mance.*

## CANTO SETTIMO.

I.

Intanto Erminia infra l'ombrose
piante
D'antica selva dal cavallo è scorta:
Nè più governa il fren la man
tremante;
E mezza quasi par tra viva e morta.
Per tante strade si raggira e tante
Il corridor, ch'in sua balia la porta;
Ch'alfin dagli occhi altrui pur si dilegua,
Ed è soverchio omai ch'altri la segua.

(77)

80

GIAMBATTISTA PIAZZETTA
*Gerusalemme Liberata*, by Torquato Tasso
published in Venice by G. B. Albrizzi, 1745
etchings with some engraving folio, 51.5 × 77.5
cm (open book)
Austrian National Library, Vienna

83

GIAMBATTISTA PIAZZETTA
*Gerusalemme Liberata*, by Torquato Tasso
published in Venice by G. B. Albrizzi, 1745
folio, 46 × 67.5 cm (open book)
The British Library Board, London

81

GIAMBATTISTA PIAZZETTA
Drawings for *Gerusalemme Liberata*
1735–53
red crayon with traces of black, approx.
33.2 × 21.8 cm (size of drawing)
Biblioteca Reale, Turin

82

GIAMBATTISTA PIAZZETTA
*Rime e Versi per l'ingresso di Luigi Pisani*
published in Venice By G. B. Albrizzi, 1753
etched title-plate, 306 × 450 mm (open book)
Department of Printing and Graphic Arts,
Houghton Library, Harvard University,
Cambridge, MA

Piazzetta's lengthy *pastorale* phase vividly reflects the European vogue for Rococo idylls and '*bergeries*', of which Boucher was the chief propagator in France. It is within this *pastorale* period that Piazzetta collaborated intensely with Albrizzi on what was to be the masterpiece of 18th-century book production: Torquato Tasso's *Gerusalemme Liberata*, which appeared in this new edition in 1745. Piazzetta made all the designs, from the dedication plate representing young Maria Theresa, Empress of Austria, as a sprightly Rococo damsel, to the final tailpiece, a double portrait of the two collaborators on the book dressed up for the occasion, set in a pastoral landscape, and looking straight at the viewer (cat. 80). These viewers, who were a sophisticated group of international subscribers, would hardly fail to notice that the Venetian pair is a counterpart of sorts to the French pair of Watteau and Julienne in the print made by Tardieu after a design by Watteau. Piazzetta himself etched the face in his own portrait.[41] Perhaps Albrizzi as publisher and editor had as great a say as Piazzetta in the choice of the subject-matter of the designs. The large rectangular illustrations at the beginning of each canto refer to a specific passage in it, such as *Erminia and the Shepherds* for Canto VII (cat. 83) and *Carlo and Ubaldo in Armida's Island* for Canto XV (cat. 80). But the head- and tailpieces, for the most part *pastorales*, connect only loosely, if at all, with Tasso's text. Thus, the idyllic scene shown in the tailpiece to Canto VIII (cat. 83), one of Piazzetta's most attractive designs, could not possibly be linked to any passage in that Canto.

For the sake of simplicity, or in order to provoke his audience of connoisseurs, for his book designs he borrowed freely from Old Master prints ranging from Stefano Della Bella to Rubens and Berchem. What has not been sufficiently recognised is the French influence on him, especially his familiarity with Julienne's two *Recueils* of 351 engravings after paintings and drawings by Watteau, published in 1726 and 1728 respectively. In general the Venetians paid French art little heed, so that Piazzetta's awareness of it is surprising. This awareness is evident in other works beyond the designs for the Tasso and the Bossuet. The walking couple in the frontispiece for *Il Newtonianismo per le Dame* (cat. 85), already published in 1737, is cast in an unmistakably French mould. Count Algarotti and his elegant pupil seem to have walked out of some genre painting by Jean-François de Troy.[42] Yet Piazzetta's French pickings appear to have been rather sporadic. In *Minerva's Homage to Venice* (cat. 84), the frontispiece for the Zanetti cousins's *Delle Antiche Statue* of a slightly later date, he reverted to his idiosyncratic female figures of earthy and weighty charm.

Piazzetta did not work exclusively for Albrizzi. While collaborating with him on the Bossuet, he also prepared 38 designs for the publisher Pasquali to illustrate a small prayer-book, *Beatae Mariae Virginis Officium*, published in 1740. Marco Pitteri, of all engravers the most sensitive to Piazzetta's style, rendered his small designs with their sophisticated tonal variations exceptionally skilfully, as can be seen in the *Annunciation* and the *Concert of Angels* (cat. 86).

84

GIAMBATTISTA PIAZZETTA
*Minerva's Homage to Venice*
(frontispiece, engraved by Felicita Sartori)
ANTON MARIA ZANETTI
*M. Am. Commodo*
(plate, engraved by Giovanni Antonio Faldoni)
from
*Raccolta delle Antiche statue . . .*
by Anton Maria Zanetti the Elder and Younger
published in Venice by G. B. Albrizzi, 1740–3
2 folio volumes, 54 × 78.5 cm (open book)
Wellesley College Library, Special Collections

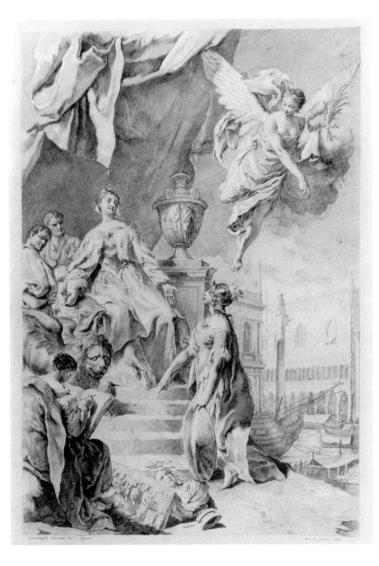
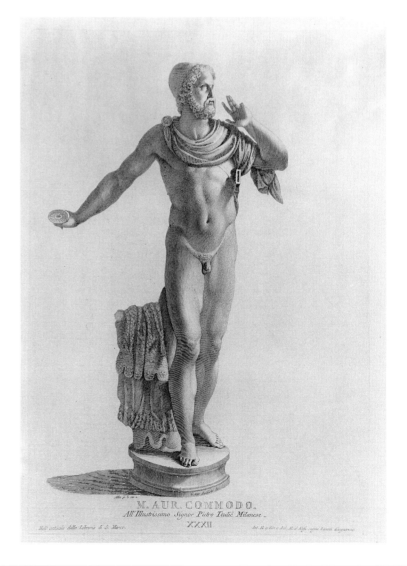

85

GIAMBATTISTA PIAZZETTA
*Il Newtonianismo per le Dame, ovvero dialoghi sopra
la luce e i colori*
by Francesco Algarotti
printed, possibly in Venice or Padua,
by G. B. Pasquali, 1737
octavo, with plates engraved by Marco Pitteri,
*c.* 22.5 × 32 cm (open book)
The British Library Board, London

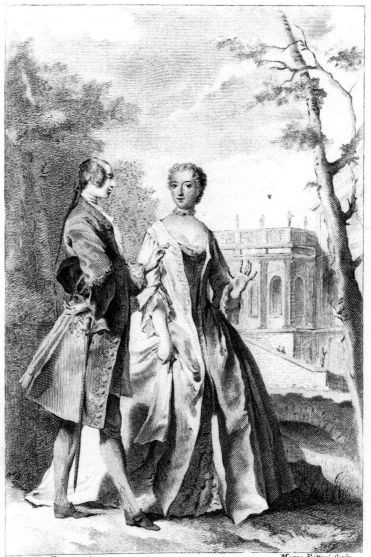

86

GIAMBATTISTA PIAZZETTA
*Beatae Marie Virginis Officium*
printed in Venice by G. B. Pasquali, 1740
small octavo, with plates engraved by Marco
Pitteri, 13 × 18.5 cm (open book)
Arthur and Charlotte Vershbow

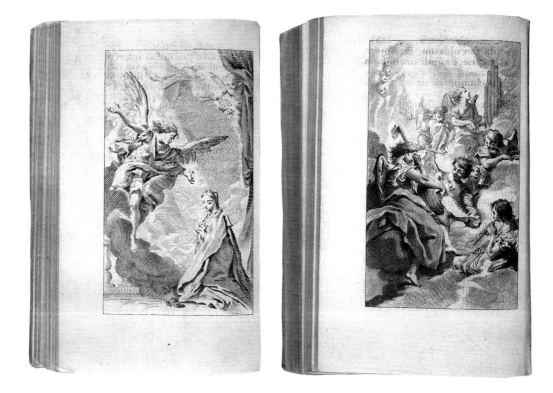

Over 400 designs and counterproofs made by Piazzetta for book publications are still extant. Destined for the engraver, they were meticulously finished, but lack the brio of Piazzetta's *têtes de caractère*. Their iconography is more arresting than their style. Each of the designs must have been preceded by numerous preparatory drawings ranging from 'first thoughts' through compositional sketches to figure studies, but few of these working sheets have come down to us. Of the hundreds of sketches that Piazzetta must have made for the Tasso designs only one has come to light: the dazzling study for Caliph Aladin (fig. 27). Even more distressing is the puzzling scarcity of Piazzetta's preparatory drawings for his paintings, though they are 'the most interesting [works] in the whole body of Piazzetta's art'.[43] The *Flying Angel* in Cleveland (cat. 87) is a capital survivor from what must have been a huge heap of preparatory sheets for the *Glory of St Dominic*, a ceiling for a chapel in SS. Giovanni e Paolo in Venice, perhaps the most prestigious commission that Piazzetta ever received. His excessive accentuation of some contours and folds of the draperies in this drawing was due to their need to be visible from afar.

*Figure 27:* Giambattista Piazzetta, study for *Gerusalemme Liberata: Caliph Aladin*, black and red chalk, 24.2 × 22 cm, 1738–40, National Gallery of Art, Washington, Julius S. Held Collection; Ailsa Mellon Bruce Fund

87

GIAMBATTISTA PIAZZETTA
*A Flying Angel*
*c.* 1726
black chalk with traces of white on blue-grey
paper, 55.5 × 42.7 cm
The Cleveland Museum of Art
Purchase from the J. H. Wade Fund

A significant portion of Piazzetta's *œuvre* consists of devotional pictures each representing a single head or half-figure of a saint, apostle or other figure. Most of these devotional images exist in several autograph or non-autograph versions and, being easy to produce, may have brought him a steady income over the years. A secular counterpart to this religious group, far smaller in number, contains highly appealing genre half-figures, predominantly male. For the most part they seem to have been produced in the late 1730s or early 1740s.[44] The smallest of these (cat. 88) is perhaps the masterpiece. For decades it went by the name of *A Young Sculptor* in view of the hammer that the protagonist was believed to be wielding.[45] Might this not rather be a war hammer similar to those seen frequently in portraits of Polish and Hungarian cavaliers? In fact it is not unlike the one held by Rembrandt's *Polish Rider* (Frick Collection, New York). Piazzetta need not have known Rembrandt's painting for this boy to have been a homage to Rembrandt.[46] For Rembrandt was greatly admired in Venice: Zanetti owned a complete set of Rembrandt's etchings, Venice's resident merchant-collector Joseph Smith acquired nine paintings by the Dutch master, and Rembrandtesque works are often listed in old Venetian inventories.[47]

88

GIAMBATTISTA PIAZZETTA
*Boy in Polish Costume*
*c.* 1741
oil on canvas, 46.5 × 37 cm
Museum of Fine Arts, Springfield, MA
James Philip Gray Collection

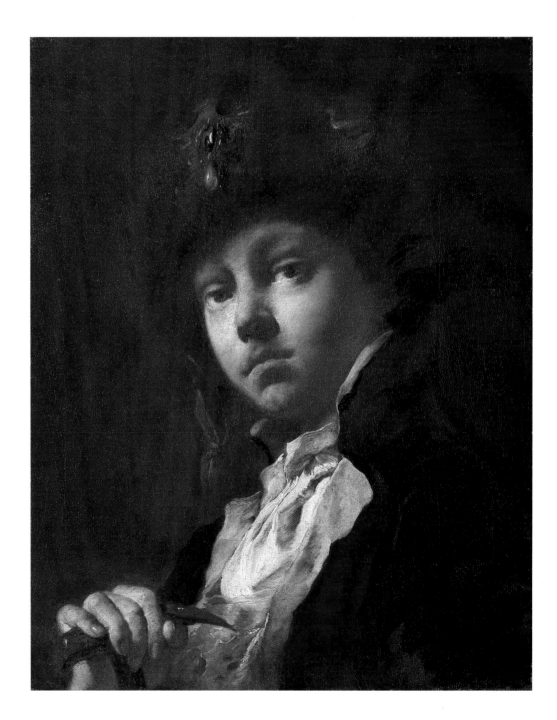

89

GIAMBATTISTA PIAZZETTA
*Studi di pittura ...*
published in Venice by G. B. Albrizzi, 1760
quarto, etching and engraving,
30 × 88.8 cm (open book)
Arthur and Charlotte Vershbow

In 1760 six years after Piazzetta's death, Albrizzi published a pattern-book prepared by Piazzetta with 24 models; the *Male Nude Lying on a Banner* (cat. 89) is typical. The *Studi di pittura* also comprises a short but reliable biography of Piazzetta by Albrizzi himself. Embedded in the decorative tailpiece of the *Studi* is a small etching dated 1738 and apparently the only one that Piazzetta ever made that may be a self-portrait in Rembrandt's manner (cat. 89). Though the resemblance with the signed and dated self-portrait of 1735 (cat. 67) is tenuous, it shows some common traits with the *St Thaddeus* etched by Pitteri in 1742, and which may also be a self-portrait.

To have represented himself in Rembrandt's manner and in Rembrandtesque accoutrements should be interpreted as a homage to the Dutch master, but also as a sign of true self-perception. Piazzetta and Rembrandt had uncannily much in common. Both viewed *chiaroscuro* as the chief vehicle of painterly expression; both had a marked bent for naturalism; and, though both were great painters, it is in their drawings that their genius stood out in sharpest relief.

XVII.

1. Like most other artists of this time, he fell into oblivion during the 19th century. A first monograph on him, by Aldo Ravà, appeared in 1921. Thereafter he fast became the subject of serious and fruitful inquiries, largely conducted or instigated by Rodolfo Pallucchini. We know a great deal about Piazzetta today, though our imperfect knowledge of his early career continues somewhat to mar out perception of his life's work as a whole.

2. Levey, 1959[1], ed. 1981, p. 151.

3. Zanetti, 1733, p. 189.

4. *Idem*, 1771, p. 457.

5. Pallucchini, 1956, p. 69.

6. So, with all due discretion, is his *Christ and the Samaritan Woman* (Modiano Collection, Bologna).

7. Blanc, 1877, p. 48, suggests that biographical circumstances must have reinforced an inborn tendency in Piazzetta to dramatic *chiaroscuro*: '*C'est un Caravage vénetien. Il avait du goût pour les éclats de lumière et les ombres fortes; mais ce goût ne fut pas précisément chez lui une imitation; il lui fut naturel et lui vint, selon toute apparence, de sa condition première*'.

8. Albrizzi, 1760, n.p.

9. Zanetti, 1771, p. 457.

10. Moretti, 1984–5, pp. 359–66. This documentation indicates that Piazzetta's training in sculpture may have gone further than mere child's play. Also that from 1705 to 1713 or even later, Piazzetta was associated with his brother-in-law, Francesco Bernardoni, a sculptor and wood-carver. They probably shared the workshop of Piazzetta's father, then deceased. Their names appear conjoined in official documents pertaining to the taxation of the sculptors' guild. In one such instance they are described conjointly as sculptors (*intagliatori*). In another Piazzetta for his part is labelled '*pitor*'. From all this material Moretti inferred that Piazzetta might have provided designs and *modelli* for sculptors during the early part of his career.

11. According to Albrizzi, Piazzetta was twenty when he completed his apprenticeship with Molinari, and he afterwards left for Bologna, probably in 1703. Until recently Piazzetta scholars worked on the assumption that he spent most of the first decade of the 18th century in Bologna. This assumption considerably blurred their perception of his early formation and development. Thanks to recent discoveries by Moretti, we now know that in 1705 Piazzetta was again residing in Venice and shared a workshop there with a sculptor. By all indications he did not leave the city thereafter.

12. Merriman, 1980, p. 195. Piazzetta's name does not appear in Crespi's studio books.

13. When, shortly after his return to Venice, Piazzetta was composing his *Girl Catching a Flea* (Museum of Fine Arts, Boston), he may have had one or another of Crespi's numerous representations of Flea Hunts in the back of his mind – unless the two artists drew independently on one of the many Dutch or French prototypes of the 17th century. Girls catching and squeezing fleas, a reference to mercenary love, were popular in Northern Baroque art: solemn Georges de La Tour painted at least one such scene.

14. Little is known about Piazzetta's initial pictorial manner. Albrizzi described one of Piazzetta's first works as a 'nocturnal scene with figures illuminated only by a lantern'. His earliest extant paintings are the pendants *The Dead Abel* and *The Good Samaritan*, described in an inventory of 1741 as his '*prima maniera*' and probably made at some point between 1698 and 1705; see Binion, 1990, p. 236. Just because of their mediocrity they have given rise to a wide variety of speculations about their genesis. As has been noted, the Samaritan's wounded patient was taken from a drawing by Molinari. Beyond this, the sensitive *chiaroscuro* handing in the *Abel* bespeaks a close familiarity with the early manner of Guercino as also with that of Johann Carl Loth, who may have been a friend of Piazzetta's father; see Levey, 1959[1], p. 14, and Ewalt, 1965, p. 35. Knox quite rightly sees in the massive muscular body a reminder that Piazzetta was the son of a sculptor; see Knox, 1992, p. 331.

15. In his excellent *catalogue raisonné* Mariuz, 1982, lists 165 autograph paintings by Piazzetta, but dates only some 30 of them before 1722, when Piazzetta was already 40 years old. This gives pause for thought. Knox's intriguing thesis (1992, pp. 33–8) that Piazzetta did large history paintings during the first decade of the century has been questioned but deserves further investigation.

16. Jones, 1981[2], II, p. 249.

17. *Idem*, 1981[2], II, p. 39, posits convincingly that Giulia also served as a model for the heroine of the Uffizi *Susanna and the Elders*. Frequently styled as a pupil or follower of Piazzetta, Giulia Lama was in fact neither. Their careers ran parallel. Certainly she was influenced by her famous contemporary, but not all of her works are markedly Piazzettesque. Her tenebrism derived in the first instance from her father, Agostino Lama, and she never shared Piazzetta's extreme naturalism. The give-and-take between the two remains to be pinned down.

18. Knox, 1992, p. 86.

19. Ruggeri, in Brussels, 1983, p. 91. See also Bottari, II, 1757, pp. 100, 104, 140, 141. Letters addressed to the Florentine collector Francesco Gabburri by Antonio Balestra in 1717, Marco Ricci in 1723, and Antonio Maria Zanetti in 1726 testify to the popularity of Piazzetta's drawings and the great demand for them.

20. Moschini ranked his talents the same way, calling him a 'good painter and excellent draughtsman'.

21. The same model appears in several other drawings and paintings by Piazzetta that have always been dated early. They include the chalk studies for the *Sleeping Girl with Basket and Turnips* in Salzburg (Mariuz, no. 15) and for the *Girl Catching a Flea* in Boston (Mariuz, no. 13), and the painting *Magdalene* in the Collection Nemere in Vienna (Mariuz, no. 27).

22. Dezallier d'Argenville, I, 1762, p. 320.

23. Ravà, 1921, posited that Piazzetta's heads were 'the most important part of his output'.

24. Martini, 1964, fig. 119.

25. Binion, 1990, pp. 93–102.

26. Another vexing problem with the heads is to differentiate originals from semi-originals. Poor replicas are easy to recognise as copies. But many extant Piazzettesque heads of high quality may be collaborative works such as are known to have existed. As Piazzetta himself indicated in a letter of 1741 to the parish priest of Meduno (Udine), he would let his assistants sketch in a basic figure, presumably after one of his originals, and then correct and finish it himself. The letter is reproduced in Pallucchini, 1947, pp. 113–14.

27. If Piazzetta did, indeed, represent himself as Thaddeus, patron saint of carpenters, he did so from an old drawing: in 1742 he was 60 years old, whereas his Thaddeus is under 40.

28. The saint's figure is often linked compositionally to Charon in Crespi's *Aeneas, Charon and the Sibyl* (Kunsthistorisches Museum, Vienna). In fact, the executioner was lifted from Guercino's *Capture of Christ* (Fitzwilliam, Cambridge) possibly after Pasquali's engraving. Moretti, 1984–5, pp. 374–5.

29. Jones, 1981[2], II, p. 175.

30. Celano, in Habig, 1973, pp. 370–1.

31. St Bonaventura, in Habig, 1973, *passim*.

32. *Legend of the Three Companions*, in Habig, 1973, p. 953.

33. *Little Flowers of St Francis*, in Habig, 1973, p. 1434.

34. Celano, in Habig, 1973, p. 310.

35. Mariuz, 1983, p. 298.

36. *Idem*, 1983, p. 298.

37. No educated guess at its hidden meaning has won general approval. The interpretation by White and Sewter (1960), who view it as an allegory of the decadence of Venice, is more fascinating than convincing: that a rustic Venus, construed as a harlot, should also personify Venice, her downfall witnessed by the youths in the background, strains credulity. Knox (1992, p. 187) sees the scene alternatively as an 'ideal vision of a healthy country wench and her companion sharing a mutual admiration for a little dog'.

38. Jones, 1981[2], II, pp. 196–7.

39. Posner, 1973, pp. 77–83.

40. Most of the 65 designs by Piazzetta for the *Oeuvres de Bossuet* deal with historical or theological subjects clearly connected with Bossuet's texts. The remaining few – *pastorales* of sorts, with erotic overtones – may appear merely decorative at first glance. Yet a tenuous connection with the text is possible for them as well, as they appear to illustrate passages on the deterioration of conjugal morality.

41. Robison, 1974, n. 6

42. Even closer to de Troy's figures are the four that appear in Platner's *Institutiones chirurgiae*, published by Albrizzi in 1747.

43. Ruggieri, in Brussels, 1983, p. 94.

44. Binion, 1990, p. 242. The dates assigned to the small masterpiece in Springfield already range all the way from 1720 to 1740. I none the less suggest *c.* 1741, as the model was unquestionably the same boy at the same age as the one for a painting of a *Boy Holding a String of Pearls* acquired by Marshal Schulenburg around January 1742.

45. But Mariuz 1982, no. 85, recently renamed it *Boy in Polish Costume*, while Jones, 1981[2], p. 143, sees the boy's implement as a walking-stick.

46. Mariuz, 1982.

47. Levi, 1900, *passim*.

GIAMBATTISTA TIEPOLO
*Rinaldo and Armida in her Garden*
*c.* 1745
oil on canvas, 187 × 260 cm
The Art Institute of Chicago
Bequest of James Deering

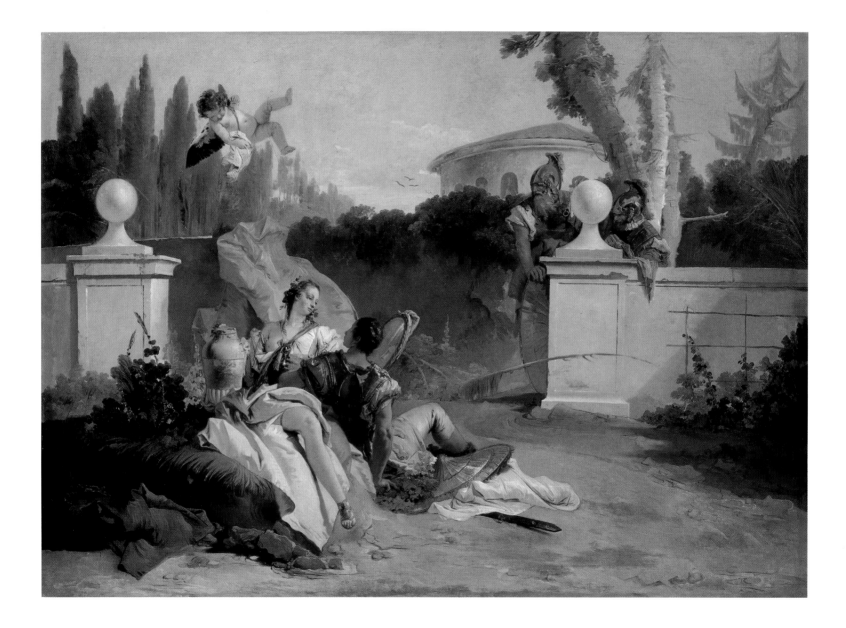

# V: *Giambattista Tiepolo*

Adriano Mariuz

The Venetian author Vincenzo da Canal, writing in 1732, described the paintings of Giambattista Tiepolo as being, from Tiepolo's earliest years, 'all spirit and fire'.[1] Even when he was young his imagination seemed driven by a darting, almost supernatural fervour. No one seeing Tiepolo's earliest public paintings, a series of Apostles of 1715–16 for the church of the Ospedaletto in Venice, would imagine that the sober, diligent Gregorio Lazzarini had been his teacher: shafts of light slash across the paintings, and the Apostles' faces are foreshortened into gloomy, grotesque masks, overwhelmed by pathos (fig. 28). At this date Tiepolo clearly inclined towards the manner of Bencovich and Piazzetta, whose neo-tenebrist style emphasised the plastic and expressive qualities of the human form through a dramatic interplay of light and shade.

The decisive quality of Tiepolo's painting of these figures suggests something of a challenge or provocation. He aimed to outdo Piazzetta in *chiaroscuro* effects and Bencovich in the expression of sentiment. When later he was confronted by Sebastiano Ricci's rediscovery of Veronese it was not enough for him to paint in the style of the 16th-century master: he had to become 'another Veronese', steeped in the flamboyance and airiness of the Baroque as well as in the elegance and playfulness of the Rococo. This was a new and hitherto unknown Veronese; in short, it was Giambattista Tiepolo, the genius of the century.

Tiepolo was born in Venice in 1696 in the working-class quarter of Castello. Unlike many contemporary painters, he was not born into an artistic family. His father was a tradesman, part-owner of a commercial boat, who died a year after Tiepolo's birth. Tiepolo's widowed mother decided to send her son to study with Gregorio Lazzarini, presumably because the boy showed early signs of ability in painting or drawing. Lazzarini, whose studio was also in Castello, was almost given the respect due to an official state painter. His enormous *S. Lorenzo Giustiniani Distributing Alms*, painted in 1691 for the patriarchal church of S. Pietro di Castello, was judged to be one of the most successful paintings executed in Venice since the 16th century: well-structured, competently drawn, clear in colour, with the figures set against an architectural background reminiscent of Veronese.

*Figure 28:* Giambattista Tiepolo, *The Apostle Thomas* (detail), oil on canvas, 1715–16, S. Maria dei Derelitti (The Ospedaletto), Venice

Tiepolo's ability to orchestrate numerous figures in a large compositon, keeping a watchful eye on every detail, may have been the lasting legacy of Lazzarini's instruction. He was given the opportunity to study more interesting works of art, which were to lie dormant in his visual memory, when he was commissioned (possibly through Lazzarini's influence) to make drawings for engravings after paintings by 16th-century masters, including Francesco Bassano, Giuseppe Salviati and Tintoretto. These prints appeared in an anthology of Venetian paintings and views entitled *Il Gran Teatro … di Venezia* (cat 25), aimed mainly at foreigners and published by the bookseller and printer Domenico Lovisa in 1720.[2] Of all the paintings he copied for engravings, the one that must have impressed him most was Tintoretto's *Assumption of the Virgin* in the church of the Gesuiti: here the energetic composition is lit by flashes of lightning and peopled by angels engaged in daring flying exercises. Some of Tintoretto's creative fury rubbed off on the youthful artist, or sounded a chord.

Study of these paintings seems to have encouraged Tiepolo to develop a heroic style and to have confirmed his taste for grand designs, already in evidence in his painting of *The Crossing of the Red Sea*[3] exhibited in 1717 at the annual open-air exhibition on the feast of S. Rocco. The young artist was proving himself a skilful director of crowd scenes set in rocky landscapes with clouds and water illuminated by dramatic flashes of light: was he to be the new Tintoretto? The subject of this painting was itself stirring, the more so in the light of current events. The war against the Turks was raging, and news was coming in daily of losses and acts of heroism; fortunately, the saints came to the assistance of the Venetians, St Spiridion appearing with a retinue of spirits on the besieged walls of Corfu. In *The Crossing of the Red Sea* the biblical episode could be interpreted as anticipating the Serenissima's victory, with God's help, over their traditional enemy. Tiepolo's painting reflected the climate of anxiety and hope prevailing in the Republic, and encouraged a general belief in a return to the heroic virtues of the past. This true Venetian, with his 'fluent and resolute'[4] style and his ability to handle complex subjects, demonstrated a boldness and talent reminiscent of the Old Masters.

Not suprisingly, the Venetian aristocracy, both old and more recent (rich families had spent considerable sums on ennoblement), from the current Doge downwards, took Tiepolo under their wing. They commissioned large paintings of historical themes to adorn the entrance halls and reception rooms of their palaces. Such was the series of canvases ordered by the Zenobio family, 'one of his first commissioned works',[5] or the *Rape of the Sabine Women* painted for Jacopo Zorzi (Hermitage, St Petersburg). Besides their pathos and expressive vigour, Tiepolo's paintings were admired for their flamboyant composition and, very soon, for the brilliance of their colours. These qualities elevated him to the level of the contemporary masters of decoration like Ricci and Pellegrini. He was possessed of an additional gift that distinguished him from the rest: his inventiveness and the originality of his imagination. The more traditional his subjects the greater his capacity to render them exciting and attractive. It is worth remembering that in the artistic theory of the period, *invenzione* was considered to be the most admirable element of any work of art, as it depends 'solely on a fertile imagination and sound

91

GIAMBATTISTA TIEPOLO
*An Artist's Academy*
*c.* 1718
black and white chalks on blue paper, 41 × 54 cm
Private Collection

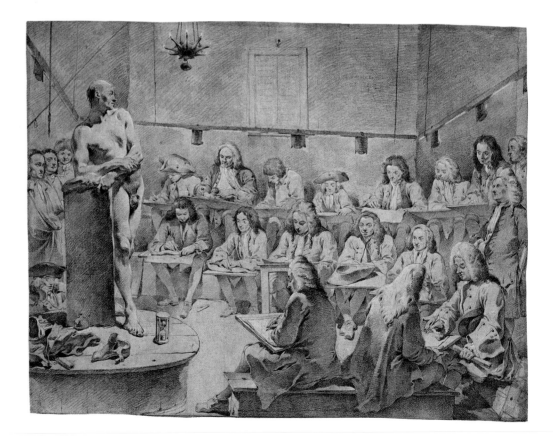

judgement, both gifts from God'.[6] It was Tiepolo's powers of invention and the 'eccentricity of his thought', as Vincenzo da Canal put it, that very soon created a demand for his drawings and encouraged engravers to reproduce his work.

*Alexander and Campaspe in the Studio of Apelles* (cat. 92) can be thought of as Tiepolo's manifesto, a kind of bravura display of the skills he had mastered. He interprets the subject in the most liberal manner, showing off the originality of his *invenzione*. Fully aware of his own talent he portrays himself in the role of Apelles, the most celebrated painter of the ancient world. As a model for Alexander the Great's beautiful mistress, Campaspe, he uses his wife, Cecilia Guardi, whom he married in 1719 (compare the much later portrait of her by their son Lorenzo, cat. 238). The two large paintings on the wall at the back, one of which is *The Bronze Serpent*, are both based on canvases painted by him. Also from his domestic circle are the young black slave by the easel and the little Maltese dog. The group posing on the dais – Alexander, his friend Ephestios and Campaspe – seem to have dropped in from another scene, together with their architectural backdrop with its huge statue of Hercules and the warriors in the distance. The painter's studio, which is synonymous with his mind, is a place where past and present intersect, where imagination and observation intermingle. Ancient history and everyday life merge; enthusiasm, which fuels the imagination for flight, mixes with the vein of

92

GIAMBATTISTA TIEPOLO
*Alexander and Campaspe in the Studio of Apelles*
1725–6
oil on canvas, 54 × 74 cm
The Montreal Museum of Fine Arts Collection
Adaline Van Horne Bequest

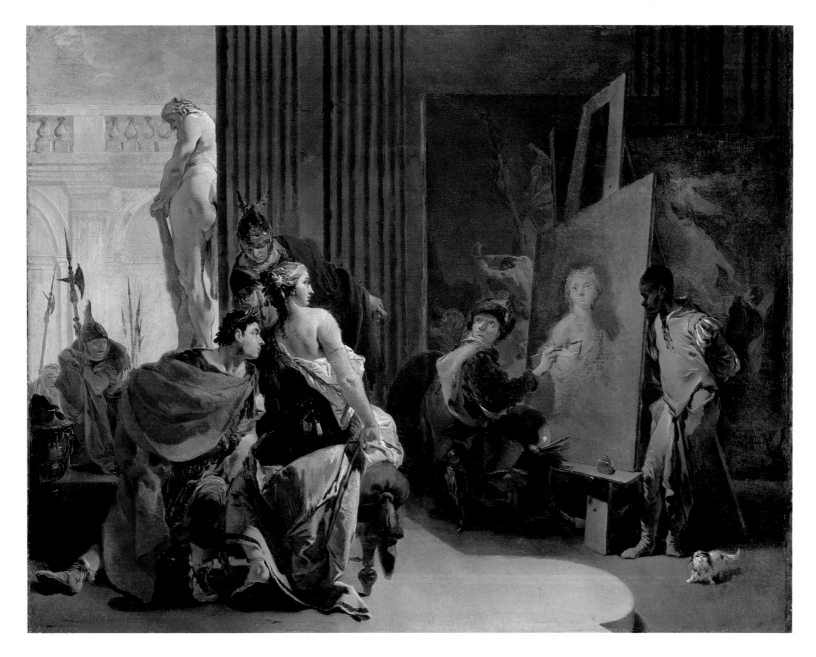

irony that gushes forth when the heroic and the quotidian meet. Tiepolo–Apelles has everything under his watchful gaze; by turning his head like a periscope he is able to take in everything, from the group of people just behind him to the portrait taking shape on the canvas in front of him. His dress, neither ancient nor modern, strikes a curious note. His fur cap casts a shadow like a mask over his eyes; his febrile stare is reminiscent of one of Rembrandt's youthful etched self-portraits. While assuming the role of Apelles, Tiepolo lets us guess at his admiration for Rembrandt, the genius of his day. He must have admired the Dutch master's independence, the freedom of his brushwork, his powerful *coups de théâtre*.

His interpretation of erotic myths, generally taken from Ovid's *Metamorphoses* (until then considered the special preserve of Sebastiano Ricci) was no less original. An example of this is the *Rape of Europa* (cat. 93), one of a set of four mythological scenes painted in the early 1720s. Recently Ricci had painted a canvas on the same subject for the Roman Prince Gabrielli; for this he had reinterpreted a famous picture by Veronese (acquired for the Doge's Palace after 1713), endowing it with Rococo elegance and a glowing colour scheme. Tiepolo may have had a glimpse of Ricci's work, and taken from it the triangular arrangement of the group of figures and the little boy carrying a tray. The small scale of the figures suggests, however, that he also had in mind the mythological paintings of Giulio Carpioni, a 17th-century Venetian painter whose 'idealised scenes, such as dreams, sacrifices, bacchanals ... with the most beautiful caprices ever created by any painter'[7] were particularly admired. Only Tiepolo could have thought of locating the event in a vast, mysterious coastal landscape, its scale emphasised by the displacement of the principal figures to the left. The composition contains two distinct tempi, an *allegro* and a *largo*, a formula that Tiepolo was to repeat later. On the rocky stage the figures, modelled with brushstrokes of light in the manner of Piazzetta, stand out vividly. The sober colour scheme, dominated by reddish browns and creamy whites, also recalls Piazzetta, as does the choice of plebeian models. There is nothing regal or worldly about this group of young girls, who look like peasants or shepherdesses from some rustic Arcadia, dressing their friend's hair. Europa seems to be taking part in the fun, but the seriousness of her expression and her vacant look reveal that for her there is more to come. To defuse the tension Tiepolo adds a touch of humour: on a cloud beside Jove's eagle a small putto tries to extinguish the lightning with a jet of urine.

Paintings like this one were intended for a sophisticated clientele able to appreciate the wit and sensuality of Tiepolo's interpretions of mythology. For the Venetian public at large he was the author of stirring religious paintings such as the *Martyrdom of St Bartholomew* (cat. 94), one of a series of twelve paintings of scenes from the lives of the Apostles commissioned in 1722 from twelve painters by a noble parishioner of the church of S. Stae. Besides Tiepolo's former teacher, Gregorio Lazzarini, all the established painters of the day were invited to submit work, including Ricci (cat. 8), Pellegrini, Pittoni and Piazzetta (cat. 70). Tiepolo was the youngest. The *Martyrdom of St Bartholomew* marks the culmination of his use of emphatic *chiaroscuro* effects and pathos. He was competing here with Piazzetta, and aimed at maximum visual impact. His figures are forged through pulsating light and shade, and stand out starkly against the dark background. The figures of the executioner and the Saint are caught in a vortex like two coiled springs, the contrast between the anguish of the martyr and the indifference of the young executioner is starkly depicted; the executioner is looking for the point of least resistance to begin his atrocious work, as if he were tuning a musical instrument.[8]

At this period Tiepolo was already trying out the technique of fresco painting that was soon to become his great speciality. Venetian painters preferred painting in oils on canvas and only occasionally had they used fresco. However, after the brilliant examples of fresco painting

93

GIAMBATTISTA TIEPOLO
*The Rape of Europa*
1720–1
oil on canvas, 99 × 134 cm
Gallerie dell'Accademia, Venice

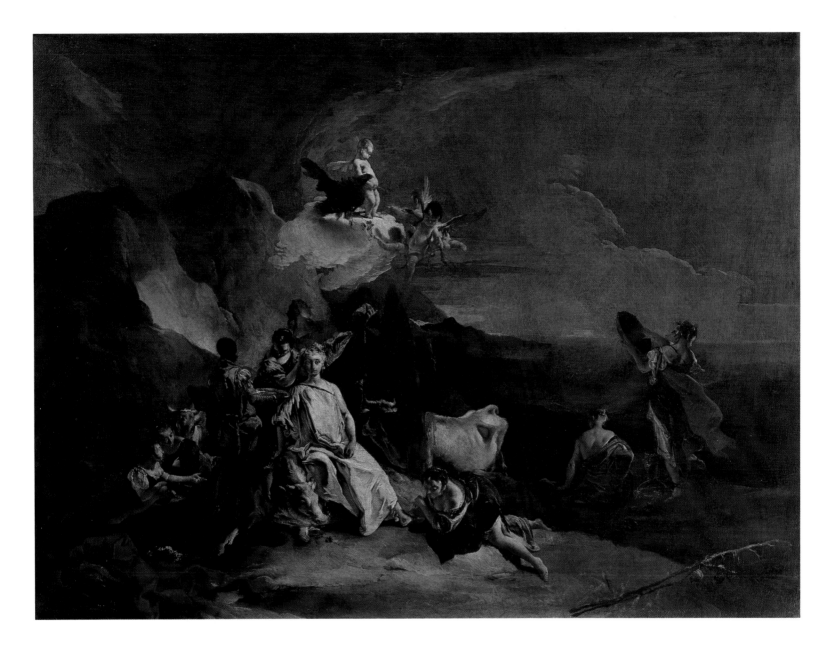

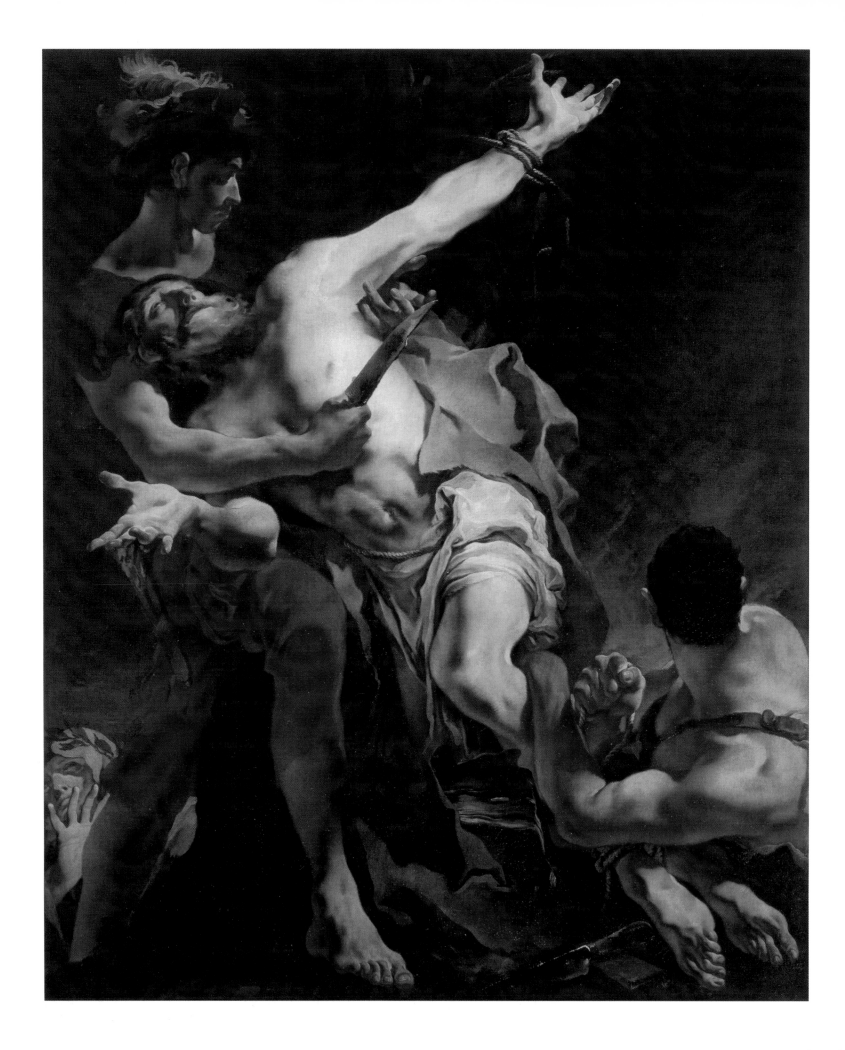

GIAMBATTISTA TIEPOLO
*The Martyrdom of St Bartholomew*
1722
oil on canvas, 167 × 139 cm
S. Stae, Venice

provided by the Frenchman Louis Dorigny in various Venetian churches and in the palace of the Zenobio family, and some frescoes by Nicolò Bambini (one of the most popular painters with the Venetian aristocracy at the turn of the century) and Sebastiano Ricci, large-scale decorative frescoes were increasingly in demand from the beginning of the century. It is no coincidence that Tiepolo's generation of painters was especially devoted to fresco; a contemporary, Giambattista Crosato, must have seen Tiepolo's early experiments and tried to emulate them.

The opportunity to paint his first masterpiece in fresco was given to Tiepolo by the Baglioni family, wealthy publishers and booksellers, recently elevated to the Venetian nobility. Around 1719 they commissioned him to decorate the grand reception room in their villa at Massanzago, near Padua.[9] Tiepolo's handling of illusionistic effects is already extraordinary. Some of the figures stretch off the wall into our space and seem almost to touch us. But their lashless, crystalline eyes stare without seeing. They are creatures from another realm, seen as in a hallucination or a flight of fancy. Tiepolo produced figures, motifs and structural elements for this fresco which he would subsequently continue to develop. Thereafter he would be commissioned frequently to decorate rooms with fresco, the medium that seemed to suit best his talents and which permitted him to work on huge surfaces; in the case of the Residenz in Würzburg, the surface was so large that it represented the whole world.

Tiepolo's first commissioned ceiling fresco in Venice was undertaken *c.* 1724–5 in the palace of a recently ennobled family of lawyers, the Sandi; to a somewhat abstruse mythological theme, illustrative of the power of eloquence and music, he gave a surprising naturalness. He invested his characters with passion, with sensibility, even with a primitive savagery here and there. He used no architectural elements; the only backdrop is the sky (fig. 29). His divinities appear in the centre, and the episodes are scattered around the cornice following the precedent of Luca Giordano's vault of the gallery in Palazzo Medici-Riccardi in Florence, painted in 1682. The compositional structure of this fresco foreshadows the design of Tiepolo's much grander frescoes in Palazzo Clerici in Milan, above the great staircase of the Residenz in Würzburg and in the throne room in the Royal Palace in Madrid.

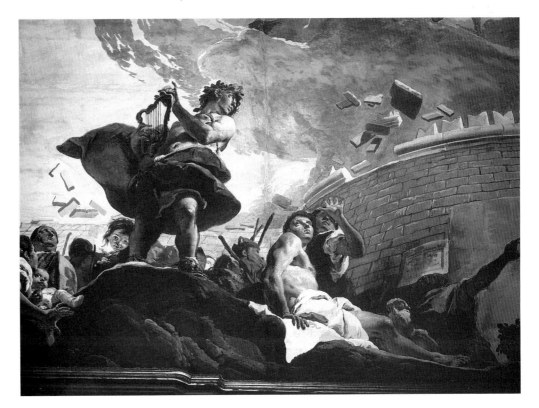

*Figure 29:* Giambattista Tiepolo, *Amphion Builds the Walls of Thebes* (detail), from the *Allegory of Eloquence*, fresco, *c.* 1724–5, Palazzo Sandi, Venice

*Figure 30:* Giambattista Tiepolo, *The Angel Appearing to Sarah*, fresco, (?)1723, Palazzo Arcivescovile, Udine

The young Tiepolo's most brilliant fresco decorations are in the Palazzo Arcivescovile (formerly Patriarcale), Udine. These were commissioned by Dionisio Dolfin, the Patriarch of Aquileia, who belonged to one of the oldest and most illustrious families in Venice. The date of the decoration of the gallery is more likely, in my opinion, to be 1723 than 1726-7 (as has generally been supposed). Tiepolo's contemporaries found it 'the work most excelling in skill and intellect, rivalling even the most outstanding of the painters of antiquity'.[10] In the Villa Baglioni Tiepolo had treated the space as a single environment, open to the heavens. Here, on the other hand, he filled the walls with *trompe l'œil* paintings alternating with niches containing statues. He designed this in collaboration with his *quadraturista*, the gifted Gerolamo Mengozzi Colonna, who worked with him on some of his most spectacular enterprises. Colonna surrounded everything – pictures and statues – with a fake cornice embellished with marble, gold, lapis lazuli vases, masks and delicate plasterwork. The frescoes simulate architecture, sculpture and painting; they even take up the challenge to simulate life itself and outdo expectation. Tiepolo's triumph here is not the way he transports us into another realm, but the way he demonstrates how a painted scene can captivate by its immediacy, its lifelike quality, its very fragrance. The clearest light, clearer than any seen hitherto in Tiepolo's painting, bathes the scene, heightening the colour; here even more than in Veronese's work the colour appears to have been distilled from the essence of spring flowers.

Tiepolo has gathered together a crowd which is half peasant, half gypsy, somewhat in the manner of Benedetto Castiglione in his large biblical scenes; he portrays them with enormous verve and expressiveness. His crowd feels perfectly at home with the angels, which appear in six out of the eight scenes; his angels are among the most seductive to be found in 18th-century painting. Each is different from the other, they have only their youth and beauty in common. They belong to a breed which will appear frequently in Tiepolo's paintings and here have an elfin quality, a look of the genie in *A Thousand and One Nights* (fig. 30).

The frescoes in the Gallery, of higher quality than anything Tiepolo had painted to date, also mark the end of a phase in his career. None of his later paintings contain the same combination of magic and humour, of stylised and allusive composition and narrative directness. It is as if, when he finished these frescoes, he underwent the kind of change that singers undergo as they get older: their pitch alters and they shift from, say, tenor to baritone. In his other large-scale work commissioned by the Dolfin family, finished in 1729, he created a new, heroic style. This commission was for a cycle of ten canvases illustrating episodes from Roman history, designed for the great hall of the family palace in Venice and now scattered between the Hermitage, St Petersburg, the Metropolitan Museum of Art, New York, and the Kunsthistorisches Museum, Vienna. These were commissioned by the brothers of the Patriarch of Aquileia: Daniele III, a talented orator and ambassador of the Venetian Republic, and Daniele IV, a brave soldier who lost his left hand in the battle of Metelino in 1690 against the Turks. Later Tiepolo painted a posthumous portrait of Daniele IV wearing a white glove on his left hand. The glove is lifeless, hollow and stiff like the shell of a crustacean. While hiding his missing left hand it also draws attention to the mutilation (fig. 31).

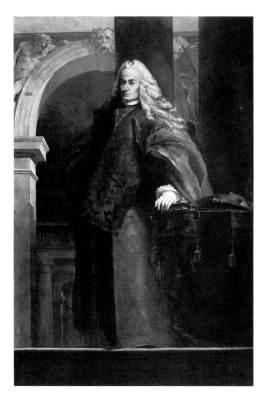

*Figure 31:* Giambattista Tiepolo, *Daniele IV Dolfin*, oil on canvas, 235 × 158 cm, *c.* 1755, Pinacoteca della Fondazione Scientifica Querini Stampalia

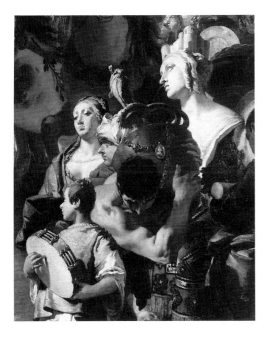

*Figure 32:* Giambattista Tiepolo, *The Triumph of Marius* (detail), oil on canvas, 480 × 370 cm, The Metropolitan Museum of Art, New York, Rogers Fund, 1965

Tiepolo understood the Dolfins' wishes completely, and painted for the family the most interesting history paintings that Venice had seen since the 16th century. Considered in relation to contemporary events (from 1718, with the Treaty of Passarowitz, the Serenissima withdrew into neutral isolation) these heroic deeds, battle scenes and military victories convey outdated messages; they extol courage of a kind which there was no longer any opportunity to display. Tiepolo projects the past into the present, recreating it with an enthusiasm only paralleled in the work of Rubens; the two triumphal processions on the largest canvases, seen from the front, appear to move inexorably towards the onlooker; the light from the side develops and strengthens through the whole spectrum (fig. 32). The clash of colours matches the vigour of expression; Tiepolo seems to have acted on the suggestion made to him by the author and playwright Scipione Maffei, who was in correspondence with the painter at least from from the early 1720s, to 'pay great attention to the expression of feelings'.[11] The aged aristrocrat must have remembered the thunder of battle, and indeed bore the scars of war as proof of his courage; Tiepolo offered him a thrilling waking dream. He also provided illustrations to Maffei's book, *Verona Illustrata* (cat. 95).

95

GIAMBATTISTA TIEPOLO
Plates and vignettes in Francesco Scipione Maffei, *Verona illustrata*, published in Verona by Jacopo Vallarsi and Pierantonio Berni
*c.* 1724
etching and engraving, *c.* 41 × 54 cm (open book)
The British Library Board, London

It is in relation to paintings like those painted for the Dolfin family that Zanetti's comments, published in 1733 (the earliest printed comments on Tiepolo's work), seem relevant: 'his great merit is his ready *invenzione*; he introduces great numbers of figures, each one distinct, each one new and different ... he combines a precise knowledge of chiaroscuro with great beauty'. Tiepolo had by this time made his first trip outside the Republic. He went to Milan to work on frescoes in the Palazzo Archinto and the Palazzo Casati (1731–2), then to Bergamo to paint frescoes in the Colleoni chapel (1732–3). By now he was recognised as a specialist at this kind of decoration. He painted a series of ceilings in the Palazzo Archinto, in one of which he repeated the subject of his first secular fresco, *Phaeton Requesting Apollo to Drive his Chariot*. In this version, however, unlike that at Villa Baglioni, Apollo is the main character, glittering in the light emitted by his own body. This Apollo, 'beautiful, beneficent, radiant, indeed the essence of illumination and enlightenment in the world, became for Tiepolo more than a myth. It is as though in Apollo he sees the source of his own power as an artist'.[12]

This may be the moment to consider Tiepolo's graphic work, an essential aspect of his art. From the start of his career he had enjoyed drawing as an additional means of expression, with equally original results. He did not draw simply to make an immediate note of his ideas, nor to

96

GIAMBATTISTA TIEPOLO
*St Jerome in the Desert Listening to the Angels*
*c.* 1732–5
pen and brown ink and brown wash,
heightened with white over black chalk, on buff
paper, 42.5. × 27.8 cm
National Gallery of Art, Washington,
The Armand Hammer Collection

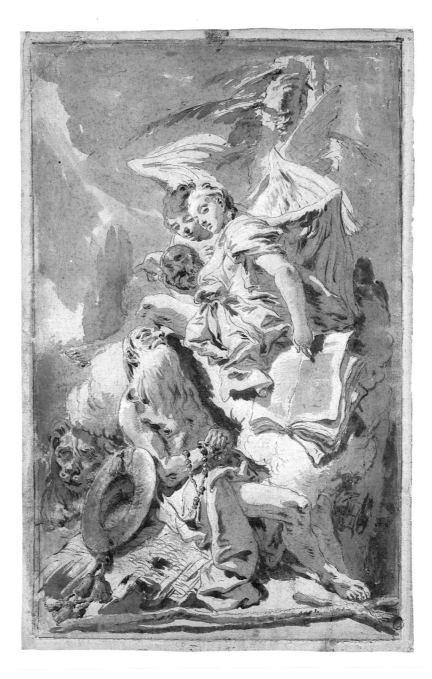

GIAMBATTISTA TIEPOLO
*Hercules*
1720s
black chalk, 60 × 44 cm
The Pierpont Morgan Library, New York
The Janos Scholz Collection

GIAMBATTISTA TIEPOLO
*The Beheading of a Male and a Female Saint*
*c.* 1732–3
pen and brown ink, brown wash, heightened
with white, over black chalk, 49.8 × 36.6 cm
Lent by The Metropolitan Museum of Art,
New York
Rogers Fund

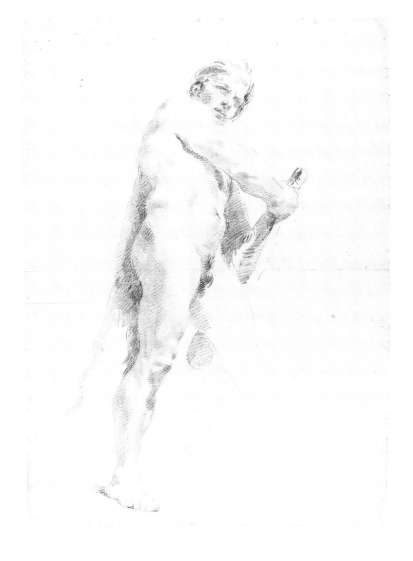

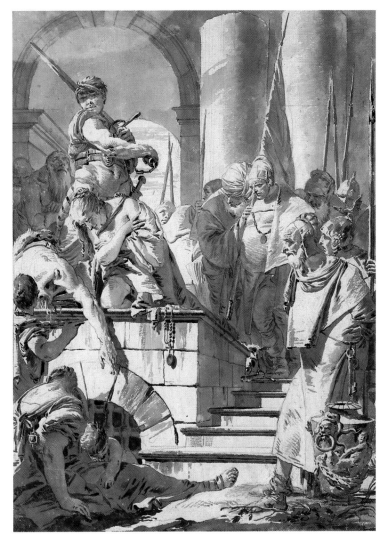

make an initial sketch for a painting or to study details; he drew to give the freest, most complete expression to his genius. His drawings can be considered as an autonomous artistic genre; they constitute an enormous part of his work, giving expression to a quite extraordinary excursion of the imagination; in this respect Tiepolo's graphic work can be compared only with that of Rembrandt.

During the 1730s and 1740s he produced drawings conceived as separate, finished works of art in pen and wash, sometimes heightened with white lead. It was undoubtedly to these that Vincenzo da Canal was referring in 1732 when he described Tiepolo's drawings that were sought out by engravers and copyists alike, and which were so popular that Tiepolo had sent entire collections of them 'to the most distant countries'. An excellent example is *St Jerome in the Desert Listening to the Angels* (cat. 96), later engraved by Pietro Monaco, or the sheet of *The Beheading of a Female Saint* (cat. 98) in which Tiepolo displays his heroic style. The subjects frequently recur, but the interpretation differs every time, just as they do in 18th-century musical variations on a theme. One of Tiepolo's favourite subjects, *The Adoration of the Shepherds* (cat. 101) gave him the possibility of combining the realistic depiction of peasants with the magical effects of the light emanating from the infant Jesus.

99

GIAMBATTISTA TIEPOLO
*Virgin and Child Adored by Bishops, Monks and Women*
*c.* 1735
pen and brown ink and brown wash over black chalk, 42.6 × 30 cm
National Gallery of Art, Washington
The Armand Hammer Collection

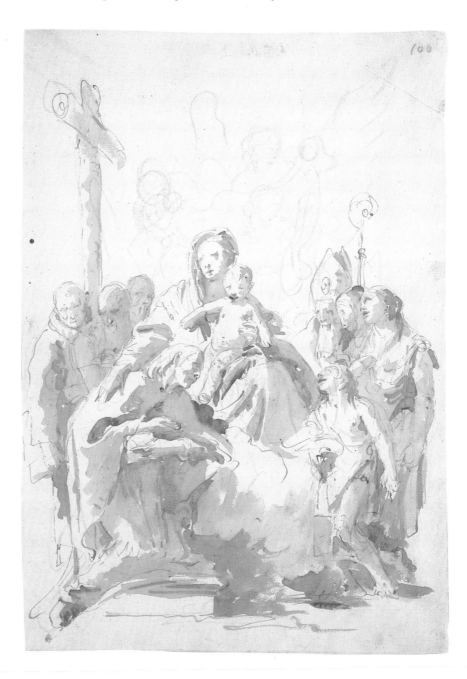

100

GIAMBATTISTA TIEPOLO
*The Meeting of Antony and Cleopatra*
*c.* 1745
pen and brown ink and brown wash, over a
little black chalk, 40.8 × 29.2 cm
Lent by The Metropolitan Museum of Art,
New York
Rogers Fund

101

GIAMBATTISTA TIEPOLO
*The Adoration of the Shepherds*
mid-1730s
pen and brown ink with brown wash over black
chalk on laid paper, 42 × 30.1 cm
National Gallery of Art, Washington
Ailsa Mellon Bruce Fund

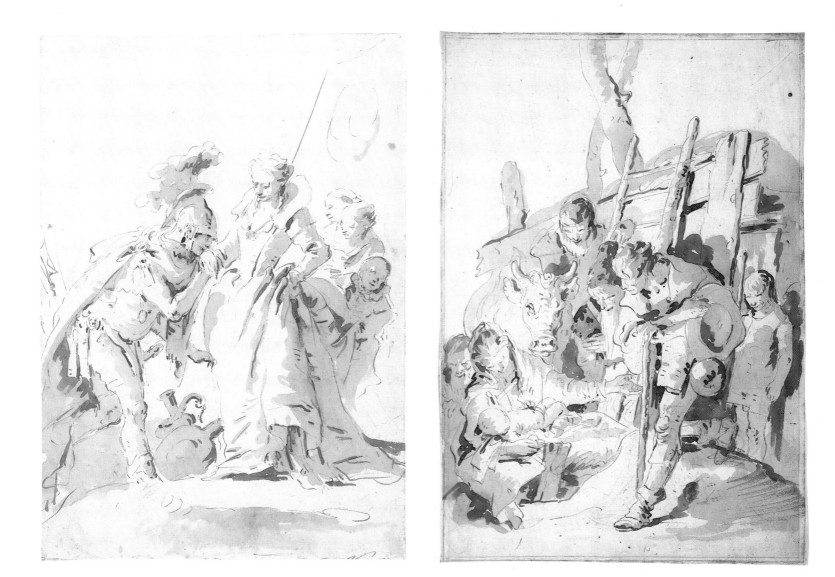

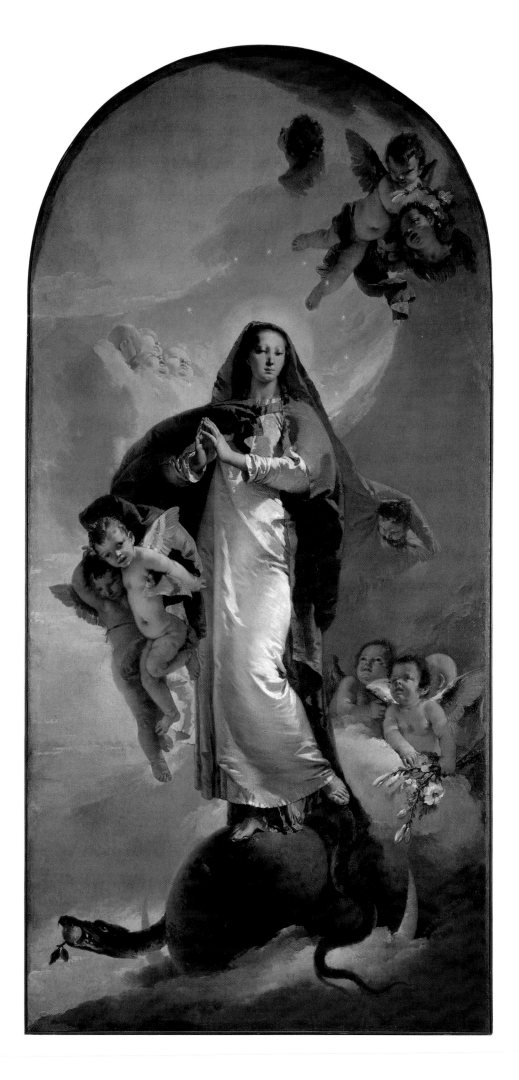

102

GIAMBATTISTA TIEPOLO
*The Immaculate Conception*
1734–5
oil on canvas, 378 × 187 cm
Pinacoteca Museo Civico di Palazzo Chiericati,
Vicenza

To return to the paintings, from the early 1730s Tiepolo began to experiment with light effects, applying those he could obtain in frescoes to his oil paintings. A commission for an altarpiece of the *Immaculate Conception* (cat. 102) for a church in Vicenza came his way because of the originality of his style. What other living painter could have portrayed so powerfully the Virgin 'wrapped in the sun, with the moon beneath her feet and a crown of twelve stars on her head'? Some years earlier Piazzetta had painted an altarpiece of the *Ecstasy of St Francis* (cat. 75) for the same church; he had depicted an evening scene, full of intense feeling; the painting is shot through with mysterious flashes of light. Tiepolo followed a different course, although not rejecting Piazzetta's lessons in realism and composition; he was inspired by the monumental figure of the Virgin, a true ivory tower, in Piazzetta's altarpiece in the church of the Fava in Venice (cat. 72). Tiepolo by now was working with light and colour rather than light and shade; the result is a verisimilitude analagous to that achieved by Canaletto in his view-paintings. A real sun illuminates the vision, which itself creates a powerful illusion of reality, though the brushstrokes and paint are clearly visible: this should remind us that we are in the presence of an artistic genius. This subject gave Tiepolo the opportunity to show his skill as a painter of feminine beauty, in this case beauty transcending human nature; above all it permitted him to try the virtuoso cadenza of the blue cloak and white silk dress of the Blessed Virgin, the raiments that reveal her celestial origins and her conception without the stain of original sin. No other Venetian painter of the day was able to achieve similar effects; Tiepolo's only rival was Veronese, and some years later Tiepolo was dubbed '*sectataire de Paul Véronèse*' by Count Tessin.[13]

Tessin arrived in Venice in 1736, charged with finding a fresco painter to decorate the Royal Palace in Stockholm. He had wisely chosen Venice as the appropriate place to look; the Venetian school of painting was pre-eminent in Italy at the time, both for the number and the quality of painters and for the variety of styles on offer; Tessin emphasised both these advantages in a letter to the clerk of works at the Royal Palace. The Venetian painters had made an international reputation for themselves as decorators on a grand scale: Ricci, Amigoni and Pellegrini had enlivened palaces throughout Europe, harmonising Baroque grandeur with charm, another element required by the century. Ricci was dead, Amigoni living in London, Pellegrini getting old; Tessin at once identified Tiepolo (who had already been recommended to him before he reached Venice) as the painter likely to answer to his requirements. He was a successor to Veronese, who could paint 'a Picture in less time than it would take another to mix his colours'; he was in addition possessed of 'infinite warmth; brilliant colours'. It did not matter if he was on occasion guilty of excess, if even the beggars in his paintings were luxuriously dressed. This was just 'the fashion of the day'. Everything was perfect, except that Tiepolo, aware of the market value of his work, was asking for too much money. The project failed, the King of Sweden lost his chance. But Tessin acquired two exquisite small canvases for himself: the *modello* of the *Beheading of John the Baptist* (National Museum, Stockholm), and a mythological painting, *Danaë and Jupiter* (cat. 103) which Tessin, attracted by 'all charming and mirthful subjects,'[14] must have particularly appreciated. His choice was clever: both paintings have a female protagonist, and they illustrate Tiepolo's ability to paint in a variety of genres, both the dramatic and the voluptuous.

103

GIAMBATTISTA TIEPOLO
*Danaë and Jupiter*
1736
oil on canvas, 41 × 53 cm
Stockholm University

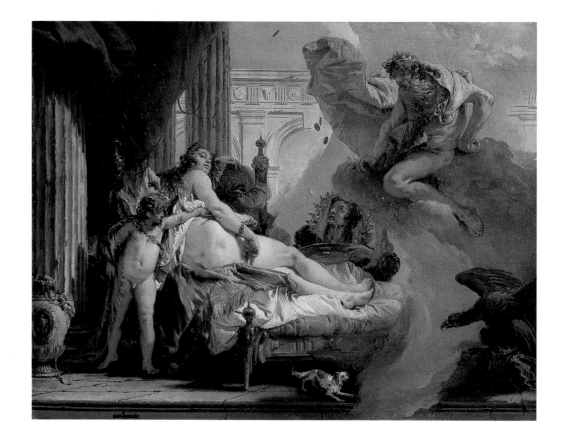

104

GIAMBATTISTA TIEPOLO
*The Finding of Moses*
*c.* 1740
oil on canvas, 202 × 342 cm
The National Galleries of Scotland, Edinburgh

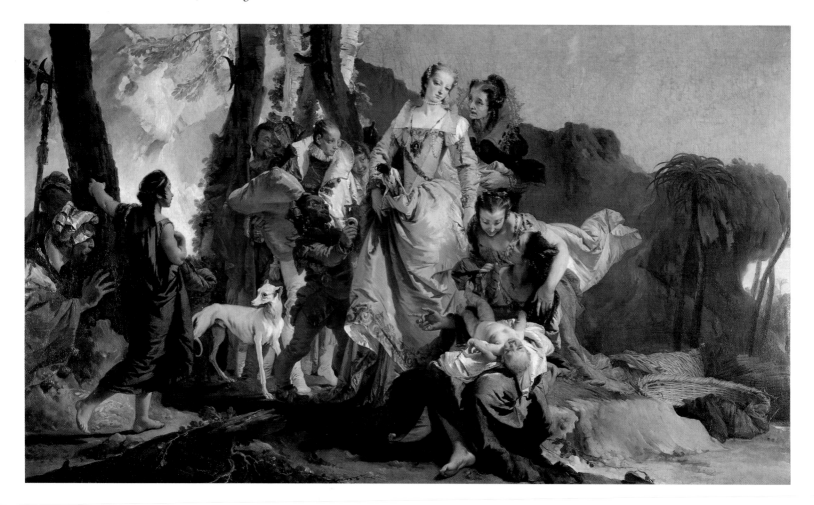

In the brilliantly coloured *Danaë* Tiepolo combined 16th-century opulence with mocking humour, as if he were using the palace as a house of ill-repute. The subject had been made famous by Titian, and Tiepolo borrowed the figure of the old woman, greedily catching the coins thrown by Jupiter on a plate, from one of Titian's versions (Kunsthistorisches Museum, Vienna), which Tiepolo knew from an engraving. In Tiepolo's version Danaë has become a lazy courtesan whom the naked Eros is trying to rouse. Looking back over her shoulder towards the spectator she affects not to recognise the illustrious but hardly attractive client: Jupiter, straddling a cloud, is old and dishevelled. The welcome extended to Jupiter's eagle by Danaë's small dog is no warmer. Among Tiepolo's contemporaries only Voltaire could have retold the myth with such freedom. The final impression given by the painting is of pearly flesh, golden fabrics unfurling in the breeze, serene Palladian architecture, crystalline light and diaphanous half-shadows. The painting is a performance in itself, guaranteed to arouse sensual feelings.

By this time Tiepolo had assembled quite a company of actors for his paintings, and part of the pleasure of looking at his work is to recognise members of his troupe in various roles and situations. For example, wearing exactly the same dress with a big lace collar, the old woman in the *Danaë* reappears next to the daughter of Pharaoh in *The Finding of Moses* (cat. 104). This is a large painting, probably designed for the reception room of a Venetian palace. The right-hand side, comprising a broad river valley and the figure of a halberdier to complete the composition, was cut off at an early date (fig. 33).

Count Tessin's comments are more relevant to *The Finding of Moses* than to any other of Tiepolo's works. It is an overt tribute to Veronese, inspired by two of the master's paintings of the same subject: the wonderful canvas from Palazzo Grimani (now in the Gemäldegalerie, Dresden) and one that once belonged to Philippe d'Orléans (now in the Walker Art Gallery, Liverpool), known to Tiepolo through an engraving by Brebiette. The baby is copied from the latter. Sebastiano Ricci also painted a *Finding of Moses* (Palazzo Taverna, Rome) using the Grimani painting as a model, and displaying his skill in imitating styles. If, as is probable on stylistic grounds, Tiepolo painted this soon after Ricci's death, his intention would also have been to assert his position as the leading exponent of the Veronese revival begun by Ricci himself. For 18th-century connoisseurs, Veronese was the painter whose paintings 'were the most agreeable, the most pleasing, the noblest ...', combining intelligence, wealth of detail and elegance'. The straightforwardness of his technique, in which 'every brushstroke can be counted', was admired, as was the variety of his characters, 'the aspect of his heads', the strangeness of the costumes 'mainly in the oriental fashion'.[15] It is precisely these aspects that Tiepolo makes his own; but his recreation turns the scene into a marvellous costume ball, halfway between fantasy and reality. Tiepolo's art, and particularly a painting like this one, can be defined in the words used by his contemporary to define poetry: it is 'a dream conducted in the presence of reason', that is, with the awareness that it is a dream.[16] The young girl on the left (the sister of Moses, according to the Bible story) stands in amazement, enchanted (as we are) by the appearance of the beautiful princess and her train. In contrast, the weeping baby represents the sudden intrusion of reality in the middle of a dream. Pharaoh's daughter is dressed in a 16th-century yellow silk gown. She is still a girl. On her face, which is juxtaposed with the anxious, wrinkled face of the old nurse (typical of Tiepolo's taste for contrasts), there is a hint of melancholy, as if her beauty were a burden to her. Some years later she reappears, grown up and confident, as Cleopatra.

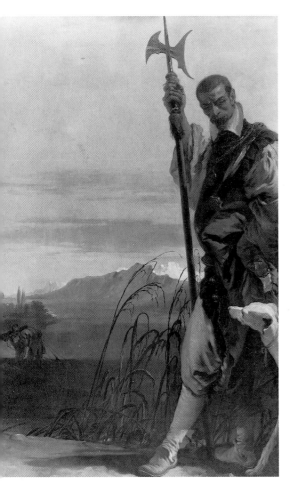

*Figure 33:* Giambattista Tiepolo, *The Halberdier*, oil on canvas, 205 × 132 cm, *c.* 1736–40, Private Collection, Turin

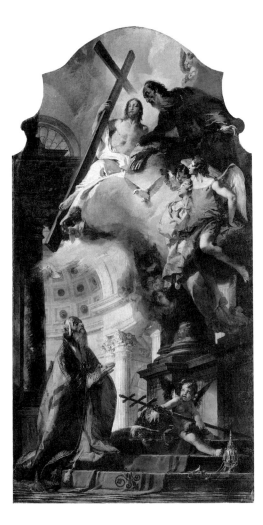

*Figure 34:* Giambattista Tiepolo, *The Vision of St Clement*, oil on canvas, 488 × 256 cm, before 1739, Alte Pinacothek, Munich

After the death of Sebastiano Ricci in 1734 the history painters competing for pre-eminence were Tiepolo, Piazzetta and Pittoni. Tiepolo was the youngest. All three enjoyed an international reputation: during the mid-1730s all three were commissioned by the Archbishop Elector of Cologne, Clemens August von Wittelsbach, to paint large altarpieces for churches in Bavaria. Tiepolo's altarpiece, *The Vision of St Clement* (fig. 34), dating from before 1739, was painted for the church of Our Lady at Nymphenburg. It is the most imposing altarpiece he ever produced and obviously well-suited to the function for which it was commissioned, as propaganda for the Catholic Church. The Nymphenburg altarpiece marks the beginning of Tiepolo's full maturity, during which period he executed a number of large decorative schemes, sacred and profane. His rising star was reaching its zenith. These were years of intense, ceaseless activity for Tiepolo; he relaunched the Baroque in his own style; at the same time, harking back again to Veronese, he launched a second Venetian Renaissance.

On the ceiling of the gallery of the Milan palace of Giorgio Clerici, frescoed by Tiepolo in 1740, Apollo, the triumphant god of light, stands holding the reins of his chariot. This was the most extensive fresco Tiepolo had painted to date: scattered through the heavens and round the edges of the cornice, he assembled the whole Greek pantheon, the gods presiding over the four elements and the Seasons, the Horae, the winds, nymphs of springs and streams, cupids, satyrs, personifications of the arts and sciences and personifications of the continents. Here they are recreated with marked leanings towards the exotic and the strange, with ambiguous sensuality, as they take part in this *divertimento* without limits (fig. 35). The subject may have been suggested by the decoration of the French palaces during the reign of Louis XIV; it was also chosen because it referred to the beneficent power of an enlightened monarch (Maria Theresa, Empress of Austria – whose marshal Giorgio Clerici was to become – who ascended the throne that year). In fact the subject is treated as the apotheosis of the creative imagination and the seductive power of art. Appropriately, a collection of poetry published to celebrate the fresco was dedicated not to Clerici, the patron, but to 'the outstanding merit of Sig. G. B. Tiepolo, the illustrious Venetian painter'.

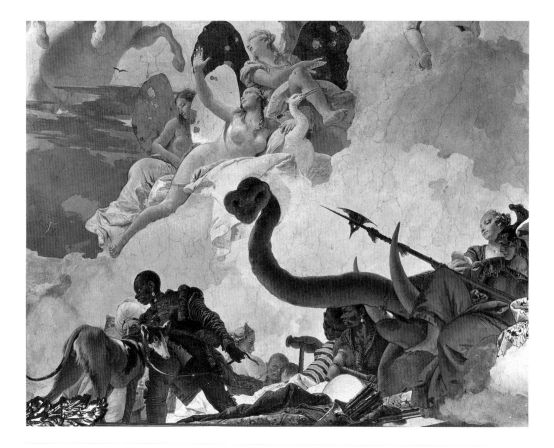

*Figure 35:* Giambattista Tiepolo, *The Course of the Chariot of the Sun* (detail showing 'Africa'), fresco, 1740, Palazzo Clerici, Milan

This painting engaged Tiepolo's imagination more than anything he had done hitherto. There is a vast number of preparatory drawings of single figures and groups. Tiepolo was an indefatigable draughtsman, certainly one of the most gifted in the history of European art, and these are some of his most admirable works (cat. 105, 106). He drew in order to find the most satisfactory solution for each figure, and also to give rein to his imagination under the stimulus of the general theme. He set his images down rapidly, using the white of paper as a source of light. To consolidate the forms and to make the areas of light stand out he used transparent patches of wash and some dark, almost black, shading. Even when drawing Tiepolo practised 'the great art of contrast': the greatest economy of means to give the best result. Unlike other painters, Tiepolo did not avail himself of 'the most beautiful of the colours that can be used for fresco painting', nor did he search for new shades all the time; he used 'subdued, rather dirty colours', 'the most ordinary shades', or sometimes 'quite beautiful, clear shades', to create the effect of 'sunshine without compare'.[17] The sun in his drawings shines just as brightly as in his paintings, and it is no surprise to see that his characters have half-closed eyes, as if the light surrounding them was almost too bright to bear.

105

GIAMBATTISTA TIEPOLO
*Reclining River God, Nymph and Putto*
*c.* 1739–40
pen and brown ink, dark brown and lighter
brown wash, over black chalk, 23.5 × 31.3 cm
Lent by The Metropolitan Museum of Art,
New York
Rogers Fund

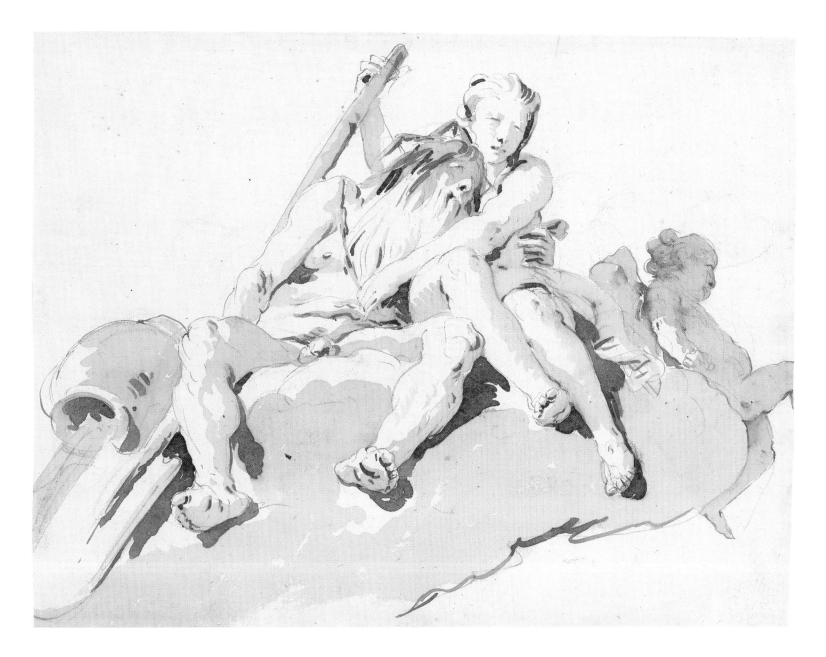

As was his usual practice, Tiepolo had prepared himself well for the job in the Clerici palace, producing a *modello* of what he planned to do (cat. 107), although it is in fact very different from the fresco. Tiepolo's finished works were never simply large-scale versions of his models; according to the shape and size of the surroundings, the position of the spectators and the sources of light, he would make quite sweeping modifications to the original plan. He created as he went along, and it was in the finished product alone that the full sweep of his imaginative and expressive powers could be properly appreciated. The model for the Palazzo Clerici shows a centripetal plan with the figure of Apollo as its axis. The fresco, in a vast gallery, is organised with two focal points: one around Apollo in his chariot (the sun god rather than the Apollo of the Muses as in the *modello*), the other around Venus and Saturn. Lacking the central planning of the *modello*, the fresco is much livelier, more animated and much freer. Along the edges the figures are disposed singly and groups, creating a serpentine border that meanders like *rocaille*.

From the late 1730s Tiepolo was involved in painting a series of religious paintings in Venice; the subjects were mostly connected with contemporary theological questions.[18] They provide an insight into 18th-century religion, as does the sacred music of Handel, Vivaldi or Bach. This is particularly true of his ceiling paintings, all focused on the glorification of the Virgin Mary, which include the church of the Gesuati (1738–9), the church of the Scalzi (1743–5; destroyed in World War I), the Scuola Grande dei Carmini (1740–9; fig. 36) and the Pietà (1754–5). Tiepolo harks back to (and transcends) Veronese's ceiling paintings, and to the Baroque tradition with figures suspended in mid-air.

106

GIAMBATTISTA TIEPOLO
*Apollo Standing in his Chariot*
*c.* 1739–40
pen and brown ink, pale and dark brown wash, over black chalk, 24.2 × 24.3 cm
Lent by The Metropolitan Museum of Art, New York
Rogers Fund

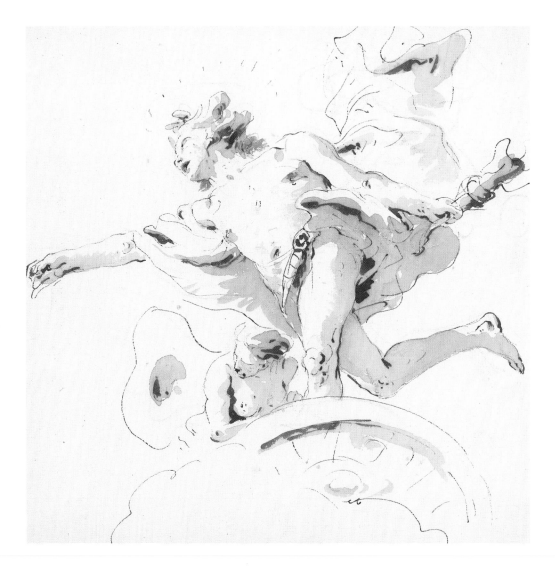

GIAMBATTISTA TIEPOLO
*The Course of the Chariot of the Sun*
1740
oil on canvas, 63 × 99 cm
Kimbell Art Museum, Fort Worth, TX

*Figure 36:* Giambattista Tiepolo, *The Virgin
Appearing to St Simon Stock* (detail), oil on
canvas, 533 × 342 cm, 1740–4, Scuola Grande
dei Carmini, Venice

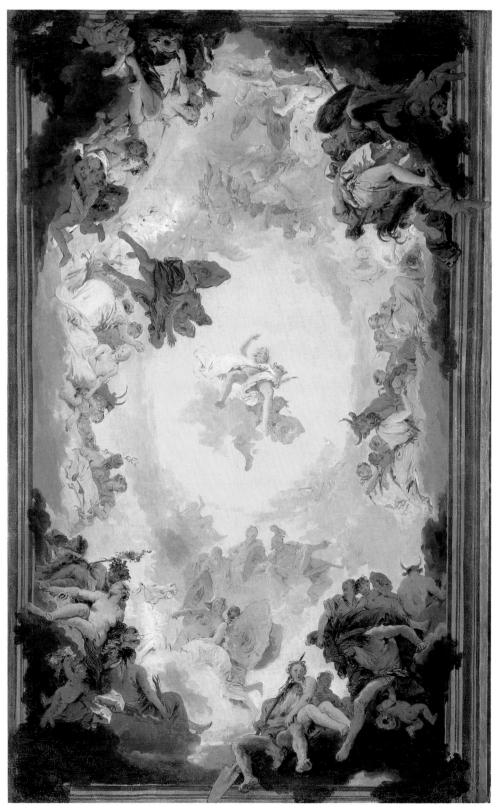

108

GIAMBATTISTA TIEPOLO
Headpiece and tailpiece in John Milton, *Paradiso
perduto*, published in Verona by Gian Alberto
Tumermani, 1742
etchings, *c*. 37.2 × 52 cm (open book)
The British Library Board, London

DELLA TRADUZZIONE
DEL
PARADISO PERDUTO
LIBRO DECIMO.

DELLA

Even when engaged in large-scale paintings, Tiepolo did not reject more modest commissions such as designing book illustrations; an example is the edition of *Paradise Lost* (cat. 108), published in 1742. He also took part in a project, which may have been intended for the Regatta of 1740 in honour of Frederick Christian of Poland, for a fabulous *bissona* (fig. 4), designed to amaze the crowds when it appeared on the waters of the Grand Canal. This was a barge such as Cleopatra might have used to travel up the River Nile on her way to meet Antony.

109

GIAMBATTISTA TIEPOLO
*The Adoration of the Magi*
*c.* 1753
etching, 43.1 × 29 cm (platemark)
National Gallery of Art, Washington
Rosenwald Collection

The frescoes in the *salone* of the Palazzo Labia, showing Cleopatra triumphant, were Tiepolo's most important private commission in Venice after the canvases he painted for Palazzo Dolfin. A little less than twenty years had passed (the frescoes are dated *c.* 1745–7), and the difference in choice of subjects, and their significance, could not be more pronounced. This was the first time that the frescoes in any Venetian palace had been painted to create a complete environment, as had been the case in villas and palaces on the mainland. This allowed Tiepolo, working with Gerolamo Mengozzi Colonna, who designed and painted the *trompe l'œil* architecture, to transform the great reception room in Palazzo Labia into the marble halls of Cleopatra's palace. On one side the palace opens on to the river port where the Queen disembarks from her gilded barge to meet Antony; on the other we see the garden and the terrace where she serves a banquet to the Roman commander (fig. 37). Tiepolo and Mengozzi Colonna offer homage to the partnership of Veronese and Palladio. The architecture simulates a theatrical backcloth on each of the two longer walls, and recalls the proscenium of Palladio's Teatro Olimpico. Tiepolo's composition is also directly descended from Veronese's celebrated banquet scenes.

During the 1740s many private palaces in Venice underwent restoration and redecoration. Inevitably Tiepolo was involved. On the ceiling painted for the Procurator Barbaro (*c.* 1750) Valour sits enthroned, portrayed as described in Cesare Ripa's manual, surrounded by Virtues, while Fame blows his trumpet. There were also patrons who preferred subjects closer to modern sensibility: in the early 1740s Manin had a room decorated with paintings illustrating episodes from Torquato Tasso's *Gerusalemme Liberata*, the amorous vicissitudes of the enchantress Armida and the hero Rinaldo (cat. 90). A large and much publicised edition of the poem with illustrations by Piazzetta was published by Albrizzi in 1745. Tiepolo, inspired for the first time by a great poem, created paintings which are almost French in refinement; Boucher comes to mind. The colours are jewel-like, the structure relaxed. This may also be a response to the tender gallantries of Amigoni's mythological paintings, which became fashionable in Venice after his return there in 1739.

*Figure 37:* Giambattista Tiepolo and Gerolamo Mengozzi Colonna, *The Banquet of Cleopatra*, fresco, *c.* 650 × 300 cm, *c.* 1745–7, Palazzo Labia, Venice

GIAMBATTISTA TIEPOLO
*Sculpture of Rinaldo and Armida*, in *Vari Studi e Pensieri*, album bound *c.* 1761
pen and wash, 21.4 × 29.2 cm; *c.* 37 × 23.5 cm (album)
The Board of Trustees of the Victoria and Albert Museum, London

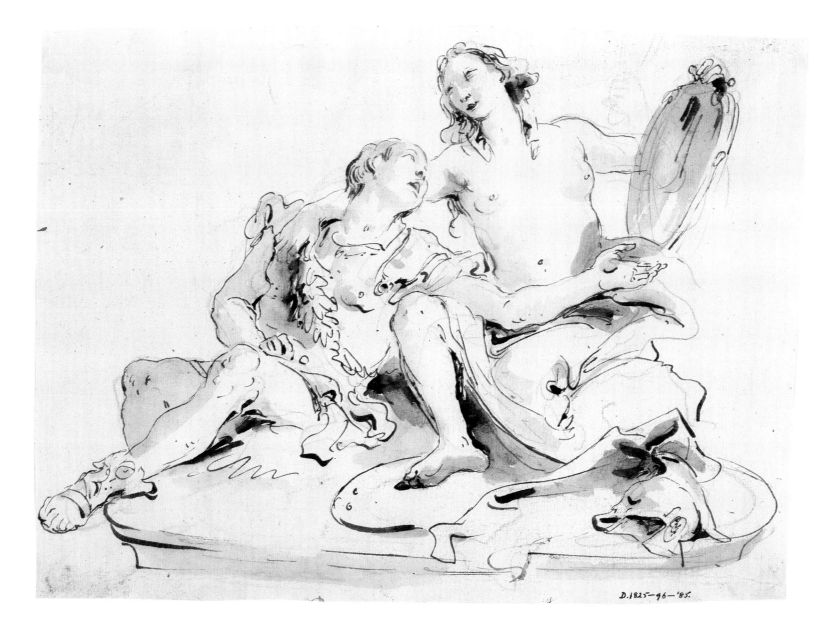

III

GIAMBATTISTA TIEPOLO
*Vari Capricci*
early 1740s
volume of etchings *c.* 48 × 70 cm (open book)
Staatliche Kunstsammlung, Dresden,
Kupferstichkabinett

The open landscapes in these paintings, the sense of suspended action, dazzlingly lit space, are all to be found in Tiepolo's less public work: his etchings. In the early 1740s, when his imagination was engaged in the creation of ever larger public works, Tiepolo seems to have felt the need to concentrate on something smaller, and he began to experiment with printmaking. He was in good company: Marieschi and Canaletto published collections of their etchings in 1741 and *c.* 1744 respectively; between 1747 and 1750 Piranesi published his *Grotteschi* and the *Invenzioni Capricciose di Carceri*. Tiepolo's etchings are like the distilled essence of his work, the mercurial element in his art. He used the copperplate like a magic mirror to reflect some of his innermost thoughts; with titles like *Capriccio* and *Scherzi*, their content is as elusive as their form and composition are straightforward. Among the flotsam of a necropolis where owls nest, gather necromancers and epicene figures, soldiers and young boys, gypsies and satyrs, even a speaking skeleton and Pulcinella. Most belong to the same strange facial type, part oriental, part gypsy, that appears in his paintings, presenting an impassive or ambiguous response, like masked revellers, to the passionate play-acting of the main protagonists. Off-stage they gather in

112

GIAMBATTISTA TIEPOLO
*Scherzi di fantasia*
(?) 1750s
etchings in a folio, with additions in pen and
brown ink, 37 × 53.5 cm (open book)
National Gallery of Art, Washington
Rosenwald Collection

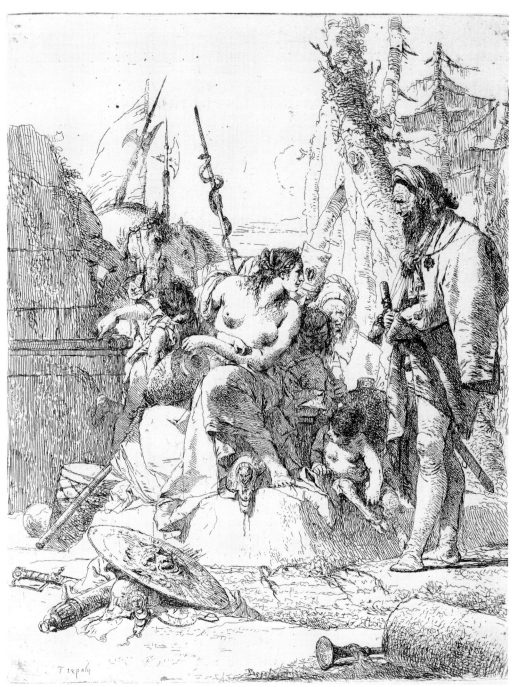

some obscure spot, apparently anxiously engaged in a kind of search. Through these characters, symbolising the contrasting yet complementary themes of life and death, youth and age, primitive instinct and ancient wisdom, the artist seems to be searching for answers to the meaning of life, beyond the conventional codes of allegory. But any possibility of finding the answer is frustrated because the subject-matter is presented as an insoluble enigma. Francesco Algarotti had struck up a close friendship with Tiepolo in 1743, and certainly had the engravings in mind when he described Tiepolo as the 'universal painter with the most fertile imagination ... who has managed to combine the manner of Veronese with the manner of Castiglione and Salvator Rosa and other more eccentric painters'.[19]

Tiepolo's fame had by this time spread throughout Europe. In 1749 he was commissioned to paint an altarpiece depicting *St James the Great* (cat. 113) for the chapel of the Spanish Embassy in London. It appears that the painting, unusually, did not meet with the purchaser's satisfaction, probably for iconographic rather than artistic reasons, and was soon sent back to Madrid. Perhaps a more traditional view of the pilgrim-saint was expected, whereas Tiepolo depicted a heroic figure, a knight without reproach on the whitest of horses, at whose appearance the light seems to have brightened and the blue of the sky grown more intense. The Saint is serene and resolute above the tumult of battle; his upturned eyes tell us that his strength comes from above rather than from weaponry. Not only does St James vanquish the Moor, he converts him too. The Moor bows his head and bends his knee in a pose that combines submission with the posture of a candidate for baptism. The composition is simpler than in Tiepolo's earlier altarpieces: here the structure moves upwards towards the apex of the red and white ensign fluttering in the breeze. The focal point is the face of the Saint, handsome and infused with spiritual feeling. A sentimental streak is emerging, a tendency towards introspection and tenderness that Tiepolo would develop further over the next decade.

The painting reached London in the summer of 1750. In December of the same year Tiepolo arrived in Würzburg, the capital of Franconia, with his painter sons Domenico and Lorenzo. This was his first trip abroad. He had been invited by the Prince-Bishop, Karl Philipp von Greiffenklau, to paint frescoes in parts of the recently built Residenz. The work was completed in 1753.

Tiepolo had been commissioned to paint an apologia for feudalism in its most archaic form, and the result is one of the greatest masterpieces of European art. Balthasar Neumann designed the Residenz, and the frescoes complement the architecture perfectly. In the dining-room, renamed the Kaisersaal after Tiepolo had finished his work, golden curtains made of stucco are drawn back to allow us to witness the marriage of Frederick Barbarossa and Beatrice of Burgundy, and to be present at the investiture of Archbishop Harold. As usual, Tiepolo sets these medieval events in the 16th century, his favoured period for any historical event. The decoration of the vault starts with a vision of Apollo driving a chariot drawn by a team of restless horses; Apollo is taking the Princess of Burgundy to the Genius of the Empire. Nymphs and cupids brim over the cornice, breaking through the stucco floral designs. The sun god has his epiphany in the immense vault over the grand staircase. As in the Palazzo Clerici – but here slim and naked like a revived Apollo Belvedere – Apollo shows himself to the universe, while the Horae prepare his chariot (fig. 1). The sun god rises beneficently, casting his rays over the planetary gods on their thrones of clouds and on the personifications of the four continents, encamped around the cornice. America, Africa, Asia, Europe, in the guise of disturbingly beautiful royal ladies, lead crowded retinues with exotic faces, dressed in a brilliant array of costumes, bearing strange wares and accompanied by animals.

113

GIAMBATTISTA TIEPOLO
*St James the Great Conquering the Moors*
1749
oil on canvas, 317 × 163 cm
Szépmüvészeti Muzeum, Budapest

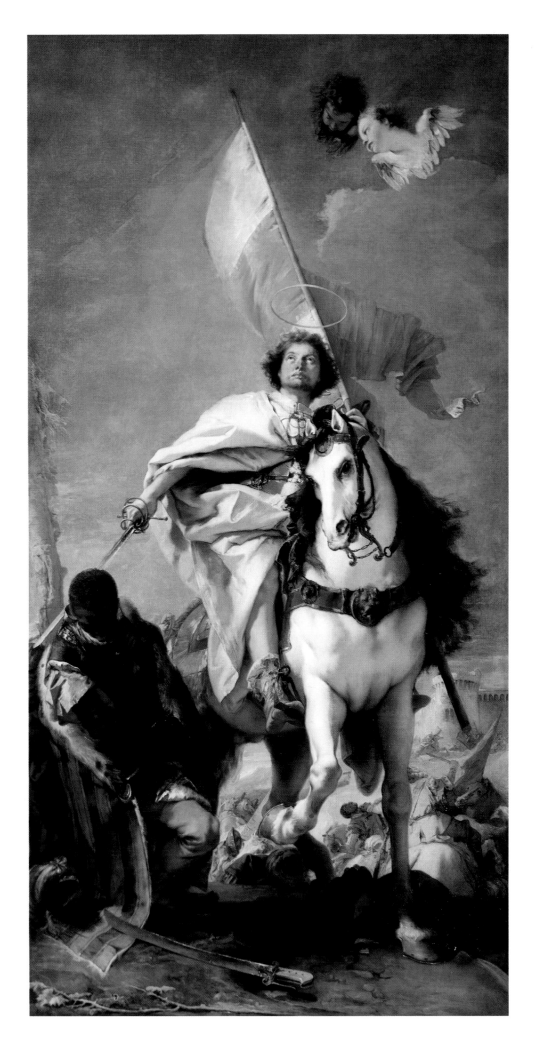

Tiepolo's handling of space magically allows us to witness events that are distant both in time and space. Painting, depicted as a woman colouring the globe, can embrace the whole world. A portrait of the Prince-Bishop is carried aloft by Glory and the Virtues. At the foot of the throne the architect Neumann and the sculptor Bossi can be seen. A group of musicians accompanies the singing of two soloists. The double-bass player is lifted from Veronese's *Marriage at Cana*; Tiepolo hints at the continuity between his painting and 16th-century art. In a corner, like a stage-director in the wings, there is a portrait of Tiepolo himself with his son and assistant, Domenico; the painter's face is strained, as if he were concentrating intently. He has eyes only for the performance he has masterminded.

The Würzburg frescoes marked a turning-point in Tiepolo's career as a decorator on a monumental scale. Although he might continue to cover ceilings with his joyful visions, he was becoming increasingly interested in the expression of emotion, known in the theoretical language of the day as *espressione degli affetti*. In this he might have been encouraged by his friend Algarotti, who had wide-ranging conversations on the subject with Tiepolo, as is evident from

114

GIAMBATTISTA TIEPOLO
*Apollo Pursuing Daphne*
1758–60
oil on canvas, 68.8 × 87.2 cm
National Gallery of Art, Washington
Samuel H. Kress Collection

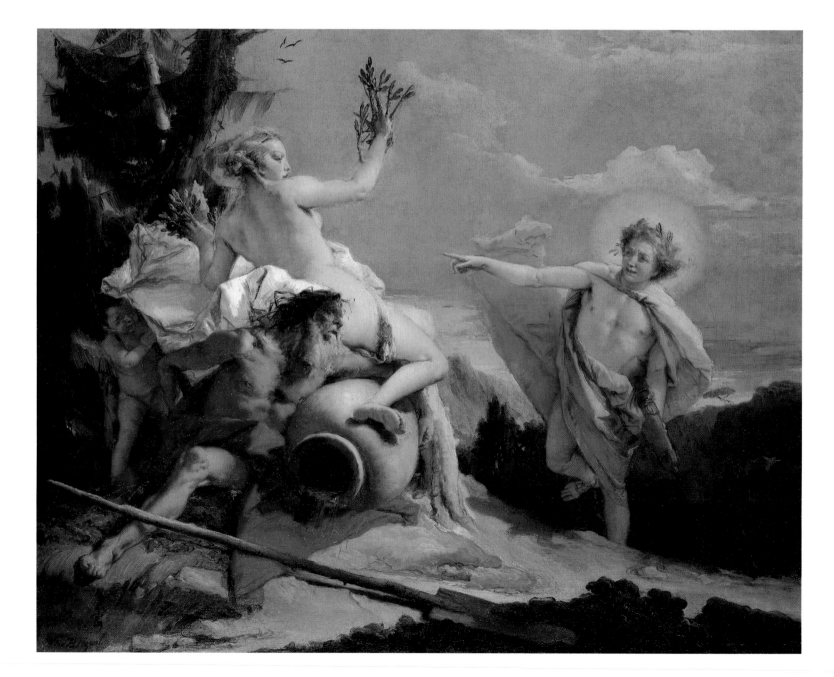

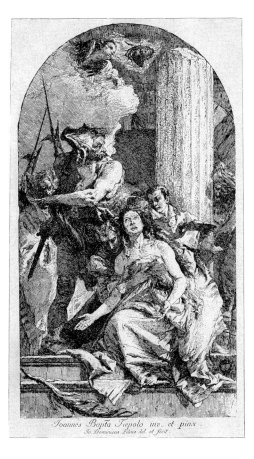

*Figure 38:* Domenico Tiepolo after Giambattista Tiepolo, *Martyrdom of St Agatha*, etching *c.* 1756, Museo Civico, Bassano del Grappa

*Figure 39:* Giambattista Tiepolo, *Rinaldo Leaving Armida* (detail), fresco, 1757, Villa Valmarana, Vicenza

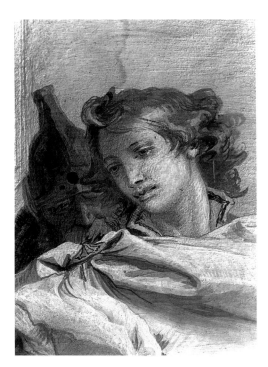

Algarotti's *Essay on Painting* (1762): 'It is not enough for a painter to be able to draw elegant forms, clothe them in choice colours and group them convincingly; to use light and dark colours to disguise the flat canvas, to clothe his figures suitably and to dispose them in graceful positions. He also needs to be able to impart grief and happiness, tenderness and anger; he must be able to write on their faces what they are thinking and feeling, what makes them sentient, communicative beings.'

Once descended from the sky Apollo becomes prey to human emotions. In a painting generally dated *c.* 1758 Tiepolo captures the distress that distorts Apollo's handsome features as Daphne escapes (cat. 114). This empathy had already been evident in his religious paintings, in particular in some of his altarpieces. *The Last Communion of St Lucy* (cat. 118) was painted shortly before his departure for Würzburg, commissioned by the Corner family for their chapel in SS. Apostoli, Venice. The skilful light effects take on a spiritual significance related to the Saint's name (Lucy derives from *lux*, light): it is as if the scene were illuminated by a ray of the supernatural light visible to the inner eye of this young female martyr, whose eyes have been gouged out.[20] The pathos is even more powerful in the *Martyrdom of St Agatha* (cat. 117), painted *c.* 1755 for the Benedictine convent at Lendinara. This is a more dramatic version of the subject painted for the Santo, Padua, admired by Algarotti for the expressive quality of the Saint's face. The emotional impact of this particular *St Agatha* is incomparably greater. The simple construction of the painting with the figures grouped in the foreground make this an extraordinarily involving picture; the drama takes place before our very eyes. The upper part of the altarpiece has been removed: in the etching by Domenico Tiepolo (fig. 38) there is a flaming heart surrounded by a crown of thorns, an emblem, one could say, for a new aspect of Tiepolo's art.

Delicate colour-schemes and subdued states of emotion distinguish the frescoes Tiepolo painted in 1757 in the Villa Valmarana, near Vicenza. Tiepolo was commissioned to illustrate some of the greatest poems of Western literature, ancient and modern: the *Iliad*, the *Aeneid*, *Orlando Furioso* and *Gerusalemme Liberata*. The subjects chosen are linked for the most part by the theme of passion, and the conflict between love and duty; the heroes of antiquity are shown in intimate moments. Achilles, without Briseis, mopes disconsolately on the sea-shore; Aeneas despairs at the gods' command that he should leave Dido; Angelica stoops sorrowfully to help the wounded Medoro; Rinaldo casts a final glance of desire at Armida. These are crucial moments in the stories; Tiepolo felt them keenly and depicted them with extraordinary originality (fig. 39). As a prelude the fresco in the entrance hall tells the story of the *Sacrifice of Iphigenia*: this is *musica da camera*, with impassioned solo arias and duets. The words written by Gluck's librettist Ranieri Calzabigi, a contemporary of Tiepolo, *à propos* of the plays of Metastasio, are just as relevant to paintings like these: he wrote that it is not possible 'to read or to see his tragedies on stage without being interested in the passion he wishes to express, without growing angry when the hero is enraged, without feeling compassion when he is moved to tears'.[21]

115

GIAMBATTISTA TIEPOLO
*Head of an Oriental*
*c.* 1760
red chalk washed with water on white paper,
28.5 × 20.5 cm
Fogg Art Museum, Harvard University Art
Museums, Cambridge, MA
Francis H. Burr Memorial Fund

116

GIAMBATTISTA TIEPOLO
*Head of St Agatha*
*c.* 1750
red and white chalks on bright blue paper,
26.8 × 17.5 cm
Staatliche Museen Preussischer Kulturbesitz,
Kupferstichkabinett, Berlin

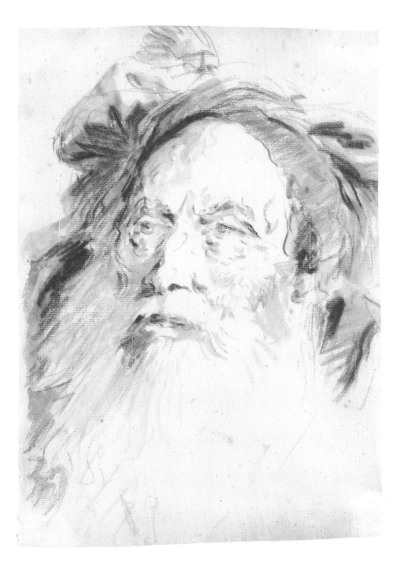

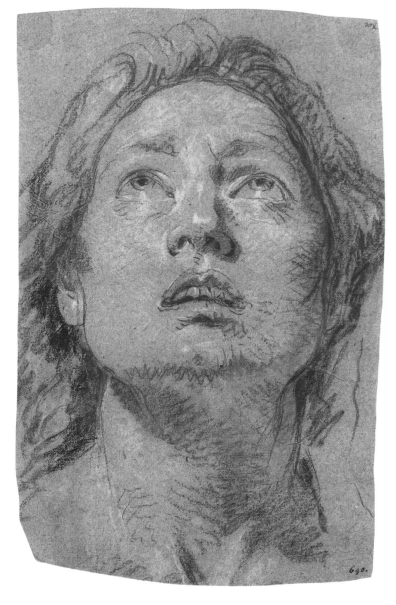

117

GIAMBATTISTA TIEPOLO
*Martyrdom of St Agatha*
*c.* 1755
oil on canvas, 184 × 131 cm
Staatliche Museen Preussischer Kulturbesitz,
Berlin, Gemäldegalerie

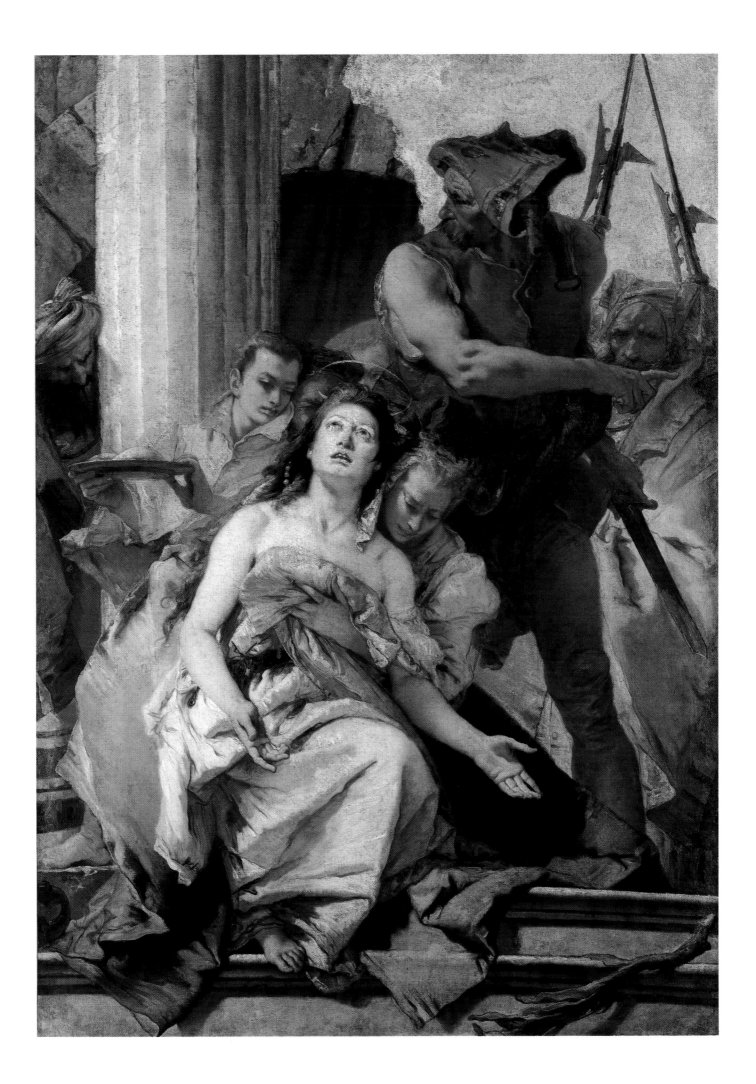

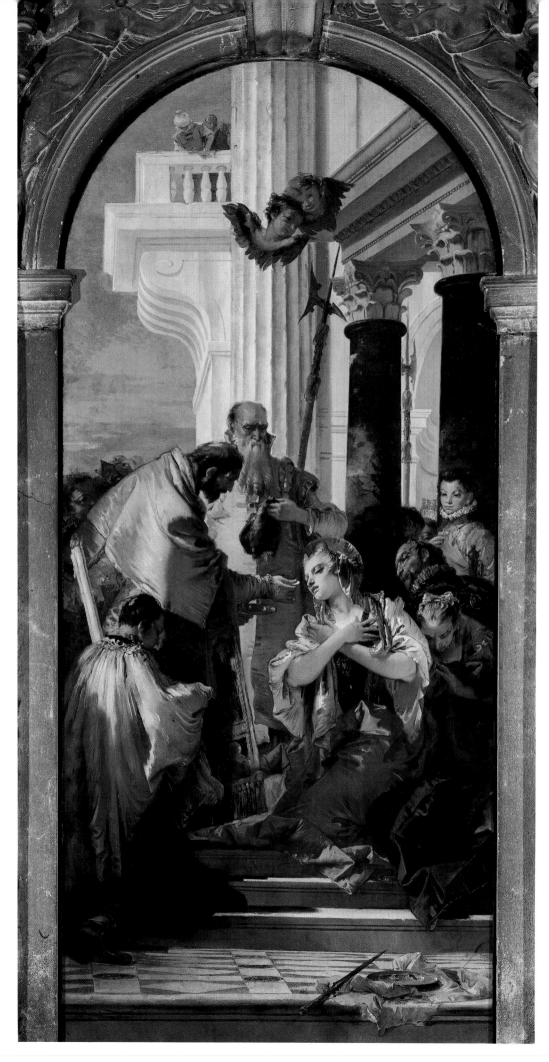

118

GIAMBATTISTA TIEPOLO
*The Last Communion of St Lucy*
1748–50
oil on canvas, 222 × 101 cm
SS. Apostoli, Venice

119

GIAMBATTISTA TIEPOLO
*Roofs and Chimneys of Country Houses*
*c.* 1759
pen and brown ink and brown wash,
17.5 × 24.3 cm
Lent by the Syndics of the Fitzwilliam Museum,
Cambridge

120

GIAMBATTISTA TIEPOLO
*Gateposts and Outbuildings of a Villa*
*c.* 1759
pen and brown ink and brown wash,
14 × 25.1 cm
Lent by the Syndics of the Fitzwilliam Museum,
Cambridge

121

GIAMBATTISTA TIEPOLO
*Punchinello Lying on the Ground*
*c.* 1760
pen and brown ink and brown wash over pencil
on white paper, 16.6 × 16 cm
Mr and Mrs Eugene V. Thaw

122

GIAMBATTISTA TIEPOLO
*A Venetian Lawyer at his Desk*
*c.* 1760
pen and black ink with grey wash, 20.5 × 14 cm
National Gallery of Art, Washington
Julius S. Held Collection, Ailsa Mellon Bruce Fund

At Valmarana Tiepolo worked with his son Domenico, his most trusted collaborator. Domenico was entrusted with the decoration of the Foresteria, an adjoining guest-house, where he was able to give free rein to his own brand of humour. When Goethe visited in 1786 he admired the juxtapostion of the natural and the sublime. Domenico's outlook was new and was based on observation rather than on imagination; his protagonists are ordinary people rather than fabulous heroes. His father was capable of approaching reality just as directly, as is evident in his drawings of rustic architecture viewed in blinding light, started while he was painting the Valmarana frescoes (cat. 119, 120). When Tiepolo focused on contemporary humanity he saw only caricatures: each individual is isolated inside a ridiculous body (cat. 122). On the eve of his departure for Spain in 1762 he had a chance to reaffirm his aesthetic credo in a kind of press hand-out. Among other things, he said that 'the mind of the painter should always aspire to the Sublime, to the Heroic, to Perfection.'[22]

As has already been noted, *Apollo and Daphne* (cat. 114) was painted at about the same time that Tiepolo was working at the Villa Valmarana; the painting is shot through with a nervous energy almost amounting to erotic tension. The hidden theme, ostensibly clothed as a Greek myth, seems to be the juxtaposition of a lustful young man and a vigorous old man, both desiring to possess the same beautiful young woman; it is the old man (the River Peneus, father of Daphne, according to legend) who eventually makes her his own.

123

GIAMBATTISTA TIEPOLO
*Seated Male Nude Seen from Behind*
*c.* 1752–3
red and white chalks on bright blue paper,
34.4 × 28 cm
Graphische Sammlung, Staatsgalerie Stuttgart

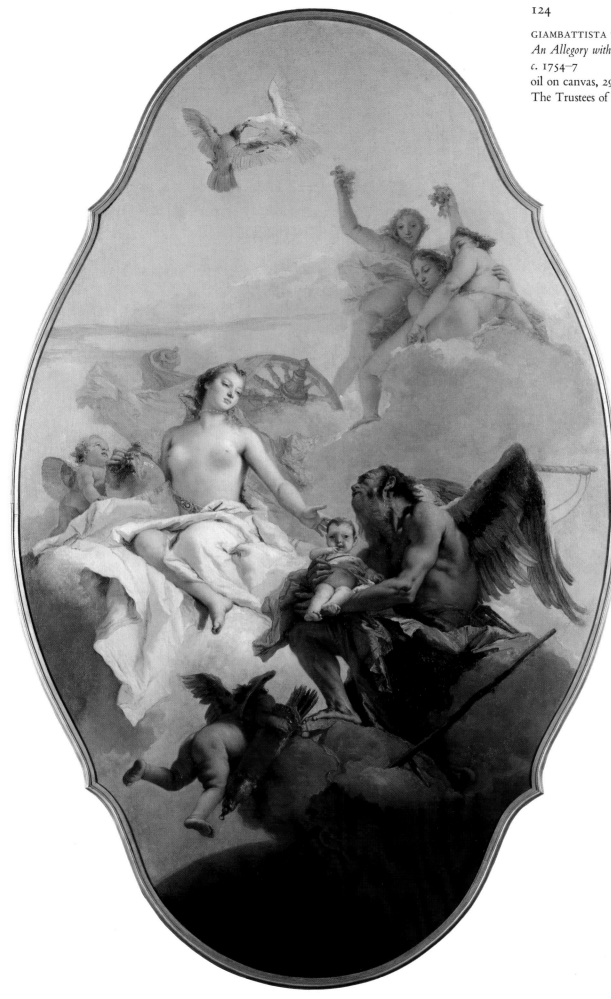

124

GIAMBATTISTA TIEPOLO
*An Allegory with Venus and Time*
*c.* 1754–7
oil on canvas, 292 × 190 cm
The Trustees of the National Gallery, London

The contrast between youth and age always interested Tiepolo. Judging by the frequency with which the theme occurs in his work, and by the intensity with which he handles the theme, it bears great significance for him. It might, perhaps, stand as an allegory of his work, between the waning civilisation he had inherited and the birth of a new radiant beauty. The characters may be personifications of rivers, or nymphs, as in *Apollo and Daphne* or in the preparatory drawing for the Palazzo Clerici (cat. 105); more frequently the old man has the attributes of Time, whether Chronos or the winged Saturn with his sickle; Saturn's hold over Tiepolo's imagination is equal to that of Apollo, and gives his art a streak of saturnine humour.

One of Tiepolo's most attractive canvases, made for the ceiling of a Venetian palace in 1754–7, probably to celebrate a marriage or the birth of an heir (cat. 124), shows Time contemplating Venus, goddess of beauty and love. Under the gratified gaze of the Graces, Venus places a new-born baby in the arms of the old man, a solid-looking child from the real world, in contrast to the winged cherub, Cupid, arriving with his quiverful of arrows. An atmosphere of domestic tranquility prevails on this Olympus; Tiepolo's vision throbs with sensuality. But there is a note of anxiety as well: Time's sickle is in evidence and the dark cloud supporting the old man casts a shadow on the terrestial globe.

125

GIAMBATTISTA TIEPOLO
*The Coronation of the Virgin*
1754
oil on canvas, 102.6 × 77.3 cm
Kimbell Art Museum, Fort Worth, TX

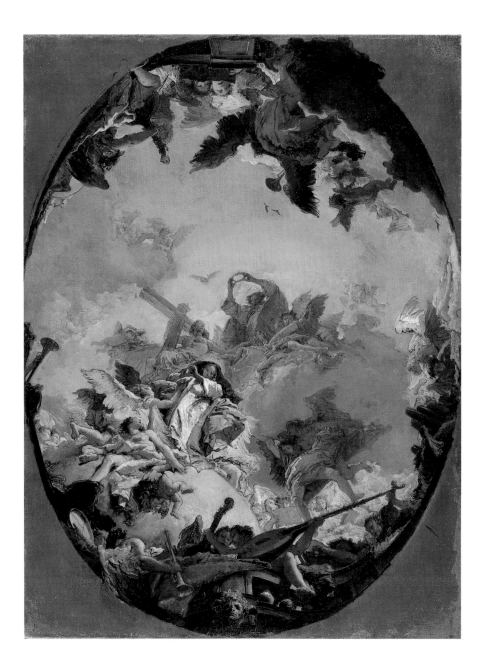

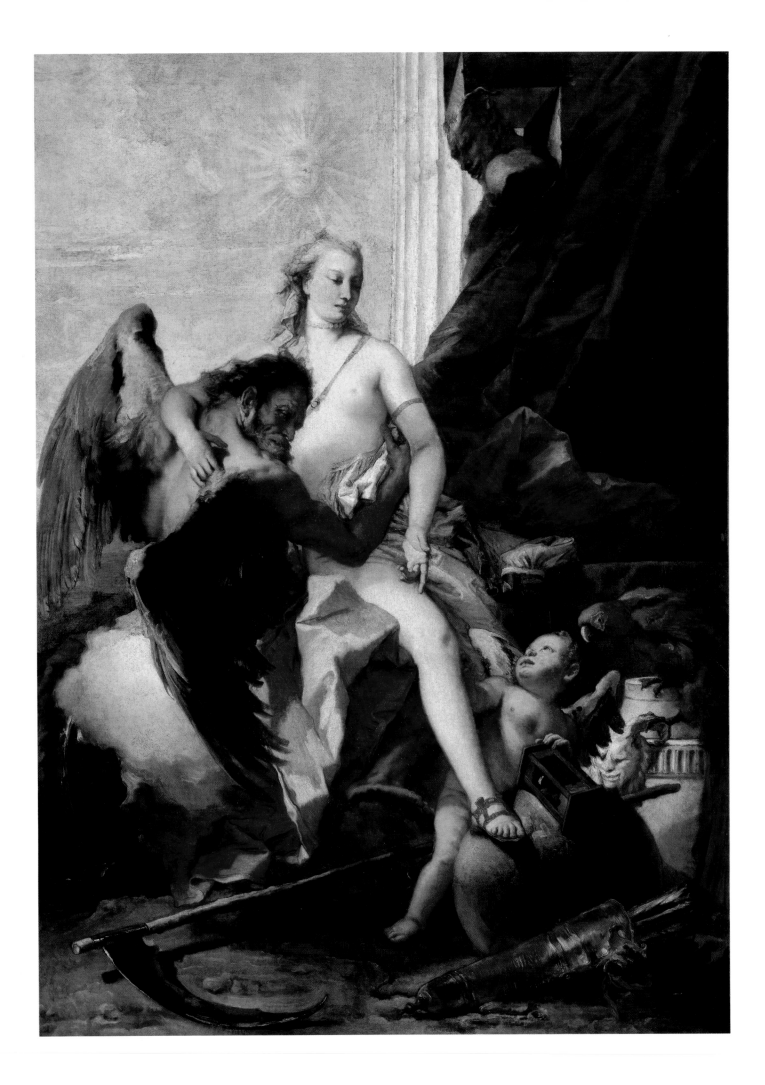

Another painting of the late 1750s, also from a Venetian palace (cat. 126), shows Time with Truth depicted according to Ripa's *Iconologia*, the handbook of symbolic images to which Tiepolo always referred ('a beautiful naked woman holds the sun aloft in her right hand . . . and beneath her right foot is the terrestrial globe'). The two figures adopt the same poses used in Tiepolo's *Allegory of Death and Sin* designed with inventiveness worthy of a 16th-century German artist to illustrate Milton's *Paradise Lost* published in 1742 (cat. 108). Tiepolo has transformed a traditional moralistic theme (Truth, the daughter of Time) into a strange seduction scene witnessed by Cupid, a grinning satyr and a parrot. Time clutches the white body of the young woman to him like a bird of prey; the embrace is matched by the composition with its opulent colours, pulsating with light and shade, rent asunder by flying feathers and cascades of drapery.

The exotic parrot appears again in a portrait of a young girl who embodies Tiepolo's ideal of feminine beauty (cat. 127). This is probably one of the 'half portraits of ladies *a capriccio*' that he was busy painting in December 1760 'for the Empress of Moscow'. Count Tassi, who left this information, thought them 'the most beautiful, most lifelike, most polished' things that he had ever seen.

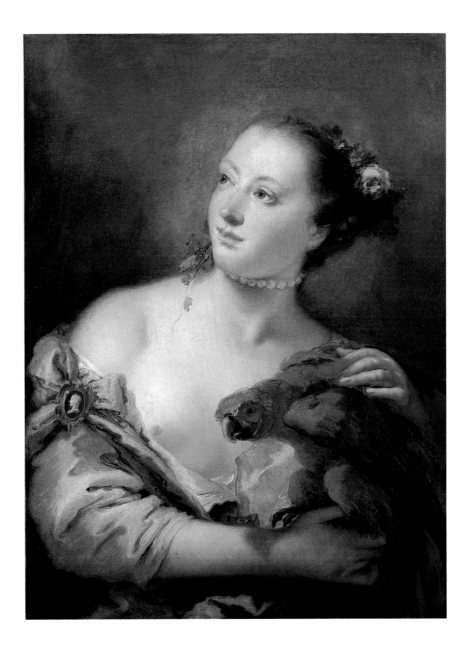

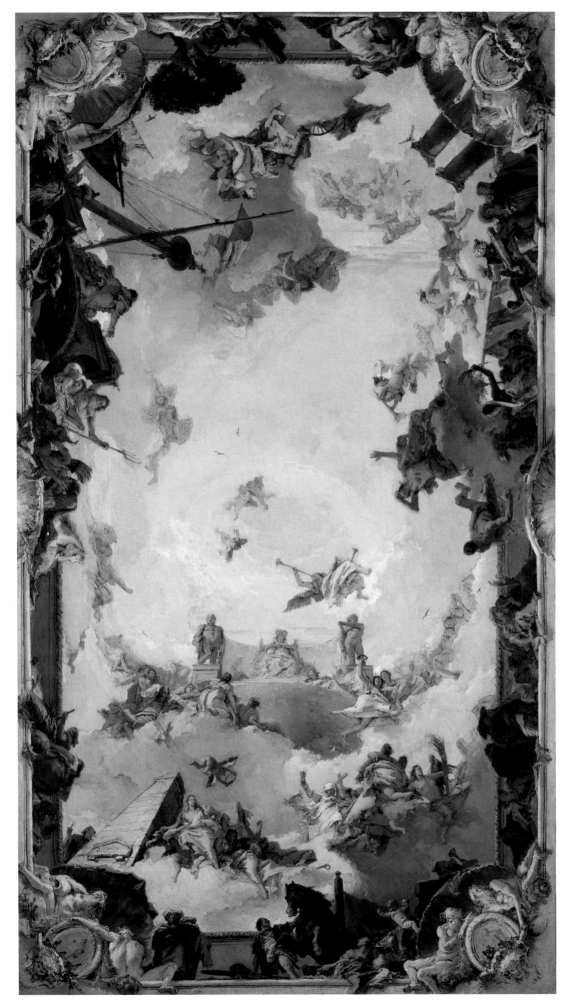

128
GIAMBATTISTA TIEPOLO
*The World Pays Homage to Spain*
1762
oil on canvas, 181 × 104.5 cm
National Gallery of Art, Washington
Samuel H. Kress Collection

Tiepolo was summoned to the Spanish court because he was considered the only painter in Europe equipped to undertake the decoration of the vault in the Throne Room in the new Royal Palace in Madrid. His departure from Venice was almost a state occasion. The Republic of Venice was conscious of the honour of the invitation even more than Tiepolo, and aware that only its artists henceforth could win it prestige. Tiepolo tried to procrastinate; he had so much work in progress. But 'those in charge', to use his own expression, would brook no delay.[23] His farewell piece, the last large commission in his native land, was the ceiling of the great hall in the Villa Pisani at Stra. His career in Italy came to an end, and with it the tradition of decorating villas with paintings extolling their owners in the company of Virtues and supported by the values of the whole civilised world, a tradition that began with Veronese's frescoes in the Villa Barbaro at Maser.

For the first time in his life Tiepolo showed signs of fatigue. The commission awaiting him seemed a 'great effort'. In a letter to his friend Tommaso Farsetti, in which he informed him that the *modello* for Spain was ready (cat. 128), he confessed that 'courage fails me for such work'. But on arriving in Spain, with the expert assistance of his sons, Tiepolo set in motion his tried and tested performance on the vaults of the Throne Room in Madrid. The personification of the Spanish monarchy replaces the Virgin and Apollo; its provinces take the place of the four continents. There is a riot of picturesque detail around the cornice, of exotic extras with extraordinary faces. Tiepolo builds thrones and obelisks in the clouds in a tottering apotheosis of absolute power. In the parts painted in his own hand, mostly the allegorical figures in the sky, he achieves amazing feats of lightness as if he were painting mirages made of light and air alone.

In a letter to Farsetti written before his departure for Spain in December 1761 Tiepolo remarked, as if to comfort himself, that he expected to return to Italy after two years. Why he chose to stay in Spain remains a mystery; he had completed his work in the Palace, even painting two extra ceilings. In addition he had for the first time met with competition in the form of Anton Raphael Mengs, the much-admired painter-philosopher, whose work was described by Winckelmann as being sure to survive when Tiepolo's had long since fallen into oblivion.[24] But Charles III's esteem for Tiepolo seems to have remained undiminished, although his confessor was a supporter of Mengs. He commissioned Tiepolo to paint the altarpieces for the church of the new Franciscan priory at Aranjuez. These were his final public works, and he was still able to astonish, this time with the dignified restraint of the composition, the avoidance of virtuoso effects, the realism of the figures. He seemed to be searching for the popular character and the intensity of Spanish religious painting of the previous century.

At certain stages of his career Tiepolo, while engaged in creating huge paintings, needed at the same time to withdraw into himself to find something intimate, almost secretive. The etchings were the result of this withdrawal, the landscape drawings, the caricatures and the series of studies of the Holy Family. In these, with a touch reduced to the merest quiver, with lines tapered to the purest arabesque, he achieved a whole range of nuances. Now in his later years, in difficult times, he painted some modestly sized religious paintings for private devotion. They seem to be painted for himself, for his private meditation, rather than for a client. Four paintings are variations on a single theme, *The Flight into Egypt*, a favourite subject of his son Domenico, who had developed it in a series of engravings during his time in Würzburg (cat. 230). The theme touches on family feeling, the pain of exile and the anguish of separation. In the most surprising of these paintings (cat. 131) the fugitives are lost in a vast, daunting alpine landscape, their way blocked by an unfathomable river. In the sky above there is no sign of the traditional angels, as if God had deserted the heavens.

*The Entombment* (cat. 132), belonging to the same group, is one of the last of Tiepolo's paintings, if not the last. Light, always an exultant presence in his painting, stops short at the threshold of the cave; it illuminates the swooning Virgin and the burial. The cave occupies almost the entire background. The entrance is wide, like a patch of sky, but dark: a black hole that swallows up even the flight of angels.

Giambattista Tiepolo died suddenly at home in Madrid on 27 March 1770. On 21 April the Venetian nobleman Pietro Gradenigo noted in his *Annali*: 'Letters from Madrid apprise me of the sad loss' of 'the famous Venetian painter, the most renowned ... well-known in Europe, and the most honoured in his own country'.[25]

1. Da Canal, ed. 1809, p. xxxii.

2. An earlier edition with a different title probably appeared in 1717. See Succi, in Gorizia and Venice, 1986–7, p. 231.

3. See Da Canal, ed. 1809, p. xxxii. According to Da Canal, Tiepolo painted the work 'in his 20s', that is in 1717, since Da Canal gives 1697 as the date of Tiepolo's birth. According to Barcham, 1989, pp. 14–27, the painting exhibited at the Fiera di S. Rocco can be identified with the *modelletto* of the same subject now in a private collection in Venice. It was probably painted for a competition, with various other artists participating, to design a cycle of Old Testament scenes for the church of SS. Cosmas and Damian on the Giudecca.

4. Da Canal, ed. 1809, p. xxxiii.

5. Da Canal, ed. 1809, p. xxxiv. On this debate see Knox, 1979², pp. 409–18. In my opinion only the *Triumph of Aurelian* (Galleria Sabauda, Turin) and *Zenobia before Aurelian* (Prado, Madrid) date from the artist's youth, around 1720; the painting *Zenobia Addressing the Soldiers* in the National Gallery of Art, Washington, is more mature in style and was probably painted about ten years later.

6. Zanetti, 1733, p. 12.

7. Orlandi, 1704, p. 235.

8. Tiepolo's use of visual sources is particularly interesting in this painting. The figure of the executioner is adapted from the executioner in Tintoretto's *Beheading of St Christopher* (or *St Paul* according to recent opinion), in the church of the Madonna dell' Orto in Venice; Tiepolo had drawn this for one of the engravings in Lovisa's anthology. The naked figure of the Saint, placed diagonally, is based on another figure by Tintoretto, Jerome in his *Apparition of the Virgin to St Jerome* (Ateneo Veneto, Venice). The scoundrel seen from behind at the bottom is quoted from a painting by the Neapolitan painter Francesco Solimena, then in the Baglioni collection in Venice (now in the Accademia, Venice). This painting nevertheless is not simply an assemblage of quotations from other paintings; it has a coherence and originality based entirely on Tiepolo's expressive and energetic handling of its component parts.

9. See Mariuz and Pavanello, 1985, pp. 101–13.

10. Da Canal, ed. 1809, p. xxxiii

11. Maffei, ed. 1825–6, p. 171. Most of the engravings of drawings by Tiepolo which illustrate Maffei's book were etched by Andrea Zucchi, who moved to Dresden in 1724 and died in 1740, never having returned to Italy. The *terminus ante quem* for these illustrations is therefore 1724; see Pedrocco, in Gorizia, 1985, p. 66.

12. Levey, 1986, p. 60.

13. For Tessin and the letter of 16 June 1736 to C. Hårleman containing his opinion of Tiepolo, see Sirén, 1902, pp. 103.

14. The quotation comes from a letter from Tessin to Anton Maria Zanetti the Elder, sent from Copenhagen on 26 October 1743 (*sic*, but probably 1748), for which see Haskell, 1963.

15. The quotations referring to Veronese come from Zanetti, 1733, pp. 44–7.

16. This definition comes from Ceva, 1706, p. 140. It was reiterated by Bettinelli, 1769. Bettinelli was an admirer of Tiepolo who in 1750 dedicated a verse encomium to him (in *Opere*, II, pp. 227–33). The essay quoted above defends the arts against the prevailing spirit of rationalism, lauding *entusiasmo*, 'that is, sensibility and imagination', and could in some respects be considered as an exposition of Tiepolo's poetic genius.

17. Zanetti, 1771, p. 465.

18. Essential reading on this is the essay by Barcham, 1989.

19. Algarotti, 1764, p. 39.

20. Giambattista Roberti, 1777, p. 28, remarks that Tiepolo, on a visit to Bassano, was impressed by the way Jacopo Bassano had painted St Lucilla's robe in his *Baptism of St Lucilla*; he wrote to tell his son Domenico that he had seen 'a miracle in the shape of a piece of black cloth that looked white'. We do not know the date of Tiepolo's visit to Bassano; it could be, however, that when he was painting the *Communion of St Lucy* he remembered the 16th-century painter's work and decided to emulate his virtuoso handling of light, particularly in certain areas of the painting, for example the altar-boy's cassock.

21. De Calzabigi, 1755.

22. Tiepolo's declaration, first drawn to our attention by Haskell, 1963, was reported in the *Nuova Veneta Gazzetta* of 20 March 1762.

23. For Tiepolo's correspondence just before his departure from Spain see Molmenti, 1909, pp. 25–7.

24. The famous critical opinion is in Winckelmann, 1763.

25. Livan, 1942, pp. 191–2.

GIAMBATTISTA TIEPOLO
*The Holy Family*
*c.* 1750s
brush and brown ink and brown wash,
31.7 × 23.5 cm
Private Collection

GIAMBATTISTA TIEPOLO
*Design for a Dedication Page to Charles III*
*c.* 1762
pen and brown ink and brown wash over black
chalk, 35.6 × 25 cm
Cooper-Hewitt National Museum of Design,
Smithsonian Institution, New York, Bequest of
Erskine Hewitt

131

GIAMBATTISTA TIEPOLO
*The Flight into Egypt*
1766–70
oil on canvas, 55.5 × 41.5 cm
Staatsgalerie, Stuttgart

132

GIAMBATTISTA TIEPOLO
*The Entombment*
1769–70
oil on canvas, 57 × 43 cm
Private Collection

133

CANALETTO
*London: The Thames with Westminster Bridge in the Distance*
1746–7
oil on canvas, 188 × 238 cm
Roudnice Lobkowicz Collection, Prague

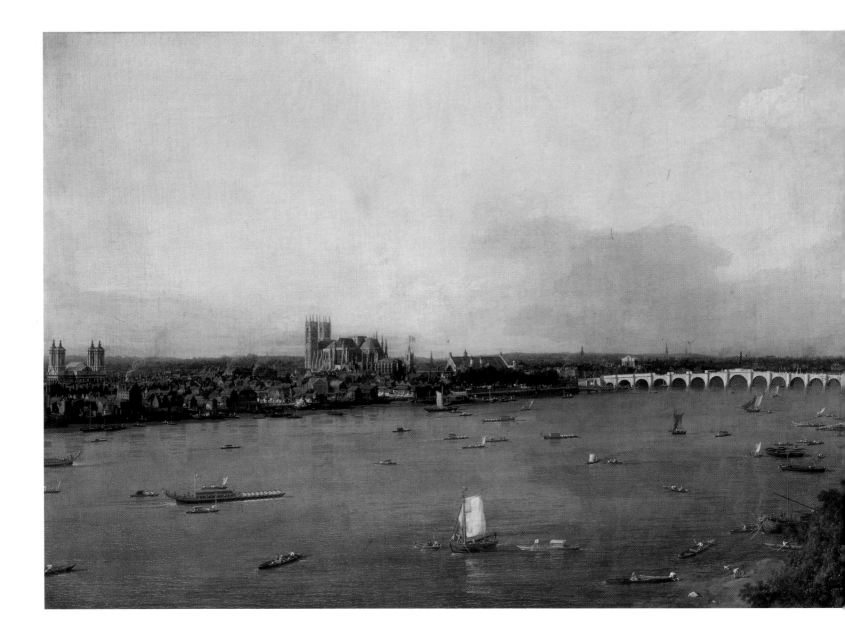

# VI: *Canaletto*

## J.G. Links

'He paints with such accuracy and cunning that the eye is deceived and truly believes that it is reality it sees, not a painting.'[1] The words are those of G.P. Guarienti, writing in 1753, after Canaletto's great days were over but while he still had fourteen years to live. Writing soon after Canaletto's death, A.M. Zanetti, younger cousin of the influential collector of the same name, and a normally perceptive critic himself, believed that such deception could only have been achieved with the aid of the camera obscura. Zanetti knew, though, that Canaletto's paintings were not at all like camera images and explained that much had still to be done by the artist to 'modify' the errors that would occur 'where scientific accuracy offends against common sense'. He ended, rather lamely, 'those learned in the art will understand what I mean' (*Il Professore m'intendera*).[2]

Neither came near to penetrating the mystery of why Canaletto's work appealed to the most unsophisticated tourist as mementoes of the wonders he had seen in Venice while still recognisable as great art by the connoisseur. Zanetti's reliance on the camera obscura as explanation was of no help. Canaletto certainly used the ruler and compass when he found them useful and he would undoubtedly have used any other instruments – convex or darkened glass, for instance – if they made it easier for him to compose his scene. An optical instrument of some kind may well have saved much raising and lowering of the head when making pencil notes of a complicated skyline. It is inconceivable, though, that such things could have played more than a insignificant part in the creation even of Canaletto's routine work, with its perceptiveness of Venetian light, its sensitivity to the fabric and condition of Venetian buildings, the feeling of movement in its figures, shipping and clouds – in short, the recreation of the atmosphere that pervades only Venice. Even today the technical means by which Canaletto achieved his effects are imperfectly understood by those Zanetti called the 'learned', whereas hardly anyone can fail to respond to the resulting work of art.

Giovanni Antonio Canal was born in Venice in 1697 and must have learnt his craft under his father, Bernardo, a successful theatrical scene-painter. They were certainly together in Rome in 1720 when their names appeared in a published libretto as having executed the scenery for a Scarlatti opera.[3] Very shortly afterwards the son, perhaps already known as Canaletto (the little Canal), was back in Venice and sufficiently well-established to receive a commission for four large paintings of which the *Rio dei Mendicanti* (cat. 134) is one. The other three pictures are of scenes familiar to all who visit Venice, but this must surely have been painted for the artist's pleasure and as an exercise in what can be made of peeling stucco, drying clothes and squalid buildings.

The brushwork is free, as in all Canaletto's early work. The viewpoint is just off the Fondamente Nuove, the northern boundary of central Venice. Few visitors would have gone there although almost all would have visited the Campo SS. Giovanni e Paolo, in the far distance although not visible, and the Scuola di S. Marco, the top of which can be seen, far left.

The right-hand half of the painting shows the scene much as it is today (fig. 40), even to the boatbuilder's yard from which a gondola is being launched. The left side of the view is dominated by the façade of S. Lazzaro dei Mendicanti, now the public hospital of Venice, but the angle of this, from his viewpoint, was not to the artist's liking. He has therefore opened up this side of his picture, as one would the page of a book, and we see it as it would appear from a point well to the right of where we are standing. It is a dull façade, but Canaletto is more concerned with the texture of the stucco and the blind man with his stick making his way along the fondamenta, than with the architecture. The effect is one of warmth and intimacy, achieved, the spectator may well feel, by the accuracy and cunning to which Guarienti referred.

The group of four paintings of which the *Rio dei Mendicanti* is one later belonged to the princes of Liechtenstein and may have been commissioned by one of them, although there is no evidence to that effect. They were great connoisseurs, exceeded in taste only by collectors such as Zaccaria Sagredo of Venice, who certainly bought at least one picture from Canaletto. It was his name that played a part in inducing Stefano Conti, a merchant in Lucca, to order a pair of views, followed by a second pair, from Canaletto instead of from Carlevaris, some of whose views he already owned. 'Sigr. Antonio Canal's' work, Conti was advised by his agent in 1725, was astounding all those in Venice who saw it. It was much like that of Carlevaris but 'you could see the sun shining in it'.[4] This was to some extent true, although the bright sunshine that pervaded Canaletto's later views was by no means a feature of his work during the mid-1720s. When Conti was told that a Canaletto view of SS. Giovanni e Paolo had been bought by the Imperial Ambassador at the annual festival outside the Scuola di S. Rocco he was so impressed that he ordered a second pair (it was this festival that Canaletto was, some ten years later, to depict in one of his finest pictures; cat. 138). Surprisingly few (less than twenty) of these early works seem to have survived to represent six years' output of a successful painter and, apart from Conti's group of four, scarcely any can be assigned to the original purchaser with certainty. The *SS. Giovanni e Paolo* bought by the Imperial Ambassador (Count Colloredo) may be one of a group of seven Canalettos now in the Dresden Gallery once owned by the Kings of Saxony; all that can be said about it with certainty is that it was painted as a venture in the hope of finding a purchaser at S. Rocco and was not commissioned.

*Figure 40:* The Rio dei Mendicanti, with the boatbuilder's yard on the right, as it is today

CANALETTO
*Rio dei Mendicanti: looking south*
1720–5
oil on canvas, 143 × 200 cm
Ca' Rezzonico, Museo del Settecento
Veneziano, Venice

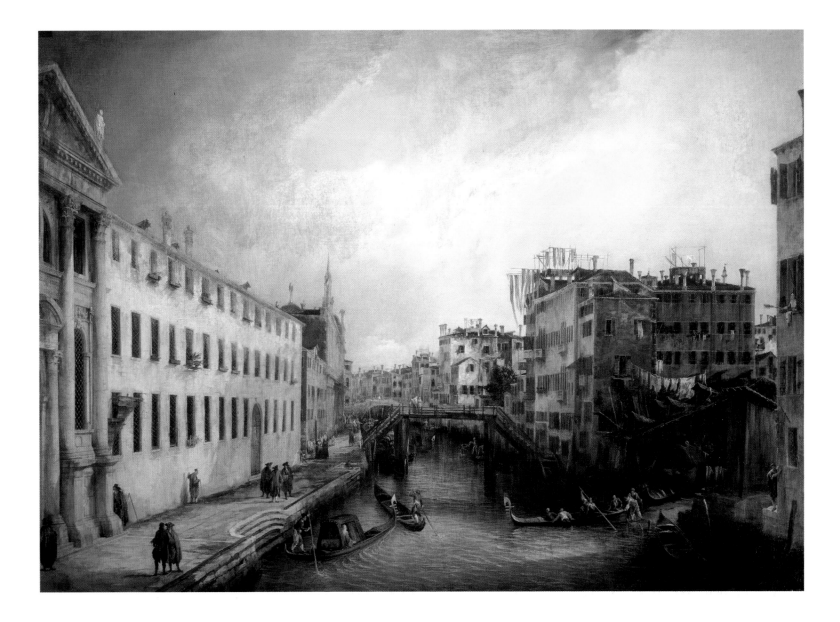

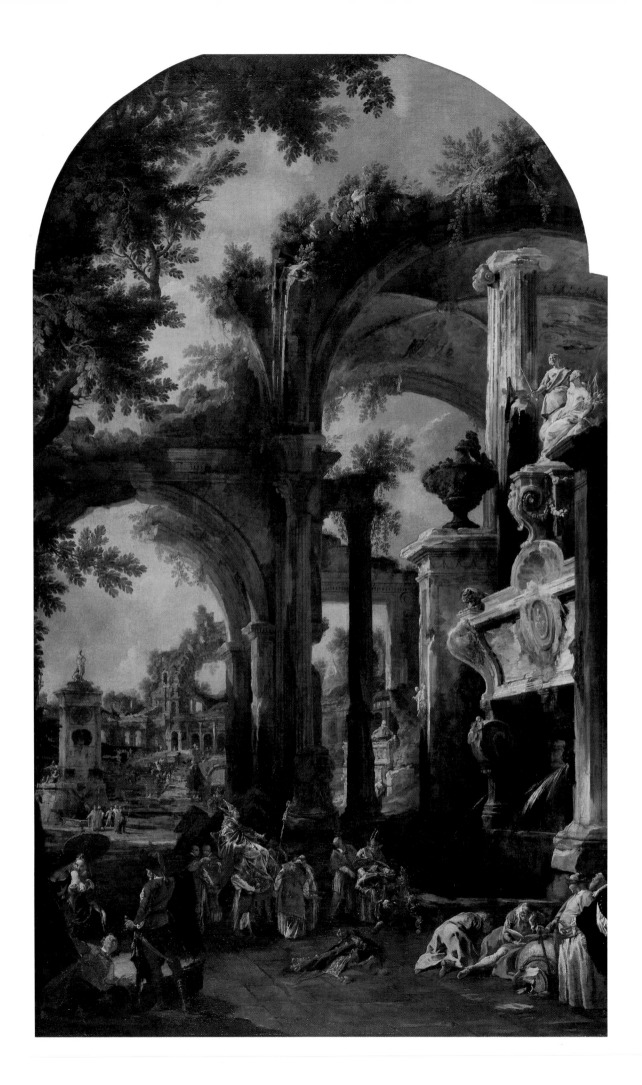

In 1727 the first evidence appears of two foreigners who were to transform Canaletto's life. Owen McSwiney (the name has various spellings) was a bankrupt Irishman, apparently of considerable charm, who had escaped his creditors in London and was now living in Italy as an agent for those who had befriended him in England. He had persuaded the Duke of Richmond's heir-apparent to embark on a scheme of 'tomb paintings' (see p. 111 and cat. 135, 37). Canaletto was participating in two of these, one of which, he wrote in 1726 to his client, who had become 2nd Duke of Richmond, was nearly finished.

In November 1727, McSwiney revealed more of his association with Canaletto. Writing to the Duke he refers to two small views he had shipped to him which were of the same size as two 'little ones' painted for a Mr Southwell, evidently known to the Duke. 'This', adds McSwiney, 'is a size he excels in and are done upon copper plates'. He then refers to the difficulties of extracting work from Canaletto, a ploy generally followed by agents to impress their own worth on their clients, and continues, 'but by the assistance of a particular friend of his, I get once in two months a piece sketch'd out, and in a little finish'd, by Force of Bribery, . . . his Excellence lyes in painting things which fall immediately under his eye'.

The last sentence cannot have referred to the large-scale, atmospheric and imaginative pictures that McSwiney might have seen in the collections of connoisseurs. If it meant that Canaletto's talents had hitherto been misdirected and that he would be better employed on McSwiney's topographically accurate 'little ones', the choice of words was still unfortunate. McSwiney's sunny pictures, 45 cm high, foreshadow the hundreds of view paintings with which Canaletto's name was for ever to be associated, but they by no means depicted what fell under the artist's eye. To McSwiney they were no doubt mementoes of Venice as Mr Southwell and others liked to remember it, but to Canaletto they were still works of art, albeit on a small scale and less redolent of the theatre than those which had been astounding all in Venice who saw them.

To achieve the effect he desired he would compose his picture from viewpoints, not only to the left or right of the main one, but nearer to and farther from his subject. He would turn buildings round, add others which would be invisible from his original viewpoint, rearrange the curves of the Grand Canal, bring his background forward or push it away, change roof-lines and simplify architecture. He would open up the sides of a view (as we have seen in the Rio dei Mendicanti) in order to present buildings at an angle that suited him. Having made his preparatory drawing from the ground, he would sometimes make the final painting (done, of course, in the studio) appear to be a view through the eyes of a man some four metres tall, at other times of one looking down from a non-existent window. All this was painted on to a ground, at first dark but getting lighter as the years progressed; the sky, the edges of the buildings and sometimes the water first, then the buildings and finally, over a background already painted, the boats and the figures. Always, the clouds seem to be moving, as do those figures who are not standing still and talking (as the majority probably are: we are in Venice). In this way, and by many other devices, did Canaletto delude McSwiney and most of his contemporaries, into believing that he painted what fell under his eye. McSwiney's views on Canaletto's character and skills may be passed over, but his letter is important in that it introduces us to Joseph Smith, by far the most important influence on Canaletto's life, for there can be no doubt whatever that he was the 'particular friend' referred to.

Smith was an Englishman who had gone to Venice as a young man and, in the event, remained there as a successful man of business for the rest of his long life. He was also a passionate collector – of books, gems, Old Masters and, particularly, contemporary drawings and paintings. As

135

CANALETTO, GIAMBATTISTA PIAZZETTA and
GIOVANNI BATTISTA CIMAROLI
*Allegorical Tomb of John, Lord Somers*
*c.* 1726
oil on canvas, 279.4 × 142.2 cm
Private Collection, on loan to Birmingham
Museums and Art Gallery

well as collecting, he loved dealing in art, and provided a full service to his many English clients in the form of framing, packing, shipping and, in some cases, temporary financing. He was the opposite of the charming but ineffectual McSwiney (who had lived in Smith's house in 1722) in almost every way, being pompous, snobbish and self-seeking. But he served his clients well, as far as can be judged, charging them only a reasonable fee for his highly efficient services. He may not have served posterity well by transforming Canaletto from a provider of great pictures for connoisseurs to a painter of small Venetian scenes that delighted the tourist. But he brought prosperity and fame abroad to Canaletto and befriended him when times became difficult. No one knows how long the handful of serious collectors would have favoured Canaletto, who in any case was free to produce the occasional masterpiece, as the present exhibition convincingly demonstrates. If, as is possible, the change of style was initiated by McSwiney rather than by Smith, it was fortunate for Canaletto that it was taken over by the solid and substantial Smith: McSwiney was not a man who could be relied on, despite his charm.

Smith seems to have decided that, before presenting the newly discovered view-painter to his English clients, he would secure for himself six great views of the Piazza S. Marco in the old style to decorate his house at Mogliano, on the mainland. Then, or perhaps before they were all finished, he would start his artist on a cycle of twelve small views of the Grand Canal. These he would keep in his Venice house, just north of the Rialto Bridge, where they would serve as examples from which visitors could commission variations of their own choice. For the benefit of those who could not visit Venice (or, perhaps, had returned home without seeing the pictures), the twelve views would be engraved by Smith's close friend and architect, Antonio Visentini, and published as a volume of etchings under the title *Prospectus Magni Canalis Venetiarum*.

Canaletto apparently complied willingly with this long-term plan, although Smith did not hesitate to issue the customary warning to at least one of his English clients that the artist was 'so much followed' that he, Smith, was fortunate to be able to get pictures from him, even having to 'submit to a painter's impertinence'. Bearing in mind that the project took at least eight years to complete, and that patron and artist maintained their association for many years afterwards, it seems likely that Smith was exaggerating his difficulties.

In the letter of 1730 in which Smith had referred to Canaletto's 'impertinence', he had added, 'The prints of the views and pictures of Venice will now soon be finish'd . . .', but in the event Visentini's engravings were not published until 1735. The delay was almost certainly due to a decision by Smith to complete the set of twelve Grand Canal views (each 46 cm high) with a pair of 'Festival' paintings, of larger format (over 77 cm high) and altogether grander in conception. So important were these considered that, after the main title of the engravings referring to the Grand Canal pictures, followed the words (in Latin), 'A Nautical Contest and Venetian Market added'. 'Venetian Market' referred to the Ascension Day ceremonies at the Molo; 'Nautical Contest' to the equally accomplished painting we know as *A Regatta on the Grand Canal* (cat. 136).

In 1709 Carlevaris had painted the Regatta (cat. 22). Canaletto has followed Carlevaris in his choice of viewpoint (an imaginary one in the air) and also in the stage of the proceedings – a race for single-oared gondolas at the point where the contestants are passing the winning-post at the *Volta di Canal* on their way to the turning point at the far end of the Grand Canal and return. The coat of arms on the *macchina* shows that Canaletto's Regatta took place during the reign of Carlo Ruzzini, Doge from 1732 to 1735, but engravings of Carlevaris's painting of 25 years earlier would have been available to him. This was the first of Canaletto's several versions of the

subject, but by no means the first occasion on which he had painted the view itself. One of the group of four pictures which included the *Rio dei Mendicanti*, painted before 1723, consisted of a painting from the same viewpoint; so did one of the King of Saxony's group, now in Dresden, and there are at least two other versions earlier than 1735. All these are lit from the right, as are all Canaletto's versions of the *Regatta* except one, making them morning pictures, whereas Carlevaris's sun came from the left, as in the afternoon. Moreover, for his *Regatta* pictures, Canaletto followed his own laying-out of the buildings on the right, beginning with the Palazzo Erizzo, rather than that of Carlevaris, which begins with one of the Contarini palaces and has a lower viewpoint. There is no reason to suppose that Canaletto used Carlevaris's engraving for his early views (although he almost certainly used other engravings for later paintings), and his picture therefore concentrates on the architecture of the scene which Carlevaris uses as a mere background to the event he is depicting. A small clue to the difference of outlook is contained in the party of spectators on the terrace of the pinkish Palazzo Capello, left of centre, (in fact, much farther away than it appears). Canaletto has made this a feature of his picture: Carlevaris passes it by as of no interest. It would be pleasant to accept the legend that the figure looking towards us from the *macchina* balcony on the left is Joseph Smith, but there are no solid grounds for doing so.

136

CANALETTO
*A Regatta on the Grand Canal*
1733–4
oil on canvas, 77.2 × 125.7 cm
Lent by Her Majesty The Queen

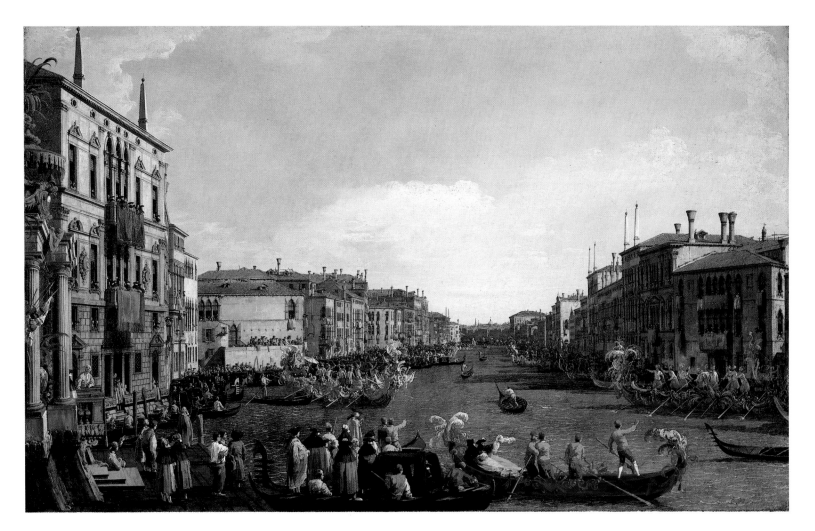

Smith never parted with his six great paintings of the Piazza S. Marco, the twelve of the Grand Canal or the two festival pictures, until his whole collection was sold to George III in 1762. The originals of the fourteen pictures engraved by Visentini and published in 1735 were, as their title-page makes clear, 'In the House of Joseph Smith, Englishman' and there can be no doubt that they were there so that visitors could order their own versions of them. Other views were added, *campi* as well as Grand Canal paintings, and in 1742 a selection of 24 of these was added to a new edition of *Prospectus*. All except one of these later views had been sold by 1742, together with the many commissioned versions which had stemmed from the original twelve.

Pleased as the businessman Smith (and Canaletto) must have been with the success of the plan, Smith the collector evidently found difficulty in parting with his treasures. Fortunately, Canaletto was not only a painter, but a consummate draughtsman as well. His drawings were of various kinds. There were his own sketches, of which many, though only a small proportion, have survived, prepared on the ground for later use as an *aide memoire* in the studio. There were the more worked-out, although still sketchy, drawings such as those referred to by McSwiney, which were evidently submitted to him and to Smith (who kept a number of them) as basis of discussion for the paintings which were to follow. Then there were the finished drawings, works of art in themselves, often based on, although not copies of, paintings which had been sold – a compensation, so to speak, for Smith's loss.

*The Grand Canal: from near Palazzo Corner* (cat. 137) is a splendid example of the latter. The Duke of Bedford had left an order with Smith for twenty views of the standard size plus two larger 'festival' scenes, one of them a version of the *Regatta* (for Smith's own version see cat. 81). Some of these were engraved by Visentini and included in the 1742 edition of *Prospectus*, but Visentini's engravings, while giving a good impression of the subject of Canaletto's paintings, gave none whatever of their artistry. For Smith, only a drawing of the subject by the master himself would provide any kind of substitute for the lost paintings (fig. 41), and he acquired several of these. In the case of the *Palazzo Corner* view, he had two drawings, each from a slightly different viewpoint, one of which is cat. 137.

*Figure 41:* Canaletto, *The Grand Canal: from near Palazzo Corner*, oil on canvas, 47 × 78.7 cm, The Marquess of Tavistock and the Trustees of the Bedford Estates, Woburn Abbey

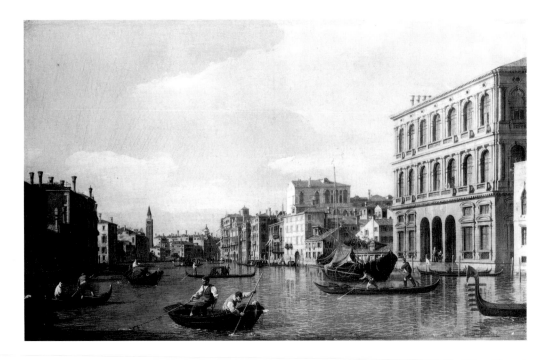

We are looking up the Grand Canal from a point not very far from its entrance. On the right is the huge Palazzo Corner and beyond it the top of the Palazzo Pisani. The campanile in the distance belonged to the church of the Carità, now part of the Accademia; it appears in a number of other paintings and drawings, notably 'The Stonemason's Yard' (National Gallery, London; see fig. 10), and fell in 1741. The composition is one of Canaletto's most complex, and is based on eight drawings from four different viewpoints in a sketchbook which has survived and is now in the Accademia. Neither of the two finished drawings follows the painting exactly, the shipping, clouds and even the proportions varying. A distinction of the one exhibited is in the raft in the right foreground, a masterly and characteristic Canaletto touch.

137

CANALETTO
*The Grand Canal: from near Palazzo Corner to the Palazzo Contarini*
*c.* 1733–5
pen and brown ink over pencil and much pin-pointing; some ruling in pencil and pen,
27 × 37 cm
Lent by Her Majesty The Queen

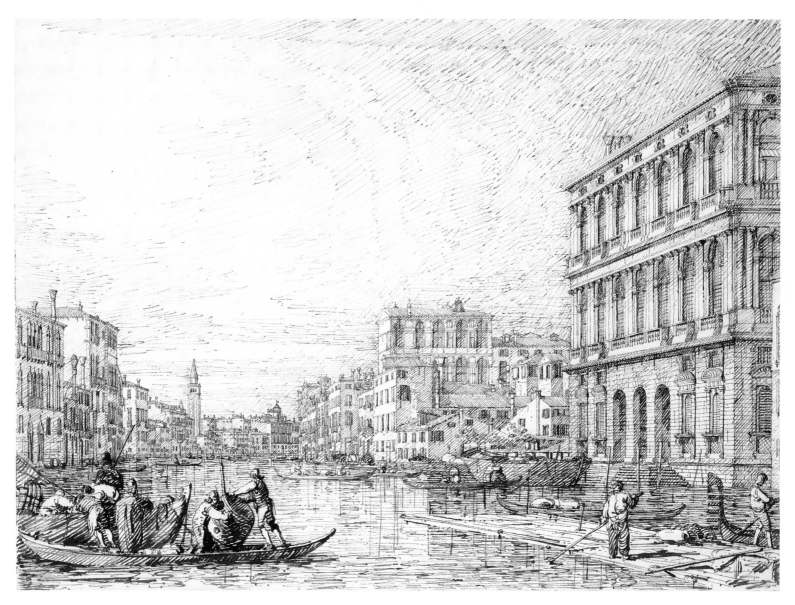

138

CANALETTO
*The Doge Visiting the Church and Scuola di S.*
*Rocco*
*c.* 1735
oil on canvas, 147 × 199 cm
The Trustees of the National Gallery, London

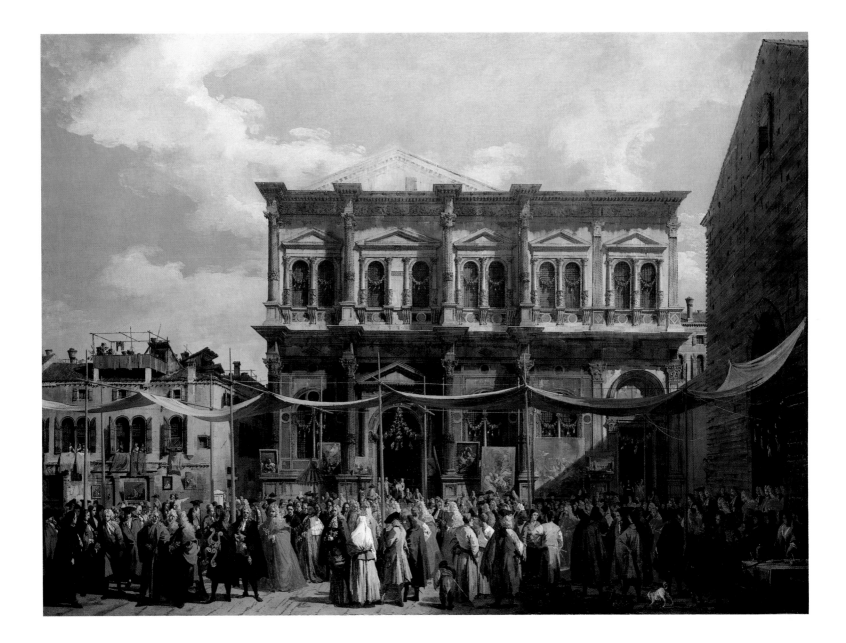

Horace Walpole wrote that 'Mr Smith engaged Canaletto to work for him for many years at a very low price and sold his works to the English at much higher rates'.[5] The Swedish Count Tessin, after a visit to Venice in 1736, wrote that Canaletto would sell a small picture for about £50 sterling and was engaged to work exclusively for four years for an English merchant called 'Smit'.[6] Both statements are demonstrably untrue. Smith certainly sold the greater part of Canaletto's output but, except for the 'Festival' pictures, all the paintings he sold seem to have been in small format. All his clients were treated equally, and Canaletto's superb craftsmanship and brilliant composition were good enough. If Canaletto wished to paint large masterpieces he was free to sell them to whom he pleased, and three examples follow of cases in which he did so, to the profound benefit of posterity.

*The Doge Visiting the Church and Scuola di S. Rocco* (cat. 138) made its first recorded appearance at a London auction in 1804 where it was intriguingly described as 'From the Vatican', but there is no firm evidence of the picture's original owner. The Doge is leaving the church, on the right, after hearing the annual mass to celebrate the deliverance of Venice from the plague of 1576 through the intervention of St Roch; he is accompanied by the Signoria, the Senators and the ambassadors, all carrying nosegays. They are passing the Scuola, which in fact it was usual for him to visit, in front of which is an exhibition of pictures that spreads to the houses on the left. Canaletto has ensured that none of the pictures can be identified, not even the one on the extreme right, which might be one of his own (it is certainly not a view of *SS. Giovanni e Paolo* such as the Imperial Ambassador had bought). The viewpoint is far enough away to accommodate the whole concourse of officials and spectators quite comfortably in the foreground and for the roof of the Scuola to be visible to a man standing on the ground. It is entirely fanciful: the *campo* is in fact less than sixty yards wide at its widest and half that on the left, the walls of the Frari making it impossible to stand farther away. So are the shadows, according to which the sun is shining brightly from the north-west on an August day. The detail of the architecture is, for once, minutely portrayed, even to the hooks from which the garlands hang. Seldom did Canaletto paint a picture carrying such total conviction.

The collection of Marshal Johann von der Schulenburg included six Canalettos, among them two lost paintings commemorating the Siege of Corfu. In February 1736 a payment of 100 *sequins*, about £55 sterling, appears in his accounts as an advance due of 120 *sequins* for a picture which is undoubtedly the *Riva degli Schiavoni: looking West* (cat. 139).[7] (When Count Tessin had written of Canaletto receiving this kind of price he referred to a *tableau de cabinet* and could not have had in mind a picture of this size, 122 × 201 cm. Schulenburg also owned two *Piazza* paintings by Canaletto for which he had paid 30 and 32 *sequins*.) The subsequent history of the *Riva* can be traced with some certainty until it was bought by Sir John Soane, so providing an extremely rare case of a non-Smith picture whose origin and history are known. The picture derives from a much smaller (46 cm high) version of the scene, now in Vienna, which may well have passed through Smith's hands: it is his usual size and he owned two drawings of the subject, as was so often the case with paintings he had sold.

Many visitors must leave Venice today without having seen this wonderful view, and this was no doubt so in Canaletto's time: he painted it but twice, whereas there are more than a dozen authentic examples of the view in the opposite direction from a viewpoint near the Doge's Palace. Earlier Venetians would have been astonished by such neglect, for it was by the canal which runs between the two buildings in the foreground that the Arsenal is reached and for the first 400 years of Venetian tourism the Arsenal was one of the first sights distinguished visitors were taken to. Today the Arsenal is desolate, and there is little to attract the visitor to this area except the Biennale exhibition and the view. On the left are the island and church of S. Giorgio Maggiore, then the Salute, followed by all the familiar buildings until the eye reaches the Doge's Palace and the Prison. A range of minor buildings then curves along the Riva degli Schiavoni (until 1780, no wider than its bridges) until the second building on the right of the picture is reached: this housed the *Forni*, the military bakeries, still readily identifiable, but the house with a typical Canaletto scene on its balcony, lovingly painted, no longer exists. Whereas the right-hand side of the picture shows the Venetians at their daily life, at the first point where the Riva widens enough to provide a meeting place, the left-hand side is a portrait of the water life of Venice and is the forerunner of the great *Bacino di S. Marco: looking East* (cat. 140) the view in the opposite direction. As well as Smith's two finished drawings, there is a free sketch of the scene, now in Darmstadt, from a viewpoint at eye-level. On the other hand, there may have been a window in the now demolished church of S. Biagio which provided Canaletto with a viewpoint which made later adjustment unnecessary.

139

CANALETTO
*The Riva degli Schiavone: looking West*
1736
oil on canvas, 122 × 201 cm
By courtesy of the Trustees of Sir John Soane's
Museum, London

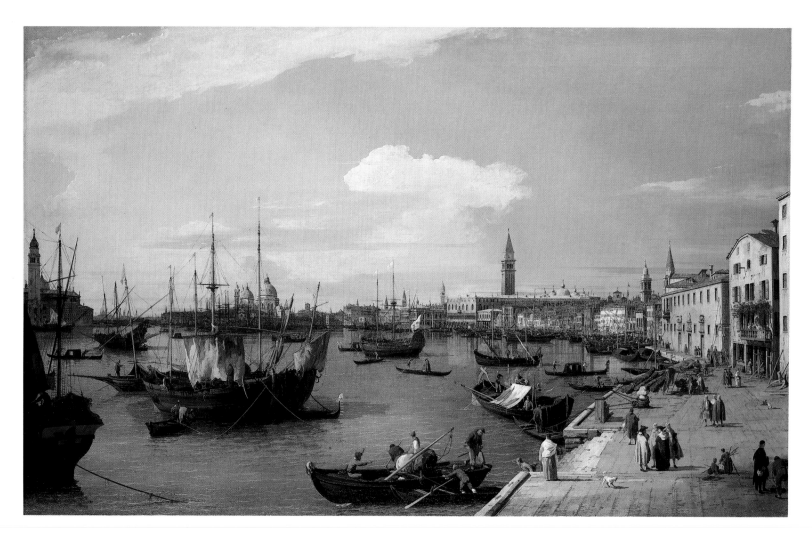

There is nothing better than the, often unreliable, family tradition to account for the thirteen paintings in the 'Canaletto room' at Castle Howard, several of which were destroyed by fire in 1940. They were said to have been 'bought from the painter himself' by one of the earls of Carlisle, but there were pictures among them which Canaletto could hardly have accepted as his own, whatever the circumstances. On the other hand, the group included two fine signed views, now in Washington, and one of Canaletto's supreme masterpieces as well as some paintings which may well have been in his studio. It is quite possible that one Earl of Carlisle may have wished to bypass Smith and ended up with a strange miscellany, followed by later additions to the collection. One can only speculate.

The masterpiece was *The Bacino di S. Marco: looking East* showing, in the distance, centre, the viewpoint of the Soane Museum *Riva*, on the right the island of S. Giorgio Maggiore and the end of the Giudecca island, and, on the left, the constellation of buildings along the Molo; shipping of every kind, some flying the flags of different nations, fill the Bacino. The main viewpoint is the Dogana, the old Customs house, but S. Giorgio appears as seen from the Molo. Recent evidence provides a date, hitherto much argued, towards the end of the 1730s.[8] The picture was bought for the Boston Museum in 1939 by W.G. Constable, its curator of paintings, who devoted much of his life to cataloguing Canaletto's works. In describing the *Bacino* he felicitously wrote of Canaletto's 'delicate precision of touch, in subtle gradations of tone and colour, and in the skilful use of light cloud to help bring multifarious detail into unity'.

140

CANALETTO
*The Bacino di S. Marco: looking East*
*c.* 1738
oil on canvas, 124.5 × 204.5 cm
Museum of Fine Arts, Boston
Abbott Lawrence Fund, Seth K. Sweetser
Fund, and Charles Edward French Fund

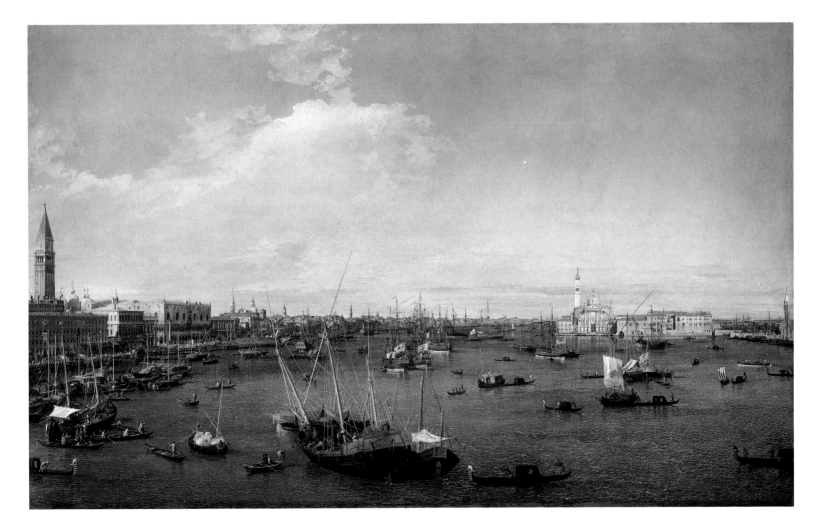

By the early 1740s a great change had taken place in Canaletto's fortunes (and, to a lesser extent, in Smith's). The English country houses had as many Canalettos as their walls would take, and the War of the Austrian Succession had reduced the flow of tourists to Venice to a trickle. For the first time, Canaletto had too little work rather than too much. Smith, despite the poor reputation his detractors gave him, proved a friend in need. He gave Canaletto work he can have had no intention of selling. Bernardo Bellotto, the son of Canaletto's sister, had been working in the studio for several years, and Smith encouraged uncle and nephew to make a voyage along the Brenta as far as Padua to provide fresh material. It is unlikely that much more work was done than the making of sketches and preliminary drawings, but the outcome was a few paintings, many drawings of high interest and quality, and a series of etchings which demonstrated Canaletto's quite astonishing skill in adapting himself to an entirely new medium.

The few paintings resulting from the Brenta trip are all based on the Brenta itself or the lagoon with the exception of the *View of a River, possibly at Padua*, (cat. 141) the location of which has never been identified. For reasons that can only be guessed at, Canaletto made a panoramic drawing, 77 cm wide, later divided and separated, showing much the same scene, followed by two drawings which entered Smith's collection (fig. 42), and an etching (fig. 43).[9] The painting probably followed some time later and if, as is almost certain, it is based on reality, it represents Canaletto's first attempt to present an entirely rural scene. Even so, he has concentrated his attention on the variety of material and design of the houses rather than painting identifiable foliage.

141

CANALETTO
*View of a River, possibly at Padua*
c. 1745
oil on canvas, 49.5 × 83 cm
Private Collection, USA

*Figure 42:* Canaletto, *A Footbridge over the River at Padua(?)*, pen and brown ink over pencil and red chalk, 18.7 × 27.3 cm, Her Majesty The Queen

*Figure 43:* Canaletto, *View of a Town on a River Bank*, etching, *c.* 29 × 42 cm (Bromberg no. 9)

142

CANALETTO
*The Portico with the Lantern*
c. 1741
etching, state 2 of 3, plate: 29.5 × 42.6 cm
Staatliche Museen Preussischer Kulturbesitz,
Kupferstichkabinett, Berlin

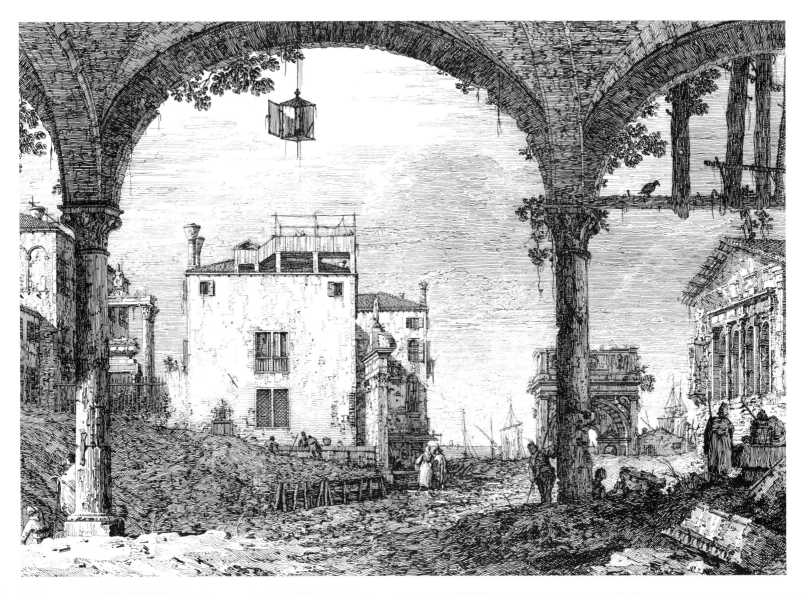

Enough has been written in these notes to establish that Canaletto seldom, if ever, painted a scene as it would appear to a stationary viewer, but there was nothing capricious about this juggling with angles or changing viewpoints. Every change was made, every step taken, with a single motive: the creation of a harmonious and evocative work of art. Occasionally, throughout his career, but particularly after about 1740, he would paint whimsical views with monuments from Venice, Padua or Rome in unlikely settings. Smith commissioned a group of such pictures containing 'the most admired Buildings at Venice elegantly Historiz'd with Figures and adjacency to the Painter's Fancy'. The true capriccio, though, in the eyes of most of Canaletto's admirers, consisted of buildings or ruins based entirely on the artist's imagination, perhaps with a recognisable monument in the distance. With these Canaletto escaped from reality. Many of them provide little or no clue to their dating and so many versions of some exist that the presence of studio assistance, or downright copying, must be suspected. There is, though, no doubt of authenticity in the case of the etchings and some of these bear the mark of a creative imagination unsurpassed by any of the artist's contemporaries.

143

CANALETTO
*La Torre di Malghera*
*c.* 1742
etching, state 2 of 3, 29.5 × 42.7 cm (plate)
National Gallery of Art, Washington
Gift of W. G. Russell Allen

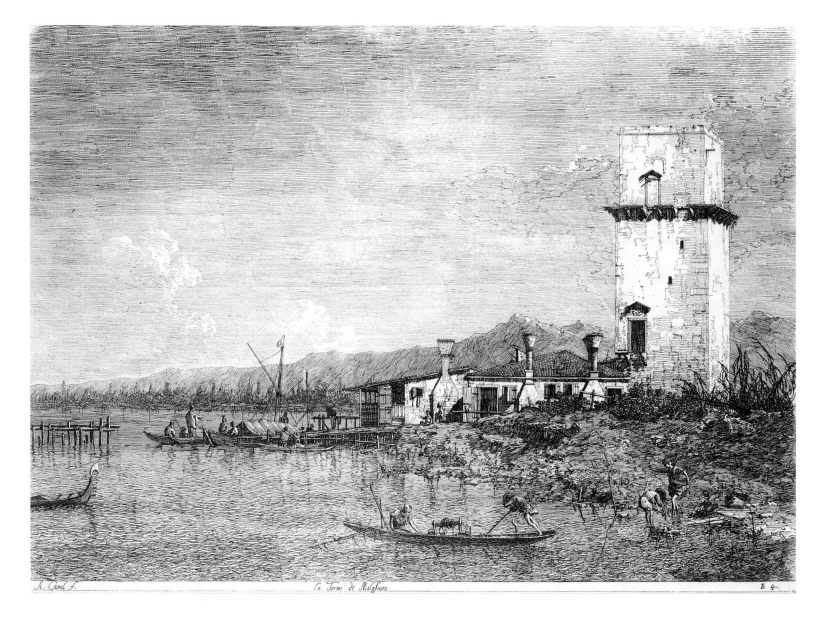

Canaletto probably made his earliest etchings in the late 1730s. The *Imaginary View of Venice* (cat. 145), one of the later plates of the series, has a house in it bearing the date '1741' and, on the title-page, is a dedication to Smith who is described as 'Console di S.M. Britanica', a post he did not attain until June 1744; publication must therefore be after that date. The title-page begins: '*VEDUTE/Altre prese da i Luoghe altre ideate*', which must mean that some were considered straightforward views of places, others imagined. Of those exhibited, '*La Torre di Malghera*' (cat. 143) and '*Le Porte del Dolo*' (cat. 144), both, in Ruth Bromberg's opinion, [10] among the last to have been executed, bear titles in Canaletto's hand and are therefore 'views'. The *Portico with a Lantern* (cat. 142) and the *Imaginary View of Venice* (cat. 145), both fairly late etchings, bear no original titles and are therefore imaginary; the latter is indeed among Canaletto's most inventive works in any medium. After only a few impressions had been printed the plate was divided vertically into two halves and subsequently printed on one page divided by margins of varying width.

144

CANALETTO
*Le Porte di Dolo*
*c.* 1743–4
etching, state 2 of 3, 29.8 × 42.7 cm (plate)
Mrs Ruth Bromberg

CANALETTO
*Imaginary View of Venice* (Undivided Plate)
dated 1741
etching, only state, 29.7 × 43.5 cm (plate)
National Gallery of Art, Washington
Ailsa Mellon Bruce Fund

146

CANALETTO
*The City of London: seen through an arch of
Westminster Bridge*
*c.* 1747–50
pen and brown ink with grey washes over
pencil, 29 × 48.5 cm
Lent by Her Majesty The Queen

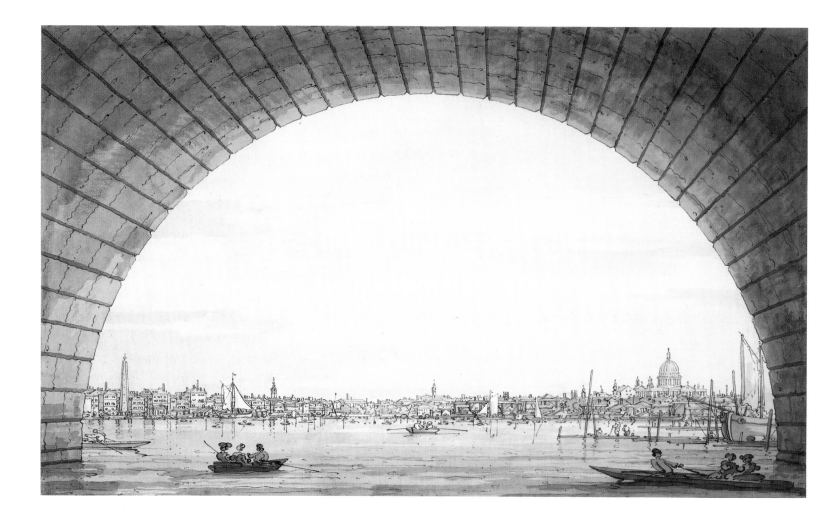

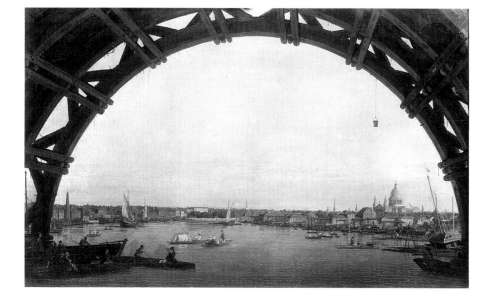

*Figure 44:* Canaletto, *The City of London: seen
through an arch of Westminster Bridge*, oil on
canvas, 57 × 95 cm, 1747, The Duke of
Northumberland

Canaletto could not continue indefinitely with only one patron, and in May 1746 his arrival in London was noted by the engraver and diarist George Vertue. There was little that Smith could do for him but he wrote to McSwiney, who had long been back in London, asking him to introduce Canaletto to the Duke of Richmond (never a Smith client). McSwiney did his best, but the Duke was away and, until his return, Canaletto had to fend for himself. He had two strokes of good fortune, the first being to meet Sir Hugh Smithson, one of the Commissioners for the new Westminster Bridge then on the point of completion. Through his wife, Sir Hugh had recently inherited the vast Percy estates and was later to become 1st Duke of Northumberland. He not only became Canaletto's principal early patron in England but led to the painting of Warwick Castle in several versions for Lord Brooke, his wife's kinsman. Canaletto's first commission for Sir Hugh was for a painting of *London: seen through an arch of Westminster Bridge* (fig. 44) and at some time he made a wash drawing based on the painting which found its way into Smith's collection (cat. 146). The wooden centring, used by the bridge's builders, is still in place in the painting and a bucket hangs down on the right; these have been removed in the drawing, together with many of the boats and figure, but the landmarks, such as the water tower on the left are clearly shown. Because of the curve of the River Thames at this point, St Paul's appears behind the wasteland of the South Bank, which is not immediately apparent to the viewer.

It seems likely that Canaletto also met a twenty-year-old visitor from Bohemia, Prince Lobkowitz, who was in England to buy horses. All that can be said with certainty is that two paintings of the Thames, one of them painted in the summer of 1746, found their way to the Prince's home some time before 1752, but whether they were commissioned by him or painted as a venture and later bought by him can only be guessed at. One shows the river from St Paul's to London Bridge on Lord Mayor's Day and is, in composition, not unlike the *Bacino* painting (cat. 140). The other (cat. 133), is a panorama, or 'prospect', in the manner of Jan Griffier and others, and quite unlike anything Canaletto had ever painted before. Its temporary return to London after almost 250 years, again owned by the Lobkowitz family after many years outside their possession, is of signal interest.

Canaletto was clearly interested in showing the new bridge in the precise state that it is known to have been at the time, and the Palace of Westminster to which it led. He chose a viewpoint high above Lambeth Palace, looking down on a far from busy river, and showed the west bank (the river flows north at this point) from St John's, Smith Square, on the left to St Paul's which is seen on the right, above the terrace of Lambeth Palace. He must have studied every aspect of the river bank during the two or three months he had been in England, and it is the loving care he has devoted to great and humble buildings that provides the endless fascination of the picture. From left to right, for example, we see, in front of the four towers of St John's, the tops of the fine houses in Millbank, 'the last [or first] in London', as they were known, with Dung, Brick, Timber and Wood wharves in front of them. We move on to the Henry VII Chapel of Westminster Abbey and St Margaret's, the Union Jack flying, with a stone wharf beside the river, and then to Westminster Hall, the spires and turrets of the old House of Commons rising just above the roofs and the trees of two gardens. A barge is being unloaded at the pier to supply the nearby wharf. At the Lambeth (Surrey) end of the bridge it can be seen that the timber 'centres' (temporary supports) are still under the last five arches, so dating the picture.[11]

Canaletto stayed in England for nine years, with an eight-month visit to Venice in 1751. For most of the first years after his final return to Venice his work seems to have been that of a tired man whose originality had deserted him, but there were spasmodic flashes of the old Canaletto. Smith sold his collection to George III in 1762, and before doing so he must have acquired one of the most brilliant of the many drawings he had had from the artist in the past 40 years. This *Architectural Fantasy* (cat. 147), despite its air of pure fantasy, invites the spectator to cross the terrace and ascend the stairs to the loggia of the palace, with confidence that he will not step beyond the credible world. In conception and execution the artist seems to show that, with pen and ink, he is still the master.

Canaletto was elected to the Venetian Academy in 1763, having been passed over earlier in the same year in favour of two nonentities, doubtless on the grounds that he was a view-painter and so inferior to others. In that year he signed and dated an 'impossible' view of the Piazza (Los Angeles County Museum) which incorporated many of the buildings he had been painting for 40 years. It is tempting to suggest that this was intended as his reception piece and that his fellow Academicians indicated that a view painting would not be appropriate. In the event, Canaletto waited two years before presenting them with his *Capriccio with Colonnade* (cat. 148) with an inscription of which only the first name and date can now be read. There is a sheet of sketches which might have been first ideas for the painting, one inscribed ('*per la cademia*' in Canaletto's hand. The baroque design is wildly capricious, slightly reminiscent of the gothic courtyard of the Ca' d'Oro, and soon became celebrated. There are many copies, a few perhaps by Canaletto; it was engraved by Josef Wagner, and ten years after Canaletto's death, was exhibited in his honour in the Piazza.

**148**

CANALETTO
*Capriccio with Colonnade*
c. 1765
oil on canvas, 131 × 93 cm
Gallerie dell'Accademia, Venice

**147**

CANALETTO
*Architectural Fantasy*
c. 1762
pen and ink and grey wash over traces of black lead and some stylus underdrawing,
36.5 × 52.6 cm
Lent by Her Majesty The Queen

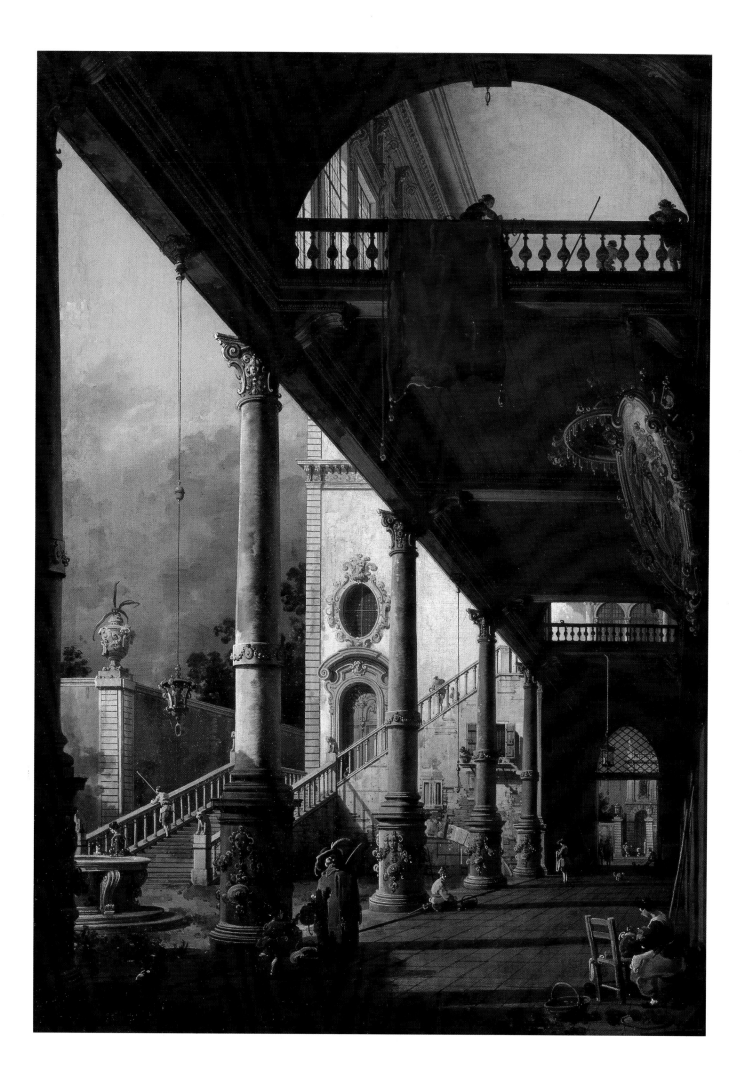

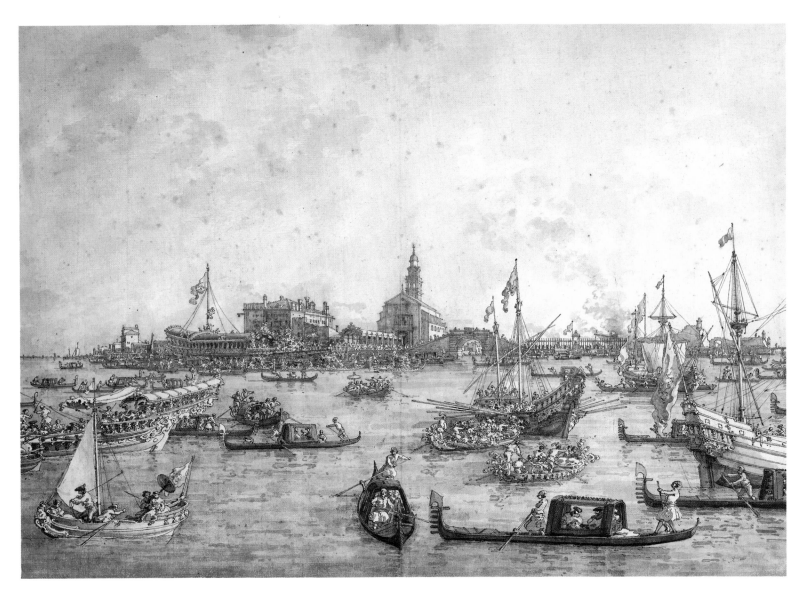

149

CANALETTO
*Festivals of the Doge: The Bucintoro leaving S. Nicolò di Lido*
*c.* 1763
pen and brown ink over traces of graphite with grey washes and many small touches of white heightening, 38.6 × 55.7 cm
National Gallery of Art, Washington
Samuel H. Kress Collection

*Figure 45:* Canaletto, Sketch for *The Bucintoro leaving S. Nicolò di Lido*, showing, above right, the view through the arch of the bridge; below the numbered buttresses of S. Nicolò are marked 'atacai', indicating that they are tied buttresses; pen and ink over pencil, 19.3 × 29.2 cm, Fogg Art Museum, Harvard University Art Museums, Cambridge, MA

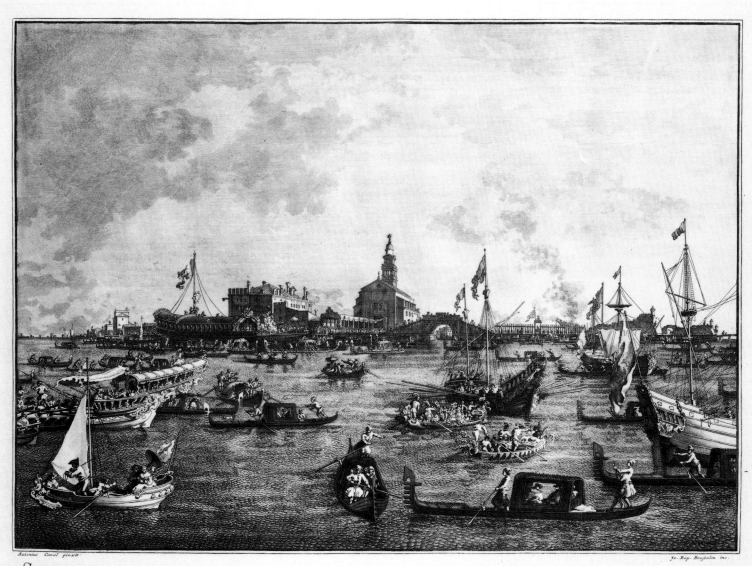

Sacris in D. Nicolai Templo rite peractis, apertoque sibi solemni ritu mari, Sereniß. Princeps in aureâ navi ad Urbem redit.

Apud Ludovicum Furlanetto supra Pontem vulgo dictum dei Barateri Cum Privilegio Excellentißimi Senatus.

N. 6.

150

GIOVANNI BATTISTA BRUSTOLON
*Festivals of the Doge: the Bucintoro leaving S. Nicolò di Lido*
*c.* 1763–6
etching and engraving, first edition of three,
44.4 × 57 cm (platemark)
National Gallery of Art, Washington
Ailsa Mellon Bruce Fund

The delay in delivering the reception piece may have been because Canaletto was making ten drawings of Festivals of the Doges which were engraved by Giovanni Battista Brustolon and published by Lodovico Furlinetto. The origin of these engravings has been much complicated by the fact that, although each is inscribed *Antonius Canal pinxit*, no paintings by Canaletto exist of the subjects, whereas there are paintings by Francesco Guardi of all of them. Drawings by Canaletto, apparently done for the engraver, were discovered some twenty years after his death and sold to Sir Richard Colt Hoare by the Venetian dealer G.M. Sasso, who described them as 'as fine as paintings' (*Belli quanti quadri*). Judging by the engravings, the two missing drawings are not certainly by Canaletto and may have been by Guardi. All that can be said with certainty about dating is that Pietro Gradenigo noted in his diary for 8 April 1766 that the first eight engravings had come on sale at 4 *lire* each;[12] the commission for the drawings may have been placed at any time before that. Whether or not a set of drawings in reverse once existed for the engraver's benefit, the probability is that the conception and compositions were Canaletto's and that, dextrous as he had become in the lively portrayal of crowd scenes, the project as a whole was as ambitious as any he had attempted in his career. There are precedents for the use of the word *pinxit* where no painting is likely to have existed.

CANALETTO
*Festivals of the Doge: The Piazzetta*
*c.* 1763
pen and brown ink with grey washes over
graphite, heightened with white, 38.1 × 55.3 cm
Ratjen Foundation, Vaduz

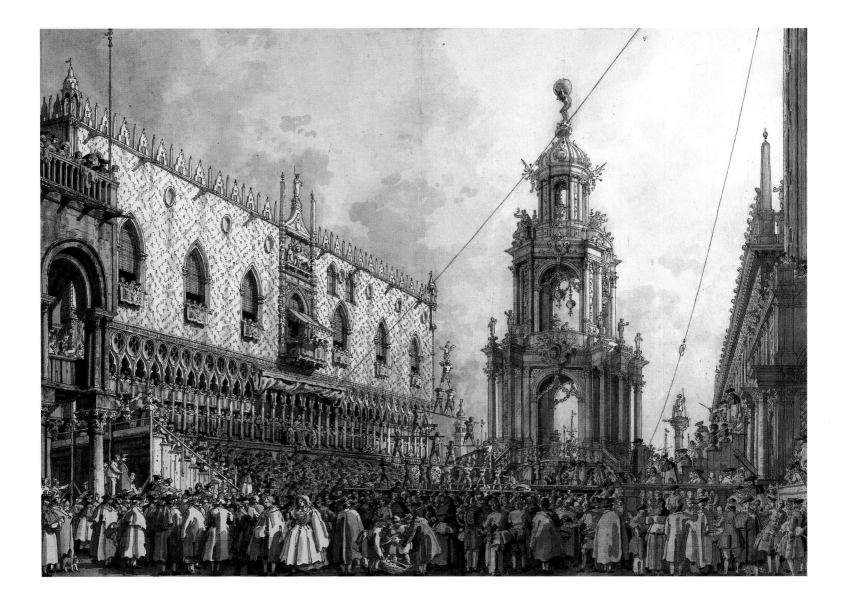

In *Festivals of the Doge: The Bucintoro leaving S. Nicolò di Lido* (cat. 149) the doge is about to return to the Molo after attending Ascension Day mass and dropping a ring into the water to symbolise the marriage of Venice to the sea, her mastery of which meant so much to her prosperity. Another in the series of drawings shows the Bucintoro departing from the Molo for the Lido, but this is quite independent of the various versions of the Ascension Day ceremony at the Molo, generally paired with the *Regatta on the Grand Canal* (cat. 136). For the present drawing Canaletto made outline drawings of the Lido waterfront (fig. 45) which reveal something of his method of working.

*Festivals of the Doge: The Piazzetta* (cat. 151) shows the Piazzetta on Maundy Thursday with the temporary structure (on at least one occasion designed by Michele Marieschi) from which a man or boy was pulled by a rope to the top of the Campanile, from which he descended to present flowers and poems to the Doge; a group of visitors on the extreme right is being given a privileged view of the scene.

Canaletto died on 19 April 1767, two years before Smith, who was more than twenty years his senior. He was a poor man but by no means destitute and, against the 1,500 or so paintings and drawings he had left to posterity, only 28 remained in his studio.

Topographical, and to a lesser extent, architectural painting and drawing in England were greatly influenced by Canaletto. Samuel Scott's work was transformed by Canaletto's stay in England and the watercolourists such as Joseph Farington and W.H. Hunt owed much to him (although he never used the medium himself and only took to wash drawing fairly late in life).

In Venice, on the other hand, he had imitators but no true followers. Francesco Guardi and Marieschi are dealt with elsewhere in this catalogue. As for the rest, when Canova asked Pietro Edwards in 1804 to find some Venetian views for him, he received a reply which ended, 'There are no more view-painters of repute'.

1. Orlandi, 1753.
2. Zanetti, 1771.
3. Constable, rev. Links, 1989, p. 9.
4. Constable, rev. Links, 1989, p. 14ff.
5. *Walpole Society*, XVI, 1927–8, p. 79.
6. Constable, rev. Links, 1989, p. 23.
7. Binion, 1990, p. 118.
8. Baetjer and Links, in New York, 1989, p. 192, note 4.
9. See under Constable, rev. Links, 1989, no. 377.
10. Bromberg, 1974, pp. 10–11.
11. Walker, 1979, p. 237ff.
12. Livan ed., 1942, p. 135.

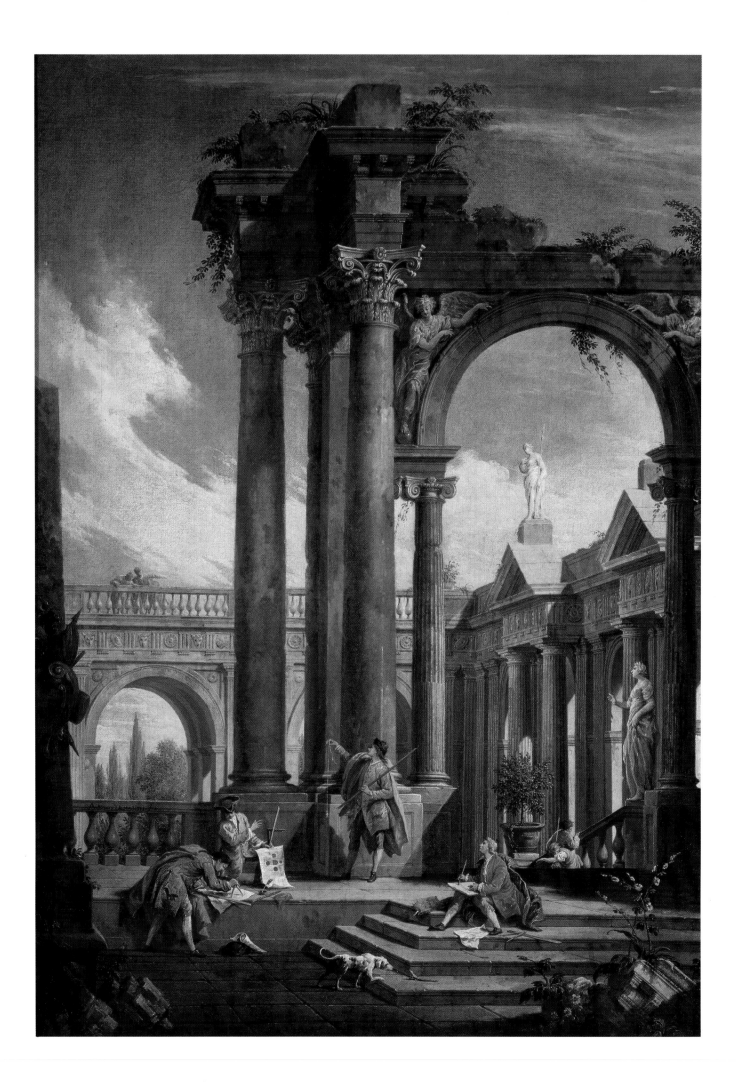

# VII: *The Neo-Palladians & Mid-century Landscape*

John Harris

It can be said without exaggeration that had it not been for Joseph Smith's tenure of the post of British Consul in Venice,[1] our perception and experience of 18th-century Venetian art would be very different, and the poorer. Although his private papers have disappeared, he was undoubtedly the catalyst for the British *milordi* and Grand Tourists in their collecting, acting as a bear-leader when they came to Venice and the Veneto, and negotiating their purchases. There is only circumstantial evidence, but one such client appears to have been Bouchier Cleeve of Foots Cray, Kent.[2] The list of Cleeve's pictures published in Thomas Martyn's *The English Connoisseur* (1766) included Marieschi's *View of the Rialto*, Carlevaris's *Doge's Palace*, two views of Venice by Canaletto and a joint work by Canaletto and Cimaroli of the *Basilica of St Mark with a Bull Feast*. Although there is no evidence of a visit to Venice by Cleeve, a connection between him and Smith is implied by the presence of a set of drawings of Foots Cray Place in Smith's copy of Isaac Ware's edition (1738) of Palladio's *I Quattro Libri dell'Architettura*.[3] Cleeve acted as his own architect in 1754, and his house, significantly a version of Palladio's famous Villa Rotonda, so admired by Smith, was contracted to be built by a professional architect, possibly Ware.

Smith was not only a powerful impresario on the Venetian scene, he was also active in Enlightenment circles, and played a crucial role in reassessing the architecture of Palladio, in commemoration of which Canaletto and Antonio Visentini were commissioned by Smith to paint a series of Palladian overdoors. Palladio had died in 1580, leaving an almost forbidding legacy, so much so that Venetian architects could not escape his influence, hence Baldassare Longhena's S. Maria della Salute of 1631. Already, Inigo Jones's architecture in England was Palladian but, unlike the purified Baroque style of Longhena, it was based on an admiration for the plainer, less Mannerist works of Palladio, such as the Villa Rotonda. It cannot be a coincidence that Palladio and Palladianism were being concurrently reassessed at the end of the century, both in Venice[4] (Andrea Tirali's S. Vidal, *c.* 1696) and in England. However, although for Venice and the Veneto it is difficult to distinguish between Palladian revival and survival, in England a distinct revival[5] was under way. If there was one place that acted as a bridge between London and Venice it was the court of the Electors Palatine at Düsseldorf, the stopping-off place for painters such as Sebastiano Ricci or Antonio Pellegrini on their way back and forth, and a hot-bed of the Palladian revival under two Venetian architects, Matteo de' Alberti and the young Giacomo Leoni, the master and pupil responsible for the Elector Johann Wilhelm's hunting-lodge, Schloss Bensberg, near Cologne. One painter who must have passed that way in 1746 was Canaletto. If by then he was not informed of the national character of the Palladian revival in England, he soon would be, especially when he painted *London: The Thames and the City from Richmond House* (Duke of Richmond and Gordon, Goodwood) for the 2nd Duke of Richmond, a Palladian enthusiast if ever there was one.

Smith's fortunes might be said to have peaked when he bought a palazzo on the Calle del Dragan and Grand Canal in 1740, and commissioned Antonio Visentini, who was both

152

ANTONIO VISENTINI
*Architectural Fantasy*
oil on canvas, 134.6 × 93.9 cm
Gallerie dell'Accademia, Venice

architect and painter, to design a new front for it (fig. 46), and to improve his mainland villa at Mogliano. Even if there are impurities in Visentini's designs, they are typical of Venetian Palladianism, which lacked the rigorous authority found in England. For his palazzo Smith required a set of overdoors[6] to commemorate the works of Palladio and English Palladianism. As there were 23 overdoors, they must have decorated at least six rooms. The first to be commissioned were Canaletto's '13 Door Pieces' of the 'Principal Buildings by Palladio', 'elegantly Historiz'd with Figures and adjacency to the Painter's Fancy'. Not only were existing buildings such as the Redentore included, but also *capricci* derived from Palladio's *I Quattro Libri dell'Architettura*, such as *Capriccio with Palladio's Design for the Rialto Bridge, Venice* (fig. 47). Canaletto completed these by 1743–4, and two years later it was Visentini's turn to paint ten overdoors in the English series.

Whether it was Visentini's choice, or Smith's, Antonio Zuccarelli, the latter's favourite landscape and figure-painter, provided Visentini with figures, or staffage. As Smith's set of overdoors was to be a trophy of the English Palladian revival, all the subjects, except for two, were selected from the trilogy of Colen Campbell's *Vitruvius Britannicus* (1715, 1717, 1725). The exceptions were a *Triumphal Arch dedicated to George II* (Her Majesty The Queen), from William Kent's *Designs of Inigo Jones* (1727), and the Palladian *Bridge at Wilton* (cat. 153), from the engraving commissioned by Lord Pembroke from Peter Fourdrinier. By choosing Campbell and Kent, Smith had turned to the two principal sources for the engraved history of the Revival in England.[7]

Even for the Veneto, the heartland of Palladio, this was an extraordinary commemoration. The choice of a Triumphal Arch and the Wilton Bridge may locate the genesis of the project to the early 1730s[8] when Roger Morris, builder of the Wilton Bridge, and George 'Bubb' Dodington, owner of the Bagnio at Eastbury Park, Dorset, were in Venice (with, perhaps, Pembroke himself), when they provided Smith with a corpus of relevant material. Whatever the reasons for the delay in promulgating this visual history of Palladianism, what matters is that the architectural reformation that had taken place in England was seen by Smith, aided by Visentini, as appropriate also for Venice and the Veneto. It was to be encouraged by them, and

*Figure 46:* Antonio Visentini, *Palazzo Balbi*, the façade of Smith's home in Venice, drawing, 1751, Department of Printing and Graphic Arts, Houghton Library, Harvard University, Cambridge, MA

*Figure 47:* Canaletto, *Capriccio with Palladio's Design for the Rialto Bridge, Venice*, oil on canvas, 90.2 × 130.2 cm, *c.* 1743–4, Her Majesty The Queen

ANTONIO VISENTINI and FRANCESCO
ZUCCARELLI
*The Bridge at Wilton*
1746
oil on canvas, 77 × 128 cm
Private Collection, Venice

later codified in a number of publications. Many of Visentini's manuscripts in the Museo Correr are not dated, among them his description of Inigo Jones as *'Imitator perfetto dell' eccelente Palladio'*,[9] but this comment can probably be located in the 1760s, the decade of Tommaso Temanza's *Vita di Andrea Palladio* (1762) and of Smith's immaculate facsimile edition (1768) of the first edition (1570) of Palladio's *I Quattro Libri dell'Architettura*, both printed by Giovanni Battista Pasquali at the Pasquali Press in Venice, Smith's own printing-house. The Press was a purposeful tool for reformist propaganda, producing Teofilo Gallacini's *Trattato . . . sopra gli Errori degli Architetti* in 1767, and its sequel, the *Osservazione di Antonio Visentini sopra gli Errori*

154

GIANFRANCESCO COSTA
*Delle delicie del fiume Brenta . . .*, published in Venice by the author, 1750
2 volumes of 140 etchings, folio, 38.4 × 102 cm (open book)
The British Library Board, London

*Veduta del Palazzo del N.H. Bon.*
LXIX

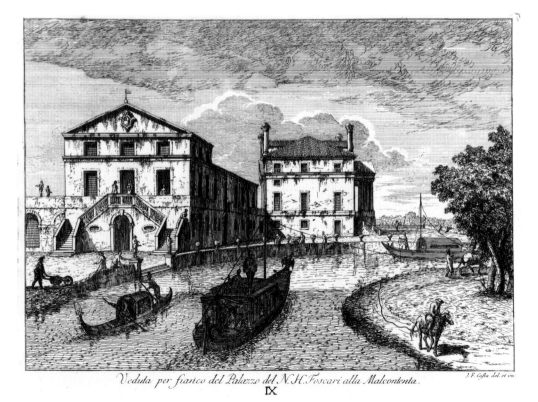

*Veduta per fianco del Palazzo del N.H. Foscari alla Malcontenta.*
IX

*degli Architetti* in 1771. The same correcting zeal can be observed in the sets of measured drawings produced in their hundreds, if not thousands, by Visentini and his studio assistants, mostly of north Italian, but especially of Venetian, architecture.[10] These catered to the *milordi* who saw them as the picture postcards of their day, and probably did not realise that Visentini often corrected what he regarded as impure details. Unfortunately no documents have been discovered to date their production precisely, but they may have been initiated in the late 1740s. Although Visentini was not alone in recording the architecture of the Veneto, there must be cause and effect between this and the architectural reformation that had occurred in England. Indeed, the great scope of Campbell's *Vitruvius Britannicus* as a celebration of national endeavour, and as a polemic of the Revival, must have acted as a catalyst on Visentini.

Gian Francesco Costa's *Della delicie del fiume Brenta* (cat. 154) of 1750 cannot be dissociated from all this topographical activity. Although Smith's patronage as promoter and publisher was not extended to Costa, these precious and evocative records of the Palladian topography of the Veneto struck a sympathetic note with the Consul. As a demonstration of the attraction of Costa to the English *milordi*, there have been more than a dozen copies on the London market of English provenance in the past century. Costa's views not only affirmed the interest of Smith and Visentini in the Palladian architecture of the Veneto, but they did so with topographical charm and accuracy. He may have influenced Zuccarelli, for some of his village views are uncommonly like the few by Zuccarelli that survive. It is often forgotten that the English consciously made a comparison between the houses and villas on the Thames and those on the Brenta, nearly always to England's advantage! But in the 18th century the Thames could boast far more riverside estates and gardens. Costa's other role was as an Enlightenment artist, even if he himself did not necessarily subscribe to Enlightenment thought. His views display a sensitivity to the depiction of the daily life of the peasants, and perhaps this is the context by which to understand Pietro Danieletti's *Peasant Philosopher* (cat. 156), a masterpiece of genre sculpture in polychromed wood.[11]

155

GIANFRANCESCO COSTA
*Architectural Fantasy: The Temple of Juno and Jupiter*
etching, 46 × 56.6 cm (platemark)
Private Collection, Geneva

Templum Junonis, ac Jovis Panellenios ab Adriano longe structum, Bibliotheca et Gymnasium Picturis et Statuis undique exornatum, Ædificiorumq; reliquias quibus Athenas amplivacarat, ex probatissimis Scriptoribus collegit Adnotavit et Sculpsit Jo Franc Costa Venetus Aliq; Ornatissimis et Clarissimis Viro Co. Com; Loan Comiti de Croismard humanium Iotum cultrore summa cavunq; Laudes Acerrimo. H. H. D.

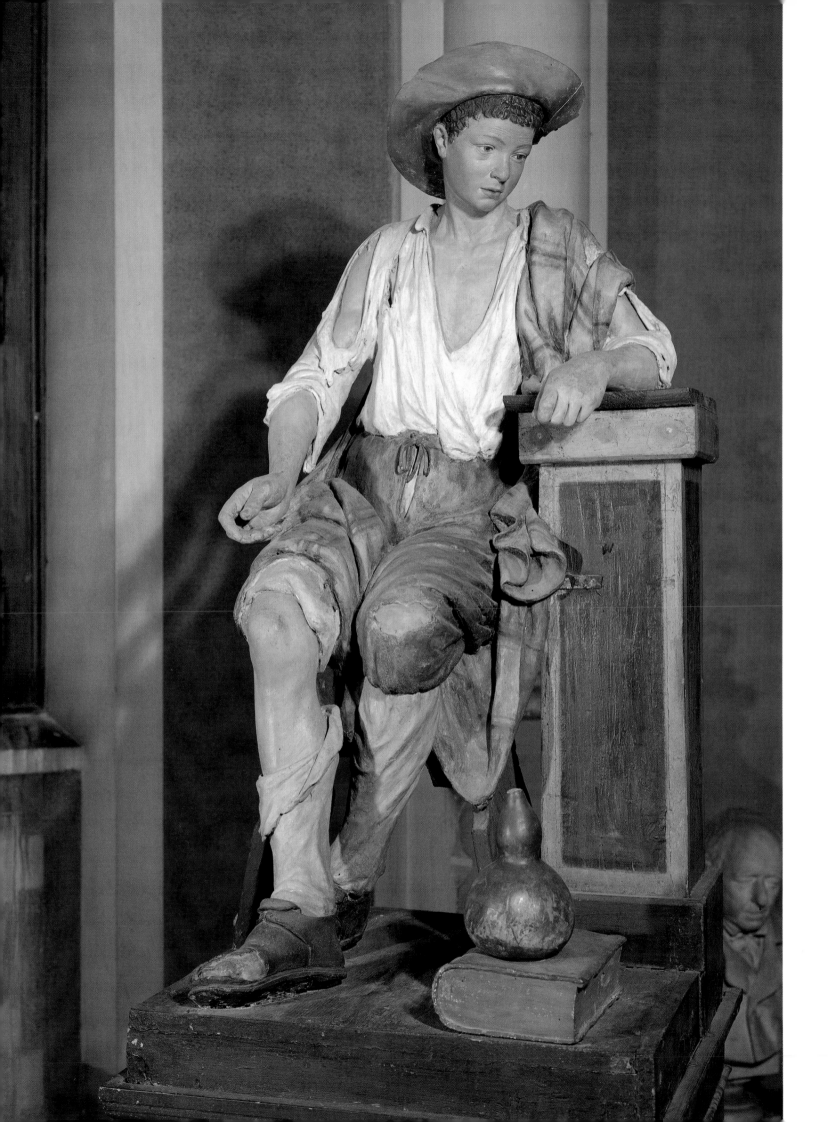

PIETRO DANIELETTI
*The Peasant Philosopher*
polychromed wood, height 213 cm
Museo d'Arte Medievale e Moderna,
Musei Civici di Padova

157

ANTONIO VISENTINI
*Regia Cappella*, etching by Vincenzo Mariotti in
*Iconografia della Ducal Basilica*, Venice 1726, folio
etching and engraving, state 1 of 2, 69 × 45.4 cm
Arthur and Charlotte Vershbow

The Pasquali Press displayed a reformist zeal for subjects other than architecture, and acted notably as a conscious rival to the Republic's establishment printer Antonio Zatta, whose *L'Augusta Ducale Basilica … San Marco* (cat. 246) of 1761, a later reprint of Visentini's *Iconografia* of 1726 (cat. 157) was a triumph of Venetian Rococo printed art. One need only mention that the Pasquali Press published Enlightenment works such as Ephraim Chambers's *Cyclopaedia; or an Universal Dictionary of Arts and Sciences* (1728). If Smith's correspondence had survived we would know more about his role in the European Enlightenment. Notable and early was his passion for Newton, whose works were published by Pasquali and others (see cat. 85), for in 1728, in emulation of the McSwiney allegorical tombs (see cat. 37, 135), Smith commissioned Marco Ricci to paint a monument to Newton the year following the scientist's death.[12] Also to be considered is Smith's friendship with Francesco Algarotti and their joint links with the Enlightenment circles of Frederick the Great at his court at Potsdam, where Algarotti was praising the Palladian works of Lord Burlington to the King.

One of the most attractive aspects of Pasquali's printing-house were the ornamental head- and tailpieces designed by Visentini. Those in Francesco Guicciardini's *Della istoria d'Italia* of 1738–40 have chapter headings (cat. 158) showing islands in the Venetian Lagoon presented in a Visentini cartouche. An interesting comparison can be made with Costa's work, for during the ten years that separated them the Enlightenment had drawn attention to the peasant classes, whereas in Visentini's headpieces for Guicciardini such sentiments are absent. However, what is even more important about the Pasquali Press is the role it played within Smith's own neighbouring *bottega*, his bookshop, called 'La Felicità delle Lettere'. This shop was not only the main channel for foreign and banned books entering the Republic, it was also a meeting-place for followers of the Enlightenment, and can be compared to Shakespeare and Company, the American bookshop in Paris where the avant-garde would meet, plot and gossip in the 1920s.

Smith's fame, however, rests on something far more conventional: his patronage and encouragement of Canaletto as a view-painter. Perhaps this has overshadowed his role as a representative of the Enlightenment in Venice, about which we possess very little first-hand knowledge. Whole-heartedly he took this painter up, and was the catalyst for Canaletto's rise to commercial success. Smith's patronage was ratified in 1735 when fourteen paintings from his collection were published and engraved by Visentini as the *Prospectus Magni Canalis Venetiarum*. It established both promoter and engraver as forces to conjure with in Venetian printing and book production. Smith's patronage of his favourite painter was undeviating. So strong was it,

158

ANTONIO VISENTINI
Headpieces, initials and tailpieces, in F. Guicciardini, *Della Istoria d'Italia*, Venice, published by Giambattista Pasquali, 1738, second of 2 vols
etchings, 45 × 63 cm (open book)
The British Library Board, London

34    LIBRO SECONDO.

*deliberate; ma che molte, o per sua mala fortuna, o, come molti diceva-no, per esser di consiglio precipitoso, su superato da gl'inimici, anzi forse, dove su principale de gli eserciti, non ottenne mai vittoria alcuna.* Come se non fusse nota al Mondo, e che lo stesso Guicciardino non avesse scritto nel Settimo la vittoria, ch'egli ebbe in Cadore delle genti di Massimiliano, e la presa di Goritia, e di Trieste, essendo pur Capitano e principale in quella impresa; se non avesse felicissimamente combattuto con i Tedeschi a Pordenone, ricuperando il Friuli; e con gli Spagnuoli sotto Este; e finalmente se passato l'Adda negli ultimi giorni della vita sua non fusse stato di così notabile ajuto al Re Francesco, che per opera sua particolare restassino rotti gli Svizzeri appresso Milano. Punge così i Sanesi acerbissimamente, e così i Lucchesi molte volte per tutta l'Istoria sua, accusandoli per nemici de i Fiorentini ne i primi versi del Secondo libro, e nel Terzo dopo che i Pisani hanno distrutto la loro Cittadella, & in diversi altri luoghi. Così morde e rappresenta afflittissimi & i Genovesi & i Pisani con orationi, con discorsi, e con descrivere minutissimamente gli assedii, e le miserie loro. Le quali cose, con tutto che possano forse essere ammesse come appartenenti al riempimento della Istoria, non resta però, che non si possano anco, e che non debbano esser giudicate altrettanto scandalose nell'Autore, quanto parranno convenienti nell'opera; anzi che l'opera stessa per questo rispetto non resti grandemente defraudata della sua propria dignità: vedendosi chiarissima l'intentione, e lo studio intenso del Guicciardino, che è di coprire con l'onestà dell'effetto della Istoria l'infettione della sua mente; & obbligar con tante ingiuriose falsità la fede, che si deve all'innocentia, & alla purità della Istoria, alla licentia, & all'interesse suo.

DEL:

DELLE CONSIDERATIONI
D I
GIO. BATISTA LEONI
S O P R A
L'ISTORIA D'ITALIA
DI M. FRANCESCO
GUICCIARDINI.

*LIBRO TERZO.*

UESTA scandalosa, & indiscreta maledicentia avendo, come diceva nel precedente libro, trafitto indifferentemente molti, e potendosi chiamare universale per tutta questa Istoria, per conseguentia si potrà aneo, e giustificatamente affirmare, e credere per naturale; poi che rare volte, e forse non mai si troverà narrata un' attione gloriosa, che la gloria, e la lode, che ne può risultare a gl'interessati in essa, non sia loro impedita, o contrappesata da considerationi tali, che il giudicio, e l'arbitrio di quest'uomo non tolga, o diminuisca apparentemente quella parte di onore, e di esistimatione, che compartisce loro l'esito, e la propria virtù. Il che essendo effetto specifico o d'una occulta corruttione di mente, o d'una manifesta, & ostinata incontentabilità del suo giudicio, molto probabile, &
e 2                              bil-

254

that it is almost as if he ignored the presence in Venice of Michele Marieschi, a powerful and compelling competitor. It is significant that no work by Marieschi was in Smith's large collection, although admittedly Marieschi died in January 1744, aged only 34. Clearly, this young painter was a force to be contended with.

Although there is much dispute as to the authenticity of many views given to Marieschi, it is possible to judge him on the series of 21 etchings of views of Venice published in 1741 as *Magnificentiores Selectioresque Urbis Venetiarum Prospectus*, to which belongs the *Regatta from Ca' Foscari in the Direction of the Grand Canal* (cat. 159). In addition there is a small and precious gathering of documented paintings, notably *The Rialto Bridge* (Bristol City Art Gallery), which possibly belonged to Bouchier Cleeve, and its companion, a view of the Bridge from the other side, sometimes attributed to Francesco Albotto, Marieschi's assistant and later imitator. The *Piazzetta dei Leoncini* (cat. 161) and his masterpiece, the *Grand Canal at the Entrance to the Cannaregio*, are shown here (cat. 162). This, with its pendant, *The Grand Canal with the Ca'Rezzonico and the Campo S. Samuele*, also in Berlin, as well as the view in Bristol, are demonstrations of Marieschi's strength as a great Venetian painter. All would appear to belong to the last years of his life, and thus are mature works. It is significant for the connections between Venice and Potsdam that the Berlin pictures were acquired for Frederick the Great by Francesco Algarotti.

159

MICHELE MARIESCHI
*The Regatta from Ca' Foscari in the Direction of the Grand Canal*
*c.* 1740
etching, state 1 of 4
31.2 × 46.3 cm (platemark), 17 × 460 mm (inscription)
Mrs Ruth Bromberg

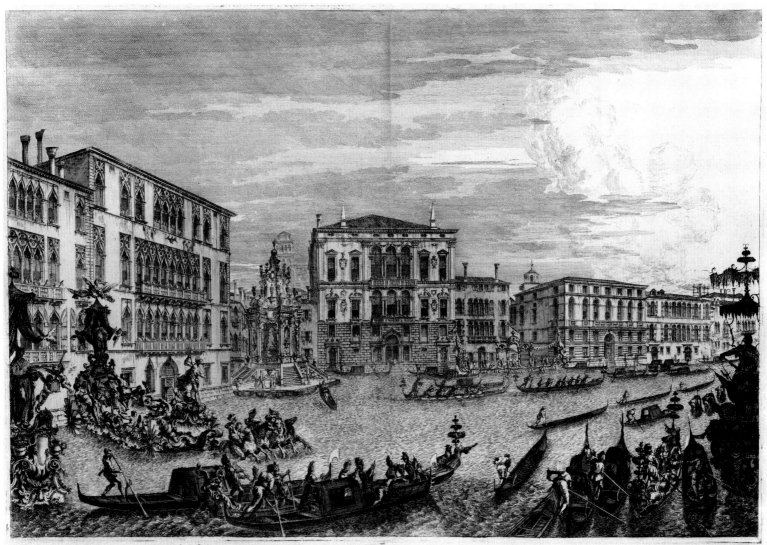

*Foscarorum ædes ad leuam, et e conspectu altera Balborum ambo præter canalem magnum; ubi etiam solenne nauticum certamen, et maxima prequentia cymbarum uel auro uel argento uel alio ornatu obducta-rum, fictasque formas exhibentium cernuntur, nec non lintres nauiculariorum pro brabio certantium. Inter easdem ædes exornata ad maiorem spectaculi dignitatem meta super acquas erigitur.*
*Mich.l Marieschi del.et inc.t*

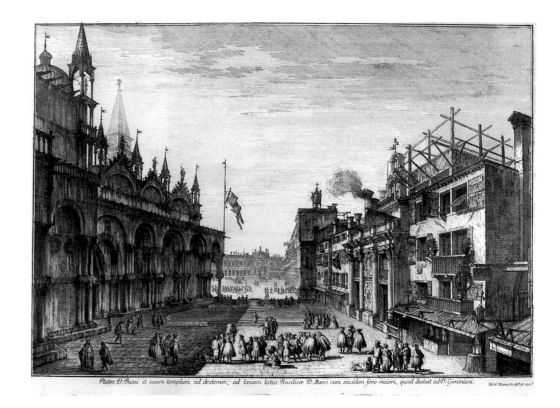

*Platea D. Bassi et suum templum ad dexteram; ad lævam latus Basilicæ D. Marci cum eiusdem foro maiori, quod destrit ad D. Giminiani.*    *Mich! Marieschi del! et inc!*

160

MICHELE MARIESCHI
*Piazzetta dei Leoni*
*c.* 1738
etching, state 2 of 4, 33 × 46.6 cm
Private Collection, London

161

MICHELE MARIESCHI
*The Piazzetta dei Leoncini (or di S. Basso), Venice*
1735–6
oil on canvas, 55.5 × 83.5 cm
Szépmüvészeti Múzeum, Budapest

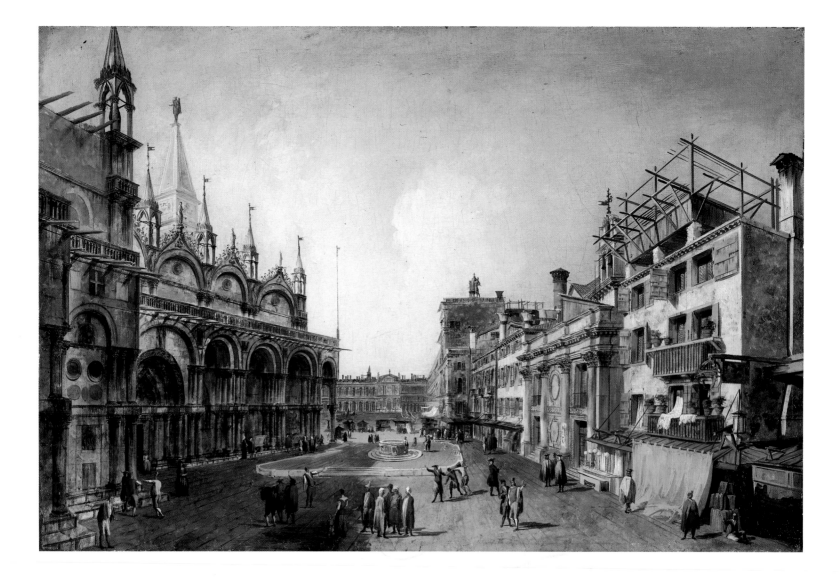

MICHELE MARIESCHI
*The Grand Canal at the Entrance to the Cannaregio*
1741–2
oil on canvas, 55 × 84 cm
Stiftung Schlösser und Gärten
Potsdam-Sanssouci

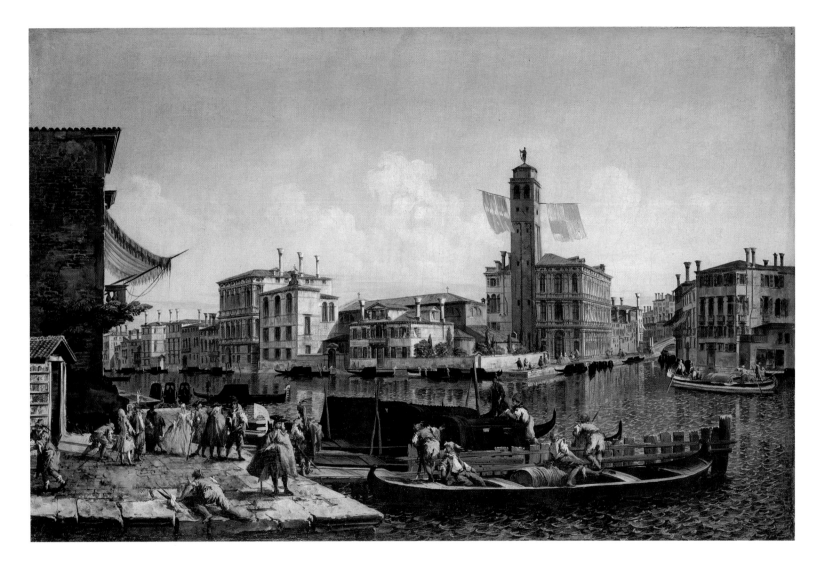

163

MICHELE MARIESCHI
*Stairwell in a Renaissance Palace*
*c.* 1740
oil on canvas, 35.5 × 55.5 cm
Nationalmuseum Stockholm

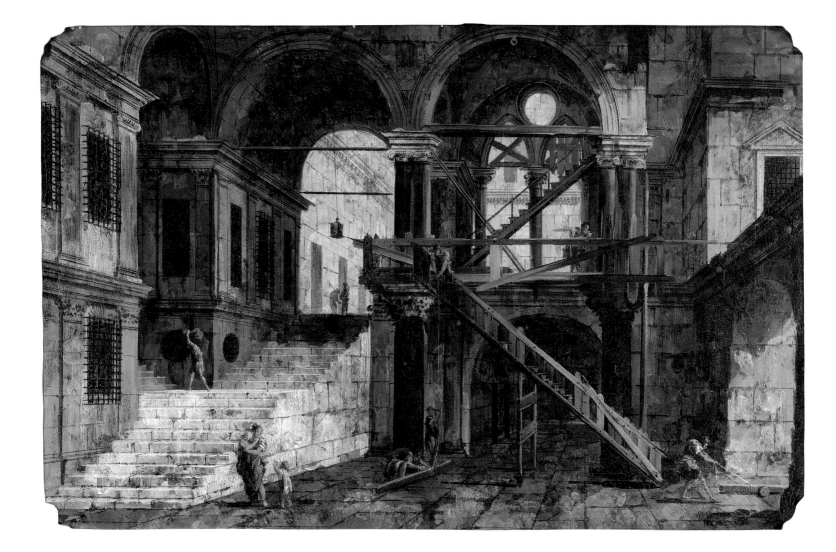

The very mention in 1789 of a 'Scuola di Marieschi', when Francesco Guardi was among those deputed to decide the authorship of two paintings attributed to Canaletto, is proof that already at this date there was confusion in determining Marieschi's hand. Antonio Guardi, Francesco's father, has been detected in the figures, or staffage, in the Rialto views, but this is still in dispute, as is the role of Albotto.

Like Visentini, Marieschi may have been an architectural view-painter with only a competency in figure painting. This is the impression conveyed by the ambitious series of views of interior courtyards in a palace[13] that introduce us to the world of Venetian scenography and stage-design. In view of the fact that the twenty or so surviving canvases could hardly have been begun as a series much later than 1742–3, even if many are studio versions, Piranesi's *Carceri d'invenzione*, the prison *capricci* (see cat. 277, 280), may well be indebted to them. More needs to be discovered about Marieschi's activity as a stage-painter after he returned to Venice from Germany in 1735. His *Architectural Fantasy* (cat. 164) is the only extant etched example and has been dated *c.* 1736–7. It encapsulates the Gothic and classical worlds of the Venetian Republic, and is characteristic of the mixed styles favoured by north Italian stage designers.

It would be rash to hint that if Smith had seen Marieschi's Rialto or Cannaregio views, he would have sensed that he had backed the wrong horse in Canaletto; but however passionate he was about his painter, a connoisseur of his discrimination cannot have failed to detect a certain stylised manufactured look in Canaletto's painting technique, and a hard-edged quality absent in Marieschi, whose views are at once authentic, natural and accurately atmospheric. Marieschi's is a Venice that really existed, whereas Canaletto's views sometimes are like Warsaw reconstructed! How instructive it would be to see Canaletto and Marieschi together in Foots Cray, or in Potsdam, as indeed we can see them in this exhibition. What can be observed in Marieschi is the debt owed by Francesco Guardi, particularly in the feeling for convincing architectural texture and the reality of the atmospheric scene.

164

MICHELE MARIESCHI
*Architectural Fantasy*
*c.*. 1736–7
etching, state 2 of 3
33.3 × 46.8 cm (platemark), 2.4 × 46.3 cm
(inscription)
Arthur and Charlotte Vershbow

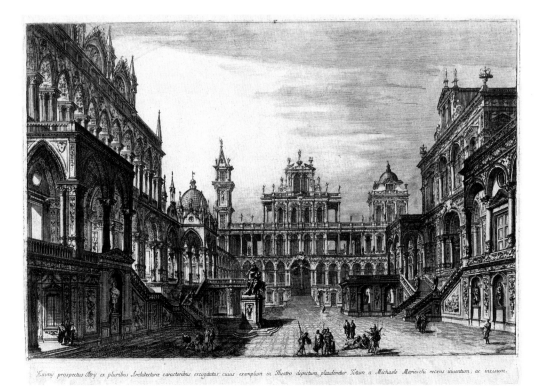

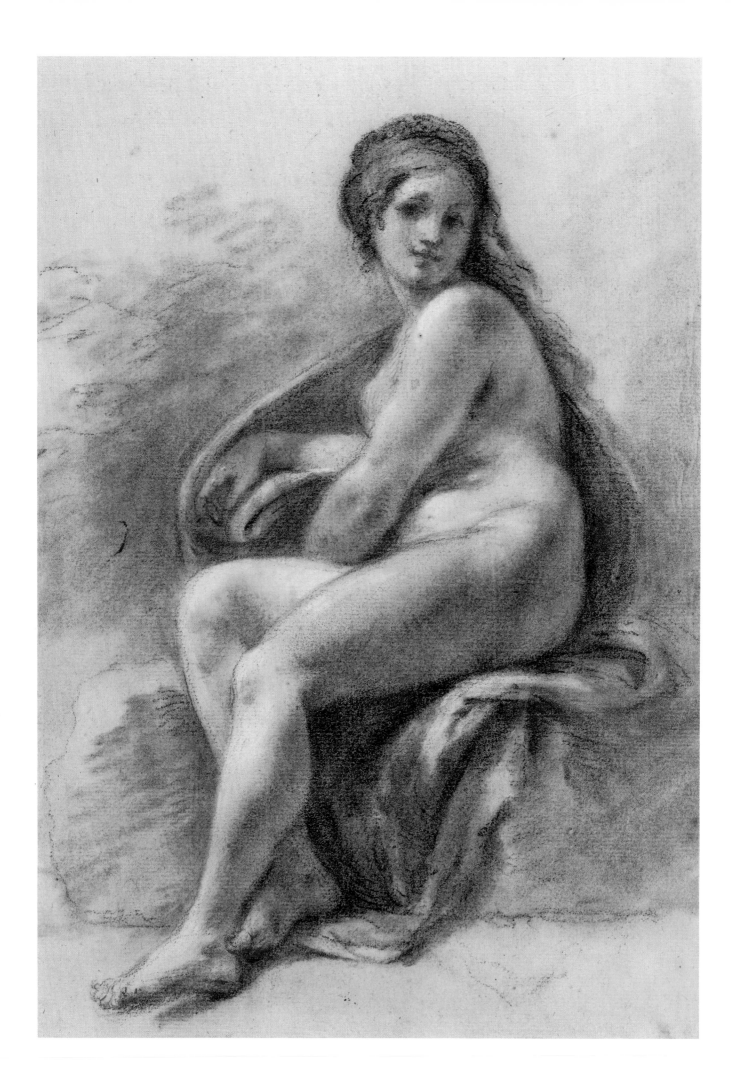

Both Canaletto and Marieschi were engaged on a threefold task: recording a beautiful city, glorifying the Venetian aristocracy, and satisfying a demand for commercial gain. It was almost as if Venice's decline had to be given a moral painterly boost. Its effervescent beauty disguised a weakening authority. Not from Venice would new styles emerge. In this sense Piranesi was Roman, not Venetian, and Canova's eyes were focused on artistic movements beyond the Veneto.

In contrast, Zuccarelli was a reactionary. To paraphrase Henry Angelo, his beautiful landscapes must forever please. As with Canaletto, he owed everything to Smith from the moment he came to Venice *c.* 1730. Perhaps this patronage is a condemnation of Smith's tastes. Zuccarelli's skies are blue, his landscapes ever green. As Richard Wilson admitted when he was in Venice painting Zuccarelli's portrait in 1751, 'the light airy manner of that painter pleased the world'. As early as 1762 George III bought more than 30 Zuccarellis from Smith. Nearly all present an attractive, standardised, unreal Italianate ideal of arcadian landscape, of which the pair of arboreal views, one (cat. 168) with peasants, the other (cat. 167) with a sportsman watering his horse, are characteristic. Many defy iconographic meaning, and

167

FRANCESCO ZUCCARELLI
*Wooded Landscape with a Sportsman Watering his*
*Mount*
oil on canvas, 77.5 × 117.5 cm
Private Collection

168

FRANCESCO ZUCCARELLI
*Wooded Landscape with Peasants*
oil on canvas, 77.5 × 117.5 cm
Private Collection

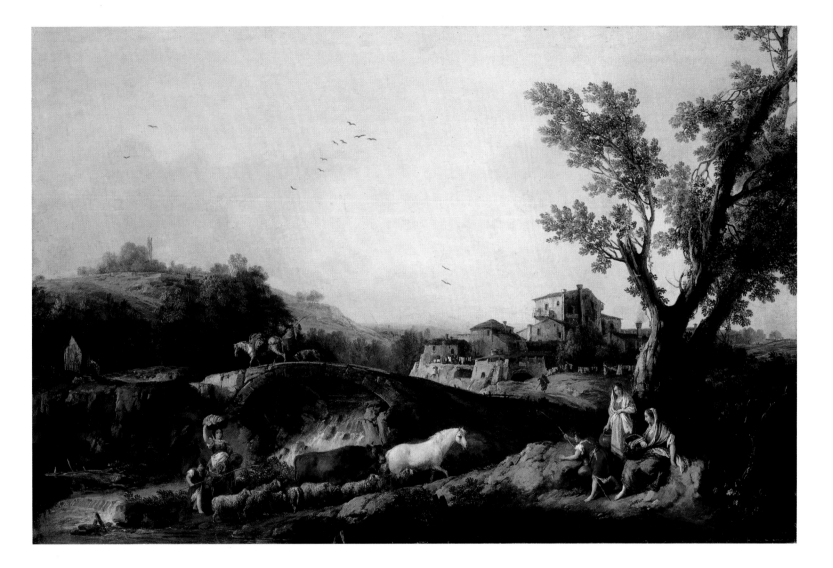

perhaps many have no meaning at all! But they are a good measure of the average taste of the English Grand Tourist, or of English collectors, who found his views pleasurably decorative, just as many a rich buyer today might hang a Renoir in the bedroom. It is not surprising that Zuccarelli became a founder member of the Royal Academy of Arts in 1768, or that, when he finally returned to Venice in 1771, he was elected President of the Venetian Academy, the same institution where Costa was Professor from 1767 to 1772, and Visentini from then until his death. These links demonstrate the intimacy of artistic relations in Venice at the court of Consul Smith.

169

FRANCESCO ZUCCARELLI
*La Batracomiomachia Greca, Latina ed Italiana*
translated by A. Lavagnoli
published in Venice by G. B. Albrizzi, 1744
octavo volume, etchings, 22.5 × 29 cmm (open book)
The British Library Board, London

1. The standard work on Consul Smith is Vivian, 1971, following her doctoral thesis (Vivian, 1966). I have drawn on both works. The literature on Smith has been later amplified by Vivian, 1989, and by London, 1993, which has the best bibliography on the subject.
2. Foots Cray does not have primacy as an example of the Palladian Rotonda in England, for it was preceded by Mereworth (1720) and Chiswick (1726), but its building may be a consequence of an exchange between Cleeve, a rich City of London pewterer, and the Venetian Consul.
3. British Library, shelf mark 60.g.1. This writer believes these drawings to be by Cleeve acting as an amateur architect.
4. See particularly, Brusatin, 1969, Bassi, 1980, and Barbieri, 1972.
5. For an account of the Palladian revival in Britain see Harris, 1994.
6. The latest work on the programme is still Levey, 1964.
7. This Visentini–Zuccarelli programme when completed featured the *Triumphal Arch* (Jones revised by Kent), Lord Pembroke's *Wilton Bridge*, Campbell's *Mereworth*, Jones's *Banqueting House*, John Webb's *New Gallery at Old Somerset House*, *General Wade's House* by Burlington, *Burlington House*, by Campbell, *Lindsey*

*House, Lincolns Inn Fields*, then regarded as a work by Jones, Vanbrugh's classicising *Bagnio at Eastbury*, and a *Caprice of Burlington's Bagnio at Chiswick with Campbell's Stourhead*. All are enlivened by Zuccarelli's characteristic arcadian figures, some of which may be authentic portraits.
8. See Harris, 1984, pp. 231–36.
9. Such as the *Proemio* to *Delle Osservazione Sopra la Fabbrica di Andrea Palladio*, Correr Library, Venice (Cicogna, 3658), quoted by Vivian, 1966.
10. For an account of Visentini as a recorder of Venetian architecture see McAndrew, 1974, in which the author failed to locate the earliest of these productions.
11. Although undated, such sentiments had already been expressed by Thomas Coram, who had set up the Foundling Hospital in London in 1739. We can also make a powerful comparison between Danieletti's figure and John Deval the Younger's sentimental monument in Cliffe Pypard church, Wiltshire, to John Spackman in 1786, where this successful and rich carpenter points to his tools at his feet and to the figures of a boy and a girl who have been educated as a result of his charitable donations.
12. See Levey, 1964, no. 616.
13. Young, 1977, pp. 3–11.

FRANCESCO ZUCCARELLI
*Mountain Landscape with Washerwomen and
Fisherman*
*c.* 1760–70
gouache on paper, 41.5 × 63.7 cm
National Gallery of Art, Washington
Gift of John Morton Morris, in Honor of the
50th Anniversary of the National Gallery of Art

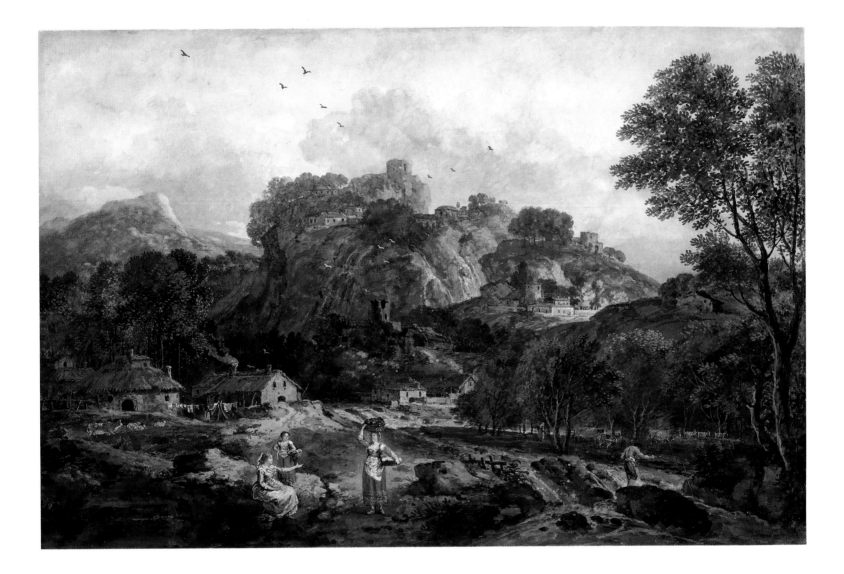

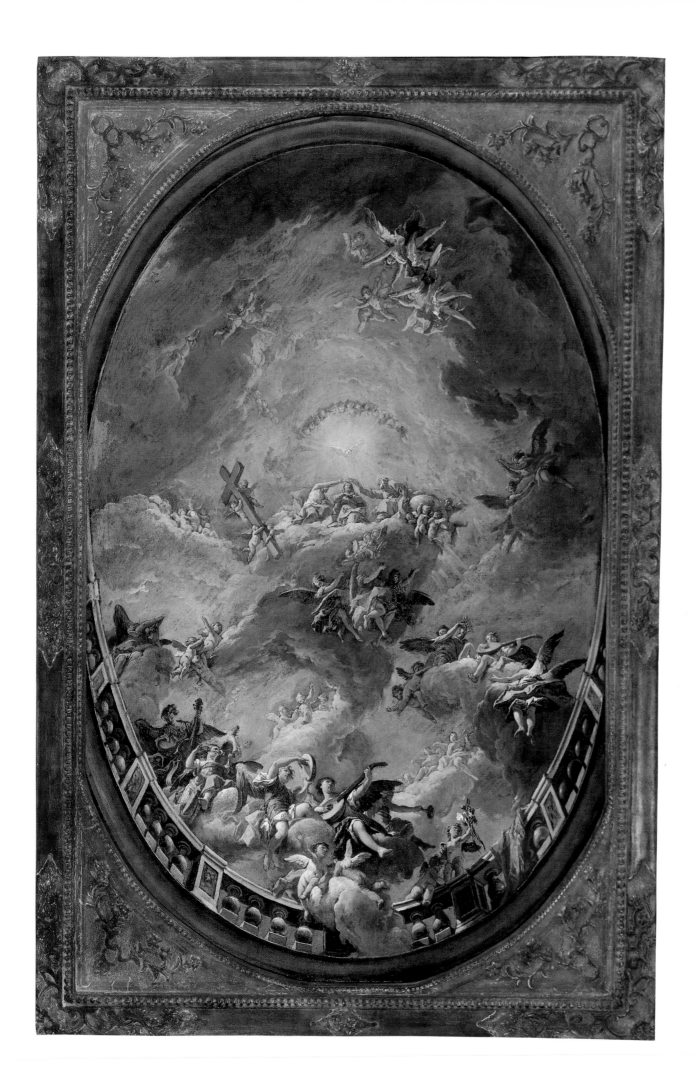

# VIII: *Artists of Religion & Genre*

Filippo Pedrocco

Sebastiano Ricci, as has been shown, introduced some important new elements to 18th-century Venetian painting, and some of the greatest decorators working in Venice and the Veneto in the 18th century were trained by him in his workshop. These included Gaspare Diziani, like Ricci, from Belluno, and Francesco Fontebasso.

Diziani began his training in Belluno with the modest *tenebroso* painter Antonio Lazzarini, then in 1709 moved to Venice where he worked with Gregorio Lazzarini before transferring to Ricci's workshop.[1] Like Ricci, as a young man Diziani made several journeys that were crucial to his artistic development: in 1717–19 he was in Dresden working with Alessandro Mauro as a stage designer at the court of August II, then in Munich where he painted several allegorical panels above the doors of the Residenz. In 1726–7 he was in Rome, invited there by the Venetian Cardinal Ottoboni; once again in collaboration with Mauro he designed a proscenium arch and scenery for the church of S. Lorenzo in Damaso.[2]

In 1734, probably at the time of Ricci's death, Diziani gave up almost all his stage work and turned to large-scale decoration, using religious subjects in particular; this was the beginning of a period of intense activity during which he worked in numerous palaces and churches in Venice and the Veneto. In his first efforts in this field his style is characterised by dramatic light and shade effects and densely applied colour; later, however, he modified the dramatic intensity of his youthful style, softening the *chiaroscuro* and beginning to show signs of great skill in composition. Echoes of Baroque masterpieces seen during his travels as a young man were tempered by light, soft colours.

A good example of Diziani's work at this stage of his career is the study for a ceiling painting of *The Coronation of the Virgin* (cat. 171); its composition can be compared with other works painted by him shortly after the middle of the century. These include the frescoed ceiling in the church of S. Bartolomeo, Bergamo, painted in 1751, and the ceiling in Palazzo Widmann in Venice (1755–60), both characterised by their dizzying spiral compositions reminiscent in certain respects of Tiepolo.

Diziani painted a great many altarpieces and some excellent scenes from popular life of freshness and subtlety. His large body of graphic work is of particularly high quality, including numerous preparatory drawings for his paintings that give some idea of his mastery of a variety of techniques.[3] His drawing is spontaneous and excitable, with lines sometimes worked over several times. It is closer to the 'open forms' of Pellegrini and Antonio Guardi than to Sebastiano Ricci's much quieter style. Diziani often uses a strong application of wash to emphasise the play of light and shade, as in *Aeneas Carrying Anchises from Troy* and *The Fall of Phaeton* (cat. 172, 173).

171

GASPARE DIZIANI
*Study for a Ceiling with the Coronation of the Virgin*
*c.* 1750–60
oil on canvas, 160 × 111.3 cm
Mr and Mrs Nelson Shanks

172

GASPARE DIZIANI
*Aeneas Carrying Anchises from Troy*
1730s
pen and brown ink and grey wash on light-
brown paper, 39.1 × 32.9 cm
National Gallery of Art, Washington
Ailsa Mellon Bruce Fund

GASPARE DIZIANI
*The Fall of Phaeton*
1745–50
pen and brown ink over red chalk with brown
and grey washes, 40.7 × 33 cm
National Gallery of Art, Washington
Andrew W. Mellon Fund

174

FRANCESCO FONTEBASSO
*Esther before Ahasuerus*
1750s
oil on canvas, 118 × 149.8 cm
The Ralph Dutton Collection,
Hinton Ampner (The National Trust)

After completing his apprenticeship in Sebastiano Ricci's workshop, Francesco Fontebasso left Venice in 1728, going first to Rome then to Bologna.[4] Influenced by this experience, he developed an academic style, somewhat heavy in the modelling and with emphatic contrasts of light and shade that are not always enlivened by his use of colour.[5]

Fontebasso worked on large-scale decorative schemes (frescoes in the church of the Gesuiti, Venice, in 1734) and was attracted by the work of Giambattista Tiepolo, to the extent that he created a synthesis between the pictorial style of Ricci and Tiepolo. This synthesis can be seen clearly in works such as *Esther before Ahasuerus* (cat. 174). In this painting Fontebasso achieves admirable effects of light, thanks in part to the warm and brilliant colour he employs. Although the subject derives from Ricci's painting, once owned by Anton Maria Zanetti the Elder, the vivid characterisation and melodramatic postures of the figures have obvious links with the world of Tiepolo. For this reason the painting is more likely to date from the middle of the century and not from Fontebasso's final years, before he regressed to more academic compositions and much duller colour.

Fontebasso worked regularly in Trent, then in 1761–2 was in St Petersburg, where he decorated a number of rooms and the chapel in the Winter Palace. His greatest body of work, however, was made for palaces in Venice, where he painted large numbers of frescoes on historical and mythological themes. His frescoes are recognisable by the heavy plasticity and oppressive *chiaroscuro*.

175

FRANCESCO FONTEBASSO
*Aeneas Carrying Anchises from Troy*
*c.* 1750
pen and brown ink and grey wash over black chalk, heightened with white, 46.3 × 32.8 cm
The Visitors of the Ashmolean Museum, Oxford

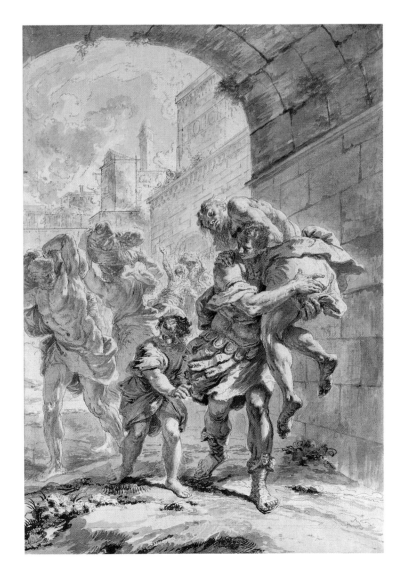

FRANCESCO FONTEBASSO
*Apollo, and Studies of Hands and a Male Head*
1740s
black chalk and pen and brown ink, 44 × 57 cm
National Gallery of Art, Washington
Gift of Mr and Mrs William N. Cafritz

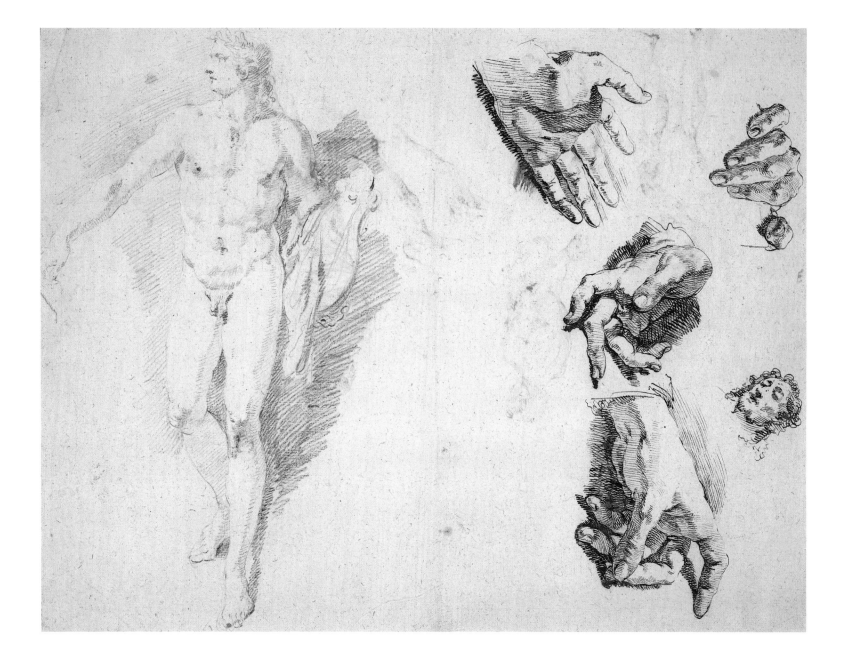

Fontebasso was a prolific draughtsman and produced sparkling, delicate work in the best tradition of the Venetian Rococo.[6] His mentors in this medium were again Sebastiano Ricci and Giambattista Tiepolo; at different stages of his career his graphic work sometimes reflects the influence of one, sometimes the other. He was not simply a passive interpreter of their work, however, and was capable of achieving a high degree of poetry independent of their influence. Examples can be found among his many 'finished' drawings, evidently intended for collectors, such as *Aeneas Carrying Anchises from Troy* (cat. 175), and the preparatory drawings for his paintings, such as the study for the figure of Apollo (cat. 176).

Fontebasso also produced numerous book illustrations; he designed the frontispiece for an edition of Petrarch's *Rime*, published by Antonio Zatta in Venice in 1756, Fontebasso's drawings being engraved by Giambattista Brustolon; four of the original drawings for an edition of the collected works of Dante Alighieri, published in four volumes between 1756 and 1757, have recently turned up on the British market. For this edition, of which some rare copies have colour-printed engravings (cat. 177), Fontebasso produced preparatory designs for the frontispiece, his subject being *Dante's Message to the People of Venice*, engraved by Giuliano Giampiccoli, and for illustrations to sixteen cantos of the *Divine Comedy*, engraved on copperplates by the various engravers who worked for Zatta.

177

FRANCESCO FONTEBASSO
*La Divina Commedia di Dante Alighieri ...*,
published in Venice by Antonio Zatta, 1757
4 volumes, quarto, the third open to show the
etched plates, printed in colour, at the beginning
of Cantos X and XI
etchings, 33.5 × 51 cm
The British Library Board, London

CANTO X.

Tom. III.

CANTO XI.

Tom. III.

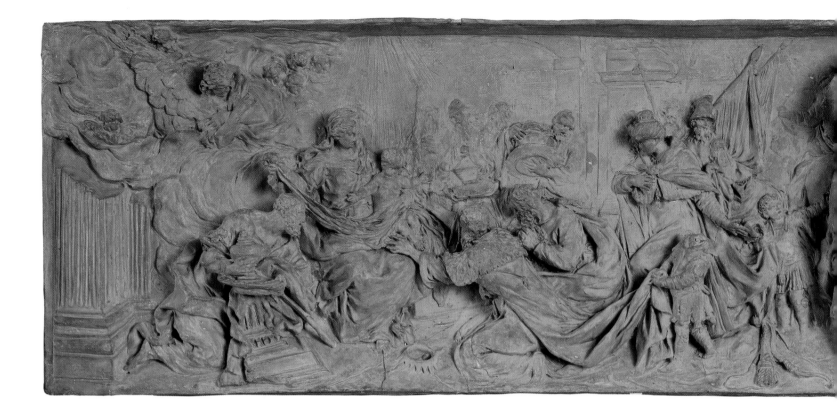

178

GIOVANNI MARIA MORLAITER
*Adoration of the Magi*
1730
terracotta relief, 34 × 103 cm
Ca' Rezzonico,
Museo del Settecento Veneziano, Venice

Gian Maria Morlaiter, the leading Venetian exponent of Rococo sculpture in Venice, had close ties with Sebastiano Ricci: documents relating to a lawsuit between the painter's heirs bear witness to the friendship between the elderly master and the young sculptor in the years immediately preceding Ricci's death.

It is interesting to note how Morlaiter's artistic career followed the same lines, as that of the painters who were the chief exponents of the Rococo in Venice at the time (apart from Ricci, Pittoni, Pellegrini and Antonio Guardi). He translated their colour values, the dynamics of their figures, their strong contrasts of light and shade and the elegance of their compositions into sculpture; his many models in terracotta and clay, now in Ca' Rezzonico in Venice, and his bas-reliefs are of exceptional quality.[7]

Morlaiter began working independently at the end of the 1720s. The two reliefs on the dado in the presbytery of the chapel of the Rosary in the church of SS. Giovanni e Paolo are dated 1730. These depict *Jesus Among the Scribes* and the *Rest on the Flight into Egypt*, and are placed alongside other reliefs illustrating scenes from the life of Jesus carved by other famous Venetian sculptors of the day. The terracotta models for these bas-reliefs are in Ca' Rezzonico. Morlaiter prepared a third maquette at the same time, for a relief depicting the *Adoration of the Magi* (cat. 178) but it was turned down, and Giovanni Bonazza was commissioned to produce the scene in marble. The sketch is nevertheless exquisite, certainly one of Morlaiter's best works. Its Rococo elegance is typical of his style from the outset, and the *horror vacui* was also a constant feature of his work. The figures are in high relief, standing out sharply against the architectural background. The narrative continuum is hectic, the modelling precise, the decorative detail exquisite.

The collaboration between Morlaiter and Giorgio Massari began in 1732, when Morlaiter was commissioned to make several pieces for the upper room of the Scuola di S. Giovanni Evangelista, recently restored by Massari. From then on Morlaiter's sculpture was included in almost all of the many new buildings constructed, restored or completed by Massari, where frescoes by Giambattista Tiepolo also often appeared. The collaboration of this trio reached its high point in the interior decoration of the church of the Gesuati, a project that, from 1740, kept the sculptor busy for at least fifteen years (fig. 48).

Morlaiter also worked with Massari on the decoration of two other churches in Venice, the Fava and the Pietà; his work on the completion of Ca' Rezzonico is also documented. For the Rezzonico family he carved portrait heads of *Pope Benedict XIV* and *Cardinal Carlo Rezzonico* (later Pope Clement XIII), both now in the presbytery of the Duomo in Padua. These two busts were commissioned on 9 August 1756 as substitutes for another pair, by Antonio Bonazza, that had been turned down; a third head, of Marshal von der Schulenburg, for his funeral monument in the Arsenal in Venice was commissioned at the same time (fig. 49). These are the only portraits by Morlaiter still extant. They confirm the decorative quality of Morlaiter's style; profound psychological analysis of his subjects were not for him. Particularly remarkable is his extreme elegance of form, intensified by his technical skill: this is court portraiture designed to emphasise the elevated position of its subject.

The latter years of the sculptor's career saw a noticeable decline in the quality of his work. One contributory factor was that he delegated a large part of the execution of his sculpture to his assistants (his son Gregorio, Antonio Sabbadini and Lorenzo Cantarutto). The statues on the great staircase in the Scuola della Carità, or the reliefs on the façade of the church of S. Rocco are heavy, almost clumsy in comparison with the expressiveness and formal elegance that marked his earlier output.

*Figure 48:* Giorgio Massari, S. Maria del Rosario (The Gesuati), Venice, 1724–36, the interior

*Figure 49:* Gian Maria Morlaiter, *Monument to Marshal von der Schulenburg*, 1746, Arsenale, Venice

Giambattista Piazzetta had large numbers of assistants too, and he organised them into a proper school with Giuseppe Angeli as its director. Besides the students in the school, who included Francesco Cappella, Egidio dall'Oglio, Giulia Lama, Domenico Maggiotto and Antonio Marinetto, known as Il Chiozzotto, his influence spread beyond his immediate circle to artists like Giuseppe Nogari.[8]

18th-century commentators agree that Nogari studied in his youth with Antonio Balestra. If he did, he does not seem to have absorbed much of his master's teaching, turning more towards the style of Piazzetta from whom he drew his interest in vivid contrasts of light and shade, and the genre subjects, including his 'Character Heads', so typical of that milieu. Nogari had a very successful career. He worked for the major collectors of the city, people like Schulenburg and Smith, and for various foreign royal families. His work was sold for high prices, particularly on the German market.

179

GIUSEPPE NOGARI
*An Elderly Woman in a Striped Shawl*
pastel on two attached sheets of paper,
50.5 × 40 cm
National Gallery of Art, Washington
Ailsa Mellon Bruce Fund

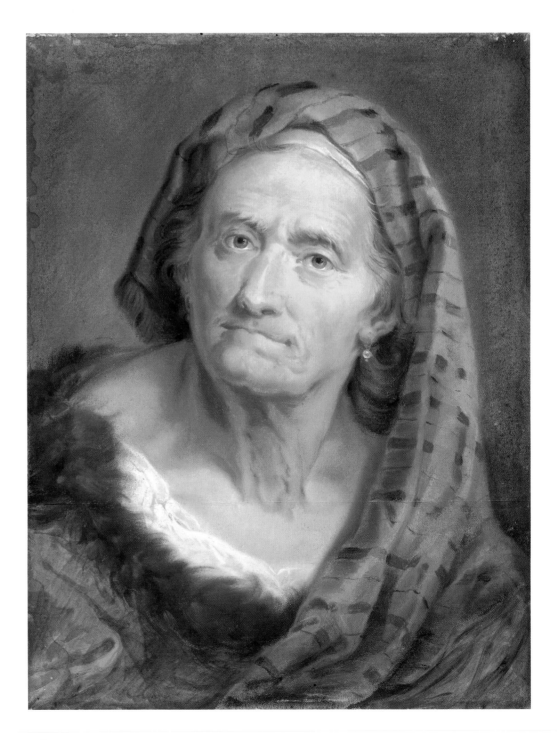

Nogari worked on two levels and in two distinct styles. His numerous historical, religious and allegorical pieces are executed in an elegant, appealing style in colours reminiscent of similar subjects by Jacopo Amigoni. Better known are his 'character heads', which demonstrate his familiarity with the paintings and drawings of Rembrandt, well-represented in private collections in Venice. *An Elderly Woman in a Striped Shawl* (cat. 179) is one of the best examples of his work in this style; it is a very skilful, polished pastel, with subtlety of detail and fine shading, its warm tones betraying Nogari's indebtedness to Piazzetta. Nogari's study of Northern artists such as Rembrandt encouraged him to accentuate the realism of his subjects; he emphasises the personalities of the different human types he portrays in a manner that could not be more different from the languid, saccharine figures in his larger paintings.

Though it may seem far-fetched to link Pietro Longhi's artistic output with that of Piazzetta, both painters shared similar experiences during their early years. Contemporary biographers agree that Pietro Longhi started work as a very young boy in the workshop of Antonio Balestra and that, after he had been there a few years, Balestra sent him to Bologna with an introduction to Giuseppe Maria Crespi. Balestra stayed in Venice until 1718, when he returned to his native Verona; it is likely that Longhi moved to Bologna soon after his original teacher left Venice. In fact his earliest known work, paintings and frescoes of mythological and religious subjects, already bear obvious traces of familiarity with the Baroque painting of Emilia.[9]

Longhi's presence in artistic circles in Bologna, and his familiarity with the work of Crespi (whether or not he actually worked in his studio) is important not merely for its influence on his religious and mythological painting, not in themselves very significant, but also because it affected the successive development of his artistic career. Crespi was one of the first Italian painters to dignify genre painting, which in the 17th century had been more or less exclusively the sphere of the Dutch; simultaneously he was one of the earliest European artists to paint conversation pieces, anticipating by some years the work of the more famous Hogarth.[10]

Longhi's training was therefore comparable to the training Piazzetta had received some twenty years earlier; this explains why the early, small paintings by Longhi with titles such as *Pastorelli*, *Contadini*, have an obvious connection, in their subject-matter and their colour schemes, with similar works by Piazzetta.

It is not known when or why Longhi gave up his career as a narrative painter when he had already gained a certain reputation among his contemporaries. At first he devoted himself to genre painting and later to the small and unusually realistic scenes that mark him as completely outside the conventional framework of 18th-century Venetian painting. The scant documentary evidence that survives may indicate that his rejection of narrative painting was gradual and took place between 1735 and 1740.[11] The new departure affected not only his choice of subject but his painting style as well. His small genre paintings of 1735 follow Crespi's example very closely, such as his *Girl Picking off Fleas* (Louvre, Paris); the colours are generally sombre with the occasional brilliant flash of bright colour. Conversely his earliest small paintings of Venetian life show his affinity with the style of the greatest Venetian exponents of the Rococo, from Rosalba Carriera to Jacopo Amigoni. From them come the stabbing brushstrokes, the unobtrusive use of coloured shading, the soft, almost pastel tones, enriched by glowing colour.

These paintings betray an interest in the work of contemporary French artists. Longhi was probably able to study the volumes of engravings of Watteau's paintings, published in Paris between 1728 and 1734, which had had been sent to Rosalba Carriera in Venice by Julienne.

PIETRO LONGHI
*Wine-pourer with a Young Man*
black and white chalk on brown paper glued
onto card, 43.8 × 29.2 cm
Museo Civico Correr, Venice

180

PIETRO LONGHI
*Young Man Sprawled in a Chair*
*c.* 1760
charcoal and white chalk on grey-brown paper,
28 × 38.8 cm
Staatliche Museen Preussischer Kulturbesitz,
Kupferstichkabinett, Berlin

Longhi's connection with France is most evident in his graphic work: in his many admirable drawings, most of them preparatory sketches for the scenes from Venetian life, the technical and stylistic means he adopts are close to those used by Watteau or Lancret.[12] This is confirmed by the preparatory sketches for the *Drunkards* and for *The Itch*, both exhibited here (cat. 181, 180). In his innumerable drawings Longhi studied in the minutest detail elements of the figures and objects that subsequently appeared in his paintings, drawing them from life. His preferred medium was charcoal or something equally soft, rather than pen or brush, and he took immense care with his white chalk highlights. His strokes are fractured but very precise, and they cover the paper rapidly and elegantly, outlining the figures and forms at high speed; his retouching adds greatly to the overall effect. His continual sketching and jotting, the way he built up figures from a variety of elements, his detailed preliminary investigations of his subjects helped to deepen and broaden his search for objective reality. No other Venetian figure painter comes near his thoroughness, though he might have a rival in the other great painter of the Enlightenment, the architectural draughtsman and painter of cityscapes, Canaletto.

Longhi has often been likened to Hogarth, presumably because they both depicted satirical scenes from everyday life. To the Venetian, however, cynical criticism of a certain section of society (the decadent Venetian aristocracy) is completely alien; he appears entirely at his ease in such society.

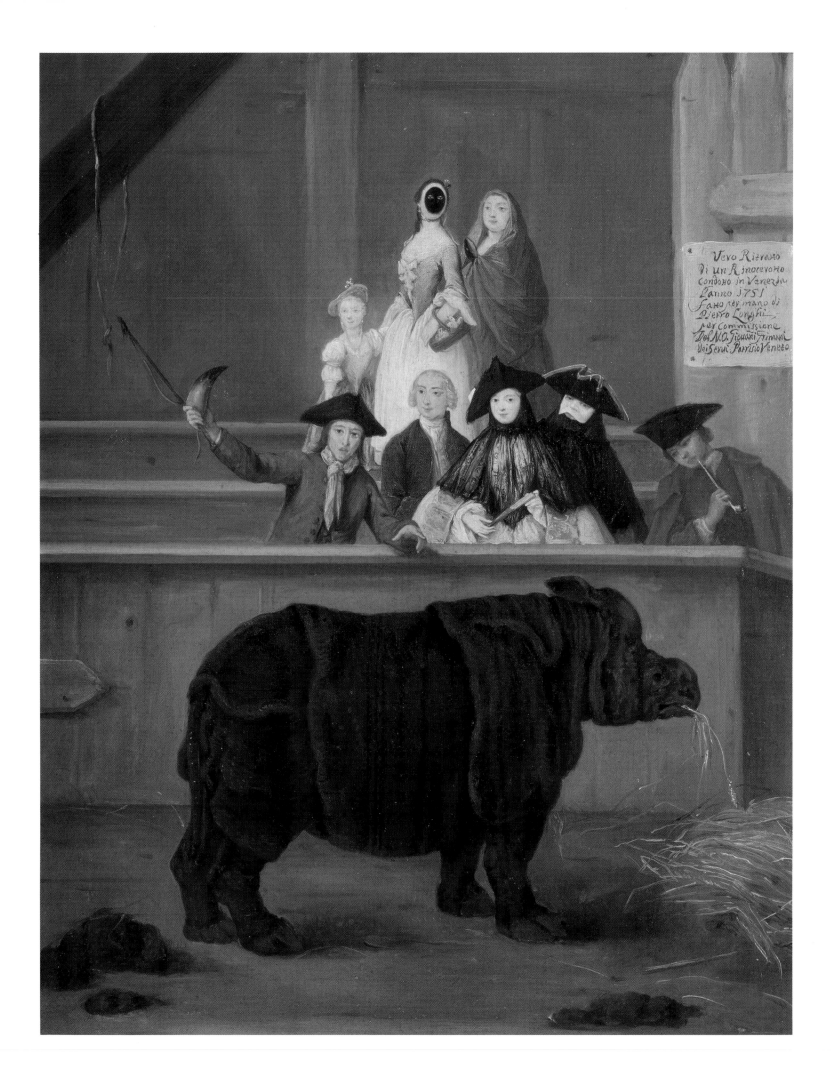

In spite of this, however, Longhi is undeniably caught up in the cultural ferment of the Enlightenment that swept Europe in the 18th century. His position within this phenomenon is proved by the way he seeks out truth so steadfastly, by his almost obsessional need to narrate realistically, by his style and gesture, and by the way he depicts faces (some of them can still be recognised) and, last but not least, by the way he uses natural rather than stage lighting.

Longhi's effect on Venetian painting can be compared with the revolution in the theatre brought about by Carlo Goldoni. Goldoni abandoned the traditional *commedia dell'arte* for theatre based on plots from real life as he observed it, and it is this shared interest in realism that links the dramatist with the painter. That Goldoni was aware of this is demonstrated by his famous sonnet, written in 1750, that starts with the lines '*Longhi, tu che la mia musa sorella | chiami del tuo pennel che cerca il vero*' (Longhi, you summon my sibling muse; your pen like mine is seeking truth).

In his earliest scenes from Venetian life Longhi had already found the mode of expression best suited to his skills, and also the one most appreciated by his customers; he was to operate within this mode for the rest of his career. His fame spread rapidly: his clients included many of the most prominent families and the major collectors in Venice, from the Veniers to the Sagredos, from the Querini to the Giovanelli, the Ruzini, the Grimani, the Barbarigos; from contemporary sources we know that he also sent work to 'the courts of Europe'.

From the end of the 1740s work poured uninterruptedly from his studio; some paintings were grouped in series and illustrated the habits and customs of the Venetian aristocracy, some canvases were made singly and depicted an unusual occurrence or event. Among the latter *The Rhinoceros* (cat. 182) is of particular interest because it chronicles an event that took place during Carnival in Venice in 1751: the rhinoceros brought from India ten years earlier by Captain Douvemont van der Meer was put on display. This painting, unanimously hailed as one of Longhi's greatest works, is remarkable for the delicate, luminous quality of its colour. Of great interest also is the series of lifelike portraits of the people seen admiring the animal, among whom we can recognise Giovanni Grimani, the nobleman who commissioned the painting, a member of that branch of the noble Venetian family who lived at the Servi; also portrayed is the owner of the rhinoceros, who holds its horn in his hand.

Identifying the constituent parts of a series that is widely scattered is no simple matter. Some of Longhi's series are on mildly erotic themes, others depict the daily round of a noblewoman, yet others the pastimes of Venetian families in the privacy of their palaces, or the bustle under the portico of the Doge's Palace, where members of the populace and the nobility mingle during the long carnival period in Venice, or the diversions of peasants, the common people and servants.

At least some of the paintings in these series are of a high standard: for example *A Painter in his Studio* (cat. 183) in which Longhi portrays an artist (possibly himself) with great realism. The artist is painting the portrait of a noblewoman, accompanied by a bored *cicisbeo*, in his studio. Giambattista Tiepolo's celebrated painting of *Alexander and Campaspe in the Studio of Apelles*, (cat. 92), painted twenty years earlier, comes to mind; it depicts a similar scene though in the historical–mythological mode. The cultural and artistic abyss between the two paintings is striking; different moods, different focus, different interests, yet Longhi and Tiepolo were more or less contemporaries.

182

PIETRO LONGHI
*The Rhinoceros*
*c.* 1751
oil on canvas, 62 × 50 cm
Ca' Rezzonico, Museo del Settecento
Veneziano, Venice

PIETRO LONGHI
*A Painter in His Studio*
1741–4
oil on canvas, 44 × 53 cm
Ca' Rezzonico, Museo del Settecento
Veneziano, Venice

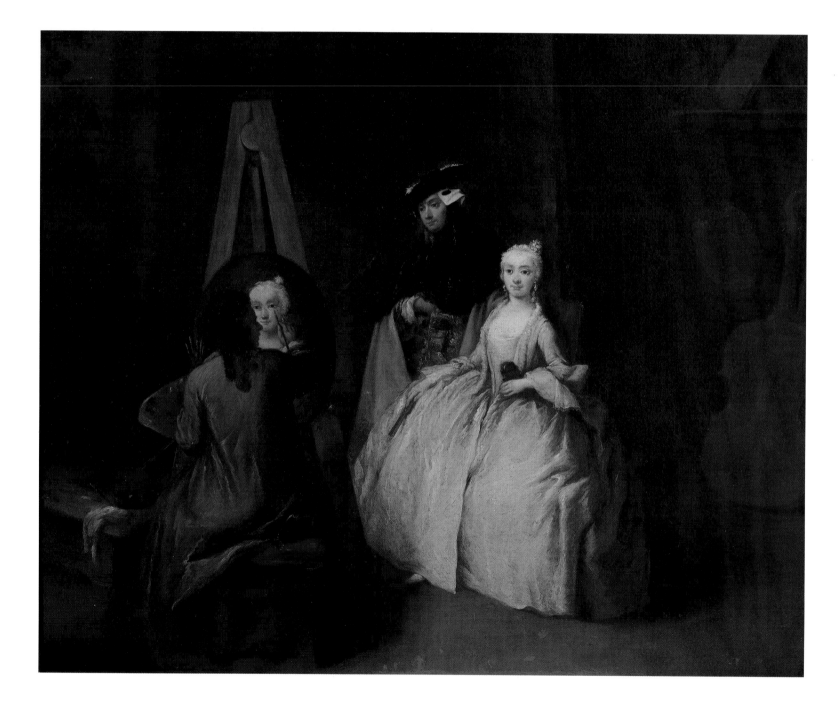

PIETRO LONGHI
*The Married Couple's Breakfast*
1744
oil on canvas, 49 × 60 cm
Lent by Her Majesty The Queen

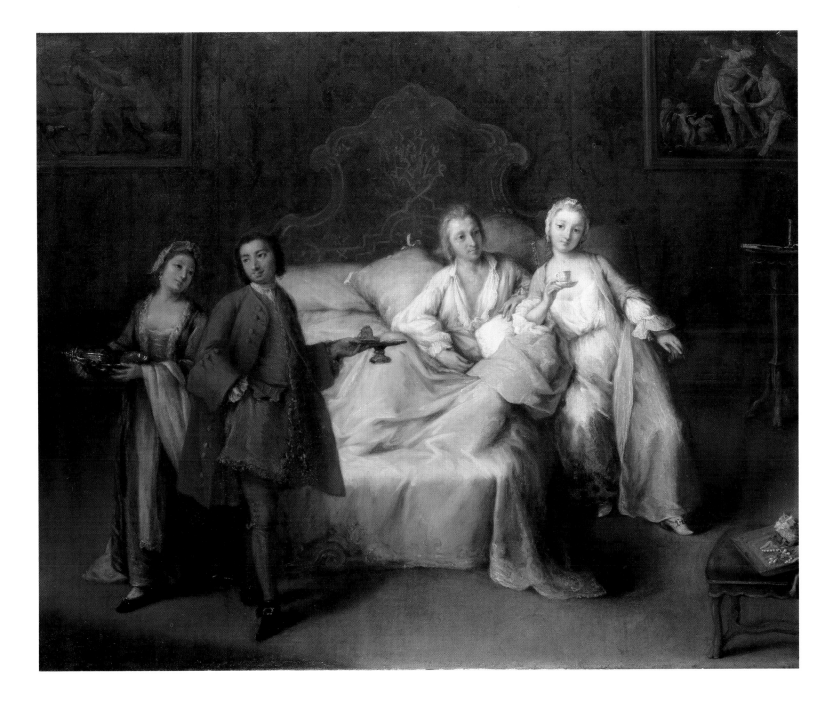

The two paintings once owned by the British Consul in Venice, Joseph Smith, *The Married Couple's Breakfast* (cat. 184) and *Blind-man's Buff* (Windsor Castle) are stylistically similar to the Ca' Rezzonico painting. Both are signed and dated 1744, and both are notable for their diffused light and for the care with which they are painted (the many preparatory sketches in the Museo Correr bear witness to this); also for Longhi's brushwork, which can catch every vibration of light and every solid object with equal skill. These paintings illustrate Longhi's uncertain handling of perspective, noticeable even in his best work; nevertheless they give him a chance to show his genius for the precise, realistic depiction of intimate aspects of contemporary Venetian life.

The two complete series in the Fondazione Querini Stampalia in Venice are of great interest: the first, dated about 1755, has as its subject the *Seven Sacraments*, the second, *The Hunt in the Valley*, dates from the 1770s. For the *Seven Sacraments* Longhi took his theme from Crespi (his paintings on the same subject are in the Gemäldegalerie in Dresden), altering it radically, however, to suit his taste and sensibility (*Extreme Unction*, cat. 185). The other series, of hunting scenes, is completely original and is one of Longhi's most successful ventures. The nobleman who commissioned the series, Gregorio Barbarigo, is shown; everything from technical details of hunting to the habits of the huntsmen is painted with the greatest regard for realism. The glorious colours, subtly altered by Longhi when painting the evening light that makes everything brown, or the first flush of dawn over the calm waters of the Venetian lagoon, anticipate the tonalism of 19th-century painters like Géricault or Courbet.

Longhi's use of brownish tones as background colour appears regularly in his painting from the late 1750s. An example is the *Masked Figures with a Fruit-seller* (cat. 186); in the foreground the aristocratic couple in their dominoes stand out against the shaded architecture of the portico. This modification of Longhi's style was superseded by a more radical change later on in his career: in his last works the brightness of his colours gives way to low, almost uniform tones. Previously applied quite thickly, now the paint becomes thin and meagre, sometimes allowing the grain of the canvas and the greyish underpainting to show through. The precision of his line softens, and is sometimes replaced by an overlay of brushstrokes that has the effect of thickening and increasing the weight of the figures. Faces begin to conform to a stereotype, and Longhi's attention to proportion in both figures and objects wavers a little. Late in his career Longhi painted several portraits, but as this was work that he did not particularly enjoy he passed it on to his son Alessandro, who had been trained in the workshop of Giuseppe Nogari.

Pietro Longhi did not found a school as such, but he certainly started a fashion in Venice: his imitators were legion, none of them able to reach the high standard of the *maestro*. Of his principal followers most are known by name only: Giuseppe de' Gobbis, Lorenzo Gramiccia from Rome, Andrea Pastò, also a painter of frescoes. In Venice his artistic influence can be found in some of the youthful works of Francesco Guardi, who certainly had Longhi's example in mind when he painted *The Ridotto* (cat. 202) and *Il Parlatorio* (fig. 53). He also made copies of some of Longhi's paintings. In some respects his straightforwardly realistic style affected the Tiepolo family, Domenico and particularly Lorenzo who, during his Venetian period, before he moved permanently to Madrid in 1762, was showing a marked degree of realism in the work he did on his own account, away from his father's workshop.

185

PIETRO LONGHI
*Extreme Unction*
before 1755
oil on canvas, 61 × 50 cm
Fondazione Scientifica Querini Stampalia,
Venice

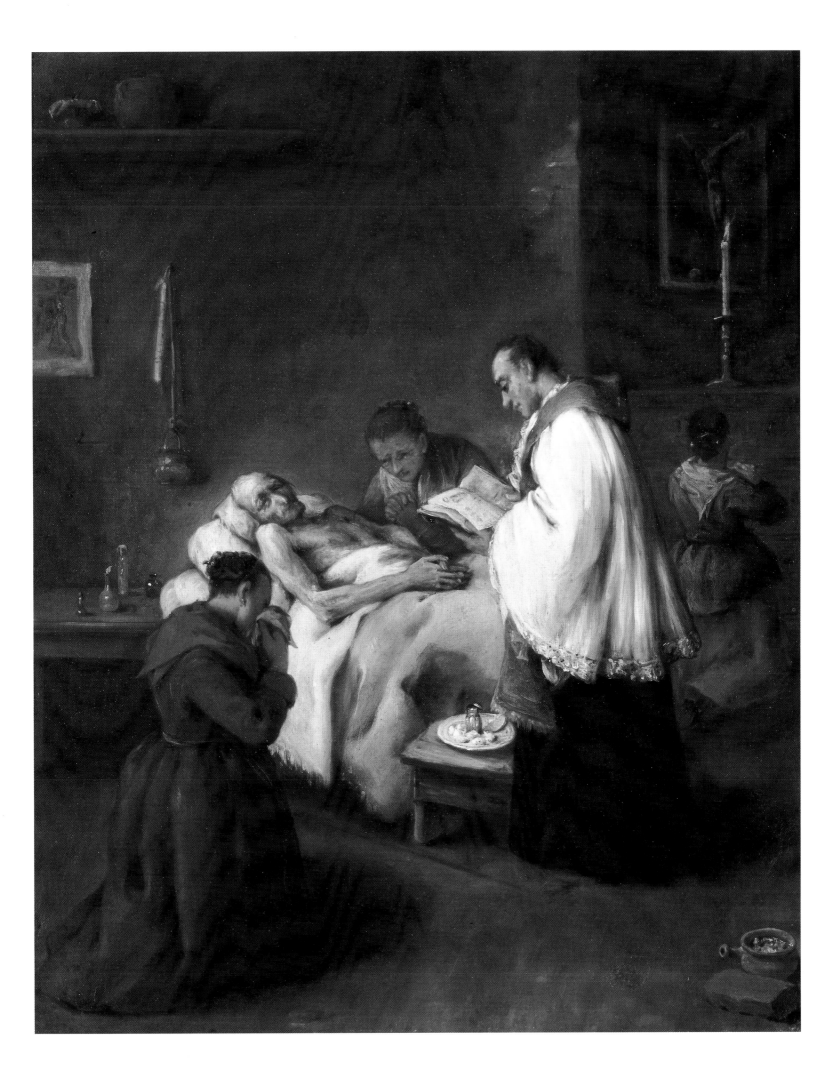

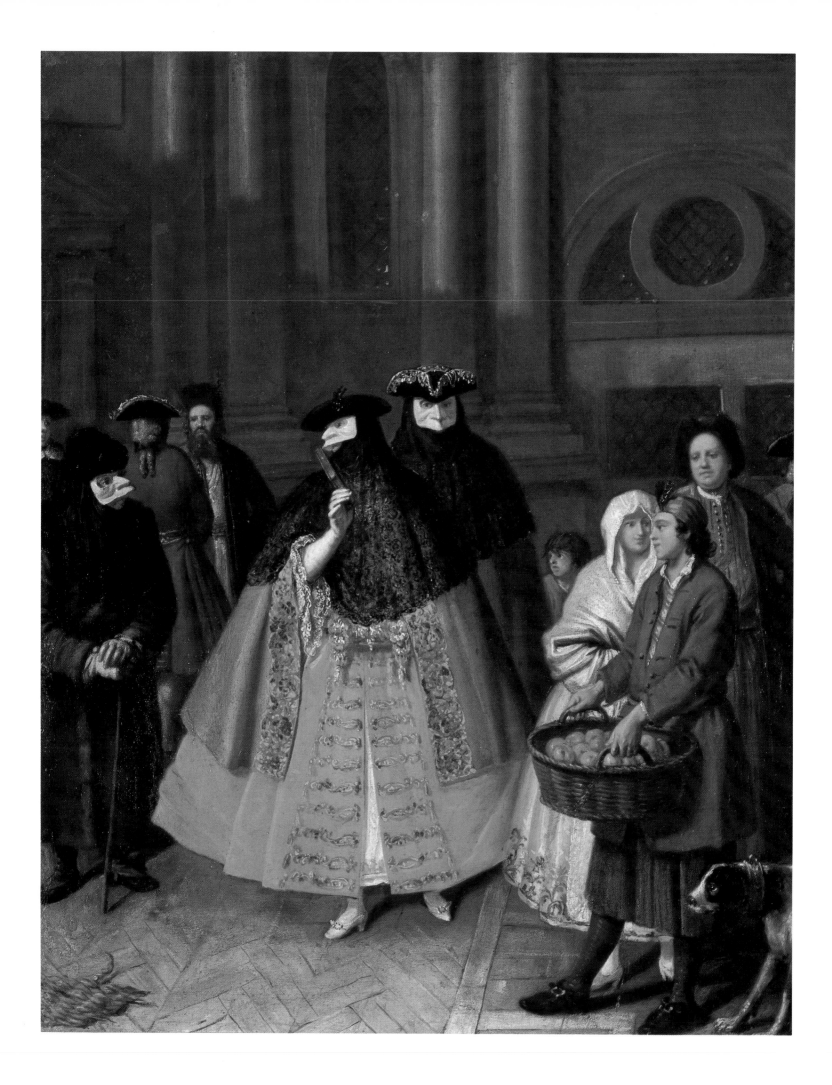

PIETRO LONGHI
*Masked Figure with a Fruit-seller*
(?) *c.* 1760
oil on canvas, 62 × 51 cm
Ca' Rezzonico, Museo del Settecento
Veneziano, Venice

Gaetano Zompini,[13] from Treviso, aimed at the same degree of realism. He came to Venice as a very young man and was first a pupil of Antonio Balestra, and then, after 1718, of Sebastiano Ricci. He is chiefly remembered for the paintings executed for the Scuola dei Carmini in Venice in 1748, inspired by Tiepolo; his career is distinguished by considerable narrative skill, exemplified in his designs for book illustrations, particularly in the illustrations to editions of Petrarch's *Rime* and the collected works of Dante Alighieri (cat. 177), published in 1756 and 1756–7 respectively by Antonio Zatta.

Zompini's most celebrated work, the collection of 60 etchings entitled *Le Arti che Vanno per via nella Città di Venezia*, an authentic catalogue of the humblest trades and crafts pursued by the working populace of Venice,[14] demonstrates his narrative skill: Zompini obtained a licence to print the volume, which according to the original plan was supposed to contain 100 engravings, on 4 March 1747. The first 40 etchings appeared in 1753 and the next twenty in the following year. The first edition, of which some copies were delicately hand-coloured by Zompini himself (cat. 188) was small, possibly only 30 or 40 copies. The work did not gain popularity until after Zompini's death, when the English Resident in Venice, John Strange, acquired the copperplates previously owned by Anton Maria Zanetti the Elder, who had played an important role in Zompini's enterprise and, after his death, that of his heirs. In 1785 he published a second edition of the collection, with an introductory memoir written by Gianmaria Sasso. This edition was followed by four more, printed in England.

Zompini's etchings, for which 95 preparatory sketches survive in the Museo Correr in Venice, depict the life of the poorest members of the working class of Venice, most of them peasants who came to the city and took on any kind of work in order to survive. His engraving style is devoid of formal elegance, and thus very unusual for Venice. His realism makes no concessions to the picturesque; it is very direct and displays the artist's understanding of, and sympathy for, his subjects. This book was published at a moment when social tension was increasing in Venice as the gap between the rich and poor widened rapidly; dedicated as it was to the most dispossessed it acquired almost the character of an indictment, and this may explain why it was initially a commercial failure.

There are clear connections between Longhi and Zompini: compare Longhi's *Fruit-seller* (cat. 186) with Zompini's etching of the *Codega*, the lantern-bearer (cat. 188). The similarity between the two couples of masked revellers suggests that Longhi knew Zompini's etching. Longhi's aristocrats are centre stage, however, as the painter recounts a moment of their daily activity during Carnival. The real protagonist of Zompini's etching is the servant obliged to provide street lighting with his lamp during the night. The verses illustrating the scene, written, according to Sasso, by Dr Questini, the priest in charge of S. Maria Materdomini and a friend of Zanetti, stress this aspect of the illustration:

*De notte, ora ai teatri, ora al Redotto*
*Son quel che col feral serve da lume;*
*E pur che i paga mi so andar per tutto.*

(At night, outside the theatres or the Ridotto,
I provide light with my lantern;
I earn the right to go where I want.)

187

GAETANO ZOMPINI
*Le Arti che Vanno per via nella città di Venezia*,
published in Venice by S. Bettinelli in 1753
volume of 60 etchings, 43.8 × 62 cm (open book)
Department of Printing and Graphic Arts,
Houghton Library, Harvard University,
Cambridge, MA

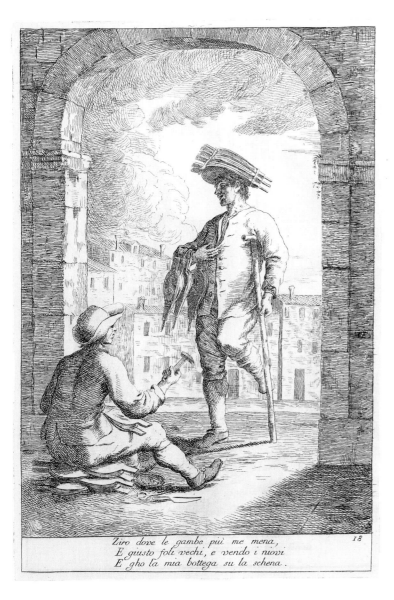

Ziro dove le gambe più me mena,
E giusto foli vechi, e vendo i nuovi
E gho la mia bottega su la schena.

18

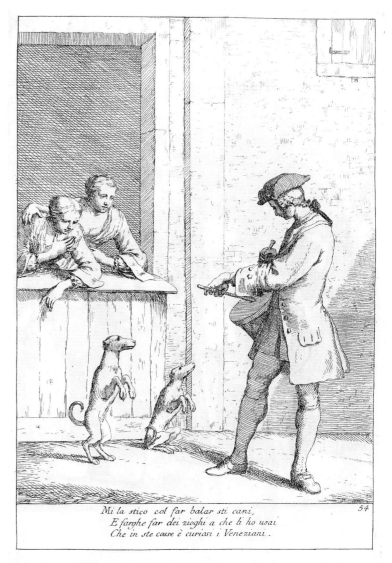

Mi la stico col far balar sti cani,
E farghe far dei zioghi a che li ho usai
Che in ste cosse è curiosi i Veneziani.

54

GAETANO ZOMPINI
*Le Arti che Vanno per la via nella città di Venezia,*
published in Venice by S. Bettinelli in 1753
volume of 60 hand-coloured etchings, 43.8 × 62 cm (open book)
Private Collection

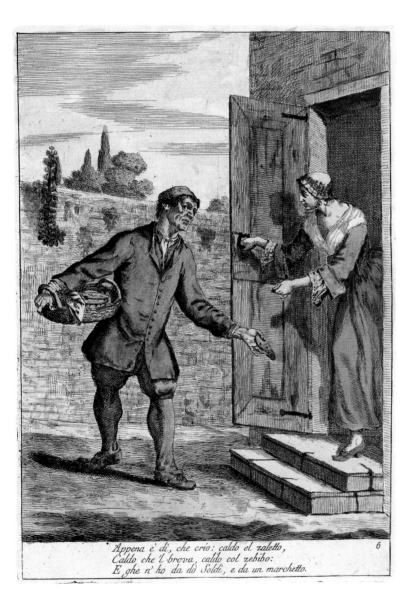

*Appena è dì, che crio: caldo el zaletto,*
*Caldo che'l brova, caldo col zebibo:*
*E ghe n'ho da dò Soldi, e da un marchetto.*

6

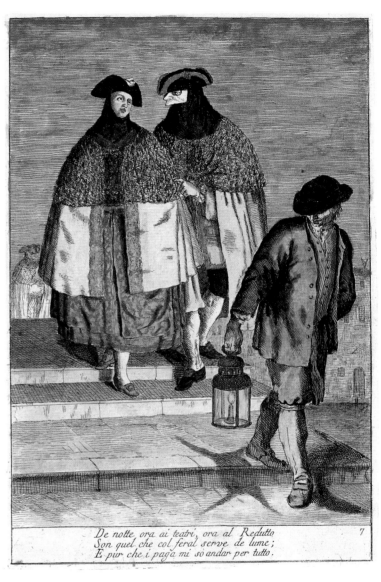

*De notte, ora ai teatri, ora al Redutto*
*Son quel che col feral serve de lume;*
*E pur che i paga mi sò andar per tutto.*

7

Recent studies,[15] based on information provided by Girolamo Zanetti, a cousin of Anton Maria Zanetti the Elder who was in close contact with Zompini, are agreed in attributing the preparatory drawings for another series of engravings to the author of the *Arti*, though they might seem to be by another hand. This series was used by the Venetian publisher Giuseppe Bettinelli to illustrate a tragi-comedy written by Zaccaria Vallaresso, a nobleman, under the arcadian pseudonym Panchiano Catuffio Bubulco, and entitled *Rutzvanscad il giovane . . .* (cat. 189); it was published in 1737. The volume is illustrated with a frontispiece, three vignettes, two decorated initial letters and nine full-page plates; some of the latter (*The Blind Musicians in the Piazza*, *The Astrologer*) are powerfully realistic and contain the same kind of tragic figures as those in the *Arti*. Zompini's complete originality is evident once again as he investigates the world of the poor and the infirm. No such subject-matter had ever been treated so directly and so sympathetically by any Venetian artist; Venice was a city whose inhabitants lived on memories of past glories and the opulence of yesteryear, hypocritically refusing to admit the existence of the large numbers of poor people who made up a considerable section of the populace.

Giorgio Fossati, like Zompini, devoted part of his career to engraving and book illustration. He came to Venice in 1716 from his native Morcote, near Lugano, and as a young man was a pupil of the architect Domenico Rossi.[16] His work as an architect was mainly devoted to the Scuola and church of S. Rocco; he was commissioned to design the new façade of the church in 1756, but in 1760, when work had already started, his plan was jettisoned in favour of designs by Bernardino Maccaruzzi.[17] An original and eclectic character, Fossati was involved in a diverse variety of projects, from scene painting to literature. In 1752 he was commissioned to decorate the nuptial bedchamber of the noblewoman Caterina Loredan.

As an engraver he will be remembered for his famous *Veduta Prospettica di Venezia*, published in 1746, and for the 216 full-page plates illustrating the *Raccolta di Varie Favole* published in three volumes by Carlo Pecora in Venice in 1744 (cat. 190). His realistic pictures of animals are interesting and unusual; perhaps more admirable are the scenes set amid Baroque architecture in which Fossati could exploit to the full his training and experience as an architect.

189

ANONYMOUS VENETIAN ARTIST
*Rutvanscad il giovane . . .*, published in Venice by Giuseppe Bettinelli, 1737 octavo, open to the etched plate *The Three Blind Musicians in the Piazza*
Department of Printing and Graphic Arts, Houghton Library, Harvard University, Cambridge, MA

190

GIORGIO FOSSATI

*Raccolta di Varie Favole delineate ed incise in rame da Giorgio Fossati architetto*, published in Venice by Carlo Pecora, 1744

2 volumes, quarto, vol. I open to plate facing p. 7; vol. II open to plate facing p. 16

Arthur and Charlotte Vershbow

1. For Diziani see, in particular, Zugni Tauro, 1971; more recently, Bergamo, 1983, and Claut, 1988.

2. Pavanello, 1981; Martini, 1989.

3. On Diziani's graphic work see: Dorigato, 'Gaspare Diziani disegnatore', in Bergamo, 1983, pp. 25–44 (with an up-to-date bibliography).

4. For Fontebasso, see Magrini 1988.

5. Pallucchini, 1960[2], p. 154.

6. On Fontebasso's graphic work see Magrini, 1990.

7. The only comprehensive studies of Morlaiter's work are Semenzato, 1966, pp. 62–5 and 136–8; Ress, 1979; Pedrocco, 1979–80, pp. 341–354.

8. The bibliography of Nogari is very meagre, but see Honour, 1957, and Pallucchini, 1960[1], pp. 128–9.

9. There are important monographs on Longhi by Pignatti, 1968 and *idem*, 1974[2]. See also the recent catalogue, Venice, 1993[3].

10. On this question see: Pajes Merriman, 1980, p. 142ff.

11. On this question see Pedrocco, in Venice, 1993[3], pp. 15–18.

12. On Longhi's graphic work see in particular Pignatti, 1990.

13. Bozzolato, 1978, provides the most complete chronology of the artist.

14. On this collection see Moretti, 1968.

15. Moretti, 1968; Pedrocco, 1978, II, pp. 59–60; Succi, in Venice, 1983[2], p. 453.

16. For a biography of Fossati and his activity as an architect, see Scattolin and Talamini, 1969.

17. Lewis, 1967; Brusatin, 1980, pp. 212–3.

191

ANTONIO GUARDI
*Erminia and the Shepherds*
c. 1750–5
oil on canvas, 251.5 × 442.2 cm
National Gallery of Art, Washington
Ailsa Mellon Bruce Fund

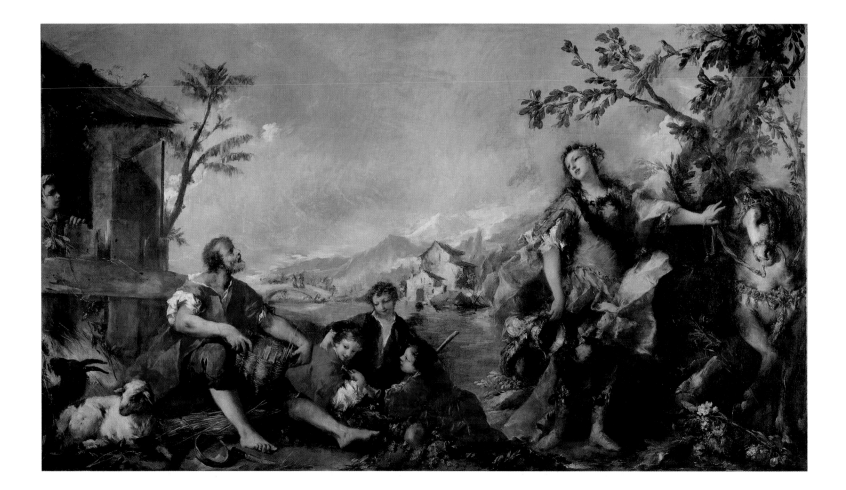

# IX: *The Brothers Guardi*

## Mitchell Merling

The present-day image of late 18th-century Venice seems inseparable from the views, genre scenes and *capriccios* of Francesco Guardi. However, he was not always so well known or held in high esteem, and his painterly vision and occasionally unusual treatment of subjects have presented something of an enigma to scholars. While the idea of him toiling for his daily bread from under the arcades of the Piazza S. Marco has now been dismissed as romantic fiction, and the opinion that his sketchy style inspired or anticipated the Impressionist vision of Venice of Monet or Whistler has long been recognised as misleading and limited, much remains to be learnt about his art.

Even more elusive is Francesco's elder brother, Antonio. He was responsible for one of the most original paintings of its date: the organ parapet in the church of the Angelo Raffaele (fig. 50). Its extreme calligraphic brushwork is evidence of a personality able to produce a masterpiece in the most extravagantly Rococo style of its period. Yet, its artist was completely forgotten after his death, and only in the second half of this century has a consensus been reached on his *œuvre*.

The discrepancy between the brothers' later equivocal reputations and the high achievement of their paintings is a problem that is more easily understood when their work is considered in context.[1] Unlike Tiepolo and Canaletto, neither brother seems to have sought international renown. Instead, they spent their lives, like Pietro Longhi, operating in and around Venice and its hinterland. Not only does the working practice of the two painters resemble much earlier models of fraternal workshops; their patronage was equally old fashioned, based on family obligation and a feudal clientele.

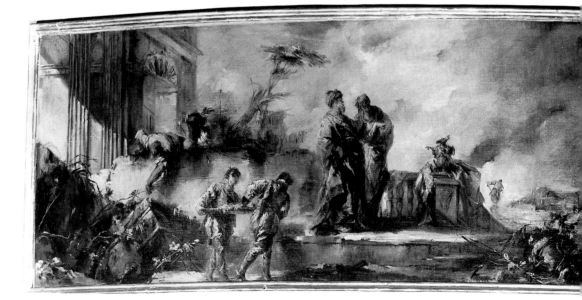

*Figure 50:* Antonio Guardi, *The Marriage of Tobias* (detail), oil on canvas, 80 × 342 cm, 1750s, from the Organ Parapet, Church of the Angelo Raffaele, Venice

From his father, Domenico, a second-rate painter, Antonio inherited the patronage of the Giovanelli and other provincial nobles.[2] But Antonio's success with the local aristocracy operated to the detriment of his fame, for the type of commission he received led to his works being installed in obscure locations, and as a consequence he did not find his way into official histories of Venetian art, despite the fact that he was a founder member of the Venetian Academy.[3] Although Francesco achieved greater popular success in his day than Antonio, he, too, restricted his horizon to Venice and the Veneto.[4]

Antonio, assisted by the young Francesco, began his career as a copyist under the patronage of Marshal Schulenburg. While Schulenburg was responsible for some of the most innovative commissions of the century, such as Piazzetta's pastoral paintings, he did not seem to hold the brothers' talents in high esteem and paid them meagre salaries, employing them to make of copies of the works of artists whom he held in greater regard, including Piazzetta.[5]

192

ANTONIO GUARDI
*A Woman in Ancient Costume*
*c.* 1739
oil on canvas 58.1 × 45.7 cm
Lent by the Syndics of the Fitzwilliam Museum, Cambridge

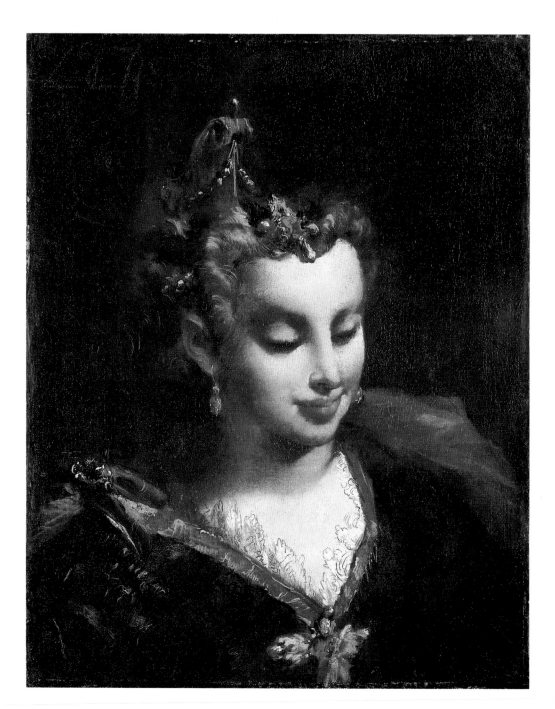

Antonio's variation on Palma Giovane's figure of Salome (cat. 192), probably made for Schulenburg, demonstrates the nature and value of such copies, for despite the small amount he was paid for them, they are far from run-of-the-mill examples of their kind. Rather, the fact that Antonio had Palma's invention to copy allowed him to devote his energy to his expressive brushwork. At the same time, he modified Palma's brightly hued palette with Piazzettesque tenebrism, allowing much of the ground-colour to serve as background, shadow and contour; he even went beyond his model in striving for decorative effects of thick impasto and loaded brushstrokes. This layering of pigment gives a bejewelled effect to the painting, which Antonio conceived as an ornamental accessory and the product of fantasy.

During the period of his employment with Schulenburg, from *c.* 1730 to 1747, Antonio also produced many highly finished wash drawings after famous paintings, such as his version of Piazzetta's *Supper at Emmaus* (cat. 193). It is not known whether these were intended to be engraved or to be kept in albums. Here, Antonio exploded the compact pyramid and tangible physicality of Piazzetta's image (cat. 61) by dissolving outlines and granting independent life to the washes. The freedom with which light and shade pass over the surface anticipates similar effects in Francesco's later views.

193

ANTONIO GUARDI
*Supper at Emmaus*
*c.* 1740
pen and sepia wash over traces of chalk,
25 × 45 cm
Private Collection

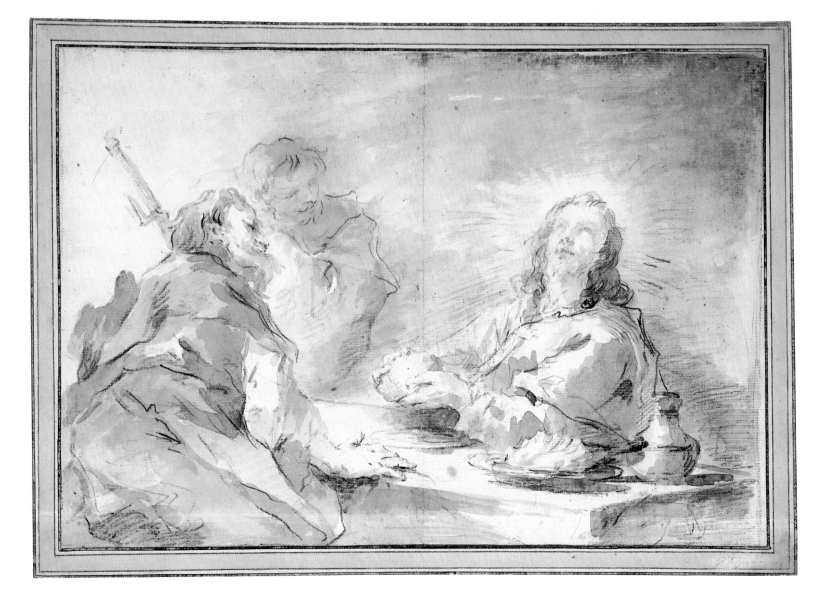

194

ANTONIO GUARDI
*The Garden of the Serraglio*
*c.* 1740–5
oil on canvas, 46.6 × 64 cm
Thyssen-Bornemisza Collection

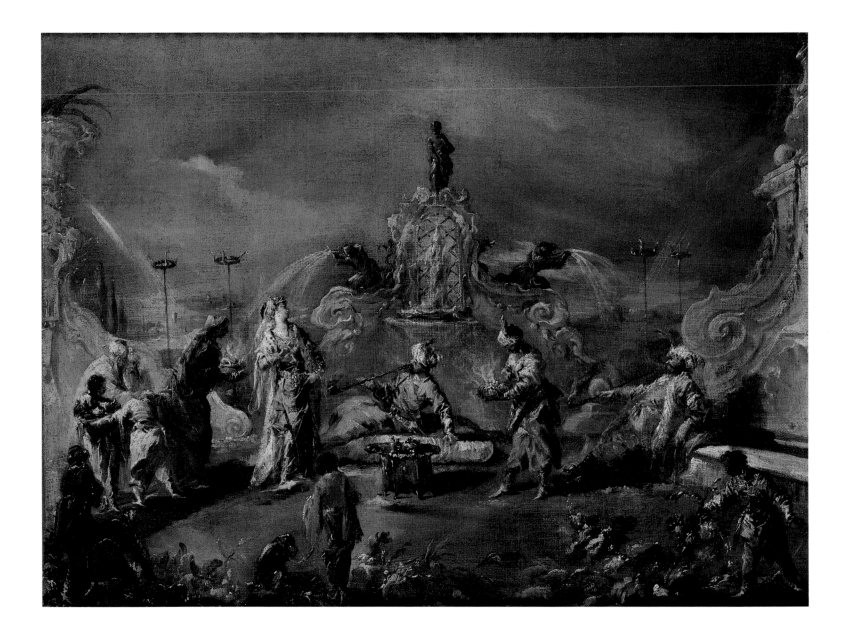

It is likely that the Guardi were given greater responsibilities as their long-standing employment with Schulenburg advanced. The Marshal's most significant commission to them was for 43 paintings based on engravings after Jean-Baptiste van Mour's scenes of Turkish life, presumably to decorate a room à la Turque. But the *Garden of the Serraglio* (cat. 194) cannot be identified as a copy after any known work of art, and thus probably is the product of Antonio's own invention, demonstrating his increasing ability to pose figures and create compositions. While other paintings from the series have been attributed to either brother or to unknown assistants, the *Garden* is clearly by Antonio alone. This daydream of Oriental life, which shows the Sultan at his ease in the fanciful setting of the harem garden, enclosed by Rococo marble fountains that look more European than Ottoman, shows Antonio to have been one of the supreme painterly painters of his time, with luxuriantly calligraphic brushwork. This staccato handling is familiar from his most famous work, the organ parapet in the church of the Angelo Raffaele.[6] In both works, the brush apparently fluttered over the rough surface of canvas, conjuring up insubstantial figures with a few strokes and decorating them with lightning dabs of colour.

Although this extremely painterly style is arguably Antonio's most congenial manner, it was not his only one; and after Schulenburg died in 1747, Antonio responded to the different demands of other patrons. Typical of his new clientele was Maria Savorgnan Barbarigo, daughter of a member of the Giovanelli family that earlier had patronised his father. She commissioned the *Madonna of the Rosary* (cat. 195) for the parish church on their estate at Belvedere, near Aquileia. The significance of the commission for the prestige of the family in its district is proclaimed by the extravagant armorial shield; and the altar must have been equally important to Antonio, for here the independence he had begun to show in the Thyssen *Serraglio* bore real fruit. None the less, the leap in scale from the cabinet paintings he made before was not easy. At some point Antonio looked for compositional ideas to Sebastiano Ricci's *Virgin and Saints* (fig. 7). But, as is demonstrated by the preliminary drawing in the Museo Correr (cat. 196), Antonio initially conceived of a composition with fewer saints differently disposed. Thus, Ricci's example was a fruitful reference towards the end of Guardi's preparation, rather than an inspiration from the beginning.

The difference between the preliminary sketch and the altarpiece represents the general change in Antonio's art from a late-Baroque to a truly Rococo vision — a change expressed mainly through his composition. The penmanship of the sketch is quick, and the arrangement of the animated figures is simple and direct. The drawing envisages an altarpiece still wedded to the sculptural model of the Renaissance, retaining a strictly pyramidal formation of figures in their niche (in fact Ricci's altarpiece does not deviate from this model). Antonio's change from drawing to painting is dramatic, for the crowding of additional figures into a shallower stage is less sculptural, and calls more attention to the painterly aspects of the surface.

The extreme staccato calligraphy of Antonio's brushwork in the Thyssen *Serraglio* or the Angelo Raffaele paintings, both of which are small works meant to be examined relatively closely, is absent from the Belvedere altarpiece. In fact, Antonio changed his brushwork according to the scale on which he worked, and the *papillotage*[7] he aimed for was not wedded exclusively to the handling, but sometimes was achieved by construction of the tonal structure and the composition. The Belvedere altarpiece is carefully built up in glazes, and only the highlights and contours are thickly and decoratively applied. The impasto emphasises the Rococo destabilisation of the surface, but is not its cause.

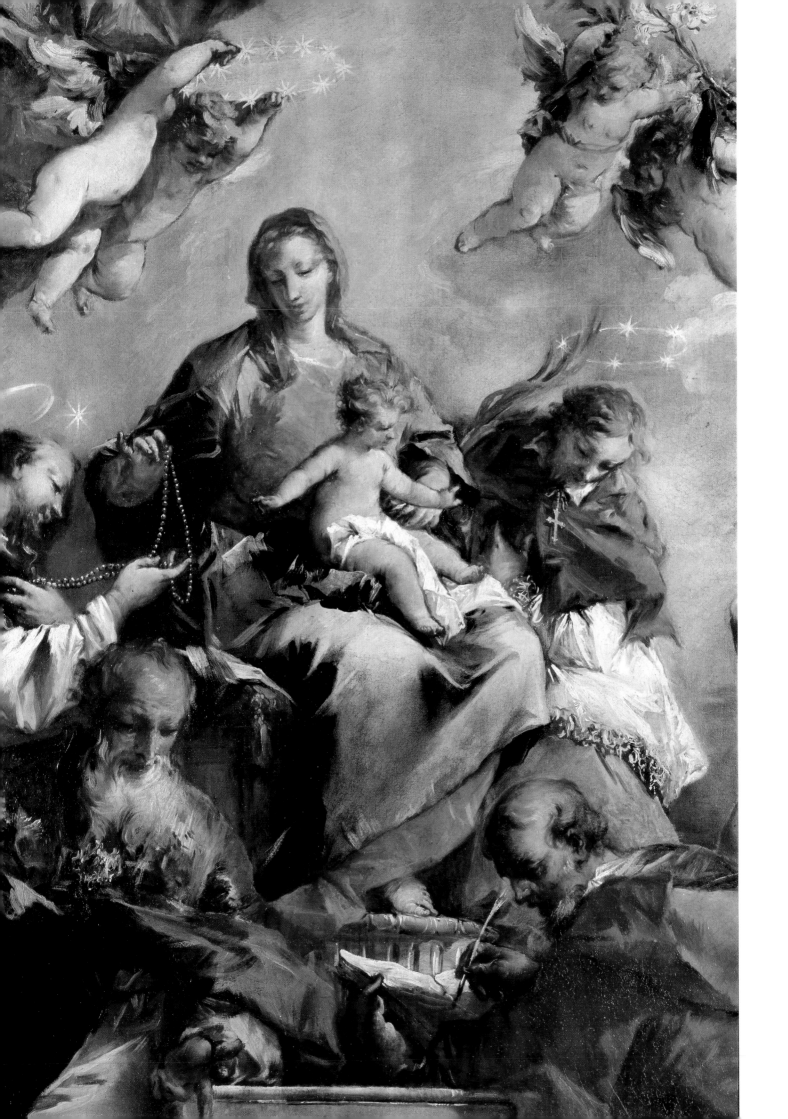

195

ANTONIO GUARDI
*Madonna of the Rosary (The Pala di Belvedere)*
(detail, left)
c. 1748–9
oil on canvas, 234 × 115 cm
Arcidiocesi di Gorizia

196

ANTONIO GUARDI
*Virgin and Child with Saints*
*c.* 1745
pen and brown wash over traces of red chalk,
36 × 22 cm
Museo Civico Correr, Venice

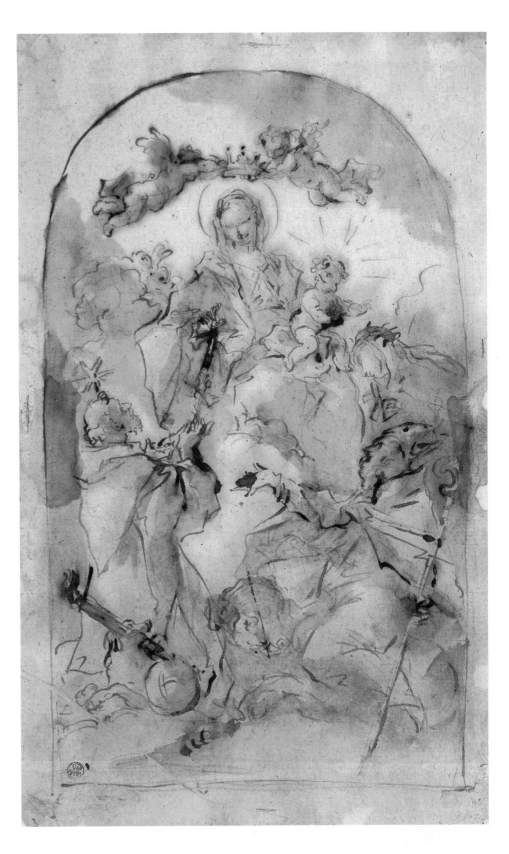

The careful study Antonio must have put into the Belvedere altarpiece may seem at odds with its appearance of being liberated from typically 'academic' restraints of hard contours and sculptural forms.[8] However, Antonio certainly studied from the nude for figures such as the St Sebastian on the right, which can be compared with an academic drawing (cat. 197). Together with Tiepolo and Piazzetta, Antonio held the Venetian attitude that finished paintings should not have an over-studied appearance, despite the amount of preparation that lay behind them.[9] Antonio's drawings also demonstrate how in Venice the imperfections of nature were corrected by the more subjective notion of 'grace' rather than by canons of Neo-classical ideals.[10]

In Antonio's search for a language for large history paintings, he inevitably emulated his brother-in-law, Giambattista Tiepolo. But while a sketch for a ceiling painting such as the *Triumph of Military Virtue* (cat. 198) is inspired generically by Tiepolo's compositions, the relationship is again one of inspiration leading to revision. Despite its martial subject-matter, one can imagine that the finished painting by Guardi would have been characterised by an insubstantial grace far from the heroic strength that was Tiepolo's aim.[11] As with the *Supper at Emmaus*, this highly finished drawing is remarkable not for the sense of sculptural presence, but for the subtlety of the pen-strokes and washes.

197

ANTONIO GUARDI
*Standing Male Nude*
*c.* 1750s
red chalk heightened with white, 42 × 27 cm
Professor William B. O'Neal, Promised Gift to
the National Gallery of Art, Washington

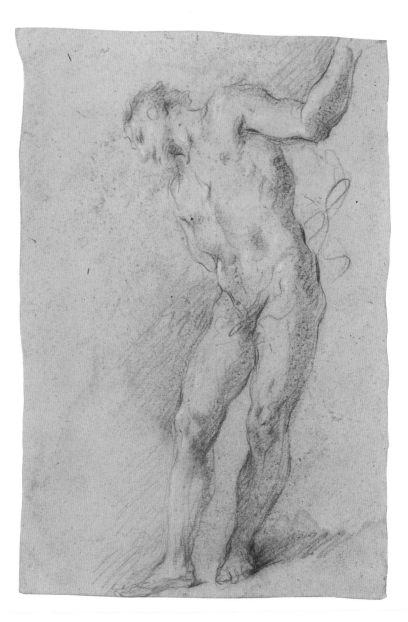

This drawing suggests that Antonio received more important commissions in the last decade of his life, though unfortunately none of these works has remained *in situ*. One of his most important cycles of profane decorative paintings, the scenes from Tasso's *Gerusalemme Liberata*, was found in a barn at Bantry House in Ireland only in the 1950s (see cat. 191). Once again, Antonio based his designs on a model he extensively altered, in this case Piazzetta's illustrations for Albrizzi's sumptuous edition of Tasso's epic poem (cat. 80). Not only did he enlarge Piazzetta's composition – the better to display the pastoral landscape in which Erminia hoped to find a peaceful life – he also replaced Piazzetta's horse with a charger related to Tiepolo's most recent altarpiece, *St James* (cat. 113). Antonio's genius is evident in the figure of Erminia, a beautiful creation, both for its dazzling brushwork, and also for the emotional truth of her expression, as she is caught between the desire to escape from the miseries of war and, on the other hand, her duty to her beloved, the injured knight Tancred. Antonio's achievement is to demonstrate the grace and subtlety of Rococo painting and its adaptability to a wide range of subjects.

198

ANTONIO GUARDI
*Triumph of Military Virtue*
*c.* 1750
pen and sepia wash
25 × 45 cm
Museo Civico Correr, Venice

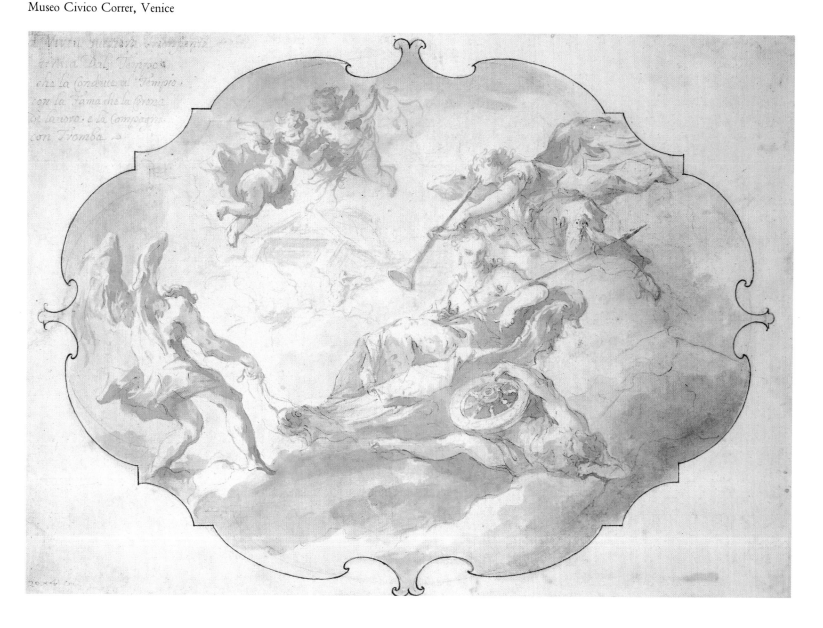

199

FRANCESCO GUARDI
*Seated Turk with a Leopard*
1760s
pen and sepia on blue paper heightened with
white, 34.5 × 39 cm
The Pierpont Morgan Library, New York,
The Janos Scholz Collection

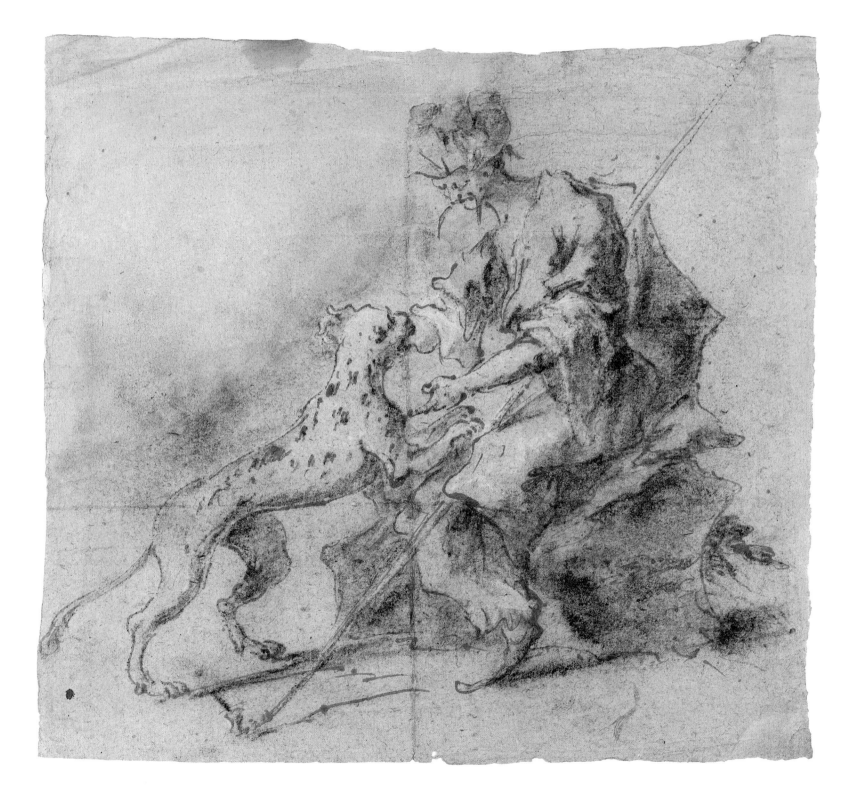

Antonio's younger brother, Francesco, began to work as a view-painter late in his career, probably because earlier he had played a considerable role in the family workshop. In undertakings such as the Tasso cycle, Francesco was an equal partner with his brother, as is evident in the figure of the shepherd in the *Erminia*, now convincingly attributed to him.[12] This shepherd demonstrates the differences in figure style between the two brothers for, compared with the evanescent painting by Antonio of the heroine, the rustic herdsman is all solid blocks of colour and relatively hard contours.

Francesco worked as a figure-painter until his final years, although such works are rare. One such painting is the *Ridotto* (cat. 202), sometimes attributed to Antonio because of its freedom of handling.[13] None the less, dated and securely attributed works from this period by Francesco, such as the *Miracle of a Dominican Saint* (fig. 51), shows that he was able to achieve a lively, painterly style which still retains a sense of the solidity of individual figures. Compared with Antonio's *Garden of the Serraglio*, Francesco's brushwork is less calligraphic, and he is more interested in tonal effects than in brilliant colour contrasts.

As is evident from *The Ridotto*, and its pendant, *The Parlatorio* (fig. 53), Francesco was capable of characterising individuals through posture, though this does not mean that he was a critical observer of human behaviour. His range as a figure-painter was not large; he was less attached than his brother to late-Baroque poses representing emotions of marvel, ecstasy or interior spirituality, and his figures have the air of greater 'truth' than Antonio's; even so slight a subject as the *Seated Turk with a Leopard* (cat. 199), compared with the Turkish figures of his brother, gives the appearance of having been observed from life, even if this is unlikely to have been the case. This drawing was probably made for transfer to a piece of furniture, and is thus one of the earliest examples of Francesco's involvement in the decorative arts.

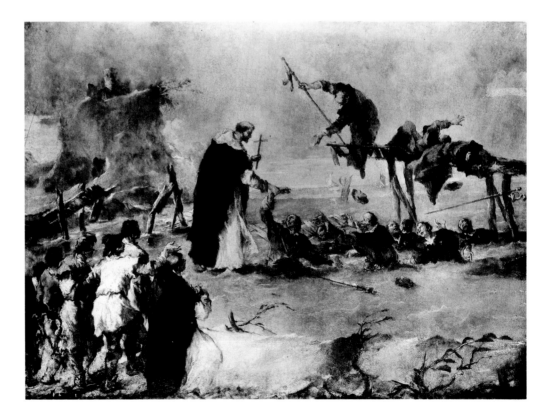

*Figure 51:* Francesco Guardi, *Miracle of a Dominican Saint*, oil on canvas, 121 × 172 cm, 1763, Kunsthistorisches Museum, Vienna

The figures in a much later drawing, the *Macchiette* (cat. 200), seem to convey genuine movement and character, yet subsequently they repeatedly appear in Francesco's paintings: similar puppet-like figures have the same reactions whether they witness the visit of a pope (fig. 52), or the devastation by fire of a quarter of the city (cat. 201).

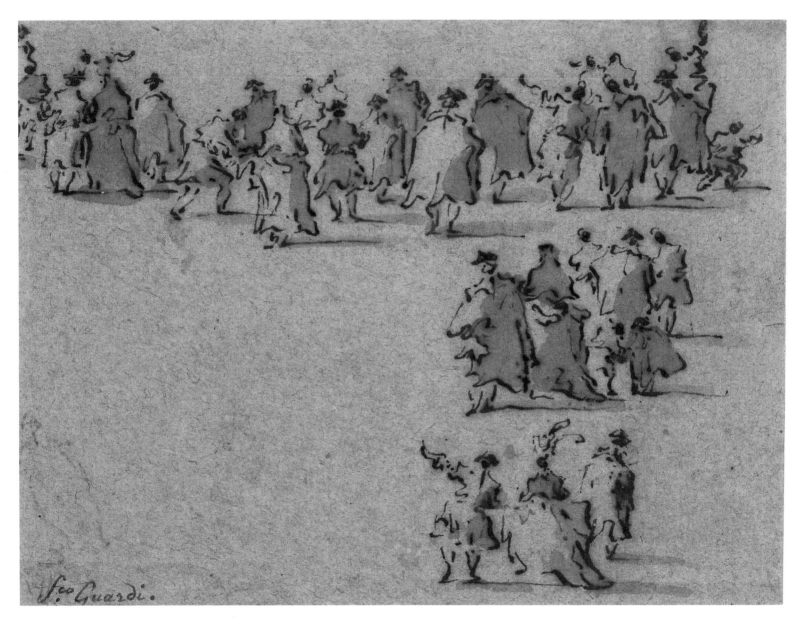

200

FRANCESCO GUARDI
*Macchiette*
1780s
pen and brown ink and brown wash on blue
paper, 16.3 × 21.9 cm
Lent by The Metropolitan Museum of Art,
New York, Gift of Harold K. Hochschild

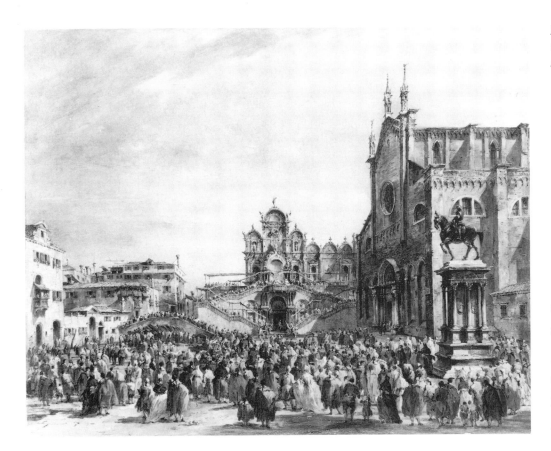

*Figure 52:* Francesco Guardi, *Pius IV Blessing the Crowd*, oil on canvas, 63.5 × 78.5 cm, 1782, Ashmolean Museum, Oxford

201

FRANCESCO GUARDI
*The Fire at S. Marcuola*
1789–90
oil on canvas, 42.5 × 62.2 cm
Lent by the Bayerischen Hypotheken- und Wechsel-Bank AG to the Bayerischen Staatsgemäldesammlung, Munich

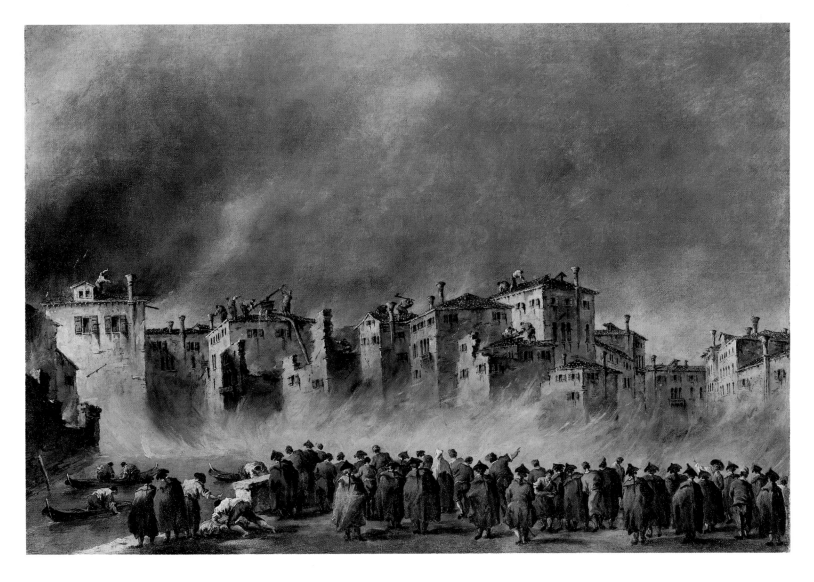

202

FRANCESCO GUARDI
*The Ridotto*
*c.* 1745–58
oil on canvas, 108 × 208 cm
Ca' Rezzonico, Museo del Settecento
Veneziano, Venice

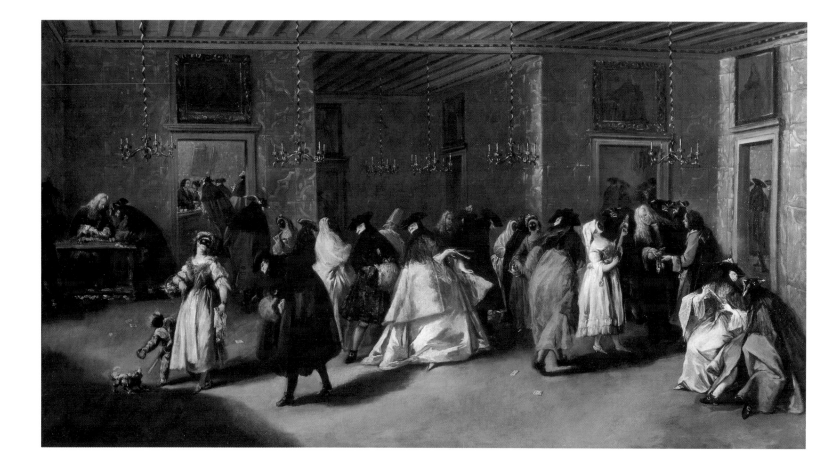

Francesco's neutrality as an observer has caused difficulties in interpreting paintings such as *The Ridotto* (cat. 202), which represents the gambling casino at S. Moisè, closed by order of the Government in the 1760s. It is unlikely that *The Ridotto* can be interpreted as Francesco's commentary on aristocratic vice. Rather, it is suggested (see entry for cat. 202) that the painting is related to Goldoni's play *Le donne gelose*, and that, like it, it criticises middle-class families who do not safeguard their daughters' virtue. Francesco's reticence to make overt social comment in his paintings may have been the result of the censorship indirectly imposed on artists by the state and Church. But the literalness of paintings such as *The Ridotto* is more likely to be an artistic strategy, comparable to Goldoni's 'realism', which the playwright defined as comedy based on nature and plausibility without overt satirical intent.[14]

It is Francesco's views, rather than his figure paintings, that possess an exceptional emotional range.[15] Although the melancholy mood of some of his paintings has given rise to a dubious interpretation of them as elegies for the 'dying Republic', this is arguably not the case.[16] In fact, one of the most convincing of Francesco's moods in landscape is celebratory, as in his luminous portrayals of festive state occasions. It is likely that the audience for these paintings included both foreigners and aristocratic Venetians. This is certainly the case with later state commissions such as the paintings recording the state visit of Pope Pius VI in 1782. But Francesco must have enjoyed such prestigious commissions from Venetians throughout her career, and it is probable that the relatively early series of Ducal ceremonies (cat. 204) was commissioned by the reigning doge, Alvise IV Mocenigo.

Such paintings were important to his contemporaries in that they provided a tangible record of the immense expenditure for these lavish events. Indeed, who today would care about the visit of the Empress Catherine the Great's son to Venice in 1782, were it not for Francesco's record of the event (cat. 208)? While critics such as Canaletto's patron, the economist and social theorist Andrea Memmo, argued for the abolition of elaborate receptions upon the grounds that Venice herself furnished enough spectacle to satisfy any visitor at no cost to the government, Francesco took the opposite view.[17] Such shows, then as now, were a huge industry in Venice, and provided work for many of its citizens, including Francesco.

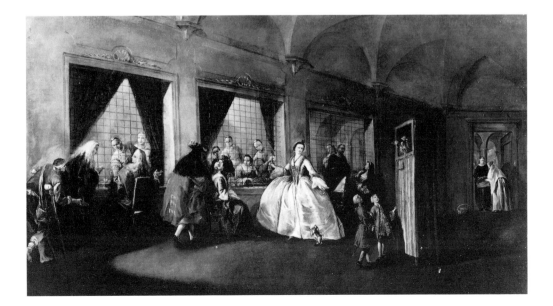

*Figure 53:* Francesco Guardi, *The Parlatorio*, oil on canvas, 108 × 208 cm, *c.* 1745–58, Ca' Rezzonico, Museo del Settecento Veneziano, Venice

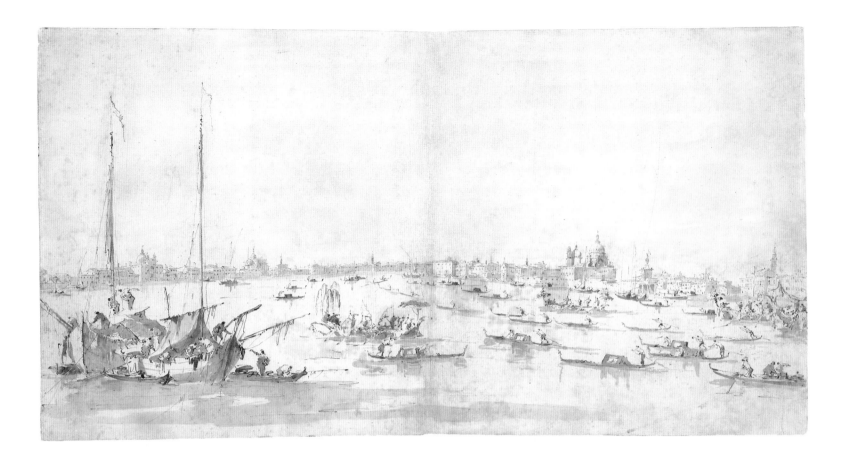

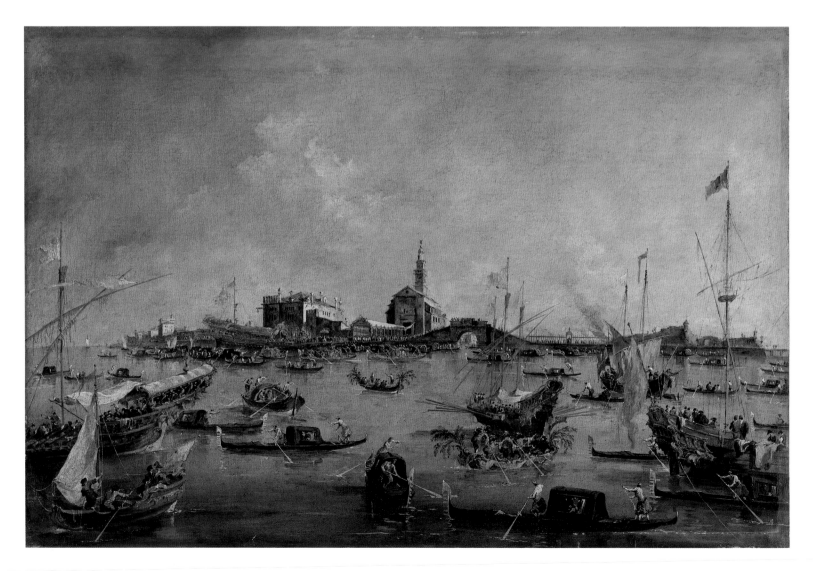

203

FRANCESCO GUARDI
*Regatta in the Bacino di S. Marco*
1784–9
pen and sepia wash with traces of charcoal,
34.9 × 67.6 cm
Lent by The Metropolitan Museum of Art,
New York
The Robert Lehman Collection

204

FRANCESCO GUARDI
*Festivals of the Doge; The Bucintoro Leaving
S. Nicolò al Lido*
1770–5
oil on canvas, 67 × 100 cm
Musée du Louvre, Paris, Département des
Peintures

205

FRANCESCO GUARDI
*The Festa della Sensa in Piazza S. Marco*
c. 1775
oil on canvas, 61 × 91 cm
Calouste Gulbenkian Museum, Lisbon

Francesco's livelihood depended on the industry of celebration, not only because he recorded such events and supplied visitors with souvenir views, but because (among his many sidelines as a decorator, see cat. 206) he also designed the ephemeral structures that were part of the show. The design for a parade boat, or *bissona* (cat. 207), was one of many he made for unknown noble patrons obliged by law to follow the Ducal barge on state occasions. This particular vessel appears in his late painting of a regatta (Alte Pinakothek, Munich), but not in the preparatory drawing for it (cat. 203). Such a change seems to indicate that neither the painting nor the drawing is meant to depict a specific event. However, both images illustrate the unique structure of the *bacino* and its spectacular use as a parade ground. Francesco has not only presented imaginary regattas, he has also elongated and tranformed the architecture of the *bacino* by using a panoramic perspective scheme reminiscent of early Netherlandish masters such as Patinir. These distortions in Francesco's views are the result of a search for a sumptuous and ornate manner in which to depict important events. Thus, *The Bucintoro Leaving S. Nicolò* (cat. 204), illustrating one of the Doge's most important ceremonial functions, is deliberately more extravagant than its source in Brustolon's engraving after Canaletto's invention (cat. 150). And *The Festa della Sensa in Piazza S. Marco* (cat. 205) appropriately shows Venice in fancy-dress with Francesco's most opulent brushwork. To create the impression of a rhythmic pictorial dance, he disobeyed some of the rules that Canaletto, for example, would have followed. Here, the pattern of light and shade across the lower half of the painting obeys its own capricious laws, and the recession of the arcades, while correct, cannot be said to be a perfect demonstration of perspective. The tiny brushstrokes used by Francesco prance across the canvas rather than construct solid forms, and the calligraphic highlights they leave behind give the surface a precious quality, akin to the elaborate finish of highly chased ormolu.

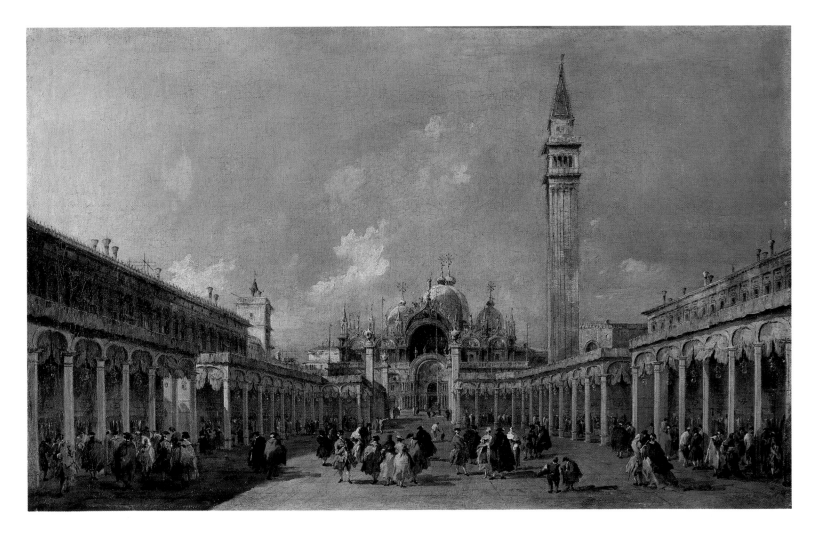

206

FRANCESCO GUARDI
*Decorative Cartouche with a Landscape*
*c.* 1770
black chalk, pen and greyish indian ink, with
light sea-green, blue, brick-red, golden yellow
and reddish-brown watercolours on white paper
41.9 × 68.89 cm
Cooper-Hewitt, National Museum, Smithsonian
Institution, New York, Bequest of Erskine
Hewitt

FRANCESCO GUARDI
*Festival Gondola with an Allegory of Fame*
*c.* 1770s
pen and ink and watercolour over black chalk
40.3 × 53.7 cm
The Board of Trustees of the Victoria and
Albert Museum, London

208

FRANCESCO GUARDI
*Concert for the Conti del Nord*
1782
pen and brown ink, wash and watercolour with
colour indications, 51.9 × 77.8 cm
The Royal Museum and Art Gallery,
Canterbury

FRANCESCO GUARDI
*Festive Dinner for the Polignac Wedding*
1790
watercolour over graphite with touches of pen
and ink, 27.5 × 41.9 cm
Museo Civico Correr, Venice

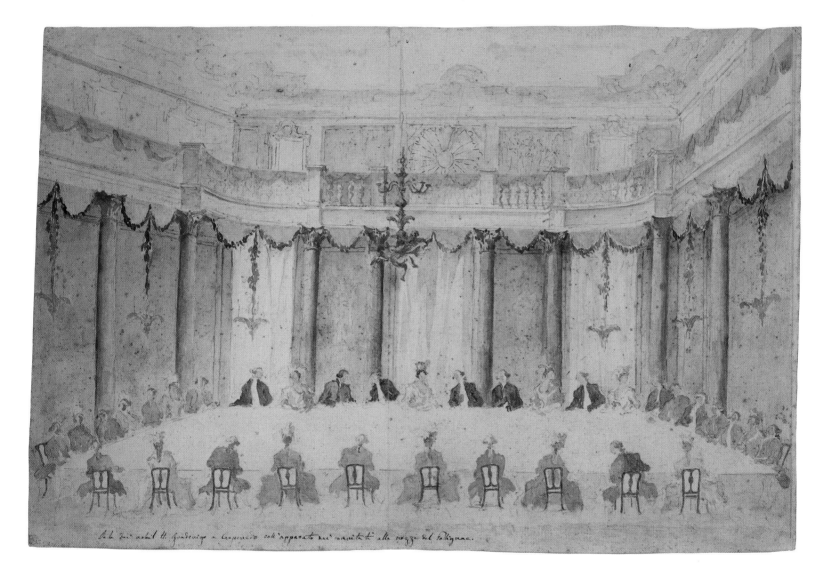

One of Francesco's last drawings, *The Festive Dinner for the Polignac Wedding* (cat. 209), is an example of the extremely rarified manner of his final years. Compared with the *Concert for the Conti del Nord* (cat. 208), which portrays the lavish festival staged by the Republic for the visit of the future Tsar of Russia in 1782, *The Polignac Wedding* of 1790 shows that Francesco eventually abandoned the overtly calligraphic penmanship and the lively *chiaroscuro* of his most exuberant Rococo style. However, the simplicity of colour, thinness of washes and the play of the blank and worked ground subtly insinuate Rococo ideas into the Neo-classical style evident in the decorations for the fête. The daring use of the empty centre of the large expanse of the table, which transposes negative and positive, must be considered one of Francesco's most bravura Rococo inventions.

FRANCESCO GUARDI
*The Rialto Bridge with Palazzo dei Camerlenghi*
*c.* 1760–3
oil on canvas, 122 × 200 cm
Paul Channon MP

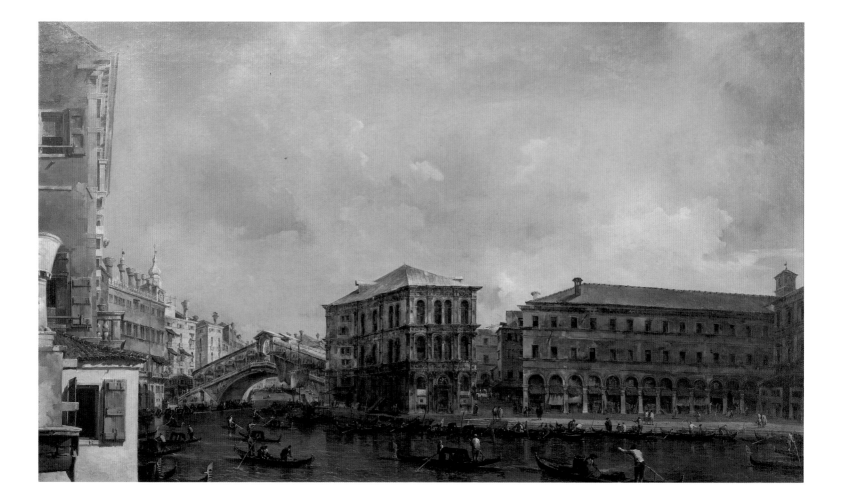

211

FRANCESCO GUARDI
*The Rialto Bridge Seen from the South*
*c.* 1760–3
oil on canvas, 122 × 205 cm
Paul Channon MP

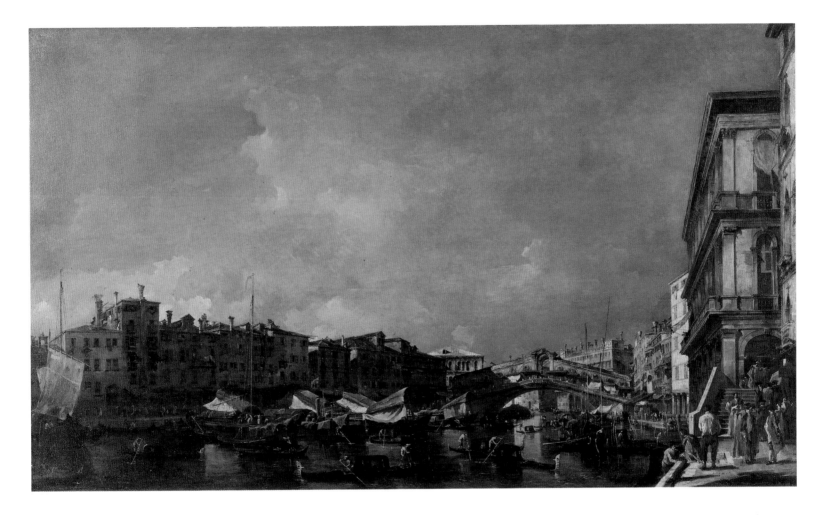

The playful spatial distortions in Francesco's paintings, although here considered to be intentional, have also given rise to controversy. Francesco, to his disadvantage, was sometimes contrasted with the more meticulous Canaletto. He was certainly not unaware of his illustrious predecessor, since his earliest manner recalls the older master's, as was noted by his earliest commentator, the chronicler Gradenigo.[18] Thus, the large *Rialto Bridge with Palazzo dei Camerlenghi* (cat. 210) may be the painting that Gradenigo recorded was publicly exhibited in Piazza S. Marco in 1763 to 'universal applause'. This painting and its pendant (cat. 211) are not in Canaletto's clear and luminous style of the 1750s, but in his earlier dark manner; and in choosing to follow Canaletto's early style Francesco may have been making an implicit criticism of the coldness and abstraction of his later manner. Guardi's interest is in an 'impressionistic' record of transitory effects, such as particular weather conditions. He has also chosen to depict moments of great activity on the canal.

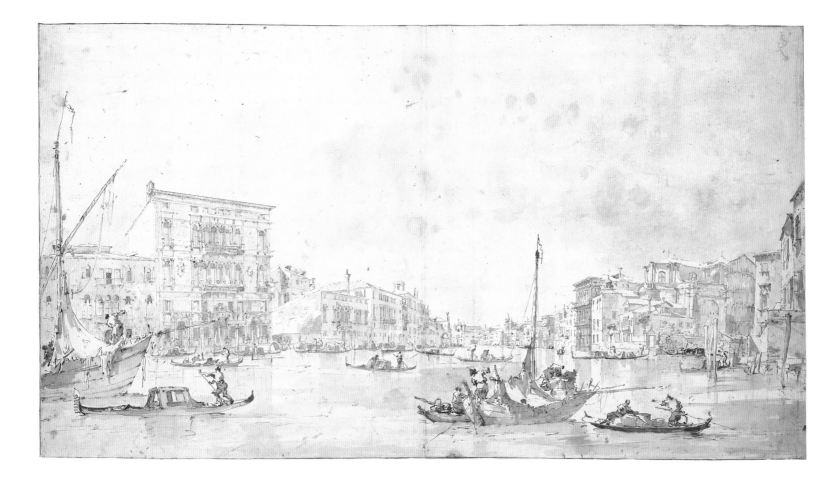

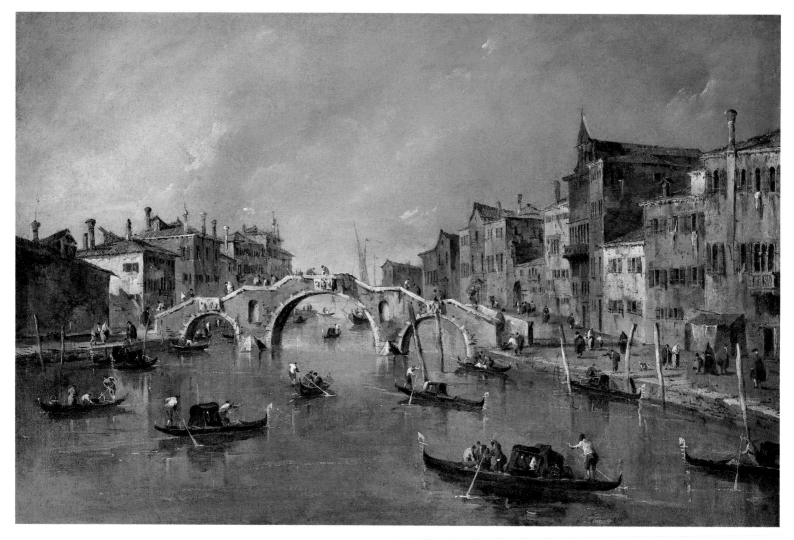

The exactitude and love of detail that are the chief characteristics of Francesco's earliest phase in painting are evident in a large presentation drawing, *The Grand Canal with Palazzo Bembo* (*c.* 1765–70; cat. 212), inspired by Canaletto's great series of views down the Grand Canal (e.g. cat. 137). Although Francesco's view is topographically accurate (the architectural features allow us to date the drawing fairly exactly), the tremulous line and the free use of wash transform the perspective tunnel of the waterway into an irregularly shaped, highly decorated corridor.

The difference between Francesco and Canaletto became even more exaggerated as Francesco's career advanced, and in his later work he dared to distort in a way that must be seen as a conscious rejection of Canaletto's example. Francesco tended to flaunt the freedom with which he invented lighting and rearranged topography, sometimes inventing buildings, or enlarging intervals of space between architectural features in order to make more rhythmic compositions. Later 'exact views' by Francesco show that he consciously disarranged the architecture, emphasising its *ad hoc* grouping as a product of the artist's whim instead of its unity in a perspectival system. His paintings thus direct the viewer's attention to individual surfaces, rather than to their groupings. This fragmentation is best compared to the effects achieved in Chardin's late still-lifes. The characterisation of these works by Chardin as demonstrating 'perceptual nervousness and self-consciousness, an awareness of the complexity and fragility of the act of perception', is also an apt description of Francesco's achievement.[19]

In the *View on the Cannaregio Canal* (cat. 213), sunlight does not define contour or *chiaroscuro*, but rather is seen as reflection – its colour sometimes very much at odds with what it illuminates. The nervous and irregular movement of Francesco's brush over the surface also underlines the quirkiness of the composition. Francesco's interest in untraditional effects comes to the fore in a late drawing such as *The Fortress of S. Andrea from the Lagoon* (cat. 214). As in *The Polignac Wedding* (cat. 209), he uses the blank support to exaggerate the island's isolation, and to encourage the play of the viewer's mind, now responsible for completing the image.[20]

These qualities of freedom and strangeness, pleasing to sophisticated connoisseurs, came under attack in Francesco's lifetime by partisans of precision and abstraction, opposed to the fantastic element then predominant in Venetian painting.[21] While his style was certainly a conscious

215

FRANCESCO GUARDI
*Isola della Madonetta in the Lagoon of Venice*
1780–90
oil on canvas, 36 × 55.5 cm
Fogg Art Museum, Harvard University Art
Museums, Cambridge, MA
Gift of Charles E. Dunlap

choice, it placed him at odds with the Neo-classical turn from pictorial freedom to rules. Thus, Pietro Edwards's letter to Canova criticises Francesco for being 'as incorrect as possible, but very spirited, much in demand, perhaps because nothing better is to be found. But as you know this painter worked for a daily stipend, bought canvases not only second hand but bad, prepared with the thinnest of primings, and used oily colours'.[22]

These damaging remarks have unfortunately been taken at face value, as if there were not ulterior motives at play in the letter, such as the pretence of all dealers that what they have found is not good enough for the connoisseur for whom they are purchasing. His conclusion, too, that the 'great branch of view paintings was becoming extinct in Venice' was a standard lament, applied to every aspect of art.[23]

But perhaps Edwards's criticism is better understood if taken only to refer to a certain style Francesco developed simultaneously with his most ornate manner of the 1770s. He evolved this 'humble style' to satisfy patrons who liked his paintings 'more loosely handled rather than highly finished and at a modest price'.[24] For example, the relatively thin brushwork of the *Isola della Madonetta in the Lagoon* (cat. 215) emphasises the poverty of the small island church protected by its two trees, and the activities of the fisherman are conveyed through their postures, summarily indicated by dashes and blobs of paint. In accord with the subject, the painting itself seems unpretentious: small in scale, and on a rough canvas which shows through the few layers of paint. Francesco may have looked to small Dutch cabinet pictures for ways in which to avoid the formality of Italian townscape painting. Unlike Canaletto's '*Stonemason's Yard*' (fig. 10), which could be described as a highly finished and large-scale scene of working-class life, Francesco sought a new, and more appropriate, pictorial language for this subject. Thus, Francesco's variety in handling the brush, his subject-matter and tone, which to some writers has suggested either incompetence or even the intervention of other hands, may be the result of a deliberate change of style to suit the subject. This would explain why, despite Edwards's misgivings, Edwards gave him an important commission. And while John Strange, the British Resident at Venice, occasionally echoed Edwards's strictures, he amassed the most important collection of Francesco's work at the time.

Strange's demand that Francesco's views be 'coloured exactly' had the practical effect of producing in the artist an uncharacteristically opulent finish and a certain liveliness of observed detail. Works made for Strange include the *Villa del Timpano Arcuato* (cat. 216) and probably the *View of Levico in the Valsugana* (cat. 217). While Francesco's drawings could be sumptuous when he chose, the large 'presentation drawing' of the area near his birthplace in the Val di Sole is unusually imposing even within the category of such luxury products. Pens and washes were carefully handled to create this complex view, which is exact without showing any sign of the use of mechanical accessories, whether ruler or calipers. Rather, it was produced freehand, probably after many preparatory drawings, and testifies to Francesco's skill as a draughtsman.

The *Villa del Timpano Arcuato* is an example of the kind of painting rich collectors preferred. Like other works of equally distinguished early provenance, such as the Colloredo *capricci*, which include the *Capriccio with an Arch in Ruin* (cat. 218), and *The Bucintoro Leaving S. Nicolò* (cat. 204), it is painted with the finest of brushes. The Abate Vianello's praise seems more justified than Edwards's condemnation. Vianello wrote not only that Francesco was '*spiritoso*', but an 'expert in depicting architecture, in handling the earth, in the rendering of the atmosphere, and in recession'.[25]

216

FRANCESCO GUARDI
*Villa del Timpano Arcuato at Paese*
*c.* 1782
oil on canvas, 48 × 78 cm
Private Collection

FRANCESCO GUARDI
*View of Levico in the Valsugana*
*c.* 1782
pen and brown ink and brown wash with traces
of charcoal, 42.6 × 63.8 cm
Mr and Mrs Eugene V. Thaw

218

FRANCESCO GUARDI
*Capriccio with an Arch in Ruin*
1770s
oil on canvas, 155 × 273 cm
Lent by The Metropolitan Museum of Art,
New York, Rogers Fund

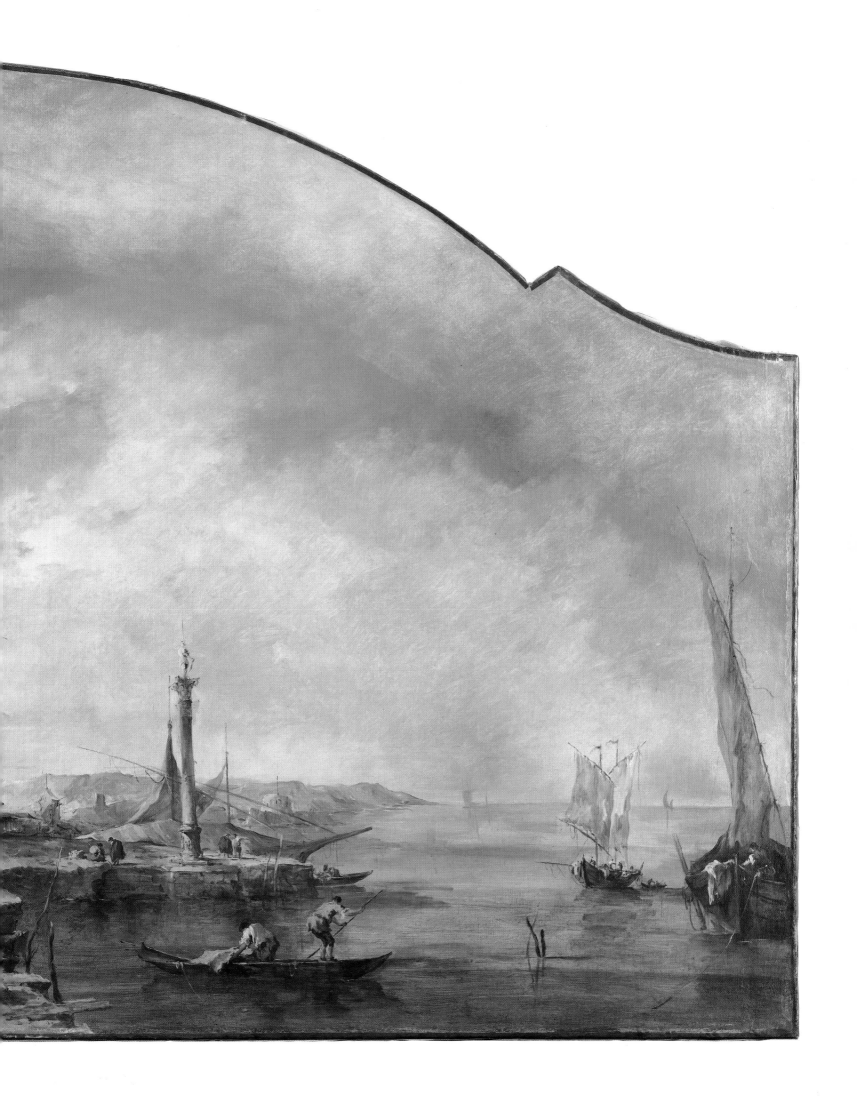

219

FRANCESCO GUARDI
*Architectural Fantasy with Roman Ruins*
*c.* 1760–5
oil on canvas, 104 × 124 cm
Museum Kunsthaus Heylshof

Francesco gave vent to his imaginative facility in his *capricci*. They follow the same stylistic development already seen in his figure and landscape paintings. But as their handling becomes looser, his ruins seem more closely to approach the emotional core of their subject, the desolation wrought by the passage of time.

Francesco's first *capricci* are copies, like the *Architectural Fantasy with Roman Ruins* (cat. 219). This demonstrates how, like his brother Antonio, Francesco modified his sources, in this case an architectural fantasy engraved by Costa (cat. 155), adopting Marco Ricci's most painterly manner for the lush landscape in which the Roman temple and the peasants of his own invention are set. The simplification and evanescent handling of the landscape motif borrowed from Canaletto for the central element of the *Decorative Cartouche with a Landscape* (cat. 206) exemplifies once again the characteristic way in which Francesco reworked motifs from his predecessors.

220

FRANCESCO GUARDI
*Capriccio with a Round Temple*
*c.* 1780s
oil on canvas, 22.3 × 17 cm
The Trustees of the National Gallery, London

*Figure 54:* Tommaso Temanza,
S. Maria Maddalena, Venice, 1760–89, façade

**221C**

FRANCESCO GUARDI
*Capriccio with a Raised Cupola in Ruin*
*c.* 1780s
oil on canvas, 10 × 7 cm
The Trustees of the National Gallery, London

**221b**

FRANCESCO GUARDI
*Capriccio with a Serlian Arch in Ruin*
*c.* 1780s
oil on canvas, 10 × 7 cm
The Trustees of the National Gallery, London

**221a**

FRANCESCO GUARDI
*Capriccio with an Arch in Ruin*
*c.* 1780s
oil on canvas, 10 × 7 cm
The Trustees of the National Gallery, London

Francesco looked to other artists for precedents for his *capricci*, and the *Capriccio with an Arch in Ruin* depends on the eminent example of Carlevaris's *Harbour View* (Her Majesty The Queen), once in Consul Smith's collection. This inspiration is surprising, for Francesco has frequently been compared unfavourably with the artists who worked for Smith, such as Canaletto and Visentini, who were part of the neo-Palladian movement spearheaded by the Consul. But the miniscule *capricci* (cat. 221a, b, c) demonstrate otherwise. Such works have been characterised as 'trinkets', and the comparison made with jewellery is apt. However, it is far from the case that, because their surface is seductive and then size diminutive, their content is without meaning.

The strange structures in Francesco's *capricci* of ruins do not refer to Rome, but rather to Venice. They have been linked with the 'decline' of Venice, on very shaky grounds.[26] They have also convincingly been connected with a nascent proto-Romantic sensibility, typified in France by Diderot's appreciation for ruin paintings.[27] Francesco's ruins are even better understood as the product of the same type of architectural imagination that resulted in Canaletto's *vedute ideate* for patrons such as Smith, as well as the visionary projects of Piranesi.[28] Francesco's ruins frequently imagine the future destruction of Venetian buildings, particularly Palladian ones. The *Capriccio with a Serlian Arch in Ruin* (cat. 221b) is inspired by the Serlian arcade from the *piano nobile* of Sansovino's library, while the *Capriccio with a Raised Cupola in Ruin* (cat. 221c) shows the choir-screen in ruins of Palladio's church of the Redentore. But his strange choices for architectural subjects are not due to ignorance of Roman examples. Rather, his 'anticipated' ruins grant the venerable status of ancient Rome to Venetian monuments by distinguished modern architects.

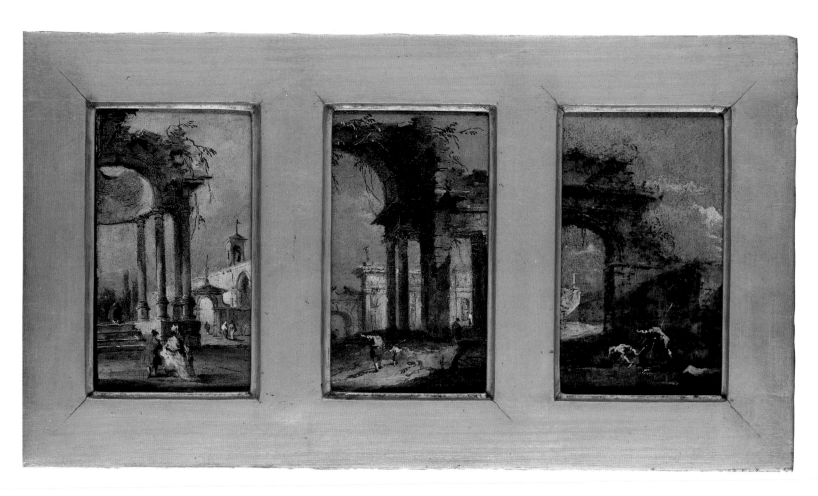

Francesco's fruitful architectural imagination did not lead him only to produce images of Venice in desolation: some of his paintings represent monuments of his own design, such as the *Capriccio with a Round Temple* (cat. 220). This is not a ruin, nor, as is usually argued, does it represent one of the end pavilions from Palladio's project for the Rialto Bridge. It is, rather, a freely imagined urban complex, best compared with neo-Palladian churches in Venice, such as Scalfarotto's S. Simeone (fig. 9), or the more contemporary (and controversial) church of the Maddalena by Temanza (fig. 54). The idea that Francesco's seemingly insubstantial *capricci* possess Neo-classical architectural features seems to go against the grain of his image as the least solid of architectural painters.[29] However, this fascinating and capable artist still possesses the ability to surprise and intrigue the modern viewer, and is more varied and intellectually challenging than at first appears.

1. Much new material is found in Pedrocco and Montecuccoli degli Erri, 1992. But the present author disagrees with Montecuccoli's conclusion that Antonio was 'nothing better than a servant' to his patrons. Binion, 1976, still remains fundamental for any discussion of the brothers' careers.

2. On Domenico see Pedrocco and Montecuccoli degli Erri, 1992.

3. On the unreliability of contemporary written sources for lives of Venetian painters see Levey, 1980, pp. 15–22.

4. On Francesco's reputation see Haskell, 1960², and *idem*, 1967. A sensitive account of the sources is also found in Rossi Bortolatto, 1974.

5. See especially Binion, 1990.

6. On the complicated critical fortune of these panels see Pedrocco, in Gorizia, 1988. Although Antonio's handling in these is usually considered to derive from non-Venetian examples such as Magnasco or Bazzani, I believe that Antonio admired the innovative brushwork of 17th-century Florentines such as Sebastiano Mazzoni.

7. *Papillotage* is the 18th-century term for the formal quality which causes the eye to flutter over the surface 'like a butterfly'.

8. See Mahon, 1965, p. 118, for a consideration of Antonio's relationship to the Academy.

9. This attitude as it relates to art criticism and art education in Venice is considered in Merling, 1992.

10. On the notion of 'grace' as it relates to Venetian art and art criticism, see Muller, 1990–1, pp. 27–36.

11. Tiepolo's aim to find a stylistic equivalent for his heroic subject-matter was quite self-conscious; see Haskell, 1980, p. 253.

12. The attribution of the shepherd to Francesco was first made by Mahon (verbally), and subsequently accepted in print by Pignatti, 1989, p. 333.

13. Succi's recent attempt to reattribute this work to Antonio is not conviving, in part because he has not compared the small interiors with figure paintings on the same scale by either brother (Succi, 1993, pp. 223–31).

14. See Pajes Merriman, in Fort Worth, 1986, pp. 61–5. On artistic reticence as a strategy of life under the Inquisition, see Levey, 1980, pp. 10–12.

15. The question of the mood of Francesco's paintings received interesting treatment in Wehle, 1941.

16. See note 24.

17. Rykwert, 1980, p. 294. For these festivities, see Molmenti, 1926, pp. 230–4.

18. Gradenigo calls Guardi 'a good scholar of the famous Canaletto', though he was probably referring to Francesco's stylistic affinity rather than to his training. But the meaning of Gradenigo's phrase has been endlessly debated.

19. Baxandall, 1985, pp. 74–104. Baxandall's account of the perceptive mode in Chardin is based on a reading of Algarotti's 'vulgar Lockeanism', and thus is not irrelevant to discussions of Venetian art.

20. On 'ideal presence' see Rothstein, 1975–6.

21. Francesco's role in this debate was treated by Haskell in Venice, 1965², 1967.

22. Haskell, 1960, p. 260.

23. See for example the pessimistic comments on the state of contemporary history painting in Venice made by Zanetti, 1771, pp. 395–8.

24. '*Chi la desidera vuol prezzo discreto, e lo amerà più di tocco forte, che finite*', quoted in Haskell 1960², p. 275.

25. Vianello, quoted in Rossi Bortolatto, 1974, p. 6.

26. Succi, 1993, p. 118: '*Un atmosfera di trepida attesa, di lunghi misteriosi silenzi, di ansia interiore, muta le antiche luminose certezze nei problemi estenziali di una città che rotola verso l'irreparibile appuntamento con la storia*'.

27. Aikema, in Amsterdam, 1990, pp. 73–5. On the poetics of ruins see Bandiera, 1982; also, the excellent study by Mortier, 1974.

28. On Canaletto's *vedute ideate*, see Barcham, 1977.

29. I have been particularly stimulated by the study of the relationship between the imagined ruin in painting and architecture in Corboz, 1978.

DOMENICO TIEPOLO
*The Minuet*
1756
oil on canvas, 80 × 109 cm
Museu Nacional d'Art de Catalunya, Barcelona
(Cambó Bequest)

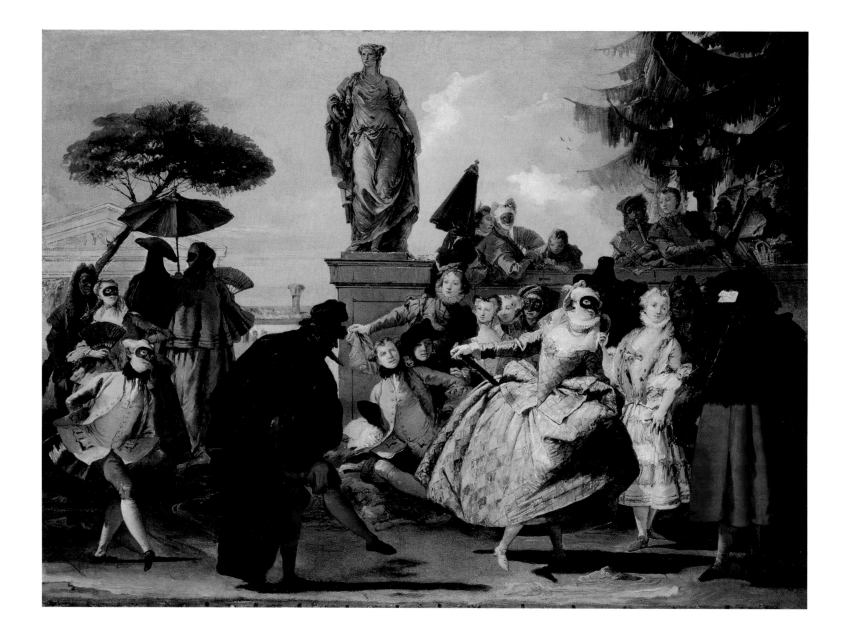

# x: *Domenico Tiepolo & his Contemporaries*

## Catherine Whistler

Domenico Tiepolo's reputation for most modern viewers rests largely on the works he produced towards the end of his life for his personal enjoyment, to be shared with a circle of friends – the frescoes for his country retreat, the Villa Zianigo, which included a Punchinello room painted in 1797, and the later series of 104 highly worked drawings exploring Punchinello's life and adventures, entitled *Divertimento per li Regazzi* (Amusements for the Young).[1] The light-hearted yet ironic tone of the frescoes is taken up in the drawings, where every aspect of humour is explored, from the slapstick and scatological to the satirical and subversive. Domenico's frescoes depict the world of circus and carnival, and if they look back to the sparkling vivacity of his earlier cabinet paintings such as *The Minuet* (cat. 222), they also share some of the earthiness and impudence of Goya's tapestry cartoons. The original and multifarious character of the Punchinello drawings is striking: the names of Hogarth, Rowlandson and Gillray have been evoked but then rejected in attempts to analyse them; if anything, the series – with its quirky arrangement, oblique narratives and interchangeable characters – belongs to the shrewd and self-mocking world of Laurence Sterne's *Tristram Shandy*.

Domenico's father, Giambattista Tiepolo, had earlier toyed with the figure of Punchinello, familiar from street theatre and the *commedia dell'arte* (cat. 121): he appears in drawings as a plump, squat figure and in some etchings as a provocative, quizzical character.[2] By contrast,

223

DOMENICO TIEPOLO
*Punchinello in a Rainstorm (The Spring Shower)*
pen and brown ink, brown wash over black chalk, 29.5 × 46.5 cm (margin); 35.5 × 47.2 cm (sheet)
The Cleveland Museum of Art
Purchase from the J. H. Wade Fund

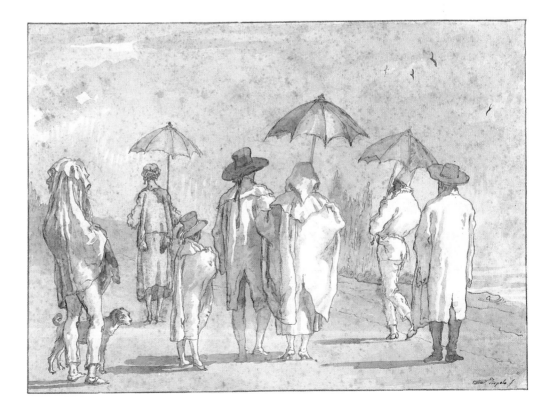

Domenico's Punchinello is a picaresque anti-hero, a lazy, mischievous creature whose escapades ridicule all manner of conventions. Domenico places this gangling figure in a kaleidoscopic welter of predicaments, including the melodramatic and pathetic, as in *Punchinello Visited in Prison* (cat. 224), and the quotidian, as in *Punchinello in a Rainstorm* (cat. 223). *Punchinello as a Portrait-painter* (cat. 225) parodies the hallowed, instantly recognisable subject of *Alexander and Campaspe in the Studio of Apelles*, as in his father's painting (cat. 92), and, a private joke, mocks Domenico's own earlier compositional drawing on which it is based.[3]

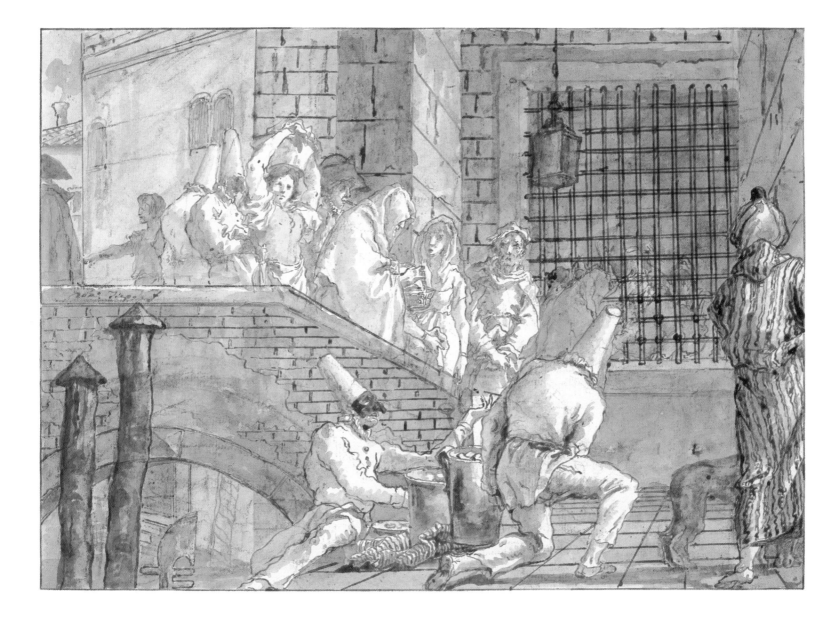

224

DOMENICO TIEPOLO
*Punchinello Visited in Prison*
pen and brown ink, brown wash over black
chalk, 29.5 × 41 cm (margin);
sheet 34.9 × 46.5 cm
National Gallery of Art, Washington
Gift of Robert H. and Clarice Smith

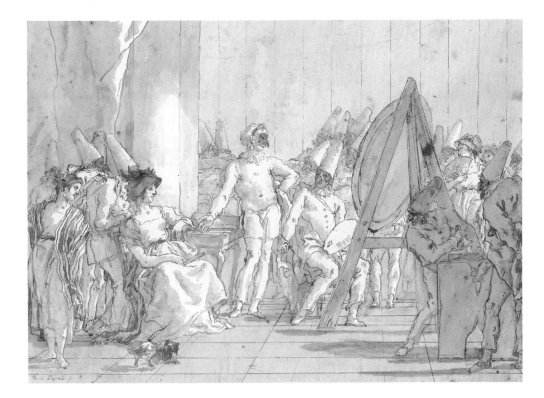

225

DOMENICO TIEPOLO
*Punchinello as a Portrait-painter*
pen and brown ink, brown wash over black
chalk, 29.5 × 41.3 cm (margin); 33.5 × 47 cm
(sheet)
Alice M. Kaplan Collection

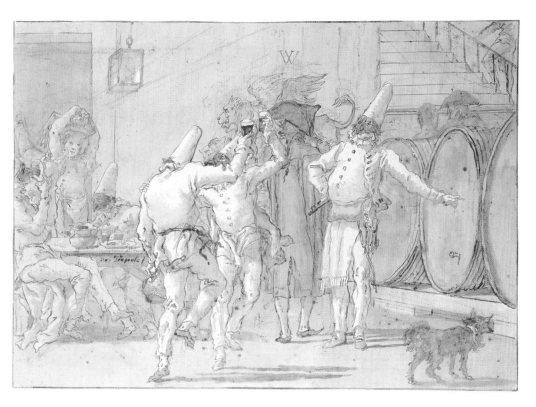

226

DOMENICO TIEPOLO
*Punchinello in a Malvasia*
pen and golden-brown ink, golden brown wash,
over black chalk, 28.8 × 41 cm
Mr and Mrs Gilbert Butler

227

DOMENICO TIEPOLO
*Scenes of Contemporary Life: Presentation of the Fiancée*
(?) 1791
pen and brown ink, brown and grey wash over black chalk, 28.7 × 40.6 cm
Private Collection

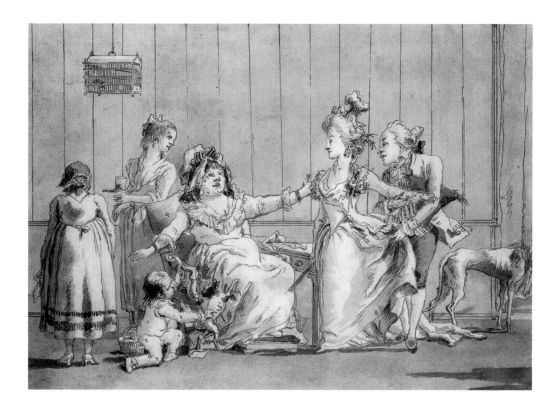

228

DOMENICO TIEPOLO
*Scenes of Contemporary Life: The Milliner's Shop*
pen and grey and brown wash, with some yellow watercolour, 32.5 × 42.5 cm
Museum of Fine Arts, Boston,
William E. Nickerson Fund

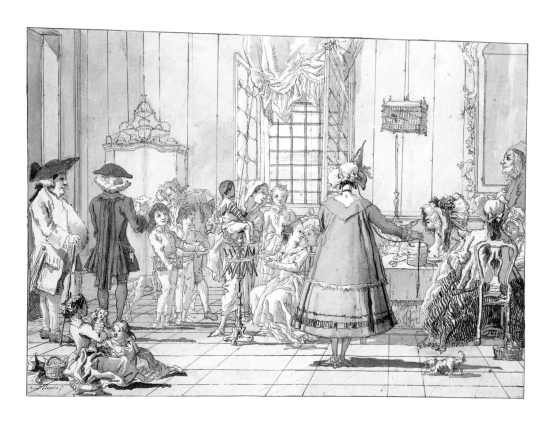

The scenes of contemporary life were made over a longer period, from *c.* 1790, as finished works of art, probably for collectors. Many poke fun at the pretensions of the buoyant *nouveaux-riches* or of gauche social climbers, as in two examples here (cat. 227, 228), while others verge on the grotesque, with overblown heads and heavily delineated features. Figures and motifs crop up from Giambattista's caricature drawings, and from Domenico's earlier work – the seated figure on the right in *The Milliner's Shop*, for instance, is directly quoted from an earlier version of *The Minuet* (Louvre, Paris). The Punchinello drawings often use these genre scenes as a starting-point: indeed, *Punchinello in a Malvasia* (cat. 226) is directly based on one of them, a scene in a wineshop with the lion of St Mark, the emblem of Venice, visible to the right. In the Punchinello drawing, however, the lion has been moved to the centre and the sign 'W' added, probably meaning *evviva* (as Byam Shaw suggested), an abbreviated patriotic cry in protest at the French and Austrian occupation that followed the fall of the Venetian Republic in 1797. Other Punchinello drawings have been interpreted as critical comments on contemporary events, but in general the drawings do not stand up to this kind of scrutiny; a reading of the group as a satirical commentary on Giambattista's art, and by extension the *ancien régime* society it is seen to represent, is equally hard to sustain. Domenico's extraordinary ability as a draughtsman – seen especially in the *Punchinello in a Rainstorm*, where the fleeting effects of a bright, rain-soaked atmosphere are beautifully conveyed by the tonal variations in the washes – together with the teasing ambiguities of narrative makes these late drawings his greatest achievement.

229

DOMENICO TIEPOLO
*Scenes from Contemporary Life: The Acrobats*
pen and ink and brown wash over black chalk,
29 × 41.3 cm
Lent by The Metropolitan Museum of Art,
New York
Rogers Fund

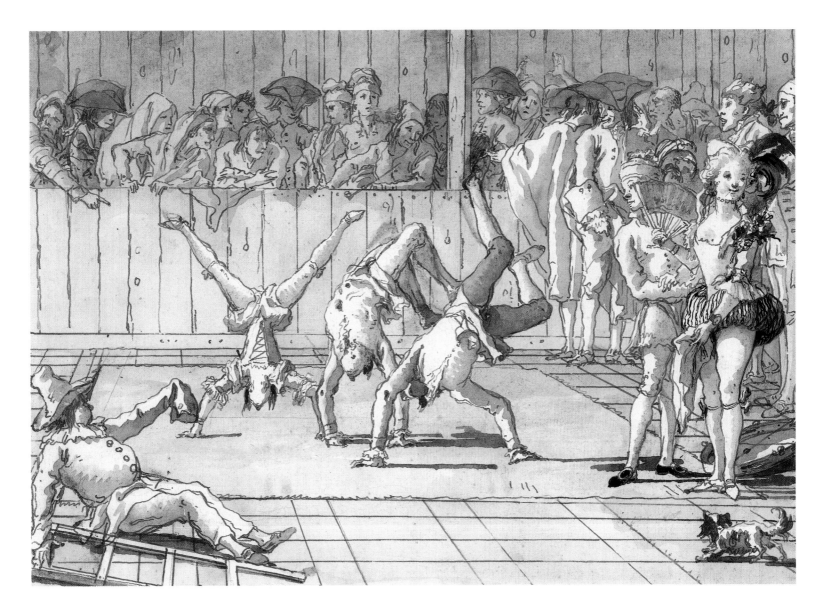

230

DOMENICO TIEPOLO
*Idee pittoresche sopra la fugga in Egitto*
1753
volume containing frontispiece, title-plate and 24
etchings, open to show *Joseph and Mary Prepare to
Leave* (pl. 5) and *Rest on the Flight into Egypt* (pl.
19)
52.5 × 35.1 cm (open book)
National Gallery of Art, Washington
Rosenwald Collection

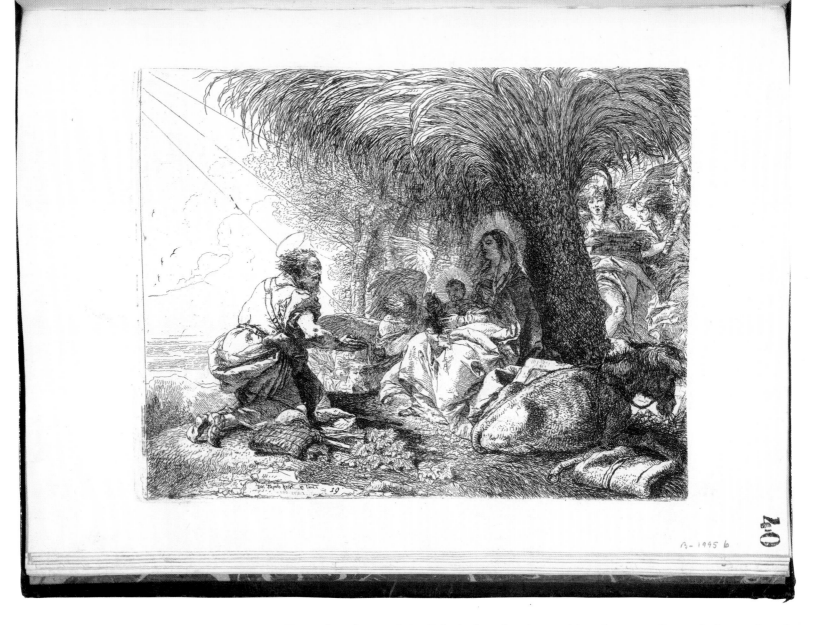

Two other characteristics link the late drawings to his early career: Domenico's practice of working in series, and his constant reference to his father's work. The 25 etchings on the *Flight into Egypt* (cat. 230), dedicated to the Prince-Bishop of Würzburg, are in many ways an artistic manifesto: Domenico revealed his powers of invention in these picturesque variations on the theme of the arduous journey of the Holy Family, accompanied by angels.[4] This and some of Domenico's later series of drawings on religious or secular themes take a particular composition or motif by Giambattista as a starting-point, as though a chord struck by the father triggered off a series of improvisations and variations by the son. Also, Giambattista's *Scherzi di Fantasia* (cat. 112), on which he was working in the 1740s, may have provided a model for the *Flight into Egypt* etchings as a series of permutations of a particular cast of characters. However, Domenico's innovative treatment of a popular sacred theme, with its mingling of human drama and religious devotion, and above all his exploration of the relationship of figures and landscape, make this series of etchings a virtuoso display of his growing powers.

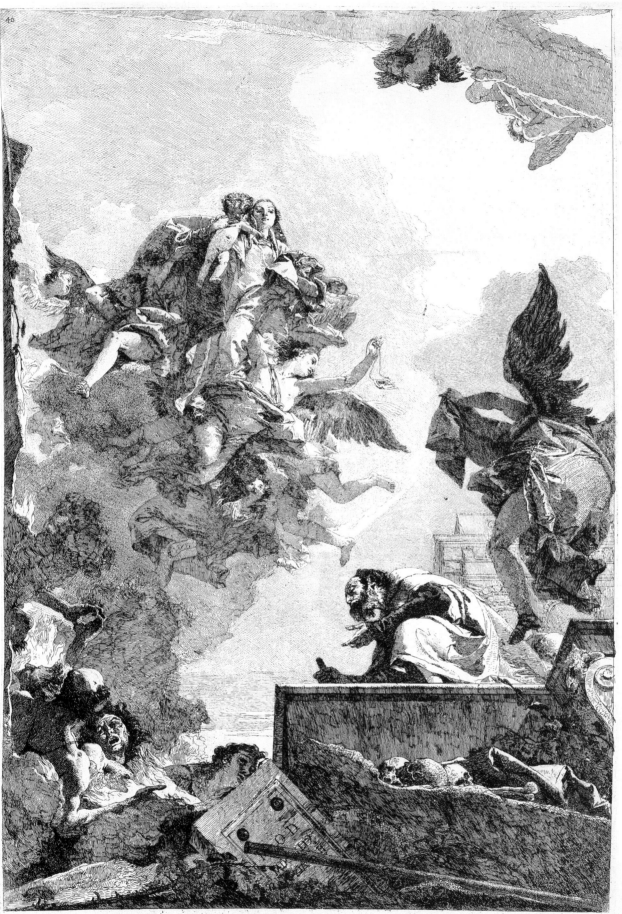

40

Ioan.ᵉˢ Baptᵃ Tiepolo inveniens et pingens.

In Sacello B. Mariæ Virginis a Monte Carmelo, prope Ecclesiam eiusdem Ordinis Venetiarum.

Domⁱᶜᵘˢ Filius delineavit et incidit.

Domenico's interest in etching dates from *c.* 1744, when, as Francesco Algarotti noted, he was already learning to follow in his father's footsteps. His artistic training in the 1740s principally consisted of his immersion in Giambattista's work through copying compositions and details from paintings and drawings. The same process was being followed by Francesco Lorenzi, who, although a few years older than Domenico, was benefiting from a parallel apprenticeship: possibly to differentiate himself from Lorenzi and other assistants in the Tiepolo studio (and to display his special relationship to the master), Domenico took up the independent activity of etching, reproducing first drawings, and then paintings, by Giambattista in this medium.[5] One of the most beautiful and important etchings of this period is *St Simon Stock* (cat. 231) from the central compartment of the ceiling of the Scuola del Carmine in Venice, which Giambattista had completed in early 1749 (fig. 36). This gorgeously painted canvas shows St Simon's heavenly vision of the Madonna of Mount Carmel bearing a promise of relief from the torments of Purgatory, vividly depicted below. Domenico's confident, controlled technique cleverly interprets the *chiaroscuro* effects of this dramatic oil painting, while the quivering strokes, curls and dots of his etching needle convey the electrifying quality of the miraculous event.

Domenico's increasing publication in etchings of his father's work reveals his extreme sensitivity to Giambattista's aims and artistic language, which equipped him so well as his chief assistant and collaborator. Yet Domenico had also developed a highly individual idiom, seen in his first public commission in 1747, a cycle of 24 paintings, including a *Via Crucis* (see fig. 55), for the Oratory of the Crucifixion in S. Polo, Venice.[6] The publication of the etchings after the *Via Crucis* (itself a narrative series) in 1749 asserted Domenico's independent character. Here, his etching technique is deliberately in tune with the forceful realism and occasional harshness of the paintings, drawing out his originality in depicting this new devotional cult.

*Figure 55:* Domenico Tiepolo, *The Stations of the Cross, VI: Christ meets St Veronica*, oil on canvas, 100 × 70 cm, S. Polo, Venice

At Würzburg, Domenico evidently built up a circle of discerning patrons, given the considerable number of pairs or groups of pictures (mainly of religious subjects) that are known. *The Institution of the Eucharist* (cat. 232), dated 1753, may have been an overdoor, given the low viewpoint of the composition. The convention of a tightly locked large-scale group pressed, off-centre, into a narrow foreground space, with a suggestion of depth beside the group, is found in overdoors by Veronese, for instance, whose work both Giambattista and Domenico had studied. Here this formula enabled Domenico to turn a moment of great religious significance in the narrative of the Last Supper into an intensely emotional drama, with a chilling interval before the withdrawn figure of Judas on the right.

The *Oriental Encampment* (cat. 233), also painted at Würzburg, is an early example of Domenico's equally inventive approach to genre painting. An exercise in the picturesque, romantic tradition, stemming from Salvator Rosa, Castiglione and the Bamboccianti, the painting is also overlaid with references to Giambattista's work (the horse and attendant on the right, the group of orientals, even the skinny dog, all refer to the *Capricci* etchings, cat. 111) of the late 1730s, and turn up elsewhere in the work of father and son. The picture has an enigmatic air: the relationship of the strolling couple on the right to the main scene is unclear; the picnic in the foreground is more refined than the drinking party behind, yet inside the tent a serious banquet may be afoot. The oddities in composition, with these groups of figures in separate, unrelated units, surely stem from one aspect of Domenico's training, the practice of copying details from his father's paintings. An enormous body of chalk drawings from the Tiepolo studio shows Giambattista studying figures, heads, hands and drapery in preparation

232

DOMENICO TIEPOLO
*The Institution of the Eucharist*
1753
oil on canvas, 98.5 × 149.5 cm
Den konelige Maleri og Skulptursamling,
Statens Museum for Kunst, Copenhagen

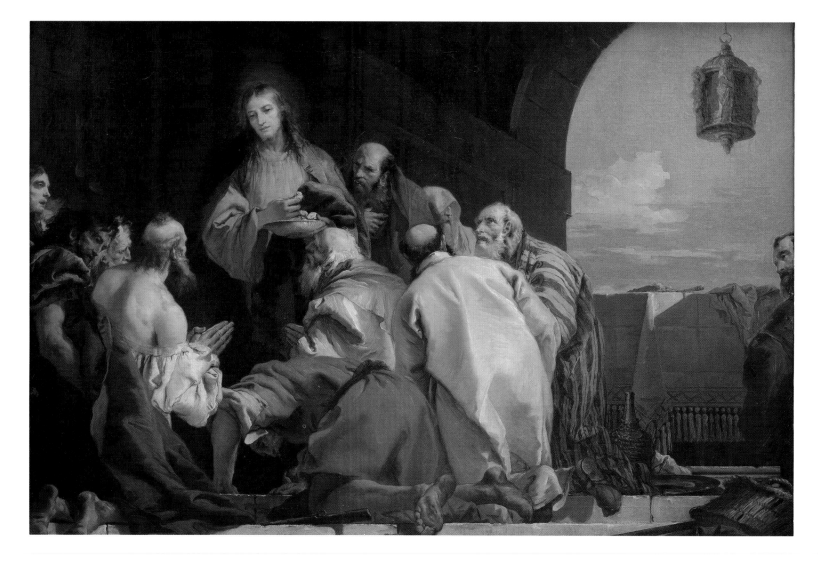

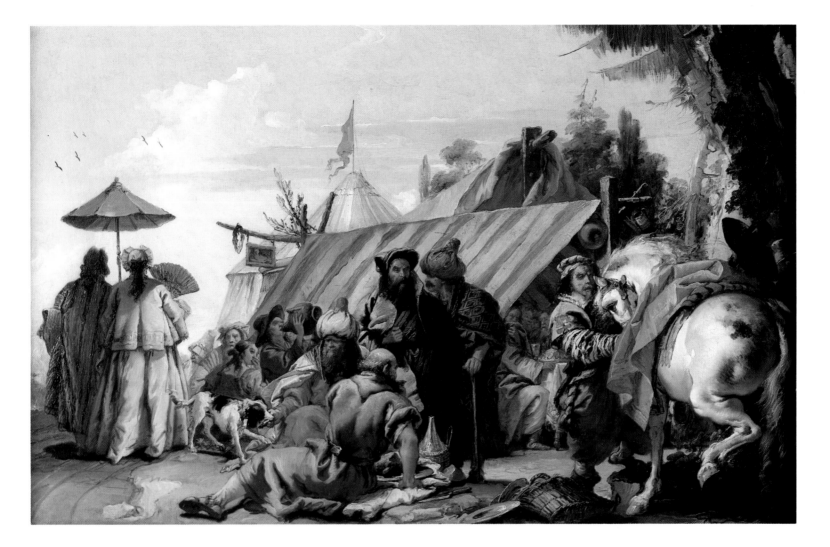

233

DOMENCO TIEPOLO
*An Oriental Encampment*
*c.* 1752
oil on canvas, 76 × 120 cm
Landesmuseum, Mainz

234

DOMENICO TIEPOLO
*Asia*
*c.* 1752–3
red and white chalks on blue paper,
26.2 × 40.2 cm
Graphische Sammlung, Staatsgalerie, Stuttgart

235

DOMENICO TIEPOLO
*The Nile*
*c.* 1752–3
red and white chalks on blue paper, 24 × 37 cm
Graphische Sammlung, Staatsgalerie, Stuttgart

236

DOMENICO TIEPOLO
*The Burchiello*
oil on canvas, 38 × 78.3 cm
Kunsthistorisches Museum, Vienna,
Gemäldegalerie

for painting, and his two sons developing a similar working pattern while also striving to perfect a 'Tiepolo' style and assemble a studio vocabulary by diligent imitation.[7] Domenico may well have intended to publish etchings when, high on the scaffolding, he copied details from the frescoes at Würzburg. The River Nile figure (cat. 235) is sharply handled, and extensively worked in a slightly finicky manner characteristic of Domenico's chalk drawings. The superb sheet (cat. 234) with the figure of Asia demonstrates the problems of attribution of these drawings, which also involve questions of their function. While the sheet is typical – including a copy of a detail from another part of the fresco – the main study is loosely handled, without the finish to the features and the nervous drawing of the drapery found in almost all of Domenico's copies of details from his father's work. As happens often from this period onwards, Domenico in some ways comes uncannily close to his father.

Domenico emerged as a mature, independent artist at Würzburg, and his particular genius can be appreciated in *The Minuet* of *c.* 1756, and in *The Burchiello* (cat. 236) of about twenty years later. Tiepolo encouraged his son to give rein to his imagination in the fresco decoration of the guest-house at the Villa Valmarana in 1757, where Domenico's witty approach to genre and fantasy subjects (including chinoiserie scenes) is seen at its best. This approach is anticipated in *The Minuet*, whose imagery may have been stimulated by the work of Pietro Longhi or Francesco Guardi. However, Domenico's rendition is more robust and imaginative, with lively brushwork and delicious colour contrasts. The picture is conceived as comic theatre, with elegant couples in masquerade mingling with insouciant youths and caricatured types: musicians, audience and dancers participate in a spectacle that is dense with flirtation and mockery. The pleasures and dangers of the carnival are evoked here in a way reminiscent of Goya's imagery, but imbued with *joie de vivre* rather than with mordant satire. *The Burchiello* – one of the most attractive genre pictures of its time – presents a close-up view of the heavy vessel making its stately progress through the waterways to Venice, flanked by a graceful gondola. Goldoni gives a vivid description in his *Memoirs* of a journey in a *burchiello*: its roomy cabin was adorned with mirrors, paintings and engravings, while the company (ten gentlefolk and their servants) between them had three violins, a violoncello, two oboes, a French horn and a guitar. Goldoni composed verses to add to the entertainment.[8]

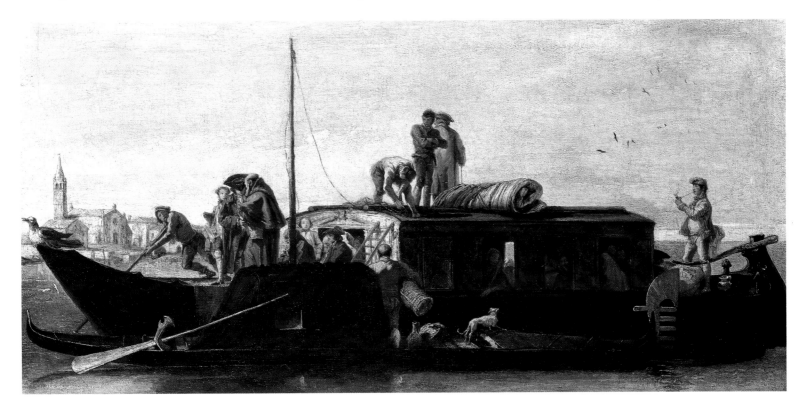

237

DOMENICO TIEPOLO
*The Building of the Trojan Horse*
1773–4
oil on canvas, 196 × 360 cm
Wadsworth Atheneum, Hartford, CT
The Ella Gallup Sumner and Mary Catlin
Sumner Collection Fund

As his father's heir, Domenico continued to produce frescoes and oils in the grand style for a diminishing market up to the early 1780s; generally, he tended to recycle figures in his father's style and compositions that were engrained in his imagination. However, *The Building of the Trojan Horse* (cat. 237), one of a group of pictures for an unidentified patron, is a highly original work. Domenico here tackled an unusual subject in a characteristically idiosyncratic manner, skewing the composition and piling up figures on the right so that the practical details of frantic building dominate the painting. His zest for the realistic (typical of the later 18th century) rather than the poetic is what, above all, sets him apart from his father.

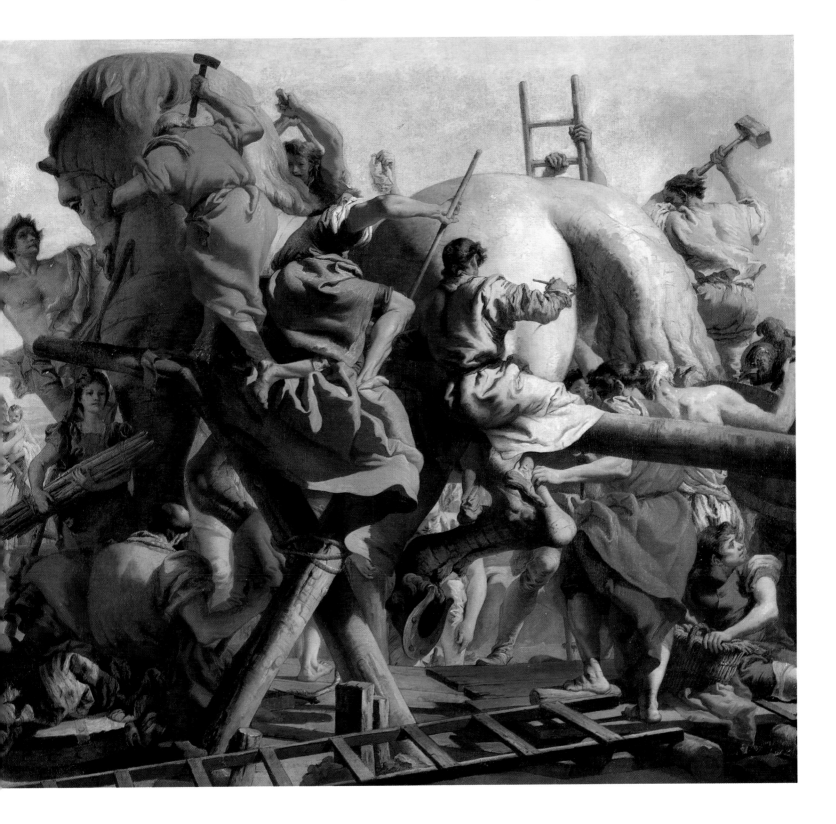

239

LORENZO TIEPOLO
*The Triumph of Mars*
*c.* 1759
etching (state 1 of 3), 55.5 × 40 cm
National Gallery of Art, Washington
Ailsa Mellon Bruce Fund

238

LORENZO TIEPOLO
*Portrait of the Artist's Mother*
1757
pastel on paper, 67 × 54 cm
Ca' Rezzonico, Museo del Settecento
Veneziano, Venice

Lorenzo Tiepolo grew up in the shadow of his more talented brother, Domenico; his distinctive character found its own expression primarily in portraiture.[9] Lorenzo's sensitivity as a draughtsman and his superb command of his favourite medium of pastel can be vividly seen in his portrait of a lady (cat. 238) traditionally identified as his mother. Richly bejewelled and attired with costly lace, Cecilia Guardi faces Lorenzo with pride and affection, aware that the portrait will testify as much to her son's developing artistic skills as to her husband's material success. Lorenzo admired Rosalba Carriera, whose work he copied, while his youthful training in chalk drawing at Würzburg must have stimulated his taste for work in that versatile medium. Already at Würzburg Lorenzo had begun to work on portraits, and his early chalk drawing of Algarotti (Küpferstichkabinett, Berlin) is a smoothly assured likeness: once again, Algarotti as a close family friend was encouraging the individual talent of a young artist. By the late 1750s Lorenzo was also making etchings after Giambattista's paintings: two of his large etchings of *c.* 1761 after lost ceilings for the court of Russia (cat. 239, 240) show the finesse of his technique. Compared with Domenico's contemporary etching of the *Triumph of Hercules* (cat. 241) after his own painting, it is clear that Lorenzo had different aesthetic aims. He developed a deliberate and refined manner of working, creating sharp, rich tonal contrasts from massed lines – as distinct from Domenico's use of vibrant strokes – with luminosity and expressiveness in view. Lorenzo's interest in obtaining intense velvety blacks in printing by using a closely hatched technique may stem from his love of pastel, with its soft effect and depth of tone.

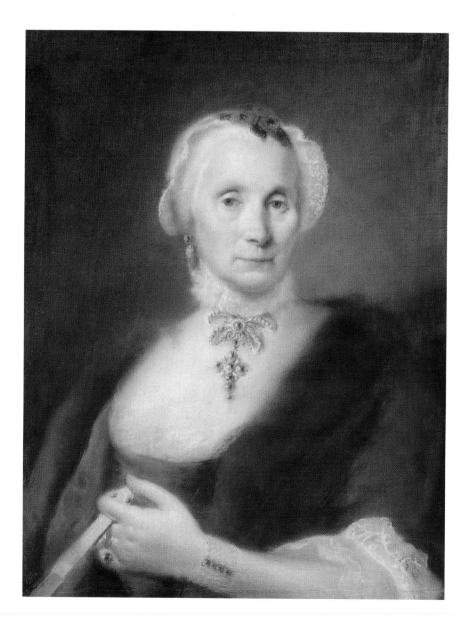

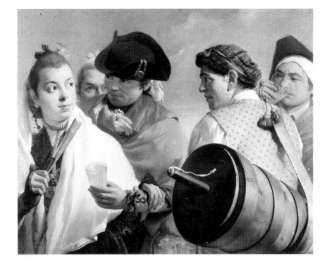

*Figure 56:* Lorenzo Tiepolo, *The Lemonade Seller,* pastel on paper, 51 × 71 cm, 1771–3, Royal Palace, Madrid

240

LORENZO TIEPOLO
*Monument to the Glory of Heroes*
*c.* 1759
etching (state 3 of 3), 66.5 × 49.9 cm
National Gallery of Art, Washington
Ailsa Mellon Bruce Fund

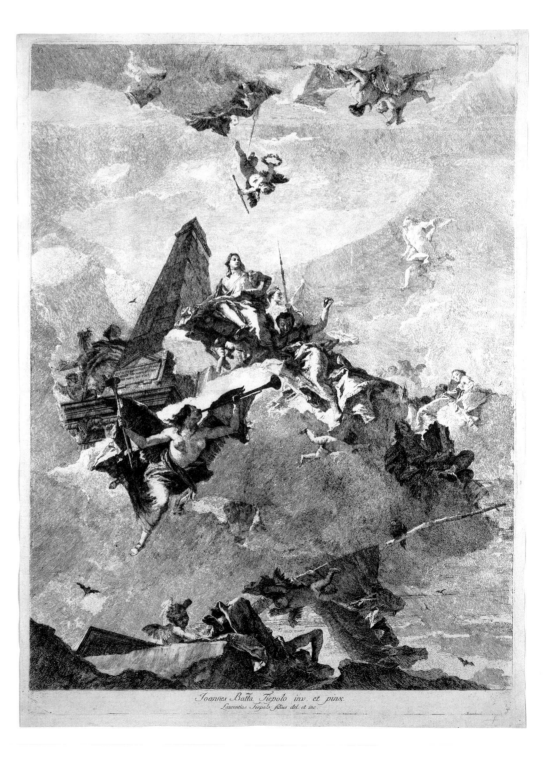

Possibly Lorenzo's most original works are the pastel genre scenes made for the private apartments of the Royal Palace in Madrid in 1771–3 (fig. 56). These half-length groups of figures in Spanish costume are remarkable for their moody and enigmatic qualities: Lorenzo was surely stimulated by Piazzetta's genre scenes and finished chalk drawings, while his point of departure must have been the details of Spanish figures around the cornice of Giambattista's Throne Room ceiling fresco of 1762–4. Lorenzo's genre scenes fed a growing taste for *costumbrismo* at the Madrid court; interestingly, they antedate the genre scenes produced as tapestry cartoons by the Bayeu brothers, Goya and other court artists in the mid-1770s.

241

DOMENICO TIEPOLO
*Triumph of Hercules*
1759
etching, 69 × 50.7 cm (platemark)
Museum of Art, Rhode Island School of Design
Gift of Henry D. Sharpe

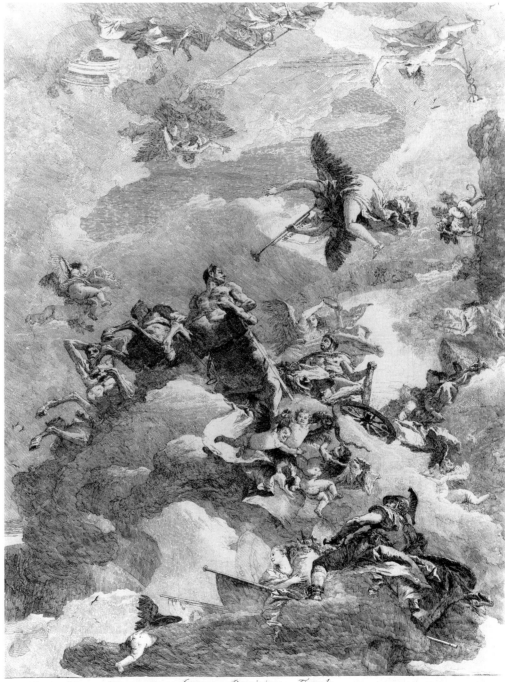

*Ioannes Dominicus Tiepolo*
invenit pinxit et delineavit

Alessandro Longhi shared with the younger Tiepolos the problem of being the artist son of a celebrated painter; however, he was not trained at home as a future collaborator, perhaps because the scale of Pietro's work did not demand such assistance, or because Pietro's own efforts at history painting had been so disastrous. Like Lorenzo Tiepolo, Alessandro quickly developed his own speciality, while the early patronage of the Pisani family gave great impetus to his career. He dedicated his artistic biographies (cat. 243) to Francesco Pisani, for whom he painted two large family group portraits; the handsome volume (cat. 244) celebrating Francesco's appointment as Procurator of S. Marco has as its frontispiece his portrait by Alessandro. It has been convincingly argued that Alessandro, rather than Pietro, ran the Pisani family's academy for drawing and engraving in the early 1760s — one of several private academies with artists as tutors to members of noble families — principally because of his interest in etching, which Pietro did not share.[10]

Alessandro's series of portraits of Venetian artists was first published in a *Raccolta di Ritratti* in 1760, and then reissued with the unusual feature of a beautifully etched text facing each portrait in the *Compendio delle Vite . . .* in late 1762. A collection of distinctive, often perceptive, portraits (including a masterly one of the elderly Piazzetta, and a romantic self-portrait), the *Compendio* is also an ambitious addition to the limited range of art-historical writing in Venice, prompted (according to the introduction) by the recent establishment of the state Academy. Alessandro's aim was celebratory rather than critical: he deals primarily with history painters and — perhaps with his own career in mind — stresses both Pisani patronage (in his text on Tiepolo) and the

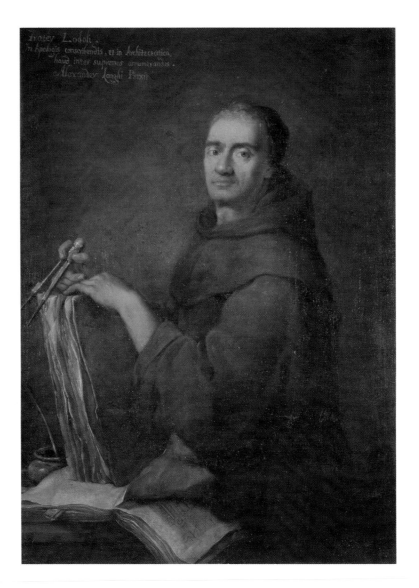

242

ALESSANDRO LONGHI
*Carlo Lodoli*
before 1771
oil on canvas, 200.6 × 93.9 cm
Gallerie dell'Accademia, Venice

importance of working as a tutor to noble families (in the passages on Nogari and Polazzo). He further emphasises that his portraits are exercises in the *maniera pittoresca* – the picturesque style, which Zanetti the Elder had admired in the prints of Rembrandt and Castiglione – and that the etchings were made in his free time, as a respite from the task of painting. In other words, Alessandro's status as a painter was paramount; further, etching was not a laborious, grubby concern but a relaxing, pleasurable occupation, suitable for the amateur.

Alessandro painted some swaggering official portraits – although, like Domenico Tiepolo, his re-use of standard formulae can seem gauche, as if established conventions had become foreign to this generation of artists, and could be handled only gingerly – but his innovations are in less formal portraiture. In the portrait of *Carlo Lodoli* (cat. 242) his instinctive response to character, and the gusto of his brushwork, make for a strongly realistic image. Lodoli (1690–1761), a Franciscan friar, was one of the most stimulating figures of the Enlightenment in Venice, acclaimed as a modern Socrates or Diogenes.[11] A friend of Consul Smith, Lodoli ran a private school attended by Venetian noblemen, including the young Algarotti; his functional theories of architecture were published by a pupil, Andrea Memmo, in 1786.[12] Alessandro's portrait, perhaps dating from *c.* 1760, reveals the friar as a stern, if slightly rumpled, character caught in the midst of work, in keeping with Memmo's description of Lodoli's caustic character and unkempt appearance. Lodoli presumably supplied the wording of the self-deprecatory inscription, as he did for another portrait by Alessandro which was later used as the frontispiece to Memmo's publication.

243

ALESSANDRO LONGHI
*Compendio delle Vite dei Pittori veneziani . . .,*
published by the author in Venice, 1762
folio, open to show etched portraits
of G. B. Tiepolo and A. Longhi
52.1 × 77.5 cm (open book)
The Metropolitan Museum of Art, New York
The Elisha Whittelsey Collection, The Elisha Whittelsey Fund

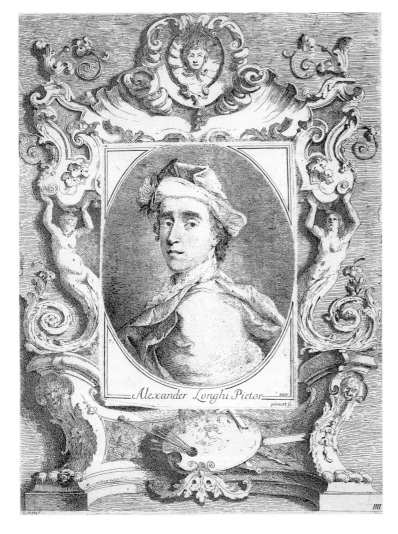

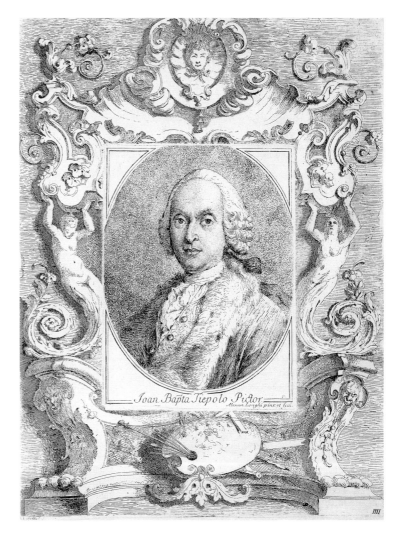

244

FRANCESCO BARTOLOZZI
Title-page, borders and vignette etchings in
*Componimenti poetici per l'ingresso solenne all dignità
di Procuratore di S. Marco per merito di Sua
Eccellenza il Signore Gian-Francesco Pisani,*
published by G. B. Albrizzi, Venice 1763
etching and engraving
36.5 × 51 cm (open book)
Museo Civico Correr, Venice

That Venetian publishers produced some of the finest illustrated books in Europe in the 18th century was partly due to the exceptional pool of talented engravers in the city, with Francesco Bartolozzi among the most prominent from 1748 to 1764. Lavish publications celebrating noble weddings or investiture in high office (as in the *Ingresso Pisani* or the *Ingresso Manin*: cat. 244, 245) could rely on Bartolozzi's picturesque vignettes, chapter headings, frontispieces and decorative devices to provide a complement to the often pedestrian verses within. Certain publishers specialised in such luxury productions. Antonio Zatta reissued the plates from Antonio Visentini's *Iconografia della Ducal Basilica* (cat. 157) in *L'Augusta Ducal Basilica dell' Evangelista Marco ...* (cat. 246) of 1761, one of the most beautiful and impressive illustrated books of the period: the example here includes some use of coloured inks to enhance its precious quality. The text was taken from various authoritative sources, and embellished with borders by Giuseppe Magnini, who often engraved illustrations for Zatta's publications.[13] The highly elaborate border around the plate with Doge Marco Foscarini's portrait employs a lively *rocaille* framework with references to the erudition and fame of the Doge (who had been responsible for restoration work at S. Marco while Procurator, and was a noted scholar[14]), while the Amigoni-like allegorical figures refer to the justice, learning and prosperity that, by implication, flourished under his rule.

Venice's healthy publishing industry, burgeoning output of journals and periodicals, and reasonably liberal censorship laws (Lodoli held the post of State Censor from 1723 to 1742), meant that the scepticism and radical ideas of Enlightenment writers could easily circulate among an educated public.[15] However, Venetian society was deeply conservative, and the English Deists and the French *philosophes* may have been admired more for their wit and urbanity or for their provocative language than for their critique of Church and society, and their call for radical reform.[16] Nevertheless, appeals to reason and to nature as sources for the ordering of society, rather than to blindly accepted hierarchies, were slowly taking root. Rationality, naturalism and historical accuracy were becoming acceptable criteria for judging works of art: the shrewdly observed genre scenes of Pietro Longhi and the realism of Alessandro's portraits appealed to progressive Venetians like Lodoli. Carlo Goldoni too was

246

GIOVANNI MAGNINI
Elaborate border containing a portrait of Marco
Foscarini and another border containing the
dedication, in A. Visentini, *L'Augusta Ducale
Basilica*, published by Antonio Zatta, Venice, 1761, folio
etching, 73 × 105 cm (open book)
British Architectural Library,
Royal Institute of British Architects, London

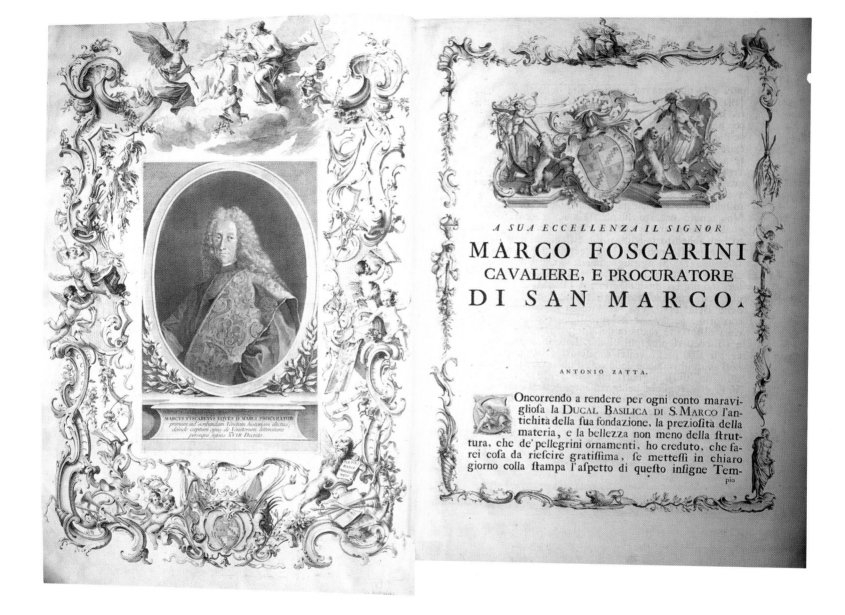

attracted by the everyday drama of ordinary life as the stuff of theatre, rejecting the comic masks and stylised farces of traditional Italian comedy, and the bombastic, overwrought language of earlier drama. Alessandro painted a perceptive and affectionate portrait of Goldoni; Lorenzo Tiepolo made a charming informal portrait drawing which was etched by Marco Pitteri for the frontispiece of the first volume of Pasquali's edition of the works of Goldoni (cat. 247). Pietro Novelli's designs for illustrations are vivacious and discerning responses to the dramatic text and to the author's directions; Antonio Baratti, a highly skilled engraver, produced exquisite plates for this edition. As he says in his *Memoirs*, Goldoni decided in *L'Adulatore* (The Flatterer) to attack a subject of a wicked and dangerous nature, and to inspire horror for the vice of sycophantic flattery with much lively comic play. (As Goldoni knew, the demand that art should have a moral or didactic intent carried much weight in Enlightenment criticism.) Pasquali's edition was to be the authorised version of the dramatist's work, with each volume having as its frontispiece an episode from the life of the author. Novelli depicts in the third volume Goldoni's first experience of acting, aged twelve, when in female dress he recited an overblown Prologue above an orchestra of musicians and singers in a private theatre: Goldoni recalls the event in his preface both to pinpoint his early passion for the stage and to illustrate the kind of theatrical rhetoric he had successfully displaced.

247

PIERO ANTONIO NOVELLI
*Delle Commedie di Carlo Goldoni, Avvocato Veneto*
published in Venice by Pasquali, 1761-78
17 volumes, octavo; vol. III
*c.* 21.5 × 29.5 cm (open book)
Arthur and Charlotte Vershbow

The *Quattro elegantissime Egloghe rusticali* (cat. 248) belong, with the more innovative *La coltivazione del Riso* (cat. 249), to an increasingly popular genre of poems devoted to rural life, ultimately deriving from Virgil and stressing the simple, healthy pleasures of the countryside, but (with an 18th-century appetite for information and belief in progress) attempting to comprehend the occupations and customs of peasant folk. In the *Quattro Egloghe* most of the illustrations present a distinctly unromantic view of peasant life, however elegantly the setting is described, in keeping with the rustic tone of the accompanying poems. Novelli's designs, engraved by Baratti, include a scene with a man pounding garlic while a woman struggles with a heavy pail, and another showing a pig being slaughtered, while one of Bartolozzi's illustrations depicts a young man stirring *polenta*. The unsigned vignettes, tailpieces and capital

248

PIETRO ANTONIO NOVELLI
*Quattro elegantissime Egloghe rusticali ...*, published in Venice by Paolo Colombani, 1760
octavo, etchings, plates and vignettes 23 × 32.5 cm (open book)
Arthur and Charlotte Vershbow

FRANCESCO LORENZI
Headpieces and tailpieces in Giovanni Battista
Spolverini, *La coltivazione del Riso*, published in
Verona by Agostino Carattoni, 1758, quarto
etchings, 29.4 × 41 cm (open book)
The British Library Board, London

letters are delightful and witty. Giambattista Spolverini's *La coltivazione del Riso*, one of a group
of didactic poems which were very much in vogue in literary circles in Verona, is an ambitious
work in free verse, drawing on contemporary history as well as geography and classical
literature; if critics no longer see Spolverini as a reincarnation of Virgil, the poem is still
acknowledged to be the best of its kind.[17] Francesco Lorenzi's stylish designs, engraved by
Domenico Cunego, depict methods of surveying as well as planting and harvesting. A
somewhat idealised view of progress in mainland agriculture is presented in text and
illustrations, which is nevertheless part of the mild enthusiasm for innovation and reform in
labour and education, if not in politics, that characterised the Enlightenment in the Veneto.
Lorenzi was a cultivated man (his early biographer, Zannandreis, describes the extent of his
studies and his membership of various learned bodies) and came from a talented family: one
brother, Bartolommeo, was a poet and author of another georgic poem, *Della coltivazione dei
monti* (1778), for which Lorenzi provided designs for illustrations, in turn engraved by his other
brother, Domenico, who had studied under Marco Pitteri.

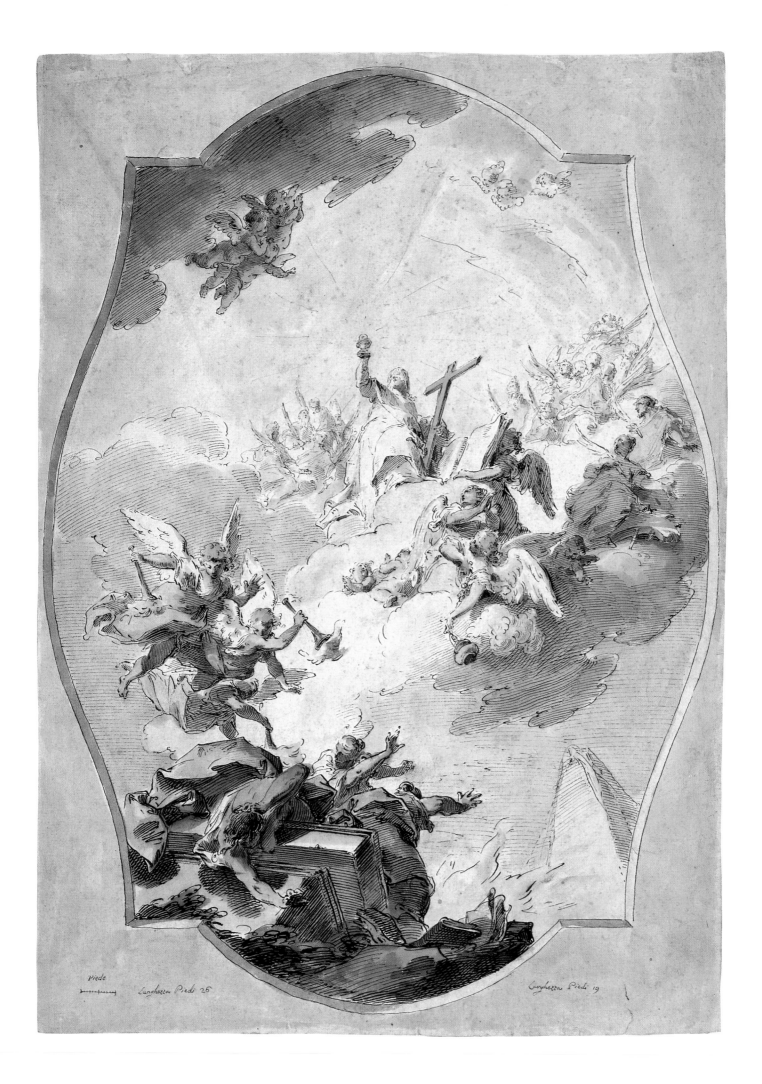

Piede

Lunghezza Piedi 25          Lunghezza Piedi 19

250

Lorenzi also supplied drawings for other book illustrations, but did not experiment with printmaking himself. Novelli's output of designs for the engraver was enormous (one particularly important set of illustrations was for Zatta's edition of the works of Metastasio of 1782–4), while he also produced some etchings. Both Lorenzi and Novelli saw themselves first and foremost as history painters, working for ecclesiastical and noble clients in the north of Italy.[18] Novelli's highly worked design of *Faith Overcoming Heresy* (cat. 250), for the ceiling decoration of an unidentified religious institution, whose measurements he noted, is fluent and assured, recalling compositions by Tiepolo. He was an extremely versatile artist, drawing on Venetian, Bolognese and Roman traditions in his altarpieces and frescoes. However, Novelli is at his most impressive as a draughtsman, whether working economically with the pen, using strong hatching and crosshatching as in the amusing *Peep-show* (cat. 251), or delicately brushing on complementary shades of wash in the fanciful chinoiserie marriage-scene (cat. 252). The taste for the imagined Orient that made chinoiserie so fashionable in 18th-century France, and later England, was absorbed in Venice, where Marco Polo's exotic tales of Cathay were still a folk memory. Venetian lacquer furniture with fanciful Chinese motifs was popular at mid-century, while Domenico Tiepolo's playful fresco decoration in the Foresteria of the Villa Valmarana at Vicenza is one of the finest examples of chinoiserie of the period. Domenico may even have contributed to the design of the chinoiserie porcelain room at the Royal Palace of Aranjuez, outside Madrid, which was created by Giuseppe Gricci for Charles III in 1763–5.[19] Unlike Domenico's vigorous and witty approach, Novelli's delicate chinoiserie drawing is essentially rococo in taste: perhaps he was responding to the demands of a particular client. With his multifarious talents, Novelli could well be regarded as the Palma Giovane of his time – both artists worked in Rome and Venice and attempted to combine the virtues of academic classicism with Venetian painterliness; Palma and Novelli were prolific draughtsmen, and both had to live with the achievements of far greater artists in view.

It is not easy in any age to follow after the soaring ascent of genius and fame, but it must have been particularly difficult for the younger generation of artists represented here, who were extremely close to their celebrated fathers or mentors. In addition, as the century waned, the undeniable conservatism of the Venetian nobility, new and old, became more entrenched, and the past glory of the Serenissima was an ever-present feature in politics as in arts. Although innovation was possible in genre and portraiture, by the 1770s the grand style of allegorical and decorative painting demanded by a dwindling pool of patrons appears in the Veneto essentially as the repetition and variation of familiar formulae. While working with that market in view, these artists are characterised by their diversity – besides their painting, all were seriously engaged in printmaking or book illustration – and by their search for other kinds of creativity. Lorenzi wrote poetry and a treatise on art, Longhi turned to artistic biography, and Novelli was a scholar who wrote his memoirs. Above all, Domenico Tiepolo remained true to his individual genius by inventing a private imaginative world in his drawings.

1. See Gealt, 1986, for a thorough study. Mariuz, 1971, is the principal monograph on the artist, while Byam Shaw, 1962, is invaluable.

2. Knox, 1984, pp. 439–46.

3. Mariuz, 1986, pp. 265–72, fig. 7.

4. Washington, 1971, pp. 93–113 provides a good introduction.

5. Whistler, 1993, pp. 385–98, with further references.

6. Pedrocco, 1989–90, pp. 108–15.

7. The fundamental study is Knox, 1980, who argues that the majority of the detail drawings from the Würzburg period are preparatory drawings by Giambattista rather than copies by Domenico.

8. Goldoni, 1828, I, pp. 45–6.

9. Thiem, 1993, pp. 138–50.

10. Montecuccoli degli Erri, 1990, pp. 41–62.

11. See Haskell, 1980, pp. 320–2.

12. Memmo, 1786.

13. Lánckoronska, 1950, lists numerous projects by Magnini for Zatta.

14. Haskell, op. cit., pp. 258–9.

15. Infelise, 1989, especially pp. 37–41.

16. See Berengo, 1979, pp. 151–62 for this view.

17. Natali, 1960, II, p. 689; Corubolo, 1989.

18. Caiani, 1972; Arban, 1970.

19. Honour, 1960.

PIERO ANTONIO NOVELLI
*The Peep-show*
pen and brown ink with grey and brown wash
over black chalk, laid on backing paper,
17 × 24.2 cm
National Gallery of Art, Washington
Julius S. Held Collection,
Ailsa Mellon Bruce Fund

252

PIERO ANTONIO NOVELLI
*The Marriage of Europe and China*
1770s–80s
pen and brown and grey ink with grey wash on
laid paper, 33.7 × 45.7 cm
National Gallery of Art, Washington
Ailsa Mellon Bruce Fund

253

BERNARDO BELLOTTO
*Venetian Capriccio*
*c.* 1745
oil on canvas, 48.5 × 73 cm
Fundación Colección Thyssen-Bornemisza,
Madrid

# XI: *Bernardo Bellotto*

Edgar Peters Bowron

Among the many view-painters who flourished in 18th-century Venice, none possessed a wider range, or attempted to enrich the conventions of the painted *veduta*, or view-painting, more than Bernardo Bellotto (1721–80). Often dismissed as an acolyte of his famous uncle, Canaletto, Bellotto surprises us with the breadth of his interests. His appetite for fresh topographical material led him to visit half a dozen cities in northern and central Italy in the early 1740s, and at 26 he left Venice for northern Europe, never to return. He spent the remainder of his life working for royal and aristocratic patrons in Dresden, Vienna, Munich and Warsaw, where his best pictures are found today. He began his career as a painter of conventional views of Venice in the manner of Canaletto, but from early on it is clear that his pictorial interests and ambitions were different from those of the older painter. Over the years Bellotto expanded his range beyond traditional view-painting, venturing into genre, portraiture, allegory and, in his Warsaw period, history painting. Although Bellotto's artistic status will always be defined by his achievements as a view-painter and landscape painter, he is equally intriguing as an artist 'whose genre qualities seem to preclude Goya and whose strong naturalism is like a breath of the 19th century, almost of Courbet'.[1]

Bellotto played a significant role in the dissemination of Venetian art throughout Europe, and he introduced the Venetian style of view-painting to cities north of the Alps, such as Vienna, where the genre of painted *vedute* hardly existed. Moreover, he anticipated a number of artistic movements that we associate with the late 18th century and early 19th – *plein-air* painting, Romanticism and realism – and it is for this reason that his paintings have been placed beside the works of Piranesi and Canova at the end of the present exhibition.

Bellotto entered the studio of Canaletto around 1735, and by 1738, at the age of seventeen, he was enrolled in the Venetian painters' guild, which suggests that he had already developed into an independent painter. The degree of Bellotto's participation in Canaletto's paintings around this time will probably never be precisely established, and even the artist's contemporaries could not easily identify his earliest individual manner. Bellotto's first biographer, Pietro Guarienti, asserted that 'his scenes of Venice were so carefully and so realistically done that it was exceedingly difficult to distinguish his work from his uncle's'.[2]

There are, none the less, views of Venice that have come to be accepted as Bellotto's work in spite of the absence of conclusive evidence, and they reveal from the outset a bold and distinctive style of painting. These include a pair of Venetian scenes, *The Piazzetta, looking North* and *The Arsenal* (1740–3; National Gallery of Canada, Ottawa), that provide the first real indications of Bellotto's potential. Pignatti first called attention to the characteristics of these pictures that are unmistakably Bellotto's own – the precision of architectural line; cold, crystalline light; sharply defined areas of light and shade; and tall, lanky figures whose facial features are abbreviated to simple blots.[3] The size of the Ottawa canvases – 150 × 122 cm each – reveal Bellotto's ease at composing on a large scale.

An early view by Bellotto in the exhibition is a *capriccio* (cat. 253), an idealised view of a landscape in the Veneto combining various architectural and landscape elements drawn from several sources and faithfully described. In 1740–1 Bellotto accompanied his uncle on a visit to the mainland, travelling along the Brenta Canal to Padua. The route was by way of Fusina to Dolo and beyond, and may also have included stops at Marghera and Mestre, but whatever the actual itinerary, Bellotto matured enormously as an artist during this period. That he looked at the landscape of the *terraferma* through Canaletto's eyes we know from their respective drawings. Bellotto and Canaletto evidently drew side by side at a number of sites on the journey, including a spot where they recorded the cluster of houses seen at the left in the Thyssen painting. The bridge and medieval structure on the right bank were, however, derived from other sources, including an etching by Canaletto, and it is typical of Bellotto's capacity for invention and of his interest in landscape that he concluded this view with a fictitious mountainous backdrop. As the prominence given the river (suggestive of the Brenta and its tributaries) in this imaginary view implies, Bellotto's Venetian origins influenced his pictorial imagination, and river landscapes became a consistent theme throughout his career as he depicted successively the Tiber, Arno, Po, Adige, Elbe, Wien and Vistula rivers and their surrounding terrain.

In 1741–2 Bellotto became active as a printmaker with a group of eight small etchings of landscape and architectural *capriccios*, based on his experiences in and around Padua. His early work in the medium is heavily indebted to Canaletto both for its subject-matter and technique. Later, in Dresden, Vienna and Warsaw, Bellotto produced a series of large and detailed reproductive etchings that occasionally rival those of his uncle in quality and interest.[4]

In 1742 the painter travelled in central Italy, visiting Florence, Lucca and Rome, and from 1744 onwards he spent months at a time in Milan, Turin and Verona, where he produced a number of topographical views. Bellotto responded to the Italian mainland differently from Canaletto: the textures and reflections of stone, soil, vegetation and water captivated him, and he was absorbed in their particularities in a way that his uncle never was. The most extraordinary of Bellotto's early Italian landscapes are his views of Gazzada near Varese (fig. 57). The contrasts of light and shade, intense colour, transparent atmosphere, and sensitivity to the rural scenery provide a foretaste of his handling a decade later of the views of Pirna and Königstein, in which Bellotto would also subordinate architecture to the surrounding countryside. The most remarkable feature of these early landscapes is his handling of light. His use of colour to reproduce precisely the hues he had observed in the open air appears to precede the interests, if not the methods, of the *plein-air* painters who roamed Italy later in the century.

The sequence of work in the 1740s reveals the emergence of Bellotto's own personality as an artist, and the rapidly diminishing influence of his uncle. Even at this early date Bellotto was distancing himself from Canaletto's style of painting, and relying on more precisely drawn architecture, heavier impasto, a bolder palette of saturated greens and blues, a colder tonality, and dark, cold grey shadows. His uncle was still the more famous artist at the time, so in 1745 when Bellotto produced two views of Turin for Charles Emmanuel III, King of Sardinia and Duke of Savoy, he signed one of them with both his given name and surname and the nickname '*Il Canaletto*', to draw attention to his relationship with his celebrated uncle.

The greatest of Bellotto's Italian river landscapes – and the last important pictures he painted in Italy – are a pair of complementary views of Verona, one seen from the Ponte Nuovo, looking up the Adige toward the Castel S. Pietro, the other a view of the city with the Ponte delle Navi, looking downstream. Bellotto painted these panoramas on two large canvases, 132 × 233 cm

254

BERNARDO BELLOTTO
*View of Verona with the River Adige from the Ponte
Nuovo*
1747–8
oil on canvas, 131 × 232 cm
Staatliche Kunstsammlungen, Gemäldegalerie
Alte Meister, Dresden

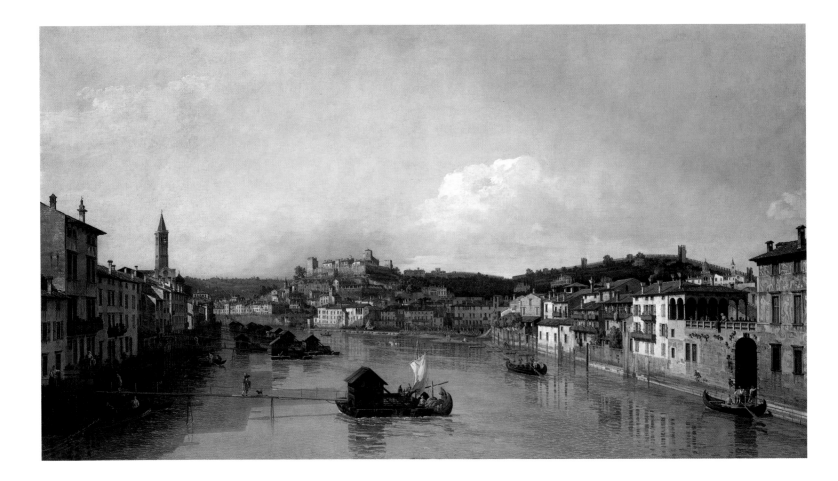

(National Trust, Powis Castle; private collection, on loan to the National Galleries of Scotland). So important were these views that he produced a second, autograph version of each (cat. 254), either in Italy shortly before his departure for Dresden or shortly after arriving at the Saxon court of Augustus III, Elector of Saxony and King of Poland. The largest and most ambitious compositions he had created to date, the Verona views in their sweep and scale established a new level of achievement for Bellotto. As one writer put it, 'From now on, seven feet was to be Bellotto's minimum width for his important townscapes, in itself, surely a mark of self confidence in a man not yet thirty years old.'[5] The Verona views were half again as large as his largest previous canvases, and the horizontal shape provided the format for the panoramic views that became his trademark. (Canaletto, by contrast, painted less than half a dozen canvases of similar size and scale.)

In July 1747, in response to an official invitation from the court of Dresden, Bellotto left Venice for ever. From the moment of his arrival in the Saxon capital, he was engaged in the service of Augustus III and of his powerful Prime Minister, Heinrich, Count von Brühl.[6] In 1748 the title of Court Painter was officially conferred on Bellotto, and his annual salary was the highest ever paid by the King to a painter. Earlier in the century the Saxon capital had been transformed architecturally, artistically and culturally by the elector's father, Augustus II (the Strong), and for its great beauty was christened 'Florence on the Elbe' by the writer J.G. Herder. The Elector's building programme had produced some of the most elegant Baroque and Rococo buildings in Europe: Matthäus Daniel Pöppelmann's Zwinger pavilions (1710–31); Georg Bähr's Frauenkirche, the most important Protestant church in Dresden (1726–43); Gaetano Chiaveri's Hofkirche, the Catholic church for the Saxon court (1738–55); and Johann Christoph Knöffel's palace for Count Brühl (1737–40).[7]

Augustus III, a passionate lover of music, the theatre and the visual arts, and the most munificent patron of the arts in Germany in his day, charged Bellotto with producing for posterity a pictorial record of the tangible accomplishments of his father and of himself. Since 1600 a tradition had been established at Dresden for topographical views accurately representing towns in the duchies of Saxony and Meissen, and the fondness of successive electors for *vedute* is shown by the fact that the court employed a permanent *Prospektmaler* (a painter of 'prospects', or views) from the 17th century onwards.[8] From the moment of his arrival, Bellotto stepped into this role and began the task of commemorating the most celebrated sites of Dresden and later, in the countryside beyond the city, of Pirna and Königstein.

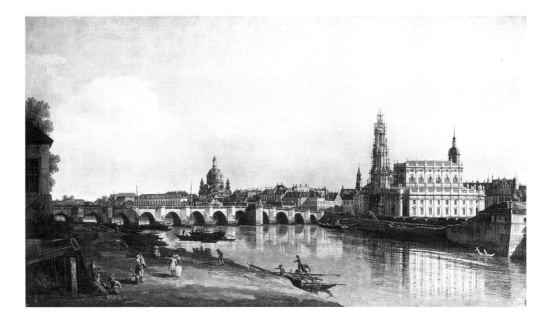

*Figure 58:* Bernardo Bellotto, *Dresden from the Right Bank of the Elbe*, oil on canvas, 133 × 237.5 cm, 1748, Gemäldegalerie Alte Meister, Staatliche Kunstsammlungen, Dresden

Between 1747 and the first months of 1753 Bellotto painted fourteen large views of Dresden that show the city's Baroque and Rococo buildings to their best advantage. The Dresden views, which conclude the stage of development initiated by the Italian views, are astonishing in their topographical precision, control of light and mathematical perspective, clarity and organisation (fig. 58). Bellotto could manipulate light and shade and arrange planes and solids with the ease of a theatrical scene-painter (in whose methods he was trained), so that every element in his paintings was organised into a unified, bold and dramatic design. Size, scale and breadth of view are a few of the differences between Bellotto's townscapes and those of Canaletto, and some of the ways in which the pupil surpassed his master. Bellotto's views of Dresden and its environs are not only his finest works, but are among the greatest achievements of 18th-century view-painting.

One of the artist's more unusual views of the city is *The Moat of the Zwinger* (cat. 255). The extraordinary vantage point Bellotto selected is typical of his theatrical approach to depicting urban topography – instead of merely representing what appeared before him, Bellotto inevitably sought to beautify, aggrandise or sensationalise the familiar, everyday view. Here Bellotto has subordinated one of the masterworks of European Baroque architecture, the Zwinger (which he also painted in a more straightforward composition, today in Dresden), to the startling and dramatic effects of a stage designer's imagination. The unorthodox view is taken from the Orangery looking towards the city in the distance, and features, on the left, the Luna bastion with its so-called Scharfe Ecke ('sharp corner'), with the trees all but hiding the entrance to the Zwinger. Visible in the middle ground is the Französischer Pavillon, the Langgalerie with the Kronentor, and the upper part of the Zoologischer Pavillon. Beneath the Kronentor is a temporary wooden bridge across the moat that slows the powerful recession of the composition and connects the Zwinger on the left to the Ostra-Alle on the opposite side. The strong orthogonals of the sides of the moat induce one's eye to jump towards a distant view of the old city. Yet, all the buildings, even those in the far distance, have been represented with equal clarity, as if seen through the zoom-lens of a powerful camera, overriding the effects of aerial perspective. Thus, on the right, the prominent house of a court official, Andreas Adam; in the background, from left to right, the Hausmannsturm in the Residenz, the opera house with the spires of the Kreuzkirche and the Sophienkirche just visible behind it, and the tower of Wilsches Tor are delineated with the precision of elements much closer to the picture plane. Like so many of the Dresden views, the *Moat of the Zwinger* has the character of a world seen through a wide-angle telescope, as contradictory as that may seem.

Between 1753 and the spring of 1756 Bellotto was commissioned by the court to paint eleven views of Pirna. In almost all of these paintings the royal palace of Sonnenstein, rising above the town, is present, and it is the principal subject in three of the views, which suggests that the King wanted to spotlight the strategic significance of the castle.[9] In the spring of 1756 Bellotto was commanded to focus his efforts on the portrayal of another royal castle, Königstein, 22 miles south-east of Dresden. He eventually produced five views of the fortress of Königstein, executed on canvases of identical size and format, that were intended to complete the Dresden and Pirna series placed in the Stallgebäude, the wing of the royal palace that housed the paintings collection after about 1731. However, Bellotto's work on the Königstein views was abruptly interrupted when Frederick the Great of Prussia opened hostilities in the Seven Years War by invading Saxony in August 1756. How far the painter had advanced towards completion of the five canvases in October when the Saxons surrendered is not known, but the siege and occupation of Dresden prevented the works from reaching the royal collection and all were in England within a few decades of their completion.

BERNARDO BELLOTTO
*Moat of the Zwinger in Dresden*
1749–53
oil on canvas, 133 × 235 cm
Staatliche Kunstsammlungen, Gemäldegalerie
Alte Meister, Dresden

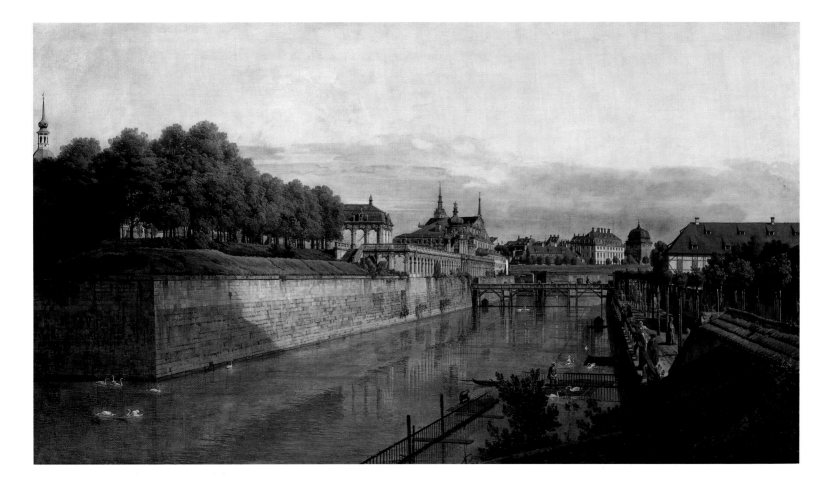

In the most dramatic of the views of the fortress (cat. 256)[10] Bellotto's panorama encompasses a broad expanse of the picturesque, craggy landscape known as 'Saxonian Switzerland' because of the bizarre sandstone cliffs scattered across the countryside. The great castle of Königstein, whose origins date to the year 1241, is placed on top of a mountain that rises precipitously from the Elbe valley, hundreds of feet below; it is a memorable sight that remains unchanged to this day. Bellotto invested this view with a monumentality rarely seen in 18th-century Italian landscape painting. His boldly contrived design hinges on the equilibrium between the fortress on its rock and the expanse of sky on the left; the tension between the broad, distant vista stretching to the horizon and the wealth of detail in the complex pattern of fields and paths; and, at the extreme edges of the composition, the poise between the Lilienstein, a prominent rock formation, and the curving road leading on the right to the castle. The fortress occupies the apex of a bold triangle; cold, remote and forbidding, it is set off by its sheer weight from the staffage in the foreground below.

The human figures and animals moderate the heroic mood of the painting and create an idyllic and pastoral atmosphere. Yet their presence exaggerates the dominance of the fortress above, which appears to exist in a realm of eternal repose where time and change are unknown. Whether Bellotto intended these rustic figures to lend the landscape allegorical or symbolic meaning, their importance is underscored by the fact that they are larger in scale and far more closely integrated into the landscape than in almost any of the artist's other view-paintings to date. From this point forward Bellotto's figures become an increasingly significant feature of his work, culminating in the Warsaw paintings in which around 3,000 have been counted, half of which can be assigned to a specific professional and social standing by their appearance and dress.[11]

256

BERNARDO BELLOTTO
*The Fortress of Königstein*
1756–8
oil on canvas, 133 × 235.7 cm
National Gallery of Art, Washington
Patron's Permanent Fund

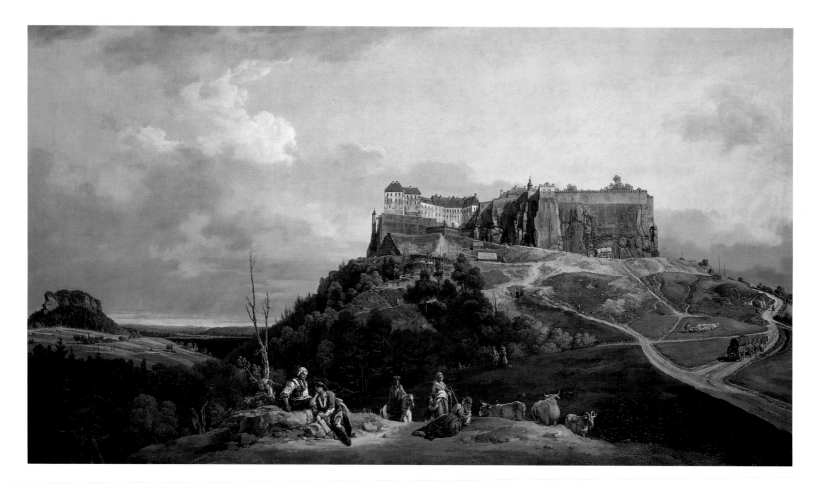

In the winter of 1758–9, when Dresden was occupied by the Prussians, Bellotto moved to Vienna, where he remained until early in 1761. The thirteen large canvases recording the principal attractions of Vienna, painted for the Empress Maria Theresa and largely concentrating on her palaces and those buildings constructed at her behest, constitute his second great series devoted to the portrayal of a single city and its immediate environs. There is an increase in realism in Bellotto's Viennese views, which he accomplished through a scrupulous and objective treatment of architectural detail and also through careful observation of everyday human activity.[12] He captures in great detail the street life in the centre of Vienna, objectively depicting the various social classes and groups conducting their daily business. Canaletto revealed a sharp eye for the minutiae of daily life in his views of Venice, but Bellotto's dedication in recording the throngs of aristocrats and peasants, noblemen and servants, monks and Jews, tradesmen and beggars suggests an almost obsessive interest in *reportage*.

Among Bellotto's views of Vienna, *The Ruined Castle of Theban* (fig. 59) is the most advanced for its time, both for its sensitive depiction of the March Valley landscape and the prominence given to a family of gypsies before their tent. Exactly what Bellotto intended to signify by placing these representatives of the rural poor below the abandoned medieval fortifications on the hill is unclear, but the bold inversion of the Imperial social and political order is striking: the Imperial summer palace of Schlosshof, the ostensible and expected subject of the painting, is barely visible in the distance. The presence of the marginalised social classes is rare in 18th-century Italian painting, and Bellotto's figures bring to mind the work of Giacomo Ceruti (1698–1767), who sympathetically portrayed peasants, mendicants and menial labourers.[13]

Bellotto's second period in Dresden, 1761–6, was marked by financial difficulties caused by the destruction of his house during the Seven Years War, the deaths of Augustus III and Count Brühl within a few months of each other in 1763, and a change in the direction of the artistic affairs of the Saxon court in favour of native artists. In order to eke out a living the painter served as the equivalent of a tutor in perspective at the Dresden Academy of Fine Arts, which was established in 1764. Out of economic necessity he made and sold prints and produced reduced replicas of his earlier views of Pirna, Königstein, Vienna and Munich. During this period he also produced serious work and explored new genres, the most imaginative being architectural capriccios and *vedute ideate* (views with purely imaginary elements).

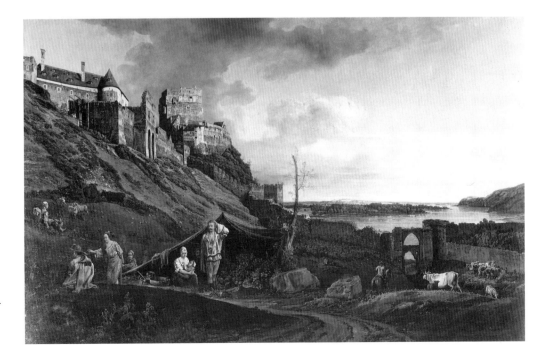

*Figure 59:* Bernardo Bellotto, *The Ruined Castle of Theban*, oil on canvas, 137 × 216 cm, 1759–60, Kunsthistorisches Museum, Vienna

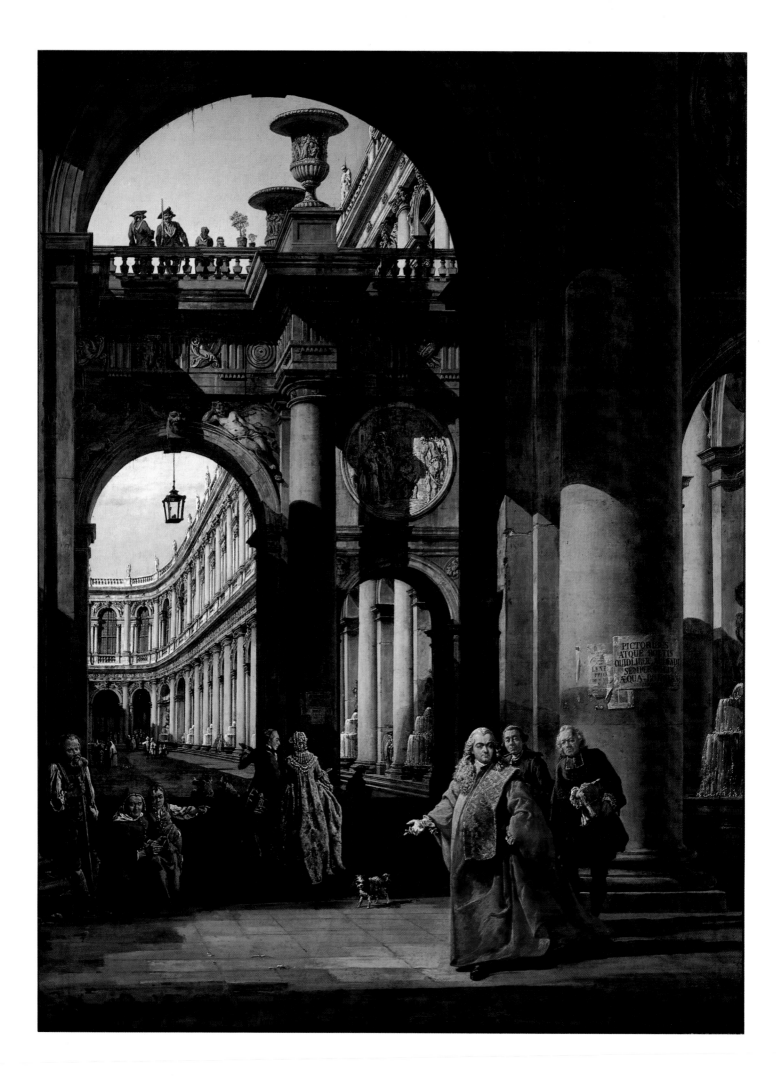

257

BERNARDO BELLOTTO
*Architectural Fantasy with a Self-portrait*
*c.* 1766
oil on canvas, 153 × 114 cm
Royal Castle, Warsaw

Typical of the fantasy architectural *capricci* is a pair of drawings in the Victoria and Albert Museum (cat. 258, 259), signed and dated 1764. These highly finished sheets are unusual in Bellotto's *œuvre*, because for him drawing was usually a more pragmatic and provisory exercise. The bulk of his drawings are outline pen drawings of architectural compositions or figure studies that were often utilised in the preparation of a painting. The careful use of wash and the evident care taken in the execution of this pair of *capricci* reveal their importance as presentation drawings. In one there are allusions to the Dioscuri on the Quirinal at Rome and to the bronze horses of S. Marco, Venice; in the other, Bellotto has created a fanciful sculptural monument combining the equestrian figure of Bartolomeo Colleoni on Andrea Verrocchio's monument in Venice with the seated slaves at the base of Pietro Tacca's monument to Ferdinand I de'

258

BERNARDO BELLOTTO
*Architectural Capriccio with an Equestrian Monument*
1764
pen and ink and wash on traces of pencil,
44.4 × 62.1 cm
The Board of Trustees of the Victoria and Albert Museum, London

259

BERNARDO BELLOTTO
*Architectural Capriccio with the Dioscuri from the Capitol*
1764
pen and ink and wash over traces of pencil,
43.8 × 62 cm
The Board of Trustees of the Victoria and Albert Museum, London

Medici at Livorno. The architecture, perched on the edge of a lagoon over which parade gondolas glide, combines a number of motifs suggestive of prototypes ranging from the Roman arch of the Sergii at Pola to the Doge's Palace and Sansovino's Library at Venice to the ruined towers in Canaletto's etched *capricci*.

The *capricci* of the second Saxon period link Bellotto to Piranesi, and to the rising tide of taste across Europe for paintings, drawings and prints with architectural fantasies as their subject. In Dresden itself changes in patronage, artistic theory and cultural politics all contributed to Bellotto's renewed interest in the genre of inventive architectural *capricci*. In enlightened and academic circles the straightforward topographical view-painting had always been a humble category, and the opinion of the new Director-General of the arts at the Saxon court, Christian Ludwig von Hagedorn (1712–80), sounds ominously like a directive to local artists: 'Works of art are enhanced only by the beauty of their invention. This is the means whereby an artist, in his creations, reaches out to the soul and speaks to the understanding. The mechanical aspect of art provides the imaginative aspect with a body, an exterior form to attract the eye. The heart wishes to be moved and the understanding to be flattered, but the eye wishes to be deceived'.[14] Bellotto responded with a number of brilliantly painted architectural *capricci*, characterised by inventive combinations of Baroque and Neo-classical architecture and dazzling perspective effects, perhaps the finest of which is an *Ideal View of a Palace* (Kunsthalle, Hamburg).[15]

Bellotto's interest in a wide spectrum of humankind continued to find expression in the occupations of the nobility and their families, their servants and court officials, 'caught in a measured, wordless narration'. The prominent juxtaposition of the highest ranks of the nobility with their servants has led to the conjecture as to 'whether this is the outcome of a deliberate objectivity on the artist's part, or whether his intention was a kind of capriccio in social and human terms, instead of with the elements of landscape and architecture'.[16] An example of such a 'social' capriccio is an architectural fantasy painted in 1762–5 (fig. 60). The view combines an imaginary palace courtyard in the Baroque style with relatively large, realistically portrayed genre figures in the foreground. The three richly dressed figures at the left have been identified as the wealthy Polish landowner Voivod Franciszek Salezy Potocki, his son Stanislaw Szczesny, and a retainer. Completely unexpected in such a group portrait or conversation piece, however, is the juxtaposition of the Potockis with the figure of a blind beggar at the far left, a peddlar at the right of the entrance and a poor man and his family seated on the steps that descend to the palace courtyard.[17]

The painting by Bellotto most engaging to 20th-century sensibility, which has received a variety of interpretations, is the artist's highly personal distillation of the miseries of war, a view of the remains of the old Kreuzkirche in Dresden (cat. 260). During the bombardment of the city by the Prussians in 1760 the church was largely destroyed, apart from the lower part of the tower. Five years later the east wall, which had been shored up with a wooden casing, suddenly collapsed on 22 June. The scene Bellotto depicted is the demolition of the upright remains of the building. The painting has been seen as a prefiguration of German Romanticism, although in fact Bellotto is working here entirely within the established pictorial conventions of 18th-century townscape painting. He has meticulously recorded a scene that he and hundreds of other citizens had witnessed – and which had been reported in the local press – with a miniaturist's fidelity and precision of touch. None the less, this is one of Bellotto's most memorable works, an evocative interpretation of the ruin and devastation of war.

*Figure 60:* Bernardo Bellotto, *Architectural Capriccio with a Portrait of two Members of the Potocki family*, oil on canvas, 153.6 × 113.6 cm, *c.* 1762–5, El Paso Museum of Art

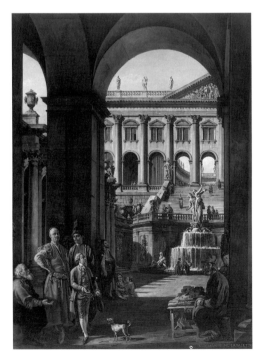

260

BERNARDO BELLOTTO
*The Ruins of the Kreuzkirche, Dresden*
1765
oil on canvas, 80 × 110 cm
Staatliche Kunstsammlungen, Gemäldegalerie
Alte Meister, Dresden

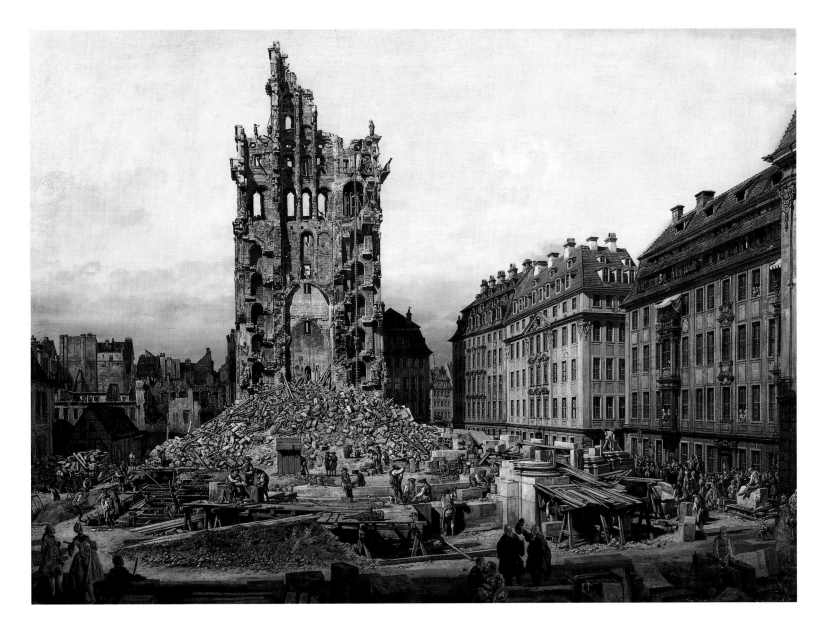

The most obvious proto-Romantic elements in Bellotto's art, however, are not the formal and thematic analogies of a work like the *Ruins of the Kreuzkirche* to the images of ruined churches painted by German Romantics such as Caspar David Friedrich.[18] Rather, it is Bellotto's characteristic treatment of spatial depth, his long, low horizons, stretching seemingly infinitely into the distance, that appear to have caught the attention of artists like Friedrich. Indeed, André Corboz's provocative comparison between Bellotto's view of *Sonnenstein Castle and Pirna from a Hill on the Königstein Road* (1753–6; Gemäldegalerie, Dresden), the background of which consists of an extensive view down the Elbe to the towers of Dresden on the horizon, and Friedrich's *Fields near Greifswald* (*c.* 1820–2; Kunsthalle, Hamburg) suggests that Bellotto's naturalism might indeed have caught the attention of a younger generation of painters.[19] The eerie naturalism of Bellotto's landscape – which in selected details possesses an almost otherworldly quality – and the richness and intensity of his palette anticipate to a remarkable degree the work of the German Romantics.

In December 1766 Bellotto and his son Lorenzo left Dresden with the intention of travelling to St Petersburg to work for the Empress of Russia, Catherine II. He probably arrived in Warsaw before the end of January 1767 and was immediately offered employment at the court of the last king of Poland, Stanislaus II August Poniatowski. He was appointed court painter in 1768, and spent the last twelve years of his life working for the King in relative comfort and security. His most important work from this period is a series of 26 views of Warsaw, intended for a particular suite, the so-called 'Canaletto Hall', in the Royal Castle. The Warsaw views are a radical departure from the classical perfection of the Dresden series, different in composition, light and colour. The canvases are much more crowded with figures, the sky has come alive, and clouds and light effects heighten the drama. There is a passionate quality to Bellotto's last pictures that reflects the exoticism of his new home.

*Figure 61:* Bernardo Bellotto, *The Market in the New Town and the Church of the Blessed Sacrament, Warsaw*, oil on canvas, 84 × 106 cm, 1778, National Museum, Warsaw

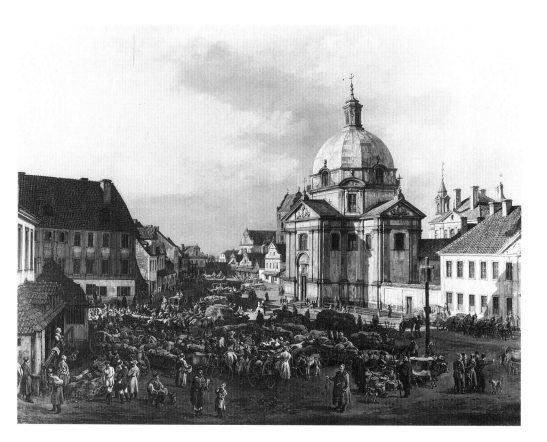

The Warsaw views are animated by a keen response to the inhabitants of the city and its environs, and the realistic treatment of the figures, which takes up more space than in the Dresden or Vienna views, anticipates the genre quality so pronounced in 19th-century paintings of the urban scene. In paintings like the *Market in the New Town, and the Church of the Blessed Sacrament, Warsaw* (fig. 61), the figures and animals compete for attention with the architecture of the city. The scene is dominated by its ostensible subject, the church of the Nuns of the Blessed Sacrament on the right, but one's attention is inevitably drawn to the throngs of merchants, traders, peasants from outlying villages, carts and wagons and farm animals filling the square. The anonymous and awkward figures of the paintings made in Italy have now evolved into a diverse and animated population going about its normal business. At this moment in Bellotto's career his art seems purged of all traces of its Venetian origins, and he has given free rein to his desire as an accurate recorder of facts, to adhere literally to what he saw or knew to be present. Bellotto's artistic personality from the beginning showed a striving towards the faithful depiction of reality, and in his late paintings this realism is paramount. No greater proof exists than the fact that the Warsaw paintings were used as models for the reconstruction of individual buildings and of whole quarters of the city after the Second World War.

The paintings of the Warsaw period reveal that Bellotto's interest in nature had deepened in this last period of his career. 'In the Warsaw paintings, everything is more concrete and objective, the individual forms of the natural phenomena are much more strongly differentiated.'[20] One senses in works like a *View Across the Country near Wilanów* (Royal Castle, Warsaw), a truthfulness, an appreciation of nature in all its variety, and an empathy for the mood, serenity and monumentality of landscape. The lyrical view of the plain stretching into the distance, although initially obscured by the genre elements in the foreground, is characteristic of Bellotto's instinctive reach for panoramic breadth in his compositions. These late landscapes reflect a deeper appreciation for the natural world, and would seem to be the result of a long dialogue between the artist and nature. The landscapes of the Warsaw period, much more than his early views of Gazzada and Pirna, enable us to see Bellotto even more clearly as a precursor of Romantic and 19th-century landscape painting. The sensibility and technique of his landscapes prefigure a variety of later developments, and it is not surprising that frequent comparisons have been made of his landscapes to the work of Corot, Daubigny, and the painters of the Barbizon School.[21]

1. Levey, 1980, p. 123.

2. Orlandi and Guarienti, 1753, p. 101.

3. Pignatti, 1967², pp. 2–3. The attribution has been disputed and the traditional attribution to Canaletto affirmed by Kozakiewicz, 1972, I, 65–7, II, nos. Z 41, Z 261, pp. 404, 449; and Constable, rev. Links, 1989, II, nos. 67, 272, pp. 218, 325.

4. For an overview see Venice and Gorizia, 1983, pp. 58–71.

5. Links, 1973, p. 108.

6. Walther, in Venice, 1986, pp. 31–56.

7. For a general overview, see Washington, 1978, pp. 15–30, 59–63; Walther, in Venice, 1986, pp. 57–59; Barcham, 1991, pp. 13–28.

8. Kozakiewicz, 1972, I, p. 82.

9. *Idem*, 1972, I, p. 84.

10. Bowron, 1993, pp. 1–14.

11. Kozakiewicz, 1972, I, p. 169.

12. *Idem*, 1972, I, pp. 118–9.

13. Gregori, 1982, and Spike, in Fort Worth, 1986, pp. 207–216.

14. Quoted by Kozakiewicz, 1972, I, p. 137.

15. Kozakiewicz, 1972, II, pp. 250–3, no. 317, repr.

16. *Idem*, 1972, I, p. 119.

17. Raleigh, 1994, cat. 43, pp. 230, 232, repr. col.

18. For example, *Winter* (1807–8; Neue Pinakothek, Munich, destr.; *Monastery Graveyard in the Snow* (1817–19; formerly Nationalgalerie, Berlin, destr.; or *Abbey in the Oakwood* (1809–10; Schloss Charlottenburg, Berlin); see Börsch-Supan, 1974, figs. 27, 40; pl. 8.

19. Corboz, 1985, I, figs. 321–2.

20. Kozakiewicz, 1972, I, p. 172.

21. *Idem*, 1972, I, pp. 195, 197–8, citing Pallucchini, Morassi, Longhi and other scholars.

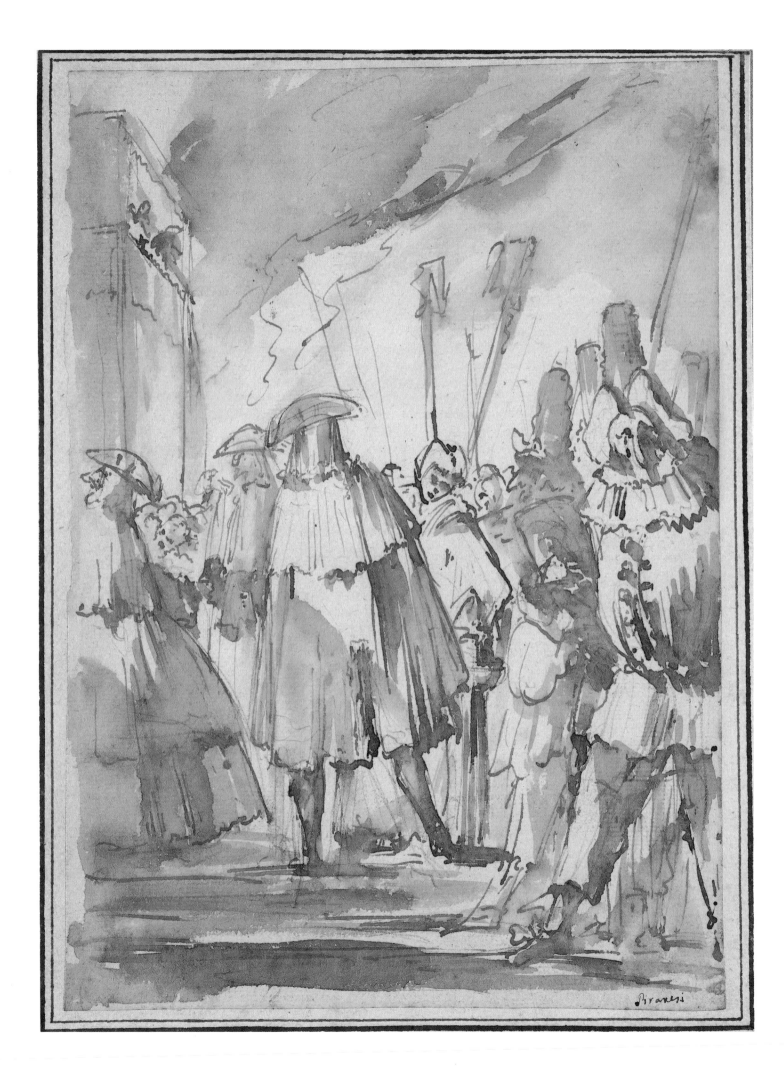

# XII: *Giovanni Battista Piranesi*

## Andrew Robison

Piranesi's appeal has been wide-ranging and constant from his own day to the present. In most general terms this comes from the intensity of his consistent vision expressed through all his work: the majesty and power of the forms and spaces of architecture, which are a wonder to mankind. In more pictorial terms Piranesi's appeal stems largely from the boldness and strength of his overall compositions combined with the delicacy and variety of his details.

Although he is rightly known as the 18th century's greatest proponent of the magnificence of ancient Roman architecture, Piranesi saw no contradiction between his adopted Romanness and his Venetian origins. Indeed, he prided himself on being a 'Venetian architect', which he frequently added to his signature. If we trace his career through a series of major works with special attention to the Venetian elements, we can see how decided they were, as well as how Piranesi forged them into a new marriage with Rome.

Giovanni Battista Piranesi was baptised in Venice's church of S. Moisè, with its massive and eccentrically decorated façade, on 8 November 1720.[1] His father was a stonemason and builder, and from him the boy must have learnt to look carefully at the methods and materials of construction. His elder brother knew Greek and Latin, and inspired Piranesi's love of Roman history; while his uncle, an engineer of the Venetian waterworks and later an architect of Palladian bias, must have given impetus to Piranesi's fascination with both professions. An early biography, based on recollections by his sons, claims Piranesi also studied stage-design and scene-painting at the school of Ferdinando Bibiena, presumably in Bologna. In any case, these themes set the background for Piranesi's desire when, not yet twenty, he made his first trip to Rome, in his own words 'to admire and learn from those august relics which still remain of ancient Roman majesty and magnificence, the most perfect there is of Architecture'. That he did, also studying modern Roman architecture, learning etching from Giuseppe Vasi, and, as Piranesi reported, thinking about how to use the accomplishments of the past in new ways. However, he could find no patron willing to pay for buildings equal in splendour to the Antique. So three years later Piranesi, prevented from giving his ideas to the world in stone, decided his only recourse was to publish his proposals through prints of his designs, the *Prima Parte di Architetture, e Prospettive* (1743), thus embarking on the much more unrestrained and imaginative career of architecture on paper.

261

GIOVANNI BATTISTA PIRANESI
*Masked Figures at a Punch and Judy Show*
1743–7
pen and brown ink and wash, 25.8 × 18.3 cm
Hamburger Kunsthalle, Hamburg

262

GIOVANNI BATTISTA PIRANESI
*Arcaded Portico Seen from an Angle* 1740–3
pen and brown ink and brown wash over black
chalk, 13.5 × 20.9 cm
The Trustees of the British Museum, London

*Figure 62:* Ferdinando Bibiena, *Direzioni a'*
*Giovani Studenti nel Disegno dell'Architettura Civile,*
plate 48, etching, 1731–2,
Private Collection

263

GIOVANNI BATTISTA PIRANESI
*A Grand Colonnaded Hall*
1740–3
pen and brown ink with grey wash over black
chalk, 13.5 × 20.6 cm
The Trustees of the British Museum, London

Many of Piranesi's earliest mature drawings show his simultaneous interest in Palladian architectural forms and north Italian stage-design. This is evident in two fine examples, possibly made before he left for Rome but more likely drawn in his first years there. In its general forms and raking perspective, even its guidelines in the foreground, Piranesi's *Arcaded Portico* (cat. 262) is clearly related to one of Ferdinando Bibiena's didactic illustrations for stage-design, showing how to construct vaster spaces through his new creation of views seen from an angle (fig. 62). Piranesi reduced Bibiena's Baroque ornamentation to focus attention on the basic structures and give his buildings a vocabulary closer to Palladio's, while at the same time he multiplied the number of basic forms and their complex interaction. Even more striking is Piranesi's *Grand Colonnaded Hall* (cat. 263), which is in fact a close variation on the interior of Palladio's Chiesa del Redentore in Venice, but with a stylised curtain added to show that this drawing is explicitly produced as a stage-design.

Both of these designs were developed further, and used by Piranesi to create etchings for the *Prima Parte* of 1743. Two of his etchings show *capricci* of ruins reminiscent of Marco Ricci (see cat. 32, 34) and confirm that Piranesi (as well as Canaletto) took many lessons in subject, style and tightly knit compositions from the earlier Venetian artist. The eleven other original plates of the *Prima Parte* demonstrate Piranesi's inventiveness in architectural proposals that make use of the forms of ancient Rome but in the free tradition of stage-designs: majestic interior halls, arched galleries lined with statues, grand courtyards and colonnades, forums studded with monuments and fountains, and a spacious, sun-filled prison interior. Of those one of his most successful is the *Magnificent Bridge* (cat. 264), prompted by Palladio's proposal to rebuild the Rialto Bridge in Venice (as shown in his *Quattro Libri dell'Architettura*), elaborating the bridge and background with magnificent structures reminiscent of ancient Rome, using the stage device of a scene shown at an angle, but resolving all these Venetian and Roman elements into a powerful overall composition. The dominant foreground arch makes a soaring frame, which encloses and holds the image, at the same time it sets a pattern that is echoed in various ways throughout the image. The effect of this simple but telling composition, etched by Piranesi at the age of 23, already indicates the pattern of success for the rest of his life: the composition of the *Magnificent Bridge* was not only revised and reused by Piranesi himself, but also imitated almost immediately by Canaletto when he went to London (cat. 146), and repeated in numerous variations by Hubert Robert and many of the other French artists who came under Piranesi's influence while they were studying in Rome.[2]

264

GIOVANNI BATTISTA PIRANESI
*A Magnificent Bridge*
1743
etching, 74.5 × 50 cm (open book)
National Gallery of Art, Washington
Andrew W. Mellon Fund

*Ponte magnifico con Logge ed Archi eretto da un Imperatore Romano, nel mezzo si vede la statua equestre del medessimo. Questo ponte viene veduto fuori di un arco d'un lato del Ponte che si unisce al sudetto, come si vede pure nel fondo un medessimo arco attaccato al principal Ponte.*

Soon after he issued the *Prima Parte*, Piranesi's financial support for his stay in Rome came to an end, so he took his chance to visit Naples and Herculaneum with his Venetian friend Antonio Corradini (see cat. 58), returning to Venice early in 1744. Later that year he was back in Rome for a while, and then again returned to Venice, this time for just over two years, from mid-1745 until mid-1747. Possibly on the first trip home, but more likely at the beginning of the second, Piranesi made a number of, for him, unusually finished figural compositions – religious, historical and genre – which indicate he was experimenting in a new direction for his art. All show his reaction to Venetian art and life, but the *Masked Figures with a Punch and Judy Show* (cat. 261) is the most strikingly Venetian of all. This carnival scene includes all those types we normally associate with Pietro Longhi and with the slightly later work of Zompini, Francesco Guardi and Domenico Tiepolo. Whether Piranesi was reacting to their common Venetian life or to specific Longhi paintings we do not know; but the particular angled stance of the masked figure in the centre makes the latter at least plausible.

By far the greatest work Piranesi produced on his second stay in Venice is a small group of drawings for decorative art. By comparison with his earlier drawings, these are created with newly spirited, broken strokes of the pen and swift and open patterns of zig-zag hatching, finished with restrained but brilliantly placed touches of various brown washes to achieve maximum light from the untouched white paper. All this demonstrates that Piranesi had now seen and absorbed the lessons of contemporary drawings by Giambattista Tiepolo. Piranesi's *Rococo Wall-frame* (cat. 265) would have been executed in stucco, just like Guardi's *Elaborate Cartouche* (cat. 206). The *Rococo Wall-frame*, one of several such designs now in the Morgan Library, reminds us of one biographer's report that during this stay at home Piranesi attempted to obtain commissions for works of architecture and interior decoration.[3] His so-called *Design for a Title-plate* (cat. 267), may have been just that, or, given its grand scale, may have been

265

GIOVANNI BATTISTA PIRANESI
*A Rococo Wall-frame*
1745–7
pen and brown ink, grey-brown wash, over black chalk, 32.5 × 37.4 cm
The Pierpont Morgan Library, New York
Bequest of the late Junius Morgan and gift of Henry S. Morgan

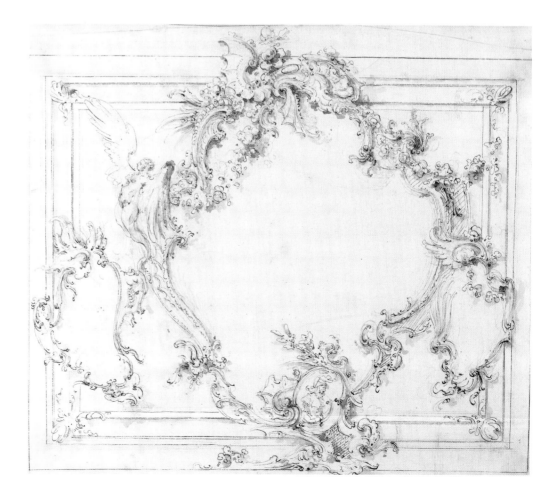

GIOVANNI BATTISTA PIRANESI
*A Festival Gondola*
1745–7
pen and brown ink, wash over black chalk,
29.6 × 68.3 cm
The Pierpont Morgan Library, New York
Bequest of the late Junius Morgan and gift of
Henry S. Morgan

another idea for an elaborate wall decoration. In any case, the drawing within this drawing, the *Rococo Pulpit*, shows Piranesi's interest extending even to ecclesiastical furniture. Unquestionably the most extraordinary of this group is his design for a magnificent *Festival Gondola* (cat. 266). As with the similar inventions for splendid craft by Giambattista Tiepolo (fig. 4) and Francesco Guardi (cat. 207), as well as those included in paintings of regattas by Carlevaris and Canaletto (cat. 22, 136), the very essence of sumptuous festivals in Rococo Venice seems caught in Piranesi's brilliant drawing for a princely boat encrusted with *rocaille*, swags of flowers and medallions, fanciful representations of all the Elements, and strongly muscled but theatrically lounging nudes. In fact, this and other drawings just at this time show Piranesi's first serious interest in the nude; and the fact he became so interested not in Rome but in Venice is one more reminder of the Venetian regard for drawing from the nude model throughout this period (cat. 60, 89, 91, 123, 165). The specific features of Piranesi's Venetian nudes, with their emphatic joints and musculature seen as a series of angular projections, reveal them as extravagant brothers of those by Antonio Guardi (cat. 197).

*Figure 63:* G.B. Piranesi, *Ara Antica*, from the *Prima Parte*, etching, 1743, National Gallery of Art, Washington, Andrew W. Mellon Fund, 1978

267

GIOVANNI BATTISTA PIRANESI
*Design for a Title-plate, with a Rococo Pulpit*
1745–7
pen and brown ink, wash and red chalk,
50.8 × 75 cm
The Pierpont Morgan Library, New York
Bequest of the late Junius Morgan
and gift of Henry S. Morgan

Besides the two *capricci* of ruins in the fashion of Marco Ricci – *mélanges* of ancient ruins and architectural fragments with pastoral figures climbing around – Piranesi had already etched for the *Prima Parte* more romantic images of ruins, probably provoked by his interest in G.B. Castiglione. Two of these show ancient architectural fragments submerged in swamp-like pools, overgrown with fungus and plants, and one image is made specifically emblematic of human and cultural decay by being littered with bones and symbols of time, learning, secular authority and religion (fig. 63). Just before he left Venice to return to Rome for good in late 1747, Piranesi revived these romantic themes in his *Capriccio* (cat. 268), drawn in his new Venetian style, and now combining his fantasies of huge architectural ensembles *à l'antique* with broken and decaying fragments and symbols, a Venetian nude and two extraordinary creatures which look like emaciated or decaying monkeys. This leads straight to his four large etchings frequently referred to as his '*Capricci*', but which Piranesi himself called *Grotteschi* (cat. 269–72).

The *Grotteschi* have long been considered Piranesi's most Venetian prints, and are usually related to Giambattista Tiepolo's *Capricci* and *Scherzi* (cat. 111, 112). In fact Piranesi etched the *Grotteschi* just after he returned to Rome in 1747. He carried with him not only his new sense of brilliant light and fluid draughtsmanship, but also a stock of creamy white Venetian paper, on which he printed the first states of the *Grotteschi*, here shown in the only known complete set. Epitomising Piranesi's renewed union between Venice and Rome, these phantasmagorias combined numerous elements: imagined structures *à l'antique*; copies of real Roman sculptures and fragments; elegant *rocaille* shells, flowing fronds, and swags of foliage and medallions; twisting asps, volutes and figures taken from Tiepolo's *Scherzi* and even from Piazzetta's *Tasso*; skeletons, bones, and symbols of ancient religion, art, war, myth and time.

268

GIOVANNI BATTISTA PIRANESI
*Capriccio*
*c.* 1747
pen and brown ink with brown wash over black chalk, 36.8 × 51.2 cm
The Pierpont Morgan Library, New York
Bequest of the late Junius Morgan
and gift of Henry S. Morgan

269

GIOVANNI BATTISTA PIRANESI
*Grottesco with a Monumental Tablet*
1747–9
etching, engraving, drypoint and scratching,
39.6 × 54.7 cm
National Gallery of Art, Washington
Ailsa Mellon Bruce Fund

270

GIOVANNI BATTISTA PIRANESI
*Grottesco with Skeletons*
1747–9
etching, engraving, drypoint and scratching,
39 × 54.6 cm
National Gallery of Art, Washington
Ailsa Mellon Bruce Fund

271

GIOVANNI BATTISTA PIRANESI
*Grottesco with the Tomb of Nero*
1747–9
etching, engraving, drypoint and scratching,
39.2 × 55.4 cm
National Gallery of Art, Washington
Ailsa Mellon Bruce Fund

272

GIOVANNI BATTISTA PIRANESI
*Grottesco with Triumphal Arch*
1747–9
etching, engraving, drypoint and scratching,
39 × 54.2 cm
National Gallery of Art, Washington
Ailsa Mellon Bruce Fund

Like Tiepolo's prints, Piranesi's *Grotteschi* entice one to find intricate and integrated iconographic meaning in these conglomerations; however, just as with Tiepolo, no convincing coherent interpretation of all their details has yet been made. What is clear is that these images include deliberate ambiguities of space and time. To take one example of spatial ambiguity: the foreground of the *Monumental Tablet* (cat. 269) can be read either as an assemblage of objects on a hillock, or as a drawing on a partially unrolled and crumpled sheet of paper. The ambiguity of time is even more provocative, and culminates in *The Triumphal Arch* (cat. 272). It is a clue to Piranesi's distinctive approach to *capricci* of ruins, by contrast with Marco Ricci's, Canaletto's or Francesco Guardi's. In this etching two of Piranesi's 'Venetian nudes' on either side of the image are clearly ancient sculptures; while the two pointing men in the middle ground are clearly 18th-century figures climbing among the ruins; but the two nudes in the centre could be either. And if one carefully studies the background figures, one sees they are a procession of ancient Romans with romanticised costumes and weapons marching through the triumphal arch to join, anachronistically, 18th-century men climbing over the surviving fragments of the Romans' own ancient civilisation. The culture of ancient Rome is not dead but living! Amid the antique ruins and artefacts mingled with bones and other symbols of decay, these figures provide a clear indication of Piranesi's faith in the vitality of ancient Roman architecture and civilisation, just as clearly as did the magnificent structures provoked by Roman ruins which were typical of the *Prima Parte*. This continuing life through the survival of ancient ruins gives a new twist to Piranesi's description of his reaction to Rome in his dedication to the *Prima Parte*: 'my spirit has been filled with such visions by these speaking ruins'.

During the 1740s Piranesi also began to produce etched views of Rome for inclusion in series, in books on archaeology or for sale as separate prints. Originally quite small, then medium in size, by the end of 1747 Piranesi's views had reached the large double-folio size of the *Vedute di Roma*, his most famous series of views. These he sold as individual works or in groups, and to them he added regular increments each year until he died. Piranesi's earliest *Vedute di Roma* show some of the most famous *piazze* in Rome, offering vistas onto architectural complexes and sculpture both ancient and modern. The *Veduta di S. Pietro in Vaticano* (cat. 273) is one of the most successful of these early views. It is also typical in the sense that the focal architecture is pushed back to the middle or far distance, distorting perspective and expanding the layout to create a more extensive and grand prospect, making the space more magnificent and giving the buildings even larger scale in contrast to the tiny figures. This is a much grander view of Rome than those typical of Piranesi's Roman predecessors like Falda or Vasi, and shows what Piranesi had learnt from similar distortions in grand prospects of Venice by Canaletto and Marieschi. Like Canaletto's figures, Piranesi's describe in detail all types of Romans, from gentlemen to friars, from tradesmen to beggars with mangy curs. From the beginning, Piranesi certainly had amazing facility as an etcher and distinctive ability to create remarkable passages, such as the clouds in this view looking like crumpled taffeta. However, in general Piranesi's linear technique based on parallels – regular, fluttering, or broken – and his soft but brilliant light bathing and unifying the entire image, although somewhat like effects in etchings by Vasi, are even more reminiscent of those by Canaletto and other Venetians. In these and similar ways many of Piranesi's early *Vedute* are intensely Venetian views of intensely Roman subjects. The point is only emphasised by noting in this etching how Piranesi used his drawing of a *Festival Gondola* (cat. 266)[4] to create the heavily decorated housing and even the swinging three-pointed composition of the grand Rococo carriage on the left: a remarkable transformed symbol of Venice set into the centre of Rome!

GIOVANNI BATTISTA PIRANESI
*Veduta di S. Pietro in Vaticano*
1747–8
etching, 39.7 × 53.2 cm
Lent by The Metropolitan Museum of Art,
New York
Harris Brisbane Dick Fund

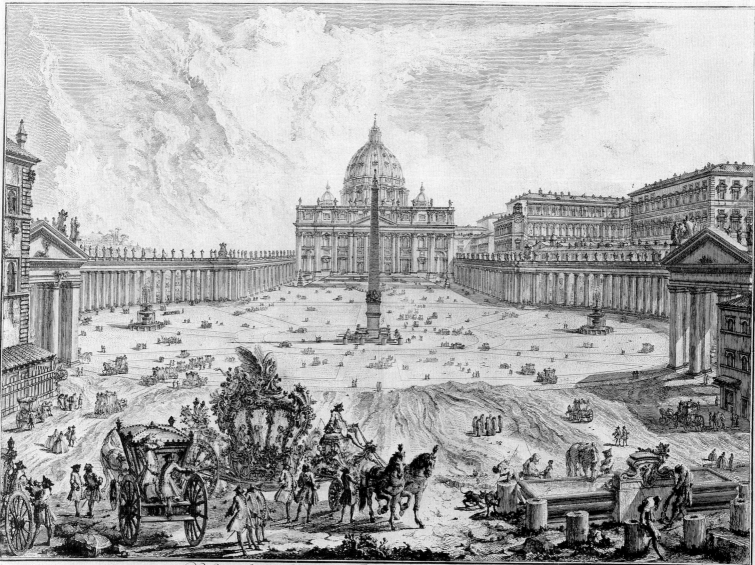

274

GIOVANNI BATTISTA PIRANESI
*A Magnificent Port*
1749–50
red and black chalk, brown and reddish wash,
squared in black chalk, 38.5 × 52.8 cm
Collection of The J. Paul Getty Museum, Malibu, CA

At the end of the 1740s and beginning of the 1750s Piranesi's fantasies on the magnificence of architecture culminated in a number of outstanding works. The *Magnificent Port* (cat. 274) and the *Fantastic Monument in a Palatial Interior* (cat. 275) show exterior and interior versions of his themes. Favoured by Piranesi at this time for large presentation drawings, the technique of both these works is a new, richly colourful combination of pen and brown washes over red chalk, where the chalk is picked up by some of the washes to give them a pink cast, adding even more variations to his browns, which themselves range widely from golden to umber.[5] The *Magnificent Port* is basically a grand triumphal arch enclosed between enormous, curved and arcaded, colosseum-like walls, and including military trophies and rostral monuments. Its low viewpoint and the crowding of the structures give a sense of endless architecture in overwhelming vertical ranges. The memory of Venice lived on, however, so this drawn version shows the waterside like a Venetian canal. When he came to make a large etching of the theme, the *Magnificent Port in the Fashion of the Ancient Romans*, Piranesi filled in the canal with steps, to make it look more like a Roman port. The *Fantastic Monument in a Palatial Interior* reflects Piranesi's experience of grand interiors in Roman Baroque churches like St Peter's. Using raking perspective on encircling galleries and a succession of domed halls, Piranesi creates enormous space and sets it into continual motion to circulate with a stately progression from the central court through vast areas hinted between and beyond what the eye can see. It is one of his most magnificent presentations of the vitality, excitement and mystery of architectural space.

275

GIOVANNI BATTISTA PIRANESI
*Fantastic Monument in a Palatial Interior*
*c.* 1750
pen and brown ink and wash over red chalk,
30.5 × 38.1 cm
Private Collection
Gift promised to the National Gallery of Art,
Washington

In the same years Piranesi made those drawings, he etched a series of prints that he did call 'Capricci', namely, his *Invenzioni Capric di Carceri*. Piranesi's *Prisons* have long been thought his most powerful, mysterious and provocative works. Beginning as early as William Beckford and Thomas De Quincey, from Romantics through addicts to existentialists, writers have used the *Prisons* to support widely different interpretations attributing to the prints singular meanings. Most early commentators were presumably looking at impressions from the greatly changed later editions, after 1761, instead of the rare printings from 1749 through the 1750s. However, any serious understanding must naturally begin with their first versions.

Piranesi's *Capricious Inventions of Prisons* arise not out of anguish or personal crisis but from the traditions of stage-design. Just to take a few architects of known interest to Piranesi – Bibiena, Juvarra and Vanvitelli – all had made stage-designs of prisons, showing ample interiors with walls and arches of plain stone blocks, barred windows, iron rings, hanging lanterns, broad and zig-zag staircases. Specifically, Piranesi's first *Prison*, included in the 1743 *Prima Parte*, was based in several aspects on an etching by Pietro Abati after a prison design by Ferdinando Bibiena. Further, much of the same architectural vocabulary can be used to create crypts, warehouses, cellars, and even the lower arcades of palaces, as in Marieschi's *Stairwell in a Renaissance Palace* (cat. 163), a type of Marieschi fantasy Piranesi may well have seen in Venice in the 1740s. Thus, with their background in the free creations of stage-design, Piranesi's *Capricious Inventions of Prisons* continue many elements of his earlier architectural fantasies.

*The Round Tower* (cat. 276) is one of the most powerful and successful in the early edition of *Capricious Inventions of Prisons*. As with many others in the set, the basic elements of its composition are a variation and development of his *Prima Parte* plates, here of the *Tempio Antico* (fig. 64). However, the effect of the two is quite different. Although much larger, the *Prison* is created with much sketchier drawing of plainer surfaces; many of the forms are merely blocked in, and changes in the drawing left evident; the background and the figures are vague; and the viewpoint is pushed down so that the architecture looms above the viewer. All these differences focus attention on the general architectural forms in the composition rather than on the details, so the large forms of the *Prisons* appear much stronger and more daring than those in the *Prima Parte*. Thus, the central tower here appears massive, and the thrust of its encircling spiral staircase seems to explode into the springing vaults, which leads the eye to further ranges of arcades and spaces, as in his drawing of the *Palatial Interior* above.

*Figure 64:* G.B. Piranesi, *Tempio Antico*, from the *Prima Parte*, etching, 1743, National Gallery of Art, Washington, Ailsa Mellon Bruce Fund

276

GIOVANNI BATTISTA PIRANESI
*Fanciful Inventions of Prisons: The Round Tower*
1749–50
etching, engraving, sulphur tint or open bite, burnishing, 55.6 × 41.8 cm
National Gallery of Art, Washington
W. G. Russell Allen, Ailsa Mellon Bruce, Lessing J. Rosenwald, and Pepita Milmore Funds

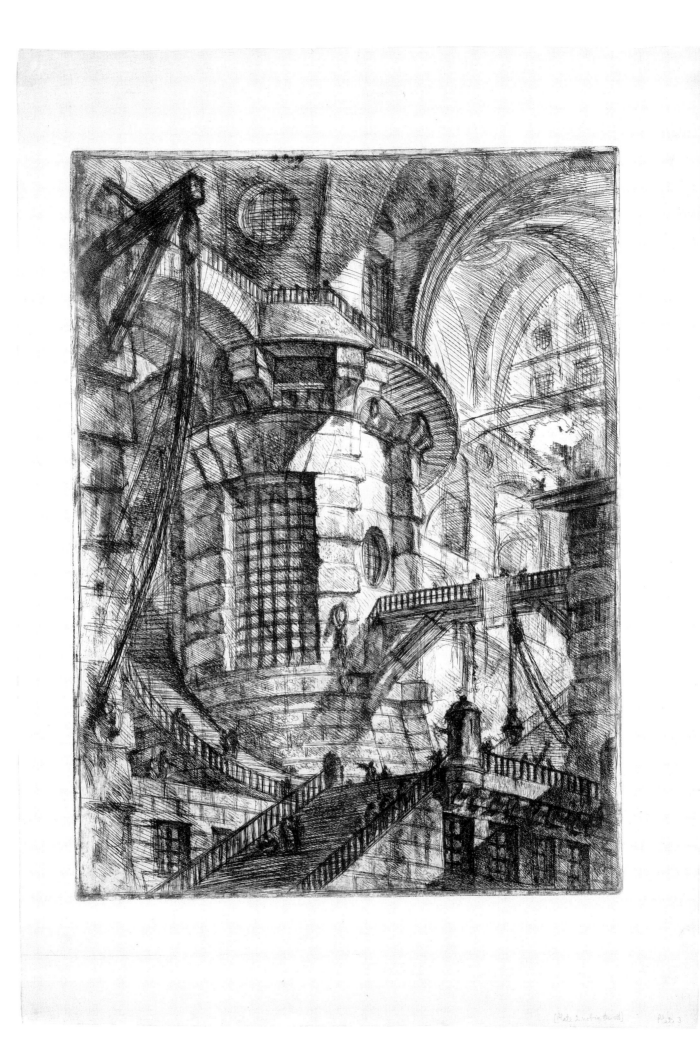

The spontaneous and sketchy linear style of the *Capricious Inventions of Prisons* evolved from Piranesi's Venetian drawings by way of the *Grotteschi*. The latter also show early examples of his experiments with tonal techniques, which in fine early impressions appear like painted strokes with a broad brush. Just as with the varicoloured washes of his contemporary drawings, Piranesi's tonal experiments in the *Prisons* etchings add a rich and palpable atmosphere. His most extraordinary development of this is in *The Pier with a Lamp* (cat. 277). The central pier with springing arches sets the theme, to be elaborated by further arches at skewed angles echoing into the distance, none of them making serious architectural sense but rather creating a powerful compositional play of forms and curves. After delineating these forms Piranesi filled the image with tone as if making layers of colour in a painting. He brushed acid directly on the copperplate to create broad strokes of tone, and in some areas he burnished the plate to lighten the tone. Then he protected some areas; again and again he brushed the acid; and again he burnished the plate to send shafts of light through what is now a dense atmosphere which envelops the massive forms. His etching teacher, Giuseppe Vasi, had thought Piranesi too passionate and impatient, 'too much a painter to be a printmaker'.[6] But this plate shows, to the contrary, Piranesi was so much a 'painter' – concerned with grand forms, light, tone, space and mass, and able to create these effects swiftly and directly – that he was a truly exciting printmaker.

277

GIOVANNI BATTISTA PIRANESI
*Fanciful Inventions of Prisons: The Pier with a Lamp*
1749–50
etching, engraving, sulphur tint or open bite,
burnishing, 41.5 × 55.8 cm
National Gallery of Art, Washington
W. G. Russell Allen, Ailsa Mellon Bruce,
Lessing J. Rosenwald, and Pepita Milmore
Funds

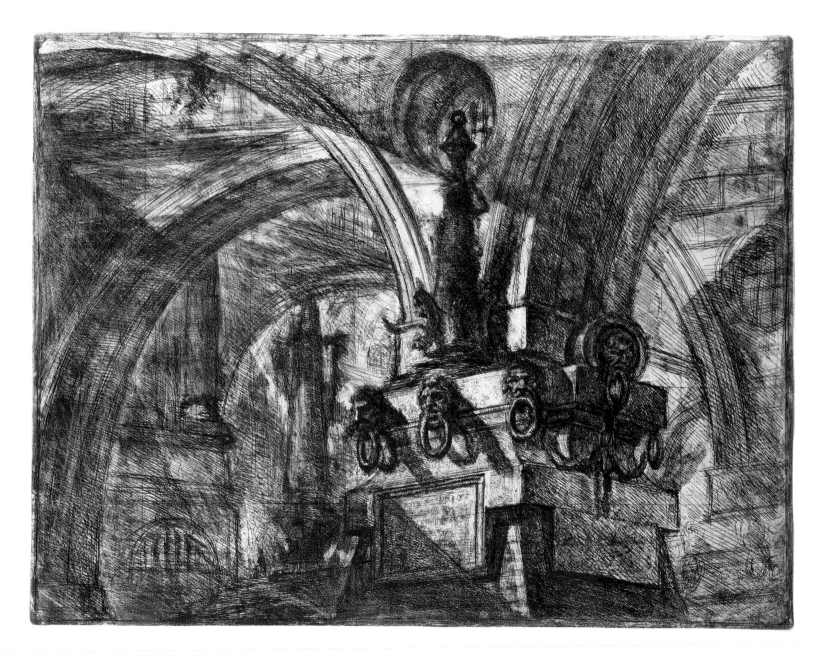

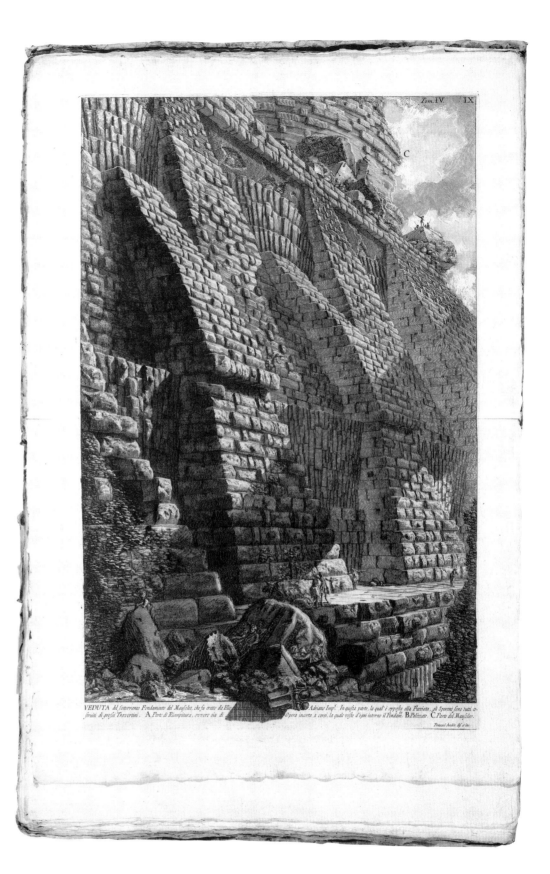

To his fantasies inspired by ancient Roman architecture and his views of ancient and modern Rome, in the early 1750s Piranesi determined to add a third portrayal of Rome from the point of view of scientific archaeology. Like many before him, he read and climbed and dug and measured the ancient remains, sepulchral monuments, bridges, theatres, baths, aqueducts and forums. After half a decade's industrious labour, he produced his four-volume *Le Antichità Romane* (1756). His archaeological attention to details of Roman antiquities led him to be specific about the construction of the buildings, to analyse each individual block or each component, pay attention to the various textures and appearances of different building materials

and to the variety of decorative detail. But Piranesi always saw these individual details in a broad context, that of admiration for the magnificence of ancient Rome. For example, drawing on boyhood experiences with his uncle, watching the construction and repair of massive waterworks in Venice, Piranesi took special interest in the foundations of Roman structures (cat. 278). However, his general regard for the extraordinary achievements of ancient builders, who had created for the centuries, led him to believe their work even more solidly grounded than it was; and his sophistication in perspective and the handling of light enabled him to portray such work as the creation of giants. Each block and brick is accurately rendered; but the whole is a wonder to modern men, depicted as tiny in their precarious relationship to its scale and mass, and constantly in theatrical gestures of admiration. The *Antichità Romane* was an immediate international success, and, added to Piranesi's architectural fantasies and growing series of views, confirmed him as the foremost artistic proponent of Roman architecture. Within a year he was elected to the Society of Antiquaries in London.

Piranesi's attention to archaeological theory also became more international. During the 1750s European architects succeeded in reaching Greece (which had been closed to the West under Ottoman rule), and measured, drew and published her monuments. Some notable French, German, British and Italian scholars proposed that the Greeks had originated all the major elements of classical architecture, and the most beautiful, while the Romans were deficient both in imagination and in taste, and their works derivative or even debased versions of those in Greece. Piranesi responded with the fourth component in his portrayal of Roman architecture, a long theoretical defence of Roman originality and taste, *Della Magnificenza ed Architettura de' Romani*, which he had finished by May 1760. To the claimed simplicity of Greek architecture, Piranesi opposed the creative variety and richness of Roman details, their imaginative freedom in using earlier forms and ornaments. To the claimed grace of Greek architecture, he replied with a distinctively Roman magnificence in their earliest surviving constructions, before contact with the Greeks, which he identified in aqueducts, city walls, paved roads, Rome's sewer system and the tunnel for draining Lake Albano. Like his view of the later foundations of Hadrian's mausoleum (cat. 278), and again reminding us of his Venetian boyhood, Piranesi praised a distinctive Roman combination of strength, utility and beauty in the enormous size of these structures and of their stone blocks, the regularity and fit of those blocks, their unadorned strength, severity, dignity and grandeur.

After finishing his theoretical treatise, Piranesi turned his attention again to his series of *Prisons*. In the first edition, these capricious architectural compositions elaborating large and simple forms were powerful in their effect, intriguing in their treatment of perspective, and marvellous in their graphic quality; but in the expanded context of Piranesi's work since 1750, they had become his only important series of prints which had no clear connection with ancient Rome. Piranesi now made extensive revisions to each of the fourteen plates from the first edition, added two new ones, and renamed the series *Prisons of Invention*. *The Gothic Arch* (cat. 279) is typical of those plates from the first edition which were revised relatively little. It is also one of the most successful images in the new edition, with its complex overall activity of zig-zag patterns and busy diagonals, held in beautiful balance through echoes and oppositions and especially through the stately progression of the major diagonal walls. One of Piranesi's aims was to expand the space of the images. So, here, he has redrawn the vague but closed background to indicate further galleries, arches, staircases, bridges and windows, showing his continued interest in the endlessly receding and repeating spaces of stage-design. In addition to the fact that his figures are still free to move around the *Prisons*, these new spaces, including several in other plates which lead to the outside, demonstrate that Piranesi did not see his prisons as structures presently intended to restrain or incarcerate. In some tension with this expanded spaciousness,

Piranesi also made the images darker. He did this not only by filling the images with additional structures and backgrounds, but also by engraving strong lines to individuate blocks of stone, bricks and timbers, sharpening their edges, and then adding further work to distinguish their surface patterns and textures. The latter changes parallel Piranesi's development in his archaeological works. The swiftly hatched walls of the earlier *Prisons* now become filled with regular and heavy stone blocks, looking just like those blocks Piranesi admired in the earliest Roman architecture. In fact, a careful analysis of further plates in this later edition of the *Prisons* series, especially the two new plates, shows that the few bound or tortured prisoners in these plates are actually ancient sculptures portraying such punishment. The multitude of other figures in the prints, that is, the modern figures, are freely wandering in the extraordinary spaces – now converted to fantasies on ancient Roman buildings – to wonder at the strength, severity and grave dignity both of ancient justice and of ancient architecture.

279

GIOVANNI BATTISTA PIRANESI
*Prisons of Invention: The Gothic Arch*
1761
etching, engraving, sulphur tint or open bite,
burnishing, 41.7 × 55.6 cm
National Gallery of Art, Washington
Mark J. Millard Architectural Collection,
acquired with assistance from The Morris and
Gwendolyn Cafritz Foundation

By comparison with its earlier edition (fig. 65), the reworked *Drawbridge* (cat. 280) includes the same type of alterations as *The Gothic Arch*, but also more radical changes in structure and tone. In this later edition, *The Drawbridge* is also the clearest demonstration of Piranesi's development of deliberate ambiguity since the *Grotteschi*, especially his use of perspective to create impossible spaces. The basic problem here is that the wooden drawbridge runs perpendicular from the wall with four hanging rings and passes in front of the tall vertical tower; but the lower wooden bridge also runs perpendicular from that wall, farther forward than the drawbridge, and then passes directly through the tower. Further analysis of this and similar perspectival impossibilities in other plates of the *Prisons* shows how cleverly Piranesi used the location and lighting of subsidiary forms, so that to a cursory glance all is fine, and only a careful analysis reveals the subtle but deliberate tricks. The meaning of these ambiguities and impossibilities is more obscure. Is it a variation on Piranesi's interest in the radical perspective of stage-design, a *trompe-l'œil* developed with these compositions of great and simple forms where he was least restrained by traditional architectural elements? Or do these impossibilities relate directly to the meaning Piranesi developed for the reworked *Prisons* as inspired by the strength, severity and magnificence of ancient Rome? It is not clear.

After the revisions of the *Prisons*, in the 1760s Piranesi continued all four components of his portrayal of the spirit and the reality of ancient Roman architecture. His massive polemical treatise naturally provoked his opponents, and led to further responses from him. While Piranesi had already received modest support from Pope Benedict XIV, the election in 1758 of a Venetian Pope, Clement XIII Rezzonico, provided opportunities for much closer relations with the papacy, which Piranesi assiduously developed. In the mid-1760s it appeared that he would obtain a major papal architectural commission, the rebuilding of the altar or even the whole tribune of St John Lateran, and Piranesi prepared presentation drawings for various solutions. While that commission came to nothing, the various members of the Rezzonico family in Rome did commission him to design furniture; and, through the Pope's nephew, Cardinal Giovambattista Rezzonico, Piranesi was selected to design and complete the remodelling of S. Maria del Priorato, the Aventine church of the Knights of Malta.[7] These sometimes rather eccentric architectural schemes and polemics are certainly of interest; however, in artistic terms Piranesi's finest work continued in drawings and prints.

*Figure 65:* G.B. Piranesi, *The Drawbridge*, from the *Capricious Inventions of Prisons*, etching, 1749–50, National Gallery of Art, Washington, Rosenwald Collection

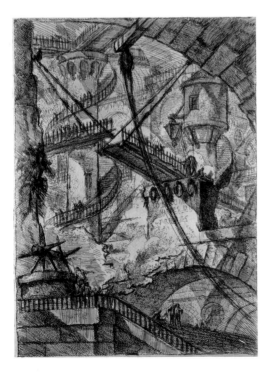

280

GIOVANNI BATTISTA PIRANESI
*Prisons of Invention: The Drawbridge*
1761
etching, engraving, scratching, 56.1 × 41.5 cm
National Gallery of Art, Washington
Mark J. Millard Architectural Collection;
acquired with assistance from The Morris and
Gwendolyn Cafritz Foundation

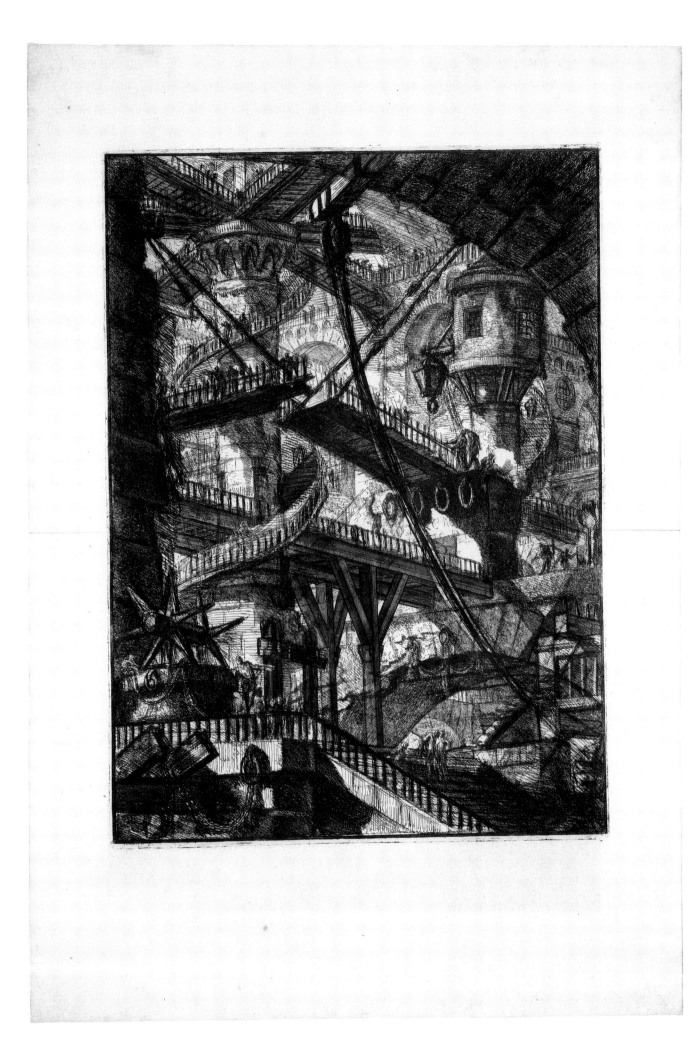

281

GIOVANNI BATTISTA PIRANESI
*Interior of the Roman Cistern at Albano*
1763–4
red chalk over a preliminary sketch in black chalk,
35 × 55.15 cm
Private Collection

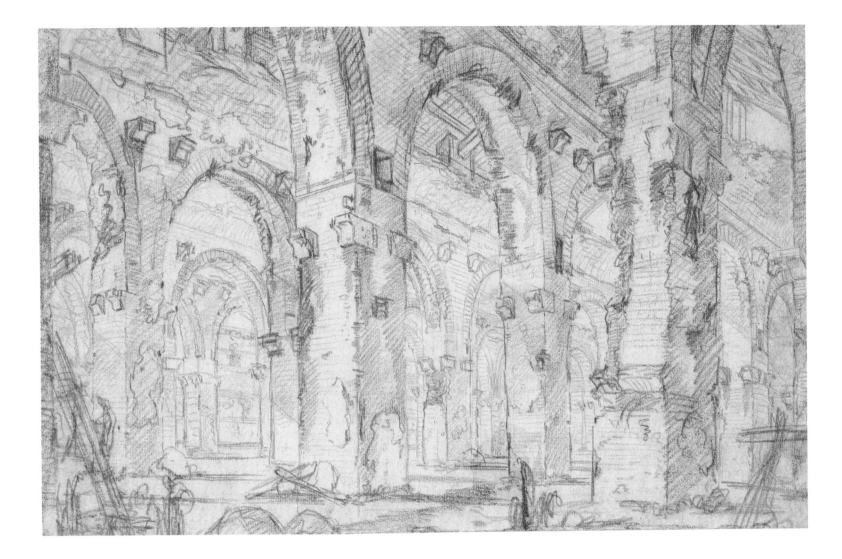

GIOVANNI BATTISTA PIRANESI
*Fantasy on a Magnificent Triumphal Arch*
1765
ink, 46.3 × 63.1 cm
National Gallery of Art, Washington
Ailsa Mellon Bruce Fund

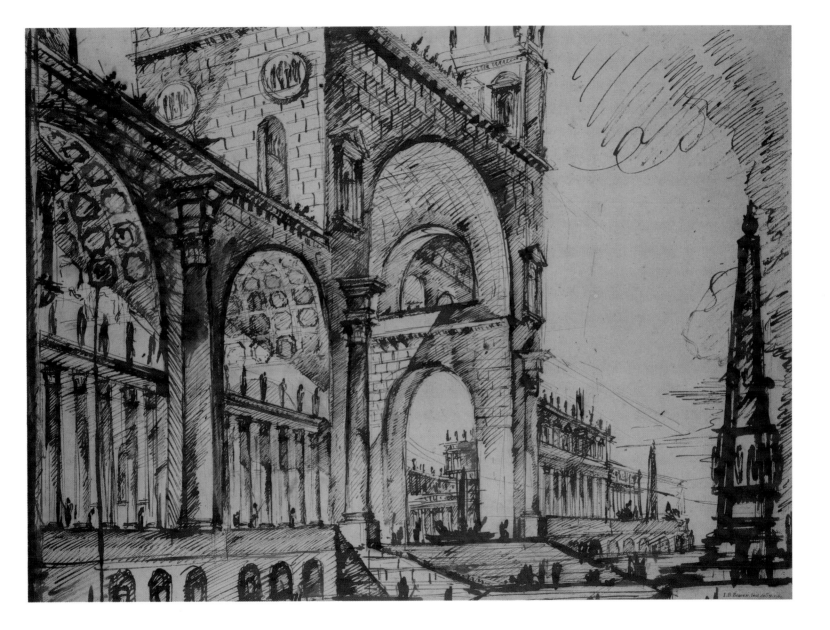

Piranesi's archaeological studies of ancient Rome focused increasingly on Hadrian's villa at Tivoli, and, through friendship with the Rezzonico family, on the area around the Pope's villa near Albano. Though few now survive, enough large drawings for his views are known to suggest that Piranesi made a preparatory design for each of his major etching plates. One of the most brilliant of these drawings comes from this period, the *Interior of the Roman Cistern at Albano* (cat. 281), an image Piranesi published as an etching in his *Antichità d'Albano* (1764). As a drawing made on site in preparation for a detailed etching, this is remarkable for its swiftness of stroke and brevity of analysis. At the same time, Piranesi captures a real sense of the whole while his 'shorthand' gives all crucial details of structure and surface. His conception of interior space, honed in his architectural fantasies, is now so much a part of Piranesi's vision of real architecture that even as he is standing in the presence of the building he sees and transforms the scene into a complex fugue of counterpoint arches, filled with flowing space moving through and around them.

In the 1760s Piranesi produced fewer architectural fantasies, though occasionally he still made major designs for his polemical works or for presentation to a patron. Among the latter is his only fully signed and dated drawing, the *Fantasy on a Magnificent Triumphal Arch* (cat. 282), dated 31 December 1765. This splendid drawing combines elements from various ancient Roman structures into a bravura work. According to a contemporary inscription it was actually drawn while the recipient, Joseph Wyndham, watched Piranesi's performance. Piranesi emphasises the magnificent scale of the fantasy, not only by the actual size of the drawing and the relative scale of his tiny figures, but also by his imaginative 'bending' of perspective whereby the major arches seem both to thrust into the background and also to open outwards as they rear upwards off the edge of the design. The pentimenti, swift outlines and spirited hatching all suggest the creative heat of *invenzione*; but, just as in the *Prisons* etchings, Piranesi subtly uses such techniques to mask deliberate and provocative perspectival contradictions. To take one of several examples here: beneath the far upper storey of the triumphal arch is a barrel-vaulted room, made plausible by a view into the interior of the near side of the upper storey; but in fact it is impossible for the far room to exist in that scale and depth given the lack of continuation of the arch beyond its far side. One wonders whether knowledge of Piranesi's perspectival contradictions in his *Prisons* may even have led Canaletto to experiment with contradictory indications of exterior and interior spaces in his *Capriccio with Colonnade* (cat. 148), painted the same year as Piranesi's drawing.

Besides the large views for inclusion in archaeological works, Piranesi continued his one-by-one series of the *Vedute di Roma*. The *Ruins of the Baths of Caracalla* (cat. 283), of 1765–6, encapsulates much of his stylistic development since the *Veduta di S. Pietro*. The parallels to developments we have seen in his other works are clear: the combination of a bold overall composition with a fluttering variety of detail, careful attention to the wide range of textures of the Roman building materials, but an obvious delight in such variety of texture for its own sake, which leads to Piranesi's free creation of an evocative range of clouds, apparently naturally but actually quite carefully located to halo and balance the forms of the ruins. Above all it is the spirit of Piranesi's vision which leaps from the image: the ruins are almost alive. Like a giant arm, the broken arch powerfully reaches up through the clouds to express not the ruined state of Roman culture but the survival of its magnificent architecture, rightly provoking wonder. While Piranesi expressed such themes in similar ways for years earlier and later, it is a striking coincidence that this particular romantic view of Roman ruins parallels much of the composition and effect of Bellotto's *Ruins of the Church of the Holy Cross* (cat. 260), painted in Dresden in the same year.

GIOVANNI BATTISTA PIRANESI
*Rovine del Sisto o sia della gran sala delle Terme*
*Antoniniane*
1765–6
etching, 43 × 65.2 cm
National Gallery of Art, Washington
Mark J. Millard Architectural Collection,
acquired with assistance from the Morris and
Gwendolyn Cafritz Foundation

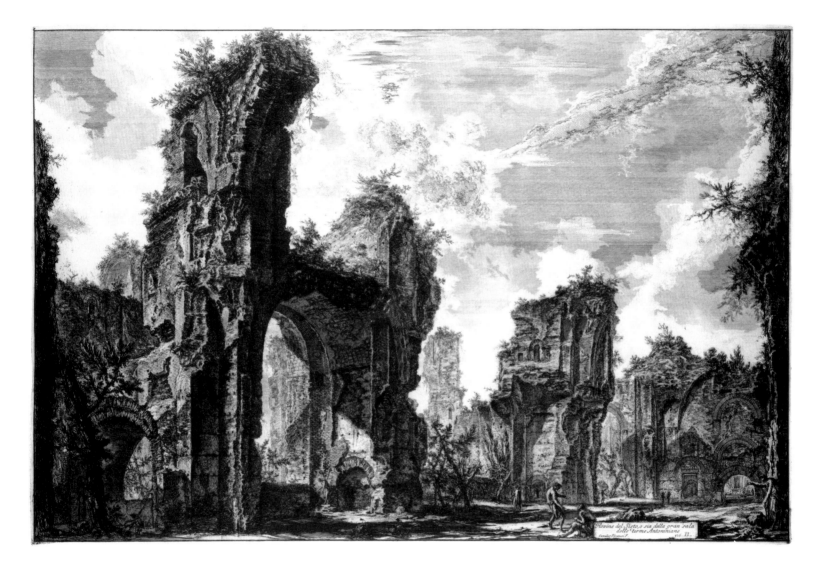

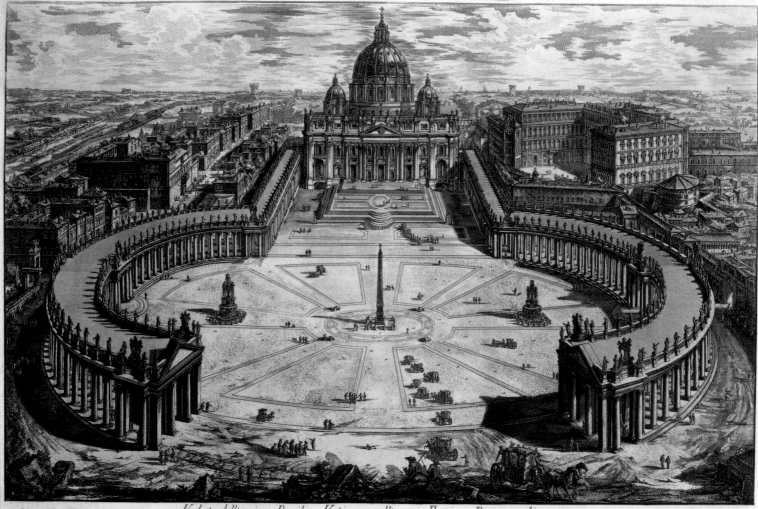

*Veduta dell'insigne Basilica Vaticana coll'ampio Portico, e Piazza adjacente*

During his final decade Piranesi continued to work in all his chosen realms. He analysed the most important ancient columns in Rome, and then the ruins of Pozzuoli and Paestum. In his *Vedute*, besides further works from Hadrian's villa, he revisited many structures he had already portrayed, for example, St Peter's (fig. 66). He made the buildings larger in the picture space, more heavily but perhaps less effectively monumental, and even resorted to bird's-eye views to make the structures seem to comprise an entire landscape. His interest in the detailed features of antiquities and his archaeological activities also led him to increased involvement with the rediscovered fragments of antiquity then being unearthed at many sites. Piranesi became one of many to provide antique vases and decorative fragments for sale to tourists, hungry for such objects, who flooded into Rome from many countries. And when the fragments were incomplete, Piranesi had no hesitation about having them repaired, reconstructing magnificent objects from the clues of shards, or even combining diverse elements to recreate new antique forms like monumental 'candelabra' (fig. 67), or elaborate fireplaces studded with the smaller fragments. From his publication of such objects and designs in his etchings Piranesi reached an international audience far beyond the tourists in Rome. A number of his antique-style fireplaces were actually built, so that his influence on the classical revival and the understanding of ancient Rome now travelled both through his drawings and etchings, and through his reconstructed and reused artefacts. Never to be caught in narrow rules, Piranesi even included in his book on fireplaces, the *Diverse Maniere d'Adornare i Cammini* (1769), designs based on ancient Greek structures and artefacts, which he praised, as well as Roman or Etruscan. Perhaps his most extraordinary designs are those bizarre ones in the Egyptian style, which include fireplaces and wall decorations as well as furniture. They show Piranesi to have been not only a major influence on the vision of antique forms evolving into Neo-classicism but also in the vanguard of what, after the turn of the 19th century, became Egyptomania.

Throughout his life Piranesi expressed awe at the potential of architecture through extraordinary and magnificent structures and spaces. He emphasised the careful study of ancient remains, and the creative use of the past. In his introduction to the *Cammini* he summarised his constant view: 'an artist, who would do himself honour, and acquire a name, must not content himself with copying faithfully the ancients, but studying their works he ought to show himself of an inventive, and I had almost said, of a creating Genius'.

*Figure 67: The Newdigate Candelabrum*, antique fragments restored by G.B. Piranesi and B. Cavaceppi, *c*. 1774–75, Ashmolean Museum, Oxford

1. For a more extensive review of Piranesi's life and work, many books provide good surveys, including Scott, 1975, and Wilton-Ely, 1978. For a more detailed discussion and interpretation of Piranesi's imaginary architectural designs, see Robison, 1986.

2. Georges Brunel, and others, 1976, nos. 58, 124, 176, and 191.

3. Legrand, 1969, p. 196. The sculptor Giovanni Maria Morlaiter (see cat. 178) was another of Piranesi's friends in his youth in Venice. Morlaiter claimed in a legal deposition that he knew Piranesi from his involvement in the profession of sculptors, which is probably explained by Piranesi's activity in decorative

arts at this time (see Moretti, in Bettagno, 1983, p. 135f.).

4. See Robison, 1973, pp. 389–92.

5. While this colourful combination can be found occasionally in the work of earlier Italian and French artists working in Rome (Mola, Vleughels), the frequency of its use in 18th-century Venice (Pellegrini, Diziani, Antonio Guardi) makes one suspect Piranesi learnt it there.

6. Legrand, 1969, p. 194.

7. On the Lateran and the Priorato projects see Nyberg, and others, 1972, and Wilton-Ely, 1993.

284

ANTONIO CANOVA
*Eurydice*
1775
Vicentine stone, 203 × 54 × 56 cm
Museo Civico Correr, Venice

285

ANTONIO CANOVA
*Orpheus*
1775–6
Vicentine stone, 203 × 85 × 54 cm
Museo Civico Correr, Venice

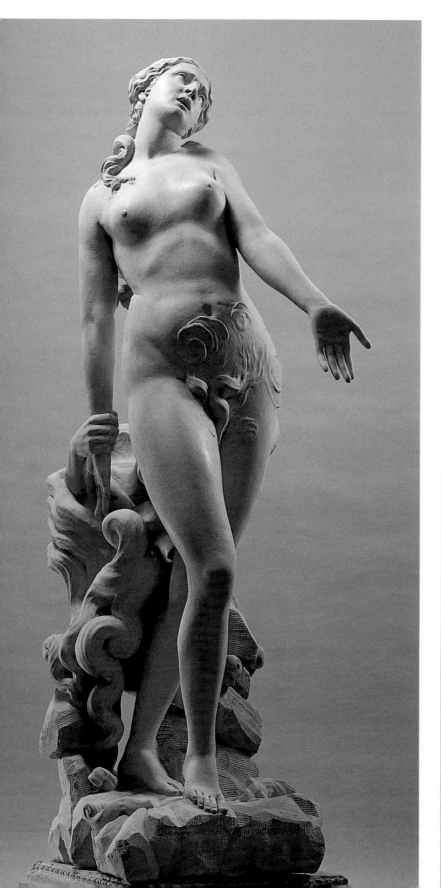

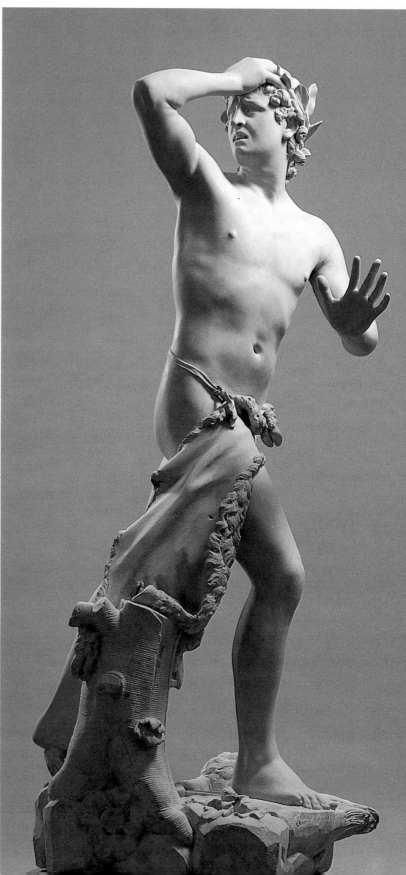

# XIII: *Antonio Canova*

Giandomenico Romanelli

Antonio Canova is one of the most outstanding, yet problematic, figures in Venetian art history. Critical opinion of his work has been so divided, and so affected by changes in taste and fashion, that it seems to bear the symptoms of the dramatic and traumatic events that marked the political demise of the Venetian Republic after a 1,000 years of independence. Thus it was that Canova, at one time one of the most celebrated and prolific artists of his day, became to some extent identified with the political and institutional calamities of which he was merely a close spectator and a skilled, sensitive interpreter. The result is that he has been associated with this disastrous period of history.[1]

Canova's life and work straddles two centuries: the 45 years of his artistic activity are equally divided between the 18th and the 19th centuries. This coincidence may have little relevance to his personality but, with hindsight, it is possible to view it as symbolic of the ambivalence with which critical opinion has assessed and passed judgement on Canova since his death. Did he represent the final flowering of the 18th century, and the natural conclusion to the ideas and visual language already in evidence (in embryonic form) in Venetian late-Baroque and Rococo sculpture, or was he the interpreter of an important turning-point, when ideas, sensibility, artistic theories and modes of expression were in diametric contrast to the aesthetics of the 18th century? This traditional approach to the problem, however, underestimates the importance that the Enlightenment had assumed in Venetian circles; a philosophical debate was in full swing over the purpose of art, on the parameters of art criticism and on the emergence of the discipline henceforward known as aesthetics. Neither Canova's personality nor his art can be understood without reference to this Venetian context; if viewed solely in the light of his (crucial) Roman experience, or from an international standpoint, they are incomprehensible.[2]

Antonio Canova's origins are to be found in the Veneto, in Possagno, a small village in the Trevisan hills near Asolo.[3] He was born in 1757. His father died when he was only four and when his mother remarried, in 1762, the boy was put in the care of his paternal grandfather, Pasino, who was to play a decisive role in his development. Pasino, the owner of a quarry and a stonemason himself, directed the young Antonio towards sculpture and apprenticed him soon after the age of ten to a family of sculptors active at the time in and around Asolo; the head of the family was Giuseppe Bernandi, also known as Il Torretto. Even at this very early age Canova showed exceptional promise as a sculptor, and it was then that he came in contact with the Venetian nobleman Giovanni Falier, his first real patron.

It was Falier who in 1773–5 commissioned the two statues, *Eurydice* and *Orpheus* (cat. 284, 285), for the garden on his villa near Asolo.[4] Antonio, though not yet eighteen, made an impression in artistic circles in Venice with the outstanding quality of these two figures in Vicentine stone; he finished the carving of *Orpheus* in 1776 and exhibited it, as was the custom, at the fair held for the feast of the Ascension in Piazza S. Marco in 1777.[5] Two years later he opened his own studio in Calle del Traghetto, at S. Maurizio, and there between 1777/8 and

1779 he carved his first sculpture in marble, *Daedalus and Icarus* (fig. 68), originally made for Pietro Vettor Pisani. Comparison of these early groups testifies to the enormous distance travelled by Antonio Canova in an astonishingly short space of time; he began as a craftsman-sculptor whose 18th-century style derived from his apprenticeship in the provincial studio of the Torretti. But, rather than a skilful stone-cutter, able to work in a given style, whether the local style of Treviso or the Venetian style, his contemporaries now found themselves face-to-face with a genius capable of revolutionising the artistic language of his day, and not only the language of sculpture. The statues of *Orpheus* and *Eurydice* bear traces of the theatrical, sentimental taste so deeply ingrained in Baroque sensibility, and of the 18th-century enjoyment of the melodramatic. We should not lose sight of the fact that the two statues were designed to be displayed in the open air in the type of garden where statuary is scattered around to be seen against a backdrop of greenery and architecture. Eurydice, according to Virgil and Ovid, was carried away to Hell; Canova personifies Destiny, against whose call the young girl writhes in vain, in the hand of one of the Furies emerging from the flames. In *Eurydice* the legacy of the Baroque tradition can be discerned and, in particular, the influence of Bernini and Algardi. When he arrived in Venice with little more than his training as a stone-dresser, Canova continued his studies (albeit informally) in a more academic atmosphere, working from the nude, following the painter Giambattista Mengardi, and most influential of all, spending his days among the statues and plaster casts of the gallery of Filippo Farsetti, where modern sculpture and copies of the most celebrated works of antiquity were displayed together.[6]

The young man demonstrated a quite unusual intelligence and cultural awareness; not only did he assiduously attend drawing and life-drawing courses, and spend his days among the plaster casts, but the names of his earliest patrons reveal that he moved in the most culturally advanced circles in Venice and would certainly have grasped early on, from listening to arguments about art and aesthetics, that he was witnessing a society in the throes of profound and radical change.[7] Equally influential was the public debate about political, institutional and economic reform in Venice. The ruling classes in the Republic, stuck fast in their old attitudes to society and institutions, rejected out of hand any suggestion of change or modernisation, thereby condemning themselves to inevitable and ignominious decline.

While *Eurydice* openly manifests a debt to Baroque sculpture, *Orpheus* possesses a new spirit, and it won instant acclaim: the 'draughtsmanship' was praised, the 'expression', the 'virile softness', the 'feeling and perfection of finish'.[8] Here the vocabulary of a new taste can clearly be discerned. This is the modern aesthetic expounded for the first time a few years earlier (as Pavanello has so tellingly pointed out[9]) in the pages of the *Dizionario delle Arti e de'Mestieri* of 1773 where, under the heading *Scultore*, the entry written by Falconet for Diderot and D'Alembert's *Encyclopédie* was reprinted. Such considerations would be of no importance if Canova had not been open to their impression, or if he had really been the rough semi-literate youth contrived by some scholars in order to exaggerate his innate powers. The reverse is true. By frequenting the drawing-rooms of the educated classes and reading the works of the most open and thoughtful members of Venice's intelligentsia; by his growing interest in the artefacts of the ancient world[10] and his simultaneous rejection of the artificiality of the Baroque, Canova developed his own intellectual stance: watchful, thoughtful and cultivated to the extent that it came naturally to him to query the techniques and methods of artistic production as well as its theoretical and aesthetic foundations.

Canova's contribution to Venetian art is his group *Daedalus and Icarus*. The two nude figures of a young man and an old one, in dignified, controlled attitudes, are different yet well-matched interpretations of the same ideal, modified by respect for realism. Canova shuns Baroque melodramatics and, equally, avoids the cold artificiality of the classical revival, and the result is miraculous.

The youth from the provinces, sensitive and highly adaptable, had benefited profoundly from his stay in Venice, extending the novelty and originality of his style to the furthest limits such an experience would allow. *Orpheus* has been seen to be something much more significant than just a straightforward, albeit extremely talented, work of art: scholars lay stress on its symbolic and historical importance as well as on its cultural message; it heralds a new poetic language.[11] *Daedalus and Icarus* marks the transition between two worlds and two differing concepts of art, between two ways of interpreting the function of art and its relationship with society. At the same time, Canova moves from one technical and stylistic phase to the next: 'All his technical expertise cannot help the wise old craftsman to fly, so instead he uses it to make wings with which his young son will fly to his death'.[12]

*Figure 68:* Antonio Canova, *Daedalus and Icarus*, marble, 220 × 95 × 97 cm, 1777–9, Museo Civico Correr, Venice

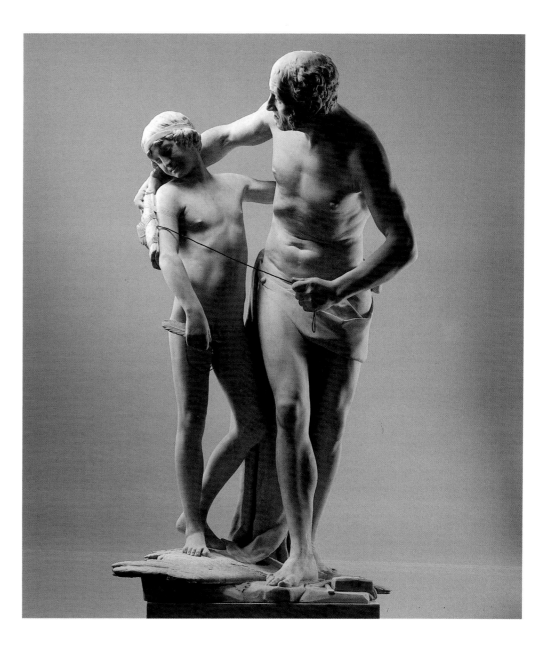

In his life and in his works, Canova seems conscious of undergoing such metamorphoses; his method of working tells us unequivocally that, at the end of the century, a turning-point has been reached. It was not until after his move to Rome, however, that the different stages of his own creative process were revealed.[13] We know that it began with one or two very rapid sketches on paper, encapsulating an idea or an intuition, and then progressed to more elaborate drawings and the first complete, articulated designs for the sculpture on paper.[14] Next came reduced-scale models in wax, plaster or clay, which gave three-dimensional form to the figures, and these were followed by less rough models, still in clay or plaster, which were formally complete to the extent that they were sometimes used exactly as they stood for the creation of the finished work. At this stage the artist developed a life-size model with which to assess the overall effect of the piece, and this would sometimes be placed in the precise location and position for which it was designed. The life-size plaster model would be marked with measurements and reference points, then work on the marble would begin, Canova from now on always choosing marble for his sculpture. This final stage was also long and complicated: assistants and marble-cutters rough-hewed the block of marble, but the completion of the statue was entirely in the hands of the artist, from the elaboration of the detail to the smoothing and polishing of the surface; the final application of oils and wax enhanced the shine and softness of the finished statue.

Canova was paid 100 gold *zecchini* for *Daedalus and Icarus*. With the money he set off in October 1779 on his long-awaited journey to Rome, to the source of the classical culture that had for so long been part of his desires and his dreams. The visit led to his leaving Venice for many years, and was to become the most significant milestone in Canova's life. He continued, nevertheless, to think of himself as a Venetian.

Initially, Canova's time was taken up with the study of antiquity, familiarising himself with the treasures of Rome, ancient and modern, and visiting archaeological sites, both there and subsequently in Campania and Sicily. Frequently he was in a state of high excitement, as the diary of a young compatriot and friend, the architect Giannantonio Selva, who often accompanied Canova on his trips in and around Rome, describes. Thanks to Senator Girolano Zulian, the Venetian ambassador to Rome, Canova came into contact with cultivated society in what was at the time the undisputed artistic capital of Europe; artists, students of antiquity, antiquarians and restorers, collectors, and men of letters thronged there. Quite soon the sculptor was recognised as one of the most promising young artists of the day. For his part, he studied, worked and struck up friendships with various people who would play a crucial part in his cultural development and in his future as an artist. Gavin Hamilton provided excellent advice about the best way to handle the stimulus and ideas gleaned from his study of classical art, and from the imitation of ancient sculpture; Quatremère de Quincy was also an enthusiastic champion of Canova's efforts. In addition there were Andrea Memmo, Giovanni Volpato, the well-known engraver from Bassano, Francesco Algarotti, the Rezzonico family (who not only looked after the young Antonio but also commissioned the monument to Pope Clement XIII – Rezzonico – in St Peter's, which thrust him to the summit of fame and fortune). These and many other patrons and intellectuals helped to transform Canova, in quite a short space of time, into the brightest star in the contemporary artistic firmament. Initially the Venetians attempted to lure him back to their city; later they required him to act as the standard-bearer for Venetian art, presumed now to have regained pre-eminence, and as a kind of Venetian cultural ambassador in Rome. His second role was to supervise the training of young artists sent from the Academy in Venice to Rome as state scholars.[15]

The monument to Pope Clement XIV in the basilica of the SS. Apostoli preceded the monument to Pope Clement XIII in St Peter's. Before either of these, Canova had carved another group, *Theseus and the Minotaur* (fig. 69), his first important work executed in Rome. This was, once again, not merely an illustration of a classical myth but also of a thesis: the victory of beauty, in all its perfection, over bestiality. But the face of Theseus, as he overcomes the bull-headed monster, wears a look of regret, reflection and melancholy that frequently recurs in Canova's work, and is an essential element of his poetry.

*Figure 69:* Antonio Canova, *Theseus and the Minotaur*, marble, 14.5 × 158.7 × 91.4 cm, 1781–3, Victoria and Albert Museum, London

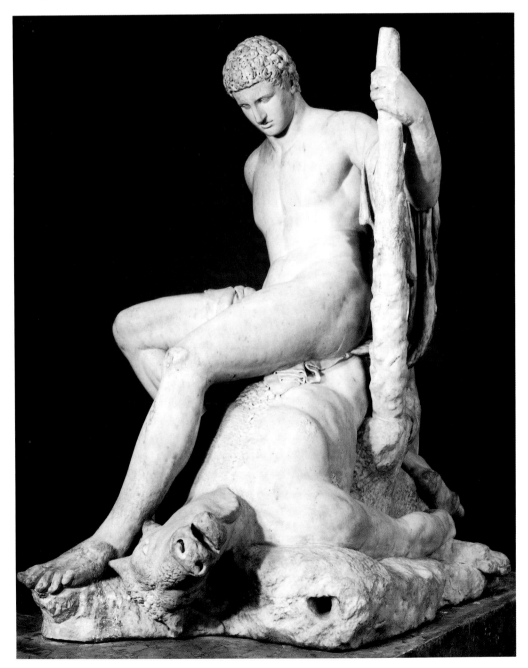

During Canova's time in Rome, particularly after he had finished the two papal tombs, he became internationally famous. Before the end of the century his patrons included collectors in France, England, Russia, Poland, Austria and Holland, as well as members of various royal houses, and prominent figures in the governing classes of Europe. Canova, in short, was the most sought after and the most highly esteemed artist of the day, and stood as the representative of the sensibility and culture of that period.

Canova's range of subjects continued to broaden to include in particular mythological subjects rich in allegorical and moral content: *Eros and Psyche* in two versions, standing and lying down, *Venus and Adonis* and *Hebe*. He found original ways, both conceptual and formal, of dealing with funeral monuments; perhaps most original of all is the pyramid in his model for a *Monument to Titian* (cat. 286), never actually made although the design was revived for the cenotaph of Maria Christina of Austria in Vienna. No less impressive are the scenes from the *Iliad* and the *Odyssey*, from the life of Socrates, and the Acts of Mercy depicted with great daring and originality in plaster bas-reliefs (cat. 287, 288). They are compositionally dynamic, rhythmical, serious and imposing, technically perfect and of Alexandrian elegance.

Canova's art at this juncture was characterised by elegance, perfection of form, idealised beauty and grace. The imitation of Antique forms, like the inspiration provided by the painted decoration of Herculaneum or the work of contemporary painters and sculptors, by now almost entirely working in a Neo-classical idiom, were dealt with by Canova with incomparable formal perfection and imaginative originality. He was following a tricky and very personal path through, on one hand, the theory and ideology of the Absolute in art, and on the other, the feeling and sensibility that bring art close to nature and reality.

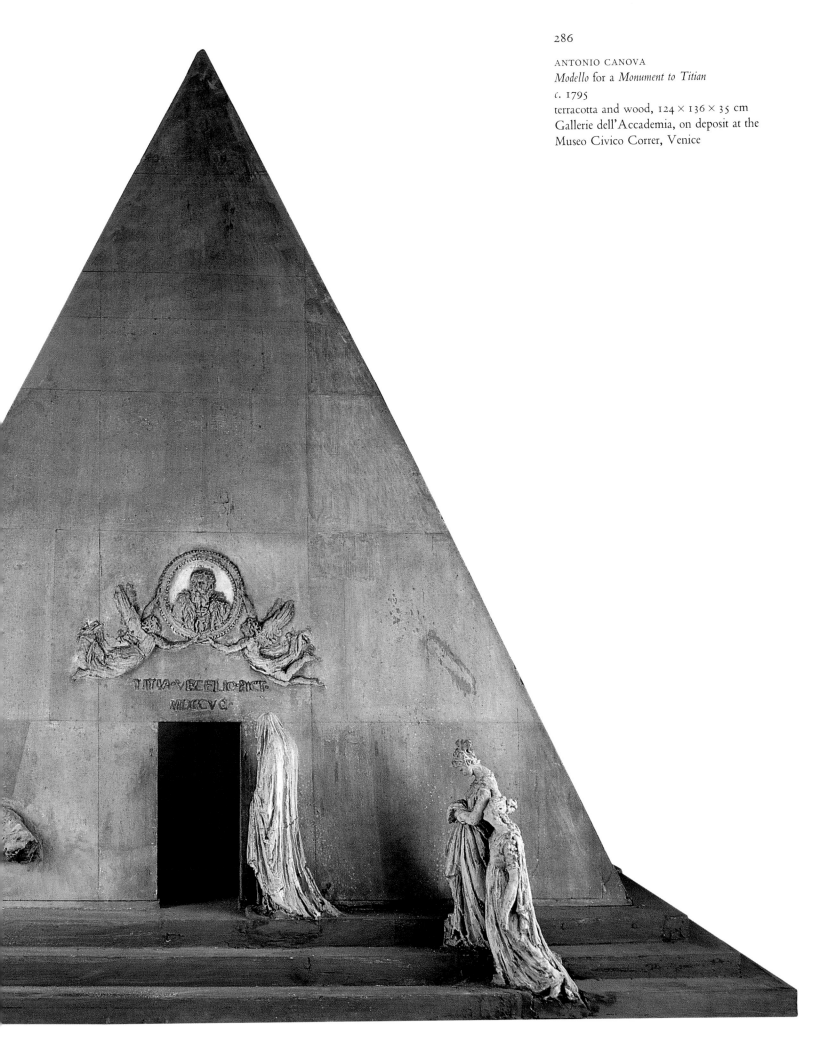

ANTONIO CANOVA
*Modello* for a *Monument to Titian*
c. 1795
terracotta and wood, 124 × 136 × 35 cm
Gallerie dell'Accademia, on deposit at the
Museo Civico Correr, Venice

287

ANTONIO CANOVA
*Teaching the Ignorant*
1795–6
plaster, *c.* 117 × 127 cm
Museo Civico Correr, Venice

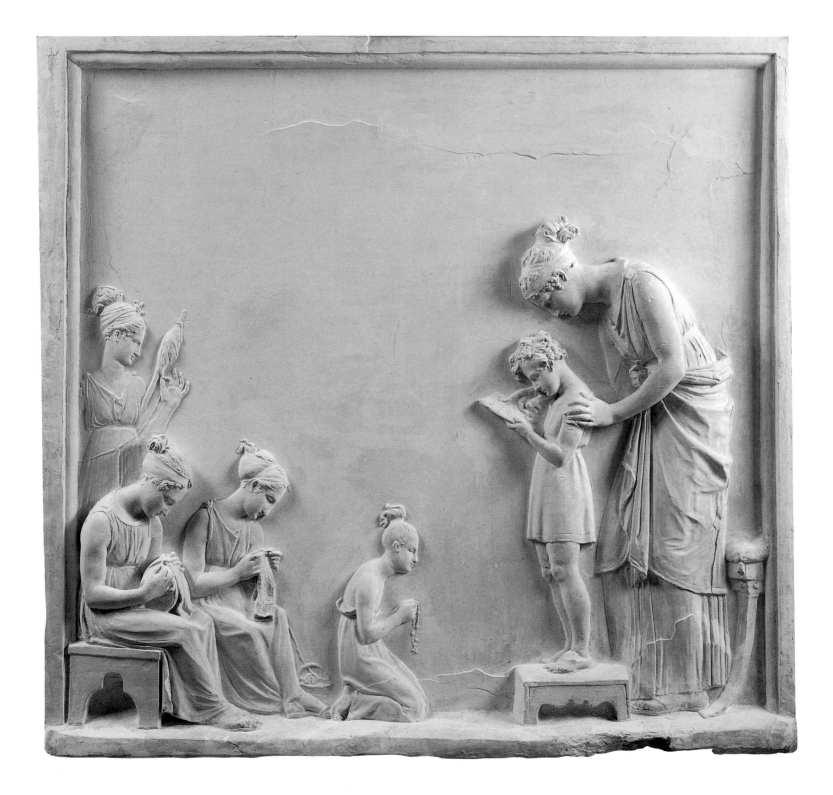

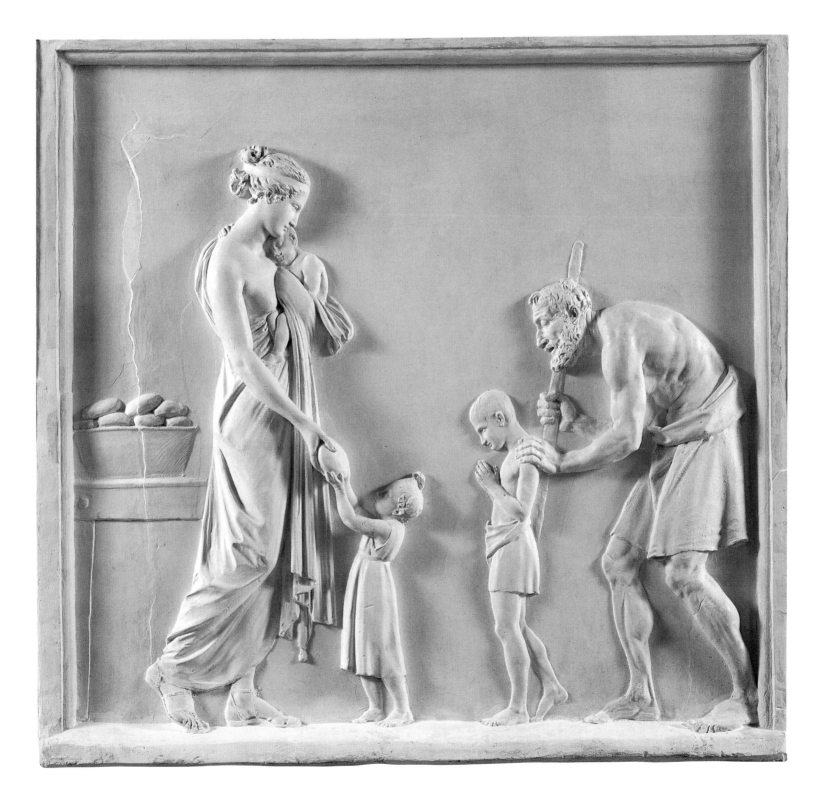

Persuaded, perhaps, by the criticism of his detractors and the advice of friends (Quatremère de Quincy, on the occasion of the unveiling of one of his masterpieces, the recumbent *Cupid and Psyche*, fig. 70, had warned him against mawkishness and excessive virtuosity), Canova decided to tackle heroic and tragic themes, encouraging his muse to change direction thematically and stylistically in favour of the sublime. This gave rise to masterpieces of a new type like the two pugilists (*Creugas* and *Damoxenos*, Vatican Museum, Rome; see cat. 289, 290), the model of *Hercules Shooting his Sons with Arrows* (Museo Civico Correr, Venice). The gigantic *Hercules and Lica* (Galleria d'Arte Moderna, Rome), and finally, *Theseus and the Centaur* (Kunsthistorisches Museum, Vienna).

289

ANTONIO CANOVA
*Male Nude (Creugas)*
1794
pen and grey ink over graphite on white paper,
45.3 × 31.5 cm
Museo Civico Correr, Venice

Canova's thematic range and his versatility of style were by this time stupendous. Nothing seemed beyond the sculptor's scope, and he pressed on almost obsessively with his quest for formal perfection and for complete control of his material, submitting the marble to effects that are at once strange and realistic – with extraordinary results. By now Canova felt on a par with his classical mentors and able to use the subjects that they used. This is the case with the *Venere Italica* (Palazzo Pitti, Florence), or the two versions of the well-known group of *Three Graces* (priv. coll., and The Hermitage, St Petersburg). In fact, in the *Perseus Triumphant* (Vatican Museum), a desire to challenge and perhaps to compete with classical statues of the same subject can already be sensed.

290

ANTONIO CANOVA
*Male Nude (Damoxenos)*
1794
pen and grey ink over graphite on white paper,
44.6 × 31.5 cm
Museo Civico Correr, Venice

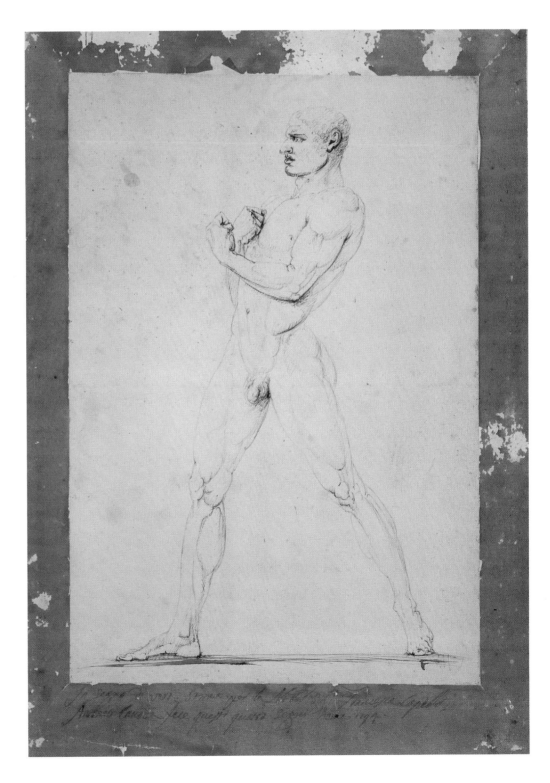

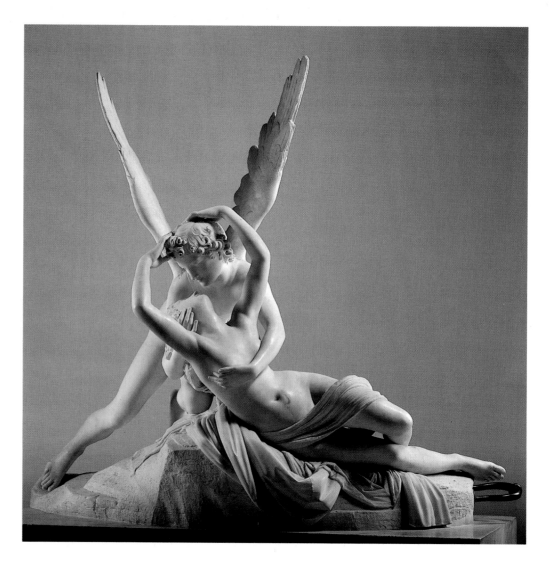

*Figure 70:* Antonio Canova, *Cupid and Psyche*, marble, 155 × 168 cm, 1787–93, Musée du Louvre, Paris

With regard to the accusations of artificial complexity levelled against the *Cupid and Psyche*, which in other respects demonstrates formal ingenuity of the highest quality, the interplay of open and closed lines created by the arms of the two lovers and the wings and right leg of Eros is often repeated elsewhere. The *Venere Italica*, or the *Dancer* in the Hermitage, or the *Three Graces* are certainly the fruit of more mature reflection, presenting the height of maturity of expression combined with compositional equilibrium and, in a more general way, cultural awareness so finely tuned as to promote Canova to the position of one of the intellectual giants of the century.

It is in his guise as a great artistic personality or as a respected cultural emissary that we find Canova at the court of the Habsburg rulers and in that of Napoleon, in the Papal palace on the Campidoglio, or in Florence, Naples and Venice. In Vienna, in 1815, he is acting as Minister Plenipotentiary of the Pope, trying to recover works of art carried off to Paris by Napoleon. From Vienna, at the end of October, he was summoned to London to give his expert opinion on the Parthenon marbles: this provided him with one of the most moving experiences of his life: 'the works of Phidias are truly flesh and blood, like beautiful nature itself' he exclaimed in a famous letter to Quatremère. From 1800 to 1820 Canova took on a variety of memorable enterprises: large cenotaphs (the most famous being those for Maria Christina in the Augustinerkirche, Vienna, for Vittorio Alfieri in S. Croce, Florence, and the cenotaph to the Stuart royal family in St Peter's, Rome). Large religious statuary, for both Catholic and Protestant patrons, show female figures standing and seated (*The Letizia Ramolino Bonaparte* in Chatsworth, taken from Roman originals, the *Leopoldina Esterhazy-Liechtenstein* in Eisenstadt;

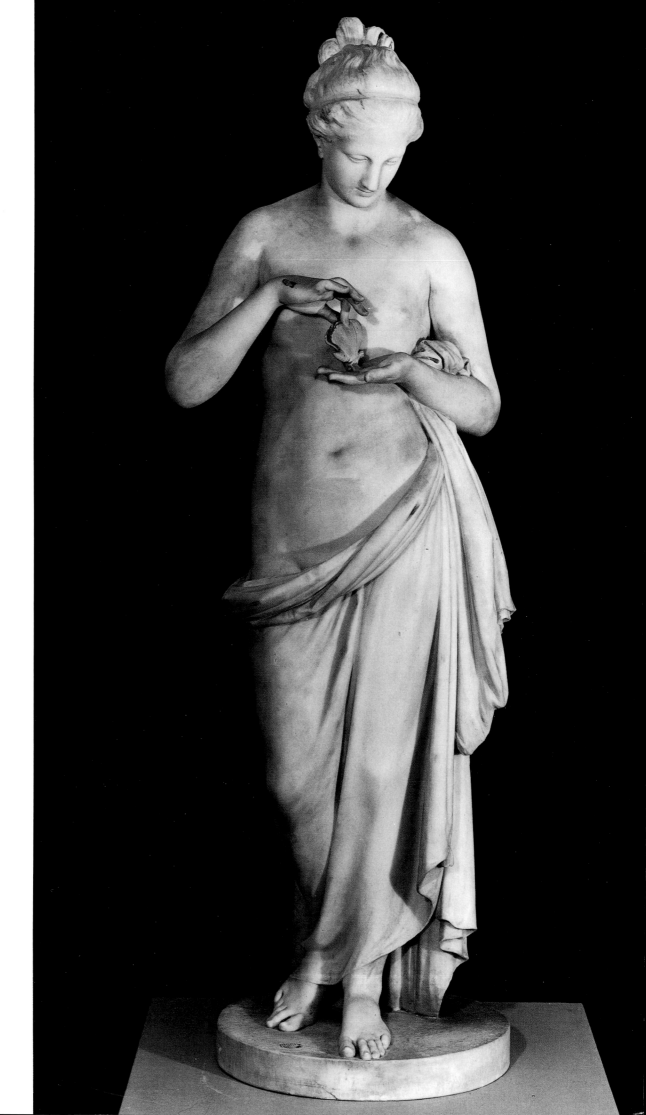

291

ANTONIO CANOVA
*Psyche*
1789–92
marble, 152 × 50 × 45 cm
Private Collection

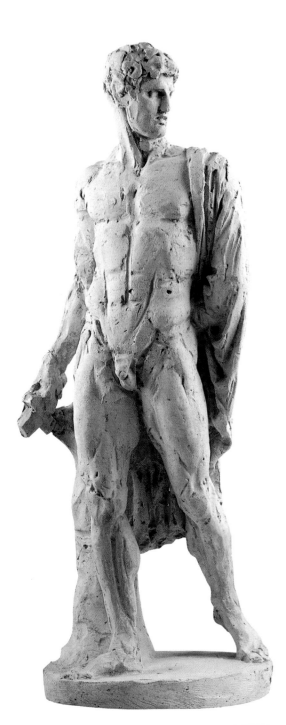

the *Maria Luisa Hapsburg dressed as Concordia* in Parma; the *Musa Polimnia* in Vienna); recumbent figures, including the *Naiad* in the Royal Collections, the *Sleeping Endymion* at Chatsworth, and the *Sleeping Nymph* and *Recumbent Magdalene* at Possagno. Of Canova's reclining and recumbent figures, the marble statue of *Paolina Borghese Bonaparte as Venus* (Borghese, Rome) achieved fame far beyond the restricted circle of connoisseurs, becoming in the popular imagination the emblem for a whole epoch. This emblem, this epoch, signified the modern world, the world of Neo-classical culture and the Empire style, the Napoleonic worlds, then the world of the Restoration, the 'century of Canova' as his great admirer, Leopoldo Cicognara[16] calls it throughout his celebrated *Storia della scultura*. How many light years is Canova's century away from the theoretical premises, the modes of expression, the art of the 18th century, the century of Tiepolo? Canova's life concludes with a carefully orchestrated 'homecoming': this consisted of the construction of a gigantic temple designed, financed and partly built by Canova himself in his birthplace, Possagno.[17] The small hill village was to be transformed into a kind of architectural showpiece; Canova chose to construct an edifice with a historical flavour that was neither new nor a copy of an existing building, being a synthesis of the two most influential buildings of Greek and Roman architecture, the Parthenon and the Pantheon. (Winckelmann's theories, transmitted to Canova by Gavin Hamilton, Quatremère de Quincy and Leopoldo Cicognara, restored the sculptor's interest in the imitation of classical models). The temple at Possagno was finished by Canova's heirs in accordance with his designs, and stands as a symbol, a declaration of Canova's allegiance to his world and to his culture; his wish to set his seal upon his world and his epoch, like a tutelary genius or a patron saint, is epitomised in his temple. The temple embodies his character and his memory and in a way it is Canova; an Olympian, semi-divine Canova.

Gravely ill and exhausted by overwork, Canova died in Venice on 13 October 1820, after a final visit to Possagno to the site where his Temple was being built.

292

ANTONIO CANOVA
*Hector*
*c.* 1808
plaster, 60 × 22.5 × 18 cm
Museo Civico Correr, Venice

1. The recent exhibition of Canova's works in Venice, 1992², gave rise to a critical and bibliographical reassessment of the great sculptor. The catalogue of the exhibition, edited by G. Pavanello and G. Romanelli, refers readers back to the great body of critical work on the subject. A recent essay by Franco Bernabei on critical attitudes to Neo-classicism is timely and comprehensive (in Venice, 1992²). Records of proceedings of the convention on Canova held in Venice in September 1992 are in the process of being published; Giulio Carlo Argan presided over the Convention, at which a number of problems concerning both Canova and the Neo-classical period were discussed in general (Istituto Veneto di Scienze, Lettere e Arti). This is an appropriate point at which to draw attention to the great contribution made to the study of the period and to the appreciation of Canova's work by the writings of Giulio Carlo Argan; in particular, his review of the period in *Studi sul Neoclassico* (1970), is striking for its lucidity and critical accuracy.

2. Certainly the richest and most complete review of the period was the exhibition and accompanying catalogue in London in 1972, *The Age of Neo-Classicism*, to which the reader is referred. Important entries on Canova are by Hugh Honour who, for several decades, has been providing invaluable studies of the sculptor, and a mass of specialised information. Space permits only the mention of the exemplary *Neo-Classicism* (1968), and the editorship of the first volume of the Edizione Nazionale delle opere di Canova, in the process of being published.

3. There are several classic texts on Canova's life: the handwritten *Biografia* in the museum in Bassano; the *Biografia* by L. Cicognara (1823), biographies by Missirini (1824) and Rosini (1824). By Missirini (1833), Quatremère de Quincy (1834), D'Este (1864) and so on until we come to Pavanello (1976) and the catalogue of the Canova exhibition cited above (1992²).

4. The date traditionally assigned to *Eurydice* (1773) has recently and convincingly been brought forward by Pavanello, on the basis of documentary evicence, to *c.* 1775 (Venice, 1992², p. 214).

5. Cf. *Giornale Enciclopedico*, (July 1777); Honour, in Venice, 1992². According to Missirini, 1824, (cited by Pavanello in Venice, 1992²) in honour of the young sculptor an excerpt from *Orpheus and Eurydice* by Ramieri de' Calzatrigi, with music by Fernando Bertoni, was performed at the *Fiera della Sensa* at Ascensiontide. The opera had been successfully staged at the Teatro S. Benedetto the previous year.

6. The importance of Filippo Farsetti's collection or models and plaster casts has recently been highlighted by Honour (Venice, 1992²) and confirmed by an exhibition (in Rome, then in Venice), *Alle origini di Canova*, in which the Farselli collection was reassembled; the few remaining items in Venice were reunited with the great majority, which had passed to the Hermitage (Androsov, 1991).

7. Canova's network of cultural relationships, created very soon after his arrival in Venice, is important and in particular includes personalities known for their broadmindedness on matters of art and scholarship. Canova was certainly part of the circle of Andrea Memmo, the most celebrated student of the theorist of proto-functionalist architecture Father Carlo Lodoli; he published his *summa*, a résumé of his architectural and religious thought (see on this the contributions by Pavanello and Romanelli in Venice, 1992²).

8. The quotations are taken from the review of the statue published in the *Giornale Enciclopedico*, (July 1777) and quoted by Pavanello in the entry on *Orfeo* in Venice, 1992².

9. Pavanello, in Venice, 1992², p. 46.

10. The study of antiquity is a central theme in Canova's cultural background. His first access to the classical world was through mythology. Then when he made his first trip to Rome the direct contact with the classical past bowled him over; it was to become the most important influence in his thought and in his sculpture (see on this, in addition to the texts quoted above, recent contributions from Howard, 1976; Micheli, 1985–6; Mellini, 1990; Favaretto, 1992). Canova's *Quaderni di Viaggio* remain an indispensable source (edited by E. Bassi, 1959).

11. This refers to Argan's famous essay on Canova's *fils* (thread), the thread that links the figure of the father, Daedalus, to the son, Icarus, in the marble group in the Museo Correr (Argan, 1969). A pioneering work in modern Canova scholarship is Zeitler, 1954.

12. Argan, in Venice, 1992², p. 4.

13. We are indebted to Hugh Honour for this information, in his contribution 'Dal bozzetto all'ultima mano' in Venice, 1992².

14. On Canova's graphic work, see Bassi, 1952, 1957, and 1959; Magagnato, 1956; Barioli, 1957; Gonzalez-Palacios, 1973; De Benedetti, 1973; Ruggeri, 1974; Barbieri, 1982; Milan, 1982; Mellini, 1984; Romanelli, 1985; Mariuz and Pavanello, 1992.

15. On the role played by Canova and on his relations with the President of the Accademia di Belle Arti, Venice, see Pavanello, in Venice, 1978, Cicognara, *Lettere* 1973; Romanelli, 1988.

16. Leopoldo Cicognara and Quatremère de Quincy were undoubtedly the most loyal promoters of Canova's work throughout Europe and were also the most vociferous champions of his fame, which almost amounted to a cult, in the early 19th century. Cicognara was the author of a very important history of sculpture in Italy; after Canova's death he changed the title of the work to *Storia della Scultura dal suo risorgimento in Italia* [...] *fino al secolo di Canova*, in homage to his friend, and in recognition of his importance to the artistic history of Italy.

17. On the *Tempio* see Romanelli, in Venice, 1992² (which also contains an extensive bibliography on the subject).

Biographies are listed alphabetically by artist. Dimensions are given in centimetres to the nearest 0.5 cm; height precedes width. References at the foot of the entries are to the general bibliography. Catalogue entries are signed with the initials of the following contributors:

I.B. István Barkóczi
E.P.B. Edgar Peters Bowron
R.B. Ruth Bromberg
D.G. Donald Garstang
M.G. Margherita Giacometti
C.H. Colin Harrison
G.M. Giorgio Marini
M.M. Mitchell Merling
O.T. Olimpia Theodoli
P.W. Patricia Wengraf

## JACOPO AMIGONI
born probably in Venice, *c.* 1682
died Madrid, 22 August 1752

Painter and draughtsman. With Sebastiano Ricci, Rosalba Carriera and Pellegrini he was one of the principal painters who diffused the Venetian style through the courts of Europe during the first half of the 18th century. His place of birth and training are unknown: while in both of his wills Amigoni declared he had been born in Venice, this does not accord with his assertion of Neapolitan origins, which may possibly have been stated for opportunistic reasons while he was in Spain. Although not documented, this claim was accepted by scholars since it helped to explain Amigoni's links with central and southern Italian painting, in particular the work of Luca Giordano. He is first mentioned in the *Fraglia* of Venetian painters in 1711 when he was working abroad, possibly at the Palatine court at Düsseldorf, where Bellucci was active; the latter's style and that of Balestra were important for Amigoni's formation. In 1717 he was called to work for the Elector of Bavaria, for whom he painted decorative fresco cycles in the palaces of Nyphenburg and Schleissheim, and in the Benedictine abbey of Ottobeuren. In 1728, before finally leaving Munich, he made a journey to Rome, Naples and Venice, and then in 1729 established himself in England for a long and productive period. Here he perfected his arcadian style, with its sensual and refined overtones and its polished chromatic scale, delicate yet cold in tone. Like the Riccis and Pellegrini he was involved with the Italian opera in London, and made friends with the castrato singer Farinelli, of whom he made several portraits. As well as being noted for his portraits Amigoni produced a large body of decorative works, mostly lost, but known through the prints made after them by Josef Wagner, the young engraver that Amigoni brought with him from Germany. Returning to Venice in 1739, in association with Wagner he opened a print shop which for many years was the centre of diffusion for his delicately Rococo style. He was called to the court of Spain in 1747, possibly through the intervention of Farinelli, who had preceded him there. He became First Painter to the King, Ferdinand VI, working as a portrait painter, and decorating palaces and theatres in a style that gradually became softly classical.              G.M.

## JACOPO AMIGONI
*Bathsheba*
*c.* 1739–47
oil on canvas, 115 × 150 cm
Staatliche Museen Preussischer Kulturbesitz, Berlin, Gemäldegalerie, on loan from the Streit Foundation (inv. 14)

This painting belongs to a group of four Old Testament scenes with life-size, half-length figures that once belonged to Sigismund Streit, a merchant from Berlin who lived in Venice 1709–50. A portrait of Streit was painted by Amigoni in 1739 (Berlin); the merchant subsequently acquired six further paintings (now lost) by the artist, all small-scale, of biblical and mythological subjects. Together with all his paintings, including four Canalettos, and his library, they were given (between 1758 and 1763) to the Gymnasium zum Grauen Kloster in Berlin, where Streit had been educated.

This painting is a fine example of the contemporary taste for mythological stories retold in a gallant manner; here the biblical story is recounted in a roguishly Rococo style, which emphasises the sensuality of the softly gleaming nude figure of Bathsheba. The small glimpse of landscape in the background and the distant figure of David are summarily indicated.

This painting and the others associated with it date either to Amigoni's sojourn in Venice, 1739–47, which might suggest that Streit commissioned them from the artist, or to 1725–6, when Amigoni was also in Venice. The earlier date is supported by the evident influence of Luca Giordano; at a later date the influence of Sebastiano Ricci would have been more pronounced. A variant of this painting, of the same size, is in the Hessisches Landesmuseum, Darmstadt.              G.M.

*Provenance:* acquired in Venice by Sigismund Streit; 1763, presented by him to the Gymnasium zum Grauen Kloster; on loan from the Streit Foundation, Berlin
*Exhibition:* Hanover and Düsseldorf, 1991, no. 2
*Bibliography:* Voss, 1918, pp. 160–6; Rohrlach, 1951, p. 199; Pilo, 1958, p. 164; *idem*, 1960, p. 179; Martini, 1964, p. 34; Berlin, 1978, p. 24; Haskell, 1980, p. 316; Hennessey, 1983, no. 3; Grohn, in Hanover and Düsseldorf, 1991, no. 2

## JACOPO AMIGONI
*The Meeting of Habrokomes and Antheia*
1743–4
oil on canvas, 97.5 × 125 cm
Staatsgalerie, Stuttgart (inv. 3351)

This painting belongs to a group of six paintings of mythological or classical subjects commissioned from four famous Venetian artists by Francesco Algarotti for the Gallery in Dresden in 1743. The meeting of Habrokomes and Antheia is taken from a love-story by Xenophon of Ephesus, written in the first half of the second century AD. The story had been popularised by an Italian translation in 1723 and one in Latin in 1726. Algarotti gave the painters precise details of the size and subject-matter of the paintings, and he was responsible for choosing a theme particularly suited to Amigoni's graceful style. Hoping to benefit from the project himself, Algarotti wrote about it in *Progetto per ridurre a compimento il Museo di Dresda* (1742; see his *Opere*, VIII, Venice, 1794, p. 353ff.), and printed a descriptions of the subjects of the six paintings. This painting is carefully described: the two young people met at the feast of Diana; Habrokomes is led by a group of young men and Antheia by a group of young women; an Ionic temple dedicated to Diana is seen in the background. Xenophon stands among the onlookers on the right composing the story under the guidance of the god Eros. Algarotti asked the painter to make a small preliminary *modello* which he kept in his own collection; it is probably the painting (Accademia, Venice, inv. no. 821) tentatively attributed to Giambattista Tiepolo. The Dresden painting was delivered by the painter in February 1744 (he received 130 *zecchini* for it) and arrived in Dresden in April 1745. The whole series was later transferred to Hubertsburg and was sold at auction in 1765. This painting only recently reappeared on the market. It was recognised as original thanks to Amigoni's unmistakable soft modelling and his porcelain colours, particularly his greens, blues and pinks.              G.M.

*Provenance:* 1743, commissioned by Francesco Algarotti for Friedrich August II of Saxony, King of Poland; Dresden Gallery; sold at auction in Amsterdam, 22 May 1765; private collection, Austria; 1980, art market
*Bibiliography:* Fogolari, 1911, p. 311; Moschini Marconi, 1970, p. 113; Ewald, 1981, p. 158; Martini, 1982, p. 484; Hennessey, 1983, no. 22; Ewald, 1988–9, p. 296; Wiemann, 1989, pp. 77–8; Ewald, 1992, p. 22

**53**

JACOPO AMIGONI
*Head of a Young Woman with a Shawl*
1740s
black and white chalks on brown paper,
29 × 25.2 cm
Staatliche Graphische Sammlung, Munich (inv.
31719)

This unpublished drawing is unusual for
Amigoni, being as different from the rapid
portraits sketched on blue paper typical of his
English period as it is from the grisailles (also in
the Staatliche Graphische Sammlung, Munich)
drawn with a fluency reminiscent of Pellegrini.
Here the subtle gradations of tone are recorded
with such precision that it is assumed to be a
preparatory drawing for a portrait. The grace
and elegance of the line brings it close to the
sweetness of Amigoni's religious painting,
particularly to a series of paintings of the Virgin
and Child executed with the delicacy of pastels.
Of the two paintings of the *Virgin and Child* now
in the Alte Pinakothek, Munich, one (inv.
2415) has the same basic composition as this,
with downcast eyes and the head draped with a
shawl. However, the date of that painting, 1720–
5, is too early for this drawing to have any
connection with it. The smooth shading of the
drawing is closer to Amigoni's second Venetian
period, when the jewel-like brightness and the
Rococo tendency of his English period were
supplemented by a new classical feeling, evident
in two small altarpieces depicting the *Immaculate
Conception* (Oratory of S. Maria del Soccorso,
Venice; Museo Civico, Pordenone) which can
be dated to his final years in Venice.         G.M.

*Provenance:* Halm-Maffei collection; 1889, given
by Reichsrat Ritter Hugo von Maffei to the
Graphische Sammlung, Munich

**54**

JACOPO AMIGONI
*Head of a Bald Man in Profile*
1740s
black and white chalk on brown paper,
28.4 × 22.9 cm
Staatliche Graphische Sammlung, Munich (inv.
31718)

This extremely delicate, unpublished drawing,
with its striking characterisation and astonishing
rendering of flesh, is so vivid that this must be a
study for a portrait. Apart from the fact that the
head is drawn in profile it might be a self-
portrait. It bears traits in common with the
youthful self-portrait now in Darmstadt
(Hessisches Landesmuseum), but even more
with the celebrated *Musical Portrait Group* (*c.*
1750; National Gallery of Victoria, Melbourne).
The same facial type appears in several paintings
of the late 1740s, for instance in the two *Stories of
Joseph* (Museo de Arte de Cataluna, Barcelona),
generally held to have been painted just before
Amigoni's departure for Spain.         G.M.

*Provenance:* Halm-Maffei collection; 1889, given
by Reichsrat Ritter Hugo von Maffei to the
Graphische Sammlung, Munich

**189**

## ANONYMOUS VENETIAN ARTIST

*Rutvanscad il giovane | Arcisopratragichissima tragedia
| elaborata ad uso del buon gusto de' Grecheggianti
Compositori | da | Catuffio Panchiano | Bubulco
Arcade*, published in Venice by Giuseppe
Bettinelli, 1737 octavo volume, open to the
etched plate *The Three Blind Musicians in the
Piazza*
printed in orange-red ink on blue paper,
20.5 × 28 cm (open book)
Museo Civico Correr, Venice (inv. G.291)
(shown in London only)
Department of Printing and Graphic Arts,
Houghton Library, Harvard University,
Cambridge, MA (inv. Typ.725.37.865) (shown
in Washington only)

The author of this humorous tragi-comedy was
Zaccaria Valaresso, who wrote under the
pseudonym 'Catuffio Panchiano', which he used
in the Venetian literary society, the Arcadia. The
story tells the fantastic adventures of Rutvanscad,
the young king of China and New Zembla,
who defended his throne against Culicutidonia,
widow of the tyrant Tettinculuffo. In the end the
widow fell to her death in a latrine. *The Three
Blind Musicians in the Piazza* shown here act as a
chorus to the narrative, in a parody of ancient
Greek tragedy. The play was probably aimed at
the sophisticated audience of the Arcadia society
who would have appreciated its satirical content.
It has been suggested that the inventor and
engraver of the eight anonymous illustrations,
two of which are repeated twice, was Gaetano
Zompini. The style of the illustrations,
particularly the one shown here, is very close to
Zompini's best known work, *Le Arti che Vanno
per via ...* (cat. 187, 188), published in 1753, in
particular plate 44, *A Choir of Deaf Mutes*, is
very similar to the etched composition shown
here. The volume is printed on blue paper, and
the illustrations are in inks ranging from orange
to deep red.         O.T.

*Bibliography:* Morazzoni, 1943, p. 221

# B

## ANTONIO BALESTRA

born Verona, 12 August 1666
died Verona, 21 April 1740

Painter, draughtsman and engraver. Born into a family of well-to-do merchants, he was given a classical education. He first studied painting with Giovanni Ceffis and then, aged 21, moved to Venice where he worked in the studio of Antonio Bellucci and also attended the Academy's life-classes. His time in Rome at Carlo Maratta's studio, from 1691, was fundamental for the formation of his classicising style. After a brief time in Naples, in 1694 he won first prize in the drawing competition for the Accademia di S. Luca in Rome. Returning to the Veneto, his *Annunciation* for the church of the Scalzi in Verona of 1697 set the seal on his success. The importance of his classicising influence in the Veneto, which had been overwhelmed by the Rococo style, can be gauged from the fact that at his school in Venice were trained Nogari, Pietro Longhi and Mattia Bortoloni. A trip in Lombardy and Emilia in 1700 to study the work of Correggio and Cignani was the start of a fruitful period of production, with commissions coming from both the Church and from private patrons. In a series of paintings of the Nativity, all nocturnes lit by supernatural light, such as that in S. Zaccaria, Venice, of 1704–7, he successfully combined elements derived from Maratta and Correggio. Returning to Verona in 1718 he brought with him the school he had founded in Venice and continued to combine a rigorous formalism with the anti-Baroque style promoted in those years by the Marchese Maffei. At this time he also produced a small number of lively etchings, still faithful to his Romano-Emilian stylistic roots. In Verona he was responsible for the local classicising style that caused a rift between Veronese art and that of Venice and Lombardy; in this his successor was Cignaroli.                    G.M.

## 13

ANTONIO BALESTRA
*Juno Placing the Eyes of Argus in the Peacock's Tail*
*c.* 1714
oil on canvas, 167.7 × 104.2 cm
The Chrysler Museum, Norfolk, VA
Gift of Mr Emile E. Wolfe, 52.59.2

The subject was a popular during the Baroque period; the interpretation of the myth, taken from Ovid's *Metamorphoses* (1.721–4) was frequently an excuse for elegant displays of colour and composition handled in a highly decorative manner. It is probable that this painting was one of three canvases seen in Balestra's studio by William Kent in 1714 as he relates in his travel diary (Honour, 1954, p. 3). The polished composition, meticulous outlines and charming colours connect this work to the pictorial style favoured by Balestra in the first decade of the century, when he was absorbing Emilian art, and also that of Maratta in Rome. This was a period of important commissions such as *Venus Appearing as a Huntress to Aeneas and Achates*, delivered to Count Bonaccorsi in Macerata in 1713 (cat. 14), or the six paintings for the castle at Pommersfelden executed for the Elector of Mainz in 1714. The subject's popularity with patrons is confirmed by the fact that Balestra made at least three other paintings of it in private collections in Verona (D'Arcais, 1978, p. 200). It has been suggested that a smaller painting (priv. coll., Verona) may be a sketch for this version.                    G.M.

*Provenance:* 1952, Gift of Emile E. Wolfe
*Exhibition:* Chicago, 1970
*Bibliography:* Martini, 1964, p. 149; Flannegan, in Chicago, 1970, pp. 48–9; Zafran, 1978, p. 251; D'Arcais, 1979, p. 23; Ghio and Baccheschi, 1989, no. 42

## 14

ANTONIO BALESTRA
*Venus Appearing as a Huntress to Aeneas and Achates*
*c.* 1713
pen and brown ink with brown wash over black chalk on laid paper, 233 × 162 mm
inscribed lower right, in brown ink: '*Ant Balestra. Vero[nese]*'; verso: stamp of J. MacGowan (Lugt 1496), in brown ink: J. McGowan's sale 1804 P.5. n 34 (W. Esdaile)
watermark: cartouche
National Gallery of Art, Washington
Ailsa Mellon Bruce Fund, inv. 1982.17.2

This drawing is related to Balestra's painting for the 'Aeneid Gallery' in the palace of Conte Raimondo Bonaccorsi di Castel San Pietro in Macerata in the Marche. According to the artist's autobiography the painting was

dispatched from Venice *c.* 1713. The decoration of the palace, one of the most ambitious late-Baroque schemes in the region, was begun in 1707 and involved a group of artists mainly from Naples, Bologna and Venice. The client requested that each should illustrate a different episode from Virgil's *Aeneid*. Balestra's painting illustrates the passage from Book I, lines 312–24 in which Venus, dressed as a huntress, appears to Aeneas and his faithful companion Achates the day after their shipwreck on the coast of Carthage. Balestra follows the text very faithfully. The pen drawing seems to have been dashed off with great speed over a very light charcoal sketch; it is obviously an early sketch for the painting, and its immediacy can be contrasted with the more polished preparatory design (Windsor Castle; inv. 3744) which comes close to the immaculate classicising finish of the final painting. This sketch has been dated to sometime between 1710 and 1713. Later Balestra repeated the composition with minimal variations in a preparatory oval drawing of the frame (Parma) made in preparation for the small etching executed by his pupil Pietro Rotari *c.* 1725. Another drawing (Biblioteca Ambrosiana, Milan, inv. 1181), echoes the disposition of the figures, but is difficult to attribute to Balestra on stylistic grounds.                    G.M.

*Provenance:* 1804, J. MacGowan; W. Esdaile; 12 August 1981, bought from Christie's London, no. 64

## 15

ANTONIO BALESTRA
Frontispiece and title-page vignettes in Antonio Pompei, *Li Cinque Ordini dell'Architettura Civile di Michel Sanmicheli*, published by Jacopo Vallarsi in Verona, 1735
etchings
25.5 × 17.2 cm (platemark of frontispiece, state 2 of 3)
31.7 × 43 cm approx (open book), 6.8 × 7 cm (platemark of *Il genio della geometria*)
inscribed on the frontispiece, lower right: '*AB. in.*'; lower left of *il genio*: '*AB. f.*'
The British Library Board, London (inv. 59.d.8)

After Balestra returned permanently to Verona in the early 1720s, he became increasingly involved in book illustration. Book production in Verona had been encouraged by the connoisseur Marchese Scipione Maffei, with whom Balestra shared an antipathy to the Baroque. Verona was enjoying a moment of glory with a revival of architecture (in the classical style) stimulated by the Marchese's book, *Verona Illustrata*, and by Conte Antonio Pompei's treatise on the

architecture of Michele Sanmicheli, the greatest Veronese architect of the Renaissance. Pompei (1705–72), a student of Balestra, had by 1732 begun to make a survey of Sanmicheli's buildings with a view to publication. In fact, his survey is an attempt to summarise the whole repertory of classical architecture. It was published in 1735; the illustrations by Balestra are generally considered to be contemporary. They include the allegory of architecture on the title-page, the genius of geometry and portraits of Alberti, Palladio, Scamozzi and Vignola at the beginning of each chapter. At least two different versions of the 1735 edition exist, one, like this copy, before the portrait of Serlio at the start of Chapter X; Pompei inserted it when the book was next printed. It has been suggested that plates engraved by Balestra at an earlier date, when still influenced by Carracci, may have been used. Three distinct states of the title-page allegory have been identified; Balestra's preparatory drawing is in the Biblioteca Palatina, Parma. The late-Baroque frame around the portrait of Sanmicheli has been changed to something more classical; this introduces the possibility that the etching may be by Pompei; indeed, Balestra's nephew, Francesco, drawing up a catalogue of his uncle's work for Francesco Gabburri, attributed the etching to Pompei.

G.M.

*Bibliography:* Heinecken, 1788, p. 71, Bartsch, 1821, XXI, p. 294, no. 4; Nagler, 835, I, p. 237; Le Blanc, 1854, I, p. 130, no. 7; Meyer, 1878, no. 5; Zannandreis, 1891, p. 314; Dillon, 1978, p. 205; Albricci, 1982, p. 83; Pilo, 1987, p. 40; Ghio and Baccheschi, 1989, p. 129, note 28g; Cirillo and Godi, 1991, no. 67; Corubolo, 1991, nos. 21 22

## FRANCESCO BARTOLOZZI
born Florence, 25 September 1728
died Lisbon, 2 March 1815

Engraver and draughtsman. At a very early age he began to study engraving, first following the course of painting and drawing held by Ignazio Hugford at the Accademia in Florence, where he was a fellow pupil of Giovambattista Cipriani. In 1748 he moved to Venice, to the famous studio of the engraver Joseph Wagner, then the principal centre of production of decorative prints in the city. He soon became Wagner's most important collaborator, and started to sign his own works in 1751, mostly prints after works by Longhi, Amigoni or Guarana; his particular speciality was book decoration, of which he became the supreme master in Venice. In 1754 he opened his own studio at S. Maria Formosa, but continued to collaborate with Wagner, whose graphic style he mastered with astonishing technical virtuosity, evident in the prints after the landscapes by Marco Ricci, Zocchi, Zais and Zuccarelli. He was soon famous outside the city, and the success of the first twelve drawings by Guercino that he engraved in facsimile led to his being invited to London in 1764 by Richard Dalton, librarian to George III. He engraved the Guercino drawings at Windsor, and later Holbein's portraits of the court of Henry VIII, collaborated with Boydell and renewed his connection with Cipriani. In 1768 he was one of the founder members of the Royal Academy in London, and in the 1770s headed a large studio, in charge of both collaborators and students, with whose help he produced a prodigious number of engravings, bringing the stipple engraving, made fashionable by Ryland, to a level of technical perfection. Implicated in the financial ruin of his son, he moved to Lisbon in 1801, where he had been called to direct the Academy of Fine Arts; there he continued to work until his death aged nearly 90. His work made in Venice remained perhaps the freshest, tied as it was to the taste of the local school of engraving. His links with Venice were still strong while he was in London, he encouraged many Venetian engravers to move to England, and his virtuoso production in the last decades of the century influenced the Venetian market and printmaking industry with the introduction of a fashion for prints in an English style.

G.M.

FRANCESCO BARTOLOZZI
Title-page, borders and vignette etchings in *Componimenti poetici per l'ingresso solenne all dignità di Procuratore di S. Marco per merito di Sua Eccellenza il Signore Gian-Francesco Pisani*, published by G. B. Albrizzi, Venice 1763 etching and engraving
title-page: 31.6 × 25.5 cm (platemark), 36.5 × 51 cm (open book)
Museo Civico Correr, Venice (inv. Cicogna 1076/op.1108.2)

The publication of eulogistic collections of poetry on the occasion of a wedding or of an appointment to a high public post became exceptionally popular in 18th-century Venice. Usually they were private commissions, a public manifestation of prestige and power, and often they are far more interesting for their appearance than for their texts. The most important editors of the city were involved in producing them, of whom Albrizzi was the favourite of the Pisani, a family of great importance in the government of the Republic, whose members frequently were appointed to positions of power. Almorò IV Gian Francesco Pisani was one of the most important figures in Venice at the beginning of the 1760s, and in 1762 Alessandro Longhi dedicated to him the *Compendio delle Vite dei Pittori Veneziani* (cat. 243). When Gian Francesco was nominated Procurator of S. Marco, Albrizzi produced this splendid edition, to which Bartolozzi contributed the elaborate cartouche of the frontispiece with an exuberant Rococo mixture of decorative and natural elements of the frames with allegorical and mythological figures surrounding the text. This decoration was republished, with minimal alterations, in the oration of Gasparo Gozzi to congratulate Pietro Vettor Pisani on his appointment as Procurator.

G.M.

*Bibliography:* De Vesme and Calabi, 1928, nos. 1564–97; Morazzoni, 1943, pp. 87, 195, 277

FRANCESCO BARTOLOZZI
Title-page, portrait and borders in *Componimenti poetici per l'ingresso solenne alla dignità di Procuratore di S. Marco per merito di Sua Eccellenza il Signor Ludovico Manin*, published by G. B. Albrizzi, Venice, 1764
etching and engraving
title-page: 30 × 21.9 cm (platemark),
36.7 × 524 cm (open book)
From the Lessing J. Rosenwald Collection,
Rare Book and Special Collections Division,
Library of Congress, Washington

In 1764, the year he left Venice, Bartolozzi finished the elaborate decoration of this volume, commissioned by Albrizzi. It includes a frontispiece with a fantastic combination of architectural and natural elements, an oval portrait of Manin in a splendid frame with floral motifs, borders, vignettes and end-pieces. Together with the *Ingresso* for Gian Francesco Pisani (cat. 244), this book stands as the ideal synthesis of Bartolozzi's extraordinary technical and stylistic virtosity in book decoration. During his time in Venice he produced almost 200 engravings which remained models of their kind for many years.

Lodovico Manin (1726–1803) was elected Procurator in 1764 and Doge in 1789, the last of the Republic. In 1766 the decoration of this volume was reused, with the coat of arms and the title changed, for a collection of poetry published on the occasion of the marriage of his son Giovanni Manin to Samaritana Dolfin. G.M.

*Bibliography:* De Vesme and Calabi, 1928, nos. 1535–63; Morazzoni, 1943, pp. 195, 272

## BERNARDO (MICHIEL) BELLOTTO
born Venice, 30 January 1721
died Warsaw, 17 November, 1780

Painter, draughtsman and printmaker. His mother was the eldest sister of the Venetian *vedutista* Canaletto, and Bellotto entered his uncle's Venetian studio *c*. 1735. By 1738 he was enrolled in the Venetian painter's guild, which suggests that by then he had developed into an independent painter. In 1740–1, Bellotto accompanied his uncle on a visit to Padua, and during the next few years he travelled independently to Rome, Florence, Lucca, Milan, Turin and Verona, producing topographical views of these cities.

In July 1747, in response to a summons to the court of Dresden, Bellotto left Venice forever. He entered the service of Augustus III, King of Poland and Elector of Saxony, and of his Prime Minister, Count Brühl. The panoramic views of Dresden, Pirna and Königstein he produced for the King stand among the greatest view paintings of the 18th century.

In 1758–9, Bellotto moved to Vienna, where he recorded the principal attractions of the city for the Empress Maria Theresa. In 1761 he painted in Munich at the court of Elector Maximilian III Joseph of Bavaria before returning to Dresden. In December 1766 Bellotto left Dresden for the court of the last king of Poland, Stanislaus Poniatowski.
E.P.B.

BERNARDO BELLOTTO
*Venetian Capriccio*
*c*. 1745
oil on canvas, 48.5 × 73 cm
Fundación Colección Thyssen-Bornemisza, Madrid

This painting is a perfect example of Bellotto's method of composing his 'ideal' landscapes; he assembled various architectural elements and random scraps of landscape to create a new view, yet the painting betrays no hint of such a process. The villa on the left, reminiscent of those along the banks of the Brenta, and the terrace and the medieval tower on the opposite sides of the bridge, recall a drawing by Bellotto (Boymans–van Beuningen Museum, Rotterdam, inv. I, 146) which is related to a gouache (Windsor Castle, R.L. 7513) usually given to Canaletto but recently attributed to Bellotto (see Marini, in Verona, 1990). The Rotterdam drawing chronicles an earlier moment in the creation of the composition, when Paduan elements were being incorporated. The medieval Torre di Ezzelino and the Riviera, both at Padua, have been identified in the drawing. Bellotto was trying these out in 1740–1, under the influence of his uncle, and they recur in an etching (De Vesme, 1906, p. 490, no. 3). The sarcophagus and urn under an awning on the tower hark back to an etching by Caneletto (Bromberg, no. 23). This painting has other sources: the landscape recalls the foothills of the Alps in Lombardy and the tower is built of bricks, like the tower in the Piazza d'Armi inside the Castello Sforzesco in Milan; these elements suggest that painting was probably executed after Bellotto's sojourn in Lombardy in 1744. G.M.

*Provenance:* unknown; acquired 1934
*Exhibitions:* Stuttgart, 1988, no. 5; Verona, 1990, no. 20
*Bibliography:* Heinemann, 1969, p. 32 no. 27; Kozakiewicz, 1972, II, p. 84 no. 109; Camesasca, 1974, no. 13; Borghero, 1986, p. 32, no. 27; Boesten-Stengel, in Stuttgart, 1988, no. 5; Marini, in Verona, 1990, no. 20

254

BERNARDO BELLOTTO
*View of Verona with the River Adige from the Ponte Nuovo*
1747–8
oil on canvas, 131 × 232 cm
Staatliche Kunstsammlungen, Gemäldegalerie Alte Meister, Dresden (inv. 604)

This view is one of the most panoramic in the city, looking down the River Adige from the level of the Ponte Nuovo towards the Castel S. Pietro and the hills circled by the medieval

crenellated walls, still to be seen today. The scene is bathed in the clear light of a late summer afternoon. The broad horizontal sweep of the canvas emphasises the sky and the river, with its boats and mills, and the shifting mirror-image of the houses and the 16th-century frescoes on the Palazzo Fiorio della Seta reflected in the water. This painting is pendant to the *View of Verona at the Ponte della Navi* (Gemäldegalerie, Dresden, inv. 605). With great originality Bellotto links the pair by presenting two opposing views seen from a central point, creating from the two a single huge panorama.

The two Dresden paintings are identical in size to two paintings of the same subjects (National Trust, Powis Castle; National Galleries of Scotland, Edinburgh), probably the last works Bellotto painted before his departure for Germany in 1747. The inscription on a drawing of the same view (Hessisches Landesmuseum, Darmstadt, inv. HZ 160) indicates that the two paintings must have been commissioned by an Englishman, but no further details are known. After his arrival in Dresden Bellotto repeated the compositions of this painting and its pendant using the Darmstadt drawing as a model. The works were presented to the royal collection in 1748, an act of overt homage to the new director of the Dresden gallery, Pietro Guarenti from Verona. Guarienti already knew Bellotto in 1745 (Marini, 1991) and was probably responsible for the painter's invitation to Dresden. By a curious twist of fate, the most modern and innovative views of Verona were unknown in that city and had no influence on local painting.                    G.M.

*Provenance: c.* 1748, presented by the artist to the royal gallery, Dresden
*Exhibitions:* Dresden and Warsaw, 1963, no. 2; Vienna, 1965, no. 7; Venice, 1967; Verona, 1990, no. 35
*Bibliography:* Fritsche, 1936, no. VG 27; Schumann, in Dresden and Warsaw, 1963, no. 2; Schumann, in Vienna, 1965, no. 7; Kozakiewicz, 1972, no. 99; Camesasca, 1974, no. 66; Brownell, in Verona, 1990, no. 35

## 255

BERNARDO BELLOTTO
*Moat of the Zwinger in Dresden*
1749–53
oil on canvas, 133 × 235 cm
Staatliche Kunstsammlungen, Gemäldegalerie Alte Meister, Dresden (inv. 609)

Many of the paintings Bellotto made during his first visit to Saxony in 1747 record the new urban developments in Dresden undertaken by the Elector Frederick August II. In this view, taken from the greenhouses of the royal orangery

and looking towards the city, the elegant Baroque pavilions of the Zwinger break the skyline; we can see part of the French pavilion and the long gallery, divided into two by the Kronentor and its wooden bridge. Behind the Kronentor is the Opera, almostly completely hiding the tower of the Kreuzenkirche in the Alte Markt.

Bellotto's strongly angled perspective lines draw the eye along the canal. Part of the city's ancient fortifications are reflected in the still waters of the moat; the new gardens and pavilions of the Zwinger shimmer in the crystalline air. With the immediacy of a photograph, Bellotto's draws the eye to passers-by standing near the canal, the coach crossing the bridge, couples lingering under the trees on the ramparts.

This is the chief painting in a series of four views of the Zwinger painted for the Elector's Gallery. Other versions are known: a smaller replica (Hermitage, St Petersburg, inv. 1341) and a later version (Federal Republic of Germany coll., see Ingelheim, no. 110) in which the two-storey building of the court laundry (built after 1752) appears on the far side of the bridge. Bellotto used this last painting in 1758 for one of the most handsome of his series of etched views of Dresden.                    G.M.

*Provenance:* 1753, presented by the artist to the Royal Gallery
*Exhibitions:* Dresden and Warsaw, 1963, no. 9; Vienna, 1965, no. 14; Venice, 1986, no. 4
*Bibliography:* Fritsche, 1936, no. VG57; Schumann, in Dresden and Warsaw, 1963, no. 9; Schumann, in Vienna, 1965, no. 14; Kozakiewicz, 1972, no. 157; Camesasca, 1974, no. 104; Walther, in Venice, 1986, no. 4

## 256

BERNARDO BELLOTTO
*The Fortress of Königstein*
1756–8
oil on canvas, 133 × 235.7 cm
National Gallery of Art, Washington
Patron's Permanent Fund, 1993.8.1

The painting is one of five large views of an ancient fortress near Dresden commissioned from Bellotto by Augustus III, King of Poland and Elector of Saxony. The panorama encompasses a broad expanse of the picturesque, craggy landscape known as 'Saxonian Switzerland', which Bellotto invested with a monumental quality rarely seen in 18th-century Italian painting. The great castle sits atop a mountain that rises precipitously from the Elbe River valley. In the distance on the left is the Lilienstein, one of the prominent sandstone formations scattered across the countryside.

Bellotto began working at Königstein in the spring of 1756. He was commissioned to paint five views of the interior and exterior of the fortress that were intended to complete his earlier views of Dresden (cat. 255) and Pirna in the royal collection. His work was interrupted when Frederick I of Prussia opened hostilities in the Seven Years War by invading Saxony in August 1756. It is thought that Bellotto completed the canvases by 1758, but none was delivered to the court and all five paintings were recorded later in the century in England, where two each remain in a private collection and in the Manchester City Art Galleries.                    E.P.B.

*Provenance:* 1756, commissioned by Frederick Augustus III, King of Poland and Elector of Saxony (*d.* 1763); Henry Temple, 2nd Viscount Palmerston (1739–1802); Henry John Temple, 3rd Viscount Palmerston (1784–1865), who gave it, perhaps to pay a debt, to William Lygon, 1st Earl Beauchamp (1747–1816), Madresfield Court, Worcestershire; thence by inheritance to Else, Countess Beauchamp (1895–1989); sale, Sotheby's, London, 11 December 1991, lot 18; Bernheimer Fine Arts Ltd and Meissner Fine Art Ltd, London. 1991–3
*Exhibition:* New York, 1992
*Bibliography:* Scharf, 1875, p. 10; Kozakiewicz, 1972, II, p. 183; Sotheby's, London, 1991, pp. 35–7; Bowron, 1993, pp. 1–14

## 257

BERNARDO BELLOTTO
*Architectural Fantasy with a Self-portrait*
*c.* 1766
oil on canvas, 153 × 114 cm
inscribed lower left: 'B. BELOTTO DE CANALETTO'; on the column to the left: 'PICTORIBUS / ATQUE POETIS / QUIDLIBER AUDENDI / SEMPER FUIT / AEQUA POTESTAS'
Royal Castle, Warsaw
On a long-term deposit to the National Museum, Warsaw (inv. DEP. 2438)

Against a background of fantastic architecture, caught in a theatrical light that creates a complex pattern of shadows, Bellotto shows himself dressed as a Venetian Procurator followed by a secretary and a servant. His declamatory gesture recalls paintings by official Venetian portrait painters, but also makes it appear to be a scene from a play, framed by the grandiose arch that opens onto the ellipsoid courtyard of a palace something like the Library of S. Marco. To give depth to the scene the perspective converges on the extreme left of the painting, underlining the spatial unity of the canvas and of its pendant, *Capriccio with the Expulsion of the Money-changers from the Temple* (Royal Castle, Warsaw), which

has a matching composition in reverse. The pairing of these two subjects is very surprising and has not been explained. Their importance to the artist is underlined by the three pairs of replicas that exist. It is impossible to arrange them in a chronological sequence. The key to Bellotto's message, which can be seen as a challenge to the viewer, may be contained in the quotation from Horace's *Ars poetica*, with the famous motto proclaiming the absolute liberty of the artist written on a piece of paper fixed to the right-hand column among torn theatrical posters. It is possible that the message was intended for members of the Dresden Academy, where a first version of the painting was exhibited in 1765. At that date, after the death of his patrons, Bellotto's position at court was becoming difficult and he determined to issue a declaration of aesthetic freedom against the rising tide of academic classicism. The architectural *capricci* of Bellotto's last years in Saxony seem to indicate his wish to reach a compromise between his innate realism and more decorative and idealised compositions in the new classicising taste. The first version of this composition is probably that in the Walter P. Chrysler Jr. Collection (*c.* 1767), followed by a version now in Milan; the Warsaw version shown here may have been made in January 1767 when Bellotto left Dresden intending to travel to Russia by way of Poland. The self-aggrandising self-portrait, in which he presents himself as a nobleman, could have been intended to impress Stanislaus Poniatowski, King of Poland, to whom it was presented, and at whose court in Warsaw Bellotto remained until his death.                G.M.

*Provenance:* 1767, probably taken from Dresden to Warsaw; perhaps in the collection of King Stanislaus Poniatowski the same year; 1798 bequeathed to Prince Joseph Poniatowski; 1914, collection of A. A. Kosen, St Petersburg; 1920s, State Collection, Warsaw; 1929, Royal Castle, Warsaw; 1939, National Museum of Art, Warsaw; 1994, Royal Castle, Warsaw
*Exhibitions:* Venice, 1955; Warsaw, 1956; London, Liverpool and York, 1957; Rotterdam, 1957; Lublin, 1960; Warsaw, 1962; Dresden and Warsaw, 1963–4; Vienna, 1965; Essen, 1966; Warsaw, 1968; Dresden, 1968; Gorizia, 1988, no. 30; Verona, 1990, no. 47
*Bibliography:* Fritsche, 1936, no. VG189; Kozakiewicz, 1972, no. 333 (with previous bibliography); Camesasca, 1974, no. 195; Bleyl, 1981, no. 53; Puppi, in Gorizia, 1988, no. 30; Marini, in Verona, 1990, no. 47

BERNARDO BELLOTTO
*Architectural Capriccio with an Equestrian Monument*
1764
pen and ink and wash on traces of pencil, 44.4 × 62.1 cm
inscribed (lower right, in brown ink): '*Bernardo Belotto/de Canaletto inv: et Fec: 1764*'
The Board of Trustees of the Victoria and Albert Museum, London (inv. E.30.1939)

This drawing and its pendant (cat. 259) are among the least known of all Bellotto's graphic work. Their technique and style, far removed from the immediacy of his preparatory drawings for paintings, is close to a group of perspective drawings, now divided between the museums of Warsaw and Darmstadt, dating from Bellotto's second sojourn in Saxony, from 1761 onwards. Two unfinished drawings of the same subject and of identical size (Warsaw National Museum, Rys. Pol. 2069, and Hessisches Landesmuseum, Darmstadt, AE2177) are preparatory to the drawings exhibited here and reveal Bellotto's careful planning of the perspective. Their explicitly theatrical qualities, with rigorous centralised perspective and flanking wings, may have some connection with Bellotto's appointment in 1764 as teacher of perspective at the Dresden Academy, the year to which these two drawings are ascribed. The compositions of these drawings are even more complex than those of his *capricci*; here he plays with a bewildering array of architectural motifs, many of them recognisable; they include the loggia of the Doge's Palace, which is placed on top of the portico of the Prison (on the left), the triumphal arch framing a circular temple, taken from an etching by Ricci (Bartsch, no. 10), the campanile of S. Francesco della Vigna, the cupola of the Salute and one end of the Biblioteca Marciana (on the right). The equestrian monument, on a plinth with figures of slaves taken from the statue of Ferdinando de' Medici in Livorno, recurs in identical form in a capriccio by Bellotto (State Museum of Western and Eastern Art, Kiev), and the figure of the horseman resembles the figure of August the Strong in the square of the Neustadt in Dresden. Another explicit reference to Venice are the gondolas by the *squero*, similar to the boats used during masked revelries on the Elbe; the tower on the gateway comes from a print published in 1740 from a design by the theatrical designer Giuseppe Galli Bibiena, who arrived at the court in Dresden in 1747, the same year as Bellotto.
    The drawing was not seen by Kozakiewicz, who knew of its existence only through a letter.                G.M.

*Provenance:* given by Miss A. Simonson in memory of her brother George A. Simonson
*Exhibition:* Ingelheim, 1987, no. 111
*Bibliography:* Kozakiewicz, 1972, no. Z.521; Ward-Jackson, 1980, no. 927; Ingelheim, 1987, no. 111

259

BERNARDO BELLOTTO
*Architectural Capriccio with the Dioscuri from the Capitol*
1764
pen and ink and wash over traces of pencil, 43.8 × 62 cm
inscribed (lower right, in brown ink): '*Bernardo Belotto | de Canaletto Inv: et Fec: 1764*'
The Board of Trustees of the Victoria and Albert Museum, London (inv. E.31. 1939)

Like its companion (cat. 258), this drawing plays games with a variety of architectural elements that Bellotto organises into a markedly theatrical whole. A river basin is crossed by an elaborate bridge surmounted by a triumphal arch on which the bronze horses from S. Marco can be recognised. Behind the façades of twin palaces reminiscent of Ca' Pesaro in Venice are elements taken from the architecture of Rome: the Tomb of Cestius, the dome of the Pantheon, a number of obelisks and Trajan's Column. In the foreground the pair of statues repeat the group of the Dioscuri on the Campidoglio, already painted by Bellotto several times in youthful views and *capricci*. A drawing (Darmstadt, inv. AE 2177) is a preliminary study for the perspective of this composition. Kozakiewicz (1972, no. 304) remarked on a certain technical aridity, which he attributed to the intervention of an assistant in Bellotto's studio; perhaps this was his son Lorenzo, who was helping his father with his teaching at the Academy at this time.                G.M.

*Provenance:* given by Miss A. Simonson in memory of her brother George A. Simonson
*Exhibition:* Ingelheim, 1987, no. 112
*Bibliography:* Kozakiewicz, 1972, no. Z. 522; Ward-Jackson, 1980, no. 926

260

BERNARDO BELLOTTO
*The Ruins of the Kreuzkirche, Dresden*
1765
oil on canvas, 80 × 110 cm
inscribed bottom centre: '*BERNAR: BELOTO DE CANALETTO. FEC. A MDCCLXV*'
Staatliche Kunstsammlungen, Gemäldegalerie Alte Meister, Dresden (inv. 638)
In 1760, during the Seven Years War, the Church of the Holy Cross (Kreuzkirche), the

oldest church in the city, collapsed under a violent bombardment from the Prussian artillery. Only the tower, already shown in many of Bellotto's paintings of the city, was left standing, although damaged. In June 1765, when restoration work was already in hand, the east side of the tower suddenly collapsed, leaving the dramatic vision of the building opened like a corpse. Bellotto had returned to Saxony from Vienna and Munich where he had gone to escape the war.

In this painting Bellotto assumes the lucid, objective eye of an historian, with surprising anticipation of modern painting. The emotional centre of the composition is the destroyed church, and the cold light reveals the chilling reality of the desolation of war. Probably the work was not commissioned, and, like its presumed pendant, *Ruins of the City of Pirna from the South-east* (Musée des Beaux-Arts, Troyes), it can be seen as an implicit denunciation by the painter of his predicament after the destruction of his house and the death of his patrons. The painting was exhibited the year it was painted at the Academy in Dresden, which bought it for 200 *Thalers*; this, the sources say, was on the grounds of compassion, despite the fact that the painter was made to provide his services for free. The faithful record of the event, here, as in the replica formerly at Warsaw and recently on the market, is made more explicit in the etching that Bellotto made the same year, whose inscription records that the view was taken from the room of the ecclesiastical supervisor, Dr Am Ende. A crowd is gathered around the new foundations; others peer curiously from the palace windows; Bellotto focuses on the workmen who are beginning to demolish the ruins on 1 July 1765, which serves as a *terminus post quem* for the painting.     G.M.

*Provennance:* 1765, bought by the Kunstakademie, Dresden; the same year, as the property of the royal family, it entered the Gemäldegalerie, Dresden
*Exhibitions:* Dresden and Warsaw, 1963–4; Vienna, 1965; Washington, New York and San Francisco, 1978, no. 10; Venice, 1986, no. 15; Amsterdam, 1990, no. 37
*Bibliography:* Fritsche, 1936, no. VG126; Kozakiewicz, 1972, no. 297 (with previous bibliography); Camesasca, 1974, no. 177; Walther, in Washington, New York and San Francisco, 1978, no. 10; *idem*, 1984, p. 105, no. 638; *idem*, in Venice, 1986, no. 15; Puppi, in Gorizia, 1988, pp. 211–12; Peeters, in Amsterdam, 1990, no. 37

## FEDERICO BENCOVICH
born Dalmatia or Venice, 1677
died Gorizia, 8 July 1753

Painter, draughtsman and printmaker. Apparently he trained with Cignani in Bologna *c.* 1695 and followed his master to Forlì, working with him in the Duomo. There the Orselli family commissioned his earliest known painting, *Juno* (1707; Palazzo Orselli Foschi, Forlì). He remained in Bologna, working with G. M. Crespi at the same time as Piazzetta, returning to Venice *c.* 1710–11, where he probably remained until 1716, but he may have also travelled to Milan, since the influence of Lombard painting is so strong in his work. Before 1715 he was commissioned to paint four works for the Gallery in Pommesfelden Castle, two of which survive (see cat 71). In 1716 he went to Vienna where he remained perhaps until 1724. He was in Milan in 1724, but returned to Venice to paint the altarpiece of the *Ecstacy of the Blessed Piero Gambacorta of Pisa* (1725–8; S. Sebastiano, Venice). In Vienna again in 1733, the year he was appointed court painter to the Bishop of Bamberg, Frederik Karl von Schönborn, in 1734 he was decorating the Bishop's Palace at Würzburg, although his work was substituted by Tiepolo's a few years later. Although he was successful and influential north of the Alps, Zanetti the Younger in *Della pittura* (1771) felt he had to defend Bencovich's reputation in Venice, whose style was already old-fashioned. For the last ten years of his life he lived in Gorizia.     O.T.

FREDERICO BENCOVICH
*Sacrifice of Iphigenia*
1715–19
oil on canvas, 182 × 287.5 cm
Germanisches Nationalmuseum, Nuremberg

This is one of four paintings commissioned from Bencovich by the Bishop of Bamberg, Frederik Karl von Schönborn, and painted in Venice before 1715; one other painting from the series survives, *Hagar and the Angel* (Graf von Schönborn, Pommersfelden). The painting is listed in an inventory published in 1719 of the works in Pommersfelden, which gives a *terminus ante quem* for its completion; from the inventory the canvas appears to have been used as a ceiling decoration in the Imperial apartment at Pommersfelden. Most critics have accepted the information except for Sitzman (1957), who gave the wrong location, Molè (1964), who described it as a *sopraporta*, and Martini (1964), who suggested it was painted while Bencovich was in Vienna.

Iphigenia was the daughter of Agamemnon, King of Mycenae, who could not set off to war against Troy because he had killed the sacred stag of the goddess Diana. The only way to propitiate the gods was to sacrifice his daughter. In the painting the young girl is shown waiting calmly for her slaughter. Bencovich invested the scene with an impending sense of anguish; the broken column foreshortened in the foreground draws the viewer into the composition, which is crammed into a confined space. To the tense, zig-zag arrangement of the figures, Bencovich added his dramatic use of colour; the sombre tonality is highlighted by patches of glowing colours.     O.T.

*Provenance:* commissioned for the Gallery at Pommersfelden
*Bibliography:* Byss, 1719; Pallucchini, 1961, pp. 63–5; Sitzman, 1957, p. 40; Molè, 1964, p. 305; Martini, 1964, p. 55; Kruckmann, 1988, pp. 1–18

## FRANCESCO BERTOS
active in Rome from 1693
died Passariano, 1738

Sculptor. He is first recorded in Rome in 1693, although no works are known from this period, or prior to it; in 1710 he is described as a sculptor working in Venice, but it is specifically mentioned that he was not Venetian by birth (the name Bertos may be of Spanish origin). Bertos clearly did settle in Venice and around 1724 was commissioned by Marshal Schulenburg to make a large group of bronzes, including an equestrian portrait of his patron (Haskell, 1980, ed. 1991, p. 312, n. 4; p. 314). He also made a number of sculptures for Zaccaria Sagredo (1653–1729).

In 1733 Bertos made a pair of bronze candlesticks for the Santo, Padua, which he had to replace in the following year after had been stolen; he also made a cross for the altar. All that remains today is the central stem of one of the candlesticks (Museo Antoniano, Padua). There are several signed works, both in marble and bronze, in Bertos's unmistakable, rather bizzare style. He made a number of allegorical pyramidal groups, and very high reliefs, in which the figures appear to be trying to escape from the fetters of their background. His style was subsequently imitated in marble by Agostino Fasolato (1712–after 1772), who collaborated with Danieletti. Bertos's predominantly secular œuvre enjoyed great popularity among the foreign, particularly British visitors to Italy. In 1737–8 he made some bronze groups for the Villa Manin, Passariano (Draper, 1986, pp. 163–5, n.1). P.W.

*Bibliography:* Zani, 1821, IV, p.15; Thieme-Becker, 1927, III, p. 510; Semenzato, 1966, pp. 58, 129; Sartori, 1976, p. 606; Haskell, 1980, ed. 1991 pp. 263–4, 312; Draper, 1986 pp. 163–5, n.1

### 59

FRANCESCO BERTOS
(?)*Calumny Carrying off Fame,* and (?)*Folly Supporting Spring*
*c.* 1710–25
bronze, each 57 × 23 × 24 cm (excluding later marble base)
Private Collection

These two unpublished two-figure statuettes, possibly representing *Calumny Carrying off Fame* and *Folly Supporting Spring,* are part of a group of eight very similar statuettes by Bertos. They are all on the same scale and of very similar dimensions. Two, perhaps depicting *Time Revealing Truth* and *Health Supporting Beauty,* were attributed by Bode to Pietro Tacca (sold R. Lepke's Kunst Auktion Haus, Berlin, 15 May 1917, lots 21, 22, pl. 4) before being correctly identified as the work of Bertos by Planiscig

(formerly in the Salomon Collection; see Planiscig, 1928–9, I, pp. 209–21). It would seem that the above groups were at some time in the 19th century in the same collection, or passed through the same dealer, since they all have identical, later, bronze base-plates.

The attribution of these groups to Bertos is confirmed by comparison with two now in the J. Paul Getty Museum, Malibu (inv. 85.SB.73.1–2), representing *Stupidity and Fortune* and *Industry and Virtue,* which are signed 'OPVS BERTOS'on top of their marble bases. Two other statuettes, on the identical type of marble bases complete with bronze swags, and also signed, were recently on the London art market. As indicated by the inscriptions on their bases, these two depict *Kindness and Gratitude* and *Intellect and Wisdom;* and like those in Malibu, each male figure stands on his right foot.

Although these eight two-figure statuettes evidently belong together, the lack of allegorical unity suggests that the series is either incomplete or that they may in fact have come from two different groups. The subjects suggested above for cat. 59 and the ex-Salomon groups must remain tentative, given Bertos's unorthodox interpretation of allegories. Variant forms of both *Calumny Carrying off Fame* and *Folly Supporting Spring* surmount the many figured groups (Getty Museum, Malibu).

The very small heads with their pointed features, set on short-waisted, muscular bodies,with slender, attenuated limbs are highly Rococo in form and idiosyncratic. While most of Bertos's bronzes, like so many Venetian bronzes, are inclined to be rather crudely filed and finished, this series of allegorical two-figure groups is exceptionally finely cast. P.W.

*Provenance:* by repute from Palazzo Sagredo, Venice
*Bibliography:* Lewy, 1927, pl. 28; Thieme-Becker, 1927, III, p. 510; Planiscig, 1928–9¹, pp. 209–21; *idem,* 1928–9², pp. 561–75; Lorenzetti and Planscig, 1934, p. 50, no. 241, fig. 84; Hildburgh, 1938, pp. 81–5; Oswald, 1955, pp. 1040–3; London, 1961, no. 201, pl. 32; Pope-Hennessy, 1963, ed. 1970, p. 393; *idem,* 1964, cats. 708–11, figs. 699–702; Wardell and Davidson, 1966, pp. 178–89; Watson, 1976, p. 22, fig. 7; Haskell, 1980, ed. 1991; Radcliffe, in Washington, 1985, no. 250; Draper, 1986, pp. 163–5, n.1; Malibu, 1986, nos. 248–9; Penny, 1992, I, p. 44

## ANDREA BRUSTOLON
born Belluno, 1662
died Belluno, 1732

Sculptor and woodcarver. He went to Venice aged 15 in 1677 when, at his father's insistence, he entered the workshop of the Genoese sculptor Filippo Parodi (1630–1702), resident in the city to execute one of his most scintillating ensembles, the tomb of the Patriarch Francesco Morosini in the church of S. Nicola da Tolentino. Brustolon must also have studied closely the bizarre creations of the woodcarver Francesco Pianta (*c.* 1632–92) in the Scuola Grande di S. Rocco. In 1679 he went to Rome for about a year. Although in the past it has been stated that he returned to Venice before moving definitively to Belluno in 1695, recently the length and importance of this second Venetian sojourn has been questioned. One of his most important works was the suite of 40 pieces of furniture known as the Fornimento Venier from the name of the Venetian patrician family that commissioned it. It would seem that the suite was executed over a long period, the pieces being sent to Venice from Belluno. In his native Dolomite area, Brustolon worked mainly for ecclesiastical patrons. Outstanding examples of his work are found in far-flung churches and oratories, the most impressive being the Altar of the Poor Souls in the church of S. Floriano, Pieve di Zoldo (1685). His fully mature style is evident in the six statues executed for Count Tiopo Piloni (1722–7). D.G.

### 18

ANDREA BRUSTOLON
Porcelain stand in the form of Hercules conquering the Hydra and Cerebus, with river-gods and Nubian slaves ('*La Forza*')
*c.* 1700
boxwood and ebony, 2 × 1.67 m
inscribed on base: '*Petri Venerii iussu – Andreas Brustolon – fecit*'
Ca' Rezzonico, Venice

This forms part of Brustolon's most celebrated work, the suite of 40 pieces of furniture (Ca' Rezzonico, Venice) known as the Fornimento Venier after Pietro Venier, who commissioned it. The suite consists of exuberantly carved armchairs (which were widely imitated), and stands for Chinese porcelain, changed by the artist's fancy into Nubian slaves and allegories of the Seasons and the Elements. Brustolon indicated the importance of this stand – it is certainly the most complex object of the series – by inscribing his name and that of the patron on the base. There is a preparatory drawing for the Hercules conquering the Hydra and Cerebus (Museo Civico, Belluno) at an early stage; the positions of the mythological beasts are reversed compared to the finished stand.

Although Biasuz dated the entire suite to the years immediately after Brustolon's return to Venice from Rome, the discovery of the date '1706' on one of the free-standing Nubian slaves suggests that the suite was executed over a period of 24 years, the finished pieces being sent from Belluno to Venice. Stylistic elements also suggest that much of the suite was fashioned at the turn of the 18th century. Brustolon's mature style is almost entirely based on the late, visionary style of Parodi of the mid-1680s and 1690s in the chapels of the Arca and the Tesoro (Santuario delle Reliquie) in the Basilica del Santo, Padua. Brustolon's highly charged interpretation of Parodi's style is evident in the allegories of the Seasons and the Elements.

The choice of ivory and mother-of-pearl for the Nubian slaves indicates that, while he was in Rome, Brustolon had seen in Palazzo Colonna the pair of monumental *scrigni* supported by crouching giants and natives with feathered head-dresses in those materials, one of which was designed by Carlo Fontana and executed, in part, by Franz I and Dominikus Stainhart between 1678 and 1680.                    D.G.

*Provenance:* commissioned by Pietro Venier di San Vio; thence by descent to Count Girolamo Contarini (son of Maria Venier, the last of her family); 1838, left by him with the entire complement of porcelain to the city of Venice; Accademia di Belle Arti; R. R. Gallerie; 1911, transferred to Museo Correr; exhibited in Ca' Rezzonico
*Bibliography:* Persicini, 1882, p. 22; Morazzoni, 1927, p. 42, pl. XIV; Lorenzetti, 1940, p. 36; Mariacher, 1965, 27–31; Semenzato, 1966, pp. 47, 48, 116; Biasuz and Buttingon, 1969, pp. 46–7, figs. 29–30; Alberici, 1980, pp. 162–84; Gonzalez-Palacios, 1986, I, pp. 319–24; Lucco, 1989, no. 21, pp. 53–4, ill. p. 208

## GIOVANNI BATTISTA BRUSTOLON
born Venice, 1712
died Venice, 1796

Printmaker. According to Moschini he trained in the studio of the engraver Josef Wagner and frequented the studio of Pietro Antonio Novelli. From 1730 he engraved portraits, religious subjects and book illustrations. His most famous work was several series of engravings after Canaletto (cat. 150), commissioned by the publisher and book-seller Ludovico Furlanetto.          R.B.

### 150

GIOVANNI BATTISTA BRUSTOLON
*Festivals of the Doge: the Bucintoro leaving S. Nicolò di Lido*
*c.* 1763–6
etching and engraving, first edition of three, 44.4 × 57 cm (plate)
inscribed lower margin: *Sacris in D. Nicolai Templo rite peractis, apertoque sibi solemni ritu mari, Sereniss Princeps in aureâ navi ad Urbem redit./ Antonius Canal pinxit. – Jo, Bap. Brustolon inc./ Apud Ludovicum Furlanetto supra Pontem vulgo dicttum dei Baretteri Cum Privilegio Excellentissimi Senatus./No. 6*
National Gallery of Art, Washington
Ailsa Mellon Bruce Fund, 1981.88.1

The central event of the Ascension Day ceremony was the elaborate Wedding of the Adriatic, when the Doge cast a gold ring into the waves to symbolise the marriage of the Venetian Republic to the sea. The mass at S. Nicolò on the Lido marked the end of the ceremonies. The subject is one of the Ducal Ceremonies and Festivals from the set of twelve *Feste Ducali* etched by Brustolon after drawings by Canaletto (see cat. 149, 151). Eight of the prints were offered for sale by subscription in March 1766, although the first print was yet to be published. Evidently the subscription was successful, and in May of that year when the publisher Ludovico Furlanetto presented a petition to the Reformatori dello Studio di Padova (the authority in the Venetian Republic that granted publishing privileges) for the privilege of publishing the set of Ducal Festivities, the number was increased to twelve, the complete set. The twenty-year privilege was granted on 6 August 1766. Although such festivals were popular with visitors, and a series of festivities and ceremonies based on drawings by the famous Canaletto must have proved an appealing souvenir, the etchings were slow in being realised. A subscription offer dated Venice, 6 August 1768, attached to the set of Ducal Festivities (Marciana, Venice) states that only four etchings had been completed by that date (Succi, 1983, p. 88). Brustolon closely followed Canaletto's preparatory drawing (cat. 149) for the etching. The difficult task of reproducing the different tonalities of the master's wash effects is accomplished with variations of line and the use of crosshatching, in addition to multiple acid bitings on controlled parts of the copperplate. Closely spaced shell-like lines intended to simulate the water of the lagoon are less successful; the expanse of water appears lifeless compared to the sparkle of Canaletto's etching *La Torre di Malghera* (cat. 143). The original copperplates for the etchings are in the Correr Museum, Venice.          R.B.

*Bibliography:* Moschini, 1924, pp. 144, 170; Alpago-Novello, 1939–40, pp. 559–60; Pallucchini, 1941, p. 60; Gallo, 1941, pp. 39–40; Watson, 1950, pp. 291–2; Gallo, 1956–7, pp. 1–10; Pignatti, 1972, no. 6; Pignatti, 1975², no. 144, pp. 41–68; Succi, in Gorizia and Venice, 1983, pp. 81–93; Constable rev. Links, 1989, pp. 525–7, no. 635, pp. 673–4

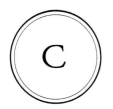

# C

GIOVANNI ANTONIO CANAL, known as CANALETTO
born Venice, 28 October 1697
died Venice, 19 April 1768

Painter, draughtsman and printmaker. His family was entitled to use a coat of arms, an inverted chevron, which he frequently used as a signature. He began his career in the studio of his father, Bernardo, a painter and designer of theatrical scenery. He first worked with his father designing stage scenery for operas performed in Venice during 1716–18. The pair also made the scenery for two operas by Alessandro Scarlatti, *Tito Sempronico Greco* and *Turno Arcino*, performed at the Teatro Catranica during the Carnival in Rome in 1720. Returning to Venice, Canaletto was inscribed in the Register of the Venetian Painters' Guild in 1720; this marks the beginning of his career as a view-painter. Canaletto's first known patron was the theatrical impresario Owen McSwiney, who introduced Canaletto to an English clientele by commissioning him and other Venetian artists to paint a series of allegorical tomb paintings commemorating distinguished Englishmen. The project was financed by the 2nd Duke of Richmond who, in 1727–8, with McSwiney acting as intermediary, purchased two paintings of the Grand Canal from the artist. From about 1729–30, Consul Joseph Smith became Canaletto's chief patron. Canaletto's set of 31 etchings *Vedute, Altre prese da i Luoghi altre ideate, . . .* (Views, Some representing actual sites, others imaginary) was published on the occasion of Smith's appointment as British Consul in 1744 and was dedicated to him. Smith acted as intermediary for Englishmen on the Grand Tour eager to acquire Canaletto's views of Venice and festival subjects. Canaletto's trip to the Venetian mainland with his nephew Bernardo Bellotto during the early 1740s resulted in numerous sketches and drawings, a few paintings of the countryside, and in addition provided subjects for etchings. In 1746, during the War of the Austrian Succession (1740–8), when fewer tourists visited Venice, Canaletto came to England. He stayed for nine years, drawing and painting views from nature, mainly of the Thames, but also painted some country houses. On his return to Venice in 1755, he continued his career as painter and draughtsman. Around 1763 he was commissioned to execute a series of twelve elaborate drawings to record festivals of the Doge for reproduction by a professional engraver. He was elected to the Venetian Academy in 1763, only five years before his death. In 1762, Consul Smith sold his unrivalled collection, the most comprehensive single group of Canaletto's work, to George III; it arrived in London the year of Canaletto's death.

R.B.

## 133

CANALETTO
*London: The Thames with Westminster Bridge in the Distance*
1746–7
oil on canvas, 188 × 238 cm
Roudnice Lobkowicz Collection, Prague

Canaletto took a sweeping view down the river from a raised viewpoint on the south bank of the River Thames. Westminster Bridge, with the parapet not quite completed, crosses the river in the far distance. The bridge was first opened for foot passengers and horses on 20 July 1746. In the right foreground is Lambeth Palace surrounded by trees in full leaf. On the left bank of the river, from left to right, are the church of St John the Evangelist, Westminster Abbey, Westminster Hall, the spires of various churches and on the extreme right, St Paul's Cathedral. The painting is the pendant to *The Thames on Lord Mayor's Day looking towards the City* (Roudnice Lobkowicz).

R.B.

*Provenance:* c. 1752, purchased with its companion in London from an unknown source by Ferdinand Filip Prince of Lobkowicz, Duke of Sagan, later of Prague
*Bibliography:* Dvořák and Matejka, II, 1910, xxvii, no. 343, p. 86; Constable, 1923, p. 283; Šafařik, 1961; Constable, rev. Links, 1989, no. 426

## 134

CANALETTO
*Rio dei Mendicanti: looking South*
1720–5
oil on canvas, 143 × 200 cm
Ca' Rezzonico, Museo del Settecento Veneziano, Venice (inv. cl. I, 2326)

One of Canaletto's earliest paintings, this monumental view shows, uncharacteristically, a scene that does not include any of the landmarks known to tourists. Seen at left, from near the Fondamenta Nuove, the Fondamenta dei Mendicanti, with the church of S. Lazzaro and the Ospizio dei Mendicanti. There a blind man with a stick gropes his way along the wall. Beyond is a wooden bridge, the Ponte del Cavallo. The crumbling plaster of the houses at right, festooned with laundry hanging out to dry, promises little comfort to the inhabitants within. In front of the *squeri*, the wooden sheds of the boat-builder's yard, a gondola is about to be launched. Movement is created on the canal by wide, undulating strokes of loosely handled paint around the oar of the gondola at left, accentuated by a burst of light on the shadowed water. The gondola, of a type used by patricians, is shown leaving the Fondamenta close to the church of S. Lazzaro; its passenger wears a wig and robe which identify him as a person of high rank. Canaletto never returned to this quiet backwater of Venice. The intimacy of the scene would find most favour with someone familiar with the setting, and it seems unlikely that the view was his personal choice.

This is one of a group of four paintings of the same size and in the same style, all formerly in the Liechtenstein collection: *Piazza S. Marco: looking East along the Central Line* and *Grand Canal: looking East, from the Campo di S. Vio* (both Thyssen-Bornemisza Coll., Madrid; C/L 1 and 182); *Grand Canal: looking North-east from the Palazzo Balbi to the Rialto Bridge* (Mario Crespi, Milan; C/L 210). Although all the paintings attributed to Canaletto now or formerly in the Liechtenstein collection are said to have been acquired from Canaletto by Josef Wenzel, Prince of Liechtenstein (1696–1772), Vincenzo Fanti's description of the collection of 1767 records no paintings by Canaletto. Twelve smaller canvases are mentioned in a 1780 catalogue of the collection of Franz Josef I, Prince of Liechtenstein (1726–87). In the 1927 guide to the Liechtenstein collection, fourteen paintings by Canaletto are listed, but only eight are of the size given in the 1780 catalogue. It would seem that the Canalettos entered the collection at various dates.

R.B.

*Provenance:* 1927, Liechtenstein, no. 191; Mario Crespi, Milan; Ca' Rezzonico, Venice
*Exhibitions:* Milan, 1955, no. 10; Venice, 1967, no. 45; Venice, 1982, no. 81; New York, 1989, no. 4
*Bibliography:* Moschini, 1954, p. 14, pl. 2 (colour), figs. 4, 5; Zampetti, in Venice, 1967, no. 45; Bettagno, in Venice, 1982, no. 81; Puppi, 1983–4, pp. 5–16; Pedrocco, in Gorizia, 1986, pp. 31–2, fig. 12; Constable, rev. Links, 1989, no. 290; Baetjer and Links, in New York, 1989, no. 4

CANALETTO, with GIAMBATTISTA PIAZZETTA and GIOVANNI BATTISTA CIMAROLI
*Allegorical Tomb of John, Lord Somers*
*c.* 1726
oil on canvas, 279.4 × 142.2 cm
Private Collection, on loan to Birmingham Museums and Art Gallery

This is one of a series of 24 large allegorical tomb paintings made to commemorate the leading figures in England of the Protestant cause and the Whig settlement. They were commissioned between 1721 and 1729–30 by the Irishman Owen McSwiney, a bankrupt impresario living in Venice who had obtained patronage for the project from the Duke of Richmond (see cat. 37). Canaletto collaborated on another painting in the series: *Allegorical Tomb of Archbishop Tillotson* (private collection; C/L 517) together with Giovanni Battista Pittoni and Giovanni Battista Cimaroli.

In the foreground lie the robe, mace, woolsack and purse of the Lord Chancellor of England, and the sword of the Sergeant-at-Arms; they allude to Somers's Lord Chancellorship (1697–1700) under William III. The tomb to the right is surmounted by allegorical figures of Justice and Peace. In the centre of the composition a bishop is borne towards the tomb surrounded by a group of ecclesiastics. Presumably, these represent the Seven Bishops. although only two are shown wearing mitres. Lord Somers (1651–1716), early in his legal career, appeared as junior counsel at the Trial of the Seven Bishops on 29–30 June 1688, when his erudition and, in particular, his final plea led to their release. For this achievement he was held to be a hero of the Whig party. The bishops (who included the Archbishop of Canterbury, William Sancroft) had defied James II by refusing to have his Declaration of Indulgence (granting Catholics and Nonconformists freedom of worship) read in churches throughout the land. As a consequence, James had them imprisoned in the Tower. Their acquittal led to popular rejoicing and was another blow to the cause of James II, who was replaced by William III later that year.

In a letter to the Duke of Richmond, dated 8 March 1726, McSwiney wrote 'That of Ld Somers is a sacrifice or Religious Ceremony (at his monument) in acknowledgment of the service done the Church, for his pleading the cause of the Bishops etc. The perspective and landscape are painted by Canaletto & Cimeroli. The figures by Geo. Battista Piacotta' (*sic.*: Piazzetta). The feathery foliage at the top of the painting seems characteristic of Cimaroli, who is represented in the Royal Collection by three oval landscapes acquired by George III with the collection of Consul Smith. Who was responsible for the figures of the ecclesiastics in the centre of the composition is more difficult to decide. In the opinion of the present writer these figures are not by the same hand as the figures of Justice and Peace on top of the tomb and those on either side of the painting which are undoubtedly the work of Piazzetta. How Cimaroli and Canaletto divided the work is unknown. Canaletto appears to have had the largest share in the project, and the tomb and ruins in the far background correspond to the free brushwork of his earliest works. It is uncertain whether the Duke of Richmond ever acquired the painting; it is not included among the ten tomb paintings in the dining-room at Goodwood described by Vertue in 1747, and engraved and published in London in 1741. The painting might have been among the tomb paintings purchased from McSwiney by Sir William Morice in 1730.        R.B.

*Provenance:* 2nd Duke of Richmond (?) or Sir William Morice 1730 (?); sold perhaps late 18th century; London art market; *c.* 1880, Earl of Plymouth; The Viscount Windsor, Shropshire
*Exhibitions:* Birmingham, 1953, no. 165; Toronto, Ottawa and Montreal, 1964–5, no. 1; Venice, 1982, no. 78; Washington, 1985–6, no. 171; New York, 1989, no. 13; Birmingham, 1993–4, no. 1
*Bibliography:* Vertue 1747, III, and V, p. 149; Watson, 1953[1], pp. 205–7; Watson, 1953[2], pp. 362–5; Constable, 1954, p. 154; Levey, 1964, nos. 459–61; Constable, in Toronto, Ottawa and Montreal, 1964–5, *Dictionary of National Biography* (Somers, John); Hill, 1980, pp. 170–1; Mariuz, 1982, no. 32; Daniels, in Venice, 1982, no. 78; Russell, in Washington, 1985–6, no. 171; Constable rev. Links, no. 516; Baetjer and Links, in New York, 1989, no. 13; Farington, in Birmingham, 1993–4, no. 1

CANALETTO
*A Regatta on the Grand Canal*
1733–4
oil on canvas, 77.2 × 125.7 cm
Lent by Her Majesty The Queen (inv. 404416)

The regatta held on the Grand Canal during the Carnival season just before Lent was one of the most colourful displays of Venetian pageantry. Palazzo Balbi is seen in the left foreground, the Rialto Bridge, partially visible, in the far distance, and beyond it SS. Giovanni e Paolo. A rapid sketch, *Grand Canal: The Palazzi dei Mocenigo and others* (Courtauld Institute Galleries, London; C/L 589), probably made on the spot, shows the palaces on the right in outline. At the extreme left is the *macchina*, the temporary floating structure from which prizes were distributed to the winners at the end of the regatta. The coat of arms of Doge Carlo Ruzzini (reg. June 1723–Jan. 1735) is shown above the columns, surmounted by a Doge's hat. A contest between single gondoliers is in progress. Their course is lined with gondolas and elaborately decorated *bissone*, the eight or ten-oared boats belonging to prominent Venetian families.

This subject was etched by Antonio Visentini with the title *Nauticum Certamen cum Prospectu ab Aedibus Balborum, ad Pontem Rivoalti*. It was included as number thirteen in the first edition of the series consisting of fourteen etchings published in 1735 under the auspices of Joseph Smith. The title-page describes them as etchings after paintings by Canaletto in the possession of Joseph Smith and displayed in his house in Venice. The series was subsequently enlarged to 38 etched views of the Grand Canal, none of which was reversed. Two preparatory drawings by Visentini for the etching are in the Museo Correr, Venice, and the British Museum, London.        R.B.

*Provenance:* Joseph Smith, Venice (no. 104 in his MS catalogue at Windsor); 1763, sold to George III; Kew Palace; 1828, Windsor
*Exhibitions:* London, 1946–7, no. 439; London, 1964, Venice, 1967, no. 64; London, 1980–1, no. 19; New York, 1989, no. 43
*Bibliography:* Cust, 1913, I, p. 153; II, p. 276; Collins Baker, 1937, p. 28; Watson, 1949, p. 16, pl. v; Levey, 1953, XCV, pp. 365–6; *idem*, 1962, pp. 267–8; *idem*, 1964, no. 396; Zampetti, in Venice, 1967, no. 64; Constable, rev. Links, 1989, no. 347; Baetjer and Links, in New York, 1989, no. 43

CANALETTO
*The Grand Canal from near Palazzo Corner to the Palazzo Contarini*
*c.* 1733–5
pen and brown ink over pencil and much pin-pointing; some ruling in pencil and pen,
27 × 37 cm
Lent by Her Majesty The Queen (inv. RL 7470)

In the right foreground, Palazzo Corner della Cà Grande (now the Prefettura) and in the middle distance, Palazzo Pisani. At left, on the other side of the Canal, Palazzi Da Mula and Barbarigo; in the distance, to the right of Palazzo Contarini, the tower of S. Maria della Carità which collapsed in 1741. Drawn with vigorous hatched lines, this composition is one of a group of highly finished pen and ink drawings of the Grand Canal, of approximately the same size and similar in technique (C/L 584, 586, 588, 590, 599). Pin-pointing and ruling in pencil and pen demonstrate that the free and natural effect of the drawing did not preclude Canaletto's careful study of perspective. Eight drawings, made on the spot with location notes, from Canaletto's sketch-book in the Accademia, Venice, provided the material for this finished drawing. Sketches 13*v*, 14, 12*v*, 13, 11*v*, 12, 10*v*, 11, form a continuous panorama for the buildings from left to right. (Pignatti, 1958, p. 33).

This atmospheric drawing provides insight into Canaletto's working method whereby sketches made on the spot were used as the basis for the drawings finished in his studio. There, aided by his exceptional visual memory, he created seemingly spontaneous views. Artists have frequently employed illusionistic effects when evoking the real world, and Canaletto, no exception, drew views that encompassed more than the eye can see from any one viewpoint.

R.B.

*Provenance:* Joseph Smith, Venice; 1763, bought by King George III
*Exhibitions:* Venice, 1962, no. 9; London, 1980–1, no. 55; Venice, 1982, no. 11
*Bibliography:* Hadeln, 1930, 22 (wrongly identifying the Palazzo Corner as the Palazzo Regina); Parker, 1948, no. 18, pl. 27; Pignatti, 1958, p. 33; *idem*, 1970, no. xvii; Miller, in Venice, 1982, no. 11; Constable rev. Links, 1989, no. 585

CANALETTO
*The Doge Visiting the Scuola di S. Rocco*
*c.* 1735
oil on canvas, 147 × 199 cm
The Trustees of the National Gallery, London (inv. 937)

To commemorate St Roch's deliverance of Venice from the plague in 1575–6, a decree was passed that the Doge should attend mass annually at the church of S. Rocco on the Saint's day, 16 August, accompanied by the Signoria, the Senate and the Diplomatic Corps. At the extreme right, members of the Doge's entourage are leaving the church under the shadow of an awning. To the left of the church is the Scuola Grande di S. Rocco. A number of paintings are shown leaning against the ground-floor wall of the School: on the Saint's day, an open-air show of works of art by contemporary and past artists was held around the church. Here Canaletto is, above all, a painter of figures. The Doge, in gold robes beneath the shade of the ceremonial parasol, is preceded by the scarlet-robed *Cancelliere Grande*. The three leading figures in the left foreground wearing mauve robes are, as Michael Levey has suggested, probably secretaries. They are followed by the Doge's chair-bearer and cushion-bearer. On the Doge's right is, probably, the Guardiano Grande of the Scuola; at his left the doyen of the Ambassadors (Levey, p. 24). Behind the Doge is carried the Sword of State. The bright nosegays of flowers held by the Doge and other members of his company were presented by officials of the confraternity of St Roch and are the symbol of protection against the plague; the garlands that decorate the windows of S. Rocco and the portal of the church apparently have the same significance.

R.B.

*Provenance:* Littlehales, sold London, 2 March 1804, no. 37, described as 'From the Vatican', bought Joubert; B. Booth, sold London, 31 May 1809, no. 99, bought Thomas Johnes; 1815, at Hafod (Johnes's house); 1833, perhaps sold with house to Duke of Newcastle; bought 1853 Wynn Ellis; 1876, bequeathed to the National Gallery, London
*Exhibitions:* British Institution, London, 1853, no. 173, as *Festival of St Luke*; Royal Academy, London, 1871, no. 236, as *Procession of the Doge*; Toronto, Ottawa and Montreal, 1964–5, no. 23
*Bibliography:* Berenson, 1894, p. 97; Ferrari, 1914, pl. 8; Watson, 1949, p. 16, pl. vi; Moschini, 1954, p. 26, pl. 17, figs. 110–13; London, 1956, pl. 5; Constable, in Toronto, Ottawa and Montreal, 1964–5, no. 23; Levey, 1971, pp. 24–6; Constable, rev. Links, 1989, no. 331

CANALETTO
*The Riva degli Schiavone: looking West*
1736
oil on canvas, 122 × 201 cm
By courtesy of the Trustees of Sir John Soane's Museum, London (inv. P66.HR)

This unusual view of the basin of St Mark's is taken from a point on the Riva di S. Biagio east of the Ponte dell' Arsenale. In the distance, outlined against the sky, the Doge's Palace, the campanile of S. Marco, the Dogana and S. Maria della Salute; at the extreme left, the dome and façade of S. Giorgio Maggiore with its onion-shaped steeple, erected 1726–8. The old façade of the church of the Pietà is in the mid-distance; reconstruction began in 1745. A drawing of the *Bacino di S. Marco: from the Piazzetta* (Her Majesty The Queen; C/L 577), may have served as a preliminary sketch. A viewpoint from the Riva di S. Biagio served for another version *Riva degli Schiavoni: looking West* (Gemäldegalerie, Vienna; C/L 121) and two drawings: *Riva degli Schiavoni: looking West* (Kupferstichkabinett, Darmstadt; C/L 575) and *Riva degli Schiavoni: looking West* (Her Majesty The Queen; C/L 576). The broad expanse of the *bacino* is crowded with sailing vessels, working boats and gondolas. In the foreground a fishing-boat is pushed away from the quay. A three-masted vessel with slackened sails freely painted with broad, fluid strokes sparkles in the sun. On the sunny quay on the right, minutely described men and women are painted in luminous colours. A man scrutinises the wares on a stall covered by a tattered canvas. Two women on the vine-covered balcony of the house on the right watch the scene below.

R.B.

*Provenance:* 1736 Marshal von Schulenburg (100 *sequins* paid in advance, total cost, 120 *sequins*); 1775, Schulenburg sale, Christie's, bought in at 199 guineas; Calonne, sold 23 March 1795, Skinner, London, no. 85 (as *View on the Grand Lake at Venice*), 165 guineas; William Beckford, Fonthill, sold 24 August and previous days 1807, Phillips, 150 guineas; bought Sir John Soane
*Bibliography:* Farington, ed. 1922–8, under 28 August 1807; Waagen, 1854, II, p. 321; Bolton, 1920, p. 79; Whitley, 1928, p. 129; Watson, 1949, p. 19, fig. 15; Moschini, 1954, fig. 70

## 140

CANALETTO
*The Bacino di S. Marco: looking East*
*c.* 1738
oil on canvas, 124.5 × 204.5 cm
Museum of Fine Arts, Boston
Abbott Lawrence Fund, Seth K. Sweetser Fund,
and Charles Edward French Fund, 39.290

This sweeping view of Venice depicts more than
the eye can see from any one viewpoint. It is
taken from at least two points on the quay
surrounding the Dogana, or Customs House.
From the Campanile on the left, the panorama
extends along the Molo and the Riva degli
Schiavoni to the church of S. Nicolò di
Castello, now demolished. In the right middle
distance rises theatrically the island of S. Giorgio
Maggiore with its famous Palladian church, next
to the imposing pink façade of the monastery.
Further right, the northern tip of the Giudecca
with the church of S. Giovanni Battista
(demolished). In the distance, the island of S.
Elena with its Gothic church now a ruin, and
on the horizon line the tree-lined Lido. The
*bacino* is crowded with craft, from gondolas and
working boats to sailing-boats flying the flags of
Venice, Great Britain, France and Denmark.
Shadowy reflections cast by the boats contrast
with the shimmering turquoise water of the
lagoon, which is rippled by Canaletto's swift,
rounded strokes graduating from almost pure
white down to the shades of the water beneath.
The boats and figures are described in a variety
of free brushstrokes and colours. There is less
freedom in the painting of the sailing vessels,
where the lines of the masts and manifold ropes
apparently were painted wth the aid of a
maulstick. In the vast expanse of space, the
transparent air of Venice is held fast, permitting
the viewer to read clearly the architectural details
seen in the distance.                          R.B.

*Provenance:* Earls of Carlisle, Castle Howard,
Yorks. The date of aquisition is uncertain; it
may have been bought together with other
Canalettos by the 5th Earl (1748–1825), who
travelled in Italy in 1768, by his father, the 4th
Earl (1694–1758), or by the 3rd Earl (1674–
1738); 1939, Museum of Fine Arts Boston
*Exhibitions:* London, 1929, no. 10; Leeds, 1936,
no. 18; New Haven, 1940, no. 5; Toronto and
Ottawa, 1964–5, no. 18; Venice, 1967, no. 71;
Venice, 1982, no. 85; New York, 1989, no. 51
*Bibliography:* Waagen, 1854, III, p. 323;
Browning, 1905, p. 340; Constable, 1929, p. 46;
Constable, 1939, p. 47; Moschini, 1954, p. 28,
pl. 18, fig. 127; Constable, in Toronto and
Ottawa, 1964–5, no. 18; Zampetti, in Venice,
1967, no. 71; Pignatti, 1970, p. 7; Byam Shaw,
in Venice, 1982, no. 85; Bettagno, 1983, nos. 1–
2, pp. 222–8; Constable rev. Links, 1989, no.
131; Baetjer and Links, in New York, 1989,
no. 51

## 141

CANALETTO
*View of a River, possibly at Padua*
*c.* 1745
oil on canvas, 49.5 × 83 cm
Private Collection, USA

An annotated panoramic sketch and two
finished drawings, as well as an etching, all relate
to this view of the mainland. The buildings and
campanile on the far bank of the river closely
follow the sketch from nature, now on two
sheets, but possibly once joined, both called
*Panoramic View of Houses and Gardens by a River,*
*perhaps at Padua* (Pierpont Morgan Library, New
York; C/L 695b; Fogg Art Museum,
Cambridge, MA, C/L 695 a and b). Two
finished drawings from Consul Smith's
collection, both entitled *Footbridge over a River at*
*Padua (?)* (C/L 696, fig. 42 and C/L 697) are
related to the left half of the painting. However,
they differ considerably from the painting, not
only in size and detail but also in character. The
exact location of the scene is unknown.
Constable suggested it was a view at Padua. My
identification of the campanile as that of S.
Rocco at Dolo on the Brenta (Bromberg, 1974,
rev. 1993, pp. 9–10) is based on the similarity of
the campanile seen on the extreme left of the
sketch (C/L 695b) with that of two etchings,
titled by Canaletto, *Al Dolo* (Bromberg 4) and
*Ale Porte del Dolo* (Bromberg 5). A recently
discovered pencil sketch, *View of Dolo* (Vivian,
1989, no. 39) on the verso of the drawing *A*
*Footbridge over a River at Padua (?)* (C/L 697 see
above), also links Dolo to this painting. The
Dolo sketch is in turn related to the preparatory
study *Dolo and the Brenta* (C/L 669) for the
etching titled by Canaletto *Al Dolo* (Bromberg
4). The etching *View of a Town on a River Bank*
(Bromberg 9) shows the painting in reverse; the
background is based on the same preliminary
sketch but the foreground is closer to the
drawings from Consul Smith's collection.
While the print presents a rustic scene with
timber-strewn foreground, fishermen and a mule,
the painting shows an idealised landscape and
different figures; a young woman crosses the
bridge and a well-dressed couple stroll with a
dog. Stylistically, I date the etching to 1741. The
picture appears to be of a later date, painted in
the studio.                                    R.B.

*Provenance:* Sir John Foley Grey, Bart., sold 15
July 1928, Christie's, no. 128; bought Savile
Gallery; Mark Oliver, London; Private
Collection, Washington
*Exhibitions:* London, 1932, no. 3 as Bellotto;
London and Birmingham, 1951, no. 10;
London, 1954–5, no. 10; Toronto, Ottawa and
Montreal, 1964–5, no. 72; New York, 1989, no.
58

*Bibliography:* Watson, in London and
Birmingham, 1951, no. 10; Constable, in
Toronto, Ottawa and Montreal, 1964–5, no. 72;
Constable, rev. Links, 1989, no. 377; Baetjer
and Links, in New York, 1989, no. 58

## ETCHINGS

*They consist of 31 prints of views, some from nature,*
*others imaginary. Although the exact date of publication*
*is unknown, the title-page with the dedication to*
*'Giuseppe Smith Console di S.M. Britanica'*
*establishes a date after 6 June 1744, when Joseph*
*Smith, Canaletto's patron, was appointed British*
*Consul. Canaletto's signature is inscribed on all the*
*prints, but only those views that are from nature, be*
*they Venice or the mainland, are inscribed with his own*
*titles. Imaginary views were not titled. Canaletto began*
*to etch around 1735. Only one of the etchings is dated,*
*the* Imaginary View of Venice (Undivided
Plate) *(cat. 145). It is inscribed 1741, but etchings in*
*a different style were made earlier.*            R.B.

## 142

CANALETTO
*The Portico with the Lantern*
*c.* 1741
etching, state 2 of 3 (Bromberg 10),
29.5 × 42.6 cm (plate)
Staatliche Museen Preussischer Kulturbesitz
Kupferstichkabinett, Berlin (inv. Sign. 2131 E)

This is the earliest and finest extant set of
etchings by Canaletto. The prints are bound in
an 18th-century leather album with the gold-
embossed coat of arms of Anton Maria Zanetti
the Elder. The series was, in fact, dedicated to
his friend and rival collector, Consul Joseph
Smith. In addition to the 31 prints comprising
the published series, the album contains seven
unpublished etchings, representing either rare or
unique states. Among these is an impression of
the rare *Imaginary View of Venice (Undivided*
*Plate)*, part of the album when it was made
(Bromberg, 1974 rev. 1993, pp. 19–21). For
another impression see cat. 145.

The album is open to show an imaginary
view, *The Portico with the Lantern*. Below the
central span of a three-arched portico, a lantern is
suspended in sharp outline against a blank area
in an otherwise covered sky. Dense vertical and
horizontal strokes on the portico, and additional
crosshatching on the ground, provide dramatic
shadow to the foreground, where light is reflected
only on the architectural fragment at right and
on the outer pillar and the ground on the left. In
the sunny landscape beyond, a classical temple, a
triumphal arch and a canopied bishop's tomb

are arranged arbitrarily close to an essentially Venetian building with chimney-pots and a roof-terrace. Above the door of the house is Canaletto's coat of arms, a cartouche carrying an inverted chevron, which he used at times as a signature.

On the edge of the bright patch of ground below the left portico pillar, long, sunlit blades of grass reveal an innovation in the etching process. Normally the blades of grass would appear as black lines silhouetted against the white ground. But here a thick white 'line' appears beside the thin black line, giving the effect of sunlit blades. It was achieved by drawing the grass with stopping-out varnish on the copper plate to prevent the acid from biting. The minute lines of the surrounding area were then drawn with the etching needle up to the outline of the blades of grass (Bromberg, 1974, rev. 1993, p. 11).                    R.B.

*Provenance:* Sir Charles Robinson (Lugt 1433); 1902, acquired by the Staatliche Museen
*Exhibitions:* Same subject, different repository London, 1974, no. 10b (Courtauld); London 1980–1, no. 101, third state (Her Majesty The Queen); Venice, 1982, no. 132 (Courtauld); Auckland, Wellington and Christchurch, 1986, no. 10 (Courtauld); London 1993, no. 59/2, third state (Her Majesty The Queen)
*Bibliography:* Haskell, 1963, p. 371; Bromberg, 1974, no. 10b; *idem*, in Venice, 1982, pp. 89–101, no. 132; *idem*, in Auckland, Wellington and Christchurch, 1986, pp. 19, 22, 23, 49, no. 10; *idem*, 1974, rev: 1993, no. 10; Schulze Altcappenberg, in Berlin, 1994, no. V. 57

## 143

CANALETTO
*La Torre di Malghera*
*c.* 1742
etching, state 2 of 3, 29.5 × 42.7 cm (plate)
National Gallery of Art, Washington
Gift of W. G. Russell Allen, 1941.1.172

Two fishermen in the water near the shore are digging for eels. Canaletto achieved a great sense of luminosity by using horizontal, widely spaced strokes that cover the plate, in contrast to small and more densely worked areas such as the landing-stage. Curved lines indicate the ruffled waters of the lagoon where a *sandalo* (flat-bottomed craft) with two fishermen glides across the foreground. A different tonality is achieved by the close oblique lines depicting the distant Euganean hills. Canaletto's primary concern is with light and shade: the tower of Malghera (now Marghera), which is largely unworked, is seen in brilliant light against the sky. The etching is one of seven large titled views from nature resulting from Canaletto's trip to the

mainland with his nephew Bernardo Bellotto during the early 1740s. A painting of the same subject, *Torre di Malghera* (C/L 369), follows the etching almost exactly. It, together with other similar paintings, is sometimes attributed to Bellotto.Canaletto's etchings were conceived as independent and original works of art; Constable noted that 'no authentic painting by Canaletto can be shown to precede any related etching, although there are a number of paintings, by no means all of them wholly by Canaletto, which follow etchings (C/L p. 650).                    R.B.

*Exhibitions:* Same subject, different repository, London, 1974, no. 2 (Courtauld); Venice, 1982, no. 119 (Courtauld); Auckland, Wellington and Christ Church, 1986, no. 2 (Courtauld)
*Bibliography:* Bromberg, 1974, no. 2; *idem*, in Venice, 1982, pp. 89–101, no. 119; *idem*, in Auckland, Wellington and Christchurch, 1986, pp. 23, 26, 32, 33, no. 2; *idem* 1974 rev: 1993, no. 2

## 144

CANALETTO
*Le Porte di Dolo*
*c.* 1743–4
etching, state 2 of 3, 29.8 × 42.7 cm (plate)
watermark: Triple Crescent
Mrs Ruth Bromberg

By contrast to other Canaletto etchings where attention is focused on architecture and views, the human figure plays a major part in this painterly composition, with its dramatic effect of light and shade. It is one of seven large titled views from nature resulting from Canaletto's trip to the mainland with his nephew Bernardo Bellotto during the early 1740s. The scene is set at the oval-shaped locks of Dolo, a town on the Brenta, with a *burchiello*, the type of passenger-barge that plyed the Brenta between Venice and Padua, moored at the quay. On the quay a vendor displays fruit on a table, and there are three figures with wares in baskets. Under the shadowy archway the butcher in his shop is surrounded by carcasses and a diminutive lace-maker in front of the shop provides contrast to the leisurely elegant couple strolling in the foreground.

In this print, executed at the very end of Canaletto's etching career, he wielded the needle expertly, displaying virtuoso strokes of varying form and intensity. Canaletto reached the full potential of the medium with this most painterly image of striking contrasts. This particularly brilliant impression is the only known example to bear the identical triple crescent watermark apart from those on impressions in Anton Maria

Zanetti the Elder's album. It is the only etching for which a preparatory sketch exists, with some differences in the figures and other details: *Le Porte del Dolo* (priv. coll.; C/L 668) in pen and brown ink over red chalk. A related drawing, *Dolo: A Sluice-gate on the Canal* (Her Majesty The Queen; C/L 667) shows the butcher's shop in the same position as in the etching, but the house with the shield stands on the right. A similar view appears on an etching of the series *Le Delicie del fiume Brenta* (II/XII) by G. F. Costa, Venice, 1750 (see cat. 154). The painting *The Lock at Dolo* (Ashmolean, Oxford; C/L 371) is based on the etching.                    R.B.

*Exhibitions:* Same subject, different repository London, 1974, no. 6 (Courtauld); Venice, 1982, no. 127 (Courtauld); Auckland, Wellington and Christchurch, 1986, no. 6 (Courtauld)
*Bibliography:* Bromberg, 1974, no. 6; *idem*, in Venice, 1982, pp. 89–101, no. 127; *idem*, in Auckland, Wellington and Christchurch, 1986, pp. 22, 23, 25, 40–1, no. 6; *idem*, 1974, rev. 1993, no. 6, watermark no. 9, p. 212

## 145

CANALETTO
*Imaginary View of Venice* (Undivided Plate)
dated 1741
etching only state, 29.7 × 43.5 cm (plate)
National Gallery of Art, Washington
Ailsa Mellon Bruce Fund, 1971.30.5

Canaletto's only dated etching suggests a panoramic view of Venice and the lagoon, although no attempt is made to provide a topographically accurate setting. Canaletto's real subject is his concern with the effect of light and shade. Close horizontal strokes on the water and closely spaced, mainly short vertical strokes, on the house with the peristyle and the *squeri* (boat-sheds) cast deep shadows in the centre area and on the lagoon beyond. Sharp contrast is provided at left, where widely spaced squiggly lines leave unworked areas to reflect light in the foreground, on the brilliantly lit house with the inscribed date, and on the stone walls and church dome beyond. A burst of sun, on the upper part of the ruined wall at right, balances the composition. Canaletto subsequently cut the completed etching in half, and the two separate prints were included in the published series. Impressions before the division, such as this, are extremely rare; only eight examples are recorded. A drawing is related to the central portion of the etching: *Roofs and Houses near the Lagoon* (C/L 665; Fogg Art Museum, Cambridge, MA). R.B.

*Exhibitions:* Same subject, different repository, London, 1974, no. 12 (Courtauld); Venice,

1982, no. 136 (Courtauld); Auckland, Wellington and Christchurch, 1986, no. 12 (Courtauld)
*Bibliography:* Bromberg, 1974, no. 12; *idem*, in Venice, 1982, pp. 89–101, no. 136; *idem*, in Auckland, Wellington and Christchurch, 1986, pp. 20, 22, 23, 52–3, no. 12; *idem*, 1974, rev. 1993, no. 12

## 146

CANALETTO
*The City of London Seen through an Arch of Westminster Bridge*
*c.* 1747–50
pen and brown ink with grey washes over pencil, 29 × 48.5 cm
Lent by Her Majesty The Queen (inv. RL 7561)

The view of the skyline stretching from the wooden water-tower of the York Buildings' Waterworks on the left, to St Paul's Cathedral on the right, is framed by the arch of Westminster Bridge which had just been completed in 1747. Canaletto evidently took the drawing back to Venice when he left England in 1750. An almost identical drawing (Albright Art Gallery, Buffalo, NY) differs only in small details and is probably earlier. Both drawings relate to a painting of a similar view *London: Seen through an Arch of Westminster Bridge* (Duke of Northumberland). This shows the arch still supported by wooden centering with a bucket suspended from the right-hand side, suggesting that work was still in progress. A print engraved by Remigius Parr after a drawing by Samuel Wale that was based on Canaletto's painting and published by the bookseller J. Brindley, London, 1747, was dedicated Sir Hugh Smithson who commissioned the painting, and was one of the Commissioners of the new Westminster Bridge. R.B.

*Provenance:* Joseph Smith, Venice; 1763, sold to King George III
*Exhibitions:* London, 1919, no. 10; London, 1929, no. 28; London, 1959, no. 50; Venice, 1962, no. 44; London, 1964, no. 133; London, 1974, no. 113; London, 1980–1, no. 88; Venice, 1982, no. 55; Birmingham, 1993–4, no. 7
*Bibliography:* Finberg, 1920–1, pp. 29, 71; Hadeln, 1930, 30, pl. 45; Parker, 1948, no. 119, pl. 77; Moschini, 1954, plate 246; Pignatti, 1970, no. xlix; Miller, in Venice, 1982, no. 55; Constable rev. Links, 1989, no. 732; Farington, in Birmingham, 1993–4, no. 7

## 147

CANALETTO
*Architectural Fantasy*
*c.* 1762
pen and ink and grey wash over traces of black lead and some stylus underdrawing, 36.5 × 52.6 cm
Lent by Her Majesty The Queen (inv. RL 7564)

This imaginary architectural view is a virtuoso exercise in the art of perspective. It could hardly have been achieved without the aid of a preliminary drawing. The traces of black lead and stylus underdrawing, in addition to some ruled pen and pencil lines, suggest that a carefully planned preliminary study, now lost, once existed for this composition. The brilliant drawing with double- and treble-washing, executed near the end of Canaletto's career, was probably one of the last to be acquired by Consul Smith before the sale of his collection to George III. The staircase and the colonnade of the loggia bring to mind the Scala dei Giganti in the courtyard of Palazzo Ducale and the Procuratie Nuove (Corboz). Canaletto's coat of arms, an inverted chevron on a shield, juts out on the upper right of the loggia. He sometimes used it as a signature; a similar cartouche appears on the etching *The Portico with the Lantern* (cat. 142). Beyond the terrace, swift freehand strokes of ink delineate the lagoon crowded with fishing-boats and ships. On the far right in the distance rise two buildings which may be loosely based on the Dogana and S. Maria della Salute. R.B.

*Provenance:* Joseph Smith, Venice; 1763 sold to King George III
*Exhibitions:* Venice, 1962, no. 50; London, 1980–1, no. 96; Venice, 1982, no. 63; New York, 1989, no. 118
*Bibliography:* Parker, 1948, no. 141, p. 88; Pignatti, 1970, no. lxiii; Miller, in Venice, 1982, pp. 50–1, no. 63; Miller, 1983, p. 39, no. 50; Corboz, 1985, p. 299; Constable, rev. Links, 1989, no. 821; Baetjer and Links, in New York, 1989, pp. 340–1, no. 118

## 148

CANALETTO
*Capriccio with Colonnade*
*c.* 1765
oil on canvas, 131 × 93 cm
signed and dated lower left: '*Anton . . . 1765*'
Gallerie dell'Accademia, Venice

Canaletto received recognition in his native city late in life; he was elected Academician in 1763, only five years before his death. This painting, signed and dated 1765 (the signature now only partly legible), was presented by him to the Venetian Academy after his election, as was the custom. It is one of the rare paintings by Canaletto to have remained in Venice. The capriccio apparently enjoyed fame and in 1777, after his death, it was exhibited in Canaletto's honour in Piazza S. Marco during the Festa della Sensa on Ascension Day. The painting was engraved and published by Wagner in 1799; another engraving was published by Zanotto in 1832. A drawing, *Capriccio: A Colonnade opening onto the Courtyard of a Palace* (in the Albertini Collection, Rome in 1941; C/L 822) agrees closely with the painting. A sheet, *Four Architectural Sketches* (Correr Museum, Venice; C/L 626 (c)), rapidly sketched and inscribed in dialect by Canaletto '*per la cademia*' (for the Academy) is apparently connected to a first idea for the design.

This is usually decribed as a capriccio, although Corboz (1982, 1985) noted that the courtyard has affinities with that of the Ca' d'Oro and has suggested the scene is not pure invention. He also pointed out the similarity of the doorway on the landing of the staircase with a design by Carlo Rainaldo for Palazzo Grillo in Rome, engraved in both a volume on architecture and one on perspective, published in 1702, with which Canaletto would have been familiar. Yet, similar courtyards are found in other Venetian palaces, and may have lingered in Canaletto's memory. In Canaletto's painterly world, the real and the imagined were never far apart. A lace-maker works on her *tombola* at the right and the crouching street-vendors display their baskets with wares to casual passers-by. These are lively portrayals that could easily have found their place in other paintings, or in his etchings. R.B.

*Provenance:* Presented by Canaletto to the Accademia Veneziana di Pittura e Scultura after his election on 11 September 1763; Gallerie dell'Accademia
*Exhibitions:* Paris, 1919, no. 7; Venice, 1982, no. 116; New York, 1989, no. 85
*Bibliography:* Zanetti, 1792, II, p. 599; Moschini, 1815, p. 573; Fogolari, 1913[2], pp. 261, 286; Ferrari, 1914, pl. 20; Watson, 1949, p. 10; Moschini, 1954, p. 48, pl. 26, fig. 277; Moschini Marconi, 1970, pp. 8–9, no. 13; Nepi Sciré, in Venice, 1982, pp. 87–8, no. 116; Corboz, in Venice, 1982, pp. 102–4; Corboz, 1985, pp. 329, 387; Constable, rev. Links, 1989, no. 509; Baetjer and Links, in New York, 1989, pp. 276–7, no. 85

FESTIVALS OF THE DOGE

*The initiative for the commission of a series of twelve drawings of Festivals of the Doge might have been sparked by the investiture of Doge Alvise IV Mocenigo, elected in 1763. His coat of arms appears on the drawing of the Giovedì Grasso Festival (cat. 151), and some sets of the etched series of twelve Ducal Festivities are preceded by his portrait (by Nazario Nazari, engraved by Marco Pitteri). The precision and coherence of the elaborate drawings, uniform in size and character and surrounded by ruled ink lines, suggest that they were made especially for the engraver. The drawings were commissioned by the publisher and bookseller Ludovico Furlanetto to be engraved by Gioranni Battista Brustolon (see cat. 150). The inscription on each etching, 'Antonius Canal pinxit' and 'Jo. Bap. Brustolon inc.', has been the subject of much speculation, particularly since Francesco Guardi made twelve paintings of the subjects. However, since no paintings of these scenes are known to have been made by Canaletto, the term* pinxit *appears to have been loosely applied by an engraver and Canaletto, in fact, provided drawings. Of Canaletto's twelve drawings only ten have been traced, all of which were bought by Sir Richard Colt Hoare in Venice, according to family records, in 1787.* R.B.

CANALETTO

*Festivals of the Doge: The Bucintoro leaving S. Nicolò di Lido*

*c.* 1763

pen and brown ink over traces of graphite with grey washes and many small touches of white heightening, 38.6 × 55.7 cm

National Gallery of Art, Washington

Samuel H. Kress Collection, 1963.15.5

After the ceremony of the Wedding of the Adriatic, the Doge attended Ascension Day mass at S. Nicolò on the Lido, from where he returned to Venice (see cat. 150 for a description of the ceremony). The *Bucintoro* (state-barge) with a large flag is seen in the background leaving the quay, surrounded by elaborately decorated gondolas and a variety of boats. In the foreground glides a gondola manned by two gondoliers; the occupants wear the traditional Venetian carnival domino, a black hooded cloak and white mask worn with a black tricorn hat. The highly accomplished use of wash and the squiggly calligraphy are typical of Canaletto's late manner. More unusual is the employment of white heightening on the present drawing and on cat. 151 with which Canaletto created subtle variations of intensity. A pen sketch in outline, *The Lido: The Waterfront* (Fogg Art Museum, Cambridge, MA; C/L 652a, b), giving a diagrammatic view of the Lido waterfront near S. Nicolò, was used for the buildings in the drawing. The awning in front of the portal of the church, erected for the Ascension Day ceremony and clearly visible on the finished drawing, is faintly indicated on the sketch. A painting of the same subject by Francesco Guardi (Louvre, Paris) differs from Canaletto's drawing and from the etching but is slightly closer to the latter. Brustolon's etching after this drawing is no. 6 in the series of twelve (see cat. 150). R.B.

*Provenance:* 2 June 1883, Stourhead Heirlooms sale, no. 31; bought Knowles; Colnaghi; Henry Oppenheimer, sold 10 July 1936, Christie's, no. 44; bought Bellesi; R. Owen, Paris; Samuel Kress; National Gallery of Art
*Exhibitions:* London, 1911, no. 74; Washington, Fort Worth and St Louis, 1974–5, no. 104; Washington, 1978, p. 76; Venice, 1982, no. 69
*Bibliography:* Colt Hoare, 1822, p. 75; Constable, 1938, p. 20, pl. 26; Hadeln, 1930, no. 15; Pignatti, 1970, no. lx; *idem,* in Washington, Fort Worth and St Louis, 1974–5, no. 104; Washington, 1978, p. 76; Bettagno, in Venice, 1982, no. 69; Constable, rev. Links, 1989, pp. 525–7, no. 635

CANALETTO

*Festivals of the Doge: The Piazzetta*

*c.* 1763

pen and brown ink with grey washes over graphite, heightened with white, 38.1 × 55.3 cm

Ratjen Foundation, Vaduz (inv. R.933)

Lavish entertainment was provided for the feast of Maundy Thursday, the Festa del Giovedì Grasso, just before Easter. Above the crowd in the Piazzetta, a youth descends a rope from the top of the Campanile to the seat of the Doge, in the centre of the loggia of the Doge's Palace, and presents him with flowers and poetic compositions. This was known as the Flight of the Turk or the Columbine. In the middle of the Piazzetta, an elaborate temporary construction from which fireworks were set off, bears the coat of arms of Doge Alvise IV Mocenigo. Near it on a platform is a human pyramid, a gymnastic display known as the *Forza d'Ercole* (the strength of Hercules). This elaborate drawing of the crowded Piazzetta is skillfully conceived; the foreground figures are observed with great detail and in some places two or three washes are superimposed. A painting of the same subject by Francesco Guardi (Louvre, Paris, C/L 636(a)) differs in details from Canaletto's drawing and the etching by Brustolon, but follows the etching a little more closely. A painting of the subject (Wallace Collection, London; C/L 330 vii.i) attributed to Canaletto differs considerably from Canaletto's drawing and the etching. Brustolon's engraved title on the etching of the Giovedi Grasso Festivities, no. 7 in the series, describes the festival as the commemoration of an ancient victory. R.B.

*Provenance:* 2 June 1883, Stourhead Heirlooms sale, no. 32; Davis: Rothschild family (probably Baron Meyer de Rothschild), Mentmore; Earl of Rosebery; sold Sothebys, 11 Dec. 1974; Colnaghi; private collection, Munich
*Exhibitions:* Venice, 1967, no. 83; Venice, 1982, no. 70; New York, 1989, no. 122
*Bibliography:* Colt Hoare, I, 1822, p. 75; Watson, 1949, p. 20, fig. 29; Moschini, 1954, pp. 48–50; Zampetti, in Venice, 1967, no. 83; Constable rev. Links, 1989, no. 636; Baetjer and Links, in New York, 1989, no. 122

## ANTONIO CANOVA

born Possagno, Treviso, 1 November 1757
died Venice, 13 October 1822

Sculptor, painter and designer. He was born into a family of stonemasons working in the Treviso area. He received his early training from his family, and at the age of ten joined the studio of Giuseppe Bernardi, known as Il Torretto (1694–1774), and moved with him to Venice; there he studied plaster casts and antique sculpture in the gallery of Filippo Farsetti and attended drawing classes at the Academy. The success of his sculpture *Dedalus and Icarus* (fig. 68), exhibited in 1779, enabled Canova to make study tours to Rome and Naples the following October. In Rome he lived in the Palazzo di Venezia, with the ambassador Girolam Zulian; there he met Pompeo Batoni, Gavin Hamilton, Francesco Piranesi and other members of the rising international Neo-classical movement. His *Theseus on the Back of the Minotaur* (1783) made him a celebrity in Rome; his funeral monuments to Pope Clement XIV (completed 1787) and Clement XIII (1783–92), which revived the Baroque tradition of funeral sculpture, gave him international renown, and led to commissions throughout Europe. Canova organised his studio with great efficiency, and soon a series of works comparable to the greatest sculpture of antiquity began to issue from it. He was hailed as the greatest sculptor of his time. In the 1790s he became more active as a painter. When Venice fell after the French invasion Canova was tempted to escape to America, but instead returned to Possagno, later going to Vienna where he had been commissioned to carve the *Funeral Monument for Maria Christina of Austria* (1798–1805), his most original sculpture. When he returned to Rome he completed the statues of the *Pugilists* for the Vatican Museum to replace the antique statues requisitioned by the French. In 1802 he took up the post of Inspector-General of Antiquities and Fine Art of the Papal State, previously held by Raphael. This prestigious position provided him with two trips to Paris, where he met Napoleon and was able in 1815 to recover the works of art looted by the French from Rome. The Bonaparte family gave him some of his most exacting commissions. He was invited to visit London to study the Parthenon marbles brought from Greece by Lord Elgin, and for the first time saw the sculpture of Phidias, recognising in it the achievement he had been striving for all his life: the breathing of warmth and life into marble. In London he was commissioned to carve the Stuart Cenotaph, unveiled in 1819 in St Peter's, Rome. Other works of this period include the lost *Monument to Washington* (1817–21), *Endymion* and a series of idealised heads. He died at the height of his fame, and was buried with full state honours, where his obsequies assumed a patriotic significance. G.M.

### 284

ANTONIO CANOVA
*Eurydice*
1775
Vicentine stone, 203 × 54 × 56 cm
inscribed (on the base, from Virgil's *Georgics*, IV.494): '*Quis me miseram, et te perdidit Orfeu? Virg:*'
Museo Civico Correr, Venice (inv. cl. XXV, 1073)

*Orpheus* (cat. 285) and *Eurydice* are among the few sculptures that survive from Canova's time in Venice before he moved permanently to Rome. They owe a great deal to the fashion in the Veneto for garden sculpture and are carved in the characteristic soft stone of Vicenza, warm in colour and opaque; their surface is very different from the gleaming marble surfaces of the artist's mature works. The statues were commissioned by the Venetian senator Giovanni Falier for his villa near Asolo, and were displayed with other sculptures carved by Canova's first teacher, Giuseppe Bernardi. All represented mythological lovers, which explains the strong sense of a dialogue between the couple. Their melodramatic gestures are Baroque in style, and reminiscent of Bernini, whose work Canova may have known from plaster casts in the Galleria Farsetti in Venice; the two statues express the vitality that is fully revealed later in *Dedalus and Icarus* (1777–9; fig. 68). Eurydice is portrayed according to Ovid (*Metamorphoses*, Book X) at the moment when she reaches out in desperation towards Orpheus, but is restrained by the hand of one of the Furies emerging from the flames of Hades. A model for *Eurydice* was made from life in Venice and the full-size sculpture was then executed at the Villa Falier, probably in 1775. G.M.

*Provenance:* Villa Falier, Predazzi di Asolo; 1954, Museo Correr
*Exhibitions:* Treviso, 1957; Venice, 1978, no. 75; Venice, 1992, no. 17
*Bibliography:* Pavanello, 1976, no. 5; *idem*, in Venice, 1978[1], no. 75; *idem*, in Venice, 1992[2], no. 117

### 285

ANTONIO CANOVA
*Orpheus*
1775–6
Vicentine stone, 203 × 85 × 54 cm
inscribed (on the base, from Virgil's *Georgics*, IV.491–2): '*Omnis effusus labor*'
Museo Civico Correr, Venice (inv. cl. XXVV, 1072)

*Orpheus* was executed in 1775–6 in Canova's studio in the cloister of the church of S. Stefano. It was commissioned by senator Giovanni Falier, for whom he had just completed *Eurydice* (cat. 284). Even more than *Eurydice*, *Orpheus* can be viewed from all sides, important for a statue to be studied in the open air. Orpheus is portrayed just as, with a desperate gesture, he turns around and thus loses Eurydice for ever after having rescued her from Hades by the enchantment of his music. The statue still shows the influence of late-Baroque sculpture. Even in the small *Apollo*, Canova's entry for his election to the Academy in 1779, there are obvious references to Bernini's group, of which there was a copy in Farsetti's collection. A preparatory study for *Orpheus* is in a sketchbook with handwritten notes and a translation of verse by Ovid, now in the possession of the Falier family in Venice. The subject was very popular at the time: in January 1776, the opera *Orpheus and Eurydice* by Ranieri de' Calzabigi was performed in Venice, and an excerpt from it was repeated during the Fiera della Sensa the following year, when Canova's statue was first exhibited to the public, meeting with great success. Canova's continuing link with the theme of these juvenile works is also illustrated by his choice of the emblems of the lyre and the serpent – which refer to the myth of Orpheus – for the coat of arms of the marquisate of Ischia, conferred on him by Pius VII in 1816, 'in memory', he wrote to Falier, 'of my first pieces of sculpture which marked the start of my public career'. In 1777 Canova made a marble replica of *Orpheus*, generally thought to be the statue in the Hermitage, St Petersburg. G.M.

*Provenance:* Villa Falier, Predazzi di Asolo; 1954, Museo Correr
*Exhibitions:* Treviso, 1957; Venice, 1978, no. 76; Venice, 1992, no. 118
*Bibliography:* Pavanello, 1976, no. 6; *idem*, in Venice, 1978[1], no. 76 (with a bibliography); *idem*, in Venice, 1992[2], no. 118

ANTONIO CANOVA
*Modello* for a *Monument to Titian*
*c.* 1795
terracotta and wood, 124 × 136 × 35 cm
inscribed: 'TITIA – VECELIO – PICT./MDCCVC'
Gallerie dell'Accademia, on deposit at the
Museo Civico Correr, Venice

The evolution of the design for the tomb of
Titian, commissioned from Canova in 1790, is
documented by a series of *bozzetti*. The tomb
was intended to be erected in the church of the
Frari, but was abandoned in 1795 on the death
of Gerolamo Zulian, the principal promotor of
the scheme, who when Venetian ambassador to
Rome in the early years of the 19th century was
Canova's first protector. From the start, Canova
associated the funerary theme with the pyramid,
to which in his first two *modelli* (Gipsoteca,
Possagno, nos. 69–70) he added a sarcophagus
with a personification of Art in mourning
similar to the figure of Temperance on the tomb
of Clement XIV in SS. Apostoli, Rome. In
this *modello* he used the pyramid of Caius
Cestius in Rome as his prototype, with an open
door towards which a funeral cortège makes its
way. The dead Titian is represented by a portrait
in a wreath held up by winged figures, while the
theme of meditation on death is emphasised by
the dark portal and the mourning figures. A few
years later, the same design was used with
minimal variations for the tomb of Maria
Christina of Austria, commissioned in August
1798 by her husband, Duke Albert von Saxen
Teschen. That in turn, served as the model for
the tomb of Canova himself in the Frari in
Venice, erected by his pupils in 1827.     G.M.

*Provenance: c.* 1835 given by Canova's brother to
G. Zardo Fantolin; 1847, Zoppetti Collection,
Venice; 1849, donated by Domenico Zoppetti to
the Museo Civico Correr
*Exhibitions:* London, 1972, no. 311; Venice,
1978, no. 114; Venice, 1992; no. 82
*Bibliography:* Honour, in London, 1972, no. 311;
Pavanello, 1976, no. 74; *idem,* in Venice, 1978[1],
no. 114 (with bibliography); *idem,* in Venice,
1992[2], no. 82

ANTONIO CANOVA
*Teaching the Ignorant*
1795–6
plaster, *c.* 117 × 127 cm
inscribed (on the pupil's slate): '*A.C./Pos./1796*'
Museo Civico Correr, Venice

ANTONIO CANOVA
*Feeding the Hungry*
1795–6
plaster, *c.* 117 × 127 cm
Museo Civico Correr, Venice

These two reliefs, which were never carved in
marble, share the theme of 'acts of mercy', which
Canova interpreted in a manner and style that is
more symbolic than narrative. The moral and
didactic content of the reliefs, which mirror each
other compositionally, was in keeping with the
ideas of the patron; they were probably ordered
by Abbondio Rezzonico, patron and friend of
Canova, to be incorporated in a free school
founded by him near Bassano where they were
exhibited in the early years of the 19th century
according to contemporary accounts. Here the
extreme compositional simplicity reaches an
almost primitive candour. A drawing related to
the same theme as the reliefs is in Album F8 at
the Museum at Bassano del Grappa (no. 1,755).
As well as these two casts, others seem to have
been made from the same moulds: Gipsoteca
Canoviana, Possagno (Bassi, 1957, nos. 78, 79);
Musee des Beaux-Arts, Dijon (Honour, 1972,
no. 330); formerly Palazzo Sambonifacio, Padua
(Pavanello, 1984, p. 153), and Istituto
Finlandese di Cultura, Rome. In *Feeding the
Hungry,* the blind old man leaning on a stick
later appeared as one of the mourners in the
funeral cortège on the Tomb of Maria Christina
of Austria, commissioned in 1798.     G.M.

*Provenance:* Correr
*Exhibitions:* Venice, 1978, no. 92; Venice, 1992,
nos. 112–13
*Bibliography:* Honour, in London, 1972, no. 330;
Pavanello, 1976, nos. 92–3; *idem,* in Venice,
1978[1], no. 92 (with bibliography); Stefani, 1990,
pp. 68–9; Pavanello, in Venice, 1992[2], nos.
112–13

ANTONIO CANOVA
*Male Nude (Creugas)*
1794
pen and grey ink over graphite on white paper,
45.3 × 31.5 cm
inscribed (handwritten, on the original mount):
'*In segno di vera stima per la Nobil Sig.ra Francesca
Capello | Antonio Canova fece questi quattro segni
Roma 1794*'
Museo Civico Correr, Venice (inv. cl. III,
5934)

This is a preparatory study for one of Canova's
best-known works, *Creugas* (Vatican Museums,
Rome), executed between 1795 and 1801. The
artist was reworking themes taken from his study
of antique sculpture, which he pursued
passionately from the moment of his arrival in
Rome. In particular it has affinities with the
*Dioscuri* in the Quirinale. Paying as much
attention to anatomy as to his heroic theme, the
sculptor takes his subject from Pausanias's
description of the duel to death of the two
warriors, Creugas of Durazzo and Damoxenos
of Syracuse at the Nemean Games. The marble
*Creugas* had not been commissioned but was
acquired by Pope Pius VII for the Vatican
Museums where, with Canova's *Perseus,* it was
placed to fill gaps left by the sculptures removed
by the French. Its success assured Canova's
fame. The drawing is dated 1794 in the
sculptor's own hand and dedicated to Francesca
Cappello, wife of the then Venetian ambassador
to Rome.     G.M.

*Exhibitions:* Venice, 1978, no. 100; New York,
1985; Venice, 1985, no. 102; Weimar, 1987;
Trent, 1990, no. 44; Venice, 1992, no. 20
*Bibliography:* Bratti, 1917, p. 436; Pavanello, in
Venice, 1978[1], no. 100; Romanelli, in Venice,
1985, no. 102; *idem,* in Trent, 1990, no. 44;
Dorigato, in Venice, 1992[2], no. 20

ANTONIO CANOVA
*Male Nude (Damoxenos)*
1794
pen and grey ink over graphite on white paper,
44.6 × 31.5 cm
inscribed (handwritten on the original mount):
'*In segno di vera stima per la Nobil Sig.ra Francesca
Capello | Antonio Canova fece questi quattro segni
Roma 1794*'
Museo Civico Correr, Venice (inv. cl. III,
5935)

This drawing, like its pendant (cat. 289), is
dated 1794 and was dedicated by Canova to the
wife of the Venetian ambassador to Rome. It is
the first sketch for the statue of *Damoxenos*
(Vatican Museums, Rome) commissioned by the

papal authorities as soon as they had acquired *Creugas.* Although a plaster model was made *c.* 1802, the sculpture itself was not completed until 1806. Many drawings intervened between this sketch and the sculpture, a number of which, dated between November 1794 and June 1796, are in the Canova albums in the Museo Civico, Bassano.

G.M.

*Exhibitions:* Venice, 1978[1], no. 101; New York, 1985; Venice, 1985, no. 45; Weimar, 1987; Trento, 1990; Venice, 1992[2], no. 21
*Bibligraphy:* Cicogna, 1854, p. 16; Bratti, 1917, p. 436; Pavanello, in Venice, 1978[1], no. 101; Romanelli, in Venice, 1985, no. 45; Dorigato, in Venice, 1992[2], no. 21

## 291

ANTONIO CANOVA
*Psyche*
1789–92
marble, 152 × 50 × 45 cm
Private Collection

At the end of the 1780s, renewing his interest in antique sculpture, Canova made a series of works of mythological subjects including the celebrated *Cupid and Psyche* (fig. 70) of 1787–93. The theme of Cupid and Psyche, taken from a fable by Apuleius of the 2nd century AD, was developed in various works up to the mid-1790s. Psyche holds a butterfly in her hands, a symbol of the soul; in the neo-Platonic interpretation of the story Psyche represented the soul seeking union with Desire (Cupid). The statue was made for Henry Blundell, but its dating is difficult to determine. In Canova's biography it is said to have been started in 1790, and is listed by the artist in 1792, possibly the year of completion. It was dated by Cicognara, D'Este and other contemporary writers to 1789, probably the year it was commissioned. The statue reached London by the summer of 1793 and was installed at Ince Blundell Hall. A replica (Kunsthalle, Bremen) of 1793–4 was by Canova for Gerolamo Zulian, one of his first patrons, who, however, died a few days before the statue arrived in Venice. It was bought by Count Giuseppe Mangilli. Canova interpreted the adolescent girl according to his own sensibility to emulate the ideal beauty of Hellenistic sculpture; the Mangilli version was widely admired throughout Italy for the modest simplicity of the standing figure, the intimate meditation of the neo-platonic theme and the technical refinement of the execution, and it inspired a sonnet by Ippolito Pindemonte (*Casto come l'immago è il gran lavoro: L'alma il feo più che il dito ...*). It seems to be in direct contrast to the sensuality of the previous group of *Cupid and Psyche.* The figure of Psyche was taken up again

by Canova in the group of *Cupid and Psyche Standing* (1796–1800; Louvre, Paris) made for Colonel John Campbell and its replica (Hermitage, St Petersburg).

G.M.

*Provenance:* bought from the sculptor by Henry Blundell; by descent
*Exhibition:* London, 1972, no. 314
*Bibliography:* Honour, in London, 1972, no. 314 (with bibliography); Pavanello, 1976, no. 68; Licht, 1983, pp. 172–5

## 292

ANTONIO CANOVA
*Hector*
*c.* 1808
plaster
60 × 22.5 × 18 cm
Museo Civico Correr, Venice

The surface of this statuette suggests that, rather than a true *bozzetto,* this is a cast taken from an original terracotta that has been lost (Mariacher, 1964, p. 195). A similar plaster cast (Gipsoteca Canoviano, Possagno) was destroyed in World War I. This statuette is related to a statue of *Hector* conceived as a pair with *Ajax* on which Canova was working from 1808 when he made the definitive *modello* in plaster (Gipsoteca Canoviana, Possagno, no. 195) which is incised with the date of July 1808. The related marble sculptures, only blocked out by Canova and finished by his associates, remained in his studio until they were bought by Baron Giacomo Treves and placed in his palace on the grand canal, where they still stand. In several letters Canova refers to the source of the subject, the Homeric epic in which the two heroes confront each other before beginning their duel to the death.

G.M.

*Provenance:* see cat. 286
*Exhibitions:* Venice, 1978[1], no. 138; Venice, 1992[2], no. 92
*Bibliography:* Pavanello, in Venice, 1978[1], no. 138 (with bibliography)

## LUCA CARLEVARIS (or CARLEVARIJS)
born Udine, 20 January 1663/4
died Venice, 12 February 1730

Painter, draughtsman, mathematician, architect and printmaker. His father, Giovanni Leonardo (died 1669), was a well-known painter and architect in Friuli, but hardly any of of his works survives. In 1679 Carlevaris and his sister Cassandra moved to Venice, in to a house next to his protector, Count Pietro Zenobio, where he remained for good, being known as 'Luca of Ca' Zenobio'. In 1699 he married Giovanna Suchietti. Around the turn of the century he may have travelled to Rome, given the evident influence of the Bamboccianti and Gaspare Vanvitelli on his work, possibly stopping in Florence and Bologna on his return. In Rome he developed a taste for painting *capricci,* or imaginary views, in the style of Pannini. On his return to Venice, he evolved a more realistic style, and began to make use of the camera obscura in his compositions. In 1703 Carlevaris published a series of 104 etchings, *Le fabriche, et vedute di Venetia ...* (cat. 24) dedicated to Doge Luigi Mocenigo. Carlevaris attracted a number of commissions for his commemorative and topographical paintings from Italian and foreign patrons, such as Stefano Conti (1654–1739) of Lucca, Marshal Schulenburg, and the 3rd Earl of Manchester. Between 1708 and 1713 he was registered in the Venetian *Fraglia.* He advised on buildings in Conegliano and Udine (1712, 1714) and he is listed there as an expert in architecture. In his portrait, etched by Faldoni after a painting by Nogari (Ashmolean, Oxford) the artist is described as an eminent mathematician. It is said that Carlevaris taught Canaletto; certainly he was an inspiration to him and to numerous other view-painters. His daughter Marianna was a pupil of Rosalba Carriera.

O.T.

## 19, 20, 21

LUCA CARLEVARIS
*Gentleman in a Tan Great-coat* 18.7 × 76 cm (inv. P51–1938)
*Lady with a Fan Seen from Behind,* 22 × 98 cm (inv. P71–1938)
*Lady with Fan and Mask,* 17.2 × 93 cm (inv. P72–1938)
three drawings mounted together, pen and ink over pencil or charcoal
The Board of Trustees of the Victoria and Albert Museum, London

These drawings represent three figure types that are also to be found in several of Carlevaris's paintings and etchings, populating his compositions with characters sketched directly from life. It is difficult to form a chronology for Carlevaris's drawings because he showed little

sign of stylistic development, few of his early drawings survive, and none is documented. The have a realistic liveliness and subtle humour that anticipates figures by the Tiepolos and Pietro Longhi. Important holdings of Carlevaris's drawings are at the British Museum, the Victoria and Albert Museum, and the Correr Museum in Venice. The 18th-century volume of drawings at the Victoria and Albert Museum from which these drawings are taken, entitled *Studi figurati diversi di Luca Callevaris*, contains 32 sheets of drawings of men and women in Venetian costume, of which only two are considered to be early.       O.T.

*Provenance:* 1887, purchased by the Victoria and Albert Museum
*Exhibition:* Udine and Rome, 1963–4, III
*Bibliography:* Ward-Jackson, 1980

22

LUCA CARLEVARIS
*Regatta on the Grand Canal in Honour of Frederick IV of Denmark*
1709
oil on canvas, 135 × 260 cm
Nationalhistoriske Museum på Frederiksborg
(no. A1027)

This painting depicts the Regatta organised by the city of Venice for the visit of Frederick IV, King of Denmark and Norway, which took place on 4 March 1709 (Paoletti, 1911). Another version of 1710 (Getty Museum, Malibu) shows the same scene a moment later: the *bissona* has advanced slightly further forwards than in this version. The King, not obviously distiguishable amid the huge crowd of spectators, probably watched the ceremony from the balcony of Palazzo Balbi on the left. In his paintings Carlevaris concentrated more on the grand and impressive celebrations his city organised than he did on the important visitors for whom the celebrations were made. The King's visit was probably in part a holiday from the war against Sweden, and his choice of Venice must have also been dictated by the fact that the city was one of the few peaceful havens in Europe at that time. The King's visit, however, took place in one of the coldest winters in memory: earlier in the year the lagoon had frozen, allowing people to cross the ice from Venice to Mestre. Carlevaris documents the Regatta with great zest and lack of idealisation, reviving in the 18th century a 15th-century tradition of commemorating civic events. Apparently King Frederick took this version back with him to Denmark; G. Baroni made an engraving after the painting that was available to the wider public. The painting has recently been restored.       O.T.

*Provenance:* Danish Royal Collection; 1914, Frederiksborg Castle
*Exhibition:* Stockholm 1962–3, no. 30
*Bibliography:* Paoletti, 1911, p. 604; Rizzi, 1967, no. 35

23

LUCA CARLEVARIS
*The Bucintoro Departing from S. Marco*
1710
oil on canvas, 134.7 × 259.3 cm
signed and dated: '*L.C.MDCCX.*'
Collection of the J. Paul Getty Museum, Malibu, CA

This painting is a pendant to the second version of the *Regatta on the Grand Canal in Honour of Frederick IV of Denmark* (Getty Museum, Malibu); both were painted in 1710. The Bucintoro, the ceremonial barge of the Doge, is about to leave the Bacino di S. Marco in one of the most spectacular festivals of the Venetian calendar: a procession of boats to enact a symbolic marriage, that of Venice to the Sea, which still takes place every year on 15 August. The Doge depicted is Giovanni II Corner (reg. 1709–22). By taking a close viewpoint Carlevaris orchestrated this complex and busy composition, incorporating large numbers of figures, and emphasising the grandeur and magnificence of the spectacle. This is one of several paintings of diplomatic and celebratory events commissioned from Carlevaris, often used as gifts from the city of Venice to ambassadors and royalty.       O.T.

*Provenance:* Barone Lazzaroni, Rome; J. Paul Getty Museum, Malibu
*Exhibitions:* Florence, 1922, p. 53; Venice, 1929, p. 49; Venice, 1937, no. 44; Rome, 1940, p. 6
*Bibliography:* Rizzi, 1967, no. 43

24

LUCA CARLEVARIS
*Le Fabriche, e Vedute di Venetia, disegnate, poste in prospettiva et intagliate da Luca Carlevarijs,*
published in Venice by Giovanni Battista Finazzi, 1703/4
volume 1 of 2, containing 104 etchings, folio, 28.3 × 76.7 cm (open book)
The British Library Board, London (inv. 746.d.22)

These two etchings come from a series, Carlevaris's earliest dated work, containing 104 views of buildings in Venice. They show his original approach to the depiction of the city. In *Altra veduta del Ponte di Rialto* (pl. 57) the Rialto Bridge is shown on the left, followed by Palazzo dei Camerlenghi and Palazzo Michiel alle Colonne. The dramatic oblique perspective of the Bridge and the curve of the Grand Canal on the right unify the composition. *Palazzo Vendramin alla Giudecca* (pl. 103) is also shown obliquely on the right, leading towards a spectacular sunset over the Canal; as usual with Carlevaris the scene is alive with figures, *gondole* and sailing-boats. The huge success of *Le Fabriche* is testified by the five editions published in Venice during the 18th century (Succi, 1987). Probably inspired by the series of prints, *Il Nuovo Teatro delle fabriche Piazze et strade … di Roma*, published by Giovan Battista Falda in Rome in 1665, Carlevaris's set has the same small format and often uses the same frontal composition as Falda's prints. The great originality and influence of the series lies mainly in the intention stated by the author in the frontispiece: the etched views were made for the benefit of foreigners, particularly the British, who wanted to see the '*Venete Magnificenze*' (Mauroner, 1931). With this set Carlevaris introduced a new, almost photographic way of depicting Venice that was later elaborated by Marco Ricci, Canaletto, Marieschi and others. Carlevaris's *Fabriche* has been described as 'The Magna Carta of Venetian view painting' (Pallucchini, 1967). A number of preparatory drawings for the set are in the British Museum.       O.T.

*Bibliography:* Mauroner, 1931, pp. 28–9; Pallucchini, 1967, pp. 101; Rizzi, 1967, pp. 102–3; Pignatti, 1980, I; Pedrocco, 1981[1], pp. 225–9; Succi, in Venice and Gorizia, 1987, pp. 112–29, nos. 98–127.

ROSALBA CARRIERA
born Venice, 17 October 1675
died Venice, 1757

Painter and pastellist. With her two sisters Gio-
vanna and Angela she received a humanist
education, studying French, history, literature and
music. According to Mariette (*Abecedario*, 1851–5,
I, pp.329–32), she started painting snuff-boxes
under the guidance of Jean Steve, a French painter.
From her correspondence we know that in 1700 she
was in contact with the French collector Louis
Vatin, for whom she produced several miniatures,
and with the miniature painter Felice Ramelli. Her
first documented work in pastel, the portrait of
*Anton Maria Zanetti the Younger* (c. 1700, National-
museum Stockholm), records her friendship with
that famous collector, draughtsman and engraver.
She was also in contact with Christian Cole,
secretary of Charles Montagu, the British ambassa-
dor in Venice, who commissioned several minia-
tures and pastels from her. In 1704 her sister Angela
married Gian Antonio Pellegrini. In 1705 Rosalba
was admitted to the Accademia di S. Luca in
Rome. From 1706 to 1713 she was given several
commissions from Johann Wilhelm, the Elector
Palatine, with whose secretary, Giorgio Maria
Rapparini, she began a regular correspondence in
1708. In the same year she portrayed King
Frederick IV of Denmark, who was on a visit to
Venice. In 1713 she portrayed Frederick Augustus
II, King of Poland. His son Augustus III became
one of Rosalba's most avid collectors. In 1715
Rosalba met the French banker Pierre Crozat, who
became, with Pierre-Jean Mariette, a great friend
and patron. In April 1720, on Crozat's invitation,
she arrived in Paris, where she stayed for a year.
There she met Rigaud, Largillière, Watteau and
other artists and connoisseurs and was greatly
admired by the French aristocracy and the Court,
who commissioned several pastels and miniatures.
In October of the same year she was admitted to the
Académie de Peinture in Paris. In 1723 Rosalba
went to Modena to portray the three daughters of
Rinaldo d'Este, Duke of Modena. In the years
1723–8 her diary records several commissions from
Joseph Smith, the British consul in Venice. In
1730 she went to Vienna, where she portrayed
members of the imperial family. In the 1730s and
'40s Rosalba's portraits acquired greater psycholo-
gical insight, as is evident in her *Self-portrait* (cat.
45) and the *Young Man in an Embroidered Jacket* (cat.
38). In 1746 she lost her sight.                    M.G.

## 38

ROSALBA CARRIERA
*Young Man in an Embroidered Jacket*
c. 1741
pastel on paper, 57 × 45 cm
Private Collection

This beautiful pastel, only recently attributed to
Rosalba, can be related to a group of portraits of
Englishmen that includes *Lord Boyne* (private
collection, London; Sani, no. 267), *Charles
Sackville, 2nd Duke of Dorset* (Sackville-West
collection, Sevenoaks; Sani, no. 280) and *Joseph
Spence* (Swiss priv. coll.; Sani, no. 338). This
young man, wearing a turban, looks out of the
picture with relaxed confidence. He is portrayed
with extreme subtlety and refinement. The
luminosity of his face recalls the work of
Liotard, and the delicate tonal range of his rich
attire contrasts with the dark background. Sani
proposes a dating close to the portrait of *Joseph
Spence*, around 1741.                              M.G.

*Provenance:* July 1985, Phillips, London
(attributed to the circle of Liotard); 4 November
1985, Phillips, London (attributed to Francis
Coates)
*Bibliography:* Sani, 1988, no. 325

## 43

ROSALBA CARRIERA
*Allegory of Painting*
c. 1725
pastel on paper, 45.1 × 35 cm
National Gallery of Art, Washington
Samuel H. Kress Collection, 1939.1.136

Sani suggests that this may portray Felicita
Sartori, Rosalba's favourite pupil, given the
similarity with the *Lady in Turkish Costume*
(Sani, no. 299), which is believed to be a
portrait of her. From 1729 Felicita spent some
years in Rosalba's house in Venice and in 1741
moved to Dresden, after her marriage to one of
Augustus III's councillors. The pastel is applied
with little strokes that animate the paper's
surface.                                           M.G.

*Provenance:* Eugene Kraemer collection; George
Petit's sale, Paris, 5–6 May 1913, no.1; Prince
Giovannelli collection, Venice; Contini
Bonacossi collection, Florence; 1933 Kress
collection
*Bibliography:* Levey, 1959[1], p. 142; Pallucchini,
1960[2], fig. 116; Shapley, 1973, p. 133, fig. 261;
*idem*, 1979, no. 247; Sani, 1988, no. 192

## 44

ROSALBA CARRIERA
*Sister Maria Caterina*
1732
pastel on paper, 44 × 35 cm
Ca' Rezzonico, Museo del Settecento
Veneziano, Venice (inv. 1790, cl. I)

The Dominican Sister Maria Caterina was well
known in 18th-century Venice for her piety and
sanctity. Antonio Dall'Agate, a painter from
Gorizia, describes in a letter dated 2 September
1732 a portrait of a Dominican nun sent to him
by Rosalba with other pastels (Sani). Dall'Agate's
description of her gaunt, exhausted face and
large shining eyes seems to correspond to this
pastel, and provides us with a precise date. It
was engraved by Isabella Piccini.                  M.G.

*Provenance:* 1911, Nicoletti bequest
*Bibliography:* Lorenzetti, 1936, p. 22; Pignatti,
1960, p. 53; Sani, 1985, p. 567; *idem*, 1988, no.
285

## 45

ROSALBA CARRIERA
*Self-portrait*
c. 1744
pastel on paper, 57.2 × 47 cm
Lent by Her Majesty The Queen (inv. 446)

This self-portrait is among the numerous works
by Rosalba owned by Joseph Smith, who seems
to have met the artist before 1720, possibly
through his lawyer, Carlo Gabrieli, who was
Rosalba's godfather. The Italian list of works in
his collection includes 38 works by Rosalba, of
which only five are still in the Royal Collection.
The present pastel was engraved by both
Wagner and Cecchi. Wagner's engraving states
that the work was given to 'the consul', and
therefore Malamani suggested a dating between
1744, when Smith became consul, and 1746,
when Rosalba lost her sight. Sani, however,
proposed a slightly earlier date, since Rosalba
looks older in the *Self-portrait* in the Ca'
Rezzonico, Venice (Sani, no. 359). Here the
artist combines the delicate and frivolous details
of the ear-rings and lacy cap with subtle
psychological insight.                             M.G.

*Provenance:* Joseph Smith, Venice; 1762, bought
by King George III
*Exhibitions:* London, 1946, no. 71; London,
1993, no. 104
*Bibliography:* Malamani, 1910, p. 102; Levey,
1956, pp. 38–9; *idem*, 1964, no. 446; Vivian,
1971, p. 173; Sani, 1988, no. 324; Vivian, 1989,
p. 17

ROSALBA CARRIERA
*Spring*
*c.* 1720–1
oil on canvas, 60 × 45 cm
G. Rossi, Milan

We know that Rosalba painted in oils from a letter written to her by the French painter Nicolas Vleughels of 16 November 1712 in which he wrote 'you can paint well enough in oil to correct similar works' (Sani, 1988, p. 283). Sani lists another portrait in oils by Rosalba of *Augustus III of Poland* (Kunsthistorisches Museum, Vienna; Sani, 1988, no. 63).

The present work seems close to two pastels by the artist: *Spring* (Musée des Beaux-Arts, Dijon; Sani, 1988, no. 118) and *Victory* (formerly Gemäldegalerie, Dresden, destroyed; Sani, 1988, no. 119). They all seem to be of the same model; and have been dated to 1720–1, during Rosalba's stay in Paris.          M.G.

*Provenance:* Lonsdale collection; Major W. J. Stromm

ANTONIO CORRADINI
born Este, 6 September 1668
died Naples, 12 August 1752

Sculptor. He is first recorded in Venice 1709–10 working on the decoration of the façade of S. Stae. Three years later he made the statue of *St Anastasia* for S. Donato at Zara. The statue evidently caught the attention of Manfrin, whose country estate was at Zara and led to the earliest of Corradini's many veiled ladies, *La Fede Velata*, completed for Manfrin in 1717; his first major commission from the Senate of the Republic, a statue of Marshal Schulenburg to celebrate his victory over the Turks, was erected in Corfu in 1718. Schulenburg bought the *modello* for this monument from Corradini, together with some marble sculptures, including a portrait that Corradini had made of him.

Corradini's talent had been recognised by Augustus the Strong, King of Poland and Elector of Saxony, since his group of *Time Unveiling Truth* was already in the gardens of the Holländisches Palais, Dresden, in 1719 (Hodgkinson). Another eleven marble groups and a series of vases were recorded in Dresden by 1728. In 1720 he made the altar of St. Emma for the See of Gurk, in the Austrian province of Carinthia and in the following year a statue, *Virginity*, for S. Maria del Carmine, Venice. A drawing made by Tiepolo of this statue, engraved by Andrea Zucchi, is dedicated to Zaccaria Sagredo. By 1722 Corradini was working on six statues and other decorations for the new Bucintoro, destroyed by fire in 1797 during the French occupation of Venice. The *Triumph of the Eucharist* for the altar of the Sacrament in the Cathedral at Este (1722–5), along with the beautiful group of the *Pietà* in S. Moisè, Venice, and a statue of *Prudence* for the Arco Foscari, date from these years. He supervised the restoration of the *Scala dei Giganti* in the Palazzo Ducale. To meet all of these contracts he clearly must have had a highly efficient workshop.

Corradini left Venice in 1730 and is thought to have spent the next ten years working in Vienna as court sculptor to the Emperor Charles VI, but during this time he is known only to have made the sculptures for St Joseph's Fountain, in the Hoher Markt, Vienna, in 1731. They were after a design by Fischer von Erlach the Younger, as were the wooden *modelli* supplied by Corradini for the gilt bronze model, now in the Domschatz of the Diözesanmuseum, Passau, for the new silver tomb of St John Nepomuk in Prague Cathedral cast by Johann Joseph Würth (Matsche). He probably settled in Rome in 1740, where he made a bust of Pope Benedict XIV for a wall monument in the Vatican, a *Sarah* and an archangel for the church of S. Giacomo, Udine, and a pair of angels after designs by Luigi Vanvitelli for the church of São Roque, Lisbon; in 1744 the sculpture was shipped to Lisbon and installed by 1750. Corradini also provided terracotta models for statues intended to

stand above the double columns surrounding the dome of St Peter's, Rome. Sometime before 1750 he went to Naples and entered the service of Raimondo di Sangro, Prince of Sansevero, who was converting his private chapel into a mausoleum. For this Corradini made the beautiful veiled figure of *Modesty*, which stands on the monument of Cecilia Caetano di Laurenziana, the patron's mother.          P.W.

*Bibliography:* Temanza, 1778, p. 80, n.(a), p. 380, in *Indice Analitico* pp. 22–3; Bottari, 1822, II, p. 125; Cicognara, 1824, VI, pp. 237–8; Lorenzetti and Planiscig, 1934, p. 77, nos. 362–75, pls. LXVII–LXIX, figs. 123–6; Mariacher, 1943, p. 34; *idem*, 1947; Biasuz, 1948; Wittkower, 1958, ed. 1973, pp.453–6, 570–1; Semenzato, 1966, pp. 12, 15, 28, 30, 33, 39, 41, 43–5, 60–2, 78, 95, 111–13 and pls. 113–6; Hodgkinson, 1970; Haskell, 1980, ed. 1991, pp. 265, n.3, 312; González-Palacios, in London, 1983; Cioffi, 1987; Goi, 1988, II, pp. 143, 145, 182, 222; Matsche, in Munich, 1993, pp. 43–5, 175–7, no. 104; Montagu, in Washington, 1993, p. 85, no. 106

58

ANTONIO CORRADINI
*Puritas (Bust of a Veiled Woman)*
*c.* 1717–25
marble, 61 cm (height)
Ca' Rezzonico, Museo del Settecento Veneziano, Venice
(inv. cl. XXV. 1089)

As Cicognara observed, Corradini used the veil as a means of accentuating, rather than concealing, the nudity of the figure. And as seen in this bust, probably representing *Puritas*, the sheer transparency of the veil heightens both the sensuality and beauty of the figure, which is closest in style and dating to the statue of *La Fede Velata* on the Altar of SS. Sacramento, in the Duomo at Este (Mariacher). It was made in 1722–5 and Corradini received the final instalment in 1726. His first *donna velata* was possibly the *Fede* that he made for Manfrin in 1717 (Haskell, ed. 1991, p. 380, n. 5) which was highly acclaimed and described at the time by the painter Antonio Balestra as 'a work that has astonished the whole city . . . to make of marble what appears to be a transparent veil, as well as a most graceful figure' (Mariacher, 1947, p. 207, n.1; Bottari, 1822, II, p. 125). Corradini reverted to this motif on many occasions, and it was his penchant that inspired others, who may also have known of his statue of the Vestal Virgin *Tuccia*, sent to Augustus the Strong in 1727, from engravings made by Leplat that were published in 1733. Sculptors who continued the tradition of the veiled figure include Sanmartino, Spinazzi, and Raffaelle Monti.

Although it has often been suggested that Corradini's style draws on the icons and imagery of the 17th century, for the present writer Corradini's cool, sensual interpretation of his *donna velata* is the bridge between the Rococo and the Neo-classicism of Canova.                    P.W.

*Provenance:* (?) Villa Pisani di Stra

*Bibliography:* Cicognara, 1824, IV, p. 205; Lazari, 1859, p. 172, nos. 916–7; Biasuz, 1935–6, p. 268; Lorenzetti, 1936, pl. 75; Callegari, 1936–7, p. 250; Mariacher, 1943, p. 34; Mariacher, 1947, pp. 205, 215, fig.167; Riccoboni, 1952, p. 151; Pope-Hennessy, 1964, no. 683, fig. 680; Matzulevitsch, 1965, pp. 80–5; Semenzato, 1966, p. 112; Radcliffe, 1968, p. 410, figs. 2–5; Keutner, 1969, fig. 196, p. 328 no. 196; Hodgkinson, 1970, pp. 3–14; Radcliffe, 1970, pp. 8–16; Pavanello, 1976, nos. 328, 332; Fittipaldi, 1980, pp. 140–2; Klášter, 1980, p.13, no.2, pl. 1; Nava Cellini, 1982, II, pp. 159–67, 182–3, 186, 188–9, 254; Cioffi, 1987, pp. 13–68, 105, 108, 110, nn. 124–7, 129–33 figs. 1–3, 5, 7, 18, 23–4, 27, 50

## GIANFRANCESCO COSTA
born Venice, 1711
died Venice 12 October 1772

Architect, painter, stage designer and etcher. He must have had some training in architecture, and he described himself as 'a theatrical engineer'. In 1734 he is recorded as a member of the *fraglia* in Venice. Costa may have been a pupil of Giambattista Tiepolo's collaborator, the stage-set designer Girolamo Mengozzi Colonna (1688–1766), and of Giambattista Crosato (1686–1758), also a scenographer. In 1742 Costa is documented as scenographer at the theatre of S. Giovanni Crisostomo, Venice, but he may have also collaborated with Mengozzi Colonna, who worked there 1731–33. His biographer Moschini wrote that Costa was on the payroll of the Grimani family, who managed the theatre. In 1742 Costa collaborated with Crosato on two works for the Carnival season at the Teatro Regio, in Turin: *Caio Fabricio* by Zeno and P. Auletta and *Tito Manlio* by Metastasio and N. Jommelli. Again in Turin in 1744 Costa designed sets for *Alessandro nelle Indie*, with music by Gluck, and *Conquista del Vello d'Oro* by G. Sardella.

Costa's series of etchings, *Rovine d'archi* ... are more archaeological than the picturesque *capricci* of Canaletto and Ricci; at least one (if not ten, as suggested by Mason) dates from 1746. He etched Palladio's *Delli cinque ordini d'architettura* published by Angiolo Passinelli in 1746, and his own *Elementi di prospettiva esposti da G.F.Costa* of a year later. In 1747 he applied for the privilege to publish his major work, granted on 2 March 1748, the series of etchings of the villas on the Brenta (cat. 154), In 1755 Costa was commissioned by the Grimani family to build the theatre of S. Benedetto, the only new theatre built in Venice in the 18th century. Finished in 1759, it was destroyed by fire in 1774. The original plan is in the Correr Museum, Venice. He may have worked in Poland in 1765–6. In 1767 Costa was made Professor of Architecture at the Venetian Academy, a new subject on the curriculum, but after three years he was obliged to give it up because of poor health.                    O.T.

GIANFRANCESCO COSTA

*Delle delicie del fiume Brenta – espresse ne palazzi e casini situati sopra le sue sponde dalla sboccatura nella laguna di Venezia fino alla città di Padova disegnate e incise da Gian Francesco Costa architetto e pittore veneziano*, published in Venice by the author, 1750

2 volumes of 140 etchings, folio, 38.4 × 102 cm (open book)

The British Library Board, London (LR.295.a.24)

This is Costa's best known work; it consists of two volumes, each with a frontispiece, a map of the Brenta and 70 plates illustrating sights along the river, starting from Fusina, near Venice, and ending at the Porta d'Ogni Santi in Padua. On this slow trip down the river Costa illustrated villas, palazzi, humble dwellings, *locande* and plots of land with equal care and attention to detail. The plates shown here are Palladio's Villa Foscari, called the Malcontenta, and the Palace of Nobiluomo Bon. The privilege to publish *Le delicie...* was granted on 2 March 1748; the first volume appeared in 1750 and the second six years later. Costa's series was indebted to Carlevaris's *Fabbriche...* of 1703 (cat. 24), Marieschi's *Magnificentiores...* of 1741 and Canaletto's views, especially in the feeling for light (Calabi, 1931). Although the topographical approach makes some of the plates rather monotonous, the spontaneous handling of to the subjects assures the series a unique place in 18th-century Venetian printmaking.                    O.T.

*Bibliography:* Calabi, 1931, p. 15; Pittaluga, 1939, n.1–2 ; Gorizia and Venice, 1983, pp. 148–53, nos.150–64

GIANFRANCESCO COSTA
*Suite des plus célèbres anciens bâtiments des grecs*,
printed in Venice, 1748, open to show
*Architectural Fantasy: The Temple of Juno and Jupiter*
etching, 46 × 56.6 cm (platework), 40 × 53.2 cm (borderline)
Private Collection, Geneva

This is one of a series of four etchings both designed and etched by Costa (Mason, 1977), datable to the mid-1740s. The plates have two states, first only etched and before Wagner's address was added, and secondly with heavily engraved reworking. Mason suggested that the etched plates were either reworked in engraving in Wagner's workshop, or that Costa and Wagner had worked together on them. The set combines antiquarian subjects such as this one, an imaginary building presumably partly based on the Pantheon in Rome, with more capricious and inventive compositions. O.T.

*Bibliography:* Mason, 1977, no. C1; *idem*, 1979, pp. 2–55

PIETRO DANIELETTI
born Padua, 1712
died Padua, 20 April 1779

Sculptor. Apprenticed as a stonemason in 1725 in Padua, Danieletti probably trained in the Bonazza workshop, which at the time was managed by Giovanni. Accepted into the stonemasons' guild in 1749, in March 1753 he was commissioned to make a large wooden figure of a *Virtue* to decorate the Organ in the Cappella dell'Arca in the Santo, Padua, and a processional figure of *St Francis*, also in wood. In 1769 he made a marble bust of G.B. Morgagni for the anatomical theatre of Padua University, and in 1771 the angels and the relief on the altar of the Chiesanuova, Padua. The high altar of S. Leonardo, Borgoricco, was possibly made by Agostino Fasolato after Danieletti's design. Between 1776 and 1780 he made twelve monuments, mostly in *pietra tenera*, for the Prato della Valle, Padua, but including a marble portrait roundel of Riccio to replace the bronze relief by Giovanni da Cavino; the *Petrarca* and *Galilei* were only completed in the year after Danieletti's death. Only two signed works are known by Danieletti; the marble baptismal font with *Charity* and *Hope* and a bas-relief of the *Baptism of Christ* in the Arcipretale, Bovolenta, and the stone statue of *Daulo* in Palazzo Dario, Padua.

While most of Danieletti's works were made for Padua and its environs, he also supplied works to patrons in Vicenza and Forlì and for the Palacio Real, Lisbon. He is said to have worked in marble, stone and wood, and apparently he was also a founder; the designs he provided for the silversmith Angelo Scarabello are said to have made his fortune (Neumayer). He was married to Caterina Albanesi, and his son Antonio became a goldsmith. P.W.

*Bibliography:* Neumayer, 1807; Pietrucci, 1858, pp. 95–7; Sartori, 1865, p. 78; Cessi, 1965, p. 46; Semenzato, 1957[1]; *idem*, 1957[2], pp. 6–7, 11; *idem*, 1966, pp. 56–7, 127–8; Barbieri 1972, p. 28 n.8; Sartori 1976, pp. 82, 230; Nava Cellini, 1982, pp. 187, 254; Lorenzoni, 1984, p. 230, fig. 313; Vicenza, 1990, pp. 244/7.23, 287/14.5

PIETRO DANIELETTI
*The Peasant Philosopher*
polychromed wood, 213 cm (height)
Museo d'Arte Medievale e Moderna, Musei Civici di Padova

This polychromed wooden statue (not made of gesso or stucco, as has been stated) is surely Danieletti's masterpiece. He drew on the tradition of the many caricatural figures made by the Marinali for the gardens of the Conti-Lampertico at Montegaldella probably between 1700 and 1720, and those in the same idiom made by Antonio Bonazza (1698–1763) and his workshop for the Villa Widmann at Bagnoli, work on which started in 1742 (Semenzato, 1966, figs. 65, 160–9). But Danieletti's interpretation also recalls a number of works in terracotta that, with varying degrees of conviction, have been attributed to Andrea Riccio, whose monument by Cavino Danieletti replaced at Prato della Valle in 1778. P.W.

*Bibliography:* Pietrucci, 1858, pp. 95–7; Tua, 1935, p. 305; Moschetti, 1938, p. 289; Semenzato, 1957[1], p. 24, figs. 20–37; *idem*, 1957[2]; *idem*, 1966, pp. 57, 128, figs. 65, 160–9, 233; Nava Cellini, 1982, pp. 187, 254

## GASPARE DIZIANI
born Belluno, 1689
died Venice, 17 August 1767

Painter and draughtsman. Diziani was first trained in Belluno. He was in Venice *c.* 1706–9, first in the studio of Gregorio Lazzarini and then in that of Sebastiano Ricci, who influenced his style. In 1717 he went to Germany, probably to Munich, where he painted four overdoors of the Four Times of Day in the Residenz (Pavanello, 1981). He was then summoned to Dresden by Augustus II the Strong, where he designed stage scenery. Diziani was back in Venice in 1720 and was invited to Rome by the Venetian cardinal Ottoboni. In 1727 he was again in Belluno, as testified by the dated altarpiece, *The Ecstasy of St Francis* painted for the church of S. Rocco. He spent the rest of his life in Venice, also working in Treviso, Padua, Rovigo and Bergamo. In 1733 he painted four canvases for the sacristy of S. Stefano in Venice. The frescoes on the staircase of Palazzo Avogadro in Castelfranco of 1747 show his fully developed Rococo style, characterised by swift brushwork and luminous colours. From 1748 to 1760 his output was prodigious, and he frescoed ceilings in various palaces and churches in Venice and the Veneto, among them Ca' Zenobio, Palazzo Contarini, Widmann, Belloni, Ca' Rezzonico and the church of the Angelo Raffaele. He was also a skilled and prolific draughtsman. In 1756 he was among the founder members of the Venice Academy, serving as its President in 1760–2. Diziani died suddenly in a coffee-shop in Piazza S. Marco.                               M.G.

## 171

GASPARE DIZIANI
*Study for a Ceiling with the Coronation of the Virgin*
*c.* 1750–60
oil on canvas, 160 × 111.3 cm
Mr and Mrs Nelson Shanks

This is a study, or *modello*, for a ceiling decoration; given the subject-matter, it was probably intended for a church, although it cannot be related to any existing ceiling by Diziani. It is characterised by swift, sketchy brushwork and striking light effects; the zig-zag composition adds to the sense of movement. In comparison with other similar works by the artist, the present study can be dated *c.* 1750–60.
                               M.G.

*Provenance:* 1967, bought on the U.S. art market

## 172

GASPARE DIZIANI
*Aeneas Carrying Anchises from Troy*
1730s
pen and brown ink and grey wash on light-brown paper, 39.1 × 32.9 cm
National Gallery of Art, Washington
Ailsa Mellon Bruce Fund, 1971.79.1

This is the most finished version of three drawings by Diziani of the same subject. The other two are in the Museo Correr, Venice, and the Budapest Museum of Fine Arts (Fenyo, 1965, fig. 30 and pl. 110). The sheet shows the influence of Sebastiano Ricci and can therefore be dated to the early 1730s. The scene is given an atmospheric quality by the sketchy view of Troy burning in the background and the vast expanse of sky above the figures. Similar drawings exist of the same subject and of the same date by Gaetano Zompini (British Museum, London) and by Francesco Fontebasso (cat. 175), and it has been suggested that there may have been a competition for which these sheets were produced.                     M.G.

*Provenance:* E. V. Thaw; 1972, Ailsa Mellon Bruce Fund
*Exhibitions:* Washington, 1974, no. 37
*Bibliography:* Scholz, 1964, p. 192, fig. 31

## 173

GASPARE DIZIANI
*Fall of Phaeton*
1745–50
pen and brown ink over red chalk with brown and grey washes, 40.7 × 33 cm
National Gallery of Art, Washington
Andrew W. Mellon Fund, 1978.52.3

In this dramatic composition Phaeton, the reckless son of Helios, having attempted to drive his father's chariot, is falling headlong into the waters of the River Eridanus (alternatively identified as the River Po). Phaeton's sisters, the Heliads, watching the scene in dismay, are turning into poplar trees. The story comes from Ovid. Pignatti (1974) dates the sheet to 1745–50, in the artist's fully mature style, when the influence of Tiepolo 'slightly outweighs that of Ricci'. The scene is animated by the use of wash, a technique also typical of Diziani's late paintings. The composition cannot be related to any known canvas or fresco by the artist. Another less elaborate version of the subject is among the numerous drawings by Diziani in the Correr Museum, Venice.                  M.G.

*Provenance:* A. L. de Mestral de Saint Saphorin; Marguerite and Madeline de Mestral; R. de Cerenville; Nathan Chaikin; David Daniels; sold 25 May 1978, Sotheby's, London, lot 37
*Exhibitions:* Minneapolis, 1971, no. 11; Washington, 1974, no. 56; Los Angeles, 1976, no. 56

## GIOVANNI ANTONIO FALDONI
born Asolo, Treviso, 1689 or 1690
died (?)Rome, c. 1770

Painter and engraver. There is little documentary evidence for the life of this artist, one of the most remarkable reproductive engravers of his time. Faldoni was active in Venice from the beginning of the 18th century, where, according to Gori Gandellini (1771), he trained with one of his brothers as a landscape painter and later as a printmaker. Gori Gandellini adds that Faldoni travelled extensively and spent some time in Paris. It was probably there that he became aware of the engraving technique of Claude Mellan (1598–1688), which he adopted and introduced to Venice. This striking technique involves continuous lines of varying thickness instead of outlines and cross-hatching. Between 1724 and 1726 Faldoni engraved for the two Zanettis a number of drawings by Parmigianino reproduced in *Raccolta di Varie Stampe* (cat. 49), and contributed several engravings to *Delle Antiche Statue Greche e Romane ...* (cat. 84). Faldoni was prolific as a reproductive engraver and book illustrator; he was especially successful in portraiture, where his debt to French engraving is particularly apparent. His engraving technique influenced the work of Giovanni Battista Pitteri, whom he apparently taught. Faldoni's fiery temperament led him to be involved in numerous violent episodes, including a fight with Pitteri; he was arrested in 1731, and exiled in 1765, after which he worked in Bassano for the Remondini workshop and in Rome (Gallo, 1941).          O.T.

*Bibliography:* Gori Gandellini, 1771; Gallo, 1941

GIOVANNI ANTONIO FALDONI
*Componimenti poetici delle più illustri rimatrici d'ogni secolo*, by Luisa Bergalli, published in Venice by Antonio Mora, 2 vols, 1726, vol. I open to show the engraved frontispiece, a portrait of Luisa Bergalli
17 × 22 cm (open book)
The British Library Board, London (inv. 11429.6.36)

These two volumes comprise an anthology of verses, selected by Luisa Bergalli, by well-known women poets. The first volume contains poems from Antiquity to the year 1575, while the second spans 1575–1726. Both volumes were published in 1726 and dedicated to Cardinal Ottoboni, who showed hardly any interest in them. Volume one is open to show a portrait by Giovanni Antonio Faldoni of Luisa Bergalli, herself a poet, known in the Arcadia, the Venetian literary society, as Irmida Partenide, who included one of her own poems in the second volume. She was born in Venice in 1703, the daughter of a small shopkeeper, but had two aristocratic godparents, Luigi Mocenigo and Pisana Cornaro. Initially she worked in Rosalba Carriera's workshop, but her interest in literature soon took over; her literary debut was at the age of 22 with the drama *Agide* for the theatre of S. Moisè, with music by Giovanni Porta. Although Bergalli apparently did not enjoy any patronage and had to work hard all her life, she had a constant friend in Apostolo Zeno, court poet at Vienna. In 1730 Bergalli married the essayist Gasparo Gozzi, with whom she had five children. She wrote numerous plays, comedies and translations. In her portrait Faldoni employed his technique based on widely spaced engraved parallel lines to great effect, without losing any plasticity, depth or feeling for texture.          O.T.

*Bibliography:* Morazzoni 1943, p. 216; *Dizionario biografico degli italiani*

## FRANCESCO FONTEBASSO
born Venice, 4 October 1707
died Venice, 30 May 1769

Painter, draughtsman and engraver. According to Longhi (1762) and Zanetti (1771), he was a pupil of Sebastiano Ricci. In 1728 he was in Rome, where he won third prize in that year's Concorso Clementino for young painters. He stopped in Bologna on the way back to Venice. His experience of Roman and Emilian art, combined with the influences of Sebastiano Ricci and Giambattista Tiepolo, are the main components of Fontebasso's style. Among his early works are two grisailles, representing Adam and Eve, in the sacristy of Villa Manin in Passariano (1732), and several altarpieces in Venetian churches. In 1736 he was given the commission to decorate the church of S. Maria Annunziata in Trent, very badly damaged in the last war. In the 1740s Fontebasso painted several decorative cycles in Venetian palaces, among them Ca' Duodo, Palazzo Bernardi and Palazzo Contarini (in collaboration with Diziani). A series of eight etched of Bacchanals by Fontebasso was published in Venice in 1744. He was also prolific as a book illustrator. From 1756 he taught at the Venetian Academy. In 1759 he painted a series of canvases for the Bishop of Trent in the castle of Buonconsiglio. In 1761 Fontebasso left for St Petersburg, where he decorated some rooms and the church of the Winter Palace; unfortunately his work was destroyed by fire. Returning to Venice at the end of 1762, in 1768 he was elected President of the Academy and died the following year.          M.G.

174
FRANCESCO FONTEBASSO
*Esther before Ahasuerus*
1750s
oil on canvas, 118 × 149.8 cm
The Ralph Dutton Collection, Hinton Ampner (The National Trust) (inv. HIN/P/7)

Esther, a young Jewess, interceded with Ahasuerus (Xerxes), King of Persia, and prevented the massacre of her people. To enter the King's presence without being summoned was punishable by death; Esther swooned with relief when the King held out his sceptre to indicate that he would receive her. This melodramatic episode appealed to contemporary taste and sensibility and it frequently occurs in 18th-century Venetian painting.

The subject had been represented several times by Fontebasso's master, Sebastiano Ricci. The present canvas is reminiscent of Ricci's compositions, but also shows the influence of Giambattista Tiepolo in the clear, silvery light that falls on the main characters in the scene.

Martini dates the painting to the artist's last period, but Magrini suggests a date in the 1750s.

M.G.

*Provenance:* Silbermann collection, Vienna; Pospisil collection, Venice
*Exhibitions:* Kingston upon Hull, 1967, no. 21
*Bibliography:* Martini, 1964, p. 238; Magrini, 1988, p. 141, no. 57

## 175

FRANCESCO FONTEBASSO
*Aeneas Carrying Anchises from Troy*
c. 1750
pen and brown ink and grey wash over black chalk, heightened with white, 46.3 × 32.8 cm
The Visitors of the Ashmolean Museum, Oxford (inv. P.II.997)

Byam Shaw has shown that Fontebasso made two series of highly finished drawings as independent works of art, one devoted to biblical subjects and the other to ancient history. These sheets, all of large dimensions and in the same style, are now dispersed in various private and public collections. An album containing 28 sheets is in the Correr Museum, Venice. The present drawing obviously belongs to the ancient history series and depicts Aeneas leaving Troy along with his son Ascanius and carrying his father, Anchises. Fontebasso's style is here indebted to Sebastiano Ricci.

M.G.

*Provenance:* 13 November 1934, Sotheby's sale, London, lot 51
*Exhibitions:* Venice, 1958, no. 88
*Bibliography:* Byam Shaw, 1954, pp. 318, 320, no. 313; Parker, 1972, II, no. 997

## 176

FRANCESCO FONTEBASSO
*Apollo, and Studies of Hands and a Male Head*
(recto)
1740s
black chalk and pen and brown ink, 44 × 57 cm
National Gallery of Art, Washington
Gift of Mr and Mrs William N. Cafritz, 1990.33.1.a

Fontebasso's confident draughtsmanship is here shown in two different media: chalk for the soft treatment of the nude Apollo and pen and ink for the fine detailing of the hands and male head. The artist uses the precise parallel hatching which is typical of his style. Fontebasso's hand studies in particular can be related to similar drawings by Giambattista Tiepolo. It seems unlikely that the hands in the drawing are the artist's own, since both left and right hands are shown.

M.G.

*Provenance:* Gift of Mr and Mrs William N. Cafritz
*Bibliography:* Paris, 1990, no. 14

## 177

FRANCESCO FONTEBASSO
*La Divina Commedia di Dante Alighieri con varie annotazioni e copiosi rami adornata. Dedicata alla Sacra Imperiale Maestà di Elisabetta Petrovna imperatrice di tutte le Russie*, published in Venice by Antonio Zatta, 1757
4 volumes, quarto, the third open to show the etched plates, printed in colour, at the beginning of Cantos X and XI
etchings, 33.5 × 51 cm
The British Library Board, London (G.11126)

The publication of Dante's *Divine Comedy* in Venice in the 18th century was a remarkable venture; it appears that the text had only once been published there since the 16th century. The project offered new subjects to the illustrators, among whom were Fontebasso, G. Schiavonio and Zompini. These compositions designed by Fontebasso, illustrating Cantos X and XI from Volume III, show the meeting of Dante and Beatrice in Paradise. The publisher, Zatta, one of the best in Venice, must have made a success with these volumes. Most copies are printed only in black ink; editions in coloured inks, as in this instance, are very rare.

O.T.

*Bibliography:* Morazzoni, 1943, p. 225; Weider, 1967, pp. 329–83

## GIORGIO FOSSATI
born Morcote, near Lake Lugano, 1705
died Venice, 1786

Architect, decorator, writer and etcher. He is described as an architect in the first volume of *Raccolta di Varie Favole . . .* (cat. 190). Apparently he was employed to design scenery for the theatres of S. Benedetto and S. Luca in Venice, and also produced ephemeral architecture for Regattas and Entrances of famous visitors to Venice, including the one organised for the entry in June 1764 for Edward Augustus, Duke of York, brother of George III. He was a keen printmaker and experimented with multi-coloured inks, although not always successfully.

O.T.

## 190

GIORGIO FOSSATI
*Raccolta di Varie Favole delineate ed incise in rame da Giorgio Fossati architetto*, published in Venice by Carlo Pecora, 1744
2 volumes, quarto, vol. I open to plate facing p. 7; vol. II open to plate facing p. 16
Arthur and Charlotte Vershbow

In the introduction to this collection of tales, Fossati wrote that he had wanted to engrave a full-page illustration to introduce each story in order to arouse the curiosity of his audience that is usually limited to 'the most pedantic schools for children of tender age'. The *Favole*, Fossati's best work, are illustrated by 261 full-page compositions such as those shown here, and a number of vignettes, all designed and engraved by the artist. Thanks to his familiarity with technical drawings, Fossati was particularly successful in compositions in which architecture has an important role; when he attempted to draw animals, his draughtsmanship appears less certain. Fossati experimented with colour printing by using different inks together, as in these two example, *Chimney*, printed in pink, and *Swans*, in blue. The text, arranged in two columns, is in French and Italian; the publication was aimed at an international public.

O.T.

*Bibliography:* Morazzoni, 1943, p. 232

# G

**ANTONIO (or GIANANTONIO)
GUARDI**
baptised Vienna, 27 May 1699
died Venice, 22 January 1761

Painter and draughtsman. The Guardi family originated in the Trentino and belonged to the Imperial nobility (patent given by the Emperor Ferdinand III, 1643). Members of the family held military and ecclesiastical positions in the region, and patronised their painter relations. Antonio's father, Domenico (1678–1716), a competent but unoriginal late Baroque painter, had close ties with Venetian and Viennese artists: when Antonio was baptised in the Schottenkirche in Vienna, Antonio Bellucci stood as godfather. Johann Michael Rottmayer was related by marriage. It is not known where Antonio trained, although it was probably not with his father. His sister Cecilia married Giambattista Tiepolo in 1719, but it is uncertain if Antonio or Francesco were professionally connected with their brother-in-law. Antonio was documented in Vienna *c.* 1719 (where he was a witness at the wedding of Giuseppe Galli-Bibbiena); his style and his subject-matter show Austrian influences. By 1730 he had established a workshop in Venice that produced copies for Marshal Schulenburg until 1746 and was also patronised by the Giovanelli family. The workshop employed many assistants, including Francesco and another brother, Nicolò (1715–86), whose work has not been identified. Antonio kept close ties with the Trentino, and executed important works there both for his own family (e.g. paintings for the church at Vigo d'Anaunia, 1738, ordered by his uncle) and for other nobles resident in Venice, such as the Savorgnan. He was elected to the Venetian Academy in 1756. The paintings of the organ parapet in the Angelo Raffaele, his masterpiece, date from the last decade of his life, as do many decorative cycles for private palaces. Until recently, his works were often confused with those of his younger brother Francesco.      M.M.

*Bibliography:* Binion, 1976; Mahon, 1965; Morassi, 1973; Pedrocco and Montecuccoli Degli Erri, 1992

ANTONIO GUARDI
*Erminia and the Shepherds*
*c.* 1750–5
oil on canvas, 251.5 × 442.2 cm
National Gallery of Art, Washington
Ailsa Mellon Bruce Fund, 1964.21.2

This illustrates an episode from Tasso's epic poem *Gerusalemme Liberata* (VII, 1–18). The Saracen princess Erminia, having escaped from the besieged city of Jerusalem in disguise in order to dress the wounds of her beloved, the Christian knight Tancred, is mistaken by Christian troops for an enemy and is pursued into the woods, where, having evaded them, she falls asleep. On waking to the sound of singing she encounters a shepherd who, his sons to hand, explains to her the pleasures of country life. His description, which briefly inspires Erminia to follow his example, is one of the most successful post-Classical expressions of the pastoral idyll.

This painting, which depicts the moment of Erminia's temporary conversion from a life of war to one of peace, is one of a series of eight canvases found at Bantry House, Co. Cork, in the 1950s. Nothing is known of their earlier history, nor how many paintings may have comprised the original cycle, which possibly first decorated a room in an Italian country house. Like the other seven extant paintings, the *Erminia* derives from Piazzetta's illustrations to Tasso's poem published in 1745 by the Albrizzi press (cat. 80, 81). However, Guardi modified his source by changing the format and substituting Piazzetta's clumsy horse with one deriving from the *St James* altarpiece, (cat. 113), painted by his brother-in-law, Giambattista Tiepolo. This is one of the few unquestionable instances of the Guardi brothers taking inspiration from their successful relative (Hannegan, 1967). The series seems to have been a joint project of the two brothers *c.* 1750 (a *terminus post quem* provided by the date of Tiepolo's *St James*). Extensive workshop participation is visible in several of the paintings. Here the figure of Erminia has the features of Antonio's calligraphic style, while the shepherd bears the hallmarks of Francesco's more rugged brushwork and solid construction. The boy in the centre has a major pentimento in his shirt-collar, probably a correction to the work of a studio assistant by one of the brothers.      M.M.

*Provenance:* Richard White, 2nd Earl of Bantry (1800–68), Bantry House, Co. Cork, Ireland (perhaps bought in Italy *c.* 1820); by descent to Mrs Shelswell-White; 1955, unnamed dealer, Dublin (as Pellegrini); bought by David Carritt for Geoffrey Merton, London; 1956, Agnew's London; Ailsa Mellon Bruce Fund
*Exhibitions:* London 1960, cat. 460 (as Francesco Guardi)

*Bibliography:* Muraro, 1959, p. 242 n. 14; Morassi 1960, pp. 247–56; Muraro, 1960, pp. 421–8; Mahon, 1965, pp. 91–9; Morassi, 1973, I, cat. 68; Knox, 1978[1], pp. 89–95; Shapley, 1979, I, pp. 231–5; Pignatti, 1989, p. 333; Pedrocco and Montecuccoli Degli Erri, 1992, cat. 153; Merling, 1993; Merling, in Washington, forthcoming

192

ANTONIO GUARDI
*A Woman in Ancient Costume*
*c.* 1739
oil on canvas 58.1 × 45.7 cm
Lent by the Syndics of the Fitzwilliam Museum, Cambridge (inv. PD.22–1952)

This 'fantastic head' is related to the copies Antonio made for Marshal Schulenburg in the late 1730s and 1740s. Its style bears comparison with two copies he made of Tintoretto's allegories of *Fortitude* and *Temperance* paid for in 1739 (location unknown; ex-Marcos Collection). The present painting reproduces the head of the figure of Salome in Palma Giovane's *Beheading of the Baptist* in the sacristy of the Gesuiti, Venice (Martini, 1984, p. 546). It is unusual in that Antonio's copies usually reproduce entire compositions. 'Fantastic heads' were a favourite category of Schulenburg's, who owned other such paintings by Piazzetta and Carriera (see Binion, in Hanover and Dusseldorf, 1991–2, p. 20). Here Antonio's technique is very close to Piazzetta's, with the red ground used to provide a contour, demonstrating the influence of Schulenburg's favourite artist on Guardi.      M.M.

*Provenance:* Arcade Gallery, London; sold 15 February, 1952, Christie's, London (as Tintoretto); 1952, Gift of the Friends of the Fitzwilliam Museum
*Exhibition:* Kingston upon Hull, 1967, no. 30
*Bibliography:* Morassi, 1960, p. 161; Goodison and Robertson, 1967, II, p. 75; Morassi, 1973, I, no. 134; Martini, 1982, p. 546; Pedrocco and Montecuccoli Degli Erri, 1992, no. 38

ANTONIO GUARDI
*Supper at Emmaus*
*c.* 1740
pen and sepia wash over traces of chalk,
25 × 45 cm
Private Collection

This drawing is after Piazzetta's painting of the same subject (cat. 61). Because the image is reversed, it has been suggested that Antonio copied a reproductive engraving by Pitteri of 1742 rather than the original; this is unlikely, however, since Pitteri's engraving shows only the head of St James, so the intermediate source for Antonio's drawing remains to be discovered. On stylistic grounds it was dated by Pignatti to the 1740s; this is plausible given that this was the period in which both Piazzetta and Guardi were extensively patronised by Schulenburg.       M.M.

*Provenance:* J. P. Richter, Lugano; 1800, priv. coll., London (as Tiepolo, Fragonard and Francesco Guardi); 1956, sold at auction, Gutekunst-Klibstein, Bern; Hugelshofer collection, Zurich
*Exhibition:* Venice, 1965[1], no. 3
*Bibliography:* Pignatti, 1967[1], no. III; Morassi, 1973, no. 9; Binion, 1976, no. 56; Gorizia, 1987, pp. 160–1

## 194

ANTONIO GUARDI
*The Garden of the Serraglio*
*c.* 1740–5
oil on canvas, 46.6 × 64 cm
Thyssen-Bornemisza Collection

Probably one of the 43 scenes of Turkish life ('*Turqueries*') painted by the Guardi workshop for Marshal Schulenburg in 1742–3, presumably to decorate a room in his Venetian palace. The present painting differs from the others in that it does not depend on any of the engravings of the *Receuil Ferriol* (1714) after Jean-Baptiste van Mour. It also has loose and vivacious brushwork comparable with the panels on the organ-loft in the Angelo Raffaele, Venice; hence its usual attribution to Antonio (Mahon, 1967, p. 179).

It has been suggested that the fountain was inspired by the French ornamental designer Jacques de LaJoüe (Washington et al., 1979–81, no. 11): although an obscure prototype, the whole series was derived from French source, and Francesco's ornamental designs also show the influence of LaJoüe. However, fountains made up of large volutes are to be found in contemporary Venetian paintings such as those by Marco Ricci.       M.M.

*Provenance:* Schulenburg coll. (?); Knoedler, New York; acquired 1956
*Exhibitions:* Venice, 1965[1], cat. 27; Washington et al., 1979–81, no. 11; Venice 1993[2], no. 5
*Bibliography:* Watson, 1960, pp. 6, 7, 13; Pignatti, 1964, p. 57; Hannegan, 1967, pp. 55–7; Heinemann, ed., 1969, cat. 122; Mahon, 1965, p. 78ff.; Morassi, 1973, I, no. 102; Binion, 1990, p. 107; Pedrocco and Montecuccoli Degli Erri, 1992, p. 130, no. 61

## 195

ANTONIO GUARDI
*Madonna of the Rosary (The Pala di Belvedere)*
*c.* 1748–9
oil on canvas, 234 × 115 cm
Arcidiocesi di Gorizia

Pictured with the Virgin and the Christ Child are SS. Antony Abbot, Dominic, John Nepomuk, Sebastian and Mark. St Dominic receives the rosary from the Virgin; St Antony is pictured with his tau-shaped crutch, his bell, and 'St Antony's fire', represented by the flaming book held by putto at his feet. St John Nepomuk was not beatified until 1721. At his forehead is the five-starred nimbus that, following his death, floated above the body as it lay in the River Vltava.

The shield at the base of the throne belongs to the Savorgnan family, Venetian nobles originally from the Friuli. This altarpiece was probably ordered by Maria Lucrezia Morosini-Savorgnan, born into the Giovanelli family, Domenico's and Antonio's first patrons (Pedrocco and Montecuccoli Degli Erri, 1993, p. 44). The Savorgnan family provided the patronage for Antonio's most important works, the organ parapet in the Angelo Raffaele and the allegorical frescoes in Ca' Rezzonico.

The Belvedere Church was reconstructed in 1746 (De Maffei, 1951, p. 89) and consecrated in 1749. The painting probably can be placed between these two dates. It was inspired by Sebastiano Ricci's altarpiece in S. Giorgio Maggiore (fig. 7), but a radical change took place between its preliminary drawing (cat. 196) and the finished work.       M.M.

*Provenance:* chiesa Parrocchiale di S. Antonio Abate, Belvedere di Aquileia
*Exhibitions:* Florence, 1922, cat. 532; Gorizia, 1956; Venice, 1965[1], cat. 16; Udine, 1966, cat. 41; Venice, 1969, cat. 111; Gorizia, 1987, cat. 3
*Bibliography:* Mahon, 1965, p. 84ff.; Morassi, 1973, I, cat. 63; Pedrocco and Montecuccoli Degli Erri, 1992 pp. 43–5, cat. 109; Delneri, in Gorizia, 1987, pp. 147–50

## 196

ANTONIO GUARDI
*Virgin and Child with Saints*
*c.* 1745
pen and brown wash over traces of red chalk,
36 × 22 cm
Museo Civico Correr, Venice (Dono Morassi)

The Saints are Dominic, Theresa and Coribian. Dominic has a star at his forehead, and receives the rosary. St Coribian of Freising was a Bavarian bishop who, on his way to Rome, subdued a bear who devoured his pack-horse, then charmed the beast into carrying his bags for the rest of the way. Morassi's identification of this saint as Urso (of Solthum?), whose attribute is also a bear, was probably erroneous since Urso was a soldier, not a bishop.

This drawing has been regarded by most authors as preparatory to the *Pala di Belvedere* (cat. 195), but this does not account for the major changes in iconography (other saints are represented) and the different style of the two works.       M.M.

*Provenance:* Maius Palme; A. Morassi coll., Milan
*Exhibitions:* Venice, 1962, no. 53; Washington, 1963–4, no. 5; Venice 1964, no. 5; Venice 1965[1], no. 2; New York, 1985, no. 26
*Bibliography:* Pignatti, 1967[1], no. VI; Morassi, 1975, no. 13; Binion, 1976, no. 76; Gorizia, 1987, pp. 158–60

## 197

ANTONIO GUARDI
*Standing Male Nude*
*c.* 1750s
red chalk heightened with white, 42 × 27 cm
verso: *Male Nude*
Professor William B. O'Neal, Promised Gift to the National Gallery of Art, Washington

These accomplished drawings are important for an understanding of the change that occurred in Antonio's art in his later career. First, they demonstrate the seriousness with which Antonio studied the human form in preparation for monumental paintings such as the Belvedere altarpiece (cat. 195). Academic drawing was an important part of Venetian artistic practice, as is demonstrated by Tiepolo's depiction of a life-class (cat. 91) and Piazzetta's *Studi di pittura* (cat. 89), and also by a rarely discussed, late genre painting by Francesco (repr. in Molmenti, 1926, p. 122).

The present drawing also furnishes further evidence that Antonio's nomination as a member of the Venetian academy in 1756 was not merely due to the fact that he was Tiepolo's brother-in-law. If, as the style seems to indicate, the drawing precedes the foundation of the

Academy, it provides evidence that Antonio participated in the resurgence of interest in academic training in Venice in the early decades of the 18th century (on the Venetian Academy and the question of teaching see Binion, 1976, pp. 20–71).

A related drawing is in Ottawa (Morassi, 1975, cat. 58). although Pedrocco (in Gorizia, 1987, pp. 168–70), uniquely does not accept the attribution of these drawings to Antonio, his doubts seem unfounded.                    M.M.

*Provenance:* J. D. Cocking; Christie's, London, 27 Nov. 1973, no. 130; Katrin Bellinger Kunsthandel, Munich
*Exhibitions:* London, 1990, no. 20
*Bibliography:* Morassi, 1975, no. 59; Gorizia, 1987, p. 167

## 198

ANTONIO GUARDI
*Triumph of Military Virtue*
*c.* 1750
pen and sepia wash
inscribed on verso: '*Giovan Antonio Guardi Veneto Pittore*' (autograph?); and on recto at upper left: '*La virtù Gueriera trionfante/tirata dal Tempo/che la conduce al Tempio/con la Fama che la corona/di lauoro e la compagna/con la tromba*'
25 × 45 cm
Museo Civico Correr, Venice (inv. cl. IV, 8221)

Five drawings from this series for an unknown commission are extant; originally there were as many as ten (Binion, 1976, no. 50). The other known ones, of varying formats and dimensions, are *Faith, Fortitude and Eloquence*, *Prudence and Temperance*, and an *Allegory of Fame* (Biblioteca Comunale, Fermo), and *Peace and Justice* (priv. coll., Paris). These are certainly designs for ceiling paintings rather than for frescoes, since one of the drawings indicates a *quadro* (Binion, 1976).

Fiocco (1965) considered this to be one of Antonio's earliest drawings. Binion concurred, and compared it to the Louvre *Bacchus and Ariadne* (Morassi, 1975, no. 36). However, Morassi, who first published this drawing (1953, p. 263), rightly assigned it to Antonio's later period on the basis of style, and Pignatti agreed, pointing out that the putti are identical with those in the Belvedere altarpiece of *c.* 1750 (cat. 195). The later dating would accord better with the type of commission characteristic of this phase of Antonio's career, such as the allegorical cycles in Ca' Rezzonico and the Cini Collection, Venice. Although these seem to have been influenced by Giambattista Tiepolo's allegorical cycles of this period, they are probably Antonio's own invention.                    M.M.

*Provenance:* Priv. coll., Geneva; Meissner collection, Zurich; 1966, gift of A. Morassi to Museo Civico Correr
*Exhibitions:* Paris, 1960, no. 299; Venice, 1965, no. 10; Venice, 1969, no. 113; Paris, 1971, no. 149; London, 1972, no. 112; New York, 1985, no. 25
*Bibliography:* Pignatti 1967[1], no. VII; Morassi, 1975, no. 40; Binion, 1976, no. 50; Gorizia, 1987, p. 163

# FRANCESCO (LAZZARI) GUARDI
baptised Venice, 5 October 1712
died Venice, 1 January 1793

Painter and draughtsman. Francesco began his career as a figure-painter in the workshop of his elder brother, Antonio, who also trained him. His first signed painting, *A Saint in Ecstasy*, (Museo Diocesano, Trent) is dated 1739. He continued to produced history paintings throughout his career, though this part of his output is not large. Apparently he worked with his brother until the latter's death, but he also accepted independent commissions. He was inscribed in the Venetian *fraglia* only after his brother's death in 1761, four years after he married Maria Pagani. In 1784 he was appointed Professor of Perspective of the Venetian Academy, replacing Visentini. It seems that view-painting became Francesco's primary activity only in the late 1750s. Gradenigo's comment that he was a 'scholar' of Canaletto has been interpreted to mean either that he was in Canaletto's studio or that he followed that master's style. A pair of views made for an English patron and exhibited in Piazza S. Marco in 1763 won him 'universal applause'; one of these may be cat. 210.

Most of Guardi's views were produced from the 1760s onwards. He worked both for the tourist trade and for foreigners resident in Venice, for local intellectuals and noble families. Pietro Longhi portrayed Francesco as a self-assured gentleman artist (1764; Ca' Rezzonico, Venice). In 1778 the Doge granted a licence for Francesco's views to be engraved. He was employed by the government to record state occasions, such as the visit to Venice of Pope Pius VI in 1782. Francesco also travelled in the Trentino in 1778 and 1782. It was probably around this time that he painted a series of country-house portraits for John Strange, the British Resident in Venice (cat. 216). After Francesco's death, his son Giacomo (1764–1835) continued the family studio, in which he produced paintings in both his father's and his own manner.                    M.M.

*Bibliography:* Simonson, 1904; Fiocco, 1923; Haskell, 1960; Binion, 1976; Mahon, 1965; Morassi, 1973; Rossi Bortolatto, 1974; Gorizia, 1987; Succi, 1993; Venice, 1993[1]

FRANCESCO GUARDI
*Seated Turk with a Leopard*
1760s
pen and sepia wash on blue paper heightened with white, 34.5 × 39 cm
The Pierpont Morgan Library, New York
The Janos Scholz Collection (acc. no. 1974.33)

This drawing is similar in theme to the Turkish scenes painted by Antonio and Francesco Guardi for Marshal Schulenburg (cat. 194), although this particular figure does not appear in any of the known paintings from the series. Neither does it seem to share a common source with those works, such as the engravings in the *Receuil Ferriol*.

Because this drawing has been pricked for transfer, it has been suggested that it was intended to decorate doors or furniture (Venice, 1957). A fragment of a drawing of a pair of pointed slippers (Metropolitan, New York; see Bean and Griswold, 1990, no. 91), is also pricked for transfer, although no firm conclusions can be made about the relationship of the two drawings.

Although Morassi (1975, no. 314) dated the present drawing to the 1780s on basis of style, the elaborate preparation of the support and the angular contours with which the figure is defined seem atypical of the quick penmanship of Guardi's later works, seen, for example, in the *Lady Wrestling with a Lion* (Morassi, 1975, no. 235).                                      M.M.

*Provenance:* J. Scholz
*Exhibitions:* Venice, 1957, no. 96; Houston, 1958, no. 39; Oakland and San Francisco, 1960, no. 37; New Haven, 1964, no. 77; Hamburg and Cologne, 1963–4, no. 73; London, 1968, no. 49; New York, 1971, no. 214
*Bibliography:* Morassi, 1975, no. 259

200

FRANCESCO GUARDI
*Macchiette*
1780s
pen and brown ink and brown wash on blue paper, 16.3 × 21.9 cm
inscribed lower left: 'f.co Guardi'
Lent by The Metropolitan Museum of Art, New York, Gift of Harold K. Hochschild, 1941 (inv. 40.91.3)

Many sheets containing groups of small figures by Francesco are known. They are called *macchiette* from the 'blottings' of wash from which they are constructed. Figures, such as the woman with the plumed head-dress and her companion in the extreme foreground, reappear many times in Guardi's œuvre (e.g. in the *Festa*

*della Sensa*, cat. 205). It is unlikely that Guardi drew these figures from life, or that they were made for any particular painting. Rather, they illustrate the play of his imagination as he arranges groups in a picturesque manner. These drawings are dated to the 1780s on the basis of the rapid penmanship and on the lady's distinctive hairstyle (Byam Shaw, 1955, pp. 37–8).                                      M.M.

*Provenance:* H.K. Hochschild, New York; 1940, presented by him to the Museum
*Exhibition:* New York, 1971, no. 189
*Bibliography:* Byam Shaw, 1951, no. 51; Morassi, 1975, no. 206; Bean and Griswold, 1990, no. 96

201

FRANCESCO GUARDI
*The Fire at S. Marcuola*
1789–90
oil on canvas, 42.5 × 62.2 cm
Lent by the Bayerischen Hypotheken- und Wechsel-Bank AG to the Bayerischen Staatsgemäldesammlung, Munich

One of Guardi's most famous images, it depicts the terrible fire that broke out on 28 November 1789 in the oil store in the quarter of S. Marcuola. Guardi skilfully depicts the strange illumination caused by the flaming oil on the surface of the canal and successfully creates a sense of recession (in other versions and drawings, it is not clear that the flaming canal separates the onlookers on the near bank from the houses).

This is the best, and probably only entirely autograph, version of the many surviving paintings and drawings of this subject, including the painting in the Accademia, Venice, and the drawings in the Metropolitan, New York, and the Museo Correr, Venice. In these other versions Guardi's son Giacomo is often thought to have intervened in the figures and architecture, or even have been entirely responsible for them (Succi, 1993, pp. 139–45).                                      M.M.

*Provenance:* Nathaniel de Rothschild Collection; 1986, Bayerisches Hypothekenun Wechsel-Bank AG, Munich
*Exhibitions:* Washington and Cincinnati, 1988–9, no. 9
*Bibliography:* Morassi, 1973, no. 313; Kultzen and Reuss, 1991, pp. 67–8

FRANCESCO GUARDI
*The Ridotto*
c. 1745–58
oil on canvas, 108 × 208 cm
Ca' Rezzonico, Museo del Settecento Veneziano, Venice (inv. 124 cl. I)

This painting depicts the main room at the Casino of the Ridotto in Palazzo Dandolo in S. Moisè. The Ridotto was the centre of gambling in the city until it was closed in 1774 following an almost unanimous vote of the Senate (Molmenti, 1926, pp. 276–8). Francesco shows the room as it was before Maccaruzzi's alterations in 1758 (the design of the new Ridotto is seen in Gabriele Bella's painting in the Querini Stampalia, Venice).

*The Ridotto* and its pendant, the *Parlatorio in the Convent of S. Zaccaria* (fig. 53), have been generally classed as genre scenes. Binion (1976, cat. 88), however, suggested that the *Ridotto* shows a scene from Goldoni's *Donne Gelose*, produced in the winter of 1752–3. The climax of this comedy takes place in the gambling house, but it is unlikely that a particular moment from the play is shown. Whether or not all the figures correspond to Goldini's characters, it is certain that the *Ridotto*, like Goldoni's play, in part represents the gambling den as a place of amorous intrigue centered on the courtship the woman with a basket and a page by the masquerader. If she is meant to illustrate, not a prostitute, but rather an unchaperoned middle-class girl in a dangerous predicament, we can modify the suggestion that the *Ridotto* and its pendant illustrate the theme of virtue and vice (Morassi, 1973, I, p. 161). More likely, the two works contrast the wisdom of Venice's aristocrats, who placed their unmarried daughters in a convent (illustrated in the *Parlatorio*, the central figure of which may represent a marriageable aristocratic woman), with the indifference of the middle-class merchants with regard to safeguarding their daughters' virtue (the woman with the basket in the *Ridotto* would thus represent a young middle-class girl like Orsetta in Goldoni's play, whose free pursuit of amorous intrigues furnishes an occasion for shocked comment by her country cousin Chiaretta).

The *Ridotto* has been attributed to Antonio on the grounds that a related drawing of the same subject (Art Institute of Chicago) bears his (possibly authentic) signature (Joachim and Folds-McCullagh, 1979, no. 128). Other versions of the *Ridotto* have been attributed to one or other of the brothers; they include versions in the Fitzwilliam Museum, Cambridge (Washington et. al., 1989–90, no. 124, as Antonio); the Cailleux Collection, Paris (Morassi, 1973, I, no. 235) and the Rothschild Collection (Morassi, 1973, I, no. 234). Another

variant is in the Heinemann collection, New York (Morassi 1973, I, no. 236; its pendant the *Andito della Sala del Maggior Consiglio*, is signed by Francesco). Another problem is that the unusually assured handling of the figures in the *Ridotto* seems closer to Antonio's brilliant brushwork than does the technique of the *Parlatorio*, but it is now generally agreed that it is unlikely that the pair are by different hands, although the *Ridotto* has been attributed to Antonio recently (Succi, 1993, pp. 223–31). It is reasonable to conclude that these works are the production of the workshop run jointly by Antonio and Francesco. Because of their large size, unusual for genre works in the Longhi manner, it is more than likely that they were produced on commission rather than speculatively.

The composition of both the *Ridotto* and the *Parlatorio* are probably loosely based on certain works by Petro Longhi (see Pignatti, 1969, pls. 168–72). Pedrocco dates the pair to the 1740s on the basis of the dates of the presumed Longhi originals and of the female costume (Pedrocco, 1993, pp. 30–7); but the relative hardness of the style seems to reflect the enamelled surfaces found in Longhi's paintings of the 1750s (see *The Rhinoceros*, 1751, cat. 182). Binion (1976, no. 88) dates the present work 1753–60, remarking that the *moretta*, a round black mask, fell out of fashion *c.* 1760. It was during the 1750s that Francesco and Longhi were in closest contact; his drawings after Longhi's *Sacraments* date from this time (see cat. 185, and Pignatti, 1987, pp. 61–5), and Longhi painted Francesco's portrait in 1764. In the handling of the figures, the *Ridotto* points towards the sureness of outline and spirited movement of those figures on a similar scale by Francesco in the *Miracle of a Dominican Saint* dated 1763 (fig. 51), and on the right bank of the Grand Canal in *The Rialto Seen from the South* (cat. 211). Thus, a cautious dating to the late 1750s seems warranted.  M.M.

*Provenance:* Correr Collection; 1830, acquired by the Museum
*Exhibitions:* Florence, 1922, no. 503; Venice, 1929, no. 5; Lausanne, 1947, no. 116; Turin, 1951, no. 128; Paris, 1960–1, no. 281; Stockholm, 1962, no. 28; Venice, 1965[1], no. 24; Gorizia, 1987, no. 7
*Bibliography:* Morassi, 1973, I, pp. 161–8, no. 233; Rossi Bortolatto, 1974, no. 55; Pedrocco, in Gorizia, 1987, pp. 30–7; Succi, 1993, pp. 223–31

FRANCESCO GUARDI
*Regatta in the Bacino di S. Marco*
1784–9
pen and sepia wash with traces of charcoal, 34.9 × 67.6 cm
Lent by The Metropolitan Museum of Art, New York
The Robert Lehman Collection, 1975 (inv. 1975.1.342)

This panoramic view of the Bacino and the Giudecca canal is remarkable both for its wide perspective and for the unusual and beautiful economy of penstrokes and washes with which Guardi has delineated the architecture. This is a preparatory drawing for the painting in Munich, but the number and disposition of the boats is different and it lacks details found in the *Festival Gondola with an Allegory of Fame* (cat. 207), which appears in the painting. These differences suggest that Francesco created imaginary paintings of regattas, although they incorporate features of actual events.

Francesco probably combined elements from various drawings he had in his studio in order to produce a convincing representation of topography not visible from any one vantage point. Thus, drawings in the Fogg Art Museum and the National Gallery of Canada, Ottawa (Morassi 1975, cat. 401, 343) together present the view seen here. The verso of the Ottawa sheet and a different drawing in the Fogg (Morassi, no. 355) show the view of the Bacino and S. Giorgio as in the painting's pendant (Bührle Collection, Zurich). Another drawing of the present subject is in Geneva (priv. coll.; Kultzen, 1976, fig. 2; Morassi, 1975, no. 295).  M.M.

*Provenance:* Lady Ashburnham, Battle Abbey, Sussex; 24 June 1953, Sotheby's, London, lot 54; Robert Lehman, New York
*Exhibitions:* New York 1971, no. 193; Washington et al., 1974–5, no. 122
*Bibliography:* Byam Shaw, 1951, no. 27; Pignatti, 1967[1], LXII; Morassi, 1975, no. 294; Byam Shaw and Knox, 1987, cat. 29

204

FRANCESCO GUARDI
*Festivals of the Doge; The Bucintoro Leaving S. Nicolò al Lido*
1770–5
oil on canvas, 67 × 100 cm
Musée du Louvre, Paris, Département des Peintures

One of a set of twelve paintings by Francesco recording ceremonies connected with the coronation and duties of doge Alvise IV Mocenigo (reigned 1763–78). They belonged to

Baron di Pestre de Seneffe when they were confiscated by the French in 1797. However, it is unlikely that they were made for him, and it has been plausibly suggested that they were commissioned by Mocenigo himself (Morassi, 1973, I, p. 181). If so, this series was the first of Francesco's many state commissions (see fig. 52).

Here the ducal barge is shown returning from S. Nicolò al Lido, the church where benediction was given after the symbolic marriage of Venice to the sea conducted each year on Ascension Day (see Muir, 1981).

All twelve paintings depend on drawings by Canaletto (cat. 149) engraved and published by G. B. Brustolon in 1766 (cat. 150), but it was probably the engravings rather than the drawings that provided Guardi with his models (Pignatti, 1977). This scene is from Brustolon's plate 6. Although Guardi copied the architecture in his model very closely, he followed his fancy in the details of some boats and passengers: the woman in the boat at lower right wears an up-to-date plumed tricorn hat, fashionable only after 1770, which does not appear in the models. This date supports the theory that the twelve paintings were executed over a long period of time (*c.* 1768–80). This painting's date is provided by the costumes, but supported by the minute and decorative use of the brush, characteristic of Francesco's style of this period.  M.M.

*Provenance:* Baron di Pestre de Seneffe; confiscated by the French government in 1797
*Exhibitions:* Venice, 1965, no. 103; Paris, 1971, no. 79; Bern, 1991, no. 136; Venice, 1993[1], no. 66
*Bibliography:* Morassi, 1973, no. 248; Pignatti, 1975[1]

205

FRANCESCO GUARDI
*The Festa della Sensa in Piazza S. Marco*
*c.* 1775
oil on canvas, 61 × 91 cm
Calouste Gulbenkian Museum, Lisbon (inv. 386A)

One of the main events of the celebration of the Feast of the Ascension in Venice was the transformation of the Piazza S. Marco into an immense market. The present work shows the temporary structure that was erected in 1775 (see Amsterdam, 1990–1, no. 45); after 1776 Maccaruzzi redesigned the square in a complex system of Serlian arcades, and the new structure was also painted by Guardi (Kunsthistorisches Museum, Vienna).

This is one of a series of four important works in the Gulbenkian, including the *Regatta 'in volta del Canal'* (Morassi, 1973, I, no. 299), the *Capriccio with Palladio's Design for the Rialto Bridge*

(Morassi, 1973, I, no. 403). Another, larger, version of the present subject in the same collection (Venice, 1993[1], no. 64), and a preliminary drawing is in the British Museum (Venice, 1993[1], 12). Succi (1993, p. 107) and others date these paintings to the 1780s, after Maccaruzzi's alterations in 1776; it seems more reasonable to suppose that they were more or less at the same time as the structure they represent.

M.M.

*Provenance:* Earl of Camperdown; March 1919, Christie's, London
*Exhibitions:* Paris, 1935, no. 214; London, 1937. no. 16; Washington 1950, no. 15; Stockholm, 1962–3, pp. 146–7; Venice, 1965[1], no. 117
*Bibliography:* Morassi, 1973, no. 277; Rossi Bortolatto, 1974, no. 500; Succi, 1993, p. 107

## 206

FRANCESCO GUARDI
*Decorative Cartouche with a Landscape*
*c.* 1770
black chalk, pen and greyish indian ink, with light sea‑green, blue, brick‑red, golden yellow and reddish‑brown watercolours on white paper, 41.9 × 68.89 cm
Cooper‑Hewitt, National Museum of Design, Smithsonian Institution, New York, Bequest of Erskine Hewitt

Guardi produced many beautiful decorative designs: for boats (cat. 207), furniture, such as *paliotti,* or altar frontals (see Pilo, 1983), ceilings (see Morassi, 1975, no. 459), and, as here, for walls. The *rocaille* style of the frame shows the influence of French *ornementistes,* though the design is certainly Francesco's own. No examples survive of stucco after Francesco's designs, though this drawing probably reflects the way some of his landscape paintings, such as the Colloredo *capricci* (cat. 218), were installed.

No painting precisely corresponds to that enframed by the cartouche (though see Morassi 1975, and 1973, I, no. 910). A variant (Kunsthalle, Hamburg; see Byam Shaw, 1951, no. 68) shows that it derives from Canaletto's etching of the *Torre di Malghera* (cat. 143). The right‑hand side of the drawing is an addition showing an alternative solution to the framing element; its penmanship and brushwork is much clumsier than the left‑hand side, though the chalk indications beneath are, perhaps, Francesco's own. It is likely that the addition was made early, for the paper is similar, and it bears the mark of the earliest known collector.

M.M.

*Provenance:* unknown sale, lot 22, (noted on *verso*); 4th Earl of Warwick; 17 July 1896, Christie's, London, lot 164; R. De Madrazo; S. Cooper and E. Hewitt

*Exhibitions:* Boston, 1958; Baltimore, 1959, no. 212; New York 1959–61, no. 30; New York, 1962, no. 46; Venice, 1965[1], no. 31; Washington et al., 1967, no. 209; New York, 1971, no. 212; London 1973, no. 100; Brooklyn, 1974; Los Angeles, 1976, no. 66; Cologne, 1980, no. 27
*Bibliography:* Byam Shaw, 1951, no. 68; Pignatti, 1967[1], no. XLVI; Morassi, 1975, no. 462

## 207

FRANCESCO GUARDI
*Festival Gondola with an Allegory of Fame*
*c.* 1770s
pen and ink and watercolour over black chalk
40.3 × 53.7 cm
The Board of Trustees of the Victoria and Albert Museum, London (inv. 143)

One of many drawings of such parade boats (*bissone*) by Francesco. It has been plausibly argued that he also designed such vessels, not merely the recorded them, for these are precision drawings filling entire sheets, and one of them is inscribed with measurements (Correr, Venice; Pignatti, 1967). By order of the Republic each noble house was expected to bring a decorated boat to state functions (Molmenti, 1926). Festive *bissone* were designed by other artists, including Piranesi (cat. 266) and Tiepolo (fig. 4).

Stylistically, this drawing would seem to have been made after the 1760s. This particular *bissona* reappears in many of Guardi's later *regatte* (Morassi, 1973, II, figs. 327, 330, 334). M.M.

*Provenance:* bought 1857
*Exhibitions:* London, 1953, no. 189; Venice, 1962, no. 86; Brussels 1983, no. 126; Venice, 1993[1], no. 16
*Bibliography:* Morassi, 1975, no. 303, Ward‑Jackson, 1980, II, no. 1032

## 208

FRANCESCO GUARDI
*Concert for the Conti del Nord*
1782
pen and brown ink, wash and watercolour with colour indications, 51.9 × 77.8 cm
The Royal Museum and Art Gallery, Canterbury

Paul Petrovich, later Tsar Paul I, and his wife Maria Teodorovna of Württemburg adopted the title of the '*Conti del nord*' when they arrived in Venice 18 January 1782 for a week's visit. Despite their incognito, they were received by the Venetian aristocracy with all the pomp due their true status. This painting illustrates one such festival, a concert given in the Sala dei Filarmonici (sometimes called the Ridotto dei

Nobili) in the Procuratie Vecchie by the famous chorus of 80 orphan girls from the institutions of the Pietà, Incurabili, Derelitti and Mendicanti. The Grand Duke and Duchess are seated at right.

This is one of a set of six subjects known to have been produced by Francesco for the occasion. The series is incomplete and dispersed (for the other related paintings and drawings, see Azzi Visentini, in Venice 1993[1], p. 180–1). This drawing is probably the presentation model for the painting in Munich (Kultzen and Reuss, 1991, pp. 66–7). The drawing is nearly the same size as the painting, but there are significant differences, most importantly the painting exaggerates the grandeur of the ballroom by reducing the size of the figures. It is not known who commissioned the paintings. It has been suggested that the former owner of this sheet, John Ingram, the British Resident in Venice, may have commissioned the series; he owned an important collection of Guardis (see Haskell, 1960, 271–2; Byam Shaw, 1977). But since the extant paintings from the series do not seem to have been in his collection, and because Ingram also possessed other series of drawings, including those of the visit of Pope Pius VI and the Polignac wedding (cat. 209), events with which he is not known to have been personally connected, it is more plausible that he collected them for their artistic merit alone. Brown (Washington and Cincinnati, 1988–9) suggests that the commission came from Pietro Edwards, Inspector of Paintings in Venice, who, on behalf of the state, ordered the paintings from Guardi recording the visit of Pius VI in 1782 (Haskell, 1960). M.M.

*Provenance:* J. Ingram (1767–1841); Hughes Ingram; Ingram Fuller Godfrey; Royal Museum, Canterbury
*Exhibitions:* Venice 1980, no. 118; Brussels, 1983, no. 122; Canterbury, 1985, no. 3; Venice, 1993[1], no. 18
*Bibliography:* Byam Shaw, 1977, no. 1

FRANCESCO GUARDI
*Festive Dinner for the Polignac Wedding*
1790
watercolour over graphite with touches of pen
and ink, 27.5 × 41.9 cm
inscribed (probably by Nicolo Barozzi, director
of the Correr Museum in the 19th century):
'*Sala dei nobil H. Gradenigo a Carpenedo coll'*
*apparato dei convitati alle nozze del Polignac*'
Museo Civico Correr, Venice (inv. cl. III 29)

This shows the dinner at the Villa Gradenigo,
Carpenedo, given to celebrate the marriage in
1790 of Armand, Duke of Polignac, to the
Baroness Idalia of Neukirchen. This was the last
important commission given to Francesco before
his death in 1793. Many of his drawings of the
marriage ceremony and related celebrations exist
(see Morassi, 1975, I, nos. 315–8; Azzi
Visentini, in Venice, 1993[1]), but no
corresponding paintings are known, and it is
possible that Francesco died without having
completed them. The suggestion that the series
was rejected must be regarded as speculative.

Compared to Francesco's other, earlier
drawings, the composition and penmanship of
this drawing is markedly restrained. This
possibly reflects the Neo-classical character of the
decorations, for other drawings from the same
series are much freer. However, the choice of
colours, the transparency of the washes, and the
delicate penmanship are all consummately
Rococo.                                          M.M.

*Provenance:* Domenico Zopetti; T. Correr; 1830,
Correr Museum
*Exhibitions:* Venice, 1929, no. 41; Venice, 1936,
no. 103; Lausanne, 1947, no. 187; Paris, 1960–
1, no. 315; Venice, 1962, no. 100; Washington
et al., 1963–4, no. 90; Venice, 1964, no. 88;
London 1965, no. 93; Venice, 1969, no. 123;
Venice, 1978[1], no. 44; Brussels, 1983, no. 124;
New York, 1985, no. 99; Venice, 1985, no. 97;
Caldes 1993, no. 38; Venice, 1992[1], no. 23
*Bibliography:* Pallucchini 1943, no. 100; Pignatti
1967[1], no. LVII; Morassi, 1975, no. 318;
Pignatti, 1983, no. 659

FRANCESCO GUARDI
*The Rialto Bridge with Palazzo dei Camerlenghi*
*c.* 1760–3
signed lower left: '*F.co. Guardi*'
oil on canvas, 122 × 200 cm
Paul Channon MP

This view, the pendant to cat. 211, of the Grand
Canal on the north side of the Rialto was
probably observed from a building on the site of
the present Palazzo Sernagiotto (Byam Shaw,
1951, no. 12). To the left of the bridge is the
Fondaco dei Tedeschi, behind that is the onion-
shaped campanile of S. Bartolommeo (rebuilt in
1754). The imposing building seen in profile at
the extreme left is Palazzo Civran (probably by
Massari, *c.* 1700). To the right of the bridge are
the Palazzo dei Camerlenghi and the arcades of
the Fabbriche Vecchie (between them can be
glimpsed the Fruit Market and the back of S.
Giacomo) and at the extreme right are
Sansovino's Fabbriche Nuove and the campanile
of S. Cassiano.

It is now usually accepted that, because of its
ambitious size and evident accomplishment, this
is the painting of the Rialto 'towards the
Cannaregio' described by Gradenigo as having
been commissioned by an English visitor and
exhibited in the Piazza S. Marco to universal
applause in 1763 (Simonson, 1904, p. 81). Its
pendant, however, does not correspond to the
one described by Gradenigo (a view of the
Bacino, for which no convincing candidates
have been put forward). There are two smaller
variants (Metropolitan, New York; Munich).
Because neither variant has a pendant
corresponding to that mentioned by Gradenigo,
and because neither of them can be described as
large, they have no greater claim than the present
picture to be the work exhibited in 1763.

It is usually stated that this view derives from
compositions by Canaletto or by Marieschi, but
Francesco did not mechanically copy any known
painting or engraving by an earlier artist. The
drawings of this composition (Musée Bonnat,
Bayonne; Kupferstichkabinett, Berlin) were
made on the spot. They both take a more
restricted viewpoint in both height and width,
but are probably preliminary to the painting
rather than records of it because they carry notes
on colour and shade (see Byam Shaw, 1951,
nos. 12–13). Francesco probably used a camera
obscura to assist him, as Gradenigo reported
(Simonson, 1904, p. 81). This instrument
would account for the presence of 'circles of
confusion' in his paintings of the 1760s, such as
are visible here, and may also have been
responsible for the distortion in perspective
(Succi, 1993, p. 48).                           M.M.

*Provenance:* bought in Italy by Mr Arcedeckne,
London; Lord Huntingfield, Yoxford, Suffolk;
Agnews, London; Lord Iveagh, Pyrford Court
*Exhibitions:* London, 1954–5, no. 50; London,
1960, no. 200
*Bibliography:* Simonson, 1904, no. 105; Byam
Shaw, 1955 p. 15 n. 5; Morassi, 1973, no. 555;
Rossi Bortolatto 1974, no. 234, 318; Succi,
1993, p. 48

FRANCESCO GUARDI
*The Rialto Bridge Seen from the South*
*c.* 1760–3
oil on canvas, 122 × 205 cm
Paul Channon MP

This painting, the pendant to cat. 210, shows
the southern face of the Rialto Bridge. The Riva
del Vin, terminating in the Palazzo dei Dieci
Savi at the foot of the bridge, is to the left; the
Riva del Ferro is to the right, and the imposing
building on the right is the Palazzo Dolfin-
Manin. From there, a bridge leads over the Rio
di S. Salvatore to the Gothic Palazzo Bembo,
the corner of which can be glimpsed on the
extreme right.

Like its pendant, this painting has been
considered to be an imitation of either Canaletto
(see the engraving by Visentini after Canaletto,
1751, part II, pl. 8) or Marieschi (1741, pl. 10;
repr. Gorizia, 1989, p. 276). However, in both
paintings Francesco has characteristically
reinvented the scene, as is evident by comparison
with the supposed sources and from his many
extant preliminary drawings, such as the study
for the figure group at right (Bean and
Griswold, 1990, no. 98). Another related
drawing (Paris, Louvre), which shows the entire
composition as in the painting, is, according to
Bettagno (Venice 1993[1], no. 5), later in style,
and possibly was made as a *ricordo* rather than a
preparatory sketch.

This painting served as the prototype for
many of Francesco's views of the Rialto. A
version in the Fondaçao Gulbenkian, Lisbon
(Morassi, 1973, no. 525) is a reduced, possibly
later, replica of the present painting; it is the only
other one of Francesco's many views of the
southern face of the Rialto to include the Dolfin-
Manin palace. Other similar views are listed in
Morassi (1973, I, nos. 525–46).            M.M.

*Provenance:* bought in Italy by Mr Arcedeckne,
London; Lord Huntingfield, Yoxford, Suffolk;
Agnews, London; Lord Iveagh, Pyrford Court
*Exhibitions:* London, 1954–5, no. 52
*Bibliography:* see cat. 210, above

FRANCESCO GUARDI
*The Grand Canal with Palazzo Bembo*
*c.* 1765–70
pen and brown wash over traces of charcoal,
42 × 75.5 cm
Lent by the Syndics of the Fitzwillian Museum,
Cambridge (inv. PD.18–1959)

To the left is the Palazzo Bembo, destroyed in
the early 19th century; to the right is the church
of S. Geremia which was consecrated in 1762
(furnishing a *terminus post quem* for the drawing).
The drawing is inscribed with colour
annotations, a typical feature of Francesco's
method in the 1760s, and belongs to the artist's
most Canalettesque phase. The painting for
which it was preparatory has not been identified;
it has been related to works in the Rothschild
Collection, Paris, and in the Musée des
Augustins, Toulouse (Morassi, 1973, nos. 569–
70, figs 542–3); Morassi erroneously identified
Palazzo Bembo as Ca' Correr. A print of this
scene by Dionigio Valesio (active in Venice *c.*
1740–80) is probably after the Rothschild or
Toulouse painting rather than this drawing (see
Gorizia, 1987, no. 75).                        M.M.

*Provenance:* G.F.J. Knowles
*Exhibitions:* London and Birmingham, 1951, no.
41; London, 1953, no. 197; London, 1954–5,
no. 570; Brussels, 183, no. 111
*Bibliography:* Byam Shaw, 1951, no. 19; Pignatti,
1967[1], no. XXVIII; Morassi, 1975, no. 381

## 213

FRANCESCO GUARDI
*View on the Cannaregio Canal*
after 1788
oil on canvas, 47.6 × 74.3 cm
National Gallery of Art, Washington
Samuel H. Kress Collection, 1939.1.113

The Cannaregio Canal is the main artery of its
quarter, although it rarely attracted much
attention from painters (only two other works on
this subject by Guardi are known: see Morassi
1973, I. nos. 575–6). More usually, artists
recorded the meeting of this canal with the
Grand Canal at S. Geremia (as in Guardi's
painting in the Alte Pinakothek, Munich; see
Venice, 1993[1], no. 33). Here the main focus is
the Ponte dei Tre Archi built by Andrea Tirali
in 1688 (rebuilt in its present form in 1794).
    This rapid, thinly painted work is usually
dated to *c.* 1770 on the basis of its technique.
Guardi painted over a used canvas (for
contemporary comments that re-using canvases
was typical of his technique see Haskell, 1960),
and x-rays have revealed a fragment of a
decorative composition consisting of a scrollwork
frame surrounding a floral arrangement (repr. in

Merling, 1993). This composition not only
recalls drawings such as cat. 206, it also
furnishes proof of Guardi's involvement in
designing decorative accessories, such as the
*paliotti* attributed to Francesco (Pilo, 1983), and
the independent flower paintings that still pose
problems (see Morassi, 1973, I, pp. 283–5). M.M.

*Provenance:* before 1924, Achillito Chiesa,
Milan; (Alessandro Contini-Bonacossi,
Florence); 1932 purchased by the Samuel H.
Kress Foundation
*Exhibitions:* New York, 1940, no. 29
*Bibliography:* Morassi, 1973, no. 577; Rossi
Bortolatto 1974, no. 340; Shapley 1979, I, pp.
236–7; Garberson, in De Grazia (forthcoming)

## 214

FRANCESCO GUARDI
*The Fortress of S. Andrea from the Lagoon*
1775–85
pen and brown ink with brown wash over black
chalk on laid paper, 30 × 45.9 cm
National Gallery of Art, Washington
Samuel H. Kress Collection, 1963.15.13

Although Shapley (1979) published this
drawing as by Giacomo Guardi, on the grounds
that it lacked the heavily worked penmanship of
Francesco's early drawings, there is no doubt
that it is by Francesco, one of the best and most
characteristic views in his late style, where a
minimum of pen and wash is used to indicate
topographical features and a black ground is
used to provide recession and open space. The
subject is Michele Sanmicheli's fortress of S.
Andrea, which lies on an island to the north of
the Lido.
    A less highly finished version of the same
subject (Canterbury; Byam Shaw, 1977, no. 6),
bears an autograph inscription by Francesco. A
different view of the fortress appears in the *Return
of the Bucintoro* (Correr; New York, 1985, no.
98), the preliminary drawing for a painting in
the Stramezzi Collection, Crema (Morassi 1973,
I, no. 644).                                    M.M.

*Provenance:* Richard Owens, Paris; 1936, sold to
Samuel Kress; 1964, Kress Collection
*Bibliography:* Morassi, 1975, no. 403; Byam
Shaw, 1977, p. 11; Shapley, 1979, I, pp. 244–5;
II, pl. 166 (attributed to Giacomo Guardi)

FRANCESCO GUARDI
*Isola della Madonetta in the Lagoon of Venice*
1780–90
oil on canvas, 36 × 55.5 cm
Fogg Art Museum, Harvard University Art
Museums, Cambridge, MA
Gift of Charles E. Dunlap (inv. 1959.185)

This painting is sometimes wrongly described as
a capriccio; in fact it depicts the island of the
Anconetta or '*della Madonetta*' (so-called because
of the small church there), which lies in the
Lagoon near Mestre. It thus belongs to another
typical category of Francesco's *œuvre*: small views
of individual islands. It is thought that such
paintings, depicting out of the way corners of
Venice, were made for locals rather than for
tourists (Haskell, 1960).
    The British Resident, John Strange,
commissioned the same subject from Guardi in
1785, probably as part of a series of ten views of
the islands surrounding Venice. However,
Strange's demand that the paintings be both
'finished and coloured exactly' seems to preclude
the possibility that this version belonged to
Strange himself (Haskell, 1960, p. 269; Venice
1993[1], no. 48). Another series of such views
(now in Budapest; see Morassi, 1973, I, no. 679)
may have belonged to Algarotti (Simonson,
1904), although Haskell argues that Guardi was
inherently foreign to Algarotti's taste (1960, n.
23).
    Another version of this subject, of the same
approximate dimensions, but more problematic
in terms of its attribution, is in the Accademia
(Venice, 1993[1], no. 48). A preliminary drawing
of the subject, of approximately the same date as
the present painting, is in the Metropolitan, New
York (Bean and Griswold, 1990, no. 91).   M.M.

*Provenance:* R. Wallace, Paris; Wildenstein,
New York; C.E. Dunlop; Gift to the Museum
*Bibliography:* Haskell, 1960, pp. 268–70; Morassi,
1973, I, no. 659; Rossi Bortolatto, 1974, no. 771;
Bowron, 1990, pp. 362, 778

FRANCESCO GUARDI
*Villa del Timpano Arcuato at Paese*
*c.* 1782
oil on canvas, 48 × 78 cm
Private Collection

One of a set of four paintings of private houses
in Venice and the *terraferma* painted for John
Strange, the British Resident in Venice from
1773 to 1790. The others are *The Gardens of the
Palazzo Contarini dal Zaffo* (Art Institute of
Chicago), *View of the Villa Loredan near Paese,
seen from the front* (priv. coll.), and *View of the
Villa Loredan near Paese, seen from the back*
(Metropolitan, New York, Wrightsman
Collection), in the last of which the Villa del
Timpano Arcuato (named for its arched roof)
can also be seen at the left. The circumstances of
the commission are not fully known. Strange
had his country residence at Paese, near Treviso.
Both the Villa Loredan, which he rented, and
the neighbouring Villa del Timpano Arcuato
belonged to the Loredan family (Mazzotti, 1954,
p. 637); the Contarini family owned the garden
shown in the Chicago painting. Strange was one
of Guardi's most influential patrons, although he
considered Guardi's flights of fancy to be alien to
the requirements of good topographical painting
(see Haskell, 1960). However, his patron's taste
for exactitude did not inhibit Guardi's magic
touch, evident in this luminous work.

Numerous drawings are connected with this
series (see Fahy and Watson, 1973, pp. 106–15;
Morassi, 1975, nos. 419–26). A portion of the
Villa del Timpano Arcuato appears on the *verso*
of a drawing (Providence, Rhode Island;
Johnson, 1983, no. 21). Another drawing shows
the villa as in this painting (Musée Wicar,
Lille).

This series is usually dated to the time of one
of Guardi's trips in the Trentino in 1778 and
1782. The later date is perhaps more likely given
that the Villa Pellegrini, seen to the right in the
*Villa Loredan* in New York, was only built in
1778 (Mazzotti, pp. 638–9).                    M.M.

*Provenance:* J. Strange; 15 March 1800, Strange
sale, Christie's, London, lot 97; Colonel
Milligan, Caldwell Hall, Burton-on-Trent,
Nottinghamshire; 13 March 1883, Christie's,
London; Charles Davies; Colnaghi's; Harold
Sidney Harmsworth, 1st Viscount Rothermere;
Herbert Bier
*Exhibitions:* London, 1954–5, no. 91; Venice,
1965, no. 139
*Bibliography:* Haskell, 1960, pp. 268–70; Ames,
1963, pp. 37–9; Morassi, 1973, I, no. 683; Rossi
Bortolatto, 1974, no. 480; Fahy and Watson,
1973, no. 12

FRANCESCO GUARDI
*View of Levico in the Valsugana*
*c.* 1782
pen and brown ink and brown wash with traces
of charcoal, 42.6 × 63.8 cm
inscribed by Francesco Guardi lower left: '*Levego
verso il Borgo di Valsugana dove la Brenta nasce*'
Mr and Mrs Eugene V. Thaw

Levico lies between Bassano and Trent on the
road to Francesco's birthplace in the Val di
Sole. He returned many times to his native
region, thus furnishing a number of possible
dates for this drawing. A related drawing
showing Borgo Valsugana, another town on the
road to Trent (Morassi, 1975, no. 416), is
inscribed by Francesco's patron John Strange. It
is possible that both drawings may date from the
same time as Guardi's country house portraits for
Strange, such as *the Villa del Timpano Arcuato,*
which is also dateable to 1782 (cat. 216). These
two drawings of Alpine subjects are
characterised by the delicacy, elegance and detail
that Strange seems to have preferred in Guardi's
works (Haskell, 1967). The verso of this
drawing shows a fragment of a view of an
unidentified walled town (repr. Venice, 1965,
'Disegni', 46).                    M.M.

*Provenance:* Maius Palme; 13 May 1929, Galerie
Georges Petit, Paris, lot 101; Mrs C.I. Stralem;
Mr and Mrs D. Stralem
*Exhibitions:* Buffalo, 1935, no. 72; Springfield,
1937; Venice, 1965, no. 46; New York, 1971,
no. 208
*Bibliography:* Pignatti, 1967[1], XXXIV; Morassi,
1975, no. 418

218

FRANCESCO GUARDI
*Capriccio with an Arch in Ruin*
1770s
oil on canvas, 155 × 273 cm
Lent by The Metropolitan Museum of Art,
New York, Rogers Fund, 1941

One of a set of three large *capricci* originally from
the Castello di Colloredo near Udine. The set
was probably commissioned expressly for the
Castle and extensively altered, probably by
Francesco himself, before installation (Zeri and
Gardner, 1973, p. 30). According to Wehle
(1941, p. 153), all three works decorated the
walls of a ground floor *salotto* that opened onto a
garden; Francesco probably also made a number
of flower paintings for this room (present
location unknown; Pilo, 1983, pp. 16–7, and
fig. 15), and may have also designed the stucco
surrounds in which the *capricci* were set;
drawings such as cat. 206 demonstrate that he
designed such decorative frames. After the

paintings' removal from the Castle copies were
set in their place, but no photograph of the room
has been published.

The motif of a ruined arch spanning a road
by a coast recurs many times in Francesco's
*oeuvre* (see Gorizia, 1988, p. 328ff.). The general
idea for this composition derives from paintings
by Carlevaris probably then in the Smith
Collection (Royal Collection; see Levey, 1991,
p. 425).

It has been suggested that the Colloredo
*capricci* were painted either in 1778 or 1782 when
Francesco travelled in the Trentino; but he often
visited his native province. The openness and
relative simplicity of the arrangement of the
elements, however, as well as the lightness of
touch, suggest that these paintings can be dated
to the late 1770s (see Pilo, 1983, p. 17 and n.
29).                    M.M.

*Provenance:* Colloredo family, Castello di
Colloredo, Alto Friuli; *c.* 1906, Steinmeyer,
Cologne; *c.* 1910, Stefan Bourgeois, Cologne;
Trotti, Paris; Baron Maurice de Rothschild,
Paris; 1912, Gimpel, Paris, and Wildenstein,
New York; 1912–41, Mrs Charles B.
Alexander, New York; 1941, Mrs Arnold
Whitridge; Mrs Winthrop W. Aldrich; Mrs
Sheldon Whitehouse, New York; 1941,
purchase, Rogers Fund
*Exhibitions:* New York, 1915, no. 24; Venice,
1965[1], no. 121
*Bibliography:* Wehle, 1941; Morassi, 1973, no.
924; Zeri and Gardner, 1973, pp. 29–30; Rossi
Bortolatto, 1974, no. 320; Pilo, 1983, pp. 16–7

219

FRANCESCO GUARDI
*Architectural Fantasy with Roman Ruins*
*c.* 1760–5
oil on canvas, 104 × 124 cm
signed on stone at lower left: '*F.co G.di*'
Museum Kunsthaus Heylshof

Succi (in Gorizia, 1988) has recently
demonstrated that this painting is not a
capriccio. Rather, it depicts the Temple of
Jupiter and Juno in Rome, as seen in
Gianfrancesco Costa's print of this subject from
his *Suite des plus célèbres bâtiments des grecs* (1748).
However, Guardi's image derives not from
Costa's, but from the copy made after Costa by
the Augsburg engraver Georg Hertel. Since
Hertel's engravings was probably made after
1760, the painting cannot be an early landscape,
as is usually suggested. A date after 1760 is in
fact supported by the scale and execution of the
foreground figures, which are Francesco's own
invention, and which are close in style and
conception to the figures in his *Miracle of a
Dominican Saint* (Kunsthistorisches Museum,

Vienna; fig. 51), securely dated to this period.

The pendant to this work is the *Architectural Fantasy with Roman Ruins and Figures* (priv. coll., see Venice 1993, no. 49), a close copy after the *Capriccio* (Museo Civico, Vicenza) by Sebastiano and Marco Ricci. Although it has been argued that it reproduces a lost copy by Antonio rather than the Riccis' original, this seems unlikely. This painting and its pendant were dated to the earliest phase of Francesco's career, *c.* 1740, mainly because of its dependence on Ricci (on the grounds that copies of paintings by other *vedutisti* were characteristic of that period). But the establishment of the later date supports the thesis that view-painting was not Francesco's primary concern until the late 1750s.

M.M.

*Provenance:* Lazzaroni coll., Paris; von Nemes coll., Budapest; 1913, acquired by Baron C.W. Heyl zu Herrnsheim
*Exhibitions:* Budapest, 1911, no. 16; Wiesbaden, 1935, no. 101; Venice, 1965[1], no. 56
*Bibliography:* Mahon, 1965, pp. 79–80; Morassi, 1973, I, p. 266, no. 703; Rossi Bortolatto, 1974, no. 185; Gorizia 1988, pp. 312–13

220

FRANCESCO GUARDI
*Capriccio with a Round Temple*
*c.* 1780s
oil on canvas, 22.3 × 17 cm
The Trustees of the National Gallery, London (inv. 2517)

Unlike the three *capricci* that follow (cat. 221a–c), this one does not represent ruins, but rather a complex of imaginary urban buildings, making it a true capriccio. Most scholars agree that it is derived from one of the end pavilions of the 'Palladian Bridge' (see Francesco's drawing of the project in Venice 1993[1], no. 10). Another drawing (Correr, Venice, see Pignatti, 1983, no. 692) shows an intermediate stage in the design. But although the Palladian inspiration is undeniable, the present work is meant to represent a free-standing temple on a plinth rather than the end pavilion of a larger structure. As such it bears comparison with a number of round churches constructed in Venice in the 18th century. Levey (1971, p. 124 n. 3) suggests that the temple recalls Scalfarotto's S. Simeone Piccolo (fig. 9), though he imagines the resemblance to be accidental. Yet, comparison with Guardi's painting of this church (Coll. Thyssen Bornemisza, Madrid) suggests that the church's façade, seen at the same angle, could have inspired the present view. A further comparison can be made with Temanza's church of the Maddalena, built 1763–89 (fig. 54). Guardi certainly shared the fashion for neo-

Palladianism fashionable at the time, and the temple in the capriccio, ultimately, is probably Guardi's own invention. His talent for this kind of work is also demonstrated by a variant capriccio (Morassi, 1973, I, no. 754). There, the colonnade around the building is replaced by an arcade of Serlian arches, reminiscent of Maccaruzzi's design for the arrangement of Piazza S. Marco for the Feast of the Ascension after 1777 (see cat. 205), a feature that probably furnishes a *terminus post quem* for both works. A drawing of a similar subject (Victoria and Albert Museum, London) seems preparatory for this painting (Byam Shaw, 1951, no. 61).

M.M.

*Provenance:* 1856 (?), S. Roger's sale, London; bought by Redford; from 1885, G. Salting; Salting Bequest 1910
*Bibliography:* Levey, 1971, pp. 123–4; Morassi, 1973, no. 753

221a

FRANCESCO GUARDI
*Capriccio with an Arch in Ruin*
*c.* 1780s
oil on canvas, 10 × 7 cm
The Trustees of the National Gallery, London (inv. 2521a)

Unlike the other miniscule *capricci* from this series (cat. 221b–c), this painting does not represent any specific Venetian structure in ruins. It is, however, generically Venetian, as is the conjunction of architecture and water typical of many of Guardi's invented views. The figures at work digging in the foreground feature in many of Guardi's paintings. Though these are sometimes described as 'treasure-seekers', they are more probably gathering shellfish.

M.M.

*Provenance:* Giacomo Tarma, Venice?; 1828, bought in Venice by the Hon. Agar Ellis; 1833, bequeathed to his son, Viscount Cliveden; sale London 21 May ff. 1895 (lot 736); George Salting; 1910, Salting Bequest
*Bibliography:* Morassi, 1973, no. 1009; Levey 1971, pp. 127–8

221b

FRANCESCO GUARDI
*Capriccio with a Serlian Arch in Ruin*
*c.* 1780s
oil on canvas, 10 × 7 cm

The Trustees of the National Gallery, London (inv. 2521b)

The ruined arch in the painting seems not to be Roman, but rather a portion of a larger 'Serlian' arcade. A drawing in the Correr shows how such a structure might have looked before it was ruined (Pignatti, 1983, no. 132). Pignatti suggests that Guardi was inspired by Visentini's *Capriccio* (cat. 152). However, it seems more likely that Guardi has imagined the ruin of one of the Serlian arches of Sansovino's library. Pignatti argues that such 'anticipated ruins' of Venetian Renaissance monuments are one of Francesco's most important contributions to Venetian landscape painting.

M.M.

*Provenance:* see cat. 221a, above
*Bibliography:* Morassi, 1973, no. 1009; II, fig. 890; Levey 1971, pp. 127–8; Succi, in Gorizia 1988, pp. 365–83

221c

FRANCESCO GUARDI
*Capriccio with a Raised Cupola in Ruin*
*c.* 1780s
oil on canvas, 10 × 7 cm
The Trustees of the National Gallery, London (inv. 2521c)

Like the *Capriccio with a Serlian Arch in Ruin* (cat. 221b), this painting also presents the 'anticipated ruin' of a Venetian structure, namely the choir-screen of Palladio's church of the Redentore, which Guardi had previously painted as a freestanding structure in a garden (Morassi, 1973, I, no. 757). The building in the background recalls the structure that appears in the *Capriccio with a Bridge* (Uffizi, Florence), and the composition is also reminiscent of actual Venetian settings, such as the entrance to the Arsenal.

M.M.

*Provenance:* see cat. 221a, above
*Bibliography:* Morassi, 1973, no. 1009; II, fig. 891; Levey 1971, pp. 127–8

## ALESSANDRO LONGHI
born Venice, 1733
died Venice, 8 November 1813

Painter and etcher. The son of the genre painter Pietro Longhi, he was trained by Giuseppe Nogari. In 1759 he entered the Accademia di Disegno in Venice and the following year exhibited, as was customary, in the Piazza S. Marco a portrait of an innkeeper that was praised by Gozzi in the *Gazzetta Veneta* as a work in the new realistic manner (Levey, 1980, p. 186). In 1760 Longhi published his *Raccolta di Ritratti*, and in 1762 the first edition of the *Compendio delle vite de pittori* . . . (cat. 243), in which he reused portraits from the *Raccolta* and added the biographies. Longhi himself claimed that etching was only a secondary occupation for him, taken up when he was free from painting commissions (Succi, 1988, p. 218). He etched several of his father's paintings. His tremulous and unusual technique shows first-hand knowledge of Rembrandt's etchings. His painted portraits, in particular *Jacopo Gradenigo* (Museo Civico, Padua) show a touch of satire, but also preserve a Rococo liveliness. He outlived virtually all the great painters of his generation.　　O.T.

ALESSANDRO LONGHI
*Carlo Lodoli*
before 1771
oil on canvas, 200.6 × 93.9 cm
inscribed upper left: '*Frater Lodoli In Apologis Conscibendis et in Architectonica, Haud inter supremos annumerandus. Alexander Longhi Pinxit*'
Gallerie dell'Accademia, Venice (inv. no. 1093)

Like his father, Alessandro Longhi painted for the indigenous Venetians, and it seems that he never portrayed tourists or visitors. His portraits were, however, celebrated for their realism. Father Carlo Lodoli (1690–1771) belonged to the Franciscan order of the Minori Osservanti. After having travelled and studied mathematics and French in Rome and elsewhere, he returned to his native Venice in 1720. There he set up a school for the children of leading families, introducing modern principles of teaching, and teaching the theories of Galileo, Francis Bacon and Giambattista Vico, among others. Because of his open mind and outspoken ideas Lodoli had a brush with the State Inquisitors, but was pardoned and later elected Revisore della Stampa, where he had great influence on all printed matter produced in the city. He was a friend of many of the most enlightened figures in Venice of the day, including Andrea Memmo, the publisher Pasquali and Consul Joseph Smith. He is best known as an architectural theorist, as stated in the inscription on Longhi's portrait. His theories were printed anonymously by his pupil Andrea Memmo in *Elementi dell' architettura Lodoliana*, first published in Rome in 1786. Lodoli's radical views on ancient and modern art and architecture were highly influential at the time: he believed that it should be primarily functional, and rejected the decorative Baroque style. He also had an extensive collection of paintings, now lost. Longhi's portrait of Lodoli, commissioned by Pietro Moscheni, is one of the few penetrating portraits of 18th-century Venice; the sitter is portrayed without flattery, holding his books and compass. In an engraving, perhaps reproducing another version of the painting, Lodoli is described as the Venetian Socrates.　　O.T.

*Provenance:* Pietro Moscheni; apparently Palazzo Mocenigo on the Grand Canal, Venice; 1931, given by Count Alvise de Robilant to the Gallerie
*Exhibition:* Venice, 1945
*Bibliography:* Levey, 1959[1], p.70; Moschini Marconi 1970, p. 45; Nepi Sciré 1985, no. 144, p. 127; Haskell 1980, pp.320–1

ALESSANDRO LONGHI
*Compendio delle Vite dei Pittori veneziani istorici più rinomati del presente secolo con suoi ritratti tratti dal naturale delineati ed incisi da Alessandro Longhi Veneziano,* published by the author in Venice, 1762
folio, open to show etched portraits of G. B. Tiepolo and A. Longhi with borders
52.1 × 77.5 cm (open book)
Lent by The Metropolitan Museum of Art, New York
The Elisha Whittelsey Collection, The Elisha Whittelsey Fund, 1950

The first edition of this publication was supervised by Longhi himself and dedicated to Senator Giovan Francesco Pisani. The biographies, which include those of Longhi and his father as well as Sebastiano Ricci and Jacopo Amigoni, are by an anonymous author. The portraits, such as the two showing Giambattista Tiepolo and Longhi's self-portrait, are surrounded by exuberant ornamental frames probably etched by Angela Baroni. This, the first of two editions, contains 24 portraits, to which a further one was added subsequently, which had already been published by Longhi in the *Raccolta di Ritratti d' Pittori Veneziani* in 1760. The privilege for this work, requested on 12 August 1762, was granted on 2 September. Longhi's portraits are some of the most lively produced in 18th-century Venice. His unusual etching technique, based on an apparently disorganised system of tremulous strokes, allows him to endow his expressive and engaging portraits with immediacy and spontaneity.　　O.T.

*Bibliography:* Morazzoni, 1943, p. 192; Gorizia and Venice, 1983, pp. 270–8

## PIETRO LONGHI
born Venice, 15 November 1701
died Venice, 8 May 1785

Painter and draughtsman. His family name was Falca (his father was the goldsmith Alessandro Falca); Longhi was a nickname. It has been suggested that the artist trained in Balestra's studio in Venice, and later worked in Bologna with G.M. Crespi. Although his Bolognese soujourn is not documented, it was recorded by contemporary writers and seems to be confirmed by Longhi's absence from Venice until 1730. A document of 1732 mentions an altarpiece by Longhi in S. Pellegrino, Bergamo. In the same year Longhi married Caterina Maria Rizzi in S. Pantalon, Venice. A year later his son Alessandro, who became a well-known portrait painter, was born. Most of Longhi's other ten children died at an early age. In 1734 Longhi signed and dated the frescoes on the staircase of Gherardo Sagredo's Venetian palace. In 1762 Piazzetta, Giambattista Tiepolo and Longhi compiled a valuation of Sagredo's collection. Between 1737 and 1773 he was listed in the Venetian *Fraglia*.

His earliest dated picture, *The Small Concert* (Accademia, Venice) dates from 1741. Letters to the publisher Giovanni Battista Remondini of 1748–53 show that he was directly involved in having prints made after his pictures. The great majority of Longhi's patrons belonged to the Venetian nobility: among them were the Sagredo family, the Grimani, for whom he painted *The Rhinoceros* (cat. 182), the Manin, who commissioned the *Portrait of the Procurator Ludovico Manin* (1764; Museo Civico, Udine), and the Barbarigo, for whom he painted the cycle of hunting scenes (Querini Stampalia, Venice). In 1756 the artist was elected a member of the Venetian Academy and was registered as counsellor in 1779. He was Director of the Venetian Academy between 1763 and 1766. He probably lived in the parish of S. Pantalon until his death, aged 85.                                          O.T.

### 180

PIETRO LONGHI
*Young Man Sprawled in a Chair*
c. 1760
charcoal and white chalk on grey-brown paper,
28 × 38.8 cm
Staatliche Museen Preussischer Kulturbesitz,
Kupferstichkabinett, Berlin (inv. Kdz 11644)

Pignatti (1969, n. 215) describes this as a preparatory drawing for the painting *The Sleeper Tickled* (Rubin de Cervin Albrizzi Collection, Venice). This is a later version of a painting (Colección Thyssen Bornemisza, Madrid) for which there is an etching in the same direction and a preparatory drawing of parts of the

composition (Correr, Venice). The earlier of the two painted versions is datable *c.* 1755, and the later one *c.* 1760, as is this drawing. The combination of grey and white chalks on coloured paper is reminiscent of drawings by French 18th-century artists such as Watteau or Pater.                                          O.T.

*Exhibitions:* Brussels, 1983, no. 70; Hanover and Düsseldorf, 1991–2, no. 117
*Bibliography:* Pignatti, 1969, p. 107

### 181

PIETRO LONGHI
*Wine-pourer with a Young Man*
black and white chalk on brown paper glued onto card, 43.8 × 29.2 cm
inscribed in ink in the centre '*traversa*' (apron)
Museo Civico Correr, Venice (inv. cl. III, 523)

Longhi's drawings, almost always taken from life. convey a freshness and immediacy that is often lost in his paintings. This drawing does not seem to be connected with any known painting. The majority of Longhi's drawings are at the Correr Museum, Venice. Their chronology is still under scrutiny because his graphic style remained constant throughout his career.                                          O.T.

*Provenance:* Collection Teodoro Correr, Venice; 1830, Fondo Correr, Museo Correr, Venice
*Bibliography:* Lazari, 1859, pp. 26–8; Pignatti, 1969, p. 111; *idem*, 1987, no. 1077

### 182

PIETRO LONGHI
*The Rhinoceros*
c. 1751
oil on canvas, 62 × 50 cm
inscribed on the left: '*Vero Ritratto | di un Rinocerotto | condotto in Venezia | l'anno 1751 | fatto per mano di | Pietro Longhi | per commissione | del N.O. Giovanni Grimani | dei Servi Patrizio Veneto*'
Ca' Rezzonico, Museo del Settecento Veneziano, Venice (inv. 1312, cl. I)

This painting commemorates the exhibition of a rhinoceros during the Carnival in Venice of 1751. The animal was brought to Europe from India by Captain Douvemont van der Meer of Leiden (Venice 1993). Before reaching Venice it was exhibited in Berlin, Frankfurt, Dresden, Leipzig, Stuttgart and Paris. J. E. Ridinger in Augsburg and J. B. Oudry in Paris made portraits of the animal, as did Francesco Lorenzi in Verona, where it was exhibited in the Arena after having been removed from Venice. In Verona the rhinoceros was also the object of a dissertation by Scipione Maffei. Other exotic

animals including a lion and an elephant, were exhibited as attractions during Carnivals in Venice. As recorded in the inscription, this painting was commissioned by Giovanni Grimani, a Venetian patrician for whom Longhi also painted a portrait of the Irish giant Cornelio Magrat (1757; Ca' Rezzonico, Venice). Grimani is shown with his family and the owner of the animal, who holds the detached horn in his hand. A version with some variations (National Gallery, London) was commissioned by Gerolamo Mocenigo, probably in the same year. Alessandro Longhi reproduced the painting in etching, with a few variations, in reverse.                                          O.T.

*Provenance:* painted for Giovanni Grimani thence by descent to the Morosini Collection; 1895, purchased for the Musei Civici Veneziani; since 1936 at Ca' Rezzonico, Venice
*Exhibitions:* Lausanne, 1947, n. 106; Stockholm, 1962–3, no. 164, p. 151; Venice, 1993, no. 63.
*Bibliography:* Pallucchini, 1947, p.53; Levey 1971, no. 101; Pignatti, 1974², no. 78; Spike, in Fort Worth, 1986, p.198

### 183

PIETRO LONGHI
*A Painter in His Studio*
1741–4
oil on canvas, 44 × 53 cm
Ca' Rezzonico, Museo del Settecento Veneziano, Venice (inv. 133, cl. I)

Longhi treated the subject of the painter at work more than once. Another, slightly smaller, version (priv. coll., London, ex-Stirling of Keir coll.), has been considered to be its prototype (Pallucchini, 1951–2). There are also two versions in a more vertical format (National Gallery of Ireland, Dublin; priv. coll., Venice, ex-O'Nians, London). This painting belonged to the Abbot Teodoro Correr (1750–1830), one of Longhi's keenest admirers, who owned over twenty paintings and a number of drawings, which he purchased from Pietro's son Alessandro (Haskell, 1980, p. 382). There are two preparatory drawings for the standing man and the painter (Correr Museum, Venice). It has been suggested that the figure of the painter may be Longhi's self-portrait.                                          O.T.

*Provenance:* Teodoro Correr, Venice; Fondo Correr; 1830, given to the City of Venice; since 1936, Ca' Rezzonico, Venice
*Exhibitions:* Lausanne, 1947; Venice, 1975; Venice, 1993, no. 47
*Bibliography:* Pallucchini, 1947, p. 54; *idem*, 1951–2, no. 213; Pignatti 1960, p. 172; *idem*, 1969, pp. 87–8; *idem*, 1974², p. 88, no. 35; Haskell, 1980, p. 382; Pignatti, 1987, p. 69; *idem*, 1990, p. 92

PIETRO LONGHI
*The Married Couple's Breakfast*
1744
oil on canvas, 49 × 60 cm
inscribed on verso: 'Petrus Longhi 1744'
Lent by Her Majesty The Queen

This dated work, painted for Consul Joseph Smith, has been grouped with other works of similar delicate colouring such as *The Simulated Faint* and *Blind-man's Buff* (both National Gallery of Art, Washington). There are five preparatory drawings (Correr, Venice) that explore other positions for the two figures on the bed. Its pendant, *Hide and Seek* (Royal Collection), was also in Consul Smith's collection. Here Longhi reinforced the character of the subject by including a painting within the painting whose two mythological characters echo the amorous glances of the two absorbed couples in the foreground. O.T.

*Provenance:* Consul Joseph Smith, Venice; 1761, sold to George III
*Bibliography:* Pallucchini, 1951–2, no. 57; Levey, 1964, p 87; Pignatti, 1969, p. 104–5; *idem*, 1974², p. 89, no. 38

185

PIETRO LONGHI
*Extreme Unction*
before 1755
oil on canvas, 61 × 50 cm
Fondazione Scientifica Querini Stampalia, Venice

Extreme Unction is the Sixth of the Seven Sacraments according to the Canonical order; the other six paintings from this series are all in the Galleria Querini Stampalia, Venice. Marco Pitteri's reproductive etching differs only in the floor, which he defined with greater detail. The print of the Crucifixion visible on the right-background wall is Longhi's homage to Pitteri: it reproduces one of Pitteri's etchings after a lost original by Piazzetta.

The representation of the Seven Sacraments was rare in the 18th century; Longhi may have known the two series by Nicolas Poussin through engravings, and may have seen the series by G. M. Crespi in 1712 (now dispersed). It has been convincingly suggested that this is the series of Seven Sacraments from one of the bedrooms of Palazzo Querini Stampalia in S. Maria Formosa listed in an inventory of 16 January 1796 (Merkel, 1979). No indication of the artist was given in the document, and the paintings were described as protected by glass, which has been seen as an indication that they might have been prints and not oils. However, the description of other paintings with glass

contradicts this. It has been suggested (Venice, 1993) that the series was commissioned by Cardinal Angelo Maria Querini (1680–1755), or more likely by his nephew Andrea Domenico Querini (1710–95). A series of sacraments by Pietro Longhi was mentioned by Carlo Goldoni, who prized the paintings and wrote a letter to Pitteri urging him to make prints after them. The letter was included in the last of ten volumes of Goldoni's comedies, dated 1755 (published Florence, 1757), giving a *terminus ante quem* for the series. The dating of the Sacraments is, however, still open to question. Apart from Pitteri's etchings and another set by Amedeo Gabrieli, who worked for the Remondini workshop, Longhi's series was reproduced later in the century by Pier Antonio Novelli and by Giovanni Volpato. Francesco Guardi made drawings (Correr, Venice) after Pitteri's etchings. O.T.

*Provenance:* Angelo Maria or Andrea Domenico Querini, Venice; Fondazione Querini Stampalia, Venice
*Exhibitions:* Fort Worth, 1986: Venice 1993, no. 74
*Bibliography:* Pallucchini 1951–2, II, pp. 57, 67; Valcanover, 1964, pp. 6–7; Pignatti, 1968, pp. 111–16; *idem*, 1969, p. 101; *idem*, 1974², pp. 93–4; Merkel, 1979; *idem*, 1987, p. 168

186

PIETRO LONGHI
*Masked Figures with a Fruit-seller*
(?) c. 1760
oil on canvas, 62 × 51 cm
Ca' Rezzonico, Venice (no. 1313)

An alternative title for this painting is *Conversation between Baute*. The *baute* are Venetian masks worn during the Carnival, which afforded the wearer anonymity so that different classes could mix, unrestricted by the usual codes of conduct. Pignatti has suggested a dating somewhere in the 1750s or 1760s, when Longhi's figures are highly characterised individuals, in the manner of works by Nogari and Alessandro Longhi. O.T.

*Provenance:* Morosini collection, Venice; Ca' Rezzonico, Venice
*Bibliography:* Pignatti, 1960, p. 105; *idem*, 1969, p. 87; *idem*, 1974², p. 96, no. 132

FRANCESCO LORENZI
born Mazzurega, near Verona, 1723
died Verona, 12 February 1787

Painter, draughtsman and fresco painter. He was born into a well-to-do family, and was the older brother of Abbot Bartolomeo, a man of letters, and of the engraver Domenico Lorenzi. After a classical education studying grammar and rhetoric in Verona, he appears to have served a three-year apprenticeship in the studio of Matteo Brida before moving to Giambattista Tiepolo's studio in Venice in the early 1740s. He was one of Tiepolo's most loyal students. In Venice he had contact with Piazzetta, and made a careful study of the work of Solimena, Titian and, most importantly, of Veronese. When Tiepolo left for Würzburg in 1750 Lorenzi returned to Verona and opened his own studio there, teaching painting in the style of Tiepolo, though with an overlay of classicism taken from Cignaroli. In the mid-1750s he provided illustrations for the didactic poems *Il baco da seta* by Z. Betti (1756) and *La coltivazione del riso* by G. B. Spolverini (1758), and in 1778 collaborated with his brother Bartolomeo Lorenzi on *Della coltivazione de' monti*. In the 1760s he painted religious pictures for churches throughout the Venetian Republic, from Bergamo to Brescia; from Vicenza to Verona. Tiepolo's presence in Verona in 1761 decorating Palazzo Canossa influenced Lorenzi's work as a fresco painter during the 1770s. Between 1778 and 1783 he worked on frescoes in Alessandria and Casale Monferrato, in which echoes of Veronese and an emergent classicism can be observed. Tiepolo's style was in some repects alien to Verona, so heavily conditioned by the influence of the academy founded there by Cignaroli, and Lorenzi's style moved gradually towards an academic, Neo-classical interpretation of Tiepolo. G.M.

FRANCESCO LORENZI

Headpieces and tailpieces in Giovanni Battista Spolverini, *La coltivazione del riso*, published in Verona by Agostino Carattoni, 1758, quarto
*c.* 1758
etchings, 29.4 × 41 cm (open book); tailpiece p. xii: 7.6 × 11 cm (platemark); headpiece p. 1: 7 × 12.1 cm; tailpiece p. 100: 4 × 10.5 cm; headpiece p. 101: 7 × 12.5 cm
binding: parchment, with the coat of arms of George III on front and back covers
The British Library Board, London (inv. 81.h.14)

On his return to Verona from Venice in 1750, Lorenzi produced a steady stream of book illustrations, becoming the undisputed master of book decoration in Verona in the second half of the century. His thorough classical education influenced the work he did for his publishers. His best-known illustrations were produced for volumes of didactic poetry currently popular in Verona. The local gentry had recently taken up agriculture with almost evangelical enthusiasm; this stimulated study of both the sciences and literature, generating no less than five didactic georgics by Veronese poets in the space of less than two decades. These ranged from *Il Baco da Seta* (*The Silk-worm*) by Zaccaria Betti, published in 1756, to *Della Coltivazione de' Monti* (*On the cultivation of mountains*), 1778, the curious result of collaboration by all three Lorenzi brothers, with text by the abbot Bartolomeo, engravings by Domenico and drawings by Francesco. These editions are characteristic of the type of book published in Verona during the Rococo period: they contain a title-page summarising the theme of the book followed by a plate bearing a portrait or the coat of arms of the dedicatee: each chapter is preceded by a small illustration, a decorative tailpiece and a decorated initial letter. Here the illustrations are closely allied to the text and deal with every aspect of the cultivation of rice, from the measuring and levelling of the ground by surveyors to the back-breaking work of the labourers who weed, yet even these scenes are invested with an arcadian elegance betraying the influence of Tiepolo. All the plates for *La coltivazione del riso* by Marchese Giovambattista Spolverini (1695–1762) were engraved by the young Veronese artist Domenico Cunego (1727–1803). It was republished in Verona by Agostino Carattoni in 1763 without the portrait of Elisabetta Farnese and with a few other minor alterations. G.M.

*Bibliography:* Lánckoronska, 1950, no. 232; Dillon and Marinelli, in Verona, 1985, no. 281; Corubolo, 1989, pp. 80–1.

GIOVANNI (or Giuseppe) MAGNINI (or Mangini)
active in Venice 1750s–1780

Engraver and book designer. Little is known of this printmaker who worked exclusively on book decoration. He was mostly employed by the editor Antonio Zatta for his de-luxe editions, at a time when Giacomo Leonardis was Zatta's other leading engraver. His work for Zatta ranged from the end-piece for an edition of Petrarch's *Rime* in 1756 and the initials designed and engraved for a *Divine Comedy* of 1757–8, to the vignette for the volume of poetry of Filippo Rovelli published in 1787, but his most elaborate and most famous creation was the fantastic borders for *L'Augusta Ducale Basilica*, published by Zatta in 1761. In the early 1760s Magnini was active at the Academy promoted by the Pisani family in their palace at S. Stefano, under the direction of Longhi and Berardi; there he was associated with the engravers Alessandri, Scattaglia and Fossati. He engraved the elaborate Rococo borders of the frontispiece and dedication for the collection of landscapes by Almorò Pisani, dedicated to his uncle Gian Francesco Pisani and published in the mid-1760s. G.M.

GIOVANNI MAGNINI

Elaborate border containing a portrait of Marco Foscarini and another border containing the dedication, in A. Visentini, *L'Augusta Ducale Basilica*, published by Antonio Zatta, Venice, 1761, in folio
etching, 73 × 105 cm (open book)
British Architectural Library, Royal Institute of British Architects, London

The plates of the *Iconografia della Ducal Basilica*, edited by Antonio Visentini in 1726 (see cat. 157), came into the possession of the publisher Antonio Zatta *c.* 1759. In 1769 he republished them, adding a painstaking *Descrizione* by Ludovico Zucconi. The result is one of the most elegant books to be printed in 18th-century Venice. Magnini engraved an ornate new title-page in various colours with a dark blue border showing an allegory of Venice and the new title: *L'Augusta Ducale Basilica dell' Evangelista San Marco nell'inclita Dominante di Venezia....* The old title-page was reused as a frontispiece; instead of the title, it shows St Mark and the coat of arms of Doge Mocenigo with a heraldic lion. At the foot of the page the inscription accrediting the engravings to Vincenzo Mariotti has been replaced with the words '*Presso A. Z.*' (Antonio Zatta, the new publisher); consequently the plates were misattributed to Zatta. Zatta probably hoped that if the public believed that these eight plates, originally published 35 years earlier, had been made expressly for this book they would be more likely to buy it. After the title a portrait was inserted of Marco Foscarini, Procurator and Cavaliere di S. Marco, who was elected Doge the following year; this was attributed to Magnini (Lanckoronska, 1950), but in fact had already been used as the frontispiece of the volume of *Letteratura Veneziana* compiled by Foscarini and printed in Padua in 1752. The elaborate border that encloses the portrait of the Procurator can be attributed to Magnini which, however, has been criticised for its excessive extravagance that does not accord with the contents of the book (Morazzoni, 1943, pp. 137–8). There are several copies of the edition of 1761 still bearing the old title, with the plates grouped together after the text; the pages are without ornamental borders, and the portrait of Marco Foscarini is lacking. G.M.

*Bibliography:* Gori Gandellini, III, 1771, p. 316; Moschini, [1924], p. 151; Pallucchini, 1941, pp. 44 and 103; Morazzoni, 1943, pp. 136–8, 214; Lánckoronska, 1950, no. 19; Mason, 1973, p. 56; Dillon, in Venice, 1976, p. 72; Succi, in Cittadella, 1986, pp. 141–6, no. 175.

**MICHELE (Giovanni) MARIESCHI**
born Venice, 1 December 1710
died Venice, 18 January 1743

Painter and engraver. Once confused with the history painter Jacopo Marieschi (1711–94), his life and his *œuvre* are still in part hypothetical given the scarcity of documents. His father, an engraver, died when he was eleven and his artistic training probably owes more to Diziani, on whose suggestion he may have made a journey to Germany referred to by his earliest biographers, possibly around 1729, although there is no documentary evidence. In 1731 he is documented working as a scene-painter and creator of ephemeral effects, and in 1735 he created the effects for the funeral ceremony of Maria Clementina Sobieski Stuart at Fano. Paralleling Canaletto's career, during the 1730s Marieschi was working both as a scene-painter and as a painter of *capricci*; only later in the decade did he develop into a view-painter. Probably this had something to do with the patronage of Marshal Schulenburg, who between 1736 and 1738 bought twelve views by Marieschi for his collection. From 1738 he began to work on the 21 large etchings published in 1741–2 with the title *Magnificentiores Selectioresque Urbis Venetiarum Prospectus* (cat. 159). This collection, his masterpiece, combines the apparently perfect vision of Canaletto's paintings with Francesco Guardi's poetic evocations. Using a very personal technique and drawing on his experience as a scene-painter, he managed to transform his urban views by using an exaggerated perspective that confers the novelty of a capricious invention even on scenes taken from life. The recent cataloguing of his graphic work has led to an increased interest in his painted *œuvre*, which is still confused; after Marieschi's early death his pupil Francesco Albotto (1721–57) continued to produce paintings in the manner of his master for fifteen years.                                    G.M.

**159**

MICHELE MARIESCHI
*The Regatta from Ca' Foscari in the Direction of the Grand Canal*
*c.* 1740
etching, state 1 of 4
31.2 × 46.3 cm (platemark), 17 × 46 cm (inscription)
inscribed lower margin, printed on a separate plate: '*Foscarorum aedes ad levam, et e conspectu altera Balborum ambo praeter canalem magnum; ubi etiam solemne nauticum certamen, et maxima prequentia cymbarum vel auro vel argento vel alio ornatu obductarum, fictasque formas exhibentium cernuntur, nec non lintres naviculariorum pro brabrio certantium. Inter easdem aedes exornata ad maiorem spectaculi dignitatem meta Super acquas erigitur.*'; and lower right: '*Mich.¹ Marieschi del.ᵗ et inci.ᵖ*'
Mrs Ruth Bromberg

This etching, dating from 1740–1, belongs to Marieschi's collection of etchings of views of Venice published as *Magnificentiores Selectioresque Urbis Venetiarum Prospectus* between 1741 and 1742. As in his painting (priv. coll.; Toledano, 1988, no. V.29.1), Marieschi takes the *Volta di Canal*, the great bend in the Canal, as his viewpoint; on the left the view is blocked by the Palazzo Giustinian-Brandolini and Ca' Foscari, while in the centre is the Palazzo Balbi. Where the Rio Foscari flows into the Grand Canal a large decorated float is moored, partially concealing the campanile of the church of the Frari. These floats were generally associated with carnival celebrations or with visits to the city by important people. Marieschi does not seem to have any particular occasion in mind here, certainly not the regatta of May 1740 in honour of Frederick Christian, Prince-Elector of Saxony, when the float was moored near Palazzo Foscarini at the confluence of Rio di S. Polo and the Grand Canal. It is more likely that the artist wanted to fill the Canal with imaginary ceremonial barges. Here the craft include Neptune's chariot and an allegory of Venice on the left; a float on the extreme right is decked out in the fashionable *chinoiserie* style. The large float, bearing numerous coats of arms, none of which can be identified, can be compared to another of Marieschi's inventions: it has the same octagonal plan and stairways as the structure he designed with Francesco Tasso for the funeral of Maria Clementina Sobieski Stuart in Fano in 1735. Marieschi repeated the etching's composition in a more vertical format in a painting formerly in the Cini collection, Venice; nearly twenty years later the etching also served as model for a painting by Francesco Guardi (Johnson collection, Philadelphia; Morassi, 1975, no. 301). The brightness of this view is enhanced by the freshness of the print, on an unusually large sheet of paper with two collectors' stamps on the back, one of which is that of G. W. Günther, a 19th-century merchant from Nuremburg.                     G.M.

*Provenance:* 19th century in the collection of G. W. Günther, Nuremburg (Lugt 1115)
*Bibliography:* Mauroner, 1940, no. 22; Pallucchini, 1941, no. 235; Mason, 1973, no. 106; Pignatti, 1975, no. 22; Succi, 1981, no. 18; *idem*, 1983, no. 295; Mason, 1984, no. 16; Dreyer, 1985, no. 90; Succi, 1987, no. 15; Dell'Orso, 1988, no. 22; Toledano, 1988, no. V.29.3; Succi, 1989, no. 15

MICHELE MARIESCHI
*Piazzetta dei Leoni*
*c.* 1738
etching, state 2 of 4, 33 × 46.6 cm
inscribed in lower margin: '*Platea D: Bassi et suum templum ad dexteram; ad laevam latus Basilicae D: Marci cum eiusdem foro maiori, quod desinit ad D: Giminiani*'; and lower right: '*Mich.l Marieschi del.t et inci.t*'
Private Collection, London

This etching can be dated *c.*1738 and is one of the earliest of the 21 large views of Venice published by Marieschi on being granted a decennial privilege on 3 June 1741; he reproduced the finest works of his brief career under the title *Magnificentiores Selectioresque Urbis Venetiarum Prospectus*. During the 1740s the art of engraving flourished in Venice and a host of publications celebrating the city were produced, from the complete edition of Canaletto's views of the Grand Canal (1742), engraved by Visentini, to the series of etchings executed and published a couple of years later by Canaletto himself. Only a few editions were supervised by Marieschi before his death in January 1743, but the success of his collection is evident from the many reprints from the first state right up to *c.* 1770 when the plates passed to the studio of Joseph Wagner at S. Zulian; the final edition was published by Giovanni Maria Pedrali at the end of the century. Using the techniques learnt during his training as a stage designer, Marieschi transforms his urban views by exaggerating their breadth, thereby lending a touch of fantasy to real places. In comparison with the paintings based on the same view (Alte Pinakothek, Munich and cat. 161) the chiaroscuro is here exaggerated by repeated shading: a great band of shadow falls across the left side of the picture, leaving a narrow beam of light to lead the eye towards the clear sky on the horizon. On the pavement of the piazza a little group of figures, thrown into relief by this trick of the light, restores equilibrium to the composition.        G.M.

*Bibliography:* Mauroner, 1940, no. 14; Pallucchini, 1941, no. 248; Zampetti, 1967, no. 125; Mason, 1973, no. 98; Pignatti, 1975², no. 7; Succi, 1981, no. 10; Mason, 1984, no. 20; Dreyer, 1985, no. 76; Succi, in Bergamo, 1987, no. 4; Dell'Orso, 1988, no. 7; Toledano, 1988, no. V.6.4; Succi, in Turin, 1989, no. 4

MICHELE MARIESCHI
*The Piazzetta dei Leoncini (or di S. Basso) in Venice*
1735–6
oil on canvas, 55.5 × 83.5 cm
Szépmüvészeti Múzeum, Budapest (inv. 628)

The Piazzetta dei Leoncini, the small piazza to the north of S. Marco is named after the red Verona marble lions around the wellhead that were carved by Giovanni Bonazza in 1722. On the left the arches of S. Marco are visible, on the right, among the houses, the clock-tower and the church of S. Basso (closed since 1810), the façade of which is said to have been designed by G. Benoni *c.* 1670. At the bottom is S. Geminiano, rebuilt by Sansovino (who was buried in it) but destroyed in 1807 by order of Napoleon.

This view was never treated by Canaletto; Marieschi was the first artist to use it. He also included it in his series of 21 etchings of Venetian views published in 1741–2. Despite the realistic setting, this can be seen as a *veduta ideata*. Marieschi imposed a false perspective on the scene, imitating the scope of a wide-angle lens, much influenced by stage-design, and indeed the square is made to resemble a stage-set. The cool, bright colours underline the effect.

The composition has two variants, one in the Alte Pinakothek, Munich (inv. no. 14788), probably dating from *c.* 1734–5; the other in a private collection (Toledano 1988, no. V.6.3), both with different figures. Marieschi seems to have developed a dryer, more matter-of-fact presentation, and the Budapest version, of *c.* 1735–6, is cooler in its approach, having stronger outlines and less painterly details. Marieschi's view seems to have inspired his contemporaries, for example Andrea Urbani, whose drawing of 1749 displays the same view, but with different figures.

This little painting was one of the last acquisitions of Prince Nicholas II Esterházy, bought in 1826.                    I.B.

*Provenance:* 1826, Esterházy coll., inv. no.1130 (as Canaletto); 1870, purchased with the entire collection by the Hungarian Government
*Exhibitions:* Gorizia, 1989, no. 24; Milan, 1991, no. 17
*Bibliography:* Fogolari, 1912, p. 56 (first attributed to Marieschi); Pallucchini, 1960², p. 194; Pigler, 1967, p. 414; Garas, 1968/ 1977, no. 41; Toledano, 1988, pp. 72–3, V.6.1–4

MICHELE MARIESCHI
*The Grand Canal at the Entrance to the Cannaregio*
1741–2
oil on canvas, 55 × 84 cm
Stiftung Schlösser und Gärten
Potsdam-Sanssouci

This spectacular, wide-angle view shows the northern bank of the Grand Canal at the entrance to the Cannaregio. On the left are Palazzo Flangini and the church of S. Geremia with its campanile alongside the 17th-century Palazzo Labia. Marieschi used the same view with minor adjustments to the figures in one of the five etchings added to his collection *Magnificentiores Selectioresque Urbis Venetiarum Prospectus*, probably at the end of 1741; the collection was published between the end of that year and the beginning of 1742. This canvas can be dated to the first months of 1742: a balustrade enclosing a statue of St John Nepomuk by Giuseppe Marchiori was erected at the expense of the Labia family on 12 May 1742 at the corner of the entrance to the Cannaregio canal. This, and another equally lively version, painted with the rapid brush strokes of Marieschi's mature style, can be dated to some time before May 1742; a third version (Earl of Malmesbury, Basingstoke) contains the new balustrade. It has been assumed that here, as in other paintings, Marieschi had assistance in painting the figures; Antonio Guardi has been credited with much of this work. Recently scholars have endeavoured to establish that in this case the paintings are entirely by Marieschi. With its pendant, *The Grand Canal with the Ca' Rezzonico and the Campo S. Samuele* (also at Potsdam), it was listed at the Sanssouci Palace in Potsdam from 1773, together with views by Canaletto and Pannini. They were probably acquired for Frederick the Great by Francesco Algarotti, his artistic adviser from 1746 to 1753, who was in Venice in 1749.                    G.M.

*Provenance:* Probably acquired by Francesco Algarotti for Frederick II of Prussia; Prussian royal collection; Sanssouci Palace, Potsdam
*Bibliography:* Fogolari, 1909, p. 246; Goering, 1944, pp. 22–4; Martini, 1964, p. 250; Morassi, 1968, p. 501; *Picture Gallery Berlin*, 1978, pp. 256–7; Succi, 1987, p. 38; Toledano, 1988, no. V.28.1; Succi, 1989, p. 147, ill. 162

MICHELE MARIESCHI
*Stairwell in a Renaissance Palace*
*c.* 1740
oil on canvas, 35.5 × 55.5 cm
Nationalmuseum Stockholm (inv. 50)

The novelty of the scenographic models of Marco Ricci and Canaletto, with their dramatic effects of light and shade, must have influenced the young Marieschi in the late 1720s when he came into contact with the theatrical world. Although it has echoes of Juvarra and knowledge of Ricci's series of theatrical designs now at Windsor (see cat. 30, 31), this is an original composition by Marieschi, elaborating, perhaps, details taken from the Doge's Palace, with an atrium and porticoes that open onto a large staircase and courtyard. Together with its pendant (National Museum, Stockholm, inv. no 51) this belongs to a group of paintings of the same subject (Young, 1977), but of varying quality, some of which, it has been suggested, are workshop productions. In these architectural *capricci*, Marieschi was experimenting with perspectival schemes particularly suited to his talent to reproduce the mellow, tactile qualities of the marble surfaces with their complex effects of light and shade. Made more complicated by the interplay of stairs and floors, where the dividing line between the ruined palace and the dark prison is extremely fine, these compositions anticipate the sensibility revealed by Piranesi's *Carceri d'invenzione* of the late 1740s (cat. 276– 80). The pendant can be dated *c.* 1740. The figures here are attributed either to Antonio Guardi (Young, 1977), or more probably to Marieschi himself, working in the style of Tiepolo (Morassi, 1959). Two other versions of the same subject are of inferior quality and their attribution to Marieschi is uncertain.        G.M.

*Provenance:* from 1792 in the Museum of Gustav III of Sweden
*Exhibitions:* Stockholm, 1915, Stockholm, 1944, Stockholm, 1962–3
*Bibliography:* Morassi, 1959, p. 232; Pallucchini, 1960², p. 195; Grate, 1962, no. 169; Palluccini, 1966, p. 323; Young, 1977, pp. 10–11, no. C1; Toledano, 1988, no. C.56.1; Cavalli-Björkman, 1990, p. 211

MICHELE MARIESCHI
*Architectural Fantasy*
*c..* 1736–7
etching, state 2 of 3
33.3 × 46.8 cm (platemark), 2.4 × 46.3 cm (inscription)
inscribed lower margin, on separate plate: '*Eximij prospectus Atrij ex pluribus Architecturae caracteribus excogitatus: cuius exemplum in Theatro depictum plauderetur. Totum a Michaele Marieschi recens inventum, ac incisum*'.
Arthur and Charlotte Vershbow

This brilliant perspective composition is the only etched example of Marieschi's work as a stage designer; that it was intended for the theatre is explained in the inscription accompanying the etching on a separate plate. Many architectural sources can be recognised here, including echoes of the courtyard of the Doge's Palace and S. Marco, filtered through memories of Bibiena's work. It can probably be dated to some time shortly after 1735; it closely anticipates his series of views of Venice, *Magnificentiores Selectioresque Urbis Venetiarum Prospectus*, begun in 1738.

A trial proof of this etching, of which a single copy exists (Museo Correr, Venice, Stampe B22, no. 17), shows that the artist omitted many of the figures at that stage (Mason, 1983). This has rekindled the debate about the possibility that studio assistants added Marieschi's figures, as has also been suggested in regard to his paintings. Recently, scholars have inclined to the view that Marieschi was responsible for everything in his compositions. Although this print does not belong with the collection of views published in 1741–2, it was included in some of the earliest editions.                                        G.M.

*Bibliography:* Mauroner, 1940, no. 1; Pallucchini, 1941, no. 232; Mason, 1973, no. 84; Succi, 1981, no. 4; Mason, 1983, pp. 212–3; *idem*, 1984, no. 2; Dreyer, in Berlin, 1985, no. 91; Succi, 1987, no. 1; *idem*, 1989, no. 1; Mason, in Geneva, 1991, no. 23

ORAZIO MARINALI
born Angarano, 24 February 1643
died Vicenza, 8 February 1720

Sculptor. He was the son of a wood sculptor, Francesco Marinali, with whom he first trained when the family moved to Bassano. As a young man Marinali went to Venice, where he is thought to have trained with the Flemish sculptor Giusto Le Court; later he worked with Le Court and Parodi in Venice; Marinali's High Baroque style may have been inspired by Bernini's works which he saw in Rome (Verci). By December 1665 he had returned to Bassano del Grappa and married that month; he seems to have stayed there until he moved his workshop to Vicenza in 1668. Accepted into the Guild of Masons and Stonecutters of Vicenza in 1674, his earliest known work, *The Meeting of Christ and Veronica* (1675; Staatliche Museum, Berlin), was made for the church of the Vergini in Castello, Venice. In 1680 he was commissioned to make a *St Paul* and an *Angel* for the altar of the Innocents in S. Giustina, Padua. The following year his brothers, Angelo (1654–1702) and Franceso (1647– after 1717), were both accepted into the Guild and began to make a greater contribution to the workshop.

During the 1680s Marinali received commissions from Bassano and Brescia, Verona and Vicenza. He worked on a number of decorative and figurative elements for the Santo, Padua (1692–1707), and contributed many statues, reliefs and decorations for the church of S. Maria di Monte Berico, Vicenza, which comprise his major monument. From the early 1690s until his death in 1720 Marinali, his brothers and workshop produced a prodigious number of statues and decorations for churches, villas and gardens of Brescia, Verona, Vicenza and its environs. For the magnificent gardens of the Conti-Lampertico at Montegaldella alone, Marinali and his workshop supplied over 100 sculptures. Most are still *in situ* and many of the preparatory drawings for them are now in the Museo Civico, Bassano. Also dating from these years are the many terracotta *bozzetti* of the works made for the Grotta da Schio (Museo Civico, Vicenza). His allegorical and caricature marble busts and garden statuary, most of which were made in *pietra tenera*, were exceptionally inventive. Many aspects of Marinali's style were later adopted by the Bonazza workshop.     P.W.

*Bibliography:* Verci, 1775, pp. 285–9; C. Tua, 1934; *idem*, 1935; P. M. Tua, 1935, pp. 99–106; Semenzato 1956; Barbieri, 1957; Wittkower 1958, ed. 1973, pp. 452, 570 n. 53; Barbieri, 1960; Puppi, 1966; Semenzato, 1966, pp. 33–8, 95–105; Sartori, 1976, pp. 145–6; Nava-Cellini, 1982, pp. 186–93, 249; Todescato, 1982; Androsov, 1987; Barbieri, in Vicenza, 1990, pp. 226–43

ORAZIO MARINALI
*Bravo: An Old Man*
*c.* 1710
marble, 58 × 56 × 30 cm (excluding base)
Fondazione Scientifica Querini Stampalia, Venice (inv. 0268/1–7)

This previously unpublished bust from the series known as the *bravi*, another of which is discussed here (cat. 17), is typical of Marinali's many caricatures of old men in various guises. This bust shown is similar to the model of a bust of *Democritus* (Museo de Arte Ponce, Puerto Rico) which, together with its pendant, *Heraclites*, are exceptionally fine, probably earlier, examples of this idiom. Other busts of *bravi* were formerly in the Mancinelli Scotti collection, Milan, and the Casa Benedetti, Salvore (Tua, Bacchi).

Among Marinali's many busts, few portraits are known: for example there is one of Pope Alexander VIII (*c.* 1690; old Duomo, Brescia) and the portrait of Cardinal Angelo Maria Querini (Galleria Querini Stampalia, Venice), which probably was made at about the same time as the *bravi* (Lorenzetti, Tua, Semenzato). For his self-portraits Marinali used the cheaper *pietra tenera* rather than marble; one made for the grotto of Schio (Museo Civico, Vicenza) is dated 1712. The other self-portrait from the Conti di Vicenza (Museo Civico, Bassano del Grappa) appears to depict Marinali a few years later (Barbieri, in Vicenza).     P.W.

*Bibliography:* Planiscig, 1919, p. 104, no. 158, fig. 156; Lorenzetti, 1927, p. 353; Tua, 1935, pp. 295–7, 303–4, 307–8, 310, figs. 6–7; Mariacher, 1967, figs. 75–7; Semenzato, 1966, pp. 97–8, 100, figs. 56, 67–70; Nava Cellini, 1982, p. 192; Bacchi, 1989, 1989, pp. 42–5; Barbieri, in Vicenza, 1990, pp. 227, 238–9, nos. 7.7, 7.8, 7.9

ORAZIO MARINALI
*Bravo: Boy with a Hat*
*c.* 1710
marble, 62 × 56 × 34 cm (excluding base)
Fondazione Scientifica Querini Stampalia,
Venice (inv. 0268/1–3)

This is one of a number of busts, known as
*bravi*, of which seven are in the Galleria Querini
Stampalia only four of which have been
published (for some of the others see Nava
Cellini, 1982; Martinelli, 1979, no. 100;
Barbieri, in Vicenza, 1990, p. 239). The features
of several of the busts in this group reappear
integrated into garden statues in variant forms;
The *Boy with a Hat* is related to a statue of a
*Bagpiper* (illustrated by Semenzato, 1966, fig. 58),
while the bust of an *Old Man* (cat. 16) closely
resembles a drawing of *Aristotle* (Museo Civico
Bassano). This bust, and its companion seem to
date from *c.* 1710, as proposed by Nava Cellini;
an alternative dating of 1690–2 was suggested by
Tua and accepted by Mariacher.          P.W.

*Bibliography:* Lorenzetti, 1927, pp. 353, 357; C.
Tua, 1935, p. 293, fig. 5, p. 296, p. 303;
Semenzato, 1966, pp. 98, 102, no. 1121, figs. 58,
70; Mariacher, 1967, figs. 74–7; *idem*, 1977, p.
19; Martinelli, 1979, no. 100; Nava Cellini,
1982, pp. 192–3, figs; Bacchi, 1989, nos. 14–5,
p. 86; Barbieri, in Vicenza, 1990, pp. 231–2/
7.3.1c, p. 238/7.6a, p. 239/7.8

## GIOVANNI MARIA MORLAITER
born Venice, 15/16 February 1700
died Venice, 22 February 1781

Sculptor. Both his father, Gregorio, and grand-
father, Andrea, came from Niederdorf in the south
Tyrol, but the family evidently moved to Venice
before 1697, when his father is recorded as a
resident. Together with Corradini, Torretti, Sebas-
tiano Ricci, Pittoni and Giambattista Tiepolo,
Morlaiter was a founder member of the unofficial
Academy in 1724. His earliest work known is a
(now lost) statue of *St Antony* (1729–30) for the
church of S. Lucia, Venice. In 1730 he made two
marble reliefs for the Cappella del Rosario in SS.
Giovanni e Paolo, whose terracotta *bozzetti*
together with a significant collection of Morlaiter's
models, including the *Adoration of the Magi* (cat.
178), are in the Ca' Rezzonico, Venice. The
statues of *St Benedict* and *St Scholastica* in the church
of Fratta, Polesine, are dated 1735; *St Antony Abbot*
in S. Antonio, Udine, is of 1736–8. From 1737
until 1754 Morlaiter worked on the Gesuati,
together with Piazzetta and Giambattista Tiepolo,
producing many statues of saints and prophets and
eight reliefs for the interior, his greatest works. He
also worked together with Tagliapietra, Torretti
and, in particular, with Bonazza on other decora-
tive elements, including those for the high altar. In
1746 Morlaiter made angels for the Marienkirche in
Prcanj, Dalmatia, and the lively busts of Pope
Benedict XIV and Cardinal Rezzonico in the
Duomo, Padua. The very beautiful angels on the
high altar of S. Maria della Fava, Venice (1753),
and the statutes of *St Peter* and *St Paul* for the parish
church of Camponogara show him at the height of
his powers.

Morlaiter became increasingly dependant on his
workshop assistants and devoted much time to the
Academy, of which he was appointed director in
1755 under the presidency of Tiepolo; he was a
member of the Jury that awarded Canova the prize
in 1775. Morlaiter's last documented commission is
the relief of *St Roch among the Victims of the Plague*
(1771; S. Rocco, Venice). His son Michelangelo
Morlaiter (1729–1806) was a painter.          P.W.

*Bibliography:* Moschini, 1806; Moschini, 1817;
Arslan, 1932; Sartorello, 1938; Rasmo 1955;
Semenzato, 1966, pp. 62–5, 136–8, figs. 202–15;
Massari, 1971; Ress, 1979; Haskell, 1980, ed. 1991,
p. 312; Nava Cellini, 1982, pp. 169–89, 259; Goi,
1988, pp. 158–60, fig. 26

GIOVANNI MARIA MORLAITER
*Adoration of the Magi*
1730
terracotta relief, 34 × 103 cm
Ca' Rezzonico, Venice

The relief of the *Adoration of the Magi*, Morlaiter's
earliest dated work, is only known from this
terracotta *modello*. It is one of his most successful
and busiest compositions with no area left
unfilled, and evinces a strong pictorial quality,
heavily influenced by the theatrical, Rococo style
of Tiepolo. It is not known why this model was
not translated into marble by Morlaiter, but the
marble relief of the same subject made for the
Cappella del Rosario, SS. Giovanni e Paolo,
Venice, by Giovanni Bonazza and his sons in
1732 owes a considerable debt to Morlaiter's
design of two years earlier.

The terracotta *bozzetti* for the larger marble
pendant reliefs of the *Flight into Egypt* and *Christ
Preaching in the Temple*, which Morlaiter executed
for the Cappella del Rosario, are also in the Ca'
Rezzonico. While Lorenzetti (1931) dated them
some 20 years later than the *Adoration of the Magi*,
Ress (1979) concluded that all three *bozzetti*
were made within a short time of one another,
and that the *Adoration of the Magi* was also
intended for the Cappella del Rosario
(Pedrocco, 1981).          P.W.

*Provenance:* by descent from Morlaiter to his son,
Michelangelo Morlaiter, from whom acquired by
the Michiel family; it subsequently passed into
the collection of the Donà dalle Rose, from
whom sold in 1934
*Exhibition:* Venice 1946, p. 162, no. 296
*Bibliography:* Fiocco, 1931; Lorenzetti, 1931, pp.
996–7; Lorenzetti and Planiscig, 1934, pl.
XLIV, figs. 85–6 no. 248 p. 54; Lorenzetti,
1935, pp. 226, 229–30, no. 3, fig. 3;
Pallucchini, in Venice, 1946, pp. 161–2, nos.
294–8; Semenzato, 1957[3], pp. 61–2, figs. 10–13,
Schönberger and Soehner, 1960, pl. 252;
Mariacher, 1964; Semenzato, 1966, pp. 1216;
Mariacher, 1971; *idem*, 1977, fig. 10, p. 22; Ress,
1979, pp. 3, 71, n. 13, pls. 1–6, 149–50;
Pedrocco, 1981[2], pp. 22–3, nos. 1–3, figs. 22–3

## GIUSEPPE NOGARI
born Venice, 1699
died Venice, 1763

Painter and draughtsman. He trained in Balestra's workshop before 1718, when his master went to Verona. Stylistically, however, he seems to have learnt more from Piazzetta, who was also active in Venice at that date. In 1726 he was first listed in the Fraglia dei Pittori. Nogari's first important patron was the Milanese Marchese Ottavio Casnedi, followed by the Swede Count Tessin, who bought some 'fanciful heads' by Nogari in Venice in May 1736. The same year Marshal Schulenburg began buying his works. In 1739 Nogari sent some 'imaginary' portraits to the Savoia family, and in 1740 he was invited to Turin by Carlo Emanuele III. There he worked extensively on the Royal Palace, decorating the ceiling of the Gabinetto degli Specchi and producing several allegorical paintings. In 1743 he returned to Venice, where he was in contact with Francesco Algarotti, who was buying works of art for Augustus III, King of Poland. Consul Smith also bought fanciful heads from Nogari and commissioned him to make portraits of artists of the 16th and 17th centuries whose works he collected: these included Titian, Jacopo Bassano, Carlo Cignani, van Dyck, Rubens and Inigo Jones (now in the Royal Collection). Also in these years Sigismund Streit bought two imaginary portraits and commissioned Nogari to paint four allegories of Education. In the early 1750s Nogari painted *The Donation of the Keys* for the cathedral at Bassano del Grappa. In 1756 he was one of the founder members of the Venetian Academy. Following his death seven years later, he was buried in S. Maria dei Frari.          M.G.

GIUSEPPE NOGARI
*An Elderly Woman in a Striped Shawl*
pastel on two attached sheets of paper, 50.5 × 40 cm
National Gallery of Art, Washington
Ailsa Mellon Bruce Fund, 1984.69.1

This is one of the few known works by Nogari in pastel. It depicts one of those 'fanciful heads', usually of old men or women, for which Nogari was famous in his day. They appealed to several collectors, including Marshal Schulenburg, Count Tessin and Sigismund Streit. Nogari's heads were influenced by Northern artists, Rembrandt in particular, as the present work suggests. The artist used the soft medium of pastel to great effect to portray the woman's strong face and to achieve subtle effects in the shawl. From its confident execution the work would seem to date from the artist's maturity in the 1750s. Robison (National Gallery of Art archives) noted that there is a striking similarity between this pastel and the painting of *A Woman Warming her Hands* (Royal Collection). A drawing by Nogari (Correr, Venice, inv. 742; Pignatti, 985, no. 57), although much less elaborate and with some notable differences, may also be related to this work.          M.G.

*Provenance:* 29 November 1983, Christie's, London, sale, no. 80; 6 June – 13 July 1984, Galérie Cailleux, Paris, sale, no. 51

## PIETRO ANTONIO NOVELLI
born Venice, 7 September 1729
died Venice, 13 January 1803/4

Painter, draughtsman and printmaker. He trained with Pittoni, but the major influences on his work were Francesco Guardi and Amigoni, Diziani and Giambattista Tiepolo. He worked in Venice, Padua, Udine, in Friuli, in Bologna after 1773, and in Rome, where he remained, apart from a few intervals, from 1779 until the end of the century. As well as working as a printmaker and draughtsman, Novelli painted in oil and fresco. Stylistically he began by inclining to the Rococo style but his later works, especially those made after his time in Bologna and Rome, became closer to the Neo-classical mode. Morazzoni described him as the most fertile and elegant illustrator of his time. He was a sensitive illustrator of contemporary poetry and plays, which he successfully interpreted with freshness and humour, if without any strong sense of drama. He left a remarkable number of preparatory drawings, an important part of his creative process. The largest holdings are in the Correr Library, Venice; the Albertina, Vienna; the Ecole des Beaux-Arts, Paris, and the Hermitage Museum, St Petersburg. From 1779 he was affiliated to the Venetian Literary Academy for the promotion of Italian poetry with the pseudonymous name of Aristeno Parassidio. His memoirs were published posthumously in Padua in 1834.          O.T.

247

PIETRO ANTONIO NOVELLI
*Delle Commedie di Carlo Goldoni, Avvocato Veneto*
published in Venice by Pasquali, 1761-78
17 volumes, octavo; vol. III: *I rusteghi; La Serva amorosa; Il Molière; L'adulatore*
*c.* 21.5 × 29.5 cm (open book)
Arthur and Charlotte Vershbow

Apparently the playwright Carlo Goldoni was financially involved in this publication of his complete works. The original plan was to publish 30 volumes in eight years, for which the privilege was submitted on 24 December 1760. Possibly as a consequence of Goldoni's departure to Paris, the project was never completed and only seventeen volumes, or possibly nineteen, as it is sometimes suggested, were published, the last dated 1777/8. The publisher was Pasquali, whose chief illustrator was Novelli; he was chosen to work on the most of the illustrations, although a few were made by Antonio Baratti and G. Giampiccoli. Shown here are two etchings from volume III: the frontispiece and the plate facing p. 242, illustrating scenes from the play *L'Adulatore*. Volume III contains three other comedies by Goldoni, *I Rusteghi, La Serva Amorosa* and *Il Molière*. This was Pasquali's

most enterprising publishing venture; the aim was to cater for the general public, and the novelty lay in the illustrations that, instead of showing standard allegorical and mythological figures, illustrated episodes from Goldoni's life, and set the plays in the intimacy of everyday Venetian life.                              O.T.

*Bibliography:* Spinelli, 1884, pp. 97–121; Morazzoni, 1943, p. 234; Pedrocco, 1975, pp. 327–8; Paris, 1978, I, p. 43; II, p. 70; Haskell, 1980, pp. 336–8; Cibolo and Pedrocco, 1981

## 248

PIETRO ANTONIO NOVELLI
*Quattro elegantissime Egloghe rusticali. Ora per la prima volta poste insieme, e con diligenza stampate da Giovanni Pringle*
published in Venice by Paolo Colombani, 1760
octavo volume, etchings, plates and vignettes
23 × 32.5 cm (open book)
Arthur and Charlotte Vershbow

This rare, small book contains four poetic compositions in pastoral style. Novelli was the main illustrator, designing three full-page compositions, including the one showing here on page 44, as well as a number of vignettes and endpieces. One of the most important features of this book is the fanciful quality of Novelli's vignettes. The book also contains an etching on p. 47 by Francesco Bartolozzi, one of his earliest prints. John Pringle (1707–82) was a well-known English scientist and surgeon, remembered for a number of medical publications.                              O.T.

*Bibliography:* De Vesme and Calabi, 1928, p. 386; Moschini, 1931, p. 122; Morazzoni, 1943, p. 251; Lapiccirella, n.d., p. 141, no. 215

## 250

PIETRO ANTONIO NOVELLI
*Faith Overcoming Heresy*
before 1791
pen and black ink with brush and watercolours, over traces of black chalk, 54.2 × 39.6 cm
watermark: seven pointed star (not in Headwood)
inscribed: recto at lower left, in pen: '*Piede . . ./. . ./. . ./. . ./Lunghezza piedi 26*'
recto at lower right, in pen:
'*Larghezza piedi 19*'
The Art Institute of Chicago, Chicago
Gift of Mr and Mrs William O. Hunt (inv. 1963.761)

First attributed to the artist by Benesch, this drawing with its calligraphic style, delicate shading and annotations of size, can be matched

in other drawings by Novelli. The format of this composition suggests it may be a preparatory drawing for a ceiling, possibly that of the Sacristy of the Cathedral of S. Martin at Lupari, mentioned in Novelli's memoirs. Faith, clad in white, holds the Cross and chalice and is surrounded by martyrs who died to defend their religion. Below them two angels set fire to heretical books, while heretics are hurled into oblivion.                              O.T.

*Provenance:* P. J. Sachs (Lugt 2091); 1963, Victor Spark, New York; purchased 1963
*Exhibition:* Pignatti 1960, p. 54, no. 115
*Bibliography:* University of Chicago (sale catalogue), 1963; Pignatti, 1960, p. 215; Chicago 1979–80, no. 149

## 251

PIETRO ANTONIO NOVELLI
*The Peep-show*
pen and brown ink with grey and brown wash over black chalk, laid on backing paper, 17 × 24.2 cm
inscribed on verso upper left in black ink: '*P.A.Novelli*'; upper centre in blue ink, underlined: '*Il Diorama*'; bottom right, Julius S. Held collection mark; on the backing paper a faint sketch in pencil of a boy holding a horse
National Gallery of Art, Washington
Julius S. Held Collection, Ailsa Mellon Bruce Fund, 1983.74.14

A group of children are looking into a *mondo nuovo* (peep-show). The peep-show was a well-known sight in Venice, especially during the Carnival, and appears in a number of paintings by Pietro Longhi. It consisted of a box in which a system of mirrors conveyed three-dimensional images illuminated by candlelight, mostly of cities such as Paris and London, the exciting 'new world'. This drawing, first attributed to Novelli by Morazzoni, is an example of the artist's genre drawings, with certain affinities to the work of Gaetano Zompini (cat. 187, 188).                              O.T.

*Provenance:* Julius S. Held Collection, New York; 1983 National Gallery of Art, Washington
*Exhibitions:* Binghamton, 1970, no. 129; Williamstown, MA, 1979, no. 30; New York, 1990, no. 41
*Bibliography:* Munhall, 1968, p. 90, fig. 6

PIETRO ANTONIO NOVELLI
*The Marriage of Europe and China*
1770s–80s
pen and brown and grey ink with grey wash on laid paper, 33.7 × 45.7 cm
watermark: coat of arms
inscribed in graphite at lower centre: '*le mariage*'; on the verso in ink: '*A Paris chez Naudet Me Des Auysen au Louvre / 1810*'
National Gallery of Art, Washington
Ailsa Mellon Bruce Fund, 1987.16.1

This is one of a series of large-format chinoiserie drawings, of which three are known (for the other two, a dance and a stage performance, see Thomas LeClaire, *Meisterzeichnungen 1500–1900*, Hamburg, 1989, no. 42 and 43). Their size and degree of finish are comparable to Domenico Tiepolo's series of finished drawings on the themes of *Scenes of Contemporary Life* and *Punchinello*. However, the Novelli drawings may also have been intended to be engraved, to form one of the many sets of large decorative prints published by firms such as Wagner and Remondini, which were frequently hand-coloured to be glazed and hung on walls. All three known drawings show figures in exotic costumes, the men almost all with 'Chinese' features, hair and dress, while the women appear Western in features and wear European costumes with exotic trimmings. Perhaps emblematic of the fanciful union between East and West which produced true chinoiserie, the present drawing shows a Chinese man and European woman apparently being joined in matrimony, with the bride's maids bringing her dowry and the groom's attendants singing. All three scenes are mounted on rococo volutes which add to their sense of unreal lightness, and which are ultimately derived from Piazzetta's book illustrations.                              A.R.

*Provenance:* Naudet 1810 (Lugt 1937); Yvonne Tan Bunzl, London; 1987, bought by the National Gallery of Art
*Bibliography:* Tan Bunzl, 1987, no. 49; Le Claire, 1989, p. 88

## PELLEGRINI, GIOVANNI ANTONIO

born Venice, 29 April 1675
died Venice, 5 November 1741

Painter and draughtsman. He studied under Paolo Pagani, with whom he went to Austria, where he remained for six years. After returning to Venice in 1696, around 1700 he went to Rome, where he studied the work of Luca Giordano and the grand fresco decorations in Baroque churches. Back in Venice in 1701 he painted the cycle of canvases for the Scuola del Cristo, next to the church of S. Marcuola and also worked in Padua. In 1704 he married Angela Carriera, sister of Rosalba. In 1708 he was invited, with Marco Ricci, to England by the 4th Earl of Manchester. In London he painted scenery, in collaboration with Marco, for two operas, *Pyrrhus and Demetrius* by Alessandro Scarlatti and Nicola Haym (with an English libretto by Owen McSwiney), and Antonio Maria Bononcini's and Silvio Stampiglia's *Camilla* (again with an English libretto by McSwiney), both presented at the Queen's Theatre, Haymarket, in 1709. In 1709–10 Pellegrini participated, with Thornhill and others, in the competition for the decoration of the dome of St Paul's. He also decorated several houses in London and elsewhere: with Ricci he worked at Castle Howard for the 3rd Earl of Carlisle; for Lord Manchester he decorated Kimbolton Castle; he also worked at Burlington House. In 1711 he became one of the directors of Kneller's Academy. He left England in 1713 and went to Düsseldorf, where he enjoyed the patronage of the Elector Palatine Johann Wilhelm. For him Pellegrini painted a decorative cycle in the Bensberg Castle (1713–14), now in the gallery of Castle Schleissheim. Following the Elector's death he went to Flanders and Holland. After returning briefly to England in 1719, Pellegrini went to Paris the following year, where he painted the ceiling (destroyed) of the Gallery of the Banque Royale. He was back in Venice by 1721, but between 1722 and 1730 he went to Würzburg, Vienna – where he painted the dome of the Salesianerkirche – Dresden and Prague. He was elected a member of the Paris Académie in 1733. In Germany again in 1736, he painted ceilings for the Residenz at Mannheim (destroyed).                               M.G.

### 39

GIOVANNI ANTONIO PELLEGRINI
*St Cecilia*
oil on canvas, 72.2 × 40.5 cm
Staatsgalerie, Stuttgart (inv. 3044)

Cecilia is depicted as the patron saint of music. This is the *bozzetto* for an altarpiece commissioned from Pellegrini for the church of St Clemens in Hanover, the construction of which was due to Abbot Agostino Steffani, born in Castelfranco Veneto in 1654. In 1688 Agostino was invited to the Hanoverian court as chapel-master and composer. Appointed to the vicariate in Hanover by Pope Clement XI he undertook to build a Catholic church. By 1713 the final project was approved and, with the patronage of the Duke-Archbishop Lothar Franz von Schönborn, the church was inaugurated in 1718, with the dedication to St Clemens Romanus. In 1716 Pellegrini was commissioned to paint two altarpieces for the new church, *St Cecilia* and a *Resurrection* (both destroyed). In August 1717 he was paid, and by September the *St Cecilia* altarpiece had arrived in Hanover.                               M.G.

*Provenance:* Art Market, Stuttgart
*Exhibitions:* Stuttgart, 1978, no. 43; Hanover and Düsseldorf, 1992, p. 184, no. 48H
*Bibliography:* Martini, 1982, p. 482, n. 79, fig. 64

### 40

GIOVANNI ANTONIO PELLEGRINI
*Judith with the Head of Holofernes*
*c.* 1710
oil on canvas, 124.7 × 102 cm
The Trustees of the Barber Institute of Fine Arts, The University of Birmingham

This probably dates from Pellegrini's years in England. The figures of Judith and her maid are handled with a lightness of touch and a bright palette that gives a shimmering effect to the paint surface. The graceful Judith, who seems oblivious to the gruesome head of Holofernes, is lit by a diagonal beam of light from the top left and stands out from the dark background. There are other similar versions of this subject, one in the Palazzo Magnani, Bologna (Volpe, 1972, pp. 70–1), and another in the Duckett Collection, Venice (Pilo, 1960, p. 179).                               M.G.

*Provenance:* acquired 1974
*Bibliography:* Spencer-Longhurst, 1983, pp. 305–7

### 41

GIOVANNI ANTONIO PELLEGRINI
*Venus and Cupid*
oil on canvas, 103 × 126.5 cm
Private Collection

According to Martini, this painting dates to Pellegrini's English period (1708–13) or from his stay in Düsseldorf (1713–16). The graceful figure is rendered with loose, dynamic brushstrokes and a vibrant tonal range.                               M.G.

*Provenance:* Zahari Collection, Malta; Piero Corsini, New York; Christie's, London, 5 July 1991, lot 7
*Bibliography:* Martini, 1982, pp. 19, 21, Pl. V, fig. 63; Pignatti, 1989, p. 278

### 42

GIOVANNI ANTONIO PELLEGRINI
*The Head of Pompey Presented to Julius Caesar*
*c.* 1707
pen and brown ink, brown wash, over red and black chalk, 28.7 × 37.3 cm
Lent by The Metropolitan Museum of Art, New York
Gift of John S. Newberry, 1961

The present drawing is similar in its style and frieze-like composition to the preparatory study for *The body of Darius brought before Alexander* (Bettagno, 1959, no.64). They both share the same nervous and abbreviated pen-work. Bettagno proposed that it could be dated to the years just before Pellegrini's departure for London in 1708.                               M.G.

*Provenance:* Private collection, Venice; John S. Newberry
*Exhibitions:* New York, 1971, no. 23
*Bibliography:* Pignatti, 1959, pp. 451, 453; *Annual Report*, 1961–2, pp. 64–6; Pignatti, 1965², no. 6; Bean and Griswold, 1990, no. 156

GIAMBATTISTA (or GIOVANNI
BATTISTA) PIAZZETTA
born Venice, 13 February 1682
died Venice 29 April 1754

Painter, draughtsman, book illustrator and etcher.
The son of a woodcarver, he first trained in
Antonio Molinari's workshop together with Ben-
covich and Giulia Lama. In 1703 he went to
Bologna, where he fell under the influence of G. M.
Crespi, adopting his genre scenes and tenebrist
colouring; he also studied Guercino. He returned
to Venice c. 1705, and in 1711 was registered in the
Venetian *fraglia*. In 1724 he married Rosa Muzioli.
Together with Sebastiano Ricci and the young
Giambattista Tiepolo he was one of the artists
chosen to paint for S. Stae in the early 1720s,
contributing *St James Led to Martyrdom* (cat. 70),
which typifies his melodramatic use of chiaroscuro
and dark palette. He also contributed to McSwi-
ney's series of paintings on tombs of British
worthies, collaborating with Canaletto and
Cimaroli on the *Allegorical Tomb of Lord Somers*
(1726; cat. 135). His greatest work in Venice was
the ceiling of *St Dominic in Glory* in SS. Giovanni e
Paolo (1725-7), when he began to lighten his
palette. He painted many great altarpieces for
Venetian churches (see cat. 72, 74), and worked
alongside his younger contemporary Giambattista
Tiepolo in the church of the Gesuati. He became
known internationally in the 1730s and 1740s
when his *Assumption of the Virgin* (fig. 12) was
comissioned by Clement August of Bavaria. From
the 1730s he collaborated with the publisher G. B.
Albrizzi on the illustrations of some of the
masterpieces of 18th-century Venetian book pub-
lishing. He also produced intimate genre scenes
(cat. 76, 78, 79) and portraits, and was a brilliant
draughtsman; his highly finished 'têtes de charactère'
(cat. 63-5) were collected as works of art in their
own right. He was one of Marshal Schulenburg's
favourite artists. He is often compared to Giambat-
tista Tiepolo, whom he influenced at the start of his
career, Tiepolo being cast as the exuberant genius
and Piazzetta as the introspective nonconformist.

O.T. and J.M.

GIAMBATTISTA PIAZZETTA
*Study of Nude Woman Seated*
1715-18
black and white chalk on white paper,
52.8 × 39.6 cm
inscribed (lower left): 'Piazzetta'
Collection Rondinelli

One of only a very few female nudes by
Piazzetta, and the most noteworthy on technical
grounds; it is characterised by a warm luminosity
which the light-coloured paper reflects to various
degrees over the whole figure. This sheet belongs
to a group of fifteen drawings signed by Piazzetta
and attributable for the most part to the years
1715-18. These were Piazzetta's earliest notable
graphic works. The existence of replicas has led
to the belief that these drawings had a double
function – as working drawings for Piazzetta
and as teaching aids for the apprentices in his
studio, where they appear to have remained for a
long time. This female nude resembles the young
model in other studies in the Alverà collection;
the drawing was engraved against a landscape
background by Valentin Daniel Preissler in
Nuremburg. It does not appear to be connected
to any known painting. G.M.

*Provenance:* 1919, Mario Alverà collection,
Venice; sale, Christie's, Rome, 11 November
1993
*Exhibitions:* Venice, 1963, no. 64; Venice, 1969;
Venice, 1983[1], no. 2
*Bibliography:* Ravà, 1921, p. 70; Pallucchini,
1934, p. 57; Bettagno, 1963, no. 53; Zampetti,
in Venice, 1969, no. 64; Mariuz, 1982, no. D.
55; Knox, in Venice, 1983[1], no. 2

61

GIAMBATTISTA PIAZZETTA
*The Supper at Emmaus*
possibly c. 1740
oil on canvas, 108.6 × 141.3 cm
traces of signature at lower left
The Cleveland Museum of Art
Purchase from the J. H. Wade Fund (inv.
31.245)

Piazzetta painted the same subject in a full-
length canvas (Museo Civico, Padua; Mariuz,
no. 126), dated c. 1745. In that composition the
Apostles express their astonishment at the
miraculous apparition of Christ; here an earlier
episode is depicted, when Christ is just starting
to break bread. The effect is therefore of a
quieter, though emotionally charged, atmosphere.
The detail of the dish of asparagus on the white
tablecloth adds a realistic note to the event, but
may also symbolise the spring. The dating of this
painting has ranged from the 1720s (Knox) to

the 1740s (Pallucchini; Mariuz); a date c. 1740
seems most probable.

The same composition appears, in reverse, in
a drawing by Antonio Guardi (cat. 193). M.G.

*Provenance:* 1787, Baglioni collection, Venice;
Castiglioni collection, Venice; Count
Castiglioni, Padua; Brass collection, Venice;
1931, acquired by the Cleveland Museum of
Art
*Exhibitions:* Venice, 1969, no. 58; Chicago,
1970, no. 34
*Bibliography:* Ravà, 1921, pp. 28, 60;
Pallucchini, 1934, pp. 41, 51, 95; *idem*, 1942, p.
19; *idem*, 1956, p. 26; *idem*, 1960[2], p. 81; *idem*,
1968, pp. 107, 119; Mariuz, 1982, no. 128;
Ruggeri, in Venice, 1983[1], p. 24; Knox, 1992,
pp. 65-6, pl. 55

62

GIAMBATTISTA PIAZZETTA
*Portrait of Giulia Lama*
c. 1715-20
oil on canvas, 69 × 55 cm
Fundación Collección Thyssen-Bornemisza,
Madrid

This was identified as a portrait of the painter
Giulia Lama (Fiocco, 1927) on the basis of its
resemblance to her *Self-portrait* of 1725 (Uffizi,
Florence; see Knox, 1992, p. 70). Giulia Lama
(1681-1747) was trained by her father,
Agostino, and was influenced to some degree by
Piazzetta. She painted altarpieces (S. Maria
Formosa and S. Vidal, both in Venice) as well
as more intimate works. Evidently she was close
to Piazzetta, who depicted her here as an allegory
of Painting, sensuously abandoned and absorbed
in her art. M.G.

*Provenance:* Miller von Aichholz Collection,
Vienna, Planiscig Collection, Vienna; Clive
Pascall Collection, London
*Exhibitions:* Venice, 1929, no. 20; London, 1954,
no. 588); Venice, 1969, no. 56; Washington,
1979, pp. 103-4; Venice, 1983, no. 9
*Bibliography:* Fiocco, 1927, pp. 27-8; *idem*, 1929,
p. 14; Pallucchini, 1933, p. 41; *idem*, 1934, p.
31; *idem*, 1956, p. 15; *idem*, 1960[2], pp. 62-3;
*idem*, 1968, p. 108; Jones, 1981[2], pp. 37-8, no.
11; Mariuz, 1982, no. 17; Knox, 1992, pp. 86-
7, pl. 69

GIAMBATTISTA PIAZZETTA
*A Young Man Embracing a Girl*
*c.* 1740
black chalk, heightened with white on blue
paper faded to grey, 39.5 × 31.6 cm
watermark: *HP* (or *HR*)
Curtis O. Baer Collection

A good part of Piazzetta's enormous output of
graphic work consists of so-called 'character
heads', highly individual portraits of artisans,
young people, soldiers, or scenes from peasant life.
With these drawings Piazzetta created an
independent graphic genre, each being carefully
finished and presented for sale to collectors; in
Venice this output can only be compared with
Rosalba Carriera's pastel drawings. These
drawings are for the most part executed in black
chalk heightened with white to accentuate the
chromatic effect. Dating them is frequently
problematic because of the number of variants
existing in the artist's studio, their poor state of
conservation and retouching, which accentuates
contrasts of light and shade in an arbitrary fashion
and gives them a uniform aspect, which certainly
was not the artist's intention. This, one of the
finest surviving drawings, was engraved by
Giovanni Cattini as plate VI in the series of fifteen
prints of genre heads by Piazzetta, first published
by Giambattista Pasquali in 1743 entitled *Icones ad
vivum expressae*; the series was republished in 1754
and 1763. In his written request to the Senate for
permission to republish Cattini's set of engravings
in 1779, the publisher and printseller Ludovico
Furlanetto mentioned that Consul Smith
contributed to expenses; probably it was Smith
who commissioned the drawings.          G.M.

*Provenance:* 20 May, 1955, H. A. Vivian Sale,
Christie's
*Exhibitions:* Cambridge, MA, 1958, no. 11;
New York, 1971, no. 38; Washington, 1983,
no. 45
*Bibliography:* Mongan, in Cambridge, 1958, no.
11; Bean and Stampfle, in New York, 1971, no.
38; Mariuz, 1982, no. D.15; Knox, in
Washington, 1983, no. 45

64

GIAMBATTISTA PIAZZETTA
*A Bravo, a Girl and an Old Woman (The
Procuress)*
*c.* 1740
black chalk, heightened with white on
discoloured grey-brown paper, 40.6 × 55.5 cm
Lent by Her Majesty The Queen (RL 01251)

This belongs to a group of 36 drawings that
once belonged to Consul Smith, and were later
acquired by George III. The drawings were
framed like paintings and hung for years in

Buckingham Palace, where they were attributed
to Sebastiano Ricci. Long exposure to daylight
altered the colour of the paper, which is now
brownish but was originally of the blue
commonly used by Piazzetta for his 'character
heads'; the medium used here, charcoal
heightened with white, is similar to that used for
the heads and half figures. Piazzetta here seems to
have gathered together three heads that originally
he made studies of independently. There is a
study of the same man in a drawing of a
gondolier (Art Institute, Chicago; Helen
Regenstein Collection, 1971. 331), and similar
old ladies appear on several sheets. The Smith
collection provenance is confirmed by the fact
that it was engraved for the collection entitled
*Icones ad vivum expressae*, first published by
Giambattista Pasquali, the printer and publisher
most trusted by Consul Smith, who probably
financed the publication. Giovanni Cattini's
print appears as plate XIV and is dedicated to
Francesco Algarotti.          G.M.

*Provenance:* Consul Joseph Smith; 1762,
purchased by George III
*Exhibitions:* London, 1960; London, 1966;
Venice, 1983[1], no. 56; Washington, 1983, no. 47;
Sidney, Melbourne and Brisbane, 1988, no. 44
*Bibliography:* Blunt and Croft-Murray, 1957, no.
32; Mariuz, 1982, no. D.39; Knox, in Venice,
1983[1], no. 56; *idem*, in Washington, 1983, no.
47; Roberts, in Sidney, Melbourne and Brisbane,
1988, no. 44

65

GIAMBATTISTA PIAZZETTA
*Young Woman taking a Pink*
*c.* 1740
black chalk, heightened with white, on paper,
40.2 × 54.9 cm
The Cleveland Museum of Art
Purchased from the J.H. Wade Fund (inv.
38.387)

A typical genre scene of Piazzetta's in which he
mixed studies of people taken from life with
generic types that recur frequently in his work.
The drawing combines three heads, apparently
with nothing in common, with great technical
virtuosity. A drawing (Museo Civico, Castello
Sforzesco, Milan) can be related to the young
woman in profile on the right, which, it has
been suggested, may be a portrait of Piazzetta's
daughter, Barbara (Pallucchini), who also served
as a model for the *Idyll on a Beach* (cat. 78). That
painting, which was finished in 1745, gives an
approximate date for this drawing. Piazzetta's
son Giacomo has been suggested as the model
for the boy on the left. Between the two probable
portraits of the artist's children, a young girl fixes
her gaze intently on the spectator.          G.M.

*Provenance:* Italico Brass collection, Venice; 1938,
J. H. Wade Fund
*Exhibitions:* Venice, 1929; Northampton, 1941;
Washington, 1983; no. 51
*Bibliography:* Pallucchini, 1934, fig. 74; Francis,
1940, p. 108; Goering, 1941, p. 262; Benesch,
1947, no. 11; Pallucchini, 1956, fig. 143;
Mariuz, 1982, no. D.12; Knox, in Washington,
1983, no. 51

66

GIAMBATTISTA PIAZZETTA
*Portrait of Field Marshal Johann Matthias von der
Schulenburg*
1738
black chalk and white heightening on grey-
brown paper, 38.3 × 33 cm
Civico Gabinetto dei Disegni, Castello
Sforzesco, Milan
(inv. Coll. E. 82/5 Gen. 4884/5)

Few portrait drawings by Piazzetta remain, but
they are all of exceptional quality. The most
remarkable are the two magnificent drawings of
his principal protector and patron, Marshal
Johann Matthias von der Schulenburg (1661–
1741), made during the 1730s.

Schulenburg was a famous soldier who had
worked in the service of the house of Savoy and
of the court of Saxony; in 1715 he had been
enlisted by the Republic of Venice as
commander-in-chief of their army, and had
defeated the Turks in a celebrated victory in
Corfu in 1716. He settled in Venice, where he
enjoyed close relations with the principal painters
of the day. He liked having his portrait painted,
particularly by Piazzetta, and he was responsible
for commissioning some of the painter's greatest
works, including the *Pastoral Scene* (cat. 79) and
the *Idyll on the Beach* (cat. 78). Schulenburg's
account book, now in the Schulenburg Archive
in Hanover, contains documents on the basis of
which this drawing has been identified with one
paid for on 18 August 1738. The calm,
confident tone of the portrait suggests that it is
later than the other, more austere, frontal view of
Schulenburg (Art Institute, Chicago; inv.
1971.325) which probably belongs to the group
paid for in 1731.          G.M.

*Provenance:* 1943, from the Raccolta Trivulzio
*Exhibitions:* Milan, 1971, no. 3; Venice, 1983,
no. 48; Hanover and Düsseldorf, 1991–2, no.
129
*Bibliography:* Pallucchini, 1956, p. 48; Precerutti
Garberi, in Milan, 1971, no. 3; Knox, in
Venice, 1983[1], no. 48; *idem*, in Washington,
1983, p. 39; Ruggeri, in Venice, 1983, p. 94;
Binion, 1990, pp. 38 and 99; Trudzinski, in
Hanover and Düsseldorf 1991–2, no. 129

GIAMBATTISTA PIAZZETTA
*Self-portrait at the Age of Fifty-two*
1735
black chalk, heightened with white, on blue-green paper, 35 × 24.1 cm
inscribed (lower margin, centre): '*Io Gio: Batta. Piazzetta disegnai di prop:a mano | in età d'Anni 52*'; (lower right): '*Adi 10 Dece | 1735*'
collection mark: Albert von Sachsen-Teschen (Lugt 174)
Graphische Sammlung Albertina, Vienna (inv. 1771, S65, V 253)

With the juvenile drawing in Windsor Castle (Royal Library, 0754), this and cat 89 are two of the only self-portraits reliably attributed to Piazzetta. Signed and dated 1735, when the painter was 52, it is close in date to the celebrated portrait of Marshal Schulenburg (cat. 66), and shares the same psychological subtlety. The technique here is freer, however, and has a spontaneity and immediacy due in part to the way the light bathes the whole drawing. It was probably acquired by Albert, Graf von Sachsen-Teschen (1738–1822), the famous collector and founder of the Albertina, during a visit to Venice in 1776.                     G.M.

*Provenance:* Albert von Sachsen-Teschen
*Exhibitions:* Venice, 1961, no. 88; Dresden and Vienna, 1978
*Bibliography:* Pallucchini, 1934, p. 100; Benesch, in Venice, 1961, no. 88; Morassi, 1971, p. 46; Knox, in Washington, 1983, p. 38; Ruggeri, in Venice, 1983, p. 94

GIAMBATTISTA PIAZZETTA
*St Stephen*
1738–42
black and white chalk on faded blue paper, 40.4 × 35.4 cm
Private Collection

St Stephen holds the palm of martyrdom and a stone: he was stoned to death. This drawing has been linked with a small painting attributed to Piazzetta (priv. coll., Venice; Martini, 1964, fig. 119). There is a similar drawing of St James (priv. coll.). In 1742 Marco Pitteri requested permission from the Venetian Senate to make engravings of fifteen drawings by Piazzetta of heads of Apostles, God the Father, Christ and the Virgin. This drawing of St Stephen, who was not an apostle, was never made into an engraving.                     G.M.

*Provenance:* Rudolf J. Heinemann
*Exhibitions:* New York, 1973, no. 34; Venice, 1983[1], no. 61; Washington, 1983, no. 58
*Bibliography:* Stampfle and Denison, in New York, 1973, no. 34; Knox, in Venice, 1983[1], no. 61; Knox, in Washington, 1983, no. 58

GIAMBATTISTA PIAZZETTA
*St Thaddeus*
1742
etching (by Marco Pitteri), 43.3 × 32.5 cm
inscribed: '*Joannes Bapt. Piazzetta pinxit|Marcus Pitteri sculpsit XII| Sanctus Thaddaeus| Venetiis cum privilegio. Excellentiss. Senatus*'
Lent by The Metropolitan Museum of Art, New York
Gift of J. G. Phillips, 1947 (inv. 47.40)

In 1742 Pitteri requested the privilege to publish a series of fifteen etchings after drawings by Piazzetta. These were probably the etchings of the heads of the twelve Apostles, Christ, God the Father and the Virgin Mary (Gallo, 1941). As the etchings of the Apostles are inscribed '*pinxit*', it has been assumed that Piazzetta's originals were paintings or oil sketches. However, there is what may be a preparatory drawing for this Saint (Sandro Vitali coll., Mariano Comense). This is one of Pitteri's most celebrated series of etchings and was admired by Fragonard, who in 1774 saw them in a print shop in Venice. In the series Pitteri perfected his development of an engraving style to convey the soft light and crumbly line of Piazzetta's chalk drawings. This was achieved by using broken lines of engraved dashes and flicks. It has been suggested that St Thaddeus is Piazzetta's self-portrait (see Binion's essay, p. 149); a similar head appears on the left of the *Assumption of the Virgin* (ex- Monastery of Konigsaal, now Zbraslav near Prague).                     O.T.

*Bibliography:* Gallo, 1941; Mariuz, 1982, no. 180; Knox, in Washington, 1983, no. 56; Venice, 1983[1], no. 78; Venice, 1983[3], no. 101

GIAMBATTISTA PIAZZETTA
*St James Led to Martyrdom*
c. 1722–3
oil on canvas, 165 × 138 cm
S. Stae, Venice

This painting belongs to a series of twelve (cat. 8, 94) originally decorating the columns of the central nave of S. Stae, which were later moved to the walls of the choir (Zanetti, 1771). The scenes from the lives of the Apostles were taken from the *Golden Legend* by Jacopo da Voragine. The series was commissioned by Andrea Stazio for his parish church in a codicil of his will, dated 10 April 1722 (Moretti, 1973). It seems therefore reasonable to suppose that the Apostles were painted c. 1722–3. Piazzetta's *St James* is one of the landmarks in his artistic development, characterised by a composition dominated by the contrasting forces of the figures of the Saint and the executioner, which form a powerful and dramatic group. Ruggeri suggested (1983) that St. James derives from Charon in Crespi's *Aeneas and the Sibyl* (Kunsthistorisches Museum, Vienna), but Binion (p. 169, n. 28) reckons the executioner is taken from Guercino's *Capture of Christ* (Fitzwilliam, Cambridge). The executioner recalls the kneeling servant in Solimena's *Rebecca and Eliezer* formerly in the Baglioni collection (Accademia, Venice).     M.G.

*Exhibitions:* Florence, 1922, no. 759; Paris, 1960–1, no. 350; Venice, 1969, no. 53; Venice, 1983, no. 15
*Bibliography:* Zanetti, 1733, p. 439; Cochin, 1758, III, p. 122; D'Argenville, 1762, p. 320; Albrizzi, 1765, p. 265; Zanetti, 1771, p. 461; Moschini, 1815, p. 144; Ravà, 1921, p. 10; Pallucchini, 1934, p. 22; *idem*, 1942, I, p. 7; *idem*, 1956, pp. 12–13; *idem*, 1971, p. 175; Moretti, 1973, pp. 319–21; Jones, 1981[2], pp. 202–10, no. 68; Mariuz, 1982, no. 33; Knox, 1992, pp. 96–8, pl. 76

GIAMBATTISTA PIAZZETTA
*Virgin and Child Appearing to St Philip Neri*
1725-6
oil on canvas, 367 × 200 cm
S. Maria della Fava, Venice

The church, nicknamed the Fava, is dedicated to S. Maria della Consolazione and St Philip Neri, and in the 18th century was the centre for the Oratorians' congregation in Venice. A new church was begun in 1705, to the design of Antonio Gaspari, and was completed in 1753 under Giorgio Massari. A first payment was made to Piazzetta on 30 January 1725, probably for the *modello* of the altarpiece, with the final one made on 30 December 1727 (Rava, 1921).

Piazzetta, however, completed his work for the Oratorians by the end of 1726, having received a payment for the Fava altarpiece on 24 December of that year (Mariuz, 1982).

The Virgin presents the Child to the kneeling St Philip Neri, founder of the Oratorians, with a proud and solemn gesture, while her floating cloak, borne by two cherubs, gives her the attribute of the Virgin of Mercy (Jones, 1981). The lily, the bishop's mitre and the two cardinal's hats, with the skull, in the lower-left corner are symbols of the wordly honours rejected by the Saint. The dynamic composition is held together by a masterful synthesis of light and colour.                                    M.G.

*Exhibitions:* Paris, 1960–1, no. 351; Venice, 1969, no. 54; Venice, 1983, no. 23
*Bibliography:* Zanetti, 1733, p. 189; Cochin, 1758, III, p. 38; D'Argenville, 1762, p. 319; Zanetti, 1771, p. 458; Moschini, 1815, p. 218; Ravà, 1921, p. 52; Fiocco, 1921, p. 108; *idem*, 1927, p. 158; Pallucchini, 1934, pp. 22–5; *idem*, 1942, p. 10; *idem*, 1956, pp. 18–20; *idem*, 1968, p. 119; Jones, 1981[2], pp. 179–83, no. 61; Mariuz, 1982, no. 42

## 73

GIAMBATTISTA PIAZZETTA
*Virgin and Child Appearing to St Philip Neri*
1724–5
oil on canvas, 112 × 63.5 cm
National Gallery of Art, Washington
Samuel H. Kress Collection, 1961.9.82

This painting is the *modello* for the Fava altarpiece (cat. 72), and is characterised by a subtle interplay of warm colours, imbued with light. In composition it is very close to the final version. A smaller canvas (Residenzgalerie, Salzburg) is considered by Mariuz (1982, no. 44) to be a '*ricordo*' of the altarpiece, commissioned by some private collector or intended for private devotion.                M.G.

*Provenance:* private collection, Rome; Loewi collection, Los Angeles; Kress collection; 1956, donated to the National Gallery of Art
*Exhibition:* Rome, 1941, no. 10
*Bibliography:* Pallucchini, 1942, pp. 59–60; *idem*, 1956, p. 20; Mariuz, 1982, no. 43; Knox, 1992, p. 102, pl. 80

GIAMBATTISTA PIAZZETTA
*Guardian Angel with St Antony of Padua and St Gaetano Thiene*
1727–30
oil on canvas, 250 × 112 cm
S. Vidal, Venice

The altarpiece represents the Guardian Angel with St Antony of Padua and St. Gaetano Thiene (Moretti, 1985). It is first mentioned by Zanetti (1733), and belongs to a series of canvases commissioned for the altars of the church from different Venetian artists, among them Sebastiano Ricci and Gianantonio Pellegrini. Piazzetta's altarpiece, recently cleaned, is placed to the right of the high altar, matching Ricci's *Virgin Immaculate* on the left (Daniels, 1976, no. 501). It is close in style to the Fava altarpiece (cat. 72) and the ceiling painting of the *Glory of St Dominic* in the Venetian church of SS. Giovanni e Paolo (Mariuz, 1982, no. 37).

A preliminary sketch for the composition is in a private collection, Switzerland (Venice, 1983, no. 28 and Washington, 1983, no. 5), while a small red-chalk study for the figure of the two saints is in the Correr Museum, Venice (Venice, 1983, no.29), and a fine sheet with the head of the Guardian Angel is in the Musée du Midi, Marseille (Washington, 1983, no. 16).      M.G.

*Exhibitions:* Venice, 1929, no. 1; Venice, 1969, no. 57; Venice, 1983, no. 24
*Bibliography:* Zanetti, 1733, p. 171; Cochin, 1758, III, p. 34; Moschini, 1815, p. 597; Fogolari, 1907, pp. 24–5; Fiocco, 1921, p. 108; Ravà, 1921, p. 17; Pallucchini, 1934, pp. 28, 40, 97; *idem*, 1942, I, p. 13; *idem*, 1956, p. 24; Pignatti, 1957, p. 396–403; Jones, 1981[2], pp. 170–8; Mariuz, 1982, no. 48; Moretti, 1984–5, p. 385; Knox, 1992, pp. 120–1, pl. 92

## 75

GIAMBATTISTA PIAZZETTA
*The Ecstasy of St Francis*
1729
oil on canvas, 379 × 188 cm
Pincoteca Museo Civico di Palazzo Chiericati, Vicenza

The painting was originally on the left altar of the church of the Aracoeli, Vicenza, belonging to the Franciscan Order of the Poor Clares. It was opposite Giambattista Tiepolo's *Immaculate Conception* on the right altar (cat. 102). Mariuz (1982) found a manuscript note in a copy of the 1779 *Descrizione della Architetture, pitture e scolture di Vicenza* in the Cini Foundation, Venice, which states that the work '*fu dipinta l'anno 1729*' ('was painted in the year 1729'). The altarpiece's iconography, based on Piazzetta's reading of the literary sources on St Francis, has been discussed by Jones (1981), who points out that Piazzetta combined themes of both the ecstasy and stigmatisation of St Francis, choosing the moment when the Saint swooned after receiving the stigmata from the crucified Christ. The artist achieves here superb dramatic tension, culminating in the central cross formed by the vigorous arm of the angel and the languid arm of the swooning Saint.                    M.G.

*Provenance:* Church of the Aracoeli, Vicenza; 1927, acquired by the Comune for the Museo Civico
*Exhibitions:* Venice, 1983, no. 26; Vicenza, 1990, no. 2.14
*Bibliography:* Cochin, 1758, III, p. 176; D'Argenville, 1762, p. 320; Vendramini, 1779, I, p. 3; Fiocco, 1921, p. 108; Ravà, 1921, p. 17; Pallucchini, 1934, pp. 29–30; *idem*, 1942, I, p. 14; *idem*, 1956, pp. 26–7; Barbieri, 1962, pp. 181–4; Ruggeri, 1979, pp. 79–80; Jones, 1981[2], pp. 218–22, no. 72; Ballarin, 1982, p. 173; Mariuz, 1982, no. 49; Knox, 1992, pp. 121–9, pl. 96

## 76

GIAMBATTISTA PIAZZETTA
*'L'Indovina' ('The Fortune-teller')*
1740
oil on canvas, 154 × 114 cm
Gallerie dell'Accademia, Venice

An 18th-century inscription on the back of the painting reads: 'Sepulchral inscription of the famous painter Piazzetta, author of this picture, done in Venice in 1740, paid fifteen *zecchini* . . .' (Moschini Marconi, 1970, p. 76). While the price seems very low for such a picture, the date has been generally accepted. As for the subject, the traditional title, *The Fortune-teller*, does not correspond to the actual scene, as the young woman in profile is not offering her hand to be read, but is trying to catch the attention of the little dog held by the fair-haired woman in the centre, who is looking teasingly out from the picture. Maxwell White and Sewter (1960) interpret it as an allegorical scene in which Venice, personified by the central figure, is a harlot, symbolising 'the tenor of contemporary Venetian life'. Their hypothesis is not accepted by most later critics, who read the picture as a genre scene inspired by Dutch 17th-century imagery of mercenary love (Jones, Mariuz). The rustic theme, however, is interpreted by Piazzetta in a typically Rococo mood, synthesised by the gracious and sensual attitude of the so-called fortune-teller, with her perky straw hat. In this work the artist uses colour to build up the figures, achieving extraordinary plasticity by applying a varied and subtle tonal range to the canvas.                            M.G.

*Provenance:* Eherenfreund, 1887
*Exhibitions:* Florence, 1922, no. 742; Paris, 1960–1, no. 354; Venice, 1969, no. 61; Venice, 1983, no. 35
*Bibliography:* Botti, 1891, p. 272; Ravà, 1921, p. 30, 43, 60; Pallucchini, 1934, pp. 13, 39, 49, 69, 97; *idem*, 1942, p. 17; *idem*, 1956, pp. 33–4; Maxwell White and Sewter, 1960, pp. 125–38; Pallucchini, 1968, pp. 112, 118; Moschini Marconi, 1970, no. 164, p. 76; Jones, 1981[2], pp. 196–7; Mariuz, 1982, no. 95; Knox, 1992, pp. 186–7, pl. 133

## 77

GIAMBATTISTA PIAZZETTA
*Oeuvres de messire Jacques Benigne Bossuet . . .*
published in Venice by G. B. Albrizzi, 1736–58
10 volumes, quarto
28 × 44 cm (open book)
Mr H. D. Lyon, London

Volume IV of Bossuet's *Oeuvres* is open to show four plates designed by Piazzetta, *Rider in a Landscape*, *Shepherd with Elegantly Dressed Young Women*, *Three Putti with a Rabbit* and *Horseman with Two Shepherdesses*. The ten volumes of Bossuet's *Oeuvres* were published in the original French in Venice between 1736 and 1758 by Count Giambattista Albrizzi (1698–1777), one the most important and enlightened publishers in 18th-century Venice; well-known engravers such as Pitteri, Orsolini and Cattini worked for him. Albrizzi was also a collector, he had travelled extensively and corresponded with cognoscenti throughout Europe. One of the main functions of the publisher was to act as a go-between the artist and the engraver, so that the end product would have reflected Albrizzi's personal taste. This was the first of Albrizzi's publications to contain illustrations by Piazzetta, and began a business partnership, as well as a close friendship, that was to last until the artist's death in 1754. It is one of Albrizzi masterpieces, comparable to the celebrated *Gerusalemme Liberata* (cat. 80, 83), on which Piazzetta also collaborated. It was the first time that the complete works of Jacques Benigne Bossuet (1627–1704), Bishop of Meaux and preacher to the court of Louis XIV, had been published. Bossuet believed in the direct relationship between God and King, without the need of the mediation of the Church; the revival of interest in Bossuet's work was a reaction to the increasing spread of heretical opinions in Europe. Initially the publication was to be dedicated to Pope Clement XII, but his portrait was never printed and instead each volume was dedicated to a female member of the Austrian royal family; the second volume, published in 1738, was dedicated to Queen Amalia. Some of Piazzetta's drawings seem to have played a role in simplifying and clarifying the author's doctrine; but his pastoral and secular decorations, such as those shown here, served as an antidote to the serious content of the work. It was remarkable that a controversial work could be published in Venice, but the city had the reputation for having more freedom in publishing than most European cities at that time, and Albrizzi was keen to cater for a wider, international audience.

O.T.

*Bibliography:* Morazzoni, 1943, p. 218; Maxwell White and Sewter, 1961, pp. 15–31; Maxwell White and Sewter, 1969, no. 76; Haskell, 1980, pp. 334–6; Knox, 1983, pp. 63–5; Venice 1983[1], no. 67b; Sciolla, in Venice and Gorizia, 1989

## 78

GIAMBATTISTA PIAZZETTA
*Idyll on the Beach*
1745
oil on canvas, 196.5 × 146 cm
Wallraf-Richartz-Museum, Cologne

This picture, the pendant of cat. 79, also belonged to Marshal Schulenburg. It was painted a few years later than cat. 79, and Piazzetta received the final instalment of a total of 110 *zecchini* for this work on 30 April 1745 (Binion, 1970). The traditional title *Idyll on the Beach*, first given by Bombe (1918), has not been accepted by later critics, who thought the scene more likely to be taking place on the banks of the River Brenta (Pallucchini, 1968) and proposed to change it to *Country Walk*. Like its pendant, the subject can be given various interpretations. Maxwell White and Sewter (1959) saw in the scene the contrast between different social classes, represented by the peasant boy in the foreground, who points contemptuously to the two aristocratic ladies behind him. Jones (1981), on the other hand, interpreted it as an erotic genre scene inspired by 17th-century Dutch imagery, and proposes that the presence of the head of a cow on the right, from an engraving by Schelte a Bolswert based on a painting by Jordaens (Maxwell White and Sewter, 1969, p. 23) indicates that the two women are prostitutes. Other critics (Pallucchini, Haskell, Mariuz, Ruggeri, Knox) agree on a simple reading of the scene as a realistic episode of rural life that would have appealed to Marshal Schulenburg, who owned a large number of genre pictures by Italian, Dutch and Flemish masters.

Like cat. 79, the present painting is related to Piazzetta's work for the publisher Albrizzi. The figure of the woman with the parasol, reminiscent of Watteau, appears in a drawing in the Biblioteca Reale, Turin (Mariuz, 1982, no.

D66) which was engraved as a head-piece in vol. IV of Bossuet's *Oeuvres* (1738, p. 113), and also in the *Antichità di Aquileia* (1739, p. 417) and in the booklet for the Pisani–Sagredo wedding (1741) (Maxwell White and Sewter, 1969, p. 20). The standing woman, in profile, derives, according to Maxwell White and Sewter (1969, p. 23) from Rubens's *Henry IV Leaving for War* in the Louvre and appears in other works by Piazzetta. Finally, the boy in the foreground who points to the main scene behind him (Klesse, 1972), returns, with the same role of detached observer, in a lost picture by Piazzetta, engraved by Berardi (Mariuz, no. 100). A fine study for his head is in the Fogg Art Museum, Cambridge, MA (Mariuz, no. 97b; Washington, 1983, no. 19). It has been suggested that it portrays the artist's son Giacomo at the age of twenty.

M.G.

*Provenance:* Marshal von der Schulenburg; 1775, Christie's sale, London; Richard von Schnitzler collection, Cologne; 1949, Wallraf-Richartz-Museum
*Bibliography:* Bombe, 1918, p. 39; Förster, 1930, p. 450; Fiocco, in Thieme-Becker, 1932, p. 569; Pallucchini, 1934, p. 43; *idem*, 1942, I, p. 18; *idem*, 1956, p. 36; Levey, 1958, p. 221; Maxwell White and Sewter, 1959, pp. 96–100; Pallucchini, 1968, p. 116; Klesse, 1972, pp. 230–3; *idem*, 1973, pp. 94–5; Haskell, 1981 ed., p. 314; Jones, 1981[2], p. 45, no. 74; Mariuz, 1982, no. 97; Ruggeri, in Venice, 1983[1], no. 36, pp. 102–3; Knox, 1992, pp. 186, 191–2, pl. 135

GIAMBATTISTA PIAZZETTA
*Pastoral Scene*
1740
oil on canvas, 191.8 × 143 cm
The Art Institute of Chicago
Charles H. and Mary F.S. Worcester Collection
(inv. 1937.68)

This painting, with the so-called *Idyll on the Beach* (cat. 78), was owned by Marshal Schulenburg, a great patron of Piazzetta and collector of his work, who in 1740 paid him 110 *zecchini* in three instalments for the present work (Binion, 1970). It belongs to a group of pastoral scenes painted by Piazzetta *c.* 1738–45 that are related to the drawings of bucolic subjects provided by the artist to his friend the publisher Albrizzi for his book illustrations (cat. 80, 83). The iconography of these works has always puzzled scholars, who have put forward a wide variety of interpretations. Among them Maxwell White and Sewter (1961) suggested a complex allegory referring to the *Oeuvres de Bossuet*, one of Albrizzi's publications (cat. 77), while Jones (1981) reads the scene as an allegory of sexual desire and pursuit (the dog and the duck) being thwarted by the power of Bacchus (the boy with the basket of grapes). Mariuz (1982) and Knox (1992), on the other hand, see the painting as a rural genre scene that Piazzetta, inspired by his book illustrations, rendered on a new monumental scale. A preparatory drawing for the youth resting his chin in both hands is in the Staedel Institute in Frankfurt (Washington, 1983, fig. 13), while a study for the head of the boy on the extreme right is in the Museo Civico del Castello Sforzesco, Milan (Venice, 1983, no. 36; Washington, 1983, fig. 12).          MG

*Provenance:* Marshal von der Schulenburg; 1775, Christie's sale, London; 1917, 17th-Century Gallery, London; 1935 G. H. Winterbotham, London, G. Bode; M.D. Koetser, London; 1936 J. Heimann, Milan, 1937 Paul Drey, New York; acquired by Charles and Mary F. S. Worcester for the Art Institute of Chicago
*Exhibitions:* London, 1935, no. 104; New York, 1938, no. 10; San Francisco, 1938, no. 10; Toledo (Ohio), 1940, no. 40; Venice, 1969, no. 62; Chicago, Minneapolis and Toledo, 1970, no. 33
*Bibliography:* Borenius, 1917, p. 15; Ravà, 1921, p. 61; Pallucchini, 1936, pp. 250–1; *Bull. Art Institute, Chicago,* 1937, pp. 97–100; Chicago, 1938, no. 22; Pallucchini, 1942, pp. 17, 18; *idem,* 1956, pp. 33, 34, 61; Levey, 1958, p. 221; Maxwell White and Sewter, 1961, pp. 17–30; Pallucchini, 1968, pp. 116–9; Binion, 1970, p. 302; Jones, 1981[2], pp. 41–3; Mariuz, 1982, no. 96; Knox, 1992, pp. 186, 190–1, pl. 134

GIAMBATTISTA PIAZZETTA
*Gerusalemme Liberata,* by Torquato Tasso
published in Venice by G. B. Albrizzi, 1745
etchings with some engraving folio, 51.5 × 77.5 cm (open book)
Austrian National Library, Vienna

The two illustrations are a Standing Nymph (the beginning of Canto XV), and the final tailpiece vignette with portraits of the publisher Albrizzi and the artist Piazzetta. One of the most beautiful 18th-century Venetian books, this edition of *Gerusalemme Liberata* was published by Count Giambattista Albrizzi in 1745. Already in 1740, Johann Gaspar Goethe, Goethe's father, had admired some of Piazzetta's preparatory drawings, as recorded in the *Italienische Reise* (Robison, 1974). In his prospectus for the work (Pierpont Morgan Library, New York) Albrizzi declared: 'I have endeavoured to distinguish my edition with the singularity and perfection of more than sixty plates, all of different designs, drawn by the celebrated painter Piazzetta, and incised in copper by the most talented engravers. This printing will satisfy not only the poets, but also the painters and the sculptors; and I expect that so many, and such fine ornaments may never be seen again in any book'. This is the dedication copy for Maria Theresa, Empress of Austria, whose portrait, at the beginning of volume I was engraved by L. Pollanzani. The volume exhibited is the publisher's sumptuous dedication copy presented to Maria Theresa, and carries her coat of arms on the binding. It is the only copy known in this exceptionally large format, with engraved borders printed on every page. There were two editions of this book, both dated 1745. The second edition, without dedication, contains a number of variations and in some cases some substantial alterations; it has sometimes been considered a counterfeit. The double portrait of the publisher and the artist in the final endpiece testifies to their friendship and to their pride in this very successful venture.          O.T.

*Provenance:* Maria Theresa of Austria; Osterriechische Nationalbibliothek, Vienna
*Bibliography:* Morazzoni, 1943, p. 256; Haskell, 1963, 57a; Maxwell White and Sewter, 1969; Robison, 1974, pp. 1–12; Knox, in Washington, 1983, no. 74–86; Radaelli, 1989; Venice, 1983; Venice, 1983, p. 147

GIAMBATTISTA PIAZZETTA
Drawings for *Gerusalemme Liberata*
1735–53
red crayon with traces of black, approx.
33.2 × 21.8 cm (size of drawing)
Biblioteca Reale, Turin (MS Varia 204)

After he had made the acquaintance of the publisher G. B. Albrizzi (1698–1777), with whom he collaborated regularly from 1736 onwards, Piazzetta's contribution to 18th-century Venetian illustrated book production was of crucial importance. The remarkable *Gerusalemme Liberata,* published by Albrizzi in two volumes in 1745, is generally considered to be the finest example of Venetian publishing of the century; Piazzetta provided a series of drawings, now mostly in two large albums in the Biblioteca Reale in Turin. These two albums, bound in red morocco, were probably assembled by Albrizzi over the years in no particular order. A third album, similarly bound, is now in the Pierpont Morgan Library in New York, and other loose sheets of drawings relating to the *Gerusalemme Liberata* are in the Hermitage in St Petersburg. Their exact chronology is difficult to determine. Knox (1983) has shown that all the material relating to Tasso's poem was produced under Piazzetta's direction, and that every single modification is attributable to him. The two volumes in Turin (MS Varia 204 and 205) contain over 200 exquisite drawings, many executed in red chalk over a fine black pencil line. The careful choice of figures, particularly in the twenty compositions designed by Piazzetta for the introductory illustrations to Tasso's twenty cantos, demonstrate the artist's perfect understanding of the poem. Although the edition was not published until 1745, the illustrations were ready a few years earlier, and Johann Caspar Goethe saw them in Venice in 1743 (Robison, 1974, note 3); this is the date that appears on the title page of Album 205 in Turin.

G.M.

*Provenance:* G. B. Albrizzi; in the collection of the Dukes of Savoy in the 18th century; 1832, Carlo Alberto di Savoia; Biblioteca Reale
*Exhibitions:* Venice, 1983, nos. 75–87; Turin, 1990, nos. 117–18
*Bibliography:* Maxwell White and Sewter, 1969, no. 201; Robison, 1974; Griseri, 1978, no. 72–73; Mariuz, 1982, no. D.71–82; Knox, in Venice, 1983[1], no. 75–87; Sciolla, in Turin, 1989, pp. 77–8; Bettagno, in Turin, 1990, nos. 117–18

**82**

GIAMBATTISTA PIAZZETTA
*Rime e Versi per l'ingresso di Luigi Pisani*
published in Venice by G. B. Albrizzi, 1753
etched title-plate, 306 × 450 mm (open book)
Houghton Library, Harvard University,
Cambridge MA

In 18th-century Venice there was a vast and
varied output of booklets, collections of essays
and occasional publications celebrating events
such as births marriages, religious investitures
and political promotions. Unlike books, these
publications were not governed by strict
censorship rules, although the Senate had the
right to halt their publication altogether. They
were usually commissioned by patricians, prelates
or corporations and were privately printed. This
volume celebrates the elevation of Luigi Pisani to
the status of Procuratore di S. Marco in 1753. It
contains celebratory verses illustrated by cheerful
compositions and elaborate frames; it is opened
to show the front binding and two pages
illustrated with examples of Piazzetta's
remarkable inventive skill. Haskell (1980, pp.
332–3) quotes a letter from Bettinelli describing
how bundles of booklets were sent to friends and
relations, like sweets and flowers, but that
nobody ever read the verses; however, no woman
would have felt properly married without an
edition of her own celebratory wedding verses.

O.T.

*Bibliography:* Morazzoni, 1943, pp. 77–104;
Haskell, 1980, pp. 332–4

**83**

GIAMBATTISTA PIAZZETTA
*Gerusalemme Liberata*, by Torquato Tasso
published in Venice by G. B. Albrizzi, 1745
folio, 46 × 67.5 × 25 cm (open book)
The British Library Board, London (inv.
76.K.7)

Showing are the full-page plate at the beginning
of Canto VII and the tail-piece of Canto VIII,
a vignette with sheep-shearing, for which
Piazzetta's original drawing is in Turin (cat.
81). The exotic Holy Land setting of
*Gerusalemme Liberata* gave Piazzetta scope for his
imagination, but for the tail-pieces he used
pastoral scenes. This volume of *Gerusalemme
Liberata*, the masterpiece of 18th-century Venetian
publishing, carries on the binding the coat of
arms of Consul Smith. The exceptional
standard of this publication is also reflected in
the list of its subscribers, which included some of
the foremost figures in the arts and politics of the
day. No less than 333 copies were sold through
subscription (Robison), which prompted
Albrizzi and Piazzetta to set to work almost
immediately on a second edition. The majority
of the plates had to be reworked, perhaps
because they had been printed to capacity; it has
also been suggested that the second edition may
be pirated. A number of preparatory drawings
by Piazzetta for the *Gerusalemme Liberata* survive
in an album (Pierpont Morgan Library, New
York), in the two volumes of Piazzetta's
drawings at the Biblioteca Reale in Turin and in
the Hermitage, St Petersburg.

O.T.

*Bibliography:* Morazzoni, 1943, p. 256; Maxwell
White and Sewter, 1969; Robison, 1974, pp. 1–
12; Knox, 1983, no. 74–86; Ossola, 1983;
Radaelli, 1989; Venice 1983; Venice, 1983, p.
147

**84**

GIAMBATTISTA PIAZZETTA
*Raccolta delle Antiche statue . . .*
published in Venice by G. B. Albrizzi, 1740–3
2 folio volumes, 54 × 78.5 cm (open book)
inscribed on the frontispiece: '*Giambattista
Piazzetta inv.et disegnat/Felicita Sartori sculpt*'
Wellesley College Library Special Collections
(inv. Durant Collection, F733AN8)

The *Raccolta delle Antiche Statue* was the joint
production of Zanetti the Elder and his
namesake and cousin Zanetti the Younger.
Work on the project began in 1725. It consists
of two volumes, published between 1740 and
1743, illustrating the Greek and Roman statues
from the Antisala in the Marciana Library and
from other public sites in Venice which had
been bequeathed by the Grimani family to the
city of Venice in the 16th century and are today
in the city's Archaeological Museum. The two
volumes contain 50 plates each, after drawings
by the Zanetti cousins; the engravings, by M.
Pitteri, G. Cattini, G. Faldoni, F. Sartori and
others – the best engravers in the Venetian
Republic – were supervised by Zanetti the
Younger. The frontispiece to the first volume,
*Minerva's Homage to Venice*, was engraved by
Felicita Sartori (*c.* 1715–60); the preparatory
drawing by Piazzetta (Pierpont Morgan Library,
New York) is in one of two albums in which
Zanetti collected the preparatory drawings for
this work. It has been suggested that the two
men behind the enthroned Venice are the
Zanetti cousins. The other plate by Piazzetta
was engraved by Marco Pitteri, it shows the
portrait of Christian IV of Denmark, to whom
the book was dedicated. The illustrations
throughout the volumes are very clear and
simplified and the text is framed by classicising
friezes. The book was subscribed to by some of
the most sophisticated cognoscenti of the time,
including Crozat, Mariette, the Duke of
Richmond, Lord Chesterfield and the Prince of
Liechtenstein. Both the subject-matter and the
simplified style anticipate the Neo-classical style
and appealed to its practitioners: this copy
belonged to John Flaxman. Lorenzetti claims
that the British Resident John Strange took the
copperplates with him when he left Venice for
London in 1789, and that an English edition of
the work was published.

O.T.

*Provenance:* John Flaxman
*Bibliography:* Lorenzetti, 1914; Morazzoni, 1943,
pp. 126–8, 262; Venice, 1979, I, p. 42; II, p.
63; Succi, in Venice and Gorizia, 1983, p. 353,
no. 454; Knox, in Washington, 1983, no.
69–70

GIAMBATTISTA PIAZZETTA
*Il Newtonianismo per le Dame, ovvero dialoghi sopra la luce e i colori*
by Francesco Algarotti
printed, possibly in Venice or Padua, by G. B. Pasquali, 1737 (title-page claims it was printed in Naples)
octavo volume, with plates engraved by Marco Pitteri, *c.* 22.5 × 32 cm (open book)
The British Library Board, London (inv. 1492. p. 12)

This is one of only two books with illustrations by Piazzetta published by the great Venetian publisher Giambattista Pasquali. The book, written by Count Francesco Algarotti, enjoyed considerable international success, was translated into English and French and went through several editions. The author simplified Isaac Newton's scientific theories of light and discussed the existence of mechanical laws governing the celestial bodies; the fact that it was first published anonymously and with the place of publication falsely given as Naples, whereas it was probably published in Venice or Padua, may have been a precautionary measures to avoid Venetian censorship in a city that still defended the belief in the divine nature of the celestial world. Pasquali would have been a willing publisher for such a controversial publication; a shrewd businessman, he was open to novel ideas and was a close friend of Carlo Lodoli (cat. 242) and Consul Smith. The frontispiece, designed by Piazzetta and etched by Pitteri, shows Algarotti instructing a lady, according to Ravà, a fair and attentive pupil from the Zenobio family. There is preparatory drawing by Piazzetta in red chalk over graphite, (Albertina, Venice). There is little-known reprint in which Pitteri's print is copied in reverse by the Venetian engraver Giuseppe Filosi (priv. coll., Venice; see Knox).    o.t.

*Bibliography:* Ravà, 1922, no. 280; Morazzoni, 1943, p. 212; Wallis and Wallis, 1973; Haskell, 1980, pp. 336-8; Knox, in Washington, 1983, nos. 66-7; Venice, 1983[1], pp. 58-62, no. 141

GIAMBATTISTA PIAZZETTA
*Beatae Marie Virginis Officium*
printed in Venice by G. B. Pasquali, 1740
small octavo, with two plates engraved by Marco Pitteri 13 × 18.5 cm (open book)
Arthur and Charlotte Vershbow

The images were a collaboration between Piazzetta and the engraver Pitteri. The text was actually engraved on metal plates by Angela Baroni instead of being printed with mobile characters, as was the norm. This considerable effort may have been dictated by aesthetic reasons. The book was commissioned by a merchant called Caime, whose complete name, nationality and place of residence are unknown, to celebrate his devotion to the Virgin Mary. The plates ended up in the Remondini workshop in 1759, who reissued, or perhaps copied, the book several times; in the 1761 Remondini catalogue six editions are listed. The two plates shown are the *Annunciation* (p. 78), and *Angel Musicians* (p. 266), both engraved by Marco Pitteri. No drawings by Piazzetta for these two compositions have come to light.   o.t.

*Bibliography:* Morazzoni, 1943, no. 215, pp. 115-7; Pallucchini, 1956, p. 194; Venice, 1983[1], no. 105; Succi, in Venice and Gorizia, 1983, p. 311; Knox, in Washington, 1983, no. 68-68a

GIAMBATTISTA PIAZZETTA
*A Flying Angel*
*c.* 1726
black chalk with traces of white on blue-grey paper, 55.5 × 42.7 cm
The Cleveland Museum of Art
Purchase from J. H. Wade Fund (inv. 38. 388)

This handsome drawing, the largest figure study in all Piazzetta's vast output of graphic work, belongs in the category of preparatory drawings for paintings. It is directly related to the angel supporting the titular saint in the *Apotheosis of St Dominic*, one of the frescoes in the cupola of the chapel of St Dominic in the church of SS. Giovanni e Paolo in Venice. The exceptional freshness of the drawing of the figure in motion, and the absence of variations in the painted version, suggest that this is a preparatory design for the fresco rather than a drawing made afterwards. The cupola was frescoed in 1727, when Piazzetta was paid for his work.   G.M.

*Provenance:* 1938, purchase from the J. H. Wade Fund
*Exhibitions:* Oberlin, 1951; Washington, 1983, no. 15
*Bibliography:* Francis, 1940, p. 109; Milliken, 1940, p. 87; Knox, in Washington, 1983, no. 15; Ruggeri, in Venice, 1983[1], p. 95

88

GIAMBATTISTA PIAZZETTA
*Boy in Polish Costume*
*c.* 1741
oil on canvas, 46.5 × 37 cm
Museum of Fine Arts, Springfield, MA
James Philip Gray Collection (inv. 34. 02)

While Pallucchini (1936) dated this picture to 1725-30, Mariuz, by comparison with other similar compositions like *Boy with Lemon* (Wadsworth Atheneum, Hartford) and *Girl with Doughnut* (private coll., USA; Mariuz, 1982, nos. 88, 89), suggested an execution in the mid-1730s. Binion, on the other hand, suggests the more likely date *c.* 1741 (p. 167). As Mariuz points out, this boy in exotic attire, portrayed with a subtle use of chiaroscuro, is a clear homage to Rembrandt, whose work was much admired by 18th-century Venetian connoisseurs (Binion, p. 167). Most critics described the boy as a sculptor because of the hammer he holds. Mariuz gave the work its present title, and Binion suggests that the boy might be holding a war hammer, similar to that held by the figure in Rembrandt's *Polish Rider* in the Frick Collection, New York.

In a red chalk study for the tailpiece to canto IX of Tasso's *Gerusalemme Liberata*, published by Albrizzi in 1745, a drummer-boy is wearing a

similar hat and has the same inclination of the head (Mariuz, no. D79). A drawing of a *Head of a Youth* (Ashmolean Museum, Oxford; Parker, 1972, no. 1034, pl. CCXXIV) seems to portray the same model, who appears also in other paintings by Piazzetta, including the *Idyll on the Beach* (1745; cat. 78), here a few years older, confirming therefore a date around 1741 for the present picture. It was much appreciated in Piazzetta's time, as shown by its various copies and versions executed by Domenico Maggiotto (Mariuz, 1982). M.G.

*Provenance:* Marquess of Breadalbane, Taymouth Castle; Frank Sabin, London; Arturo Grassi, Florence; Art Museum, Worcester
*Bibliography:* Pallucchini, 1936, pp. 188–9; Jones, 1981², p. 143; Mariuz, 1982, no. 85; Ruggeri, in Venice, 1983¹, p. 22

## 89

GIAMBATTISTA PIAZZETTA
*Studi di pittura Già dissegnati da Giovanni Battista Piazzetta et ora con l'intaglio di Marco Pittoni*
published in Venice by G. B. Albrizzi, 1760
quarto, oblong etching and engraving, 30 × 88.8 cm (open book)
Arthur and Charlotte Vershbow

This volume reproduces 24 drawings by Piazzetta, which are etched and engraved twice, once only in line by Bartolozzi, and again with stipple by Pitteri. Albrizzi commissioned Piazzetta to make the drawings for the book but by the time it was finally published, Piazzetta had been dead for six years. The preparatory drawings by Piazzetta for this work, together with others to a total of 201, are in an album (Pierpont Morgan Library, New York) that was offered for sale by Albrizzi for 200 *zecchini*, in his 1773 catalogue. *Studi di pittura* is a model-book in the tradition of earlier ones such as the one by G. Palma published by G. Franco at the beginning of the 17th century. It was used by students of the Venetian Academy until the 19th century (Fogolan, 1931), although Albrizzi aimed it also at art lovers; the volume contains a biography of Piazzetta written by Albrizzi. The openings shown are a self-portrait etched by Piazzetta, dated 1738, and an academic study of a *Male Nude Lying on a Banner* (pl. XVII). The self-portrait shows a young man and presumably was made several years earlier. Albrizzi describes it in the biography as being in the manner of Rembrandt. O.T.

*Exhibition:* Washington, 1983, nos. 97, 99
*Bibliography:* Pallucchini, 1956, p. 9; Venice, 1983¹, pp. 79–82, no. 159; Knox, in Washington, 1983, nos. 96–9; Succi, in Washington, 1983, no. 354

GIOVANNI BATTISTA PIRANESI
born Mojano di Mestre, Venice, 4 October 1720
died Rome, 9 November 1778

Draughtsman, etcher, antiquary and architect. The son of a stonemason and builder, he was first educated by his elder brother Angelo, a Carthusian monk with extensive knowledge of Roman history, and by his maternal uncle Matteo Lucchesi, an engineer in the waterworks magistrature and a neo-Palladian architect. Although there is no evidence that he trained with Ferdinando Bibiena, that master's influence was one of the driving forces behind Piranesi's inventions. In 1740 he went to Rome, perhaps as draughtsman to the household of the Venetian Ambassador, Francesco Venier; in Rome he studied perspective with D. and G. Valeriani, and etching with G. Vasi. His study of Roman ruins prompted him, in 1742–3, to etch plates for his *Prima Parte di Architetture, e Prospettive*. The aim of this publication, as he stated in the dedication, was to improve contemporary architecture through study of the architecture of the past. Piranesi seems to have visited Naples, and returned to Venice twice (1744 and 1745–7) before settling permanently in Rome in 1747. During his time in Venice he absorbed current Venetian stylistic modes which influenced his early drawings (cat. 266–8) and the four etchings of *Grotteschi* (cat. 269–72), all made on his return to Rome. The address on the *Grotteschi* shows that Piranesi was acting as publisher of his own prints, and continued to do so, except from around 1749 to 1761 when the bookseller Giovanni Bouchard acted as his publisher. After a somewhat difficult beginning when he had to sell his etched copper-plates for *Varie Vedute di Roma...*, he always retained the ownership of his plates, thus maintaining total control over their printing. In 1750 Bouchard published *Opere Varie di Architettura, Prospettiva...*, which testify to Piranesi's growing fame; an extended version of this work, retitled *Le Magnificenze di Roma*, was published a year later. The four volumes of *Le Antichità Romane*, published in 1756, brought him international fame. He cultivated the friendship of British architects travelling to Italy, including William Chambers and Robert Adam, and in 1757 was elected to the Society of Antiquaries in London; four years later he became a member of the Accademia di S. Luca in Rome. Through his antiquarian works, such as *Della Magnificenza ed Architettura dei Romani* (1761), Piranesi promoted the merits of ancient Roman architecture at a time when ancient Greek architecture was much in vogue. He made only one, not very successful, attempt to practice architecture in a new style, designing S. Maria del Priorato, Rome (1764–6). Piranesi's *Vedute di Roma*, 135 views of Roman churches, squares and palaces, were etched over 30 years. The *Vedute*, sold usually in groups or in albums, have a freer and more painterly approach to etching in comparison to his pre-

decessors, and display to the full his unique feeling for architecture and archaeology. Perhaps his most impressive work, with great appeal to successive generations of romantics, was the set of *Carceri*, or prisons, first issued in 1749–50 with fourteen plates, and reissued in 1761, with the addition of two plates. The earlier issue is in the tradition of architectural fantasies in the form of stage-design; the later reworking of the plates dramatised these ambiguous compositions. He also published on furniture and on the decorative arts, for example *Diverse Maniere d'adornare i Camini*, 1769, which includes a number of plates in the Egyptian taste, and *Vasi, Candelabri...* collected in 1778. His son Francesco was involved in his last work, *Differentes vues... de Pesto*, 1778. O.T.

## 261

GIOVANNI BATTISTA PIRANESI
*Masked Figures at a Punch and Judy Show*
1743–7
pen and brown ink and wash, 25.8 × 18.3 cm
Hamburger Kunsthalle (inv. 1915/638)

This is one of several striking drawings of similar style and measurements that are generally thought to have been made in Venice *c.* 1747, shortly before Piranesi settled for good in Rome. The other four are dispersed between the Ashmolean Museum, Oxford, a private collection in Munich, and the Pierpont Morgan Library, New York. The choice of subject may have been influenced by contemporary Venetian artists, in particular Pietro Longhi, and possibly Zompini. O.T.

*Bibliography:* Venice, 1978³, 1978, no. 15; Brussels, 1983, no. 133

GIOVANNI BATTISTA PIRANESI
*Arcaded Portico Seen from an Angle*
c. 1740–3
pen and brown ink and brown wash over black
chalk, 13.5 × 20.9 cm
The Trustees of the British Museum, London

GIOVANNI BATTISTA PIRANESI
*A Grand Colonnaded Hall*
1740–3
pen and brown ink with grey wash over black
chalk, 13.5 × 20.6 cm
inscribed twice by the artist: '*chiaro*'
The Trustees of the British Museum, London
(1908–6–16–28)

These two early drawings, made either in Venice
or, more probably, soon after Piranesi first
arrived in Rome, have been connected to his first
published work, *Prima Parte di Architetture, e
Prospettive* of 1743 (Robison, 1977, 1986). They
both show the artist's interest in stage-design as
well as Palladian architecture, and his
increasingly bold treatment of architectural
drawing. *A Grand Colonnaded Hall*, preparatory
for the etching *Vestibolo d'antico tempio* (Robison,
no. 11), is based on the interior of Palladio's
church of the Redentore in Venice. The curtain
on the ceiling indicates that it was conceived
initially as a stage design. In the etching Piranesi
altered the background, breaking it into a series
of halls. The *Arcaded Portico Seen from an Angle*
(cat. 262) is even more indebted to the influence
of Bibiena's published works, in particular
*Direzioni a' Giovani Studenti nel Disegno
dell'Architettura Civile*, published first in Bologna
in 1731–2. Piranesi's drawing closely recalls
Bibiena's plate 48 from the *Direzioni . . .* in
details such as the statues over the balustrade, but
especially in the low viewpoint, commonly used
in stage-design.                                      O.T.

*Bibliography:* Robison, 1974, pp. 395–6; *idem*,
1986, pp. 13–14

GIOVANNI BATTISTA PIRANESI
*A Magnificent Bridge*
1743
etching, 74.5 × 50 cm (open book)
National Gallery of Art, Washington
Andrew W. Mellon Fund, 1978.3.1

*Prima parte di Architetture, e Prospettive* (1743) was
Piranesi's first published work. *Ponte Magnifico* is
plate 8 of the series; its design is ultimately
derived from Palladio's project for the Rialto
Bridge in Venice (see fig. 47), included in Book
III, chapter XIII of his *Quattro Libri dell'
Architettura*, published in 1570. Piranesi's
interpretation also recalls stage-designs and the
work of Bibiena. This was one of Piranesi's
most influential etchings, and the view through
the arch was almost immediately copied by
Canaletto in his drawn *View of London through
Westminster Bridge* (see cat. 146), establishing a
format that was used by a number of later artists,
including Paul Sandby in his *Bridge of
Magnificence* of 1781. This impression comes from
a unique copy of the third issue of the first
edition, and is the second state of five. The
binding is contemporary.                           O.T.

*Provenance:* Auvermann & Reiss, Glashutten im
Taunus
*Bibliography:* Focillon, 1918, no. 7; Robison,
1986, no. 6

GIOVANNI BATTISTA PIRANESI
*A Rococo Wall-frame*
1745–7
pen and brown ink, grey-brown wash, over
black chalk, 32.5 × 37.4 cm
The Pierpont Morgan Library, New York
Bequest of the late Junius Morgan and gift of
Henry S. Morgan, acc. no. 1966.11:12

This, and other similar drawings, have been
taken as evidence that Piranesi, on his return to
Venice in the mid-1740s, tried to obtain
commissions for architecture and interior design
from the Venetian aristocracy. The frame would
have been executed in stucco and probably
gilded, as part of a larger Rococo decorative
scheme. Francesco Guardi made similar designs
(see cat. 206).                                      O.T.

*Bibliography:* Stampfle, 1948, p. 124; Thomas,
1954, pp. 16–17, 41; New York, 1971, p. 93,
no. 219; London, 1978², p. 14, no. 10; Robison,
1986, p. 10

GIOVANNI BATTISTA PIRANESI
*A Festival Gondola*
1745–7
pen and brown ink, wash over black chalk,
29.6 × 68.3 cm
The Pierpont Morgan Library, New York
Bequest of the late Junius Morgan and gift of
Henry S. Morgan, acc. no. 1966.11:10

This is the finest of the surviving drawings made
by Piranesi while in Venice. The *bissona*, the
elaborate ceremonial gondola used in water-
festivals, was also drawn by other artists,
including G. B. Tiepolo (fig. 4) and Francesco
Guardi (cat. 207). In this drawing Piranesi
succeeded in orchestrating various decorative
motifs, including swags of flowers and nude
figures, where 'each echoes or balances another
with the exquisite precision of a Mozart quartet'
(Thomas, p. 15). A few years later Piranesi
transformed the Venetian festival *bissona* into the
carriage placed at the centre of his earliest view of
St Peter's Square in Rome (cat. 273; see
Robison, 1973).                                      O.T.

*Bibliography:* Stampfle, 1948, pp. 123–4, 129;
Thomas, 1954, pp. 16–17, 41; New York,
1971, p. 92, no. 219; Robison, 1973, pp. 389–
92; London, 1978², p. 14, no. 11; Robison
1986, p. 10

GIOVANNI BATTISTA PIRANESI
*Design for a Title-plate, with a Rococo Pulpit*
1745–7
pen and brown ink, wash and red chalk,
50.8 × 75 cm
The Pierpont Morgan Library, New York
Bequest of the late Junius Morgan and gift of
Henry S. Morgan, acc. no. 1966.11:8

This is another of the drawings on Venetian
paper in a Venetian Rococo style (see also cat.
265, 268) dating from Piranesi's second sojourn
in Venice in the mid-1740s. The *Design for a
Title-plate* includes motifs such as the *trompe-l'œil*
scrolled sheet and the tablet, which were later
reused by Piranesi in other works. Because only
the pulpit is pricked for transfer, Stampfle
proposed that Piranesi intended the two
compositions to be considered separately.
According to Robison (1986, p. 27), the pulpit
and the plan are later additions by Piranesi to a
finished drawing. The influence of Tiepolo's
fluid style is particularly evident in this drawing.
Although the exact relationship between Piranesi
and Tiepolo is still unresolved, Piranesi's broad
sweeps of wash seem to derive directly from
Tiepolo's drawing style.                             O.T.

*Bibliography:* Stampfle, 1948, pp. 123–4; New York, 1971, p. 92, no. 221; London, 1978², p. 13, no. 9; Robison, 1986, p. 10

268

GIOVANNI BATTISTA PIRANESI
*Capriccio*
*c.* 1747
pen and brown ink with brown wash over black chalk, 36.8 × 51.2 cm
The Pierpont Morgan Library, New York
Bequest of the late Junius Morgan and gift of Henry S. Morgan (acc. no. 1966:11:9)

This is another of Piranesi's drawings from the Pierpont Morgan Library, probably made during the end of Piranesi's stay in Venice. Although still showing the influence of Tiepolo and of contemporary Venetian art, it typifies Piranesi's keen interest in conveying the spirit of decaying antique ruins, which he was developing at the time. The composition, crowded with architectural structures and parts of columns, covered with foliage and clouds of smoke, is worked over with wash; less blank paper is left to show through, conveying the effect of light, as he had done in a group of drawings included here (cat. 265–7) that are more Venetian in spirit. This evocative composition has been connected (Robison, p. 31) to Piranesi's early fantasies, to the set of *capricci* etched around the same time, in particular the *Grottesco with Skeletons* (cat. 270).      O.T.

*Bibliography:* Robison, 1986, p. 31

269

GIOVANNI BATTISTA PIRANESI
*Grottesco with a Monumental Tablet*
1747–9
etching, engraving, drypoint and scratching, 39.6 × 54.7 cm
National Gallery of Art, Washington
Ailsa Mellon Bruce Fund, 1986.8.2

The set of four etchings called *Grotteschi* is usually considered the most Venetian of Piranesi's works. Although the influence of Tiepolo's *Scherzi* (cat. 112) is evident, Robison (p. 27) has recognised the influence of other earlier printmakers, especially G. B. Castiglione and Salvator Rosa, in the subjects and their treatment. *Grottesco with a Monumental Tablet* has been connected to two designs for title- or inscription plates, both at the Pierpont Morgan Library, New York (see cat. 267). In this etching Piranesi further enhanced the spatial ambiguities of his composition by placing objects on a *trompe-l'œil* sheet of crumpled paper: it is not clear if we are looking at the objects, or at

drawings of them. This impression is from the only known complete set from the first edition, dated 1747–9 (Robison); originally it was stitched together with the other three plates of *Grotteschi*, indicating that the set was sold separately from other etchings by Piranesi. The set was published in six editions, between 1747 and *c.* 1940; there are four states of this plate, numbered 27, *c.* 1790. It is signed in the plate at lower-left margin.      O.T.

*Provenance:* Duke of Devonshire, Chatsworth House, Derbyshire; 5 December 1985, sold Christie's, London; David Tunick, New York
*Bibliography:* Focillon, 1918, no. 23; Hind, 1922, p. 80, no. 27; Robison, 1986, no. 24

270

GIOVANNI BATTISTA PIRANESI
*Grottesco with Skeletons*
1747–9
etching, engraving, drypoint and scratching, 39 × 54.6 cm
National Gallery of Art, Washington
Ailsa Mellon Bruce Fund, 1986.8.4

This etching is rich in recognisable works of art, such as the antique statue of the Farnese *Hercules* on the left, combined together and linked by Piranesi's extraordinary vision. There are five states of this plate, numbered 24, *c.* 1790. It is signed in the plate at lower-right margin. There is a related drawing (cat. 268) at the Pierpont Morgan Library, New York, and another drawing for the reclining skeleton at the Biblioteca Estense, Modena. (See also cat. 269, 271, 272.)      O.T.

*Provenance:* see cat. 269
*Bibliography:* Focillon, 1918, no. 20; Hind, 1922, p. 80, no. 24; Robison, 1986, no. 21

271

GIOVANNI BATTISTA PIRANESI
*Grottesco with the Tomb of Nero*
1747–9
etching, engraving, drypoint and scratching, 39.2 × 55.4 cm
National Gallery of Art, Washington
Ailsa Mellon Bruce Fund, 1986.8.3

In this etching the spatial ambiguities found in the other *Grotteschi* are less evident, but the whole composition appears to be floating on air, supported by smoke and foliage. The central monument is an existing Roman tomb, indicating that the preparatory drawing (National Gallery of Art, Washington) was done after Piranesi's return to Rome (Robison, 1977). The twisting snakes are reminiscent of

those in one of Tiepolo's *Scherzi* (cat. 112). This impression is from the only known complete set from the first edition of 1747–9 (see cat. 269). There are six states of this plate, numbered 26, *c.* 1790. It is signed in the plate at lower-left margin. (See also cat. 269, 270, 272.)      O.T.

*Provenance:* see cat. 269
*Bibliography:* Focillon, 1918, no. 22; Hind, 1922, p. 80, no. 26; Robison, 1977, pp. 387–93; *idem*, 1986, no. 23

272

GIOVANNI BATTISTA PIRANESI
*Grottesco with Triumphal Arch*
1747–9
etching, engraving, drypoint and scratching, 39 × 54.2 cm
National Gallery of Art, Washington
Ailsa Mellon Bruce Fund, 1986.8.1

The river-god at centre left, and the head of the herm are very similar to those in G. B. Tiepolo's *Scherzi* (cat. 112). In this etching Piranesi introduced a remarkably ambiguous treatment of time and of the human figure: while the river-god and the reclining figure opposite it are obviously meant to be sculptures, the group of men in the middle-ground, some in contemporary dress and hats, are real human beings examining the ruins (Robison, 1986). In Piranesi's mind the antique world was very much alive; he wrote in his dedication to the *Prima Parte* that the images of ancient Rome had filled his spirit with speaking ruins. There are five states of this plate, numbered 25, of *c.* 1790. It is signed in the plate at lower-left margin. (See also cat. 269, 270, 271.)      O.T.

*Provenance:* see cat. 269
*Bibliography:* Focillon, 1918, no. 21; Hind, 1922, p. 80, no. 25; Robison, 1986, pp. 30–1, no. 22

273

GIOVANNI BATTISTA PIRANESI
*Veduta di S. Pietro in Vaticano*
1747–8
etching, 39.7 × 53.2 cm
Lent by The Metropolitan Museum of Art,
New York
Harris Brisbane Dick Fund, 1937
(inv. 37.45.3.44)

Piranesi was engaged in making his 135 *Vedute
di Roma* throughout his career. The etchings were
issued singly or in groups during his lifetime; the
sequence and number of views in surviving sets
vary from one copy to another, suggesting that
these were compiled for each buyer individually.
The view of St Peter's Square is one of the
earliest; the acute perspective is more dramatic
than any earlier views made by his predecessors,
including his teacher Vasi, and has more in
common with Venetian views by his
contemporaries Canaletto and Marieschi.
Piranesi transformed his drawing of the Venetian
festival *bissona* (cat. 266) into the curious carriage
in the centre of the square (Robison, 1973). O.T.

*Bibliography:* Focillon, 1918, no. 787; Hind,
1922, no. 3; Robison, 1973, pp. 389–92;
London, 1978², pp. 36–7

274

GIOVANNI BATTISTA PIRANESI
*A Magnificent Port*
1749–50
red and black chalk, brown and reddish wash,
squared in black chalk, 38.5 × 52.8 cm
Collection of The J. Paul Getty Museum,
Malibu, CA

This and cat. 275 belong to a group of visionary
drawings dating from the late 1740s and early
1750s. Although based on a stage-design format,
Piranesi's drawings are exuberant inventions
based on ancient architecture. They are
exceptional in their scale, proportions, complex
compositions and novel use of pink-coloured
wash. They represent exterior and interior views
of multi-tiered architectural structures conceived
on a gigantic scale, populated with a vast
quantity of figures, sculpture and decorative
features. This drawing is related to an etching
entitled *Fantastic Port Monument* (Robison, no.
26). A Roman triumphal arch is enclosed in a
structure reminiscent of the Colosseum. The low
viewpoint and crowded architecture give a sense
of endless depth. O.T.

*Bibliography:* Robison, 1986, pp. 35–6

275

GIOVANNI BATTISTA PIRANESI
*Fantastic Monument in a Palatial Interior*
c. 1750
pen and brown ink and wash over red chalk,
30.5 × 38.1 cm
Private Collection
Gift promised to the National Gallery of Art,
Washington

Like cat. 274, this drawing represents Piranesi's
ultimate fantasy of ancient architecture. Elements
taken from interiors of Baroque Roman churches
such as St Peter's are set into a spiral of gigantic
structures, populated by tiny figures and
encrusted with sculpted decoration. The central
monument, a figure crowned by an angel on a
sphere, appears in two other drawings from the
same period, a simpler one in Boston, and a
larger and more complex composition in the
Louvre. This drawing has been connected to the
etching *Fantastic Port Monument* (Robison, no.
27), which was apparently never published and
is not known in any early impressions, and is
therefore difficult to date. The etched
copperplates for this composition were discovered
on the *verso* of two copperplates for the *Vedute di
Roma*, dated 1747–9; Piranesi might have been
dissatisfied with the etching and reused the plates
for his *Vedute*, incidentally providing a *terminus
ante quem* for *Fantastic Port Monument*. O.T.

*Bibliography:* Robison, 1986, pp. 33–4

276

GIOVANNI BATTISTA PIRANESI
*Fanciful Inventions of Prisons: The Round Tower*
1749–50
etching, engraving, sulphur tint or open bite,
burnishing, 55.6 × 41.8 cm
National Gallery of Art, Washington
W. G. Russell Allen, Ailsa Mellon Bruce,
Lessing J. Rosenwald, and Pepita Milmore
Funds, 1976.35.2

*Invenzioni Capric di Carceri all Acqua Forte*,
Piranesi's most original set of etchings, was first
published in Rome, in a set of fourteen plates in
1749–50. Perhaps his most impressive work, the
*Prisons* had great appeal to successive generations
of romantics. It followed the publication of
*Prima Parte* (cat. 263), and the set of *Grotteschi*
(cat. 269–72). This impression is a first state
from the first issue of the first edition. O.T.

*Provenance:* Philip Hofer; Ferdinando Salamon,
Milan; Armando Neerman
*Bibliography:* Focillon, 1918, no. 26; Hind, 1922,
no. 3; London, 1978², pp. 72–83; Wilton-Ely,
1978, pp. 81ff.; Robison, 1986, no. 30

277

GIOVANNI BATTISTA PIRANESI
*Fanciful Inventions of Prisons: The Pier with a Lamp*
1749–50
etching, engraving, sulphur tint or open bite,
burnishing, 41.5 × 55.8 cm
National Gallery of Art, Washington
W. G. Russell Allen, Ailsa Mellon Bruce,
Lessing J. Rosenwald, and Pepita Milmore
Funds, 1976.35.13

This plate is one of the most technically
accomplished of Piranesi's *Prisons*. He brushed
streaks of acid on the plate like multiple layers of
paint; in some areas he burnished out previously
etched lines, and strengthened other parts,
repeating the process several times to create the
highly charged atmospheric effect. His style and
technique having developed following the
slightly earlier *Grotteschi* (cat. 269–72), he
experimented with techniques to create painterly
effects of light and to demonstrate his great
facility in the etching medium. Parts of this
grand composition are reminiscent of *Gruppo di
Colonne* (Robison, no. 15) in *Prima Parte*. O.T.

*Provenance:* see cat. 276
*Bibliography:* Focillon, 1918, no. 38; Hind, 1922,
no. 15; London, 1978², pp. 72–83; Wilton-Ely,
1978, pp. 81ff.; Robison, 1986, no. 41

278

GIOVANNI BATTISTA PIRANESI
*Foundations of the Mausoleum of Hadrian*
1756
etching in *Antichità Romane*, 1756, vol. IV,
pl. IX
82.5 × 54 cm (open book)
National Gallery of Art, Washington
Mark J. Millard Architectural Collection,
1984.8.4

From the outset of his career Piranesi was
passionately involved in the archaeological study
of Roman antiquities. While in his *Vedute* he
recorded the famous sights of ancient and
modern Rome, and in his architectural fantasies
he tried to capture the spirit and grandeur of the
past, in his archaeological works he developed
techniques for conveying the physical qualities of
the structures, as well as space, mass and
volume. In the debate on the respective merits of
ancient Greek and Roman architecture, Piranesi
was the staunch champion of Rome. The four
volumes of the *Antichità Romane*, containing 250
plates, are a landmark in archaeological studies,
combining an advanced technique and a
profound knowledge of engineering and
architecture together with Piranesi's highly
original approach. In the preface Piranesi
declared that he was aiming at an audience of
architects as well as archaeologists. He realised

that a building is only understood fully by combining plans, sections, elevations and internal views (London, 1978, p. 47). The scope of his gigantic reconstruction of the foundations of Hadrian's Mausoleum have been seen as deriving from his training in Venice in the Magistratura delle Acque. As a result of this publication, which brought him international acclaim, and despite the controversy with James Caulfeild, 1st Earl of Charlemont, who had promised Piranesi his patronage for this work, he was elected Honorary Fellow of the Society of Antiquaries in London in 1757. This copy from an early issue contains the three printed 'Lettere di Giustificazione' bound in the first volume. It is bound in a contemporary decorative paper binding.                                                    O.T.

Bibliography: Focillon, 1918, p. 340; London, 1978², pp. 47–8

## 279

GIOVANNI BATTISTA PIRANESI
Prisons of Invention: The Gothic Arch
1761
etching, engraving, sulphur tint or open bite, burnishing, 41.7 × 55.6 cm
National Gallery of Art, Washington
Mark J. Millard Architectural Collection; acquired with assistance from The Morris and Gwendolyn Cafritz Foundation, 1983.118.15

There is a preparatory drawing (British Museum, London, 1908/6/16/8), and a number of related drawings (National Galleries of Scotland, Edinburgh, and Hamburger Kunsthalle).                                          O.T.

Provenance: see cat 280
Bibliography: Focillon, 1918, no. 37; Hind, 1922, no. 14; London, 1978², pp. 72–83; Wilton-Ely, 1978, pp. 81ff.; Robison, 1986, no. 40.

## 280

GIOVANNI BATTISTA PIRANESI
Prisons of Invention: The Drawbridge
1761
etching, engraving, scratching, 56.1 × 41.5 cm
National Gallery of Art, Washington
Mark J. Millard Architectural Collection; acquired with assistance from The Morris and Gwendolyn Cafritz Foundation, 1983.118.8

This plate and cat. 279, both from the rare first issue of the second edition, before the Roman numerals, show Piranesi's reworking of the set of the Carceri published in 1761, more than ten years after the first edition. By reworking Piranesi achieved darker, more detailed and sombre etchings. The change in mood in the Carceri is not, however, an isolated accident, for his work as a whole had been developing in that direction. The Drawbridge is one of the more radically changed plates, in which Piranesi burnished whole areas of the composition and re-drew them. In this plate, for example, he added another drawbridge at the centre of the composition. There is a related drawing (Hamburger Kunsthalle), although it was probably done after the etching.            O.T.

Provenance: John Ker, Duke of Roxburgh; 1886, H. H. Bishop; Philip Hofer; Lucien Goldschmidt, New York; Mark Millard
Bibliography: Focillon, 1918, no. 30; Hind, 1922, no. 7; London, 1978², pp. 72–83; Wilton-Ely, 1978, pp. 81ff.; Robison, 1986, no. 33

## 281

GIOVANNI BATTISTA PIRANESI
Interior of the Roman Cistern at Albano
1763–4
red chalk over a preliminary sketch in black chalk, 35 × 55.15 cm
Private Collection

Piranesi's archaeological studies in the area around the town of Albano were encouraged by Pope Clement XIII, who had a summer residence nearby. The treatise on Antichità d'Albano, published in 1764 and dedicated to the Pope, is usually bound with two other works, the Emissario and Due Spelonche. This drawing is a preparatory study for Plate XXII, Interior of an Underground Reservoir at Castel Gandolfo. A quick sketch, it was probably done on the site, and is in the same direction as the etching.        O.T.

Bibliography: Thomas, 1954, p. 54, no. 52; London, 1978², no. 163

## 282

GIOVANNI BATTISTA PIRANESI
Fantasy on a Magnificent Triumphal Arch
1765
pen, brush and brown ink, 46.3 × 63.1 cm
inscribed at lower-right margin in ink: 'I.B.Piranesi fecit dec.31 1765'; on verso: 'Piranesi Drawn at Rome in the presence of Joseph Windham Esqr.'
National Gallery of Art, Washington
Ailsa Mellon Bruce Fund, 1986.32.1

This architectural fantasy is Piranesi's only fully signed and dated drawing. Made on 31 December 1765, according to a contemporary inscription on the verso, it was drawn by Piranesi in the presence of Joseph Wyndham, the recipient of this presentation drawing.        O.T.

Provenance: according to a manuscript at Hoveton House, Wroxham, since 1800, T. R. C. Blofeld, Hoveton
Bibliography: Rome, 1959, no. 459; Morassi, 1959, pp. 56–8

## 283

GIOVANNI BATTISTA PIRANESI
Rovine del Sisto o sia della gran sala delle Terme Antoniniane
1765–6
etching, 43 × 65.2 cm
National Gallery of Art, Washington
Mark J. Millard Architectural Collection, acquired with assistance from the Morris and Gwendolyn Cafritz Foundation, 1985.61.80

A plate from the Vedute di Roma, the ruins of the Baths of Caracalla, in Piranesi's mature style, shows his keen understanding of architecture and of the ancient world. In his perception the ruins of a grand building are by no means lifeless and decaying, for they have great force and vitality by nature of their scale and grandeur.        O.T.

Bibliography: Focillon, 1918, no. 851, Hind, 1922, no. 77; Wilton-Ely, 1978, no. 76

## GIOVANNI BATTISTA PITTONI

born Venice, 6 June 1687
died Venice, 16 November 1767

Painter and draughtsman. He studied under his uncle, Francesco Pittoni, a mediocre history painter. From the early 1720s Pittoni ran a very active and successful workshop in Venice, in which the Bohemian artist Anthony Kern worked from 1723–30. The 1723 altarpiece made for the church of S. Corona, Vicenza (Zava Boccazzi, no. 239), and the mythological paintings for the Porto Godi family (see cat. 55) are good examples of his refined and harmonious, fully Rococo style. From 1726 to 1730 Pittoni, working in collaboration with Canaletto and others, painted the figures for four allegorical tombs (those of Archbishop Tillotson, Stanhope, Dorset and Isaac Newton) commissioned by Owen McSwiney. The artist's work in fresco (Palazzetto Widmann, Bagnoli, near Padua) dates from the late 1720s. In the 1730s he received several commissions from beyond Venice, from the house of Savoy in Turin (1732–3) and the Spanish court (1736–7). In 1743 Pittoni, with Tiepolo, Piazzetta, Amigoni and Zuccarelli, was among the artists chosen by Algarotti to paint a series of canvases for Augustus III's gallery in Dresden. He also painted many altarpieces, particularly in Lombardy and Germany. Pittoni, in contrast to his contemporaries, executed all his foreign commissions in Venice. His mature works were often inspired by the work of Sebastiano Ricci. In the 1750s he painted several small-scale pictures, mainly of religious subjects, in which he found a new freshness and lightness of touch. From 1758 to 1760 and again in 1763 he was President of the Venetian Academy.    M.G.

### 55

GIOVANNI BATTISTA PITTONI
*Diana and Actaeon*
*c.* 1722
oil on canvas, 149 × 200 cm
Pinacoteca Museo Civico di Palazzo Chiericati, Vicenza

This painting, together with *Olindo and Sophronia* (also in the Museo Civico, Vicenza; Zava Boccazzi, no. 241) and the two small pendants *Juno and Argus* and *Venus and Mars* in a Milan private collection (Zava Boccazzi, nos. 113–14), was probably commissioned from Pittoni by the Porto Godi family of Vicenza, who owned the whole group. It is close in style to the S. Corona altarpiece in the same town (1723) and can be dated *c.* 1722. In this canvas Pittoni achieves a rare formal perfection, combined with a fresh chromatic range and a grace of movement that belong to his most highly evolved Rococo style. Diana and her nymphs are shown in an idyllic landscape, and even the death of Actaeon, torn apart by dogs in the distant background, does not disturb the serene mood.    M.G.

*Provenance:* Porto Godi family, Vicenza; 1826, bequeathed by Paolina Porto Godi to the Museo Civico
*Exhibitions:* Florence, 1922, no. 769; Venice, 1929, no. 8; Venice, 1946, no. 321; Lausanne, 1947, no. 86; Munich, 1958, no. 161; Paris, 1960, no. 362; Vicenza, 1990, no. 29
*Bibliography:* Coggiola Pittoni, 1927–8, pp. 676, 680–1; Zava Boccazzi, 1979, no. 242, p. 180; Binion, 1981, pp. 96–9; Ballarin, 1982, p. 159

### 56

GIOVANNI BATTISTA PITTONI
*St Jerome with an Angel, St Peter of Alcantara and a Franciscan*
1725–7
oil on canvas, 275 × 143 cm
The National Galleries of Scotland, Edinburgh

The presence of Peter of Alcantara (1499–1562), a Spanish Franciscan saint, is unusual in Venetian altarpieces and may have been requested by the nuns of S. Chiara, who commissioned the altarpiece for their church of S. Maria dei Miracoli, Venice. The altarpiece is mentioned as an 'opera bellissima' by Zanetti the Elder in his *Descrizione* (1733), and is recorded again by Zanetti the Younger (1771) and Moschini (1815), when it was placed on the last altar to the left. It was last recorded in the church in 1847 and then vanished until it reappeared on the Paris art market in 1903.

Pittoni used a dynamic spiral composition that culminates in the *contrapposto* of the figures of the angel and St Jerome. A preparatory drawing for this altarpiece ( Brera, Milan; Zava Boccazzi,

1979, no. D.3) shows that originally the canvas was arched at the top, with a larger area of sky above the figures.    M.G.

*Provenance:* Church of S. Maria dei Miracoli, Venice; Hochom sale, Paris, June 1903 (attributed to Sebastiano Ricci); Cooper Hewitt Museum, New York; Sotheby's, London, March 1960, lot 69; Colnaghi, London, 15 June–15 July 1960; National Gallery of Scotland
*Bibliography:* Zanetti, 1733, p. 380; Zanetti, 1771, p. 461; Moschini, 1815, I, p. 651; Moschini, 1847, II, p. 184; Arslan, 1951, n.6, p.30; Haskell, 1960, p. 366; Levey, 1966, p. 49; *Cat. Nat. Gall. of Scotland,* 1970, p. 67, no. 2238; Zava Boccazzi, 1974, fig. 249; Wright, 1976, p. 161; Zava Boccazzi, 1979, no. 59

### 57

GIOVANNI BATTISTA PITTONI
*The Sacrifice of Polyxena*
early 1730s
oil on canvas, 128.3 × 95.3 cm
Collection of the J. Paul Getty Museum, Malibu, CA

This painting, together with its pendant *Antiochus and Stratonica* (Springfield Museum of Fine Arts, MA), belonged to Marshal Schulenburg. The subject is taken from Ovid's *Metamorphoses* (XIII.448–1): Polyxena, daughter of Priam, King of Troy, was sacrificed on the tomb of the Greek hero Achilles by Priam's son, Neoptolemus. Pittoni painted this theme several times at the beginning of the 1730s. The present version is very close to two others, one in the Hermitage, St Petersburg, and one formerly in the Parker Collection, London (Zava Boccazzi, 1979, nos. 79 and 254). The scene of sacrifice is turned by Pittoni into a sweet melodrama. The graceful figure of Polyxena, led by the hand by the old priest, and the elegant Neoptolemus, who points to the sacrificial altar with a chivalrous gesture seem like actors on a stage, while the tomb of Achilles flanked by paired columns and the backdrop with arch and Doric frieze could all be stage scenery. Two drawings (Fondazione Cini, Venice) are studies for the hands of the priest and Polyxena (Zava Boccazzi, no. D.37) and for the figures of Polyxena and Neoptolemus (Zava Boccazzi, no. D.34).    M.G.

*Provenance:* Schulenburg collection; Prince Schwarzburg-Rudolstadt collection; Norfolk Museum of Arts and Sciences, Chrysler collection
*Exhibitions:* New York, 1961, no. 34; Norfolk, VA, 1968, no. 60
*Bibliography:* Zava Boccazzi, 1979, no. 101

## MARCO (ANTONIO) RICCI
born Belluno, 5 June 1676
died Venice, 21 January 1730

Painter, draughtsman and printmaker. Son of Gerolamo and nephew of the painter Sebastiano. Marco probably started working with his uncle in Milan (1694–6), where he may have met Alessandro Magnasco, as has been suggested by Sonino, Francesco Peruzzini and Pieter Mulier (Cavalier Tempesta), all of whom seem to have had a significant influence on the young artist. In 1696 he went to Venice with Sebastiano, but had to flee after killing a gondolier. In 1706–7 he collaborated with his uncle in the decoration of the Sala d'Ercole in Palazzo Marucelli, Florence (cat. 1). While there he also worked with Magnasco and probably visited Rome and met Filippo Juvarra. In October 1708 he was brought to England, with Pellegrini, by Charles Montagu, 4th Earl of Manchester. The two artists painted stage scenery for two Italian operas, *Pyrrhus and Demetrius* by Alessandro Scarlatti and Nicola Haym, and *Camilla* by Antonio Maria Buononcini and Silvio Stampiglia, both performed at the Queen's Theatre, Haymarket, with English libretti by the theatrical impresario McSwiney. They also collaborated in the decoration of Lord Manchester's residence in Arlington Street, now destroyed. For the country residence of Charles Howard, 3rd Earl of Carlisle, Marco painted several landscapes, capriccios, a *View of the Mall in St James's Park* and one of those *Opera Rehearsals* which are an interesting genre in his English production. He collaborated with Pellegrini in the execution of six large mythological canvases for Burlington House, later transferred to Narford Hall, Norfolk. Marco returned to Venice towards the end of 1711 but in 1712 was back in England with his uncle Sebastiano, with whom he collaborated on many commissions. In 1715 they returned to Venice, living there together until Marco's death. In Venice Marco resumed his old friendship with Zanetti the Elder, who became, with Consul Smith, one of his most important patrons. Around 1718 he worked with Sebastiano on the lost frescoes of Bishop Bembo's Villa Belvedere in Belluno. He is recorded as having painted scenery for the Teatro Sant'Angelo in 1718–19 and the Teatro Grimani in S. Giovanni Grisostomo in 1726. In the 1720s Marco's output was prodigious: he produced landscapes and capriccios, gouaches on vellum, drawings (includ-

ing stage designs and caricatures) and, from 1723, etchings. He collaborated with Sebastiano on the *Allegorical Tomb of the Duke of Devonshire* and on that of Sir Clowdisley Shovell (cat. 37), commissioned by McSwiney, and on the large canvases executed for Vittorio Amedeo, Duke of Savoy (1725–6). M.G.

### 26

MARCO RICCI
*The Opera Rehearsal*
oil on canvas, 47.5 × 56 cm
inscribed on the stretcher by Horace Walpole: *...I believe it was not painted by | Hogarth, as the Singers, of which the woman in | black is Signora Margheritta, were antecedent | in time to Hogarth's paintings, as appears by | the dresses, which are of the latter end of | Queen Anne's reign*; and a later addition, also in his hand: *It was certainly painted by | Sebastian Ricci and the | landscape by Marco Ricci*
Private Collection, USA

This belongs to a group of paintings inspired by Marco's employment as a scene-painter at the Haymarket and by his contacts with the world of Italian opera. Another version, painted in tempera on vellum, was in the collection of the late Lord Knutsford. All the musical conversation-pieces are now ascribed entirely to Marco, and their humorous qualities are paralleled by his numerous caricature drawings owned by Consul Smith (see fig. 24).

The singer standing in the centre, directing the orchestra, has been identified as Nicola Grimaldi (1673–1732), known as Nicolini, who made a successful London début in the opera *Pyrrhus and Demetrius* by Alessandro Scarlatti for which Marco Ricci and Pellegrini had painted the scenery. The seated woman in black is the singer Francesca Margherita de l'Epine (1683–1746), while the woman in white, seated on the opposite side, can be identified tentatively as Francesca's great rival, Catherine Toft, future wife of Joseph Smith. However, as Sonino remarks, she looks quite different from the singer in white in another version (Castle Howard), who is also identified as Catherine Toft. The man playing the harpsichord is Nicola Haym, who adapted *Pyrrhus and Demetrius* for the English stage, while the man in red drinking tea is the impresario John James Heidegger (1666–1749). The two portraits flanking the landscape on the wall have been identified by Levey as those of Marco (left) and Sebastiano (right). M.G.

*Provenance:* Charles Stanhope sale, London, 3 June 1760 (as by Hogarth) ; John, 4th Duke of Argyll; his sale, Langford & Son, London, 19–23 March 1771; Walpole Collection, Strawberry Hill until 1797; Mrs Damer; Maria Walpole,

Countess of Waldegrave; HRH The Duchess of Gloucester, died 1807; 7th Earl of Waldegrave; Strawberry Hill Sale, 25–17 April 1842, 20th day, lot 115; John Graham of Edmond Castle Cumberland, and thence by descent; Sotheby's, London, 8 April 1987, lot 13; Colnaghi, London
*Exhibitions:* London, 1960, no. 432 (as by Sebastiano and Marco); Paris, 1960–1, no. 366; Stockholm, 1962–3, no. 136; Bassano, 1963, no. 28 (Knutsford version reproduced in error)
*Bibliography:* Vertue, 1786, p. 629; Walpole, 1798, II, p. 498; Strawberry Hill sale cat., 1842, pp. XVII, 205, 206; Watson, in London and Birmingham, 1951, pp. 30–32, under no. 104; Pallucchini, 1955, p. 178; Blunt and Croft-Murray, 1957, p. 143; Wheeler, 1960, p. 52; White, 1960, XIV, no. 3; Valcanover, 1960–1, no. 366; Levey, 1961, p. 140; Daniels, 1976[1], no. 188; *idem*, 1976[2], no. 625; Martini, 1982, p. 495, n. 134; Colnaghi cat., London, winter 1987, pp. 8–9; Vivian, 1989, p. 20; Scarpa Sonino, 1991, no. 53; Belluno, 1993, pp. 101–3

### 27

MARCO RICCI
*Extensive Pastoral Landscape*
*c.* 1730
tempera on kid or goatskin, 30.8 × 45.7 cm
Lent by The Metropolitan Museum of Art, New York, Rogers Fund, 1967 (inv. 67.67)

In this atmospheric landscape the right foreground, in heavy shadow, contrasts with the left-hand side in which animals and humans are struck by a clear, transparent light. The distant low horizon, broken only by the foliage of the trees, may be a reflection of Marco's study of Netherlandish painters. M.G.

*Provenance:* Christie's, London, 29 March, 1966, lot 96; 1967, acquired by the Rogers Fund, The Metropolitan Museum of Art
*Exhibitions:* New York, 1971, no. 28
*Bibliography:* New York, 1967–8, p. 87; New York, 1968, p. 303, repr. p. 302; Hibbard, 1980, p. 358; Bean and Griswold, 1990, p. 181, no. 173; Scarpa Sonino, 1991, p. 150, no. 48

### 28

MARCO RICCI
*Wooded River Landscape with Shepherds*
1725–9
oil on canvas, 73.7 × 125.1 cm
Lent by Her Majesty The Queen (inv. 401005)

This landscape, with two others and a capriccio by Marco in Consul Smith's collection, were sold to George III in 1762. The four paintings are attributed to Marco in the Italian List (nos.

112–15), with the intervention of Sebastiano in the figures. While this may be true of the other three, the present picture seems entirely to be Marco's work. This pastoral landscape, spreading across the canvas with an airy softness of touch and a diffused luminosity reveals Marco's deep feeling for nature and is an exceptional example of his superb achievements in the last phase of his career.     M.G.

*Provenance:* Joseph Smith, Venice; 1762, sold to King George III
*Exhibition:* Bassano, 1963, no. 58
*Bibliography:* Osti, 1955, pp. 31–4; Pallucchini, 1955, pp. 187, 189; Levey, 1964, no. 625; Vivian, 1971, p. 180; Daniels, 1976[1], no. 163b; idem[2], 1976, no. 491; Scarpa Sonino, 1991, no. 115

## 29

MARCO RICCI
*Fortified Village along a River*
1720s
brown ink over traces of graphite, 26.4 × 37.5 cm
National Gallery of Art, Washington
Gift of Mrs Rudolf J. Heinemann, 1988.26.1

The mount of this drawing seems to correspond to those of other sheets by Marco Ricci that once were probably bound together in a folio volume inscribed '*Marco Ricci Bellunensis Pictoris Eximii Schedae*' (Blunt). The volume, which contained 141 landscape drawings of varying sizes, formed part of the Geiger Collection, sold at Sotheby's 7–10 December 1920; the drawings were dispersed among various public and private collections.

The present drawing, like others by the artist, is reminiscent of the graphic work of Domenico Campagnola and is quite close in handling to Marco's etchings. The ink is applied with a fine quill, and the volume of the buildings is created with extremely regular parallel hatching. The penwork breaks off suddenly to leave the blank white paper, as on the river-bank in the foreground, the water and the bridge beyond. This sheet has some similarities, such as the bridge and the tower in the middle distance, with Marco's etching in the Museo Civico, Bassano, Remondini Coll, no. 3810 (Succi, 1993, no. 11).     M.G.

*Provenance:* Gift of Mrs Rudolf J. Heinemann
*Bibliography:* Blunt and Croft-Murray, 1957, p. 32

## 30

MARCO RICCI
*Palatial Interior with a Wall Painting and Furniture*
c. 1726
pen with brown wash over black chalk, 40.3 × 25.9 cm
Lent by Her Majesty The Queen (inv. RL5882)

Most of the drawings by Marco Ricci in the Royal Collection are listed in the 18th-century 'Inventory A' in two volumes and a portfolio. The present sheet belongs to the second volume, which contains 54 (altered in a later hand to 55) 'Ruins, and Designs for Scenes and Various Compositions'.

The style of this grand Baroque interior, a design for stage scenery, is close to Filippo Juvarra's drawings, also made for the theatre. The artists probably met in Rome before Marco went to England in 1708; both tended to draw realistic architecture for their stage scenery, in contrast with the fantastic creations of the Bibienas.     M.G.

*Provenance:* Joseph Smith, Venice; 1762 sold to King George III
*Bibliography:* Blunt and Croft-Murray, 1957, p. 43, no. 177

## 31

MARCO RICCI
*A Villa Courtyard with a Fountain*
c. 1726
pen and brown ink, 36.4 × 30.3 cm
inscribed in the artist's hand: '*4 Telari p. parte e sopra il sesto taglio i prospetto primo e ditro il 7m*'; on verso: '*No.16 JS*'
Lent by Her Majesty The Queen (inv. RL5877)

The inscription refers to a future use of the drawing for stage scenery. '*Telari*' refers to the movable wings on either side of the stage, while *tagli* are the sections into which the designer divides the stage, determining foreground, middle ground and background. Here Marco probably intended to place the backdrop with the wall and the fountain in the sixth section and behind the perspective of trees, creating a feeling of space, which seems to expand beyond the wall and into the trees.

As with all his other scene paintings in the Royal Collection, it is impossible to relate Marco's designs to the operas on whose sets he is known to have worked. Stylistically the Royal Collection's drawings may be dated to the late period of Marco's career, when he was working in Venice for the theatres of S. Angelo and S. Giovanni Crisostomo.     M.G.

*Provenance:* Joseph Smith, Venice; 1762, bought by King George III
*Bibliography:* Blunt and Croft-Murray, 1957, p. 45, no. 209; Succi, 1988, p. 147, fig. 22

## 32

MARCO RICCI
*Capriccio of Roman Ruins*
tempera on kid or goat skin, 31 × 45.5 cm
National Gallery of Art, Washington
Ailsa Mellon Bruce Fund, 1982.38.2

This elaborate capriccio of architecture and sculpture with figures is theatrically baroque in character. Strong contrasts of chiaroscuro animate the scene with its distant view of the ruins bathed in light. The structure of the fountain on the left is similar to one in an etching from the Remondini Collection (no. 3824) in the Museo Civico, Bassano (Succi, 1993, no.12).     M.G.

*Provenance:* Galerie van Diemen and Co., Berlin, 1920; Stichting Nederlandsch Kunstbezit, inv. no. 1216; Sotheby's, London, 25 March 1982, lot 54
*Bibliography:* Scarpa Sonino, 1991, no. 10

## 33

MARCO RICCI
*Classical Ruins with Plunderers*
etching, state 1 of 2, 24.4 × 35.2 cm
Museo Biblioteca Archivio di Bassano del Grappa, Remondini Collection (inv. 3842)

As we know from his correspondence, Marco began to experiment with etching in 1723 and continued to use the technique until the end of his life. This is a superb example of the extreme accomplishment and refinement he achieved in his last years. Here ruined architecture, sculpture, wild vegetation and figures are combined with great invention and an almost pre-Romantic sensibility. The strong light streams through the open gate to reveal the plunderers at work, creating a dramatic contrast with the foreground in shadow.

This etching, in reverse, was included by Giuliano Giampiccoli in his *Raccolta* (I Ed. II/ 9). It is also similar to a tempera painting by Marco of the same subject (James Parker Collection, New York; Scarpa Sonino, 1991, fig. 309). In the first state the sky is almost completely white and the ruins on the right are merely outlined. In the second state, also in the Museo Civico, Bassano (Remondini Coll., no. 3843), the sky and the ruins are more finished.     M.G.

*Provenance:* Remondini Collection
*Exhibitions:* Bassano, 1963, no. 222/3; Belluno, 1968, no. 24 (2nd state); Venice, 1983, no. 438 (2nd state)
*Bibliography:* Pilo, 1961, pp. 166–74; Succi, 1993, no. 28; Bellini, 1993, no. 28

MARCO RICCI
*Classical Ruins with a Sphinx*
*c.* 1725
etching, state 1 of 5, 40.5 × 32.3 cm
signed lower right: '*MR f*'.
Museo Biblioteca Archivio di Bassano del
Grappa, Remondini Collection (inv. 3857)

This etching belongs to the set of twenty plates,
*Varia Marci Ricci Pictoris Praestantissimi
Experimenta...*, published by Carlo Orsolini in
Venice in 1730. In this capriccio, a beautiful
example of Marco's masterly use of engraving,
the crumbling architecture, sculpture and figures
are combined to create a mysterious and rarefied
ensemble. A subtle interplay of light and
shadows culminates with the distant view of the
Gothic church, bathed in sunlight.

While in the first state there are white patches
along the top-left margin and under the central
arch, in the second state, also in the Museo
Civico, Bassano (Remondini Collection, no.
3856), the sky is darker. M.G.

*Provenance:* Remondini Collection
*Exhibitions:* Bassano, 1963, no. 232 (2nd state);
Belluno, 1968, no. 30 (2nd state); Venice, 1983,
no. 421
*Bibliography:* Bartsch, 1821, XXI, no. 9;
Alpago-Novello, 1939–40, no. 9; Succi, 1993,
no. 9; Bellini, 1993, no. 9

MARCO RICCI
*The Courtyard of a Country House*
tempera on kid or goatskin, 31.1 × 45.7 cm
Lent by Her Majesty The Queen (inv. ML593)

A superb example of one of the 33 gouaches by
Marco (nos. 116–48 on the Italian List) sold to
George III by Joseph Smith. Unfortunately,
owing to the delicacy of the medium and
support, the left part of the picture is slightly
damaged. In this intimate and delicate scene,
Marco has captured a lively moment of everyday
life in a rustic courtyard. The episodes of the
women doing the washing, the boy picking a
lemon, the encounter at the door, are rendered
with immediacy and freshness. Marco's
sensitivity towards the effects of natural light is
evident in the warm sunlight that filters through
the pergola, creating a deep shadow on the
adjoining façade. M.G.

*Provenance:* Joseph Smith, Venice; 1762, sold to
King George III
*Exhibitions:* London, 1946–7, no. 400; Bassano,
1963, no. 86; London, 1993, no. 112
*Bibliography:* Blunt, 1948, pp. 127, 130;
Pallucchini, 1955, pp. 187–8; Donzelli, 1957, p.
202; Pallucchini, 1960², p. 40; Levey, 1964, no.
593; Scarpa Sonino, 1991, no. 95

MARCO RICCI
*Stormy Landscape*
*c.* 1725
tempera on kid or goatskin backed with paper,
30.9 × 44.7 cm
National Gallery of Art, Washington
Ailsa Mellon Bruce Fund and Gift of David
Tunick, 1980.13.1

Marco increasingly used tempera on kid or
goatskin in the 1720s. The technique allowed
him to lighten his palette and to achieve new
atmospheric effects in his landscape views. The
theme of the storm often recurs in Marco's
landscapes; here the strong wind and overcast
sky threatens both humans and animals. The
forked lightning is reminiscent of some paintings
by Tempesta, who was an important influence
on Marco. The present picture is similar to one
of the same subject in a private collection, Milan
(Scarpa Sonino, 1991, no. 40, fig. 219, pl.
XX). M.G.

*Provenance:* Princess Sophia Matilda of
Gloucester; Henry, Duke of Grafton; David
Tunick

MARCO and SEBASTIANO RICCI
*Allegorical Tomb of Admiral Sir Clowdisley Shovell*
*c.* 1725
oil on canvas, 222.3 × 158.8 cm
signed lower left: '*B M RICCI | Faciebant*'
National Gallery of Art, Washington
Samuel H. Kress Collection, 1961.9.58

Sebastiano Ricci painted the figures and most of
the sculpture; the landscape is the work of Marco
Ricci. Admiral Sir Clowdisley Shovell, here
portrayed as a Roman admiral seated on a
marble fountain reminiscent of Bernini's works,
was the hero of the capture of Gibraltar (1704).
The present picture was commissioned from
Marco and Sebastiano by Owen McSwiney for
his series of 24 paintings of allegorical tombs
commemorating great Englishmen to be painted
by leading Italian artists. For the same series the
Riccis also collaborated on the *Allegorical Tomb
of the Duke of Devonshire* (Barber Institute of
Fine Arts, Birmingham). The series was
originally intended for the Duke of Richmond's
residence, Goodwood House, and, according to
the correspondence between the Duke and
McSwiney, the two paintings by the Riccis were
completed in October 1725. The present picture
did not appear among the ten which decorated
Goodwood's dining-room (Vertue, 1747); it was
published by McSwiney as hanging in the
'cabinet de Monseigneur le Duc de Richmond'
in the volume of engravings *Tombeaux des Princes*
(1741). Like the other paintings in the group,
the canvas was originally arched at the top, as
shown in the etching by Tardieu. A smaller
version, painted in grisaille and attributed to
Fratta, appeared at Sotheby's, London, lot 111,
on 8 July 1964 M.G.

*Provenance:* Duke of Richmond, Somerset
House; Colthurst coll., Blarney Castle; Koetser
coll., New York; 1953, S.H. Kress coll.,
Washington; 1975, National Gallery of Art,
Washington
*Bibliography:* Vertue, ed. 1786, V, pp. 149–50;
The Earl of March, 1911, II, pp. 600–2; Voss,
1926, p. 35; Valcanover, 1954, pp. 52, 57;
Suida and Shapley, 1956, pp. 148–9; Blunt and
Croft-Murray, 1957, p. 31; Wittkower, 1958,
fig. 297; Pallucchini, 1960², p. 40; Milkovich,
1966, p. 12; Croft-Murray, 1970, II, p. 241, no.
21; Paris, 1971, under no. 197; Jaffé, in
Cambridge, 1973–4, p. 9; Daniels, 1976¹, no.
531; *idem*, 1976², no. 426; Mazza, 1976, pp. 90–
1; Shapley, 1979, pp. 402–6, pls. 286, 286A;
Haskell, 1980, pp. 289–90; Knox, 1983, pp.
228–35; Haskell, 1987, pp. 14–16; Scarpa
Sonino, 1991, no. 112

## SEBASTIANO RICCI

born Belluno, christened 1 August 1659
died Venice, 15 May 1734

Painter, draughtsman and engraver. According to Pascoli (1736), aged twelve he was apprenticed in Venice to Luca Cervelli (c. 1625–c. 1700). He was also influenced by Luca Giordano, who worked in Venice in the early 1650s, and the 1660s, again in 1682. By 1681 Ricci was in Bologna, where he came into contact with Ferdinando Bibiena and Carlo Cignani. In December 1685 he was commissioned by Conte Scipione Rossi to decorate, in collaboration with Bibiena, the Oratorio of the Madonna del Serraglio, near Parma. In 1687–8 he painted scenes from the life of Pope Paul III for Ranuccio II Farnese, Duke of Parma. After returning to Bologna, he fled to Turin with the daughter of his friend the painter Giovanni Francesco Peruzzini and, arrested, was saved from the death penalty by Duke Ranuccio who offered him refuge in his palace in Rome. There Sebastiano admired the frescoes by Annibale Carracci and Pietro da Cortona in Palazzo Farnese. In 1692 he decorated the ceiling of the Sala degli Scrigni in Palazzo Colonna. He left Rome in 1695 and returned to Venice, stopping in Florence, Bologna, Modena and Milan, where he met Magnasco. In 1702 he went to Vienna and worked at Schönbrunn. In Florence (1706–7) he worked in the Palazzo Pitti and in the Palazzo Marucelli (see cat. 1). He was back in Venice in 1708 and painted an altarpiece for S. Giorgio Maggiore (fig. 7) in which Veronese is reinterpreted in a fluid and dynamic Rococo manner. In the winter of 1711–12 he arrived in London with his nephew Marco. There he found an enthusiastic patron in Lord Burlington, for whom he decorated the staircase of his residence in Piccadilly (fig. 14) and painted several pictures, now at Chiswick House and Chatsworth. He also worked for Lord Portland in his London house in St James's Square and in the chapel of Bulstrode House in Buckinghamshire. Those works are now lost. After painting *The Resurrection* for the apse of the chapel of Chelsea Hospital, in 1716 Sebastiano left England with Marco and returned, via Paris, to Venice, where he lodged in the Procuratie Vecchie. In 1718 he was made a member of the Académie Royale. In the 1720s, in collaboration with Marco, he painted many works for the House of Savoy and several pictures, including a New Testament series, for Joseph Smith. In 1733 he executed the splendid altarpieces for the Venetian churches of the Gesuati and S. Rocco. His last great commission was for the Karlskirche in Vienna (see cat. 9).          M.G.

## 1

SEBASTIANO RICCI
*The Punishment of Love*
1706–7
oil on canvas, 285 × 285 cm
Università degli Studi di Firenze

This ceiling-painting is part of the decorative cycle of five rooms on the ground floor of Palazzo Marucelli-Fenzi commissioned from Ricci by Canon Orazio Marucelli. Although D'Arcais proposed the date 1703 on the basis of stylistic similarities with the decoration of Palazzo Fulcis-De Bertoldi in Belluno, most critics agree on the dating 1706–7, confirmed by two letters from Sebastiano to Marucelli (Haskell, 1985, pp. 364–5) and by a dated preparatory drawing in the Uffizi. The cycle, whose theme is the struggle between Vice and Virtue, culminates in the Sala d'Ercole, whose walls and ceiling are frescoed with the hero's labours.

The present canvas decorates the ceiling of the third room and represents Cupid being punished, to the distress of his mother Venus, whose attendants try to comfort her. Here Sebastiano has lightened his palette and, though the two groups are still counterbalanced in a rather Baroque manner, the scene has a transparency and brightness that prefigures the Rococo.          M.G.

*Exhibitions:* Florence, 1960, no.125; Florence and Detroit, 1974, no.179; Udine, 1989, no.24
*Bibliography:* D'Arcais, 1973, I, pp. 20–5; Daniels, 1973, p.172; Schulze, 1974, p.22; Daniels, 1976[1], no.108, p.35; *idem*, 1976[2], no. 221, p.106

## 2

SEBASTIANO RICCI
*Harpagus Bringing Cyrus to the Shepherds*
c. 1706–8
oil on canvas, 259 × 201 cm
Hamburger Kunsthalle, Hamburg

Astyages, King of Persia, having been warned that his grandchild Cyrus would one day dispossess him, ordered his general Harpagus to kill him. Instead, Harpagus gave the child to a family of shepherds who raised him, thereby making the prophecy come true.

While Arslan dated the painting c. 1724, Pallucchini and Daniels agree on a much earlier execution, around 1706–8, close to the Marucelli cycle. A preparatory sketch for the boy in the left foreground is in the Accademia, Venice (Daniels, 1976, no.250).          M.G.

*Provenance:* acquired 1929
*Bibliography:* Arslan, 1937, p. 218; Pallucchini, 1952[2], p.72; Daniels, 1976[1], no. 118, p. 41; *idem*, 1976[2], no. 250, p. 109

## 3

SEBASTIANO RICCI
*The Flight into Egypt*
c. 1713
oil on canvas, 87.3 × 113 cm
The Duke of Devonshire and the Chatsworth House Trust

This picture, with others by Sebastiano at Chatsworth, probably belonged to the 3rd Earl of Burlington. His only surviving daughter, Charlotte, married the Marquess of Hartington, heir to the Duke of Devonshire, thus bringing Lord Burlington's entire inheritance to the Cavendish family. The pendant of this canvas, *The Presentation in the Temple*, also at Chatsworth, is signed and dated 1713.

According to Osti, the unusual iconography could have been inspired by Annibale Carracci's lunette of the same subject in the Galleria Doria Pamphilj, Rome.          M.G.
*Provenance:* 3rd Earl of Burlington (?); the Duke of Devonshire
*Exhibitions:* London and Birmingham, 1951, no. 111; London, 1954–5, no. 27; Nottingham, 1957, no. 20; Kingston-upon-Hull, 1967, no. 61; London, 1978[1], no. 6
*Bibliography:* Osti, 1951, p. 122; Nicolson, 1963, p. 122, note 17; Daniels, 1975, p. 69; *idem*, 1976[1], no. 9; *idem*, 1976[2], no. 288

**4**

SEBASTIANO RICCI
*Susanna and the Elders*
1713
oil on canvas, 40.5 × 32.3 cm
signed lower left: '*Riccius fecit 1713*'
The Duke of Devonshire and Chatsworth
House Trust

This picture was acquired before 1720 by the
2nd Duke of Devonshire as Annibale Carracci
(Watson) and in 1761 was hung in the Great
Drawing Room, Devonshire House, Piccadilly
(Dodsley). As suggested by Daniels, the
composition is based on a lost painting by
Carracci, known through a copy in the Palazzo
Doria Pamphilj, Rome. The scene is enlivened
by vibrant colours, laid on the canvas with
energetic and fluid brushstrokes, in a typically
Rococo manner. The architectural and
decorative details are reminiscent of Veronese.
Another painting by Ricci at Chatsworth of the
same subject is a copy of a Veronese now in the
Louvre.                                            M.G.

*Provenance:* acquired before 1720 by the 2nd
Duke of Devonshire
*Exhibitions:* London, 1948, no. 50; Nottingham,
1973, no. 11; London, 1978[1], no. 5; Udine,
1989, no. 34
*Bibliography:* Dodsley, 1761, II, p. 226; Watson,
1948, p. 248; Osti, 1951, p. 122; Nicolson,
1963, p. 122; Daniels, 1975, p. 69; *idem* 1976[1],
no. 7; *idem*[2], 1976, no. 285

**5**

SEBASTIANO RICCI
*Bacchus and Ariadne*
c. 1716
oil on canvas, 126.5 × 175.5 cm
Germanisches Nationalmuseum, Nuremberg

Hymen, the god of marriage, crowned with pink
roses and bearing a torch, officiates at the
wedding of Bacchus and Ariadne. A similar
version of the same subject, probably painted for
Lord Burlington, is at Chiswick House.
Pallucchini's dating to the period just after
Sebastiano's time in England has been generally
accepted. A drawing at Windsor was related to
the present picture by Blunt, but in fact it is
closer to another version formerly in a private
collection, Milan (Daniels, no. 243).       M.G.

*Provenance:* Elector Lothar Franz Von
Schönborn (1655–1729); then by descent
*Exhibitions:* Venice, 1959, no. 235; Paris, 1960–
1, no. 376; Venice, 1969, no. 11; Udine, 1989,
no. 40
*Bibliography:* Pallucchini, 1952[2], p. 79;
Valcanover, 1954, p. 32; Blunt and Croft
Murray, 1957, p. 55; Daniels, 1976[1], no. 352;
*idem*, 1976[2], no. 346

**6**

SEBASTIANO RICCI
*Head of a Girl Wearing a Ruff*
1716–20
black chalk, pastels, heightened with white, on
greyish blue paper, 38.4 × 25.3 cm
inscribed: '*Del Sig.r Sebastian Rizzi ma est donné
par Il Sig.r Ant.o Maria Zanetti qondam
Gerolimin...marquant a Venise très fameaux dilectant*'
Nationalmuseum, Stockholm (inv.
NMH1530/1863)

According to the inscription, this sheet was
given to the French banker and patron of the arts
Pierre Crozat by Anton Maria Zanetti the
Elder, and was subsequently owned by the
Swedish Count Tessin, an enthusiastic collector
of French and Venetian art. This delightful
drawing shows the influence of the young
Watteau on Sebastiano. In 1716, during his stay
in Paris, Ricci was taken to see the French artist
by Crozat. Watteau made a strong impression
on Sebastiano, as we may judge from his careful
copies after drawings by the French master. The
present sheet is not connected to any specific
work by Watteau, but the delicate and pictorial
rendering of the girl's head has a French flavour.
                                                    M.G.

*Provenance:* A.M. Zanetti the Elder; Pierre
Crozat; C.G. Tessin; Kongl. Biblioteket;
Kongl. Museum
*Exhibitions:* Stockholm, 1962, no. 272; Venice,
1974, no. 86

**7**

SEBASTIANO RICCI
*Head of a Pharisee*
c. 1729–30
black, white and red chalks, 31.2 × 24.4 cm
Lent by Her Majesty The Queen

This large study corresponds exactly to the
bearded Pharisee seated in the centre foreground
of the painting *The Magdalene Anointing Christ's
Feet* in the Royal Collection (Levey, 1964, 639;
Daniels, 1976, 158). The picture belongs to a
group of seven large canvases by Sebastiano
(probably with Marco's collaboration in the
backgrounds) representing New Testament
scenes executed between 1726 and 1730. The
whole series was among the paintings by Ricci
acquired in 1762 by George III from Consul
Smith.
    The very expressive head is a superb example
of Sebastiano's late style. The different coloured
chalks are freely and boldly used to achieve a
dramatic modelling and a powerful
characterisation of the old Pharisee.       M.G.

*Provenance:* Joseph Smith Collection, Venice;
1762, sold to King George III
*Exhibitions:* Frankfurt, Fort Worth Richmond
(Virginia), Edinburgh, 1989, no. 7; London,
1993, no. 66
*Bibliography:* Blunt and Croft-Murray, 1957, no.
269; Daniels, 1976[1], no. 448/2

**8**

SEBASTIANO RICCI
*The Liberation of St Peter*
1722
oil on canvas, 165 × 138 cm
S. Stae, Venice

This is one of twelve canvases depicting the
Apostles painted by various contemporary artists
and donated to the church of S. Stae by Andrea
Stazio. He died on 5 May 1722 and in a codicil
to his will, dated 10 April 1722, he left
appropriate funds for the donation (Moretti).
Sebastiano presumably received the commission
in the second half of 1722. The Apostles were
originally placed in the central nave (Zanetti,
1733); in 1771 they were set into stucco frames
on the side walls of the choir, in four groups of
three. Sebastiano's *St Peter* is flanked by
Balestra's *St John* on the right and Piazzetta's *St
James* (cat. 70) on the left.
    The composition appears also in a preparatory
sketch (Accademia, Venice; Rizzi, 1975,
no. 77).                                      M.G.

*Exhibitions:* Venice, 1971, no. 44; Venice, 1983[1],
no. 19; Munich, 1987, no. 3; Udine, 1989, no.
50

*Bibliography*: Zanetti, 1733, p. 439; Zaretti (the Younger), 1771, p. 662; Derschau, 1922, pp. 111–12; Lorenzetti, 1926, 1961 ed., p. 478; Arslan, 1936, p. 242; Levey, 1959[1], p. 36; Moretti, 1973, pp. 318–20; Daniels, 1976[1], no. 457; idem, 1976[2], no. 404

## 9

SEBASTIANO RICCI
*The Assumption of the Virgin*
1733–4
95 × 51.5 cm
Szépmuvészeti Múzeum, Budapest
(inv. 642)

This small *bozzetto* is Ricci's preparatory sketch for the altar commissioned by the Holy Roman Emperor Charles VI for the Karlskirche in Vienna. The finished painting was placed in the second side chapel on the left, and was Ricci's last important undertaking. Ricci's work was known already in Vienna: he decorated the Blue Staircase (originally the Mirror Room) in Schönbrunn Palace in 1701–2 for Charles's father, Leopold I. Gregory of Tours (d.593/4) gave the first account of the Assumption of the Virgin, and despite the lack of a biblical reference, it became one of the most sacred events in the calendar of the Roman Catholic Church. The Budapest piece is the artist's first idea; its freshness and dynamism was much praised by contemporaries and, according to Pascoli, it 'gained the approval not only of His Majesty, but of all the nobility, and all the professors and connoisseurs'. Its success is illustrated by several variants by Ricci, of which those in Prague, Aschaffenburg (Munich), and Lvov are worth mentioning. It also influenced Hungarian painting; several 18th-century repetitions of the composition exist in provincial churches in western Hungary.

The composition is developed along a three-dimensional S-shape, divided into three planes. It is a more elaborate and balanced composition than Ricci's earlier treatment of the subject in Clusone, Bergamo. The exceptional virtuoso choreography of the figures, the vitality, the vaporous flights of paint, and extraordinary freshness of the colour scheme create the dynamism of this first idea. This is underlined by the numerous visible pentimenti and the speedy brushwork, showing the influence of Magnasco. The supreme ease and immediacy are characteristic of the greatest 18th-century Venetian masters, who lifted the genre of *bozzetto* to astonishing heights. There are differences between the sketch and the finished painting, for instance there are fewer putti in the *bozzetto*. More important is the intervention of pupils in the altarpiece, which is less spirited and less colourful as a result.　　　　I.B.

*Provenance*: by 1812, Esterházy Collection (Cat. VII. no. 23), Inv. 1820 no. 254; 1870, purchased with the entire collection by the Hungarian Government
*Exhibitions*: Dresden, 1968, no. 152; Venice, 1969, no. 19; Udine, 1989, no. 73; Saragossa, 1990, no. 196; Hanover, 1991–2, no. 71
*References*: Zampetti, 1959–60; Safařik, 1964; Pigler, 1967 p. 577; Kiel, 1969 p. 496; Zampetti, 1971, 2, p. 63; Daniels, in Milan, 1976, no. 527; Daniels, in Hove, 1976, p. 21; Udine 1975; Garas, 1977, no. 7

## 10

SEBASTIANO RICCI
*Bacchus, Reclining Woman and Silenus*
1708–10
pen and wash in two colours, golden brown and grey-brown, 28.1 × 27.9 cm
inscribed on verso: '*No. 52 J S*'
Lent by Her Majesty The Queen

This is one of 211 drawings by Sebastiano Ricci bought by George III from Consul Smith in 1762. Many are still mounted in the folio volume made up for their original collector, with two elaborately decorated title-pages by Visentini, including Smith's coat of arms. This volume, and one in the Accademia, Venice, to which it is closely related, are the most important collections of Sebastiano's drawings, dating mostly from the end of the artist's career. The present sheet, however, seems to belong to his early years. As other drawings in the Royal Library, it is characterised, as Blunt noted, by 'a method of repeated hatching' and 'an unusually luminous wash'.　　　　M.G.

*Provenance*: Joseph Smith, Venice; 1762 sold to King George III
*Bibliography*: Blunt and Croft-Murray, 1957, p. 46, no. 347

## 11

SEBASTIANO RICCI
*Extensive Pastoral Landscape with Hill-town*
*c.* 1720
pen and brown ink and wash, 37 × 52 cm
Gallerie dell'Accademia, Venice

This is one of 133 drawings by Sebastiano Ricci contained in an album which once belonged to Zanetti the Elder (Morassi). The present sheet shows Sebastiano's interpretation of the landscape near his birthplace, Belluno, as the hill town and the distant mountains seem to suggest. While his nephew Marco favoured realistic scenes of the countryside, Sebastiano's landscapes are idyllic in mood. The diffused light softens the contours of the figures, the pen is used with

great rapidity and expressiveness and the delicate use of the wash gives a spacious atmospheric effect to the scene. Pignatti dates this landscape to the late 1720s.　　　　M.G.

*Provenance*: Anton Maria Zanetti the Elder; Francesco Algarotti ; Cernazai collection; Dal Zotto collection; 1919 donated to the Accademia by the Dal Zotto heirs
*Exhibitions*: Venice, 1929, no. 303; Paris, 1960–1, no. 382; Venice, 1963, no. 72; Groningen and Rotterdam, 1964, no. 85; Paris, 1971[2], no. 5; London, 1972[2], no. 5; Udine, 1975[1], no. 120
*Bibliography*: Morassi, 1926, p. 263, no. 54; Pignatti, 1974[1], no. 24

## 12

SEBASTIANO RICCI
*Bed with Sea-horses and Fortune*
pen and brown ink and brown wash over black chalk, 25 × 20 cm
Gallerie dell'Accademia, Venice

This unusual drawing could have been inspired, according to Morassi, by Brustolon's preparatory studies for furniture designs. While Pignatti suggested that it displayed the taste for chinoiserie that was widespread in the 1730s, Rizzi proposed a date at the beginning of the century. He also noted that some decorative motifs, like the sea-horses, the shell and the flying drapery above the figure of Fortune are also present in the *Triumph of Galatea* now on the staircase of Burlington House.

The sheet, however, with its curly and quivering lines, expresses a fully Rococo and decorative taste and would therefore seem to date from a later period.　　　　M.G.

*Provenance*: Anton Maria Zanetti the Elder; Francesco Algarotti; Cernazai; Dal Zotto
*Exhibitions*: Venice, 1963, no. 73; Udine, 1975, no. 21
*Bibliography*: Morassi, 1926, pp. 259–60, no. 25; Pignatti, 1974[1], no. 25; Rizzi, in Udine, 1975[1], under no. 21

## GIAMBATTISTA (or GIOVANNI BATTISTA) TIEPOLO
born Venice, 5 March 1696
died Madrid, 27 March 1770

Painter, draughtsman and engraver. In 1710 he entered the workshop of Lazzarini, but was also influenced by Piazzetta and Sebastiano Ricci, as well as by Veronese. His earliest works (1715–16) are the *Apostles* on five pendentives in the church of Ospedaletto (S. Maria dei Derelitti), Venice. The *Sacrifice of Isaac*, in the same church, dates to *c.* 1724. He is first listed in the *fraglia* of Venetian painters in 1717. In 1719 he married Cecilia Guardi, sister of Antonio and Francesco. In 1724–5, with the frescoes in S. Maria degli Scalzi and in Palazzo Sandi, Venice, Tiepolo revealed his own individual style, which reached full expression in the decoration of the Archbishop's Palace, Udine, commissioned by Dionisio Dolfin (1726–9). Here the feigned architectural elements were painted by Gerolamo Mengozzi Colonna, who collaborated with Tiepolo on many frescoes. In 1730–1 Tiepolo worked in the Archinto and Bugnani Casati Palaces in Milan. In 1732–3 he decorated the Colleoni chapel, Bergamo, and in 1734 Villa Loschi al Biron, near Vicenza. In 1737–9 he frescoed the vault of the Venetian church of the Gesuati and in 1740 the ceiling of the *salone* of Palazzo Clerici, Milan (see cat. 107). In 1743 Tiepolo met Algarotti, who was buying works of art for Augustus III of Saxony; Algarotti's influence on Tiepolo can be seen in the frescoes in Villa Cordellina, Montecchio Maggiore, Vicenza (1743–4). The decoration of Palazzo Labia in Venice, where Tiepolo collaborating with Gerolamo Mengozzi, achieved the most surprising scenographic effects, was carried out in 1746–7. Between 1743 and 1749 he produced the canvases for the Scuola del Carmine, Venice. At the end of 1750 he, with his sons Domenico and Lorenzo, left for Würzburg, to decorate the Residenz of Prince-Bishop Karl Philipp von Greiffenklau. Back in Venice at the end of 1753, Tiepolo frescoed the church of the Pietà (1754–5; see cat. 125), the Villa Valmarana in Vicenza (1757) and the ceiling of Villa Pisani at Stra, near Treviso (1761–2). His decorative cycles are always paralleled by a continuous production of paintings for religious and private commissions. In addition, Tiepolo was a prolific draughtsman and engraver, and his series of *Capricci* and *Scherzi* (cat. 111, 112) are masterpieces of 18th-century etching. In 1755 he was elected President of the Venetian Academy. In

June 1762 he and his sons arrived in Madrid, having been invited by Charles III to decorate rooms in the Royal Palace (see cat. 128). In 1767–9 he painted seven canvases for the church of S. Pascuale Baylon in Aranjuez; they were installed shortly after Tiepolo's sudden death in Madrid.

## 90

GIAMBATTISTA TIEPOLO
*Rinaldo and Armida in her Garden*
*c.* 1745
oil on canvas, 187 × 260 cm
The Art Institute of Chicago
Bequest of James Deering (inv. 1925.699)

This belongs to a set of four canvases in the Art Institute of Chicago which, with four others in the National Gallery, London, may have once decorated a room in Palazzo Dolfin-Manin, near Rialto (Knox, 1978); this thesis is generally accepted, although there is no evidence that they came from there (Gemin and Pedrocco, 1993, p. 356). All the paintings illustrate episodes from Tasso's epic poem *Gerusalemme Liberata* and are stylistically similar. The Christian knight Rinaldo, during the seige of Jerusalem, was abducted by the sorceress Armida to an enchanted garden, The lovers are shown in an idyllic landscape, reminiscent of the countryside of the Veneto, bathed in transparent light, gazing into one other's eyes (Rinaldo also holds up a mirror up to the enchantress), lost in their magic spell while one of the soldiers sent to rescue Rinaldo looks on.

While some critics relate the series to Tiepolo's decoration of the Villa Valmarana, Vicenza (1757), others propose they should be dated *c.* 1745 (Levey, 1963; Thomas, 1969; Knox, 1978). The scene was engraved by Lorenzo Tiepolo (De Vesme, no. 4). M.G.

*Provenance:* Count Serbelloni, Palazzo Pisani a Santo Stefano, Venice (?); Cartier collection, Genoa; Sedelmeyer, Paris; J. Deering collection, Chicago; 1925, donated to the Art Institute
*Exhibitions:* Chicago, 1938, no. 7; Venice, 1971, no. 63
*Bibliography:* Malaguzzi Valeri, 1908, pp. 178–9; Molmenti, 1909, pp. 145–6; Sack, 1910, p. 236; Morassi, 1943, p. 35; *idem*, 1955, pp. 150–1; *Paintings in the Art Institute of Chicago*, 1961, pp. 448–9; Morassi, 1962, p. 8; Levey, 1963, p. 294; Pallucchini, 1968[1], no. 221; Thomas, 1969, pp. 27–48; Knox, 1978[1], pp. 49–95; Gemin and Pedrocco, 1993, no. 289

GIAMBATTISTA TIEPOLO
*An Artist's Academy*
*c.* 1718
black and white chalks on blue paper, 41 × 54 cm
Private Collection

Until the establishment by the Venetian state of an official Academy in 1750, life-drawing was only taught in private schools of drawing. Of these, the most important at the turn of the 18th century was that run by Antonio Molinari, which was inherited by Gregorio Lazzarini on Molinari's death in 1704. In 1720 the school moved to S. Zulian, near the workshop of the newly founded Arte degli Incisori e Stampatori in Rame, and by 1722 it had been taken over by Piazzetta.

Tiepolo entered Lazzarini's studio *c.* 1710, when he was fifteen and apparently first exhibited in 1715–16 (da Canal). Although most of his early works betray the influence of Piazzetta, there is no evidence that he studied with him. Morassi's identification of this drawing as a scene in Piazzetta's studio is therefore questionable, and if Knox's date of *c.* 1718 is accepted, it would depict Lazzarini's academy. The arrangement of the room is typical of such schools, with a nude model on a platform and raised banks of seats around him. Light is provided from a strong central source, and from wall-lamps with adjustable shades. An hour-glass measures the length of pose, necessary both for the comfort of the model and the discipline of the pupils, and a line above the model's head enables him to pose with raised arms. While the disposition of forms and the strongly localised areas of shading show the influence of Piazzetta, the amusingly rounded faces and wide eyes, and the energetic fluency of line, are very much Tiepolo's own. C.H.

*Provenance:* John Postle Heseltine (cf. L. 1507–8); his sale, Sotheby's, London, 27 May 1935 (as Pitteri); Giovanni Rasini, Milan; Christie's London, 6 July 1993, no. 90
*Bibliography:* Morassi, 1971; Levey, 1986, p. 8, pl. 11; Knox, 1992, p. 211, pl. 151

GIAMBATTISTA TIEPOLO
*Alexander and Campaspe in the Studio of Apelles*
1725–6
oil on canvas, 54 × 74 cm
The Montreal Museum of Fine Arts Collection
Adaline Van Horne Bequest

The subject is taken from Pliny the Elder's,
*Natural History* (xxxv.36): Campaspe,
Alexander the Great's courtesan, was painted by
Apelles in his studio. The painter fell in love
with the young woman and Alexander gave her
to him. Tiepolo portrayed himself as Apelles
and his wife, Cecilia Guardi, as Campaspe
(Pignatti, 1951). The combination of real people
and ancient legend gives a light and playful
character to the scene, while the subdued browns
and ochres, still reminiscent of Piazzetta, contrast
with the rich and luminous tones of the figures
of Campaspe and Alexander. The painting is
dated *c.* 1725–30, at the same time as the ten
canvases for the Dolfin palace in Venice and the
frescoes for the Archbishop's palace in Udine.
The Palladian loggia in the left background is
reminiscent of Veronese, while the statue of
Hercules derives from the Farnese *Hercules*. M.G.

*Provenance:* A. Zaeslin, Basle; Sigmaringen
Museum; Schweitzer collection, Berlin; 1911,
Colnaghi, London; Van Horne collection,
Montreal; 1945, donated to the Museum
*Exhibitions:* Venice, 1951, no. 45; Chicago,
1970, no. 40; Venice, 1971, no. 18;
Birmingham, Alabama, 1978, no. 6
*Bibliography:* Molmenti, 1909, pp. 272–3; Sack,
1910, p. 193; Morassi, 1941, p. 16; Pignatti,
1951, p. 31; Morassi, 1955, p. 13; *idem*, 1962,
pp. 29–30; Pallucchini, 1968¹, no. 42; Levey,
1986, pp. 18–19; Barcham, 1989, pp. 85–7;
Gemin and Pedrocco, 1993, no. 97

93

GIAMBATTISTA TIEPOLO
*The Rape of Europa*
1720–1
oil on canvas, 99 × 134 cm
Gallerie dell'Accademia, Venice

This canvas is identical in dimensions and style
to three others, also in the Accademia, all
illustrating subjects from Ovid's *Metamorphoses*.
Given that the four paintings were all in different
collections in Belluno, it seems probable that
they originally came from a private house in that
town. Formerly attributed to Sebastiano Ricci,
Voss's attribution to Tiepolo is generally
accepted. They belong to a phase of
Giambattista's artistic development when he
began to abandon the dramatic style, typical of
his early works, in favour of a lighter palette.
This was probably due to the influence of

Sebastiano Ricci who returned to Venice in
1718; there is also an echo of Giulio Carpioni
(*c.* 1613–78), whose work Tiepolo studied at
this time. A date of *c.* 1720–1 is generally
accepted. M.G.

*Provenance:* F. Agosti collection, Belluno; 1898,
acquired by the Gallerie dell'Accademia
*Exhibitions:* Venice, 1951, no. 9; Venice, 1969,
no. 159
*Bibliography:* Voss, 1922, p. 426; Morassi, 1955,
p. 9; *idem*, 1962, pp. 53–4; Pallucchini, 1968¹,
no. 19; Moschini Marconi, 1970, pp. 107–8;
Rizzi, 1971¹, fig. 8; Nepi Sciré and Valcanover,
1985, pp. 173–4; Levey, 1986, pp. 16–18; Nepi
Sciré, 1991, pp. 242–3; Gemin and Pedrocco,
1993, no. 29

94

GIAMBATTISTA TIEPOLO
*The Martyrdom of St Bartholomew*
1722
oil on canvas, 167 × 139 cm
S. Stae, Venice

This is one of a series of twelve canvases
depicting scenes from the lives of the twelve
Apostles that were originally placed in the
central nave of S. Stae and were later moved to
the walls of the choir (Zanetti, 1733 and 1771).
The Venetian nobleman Andrea Stazio left
money in his will for a series of paintings to
decorate his parish church. He died in May
1722, and the twelve Venetian artists chosen for
the commission, who included Sebastiano Ricci
(cat. 8) and Piazzetta, painted their canvases in
the second half of that year (Moretti, 1973).
Tiepolo was the youngest of the artists.
   This is one of the key works of Giambattista's
early years, still showing the influence of
Piazzetta – whose *St James Led to Martyrdom* (cat.
70) belongs to the same series – in the dramatic
chiaroscuro that accentuates the interplay of the
figures, culminating in St Bartholomew's
outstreched arm. The figure of the executioner in
the right foreground is taken, in reverse, from the
servant in Solimena's *Rebecca and Eliezer*
(Accademia, Venice) which was in the house of
the Baglioni family in Venice for whom Tiepolo
decorated the salone of their villa at Massanzago,
near Padua. M.G.

*Exhibitions:* Florence, 1922, no. 977; Venice,
1951, no. 4; Paris, 1960–1, no. 386; Venice,
1969, no. 157; Venice, 1971, no. 7; Venice,
1983, no. 16
*Bibliography:* Zanetti, 1733, p. 440; *idem*, 1771, p.
467; Arslan, 1935–6, pp. 184, 254; Morassi,
1955, p. 8; *idem*, 1962, p. 58; Pallucchini, 1968¹,
no. 29; Moretti, 1973, pp. 318–20; Muraro,
1975, p. 59; Martini, 1982, p. 510; Levey, 1986,
p. 12; Barcham, 1989, pp. 42–3; Gemin and
Pedrocco, 1993, no. 43

GIAMBATTISTA TIEPOLO
Plates and vignettes in Francesco Scipione
Maffei, *Verona illustrata*, published in Verona by
Jacopo Vallarsi and Pierantonio Berni, vol. I,
1732; vol. II, 1731; vol. III, *Notizia delle cose in
questa città più osservabili*
*c.* 1724
etching and engraving, *c.* 41 × 54 cm (open
book), *c.* 16 × 9.3 cm (the vignettes, columns
217–6)
The British Library Board, London (inv. 181.i.)

Giambattista Tiepolo's earliest published works
were drawings of various 16th-century paintings
reproduced by Andrea Zucchi in Lovisa's
anthology, *Il gran teatro delle pitture di Venezia*,
first published in 1717. In 1724 he was
personally invited by Marchese Scipione Maffei
to make drawings of the marble sculptures in the
Galleria Bevilacqua, Verona, and of other
antiquities, for Maffei's comprehensive guide to
local history, *Verona illustrata*. This monumental
work was published in association with Jacopo
Vallarsi and Pierantonio Berno. Tiepolo
illustrated almost the whole of the third volume,
with twelve plates showing some of the Antique
pieces collected by Mario Bevilacqua (most were
sold to the Bavarian royal family early in the
19th century), the statue of Serapion from
Maffei's collection and several tailpieces. The
small statue of *Pan*, some busts of Roman
emperors, the portrait of *Livia* (more probably
Aphrodite), the *Dionysius* and a bust of *Antinous*
are still in Munich. The etching of the *Antinous*
bust was reused by the publisher Ramanzini in
1745 on the title-pate of *Merope*, by Maffei. The
engraving of the plates, almost entirely the work
of Andrea Zucchi, must have been well
advanced before the publication of the first
edition. After Zucchi moved to Dresden in 1724
the engraving was completed by his younger
brother Francesco. G.M.

*Provenance:* 1825, presented by Sir Richard Colt
Hoare, Bt
*Bibliography:* Dillon, Marinelli and Marini, in
Verona, 1985, no. 358; Pedrocco, 1985, no. 2

GIAMBATTISTA TIEPOLO
*St Jerome in the Desert Listening to the Angels*
*c.* 1732–5
pen and brown ink and brown wash,
heightened with white over black chalk, on buff
paper, 42.5 × 27.8 cm
National Gallery of Art, Washington
The Armand Hammer Collection, 1991.217.9

Da Canal noted (p. xxxii) that as early as
1715–20, when Tiepolo was working on the
frescoes at the Palazzo Baglioni, he 'had a very
fertile imagination; so that engravers and copyists
seek to make prints of his works, to capture the
strangeness and inventiveness of his ideas'. By
1743, when Pietro Monaco's *Raccolta di
cinquantacinque storie sacre incise in altrettanti rame*
was published, his presentation drawings were
widely esteemed. This collection of prints after
works by both Old Master and contemporary
artists reproduced eight drawings by Tiepolo,
which may have been made specifically for the
series, among them this drawing. The fact that
many of the works reproduced in the volume
were owned by Monaco himself has led Haskell
(1980, p. 345) to speculate that they were
intended to advertise Monaco's activities as a
dealer. Certainly, when the expanded edition of
the collection, *Raccolta di centododici stampe . . .,*
appeared in 1763, a number of the originals had
changed owners. Tiepolo's drawings form a
homogeneous group, all in his carefully finished
style of the early 1730s. Knox now believes that
the drawing he published as Tiepolo's original
(Museo Correr, Venice), is a copy by Giovanni
Raggi (1712–92).                                    C.H.

*Provenance:* Pietro Monaco (1707–72); Ann
Payne Robertson (by whom lent to The
Metropolitan Museum of Art, New York); sale,
Sotheby's, London, 26 November 1970, no. 71;
purchased by Armand Hammer Foundation;
1991 presented to the National Gallery
*Exhibitions:* Washington and Fort Worth, 1974–
5, no. 68; Los Angeles, 1976, no. 58;
Washington, 1978, no. 73; Washington, 1987,
no. 15 (with full bibliography)
*Bibliography:* Knox, 1965, no. 3 (for Monaco's
*Raccolta* and Correr version of drawing)

GIAMBATTISTA TIEPOLO
*Hercules*
1720s
black chalk, 60 × 44 cm
The Pierpont Morgan Library, New York
The Janos Scholz Collection, acc. no. 1981.108

Tiepolo's earliest surviving nude studies, such as
the seated man at Stuttgart (Stuttgart 1970, no.
1), *c.* 1720, are intensely dramatic exercises in the
*chiaroscuro* modelling of muscular figures. The

outlines are strong and shading vigorously
applied. This study of a nude posed as Hercules
is more conventionally drawn, even academic in
its regularity of hatching, and the impression
more elegant than dramatic. Nevertheless, it is
notably less rigid than the black chalk
compositional drawings, *c.* 1718, in the artist's
'engraver's manner', characterised by continuous
outlines and careful cross-hatching.

The model is posed as Hercules with the
studio props of an animal skin and club;
imaginary statues of Hercules appear in a
number of Tiepolo's early compositions, most
notably the *Rape of the Sabines* (*c.* 1722–4;
Hermitage, St Petersburg), and *Alexander and
Campaspe in the Studio of Apelles* (cat. 92).    C.H.

*Provenance:* Janos Scholz
*Bibliography:* Scholz, in New York, 1976, no.
136

GIAMBATTISTA TIEPOLO
*The Beheading of a Male and a Female Saint*
*c.* 1732–3
pen and brown ink, brown wash, heightened
with white, over black chalk, 49.8 × 36.6 cm
Lent by The Metropolitan Museum of Art,
New York
Rogers Fund (inv. 37.165.15)

Like companion sheets of the *Decapitation of SS.
Nazarius and Celsus* (Metropolitan Museum of
Art, New York; Bean and Griswold, no. 187),
and the *Martyrdom of a Saint* (private collection,
Milan; Orloff, no. 162), this drawing is closely
related in both style and subject-matter to the
fresco of the *Decapitation of St John the Baptist*,
which Tiepolo painted in the Colleoni Chapel
at Bergamo in 1732–3. These large and
impressive drawings, with their muscular figures,
steep perspective and dramatic chiaroscuro, were
clearly made as independent works. The saints
in the present drawing have been identified as
Cyprian and Justina, who were martyred at
Nicomedia in 258, and the generalised oriental
costume would seem to confirm this.           C.H.

*Provenance:* the mounter François Renaud (L.
1042); Guillaume de Gontaut, Marquis de
Biron (1859–1939); 1937, purchased in Geneva
*Exhibitions:* New York, 1938, no. 37; New
York, 1971, no. 62
*Bibliography:* Bean and Griswold, 1990, no. 188
(with full bibliography)

GIAMBATTISTA TIEPOLO
*Virgin and Child Adored by Bishops, Monks and
Women*
*c.* 1735
pen and brown ink and brown wash over black
chalk, 42.6 × 30 cm
National Gallery of Art, Washington
The Armand Hammer Collection,
1991.217.10

This is one of the most impressive sheets from an
album of drawings consisting largely of
presentation drawings, which Knox assumes
belonged to Gregory Vladimirovitch Orloff.
There is no reason to suppose that Tiepolo had
specific characters in mind for the subsidiary
figures; rather, they are representative of various
classes, both religious and lay. While the
technique is essentially the same as that of most
presentation drawings of the 1730s, the contours
are more energetically drawn, in shorter strokes of
the pen, and the washes more freely applied than
in the *St Jerome* (cat. 96), indicating a date in the
mid-1730s date for many of the Orloff drawings.
The figure on the right is an adaptation of St
Sebastian in another Orloff drawing (Orloff, no.
135), which is itself closely related to various
altarpieces of the mid-1730s ( Knox, in
Cambridge, 1970, no. 15).                     C.H.

*Provenance:* Gregory Vladimirovitch Orloff
(1777–1826); Prince Alexis Orloff; his sale,
Paris, Galerie Georges Petit, 29–30 April 1920,
no. 134; W. W. Crocker, Burlingame, CA.;
Augustus Pollack, Monterey, CA.; R.M. Light
& Co., Inc., Boston; 1971, purchased by
Armand Hammer
*Exhibitions:* Chicago, 1938, no. 47; Washington,
1974, no. 70; Washington, 1978; Washington,
1987, no. 16 (with full bibliography)
*Bibliography:* Benesch, 1947, no. 19; Mongan,
1949, pp. 106–7; Knox, 1961, no. 15

GIAMBATTISTA TIEPOLO
*The Meeting of Antony and Cleopatra*
*c.* 1745
pen and brown ink and brown wash, over a
little black chalk, 40.8 × 29.2 cm
Lent by The Metropolitan Museum of Art,
New York
Rogers Fund (inv. 37.165.10)

Between 1743 and 1747, Tiepolo painted at least
four large canvases and a number of associated
oil sketches showing *The Meeting of Antony and
Cleopatra* and *The Banquet of Cleopatra*. The
earliest was the *Banquet* (National Gallery of
Victoria, Melbourne) offered by Algarotti to
Augustus III of Saxony in 1744 and its sketch
(Musée Cognacq-Jay, Paris), which was

engraved by Pietro Monaco in 1743. There followed two sets of oil sketches, one horizontal: *The Banquet of Cleopatra* (National Gallery, London) and the *Meeting of Antony and Cleopatra* (Wrightsman Collection), and one vertical: *The Banquet of Cleopatra* (Stockholm University Art Collection) and the *Meeting of Antony and Cleopatra* (National Galleries of Scotland), which are all associated with the two great frescoes in the *salone* of Palazzo Labia, Venice. In the horizontal sketch of the *Meeting*, which takes place on the seashore, Cleopatra holds out her hand to Antony, who bows to kiss it. This graceful group was studied in the present drawing, in which the Queen of Egypt, with the disdainful air characteristic of so many of Tiepolo's grand ladies, receives the homage, booty and slaves of the Roman consul. There is a related drawing (Woodner Collection; see London, 1987, no. 32). C.H.

*Provenance:* see cat. 105, above
*Exhibition:* New York, 1971, no. 110
*Bibliography:* Bean and Griswold, 1990 no. 233 (with full bibliography); Fort Worth, 1993, under nos. 35–7

## 101

GIAMBATTISTA TIEPOLO
*The Adoration of the Shepherds*
mid-1730s
pen and brown ink with brown wash over black chalk on laid paper, 42 × 30.1 cm
National Gallery of Art, Washington
Ailsa Mellon Bruce Fund, 1982.39.1

Among the drawings by Giambattista Tiepolo reproduced in Pietro Monaco's *Raccolta* was an *Adoration of the Shepherds* (Knox, 1965, fig. 8). The model for Monaco's print has not been traced, but a number of representations of the same subject survive (e.g., Museo Civico, Bassano, and Albertina, Vienna; Knox, 1965, figs 11–12). This unpublished drawing however, is more innovative, with a boldly foreshortened shepherd standing in the foreground, and the picture-plane receding diagonally to the left. The composition is airy and spacious, and the light gently but forcefully emanates from the Christ Child. C.H.

*Provenance:* deposited by Giuseppe Maria Tiepolo in the convent of the Somaschi, S. Maria della Salute, Venice (suppressed in 1810); Conte Leopoldo Cicognara, by whom given in part-exchange for a sculpture to Antonio Canova; his half-brother Giambattista Sartori-Canova; Francesco Pesaro; 1842, purchased by Edward Cheney; his brother-in-law, Col. Alfred Capel Cure; his sale, Sotheby's London, 20 April 1885, no. 1024; E. Parsons and Sons;

P. & D. Colnaghi; Richard Owen, Paris; Mrs Vincent; by whom sold, Sotheby's, London, 6 July 1967, no. 21; John and Paul Herring; Rosenberg & Stiebel; H. Shickman Gallery, New York; 1982, purchased by the National Gallery

## 102

GIAMBATTISTA TIEPOLO
*The Immaculate Conception*
1734–5
oil on canvas, 378 × 187 cm
Pinacoteca Museo Civico di Palazzo Chiericati, Vicenza (inv. A 107)

The painting was originally placed above the right altar in the church of Aracoeli, Vicenza, opposite the *Ecstasy of St Francis* by Piazzetta (cat. 75). The altar was being built in 1732–3 (Saccardo, 1977) and Tiepolo may have painted the altarpiece in 1734, when he went to Vicenza to fresco Villa Loschi Zileri dal Verme, or immediately afterwards. There are clear stylistic similarities between these works. The *bozzetto* for this altarpiece is in the Musée de Picardie, Amiens (Gemin and Pedrocco, 1993, no. 175a). It differs from the altarpiece in several respects and is executed in a freer and more dynamic manner. In the 1760s Tiepolo painted the subject again (Prado, Madrid). M.G.

*Provenance:* church of Aracoeli, Vicenza; 1849, Carlo Clemente Barbieri; 1854, donated to the Museo Civico
*Exhibitions:* Venice, 1929, no. 1; Venice, 1969, no. 170; Vicenza, 1990, no. 1.2
*Bibliography:* Barbieri, 1962, II, pp. 234–7; Morassi, 1962, pp. 1, 11, 64; Pallucchini, 1968[1], no. 108; Saccardo, 1977, p. 12; Ballarin, 1982, p. 168; Barcham, 1989, p. 102; Rigon, 1989, p. 67; Gemin and Pedrocco, 1993, no. 175

## 103

GIAMBATTISTA TIEPOLO
*Danaë and Jupiter*
1736
oil on canvas, 41 × 53 cm
Stockholm University (inv. SU 230)

This painting was bought by the Swedish collector Count Tessin during his stay in Venice in May 1736 (Siren, 1902). It can be dated to the same year. The scene is taken from Ovid's *Metamorphoses*: Jupiter visits Danaë in the form of a shower of gold coins. Tiepolo's humourous interpretation included such details as Cupid lifting Danaë's shirt, the greedy old maid and the squabble between the god's eagle and the girl's little dog. Tiepolo achieves masterly effects in the soft and sensual treatment of the female nude.

The classical loggia in the background is a quotation from Veronese. M.G.

*Provenance:* Count Tessin; Gustav III of Sweden; Hertig Fredrich Adolf; Princess Sophia Albertina; (?) Lolotte Stenboch; Sergesteen collection; Pier Swartz; 1915, Stockholm University
*Exhibitions:* Venice, 1951, no. 45; Stockholm, 1962–3, no. 145; Venice, 1969, no. 171; Venice, 1971, no. 27
*Bibliography:* Siren, 1902, pp. 109–12; Morassi, 1955, pp. 16 and 154; Morassi, 1962, p. 49; Pallucchini, 1968[1], no. 111; Karling, 1978, pp. 233–4; Levey, 1986, pp. 70–3; Gemin and Pedrocco, 1993, no. 209

## 104

GIAMBATTISTA TIEPOLO
*The Finding of Moses*
c. 1740
oil on canvas, 202 × 342 cm
The National Galleries of Scotland, Edinburgh (inv. 92)

The canvas originally extended further to the right; a strip showing a section of the River Nile and the figure of a halberdier was cut off before 1845 and is now in a private collection, Turin (see fig. 33; Gemin and Pedrocco, 1993, no. 213; 205 × 132 cm). An old copy of the whole composition is in the Stuttgart Staatsgalerie. The rich and vibrant tonal range, the grand character of the figures and some typological details (the old maid-servant is very similar to the one in the Stockholm *Danaë and Jupiter* (cat. 103) suggest a date towards the end of the 1730s or early '40s.

Tiepolo was probably inspired by Veronese's painting of the same subject (Gemäldegalerie, Dresden), originally in Palazzo Grimani, Venice (Robertson, 1949). M.G.

*Exhibition:* London, 1931, no. 518
*Bibliography:* Molmenti, 1909, p. 263; Sack, 1910, p. 223; Morassi, 1943, p. 35; Robertson, 1949, p. 99; Morassi, 1955, p. 151; *idem*, 1962, p. 11; Pallucchini, 1968[1], no. 131; Brigstocke, 1978, pp. 142–5; Levey, 1986, pp. 77–80; Gemin and Pedrocco, 1993, no. 212

GIAMBATTISTA TIEPOLO
*Reclining River God, Nymph and Putto*
*c.* 1739–40
pen and brown ink, dark brown and lighter
brown wash, over black chalk, 23.5 × 31.3 cm
Lent by The Metropolitan Museum of Art,
New York Rogers Fund (37.165.32)

When preparing an important decorative
commission, it was Tiepolo's usual practice to
make an oil sketch of the whole composition,
and study individual figures or groups in pen
and ink drawings. One of the largest groups of
such drawings is associated with the decoration
of the Palazzo Clerici in Milan, where Tiepolo
worked in 1739–40. They are rapidly sketched
in black chalk, and refined in pen and brown
ink and luminous golden wash. These figures of
a grizzled river-god lovingly embracing a nymph
appear at the bottom of the *modello* for the ceiling
of the Palazzo Clerici (cat. 107), save that in the
*modello*, the putto has moved slightly to the right,
and the river-god reclines more comfortably on a
red drapery rather than on a cold, wet cloud.
Unlike many details, this group was
incorporated almost directly into the final fresco,
but, whereas in the sketch, it represented the
River Nile, in the fresco, it became merely an
unidentifiable river.                               C.H.

*Provenance:* (?)deposited by Giuseppe Maria
Tiepolo in the convent of the Somaschi, S.
Maria della Salute, Venice (suppressed in 1810),
as part of the album *Vari Pensieri T: I* [*Tomo
Primo*]:, the greater part of which is now in the
Fondazione Horne, Florence; Guillaume de
Gontaut, Marquis de Biron (1859–1939); 1937,
purchased in Geneva
*Exhibitions:* Chicago, 1938, no. 70; New York,
1938, no. 45; New York, 1971, no. 87
*Bibliography:* Freeden and Lamb, 1956, pl. 44;
Bean and Griswold, 1990, no. 199; Fort Worth,
1993, under no. 20

106

GIAMBATTISTA TIEPOLO
*Apollo Standing in his Chariot*
*c.* 1739–40
pen and brown ink, pale and dark brown wash,
over black chalk, 24.2 × 24.3 cm
Lent by The Metropolitan Museum of Art,
New York Rogers Fund (inv. 37.165.35)

At the time of the preparations for the decoration
of the Palazzo Clerici, Tiepolo's powers of
invention were at their height, and he poured
forth innumerable ideas for all parts of the
composition. In the oil sketch of *The Course of
the Chariot of the Sun* (cat. 107) and two other
drawings in the Metropolitan Museum of Art
(Bean and Griswold, 1990, nos. 192–3), Apollo

is seen *di sotto in su*, holding his lyre and
supported by nymphs and putti. Tiepolo
subsequently changed the composition
completely, probably working it out in another
oil sketch, and Apollo eventually appeared,
driving his chariot across the heavens. This
drawing was made at an intermediate stage
between the sketch and the fresco, and shows
Apollo as the sun-god carrying a torch and
urging his horses forward.                          C.H.

*Provenance:* see cat. 105, above
*Exhibitions:* New York, 1938, no. 41; New
York, 1971, no. 77
*Bibliography:* Bean and Griswold, 1990, no. 194
(with full bibliography)

107

GIAMBATTISTA TIEPOLO
*The Course of the Chariot of the Sun*
1740
oil on canvas, 63 × 99 cm
Kimbell Art Museum, Fort Worth, TX
(inv. AP 1985.04)

This is the *modello* for the ceiling of the main
*salone* of Palazzo Clerici, Milan. The fresco was
commissioned by Marchese Giorgio Antonio
Clerici, who was refurbishing his palace before
his marriage to Fulvia Visconti, planned for
1741 (Gemin and Pedrocco, 1993). The dating
of the fresco to 1740 is confirmed by several
contemporary sources, among them a collection
of poems dedicated to Tiepolo 'on the occasion
of his stay in the house of H.E. the Marchese
Giorgio Clerici in the year 1740'. The *modello*
differs in several respects from the final fresco,
probably because the artist was unaware of the
actual size of the *salone*, which is barrel-vaulted
and extremely long. In the present canvas the
chariot of the Sun appears in the centre,
surrounded by the Olympian gods, while on the
ceiling (fig. 35) Tiepolo added the Four
Continents and illusionistic architectural
elements. The *modello*, however, already has a
rich and luminous chromatic range.              M.G.

*Provenance:* Groult collection, Zurich;
Hausamann collection, Zurich
*Bibliography:* Molmenti, 1909, pp. 136–44 and
258; Sack, 1910, pp. 78 and 168–9; Morassi,
1943, p. 24; Pignatti, 1951², pp. 58–67; Morassi,
1955, pp. 145–6; *idem*, 1962, pp. 25 and 69;
Pallucchini, 1968¹, no. 132a; Precerutti Garberi,
1971, pp. 38–44; Levey, 1986, pp. 91–8;
Barcham, 1989, p. 208; Gemin and Pedrocco,
1993, no. 237a

GIAMBATTISTA TIEPOLO
Headpiece and tailpiece in John Milton, *Paradiso
perduto*, published Paris (actually Verona) by
Gian Alberto Tumermani, *c.* 1740 for the
headpiece, Canto X; *c.* 1737 for the tailpiece p.
122
etchings, *c.* 37.2 × 52 cm (open book),
12.8 × 16.2 cm (headpiece Book X), 13 × 11.9
cm (tailpiece, Book IV)
The British Library Board, London (inv.
11626.K.5)

Paolo Rolli's successful blank-verse translation of
Milton's *Paradise Lost* went into many editions;
of these this sumptuous folio edition published
by Gian Alberto Tumermani must be the most
elaborate. Tumermani, who had been working
in Verona since 1726, had the illustrations
engraved in Venice by Francesco Zucchi (1692–
1764) after drawings by a variety of
contemporary artists; the title-page (bearing the
*Istruzione di Adamo*) was designed by Piazzetta,
while other illustrations are by Balestra, Mela,
Piatti, Crosato, Cignaroli and Tiepolo. Each
book is introduced by a vignette surrounded by
an elaborate Rococo frame designed by Antonio
Visentini with iconographic details echoing the
subject of the main picture; these details were
probably not included in the previous
Tumermani edition of *Paradise Lost*, published in
two octavo volumes in 1740. The vignettes alone
were copied by Antonio Baratta (accurately,
though he did not achieve the same quality) for
the edition published by Bartolomeo Occhi
ostensibly published in Paris (really in Venice)
in 1758. Giambattista Tiepolo's drawing, now
lost, for the allegory of *La morte e il peccato*
(Death and Sin), used to illustrate Book X, adds
a touch of exuberance. As a tailpiece to Book X
the publisher used the plate engraved by Zucchi
showing *Dorinda che accarezza il cane* (Dorinda
caressing the dog), used previouly to illustrate
Act II, Scene ii of the tragi-comedy *Il Pastor
Fido* by Giovan Battista Guarini, also published
by Tumermani in Verona in 1737. It bears little
relation to Milton's text.                          G.M.

*Bibliography:* Morazzoni, 1943, p. 243;
Lánckoronska, 1950, no. 160; Gasparrini
Leporace, in Venice, 1955, p. 25; Pallucchini,
1956, p. 60; Knox, 1983, no. 73; Pedrocco, in
Venice, 1983, no. 109; Perosa, in Venice, 1983,
no. 140; Pedrocco, 1985, no. 6

GIAMBATTISTA TIEPOLO
*The Adoration of the Magi*
*c.* 1753
etching, 43.1 × 29 cm (platemark)
National Gallery of Art, Washington
Rosenwald Collection, 1959.16.14

This is Tiepolo's largest etching. Most scholars have agreed to date it *c.* 1753 because of its similarities to his altarpiece of the same subject painted for the Benedictine Church of Schwarzach, signed and dated 1753 (Alte Pinakothek, Munich), and also on the basis of stylistic and technical similarities to the series of etchings, the *Scherzi* (cat. 112). Rizzi, however, dates the print to *c.* 1740, thus placing the altarpiece after the etching. The *terminus ante quem* for the etching is 1757, the year it was listed in the artist's inventory. Three drawings have been connected with the etching, although none is stricly a preparatory study ( Metropolitan Museum of Art, New York; Achenbach Foundation for Graphic Arts, San Francisco; The Cleveland Museum of Art). All are fairly finished studies, showing that Tiepolo probably had been experimenting with the subject for some time before conceiving the etching.

Tiepolo's debt to Veronese is evident when the composition is compared to Veronese's painting of the same subject in the National Gallery, London. This print is exceptional for Tiepolo because of its remarkable size, the traditional religious subject of the plate as opposed to the capricious themes of Tiepolo's printed *œuvre*, but especially because of the complexity of the composition. Basan (1767) considered this to be Giambattista's masterpiece in etching.                                                    O.T.

*Provenance:* G. Zanetti the Elder, Venice; possibly Baron D. Vivant-Denon, Paris (Lugt, 779–80); A. Caironi, Milan (Lugt, 426); Pierre Berès, Paris; 1951, Lessing J. Rosenwald; gift to the National Gallery of Art
*Exhibition:* Washington 1972, no. 41
*Bibliography:* Basan, 1767, p. 46; De Vesme, 1906, p. 382, no. 1; Pignatti, 1965[1], 1; Rizzi, 1971, no. 27; Venice and Gorizia, 1983, pp. 354–81; Gorizia, 1985, no. 69

GIAMBATTISTA TIEPOLO
*Sculpture of Rinaldo and Armida* and *A Bearded Elderly Figure with Two Dogs*, in *Vari Studi e Pensieri*, album bound *c.* 1761
pen and wash, 21.4 × 29.2 cm and 28.2 × 18.4 cm; *c.* 37 × 23.5 cm (album)
The Board of Trustees of the Victoria and Albert Museum, London (inv. 99A5)

When Giambattista Tiepolo left Venice for Spain in 1762, he left behind the majority of his drawings, which were bound up into volumes. Some appear to have been entrusted to Tiepolo's patron Count Algarotti, like this one, lettered *Vari Studi e Pensieri T: I:* ['*Tomo Primo*'] on its spine. It consists of working drawings, almost all in pen and ink and wash. They range from slight scribbles to complete compositional studies for important commissions, and in date from the *Apollo and Marsyas* for the Palazzo Sandi of 1725 (now in the Villa dei Conti da Schio at Castelgomberto), right up to a brief sketch for the ceiling of the throne room in the Royal Palace at Madrid, which Giambattista and his assistants painted in 1762–4. The most numerous group is related to the two series of etchings by Giambattista, *Scherzi di Fantasia* and *Capricci* (cat. 111, 112).

The drawing of Rinaldo and Armida dates from autumn 1743, when Tiepolo was working for the distinguished lawyer Carlo Cordellina at his villa near Montecchio Maggiore, west of Vicenza. In addition to painting the frescoes in the main *salone*, the *Continence of Scipio* and the *Family of Darius before Alexander* on the walls, and *Glory and Virtue* on the ceiling, Tiepolo provided designs for the garden sculpture, which was executed in marble by Giacomo Cassetti (1682–1757), a pupil and son-in-law of the Vicentine sculptor Orazio Marinali. Cassetti made at least two groups from Tiepolo's designs, *Jupiter and Juno*, for which the album contains designs for single figures, and *Rinaldo and Armida*, for which this drawing and another (Knox, 1975, no. 74) survive.

The drawing of the old man with two dogs seated on a cloud may, like another of the *Vari Studi* (Knox, 1975, no. 81), be a very early study for the group of Pluto and Proserpina in the ceiling fresco in the Palazzo Labia, executed in the mid-1740s. The underdrawing in the other study suggests that Tiepolo's original idea was to show Venus and Vulcan, an idea quickly abandoned in favour of the single male figure and accompanying dogs.                              C.H.

*Provenance:* Count Francesco Algarotti; his brother, Count Bonomo Algarotti (d. 1776); his daughter Elisabetta, Contessa Corniani; her son, Count Bernardino Corniani-Algarotti; by whom sold to Edward Cheney (1803–84), 1852; his brother-in-law, Col. Alfred Capel Cure;

sale, Sotheby's, London, 29 April 1885, lot 1024; E. Parsons and Sons; 1885, purchased by the Museum
*Bibliography:* Knab, 1960, p. 143; Knox, 1975[1], nos. 75, 82

GIAMBATTISTA TIEPOLO
*Vari Capricci*
(?) early 1740s
volume of etchings open to show *Death Giving Audience* and *Prisoner with Figures Regarding a Pyre*, *c.* 48 × 70 cm (open book)
Staatliche Kunstsammlung, Dresden, Kupferstichkabinett (inv. B 639. 3)

The set comprises ten etchings signed by Giambattista. Although the subject-matter has been connected to contemporary interest in alchemy and the occult, it seems more likely that the set belongs to the tradition of *capricci*, or fantasies, favoured in the 17th century by Stefano della Bella, Jacques Callot and G. B. Castiglione and translated by Tiepolo into his own idiom; the tradition was later continued by G.B. Piranesi and by Goya. Etching was probably a relaxing activity for Tiepolo, and the compositions reflect the ease and invention of the artist free from pressure from patrons.

This exceptionally fine and early album, one of the masterpieces of 18th-century Venetian graphic art, was once in the collection of Zanetti the Elder, and bears his coat of arms on the binding. A number of drawings have been connected with the *Capricci*, from quick sketches to more finished compositions. The set has been dated either to 1745–9 (Knox) or 1735– 40 (Rizzi), after the completion of the *Scherzi*. Other writers, including Russell, have suggested that Tiepolo completed the *Capricci* in the early 1740s before starting the *Scherzi*. This dating would seem to be confirmed by the fact that the series, of which only one state is known, was first published in 1743 and again in 1749, when it was included in the second volume of the second and third editions of Zanetti the Elder's *Raccolta di varie stampe*. Zanetti acted as Tiepolo's mentor in his printing venture. The *Capricci* were published again, for the last time, in 1785, with the addition of a title-plate designed by G. dal Pian and dedicated to the Venetian patron and collector Gerolamo Manfrin.                          O.T.

*Provenance:* Gerolamo Zanetti the Elder, Venice; Kupferstichkabinett, Dresden
*Bibliography:* De Vesme, 1906, nos. 9–10; Knox, 1966, pp. 585–6; Rizzi, 1971[2], nos. 35–6; Washington, 1972, nos. 7 and 8; Venice and Gorizia, 1983, nos. 509, 516; Venice, 1988, nos. 42, 71; Turin, 1988, pp. 275–82

GIAMBATTISTA TIEPOLO
*Scherzi di fantasia*
(?) 1750s
etchings in a folio, with additions in pen and
brown ink, 37 × 53.5 cm (open book)
National Gallery of Art, Washington
Rosenwald Collection, 1951.16.68–101

Giambattista's printed *œuvre* consists of 35
etchings, all but two included in the *Scherzi* and
the *Capricci* series. The dating of the two sets is
still the subject of debate. Opinions on the
precedence of one series over another depends on
one's perception of Tiepolo's artistic development
(Russell, in Washington, 1972). While Knox
sees Giambattista developing into the stylistic
freedom of the *Capricci*, others have seen the
*Scherzi* as a more complex and disciplined
approach to etching. Unlike the *Capricci* it seems
that the *Scherzi* was not marketed commercially
during the artist's lifetime, with a few exceptions
such as this proof set from Zanetti's library and a
set presented to Pierre Mariette. Eight years after
his father's death in 1778, Domenico published
fourteen plates of the *Scherzi*, the two loose
etchings of *St Joseph* and *The Adoration*, together
with some of his own prints. He later published
the set again, including all 23 *Scherzi* and the
two loose etchings, but not his own prints. From
recently published documents it appears that
Giambattista was still working on the plates in
1758, and it is possible that work on the set
spanned several years. This is also confirmed by
the diversities in style found within the plates of
the *Scherzi* and by the considerable number of
surviving drawings, from quick sketches to more
finished compositions, connected to this set.

The *Scherzi* seem to belong to the *Capriccio*
genre favoured by etchers such as G. B.
Castiglione, Jacques Callot and Salvator Rosa
in the previous century. The two plates shown
here of *Two Orientals Conversing with Punchinello*
(De Vesme, no. 21) and *A Young Mother
Conversing with an Oriental* (De Vesme, no. 27)
include many exotic characters that appear
throughout the *Scherzi*, some taken from the
*commedia dell'arte*, but also children, animals and
scantily dressed, beautiful men and women. The
iconography of the series is still a mystery: the
plates do not have any obvious narrative or
specific order. One (unconvincing) suggestion is
that they allude to the Inquisition's condemn-
ation of witchcraft. Most probably these etchings
are the fruit of Tiepolo's *'invenzione'*.          O.T.
*Provenance:* G. Zanetti the Elder, Venice;
Rosenwald Collection
*Exhibition:* Washington, 1972, nos. 23, 29
*Bibliography:* De Vesme, 1906, nos. 21 and 27;
Rizzi, 1971², nos. 12 and 18; Venice and
Gorizia, 1983, pp. 354–81; Gorizia, 1985, nos.
56 and 60

GIAMBATTISTA TIEPOLO
*St James the Great Conquering the Moors*
1749
oil on canvas, 317 × 163 cm
Szépművészeti Muzeum, Budapest (inv. 649)

Legend has it that St James appeared at the
Battle of Clavijo in 844 to help the Spaniards in
their fight against the Moorish invaders. This
was the first victory for the Spanish Christians
against the conquerors of the Iberian Peninsula,
and was the start of the *Reconquista* of Spain; St
James the Great was later adopted as patron
saint of the country.

The painting was commissioned by Richard
Wall, Spanish Ambassador in London, for the
chapel in the Spanish Embassy. It was painted
in Venice before Tiepolo left for Würzburg, and
warmly received – Doge Grimani saw it –
before travelling to London. Wall and the
Embassy chaplains were afraid the horse might
cause a scandal; in any case the painting did not
fit the chapel. In addition the ambassador
thought it might be more appropriate to have it
painted by a Spanish artist; he suggested that
Tiepolo's painting be presented to the King of
Spain and this seems to have happened.

The choice of St James was appropriate for
the altar of the Embassy's chapel in London, the
capital of a rival 'heretic' empire. Tiepolo
presented him as a fearless Christian warrior
mounted on a white charger, suggestive of the
triumph and glory of the Catholic Church. The
substitute altarpiece, by Preciado de la Vega,
more conventionally showed St James as a
pilgrim; its sketch is in the Prado.

A chalk drawing of the Saint's head, also in
Budapest, has been attributed both to
Giambattista and to Domenico, but, given the
marked difference of the expression of the face
from that of the print by Domenico, we are
inclined to believe the study is by Giambattista.
The painting anticipates later developments in
Tiepolo's style, and combines a decorative
quality, with a certain objectivity, characteristics
that have not usually been attributed to Tiepolo
before he went to Würzburg. The painting has
an original Venetian Rococo frame.          I.B.

*Provenance:* 1749, commissioned by Ambassador
Ricardo [Richard] Wall, for the chapel of the
Spanish Embassy in London; by 1751, Spanish
Royal Collections (?); during the Napoleonic
Wars probably purchased in Madrid by
Edmund Bourke, ambassador of Denmark;
London; William Buchanan sale, 1 June 1816,
lot 49 (probably put up by Bourke); European
Museum sale, London, March 1819, lot 590
(put up by Bourke); bought by Prince Esterházy
with the second lot of Bourke's collection, from
his widow in Paris: inventoried 5 December
1821, no. 1082; 1870, bought by the Hungarian

Government with the entire Esterházy
Collection. Together with the rest of the
collection, the canvas was rolled up to be taken
to Germany; in February 1945, it was found
lying in the snow on the Hungarian border
*Exhibition:* 1974, Budapest, p. 25
*Bibliography:* Pigler, 1967, p. 687; Pallucchini,
1968¹, no.241; Garas, 1977, nos. 15–16; Pérez
Sánchez, 1977; Levey, 1986, pp. 167–70

GIAMBATTISTA TIEPOLO
*Apollo Pursuing Daphne*
1758–60
oil on canvas, 68.8 × 87.2 cm
inscribed bottom left corner: *'Gio.B.Tiepolo'*
National Gallery of Art, Washington
Samuel H. Kress Collection, 1952.5.78

The subject is taken from Ovid's *Metamorphoses*
(I:452ff): the nymph Daphne seeks refuge from
Apollo with her father, the river-god Peneus,
but is transformed into a bay-tree.

This canvas was one of two overdoors in the
Gsell collection, Vienna (Sack, 1910; Morassi,
1962); the other is *Venus in Vulcan's Forge*
(Johnson collection, Philadelphia; Gemin and
Pedrocco, 1993, no. 478). The pair has been
related to the Valmarana frescoes (1757), and
therefore a date around 1758–60 seems probable
(Morassi; Pallucchini,1968). There are
similarities between Apollo and Daphne and the
Olympian gods, in particular Apollo and
Diana, in the Foresteria of the Villa Valmarana,
while the old river-god is quite close to the figure
of Time in cat. 126 (Gemin and Pedrocco,
1993).          M.G.

*Provenance:* Gsell collection, Vienna; Kann
collection, Paris; Mme Delaney, Paris; 1933,
Charpentier's sale, Paris; Pierre Louth, Paris;
Charpentier's sale, Paris, 1950; Rosenberg and
Stiebel's, New York; 1950, Kress collection
*Exhibition:* Birmingham Alabama, 1978, no. 18
*Bibliography:* Sack, 1910, p. 233; Venturi, 1933,
no. 593; Morassi, 1952, p. 92; Morassi 1955, p.
156; Morassi, 1962, p. 67; Pallucchini, 1968¹,
no. 253; Rusk and Shapley, 1979, pp. 449–50;
Gemin and Pedrocco, 1993, no. 479

GIAMBATTISTA TIEPOLO
*Head of an Oriental*
*c.* 1760
red chalk washed with water on white paper,
28.5 × 20.5 cm
Fogg Art Museum, Harvard University Art
Museum, Cambridge, MA
Francis H. Burr Memorial Fund (inv. 1946.52)

Domenico Tiepolo's *Raccolta di teste* comprised
two volumes of 30 etchings after paintings and
drawings by his father. The dates of
Giambattista's models range from the 1740s to
the 1760s, and included isolated figures from
history paintings as well as compositions, both
drawn and painted, of single heads.

The tradition for such etchings began with
Rembrandt in the 1640s, and continued with
thirteen *Varie teste di capricci* by Johann Heinrich
Schönfeld (1609–82). The most important
model, however was G.B. Castiglione, who had
etched two series, *Les Petites têtes d'hommes coiffées
à l'orientale* and *Les Grandes têtes d'hommes coiffées à
l'orientale* (Bartsch, XXI, nos. 32–53), in the
1650s. Castiglione also made a monotype of a
bearded oriental in a rich turban that Domenico
Tiepolo gave to Algarotti, who passed it to
Count Brühl (it was probably another
impression of the monotype at Windsor; Blunt,
no. 217).

This head is unusual in size, in the technique
of washing red chalk with water (most of
Giambattista's fantastic heads are in pen and
ink), and in expressive power. Like another
example (ex-Federico Gentili, Paris; Brizio, pl.
17), which is similar in technique and
composition, it depended less on reality and
artistic antecedants than on Tiepolo's
extraordinary imagination.                    C.H.

*Provenance:* deposited by Giuseppe Maria
Tiepolo in the convent of the Somaschi, S.
Maria della Salute, Venice (suppressed in 1810);
Conte Leopoldo Cicognara, by whom given in
part exchange for a sculpture to Antonio
Canova; his half-brother Giambattista Sartori-
Canova; Francesco Pesaro; purchased by
Edward Cheney (1803–84), 1842; his brother-
in-law, Col. Alfred Capel Cure; sold
Sotheby's, London, 20 April 1885, no. 1024; E.
Parsons and Sons; P. & D. Colnaghi; Richard
Owen; 1931, Philip Hofer; from whom
purchased
*Exhibitions:* New York, 1938, no. 50;
Cambridge, 1970, no. 94
*Bibliography:* Sack, no. 164; Millier, pl. 17;
Knox, 1970, no. II, 11

GIAMBATTISTA TIEPOLO
*Head of St Agatha*
*c.* 1750
red and white chalks on bright blue paper,
26.8 × 17.5 cm
Staatliche Museen Preussischer Kulturbesitz,
Kupferstichkabinett, Berlin

Tiepolo's usual working practice when painting
the numerous altarpieces with saints in the 1750s
was to make studies of the heads, hands, feet and
draperies of the principal figures in red and white
chalks on blue paper, and a *modello* of the whole
composition in oils. This drawing is a study for
the head of the Saint in the altarpiece of *The
Martyrdom of St Agatha* (*c.* 1756; cat. 117).
Compared with another drawing for the same
head (also in Berlin; Knox, 1980, no. M22), it
is notably successful in capturing the martyr's
mood of resignation.                    C.H.

*Provenance:* Johann Dominik Bossi (1767–1853;
reputedly a pupil of Domenico); his daughter,
Maria Theresa Caroline Bossi (1825–81), and
son-in-law, Karl Christian Friedrich Beyerlen
(1826–81); sale, H.G. Gutekunst, Stuttgart, 27–
8 March 1882; 1955, purchased from a private
collection, Frankfurt am Main (KdZ 24626)
Exhibition: Berlin, 1973, no. 151a
*Bibliography:* Knox, 1980, no. M41

GIAMBATTISTA TIEPOLO
*Martyrdom of St Agatha*
*c.* 1755
oil on canvas, 184 × 131 cm
Staatliche Museen Preussischer Kulturbesitz,
Berlin, Gemäldegalerie

The altarpiece was painted for the Benedictine
nuns' church of S. Agata in Lendinara (near
Rovigo). The canvas was originally arched at
the top, as shown in its engraving by Domenico
Tiepolo (Succi, 1988, no. 74, pp. 174–5). The
painting has been variously dated *c.* 1750
(Molmenti; Lorenzetti), 1755–60 (Pignatti,
1951), 1754–7 (Knox, 1979), and *c.* 1755, on
the basis of stylistic similarities with the *S. Tecla*
altarpiece at Este (Gemin and Pedrocco, 1993,
no. 486). Tiepolo had painted the same subject
twenty years earlier in the Basilica del Santo in
Padua, but in the present altarpiece, dominated
by the central figure of the martyr with her
upturned face, while her servant mercifully
covers her mutilated chest, he achieves a supreme
dramatic tension that the earlier version lacks.

A preparatory sketch of the hands of the boy
holding the platter is in the Correr Museum,
Venice, while a drawing of the Saint's head is in
the Berlin Kupferstichkabinett (cat. 116).    M.G.

*Provenance:* church of S. Agata, Lendinara;
Munro collection, London; 1878, acquired by
the Berlin museum
*Exhibition:* Venice, 1951, no. 81 *bis*
*Bibliography:* Brandolese, 1795, pp. xxiii–xxiv;
Molmenti, 1909, p. 264; Sack, 1910, p. 183;
Morassi, 1943, p. 32; Lorenzetti, 1951; Pignatti,
1951, p. 134; Morassi, 1962, p. 4; Pallucchini,
1968[1], no. 198; Frerichs, 1971, p. 237; Knox, in
Venice, 1979, p. 96; Succi, 1988, p. 174;
Gemin and Pedrocco, 1993, no. 431

GIAMBATTISTA TIEPOLO
*The Last Communion of St Lucy*
1748–50
oil on canvas, 222 × 101 cm
SS. Apostoli, Venice

The altarpiece comes from the Corner chapel in
SS. Apostoli, for which it was painted. The
roof of the church collapsed in 1748 and
rebuilding lasted several years. Barcham (1989)
proposes that *St Lucy* was painted between 1748
and the autumn of 1750 when Tiepolo departed
for Würzburg. The *bozzetto* for the altarpiece
(Civiche Raccolte d'Arte, Milan; see Molmenti,
1909) differs from the final version, but the
overall composition is the same, and the classical
architecture, reminiscent of Veronese, appears as
a backdrop in both canvases. The man kneeling
behind St Lucy's attendant has been identified as
the Procurator Nicolò Corner, and the boy at
the back as Nicolò's son Giulio, a future
Venetian senator (Merkel). The altarpiece,
which has recently been restored, has always
been praised for its luminous colours,
harmonious composition and moving portrayal
of the dying saint.                    M.G.

*Exhibitions:* Venice, 1951, no. 68; Venice, 1971,
no. 55; Vicenza, 1993, no. 15
*Bibliography:* Molmenti, 1909, p. 66; Sack, 1910,
pp. 92, 157; Fogolari, 1913, p. 26; Orlandini,
1914, p. 43; Pignatti, 1951[2], p. 84; Morassi,
1962, pp. 24 and 55; Pallucchini, 1968[1], no.
171; Barcham, 1989, pp. 202–6; Merkel, 1993,
p. 87; Gemin and Pedrocco, 1993, no. 385

**119**

GIAMBATTISTA TIEPOLO
*Roofs and Chimneys of Country Houses*
*c.* 1759
pen and brown ink and brown wash,
17.5 × 24.3 cm
Lent by the Syndics of the Fitzwilliam Museum,
Cambridge (PD.27–1959)

**120**

GIAMBATTISTA TIEPOLO
*Gateposts and Outbuildings of a Villa*
*c.* 1759
pen and brown ink and brown wash, 14 × 25.1
cm
Lent by the Syndics of the Fitzwilliam Museum,
Cambridge (PD.30–1959)

Between August and late September 1759,
Giambattista and Domenico Tiepolo were at
Udine painting frescoes and an altarpiece for the
Oratorio della Purità. As a diversion from his
work, Giambattista made a group of landscape
drawings in pen and wash of villas and farms in
the surrounding countryside. Like these
characteristic examples, they evoke the heat and
dramatic shadows of an Italian summer.
Individual architectural elements, such as
chimneys and gateposts, are seen from close
viewpoints and unexpected angles, and many of
the drawings were made from rooftops or
upstairs windows. Only one of the drawings
shows an identifiable building, the Duomo at
Udine (Fitzwilliam, Cambridge; Knox, 1973,
no. 50). Unfortunately, Tiepolo incorporated
none of this material into his paintings, although
the view of Este in the S. Tecla altarpiece (1758;
S. Tecla, Este) indicates what he might have
achieved in this field.      C.H.

*Provenance:* perhaps from an album of landscape
drawings; (?) Count Bernardino Corniani-
Algarotti; (?) Edward Cheney (1803–84); his
brother-in-law, Col. Alfred Capel Cure; (?)
sold Sotheby's, London, 20 April 1885, no.
1024; G.J.F. Knowles, by whom bequeathed,
1959
*Exhibition:* Venice, 1992, no. 75
*Bibliography:* Udine, 1965, nos. 106; Knox,
1973, nos. 48, 51

**121**

GIAMBATTISTA TIEPOLO
*Punchinello Lying on the Ground*
*c.* 1760
pen and brown ink and brown wash over pencil
on white paper, 16.6 × 16 cm
inscribed: '*18*'
Mr and Mrs Eugene V. Thaw

Giambattista Tiepolo was evidently fascinated by
the figure of Punchinello, and between *c.* 1735
and *c.* 1762 he made at least 22 drawings and
two paintings showing his antics. This drawing
illustrates Punchinello at the time of the *Venerdi
gnoccolare*, a Veronese festival held on the last
Friday in Carnival, devoted to eating vast
quantities of gnocchi and drinking gallons of
wine. Here, we see Punchinello flat on his back,
from a vantage-point below the soles of his feet,
sleeping off the effects of over-eating. In other
drawings in the series Tiepolo illustrates the
inevitable consequences of this gross self-
indulgence (Museo Correr; Venice, 1963, no.
85; Knox, 1984, fig. 18).
    This drawing was engraved in aquatint by the
Abbé Richard de Saint-Non, who had no
doubt seen it when he visited Algarotti in
Venice in 1761, among his collection of '*les plus
belles polichinelles du monde de notre célèbre
Tiepoletto*'.      C.H.

*Provenance:* probably Francesco Algarotti; Dan
Fellows Platt; Kleinberger; Seligman, Rey
(1938); A.A. Mitchell; Komor
*Exhibitions:* Cambridge, 1970, no. 86; New
York, 1975, no. 48; Birmingham and
Springfield, 1978, no. 69
*Bibliography:* Byam Shaw, 1962, p. 54, n. 2;
Knox, 1984, p. 443

**122**

GIAMBATTISTA TIEPOLO
*A Venetian Lawyer at his Desk*
*c.* 1760
pen and black ink with grey wash, 20.5 × 14 cm
National Gallery of Art, Washington
Julius S. Held Collection, Ailsa Mellon Bruce
Fund, 1984.3.67

One of Tiepolo's diversions in later life was to
make caricatures, usually of single figures, in pen
and ink. 106 of these were collected in an album
lettered '*Tomo Terzo di Caricature*' (implying the
existence of at least two further albums). The
majority of these drawings are of standing men,
often seen from behind, tall or small, portly or
skinny, wearing voluminous clothes, odd hats
and wigs and bizarre expressions. Some,
however, show seated figures engaged in reading
and writing, but, as in the Punchinello series, it
is the figures rather than their occupations that
are amusing. Apart from those formerly in this

album, there are eight comparable caricatures in
the Morelli Collection in Milan (Bora, nos. 89–
92).      C.H.

*Provenance:* Domenico Tiepolo; (?) sold to
Count Bernardino Corniani-Algarotti; (?) by
whom sold to Edward Cheney (1803–84), 1852;
his brother-in-law, Col. Alfred Capel Cure;
sale, Sotheby's, London, 29 April 1885, lot
1024; Marquess of Breadalbane, Langton House,
Duns, Berwickshire; sale, Dowells, Edinburgh,
25 March 1925, no. 1004; purchased by John
Grant, bookseller, Edinburgh; purchased by
Arthur Kay, Edinburgh, *c.* 1926; his sale,
Christie's London, 8–9 April 1943, probably
part of no. 248 (as 'a man, seated at a table,
writing'); Frederick Stern; Julius Held, from
whom purchased 1984
*Exhibitions:* Held Collection, 1970, no. 135;
Binghamton et al., 1970, no. 26; Williamstown,
1979, no. 134

      C.H.

**123**

GIAMBATTISTA TIEPOLO
*Seated Male Nude Seen from Behind*
*c.* 1752–3
red and white chalks on bright blue paper,
34.4 × 28 cm
Graphische Sammlung, Staatsgalerie Stuttgart

This is one of a group of eleven studies of male
nudes at Stuttgart, which are stylistically related
to the decorations in the Würzberg Residenz,
where Tiepolo worked between early 1752 and
November 1753. Although this robust figure
does not correspond directly with any in the
frescoes, it is similar to the pair of nudes seen
from the back in the lower part of the ceiling of
the Kaisersaal, one of whom wears rushes in his
hair (Freeden and Lamb, pls. 75–6). Compared
with the *Hercules* (cat. 97), the drawing is free
and economical, with shading drawn lightly and
rapidly, and highlights indicated only briefly.
      C.H.

*Provenance:* see cat. 116, above; sale H.G.
Gutekunst, Stuttgart, 27–8 March 1882, when
purchased (inv. no. 1452).
*Exhibitions:* Stuttgart 1953, no. 25; Stuttgart,
1970, no. 99
*Bibliography:* Molmenti, p. 241; Sack, no. 280;
Hadeln, 1927, no. 121; Freeden and Lamb,
1956, pls. 75–6; Knox, 1980, no. M372

GIAMBATTISTA TIEPOLO
*An Allegory with Venus and Time*
*c.* 1754–7
oil on canvas, 292 × 190 cm
The Trustees of the National Gallery, London
(inv. 6387)
This canvas, with four grisaille allegorical
roundels (Bute House, London), once decorated
the ceiling of Palazzo Contarini, Venice. On 21
June 1758 Domenico Tiepolo sent his etching of
the present work to Mariette, with a letter saying
that it represented '*il parto di Venere, e le Grazie in
Ca' Contarini*' (Frerichs, 1971). The canvases
were probably removed at the end of 1855, when
the contents were put up for sale and seen by
Otto Mundler, a travelling agent for London's
National Gallery (Levey, 1971). While the
subject has generally been identified as Venus
handing Cupid to Time, Levey suggests that
Venus's new-born son might be Aeneas, not
Cupid (who is winged), being handed over to
Time, who here symbolises immortality. Above,
the Three Graces celebrate the birth. The scene
might refer to the birth of an heir in the patrician
family who commissioned the decoration.

A drawing in the Metropolitan Museum of
Art, New York (Bean and Griswold, 1990, no.
211), which shows a different composition of the
same subject, could be related to the Ca'
Contarini ceiling.

While Levey dates the canvas to 1754,
immediately after Tiepolo's return from
Würzburg, Succi, followed by Gemin and
Pedrocco, date it just before Domenico's etching
of 1758, and compare it to the frescoes in the
Villa Valmarana, Vicenza, of 1757.          M.G.

*Provenance:* Palazzo Contarini, Venice; 1876,
Bischoffsheim collection, Bute House, London;
*c.* 1923, house acquired by the Egyptian (later
United Arab Republic) government as its
embassy; United Arab Republic Embassy sale,
Christie's, London, 27 June 1969 (lot 68),
bought by the National Gallery, aided by a
Special Grant and a contribution from the
Pilgrim Trust
*Bibliography:* Leroi, 1876, pp. 294–7; De
Chennevières, 1898, pp. 94–5; Sack, 1910, p.
206; Morassi, 1962, pp. 18 and 71; Watson,
1965, pp. 186–8; Levey, 1971, pp. 228–31;
Succi, 1988, p. 192; Gemin and Pedrocco,
1993, no. 472

GIAMBATTISTA TIEPOLO
*The Coronation of the Virgin*
1754
oil on canvas, 102.6 × 77.3 cm
Kimbell Art Museum, Fort Worth
(inv. AP 1984.10)

This is the *bozzetto* for the large oval fresco that
decorates the ceiling of the church of S. Maria
della Visitazione (the Pietà) in Venice. The
decorative cycle, which also includes the ceiling
of the choir and one wall, was begun by
Giambattista on 13 June 1754 and completed in
August 1755 (Pallucchini, 1968, p. 84). In the
triumphal scene of the Virgin's Coronation,
celebrated by choirs of angels and young girls,
Tiepolo seems to refer to the concerts given in the
church by the girls living in the adjacent
Foundling Hospital.

This beautiful *bozzetto*, which shows several
differences to the ceiling, is painted with rapid
and vibrant strokes, anticipating the harmonious
composition and swirling movement of the final
version.                                    M.G.

*Provenance:* Cecilia Tiepolo (?); Edward Cheney
collection, London; Rosebery collection,
London; Sotheby's sale, London, 24 March
1976; Sotheby's sale, London, 8 April 1981;
acquired by the Kimbell Art Museum
*Exhibitions:* Venice, 1951, no. 80 *bis*; London,
1951, p. 34
*Bibliography:* Pallucchini, 1968[1], no. 216a;
Howard, 1986, pp. 11–28; Levey, 1986, pp.
218–20; Niero, 1988, pp. 21–8; Barcham, 1989,
pp. 159–60; Gemin and Pedrocco, 1993, no.
426a

GIAMBATTISTA TIEPOLO
*Time Revealing Truth*
*c.* 1758
oil on canvas, 231 × 167 cm
Museum of Fine Arts, Boston
Charles Potter Kling Fund (61.1200)

Truth, a naked woman with her foot on the
globe and with the sun shining above her head
is unveiled by her father, winged Time; a cupid
holds Time's hour-glass and his scythe lies on
the ground. The iconography is taken from
Ripa's *Iconologia*, but the erotic overtones were
supplied by Tiepolo.

The painting has been dated either *c.* 1745–50
(Lorenzetti; Morassi; Pallucchini), relating it to
the Palazzo Labia cycle, or *c.* 1758 by Gemin
and Pedrocco, who note close similarities
between the figure of Time, the *Neptune* (Doge's
Palace, Venice; Gemin and Pedrocco, no. 470)
and *An Allegory with Venus and Time* (cat. 124).
These last two works have been dated to 1758
and therefore a similar date should apply to the
present painting.                          M.G.

*Provenance:* Baron de Schwiter collection, Paris;
Blumenthal collection, Paris; 29 November
1935, Charpentier's sale, Paris; Cotnareanu
collection, Paris; 14 October 1960, Charpentier's
sale, Paris; 1961, acquired by the Boston
Museum of Fine Arts
*Exhibition:* Venice, 1951, no. 62
*Bibliography:* De Chennevières, 1898, pp. 114–5;
Molmenti, 1909, p. 225; Sack, 1910, p. 221;
Morassi, 1943, p. 26; *idem*, 1962, p. 40;
Pallucchini, 1968[1], no. 188; *100 Paintings from the
Boston Museum*, 1970, no. 42, p. 67; *Museum of
Fine Arts Boston. Western Art*, 1971, p. 192, no.
100; Gemin and Pedrocco, 1993, no. 471

GIAMBATTISTA TIEPOLO
*Woman with a Parrot*
1760–1
oil on canvas, 72 × 53.5 cm
The Visitors of the Ashmolean Museum,
Oxford (inv. A 876)

This splendid half-length portrait probably
formed a pair with a similar painting of a
*Woman with Furs* that was on the art market *c.*
1930 (present whereabouts unknown); two
pastels by Lorenzo (National Gallery of Art,
Washington), formerly in the Labia collection
reproduce the portraits, supporting the hypothesis
that originally they were in the same collection.
Rizzi (1971) related this picture to a letter
written by F. M. Tassi to the Conte Carrara in
Bergamo on 15 December 1760, stating that
Tiepolo 'is now painting some half-length
imaginary female figures for the Empress of

Moscow [i.e. of Russia], and it is impossible to see more beautiful, real and accomplished things'. It seems, therefore, that the present painting is one of the works executed by Tiepolo for the Tsarina Elizabeth Petrovna. While Levey (1986) suggests this painting recalls the pastels of Rosalba Carriera (see fig. 5), Gemin and Pedrocco (1993) suggest that this kind of 'fancy' painting derives from 16th-century female portraits.

A red chalk drawing in the Ashmolean Museum, Oxford (Parker, 1972, no. 1082), shows a different version of the same subject. While Parker ascribes the sheet to Giambattista, Rizzi gives it to Domenico.   M.G.

*Provenance:* Christie's, London, Brocklebank sale, 8 July 1938; Durlacher collection, London; Private collection, New York; E. E. Cook collection; 1955, donated to the Ashmolean
*Exhibitions:* Venice, 1971, no. 73; Paris, 1981, no. 48
*Bibliography:* Parker, 1956, p. 537; *idem*, 1958, p. 94; Morassi, 1962, p. 37; Pallucchini, 1968[1], no. 249; Rizzi, 1971; Parker, 1972, p. 537; Rusk Shapley, 1973, p. 156; Levey, 1986, pp. 245–6; Gemin and Pedrocco, 1993, no. 502

## 128

GIAMBATTISTA TIEPOLO
*The World Pays Homage to Spain*
1762
oil on canvas, 181 × 104.5 cm
National Gallery of Art, Washington
Samuel H. Kress Collection, 1943.4.39

This is the *modello* for the large fresco (27 × 10 m) on the ceiling of the throne room in the Royal Palace, Madrid, executed by Giambattista, with the collaboration of his sons Domenico and Lorenzo, between June 1762, when they arrived in Madrid, and 1764. Giambattista had painted the *modello* for the ceiling before his departure from Venice, having received detailed instructions on the room's dimensions and the subject-matter from Count Felice Gazzola, the Spanish ambassador in Venice, as Tiepolo related in a letter of 28 September 1761 (E. Battisti, *Arte Antica e Moderna,* IX, 1960, p. 79).

The ceiling represents the Glory of Spain: personifications of the Four Continents animate the illusionistic architectural framework while Virtues and Olympian gods occupy the vast expanse of blue sky. The throne of the Spanish monarchy, flanked by statues of Apollo and Minerva (Hercules in the *modello*), appear above a pyramid, symbol of Eternity (Gemin and Pedrocco, 1993); it bears a Latin inscription celebrating Charles III's magnanimity. According to Shapley (1979), who cites Ripa's *Iconologia* (1611, p. 204ff.), the pyramid symbolises 'The Glory of Princes' bearing witness to the magnificent buildings they erect.

The fresco follows the present *bozzetto* very closely in terms of the composition. Several themes and motifs used in earlier schemes are repeated on the Throne Room ceiling; Tiepolo created a harmonious ensemble, with daring foreshortening and luminous colours that open up the ceiling to a phantasmagorical world. M.G.

*Provenance:* Pagliano collection, Venice; Edward Cheney (1803–84); his brother-in-law, Col. Alfred Capel Cure; Contini Bonacossi collection, Florence; Kress collection; 1943, donated to the National Gallery of Art
*Bibliography:* Molmenti, 1909, pp. 183–91; Sack, 1910, pp. 138–40, 209, 218, 223; Morassi, 1955, pp. 36–9, 152–3; *idem*, 1962, pp. 6, 8, 21, 33; Pallucchini, 1968[1], no. 279a; Rizzi, 1971, fig. 74; Shapley, 1979, pp. 445–8; Jones, 1981, pp. 220–7; Whistler, 1986, pp. 199–203; Levey, 1986, pp. 255–69; Gemin and Pedrocco, 1993, no. 516a

## 129

GIAMBATTISTA TIEPOLO
*The Holy Family*
*c.* 1750s
brush and brown ink and brown wash, 31.7 × 23.5 cm
Private Collection

This unpublished drawing is typical of Tiepolo's various treatments of the subject of the Holy Family, which are notable for the variety of mood, from playful to flamboyant, achieved by subtle changes in pose and position all executed in the luminous wash and fleeting pen-work typical of the period between the return from Würzburg and the departure for Madrid.   C.H.

*Provenance:* sale, Galerie Kornfeld, Berne, 22 June 1984, no. 203

GIAMBATTISTA TIEPOLO
*Design for a Dedication Page to Charles III*
*c.* 1762
pen and brown ink and brown wash over black chalk, 35.6 × 25 cm
Cooper-Hewitt National Museum of Design, Smithsonian Institution, New York, Bequest of Erskine Hewitt (inv. 1938–57–219)

During the early 1750s Count Felice Gazzola, an engineer in the service of Charles III, King of Spain and the Two Sicilies, gathered material for a book on the newly discovered ruins of Paestum. By December 1755 the Abbé Barthélemy could write to the Comte de Caylus that Gazzola hoped to complete his drawings in the following spring and send them to Paris to be engraved. In fact, it was not until 1769 that the drawings reached the engraver, who was not French, but the Venetian Giovanni Volpato. Meanwhile, Gazzola had been instrumental in arranging the Tiepolo family's visit to Spain, and had commissioned a frontispiece to his book from Giambattista. Since the artist had all but abandoned book illustration after Maffei's *Verona illustrata* of 1731–2 (cat. 95), the design was probably undertaken as a personal favour, and may have been ready before the Tiepolos left Venice in March 1762. Two drawings for this project survive, the first a preliminary study in the Prado, the second this sheet, which served as Volpato's model. It shows Glory placing a bust of Charles III on a pedestal. At its base are attributes of the Arts, and a winged Genius hovers on the right. Publication of the volume was delayed further, and although Volpato originally engraved the dedicatory lines in Italian, in the name of Gazzola, the *Rovine della città di Pesto detta ancora Posidonia* only appeared in 1784, four years after the author's death, with a new dedication in Latin, in the name of a new author, Paolantonio Paoli.   C.H.

*Provenance:* Erskine Hewitt; 1938, bequeathed by him to the Museum
*Exhibitions:* New York, 1962, no. 69; Cambridge, 1970, no. 96; New York, 1971, no. 50
*Bibliography:* Gorizia, 1985, under no. 8, and pp. 66–7; Bassano and Rome, 1988, under no. 146

GIAMBATTISTA TIEPOLO
*The Flight into Egypt*
1766–70
oil on canvas, 55.5 × 41.5 cm
Staatsgalerie, Stuttgart (inv. 3303)

This little canvas is one of a series of four
paintings on the same theme made by
Giambattista in Spain at the end of his life, *c.*
1766–70. The others are in Lisbon, New York
and Bellagio, near Como (Gemin and
Pedrocco, 1993, nos. 531, 533, 534). They could
have been inspired by Domenico's collection of
etchings published in 1753 with the title *Idee
Pittoresche sopra la Fugga in Egitto* (cat. 230). Mary
and Joseph rest by the waters of a river,
apparently lost in a hostile landscape, dominated
by inaccessible mountains, broken only by the
lofty pine-tree.                                        M.G.

*Provenance:* Ferreira Pinto-Basto collection,
Lisbon; Christie's sale, London, 11 April,
1975; Staatsgalerie, Stuttgart
*Bibliography:* Fiocco, 1940, p. 12; Morassi, 1943,
pp. 39, 41; *idem*, 1955, pp. 38–9; *idem*, 1962, p.
16; Pallucchini, 1968[1], no. 293; Martini, 1982,
p. 511; Levey, 1986, p. 269; Gemin and
Pedrocco, 1993, no. 532

GIAMBATTISTA TIEPOLO
*The Entombment*
1769–70
oil on canvas, 57 × 43 cm
Private Collection

This small painting dates from the very end of
Tiepolo's life, *c.* 1769–70 (Pallucchini, 1968).
The bare, rocky setting of the *Flight into Egypt*
(cat. 131) reappears. The figures seem to be silent
and resigned; in the foreground the Virgin
swoons; a flight of angels mourns over Christ's
dead body lit by a raking silvery light.     M.G.

*Bibliography:* Fiocco, 1940, p. 12; Morassi, 1943,
p. 39; *idem*, 1962, p. 16; Pallucchini, 1968[1], no.
300; Levey, 1986, p. 268; Gemin and Pedrocco,
1993, no, 537

DOMENICO (or GIOVANNI
DOMENICO) TIEPOLO
born Venice, 30 August 1727
died Venice, 3 March 1804

Painter, draughtsman and etcher. The most
talented son of Giambattista Tiepolo, he trained
with his father and spent his early years as a devoted
member of the family studio, working as Giambat-
tista's assistant until the latter's death in 1770. His
earliest recorded works were drawings after Old
Master paintings, made for Francesco Algarotti in
1743 (untraced; cf. the copy after Bellini, Victoria
and Albert Museum, London), and he also made
large numbers of copies, both in chalk and oil, of
his father's compositions, thus assimilating the
Tiepolo 'house-style'. However, his independent
works of this period, such as the *Stations of the Cross*
for S. Polo (1747; fig. 55) and the altarpieces in S.
Francesco di Paola, already show an emphasis on
tough realism absent from Giambattista's work.
On the Tiepolo family's return from Würzburg, he
was elected a member of the Venetian Academy in
1756, and the following year he decorated the
Foresteria of the Villa Valmarana with genre
scenes. He accompanied his father to Madrid in
1762, where he assisted in the decoration in the
royal palace and painted religious works for private
patrons. During the 1770s and 1780s Domenico
Tiepolo assumed his father's reputation as the
leading history painter in Venice, and was awarded
numerous commissions, both sacred and secular,
among them frescoes for the Casale sul Sile (1781);
S. Lio (1783); Palazzo Contarini dal Zaffo
(1784); and the *Glory of Jacopo Giustiniani* on the
ceiling of the doge's palace at Genoa. In the 1790s,
he concentrated on completing the decorations in
the family villa at Zianigo (1791–7), and on
making series of drawings on the subjects of
Punchinello and scenes from contemporary life.
                                                      C.H.

DOMENICO TIEPOLO
*The Minuet*
1756
oil on canvas, 80 × 109 cm
Museu Nacional d'Art de Catalunya, Barcelona
(Cambó Bequest)

During the 1750s Domenico painted a number
of similar compositions on the themes of *The
Minuet* and *The Quack Doctor*. The first pair,
made in 1754, were bought by Francesco
Algarotti (Louvre, Paris), and engraved by
Giacomo Leonardis in 1765. They were
followed in 1756 by a smaller pair, cat. 222 and
its pendant, also in Barcelona. A year later, the
artist used similar scenes in his decoration of the
Foresteria of the Villa Valmarana. A further
cabinet painting of *The Minuet*, bought by
Heinrich Merck of Darmstadt as a souvenir of a
typical Venetian scene (Wrightsman Collection,
New York; Mariuz, 1971, pp. 130), has no
pendant. Further evidence of the popularity of
such compositions can be seen in the copies
made by Francesco Guardi after the Barcelona
paintings (Louvre, Paris; Byam Shaw, 1933, p.
47).

Beneath a statue of Flora, a group of Venetian
ladies and gentleman on holiday on the
mainland watch a couple dressed as Pantaleone
and Columbine perform a stately minuet. The
couple shaded by the umbrella among the
spectators were adapted from a similar pair in
Domenico's painting of *An Oriental Encampment*
(cat. 233). There is a preparatory drawing for
this painting (Louvre, Paris; Knox, 1980, no.
D.51).                                                C.H.

*Provenance:* Papadopoli Collection, Venice; sold
1929; 1930 Francisco Cambó; 1947 bequeathed
by Cambó (inv. no. 64989)
*Exhibitions:* Munich, 1958, no. 203; Madrid and
Barcelona, 1990–1, no. 35
*Bibliography:* Molmenti, 1909, p. 206; Sack,
1927, pp. 119, 162; Byam Shaw, 1933, pp. 48–
9; Mariuz, 1983, pp. 50, 52, 111–12; Knox,
1980, p. 276; Ballarin, in Madrid and
Barcelona, 1990–1, no. 35 (with full
bibliography)

## 223

DOMENICO TIEPOLO
*Punchinello in a Rainstorm (The Spring Shower)*
pen and brown ink, brown wash over black
chalk, 29.5 × 46.5 cm (margin); 35.5 × 47.2 cm
(sheet)
inscribed lower right: 'Dom.o. Tiepolo f.';
numbered '74' in modern pencil over abraded
area of paper in upper-left corner of margin
The Cleveland Museum of Art
Purchase from the J. H. Wade Fund
(inv. 37.573)

One of the most attractive of the drawings in the
series *Divertimento per li regazzi* (see cat. 225).
Domenico's recurring theme of figures seen from
behind gives a half-melancholy, half-humorous
atmosphere, like a tearful smile. Six characters
and a dog, surprised by a downpour (but the
shadows they cast suggest that the sun may be
about to come out again), are walking along an
empty road. There are two Punchinellos among
them; one has pulled his jacket over his dunce's
cap to protect himself from the rain, giving
himself an even stranger silhouette.

Domenico has borrowed the five figures on
the right from an earlier drawing (private
collection, Rome; reproduced in Passariano,
1971, no. 88), replacing a man holding an
umbrella with a Punchinello (Vetrocq, in
Bloomington, Stanford and New York, 1979–
80). He also copied the thin lady (adding an
umbrella) from a drawing with a caricature of
two women (Metropolitan Museum of Art,
New York, Lehman collection). The resulting
composition emphasises the figures' isolation
from each other, bringing to mind Watteau's
melancholy clowns, and anticipating the more
overtly emblematic musicians and *saltimbanques* of
Manet and Picasso (Vetrocq, 1979–80).   A.M.

*Provenance:* anonymous collection, London; sale,
Sotheby's, London, 6 July 1920, part of lot 41;
Richard Owen, Paris; Italico Brass, Venice
*Exhibitions:* Paris, 1921; San Francisco, 1940, no.
99, repr.; Detroit, 1950; Detroit, 1952, no. 82,
repr.; Bloomington, Stanford and New York,
1979–80, no. 23, repr.
*Bibliography:* Francis, 1939, p. 48; repr. opp. p.
50; Benesch, 1947, no. 42; Tietze, 1947, no. 99;
Morassi, 1953, p. 54, fig. 43; Mariuz, 1971, p.
89, fig. 36; Gealt, 1986, no. 68, repr.

## 224

DOMENICO TIEPOLO
*Punchinello Visited in Prison*
pen and brown ink, brown wash over black
chalk, 29.5 × 41 cm (margin); sheet 34.9 × 46.5
cm (sheet)
National Gallery of Art, Washington
Gift of Robert H. and Clarice Smith, 1979.76.3

A group of four drawings in the *Divertimento per
li regazzi* (see cat. 225) illustrates Punchinello's
brush with the law, from his arrest (Cleveland
Museum of Art; Gealt no. 36), to his trial and
subsequent pardon (Cleveland Museum of Art;
Gealt no. 39), and to his release celebrated with
his companions (National Gallery of Art,
Washington). At first glance the subject of this
drawing, which is set on a busy street-corner in
Venice, looks like a street scene; there are men
and women, a butcher's boy with a basket of
meat on his head (the same figure appears in
*Punchinello in a Malvasia*, cat. 226), an oriental
gentleman in a turban and caftan. Mingling
with the crowd of people crossing the bridge are
two Punchinellos; two others sit at the foot of the
bridge selling *gnocchi* in paper cones. The
Punchinello of the title is relegated to the
background and can only just be seen behind
the iron bars of the prison. He is touching his
hat with his hand in a gesture of despair, while
talking to a woman in a cloak, possibly his
companion. Domenico's plan is an ingenious
one: instead of showing the main character in the
foreground, he fills the foreground with the
bustling life of the street to emphasise the only
state denied to Punchinello – freedom. The
prison wall of heavy blocks of dressed stone, in
shadow, the brick on the side of the bridge, the
network of lines on the pavement, all contribute
to the feeling of enclosure and oppression.   A.M.

*Provenance:* anonymous collection, London; sale,
Sotheby's, London, 6 July 1920, part of lot 41;
Richard Owen, Paris; Paul Suzor, Paris; David
Carritt Ltd, London; Robert H. and Clarice
Smith
*Exhibitions:* Musée des Arts Décoratifs, Paris,
1921; Paris, 1971, no. 310, repr.; Bloomington,
Stanford, New York, 1979–80, no. 33, repr.
*Bibliography:* Gealt, 1986, no. 38, repr.

## 225

DOMENICO TIEPOLO
*Punchinello as a Portrait-painter*
pen and brown ink, brown wash over black
chalk, 29.5 × 41.3 cm (margin); 33.5 × 47 cm
(sheet)
inscribed lower left: 'Domo Tiepolo f.'; numbered
in ink in upper left corner of margin: '70',
second numeral apparently altered from '9' in
original ink
Alice M. Kaplan Collection

This is one of a series of 104 drawings entitled
*Divertimento per li regazzi*, executed by Domenico
in the last years of his life. The main protagonist
is Punchinello, the leading masked character in
the *commedia dell' arte*, and the only one able to
perform all the roles: he bursts on to the stage to
mimic the life of Everyman. One group of
drawings shows Punchinello and his
companions taking on a variety of professions, in
this case that of portrait-painter. *Alexander and
Campaspe in the Studio of Apelles* was painted
three times by Giambattista Tiepolo (see cat.
92); Domenico used the same subject in a
youthful drawing (private collection; Mariuz,
1986, p. 269, fig. 7), and here he has virtually
repeated the same composition, but all the
characters except for the women have become
Punchinello. In another drawing in the series
(Gealt, no. 87) Punchinello appears as a
historical painter and is seen at work on a large
picture of *The Sacrifice of Iphigenia*, based on the
fresco by Giambattista Tiepolo in the Villa
Valmarana, Vicenza. That drawing parodies
Domenico's father's 'sublime style' and, by
making the painter a figure of fun, parodies the
profession of painting.   A.M.

*Provenance:* anonymous collection, London; sale,
Sotheby's, London, 6 July 1920, part of lot 41;
Richard Owen, Paris; Robert Goelet, New
York; sale, Sotheby's, London, July 6 1967, lot
38, repr.; Seiferheld Galleries, New York
*Exhibitions:* Musée des Arts Décoratifs, Paris
1921; New York, 1971, no. 279, repr.;
Southampton, 1971; Bloomington, Stanford and
New York, 1979–80, no. 28, repr.
*Bibliography:* Byam Shaw, 1962, pp. 57, 92, no.
89; Mariuz, 1979, p. 203, repr.; *idem*, in Brussels,
1983, p. 76, fig. 9; Gealt, 1986, no. 54, repr.;
Mariuz, 1986, p. 269, fig. 6

DOMENICO TIEPOLO
*Punchinello in a Malvasia*
pen and golden-brown ink, golden brown wash,
over black chalk, 28.8 × 41 cm
inscribed on table edge: 'Do: Tiepolo f.';
numbered '41' in ink in upper-left corner of
margin
Mr and Mrs Gilbert Butler

The composition is based on one of Domenico's
scenes from contemporary life, dated 1791 (Ecole
des Beaux-Arts, Paris), which depicts a hostelry
(called a 'Malvasia' after the malmsey, or wine,
served there). The host and most of the
customers have assumed the aspect of
Punchinello. The lion of St Mark, symbol of
Venice, is larger here than in the earlier drawing
and is stuck in the middle of the wall and with
a large W over its back; W stands for *evviva*,
long live the Lion of St Mark and the Republic
of Venice. Byam Shaw (1962, p.58) suggests
that this might be an expression of patriotism
during the French occupation of Venice in
1797, following the fall of the Republic.
Domenico's fluent, lively draughtsmanship
reaches its climax in the portrayal of the two
drunken Punchinellos performing their crazy
dance; the host, with an imperious gesture, is
showing them the door. Between the dancers and
the host, by way of contrast, is a figure in
contemporary dress with his back turned to the
scene. Domenico took the idea for the staircase
in the background with a figure climbing it, and
the hanging lamp, from his father's painting of
the *Last Supper* for the Duomo in Desenzano; he
had made an engraving after it.          A.M.

*Provenance:* anonymous collection, London; sale,
Sotheby's, London, July 6, 1920, part of lot 41;
Richard Owen, Paris; Raymond Bloch, Paris;
Mme Guy Schwob, Paris; sale, Sotheby's,
London, 23 March 1971, lot 66, repr.;
Colnaghi's, London; Robert M. Light, Santa
Barbara
*Exhibitions:* Paris, 1921; Bloomington, Stanford
and New York, 1979–80, no. 27, repr.
*Bibliography:* Byam Shaw, 1962, p. 57, no. 1, 58;
Gealt, 1986, no. 52, repr.

DOMENICO TIEPOLO
*Scenes of Contemporary Life: Presentation of the
Fiancée*
(?) 1791
pen and brown ink, brown and grey wash over
black chalk, 28.7 × 40.6 cm
Private Collection

Although not signed or dated, this drawing can
probably be ascribed to 1791 like most of the
drawings in *Scenes of Contemporary Life*. The
presentation of the bride-to-be (or it may be just
a social call) gives an opportunity for two
sharply contrasted society ladies to meet. The
straight-backed younger one, coiffed according to
the latest fashion, is followed by her adoring
beau who seems to want to hide in his loved
one's skirts. The large, expansive woman in the
armchair is used to being at the centre of a
hubbub of young children and dogs. Indifferent
to the encounter are the greyhound on the right,
about to leave the room, and on the left the
stocky figure of the maid, seen from behind, a
silent and solitary presence in contrast to the
general animation. Her figure is taken from a
youthful drawing by Domenico (Correr,
Venice; Bean and Stampfle, in New York,
1971). She also appears in one of the engravings
(no. 7) of the *Flight into Egypt*.
   Here, as in other drawings in the series, the
Neo-classical simplicity of the setting sets off the
vivacity and energy with which the figures and
animals are drawn. The only piece of furniture
against the background of the vertically striped
wallpaper is the birdcage, which appears in
other drawings in this series exhibited here (cat.
228).          A.M.

*Provenance:* Martin Wilson
*Exhibitions:* New York, 1971, no. 264, repr.
*Bibliography:* Pignatti, 1965, p. 213, no. 119.
repr.; Stampfle and Denison, 1973, p. 62, no.
112, repr.

DOMENICO TIEPOLO
*Scenes of Contemporary Life: The Milliner's Shop*
pen and grey and brown wash, with some
yellow watercolour, 32.5 × 42.5 cm
inscribed lower left: 'Dom.o Tiepolo f.'
Museum of Fine Arts, Boston,
William E. Nickerson Fund, 1947 (inv. 47.2)

Although not dated, this drawing forms part of
a series depicting *Scenes of Contemporary Life*,
most of which bear the date 1791; this and the
series entitled *Divertimento per li regazzi* are
certainly Domenico's masterpieces. Together they
constitute a kind of *comédie humaine* of late-18th
century Venice. In the milliner's workshop
human interest is provided by the employees, the

customers and their companions and a crowd of
children playing games. On the table on the
right a bonnet in the latest fashion is perched on
a milliner's dummy. The composition is broken
up by static figures seen from behind. Domenico
repeats figures from earlier works according to his
custom; the back view of the woman seated on
the far right is from the *Minuet* (Louvre, Paris;
Byam Shaw, 1962); the fat man on the left is the
subject of a caricature (sale, Christie's, London,
29 March 1966, lot 221; see Knox, in
Cambridge, 1970).          A.M.

*Provenance:* Oppenheimer; sale, Christie's,
London, 10 July 1936, lot 188
*Exhibitions:* London, 1917, no. 67; London,
1930, no. 829; Detroit, 1952; Baltimore, 1959,
no. 222; Cambridge, MA, 1970, no. 102, repr.
*Bibliography:* Popham, 1931, no. 135, pl.
CCLXIII; Morassi, 1953, p. 54, fig. 42; Byam
Shaw, 1962, p. 89, no. 74, repr.: Pedrocco,
1990, p. 89, no. 30

DOMENICO TIEPOLO
*Scenes of Contemporary Life: The Acrobats*
pen and ink and brown wash over black chalk,
29 × 41.3 cm
Lent by The Metropolitan Museum of Art,
New York
Rogers Fund, 1968.544

Acrobats were a familiar sight in Venice during
the Carnival. Their most celebrated performance
was held on Maundy Thursday (Giovedi
Grasso), when teams created a human pyramid,
known as the Labours of Hercules, to
commemorate the momentous victory of the
Venetian fleet over Ulrich of Aquileia in 1162.
This performance in Piazza S. Marco was first
depicted by Giacomo Franco in the *Habiti
d'huomini et donne venetiane* (1610), and similar
compositions appeared in the 18th century in a
drawing by Canaletto of *c.* 1763–6 (priv. coll.;
Constable and Links, no. 636), which was
engraved by Brustolon, and in a painting by
Gabriel Bella of *c.* 1782 (Fondazione Querini
Stampalia, Venice; Venice, 1978, no. 14).
Domenico Tiepolo's depictions of acrobats are
more informal than those of his predecessors and
imbued with gentle humour.
   Like most of this series, this drawing was
probably made *c.* 1791, and is connected with
other works of that decade. The main part of the
composition, including the actress holding the
fan, reappears in the fresco of *Punchinello and the
Acrobats* made for the Villa Zianigo, of 1793
(now Ca'Rezzonico, Venice), and a close
relative of this actress is among the bystanders in
*Punchinello on the Tightrope* (Bloomington and
Stanford, no. S56).          C.H.

*Provenance*: Alfred Beurdeley (1847–1919; cf. L. 421); Adrien Fauchier-Magnan; sale, Palais Galliera, Paris, 27 June 1967, no. 161; Galerie Cailleux, Paris; P. & D. Colnaghi Ltd, London; from whom purchased (Rogers Fund, 68.54.4)
*Exhibition*: New York, 1971, no. 263
*Bibliography*: Byam Shaw, 1962, no. 65; Bean and Griswold, 1990, no. 263 (with full bibliography)

## 230

DOMENICO TIEPOLO
*Idee pittoresche sopra la fugga in Egitto*
1753
volume containing frontispiece, title-plate and 24 etchings, open to show *Joseph and Mary Prepare to Leave* (pl. 5) and *Rest on the Flight into Egypt* (pl. 19)
52.5 × 35.1 cm (open book)
inscribed in ink lower centre: '*con otto prove duplicte avanti lettere*'
National Gallery of Art, Washington, Rosenwald Collection, 1951.16.102–152

Domenico's printed *oeuvre* consists of 135 etchings, including a number of prints after his father's paintings and frescoes, and the series of the *Flight into Egypt*, Domenico's most original etched work. Published in 1753 and dedicated to the Prince-Bishop of Würzburg, for whom Domenico was working at that time, *Idee pittoresche . . .* was probably begun in Venice, since Tiepolo arrived in Würzburg in 1753 and two prints in the series date from before then. The set consists of 24 narrative compositions illustrating the long and dangerous journey of the Holy Family into Egypt.

The two plates shown belong to one of the earliest sets. Eight plates are printed lightly and unevenly on thin paper; they have not been trimmed, and include small corrections, probably made by Domenico himself; for example in *Joseph and Mary Prepare to Leave* the small triangle between the donkey's nose and Joseph's cloak is filled in with ink strokes. *The Rest on the Flight* is dated 1752. They are bound in album once in the collection of Zanetti the Elder, whose coat of arms is on the binding. Domenico's visual debt to his father's work, and to other artists, is evident; however Morassi has dated most of Giambattista's paintings of the same theme later than these etchings, suggesting that the father was prompted by his son's work. In addition to the published plates there are three other compositions belonging to the series which were rejected, probably because of stylistically or technical faults (Rizzi, 1970, nos. 94–6). There are different states of the plates; most have two or three states, before all numbers and before some extra work.                                            O.T.

*Provenance*: Gerolamo Zanetti the Elder, Venice; A. Caironi, Milan (Lugt 426); Pierre Berès, Paris; 1951, L. J. Rosenwald
*Exhibition*: Washington, 1972
*Bibliography*: De Vesme, 1906, nos. 1–27; Morassi, 1960; Rizzi, 1971[1], nos. 67–96; Gorizia and Venice, 1983, nos. 509–16; Milan, 1988, no. 42–71

## 231

DOMENICO TIEPOLO
*The Madonna del Carmelo appearing to St Simon Stock*
1749 (dated on the stone)
etching and engraving, 61.3 × 39.8 cm (plate)
National Gallery of Art, Washington, Gift of W. G. Russell Allen, 1941.1.202

This etching, a *tour de force* by Domenico, reproduces the central canvas of the ceiling decoration by Giambattista Tiepolo in the Scuola dei Carmini in Venice of 1742 (see fig. 36). It shows an angel in the Virgin's retinue offering the scapular to the Saint to help the living reach salvation and to release the souls from Limbo. This etching was mentioned by Mariette in his *Indice*, and by Zanetti in 1771 in *Stampe tratte da pittura di Giovanni Battista Tiepolo*. There are two states of this print, before and after the number 40 at upper-left corner; the impression shown here is with the number.   O.T.

*Bibliography*: De Vesme, 1906, no. 57; Rizzi, 1971[1], no. 98; Succi, 1985, no. 34; Mirano, 1988, no. 34

## 232

DOMENICO TIEPOLO
*The Institution of the Eucharist*
1753
oil on canvas, 98.5 × 149.5 cm
inscribed on a scroll on the left-hand side: '*Dom: Tiepolo fecit Anno 1753*'
Den konelige Maleri og Skulptursamling, Statens Museum for Kunst, Copenhagen (inv. Sp 160)

This painting repeats (with variations) a composition painted the previous year now in the Residenz, Würzburg. The scene is in fact closer to the Communion of the Apostles than to the Institution of the Eucharist; Sebastiano Ricci painted a *Communion of the Apostles* for the church of Corpus Domini, Venice, which had been well received (cf. Daniels, 1976, nos. 404–6); Domenico certainly had that painting in mind when he was planning the work exhibited here. The lifelike faces of the Apostles, on the other hand, come from his father's repertory, in particular from the *Last Supper* painted for the

Duomo in Desenzano, and the *Assumption of the Virgin*, painted in 1752 for the chapel of the Residenz in Würzburg.

This painting is an important example of Domenico Tiepolo's religious work; typically, immediacy and realism are his first priority. Compared with the painting executed the previous year this composition is simple; the effect is of greater intimacy. The Apostles form a ring around the moving figure of Christ; one (Judas perhaps) stands alone on the far right. Domenico has reused the severe arch with its elaborate hanging lamp from the painting *Jesus Receiving the Cross* from the *Via Crucis* cycle of 1747 (Oratory of the Crucifix, S. Polo, Venice). Preparatory drawings in red and white chalk are in the Museo Correr, Venice, and the Hermitage, St Petersburg (cf. Knox, 1980, A. 68, 76v, 77, 77v; C. 8; D. 40v, 45). The artist repeated the same subject in 1778, in a painting (Accademia, Venice; cf. Mariuz, 1971, p. 139) presented to the Venetian Academy, of which he was a member from 1756.          A.M.

*Provenance*: by 1761, Royal collection, Denmark
*Bibliography*: Sack, 1910, p. 312; Precerutti Garberi, 1960, p. 270; Olsen, 1961, p. 91; Mariuz, 1971, pp. 32, 118, fig. 43; Knox, 1980, p. 297, fig. 167

## 233

DOMENICO TIEPOLO
*An Oriental Encampment*
*c.* 1752
oil on canvas, 76 × 120 cm
Landesmuseum, Mainz (inv. 266)

This is one of the first, if not the first, of Domenico's genre paintings. It was painted during his stay in Würzburg (1750–3); with its bright, creamy colours and fluent brushstrokes, it is similar in style to paintings like *Christ Healing the Blind Man* (Wadsworth Atheneum, Hartford), signed and dated 1752. The oriental figures and the throng are typical of Domenico's repertory from his early days, at the time he painted the *Via Crucis* in the Oratory of the Crucifix attached to the church of S. Polo in Venice. The horse on the right is a quotation from Giambattista Tiepolo's painting *The Meeting of Antony and Cleopatra*, now in the Museum of Arkhangel'sk (Sack, 1910). There is a preparatory drawing of this detail by Domenico (Martin von Wagner Museum, Würzburg; Knox, 1976, F3, p. 163), possibly a copy of a lost drawing by his father. Other borrowings are less blatant: the figure seated at table under the awning with his napkin held to his lips is a combination of two figures in Giambattista's *Last Supper*, painted for the Duomo in Desenzano and engraved by

Domenico. Domenico fuses his various sources into a well-orchestrated and highly original whole; he combines minute observation with a taste for whimsy, the realistic with the exotic. With a touch of irony he plays on the contrast between the throng of travellers busily eating and drinking, some of them under the shelter of a broadly striped awning with an inn-sign, probably derived from a Flemish painting, and the elegant urban couple seen from behind, walking away under the shade of a Chinese parasol.

The theme of the pair of lovers out walking, seen from behind (which may have been suggested by one of Callot's *Capricci, La Promenade*) is repeated in Domenico's *Minuet with Pantaleone and Colombina* (Museo de Arte, Barcelona) and in one of the frescoes in the Foresteria of the Villa Valmarana ai Nani, Vicenza. This couple also reappears in a drawing, *The Landing* (Hermitage, St Petersburg), a kind of contemporary version of the *Meeting of Antony and Cleopatra* in which the only element of fantasy is a small Eros bearing a torch; this is attributed to Domenico by Knox (1980, M. 155, p. 228).

According to Sack (1910), traces of Domenico's signature can be seen on the rustic basket in the foreground; the basket itself frequently appears in Domenico's paintings and almost constitutes a signature in itself.     A.M.

*Provenance:* 1841, Metzler collection
*Exhibition:* Ingelheim am Rhein, 1987, no. 88
*Bibliography:* Molmenti, 1909, pp. 209–10 (as Giambattista); Sack, 1910, p. 309; Precerutti Garberi 1960, pp. 276–7; Morassi, 1962, p. 23; Mariuz, 1971, pp. 33, 125, fig. 82; Knox, 1980, p. 305

## 234

DOMENICO TIEPOLO
*Asia*
*c.* 1752–3
red and white chalks on blue paper, 26.2 × 40.2 cm
Graphische Sammlung, Staatsgalerie, Stuttgart

## 235

DOMENICO TIEPOLO
*The Nile*
*c.* 1752–3
red and white chalks on blue paper, 24 × 37 cm
Graphische Sammlung, Staatsgalerie, Stuttgart

Although Domenico Tiepolo provided general assistance to his father in the execution of the decoration of the Residenz at Würzburg, and independently painted three overdoors in the Kaisersaal, he found time to undertake a number of other works, including several altarpieces and the suite of etchings on the *Flight into Egypt* (cat. 230). He also made a large series of drawings in red chalk after the new decorations in the Residenz, partly as a continuation of the long process of assimilating his father's style, partly, perhaps, with a view to translating them into etchings and thereby publicising Giambattista's greatest achievement in Venice. These two examples are copied from sections of *Apollo and the Continents*, the vast ceiling fresco on the staircase, and show *Asia* mounted on an elephant and the personification of the Nile from *Africa*. In the first sheet, Domenico has also included a classical bust from the cornice beneath *Africa* (Freeden and Lamb, pl. 93). The very finished, slightly fussy style of drawing is also characteristic of Domenico's etchings of this period. Eventually he made only four etchings after the Würzburg frescoes (Rizzi, 1971, nos. 151–3, 227).

Knox has consistently defended the view, earlier proposed by Sack, Hadeln and Hetzer, that the Stuttgart drawings are, in fact, preparatory studies by Giambattista. However, it is unlikely that he would have prepared so many detailed drawings, especially after making an unusually large and elaborate oil sketch (Metropolitan Museum of Art, New York). Moreover, there is a 'tremulous, hairy quality in the chalk line' (Byam Shaw, 1962, p. 25) that is quite unlike the bold and assured style of Giambattista.     C.H.

*Provenance:* the painter to the Bavarian Court, Johann Dominik Bossi (1767–1853), reputedly a pupil of Domenico; his daughter, Maria Theresa Caroline (1825–81), and son-in-law, Karl Christian Friedrich Beyerlen (1826–81); sale at H. G. Gutekunst, Stuttgart, 27–8 March 1882, when purchased
*Exhibitions:* Stuttgart, 1953, nos. 57, 54; Stuttgart, 1970, nos. 91, 93

*Bibliography:* Molmenti, 1909, pp. 239–40; Sack 1910, no. 309; Hadeln, 1927 nos. 146, 139; Byam Shaw, 1962, pp. 24–7; Morassi, 1970, pp. 300–4; Byam Shaw, 1971, pp. 271–3; Knox, 1980, nos. M364, M366

## 236

DOMENICO TIEPOLO
*The Burchiello*
oil on canvas, 38 × 78.3 cm
inscribed on sack on right: '*D.T.*'
Kunsthistorisches Museum, Vienna, Gemäldegalerie (inv. 6424)

A *burchiello* is a large barge; one used to ply between Venice and Padua across the navigable part of the Brenta canal. The church (now ruined) in the background on the left is on the island of S. Giorgio in Alga, which lies on the shipping route between Fusina and the Giudecca. Here the church appears as it does in an engraving in Vincenzo Coronelli's *Isolario* (1696), before alterations were made after it was damaged by fire in 1716.

Domenico has caught the precise moment of departure. The *burchiello* swarms with passengers; the helmsman has taken up his position astern while the boatman is struggling with a long pole to push off the craft. A gondola has drawn up alongside bringing one final piece of luggage. The horizontal shape seems to have been chosen in order to accommodate both crafts as completely as possible. Every detail is registered, including the stripes on a piece of fabric and a flock of seagulls. All is harmonised by the pale glow of light over the lagoon.

This painting is thought to be the pendant to the *Departure of the Gondola* (Wrightsman collection, New York), and has been dated to the first years of Domenico's sojourn in Spain, between 1762 and 1764 (Pallucchini 1960), although this is still open to question. A drawing by Domenico (Boymans–van Beuningen Museum, Rotterdam; cf. Venice, 1985, n. 110, p. 119), executed in the 1790s, repeats the right-hand side of the painting with some variations. Byam Shaw (1962, p. 47, n. 3) noted another drawing by Domenico that focuses on the left-hand part of the painting.     A.M.

*Provenance:* 1923, acquired by the Museum
*Exhibition:* Venice, 1951, no. 122; Paris, 1960–1, no. 441; Passariano, 1971, no. 81
*Bibliography:* Morassi, 1941, p. 275, repr.; Lorenzetti, 1951, p. 162; Pallucchini, 1960², p. 261, fig. 690; Mariuz, 1971, pp. 70, 150, fig. 190; Knox, 1980, p. 324

DOMENICO TIEPOLO
*The Building of the Trojan Horse*
1773–4
oil on canvas, 196 × 360 cm
Wadsworth Atheneum, Hartford, CT
The Ella Gallup Sumner and Mary Catlin
Sumner Collection Fund (inv. 1150.658)

This painting depicts the construction of the
colossal wooden horse that enabled the Greeks to
capture the city of Troy. In the background the
walls of the besieged city can be seen. The figure
on the left pointing at the horse has been
tentatively identified as Odysseus, the instigator
of the lethal strategy. Behind him stands Sinon,
who persuaded the Trojans to allow the horse
into the city (Levey, 1971, pp. 238–9).

Three *modelli* exist that illustrate the story of
the fall of Troy in episodes taken from the
*Aeneid*, Book II. One (National Gallery,
London) is a vivid sketch for the painting
exhibited here; the other two depict *The
Procession of the Trojan Horse into Troy* (National
Gallery, London) and *The Greeks Sacking Troy*
(in the D'Atri collection, Paris, in 1938). It has
been suggested that this is the only surviving
painting of a cycle of three made for a large
private palace, judging by the size of the present
canvas.

Domenico left five drawings of details for this
painting (one in the Hermitage, St Petersburg,
and four in the Museo Correr, Venice; cf.
Knox, 1980, B. 69, D. 98–101). He used some
of the studies he had made for the *Flagellation of
Christ* (Prado, Madrid) one of the *Scenes of the
Passion of Christ* (1771–2; see Knox 1980, B. 59,
60, D. 70). The study for *Abraham and the Three
Angels* (Accademia, Venice) on the back of D.
98, commissioned from Domenico in March
1773, has led to the dating of the Hartford
painting to *c*. 1773–4 (Knox, 1966). This is
confirmed by the restless, energetic drawing and
brilliant colours.

Domenico concentrates his attention chiefly
on the group of carpenters milling about the
huge horse; it looks like a scene in the yard of
the Arsenal in Venice. Such subjects were
popular around this time: Novelli's *Aeneas
Fleeing Troy*, painted for the Russian royal
family, won great praise when exhibited in
Piazza S. Marco on 31 August 1772 (Livan,
1942, p. 225).                    A.M.

*Provenance:* Count Pignatelli; Château de Fervoz
(Namur); Seligman, 1913; Lennie Davis, 1923;
Charpentier sale, 17 December 1938, lot. 6
*Bibliography: Sedelmeyer Collection: Ten
Masterpieces by G. B. Tiepolo*, 1913 (VIII);
Levey, 1956, p. 105–6; Morassi, 1962, p. 14;
Knox, 1966, pp. 13–14; Levey, 1971, pp. 238–
9; Mariuz, 1971, pp. 78, 120, fig. 270; Knox,
1980, p. 300, fig. 300

DOMENICO TIEPOLO
*Triumph of Hercules*
1759
etching, 69 × 50.7 cm (plate)
inscribed: '*Joannes Dominicus Tiepolo/invenit pinxit
et delineavit*'
Museum of Art, Rhode Island School of Design
Gift of Henry D. Sharpe, 47.712

Despite its inscription, which claims that
Domenico both designed and etched the subject,
the print reproduces a lost painting by
Giambattista painted for the Winter Palace in St
Petersburg, although some scholars believe the
original was part of a lost cycle by Giambattista.
There is also a small *modello* for the painting
(Colleción Thyssen Bornemisza, Madrid). Succi
(Mirano, 1988) has identified four states for this
etching, before and after the inscription and
number 42 at the upper-left corner.       O.T.

*Bibliography:* De Vesme, 1906, no. 101; Rizzi,
1971, no. 147; Mirano, 1988, no. 90

LORENZO (BALDISSERA) TIEPOLO
born Venice, 8 August 1736
died Húmera, near Madrid, 2 May 1776

Painter, engraver, draughtsman and pastellist. He
was the youngest son of Giambattista Tiepolo and
of Cecilia Guardi, sister of the painters Antonio
and Francesco Guardi. Though overshadowed by
his elder brother, Domenico, Lorenzo started work
in his father's studio as a boy, making his
professional début as part of the family team
commissioned to decorate the Residenz in Würz-
burg between 1750 and 1753. In his independent
work he concentrated first on portraiture, in
particular on delicate pastel portraits reflecting the
influence of Rosalba Carriera. In 1761 his name
figures in the list of the Venetian *Fraglia*, but he left
Venice for good the following year, accompanying
his father and his brother to Madrid, where they
had been invited by Charles III to decorate the new
Royal Palace. During the years immediately
preceding his departure for Spain he produced his
most attractive etchings (a relatively small total
output); although they are only reproductions of
this father's work, they are imbued with great
feeling. In the early years in Madrid, while
collaborating with his father, he also frescoed
several ceilings in the royal palace with his brother,
and painted portraits of the Bourbon princes. Later
he was commissioned to do pastel portraits. In 1768
he requested an official position in the service of
Charles III but this was not granted until 1770
when, a few days after the death of his father and
after Domenico's return to Venice, he accepted the
King's salary, although the official title, *Pintor de
Cámara* was never granted him. After a long illness
he died just before his fortieth birthday, in the small
village of Húmera near Madrid, where he may have
gone to work in the palace of Somosagua, now
destroyed.                    G.M.

238

LORENZO TIEPOLO
*Portrait of the Artist's Mother*
1757
pastel on paper, 67 × 54 cm
inscribed on back: '*Lorenzo Tiepolo figlio fecit anno
1757*'
Ca' Rezzonico, Museo del Settecento
Veneziano, Venice (inv. 1211 cl. I)

This was long supposed to be a portrait of
Lorenzo's wife, although he did not marry
Maria Corradi, the daughter of a Venetian
merchant in Madrid, until 1773. This delicate
pastel portrait is more likely to be of his mother,
Cecilia Guardi, sister of the painters Antonio
and Francesco and wife of Giambattista
Tiepolo. This identification is supported by a
date discovered on the back of the paper, and by
comparison with two other probable portraits of

Cecilia, one in Giambattista Tiepolo's *Alexander and Campaspe in the Studio of Apelles* (cat. 92), the other in *The Tiepolo Family* (British Railways Pension Fund, London), probably attributable to Domenico Tiepolo, which shows his mother with her youngest son, Giuseppe Maria, a priest at S. Maria della Salute, and her three daughters Orsola, Angelica and Elena. The group portrait is generally dated before the departure of Giambattista, Domenico and Lorenzo Tiepolo for Spain in March 1762. Various details of Cecilia's clothing appear in both the pastel and the group portrait, and the atmosphere of affectionate intimacy suggests that both were painted exclusively for the family. In 1757, the date on the back of the pastel, Cecilia Guardi was 55. This is the first known work by Lorenzo, who was then 21; it presages an interest in pastel portraiture in which he adapted his father's style into something more refined and tender, reminiscent of Rosalba Carriera. This portrait preceded Lorenzo's enrolment in the Venetian *Fraglia* by four years; his other early paintings have been attributed to him on the grounds of their stylistic similarity to this delicate and elegant work.                    G.M.

*Exhibitions*: Venice, 1951; Passariano and Udine, 1971; Paris, 1982
*Bibliography*: Lorenzetti, 1936, p. 23; *idem*, 1951, p. 176; Pignatti, 1951², p. 2; Pallucchini, 1960², p. 163; Pignatti, 1960, pp. 379–80; Precerutti Garberi, 1967, p. 50; Rizzi, 1971¹, no. 91; Chiarini, in Paris, 1982, no. 50; Thiem, 1993, pp. 142, 149, n. 43

239

LORENZO TIEPOLO
*The Triumph of Mars*
*c.* 1759
etching (state 1 of 3), 55.5 × 40 cm
National Gallery of Art, Washington
Ailsa Mellon Bruce Fund, 1982.47.1

In the first edition of Domenico's catalogue of the printed work of the three Tiepolos (see cat. 240) this etching is called *Mars and the Three Graces* (no. 39), and is described as being '*In Petroburgh*'. The subject appears, however, more like an allegory of Valour. Venus has been identified as the Empress Elizabeth of Russia (on the basis of a contemporary portrait engraved by Joseph Wagner), and Mars may be the Empress's favourite, Count Alexis Razumovsky. In the invoice of works acquired by Mariette of 1762 this etching is described as 'the small ceiling with Mars', to identify it from the other three large etchings after ceiling designs made for the Russian court. Giambattista's painting on which it is based, was probably one of those made in 1749 for the Empress Elizabeth's new

Winter Palace in St Petersburg. The original was in the Chinese Pavilion at Oranienbaum, near St Petersburg, until the end of the Second World War, but has since disappeared.

In spite of his youth, Lorenzo already displays considerable individuality as an engraver, and is able to recreate his father's paintings with imagination and great technical mastery, in particular in conveying the quality of light.   G.M.

*Bibliography*: De Vesme, 1906, no. 8; Sack, 1910, no. 8; Pallucchini, in Venice, 1941, no. 409; Pignatti, 1965², no. LXXII; Frerichs, 1971, p. 248; Rizzi, 1971², no. 229; Knox and Dee, in Ottawa, 1976, no. 137; Succi, 1983 in Venice; no. 537; *idem*, in Turin, 1988, no. 7

240

LORENZO TIEPOLO
*Monument to the Glory of Heroes*
*c.* 1759
etching (state 3 of 3), 66.5 × 49.9 cm
inscribed upper left: '*43*'; on base of monument: '*ET DECUS IMPERUMQUE ET OPES/REGALIA IURA MUNERA SUNT HERO:/UM MUNERA SED FIDEI*', bottom centre: '*Joannes Batta Tiepolo inv. et pinx./Laurentius Tiepolo filius del. et inc.*'
National Gallery of Art, Washington
Ailsa Mellon Bruce Fund, 1984.83.1

Lorenzo Tiepolo's small output of etchings was restricted to copies of his father's paintings. This print, and perhaps that of *S. Tecla* taken from Giambattista's altarpiece at Este, best show Lorenzo's extraordinary ability to translate his father's radiant colour schemes into a different medium. This etching is listed in the first three editions of Domenico's catalogue of the collected prints of the three Tiepolos with the title *The Magnificence of Princes*, followed by the words: '*in Petroburgh*' (i.e. St Petersburg). Domenico's print is presumably after Giambattista's 'large ceiling painted on canvas for the Court in Moscow' which the painter mentioned he was working on in a letter to Algarotti of 16 March 1761. This, in turn, was probably for the new Winter Palace in St Petersburg being built for the Empress Elizabeth of Russia by the Italian architect Rastrelli. In the invoice sent to Mariette in 1762 this etching was valued at twelve *lire*. A drawing, probably by Domenico (Orloff sale catalogue, 1920), is related to the ceiling design, but is not specifically preparatory for this etching.
                                      G.M.

*Bibliography*: De Vesme, 1906, no. 7; Sack, 1910, no. 7; Frerichs, 1971, p. 246–7; Rizzi 1971², no. 28; Knox and Dee, in Ottawa, 1976, no. 136; Tunick, 1981, no. 288; Succi, in Venice, 1988, no. 9

GIUSEPPE VALERIANI
born probably Rome, *c.* 1690
died St Petersburg, 12 April 1762

Theatrical designer, scene-painter and landscape painter. The affinity of his work to Pannini's stage design and its links with the Antique, suggest that he trained in Rome. With his brother Domenico he worked as a perspective painter in Marco Ricci's studio in Venice, where he was made a member of the *fraglia* in 1718, immediately after Domenico Lovisa's anthology of engravings, on which he had collaborated, had been published. In the mid-1720s he was one of the Venetian artists commissioned by Owen McSwiney to contribute to the series of tombs commemorating illustrious Englishmen. In the *Allegorical Tomb of William III* (1729; Collection of the Duke of Kent) and the *Allegorical Tomb of Sir Isaac Newton* (1727–30; Fitzwilliam Museum, Cambridge), in collaboration with Cimaroli, Balestra, Pittoni and his brother Domenico, he designed large-scale theatrical architectural schemes, influenced by Bibiena. Between 1731 and 1733 he worked under the direction of Filippo Juvarra for the court in Turin, painting frescoes in the Rococo style in the hunting-lodge at Stupinigi. He worked in Rome *c.* 1736 in the circle of Cardinal Ottoboni, and in Spoleto in 1740. He probably returned to Venice during this period to work on the frescoes in the church of the Scalzi; there he was in contact with Piranesi, who later collaborated with him on theatrical designs. In 1742 he left Italy and settled in St Petersburg where he was responsible for stage design at the court of the Empress Elizabeth.           G.M.

25

GIUSEPPE VALERIANI
*Altra veduta di S. Giorgio Maggiore verso la Gracia*, etched by Filippo Vasconi after a drawing by Giuseppe Valeriani, in *Il Gran Teatro delle . Pitture e Prospettive di Venezia*, vol. II, published by Domenico Lovisa, Venice, 1720
*c.* 1717
etching
33.2 × 46.5 cm (platemark),
49.5 × 135 cm approx. (open book)
inscribed lower margin: '*Gioseppe Valeriani delineò – Filippo Vasconi Sculp*'; '*18*' | '*Altra veduta di S. Giorgio Maggiore verso la Gracia. | A. Muro del Giardino di Ca' Nani. B. S. Gio: della Zuecca. C. Monastero di S. Giorgio. D. Chiesa di S. Giorgio. E.*

*Cuppola in distanza della Chiesa di S.S.ti Gio: e Paolo. | Per Domenico Lovisa.*'
The British Library Board, London
(559*/g.6–g.7)

The etching shows the southern entrance to St Mark's basin, the so-called Canale della Grazia, between the island of Giudecca and, to the right, the island of S. Giorgio Maggiore, on which can be seen the Benedictine monastery and the cupola of Palladio's basilica. On the left are the crenellated towers (no longer extant) of the garden wall of Palazzo Nani, which had housed an Accademia Filosofica. Behind the towers rises the campanile of S. Giovanni Battista. The combination of the visual image and topographical information supplied in the caption is typical of the books published by the famous bookseller and typographer Domenico Lovisa, and has links with the series of etchings published earlier by Carlevaris (cat. 24) and Coronelli. In April 1715, reviving a scheme proposed some years earlier by the Chancellor G. B. Nicolosi but abandoned for lack of funds, Lovisa published a broadsheet advertising a series of 100 engraved prints to be issued at the rate of four a month. The success of the collection can be judged by the large number of editions it went through, each with a varying number of plates from a total of 120; the first edition, undated, was probably published in 1717, to be followed in 1720 by a more widely circulated one. The plates were last reused by the engraver Tiedoro Viero in 1786.

The two volumes contained celebrated views of Venice together with plates of the most important paintings in the Doge's Palace and other public buildings. This etching was made by Carlo and Andrea Filippo Vasconi (*c.* 1687–1730) after a drawing by Giuseppe Valeriani. Vasconi moved to Venice from Rome just as Lovisa was becoming established; he had previously worked as a stage designer, and this, combined with his lucid handling of perspective, make his Venetian city views exceptionally lively and attractive. G.M.

*Bibliography:* Moschini, [1924], pp. 56–60; Calabi, 1939, pp. 8–11; Gallo, 1941, pp. 8–9; Morazzoni, 1943, pp. 66–7; Semenzato, 1964; Mason, in Geneva, 1973, pp. 32–5; Succi, in Venice, 1983, pp. 230–3; Lechner, 1990, no. 106; Bonannini, 1993, pp. 67–8

## ANTONIO MARIA VISENTINI
born Venice, 21 November 1688
died Venice, 26 January 1782

Painter, architect, designer, engraver. A professor of perspective and theorist allied to the new ideas of the Enlightenment, the multi-talented Visentini found his natural place in the circle around Consul Smith, with whom he was in contact as early as 1717. He was first apprenticed to Pellegrini around 1708, just before Pellegrini went to England, and was inscribed in the Venetian *Fraglia* in 1711. His first work as a master of perspective was the publication of the large plates of the basilica of S. Marco in 1726. But his most important work as an etcher, beginning *c.* 1730, was series of plates he made on the suggestion of Smith after Venetian view-paintings by Canaletto. The promotional aspect of the work, published in 1735 as a sort of catalogue of the works in Smith's collection, was superceded by the amplified edition of 1742 entitled *Urbis Venetiarum Prospectus Celebriores*. In the 1740s he produced many drawings and engravings, in particular for the splendid editions of the Pasquali press, which was also patronised by Smith. In the climate of neo-Palladianism promoted by the British Consul were born the Venetian *capricci* and the series of overdoors painted with neo-Palladian buildings that Visentini painted in collaboration with Zuccarelli. Visentini was appointed Professor of Perspective at the Venetian Academy in 1764, but effectively taught there between 1772 and 1778, where he made important contributions to the theory of architecture. His friendship with Smith, which lasted almost all his life, is attested to by the hundreds of drawings and prints that were in the Consul's collection and subsequently sold to George III. G.M.

### 152

ANTONIO VISENTINI
*Architectural Fantasy*
oil on canvas, 134.6 × 93.9 cm
inscribed left, on the edge of the balustrade:
'*Antonio Visentini. f.*'; in the centre, on the book:
'*PALL/ADIO*'
Gallerie dell'Accademia, Venice (inv. 465)

Standing in a curved colonnade with echoes of Veronese and Palladian architecture, which could be the background for a painting by Sebastiano Ricci, a group of architects busy themselves measuring and drawing the ruins of an imposing ancient building. The architects, the drawing instruments, the plumb-line and especially the volume of Palladio lying within easy reach all allude to the teaching of architectural perspective as an essential element of painting. This painting has been connected with the establishment of the chair of perspective at the Venetian Academy for which Visentini was nominated in 1764; as was customary he painted a reception-piece, the present work. At about the same time he produced an instruction manual for students of painting, illustrating it with copious examples (the manuscript is in the Vatican Library). Gian Francesco Costa was officially appointed to the professorship in 1767 and remained there until 1772, when Visentini succeeded him permanently. It seems likely that Visentini presented this painting to the Academy only when his election was confirmed in 1772; this would explain its absence from the 1771 edition of Zanetti's *Della Pittura*. The painting is first mentioned in 1777, when it was exhibited at the Fiera della Sensa. It figures with other perspectives pieces by Canaletto and Moretti in a book of engravings published by the copperplate engraver Joseph Wagner in 1779. The stage-set quality of the architecture has prompted comparison with the work of Pannini, though Visentini's perspective is more exaggerated, perhaps because of the specific purpose for which the work was painted; we are given a foretaste of the artist's later taste for neo-Palladian and classical forms. The triumphal arch has interesting similarities with an early capriccio by Canaletto (C/L, 1989, no. 479). A *bozzetto* on wood, a study for the central group of figures, brilliantly and freshly painted, has recently appeared on the art market (Hazlitt, Gooden & Fox Ltd, 1990). G.M.

*Provenance:* between 1772 and 1778, presented by the artist to the Accademia di Pittura; 1807 acquired by what is today the Gallerie dell'Accademia
*Exhibitions:* Venice, 1967, no. 129; Gorizia and Venice, 1986
*Bibliography:* Pallucchini, 1960, p. 207; Zampetti, in Venice, 1967, no. 129; Moschini Marconi, 1970, no. 259; Nepi Sciré and Valcanover, 1985, no. 308; Delneri, in Gorizia and Venice, 1986, no. 195; Pallucchini, 1986, p. 296; Baer, in London, 1990, no. 20; Nepi Sciré, 1991, no. 165

### 153

ANTONIO VISENTINI and FRANCESCO ZUCCARELLI
*The Bridge at Wilton*
1746
oil on canvas, 77 × 128 cm
inscribed lower left: '*Visentini e Zuccarelli/ Fecerunt Venetiis 1746*'
Private Collection, Venice

This belongs to a series of eleven paintings commissioned in 1745–6 by Joseph Smith from Antonio Visentini and Francesco Zuccarelli. The series was planned to complement the series of thirteen paintings executed by Canaletto in

1744 for Smith's palace in Venice. Smith's plan was to relate the architecture of Palladio and the principal monuments of Venice, depicted in Canaletto's series, with illustrations of neo-Palladian architecture in England, based largely on the plates in *Vitruvius Britannicus* by Colin Campbell, and those in William Kent's *Designs of Inigo Jones*. Both groups were sold to George III in 1762, but there are only eight paintings left in the Royal Collection today. This painting may have been given by George III to Richard Dalton, superintendent of Windsor's library and galleries, who had supervised the shipping of the collection from Venice to London. It appears in the list of Dalton's collection auctioned at Christie's on 9–10 April 1791.

It depicts the bridge built in 1737 by Roger Morris for Henry Herbert, 9th Earl of Pembroke, at Wilton House in Wiltshire. The new design made it necessary to alter the course of the River Nadder, and the 17th-century garden was done away with almost entirely, though remnants of it can be seen on the left where the loggia stands at the end of the Bowling Green. Visentini probably based his painting on an etching of Morris's bridge by Fourdrinier; the bridge in turn reflects, in a much simplified form, the monumental designs published by Palladio in his proposal for rebuilding the Rialto Bridge (Palladio's project for the bridge was turned down; see fig. 47). Zuccarelli's contribution here, as in other paintings in the series, is restricted to the figures, which are typical of the 'arcadian' repertory found in his landscape paintings. G.M.

*Provenance:* 1746, commissioned by Consul Smith; 1762, sold to George III; probably then presented by George III to Richard Dalton; 9–10 April 1791, sale Christie's, London; bought for 7 guineas by Sheffield
*Exhibitions:* Gorizia and Venice, 1986, no. 194; Venice, 1987
*Bibliography:* Blunt, 1958, pp. 283–4; Vivian, 1971, no. 163–73; Haskell, 1980, pp. 308–9; Harris, 1984, p. 234; Delneri, in Gorizia and Venice, 1986, no. 194; Magnifico, in Venice, 1987, no. 51; Delneri, 1988, p. 244; Levey, 1991, p. 166

ANTONIO VISENTINI
*Regia Cappella*, etching by Vincenzo Mariotti in *Iconografia della Ducal Basilica*, Venice 1726, folio
c. 1726
etching and engraving, state 1 of 2, 69 × 45.4 cm
inscribed lower margin: 'REGIA CAPELLA DELLA DUCAL BASILICA DI S. MARCO/ OVE RISIEDE IL SERENISSIMO DOGE NELLE FONTIONI PUBLICHE./ *Antonio Visentini Pittore é Prospettico delineò. Si vende dal'istesso in Campiel di Ca' Zen in Birri co' Privilegio. P. Vincenzo di S. Maria delle Scuole Pie Prospettico, et Architetto scolpì*'
Arthur and Charlotte Vershbow

The publication in 1726 of eight large plates, with eleven plans and sections of the basilica of S. Marco, entitled *Iconografia della Ducal Basilica*, made the public aware of Visentini's great talent for architectural drawing and perspective. As early as 1722 Viscentini was trying to obtain the privilege to publish the ambitious project, originally planned to include other churches in the city as well. Contrary to what has been thought until very recently, Visentini did not execute the etchings. As is made clear on all the first state prints, they were etched by Father Vincenzo Mariotti, a painter of perspective and pupil of Andrea Pozzo, for whom he had worked in Rome in the last years of the 17th century. In a more widely known edition of 1761, Antonio Zatta, the publisher, reprinted the copperplates and inserted them into his sumptuous volume *L'Augusta Ducale Basilica ...* (see cat. 246), adding a *Descrizione* of the basilica of S. Marco; he obliterated all reference on the copperplates to Visentini and Mariotti and substituted his own name.

The engraver has followed Visentini's skilled preparatory drawing (Museo Correr, Venice, Stampe A 9). It is possible to catch the brilliance of the marble and mosaics in the Presbytery of S. Marco, and the scene is enlivened with the figures of noblemen and officials visiting the Pala d'Oro. This was the place reserved for the Doge during public ceremonies in the basilica, the official church of the Republic. G.M.

*Bibliography:* Gori Gandellini, III, 1771, p. 316; Moschini, [1924], p. 151; Pallucchini, in Venice, 1941, pp. 44 and 103; Morazzoni, 1943, p. 214; Mason, 1973, p. 56; Dillon, 1976, p. 72; Succi, 1984; *idem*, 1986, pp. 141–6, nos 174–5

ANTONIO VISENTINI
Headpieces, initials and tailpieces, in F. Guicciardini, *Della Istoria d'Italia*, Venice, published by Giambattista Pasquali, 1738, second of 2 vols
1736–8
etchings, 45 × 63 cm (open book)
The British Library Board, London (inv. 181.i.3)

The two volumes of Francesco Guicciardini's *Istoria d'Italia* are masterpieces of 18th-century Venetian typography. The harmonious relationship between text and illustrations, and the skilful distribution of borders and decoration are the happy outcome of a combination of the patronage of Consul Smith, the editorial skill of Giambattista Pasquali and the talent of Antonio Visentini, the illustrator. The idea of publishing a new edition of the history of Florence was hatched in 1735; Smith asked Anton Francesco Gori, the scholar and man of letters, for material and advice from Florence. Gori had received from G. Ferretti the sketch for a portrait of Guicciardini engraved by J. M. Liotard for the title-page, and a biography of the historian by D. M. Manni. The task of illustration was handed over entirely to Visentini, who designed and engraved headpieces with views of the islands in the lagoon for each of the twenty books, initial letters with small pictures of Venice and many decorative endpieces. At the beginning of 1737 the etching was already in hand but publication was postponed for some time, and although the title-page bears the date 1738, the dedication to Francesco III of Lorraine, Grand Duke of Tuscany, preceding the first volume is dated 31 January 1739. The preparatory drawings for the etchings passed with the Smith collection into the collection of George III, and are now in the Library at Windsor Castle. The plates with the views of the Lagoon, later purchased by the editor Teodoro Viero and republished in 1777 with the title *Isolario Veneto*, dedicated to '*Sig.r Tommaso Moore Slade Cavaliere Inglese*', are today in a private collection in Pavia, in a state later than any of the four known states. The name of the final 19th-century editor, Giuseppe Battaggio, has been rubbed out. A second edition of the *Istoria d'Italia*, published in 1740 with new critical texts containing anti-papal references, bears the misleading imprint '*A La Haia presso Pietro Gosse*' (published in the Hague by Pietro Gosse) to avoid problems with the Venetian censors. G.M

*Bibliography:* Pallucchini, in Venice, 1941, p. 44; Morazzoni, 1943, p. 237; Lanckoronska, 1950, no. 135; Blunt and Croft Murray, 1957, nos. 464–506; Succi, 1983, pp. 543–71, nos. 71; *idem*, 1985; *idem*, 1986, nos 43–75; Vivian, 1989, no. 25; De Grassi, in Pordenone, 1990, pp. 67–84

## ANTON MARIA ZANETTI (ZANETTI the ELDER)
born Venice, 20 February 1679/80
died Venice, 31 December 1767

Draughtsman, printmaker, collector and connoisseur. The son of Gerolamo, a physician, he is sometimes confused with his namesake, Anton Maria Zanetti the Younger (1706–78), the son of his cousin Alessandro, who worked at the Marciana Library and was responsible for a number of erudite publications. Zanetti the Elder trained first in the workshop of the painter Nicolò Bambini, and later with Sebastiano Ricci and Antonio Balestra. At the beginning of the 18th century he travelled to Bologna, where he worked with the painter Viano. In 1708, under the supervision of the French printmaker N. S. Edelink, he engraved Tintoretto's *St Peter*, part of the decoration of the Madonna dell' Orto, Venice. Already at the turn of the century his house had become a meeting-place for Venetian and foreign artists, connoisseurs and collectors, and Sebastiano and Marco Ricci were among his close friends. He also gained an international reputation as an art connoisseur and expert in antique gems. In 1720–2 he travelled to Paris via Rotterdam, where he acquired a considerable collection of etchings by Rembrandt and engravings by Albrecht Dürer and Lucas van Leyden. Zanetti's vast collection of prints, of which he was very proud, together with his gems and drawings, were influential in fermenting new ideas among contemporary artists and *littérateurs*, as Goldoni recorded. In Paris he met with his friends Rosalba Carriera and Antonio Pellegrini, and shared with them the hospitality of connoisseurs such as Pierre Crozat and Jean-Pierre Mariette, with whom he corresponded throughout his life. Some of his letters survive in libraries in Florence (Marucelliana and Laurenziana), Venice (Marciana), and Vienna. In Paris he was introduced to the Duc d'Orléans, Prince Regent of France, who asked for his advice in the purchase of paintings for his gallery. From Paris, Zanetti went to London, where he was welcomed by leading collectors, and where he was able to acquire the Duke of Arundel's collection of drawings by Parmigianino. On his return to Venice, Zanetti began the most prolific period of his life, as artist, printmaker, art dealer and sometime agent between his artist-friends and important European collectors; he was also very close to Consul Smith and Marshal Schulenburg.

In 1736 he travelled to Vienna to buy paintings for Prince Eugene of Savoy. Zanetti considered his major accomplishment to be his *Diversarum iconum*, in which he revived the technique of the *chiaroscuro* woodcut much favoured by Parmigianino. Apparently, he also etched and engraved under the guidance of Marco Ricci. In collaboration with Zanetti the Younger he published *Delle Antiche Statue . . .* (cat. 84; 1740–3); in *Dactyliotheca Zanettiana*, 1750, he illustrated his collection of gems. On his death, his vast collection passed to his nephews and was dispersed soon afterwards; in 1804 the writer Abbott Lena was already lamenting that everything from the Zanetti's marvellous collection had passed over the Alps and across the sea (*Esposizione storica . . . di pitture in Venezia*, MS, Correr, Venice). O.T.

### 47
ANTON MARIA ZANETTI
*Self-portrait in a Mask, Drawing a Caricature*
pen and brown ink, 28.4 × 20.9 cm
Lent by Her Majesty The Queen

The man standing and sketching with a crayon on a sheet of paper wears a three-corner hat and Carnival mask, the *bauta*. It has been suggested that this is Zanetti's witty self-portrait. Like Marco Ricci and the Tiepolos, he made caricatures throughout his life, especially of contemporary opera singers. The album that contains this drawing and cat. 48 was assembled by Consul Smith, a friend of Zanetti's. This album contains also drawings by other artists, including Marco Ricci and Fossati, meticulously listed by Consul Smith at the beginning of the volume. Another album of Zanetti's caricatures is at the Cini Foundation, Venice. O.T.

*Provenance:* Consul Joseph Smith, Venice; 1761, sold to George III
*Bibliography:* Blunt and Croft-Murray, 1957, no. 197

### 48
ANTON MARIA ZANETTI
*Seven Men Standing on a Quay*
pen and brown ink, 34 × 49 cm
Lent by Her Majesty The Queen

Like cat. 47, this drawing is included in the album put together by Consul Smith. Although some of the subjects of Zanetti's caricatures have been identified, many are still anonymous, as in this instance. The humorous types in this caricature, however, seem to be taken from Venetian café society of the time. O.T.

*Provenance:* Consul Joseph Smith, Venice; 1761, sold to George III
*Bibliography:* Blunt and Croft-Murray, 1957, no. 186

### 49
ANTON MARIA ZANETTI
[*Diversarum iconum*], later called *Raccolta di varie stampe . . .*
published in Venice in the late 1720s
23 × 18.5 cm (open book)
National Gallery of Art, Washington
Rosenwald Collection, 1952.8.486–535

The volume is open to show a *Standing Apostle with a Book* and the *Adoration of the Shepherds*, *chiaroscuro* woodcuts printed from three blocks. This collection was probably first published in the late 1720s in one volume. The rare early volume shown here contains 40 *chiaroscuro* woodcuts by Zanetti, Zanetti's portrait by Rosalba Carriera engraved by Faldoni, two etched plates by Zanetti, six engravings by Faldoni and one by Andrea Zucchi. The various plates are dated between 1721 and 1726. These were mounted by Zanetti on album pages with gilt and watercolour borders, the colours of the border carefully varied to complement the colours of the prints.

In the third edition the plates follow a letter of dedication to Prince Wenceslav of Liechtenstein. In the letter Zanetti writes that, after having printed 30 copies of the volumes, he destroyed the woodblocks to avoid further printing after his death, which, because of the difficulty of the printing technique would have necessarily been below his high standard. In this important work Zanetti rediscovered a complicated *chiaroscuro* woodcut technique used in Italy mainly in the 16th century. Zanetti was an avid print collector throughout his life, and aimed at owning the complete works by major artists, such as Rembrandt and Callot. While in England *c.* 1722 he bought a large group of drawings by Parmigianino from the Earl of Arundel. Knowledge of these prints must have prompted his interest in experimenting with the technique of *chiaroscuro* woodcut soon after his return to

Venice, as is indicated by a letter from Rosalba Carriera to Mariette of 18 September 1722 (Succi, 1983, p. 439). The majority of the *chiaroscuro* woodcuts in the *Raccolta* are after drawings by Parmigianino – himself a great printmaker – in Zanetti's collection; others are after Raphael, Giacomo Caraglio and Lelio Orsi; seventeen are anonymous. Twenty plates are dedicated to Zanetti's friends, including Crozat, Mariette, Consul Smith and Rosalba Carriera. The present volume is bound in full red morocco, richly gilt, with an early version of Zanetti's arms on the cover.    O.T.

*Provenance:* Anton Maria Zanetti, Venice; Ambrose Firmin Didot (sale 1882); Pierre Berè; Lessing J. Rosenwald
*Bibliography:* Vicenza 1969; Venice and Gorizia, 1983, p. 440, no. 593

## GAETANO GHERARDO ZOMPINI
born Nervesa, 24 September 1700
died Venice, 20 May 1778

Painter, book illustrator and engraver. He was a pupil of the painter Niccolò Bambini and a follower of Marco Ricci, but most of his paintings are lost or destroyed, and his greatest work was done as a printmaker. His major undertaking, *Le Arti che Vanno per via* (cat. 187, 188), first published in 1753, is a collection of scenes of street-traders sympathetically portrayed.

By illustrating the life of a stratum of Venetian society that was not usually the subject of contemporary art, Zompini made one of the few serious attempts to break new ground in subject-matter in 18th-century Venice. The publication was a success, and Zompini was befriended by Antonio Zanetti the Elder for whom he had etched a series of prints, the *Varii Capricci*, after drawings in Zanetti's collection by the 16th-century artist G.B. Castiglione. Zompini also worked for other Venetian publishers, including Zatta, for whom he contributed designs to the *Divine Comedy* in 1757 and to *Orlando Furioso* in 1772. The illustrations to the play *Rutzvanscad* (cat. 189) by Zaccaria Valaresso, published in Venice in 1736 by Bettinelli, have been convincingly attributed to him.

He died blind and poor, like a character from *Le Arti*.    O.T.

### 187

GAETANO ZOMPINI
*Le Arti che Vanno per via nella città di Venezia,*
published in Venice by S. Bettinelli in 1753
volume of 60 etchings, 43.8 × 62 cm (open book)
Department of Printing and Graphic Arts, Houghton Library, Harvard University, Cambridge, MA (inv. Typ.725.53.897F)

This series of Venetian street-traders is Zompini's major undertaking, and one of the most interesting and original works in the genre of the time. It has been suggested that Zompini was inspired by *Le Arti di Bologna* engraved by Giuseppe Mitelli (1674–1718) and by other series of street-criers. The preparatory drawings are in the Correr Museum, Venice, in an album originally in Zanetti's library. Dated 1754, the album contains 60 drawings in sepia, or else coloured with chinese ink or given a bluish tint, which are arranged in the same order as the etchings in the published series. Additional sketches show variations on the published compositions; other drawings exist that could indicate the series was intended to have 100 plates, of which only 60 were eventually published. There are six editions of the series; only the very rare first edition, dated 1753 on the title-plate, was published during Zompini's

lifetime; the verses in Venetian dialect at the bottom of each plate were written by Dr Questini, a priest and the friend of Zanetti and Zompini. The earliest edition apparently contained 40 plates, to which twenty were added soon afterwards. Apparently the plates were then taken to England and were still in use in the mid-19th century for the last edition. Like the volume of drawings in the Correr, this volume from the first edition comes from the library of Antonio Zanetti the Elder, who was Zompini's patron. The album is open to show plate 18, *Dai foli*, the vendor of fire-bellows, and plate 54, *Fa ballar i cani*, the dog-trainer, one of the many entertainers working in Venice at the time.    O.T.

*Provenance:* Antonio Zanetti the Elder, Venice; Houghton Library
*Bibliography:* Battistella, 1916, p. 93; Lapiccirella, n.d., no. 5. 13–15; Bozzolato, 1978; Succi, in Venice and Gorizia, 1983, pp. 451–63.

### 188

GAETANO ZOMPINI
*Le Arti che Vanno per la via nella città di Venezia,*
published in Venice by S. Bettinelli in 1753
volume of 60 hand-coloured etchings, 43.8 × 62 cm (open book)
Private Collection

It has been suggested that the British Resident, the collector John Strange (1732–99), who lived in Venice between 1773 and 1787, asked the Venetian art dealer Gianmaria Sasso to buy Zompini's copperplates for *Le arti …* and *Varii Capricci*, the set of etchings after drawings by G.B. Castiglione in the collection of Antonio Zanetti the Elder. While still in Venice Strange used the plates to prepare the third edition of *Le Arti …*, which was published in London. This was the first of at least three English editions; a short biography of the artist written by Sasso was included, together with verses in English that explain the subjects of the prints. Sasso mentioned that a number of sets from the first edition were hand-coloured by Zompini; also, since this particular set comes from Zanetti's celebrated library it must have been one of the earliest volumes issued and one of the most carefully coloured, given that Zanetti was Zompini's patron in this venture, and a protector of the artist. The fine hand-colouring is visible in plate 6, *Zaletto*, the vendor of fried cakes, and plate 7, *Codega*, the lantern-bearer, who escorts theatre-goers home.    O.T.

*Bibliography:* Battistella, 1916, p. 93; Lapiccirella, n.d., nos. 13–15; Bozzolato, 1978; Succi, in Venice and Gorizia, 1983, pp. 451–63

# FRANCESCO ZUCCARELLI

born Pitigliano, Florence, 15 August 1702
died Florence, 30 December 1788

Painter and draughtsman. He was probably trained in Florence and Rome, where he studied the 17th-century landscape painters, particularly Claude Lorrain, as well as later artists such as Locatelli and Pannini. He moved to Venice c. 1730, where he was influenced by Sebastiano Ricci to such a degree that he is sometimes considered to have been his pupil. In Venice he was an immediate success, enjoying the patronage of, among others, Marshal Schulenburg, Consul Smith and Count Algarotti, who recommended him to the Elector of Saxony. Zuccarelli excelled as a landscape painter, although he also painted religious, historical and mythological compositions; he introduced a more mellow and airy palette to the typically Venetian colours. He sometimes collaborated with other artists, including Bellotto and Visentini, as in the *View of Burlington House* (1746; Royal Collection).

In 1746 he made some prints using both etching and engraving in J. Wagner's workshop in Venice, where Visentini was also employed. Encouraged by Consul Smith, Zuccarelli spent the years 1752–62 in London, returning in 1765 to deliver Algarotti's bequest to Lord Chatham, possibly in person. In London he was a great success, and was invited to exhibit at the Free Society and at the Society of Artists. In 1768 he was a founder member of the Royal Academy of Arts. In 1771 he was again in Venice when he was elected President of the Venetian Academy.    O.T.

## 165

FRANCESCO ZUCCARELLI
*Seated Female Nude*
charcoal and grey wash heightened with white bodycolour and red chalk on cream paper, 34.5 × 23.9 cm
The Board of Trustees of the Victoria and Albert Museum, London (inv. E1661–1914)

This drawing comes from one of two albums that belonged to the 18th-century English architect Richard Norris. Entitled *Sketches Taken in Italy 1769*, the albums contain a number of drawings of buildings, ornaments and sculptures by Norris himself and various other artists including Giuseppe Manocchi (c. 1731–82) who worked in Rome. Zuccarelli's drawings were much sought after by English collectors. A number of his drawings survive, including genre drawings of figures, some of which are connected to figures in his paintings; this drawing has not been related to any painting and may have been intended to be a finished work.    O.T.

*Provenance:* Richard Norris (d. 1792); 1914, bought by the Victoria and Albert Museum
*Bibliography:* Rassi-Rathgeb, 1949

## 166

FRANCESCO ZUCCARELLI
*A Country Dance*
gouache on paper, c. 30 × 40 cm
Mr and Mrs Marco Grassi

This is a particularly lively example of one of Zuccarelli's bucolic genre scenes. The crowd in the background are watching the couple dancing to the rhythm of the tambourine. An oil painting of the same subject (ex-Crespi collection; subsequently ex-Biki Leonardi collection, Rome) has some similarities to this gouache, and is sometimes dated to Zuccarelli's first sojourn in England.    O.T.

*Bibliography:* Venice, 1969, p. 276, no. 124; Levey, 1980, pp. 87–94

## 167

FRANCESCO ZUCCARELLI
*Wooded Landscape with a Sportsman Watering his Mount*
oil on canvas, 77.5 × 117.5 cm
Private Collection

A signed drawing of a horseman watering his mount at a fountain with dogs and washerwomen, loosely related to this painting and in reverse, was offered at Christie's, London (7 July 1987, lot 48). Another drawing of a washerwoman and a boy driving a goat and a cow, possibly the first idea for the group below the bridge was on the market in 1958 (*Burlington Magazine*, June 1958). This is a pendant to the *Wooded Landscape with Peasants* (cat. 168).    O.T.

*Provenance:* acquired in the 18th-century by a private collector; Christie's, London, sale 15 April 1992, lot 58

## 168

FRANCESCO ZUCCARELLI
*Wooded Landscape with Peasants*
oil on canvas, 77.5 × 117.5 cm
Private Collection

A pendant to the *Wooded Landscape with a Sportsman Watering his Mount* (cat. 167), this is a typical example of Zuccarelli's pastoral landscapes much favoured by 18th-century British collectors.    O.T.

*Provenance:* acquired in the 18th-century by a private collector; Christie's, London, sale 15 April 1992, lot 58

## 169

FRANCESCO ZUCCARELLI
Frontispiece and (probably) vignettes in Homer, *Batracomiomachia*
published by G.B. Albrizzi in Venice, 1744
etchings with engraving, 22.5 × 29 cm (open book)
The British Library Board, London (76.d.14)

This ancient parody of Homer's *Iliad* was misattributed to him at an early date. The story begins with a friendly gesture: a mouse is invited by a frog to ride on his back and visit the frog's kingdom; but the frog is frightened by a snake and dives, leaving his passenger to drown in the sight of a fellow mouse. Misinterpretation leads to war. At first the mice win, and then Athena pleads with Zeus; his thunderbolts fail, but an army of crabs manage to stop the fighting.

The distinctive 18th-century combination of scholarship and humour is clear throughout Albrizzi's edition. The Greek text was researched, the Latin translation carefully chosen, and the Italian translation made by Antonio Lavagnoli, who wrote lengthy introductions and dedicated his work to the Venetian nobleman Alvise Foscarini. Zuccarelli's design for the frontispiece, etched by Giuseppe Patrini, shows the opening events set in a typical Zuccarelli landscape, a pastoral scene with background mountains warmed by sunlight. This is followed by a succession of unsigned and witty vignettes and subtly misprinted initials. Poor Athena's mock fright at the frogs on the title page culminates in the portrait headpieces to the three linguistic sections; the Greek with a very Greek Homer, the Latin with a sturdy Roman, and the Italian with a leering satyr!    A.R.

*Provenance:* Consul Joseph Smith (a presentation copy, with manuscript inscription from Lavagnoli); George III
*Bibliography:* Morazzoni, 1943, p. 245

## 170

FRANCESCO ZUCCARELLI
*Mountain Landscape with Washerwomen and Fisherman*
c. 1760–70
gouache on paper, 41.5 × 63.7 cm
National Gallery of Art, Washington
Gift of John Morton Morris, in Honor of the 50th Anniversary of the National Gallery of Art, 1990.76.1

Although the figures – whether mythological or pastoral – dictate the subject of Zuccarelli's compositions, the landscape is his real subject. The artist's palette lightened during his stay in London, becoming more airy and delicate.    O.T.

*Bibliography:* Levey, 1959, pp. 1–20; *idem*, 1980, pp. 87–94

# Bibliography

ALBERICI, 1980 C. Alberici, *Il Mobile Veneto*, Milan, 1980.

ALBRICCI, 1982 G. Albricci, 'Contributi per un catalogo delle incisioni di Antonio Balestra', *Saggi e Memorie di Storia dell'Arte*, XIII, 1982, pp. 73–88.

ALBRIZZI, 1760 G.B. Albrizzi, *Studi di pittura*, Venice, 1760.

ALBRIZZI, 1765 G.B. Albrizzi, *Forestiero Illuminato . . .*, Venice, 1765.

ALGAROTTI, 1791–4 F. Algarotti, *Opere*, 17 vols, Venice, 1791–4.

ALPAGO-NOVELLO, 1939–40 L. Alpago-Novello, 'Gli incisori bellunesi', *Atti del Reale Istituto Veneto di Scienze e Lettere ed Arti*, 1939–40, pp. 559–60.

AMES, 1963 W. Ames, 'The Villa del Timpano Arcuato by Francesco Guardi', *Master Drawings*, I, iii, 1963, pp. 37–9.

AMRHEIN, 1890 A. Amrhein, 'Reihenfolge der Mietglieder des adeligen Domstiftes zu Würzburg', *Archiv des Historischen Vereines von Unterfranken und Aschaffenburg*, XXXIII, Würzburg, 1890.

AMSTERDAM, 1990 *Painters of Venice: The Story of the Venetian 'veduta'*, exh. cat. by B. Aikema and B. Baker, Rijksmuseum, Amsterdam, 1990.

ANDROSOV, 1978 S.O. Androsov, 'Nuovi contributi su opere di Orazio Marinali', *Monumenti di cultura*, Moscow, 1978, pp. 222–9.

ANDROSOV, 1991 S.O. Androsov, 'Da Pietro I a Paolo I: Mecenati russi e scultori italiani nel XVIII secolo, *Canova all'Ermitage: Le sculture del museo di San Pietroburgo*, exh. cat., Rome, 1991, pp. 27–39.

ANDROSOV, 1993 S.O. Androsov, 'Skulpturen auf dem Venezianischen Kunstmarkt im frühen 18. Jahrhundert', *Kunstchronik*, XLVI, 1993, pp. 380–5.

ANDROSOV and NEPI SCIRÉ, 1992 S.O. Androsov and G. Nepi Sciré, *Alle origine del Canova. Le terrecotte della collezione Farsetti*, Venice, 1992.

ARBAN, 1970 A. Arban, 'L'attività padovana di Pier Antonio Novelli', *Arte Veneta*, XXIV, 1970, pp. 185–98.

ARETIN, 1986 K.O. von Aretin, *Stände und Gesellschaft im Alten Reich*, ed. G. Schmidt, Stuttgart, 1989.

ARGAN, 1969 G.C. Argan, 'Il filo del Canova', *Momenti del marmo*, Rome, 1969.

ARGAN, 1970 G.C. Argan, 'Studi sul Neoclassico', *Storia dell'arte*, VII, viii, 1970.

ARISI, 1961 F. Arisi, *Dipinti farnesiani di Sebastiano Ricci, Giovanni Battista Draghi, Francesco Manti, Ilario Spolverini*, exh. cat., Piacenza, 1961.

ARSLAN, 1932 W. Arslan, 'G.B. Tiepolo e G.M. Morlaiter ai Gesuati', *Rivista della città di Venezia*, 1932, pp. 19–25.

ARSLAN, 1936 W. Arslan, 'Studi sulla pittura del primo Settecento veneziano', *La Critica d'Arte*, I, 1936, pp. 184–97, 238–50.

ARSLAN, 1951 W. Arslan, 'Breve Nota su Pittoni', *Bollettino d'Arte*, XXXVI, 1951, pp. 27–30.

ASHTON, 1978 M. Ashton, 'Allegory, Fact and Meaning in Giambattista Tiepolo's Four Continents in Würzburg', *The Art Bulletin*, LX, 1978, pp. 109–25.

AUCKLAND, WELLINGTON and CHRISTCHURCH, 1986 *Canaletto: Master of Venice*, exh. cat. by R. Bromberg et al., Auckland City Art Gallery, Auckland; National Art Gallery, Wellington; Robert McDougall Art Gallery, Christchurch, 1986.

AZZI VISENTINI, 1985 M. Azzi Visentini, 'Un Guardi ritrovato', *Arte Veneta*, XXXIX, 1985, pp. 178–9.

AZZI VISENTINI, 1993 M. Azzi Visentini, 'Feste', *Francesco Guardi; Vedute capricci Feste*, Venice, 1993.

BALLARIN, 1982 A. Ballarin, *Pinacoteca di Vicenza*, Vicenza, 1982.

BALTIMORE, 1959 *Age of Elegance: The Rococo and its Effect*, exh. cat. by A.D. Breeskin, G. Boas and J.D. Breckenridge, Baltimore Museum of Art, 1959.

BANDIERA, 1982 J. Bandiera, *The Pictorial Treatment of Architecture in French Painting, 1701 to 1804*, PhD. Diss., Institute of Fine Arts, New York University, 1982.

BARBIERI, 1957 F. Barbieri, 'Terrecotte, marmi e disegni dei Marinali presso il Museo Civico di Vicenza', *Studi in onore di F.M. Mistrorigo*, Vicenza, 1957, pp. 111–97.

BARBIERI, 1960 F. Barbieri, *L'attività di Marinali per la decorazione della basilica di Monte Berico*, Vicenza, 1960.

BARBIERI, 1962 F. Barbieri, *Il Museo Civico di Vicenza*, II, *Dipinti e sculture dal XVI al XVII secolo*, Venice, 1962.

BARBIERI, 1972 F. Barbieri, *Illuministi e Neoclassici a Vicenza*, Vicenza, 1972.

BARBIERI, 1982 F. Barbieri, 'Dai disegni al marmo tra sensi e ragione', *Disegni di Canova del Museo di Bassano*, exh. cat., Milan, 1982.

BARBIERI, 1990 F. Barbieri, 'Le scene della scultura', *I Tiepolo e il Settecento Vicentino*, exh. cat., Vicenza, Montecchio Maggiore and Bassano del Grappa, 1990.

BARCHAM, 1977 W. Barcham, *The Imaginary View Scenes of Antonio Canaletto*, New York, 1977.

BARCHAM, 1989 W. Barcham, *The Religious Paintings of Giambattista Tiepolo: Piety and Tradition in Eighteenth-century Venice*, Oxford, 1989.

BARCHAM, 1991 W. Barcham, 'Two views by Bernardo Bellotto: View of Dresden with the Frauenkirche at Left and View of Dresden with the Hofkirche at Right,' *North Carolina Museum of Art Bulletin*, XV, 1991, pp. 13–28.

BARIOLI, 1957 G. Barioli, *Mostra dei disegni di Antonio Canova nel secondo centenario della nascita*, exh. cat., Bassano, 1957.

BARTSCH, 1803–21 A. von Bartsch, *Le Peintre-graveur*, 21 vols, Vienna, 1803–21.

BASAN, 1767 F. Basan, *Dictionnaire des graveurs anciens et modernes*, 3 vols, Paris, 1767.

BASAN, 1791 F. Basan, *Supplément au Dictionnaire des graveurs anciens et modernes*, Brussels, 1791.

BASSANO, 1963 *Marco Ricci*, exh. cat., Palazzo Sturm, Bassano, 1963.

BASSANO and ROME, 1988 *Giovanni Volpato*, exh. cat. ed. G. Marini, Museo-Biblioteca-Archivio, Bassano, and Istituto Nazionale per la Grafica, Rome, 1988.

BASSI, 1941 E. Bassi, *Di regia Accademia di belle Arti di Venezia*, Florence, 1941.

BASSI, 1952 E. Bassi, *Antonio Canova: Monocromi e disegni*, exh. cat., Florence, 1952.

BASSI, 1957[1] E. Bassi, *La Gipsoteca di Possagno: Sculture e dipinti di Antonio Canova*, Venice, 1957.

BASSI, 1957[2] E. Bassi, *Antonio Canova, i grandi maestri del disegno*, Milan, 1957.

BASSI, 1959 E. Bassi, *Il Museo Civico di Bassano: I disegni di Antonio Canova*, Venice, 1959.

BASSI, 1978 E. Bassi, 'L'Accademia di Belle Arti e Leopoldo Cicognara', *Venezia e l'età di Canova*, Venice, 1978.

BASSI, 1980 E. Bassi, *Architettura del Sei e Settecento a Venezia*, Venice, n.d.; reprint, Venice, 1980.

BASSI, 1987 E. Bassi, *Palazzi di Venezia. Admiranda Urgis Venetae*, 3rd ed., Venice, 1987.

BASSI-RATHGEB, 1949 R. Bassi-Rathgeb, *Un album inedito di Zuccarelli*, Bergamo, 1949.

BATTISTELLA, 1929 O. Battistella, *Gaetano Zompini*, Bologna, 1929.

BATTISTI, 1954 E. Battisti, 'Antonio Balestra' *Commentari*, I, 1954, pp. 26–39.

BAXANDALL, 1985 M. Baxandall, *Patterns of Intention: On the Historical Explanation of Pictures*, New Haven and London, 1985.

BEAN and GRISWOLD, 1990 J. Bean and W. Griswold, *18th-Century Italian Drawings in the Metropolitan Museum of Art*, New York, 1990.

BELLINI, 1993 P. Bellini, 'Marco Ricci, contributi per un catalogo delle acqueforti', *Grafica d'Arte*, XIII, 1993, pp. 11–25.

BELLUNO, 1954 *Pitture del Settecento nel Bellunese*, exh. cat. by F. Valcanover, Palazzo dei Vescovi, Belluno, 1954.

BELLUNO, 1968 *Marco Ricci e gli incisori bellunesi del Settecento*, exh. cat. by B. Passamani, Belluno, 1968.

BELLUNO, 1993 *Marco Ricci e il paesaggio veneto del Settecento*, exh. cat. by D. Succi and A. Delneri, Palazzo Crepadona, Belluno, 1993.

BENESCH, 1947 O. Benesch, *Venetian Drawings of the Eighteenth Century in America*, New York, 1947.

BERENGO, 1979 M. Berengo, 'Il problema politico-sociale di Venezia e della sua terraferma', *Storia della civiltà veneziana*, III, Florence, 1979.

BERENSON, 1894 B. Berenson, *Venetian Painters of the Renaissance*, New York and London, 1894.

BERGAMO, 1983 *Il cielo domenicano di Gaspare Diziani: Studi e ricerche in occasione del restauro*, Bergamo, 1983.

BERGAMO, 1987 *Michele Marieschi: Venezia in Scena*, exh. cat., ed. D. Succi, Galleria Lorenzelli, Bergamo, 1987.

BERLIN, 1973 *Vom Späten Mittelalter bis zu Jacques Louis David: Neuerworbene und neubestimmte Zeichnungen im Berliner Kupferstichkabinett*, exh. cat. by M. Winner et al., Kupferstichkabinett, Berlin, 1973.

BERLIN, 1978 *Picture Gallery Staatliche Museen Preussischer Kulturbesitz, Berlin. Catalogue of Paintings, 13th–18th Century*, Berlin, 1978.

BERLIN, 1985 *Veduten architektonisches Capriccio und Landschaft*, exh. cat., ed. P. Dreier, Berlin, 1985.

BERLIN, 1994 *Das Berliner Kupferstichkabinett: Ein Handbuch zur Sammlung*, ed. A. Dückers, Berlin, 1994.

BERN, 1991 *Emblèmes de la liberté: l'image de la république dans l'art du XVIe au XXe siècle: 21e exposition du Conseil de l'Europe*, exh. cat. by D. Gambone and G. Germann, Musée d'Histoire de Berne et Musée des Beaux-Arts de Berne, 1991.

BETTAGNO, 1963 A. Bettagno, *Disegni veneti del Settecento della Fondazione Giorgio Cini e delle collezioni venete*, exh. cat., ed. A. Bettagno, Venice, 1963.

BETTAGNO, 1983 A. Bettagno, 'In margine a una Mostra', *Notizie di Palazzo Albani* XII, 1983, pp. 222–8.

BETTINELLI, 1799–1801 S. Bettinelli, 'Dell'entusiasmo delle Belle Arti', Milan, 1769, in *Opere*, Venice, 1799–1801.

BIADENE, 1992 S. Biadene, 'Le feste per i Conti del Nord: "ironico e malinconico" crepuscolo del rococo', *Per Giuseppe Mazzariol* (Quaderno di venezia arti, I), ed. M. Brusatin, Rome, 1992.

BIALOSTOCKI, 1964 J. Białostocki, 'Bernardo Bellotto in Dresden and Warsaw', *The Burlington Magazine*, CVI, 1964, pp. 289–90.

BIANCONI, 1779, 1802 G.L. Bianconi, 'Elogio Storico del Cavalier G.B. Piranesi', *Antologia Romana*, n.s. 34–6, Feb–March 1779; reprinted in *Opere*, II, Milan, 1802, pp. 127–40.

BIASUZ, 1935–6 G. Biasuz, 'L'Opera di A. Corradini fuori d'Italia', *Bollettino d'Arte*, ser. 3, XXIX, 1935–6, pp. 268–79.

BIASUZ, 1948 G. Biasuz, 'Aggiunta all'opera de Antonio Corradini', *Arte Veneta*, II, 1948, p. 153.

BIASUZ and BUTTIGNON, 1969 G. Biasuz and M.G. Buttignon, *Andrea Brustolon*, Padua, 1969.

BINGHAMTON, 1970 *Selection from the Drawing Collection of Mr and Mrs Julius S. Held*, exh. cat., Binghamton, 1970.

BINION, 1970 A. Binion, 'From Schulenburg's Gallery and Records', *The Burlington Magazine*, CXII, 1970, pp. 297–303.

BINION, 1976 A. Binion, *Antonio and Francesco Guardi: Their Life and Milieu with a Catalogue of their Figure Drawings*, New York and London, 1976.

BINION, 1983 A. Binion, 'Two Compositional Studies by Piazzetta', *Master Drawings*, XXI, 1983, pp. 431–3.

BINION, 1990 A. Binion, *La galleria scomparsa del maresciallo von der Schulenburg: Una mecenate nella Venezia del Settecento*, Milan, 1990.

BINION, 1991 A. Binion, 'Von Venedig gen Norden: Schulenburgs unstete Galeria', *Venedigs Ruhm im Norden*, exh. cat., Hanover and Düsseldorf, 1991, pp. 16–22.

BIRKE, 1991 V. Birke, *Die Italienische Zeichnungen der Albertina*, Munich, 1991.

BIRMINGHAM, 1953 *Works of Art from Midland Houses*, exh. cat., Birmingham Museums and Art Galleries, 1953.

BIRMINGHAM, 1993–4 *Canaletto and England*, exh. cat., Birmingham Museums and Art Galleries, 1993–4.

BIRMINGHAM and SPRINGFIELD, 1978 *The Tiepolos: Painters to Princes and Prelates*, exh. cat. by E. Weeks, Birmingham Museum of Art, Birmingham, AL, and Springfield Museum of Art, Springfield, MA, 1978.

BLANC, 1877 C. Blanc, *Histoire des peintres de toutes les écoles, Ecole Vénitienne*, Paris, 1877.

BLEYL, 1981 M. Bleyl, *Bernardo Bellotto gennant Canaletto: Zeichnungen aus dem Hessischen Landesmuseum Darmstadt*, Darmstadt, 1981.

BLOOMINGTON, STANFORD and NEW YORK, 1979–80 *Domenico Tiepolo's Punchinello Drawings*, exh. cat. by M.E. Vetrocq and A.M. Gealt, Indiana University of Art, Bloomington, 1979; Stanford University Museum of Art, Stanford, 1979; The Frick Collection, New York, 1980.

BLUNT, 1948 A. Blunt, 'Dipinti venezani del XVII e del XVIII secolo nelle Collezioni Reali d'Inghilterra', *Arte Veneta*, II, 1948, pp. 127–30.

BLUNT, 1954 A. Blunt, *The Drawings of G.B. Castiglione and Stefano della Bella in the Collection of Her Majesty the Queen at Windsor Castle*, London, 1954.

BLUNT, 1958 A. Blunt, 'A neo-Palladian Programme executed by Visentini and Zuccarelli for Consul Smith', *The Burlington Magazine*, C, 1958, pp. 283–4.

BLUNT and CROFT-MURRAY, 1957 A. Blunt and E. Croft-Murray, *Venetian Drawings of the XVII and XVIII Centuries in the Collection of Her Majesty the Queen at Windsor Castle*, London, 1957.

BOESTEN-STENGEL, 1988 A. Boesten-Stengel, in *Meisterwerke der Sammlung Thyssen-Bornemisza. Gemälde des 14.–18. Jahrhunderts*, exh. cat., Staatsgalerie Stuttgart, 1988.

BOLTON, 1920 A.T. Bolton, *Description of the House and Museum of Sir John Soane*, London, 1920.

BOMBE, 1918 W. Bombe, 'Die Sammlung Dr. Richard von Schnitzler in Köln', *Der Cicerone*, X, 1918, pp. 37–49.

BONANNINI, 1993 A. Bonannini, 'Dall'ideazione alla realizzazione: note sulla raccolta di D. Lovisa' in *Venezia-Venezia 1717–1793*, exh. cat., Palazzo Ducale, Venice, 1993, pp. 23–8.

BORA, 1988 G. Bora, *I Disegni della collezione Morelli*, Bergamo, 1988.

BORIS and CAMMAROTA, 1990 F. Boris and G. Cammarota, 'La collezione di Carlo Broschi detto Farinelli', *Accademia Clementina Atti e Memorie*, XXVII, 1990.

BORENIUS, 1917 T. Borenius, 'Notes on G.B. Piazzetta', *The Burlington Magazine*, XXX, 1917, pp. 10–16.

BORGHERO, G. Borghero, *Collezione Thyssen-Bornemisza: Catalogo delle opere esposte*, Milan, 1986.

BÖRSCH-SUPAN, 1974 J. Börsch-Supan, *Caspar David Friedrich*, New York, 1974.

BOSTON, 1958 *Master Drawings of Venice*, exh. cat., Museum of Fine Arts, Boston, MA, 1958.

BOTT, 1989 K. Bott, '"La mia galleria Pommersfeldiana"', *Die Geschichte der Gemäldegalerie des Lothan Franz von Schönborn*', *Die Grafen von Schönborn. Kirchenfürsten, Sammler, Mäzene*, exh. cat., Nationalmuseum Nuremberg, 1989.

BOTTARI, 1757, 1822 G. Bottari, *Raccolta di lettere sulla pittura scultura ed architettura*, Florence, 1757; Milan, 1822.

BOTTI, 1891 G. Botti, *Catalogo delle Gallerie di Venezia*, Venice, 1891.

BOWRON, 1990 E.P. Bowron, *European Paintings before 1900 in the Fogg Art Museum: A Summary Catalogue Including Paintings in the Busch-Reisinger Museum*, Cambridge, MA, 1990.

BOWRON, 1993 E.P. Bowron, *Bernardo Bellotto: The Fortress of Königstein*, Washington, 1993.

BOZZOLATO, 1978 G. Bozzolato, *Gaetano Zompini incisore senza fortuna*, Padua, 1978.

BRANDOLESE, 1795 P. Brandolese, *Del Genio de'Lendinaresi per la pittura*, Padua, 1795.

BRATTI, 1917 R. Bratti, 'Antonio Canova nella sua vita artistica privata', *Nuovo Archivio Veneto*, XXXII, 1917.

BRAUBACH, 1963–5 M. Braubach, *Prinz Eugen von Savoyen: Eine Biographie*, Vienna, 1963–5.

BRAUBACH, 1965 M. Braubach, 'Die Gemäldesammlung des Prinzen Eugen von Savoyen', *Festschrift für Herbert von Einem*, ed. G. von der Osten and G. Kauffman, Berlin, 1965.

BRIGANTI, 1966 G. Briganti, *Gaspar van Wittel, e l'origine della veduta settecentesca*, Rome, 1966.

BRIGSTOCKE, 1978 H. Brigstocke, *Italian and Spanish Paintings in The National Gallery of Scotland*, Edinburgh, 1978.

BRIZIO, 1933 A.M. Brizio, 'Unpublished Drawings by G.B. Tiepolo', *Old Master Drawings*, VIII, 1933, pp. 16–20.

BROMBERG, 1974, 1993 R. Bromberg, *Canaletto's Etchings*, London and New York, 1974; 2nd ed. San Francisco, 1993.

BROWN, 1988 P.F. Brown, *Venetian Painting in the Age of Carpaccio*, New Haven and London, 1988.

BROWNING, 1905 H.E. Browning, article in *Magazine of Art*, 1905, p. 340.

BRUNEL et al., 1976 G. Brunel et al., *Piranèse et les Français*, Rome, 1976.

BRUSATIN, 1969 M. Brusatin, ed., *Illuminismo e Architettura dell '700 Veneto*, Castelfranco, 1969.

BRUSATIN, 1980 M. Brusatin, *Venezia nel Settecento: Stato, Architettura e Territorio*, Turin, 1980, pp. 212–3.

BRUSSELS, 1983 *Dessins vénitiens du dix-huitième siècle*, exh. cat. ed. E. Goldschmidt, Palais des Beaux-Arts, Brussels, 1983; English edition as *Masterpieces of Eighteenth-century Drawing*, London, 1983.

BUDAPEST et al., 1968 *Malarstowo Weneckie XV–XVIII W.*, exh. cat. Budapest, Dresden and Prague, Warsaw, 1968.

BUFFALO, 1935 *Master Drawings Selected from the Museums and Private Collections of America*, exh. cat. by A. Mongan, The Buffalo Fine Arts Academy, Buffalo, 1935.

BURDA, 1967 H. Burda, *Die Ruinen in den Bildern Hubert Roberts*, Munich, 1967.

BÜTTNER and MÜLBE, 1980 F. Büttner and W.-C. von der Mülbe, *Giovanni Battista Tiepolo: Die Fresken in der Residenz zu Würzburg*, Würzburg, 1980.

BYAM SHAW, 1933, 1968 J. Byam Shaw, 'Some Venetian Draughtsmen of the Eighteenth Century', *Old Master Drawings*, VII, 1933, pp. 47–63; reprinted in *James Byam Shaw: Selected Writings*, London, 1968, pp. 70–85.

BYAM SHAW, 1951 J. Byam Shaw, *The Drawings of Francesco Guardi*, London, 1951.

BYAM SHAW, 1954 J. Byam Shaw, 'The Drawings of F. Fontebasso', *Arte Veneta*, VIII, 1954, pp. 320–5.

BYAM SHAW, 1955 J. Byam Shaw, 'Guardi at the Royal Academy', *The Burlington Magazine*, XCVII, 1955, pp. 12–19.

BYAM SHAW, 1962 J. Byam Shaw, *The Drawings of Domenico Tiepolo*, London, 1962.

BYAM SHAW, 1976 J. Byam Shaw, 'Guardi Drawings,' *The Burlington Magazine*, CXVIII, 1976, pp. 856–9.

BYAM SHAW, 1977 J. Byam Shaw, 'Some Guardi Drawings Rediscovered', *Master Drawings*, XV, 1977, pp. 3–15.

BYAM SHAW and KNOX, 1987 J. Byam Shaw and G. Knox, *The Robert Lehman Collection, VI: Italian Eighteenth-century Drawings*, New York and Princeton, 1987.

BYSS, 1719 J. Byss, *Furtrefflicher Gemäld und Bilder Schatz in denen Gallerie und Zimmern des Pommersfeldischen nuerbauten fürtrefflichen Privat-Schloss zu finden ist*, Bamberg, 1719.

CAIANI, 1972 A.M. Caini, 'Affreschi e disegni inediti di Francesco Lorenzi', *Arte Veneta*, XXVI, 1972, pp. 154–66.

CALABI, 1931 A. Calabi, *La gravure italienne au XVIIIe siècle*, Paris, 1931.

CALABI, 1939 A. Calabi, 'Note su G.B. Tiepolo incisore', *Die Graphschen Künste*, 1939, p. 7.

CALDES, 1993 *Francesco Guardi: Disegni del Museo Correr di Venezia*, exh. cat. by A. Dorigato, Castel Caldés, Caldés, 1993.

CALLEGARI, 1936–7 A. Callegari, 'Le opere di Antonio Corradini a Este', *Bollettino d'Arte*, XXX, 1936–7, pp. 250–3.

CAMBRIDGE, 1973–4 *The European Fame of Isaac Newton*, exh. cat. by M. Jaffé, Cambridge, 1973–4.

CAMBRIDGE MA, 1958 *Drawings from the Collection of Curtis O. Baer*, exh. cat., ed. A. Mongan, Fogg Art Museum, Cambridge, MA, 1958.

CAMBRIDGE MA, 1970 *Tiepolo: A Bicentenary Exhibition 1770–1970; Drawings, mainly from American Collections, by Giambattista Tiepolo and Members of his Circle*, exh. cat. by G. Knox, Fogg Art Museum, Harvard University, Cambridge, MA, 1970.

CAMESASCA, 1974 E. Camesasca, *L'opera completa del Bellotto*, Milan, 1974.

CANTERBURY and CAMBRIDGE, 1985 *Guardi, Tiepolo and Canaletto from the Royal Museum, Canterbury and Elsewhere*, exh. cat., Royal Museum, Canterbury and Fitzwilliam Museum, Cambridge, 1985.

CARRIERA, 1865 *Rosalba Carriera, Journal de Rosalba Carriera pendant son séjour à Paris en 1720 et 1721*, trans. and ed. Alfred Sensier, Paris, 1865.

CASTELFRANCO, 1969 *Illuminismo e Architettura del '700 Veneto*, exh. cat., Castelfranco, 1969.

CATTON RICH, 1938 D. Catton Rich, *Catalogue of the Charles H. and Mary F.S. Worcester Collection of Paintings, Sculpture and Drawings*, Chicago, 1938.

CAVALLI-BJÖRKMAN, 1990 G. Cavalli-Björkman, *Nationalmuseum Stockholm. Katalog över äldre u Händskt malerie*, Stockholm, 1990.

CESSI, 1965 F. cessi, *Andrea Briosco detto il Riccio, Scultore*, Trent, 1965.

CHICAGO, 1938 *Loan Exhibition of Paintings, Drawings and Prints by the two Tiepolos: Giambattista and Giandomenico*, exh. cat. by D. Catton Rich, Art Institute, Chicago, 1938.

CHICAGO 1963 *Chicago Collectors*, exh. cat., Art Institute of Chicago, 1963

CHICAGO, 1970 *The Helen Regenstein Collection of European Drawings*, exh. cat., The Art Institute, Chicago, 1970.

CHICAGO MINNEAPOLIS and TOLEDO, 1970–1 *Painting in Italy in the Eighteenth Century: Rococo to Romanticism*, exh. cat., by J. Maxon and J. Rischel, The Art Institute of Chicago, Minneapolis Institute of Art, Museum of Art of Toledo, 1970–1.

CIBOLO and PEDROCCO, 1981 G.A. Cibolo and F. Pedrocco, *Il teatro illustrato nelle edizioni del settecento*, Venice, 1981; 2nd ed. 1992.

CICOGNA, 1854 E. Cicogna, *Lettera di Antonio Canova intorno ad una Madonnina in basso rilievo di marmo opera prima scolpita da lui circa l'anno 1770*, Venice, 1854.

CICOGNARA, 1823 L. Cicognara, *Biografia di Antonio Canova*, Venice, 1823.

CICOGNARA, 1824 L. Cicognara, *Storia della Scultura dal suo risorgimento in Italia fino al secolo del Canova*, Prato, 1824.

CICOGNARA, 1973 L. Cicognara, *Lettere ad Antonio Canova*, ed. G. Venturi, Urbino, 1973.

CIOFFI, 1987 R. Cioffi, *La cappella Sansevero: Arte barocca e ideologia massonica*, 10/7, Salerno, 1987.

CIRILLO and GODI, 1991 G. Cirillo and G. Godi, *I disegni della Biblioteca Palatina di Parma*, Parma, 1991.

CITTADELLA 1986 *Canaletto e Visentini, Venezia e Londra*, exh. cat., ed. D. Succi, Cittadella, 1986.

CLAUT, 1988 S. Claut, 'Per Gaspare Diziani: questioni cronologiche e qualche inedito', *Arte Veneta*, XLII, 1988, pp. 146–51.

COCHIN, 1758 C.N. Cochin, *Voyage d'Italie*, Paris, 1758.

COGGIOLA PITTONI, 1927–8 L. Coggiola Pittoni, 'Opere inedite di Giambattista Pittoni', *Dedalo*, III, 1927–8, pp. 671–95.

COLLINS BAKER, 1937 C.H. Collins Baker, *Catalogue of the Principal Pictures in the Royal Collection at Windsor Castle*, London, 1937.

COLOGNE, 1961 *Kurfürst Clemens August*, exh. cat. by M. Goes, Schloss Augustusburg, Brühl, Cologne, 1961.

COLOGNE, 1980 *Idee und Anspruch der architektur. Zeichnunger des 16. bis 20. Jahrhunderts aus dem Cooper-Hewitt Museum, New York*, exh. cat. by E. Evans Dee, Wallraf-Richartz-Museum, Cologne, 1979–80.

CONSTABLE, 1923 W.G. Constable, 'Some Unpublished Canalettos', *The Burlington Magazine*, XLII, 1923, pp. 278–88.

CONSTABLE, 1929 W.G. Constable, 'Canaletto at the Magnasco Society', *The Burlington Magazine*, LIV, 1929, p. 46.

CONSTABLE, 1929–30 W.G. Constable, 'Antonio Canale', *Old Master Drawings*, IV, 1929–30, p. 5.

CONSTABLE, 1939 W.G. Constable, article on the *Baccino di San Marco looking East*, *Bulletin Museum of Fine Arts, Boston*, 1939, p. 47.

CONSTABLE, 1954 W.G. Constable, 'An Allegorical Painting by Canaletto and others' (letter), *The Burlington Magazine*, XCVI, 1954, p. 154.

CONSTABLE, rev. LINKS, 1989 W.G. Constable, *Canaletto: Giovanni Antonio Canal, 1697–1768*, 2nd ed. rev. by J.G. Links, reissued with supplement and additional plates, 2 vols., Oxford, 1989.

CONTI 1971 A. Conti, *Storia del restauro*, Milan, 1971.

CONTI, 1981 A. Conti, 'Vicende e cultura del restauro', *Storia dell'Arte Italiana*, Turin, 1981, pp. 59–67.

CORBOZ, 1978 A. Corboz, 'Peinture militante et architecture révolutionnaire: à propos du thème du tunnel chez Hubert Robert', *Geschichte und Theorie der Architektur*, XX, 1978.

CORBOZ, 1979 A. Corboz, 'Pygmalion, serviteur des deux maîtres (Introduction à une expérience canovienne qui n'aura pas lieu)', *Genava*, XXXVII, 1979, pp. 165–75.

CORBOZ, 1985 A. Corboz, *Canaletto: Una Venezia immaginaria*, 2 vols., Milan, 1985.

CORUBOLO, 1989 A. Corubolo, 'Disegni di Francesco Lorenzi e Giandomenico Cignaroli per il libro veronese del secondo Settecento', *Verona Illustrata*, II, 1989, pp. 77–87.

CORUBOLO, 1991 A. Corubolo, 'Antonio Balestra per il libro', *Verona Illustrata*, IV, 1991, pp. 115–31.

CRISPOLTI, 1961 E. Crispolti, 'Fantasy', *Encyclopedia of World Art*, V, London, 1961, cols. 350–8.

CROFT-MURRAY, 1962, 1970 E. Croft-Murray, *Decorative Painting in England 1537–1837*, London, 2 vols, 1962, 1970.

CSENDES, 1985 Csendes, 'Die Stadt Wien als kaiserliche Haupt und Residenzstadt. Von den Zerstörungen des Jahres 1683 zum barocken Juwel', *Prinz Eugen und das barocke Österreich*, ed. K. Gutkas, Salzburg and Vienna, 1985.

CUSHMAN DAVIS, 1962 J. Cushman Davis, *The Decline of the Venetian Nobility as a Ruling Class*, Baltimore, 1962.

CUSHMAN DAVIS, 1975 J. Cushman Davis, *A Venetian Family and its Fortune, 1500–1900: The Donà and the Conservation of their Wealth*, Philadelphia, 1975.

CUST, 1913 L. Cust, 'Notes on Pictures in the Royal Collection', *The Burlington Magazine*, XXIII, 1913, I, p. 153, II, p. 276.

CZÉRE, 1990 A. Czére, *Italienische Barockzeichnungen*, Budapest, 1990.

CZÉRE, 1994 A. Czére, 'Egy újabban felbukkant kép az Esterházy gyűjteményból' [A Recently Emerged Painting from the Esterhazy Collection], *Művészettörténeti Értesító*, I–II, 1994, pp. 41–4.

CZOBOR, 1953 A. Czobar, 'Un tableau récemment acquis de Gaetano Gandolfi au Musée Hongrois des Beaux-Arts', *Acta historiae Artium Academiae Scientiarum Hungaricae*, I, 1953, pp. 175–80.

D'ARCAIS, 1964 F. D'Arcais, 'L'attività viennese di Antonio Bellucci', *Arte Veneta*, XVIII, 1964.

D'ARCAIS, 1973 F. D'Arcais, 'I complessi decorativi fiorentini di Sebastiano Ricci', *Antichità Viva*, 1973, II, pp. 18–25; IV, pp. 15–28; VI, pp. 6–13.

D'ARCAIS, 1974 F. D'Arcais, 'Antonio Balestra', *Maestri della pittura veronese*, ed. P. Brugnoli, Verona, 1974, pp. 359–66.

D'ARCAIS, 1978 F. Darcais, 'Antonio Balestra', in *La pittura a Verona tra Sei e Settecento*, exh. cat. ed. L. Magagnato, Verona, 1978, pp. 196–204.

D'ARCAIS, 1979 F. D'Arcais, 'Inediti di A. Balestra', *Antichità Viva*, XVIII, 1979, pp. 21–7.

D'ARCAIS, 1981 F. D'Arcais, 'Antonio Balestra', *Lione Pascoli: Vite de' Pittori, Scultori ed architetti Viventi*, ed. V. Martinelli and F. Mancini, Perugia, 1981, pp. 21–7.

D'ARCAIS, 1984 F. D'Arcais, 'Per l'attività grafica di Antonio Balestra', *Arte Veneta*, XXXVIII, 1984, pp. 161–5.

DA CANAL, 1809 V. Da Canal, *Vita di Gregorio Lazzarini*, ed. G. Moschini, Venice, 1809.

DA CANAL, 1810 V. Da Canal, 'Della maniera del dipingere moderno', *Il Mercurio filosofico, letterario e poetico*, III, 1810, pp. 13–20.

DAL POZZO, 1718 F. Dal Pozzo, *Le vite de' pittori, degli scultori et architetti veronesi*, Verona, 1718.

DANIELS, 1973 J. Daniels, 'Sebastiano Ricci and the Marucelli', *The Connoisseur*, 1973, pp. 166–79.

DANIELS, 1976[1] J. Daniels, *Sebastiano Ricci*, Hove, 1976.

DANIELS, 1976[2] *L'Opera Completa di Sebastiano Ricci*, Milan, 1976.

DAZZI, 1951 M. Dazzi, 'Scheda per il Procuratore di Giambattista Tiepolo', *Arte Veneta*, V, 1951, pp. 178–85.

DAZZI and MERKEL, 1979 M. Dazzi and E. Merkel, *Catalogo della Pinacoteca della Fondazione Scientifica Querini Stampalia*, Vicenza, 1979.

DE BENEDETTI, 1973 E. De Benedetti, 'Nota ai disegni giovanili di Canova', *Studi canoviani*, Quaderni sul Neoclassico, I–II, Rome, 1973.

DE' CALZABIGI, 1755 R. de' Calzabigi, *Dissertazione ... su le poesi drammatiche del Sig. Abate Pietro Metastasio*, Paris, 1755.

DE CHENNEVIÈRES, 1898 H. De Chennevières, *Les Tiepolos*, Paris, 1898.

DELL'ACQUA GIUSTI, 1873 A. Dell'Acqua Giusti, *L'Accademia e la galleria di Venezia. Due relazioni storiche per l'esposizione di Vienna del 1873*, Venice, 1873.

DE MAFFEI, 1959 F. De Maffei, *Gian Antonio Guardi pittore di figura*, Verona, 1959.

DEMEL, 1987 B. Demel, 'Kurfürst Clemens August von Bayern, (1700–1761) als hoch- und Deutschmeister', *Clemens August. Fürstbischof, Jagdherr, Mäzen*, exh. cat., Schloss Clemenswerth, Bramsche, 1987, pp. 79–108.

DERSCHAU, 1916 J. von Derschau, 'Irrige Zuschreibungen an S. Ricci ...' *Monatschrift für Kunstwissenschaft*, 1916, pp. 161–9.

DERSCHAU, 1922 J. von Derschau, *Sebastiano Ricci: Ein Beitrag zu den Anfängen der venezianischen Rokoko Malerei*, Heidelberg, 1922.

DETROIT, 1950 *Old Master Drawings in Midwestern Museums*, exh. cat., Detroit Institute of Arts, Detroit, 1950.

DETROIT and INDIANAPOLIS, 1952 *Venice 1700–1800*, Detroit Institute of Arts, Detroit, John Herron Art Institute, Indianpolis, 1952.

DE VESME, 1906 A. De Vesme, *Le Peintre-graveur Italien*, Milan, 1906.

DE VESME and CALABI, 1928 A. De Vesme and A. Calabi, *Francesco Bartolozzi Catalogue des Estampes et notice biographique*, Milan, 1928.

DE VITO BATTAGLIA, 1958 S. De Vito Battaglia, 'Un'opera romana di Sebastiano Ricci', *Rivista dell'Istituto Nazionale di Archeologia e Storia dell'Arte*, 1958, pp. 334–56.

DEZALLIER D'ARGENVILLE, 1762 A.-J. Dézallier d'Argenville, *Abrégé de la vie des plus fameux peintres*, Paris, 1762.

DI FEDERIGO, 1977 F. Di Federigo, *Francesco Trevisani*, Washington, 1977.

DILLON, 1978 G. Dillon, 'Le incisioni di Antonio Balestra', *La pittura a Verona tra Sei e Settecento*, ed. L. Magagnato, Vicenza, 1978, pp. 204–6.

DODSLEY, 1761 R. Dodsley, *London and its Environs Described*, London, 1761.

DONZELLI, 1957 C. Donzelli, *Pittori veneti del Settecento*, Florence, 1957.

DORIGATO, 1992 A. Dorigato, 'Storie di collezionisti a Venezia: il residente inglese John Strange', *Per Giuseppe Mazzariol*, Quaderno di venezia arti, 1, ed. M. Brusatin, Rome, 1992.

DRAPER, 1984 J.D. Draper, 'Notes on the Brustolon style', *Antologia di Belle Arti*, XXIII–XXIV, 1984, pp. 85–9.

DRAPER, 1986 J. Draper, 'The Jack and Belle Linsky Collection. Addenda to the Catalogue', *Metropolitan Museum Journal*, XXI, 1986, pp. 151–84.

DRESDEN, 1968 *Venezianische Malerei 15. bis 18. Jahrhundert*, exh. cat., Dresden, 1968.

DRESDEN and VIENNA, 1978 *Die Albertina und das Dresdner Kupferstichkabinett*, exh. cat., Dresden and Vienna, 1978.

DRESDEN and WARSAW, 1963 *Bernardo Bellotto genannt Canaletto in Dresden und Warschau*, exh. cat., Dresden and Warsaw, 1963.

DUCHARDT, 1969 H. Duchardt, *Philipp Karl von Eltz: Kurfürst von Mainz, Erzkanzler des Reiches*, Mainz, 1969.

DVŌRÁK and METJKA, 1910 M. Dvōrák and B. Metjka, *Der Politische Berzirk Raudnitz, II: Topographie der historischen und Kunst-Denkmäler im Königreiche Böhmen; Raudnitzer Schloss*, Prague, 1910.

ERNST, 1963 S. Ernst 'Les tableaux de G.B. Tiepolo en Russie. A propos de *A Complete Catalogue of the Paintings of G.B. Tiepolo*, de Antonio Morassi', *Paragone*, CLVI, 1963.

ESSEN, 1966 *Europäische veduten des Bernardo Bellotto gennant Canaletto*, exh. cat., Villa Hügel, Essen, 1966.

EVANS, 1979 R.J.W. Evans, *The Making of the Habsburg Monarchy 1550–1700*, Oxford, 1979.

EVDOKIMOVA, 1983 V. Evdokimova, 'Proizvedenija A. Canovy v Archangel'skom', *Iskusstvo*, VIII, 1983.

EWALD, 1981 G. Ewald, in 'Staatsgalerie Stuttgart. Neuerwerbungen', *Jahrbuch der Staatlichen Kunstsammlungen in Baden-Württemberg*, XVIII, 1981, p. 158.

EWALD, 1988–9 G. Ewald, 'Acquisti recenti di pittura italiana del Settecento per la Galleria statale di Stoccarda', *Labyrinthos*, VII–VIII, 13/16, 1988–9, pp. 277–99.

EWALD, 1992 G. Ewald, in *Alte Meister: Staatsgalerie Stuttgart*, Stuttgart, 1992.

EWALT, 1965 G. Ewalt, *Johann Carl Loth*, Amsterdam, 1965.

FAHY and WATSON, 1973 E. Fahy and F.J.B. Watson, *The Wrightsman Collection, V: Paintings, Drawings, Sculpture*, New York, 1973.

FARINGTON, 1922–8 J. Farington, *Diary*, 8 vols, ed. J. Grieg, London, 1922–8.

FASOLO, 1942 G. Fasolo, 'I Marinali, I', *Odeo Olimpico*, II, 1942, pp. 45–75.

FASOLO, 1943 G. Fasolo, 'I Marinali, II', *Odeo Olimpico*, III, 1943, pp. 207–9.

FERRARI, 1900 F. Ferrari, 'Gli acquisti dell'Algarotti nel Regio Museo di Dresda', *L'Arte*, III, 1900, pp. 150–4.

FERRARI, 1914 G. Ferrari, *I due Canaletto*, Turin, 1914.

FINBERG, 1920–1 H.F. Finberg, 'Canaletto in England', *Walpole Society*, 1920–1.

FIOCCO, 1921 G. Fiocco, 'Giovan Battista Piazzetta', *Dedalo*, II, 1921, pp. 101–22.

FIOCCO, 1923 G. Fiocco, *Francesco Guardi*, Florence, 1923.

FIOCCO, 1927 G. Fiocco, 'Aggiunte di Francesco Maria Tasis alle Guide di venezia di Anton Maria Zanetti', *Rivista di Venezia*, VI, 1927, pp. 141–60.

FIOCCO, 1929 G. Fiocco, 'Il ritratto di Giulia Lama agli Uffizi', *Rivista d'Arte*, XI, pp. 113–7.

FIOCCO, 1931 G. Fiocco, 'Attribuzione di due modelletti di terracotta', *Dedalo*, XI, 1931, pp. 119–20.

FIOCCO, 1940 G. Fiocco, *Pitture del Settecento Italiano in Portogallo*, Rome, 1940.

FIOCCO, 1965 G. Fiocco, *Dodici disegni di Francesco Guardi*, Turin, 1965.

FITTIPALDI, 1980 T. Fittipaldi, *Scultura Napoletana del Settecento*, Naples, 1980.

FLORENCE, 1922 *Mostra della pittura italiana del Sei e Settecento*, exh. cat. by N. Tarchiani, Palazzo Pitti, Florence, 1922.

FLORENCE, 1960 *Mostra dei Tesori segreti delle case dei Fiorentini*, exh. cat. by M. Gregori and M. Bacci, Florence, 1960.

FLORENCE, 1986–7 *Il Seicento Fiorentino*, exh. cat., 3 vols, Palazzo Strozzi, Florence, 1986–7.

FLORENCE and DETROIT, 1974 *Gli Ultimi Medici il Tardo Barocco a Firenze 1670–1743*, exh. cat., Palazzo Pitti, Florence, The Detroit Institute of Arts, Detroit, 1974.

FOCILLON, 1918 H. Focillon, *Giovanni Battista Piranesi, essai de catalogue raisonné de son oeuvre*, Paris, 1918.

FOGOLARI, 1909 G. Fogolari, 'Michele Marieschi pittore prospettico veneziano', *Bollettino d'Arte*, III, 1909, pp. 241–51.

FOGOLARI, 1911 G. Fogolari, 'Dipinti veneziani settecenteschi nella Galleria del Conte Algarotti', *Bollettino d'Arte*, V, 1911, pp. 311–17.

FOGOLARI, 1912 G. Fogolari, 'Ricordi della Pittura Veneziana del vecchio campanile di S. Marco', *Rassegna d'Arte*, XII, 1912, pp. 49–58.

FOGOLARI, 1913[1] G. Fogolari, 'L'Accademia Veneziana di Pittura e Scultura del Settecento', *L'Arte*, XVI, 1913, pp. 241–72, 364–94.

FOGOLARI, 1913[2] G. Fogolari, *Tiepolo nel Veneto*, Milan, 1913.

FOGOLARI, 1934 G. Fogolari, *Michele Marieschi*, in *Enciclopedia Italiana*, XXII, Rome, 1934, p. 320.

FÖRSTER, 1930 D.H. Förster, 'Die Strandidylle von Piazzetta', *Pantheon*, VI, 1930, pp. 449–51.

FORT WORTH, 1986 *Giuseppe Maria Crespi and the Emergence of Genre Painting in Italy*, exh. cat. by J. Spike, Kimbell Art Museum, Fort Worth, 1986.

FORT WORTH, 1993 *Giambattista Tiepolo: Master of the Oil Sketch*, exh. cat. by B.L. Brown, Kimbell Art Museum, Fort Worth, 1993.

FRANCIS, 1939 H.S. Francis, 'Six Drawings from the Life of Pulcinella by the Younger Tiepolo', *Bulletin of the Cleveland Museum of Art*, XXVI, April 1939, pp. 46–9.

FRANCIS, 1940 H.S. Francis, 'Two Drawings by Piazzetta', *The Bulletin of the Cleveland Museum of Art*, XXVII, July 1940, pp. 108–9.

FRANKFURT, FORT WORTH, RICHMOND, 1989 *The Consul Smith Collection*, exh. cat. by F. Vivian, Schirn Kunstalle, Frankfurt, et al., 1989.

FREEDEN and LAMB, 1956 M.H. Freeden and C. Lamb, *Das Meisterwerk des Giovanni Battista Tiepolo: Die Fresken der Würzburger Residenz*, Munich, 1956.

FRERICHS, 1971 L.C. Frerichs, 'Nouvelles sources pour la connaissance de l'activité de graveur des trois Tiepolo', *Nouvelles de l'Estampes*, IV, 1971, p. 213ff.

FRITSCHE, 1936 H.A. Fritsche, *Bernardo Bellotto gennant Canaletto*, Burg B. Magdeburg, 1936.

GALLO, 1941 R. Gallo, 'L'incisione nel 700 a Venezia e a Bassano', *Atti dell'Istituto Veneto di Scienze, Lettere ed Arti*, 1941, pp. 39–40.

GALLO, 1953 R. Gallo, 'Note d'archivio su Francesco Guardi,' *Arte Veneta*, VII, 1953, pp. 155–6.

GALLO, 1956–7 R. Gallo, 'Canaletto, Guardi, Brustolon,' *Atti dell'Istituto Veneto di Scienze, Lettere ed Arti*, CXV (Classe di scienze morali e lettere), 1956–7, pp. 1–10.

GARAS, 1963 K. Garas, 'Ein unbekanntes Hauptwerk Sebastiano Ricci', *Pantheon*, XXI, 1963, pp. 235–41.

GARAS, 1968, 1977 K. Garas, *Eighteenth-century Venetian Painting*, Budapest, 1968, 3rd ed., Budapest, 1977.

GARAS, 1971 K. Garas, 'Giovanni Antonio Pellegrini in Deutschland', *Studi di Storia dell'Arte in onore di A. Morassi*, Venice, 1971, pp. 285–92.

GEALT, 1986 A. Gealt, *Domenico Tiepolo: Punchinello Drawings*, London, 1986.

GEMIN and PEDROCCO, 1993 M. Gemin and F. Pedrocco, *Giambattista Tiepolo*, Venice, 1993.

GENEVA, 1973 *Vues venetiennes du XVIIIe siècle*, exh. cat. by R.M. Mason, Geneva, 1973.

GENEVA, 1978 *Art Vénitien en Suisse et au Liechtenstein*, exh. cat., Geneva, 1978.

GENEVA, 1991 *Une Venise Imaginaire: Architectures, vues et scènes Capricieuses dans la gravure vénetienne du XVIIIe siècle*, exh. cat. by R.M. Mason, Musée d'Art et d'Histoire, Geneva, 1991.

GHIDIGLIA QUINTAVALLE, 1956–7 A. Ghidiglia Quintavalle, 'Premesse giovanili di Sebastiano Ricci', *Rivista dell'Istituto di Archeologia e Storia dell'Arte*, 1956–7, pp. 395–415.

GHIO and BACCHESCHI, 1989. L. Ghio and E. Baccheschi, 'Antonio Balestra', *I pittori bergamaschi dal XIII al XIX secolo: Il Settecento*, II, Bergamo, 1989, pp. 79–91.

GLASER, 1993 'Friedrich der Grosse und Kurbayern', *Friedrich der Grosse*, exh. cat., Munich, 1993.

GOERING, 1934 M. Goering, 'Die Tätigkeit der Venezianer Piazzetta und Pittoni für den Kurfürsten Clemens August von Köln', *Westfalen; Hefte für Geschichte, Kunst und Volkskunde*, XIX, 1934.

GOERING, 1939 M. Goering, 'Ein neuentdecktes Mädchenbildnis von G.B. Tiepolo', *Pantheon*, XXVII, 1939, pp. 147–9.

GOERING, 1941 M. Goering, 'Giovanni Battista Piazzetta als Zeichner', *Pantheon*, XXVIII, 1941, pp. 259–63.

GOERING, 1944[1] M. Goering, *Francesco Guardi*, Vienna, 1944.

GOERING, 1944[2] M. Goering, 'Wenig bekannte und neu gefundene Werke von G.B. Tiepolo', *Pantheon*, XXXII, 1944, pp. 98–100.

GOI, 1988 P. Goi, *La scultura nel Friuli-Venezia Giulia, dal quattrocento al novecento*, 2 vols, Pordenone, 1988.

GOLDONI, 1828 C. Goldoni, *Memoirs of Goldoni*, trans. J. Black, 2 vols, London, 1828.

GONZALEZ PALACIOS, 1972 A. González Palacios, 'Sei fogli di Antonio Canova', *Arte Illustrata*, V. 1972.

GONZALEZ PALACIOS, 1984 A. González Palacios, 'The furniture of Doge Paolo Renier', *Furniture History*, XX, 1984, pp. 28–37.

GONZALEZ-PALACIOS, 1986 A. González-Palacios, *Il Tempio del Gusto: Le arti decorative in Italia fra classicismi e barocco. La Toscana e l'Italia settentrionale*, I, Milan, 1986.

GOODISON and ROBERTSON, 1967 J.W. Goodison and G.H. Robertson, *Catalogue of Paintings, Fitzwilliam Museum of Cambridge; II: Italian Schools*, Cambridge, 1967.

GORI GANDELLINI, 1771 G. Gori Gandellini, *Notizie istoriche degli intagliatori*, Siena, 1771.

GORIZIA, 1956 *Il Settecento Goriziano*, exh. cat., Gorizia, 1956.

GORIZIA, 1985 *Giambattista Tiepolo: Il segno e l'enigma*, exh. cat., ed. D. Succi, Castello di Gorizia, 1985.

GORIZIA, 1987 *Guardi, Metamorfosi dell'immagine*, exh. cat. by P. Casadio et. al., Castello di Gorizia, 1967.

GORIZIA, 1988 *Capricci veneziani del Settecento*, exh. cat. by D. Succi et al., Castello di Gorizia, 1988.

GORIZIA, 1989 *Marieschi tra Canaletto e Guardi*, exh. cat. by D. Succi, Castello di Gorizia, 1989.

GORIZIA and VENICE, *see* VENICE and GORIZIA.

GREGORI, 1982 M. Gregori, *Giacomo Ceruti*, Bergamo, 1982.

GRISERI, 1978 A. Griseri, *I grandi disegni italiani nella Biblioteca Reale di Torino*, Milan, 1978.

GRONINGEN and ROTTERDAM, 1964 *18e eeuwse Venetiaanse Tekeninge*, exh. cat. by F. Valcanover, introduction by T. Pignatti, Groningen and Rotterdam, 1964.

GRUBER, 1992 A.C. Gruber, *L'Art Décoratif en Europe, II: Classique et Baroque*, Paris, c. 1992.

GUALDARONI, 1974 R. Gualdaroni, 'Raphael: Un pintor veneciano en la corte de los Borbones de España; Santiago Amigoni', *Archivo Español de Arte*, XCVII, 1974, pp. 129–47.

HABIG ed., 1973 M.A. Habig, ed., *Omnibus of Sources for the Life of St Francis*, Chicago, 1973.

HADELN, 1927 D. von Hadeln, *Handzeichnungen von Giovanni Battista Tiepolo*, 2 vols, Munich, 1927.

HADELN, 1930, 1939 D. von Hadeln, *Die Zeichnungen von Antonio Canal genannt Canaletto*, Vienna, 1930, English translation by Campbell Dodgson, 1939.

HAMBURG and COLOGNE, 1963–4 *Italienische Meisterzeichnungen vom 14. bis 18. Jahrhundert aus amerikanischen besitz: Die Sammlung Janos Scholz*, exh. cat. by W. Stubbe, Kunsthalle, Hamburg; Wallraf-Richartz-Museum, Cologne, 1963–4.

HANNEGAN, 1966 B. Hannegan, 'Guardi at Venice', *Art Bulletin*, XLVIII, 1966, pp. 248–52.

HANOVER and DÜSSELDORF, 1991 *Venedigs ruhm im Norden: Die grossen venezianischen Maler des 18. Jahrhunderts, ihre Auftragger und ihre Sammler*, exh. cat., Niedersächisches Landesmuseum, Hanover, and Kunstmuseum, Düsseldorf, 1991.

HARRIS, 1984 J. Harris, 'An English neo-Palladian episode and its connection with Visentini in Venice', *Architectural History*, XXVII, 1984, pp. 231–6.

HARRIS, 1994 J. Harris, *The Palladian Revival: Lord Burlington, his Villa and Gardens at Chiswick*, New Haven and London, 1994.

HASKELL, 1960[1] F. Haskell, 'A Pittoni Altarpiece for Edinburgh', *The Burlington Magazine*, CII, 1960, p. 366.

HASKELL, 1960[2] F. Haskell, 'Francesco Guardi as a *vedutista* and some of his patrons', *Journal of the Warburg and Courtauld Institutes*, XXIII, 1960, pp. 256–76.

HASKELL, 1963, 1980, 1991 F. Haskell, *Patrons and Painters: Art and Society in Baroque Italy* London, 1963, 2nd ed. London and New Haven, 1980, rev. 1991.

HASKELL, 1966 F. Haskell, *Mercenati e pittori*, Florence, 1966.

HASKELL, 1987 F. Haskell, *Le Metamorfosi del Gusto*, Turin, 1987.

HASKELL, 1993 F. Haskell, 'Su Francesco Guardi vedutista e alcuni suoi clienti', *Francesco Guardi: Vedute capricci feste*, exh. cat., Fondazione Giorgio Cini, Venice, 1993.

HEILINGSETZER, 1988 G. Heilingsetzer, 'Prinz Eugen und die Führungsschict der österreichischen Grossmacht 1683–1740, *Österreich und die Osmanen – Prinz Eugen und seine Zeit*, ed. E. Zöllner and K. Gutkas, Vienna, 1988, pp. 120–37.

HEINE, 1974 B. Heine, 'Tiepolos Dreifaltigkeitsbild in der Klosterkirche zu Nymphenburg', *Pantheon*, XXXII, 1974, pp. 144–52.

HEINECKEN, 1788 C.H. von Heinecken, *Dictionnaire des artistes dont nous avons des estampes, avec une notice détaillé de leurs ouvrages gravée*, II, Leipzig, 1788.

HEINEMANN, 1969 R. Heinemann, ed. *Catalogue of the Thyssen-Borneszima Collection*, Lugano-Castagnola, 1969.

HEINZ, 1963 G. Heinz, 'Die italienischen Maler im Dienste des Prinzen Eugen', *Prinz Eugen und sein Belvedere*, Sonderheft der Mitteilunger der Österreichischen Galerie zur 300. Wiederkehr des Geburtstages des Prinzen Eugen, Vienna, 1963.

HENNESSEY, 1983 L.G. Hennessey, *Jacopo Amigoni (c. 1695–1762): An Artistic Biography with a catalogue of his Venetian paintings*, Ann Arbor, 1983.

HERES, 1991 G. Heres, *Dresdener Kunstsammlungen im 18. Jahrhundert*, Leipzig, 1991.

HIBBARD, 1980 H. Hibbard, *The Metropolitan Museum*, New York, 1980.

HILDBURGH, 1938 W. Hildburgh, 'Some Bronze Groups by Francesco Bertos', *Apollo*, XXVII, 1938, pp. 81–5.

HILL, 1980 C. Hill, *The Century of Revolution, 1603–1714*, 2nd ed., Walton on Thames, 1980.

HIND, 1922 A.M. Hind, *Giovanni Battista Piranesi: A Critical Study*, London, 1922.

HOARE, 1822–44 Sir Richard Colt Hoare, *The History of Modern Wiltshire*, 6 vols, 1822–44.

HODGKINSON, 1970 T. Hodgkinson, 'Two garden sculptures by Antonio Corradini', *Victoria and Albert Museum Bulletin*, IV, London, 1968, pp. 37–49, rev. 1970.

HOHENZOLLERN, 1992 J.G. Prinz von Hohenzollern, 'Fürstliches Sammeln', *Friedrich der Grosse*, exh. cat., Munich, 1992.

HOLLER, 1986 W. Holler, *Jacopo Amigonis Frühwerk in Süddeutschland*, Hildesheim, 1986.

HOLST, 1951 N. von Holst, 'La pittura veneziana tra il Reno e la Neva', *Arte Veneta*, V, 1951.

HOLST, 1960 N. von Holst, *Künstler, Sammler, Publikum. Ein Buch für Kunst- und Museumsfreunde*, Darmstadt, 1960.

HONOUR, 1954 H. Honour, 'John Talman and William Kent', *Connoisseur*, CXXXIV, 1954, pp. 3–7.

HONOUR, 1957 H. Honour, 'Giuseppe Nogari', *Connoisseur*, CXL, 1957, pp. 154–9.

HONOUR, 1968 H. Honour, *Neo-classicism*, Harmondsworth, 1968.

HOUSTON, 1958 *The Guardi Family*, exh. cat. by J. Byam Shaw, The Museum of Fine Arts of Houston, 1958.

HOWARD, 1976 S. Howard, 'The Antiquarian market in Rome and the rise of Neo-classicism: A basis for Canova's new classics', *Studies on Voltaire and the XVIII Century*, CLI–CLV, 1976.

HOWARD, 1980 D. Howard, *The Architectural History of Venice*, London, 1980.

HOWARD, 1986 D. Howard 'Giambattista Tiepolo's Frescoes for the Church of the Pietà in Venice', *Oxford Art Journal*, IX, 1986, pp. 11–28.

HUBALA, 1989 E. Hubala, *Die Grafen von Schönborn. Kirchenfürsten, Sammler, Mäzene*, exh. cat., Germanisches Nationalmuseum, Nuremberg, 1989.

HUSE and WOLTERS, 1989 N. Huse and W. Wolters, *Venezia: l'arte del rinascimento: Architettura, scultura, pittura, 1460–1590*, Venice, 1989.

HÜTTINGER, 1978 E. Hüttinger, 'Bemerkungen zur Venzianischen Malerei und zum Thema "Schweiz-Venedig"', *Venezianische Kunst in der Schweiz und in Liechtenstein*, exh. cat., Pfäffikon and Geneva, 1978.

INFELISE, 1989 M. Infelise, *L'Editoria veneziana nel '700*, Milan, 1989.

INGELHEIM, 1987 *Kunst in Venedig 16.–18. Jahrhundert: Gemälde und Zeichnungen*, Museum Altes Rathaus, Ingelheim am Rhein, 1987.

INGRAO, 1979 C. Ingrao, *In Quest of Crisis; Emperor Joseph I and the Habsburg Monarchy*, West Lafayette, IN, 1979.

JOACHIM and FOLDS MCCULLACH, 1979 H. Joachim and S. Folds McCullagh, *Italian Drawings in the Art Institute of Chicago*, Chicago and London, 1979.

JOHNSON, 1983 D. Johnson, *Old Master Drawings from the Museum of Art, Rhode Island School of Design*, Providence, 1983.

JONES, 1981[1] L.M. Jones, 'Peace, Prosperity and Politics in Tiepolo: Glory of the Spanish Monarchy', *Apollo*, CCXXXVI, 1981, pp. 220–7.

JONES, 1981[2] L.M. Jones, *The Paintings of Giovanni Battista Piazzetta*, Ann Arbor, 1981.

KALEY, 1980 D. Kaley, *The Church of the Pietà*, Venice, 1980.

KARLING, 1978 S. Karling, *The Stockholm University Collection of Paintings*, Uppsala, 1978.

KEUTNER, 1969 H. Keutner, *Sculpture: Renaissance to Rococo*, Greenwich, CT, 1969.

KIEL, 1969 H. Kiel, 'Dal Ricci al Tiepolo: I Pittori di Figura del Settecento a Venezia', *Pantheon*, XXVII, 1969, pp. 494–7.

KINGSTON-UPON-HULL, 1967 *Venetian Baroque and Rococo*, exh. cat., Ferens Art Gallery, Kingston-upon-Hull, 1967.

KIRSCHBAUM, 1990 *Lexion der christlichen Ikonographie*, 8 vols, ed. E. Kirschbaum, Rome, Freiburg, Basel and Vienna, 1990.

KLÁŠTER, 1980 J. Klášter, *Ignác Platzer skici, modely a kresby z pražské sochařské dílny pozdního baroku*, Národní Gallery, Prague, 1980.

KLESSE, 1972 B. Klesse, 'Studien zu italienischen und französischen Gemälden' *Wallraf-Richartz-Jahrbuch*, XXXIV, 1972, pp. 230–3.

KLESSE, 1973 B. Klesse, *Katalog der Italienischen, Französchen und Spanischen Gemälde bis 1800 im Wallraf-Richartz Museum*, Cologne, 1973.

KNAB, 1960 E. Knab, 'George Knox Katalog der Tiepolo-Zeichnung und die Tiepolo-Forschung', *Österreichische Zeitschrift für Kunst und Denkmalpflege*, IV, 1960, p. 140.

KNOX, 1961 G. Knox, 'The Orloff Album of Tiepolo Drawings', *The Burlington Magazine*, CIII, 1961, pp. 269–75.

KNOX, 1965 G. Knox, 'A Group of Tiepolo Drawings owned and engraved by Pietro Monaco', *Master Drawings*, III, 1965, pp. 389–97.

KNOX, 1966 G. Knox, review of T. Pignatti, *Le Acqueforti dei Tiepolo*, *The Burlington Magazine*, CVIII, 1966, pp. 585–6.

KNOX, 1970 G. Knox, *Domenico Tiepolo: Raccolta di teste, 1770–1970*, Udine, 1970.

KNOX, 1973 G. Knox, *Un Quaderno di vedute di Giambattista e Domenico Tiepolo*, Milan, 1973.

KNOX, 1975[1] G, Knox, *Catalogue of the Tiepolo Drawings in the Victoria and Albert Museum*, 2nd ed., London, 1975.

KNOX, 1975[2] G. Knox, 'Some Notes on Large Paintings Depicting Scenes of Antique History by Ricci, Piazzetta, Bambini and Tiepolo', *Atti del congresso internazionale di studi su Sebastiano Ricci e il suo tempo*, Milan, 1975.

KNOX, 1978[1] G. Knox, 'The Tasso Cycles of Giambattista Tiepolo and Gianantonio Guardi', *Museum Studies*, IX, 1978, pp. 89–95.

KNOX, 1978[2] G. Knox, 'Giambattista Tiepolo's Processional Mace for the Scuola dei Carmini', *Master Drawings*, XVI, 1978, pp. 48–50.

KNOX, 1979[1] G. Knox, 'Anthony and Cleopatra in Russia: A Problem in the editing of Tiepolo Drawings', *Editing Illustrated Books: Papers given at the fifteenth annual conference on editorial problems, University of Toronto, 2–3 November 1979*, ed. William Blissett, New York and London, pp. 35–55.

KNOX, 1979[2] G. Knox, 'Giambattista Tiepolo: Queen Zenobia and Ca' Zenobio, "una delle prime sue fattura"', *The Burlington Magazine*, CXXI, 1979, pp. 409–18.

KNOX, 1980 G. Knox, *Giambattista and Domenico Tiepolo: A Study and Catalogue Raisonné of the Chalk Drawings*, Oxford, 1980.

KNOX, 1983 G. Knox, 'The "Tombs of Famous Englishmen" as described in the Letters of Owen McSwiney to the Duke of Richmond', *Arte Veneta*, XXXVII, 1983, pp. 228–35.

KNOX, 1984 G. Knox, 'The Punchinello Drawings of Giambattista Tiepolo', *Interpretazioni veneziani*, Venice, 1984, pp. 439–46.

KNOX, 1988 G. Knox, 'Antonio Pellegrini and Marco Ricci at Burlington House and Narford Hall', *The Burlington Magazine*, CXXX, 1988, pp. 846–53.

KNOX, 1992 G. Knox, *Giambattista Piazzetta*, Oxford, 1992.

KOSAREVA, 1960 N.K. Kosareva, *Antonio Canova. Amur i Psicheja*, Leningrad, 1960.

KOSAREVA, 1961 N.K. Kosareva, *Kanova i ego proizvedenija v Ermitaze*, Leningrad, 1961.

KOZAKIEWICZ, 1972 S. Kozakiewicz, *Bernardo Bellotto*, trans. by Mary Whittall, 2 vols., London and New York, 1972.

KRUCKMANN, 1988 P.O. Kruckmann, *Federico Benkovitch*, Hildesheim, 1988.

KULTZEN, 1968 R. Kultzen, *Francesco Guardi in der Alten Pinakothek, München*, Munich, 1968.

KULTZEN, 1986 R. Kultzen, *Venezianische Gemälde des 17. Jahrhunderts*, Bayerische Staatsgemäldesammlungen, Alte Pinakothek, Gemäldekatalog, München, 1986.

KULTZEN and REUSS 1991 R. Kultzen and R. Reuss, *Venezianische Gemälde des 18 Jahrhunderts*, Bayerische Staatsgemäldesammlungen, Alte Pinakothek, München, Gemäldekatalog, Munich, 1991.

LÁNCKORONSKA, 1950 M. Lánckoronska, *Die Venezianische Buchgraphik des XVIII Jahrhunderts*, Hamburg, 1950.

LANZI, 1795 L. Lanzi, *Storia pittorica della Italia*, Bassano, 1795.

LAPICCIRELLA, n.d. L. Lapiccirella, *Libri illustrati veneziani dell' XVIII secolo*, dealer's catalogue, Florence, n.d.

LARSSON, 1991–2 L.O. Larrson, 'Carl Gustav Tessin und Venedig', *Venedigs Ruhm im Norden*, Hanover and Düsseldorf, 1991–2, pp. 38–41.

LAUSANNE, 1947 *Trésors de l'art vénitien*, exh. cat. by R. Pallucchini, Musée Cantonal des Beaux-Arts, Lausanne, 1947.

LAZARI, 1859 V. Lazari *Notizia delle opera d'arte e d'antichità della Raccolta Correr*, Venice, 1859.

LE BLANC, 1854 C. Le Blanc, *Manuel de l'amateur d'estampes*, 1854.

LE CLAIRE, 1989 T. Le Claire, *Kunsthandel Meisterzeichnungen 1500–1900*, Munich, 1989.

LEEDS, 1936 *Masterpieces from the Collections of Yorkshire and Durham*, exh. cat., Leeds, 1936.

LEGRAND, 1969 J.G. Legrand, 'Notice sur la view et les ouvrages de J.-B. Piranesi', *Nouvelles de l'estampe*, V, 1969, pp. 194–6.

LEROI, 1876 P. Leroi, 'L'Italia fara da sé', *L'Art*, 1876, pp.294–8.

LEVEY, 1953 M. Levey, 'Canaletto's Regatta Paintings', *The Burlington Magazine*, XCV, 1953, pp. 365–6.

LEVEY, 1956 M. Levey, *National Gallery Catalogues, The Eighteenth Century Italian Schools*, London, 1956.

LEVEY, 1957 M. Levey, 'The Modello for Tiepolo's Altarpiece at Nymphenburg', *The Burlington Magazine*, XCIX, 1957, pp. 256–61.

LEVEY, 1958 M. Levey, 'A Note on Marshal Schulenburg's Collection', *Arte Veneta*, XII, 1958, p. 221.

LEVEY, 1959[1], 1980 *Painting in XVIIIth-Century Venice*, London, 1959, 2nd edition, Oxford, 1980.

LEVEY, 1959[2] M. Levey, 'F. Zuccarelli in England', *Italian Studies*, XIV, 1959, pp. 1–20.

LEVEY, 1961 M. Levey, 'The Eighteenth-century Italian Painting Exhibition at Paris: Some corrections and suggestions', *The Burlington Magazine*, CIII, 1961, pp. 139–43.

LEVEY, 1962[1] M. Levey, review of Constable's *Canaletto*, *The Burlington Magazine*, CIV, 1962, pp. 267–8.

LEVEY, 1962[2] M. Levey, 'Two Footnotes to any Tiepolo Monograph', *The Burlington Magazine*, CIV, 1962, pp. 118–19.

LEVEY, 1963 M. Levey, review of A. Morassi, *A Complete Catalogue of the paintings of G.B. Tiepolo*, *The Art Bulletin*, XLV, 1963, pp. 293–5.

LEVEY, 1964, 1991 M. Levey, *The Later Italian Pictures in the Collection of Her Majesty The Queen*, London, 1964, 2nd ed. Cambridge, 1991.

LEVEY, 1966 M. Levey, *Rococo to Revolution*, London, 1966.

LEVEY, 1971, 1986 M. Levey, *National Gallery Catalogues: The Seventeenth- and Eighteenth-century Italian Schools*, 1st ed. London, 1971, 2nd ed. London, 1986.

LEVEY, 1986, 1994 M. Levey, *Giambattista Tiepolo: His Life and Art*, New Haven and London, 1986, rev. 1994.

LEVEY, 1988 M. Levey, *Giambattista Tiepolo: La sua vita, la sua arte*, Milan, 1988.

LEVI, 1900 C. Levi, *Le collezioni veneziane d'arte e d'antichità dal secolo XIV ai nostri giorni*, Venice, 1900.

LEWIS, 1967 D. Lewis, 'Notes on XVIIIth-Century Venetian Architecture, II', *Bollettino dei Musei Civici Veneziani d'Arte e di Storia*, III, 1967, pp. 40–1.

LEWY, 1927 E. Lewy, *Pietro Tacca, ein Beitrag zur Geschichte der Florentiner Skulptur*, Cologne, 1927.

LINKS, 1973 J.G. Links, 'Bellotto Problems,' *Apollo*, XCVII, 1973, pp. 107–10.

LINKS, 1977 J.G. Links, *Canaletto and his Patrons*, London, 1977.

LIVAN, 1942 L. Livan, ed., *Notizie tratte dai Notatori e dai Annali del N.H. Pietro Gradenigo*, Venice, 1942.

LONDON, 1877 *Exhibition of Works by the Old Masters, and by deceased Masters of the British School*, exh. cat., Royal Academy, London, 1877.

LONDON, 1911 *Venetian Painting of the Eighteenth Century*, exh. cat., Burlington Fine Arts Club, London, 1911.

LONDON, 1919 *Drawings and Pictures of London*, exh. cat., Burlington Fine Arts Club, London, 1919.

LONDON, 1929 *Catalogue of Oil Paintings and Drawings by Antonio Canal*, exh. cat., Magnasco Society, Sixth Loan Exhibition (at Spink & Son), London, 1929.

LONDON, 1930 *Italian Art*, exh. cat., Royal Academy of Arts, London, 1930.

LONDON, 1937 *Pictures of the Gulbenkian Collection*, exh. cat., London, 1937.

LONDON, 1946–7 *The King's Pictures*, exh. cat., Royal Academy, London, 1946–7.

LONDON, 1953 *Drawings by Old Masters*, exh. cat. by K.T. Parker and J. Byam Shaw, Royal Academy, London, 1953.

LONDON, 1954–5 *European Masters of the XVIIIth Century*, exh. cat. by B. Ford, J. Byam Shaw and F.J.B. Watson, Royal Academy, London, 1954–5.

LONDON, 1959 *Canaletto in England*, exh. cat., Guildhall, London, 1959.

LONDON, 1960 *Italian Art in Britain*, exh. cat. by E.K. Waterhouse, Royal Academy, London, 1960.

LONDON, 1964 *Italian Art*, exh. cat., The Queen's Gallery, Buckingham Palace, London, 1964.

LONDON, 1968 *Italian Drawings from the Collection of Janos Scholz*, exh. cat. by J. Scholz, Arts Council Gallery, London, 1968.

LONDON, 1972[1] *The Age of Neo-Classicism*, exh. cat., Royal Academy of Arts and Victoria and Albert Museum, London, 1972.

LONDON, 1972[2] *Venetian Drawings of the Eighteenth Century*, exh. cat. by A. Bettagno, Heim Gallery, London, 1972.

LONDON, 1974[1] *George III, Collector and Patron*, exh. cat., The Queen's Gallery, Buckingham Palace, London, 1974.

LONDON, 1974[2] *Canaletto: Etchings*, exh. cat. by Ruth Bromberg, Courtauld Institute Galleries, University of London, 1974.

LONDON, 1978[1] *Works by Sebastiano Ricci from British Collections*, exh. cat. by J. Daniels, Colnaghi, London, 1978.

LONDON, 1978[2] *Piranesi*, exh. cat. by J. Wilton-Ely, Arts Council of Great Britain, 1978.

LONDON, 1980–1 *Canaletto*, exh. cat., The Queen's Gallery, Buckingham Palace, London, 1980–1.

LONDON, 1983 *The Adjectives of History, Furniture and Works of Art*, exh. cat. by A. González-Palacios, P. & D. Colnaghi, London, 1983.

LONDON, 1987[1] *Drawing in England from Hilliard to Hogarth*, exh. cat. by L. Stainton and C. White, British Museum, London, 1987.

LONDON, 1987[2] *Master Drawings: The Woodner Collection*, exh. cat. by C. Lloyd, Royal Academy of Arts, London, 1987.

LONDON, 1990 *Meisterzeichnungen, Master Drawings 1500–1600*, exh. cat. by Katrin Bellinger Kunsthandel at Harari and Johns, London, 1990.

LONDON, 1993 *A King's Purchase, King George III and the Collection of Consul Smith*, exh. cat., The Queen's Gallery, Buckingham Palace, London, 1993.

LONDON and BIRMINGHAM, 1951 *Eighteenth-century Venice*, exh. cat. by F.J.B. Watson, Whitechapel Art Gallery, London, and Birmingham Museum and Art Gallery, 1951.

LONDON, LIVERPOOL and YORK, 1957 *European Pictures from an English County*, Agnew & Sons, London, Liverpool and York, 1957.

LONDON et al., 1961 *Italian Bronze Statuettes*, exh. cat., The Victoria and Albert Museum, London, 1961; Rijksmuseum, Amsterdam, 1961–2; Palazzo Strozzi, Florence, 1962.

LONDON et al., 1965 *Venetian Drawings of the Eighteenth Century from the Correr Museum*, exh. cat. by T. Pignatti, The Arts Council, London, 1965.

LONDON and NEW YORK, 1973 *An American Museum of Decorative Arts and Design: Designs from the Cooper-Hewitt Collection, New York*, exh. cat. by L. Taylor et al., Victoria and Albert Museum, London, Brooklyn Museum of Art, New York, 1973–4.

LONGHI, 1792, 1900 A. Longhi, *Compendio delle vite de' pittori veneziani istorici*, 1792, Venice, 1900.

LONGHI, 1946 R. Longhi, *Viatico per cinque secoli di pittura veneziana*, Florence, 1946.

LORENZ, 1983 H. Lorenz, 'Zur Internationalität der Wiener Barockarchitektur', *Wien und der europäische Barock. Akten des XXV, Internationalen Kongresses für Kunstgeschichte, Vienna, 1983*.

LORENZ, 1985 H. Lorenz, 'Barockarchitektur in Wien und im Umkreis der kaiserlichen Residenzstadt', *Prinz Eugen und das barock Österreich*, ed. K. Gutkas, Salzburg and Vienna, 1985.

LORENZETTI, 1917 G. Lorenzetti, 'Un dilettante incisore veneziano del XVIII secolo: Antonio Maria Zanetti di Girolamo', *Miscellanea di Storia Veneta*, XII, 1917.

LORENZETTI, 1927, 1956 G. Lorenzetti, *Venezia e il suo estuario*, Venice, 1927, 2nd edition, Venice, 1956.

LORENZETTI, 1931 G. Lorenzetti, 'Di un gruppo di bozzetti di gian Maria Morlaiter', *Dedalo*, XI, 1931, pp. 988–1012.

LORENZETTI and PLANISCIG, 1934 G. Lorenzetti and L. Planiscig, *Catalogo della Collezione Donà dalle Rose a Venezia*, Venice, 1934.

LORENZETTI, 1935 G. Lorenzetti, 'Modelli e bozzetti di terracotta e di terracruda di Giovanni Maria Morlaiter', *Rivista di Venezia*, XIV, 1935, pp. 225–42.

LORENZETTI, 1936 G. Lorenzetti, *Ca' Rezzonico*, Venice, 1936.

LORENZETTI, 1940 G. Lorenzetti, *Ca' Rezzonico*, 3rd edition, Venice, 1940.

LORENZONI, 1984 G. Lorenzoni, *Le Sculture del Santo di Padova*, Vicenza, 1984.

LOS ANGELES, 1971 *The Armand Hammer Collection*, exh. cat., Los Angeles, 1971.

LOS ANGELES, 1976 *Old Master Drawings from American Collections*, exh. cat. by E. Feinblatt, Los Angeles County Museum of Art, Los Angeles, 1976.

LOVISA, 1715, 1720 D. Lovisa, ed., *Il Gran teatro di Venezia*, Venice, 1715, 1720.

LUBLIN, 1960 *Wystawa malarstwa pólnocno-wloskiego póznego baroku*, exh. cat., Lublin, 1960.

LUCCO, 1989 M. Lucco, *Catalogo del Museo Civico di Belluno, II. I Disegni*, Belluno, 1989.

MACANDREW, 1980 H. MacAndrew, *Ashmolean Museum Oxford: Catalogue of the Collection of Drawings, III, Italian Schools: Supplement*, Oxford, 1980.

MADRID, 1986 *Carreño Rizi, Herrera*, exh. cat. by A.E. Pérez Sánchez, Museo del Prado, Madrid, 1986.

MADRID and BARCELONA, 1990–1 *Colección Cambó*, exh. cat. by J. Sureda, I. Pons et al., Museo del Prado, Madrid, and Museu d'Art de Catalunya, Barcelona, 1990–1.

MAFFEI, 1732, ed. 1825–6 S. Maffei, *Verona illustrata*, Verona, 1732, ed. Milan, 1825.

MAGAGNATO, 1956 L. Magagnato, *Disegni del Museo Civico di Bassano da Carpaccio a Canova*, exh. cat., Venice, 1956.

MAGRINI, 1988 M. Magrini, *Francesco Fontebasso*, Vicenza, 1988.

MAGRINI, 1990 M. Magrini, 'Francesco Fontebasso: I disegni', *Saggi e Memorie di Storia dell'Arte*, XVII, 1990, pp. 163–211.

MAHON, 1965 D. Mahon, 'The brothers at the *Mostra dei Guardi*, some impressions of a neophyte', *Problemi Guardeschi. Atti del Convegno di Studi Promissi della mostra dei Guardi Venezia 13–14 Settembre 1965*.

MALAGUZZI-VALERI, 1908 F. Malaguzzi-Valeri, 'Quattro Nuovi dipinti di Tiepolo', *Rassegna d'Arte*, VIII, 1908, pp. 178–9.

MALAMANI, 1910 V. Malamani, *Rosalba Carriera*, Bergamo, 1910.

MALAMANI, 1911 V. Malamani, *Canova*, Milan, 1911.

MALIBU, 1986 *J. Paul Getty Museum Journal, Acquisitions 1985*, XIV, 1986.

MARCONI, 1970 S.M. Marconi, *Opere d'arte dei secoli XVII, XVIII, XIX, Galleria dell'Accademia di Venezia*, Rome, 1970.

MARIACHER, 1943 G. Mariacher, 'Antonio Corradini scultore in legno', *Le Tre Venezie*, 1943, p. 23.

MARIACHER, 1947 G. Mariacher, 'Lo scultore Antonio Corradini', *Arte Veneta*, I, iii, 1947, pp. 203–16.

MARIACHER, 1957 G. Mariacher, 'Bozzetti inediti di Antonio Canova al Museo Correr di Venezia', *Arte Neoclassica, atti del convegno, Ottobre 1957*, pp. 185–98.

MARIACHER, 1964 G. Mariacher, 'Un bozzetto di G.M. Morlaiter identificato', *Bollettino dei Musei Civici Veneziani*, IX, 1964, pp. 59–61.

MARIACHER, 1965 G. Mariacher, 'Nuovi appunti su Brustolon a Ca' Rezzonico e al Museo Correr', *Bollettino dei Musei Civici Veneziani*, X, 1–2, 1965, pp. 25–39.

MARIACHER, 1967[1] G. Mariacher, 'G.M. Morlaiter e la scultura veneziana del Rococo', *Sensibilità e Razionalità del Settecento*, II, Venice, 1967.

MARIACHER, 1967[2] G. Mariacher, *Ca' Rezzonico: An Illustrated Guide*, Venice, 1967.

MARIACHER, 1971 G. Mariacher, 'Nuovi bozzetti identificati di G.M. Morlaiter', *Studi di Storia dell'Arte*. 1971, p. 366.

MARIACHER, 1977 G. Mariacher, 'Venetian Small Sculptures and Bozzetti in the Ca' Rezzonico', *Apollo*, CVI, 1977, pp. 17–23.

MARINI, 1991 G. Marini, 'Il fiume e il castello: precisioni per il viaggio romano di Bernardo Bellotto', *Artibus et Historiae* XXIV, 1991, pp. 147–63.

MARINI, 1993 '"Con la propria industria e sua professione". Nuovi documenti per la giovinezza di Bellotto', *Verona Illustrata*, VI, 1993, pp. 125–40.

MARIUZ, 1971 A. Mariuz, *Giandomenico Tiepolo*, Milan, 1971.

MARIUZ, 1979 A. Mariuz, 'Due mostre su Giandomenico Tiepolo', *Arte Veneta*, XXXIII, 1979, pp. 201–5.

MARIUZ, 1982 A. Mariuz, *L'opera completa del Piazzetta*, Milan, 1982.

MARIUZ, 1983 A. Mariuz, 'I dipinti del Piazzetta e della scuola in Palazzo Vendramin-Calergi', *Arte Veneta*, XXXVII, 1983, pp. 293–304.

MARIUZ, 1986 A. Mariuz, 'I disegni di Pulcinella di Giandomenico Tiepolo', *Arte Veneta*, XL, 1986, pp. 265–72.

MARIUZ, 1988 A. Mariuz, 'Capricci veneziani del Settecento,' *Arte veneta*, XLII, 1988, pp. 119–32.

MARIUZ and PAVANELLO, 1985 A. Mariuz and G. Pavanello, 'I primi affreschi di Giambattista Tiepolo', *Arte Veneta*, XXXIX, 1985, pp. 101–3.

MARIUZ and PAVANELLO, forthcoming A. Mariuz and G. Pavanello, 'Disegni inediti di Antonio Canova da un taccuino "Canal"', *Scitti per Elena Bassi*, Venice, forthcoming.

MARTINELLI, 1979 V. Martinelli, *Manierismo, Barocco, Rococò nella scultura italiana*, Milan, 1979.

MARTINI, 1964 E. Martini, *La pittura veneziana del Settecento*, Venice, 1964.

MARTINI, 1982 E. Martini, *La pittura del Settecento veneto*, Udine, 1982.

MARTINI, 1989 E. Martini, 'Note varie su Gaspare Diziani', *Notizie da Palazzo Albani*, II, 1989, pp. 79–88.

MASON, 1977 R.M. Mason, 'Les Eaux-fortes archaeologiques de Gianfrancesco Costa, *Print Collector/Il Conoscitore di Stampe*, XLI, 1977, pp. 2–55.

MASON, 1979 R.M. Mason, 'Nuovo catalogo delle incisioni archeologiche di Gianfrancesco Costa', *Print Collector/Il Conoscitore di Stampe*, 1979, pp. 2–55.

MASON, 1983 R.M. Mason, 'Marieschi et son autre main: sur en état inedit d'une eau-forte capriceuse', *Arte Veneta*, XXXVII, 1983, pp. 212–13.

MASON, 1984 R.M. Mason, 'Michele Marieschi: Venise telle que ses vues l'imaginent', *Genava*, XXXII, 1984, pp. 121–5.

MASSARI, 1971 A. Massari, *L'architetto Giorgio Massari*, Venice, 1971.

MATSCHE, 1981 F. Matsche, *Die Kunst im Dienst der Staatsidee Kaiser Karls VI. Ikonographie, Ikonologie und Programmatik des 'Kaiserstils'*, II, Berlin and New York, 1981.

MATSCHE, 1993 F. Matsche, 'Das Grabmal des Johannes von Nepomuk im Prager Veitsdom als sakrales Denkmal', *Johannes von Nepomuk 1393–1993*, exh. cat., Bayerisches Nationalmuseum, Munich, 1993.

MATZULEVITSCH, 1965 G. Matzulevitsch, 'La Donna Velata del Giardino d'estate di Pietro il Grande', *Bollettino d'Arte*, L, 1965, pp. 80–5.

MAURONER, 1931, 1945 F. Mauroner, *Luca Carlevarijs*, Venice, 1931, 1945.

MAURONER, 1940 F. Mauroner, 'Michiel Marieschi', *The Print Collector's Quarterly*, XXVII, 1940, pp. 179–215.

MAXWELL WHITE and SEWTER, 1959 D. Maxwell White and A.C. Sewter, 'Piazzetta's so-called Group on the Seashore', *Connoisseur*, CXLIII, 1959, pp. 96–100.

MAXWELL WHITE and SEWTER, 1960 D. Maxwell White and A.C. Sewter, 'Piazzetta's so-called Indovina, an Interpretation', *Art Quarterly*, XXIII, 1960, pp. 124–38.

MAXWELL WHITE and SEWTER, 1961[1] D. Maxwell White and A.C. Sewter, *I disegni di G.B. Piazzetta nella Biblioteca Reale di Torino*, Rome, 1960.

MAXWELL WHITE and SEWTER, 1961[2] D. Maxwell White and A.C. Sewter, 'Piazzetta's Bossuet', *Art Quarterly*, Spring, 1961, pp. 15–31.

MAZZA, 1976 B. Mazza, 'Le vicende dei "Tombeaux des Princes": Matrici, storia e fortuna della series McSwiny tra Bologna e Venezia', *Saggi e memorie di storia dell'arte, Fondazione Giorgio Cini*, X, 1976, pp. 70–102, 141–51.

MAZZAROTTO, 1980 B.T. Mazzorotto, *Le feste veneziane: i giochi popolari, le cerimonie religiose e il governo*, 2nd ed, Florence, 1980.

MAZZOTTI, 1954 G. Mazzotti, *Le ville venete*, Treviso, 1954.

MCANDREW, 1974 J. McAndrew, *Catalogue of the Drawings Collection of the Royal Institute of British Architects, Antonio Visentini*, Farnborough, 1974.

MELLER, 1915 S. Meller, *As Esterházy Képtár Története* [History of the Esterházy Collection], Budapest, 1915.

MELLINI, 1984 G.L. Mellini, *Antonio Canova: Disegni scelti e annotati*, Florence, 1984.

MEMMO 1786 A. Memmo, *Elementi dell'Architettura Lodoliana*, Rome, 1786.

MERKEL, 1981 E. Merkel, 'I due primi restauri della Pala Costanza di Giorgione', in *Giorgioni e la cultura veneta tra '400 e '500*, Rome, 1981.

MERLING, 1993 M. Merling, 'Problems in the organisation of the Tasso firm: Evidence from the Tasso Cycle', *Atti del Covegno Guardesco, Venezia, 1993*.

MERRIMAN, 1980 M.P. Merriman, *Giuseppe Maria Crespi*, Milan, 1980.

MILAN, 1955 *Settecento Veneziano*, exh. cat., Milan, 1955.

MILAN, 1971 *G.B. Piazzetta e l'accademia*, exh. cat., ed. M. Preceruti Garberi, Castello Sforzesco, Milan, 1971.

MILAN 1975 *Sebastiano Ricci Disegnatore*, exh. cat. Milan, 1975.

MILAN, 1982 *Disegni di Canova del Museo di Bassano*, exh. cat., Milan, 1982.

MILAN, 1987[1] *Vedute italiane del '700 in collezioni private italiane*, exh. cat., by M. Magnifico and M. Ufili, Milan, 1987.

MILAN, 1987[2] *Antonio Visentini*, exh. cat., Il Gabinetto Salamon, Milan, 1987.

MILAN, 1988 *Michele Marieschi*, exh. cat., Il Gabinetto Salamon, Milan, 1988.

MILAN, 1989 *Il conoscitore d'arte. Sculture dal XV al XIX secolo della collezione di Federico Zeri*, exh. cat. by A.C. Bacchi, Museo Poldi Pezzoli, Milan, 1989.

MILAN, 1990[1] *Bernardo Bellotto: Verona e le città Europea*, exh. cat. ed. S. Marinelli, Milan, 1990.

MILAN, 1990[2] *La Pittura in Italia: Il Settecento*, 2 vols., Milan, 1990.

MILAN, 1990[3] *Itinerario veneto: Dipinti e disegni del '600 e '700 Veneziano del Museo di Belle Arti di Budapest*, ed. Z. Dobos, Milan, 1990.

MILKOVICH, 1966 M. Milkovich, *Sebastiano and Marco Ricci in America*, exh. cat., Kentucky University, Lexington, 1966.

MILLEKEN, 1940 W.M. Milleken, 'Two Drawings by Piazzetta', *The Burlington Magazine*, LXXVI, 1940, pp. 78–9.

MILLER, 1983 *Fifty Drawings by Canaletto from the Royal Library, Windsor Castle*, (facsimile of drawings in the Royal Collection with introduction by C. Miller), London and New York, 1983.

MILLIER, 1956 A. Millier, *The Drawings of Tiepolo*, Los Angeles, 1956.

MOLÈ, 1964 W. Molè, 'Bencovich', *Kindler Malerei Lexikon*, I, 1964.

MOLMENTI, 1909 P. Molmenti, *G.B. Tiepolo: la sua vita e le sue opere*, Milan, 1909.

MOLMENTI, 1926 P. Molmenti, *La storia di Venezia nella vita privata*, 3 vols, Bergamo, 1926.

MONGAN, 1949 A. Mongan, *One Hundred Master Drawings*, Cambridge, MA, 1949.

MONTAGU, 1993 J. Montagu, 'João V and Italian Sculpture', *The Age of the Baroque in Portugal*, exh. cat., National Gallery of Art, Washington, 1993, pp. 80–7.

MONTECUCCOLI DEGLI ERRI, 1990 F. Montecuccoli Degli Erri, 'Almorò Pisani, un patrizio dilettante di incisione', *Bollettino dei Musei Civici Veneziani*, XXXIV, 1990, pp. 41–62.

MONTECUCCOLI DEGLI ERRI, 1993 F. Montecuccoli Degli Erri, 'Commitenze artistiche di una famiglia patrizia emergente: i Giovanelli di Venezia', *Atti dell'Istituto Veneto di Scienze Lettere ed Arti*, n.s., XV, 1993, pp. 691–793.

MORASSI, 1926 A. Morassi, 'Un libro di disegni e due quadri di Sebastiano Ricci', *Cronache d'Arte*, 1926, pp. 256–73.

MORASSI, 1941 A. Morassi, 'Domenico Tiepolo', *Emporium*, June 1941, pp. 264–82.

MORASSI, 1941–2 A. Morassi, 'Novità e precisioni sul Tiepolo', *Le Arti*, 1941–2, p. 16.

MORASSI, 1943 A. Morassi, *Tiepolo*, Bergamo, Milan and Rome, 1943.

MORASSI, 1949 A. Morassi, 'Some Drawings by the Young Tiepolo', *The Burlington Magazine*, XCI, 1949, p. 85.

MORASSI, 1952 A. Morassi, 'Settecento Inedito, III', *Arte Veneta*, VI, 1952, p. 92.

MORASSI, 1953 A. Morassi, 'Una mostra del Settecento veneziano a Detroit', *Arte Veneta*, VII, 1953, pp. 49–62.

MORASSI, 1955 A. Morassi, *G.B. Tiepolo*, London, 1955.

MORASSI, 1957 A. Morassi, 'I quadri veneti del Settecento nella riaperta "Alte Pinakothek" di Monaco ed una nuova pala del Tiepolo', *Arte Veneta*, XI, 1957, pp. 173–80.

MORASSI, 1958 A. Morassi, *Dessins vénitiens du dix-huitième siècle de la collection du duc de Talleyrand*, Milan, 1958.

MORASSI, 1959 A. Morassi, 'Giambattista Tiepolo, Painter of "macchiette"', *The Burlington Magazine*, CI, 1959, pp. 227–32.

MORASSI, 1960 A. Morassi, 'Antonio Guardi al Servizio del Feldmaresciallo Schulenburg', *Emporium*, 1960, pp. 147–64, 199–212.

MORASSI, 1962 A. Morassi, *A Complete Catalogue of the Paintings of G.B. Tiepolo*, London, 1962.

MORASSI, 1968 A. Morassi, 'Appunti su Michele Marieschi, "alter ego" del Canaletto', *Festschrift Ulrich Middeldorf*, Berlin, 1968, pp. 487–502.

MORASSI, 1971 A. Morassi, 'A "Scuola del nudo" by Tiepolo', *Master Drawings*, IX, 1971, pp. 43–50.

MORASSI, 1973 A. Morassi, *Guardi: I Dipinti*, 2 vols, Milan, 1973.

MORASSI, 1975 A. Morassi, *Guardi: I Disegni*, Milan, 1975.

MORAZZONI, 1927 G. Morazzoni, *Mobili veneziani del '700*, Milan, 1927.

MORAZZONI, 1943 G. Morazzoni, *Il libro illustrato veneziano del Settecento*, Milan, 1943.

MORETTI, 1968 L. Moretti, *Gaetano Zompini: Le Arti che vanno per via nella città di Venezia*, Venice, 1968.

MORETTI, 1978 L. Moretti, 'Documenti e appunti su Sebastiano Ricci (con qualche accenno su altri pittori del settecento)', *Saggi e Memorie di Storia dell'Arte*, XI, 1978, pp. 96–125.

MORETTI, 1983 'Nuovi documenti Piranesiani', *Piranesi tra Venezia e l'Europa*, ed. A. Bettagno, Florence, 1983, p. 135ff.

MORETTI, 1984–5 L. Moretti, 'Notizie e appunti su G.B. Piazzetta, alcuni piazzetteschi e G.B. Tiepolo', *Atti dell'Istituto Veneto di Scienze, Lettere ed Arti*, CXLIII, 1984–5, pp. 70–3.

MORTIER, 1974 R. Mortier, *La poétique des ruines en France*, Geneva, 1974.

MOSCHETTI, 1938 A. Moschetti, *Il Museo Civico di Padova*, Padua, 1938.

MOSCHINI, 1806 G.A. Moschini, *Della letteratura veneziana del secolo XVIII*, III, 1806, pp. 70–3.

MOSCHINI, 1815 G.A. Moschini, *Guida per la città di Venezia all'amico delle Belle Arti*, 2 vols, Venice, 1815.

MOSCHINI, 1817 G.A. Moschini, *Guida per la città di Padova all'amico delle Belle Arti*, Venice, 1817.

MOSCHINI, 1924 V. Moschini, *Dell'incisione in Venezia*, Venice, 1924.

MOSCHINI, 1931 V. Moschini, *La Pittura Italiana del Settecento*, Florence, 1931.

MOSCHINI, 1952 V. Moschini, *Francesco Guardi*, Milan, 1952.

MOSCHINI, 1954 V. Moschini, *Canaletto*, Milan, 1954.

MOSCHINI MARCONI, 1970 S. Moschini Marconi, *Gallerie dell'Accademia di Venezia. Opere d'arte dei secoli, XVII, XVIII, XIX*, Rome, 1970.

MUIR, 1981 E. Muir, *Civic Ritual in Renaissance Venice*, Princeton, 1981.

MULLER, 1990–1 J. Muller, 'The Quality of Grace in the Art of Anthony van Dyck', *Anthony van Dyck*, exh. cat., National Gallery of Art, Washington, 1990–1.

MUNHALL, 1968 E. Munhall, 'Savoyards in French Eighteenth-century Art', *Apollo*, LXXXVII, 1968, p. 90.

MUNICH, 1958 *Europäisches Rokoko Kunst und Kultur des 18. Jahrhunderts*, exh. cat., Residenz, Munich, 1958.

MUNICH, 1987 *Venedig Malerei des 18. Jahrhunderts*, exh. cat., Kunsthalle Munich, 1987.

MUNICH, 1992 *Friedrich der Grosse: Sammler und Mäzen*, exh. cat., Munich, 1992.

MURARO, 1958 M. Muraro, 'An Altarpiece and other Figure Paintings by Francesco Guardi', *The Burlington Magazine*, C, 1958, pp. 3–13.

MURARO, 1959 M. Muraro, 'Figure di Francesco Guardi', *Emporium*, CXXX, 1959, pp. 234–52.

MURARO, 1975 M. Muraro, 'Giovanni Battista Tiepolo tra Ricci e Piazzetta', *Atti del Congresso Internazionale di studi su Sebastiano Ricci e il suo tempo, Venezia*, 1975.

MURARO, 1993 M. Muraro, *I Guardi del Museo Gulbenkian*, Lisbon, 1993.

MURRAY, 1971 P. Murray. *Piranesi and the Grandeur of Ancient Rome*, London, 1971.

NAPLES, 1980 *Civiltà del '700 a Napoli, 1734–99*, exh. cat., Museo di Capodimonte, Naples, 1980.

NATALE, 1991 M. Natale, *Itinerario Veneto: Dipinti e disegni del '600 e '700 veneziano del Museo di Belle Arti di Budapest*, Milan, 1991.

NATALI, 1989 G. Natali, *Storia Letteraria d'Italia: Il Settecento*, Milan, 5th ed. 1989.

NAVA CELLINI, 1982 A. Nava Cellini, *Storia dell'Arte in Italia La Scultura del Settecento*, Turin, 1982.

NEGRI ARNOLDI, 1981 P. Negri Arnoldi, *Il catalogo dei Beni Culturali e Ambientali*, Urbino, 1981.

NEPI SCIRÉ 1984 G. Nepi Sciré, 'Il restauro del Convito in casa di Levi di Paolo Veronese', in *Quaderni della Soprintendenza ai Beni Artistici e Storici di Venezia*, Venice, 1984.

NEPI SCIRÉ, 1991 G. Nepi Sciré, *I Capolavori dell'Arte Veneziana, Le Gallerie dell'Accademia*, Venice, 1991, English trans. as *Treasures of Venetian Painting: The Gallerie dell'Accademia di Venezia*, London, 1991.

NEPI SCIRÉ and VALCANOVER 1985 G. Nepi Sciré and F. Valcanover, *Gallerie dell'Accademia di Venezia*, Milan, 1985.

NEUMAYER, 1807 A. Neumayer, *Illustrazione del Prato delle Valle o Piazza delle Statue di Padova*, Padua, 1807.

NEW HAVEN, 1940 *Eighteenth-century English and Italian Landscape Painting*, exh. cat., Yale University Art Gallery, New Haven, 1940.

NEW HAVEN, 1964 *Italian Drawings from the Collection of Janos Scholz*, exh. cat., Yale University Art Gallery, New Haven, 1964.

NEW YORK, 1915 *Loan Exhibition of Fifty-nine Masterpieces of Ancient and Modern Schools*, exh. cat., Benjamin Altman Gallery, New York, 1915.

NEW YORK, 1938 *Tiepolo and his Contemporaries*, exh. cat. by H.B. Wehle, The Metropolitan Museum of Art, New York, 1938.

NEW YORK, 1940 *Masterpieces of Art*, exh. cat., New York World's Fair, New York, 1940.

NEW YORK, 1959–61 *Five Centuries of Painting*, exh. cat., Cooper Union Museum, New York, 1959–61.

NEW YORK, 1961 *Venetian Paintings of the Eighteenth Century*, exh. cat., Finch College Museum of Art, New York, 1961.

NEW YORK, 1962 *Extravagant Drawing of the Eighteenth Century*, exh. cat. by R. Wunder, Cooper-Hewitt Museum, New York, 1962.

NEW YORK, 1967–8 *The Metropolitan Museum of Art Annual Report*, New York, 1967–8.

NEW YORK, 1971 *Drawings from New York Collections III. The Eighteenth Century in Italy*, exh. cat., The Metropolitan Museum of Art, New York, 1971.

NEW YORK, 1972 *Giovanni Battista Piranesi: Drawings and Etchings*, exh. cat. by D. Nyberg et al., Columbia University, New York, 1972.

NEW YORK, 1973 *Drawings from the Lore and Rudolf Heinemann Collection*, exh. cat., The Pierpont Morgan Library, ed. F. Stampfle and C.D. Denison, New York, 1973.

NEW YORK, 1976 *Italian Master Drawings 1350–1800 from the Janos Scholz Collection*, exh. cat., New York, 1976.

NEW YORK, 1978 *The Splendor of Dresden: Five Centuries of Art Collecting*, exh. cat., New York, 1978.

NEW YORK, 1983 *Views from the Grand Tour*, exh. cat. by C. Whitfield, Colnaghi, New York, May–June 1983.

NEW YORK, 1985 *Drawings from Venice: Masterworks from the Museo Correr*, exh. cat. by T. Pignatti and G. Romanelli, The Drawing Center, New York, 1985.

NEW YORK, 1989 *Canaletto*, exh. cat. by K. Baetjer and J.G. Links, The Metropolitan Museum of Art, New York, 1989.

NEW YORK, 1990 *Julius S. Held: Drawings from his Collection*, Columbia University, New York, 1990.

NICOLSON, 1963 B. Nicolson, 'Sebastiano Ricci and Lord Burlington', *The Burlington Magazine*, CV, 1963, pp. 121–4.

NIERO, 1979 A. Niero, *Tre Artisti per un Tempio: S. Maria del Rosario – Gesuati, Venezia*, Padua, 1979.

NIERO, 1988 A. Niero, *Guida alla Chiesa di Santa Maria della Pietà a Venezia*, Venice, 1988.

NORTHAMPTON, MA, 1941 *Italian Drawings, 1330–1780*, exh. cat., Smith College, Northampton, MA, 1941.

NORWICH, 1982, 1989 J.J. Norwich, *A History of Venice*, London, 1982, New York, 1989.

NOTTINGHAM, 1973 *Paintings and Drawings from Chatsworth*, exh. cat., University Gallery, Nottingham, 1973.

NOVELLI, 1982 M. Novelli, 'Nuovi accertamenti sul soggiorno bolognese di Sebastiano Ricci e sui suoi rapporti col Peruzzini', *Arte Veneta*, XXXII, 1982, pp. 346–51.

OAKLAND and SAN FRANCISCO, 1960 *Venetian Drawings 1600–1800*, exh. cat. by A. Neumeyer, Mills College, Oakland, and California Palace of the Legion of Honor, San Francisco, 1960.

OBERLIN, 1951 *Exhibition of Master Drawings of the 18th Century in France and Italy*, exh. cat., Allen Memorial Art Museum, Oberlin, 1951.

OLIVATO PUPPI, 1974[1] L. Olivato Puppi, 'Gli affari sono gli affari: Giovan Maria Sasso tratta con Tomaso degli Obizzi', *Arte Veneta*, XXVIII, 1974, pp. 298–304.

OLIVATO PUPPI, 1974[2] L. Olivato Puppi, *Provvedimenti della Repubblica Veneta per la salvaguardia del patrimonio pittorico nei secoli XVII e XVIII*, Venice, 1974.

OLSEN, 1961 H. Olsen, *Italian Paintings and Sculptures in Denmark*, Copenhagen, 1961.

ORLANDI, 1704, 1753 P.A. Orlandi, *Abecedario Pittorico, corretto e accresciuto da P. Guarienti*, Venice, 1704, 1753.

ORLANDINI, 1914 G. Orlandini, *La Cappella Correr nella chiese dei SS. Apostoli*, Venice, 1914.

ORLOFF, 1920 *Catalogue de tableaux anciens … dessins par G.-B. Tiepolo composant la collection de son excellence feu le Prince Alexis Orloff*, sale cat., Galerie Georges Petit, Paris, 29–30 April 1920.

ORSO, 1985–6 M. Orso, 'Gian Maria Sasso mercante, collezionista e scrittore d'arte della fine del Settecento a Venezia', *Atti dell'Istituto veneto di Scienze, Lettere ed Arte*, CXLIV, 1985–6, pp. 37–55.

OSTI, 1951 O. Osti, 'Sebastiano Ricci in Inghilterra', *Commentari*, II, 1951, pp. 119–23.

OSTI, 1955 O. Osti, 'In margine alla mostra di Belluno: Marco Ricci', *Commentari*, VI, 1955, pp. 31–4.

OSWALD, 1955 A. Oswald, 'Glynde Place, Sussex – II', *Country Life*, CXVII, 21 April 1955, pp. 1040–3.

OTTAWA, 1976 *Etchings of Tiepolo*, exh. cat., Ottawa, 1976.

PADOAN URBAN, 1968 L. Padoan Urban, 'La Festa della Sensa nelle Arti e nell'iconografia', *Studi Veneziani*, X, 1968, pp. 291–353.

PAJES MERRIMAN, 1980 M. Pajes Merriman, *Giuseppe Maria Crespi*, Milan, 1980.

PALLUCCHINI, 1933 R. Pallucchini, 'Attorno al Piazzetta', *Rivista di Venezia*, XII, 1933, pp. 565–78.

PALLUCCHINI, 1934 R. Pallucchini, *L'Arte di G.B. Piazzetta*, Bologna, 1934.

PALLUCCHINI, 1936[1] R. Pallucchini, 'Opere inedite di Giambattista Piazzetta', *L'Arte*, XXXIX, 1936, pp. 187–205.

PALLUCCHINI, 1936[2] R. Pallucchini, 'Ein wiedergefundenes Werk des Piazzetta', *Pantheon*, XVIII, 1936, pp. 250–1.

PALLUCCHINI, 1942 R. Pallucchini, *Giovan Battista Piazzetta*, Rome, 1942.

PALLUCCHINI, 1943 R. Pallucchini, *I disegni del Guardi nel Museo Correr di Venezia*, Venice, 1943.

PALLUCCHINI, 1947 R. Pallucchini, 'Opere tarde del Piazzetta', *Arte Veneta*, XXII, 1947, pp. 108–16.

PALLUCCHINI, 1950 R. Pallucchini, 'Giunte e Sebastiano Ricci', *Proporzioni*, III, 1950, pp. 212–5.

PALLUCCHINI, 1951–2 R. Pallucchini, *La Pittura veneziana del Settecento*, Florence, 1951–2.

PALLUCCHINI, 1952 R. Pallucchini, 'Studi Ricceschi, I: Contributo a Sebastiano' *Arte Veneta*, VI, 1952, pp. 63–84.

PALLUCCHINI, 1955 R. Pallucchini, 'Studi Ricceschi, II: Contributo a Marco', *Arte Veneta*, IX, 1955, pp. 171–98.

PALLUCCHINI, 1956 R. Pallucchini, *Piazzetta*, Milan, 1956.

PALLUCCHINI, 1960[1] R. Pallucchini, 'Nogari', *Connoisseur*, 1960, pp. 128–9.

PALLUCCHINI, 1960[2] R. Pallucchini, *La pittura veneziana del Settecento*, Venice and Rome, 1960.

PALLUCCHINI, 1961 R. Pallucchini, review of M. Levey, *Painting in XVIIIth Century Venice*, Gazette des Beaux Arts, 1961, pp. 63–5.

PALLUCCHINI, 1965 R. Pallucchini, Nota alla Mostra dei Guardi', *Arte Veneta*, XIX, 1965, pp. 215–37.

PALLUCCHINI, 1966 R. Pallucchini, 'Considerazioni sulla mostra bergamasca del Marieschi', *Arte Veneta*, XX, 1966, pp. 314–25.

PALLUCCHINI, 1967 R. Pallucchini, 'F. Guardi: ultima voce del rococo veneziano', *Sensibilità e razionalità nel Settecento*, Venice, 1967.

PALLUCCHINI, 1968[1] A. Pallucchini, *L'opera completa di Giambattista Tiepolo*, Milan, 1968.

PALLUCCHINI, 1968[2] R. Pallucchini, 'Miscellanea piazzettesca', *Arte Veneta*, XXII, 6, 1968, pp. 107–30.

PALLUCCHINI, 1971 R. Pallucchini, 'Schede venete Settentesche', *Arte Veneta*, XXV, 1971, pp. 153–81.

PALLUCCHINI, 1981 R. Pallucchini, *La pittura veneziana del Seicento*, 2 vols, Milan, 1981.

PALLUCCHINI, 1986 R. Pallucchini, 'Risarcimento di Antonio Visentini', *Arte Veneta*, XL, 1986, pp. 291–302.

PALUMBO FOSSATI, 1976 C. Palumbo Fossati, *J. Fossati di Morcote*, Milan, 1976.

PANOFSKY, 1924, 1960 E. Panofsky, *Idea: Ein Beitrag zur Begriffsgeschichte der älteren Kunsttheorie*, 1924, Berlin 1960.

PAOLETTI, 1832 E. Paoletti, *Continuazione alla storia della Repubblica di Venezia*, Venice, 1832.

PARIS, 1919 *Venezia*, exh. cat., Petit Palais, Paris, 1919.

PARIS, 1935 *Exposition de l'art italien de Cimabue à Tiepolo*, exh. cat., Paris, 1935.

PARIS, 1952 *Tiepolo e Guardi: Exposition de peintures et dessins provenant de collections publiques et privées*, exh. cat. by J. Cailleux, Galerie Cailleux, Paris, 2 vols, 1952.

PARIS, 1960–1 *La peinture italienne au XVIIIe siècle*, exh. cat. by F. Valcanover, Petit Palais, Paris, 1960–1.

PARIS, 1971[1] *Venise au dix-huitième siècle. Peintures, dessins et gravures des collections françaises*, Orangerie des Tuileries, Paris, 1971.

PARIS, 1971[2] *Venise au dix-huitième siècle*, exh. cat. by A. Bettagno, Galerie Heim, Paris, 1971.

PARIS, 1982 *Le Portrait en Italie au siècle de Tiepolo*, exh. cat., Petit Palais, Paris, 1982.

PARIS, 1990, *Paul Prouté catalogue*, Paris, 1990.

PARIS and TORONTO, 1983 *Dessins venitiens du XVIIIe siècle*, exh. cat., Paris and Toronto, 1983.

PARKER, 1948 K.T. Parker, *The Drawings of Antonio Canaletto in the Collection of His Majesty The King at Windsor Castle*, Oxford and London, 1948.

PARKER 1972 K.T. Parker, *Catalogue of Drawings in the Ashmolean Museum*, 2 vols, Oxford, 1972.

PARMA, 1991 *G.B. Piranesi e la veduta a Roma e a Venezia nella prima metà del settecento*, Fondazione Magnani Rocca, Parma, 1991.

PARSONS, 1970 M.M. Parsons, 'Raffaello Monti, The Veiled Lady', *Minneapolis Institute of Arts Bulletin*, LIX, 1970, pp. 36–7.

PASCOLI ed., D'ARCAIS, 1981 L. Pascoli, *Vite de' pittori, scultori ed architetti moderni ...*, Rome, 1730–6; ed; F. D'Arcais, Treviso, 1981.

PAVANELLO, 1976 G. Pavanello, *L'opera completa del Canova*, Milan, 1976.

PAVANELLO, 1981 G. Pavanello, 'Per Gaspare Diziani decoratore', *Arte Veneta*, XXXV, 1981, pp. 126–36.

PAVANELLO, 1984 G. Pavanello, 'Antonio Canova: i bassorilievi "Rezzonico"', *Bollettino del Museo Civico di Padova*, LXXIII, 1984, pp. 145–162.

PEDROCCO, 1979–80 E.M. Pedrocco, 'Gian Maria Morlaiter, scultore veneziano', *Atti dell'Istituto Veneto di Scienze, Lettere ed Arti*, CXXXVIII, 1979–80, pp. 341–54.

PEDROCCO, 1981¹ E.M. Pedrocco, 'Due disegni inediti di Luca Carlevaris al Museo Correr di Venezia', *Festschrift for A.E. Popham*, Parma, 1981, pp. 225–9.

PEDROCCO, 1981² E.M. Pedrocco, 'Catalogo dei bozzetti del "fondo di bottega" di Gianmaria Morlaiter', *Bollettino dei civici Musei Veneziani d'arte e di Storia*, XXVI, 1981, pp. 21–34.

PEDROCCO, 1985 E.M. Pedrocco, 'Giambattista Tiepolo illustratore di libri', *Giambattista Tiepolo: Il segno e l'enigma*, exh. cat., ed. D. Succi, Gorizia, 1985.

PEDROCCO, 1975 F. Pedrocco, 'Editoria illustrata veneziana del settecento: G.B. Pasquali', *Atti dell'Istituto Veneto di Scienze, Lettere ed Arti*, CXXXV, 1975, pp. 327–8.

PEDROCCO, 1978 F. Pedrocco, 'Rutzvanscad il giovane ...', *Venise: une civilisation du livre*, II, Paris, 1978, pp. 59–60.

PEDROCCO, 1989–90 F. Pedrocco, 'L'Oratorio del Crocefisso nella Chiesa di San Polo', *Arte Veneta*, XLIII, 1989–90, pp. 108–15.

PEDROCCO, 1990 F. Pedrocco, *Disegni di Giandomenico Tiepolo*, Milan, 1990.

PEDROCCO, 1993 F. Pedrocco, 'Longhi', *Art e Dossier*, November, 1993, pp. 15–18.

PEDROCCO and MONTECUCCOLI DEGLI ERRI, 1992 F. Pedrocco and F. Montecuccoli Degli Erri, *Antonio Guardi*, Milan, 1992.

PENNY, 1992 N. Penny, *Catalogue of European Sculpture in the Ashmolean Museum, 1540 to the Present Day*, Oxford, 1992.

PÉREZ SÁNCHEZ, 1977 A.E. Pérez Sánchez, 'Nueva documentación para un Tiepolo problemático', *Archivo Español de Arte*, L, 1977, pp. 75–80.

PÉREZ SÁNCHEZ, 1978 A.E. Pérez Sánchez, *I Grandi disegni italiani nelle collezione di Madrid*, Milan, 1978.

PERSICINI, 1882 P.N. Persicini, *Di Andrea Brustoloni, Scultore bellunese*, Padua, 1882.

PEVSNER 1982 N. Pevsner, *Le Accademia d'Italia*, Turin, 1982.

PFAFFIKON and GENEVA, 1978 *Venezianische Kunst in der Schweiz und in Liechtenstein*, exh. cat., Pfäffikon and Geneva, 1978.

PIACENZA, 1961 *Dipinti farnesiani di Sebastiano Ricci, Giovanni Battista Draghi, Francesco Manti, Ilario Spolverini*, exh. cat. by F. Arisi, Piacenza, 1961.

PIETRUCCI, 1858, 1970 N. Pietrucci, *Biografia degli artisti padovani*, Padua, 1858, reprinted Bologna, 1970.

PIGLER, 1967 A. Pigler, *Katalog der Galerie Alter Meister*, Budapest, 1967.

PIGLER, 1974 A. Pigler, *Barockthemen I–III*, Budapest, 1974.

PIGNATTI, 1947 T. Pignatti, 'Per l'iconografia di Francesco Guardi', *Arte Veneta*, I, 1947, p. 294.

PIGNATTI, 1951¹ T. Pignatti, *Novità su Lorenzo Tiepolo*, Venice, 1951.

PIGNATTI, 1951² T. Pignatti, *Tiepolo*, Verona, 1951.

PIGNATTI, 1957 T. Pignatti, 'Nuovi disegni del Piazzetta', *Critica d'Arte*, IV, 1957, pp. 396–403.

PIGNATTI, 1958 T. Pignatti, *Il Quaderno di Desegni del Canaletto alle Gallerie di Venezia*, Milan, 1958.

PIGNATTI, 1959 T. Pignatti, 'Pellegrini Drawings in Venice', *The Burlington Magazine*, CI, 1959, pp. 451–2.

PIGNATTI, 1960 T. Pignatti, *Il Museo Correr di Venezia: Dipinti del XVII e del XVIII secolo*, Venice, 1960.

PIGNATTI, 1964 T. Pignatti, 'Disegni di figura dei Guardi', *Critica d'Arte*, XI, 1964, pp. 57–72.

PIGNATTI, 1965¹ T. Pignatti, *I disegni veneziani del Settecento*, Treviso, 1965.

PIGNATTI, 1965² T. Pignatti, *Le acqueforti dei Tiepolo*, Florence, 1965.

PIGNATTI, 1967¹ T. Pignatti, *Disegni dei Guardi*, Florence, 1967.

PIGNATTI, 1967² T. Pignatti, 'Bernardo Bellotto's Venetian Period (1738–1743)', *The National Gallery of Canada Bulletin*, V, 1–2, 1967, pp. 1–17.

PIGNATTI, 1968 T. Pignatti, *Pietro Longhi*, Venice, 1968.

PIGNATTI, 1969 T. Pignatti, *Pietro Longhi*, London, 1969.

PIGNATTI, 1970 T. Pignatti, *Canaletto: Selected Drawings*, University Park, PA (trans. S. Rudolph), Italian edition, Florence, 1970.

PIGNATTI, 1972 T. Pignatti, *Le Dodici Feste Ducali di Canaletto-Brustolon*, facsimile ed., with foreword by T. Pignatti, Venice, 1972.

PIGNATTI, 1974¹ T. Pignatti, *I grandi disegni italiani nelle collezioni di Venezia*, Milan, 1974.

PIGNATTI, 1974² T. Pignatti, *Pietro Longhi: Tutta la pittura*, Milan, 1974.

PIGNATTI, 1975¹ T. Pignatti, 'Le feste ducali: Canaletto, Brustolon, Guardi', *Critica d'Arte*, CXLIV, 1975, pp. 41–68.

PIGNATTI, 1975² T. Pignatti, *Le Prospettive di Venezia di Michele Marieschi*, Venice, 1975.

PIGNATTI, 1980 T. Pignatti, *Disegni antichi del Museo Correr di Venezia*, Venice, 1980.

PIGNATTI, 1983 T. Pignatti, *Disegni antichi del Museo Correr di Venezia III: Galimberti-Guardi*, Venice, 1983.

PIGNATTI, 1987 T. Pignatti, 'Pietro Longhi', *Disegni antichi del Museo Correr di Venezia*, IV, Venice, 1987.

PIGNATTI, 1989 T. Pignatti, *Venezia: Mille anni d'arte*, Venice, 1989.

PIGNATTI, 1990 T. Pignatti, *Disegni di Pietro Longhi*, Milan, 1990.

PILO, 1958 G.M. Pilo, 'Studiando l'Amigoni', *Arte Veneta*, XII, 1958, pp. 158–68.

PILO, 1960 G.M. Pilo, 'Ricci, Pellegrini, Amigoni: nuovi appunti su un rapporto vicendevole', *Arte Antica e Moderna*, X, 1960, pp. 174–89.

PILO, 1976 G.M. Pilo, *S. Ricci e la pittura veneziana del Settecento*, Pordenone, 1976.

PILO, 1983 G.M. Pilo, *Francesco Guardi: I Paliotti*, Milan, 1983.

PILO, 1987 G. Pilo, '"Rittratti" e "Figure" dei Carracci interpretati da Antonio Balestra', *Paragone*, IV, 1987, pp. 22–50.

PINTO, 1982 S. Pinto, *La promozione delle arti negli stati italiani dall'età della Riforma all'unità*, Turin, 1982, II, pp. 859–76.

PITTALUGA, 1939 M. Pittaluga, *Acquafortisti Veneziani del Settecento*, Florence, 1939.

PITTONI, 1915 L.C. Pittoni, 'Il viaggio di Pio VI negli stati veneti e nella Dominante', *Nuovo Archivio Veneto*, n.s., LVII, 1915, pp. 167–208.

PLANISCIG, 1919 L. Planiscig, *Die Estensische Kunstsammlung, I: Skulpturen und plastiken des Mittelalters und der Renaissance*, Vienna, 1919.

PLANISCIG, 1928–9¹ L. Planiscig, 'Francesco Bertos, *Dedalo*, IX, 1928–9, pp. 209–21.

PLANISCIG, 1928–9² L. Planiscig, 'Dieci opere di Francesco Bertos conservate nel Palazzo Reale di Torino, *Dedalo*, IX, 1928–9, pp. 561–75.

POLAZZO, 1978 M. Polazzo, *Antonio Balestra pittore veronese, 1666–1749*, Verona, 1978.

POMIAN, 1987 K. Pomian, *Collectors and Curiosities, Paris and Venice, 1500–1800*, Cambridge MA, 1990 (first published as *Collectionneurs, amateurs et curieux*, Paris, 1987).

POPE-HENNESSY, 1963 J. Pope-Hennessy, *Italian High Renaissance and Baroque Sculpture*, London, 1963.

POPE-HENNESSY, 1964 J. Pope-Hennessy, *Catalogue of Italian Sculpture in the Victoria and Albert Museum*, London, 1964.

POPHAM, 1931 A.E. Popham, *Italian Drawings Exhibited at the Royal Academy*, London, 1931.

PORDENONE, 1990 *Il libro veneziano illustrato nel Settecento*, exh. cat., ed. M. De Grassi, Pordenone, 1990.

POSNER, 1973 D. Posner, *Watteau: The Lady at her Toilet*, New York, 1973.

POSSE, 1931 H. Posse, 'Die Briefe des Grafen Francesco Algarotti an den sächsischen Hof und seine Bilderkäufe für die Dresdener Gemäldegalerie, 1743–1747', *Jahrbuch der Preussischen Kunstsammlungen*, LII, 1931.

PRECERUTTI GARBERI, 1967 M. Precerutti Garberi, 'Il terzo dei Tiepolo: Lorenzo', *Pantheon*, XXV, 1967, pp. 44–57.

PRECERUTTI GARBERI, 1971¹ M. Precerutti Garberi, 'Asterischi sull'attività di Domenico Tiepolo a Würzburg', *Commentari*, XI, 1960, pp. 267–83.

PRECERUTTI GARBERI, 1971² M. Precerutti Garberi, *Giambattista Tiepolo. Gli Affreschi*, Turin, 1971.

PRESS, 1986 V. Press, 'The Habsburg Court as Center of the Imperial Government', *Journal of Modern History*, LVIII, Supplement (Politics and Society in the Holy Roman Empire, 1500–1806), 1986, pp. 23–45.

PRESS, 1991 V. Press, *Kriege und Krisen, Deutschland 1600–1715*, Munich, 1991.

PUPPI, 1967 L. Puppi, 'Nuovi documenti sui Marinali', *Atti dell'Istituto veneto di Scienze, Lettere ed Arti*, CXXV, 1967, pp. 195–215.

PUPPI, 1968 L. Puppi, 'Carlo Cordellina committente di artisti', *Arte Veneta*, XXII, 1968, pp. 212–16.

PUPPI, 1983–4 L. Puppi, 'La Gondola del Procuratore. Committenza e Peripezie di Collezione di quattro dipinti del Canaletto', *Bollettino Civici Musei Veneziani d'Arte e di Storia*, XXVIII, 1983–4, pp. 5–16.

QUINTAVALLE, 1956–7 A. Ghidiglia Quintavalle, 'Premesse giovanili di Sebastiano Ricci', *Rivista dell'Istituto di Archaeologia e Storia dell'Arte*, 1956–7, pp. 395–415.

RADAELI 1989 F. Radaeli, *Alcune note sul Tasso del Piazzetta*, Milan, 1989.

RADCLIFFE, 1968 A. Radcliffe, 'New Treasures at the Victoria and Albert Museum', *Apollo*, XCVII, 1968, pp. 406–14.

RADCLIFFE, 1970 A. Radcliffe, 'Monti's Allegory of the Risorgimento', *Victoria and Albert Museum Bulletin*, I, iii, 1965, pp. 25–38; rev. reprint 1970.

RALEIGH et al., 1994–5 *A Gift to America: Masterpieces of European Painting from the Samuel H. Kress Collection*, exh. cat., North Carolina Museum of Art, Raleigh, 1994; The Museum of Fine Arts, Houston; Seattle Art Museum; The Fine Arts Museum of San Francisco, 1994–5.

RASMO, 1955 N. Rasmo, 'Sulle origini dello scultore Giovan Maria Morlaiter', *Cultura Atesina*, IX, 1955.

RAVÀ, 1921 A. Ravà, *G.B. Piazzetta*, Florence, 1921.

RAVE, 1993 A.B. Rave, 'Die Venezianische Malerei des 18. Jahrhunderts. Nachlese zu einem Münchner Sammlungskatalog', *Kunstchronik*, XLVI, 1993, pp. 398–412.

REAU, 1955 L. Reau, *Iconographie de l'art chrétien*, Paris, 1955.

RESS, 1979 A. Ress, *Giovanni Maria Morlaiter. Ein venezianischer Bildhauer des 18. Jahrhunderts*, Munich, 1979.

RICCOBONI, 1952 A. Riccoboni, 'Sculture inedite di Antonio Corradini', *Arte Veneta*, VI, 1952, pp. 151–61.

RIGON, 1989 F. Rigon, 'La pittura a Vicenza nel Settecento', *La Pittura in Italia. Il Settecento*, Milan, 1989.

RIZZI, 1967 A. Rizzi, *Luca Carlevarijs*, Venice, 1967.

RIZZI, 1971¹ A. Rizzi, *L'opera grafica dei Tiepolo – Le acquaforti*, Venice, 1971.

RIZZI, 1971² A. Rizzi, *The Etchings of the Tiepolos: Complete Edition*, London, 1971.

ROBERTSON, 1949 G. Robertson, 'Tiepolo and Veronese's "Finding of Moses"', *The Burlington Magazine*, XCI, 1949, pp. 99–100.

ROBISON, 1973 A. Robison, 'Piranesi's Ship on Wheels', *Master Drawings*, II, 1973, pp. 389–92.

ROBISON, 1974 A. Robison, 'The Albrizzi-Piazzetta Tasso', *Non Solus*, I, 1974, pp. 1–12.

ROBISON, 1986 A. Robison, *Piranesi: Early Architectural Fantasies. A Catalogue Raisonné of the Etchings*, Washington, 1986.

ROHRLACH, 1951 P. Rohrlach, 'La Collezione dei quadri Streit nel Graues Kloster a Berlino', *Arte Veneta*, V, 1951, pp. 198–201.

ROHRLACH, 1974 P. Rohrlach *Venedig im 18. Jahrhundert. Bilder as der Streit'schen Stiftung*, exh. cat., Berlin, Dahlem Museum, 1974.

ROLAND MICHEL, 1984 M. Roland Michel, *La Joüe et l'art rocaille*, Neuilly-sur-Seine, 1984.

ROMANELLI, 1985 G. Romanelli, 'Il disegno veneziano di età neoclassica', *Disegni dalle collezioni del Museo Correr, XV–XIX secolo*, exh. cat., ed. G. Romanelli and T. Pignatti, Venice, 1985.

ROME, 1940 *Mostra del Paessaggio veneziano del Settecento*, exh. cat. by A. Morandotti, Rome, 1940.

ROME, 1941 *Mostra di pitture veneziane del Settecento*, exh. cat. Rome, 1941.

ROME, 1959 *Il settecento a Roma*, Rome, 1959.

ROSENBERG, 1976 P. Rosenberg, 'S. Ricci et la France: à propos de quelques textes anciens', *Congresso internazionale di studi su Sebastiano Ricci e il suo tempo (Biennale d'Arte antica VII)*, Milan, 1976.

ROSSI BORTOLATTO, 1974 L. Rossi Bortolatto, *L'opera completa di Francesco Guardi*, Milan, 1974.

ROTHSTEIN, 1975–6 E. Rothstein, '"Ideal presence" and the "Non Finito"', *Eighteenth Century Studies*, IX, 1975–6, pp. 307–32.

ROTTERDAM, 1957 *Bernardo Bellotto Schilderijen en tekeningen uit het Nationaal Museum te Warshau*, exh. cat., Museum Boymans, Rotterdam, 1957.

RUGGIERI, 1974 U. Ruggieri, 'Un taccuino di Antonio Canova', *Critica d'Arte*, XX, 1974.

RUGGIERI, 1979 U. Ruggieri, 'Nuove opere del Piazzetta e della sua scuola', *Arte Veneta*, XXXIII, 1979, pp. 79–86.

RUGGIERI, 1984 U. Ruggieri, 'I ritratti di Rosalba Carriera sorridan con malinconia', *Antiquariato Boletti*, February 1984, pp. 52–4.

RYKWERT, 1980 J. Rykwert, *The First Moderns: The Architects of the Eighteenth Century*, Cambridge, MA, and London, 1980.

SACCARDO, 1977 M. Saccardo, 'Nell' antica chiesa dell'Araceli; la "mano" dell' architetto Guarini', *Vicenza*, II, March/April 1977, pp. 10–14.

SACCARDO, 1981 M. Saccardo, *Notizie d'Arte e di Artisti vicentini*, Vicenza, 1981.

SACCARDO, 1983 M. Saccardo, *Sul pittore vicentino Giovanni Antonio De Pieri. Documenti e dati*, Vicenza, 1983.

SACK, 1910 E. Sack, *Giambattista und Giandomenico Tiepolo: Ihr Leben und ihre Werke*, 2 vols, Hamburg, 1910.

SAFAŘIK, 1961 E.A. Safaŕik, *Canaletto's View of London*, Prague; English trans. London, 1961.

SAFAŘIK, 1964 E.A. Safaŕik, 'Il Settecento Veneziano nelle collezioni cecoslovacche', *Arte Veneta*, II, 1964, pp. 110–18.

SAGRESTANI, 1971 G. Sagrestani, 'Vita di Bastiano Ricci pittore veneziano', A. Matteoli, 'Le vite di artisti dei secoli XVII–XVIII di Giovanni Camillo Sagrestani', *Commentari*, XXII, 1971, pp. 201–2.

SANI, 1985 B. Sani, ed., *Rosalba Carriera, Lettere, Diari, Frammenti*, Florence, 1985.

SANI, 1987 B. Sani, 'La "furia francese" de Rosalba Carriera. Ses rapports avec Watteau et les artistes français', *Antoine Watteau (1684–1721): The Painter, His Age and His Legend*, ed. F. Moureau and M. Morgan Grasselli, Paris and Geneva, 1987, pp. 73–84.

SANI, 1988 B. Sani, *Rosalba Carriera*, Florence, 1988.

SARTORELLO, 1937–8 C. Sartorello, *Antonio Bonazza, Scultore Padovano*, Diss., l'Istituto di storia del l'Arte dell'Università di Padova, 1937–8.

SARTORI, 1976 A. Sartori, *Documenti per la Storia dell'arte a Padova*, IV, Vicenza, 1976.

SARTORI, 1865 F. Sartori, *Guida delle chiese di Padova e delle sua docesi*, Padua, 1865.

SAVINI, 1965 B.S. Savini, *Ill collezionismo veneziano nel Seicento*, Padua, 1965.

SCARPA SONINO, 1991 A. Scarpa Sonino, *Marco Ricci*, Milan, 1991.

SCATTOLIN and TALAMINI, 1969 G. Scattolin and T. Talamini, 'Un edificio di Giorgio Fossati (Contributo al studio dell'edifizia residenziale del XVIII secolo a Venezia)', *Arte Veneta*, XXI, 1969, pp. 192–201.

SCHARF, 1875 G. Scharf, *A Descriptive and Historical Catalogue of the Pictures at Knowsley Hall*, London, 1875.

SCHILLING, 1989 H. Schilling, *Höfe und Allianzen. Deutschland, 1648–1763 (Das Reich und die Deutschen, V)*, Berlin, 1989.

SCHLEGEL, 1988 U. Schlegel, *Die italienischen Bildwerke des 17. und 18 Jahrhunderts*, Staatliche Museen Preussischer Kulturbesitz, Berlin, 1988.

SCHLEIER, 1982 E. Schleier, 'Sigismund Streit', *Canaletto, Disegini, dipinti, incisioni*, exh. cat. ed. A. Bettagno, Venice, 1982.

SCHLEIER, 1991–2 E. Schleier, 'Sigismund Streit, ein Berliner Kaufmann in Venedig, als Sammler und Auftraggeber zeitgenössischer venezianischer Malerei', *Venedigs Ruhm im Norden*, exh. cat., Hanover and Düsseldorf 1991–2, pp. 32–7.

SCHMITT, 1921 O.E. Schmitt, *Minister Graf Brühl und C.H. von Heinecken. Briefe und Akten, Charakteristiken und Darstellungen zur sächsischen geschichte (1733–1763)*, Leipzig, 1921.

SCHOLZ, 1964 J. Scholz, 'Visiting Venetian Drawings at the National Gallery', *Art Quarterly*, XXVI, 1964, pp. 185–95.

SCHÖNBERGER and SOEHNER, 1960 A. Schönberger and H. Soehner, *Europäisch Rokoko, die Welt des Rokoko, Kunst und Kultur des 18 Jarhunderts*, Munich, 1960.

SCHREIBER, 1974 C. Schreiber, *Sigismund Streit: ein Berliner Kaufmann in Venedig*, Berlin, 1974.

SCHRÖCKER, 1978 A. Schröcker, *Ein Schönborn im Reich: Studien zur Reichs politik des Fürstbischofs Lothar Franz von Schönborn (1655–1729)*, Wiesbaden, 1978.

SCHRÖCKER, 1981 A. Schröcker, *Die Patronage des Lothar Franz von Schönborn (1655–1729)*, Sozialgeschichtliche Studien zum Beziehungsnetz in der Germania sacra, Wiesbaden, 1981.

SCHUDT, 1959 L. Schudt, *Italienreisen im 17 und 18. Jahrhunderts*, Vienna and Munich, 1959.

SCHULZE, 1974 F. Schulze, 'Twilight of the Medici', *Art News*, May 1974, pp. 20–2.

SCIOLLA ed., 1985 G.C. Sciolla, ed, *La collezione d'arte della Biblioteca Reale di Torino. Disegni, Incisioni, manoscritti figurati*, Turin, 1985.

SCOTT, 1973[1] B. Scott, 'Pierre Crozat, a Maecenas of the Régence', *Apollo*, XCVII, 1973, p. 14ff.

SCOTT, 1973[2] B. Scott, 'Pierre-Jean Mariette, Scholar and Connoisseur', *Apollo*, XCVII, 1973, pp. 54–9.

SCOTT, 1975 J. Scott, *Piranesi*, London, 1975.

SELVA, 1776 G. Selva, *Catalogo dei quadri dei disegni e dei libri che trattano dell'arte del disegno della galleria del fu. Sig. Conte Algarotti in venezie*, Venice, 1776.

SEMENZATO, 1956 C. Semenzato, 'Per un catalogo degli scultori Marinali', *La Critica d'Arte*, XVIII, pp. 589–91.

SEMENZATO, 1957[1] C. Semenzato, 'La scultura padovana del 700: Pietro Danieletti', *Padova*, X, 1957.

SEMENZATO, 1957[2] C. Semenzato, 'Giovanni Gloria – Jacopo Gabano – Agostino Fasolato', *Padova*, X, 1957.

SEMENZATO, 1957[3] C. Semenzato, *Antonio Bonazza (1698–1763)*, Venice, 1957.

SEMENZATO, 1964 C. Semenzato, 'Il Gran Teatro di Venezia', in *Meraviglie di Venezia*, ed. R. Pallucchini, Milan, 1964.

SEMENZATO, 1966 C. Semenzato, *La Scultura veneta del Seicento e del Settecento*, Venice, 1966.

SHAPLEY and SUIDA, 1956 F.R. Shapley and W.E. Suida, *Paintings and Sculpture from the Kress Collection*, National Gallery of Art, Washington, 1956.

SHAPLEY, 1973 F.R. Shapley, *Paintings from the Samuel H. Kress Collection: Italian Schools XVI–XVIII Centuries*, 3 vols, London and New York, 1973.

SHAPLEY, 1979 F.R. Shapley, *National Gallery of Art, Washington: Catalogue of the Italian Paintings*, 2 vols., Washington, 1979.

SIDNEY, MELBOURNE and BRISBANE, 1988 *A Study in Genius: Master Drawings and Watercolours from the Collection of Her Majesty The Queen in the Royal Library, Windsor Castle*, exh. cat., ed. J. Roberts, Art Gallery of New South Wales, Sidney; National Gallery of Victoria, Melbourne; Queensland Art Gallery, Brisbane, 1988.

SIMONSON, 1904 G. Simonson, *Francesco Guardi, 1712–1793*, London, 1904.

SIRÉN, 1902 O. Sirén, *Dessins et tableaux de la Renaissance Italienne dans les collections de Suède*, Stockholm, 1902.

SITZMAN, 1957 K. Sitzman, *Kunstler und Kunsthandwerker in Ostfranken*, Kulmbach, 1957.

SPENCER-LONGHURST, 1983 P. Spencer-Longhurst, 'The Golden Jubilee of the Barber Institute', *Apollo*, CXVIII, 1983, pp. 305–7.

STAMPFLE, 1948 F. Stampfle, 'An Unknown Group of Drawings by G.B. Piranesi', *Art Bulletin*, XX, 1948, pp. 121–41.

STEFANI, 1990 O. Stefani, *I rilievi di Canova*, Milan, 1990.

STOCKHOLM, 1915 *Tavlor o. tecknigar äv venetianska malare*, exh. cat., Nationalmuseum, Stockholm, 1915.

STOCKHOLM, 1944 *Äldre italiensk konst ur svenska o. finska samligar*, exh. cat., Nationalmuseum, Stockholm, 1944.

STOCKHOLM, 1962 *Konstens Venedig. Utställning anordnad med anledning av Konung Gustaf VI Adolfs ätioårsdag*, exh. cat., ed. P. Grate, Nationalmuseum, Stockholm, 1962.

STUFFMAN, 1968 M. Stuffman, 'Les tableaux de la collection de Pierre Crozat; Historique et destinée d'un ensemble célèbre, établis en partant de l'inventaire après décès inédit du collectionneur, 30 mai – 8 juin 1740', *Gazette des Beaux-Arts*, LXXII, 1968, pp. 11–144.

STUTTGART, 1953 *Zeichnungen von Giovanni Battista und Domenico Tiepolo in der Graphischen Sammlung der Württembergisches Staatsgalerie, Stuttgart*, exh. cat. by E. Petermann, 1953.

STUTTGART, 1970 *Tiepolo: Zeichnungen von Giambattista, Domenico und Lorenzo Tiepolo aus der Graphischen Sammlung der Staatsgalerie Stuttgart aus württembergischem Privatbesitz und dem Martin von Wagner Museum der Universität Würzburg*, exh. cat. by G. Knox and C. Thiem, Staatsgalerie Stuttgart, 1970.

STUTTGART, 1988 *Meisterwerke der Sammlung Thyssen-Bornemisza Gemälde des 14–18 Jahrhunderts*, Staatsgalerie, Stuttgart, 1988.

SUCCI, 1981 D. Succi, *Le incisioni di Michele Marieschi (1710–1743), vedutista veneziano, con un'acquaforte inedita*, Gorizia, 1981.

SUCCI, 1984 D. Succi, *Venezia nella felicità illuminata delle acqueforti di Antonio Visentini*, Treviso, 1984.

SUCCI, 1988 D. Succi, *Capricci Veneziani del Settecento*, Turin, 1988.

SUCCI, 1992 D. Succi, *Uno straordinario capolavoro commissionato nel 1748 per il Palazzo Dolfin Manin a Rialto*, Bergamo, 1992.

SUCCI, 1993 D. Succi, *Francesco Guardi*, Milan, 1993.

TALBOT, 1993 M. Talbot, ed., *Vivaldi (Master Musicians Series)*, London, 1993.

TAN BUNZL, 1987 Y. Tan Bunzl, *Old Master Drawings*, London, 1987.

TATRAI, ed., 1991 V. Tatrai, ed., *Museum of Fine Arts, Budapest, Old Master's Gallery*, Budapest and London, 1991.

TEMANZA, 1778 T. Temanza, *Vita dei più eccellenti architetti e scultori a Venezia*, Venice, 1778.

THE EARL OF MARCH, 1911 The Earl of March, *A Duke and His Friends: The Life and Letters of the Second Duke of Richmond*, London, 1911.

THIEM, 1993 C. Thiem, 'Lorenzo Tiepolos Position innerhalb der Künstlerfamilie Tiepolo', *Pantheon*, LI, 1993, pp. 138–50.

THIEM, 1994 C. Thiem, article in *Master Drawings*, 1994, forthcoming.

THIEME and BECKER, 1927 U. Thieme and F. Becker, *Künstler Lexicon*, Leipzig, 1907–50.

THOMAS, 1954 H. Thomas, *The Drawings of Giovanni Battista Piranesi*, London, 1954.

THOMAS, 1969 H.A. Thomas, 'Tasso and Tiepolo in Chicago', *Museum Studies*, IV, 1969, pp. 27–48.

TIETZE, 1947 H. Tietze, *European Master Drawings in the United States*, London, 1947.

TODESCATO, 1982 G.M. Todescato, *Origini del santuario della Madonna di Monte Berico*, Vicenza, 1982.

TOLEDANO, 1988 R. Toledano, *Michele Marieschi. L'opera completa*, Milan, 1988.

TORONTO, OTTAWA and MONTREAL, 1964–5 *Canaletto*, exh. cat. by W.G. Constable, The Art Gallery of Toronto; The National Gallery of Canada, Ottawa; The Museum of Fine Arts, Montreal, 1964–5.

TRENT, 1990 *Disegni veneziani dalle collezioni del Museo Correr*, Castello del Buonconsiglio, Trent, 1990.

TREVISO, 1957 *Mostra Canoviana*, Palazzo dei Trecento, Treviso, 1957.

TUA, 1934 C. Tua, 'Orazio Marinali e le statua da giardino', *Illustrazione Italiana*, V, 1934.

TUA, 1935[1] C. Tua, 'Orazio Marinali e i suoi tre fratelli', *Rivista d'Arte*, XVII, iii, 1935, pp. 281–322.

TUA, 1935[2] P.M. Tua, 'Alcune opere di poco note di Orazio Marinali', *Rivista di Venezia*, XIV, iii, 1935, pp. 99–106.

TUNICK, 1981 D. Tunick, *Italian Prints of the Eighteenth Century: The Illustrated Bartsch, XI*, New York, 1981.

TURIN, 1951 *La moda in cinque secoli di pittura*, exh. cat., Turin, 1951.

TURIN, 1988 *Capricci veneziani del Settecento*, exh. cat., ed. D. Succi, Turin, 1988.

TURIN, 1989 *Marieschi: Tra Canaletto e Guardi*, exh. cat, ed. D. Succi, Turin, 1989.

TURIN, 1989–90 *Da Leonardo a Rembrandt: Disegni della Biblioteca Reale di Torino*, exh. cat. ed. A. Bettagno, Biblioteca Reale, Turin, 1989–90.

UDINE, 1965 *Disegni del Tiepolo*, exh. cat. by A. Rizzi, Loggia del Lionello, Udine, 1965.

UDINE, 1966 *Mostra della pittura veneta del '700 in Friuli*, exh. cat., Udine, 1966.

UDINE, 1971 *Mostra del Tiepolo, Dipinti, Disegni e Acqueforti*, exh. cat. by A. Rizzi, Villa Manin di Passariano, Udine, 1971.

UDINE and ROME 1963–4 *Disegni, incisioni e bozzetti del Carlevarijs*, exh. cat., Udine and Rome, 1963–4.

UDINE, 1975[1] *Sebastiano Ricci Disegnatore*, exh. cat. by A. Rizzi, Biennali d'Arte Antica, Udine, 1975.

UDINE, 1975[2] *Atti del Congresso internazionale di studi su Sebastiano Ricci e il suo tempo*, Biennale d'Arte Antica, Udine, 1975.

UDINE, 1989 *Sebastiano Ricci*, exh. cat. by A. Rizzi, Villa Manin di Passariano, Udine, 1989.

UDINE and ROME, 1963–4 *Disegni incisioni e bozzetti del Carlevarijs*, exh. cat. by A. Rizzi, Udine and Rome, 1963–4.

URREA, 1988 J. Urrea, 'Una famiglia di pittori veneziani in Spagna: I Tiepolo', *Venezia e la Spagna*, Milan, 1988, pp. 221–52.

VALCANOVER, 1954 *Pitture del Settecento nel Bellunese*, exh. cat., Palazzo dei Vescovi, Belluno, 1954.

VALCANOVER, 1964 F. Valcanover, *Pietro Longhi*, I maestri del colore, Milan, 1964.

VENDRAMINI, 1779 F. Vendramini, *Descrizione dell'architetture, pitture e sculture di Vicenza*, Vicenza, 1779.

VENICE, 1929 *Il settecento Italiano*, exh. cat., Palazzo dei Giardini, Venice, 1929.

VENICE, 1937 *Le feste e le maschere veneziane*, exh. cat. by G. Lorenzetti, Ca' Rezzonico, Venice, 1937.

VENICE, 1941 *Mostra degli incisori veneti del Settecento*, exh. cat. by R. Pallucchini, Venice, 1941.

VENICE, 1945 *Cinque secoli di pittura veneta*, Venice, 1945.

VENICE, 1946 *I Capolavori dei Musei Veneti*, exh. cat., by R. Pallucchini, Procuratie Nuove, Venice, 1946.

VENICE, 1951 *Tiepolo*, exh. cat., by G. Lorenzetti, Palazzo Ducale, Venice, 1951.

VENICE, 1954 *Pittura del Settecento nel Bellunese*, exh. cat. by F. Valcanover, Venice, 1954.

VENICE, 1955 *Il Libro illustrato nel settecento a Venezia*, exh. cat., ed. T. Gasparrini Leporace, Venice, 1955.

VENICE, 1957 *Disegni veneti della collezione Janos Scholz*, exh. cat. by M. Muraro, Fondazione Giorgio Cini, Venice, 1957.

VENICE, 1958 *Disegni veneti di Oxford*, exh. cat., by K.T. Parker, Fondazione Giorgio Cini, Venice, 1958.

VENICE, 1961 *Disegni veneti dell'Albertina di Vienna*, exh. cat. ed. O. Benesch, Fondazione Giorgio Cini, Venice, 1961.

VENICE, 1962 *Canaletto e Guardi: catalogo della mostra di disegni*, exh. cat. by K.T. Parker and J. Byam Shaw, Fondazione Giorgio Cini, Venice, 1962.

VENICE, 1963 *Disegni Veneti della Fondazione Cini e delle collezione venete*, exh. cat. by A. Bettagno, Fondazione Giorgio Cini, Venice, 1963.

VENICE, 1964 *Disegni veneti del Settecento nel Museo Correr di Venezia*, exh. cat. by T. Pignatti, Fondazione Giorgio Cini, Venice, 1964.

VENICE, 1965[1] *Mostra dei Guardi*, exh. cat. by P. Zampetti, Palazzo Grassi, Venice, 1965.

VENICE, 1965[2] 'Problemi Guardeschi', *Atti del Convegno di Studi Promossi della mostra dei Guardi, Venezia 13–14 settembre 1965*.

VENICE, 1967 *I vedutisti veneziani del Settecento*, ex. cat. by P. Zampetti, Palazzo Ducale, Venice, 1967.

VENICE, 1969 *Dal Ricci al Tiepolo: I pittori di figura del Settecento a Venezia*, exh. cat. by P. Zampetti, Palazzo Ducale, Venice, 1969.

VENICE, 1971 *Arte a Venezia*, exh. cat. by G. Mariacher, Palazzo Ducale, Venice, 1971.

VENICE, 1976 *Aspetti dell'incisione veneziana del Settecento*, exh. cat., ed. G. Dillon, Venice, 1976.

VENICE, 1978[1] *Venezia nell'età di Canova 1780–1830*, exh. cat. by E. Bassi et al., Museo Correr, Venice, 1978.

VENICE, 1978[2] *I giochi veneziani del Settecento nei dipinti di Gabriel Bella*, exh. cat. by M. Gambier, M. Gemin and E. Merkel, Fondazione Querini Stampalia, Venice, 1978.

VENICE, 1978[3] *Disegni di Giambattista Piranesi*, exh. cat., Fondazione Giorgio Cini, Venice, 1978.

VENICE, 1979 *Tiepolo, tecnica e immaginazione*, exh. cat., Palazzo Ducale, Venice, 1979.

VENICE, 1980 *Disegni veneziani di collezioni inglesi*, exh. cat. by J. Stock, Fondazione Giorgio Cini, Venice, 1980.

VENICE, 1982 *Canaletto: Disegni, Dipinti, Incisioni*, exh. cat. ed. by A. Bettagno et al., Fondazione Giorgio Cini, Venice, 1982.

VENICE, 1983[1] *Giambattista Piazzetta: Il suo tempo, la sua scuola*, exh. cat. by U. Ruggieri, Fondazione Giorgio Cini, Venice, 1983.

VENICE, 1983[2] *Da Carlevarijs ai Tiepolo: Incisori veneti e friulani del Settecento*, exh. cat., Venice, 1983.

VENICE, 1983[3] *Piazzetta, disegni, incisioni, libri e manoscritti*, exh. cat., Fondazione Giorgio Cini, 1983.

VENICE, 1985 *Disegni dalle collezioni del Museo Correr, XV–XVIII secoli*, exh. cat., ed. E. Chigi, A. Dorigato and G. Romanelli, Fondazione, Giorgio Cini, Venice 1985.

VENICE, 1986 *Bernardo Bellotto: Le vedute di Dresda. Dipinti e incisioni dal musei di Dresda*, exh. cat. by A. Bettagno, Fondazione Giorgio Cini, Venice, 1986.

VENICE, 1987 *Vedute veneziane del '700 in collezioni private italiane*, Museo Diocesano d'Arte Sacra, Venice, 1987.

VENICE, 1988 *I Tiepolo: Virtuosisimo e ironia*, exh. cat., Mirano, Venice, 1988.

VENICE, 1989 *Tiepolo, technica e immaginazione*, exh. cat., Doge's Palace, Venice, 1989.

VENICE, 1992[1] *Da Pisanello a Tiepolo: Disegni veneti dal Fitzwilliam Museum di Cambridge*, exh. cat. by D. Scrase, Fondazione Giorgio Cini, Venice, 1992.

VENICE, 1992[2] *Antonio Canova*, exh. cat., ed. G. Pavanello and G. Romanelli, Museo Correr, Venice, 1992.

VENICE, 1993[1] *Guardi: Vedute Capricci Feste*, exh. cat. by A. Bettagno et al., Fondazione Giorgio Cini, Venice, 1993.

VENICE, 1993[2] *Guardi: Quadri Turcheschi*, exh. cat. by A. Bettagno et al., Galleria di Palazzo Cini, Venice, 1993.

VENICE, 1993[3] *Pietro Longhi*, exh. cat., Museo Correr, Venice, 1993.

VENICE and GORIZIA, 1983 *Da Carlevarijs ai Tiepolo: Incisioni veneti e friulani del Settecento*, exh. cat. by D. Succi, Museo Correr, Venice, and Palazzo Attems, Gorizia, 1983.

VENICE and GORIZIA, 1986–7 *Canaletto e Visentini, Venezia e Londra*, exh. cat. by D. Succi, Ca' Pesaro, Venice and Gorizia, 1986–7.

VERCI, 1775 G. Verci, *Notizie intorno alla vita e alle opere de' pittori, scultori e intagliatori della città de Bassano*, Venice, 1775.

VERONA, 1978 *La pittura a Verona tra Sei e Settecento*, exh. cat. by F. D'Arcais, Verona, 1978.

VERONA, 1985 *La collezione di antiche stampe*, exh. cat., Museo di Castelvecchio, Verona, 1985.

VERONA, 1990 *Bernardo Bellotto. Verona e le città europee*, exh. cat., Museo di Castelvecchio, Verona, 1990.

VERTUE, 1713, ed. 1786, 1929–50 G. Vertue, 'Notebooks', *Walpole Society*, XVIII–XXX, 1929–50.

VEY, 1963 H. Vey, 'Die Gemälde des Kurfürsten Clemens August', *Wallraf-Richartz Jahrbuch*, XXV, 1963, pp. 193–226.

VICENZA, 1990 *I Tiepolo e il Settecento vicentino*, exh. cat. by F. Barbieri, Vicenza, Montecchio Maggiore and Bassano del Grappa, 1990.

VICENZA, 1993 *Restituzioni 93*, exh. cat., Palazzo Leoni Montanari, Vicenza, 1993.

VIENNA, 1965 *Bernardo Bellotto genannt Canaletto*, exh. cat., Obers Belvedere, Vienna, 1965.

VIGNI, 1942, 1972 G. Vigni, *Disegni del Tiepolo*, 1942, 2nd edition, Trieste, 1972.

VIVIAN, 1966 F. Vivian, *Joseph Smith, Patron and Collector*, University of London, PhD. Thesis, 1966.

VIVIAN, 1971 F. Vivian, *Il Console Smith, mercenate e collezionista*, Vicenza, 1971.

VIVIAN, 1989 F. Vivian, *The Consul Smith Collection*, exh. cat., Munich, 1989.

VLIET, 1966 P. van Vliet, 'Spaanso schilderijen in het Rijksmuseum, afkomstig van schenkingen van Koning Willem I', *Bulletin van het Rijksmuseum*, IV, 1966, pp. 131–60.

VOSS, 1918 H. Voss, 'Jacopo Amigoni und die Anfänge der Malerei des Rokoko in Venedig', *Jahrbuch der Preussischen Kunstsammlungen*, XXXIX, 1918, pp. 145–70.

VOSS, 1922 A. Voss, 'Uber Tiepolos Jugendentenwicklung', *Kunst und Kunstler*, XX, 1922, p. 426.

VOSS, 1926 A. Voss, 'Studien zur venzianischen Veduten malerei des XVIII Jahr', *Repertorium für Kunstwissenschaft*, 1926, pp. 13–45.

WAAGEN, 1854 H. Waagen, *Treasures of Art in Great Britain*, 3 vols, London, 1854.

WALKER, 1979 R.J.B. Walker, *Old Westminster Bridge*, Newton Abbot, 1979.

WALLIS and WALLIS, 1977 P. Wallis and R. Wallis, *Newton and Newtoniani: A Bibliography*, Folkestone, 1977.

WALPOLE, ed. 1849 H. Walpole, *Anecdotes of Painting in England*, ed. R.N. Wornum, London, 1849.

WANDRUSZKA, 1963 A. Wandruszka, *Österreich und Italien im 18. Jahrhundert*, Munich, 1963.

WARD-JACKSON, 1980 P. Ward-Jackson, *Victoria and Albert Museum Catalogues, Italian Drawings, II: 17th–18th Century*, London, 1980.

WARDWELL and DAVIDSON, 1966 A. Wardwell and M. Davidson, 'Three Centuries of the Decorative Arts in Italy', *Apollo*, LXXXIV, 1966, pp. 178–89.

WARNKE, 1985 M. Warnke, *Hofkünstler. Zur Vorgeschichte des modernen Künstlers*, Cologne, 1985.

WARSAW, 1956 *Wystawa malarstwa wloskiego w zbiorach polskich*, exh. cat., National Museum, Warsaw, 1956.

WARSAW, 1962 *Szluka warzawska od sredniowiecza do polowy XX wieku*, exh. cat., National Museum, Warsaw, 1962.

WARSAW, 1968 *Malarstwo weneckie XV–XVIII wieku*, *Nationalmuseum Warschau*, exh. cat., National Museum, Warsaw, 1968.

WASHINGTON, 1950 *European Pictures from the Gulbenkian Collection*, exh. cat., National Gallery of Art, Washington, 1950.

WASHINGTON, 1971–2 *Rare Etchings by Giovanni Battista and Giovanni Domenico Tiepolo*, exh. cat. by H. Diane Russell, National Gallery of Art, Washington, 1971–2.

WASHINGTON, 1974 *Recent Acquisitions and Promised Gifts*, National Gallery of Art, Washington, 1974.

WASHINGTON, 1978 *Master Drawings from the Collection of the National Gallery of Art and Promised Gifts*, exh. cat. by A. Robison, Washington, 1978.

WASHINGTON, 1983 *Piazzetta: A Tercentenary Exhibition*, exh. cat. by G. Knox, National Gallery of Art, Washington, 1983.

WASHINGTON, 1987 *Master Drawings from the Armand Hammer Collection*, exh. cat. by A. Robison et al., National Gallery of Art, Washington, 1987.

WASHINGTON, forthcoming *The Collections of the National Gallery of Art Systemic Catalogue: Italian Paintings of the 17th and 18th Centuries*, ed. D. De Grazia, National Gallery of Art, Washington, forthcoming.

WASHINGTON et al., 1963–4 *Venetian Eighteenth-century Drawings from the Correr Museum*, exh. cat. by T. Pignatti, National Gallery of Art, Washington, et. al., 1963–4.

WASHINGTON, FORT WORTH and ST LOUIS, 1979–81 *Old Master Paintings from the Collection of Baron Thyssen-Bornemisza*, exh. cat. by A. Rosenbaum, National Gallery of Art, Washington; Kimbell Art Museum, Fort Worth; St Louis Art Museum, 1979–81.

WASHINGTON, NEW YORK and SAN FRANCISCO, 1978–9 *The Splendor of Dresden: Five Centuries of Art Collecting*, exh. cat., National Gallery of Art, Washington; The Metropolitan Museum of Art, New York; The Fine Arts Museum of San Francisco, California Palace of The Legion of Honor, 1978–9.

WASHINGTON and NEW YORK, 1986 *The Age of Bruegel: Netherlandish Drawings in the Sixteenth Century*, exh. cat. by J.O. Hand, J.R. Judson, W.M. Robinson and M. Wolff, National Gallery of Art, Washington, and The Pierpont Morgan Library, New York, 1986.

WASHINGTON and CINCINNATI, 1988–9 *Masterpieces from Munich*, exh. cat. by B.L. Brown and A.K. Wheelock, Jr., National Gallery of Art, Washington, and Cincinnati Art Museum, 1988–9.

WATERHOUSE, 1967 E.K. Waterhouse, *Catalogue of Paintings in the James A. de Rothschild Collection at Waddesdon Manor*, Freiburg, 1967.

WATSON, 1948 F.J.B. Watson, 'Sebastiano Ricci as a Pasticheur', *The Burlington Magazine*, XC, 1948, p. 290.

WATSON, 1949, 1954 F.J.B. Watson, *Canaletto*, London and New York, 1949; 2nd ed, 1954.

WATSON, 1950 F.J.B. Watson, 'Canaletto and Brustolon', *The Burlington Magazine*, XCII, 1950.

WATSON, 1953[1] F.J.B. Watson, 'G.B. Cimaroli: A Collaborator of Canaletto', *The Burlington Magazine*, XCV, 1953, pp. 205–7.

WATSON, 1953[2] F.J.B. Watson, 'An Allegorical Painting by Canaletto, Piazzetta and Cimaroli', *The Burlington Magazine*, XCV, 1953, pp. 362–5.

WATSON, 1960 F.J.B. Watson, 'A Series of Turqueries by Francesco Guardi', *Baltimore Museum of Art News*, XXIV, 1960, pp. 3–13.

WATSON, 1968 R. Watson, 'Guardi and the visit of Pius VI to Venice in 1782', *Report and Studies in the History of Art*, Washington, II, 1968, pp. 114–41.

WAZBINSKI, 1971 Z. Wazbinski, 'Mariae Himmelfahrt von Sebastiano Ricci für die Karlskirche in Wien', *Wiener Jahrbuch der Kunstgeschichte*, XXIV, 1971, pp. 101–6.

WEHLE, 1941 H.B. Wehle, 'A Fantastic Landscape by Guardi', *Metropolitan Museum Bulletin*, XXXVI, 1941, pp. 153–9.

WEIMAR, 1987 *Von jenseit der Alpen. Venetianische Zeichnungen von 15. bis zum 19. Jahrhundert aus der Sammlung des Museo Correr Venedig*, exh. cat., Weimar, 1987.

WESSEL, 1984 T. Wessel, *Sebastiano Ricci und die Rokokomalerei*, Freiburg, 1984.

WHEELER, 1960 C. Wheeler, *Italian Paintings from British Collections*, London, 1960.

WHISTLER, 1985 C. Whistler, 'G.B. Tiepolo and Charles III: The Church of S. Pascual Baylon at Aranjuez', *Apollo*, CXXI, 1985, pp. 321–7.

WHISTLER, 1986 C. Whistler, 'G.B. Tiepolo at the Court of Charles III', *The Burlington Magazine*, CXVIII, 1986, pp. 199–203.

WHISTLER, 1993 C. Whistler, 'Aspects of Domenico Tiepolo's early Career', *Kunstchronik*, August 1993, pp. 385–98.

WHITE, 1960 E.W. White, 'The Rehearsal of an Opera', *Theatre Notebook*, 1960, XIV, no. 3.

WHITLEY, 1928 W.T. Whitley, *Art in England, 1800–1820*, London, 1928.

WIEDER, 1967 J. Wieder, 'Die erste Gesamtsansgabe von Dante's *Opere* 1757–8 und ihre illustration', *Festschrift Otto Schafer zum 75 Geburstag*, Stuttgart, 1967, pp. 329–83.

WIEMANN, 1989 E. Wiemann, *Italienische Malerei*, Stuttgart, 1989.

WIESBADEN, 1935 *Italienische Malerei der 17 und 18 Jahrhunderts*, exh. cat. by H. Voss, Wiesbaden, 1935.

WILLIAMSTOWN, 1979 *Master Drawings from the Collection of Ingrid and Julius S. Held*, Williamstown, 1979.

WILTON-ELY, 1978 J. Wilton-Ely, *The Mind and Art of Giovanni Battista Piranesi*, London, 1978.

WILTON-ELY, 1993 J. Wilton-Ely, *Piranesi as Architect and Designer*, New York, 1993.

WITTKOWER, 1958, 1973 R. Wittkower, *Art and Architecture in Italy 1600–1750*, The Pelican History of Art, London, 3rd ed. 1973.

WOOLF and GANDON, 1767 J. Woolf and J. Gandon, *Vitruvius Britannicus*, IV, 1767.

WRIGHT, 1976 C. Wright, *Old Master Paintings in Britain: An Index of Continental Old Master Paintings executed before c. 1800 in Public Collections in the United Kingdom*, London, 1976.

YOUNG, 1977 E. Young, 'Michele Marieschi: Another signed view of Venice and his capricci of Palace or Prison interiors', *The Connoisseur*, Sept–Oct. 1977, pp. 3–11.

ZAFRAN, 1978 E. Zafran, 'From the Renaissance to the Grand Tour', *Apollo*, 1978, pp. 242–53.

ZAMPETTI, 1969–70 P. Zampetti, 'Il testamento di Sebastiano Ricci', *Arte Veneta*, XIV, 1969–70, pp. 229–31.

ZAMPETTI, 1971 P. Zampetti, *A Dictionary of Venetian Painters*, 4 vols, Leigh-on-Sea 1971.

ZANETTI, 1733 A.M. Zanetti, *Descrizione di tutte le pubbliche pitture della Città di Venezia e isole circonvicine …*, Venice, 1733.

ZANETTI, 1771, 1792 A.M. Zanetti, *Della Pittura Veneziana e delle Opere Pubbliche dei veneziani maestri*, Venice, 1771, 2nd ed., 1792.

ZANNANDREIS, 1891 D. Zannandreis, *Vite dei pittori, scultori e architetti veronesi*, ed. G. Biadego, Verona, 1891.

ZAVA BOCCAZZI, 1974 F. Zava Boccazzi, 'Per il catalogo di Giambattista Pittoni: proposte e inediti', *Arte Veneta*, XXVIII, 1974, pp. 179–204.

ZAVA BOCCAZZI, 1979 F. Zava Boccazzi, *Pittoni*, Venice, 1979.

ZEITLER, 1954 R. Zeitler, *Klassicismus und Utopia*, Stockholm, 1954.

ZERI and GARDNER, 1973, F. Zeri and E. Gardner, *Italian Paintings in the Metropolitan Museum of Art: Venetian School*, Metropolitan Museum of Art, New York, 1973.

ZORZI 1972 A. Zorzi, *Venezia scomparsa*, Milan, 1972, pp. 603–4.

ZUGNI TAURO, 1971 A.P. Zugni Tauro, *Gaspare Diziani*, Venice, 1971.

# Photographic Credits

All works of art are reproduced by kind permission of the owners. Specific acknowledgements are as follows:

Barcelona, MNAC Photographic Service (Calveras/Sagristà), cat. 222
Riccardo Baros, New Jersey, cat. 171
Dean Beasom, USA, cat. 26, 29, 32, 36, 49, 96, 99, 101, 109, 112, 122, 170, 173, 179, 214, 224, 230, 251, 252
Berlin, Jörg P. Anders, cat. 51, 116, 117, 142, 180
Birmingham, The City of Birmingham Museum and Art Gallery, cat. 135
Michael Bodycomb, USA, cat. 107, 125
Herbert Boswank, Dresden cat. 111
Riccardo Carafelli, USA, cat. 114, 128, 191
Cathy Carver, cat. 241
Chatsworth Photo Library, cat. 3
Philip A. Charles, USA, cat. 141
Chicago, © 1994 The Art Institute of Chicago, cat. 42, 90, 250, fig. 5
Cologne, Rheinisches Bildarchiv, cat. 78
Dresden, Hufu Haus, Hans Peter Klut, cat. 255, 260
Edinburgh, Antonia Reeve Photography, cat. 56, 104
Luciano Fincato, Padua, cat. 156
Florence, Archivi Alinari, fig. 6
Florence, Scala, cat. 1, 195 (detail)
Richard Foley, USA, cat. 84
Heidelberg-Dielheim, © Edm. von König GmbH & Co. Kg, fig. 1
Dénes Jósza, Budapest, cat. 113, 161
Ingeborg Klinger, Heidelberg, cat. 219
London, Christie's Images, cat. 167, 168
London, The Conway Library, Courtauld Institute of Art, cat. 291; fig. 13
London, A.C. Cooper Ltd., cat. 45, 246
London, Prudence Cuming Associates Ltd., cat. 4, 38, 59, 77, 91, 144, 159, 160, 174, 188, 194, 210, 211
London, Photo courtesy of the Trustees of the V&A/Photographer P. de Bay, cat. 19, 20, 21, 110, 165, 258, 259; fig. 69
Madrid, © Patrimonio Nacional, fig. 56
Gianni Mari, Milan, fig. 35
Jane Martineau, fig. 40
Brian Merret, MBAM/MMFA, Montreal, cat. 92
Milan, Luca Carrá, cat. 41, 46
Milan, Saporetti, cat. 66
Munich, Alte Pinakothek, cat. 201; fig. 34
New York, Photograph Services, The Metropolitan Museum of Art, cat. 225
Paris, Réunion des Musées Nationaux, cat. 204, fig. 11
Ken Pelka, USA, cat. 130, 206
Peissenberg, Artothek, cat. 201
Prague, Fotografoval Cestmir, cat. 133
András Rázsó, Budapest, cat. 9
Rome, Photo courtesy of Christie's, Rome, cat. 60
Rome, Foto Industrial, lda. cat. 132
The Royal Collection, © 1994 Her Majesty The Queen, cat. 7, 10, 28, 30, 31, 35, 45, 47, 48, 64, 136, 137, 146, 147, 184; fig. 24, 42, 47
Rodney Todd-White, UK, cat. 184
Turin, Umberto Viani fotografo, cat. 81
Venice, Archivio Veneziano, © Sarah Quill, fig. 8, 9
Venice, Gabinetto Fotografico, Soprintendenza ai Monumenti Medioevali e Moderni, fig. 29
Venice, Foto Bertarello, cat. 153
Venice, Osvaldo Böhm, cat. 8, 11, 12, 16, 17, 18, 44, 58, 70, 72, 74, 76, 93, 94, 118, 134, 148, 152, 178, 181, 182, 183, 185, 186, 189, 196, 198, 202, 109, 238, 242, 244, 289, 290, 291; fig. 7, 20, 48, 49, 50, 53, 54, 55
Venice, Cameraphoto, fig. 18
Venice, Fondazione Giorgio Cini, Istituto di Storia dell'Arte, fig. 28
Venice, Mimmo Jodice, cat. 188, 284, 285, 286, 287
Reinaldo Viejus, Lisbon, cat. 205
Vicenza, Fototecnica, cat. 57, 75, 102
Vienna, Bundesdenkmalamt, fig. 12
Vienna, K. Photoservice, cat. 236
Elke Walford, Hamburg, cat. 2, 261

# INDEX: *Biographies & Catalogue Entries*